Volume Two
Art History

VOLUME TWO
ART HISTORY
Marilyn Stokstad
University of Kansas

with the collaboration of
Marion Spears Grayson
and with chapters by Stephen Addiss,
Bradford R. Collins, Chu-tsing Li,
Marylin M. Rhie,
and Christopher D. Roy

Prentice Hall, Inc., and Harry N. Abrams, Inc., Publishers

To my sister, Karen L.S. Leider, and my niece, Anna J. Leider

Publishers: *Paul Gottlieb, Bud Therien*
Project management and editorial direction: *Julia Moore*
Project consultation: *Jean Smith*
Developmental editing, Prentice Hall: *David Chodoff*
Developmental editing, Abrams: *Ellyn Childs Allison, Sabra Maya Feldman, Mark Getlein, James Leggio, Sheila Franklin Lieber, Julia Moore, Diana Murphy, Jean Smith, Elaine Banks Stainton*
Art direction: *Samuel N. Antupit, Lydia Gershey*
Design and production: *Lydia Gershey, Yonah Schurink of Communigraph*
Photo editing, rights and reproduction: *Lauren Boucher, Jennifer Bright, Helen Lee, Catherine Ruello*
Marketing strategy, Prentice Hall: *Alison Pendergast*
Market research, Prentice Hall: *Seth Reichlin*
Maps and timelines: *York Production Services*
Illustration: *John McKenna*
Copy editing: *Richard G. Gallin, Joanne Greenspun*
Project editing: *Kate Norment, Denise Quirk*
Indexing: *Peter and Erica Rooney*
Glossary: *Rebecca Tucker*
Editorial assistance, Prentice Hall: *Marion Gottlieb*
Project assistance, Abrams: *Monica Mehta*
Project assistance, Prentice Hall: *Lee Mamunes*

Library of Congress Cataloging-in-Publication Data

Stokstad, Marilyn, 1929–
 Art history / Marilyn Stokstad, with the collaboration of Marion Spears Grayson; and with
 contributions by Stephen Addiss . . . [et al.].
 p. cm.
 Includes bibliographical references and index.
 ISBN 0–8109–1960–5 (Abrams hardcover). —ISBN 0–13–357542–X (Prentice Hall hardcover).
 ISBN 0–13–357500–4 (paperback, vol. 1). —ISBN 0–13–357527–6 (paperback, vol. 2).
 1. Art—History. I. Grayson, Marion Spears. II. Addiss, Stephen, 1935– . III. Title.
 N5300.S923 1995
 709—dc20 95–13402
 CIP

Printed and bound in Japan

On the cover and pages 2–3: Robert Delaunay. *Homage to Blériot.* 1914. Tempera on canvas. Kunstmuseum, Basel, Switzerland (details of fig. 28-46)

On the chapter-opening pages: 610–611, Laurana, Courtyard of the Ducal Palace, Urbino (detail of fig. 17-59); 678–679, Brueghel the Elder, *Carrying of the Cross* (detail of fig. 18-57); 748–749, Peeters, *Still Life with Flowers, Goblet, Dried Fruit, and Pretzels* (detail of fig. 19-44); 820–821, page from *Hamza-nama,* a Mughal manuscript from North India (detail of fig. 20-5); 834–835, Shitao, *Landscape,* from a Qing dynasty album (detail of fig. 21-12); 852–853, contemporary Japanese ceramic vessels (detail of fig. 22-16); 872–873, Machu Picchu, Peru (detail of fig. 23-7); 892–893, feather cloak, from Hawaii (detail of fig. 24-11); 908–909, Ashanti *kente* cloth, from Ghana (detail of fig. 25-11); 926–927, Turner, *The Fighting 'Téméraire'* (detail of fig. 26-28); Renoir. *Moulin de la Galette* (detail of fig. 27-47); Robert Delaunay, *Homage to Blériot* (detail of fig. 28-46); Paik, *Electronic Superhighway* (detail of illustration on page 1156)

Brief Contents

Preface

I have been privileged to teach art history for nearly four decades. Over that time I have become persuaded that our purpose in the introductory course should not be to groom scholars-to-be but rather to nurture an educated, enthusiastic public for the arts. I have also come to believe that we are not well-enough served by the major introductory textbooks presently available, all of which originated two or more generations ago. What is needed is a new text for a new generation of teachers and students, a text that balances formalist traditions with the newer interests of contextual art history and also meets the needs of a diverse and fast-changing student population. In support of that philosophy I offer *Art History*.

I firmly believe students should *enjoy* their art history survey. Only then will they learn to appreciate art as the most tangible creation of the human imagination. To this end we have sought in many ways to make *Art History* a sensitive, accessible, engaging textbook.

We have made *Art History* contextual, in the best sense of the term. Throughout the text we treat the visual arts not in a vacuum but within the essential contexts of history, geography, politics, religion, and culture; and we carefully define the parameters—social, religious, political, and cultural—that either constrained or liberated individual artists.

Art History **is both comprehensive and inclusive.** Our goal has been to reach beyond the West to include a critical examination of the arts of other regions and cultures, presenting a global view of art through the centuries. We cover not only the world's most significant paintings and works of sculpture and architecture but also drawings, photographs, works in metal and ceramics, textiles, and jewelry. We have paid due respect to the canon of great monuments of the history of art, but we also have treated artists and artworks not previously acknowledged. We have drawn throughout on the best and most recent scholarship, including new discoveries (the prehistoric cave paintings in the Ardèche gorge in southern France, for example) and new interpretations of well-known works. And, bearing in mind the needs of undergraduate readers, we have sought wherever feasible to discuss works on view in many different museums and collections around the United States, including college and university museums.

No effort has been spared to make this book a joy to read and use—in fact, to make it a work of art in itself. Chapter introductions set the scene for the material to come, frequently making use of contemporary references to which readers can easily relate. While the text carries the central narrative of *Art History*, set-off boxes present interesting and instructive material that enriches the text. A number of thought-provoking boxes focus on such critical issues as "the myth of 'primitive' art" and the way the titles given to works of art may affect our perception of them. Other boxes provide insights into contextual influences, such as women as art patrons, the lives of major religious leaders, and significant literary movements. **Elements of Architecture** boxes explicate basic architectural forms and terminology.

Technique boxes explore how artworks have been made, from prehistoric cave paintings to Renaissance frescoes to how photography works. **Maps and timelines** visually place artworks in time and space, and time scales on each page let readers know where they are within the period each chapter covers. A **Parallels** feature in every chapter presents comparative information in tabular form that puts the major events and artworks discussed in that chapter in a global context. Finally, *Art History* includes **an unprecedented illustration program** of some 1,350 photographs—more than half in full color and some not published before—as well as hundreds of original line drawings (including architectural plans and cutaways) that have been created specifically for this book.

In addition, a complete ancillary package, including slide sets, CD-ROM, videodisc, videos, a student Study Guide, and an Instructor's Resource Manual with Test Bank, accompanies *Art History*.

Art History **represents the joint effort of a distinguished team of scholars and educators.** Single authorship of a work such as this is no longer a viable proposition: our world has become too complex, the research on and interpretation of art too sophisticated, for that to work. An individual view of art may be very persuasive—even elegant—but it remains personal; we no longer look for a single "truth," nor do we hold to a canon of artworks to the extent we once did. An effort such as this requires a team of scholar-teachers, all with independent views and the capability of treating the art they write about in its own terms and its own cultural context. The overarching viewpoint—the controlling imagination—is mine, but the book would not have been complete without the work of the following distinguished contributing authors:

Stephen Addiss, Tucker Boatwright Professor in the Humanities at the University of Richmond, Virginia

Bradford R. Collins, Associate Professor in the Art Department, University of South Carolina, Columbia

Chu-tsing Li, Professor Emeritus at the University of Kansas, Lawrence

Marylin M. Rhie, Jessie Wells Post Professor of Art and Professor of East Asian Studies at Smith College

Christopher D. Roy, Professor of Art History at the University of Iowa in Iowa City

Finally, the book would not have been possible without the substantial efforts of Marion Spears Grayson, an independent scholar with a Ph.D. from Columbia University who previously taught at Tufts University and Rice University. Her refinements and original contributions greatly enhanced the overall presentation. The book has also benefited greatly from the invaluable assistance and advice of scores of other scholars and teachers who have generously answered my questions, given their recommendations on organization and priorities, and provided specialized critiques.

Acknowledgments

Writing and producing this book has been a far more challenging undertaking than any of us originally thought it would be. Were it not for the editorial and organizational expertise of Julia Moore, we never would have pulled it off. She inspired, orchestrated, and guided the team of editors, researchers, photo editors, designers, and illustrators who contributed their talents to the volume you now hold. Paul Gottlieb and Bud Therien convinced me to undertake the project, and with Phil Miller were unfailingly supportive throughout its complex gestation. A team of developmental editors led by David Chodoff at Prentice Hall and Jean Smith at Abrams refined the final manuscript to make it clear and accessible to students. Special thanks are due to Ellyn Childs Allison, Sheila Franklin Lieber, and Steve Rigolosi for their careful developmental work during the crucial early stages; to Mark Getlein for his extraordinary care in developing the chapters on Asian and African art; and to Gerald Lombardi for his work on the chapters on Western art since the Renaissance. Photo researchers Lauren Boucher, Jennifer Bright, Helen Lee, and Catherine Ruello performed miracles in finding the illustrations we needed—and, because of their zeal in finding the best pictures, sometimes helped us see what we wanted. John McKenna's drawings have brought exactly the right mix of information, clarity, and human presence to the illustration program. Special thanks also to Nancy Corwin, who was an essential resource on the history of craft, and to Jill Leslie Furst for her assistance on the chapters on the art of Pacific cultures and the art of the Americas. Designer Lydia Gershey and associate Yonah Schurink have broken new ground with their clear and inviting design and layout. Alison Pendergast, marketing manager, contributed many helpful insights as the book neared completion. My research assistants at the University of Kansas, Katherine Giele, Richard Watters, and Michael Willis, have truly earned my everlasting gratitude.

Every chapter has been read by one or more specialists: Barbara Abou-El-Haj, SUNY Binghamton; Jane Aiken, Virginia Polytechnic; Vicki Artimovich, Bellevue Community College; Elizabeth Atherton, El Camino College; Ulku Bates, Columbia University; Joseph P. Becherer, Grand Rapids Community College; Janet Catherine Berlo, University of Missouri, St. Louis; Roberta Bernstein, SUNY Albany; Edward Bleiberg, University of Memphis; Daniel Breslauer, University of Kansas; Ronald Buksbaum, Capital Community Technical College; Petra ten-Doesschate Chu, Seton Hall University; John Clarke, University of Texas, Austin; Robert Cohon, The Nelson-Atkins Museum of Art; Frances Colpitt, University of Texas, San Antonio; Lorelei H. Corcoran, University of Memphis; Ann G. Crowe, Virginia Commonwealth University; Pamela Decoteau, Southern Illinois University; Susan J. Delaney, Mira Costa College; Walter B. Denny, University of Massachusetts, Amherst; Richard DePuma, University of Iowa; Brian Dursam, University of Miami; Ross Edman, University of Illinois, Chicago; Gerald Eknoian, DeAnza State College; Mary S. Ellett, Randolph-Macon College; James D. Farmer, Virginia Commonwealth University; Craig Felton, Smith College; Mary F. Francey, University of Utah; Joanna Frueh, University of Nevada, Reno; Mark Fullerton, Ohio State University; Anna Gonosova, University of California, Irvine; Robert Grigg; Glenn Harcourt, University of Southern California; Sharon Hill, Virginia Commonwealth University; Mary Tavener Holmes, New York City; Paul E. Ivey, University of Arizona; Carol S. Ivory, Washington State University; Nina Kasanof, Sage Junior College of Albany; John F. Kenfield, Rutgers University; Ruth Kolarik, Colorado College; Jeffrey Lang, University of Kansas; William A. Lozano, Johnson County Community College; Franklin Ludden, Ohio State University; Lisa F. Lynes, North Idaho College; Joseph Alexander MacGillivray, Columbia University; Janice Mann, Wayne State University; Michelle Marcus, The Metropolitan Museum of Art; Virginia Marquardt, University of Virginia; Peggy McDowell, University of New Orleans; Sheila McNally, University of Minnesota; Victor H. Miesel, University of Michigan; Vernon Minor, University of Colorado, Boulder; Anta Montet-White, University of Kansas; Anne E. Morganstern, Ohio State University; William J. Murnane, University of Memphis; Lawrence Nees, University of Delaware; Sara Orel, Northeast Missouri State University; John G. Pedley, University of Michigan; Elizabeth Pilliod, Oregon State University; Nancy H. Ramage, Ithaca College; Ida K. Rigby, San Diego State University; Howard Risatti, Virginia Commonwealth University; Ann M. Roberts, University of Iowa; Stanley T. Rolfe, University of Kansas; Wendy W. Roworth, University of Rhode Island; James H. Rubin, SUNY Stony Brook; John Russell, Columbia University; Patricia Sands, Pratt Institute; Thomas Sarrantonio, SUNY New Paltz; Diane G. Scillia, Kent State University; Linda Seidel, University of Chicago; Nancy Sevcenko, Cambridge, Massachusetts; Tom Shaw, Kean College; Jan Sheridan, Erie Community College; Anne R. Stanton, University of Missouri, Columbia; Thomas Sullivan, OSB, Benedictine College (Conception Abbey); Janis Tomlinson, Columbia University; the late Eleanor Tufts; Dorothy Verkerk, University of North Carolina, Chapel Hill; Roger Ward, The Nelson-Atkins Museum of Art; Mark Weil, Washington University, St. Louis; Alison West, New York City; Randall White, New York University; and David Wilkins, University of Pittsburgh.

Others who have tried to keep me from errors of fact and interpretation—who have shared ideas and course syllabi, read chapters or sections of chapters, and offered suggestions and criticism—include: Janet Rebold Benton, Pace University; Elizabeth Gibson Broun, National Museum of America Art; Robert G. Calkins, Cornell University; William W. Clark, Queens College, CUNY; Jaqueline Clipsham; Alessandra Comini, Southern Methodist University; Susan Craig, University of Kansas; Charles Cuttler, University of Iowa; Ralph T. Coe, Santa Fe; Nancy Corwin, University of Kansas; Patricia Darish, University of Kansas; Lois Drewer, Index of Christian Art; Charles Eldredge, University of Kansas; James Enyeart, Eastman House, Rochester; Ann Friedman, J. Paul Getty Museum; Mary D. Garrard, American University; Walter S. Gibson, Case Western Reserve University; Stephen Goddard, University of Kansas; Paula Gerson; Dorothy Glass, SUNY Buffalo; the late Jane Hayward, The Cloisters, The Metropolitan Museum of Art; Robert Hoffmann, The Smithsonian Institution; Luke Jordan, University of Kansas; Charles Little, The Metropolitan Museum of Art; Karen Mack, University of Kansas; Richard Mann, San Francisco State University;

Bob Martin, Haskel Indian Nations University; Amy McNair, University of Kansas; Sara Jane Pearman, The Cleveland Museum of Art; Michael Plante, H. Sophie Newcomb Memorial College; John Pultz, University of Kansas; Virginia Raguin, College of the Holy Cross; Pamela Sheingorn, Baruch College, CUNY; James Seaver, University of Kansas; Caryle K. Smith, University of Akron; Walter Smith, University of Akron; Lauren Soth, Carleton College; Linda Stone-Ferrier, University of Kansas; Michael Stoughton, University of Minnesota; Elizabeth Valdez del Alamo, Montclair State College; and Ann S. Zielinski, SUNY Plattsburgh.

Finally, the book was class tested with students under the direction of these teachers: Fred C. Albertson, University of Memphis; Betty J. Crouther, University of Mississippi; Linda M. Gigante, University of Louisville; Jennifer Haley, University of Nebraska, Lincoln; Cynthia Hahn, Florida State University; Lawrence R. Hoey, University of Wisconsin, Milwaukee; Delane O. Karalow, Virginia Commonwealth University; Charles R. Mack, University of South Carolina, Columbia; Brian Madigan, Wayne State University; Merideth Palumbo, Kent State University; Sharon Pruitt, East Carolina State University; J. Michael Taylor, James Madison University; Marcilene K. Wittmer, University of Miami; and Marilyn Wyman, San Jose State University.

A Final Word

As each of us develops a genuine appreciation of the arts, we come to see them as the ultimate expression of human faith and integrity as well as creativity. I have tried here to capture that creativity, courage, and vision in such a way as to engage and enrich even those encountering art history for the very first time. If I have done that, I will feel richly rewarded.

Marilyn Stokstad
Spring 1995

Contents

CHAPTER 17 Early Renaissance Art in Europe 610

CHAPTER 18 Renaissance Art in Sixteenth-Century Europe 678

CHAPTER 29 Art in the United States and Europe since World War II *1106*

Bradford R. Collins

Use Notes

The various features of this book reinforce each other, helping the reader to become comfortable with terminology and concepts specific to art history.

Introduction and Starter Kit The Introduction is an invitation to the pleasures of art history. The Starter Kit that follows the Introduction is a highly concise primer of basic concepts and tools. The outside margins of the Starter Kit pages are tinted to make them easy to find.

Captions There are two kinds of captions in this book: short and long. Short captions identify information specific to the work of art or architecture illustrated:

> artist (when known)
> title or descriptive name of work
> date
> original location (if moved to a museum or other site)
> material or materials a work is made of
> size (height before width) in feet and inches, with
> centimeters and meters in parentheses
> present location

The order of these elements varies, depending on the type of work illustrated. Dimensions are not given for architecture, for most wall painting, or for architectural sculpture. Some captions have one or more lines of small print below the identification section of the caption that gives museum or collection information. This is rarely required reading.

Long captions contain information of many kinds that complements the main text.

Definitions of Terms You will encounter the basic terms of art history in three places:

> IN THE TEXT, where words appearing in **boldface** type are defined, or glossed, at the first use; some terms are explained more than once, especially those that experience shows are hard to remember.

> IN BOXED FEATURES on technique and other subjects and in Elements of Architecture boxes, where labeled drawings and diagrams visually reinforce the use of terms.

> IN THE GLOSSARY at the end of the volume, which contains all the words in **boldface** type in the text and boxes. The Glossary begins on page G1, and the outside margins are tinted to make the Glossary easy to find.

Maps, Timelines, Parallels, and Time Scales At the beginning of each chapter is a map with all the places mentioned in the chapter. Above the map, a timeline runs from the earliest through the latest years covered in that chapter. Small drawings of major artworks in the chapter are sited on the map at the places from which they come and are placed on the timelines at the times of their creation. In this way these major works are visually linked in time and place.

Parallels, a table near the beginning of every chapter, uses the main chapter sections to organize artistic and other events "at home and abroad." The Parallels offer a selection of simultaneous events for comparison without suggesting that there are direct connections between them.

Time scales appear in the upper corners of pages, providing a fast check on progress through the period.

Boxes Special material that complements, enhances, explains, or extends the text is set off in three types of tinted boxes. Elements of Architecture boxes clarify specifically architectural features, such as "Space-Spanning Construction Devices" in the Starter Kit (page 32). Technique boxes (see "Lost-Wax Casting," page 31) amplify the methodology by which a type of artwork is created. Other boxes treat special-interest material related to the text.

Bibliography The Bibliography, at the end of this book beginning on page B1, contains books in English, organized by general works and by chapter, that are basic to the study of art history today, as well as works cited in the text.

Dates, Abbreviations, and Other Conventions This book uses the designations BCE and CE, abbreviations for "before the Common Era" and "Common Era," instead of BC ("before Christ") and AD ("Anno Domini," "the year of our Lord"). The first century BCE is the period from 99 BCE to 1 BCE; the first century CE is from the year 1 CE to 99 CE. Similarly, the second century BCE is the period from 199 BCE to 100 BCE; the second century CE extends from 100 CE to 199 CE.

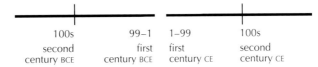

100s	99–1	1–99	100s
second century BCE	first century BCE	first century CE	second century CE

Circa ("about" or "approximately") is used with dates, spelled out in the text and abbreviated to "c." in the captions, when an exact date is not yet verified.

An illustration is called a "figure," or "fig." Figure 6-70 is the seventieth numbered illustration in Chapter 6. Figures 1 through 29 are in the Introduction and the Starter Kit. There are two types of figures: photographs of artworks or of models, and line drawings. The latter are used when a work cannot be photographed or when a diagram or simple drawing is the clearest way to illustrate an object or a place.

When introducing artists, we use the words *active* and *documented* with dates—in addition to "b." (for "born") and "d." (for "died"). "Active" means that an artist worked during the years given. "Documented" means that documents link the person to the date.

Accents are used for words in Spanish, Italian, French, and German only.

With few exceptions, names of museums and other cultural bodies in Western European countries are given in the form used in that country.

Titles of Works of Art Most paintings and sculpture created in Europe and the United States in the last 500 years have been given formal titles, either by the artist or by critics and art historians. Such formal titles are printed in italics. In other traditions and cultures, a single title is not important or even recognized. In this book we use formal titles of artworks in cases where they are established and descriptive titles of artworks where titles are not established. If a work is best known by its non-English title, such as Manet's *Le Dejeuner sur l'Herbe* (*The Luncheon on the Grass*), the original language precedes the translation.

Introduction

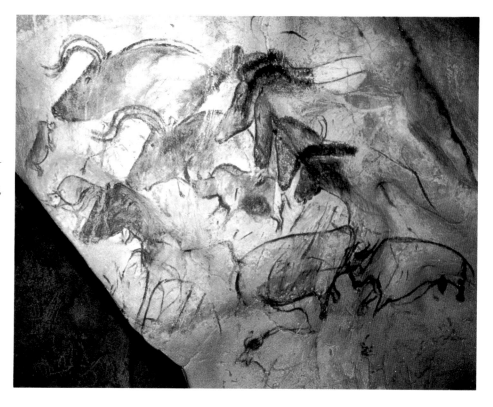

1. Wall painting with four horses, Vallon-Pont-d'Arc, Ardèche gorge, France. c. 28,000 BCE. Paint on limestone

I stood in front of that exquisite panel with the four horses' heads and . . . I was so overcome that I cried. It was like going into an attic and finding a da Vinci [painting]. Except that this great [artist] was unknown." With these words Jean Clottes, an eminent French authority on prehistoric cave art, described viewing one of the 300 breathtakingly beautiful paintings just discovered in a huge limestone cavern near the Ardèche River in southern France (Marlise Simons, "In a French Cave, Wildlife Scenes from a Long-Gone World," *The New York Times*, January 24, 1995, page C10).

These remarkable animal images, fixed in time and preserved undisturbed in their remote cavern, were created some 30,000 years ago (fig. 1). That such representations were made at all is evidence of a uniquely human trait. And what animals are painted here? When were they painted, and how have they been preserved? Why were the paintings made, and what do they tell us about the people who made them? All these questions—what is depicted, how, when, why—are subjects of art history. And, because *these* magnificent images come from a time before there were written records, they provide the best information available not just about early humans' art but also about their reality.

ART AND REALITY

What is art? And what is reality? Especially today, why should one draw or paint, carve or model, when an image can be captured with a camera? In a nineteenth-century painting, *Interior with Portraits* (fig. 2), by the American artist Thomas LeClear, two children stand painfully still while a photographer prepares to take their picture. The paintings and sculpture that fill the studio have been shoved aside to make way for a new kind of art—the photograph. As the photographer adjusts the lens of his camera, we see his baggy pants but not his head. Is LeClear suggesting that the painter's head (brain and eye) is being replaced by the lens (a kind of mechanical brain and eye) of the camera? Or even that the artist and the camera have become a single recording eye? Or is this painting a witty commentary on the nature of reality? Art history leads us to ask such questions.

LeClear's painting resembles a snapshot in its record of studio clutter, but LeClear made subtle changes in what he saw. Using the formal elements of painting—the arrangement of shapes and colors—he focused attention on the children rather than on the interesting and distracting objects that surround them. Light falls on the girl and boy and intensifies the brilliant coral and green of the cloth on the floor. Softer coral shades in the curtain and the upholstered chair

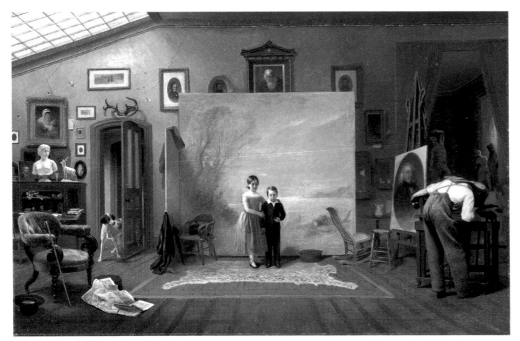

2. Thomas LeClear. *Interior with Portraits*. c. 1865. Oil on canvas, 25⁷/₈ x 40¹/₂" (65.7 x 102.9 cm). National Museum of American Art, Smithsonian Institution, Washington, D.C. Museum purchase made possible by the Pauline Edwards Bequest

frame the image, and the repeated colors balance each other. LeClear also reminds us that art is an illusion: the photograph will show the children in a vast landscape with a rug and animal skin, but the painting reveals that the landscape is just a two-dimensional painted backdrop and the rug and animal skin just slightly worn, painted cloth. These observations make us realize that the painting is more than a portrait; it is also a commentary on the artist as a creator of illusions.

Certainly there is more to this painting—and to most paintings—than one first sees. We can simply enjoy *Interior with Portraits* as a record of nineteenth-century America, but we can also study the history of the painting to probe deeper into its significance. Who are the children? Why was their portrait painted? Who owned the painting? The answers to these questions lead us to further doubts about the reality of this seemingly "realistic" work.

Thomas LeClear worked in Buffalo, New York, from 1847 to 1863. The painting, which is now in the National Museum of American Art in Washington, D.C., once belonged to the Sidway family of Buffalo. Family records show that the girl in the painting, Parnell Sidway, died in 1849; the boy, her younger brother James Sidway, died in 1865 while working as a volunteer fire fighter. Evidence suggests that the painting was not made until the 1860s, well after Parnell's death and when James was a grown man—or possibly after his death, too. LeClear moved to New York City in 1863, and the studio seen in the painting may be one he borrowed from his son-in-law there. Another clue to the painting's date is the camera, which is a type that was not used before 1860. The Sidway children, then, could never have posed for this painting. It must, instead, be a memorial portrait, perhaps painted by LeClear from a photograph. In short, this image of "reality" cannot be "real." Art historical research reveals a story entirely different from what observation of the painting alone suggests.

This new knowledge leads us to further speculations on the nature of art. The memorial portrait, with its re-creation of vanished childhood, is a reflection on life and death. In

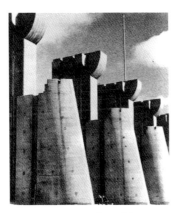

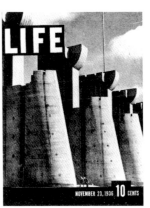

3. Margaret Bourke-White. *Fort Peck Dam, Montana.* 1936

4. First cover, *Life* magazine, November 23, 1936

this context, the ambiguities we noticed before—the contrast between the reality of the studio and the unreal landscape on the cloth in the background, the juxtaposition between the new medium of photography and the old-fashioned, painted portrait on an easel—take on deeper significance. LeClear seems to be commenting on the tension between nature and art, on art and reality, and on the role of the artist as a recording eye and controlling imagination.

But what about the reality of photographs? Today the camera has become a universal tool for picture making. Even though we know that film can be manipulated and photographs made to "lie," we generally accept that the camera tells the truth. We forget that in a photograph a vibrant, moving, three-dimensional world has been immobilized, reduced to two dimensions, and sometimes recorded in black and white.

Photographs can be powerful works of art. In the 1930s and 1940s people waited as eagerly for the weekly arrival of *Life* magazine, with its photojournalism and photo essays, as people do today for their favorite television program. An extraordinary photographer of that time was Margaret Bourke-White, whose photograph of Peck Dam (fig. 3), used on the cover of the first issue of *Life* in 1936 (fig. 4), made a

dramatic social-political statement about the role of government. In the depths of the economic depression of the 1930s, public works like the dam in the picture, which controlled floods and provided electric power, gave people hope for a better life. Bourke-White's photograph is a symbol of the power of technology and engineering over nature. It seems to equate the monumental grandeur of the dam with the architectural marvels of the past—Egyptian pyramids, the Roman Colosseum, medieval European castles. The arrangement of elements in the image reflects techniques that had been perfected by artists over the centuries: the repetition of simple forms, a steady recession into space, and a dramatic contrast of light and dark. Two red bands with bold white lettering turn the photograph into a handsome piece of **graphic design**, that is, a work in which art and design, typography, and printing are brought together to communicate a message.

Bourke-White's skillful capturing of the powerful dam reminds us that the camera is merely a mechanical tool for making records until an artist puts it to use. Anyone who has ever taken a snapshot of a friend only to find that the finished picture includes unnoticed rubbish and telephone wires will recognize the importance of the human brain's ability to filter and select. But an artist's vision can turn the everyday world into a superior reality—perhaps simply more focused or intense, certainly more imaginative.

We can easily understand a photograph of a dam, the imagery in a painting of a nineteenth-century artist's studio is not too strange to us, and even prehistoric animal paintings in a cave have a haunting familiarity. Other works, however, present a few more challenges. The fifteenth-century painting *The Annunciation,* by Jan van Eyck (fig. 5), is an excellent example of how some artists try to paint more than the eye can see and more than the mind can grasp. We can enjoy the painting for its visual characteristics—the drawing, colors, and arrangement of shapes—but we need the help of art history and information about the painting's cultural context if we want to understand it fully. Jan van Eyck (1390–1441) lived in the wealthy city of Bruges, in what is now Belgium, in the first half of the fifteenth century. The painting seems to be set in Jan van Eyck's own time in a church with stone walls and arches, tile floor, wooden roof, stained-glass windows, and wall paintings. The artist has so carefully re-created the colors and textures of every surface that he convinces us of the truth of his vision. Clearly something strange and wonderful is happening. We see a richly robed youth with splendid multicolored wings interrupting a kneeling young woman's reading. The two figures gesture gracefully upward toward a dove flying down streaks of gold. Golden letters float from their lips, forming the Latin words that mean "Hail, full of grace" and "Behold the handmaiden of the Lord." But only if we know something about the symbols, or **iconography**, of Christian art does the subject of the painting become clear. The scene is the Annunciation, the moment when the angel Gabriel tells the Virgin Mary that she will bear the Son of God, Jesus Christ (recounted in the New Testament of the Christian Bible, Luke l:26–38). All the details have a meaning. The dove symbolizes the Holy Spirit. The white lilies are symbols of Mary. The one stained-glass window of God (flanked by wall paintings of Moses) is

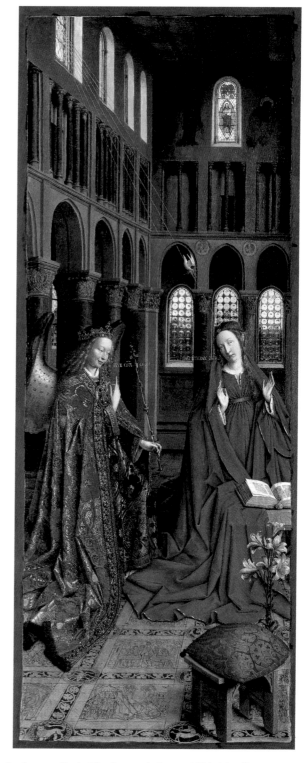

5. Jan van Eyck. *The Annunciation*. c. 1434–36. Oil on canvas, transferred from panel, painted surface 35³⁄₈ x 13⁷⁄₈" (90.2 x 34.1 cm). National Gallery of Art, Washington, D.C. Andrew W. Mellon Collection 1937.1.39

juxtaposed with the three windows enclosing Mary (representing the Trinity of Father, Son, and Holy Spirit), and this contrast suggests that a new era is about to begin. The signs of the zodiac in the floor tiles indicate the traditional date of the Annunciation, March 25. The placement of the figures in a much later architectural setting is quite unreal, however.

Art historians explain that Jan van Eyck not only is representing a miracle but also is illustrating the idea that Mary is the new Christian Church.

Art historians learn all they can about the lives of artists and those close to them. Seeking information about Jan van Eyck, for example, they have investigated his brother Hubert, Jan's wife, Margaret, and his chief patron, the duke of Burgundy. They are also fascinated by painting techniques—in this case the preparation of the wood panel, the original drawing, and the building of the images in transparent oil layers. The history of the painting (its **provenance**) is important too—its transfer from wood panel to canvas, its cleaning and restoration, and its trail of ownership. The painting, given by American financier Andrew W. Mellon to the National Gallery of Art in Washington, D.C., was once owned by Tsar Nicholas I of Russia.

In this book we study the history of art around the world from earliest times to the present. Although we treat Western art in the most detail, we also look extensively at the art of other regions. The qualities of a work of art, the artist who made it, the patron who paid for it, the audiences who have viewed it, and the places in which it has been displayed—all are considered in our study of art's history.

ART AND THE IDEA OF BEAUTY

For thousands of years people have sought to create objects of beauty and significance—objects we call art—that did more than simply help them survive. The concept of beauty, however, has found expression in a variety of **styles**, or manners of representation. The figure from Galgenburg, Austria, made more than 33,000 years ago, illustrates an **abstract** style (fig. 6). Its maker simplified shapes, eliminated all but the essentials, and emphasized the underlying human forms. An equally abstract vision of woman can be seen in Kitagawa Utamaro's *Woman at the Height of Her Beauty* (fig. 7). This late-eighteenth-century Japanese work, printed in color from a **woodblock**, or image carved out of a block of wood, is the creation of a complex society regulated by convention and ritual. The woman's dress and hairstyle defy the laws of nature. Rich textiles turn her body into a pattern, and pins hold her hair in elaborate shapes. Utamaro renders the patterned silks and carved pins meticulously, but he depicts the woman's face with a few sweeping lines. The elaboration of surface detail to create ornamental effects combined with an effort to capture the essence of form is characteristic of abstract art.

Two of the other works we have looked at so far—LeClear's *Interior with Portraits* and Jan van Eyck's *Annunciation*—exemplify a contrasting style known as **realism**. Realistic art, even if it represents an imagined or supernatural subject, has a surface reality; the artists appear, with greater or lesser accuracy, to be recording exactly what they see. Realistic art, as we have noted, can carry complex messages and be open to individual interpretation.

Realism and abstraction represent opposite approaches to the representation of beauty. In a third style, called **idealism**, artists aim to represent things not as they are but as they ought to be. In ancient Greece and Rome artists made intense observations of the world around them and then subjected

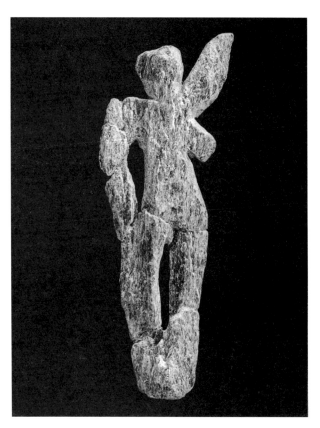

6. Human figure, found at Galgenburg, Austria. c. 31,000 BCE. Stone, height 3" (7.4 cm). Naturhistorisches Museum, Vienna

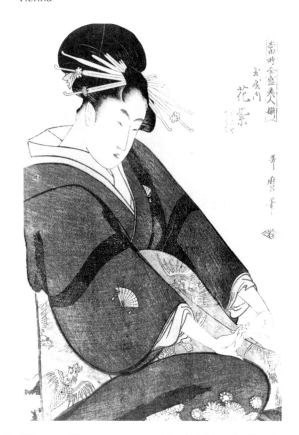

7. Kitagawa Utamaro. *Woman at the Height of Her Beauty.* Mid-1790s. Color woodblock print, 15⅛ x 10" (38.5 x 25.5 cm). Spencer Museum of Art, University of Kansas, Lawrence
William Bridges Thayer Memorial

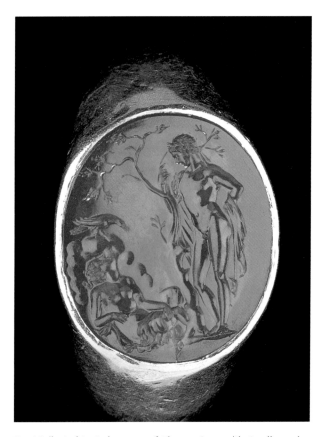

8. Attributed to Aulos, son of Alexas. Gem with Apollo and
 Cassandra. 40–20 BCE. Gold with engraved carnelian, ring
 1³/₈ x 1" (3.4 x 2.5 cm), gem ¹³/₁₆ x ³/₄" (1.9 x 2.1 cm).
 The Nelson-Atkins Museum of Art, Kansas City, Missouri
 Purchase: Acquired through the generosity of Mr. and Mrs. Robert
 S. Everitt (F93-22)

Apollo fell in love with Cassandra, and although she
rejected him he gave her a potent gift—the ability to fore-
tell the future, symbolized by the raven. To show his
disappointment, the frustrated Apollo added a spiteful
twist to his gift—no one would believe Cassandra's
prophetic warnings. Today, doom-sayers are still called
Cassandras, and ravens are associated with prophecy.

their observations to mathematical analysis to define what
they considered to be perfect forms. Emphasizing human
rationality, they eliminated accidents of nature and sought
balance and harmony in their work. Their sculpture and
painting established ideals that have inspired Western art
ever since. The term *Classical,* which refers to the period in
ancient Greek history when this type of idealism emerged,
has come to be used broadly (and with a lowercase *c*) as a
synonym for the peak of perfection in any period.

Classical idealism can pervade even the smallest works
of art. About 2,000 years ago a Roman gem cutter known as
Aulos added the opulence of imperial Rome to the ideals of
Classical Greece when he engraved a deep-red, precious
stone with the figures of the tragic princess Cassandra and the
Greek god Apollo (fig. 8). Cassandra sleeps by rocky cliffs and
a twisting laurel tree that suggest the dramatic natural setting
of Delphi, Greece, a site sacred to Apollo. The god leans on the
laurel tree, also sacred to him, with his cloak draped loosely
and gracefully behind him. Apollo and Cassandra have the
strong athletic bodies and regular facial features that charac-

terize Classical art, and their graceful poses and elegant drap-
ery seem at the same time ideally perfect and perfectly natur-
al. These beautiful figures and their story of frustrated love
were not meant to be seen in a museum (a *museum* literally
is the home of Apollo's Muses, the goddesses of learning and
the arts). The carved gem was set in a gold finger ring and
would have been constantly before its wearer's eyes. This
sculpture reminds us that exceptional art can come in any size
and material and can be intended for daily personal use as
well as for special, occasional contemplation.

The flawless perfection of Classical idealism could be
dramatically modified by artists more concerned with emo-
tions than pure form. The calm of Cassandra and Apollo con-
trasts with the melodramatic representation of a story from
the ancient Greek legend of the Trojan War. The priest
Laocoön (fig. 9), who attempted to warn the Trojans against
the Greeks, was strangled along with his two sons by ser-
pents. Heroic and tragic, Laocoön represents a good man
destroyed by forces beyond his control. His features twist in
agony, and the muscles of his superhuman torso and arms
extend and knot as he struggles. This sculpture, then at least
sixteen centuries old, was rediscovered in Rome in the
1500s, and it inspired artists such as Michelangelo to develop
a heroic style. Through the centuries people have returned
again and again to the ideals of Classical art. In the United
States official sculpture and architecture often copy Classi-
cal forms, and even the National Museum of American Art is
housed in a Greek-style building.

How different from this ideal of physical beauty the
perception and representation of spiritual beauty can be. A
fifteenth-century bronze sculpture from India represents
Punitavati, a beautiful and generous woman who was deeply
devoted to the Hindu god Shiva (fig. 10). Abandoned by her
greedy husband because she gave food to beggars, Punita-
vati offered her beauty to Shiva. Shiva accepted her offering,
turning her into an emaciated, fanged hag. According to leg-
end, Punitavati, with clanging cymbals, provides the music
for Shiva as he dances the cosmic dance of destruction and
creation that keeps the universe in motion. To the followers
of Shiva, Punitavati became a saint called Karaikkalammai-
yar. The bronze sculpture, although it depicts the saint's
hideous appearance, is nevertheless beautiful both in its for-
mal qualities and in its message of generosity and sacrifice.

Some works of art defy simple categories, and artists
may go to extraordinary lengths to represent their visions.
The art critic Robert Hughes called James Hampton's (1909–
1964) *Throne of the Third Heaven of the Nations' Millennium
General Assembly* (fig. 11) "the finest piece of visionary art
produced by an American." Yet this fabulous creation is
composed of discarded furniture, flashbulbs, and all sorts of
trash tacked together and wrapped in aluminum and gold
foil and purple paper. The primacy of painting, especially oil
painting, is gone. Hampton's inspiration, whether divine or
not, knows no bounds. He worked as a janitor to support
himself while, in a rented garage, he built his monument to
Jesus. In rising tiers, thrones and altars are prepared for Jesus
and Moses, the New Testament at the right, the Old Testa-
ment at the left. Everything is labeled and described, but
Hampton invented his own language and writing system to
express his vision. Although his language is still not fully

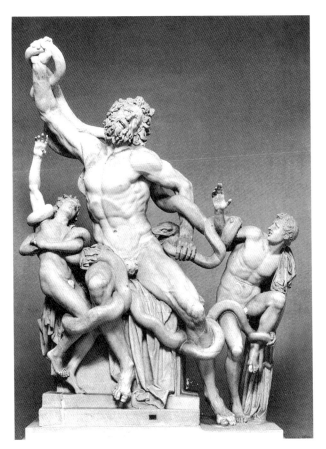

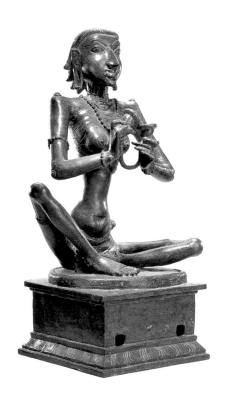

9. Hagesandros, Polydoros, and Athanadoros of Rhodes. *Laocoön and His Sons*, perhaps the original of the 2nd or 1st century BCE or a Roman copy of the 1st century CE. Marble, height 8' (2.44 m). Musei Vaticani, Museo Pio Clementino, Cortile Ottagono, Rome

10. *Punitavati* (*Karaikkalammaiyar*), Shiva saint, from Karaikkal, India. 15th century. Bronze, height 16¼" (41.3 cm). The Nelson-Atkins Museum of Art, Kansas City, Missouri
Purchase: Nelson Trust (33-533)

understood, its major source is the Bible, especially the Book of Revelation. On one of many placards he wrote his artist's credo: "Where there is no vision, the people perish" (Proverbs 29:18).

These different ideas of art and beauty remind us that as viewers we enter into an agreement with artists, who, in turn, make special demands on us. We re-create works of art for ourselves as we bring to them our own experiences. Without our participation they are only hunks of stone or metal or pieces of paper or canvas covered with ink or colored paints. Artistic styles change with time and place. From extreme realism at one end of the spectrum to entirely non-representational art at the other, artists have worked with varying degrees of realism, idealism, and abstraction. The challenge for the student of art history is to discover not only how but why these changes have occurred and ultimately what of significance can be learned from them, what meaning they carry.

ARTISTS

We have focused so far on works of art. What of the artists who make the art? Biologists have pointed out that human beings are mammals with very large brains and that these large brains demand stimulation. Curious, active, inventive humans constantly look, taste, smell, and listen. They invent fine arts, fine food, fine perfume, and fine music. They play games, invent rituals,

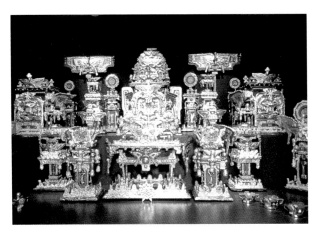

11. James Hampton. *Throne of the Third Heaven of the Nations' Millennium General Assembly*. c. 1950–64. Gold and silver aluminum foil, colored Kraft paper, and plastic sheets over wood, paperboard, and glass, 10'6" x 27' x 14'6" (3.2 x 8.23 x 4.42 m). National Museum of American Art, Smithsonian Institution, Washington, D.C.

and speculate on the nature of things, on the nature of life. They constantly communicate with each other, and some of them even try to communicate with the past and future.

We have seen that some artists try to record the world as they see it, and they attempt to educate or convince their viewers with straightforward stories or elaborate symbols.

Others create works of art inspired by an inner vision. Like the twentieth-century American Georgia O'Keeffe (fig. 12) they attempt to express in images what cannot be expressed in words. An organized religion such as Christianity or Buddhism may motivate them, but the artists may also divorce themselves from any social group and attempt to record personal visions or intense mystical experiences. These inner visions may spring from entirely secular insights, and the artist's motivation or intention may be quite different from the public perception of her or his art.

Originally, artists were considered artisans, or craftspeople. The master (and sometimes the mistress) of a workshop was the controlling intellect, the organizer, and the inspiration for others. Utamaro's color woodblock prints, for example, were the product of a team effort. In the workshop Utamaro drew and painted pictures for his assistants to transfer to individual blocks of wood. They carved the lines and color areas, covered the surface with ink or colors, then transferred the image to paper. Since ancient times artists have worked in teams to produce great buildings, paintings, and stained glass. The same spirit is evident today in the complex glassworks of American Dale Chihuly. His team of artist-craftspeople is skilled in the ancient art of glassmaking, but Chihuly remains the controlling mind and imagination. Once created, his pieces are transformed whenever they are assembled. Thus each work takes on a new life in accordance with the mind, eye, and hand of each owner-patron. Made in the 1990s, *Violet Persian Set with Red Lip Wraps* (fig. 13) has twenty separate pieces whose relationship to each other is determined by the imagination of the assembler. Like a fragile sea creature of the endangered coral reefs, the glass is vulnerable to thoughtless depredation, yet it is timeless in its reminder of primeval life. The purple captures light, color, and movement for a weary second. Artists, artisans, and patrons unite in an ever-changing individual yet communal act of creation.

About 600 years ago, artists in western Europe, especially in Italy, began to think of themselves as divinely inspired creative geniuses rather than as team workers. Painters like Guercino (Giovanni Francesco Barbieri, 1591–1666) took the evangelist Luke as their model, guide, and protector—their patron saint. People believed that Saint Luke had painted a portrait of the Virgin Mary holding the Christ Child. In Guercino's painting *Saint Luke Displaying a Painting of the Virgin* (fig. 14), the saint still holds his palette and brushes while an angel holds the painting on the easel. A book, a quill pen, and an inkpot decorated with a statue of an ox (a symbol for Luke) rest on a table behind the saint, reminders that he wrote one of the Gospels of the New Testament. The message Guercino conveys is that Saint Luke is a divinely inspired and endowed artist and that all artists share in this inspiration through their association with their patron saint.

Even the most inspired artists had to learn their trade through study or years of **apprenticeship** to a master. In his painting *The Drawing Lesson* (fig. 15), Dutch artist Jan Steen (1626–1679) takes us into an artist's studio where an apprentice watches his master teaching a young woman. The woman has been drawing from a sculpture because women then were not permitted to work from live nude models.

12. Georgia O'Keeffe. *Portrait of a Day, First Day.* 1924. Oil on canvas, 35 x 18" (89 x 45.8 cm). Spencer Museum of Art, University of Kansas, Lawrence

Gift of the Georgia O'Keeffe Foundation

The year before she painted *Portrait of a Day, First Day,* O'Keeffe wrote, "One day seven years ago [I] found myself saying to myself—I can't live where I want to—I can't go where I want to—I can't even say what I want to— School and things that painters have taught me even keep me from painting as I want to. I decided I was a very stupid fool not to at least paint as I wanted to and say what I wanted to when I painted as that seemed to be the only thing I could do that didn't concern anybody but myself—that was nobody's business but my own. . . I found that I could say things with color and shapes that I couldn't say in any other way—things that I had no words for. Some of the wise men say it is not painting, some of them say it is" (cited in *Alfred Stieglitz Presents One Hundred Pictures: Oils, Watercolors, Pastels, Drawings by Georgia O'Keeffe, American,* The Anderson Galleries, New York, exhibition brochure, January 29–February 10, 1923).

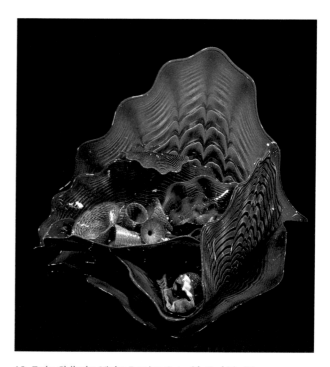

13. Dale Chihuly. *Violet Persian Set with Red Lip Wraps.* 1990. Glass, 26 x 30 x 25" (66 x 76.2 x 63.5 cm). Spencer Museum of Art, University of Kansas, Lawrence

Peter T. Bohan Acquisition Fund

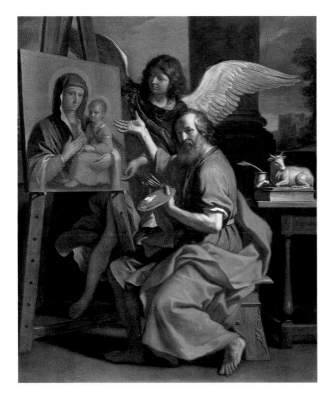

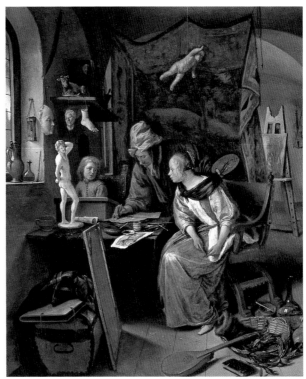

14. Guercino. *Saint Luke Displaying a Painting of the Virgin.* 1652–53. Oil on canvas, 7'3" x 5'11" (2.21 x 1.81 m). The Nelson-Atkins Museum of Art, Kansas City, Missouri
Purchase (F83-55)

15. Jan Steen. *The Drawing Lesson.* 1665. Oil on wood, 19³⁄₈ x 16¹⁄₄" (49.3 x 41 cm). The J. Paul Getty Museum, Malibu, California

Plaster reproductions hang on the wall and stand on the shelf, and a carved boy-angel has been suspended from the ceiling in front of a large tapestry. The painter holds his own palette, and we see his painting set on an easel in the background. Like Thomas LeClear's painting of the photographer's studio, *The Drawing Lesson* is a valuable record of an artist's equipment and workplace, including such things as the musical instruments, furniture, glass, ceramics, and basketry used in the seventeenth century.

The painting is more than a realistic **genre painting** (scene from daily life) or **still life** (an arrangement of objects). *The Drawing Lesson* is also an **allegory**, or symbolic representation of the arts. The objects in the studio symbolize painting, sculpture, and music. The sculpture of the ox on the shelf is more than a bookend; as we have already seen, it symbolizes Saint Luke, the painters' patron saint. The basket in the foreground holds not only the woman's fur muff but also a laurel wreath, a symbol of Apollo and the classical tribute for excellence.

ARTISTS AND ART HISTORY Artists draw on their predecessors in ways that make each work a very personal history of art. They build on the works of the past, either inspired by or reacting against them, but always challenging them with their new creations. The influence of Jan Steen's genre painting, for example, can be seen in Thomas LeClear's *Interior with Portraits,* and Guercino's Saint Luke is based on an earlier **icon**—or miraculous image—he had seen in his local church. In his 1980–1990 *Vaquero* (Cowboy), Luis Jimenez revitalizes a sculptural form with roots in antiquity, the equestrian monument, or statue of a horse and rider (fig. 16).

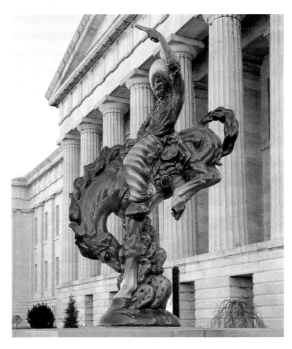

16. Luis Jimenez. *Vaquero.* Modeled 1980, cast 1990. Cast fiberglass and epoxy, height 16'6" (5.03 m). National Museum of American Art, Smithsonian Institution, Washington, D.C.

This white-hatted, gun-slinging bronco buster whoops it up in front of the stately, classical colonnade of the Old Patent Building (now the National Museum of American Art, the National Portrait Gallery, and the Archives of American Art). The Old Patent Office was designed in 1836 and finished in 1867. One of the finest Neoclassical buildings in the United States and the site of Abraham Lincoln's second inaugural ball, it was supposed to be destroyed for a parking lot when it was acquired by the Smithsonian in 1958.

Vaquero also reflects Jimenez's Mexican and Texan heritage and his place in a tradition of Hispanic American art that draws on many sources, including the art of the Maya, Aztec, and other great Native American civilizations, the African culture of the Caribbean Islands, and the transplanted art of Spain and Portugal.

Equestrian statues have traditionally been stately symbols of power and authority, with the rider's command over the animal emblematic of human control over lesser beings, nature, and the passions. Jimenez's bucking bronco turns this tradition, or at least the horse, on its head. Rather than a stately symbol of human control, he gives us a horse and cowboy united in a single exuberant and dynamic force. Located in front of the National Museum of American Art, the work can be seen as a witty satire on Washington, D.C.'s bronze monuments to soldiers. At the same time, it reminds us that real *vaqueros* included hard-working African Americans and Hispanic Americans who had little in common with the cowboys of popular fiction.

In his work, Jimenez has abandoned traditional bronze and marble for fiberglass. He first models a sculpture in a plastic paste called plasticine on a steel armature; then he makes a fiberglass mold, from which he casts the final sculpture, also in fiberglass. The materials and processes are the same as those used to make many automobile bodies, and as with automobiles, the process allows an artist to make several "originals." After a sculpture is assembled and polished, it is sprayed with the kind of acrylic urethane used to coat the outside of jet airplanes. Jimenez applies colors with an airbrush and coats the finished sculpture with three more layers of acrylic urethane to protect the color and emphasize its distinctive, sleek, gleaming surface. *Vaquero* is true public, popular art. It appeals to every kind of audience from the rancher to the connoisseur.

When artists appropriate and transform images from the past the way Jimenez appropriated the equestrian form, they enrich the **aesthetic** vocabulary of the arts in general. *Vaquero* resonates through the ages with associations to cultures distant in time and place that give it added meaning. This kind of aesthetic free-for-all encourages artistic diversity and discourages the imposition of a single correct or canonical (approved) approach or point of view. In the jargon of our time, no medium is *privileged*, and no group of artists is *marginalized*.

ART AND SOCIETY

The visual arts are among the most sophisticated forms of human communication, at once shaping and shaped by the social context in which they find expression. Artists are often interpreters of their times. They can also be enlisted to serve social ends in forms that range from heavy-handed propaganda to the more subtle persuasiveness of Margaret Bourke-White's photographs for *Life* magazine. From the priests and priestesses in ancient Egypt to the representatives of various faiths today, religious leaders have understood the value of the visual arts in educating people about doctrine and in reinforcing their faith. Especially beginning in the eleventh century in western Europe, architecture and sculpture provided settings for elaborate rites and inspiring and instructive art. At the Cathedral of Santiago de Compostela in north-

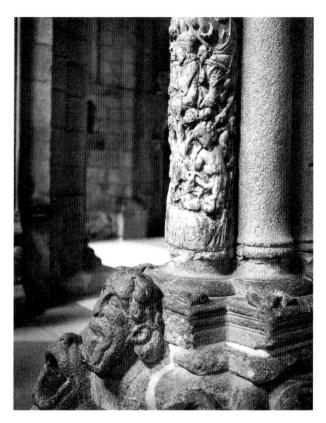

17. *Pórtico de la Gloria*. Photograph by Joan Myers. 1988

Tradition required that pilgrims to the Cathedral of Santiago de Compostela place their fingers in the tendrils of the carved Tree of Jesse as they asked Saint James's blessing on arrival in the church. Millions of fingers have worn away the carving, leaving a rich patina of age. The twefth-century sculpture still inspires twentieth-century artists such as photographer Joan Myers.

western Spain, which shelters the tomb of Saint James, the marble of the central portal has been polished and the twelfth-century sculpture have been worn down by the touch of pilgrims' fingers (fig. 17).

Marxist art historians once saw art as an expression of great social forces rather than of individual genius, but most people now agree that neither history and economics nor philosophy and religion alone can account for the art of a Rembrandt or Michelangelo. The same applies to extraordinary "ordinary" people, too, who have created powerful art to satisfy their own inner need to communicate ideas. In Lucas, Kansas, in 1905, Samuel Perry Dinsmoor, a visionary populist, began building his Garden of Eden (fig. 18). By 1927 he had surrounded his home with twenty-nine concrete trees ranging from 8 to 40 feet high. He filled the branches with figures that told the biblical story of the Creation and the Expulsion from the Garden of Eden under the ever-present—and electrified—Eye of God. Adam and Eve succumb to the serpent; Cain strikes down Abel. Evil and death enter the world as creatures attack each other. In Dinsmoor's modern world, people defend themselves through their right to vote. Under the protection of the Goddess of Liberty draped in an American flag, a man and woman literally cut down big business with a saw labeled "ballot." Dinsmoor communicated his ideas forcefully and directly through haunting imagery. At dusk his electric

18. Samuel Perry Dinsmoor. *Goddess of Liberty and the Destruction of the Trusts by the Ballot.* Garden of Eden, Lucas, Kansas. 1905–32. Painted concrete and cement, over-lifesize

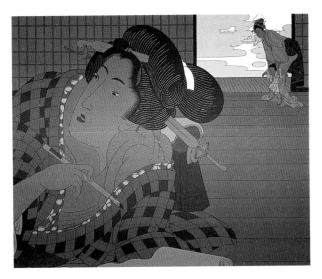

19. Roger Shimomura. *Diary* (Minidoka Series #3) 1978. Acrylic on canvas, 4'11⅞" x 6'1/16" (1.52 x 1.83 m). Spencer Museum of Art, University of Kansas, Lawrence

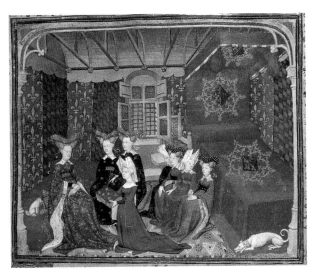

20. *Christine Presenting Her Book to the Queen of France.* 1410–15. Tempera and gold on vellum, image approx. 5½ x 6¾" (14 x 17 cm). The British Library, London
MS. Harley 4431, folio 3

light bulbs—his repeated "Ever-Seeing Eye of God"—illuminate the concrete and cement figures with an unearthly glow.

Not all art with social impact is public on the scale of a pilgrimage church or a half-acre concrete Garden of Eden. Artists like Roger Shimomura turn painting and prints into powerful statements. American citizens of Japanese ancestry were forcibly confined in internment camps during World War II. Shimomura based his 1978 painting *Diary* (fig. 19) on his grandmother's record of the family's experience in an internment camp in Idaho. Shimomura painted his grandmother writing while he (the toddler) and his mother stand by an open door—a door that opens on a barbed-wire-enclosed compound. In his painting Shimomura has combined two formal traditions, the Japanese art of color woodblock prints (see fig. 7) and American Pop Art to create a personal style that expresses his own dual culture as it makes a powerful political statement.

ARTISTS AND PATRONS Rare, valuable, beautiful, and strange things appeal to human curiosity. People who are not artists "use" art, too. They have collected special objects since prehistoric times when people buried the dead with necklaces of fox teeth. Collections of "curiosities" were passed along from one generation to the next, gaining luster or mysterious power with age. Art enhanced the owners' prestige, created an aura of power and importance, and impressed others. Many collectors truly

love works of art. When collectors study diligently, they become scholars; when their expertise turns to questions of refined evaluation, they become what we call **connoisseurs**.

The patrons of art constitute a very special kind of audience for the artist. Patrons provide economic support for art and vicariously participate in its creation. In earlier periods artists depended on the patronage of individuals and the institutions they represented. An early-fifteenth-century painting shows the French writer Christine de Pisan presenting her work to the queen of France (fig. 20). Christine was a patron, too, for she hired painters and scribes to copy, illustrate, and decorate her books. She especially admired the painting of a woman artist named Anastaise, considering her work unsurpassed in the city of Paris, which she believed had the world's best painters of miniatures.

When a free market developed for art works, artists became entrepreneurs. In a painting by the seventeenth-

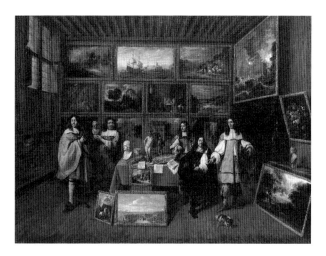

21. Gillis van Tilborch. *Cabinet d'Amateur with a Painter.* c. 1660–70. Oil on canvas, 38¼ x 51" (97.15 x 129.54 cm). Spencer Museum of Art, University of Kansas, Lawrence

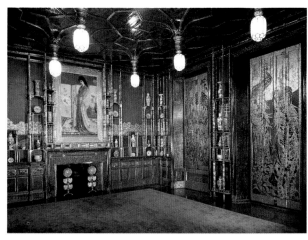

22. James McNeill Whistler. *Harmony in Blue and Gold.* The Peacock Room, northeast corner, from a house owned by Frederick Leyland, London. 1876–77. Oil paint and metal leaf on canvas, leather, and wood, 13'11⅞" x 33'2" x 19'11½" (4.26 x 10.11 x 6.83 m). Freer Gallery, Smithsonian Institution, Washington, D.C. (04.61)

century Flemish painter Gillis van Tilborch, an artist and an art dealer display their wares to patrons, who examine the treasures brought before them (fig. 21). Paintings cover the walls, and sculpture and precious objects stand on the table and floor. The painting provides a fascinating catalog of the fine arts of the seventeenth century and the taste of seventeenth-century connoisseurs.

Relations between artists and patrons are not always so congenial as Tilborch portrayed them. Patrons can change their minds about a commission or purchase or fail to pay their bills. Such conflicts can have simple beginnings and unexpected results. In the late nineteenth century the Liverpool shipping magnate Frederick Leyland asked James McNeill Whistler, an American painter living in London, what color to paint the shutters in the dining room where he planned to hang Whistler's painting *The Princess from the Land of Porcelain.* The room had been decorated with expensive embossed and gilded leather and finely crafted shelves to show off Leyland's Asian porcelain collection. Whistler was inspired by the Japanese theme of his own painting as well as the porcelain, and he was also caught up in the wave of enthusiasm for Japanese art sweeping Europe. He painted the window shutters with splendid turquoise, blue, and gold peacocks. Then, while Leyland was away, he painted the entire room (fig. 22), replacing the gilded leather on the walls with turquoise peacock feathers. Leyland was shocked and angry when he saw the results. Whistler, however, memorialized the confrontation with a painting of a pair of fighting peacocks on one wall of the room. One of the peacocks represents the outraged artist, and the other, standing on a pile of coins, represents the incensed patron. The Peacock Room, which Whistler called *Harmony in Blue and Gold,* is an extraordinary example of total design, and Leyland did not change it. The American collector Henry Freer, who sought to unite the aesthetics of East and West, later acquired the room and donated it on his death to

a museum in the Smithsonian Institution in Washington, D.C., where it can now be appreciated by all. Today museums are the primary collectors and preservers of art.

THE KEEPERS OF ART: MUSEUMS

From time immemorial people have gathered together objects that they considered to be precious, objects that were made of valuable material or that conveyed the idea of power and prestige. The curators, or keepers of such collections, assisted patrons in obtaining the best pieces. The idea of what is best and what is worth collecting and preserving varies from one generation to another. Yesterday's popular magazine (see fig. 4) is today's example of fine photography and graphic design.

An art museum can be thought of in two ways: as a scholarly research institute where curators care for and study their collections and teach new scholar-curators, and as a public institution dedicated to exhibiting and explaining the collections. The first university art museum in the United States was established in 1832 at Yale University. Today museums with important research and educational functions are to be found in many universities and colleges, and museums with good collections are widespread. One does not have to live in a major population center to experience wonderful art. Of the twenty-six works illustrated in this chapter, eleven are located near the author in Kansas and Missouri, and four of these are in a single university museum. No one would assert that Kansas is the art capital of the world; the point is that encounters with the real objects are not out of most people's range. And no matter how faithful the quality of reproductions in a book or a slide or a monitor showing an image from a CD-ROM, there is no substitute for a "live interview" with an actual work of art or architecture.

The display of art is a major challenge for curators. Art must be put on public view in a way that ensures its safety

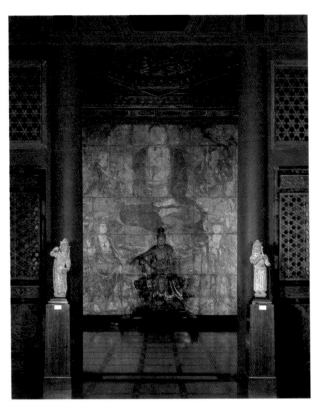

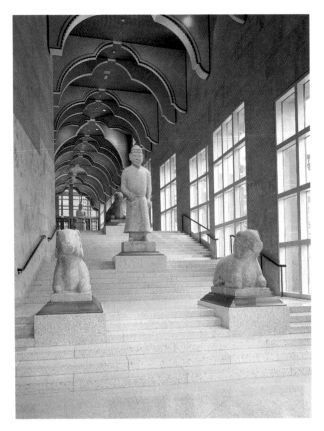

23. *The Water and Moon Kuan-yin Bodhisattva*. Northern Sung or Liao dynasty, 11th–12th century. Wood with paint, height 7'11" (2.41 m). Mural painting, 14th century; wooden screens, 17th century. The Nelson-Atkins Museum of Art, Kansas City, Missouri
Purchase: Nelson Trust (34.10)

24. Robert Venturi and Denise Scott-Brown. Stair Hall with Ming dynasty tomb figures, Seattle Art Museum. 1986–91

and also enhances its qualities and clarifies its significance. The installation of Chinese sculpture at the Nelson-Atkins Museum of Art in Kansas City (fig. 23) and at the Seattle Art Museum (fig. 24) illustrate two imaginative approaches to this challenge.

A polychromed and gilded wooden bodhisattva, or enlightened being, in the Nelson-Atkins Museum of Art sits majestically in front of a mural painting of the Buddha. The sculpture and painting are exceptional in their own right, and together they form a magnificent ensemble, placed in a re-created temple setting with screens from the seventeenth century. The curators successfully established an environment that recalls the religious context of the art, subtly emphasizes its importance, and provides it with a measure of security.

The Seattle Art Museum had different problems to solve. Their carved-stone Chinese tomb figures had stood outdoors in a park for years. Weather-beaten and moss-covered, they had been almost ignored. The new Seattle Art Museum, designed by Robert Venturi and Denise Scott-Brown and finished in 1991, had a monumental stairwell that united the museum interior with the steep city street outside. The figures were cleaned, restored, and placed on the stairs like welcoming guardians for the galleries above. Set under colorful festive arches, they provide a monumental and semi-

serious contrast to the witty, theatrical, and "irreverent" architecture—the museum coffee shop interrupts their stately procession—and serve as an appropriate symbol for a city that prides itself as a link between East and West.

"I KNOW WHAT I LIKE"

Our involvement with art may be casual or intense, naive or sophisticated. At first we may simply react instinctively to a painting or building or photograph, but this level of "feeling" about art—"I know what I like"—can never be fully satisfying.

Opinions as to what constitutes a work of art change over time. Impressionist paintings of the late nineteenth century, now among the most avidly sought and widely collected, were laughed at when first displayed. They seemed rough and unfinished—merely "impressions"—rather than the careful depictions of nature people then expected to see. Impressionist painters like Claude Monet in his *Boulevard des Capucines, Paris* (fig. 25) tried to capture in paint on canvas the reflected light that registers as color in human eyes. Rather than carefully drawing forms he knew to exist—the branches and leaves of trees, dark-clothed figures—he recorded immediate visual sensations with flecks of color. The rough texture provides a two-dimensional interest that is quite independent of the painting's subject. The mind's eye

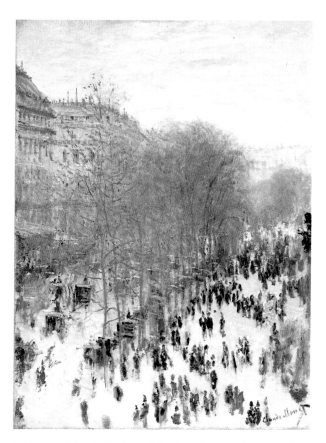

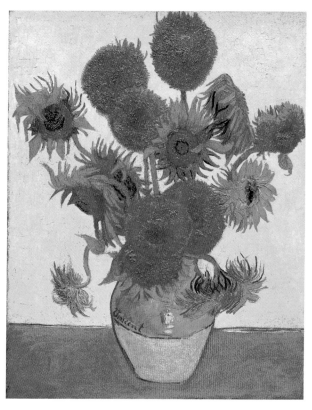

25. Claude Monet. *Boulevard des Capucines, Paris.* 1873–74. Oil on canvas, 31¼ x 23¼" (79.4 x 59.1 cm). The Nelson-Atkins Museum of Art, Kansas City, Missouri

Purchase: the Kenneth A. and Helen F. Spencer Foundation Acquisition Fund (F72-35)

26. Vincent van Gogh. *Sunflowers.* 1888. Oil on canvas, 36¼ x 28¾" (92.1 x 73 cm). The National Gallery, London

interprets the array of colors as the solid forms of nature, suddenly perceiving the coral daubs in the lower right, for example, as a balloon man. When the critic Louis Leroy reviewed this painting the first time it was exhibited, he sneered: "Only, be so good as to tell me what those innumerable black tongue-lickings in the lower part of the picture represent?" (*Le Charivari*, April 25, 1874). Today we easily see a street in early spring filled with horse-drawn cabs and strolling men and women. In this magical moment the long-dead artist and the live viewers join to re-create nineteenth-century Paris.

Art history, in contrast to art criticism, combines the formal analysis of works of art—concentrating mainly on the visual elements in the work of art—with the study of the works' broad historical context. Art historians draw on biography to learn about artists' lives, social history to understand the economic and political forces shaping artists, their patrons, and their public, and the history of ideas to gain an understanding of the intellectual currents influencing artists' work. They also study the history of other arts—including music, drama, literature—to gain a richer sense of the context of the visual arts. Every sculpture or painting presents a challenge. Even a glowing painting like Vincent van Gogh's *Sunflowers* (fig. 26), of 1888, to which we may react with spontaneous enthusiasm, forces us to think about art, as well as feel and admire it.

Our first reaction is that *Sunflowers* is a joyous, colorful painting of a simple subject. But this is far more than a bunch of flowers in a simple pot in a sunlit room. Art history makes us search for more. The surface of the painting is richly built up—van Gogh laid on the thick oil paint with careful calculation. The brilliant yellow ground that looks flat in a reproduction in fact resembles a tightly woven basket or textile, so deliberately and carefully placed are the small brushstrokes. The space is suggested simply—by two horizontal stripes, two bands of gold different in intensity and separated by just the slightest blue line, the color of maximum contrast. Here, in fact, there is no space, no setting; we imagine a table, a sun-filled room. But did van Gogh see a pot of flowers on a windowsill, against the blazing, shimmering heat and light of the true sun? Van Gogh had a troubled life, and that knowledge makes us reflect on the possible meaning of the painting to him—for the painting, despite its brightness, reflects something ominous, a foreboding of the artist's loneliness and despair to come.

As viewers we participate in the re-creation of a work of art, and its meaning changes from individual to individual, from era to era. Once we welcome the arts into our life, we have a ready source of sustenance and challenge that grows, changes, mellows, and enriches our daily experience. No matter how much we study or read about art and artists, eventually we return to the contemplation of the work itself, for art is the tangible evidence of the ever-questing human spirit.

Starter Kit

This is a very basic primer of concepts and working assumptions used in the study of art history—a quick reference guide for this entire book and for encounters with art in general.

What Art Is

A work of art may be described in basic, nonphilosophical terms as having two components: FORM and CONTENT. It is also distinguished by STYLE, MEDIUM, and PERIOD.

FORM. Referring to purely visual aspects of art and architecture, form includes LINE, COLOR, TEXTURE, SPATIAL QUALITIES, and COMPOSITION. These various attributes are often referred to as FORMAL ELEMENTS.

Line is an element—usually drawn or painted—that defines SHAPE with a more-or-less continuous mark. The movement of the viewer's eyes over the surface of the work of art may follow a path determined by the artist and so create imaginary lines, or LINES OF FORCE.

Color has several attributes. These include HUE, VALUE, and INTENSITY.

> HUE is what we think of when we hear the word *color*. Red, yellow, and blue are the PRIMARY COLORS because other colors (SECONDARY COLORS of orange, green, and purple) can be created by mixing (combining) them. Red, orange, and yellow are known as warm colors; and green, blue, and purple as cool colors.
>
> VALUE is the relative degree of lightness or darkness in the range from white to black and is created by the amount of light reflected from an object's surface. A dark green has a deeper value than a light green, for example, and light gray has a lighter value than dark gray.
>
> INTENSITY is the degree of brightness or dullness of color. For this reason, the word *saturation* is synonymous with *intensity*.

Texture is the tactile quality of a surface. It is perceived and described with words like *smooth, polished, satiny, rough, coarse,* or *oily*. Texture takes two forms: the texture of the actual surface of the work of art and the implied (imaginary) surface of the object the artist is representing.

Spatial qualities include MASS, VOLUME, and SPACE.

> MASS and VOLUME are properties of three-dimensional objects. They take up space.
>
> SPACE may be three-dimensional and actual, as with sculpture and architecture, or may be represented in two dimensions. Unfilled space is referred to as NEGATIVE SPACE; solids are referred to as POSITIVE SPACE.

Composition is the organization, or arrangement, of form in a work of art.

> PICTORIAL DEPTH (SPATIAL RECESSION) is a specialized aspect of composition in which the three-dimensional world is

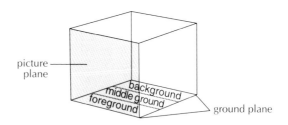

27. Diagram of picture space

represented in two dimensions in paintings and drawings. Artists have used many methods to depict objects as seeming to recede from the two-dimensional surface, called the PICTURE PLANE. The area "behind" the picture plane is called the PICTURE SPACE and conventionally contains three "zones": FOREGROUND, MIDDLE GROUND, and BACKGROUND (fig. 27). Perpendicular to the picture plane, forming the "floor" of the space, is the GROUND PLANE.

Various techniques for conveying a sense of pictorial depth have been preferred by artists in different cultures and at different times (fig. 28).

CONTENT. Content is a less specific aspect of a work of art than is form. There is also less agreement as to what content is. Content includes SUBJECT MATTER, which quite simply is what is represented, even when that consists strictly of lines and formal elements—lines and color without recognizable subject matter, for example. Content includes the IDEAS contained in a work. When used inclusively, the term *content* can embrace the social, political, and economic contexts in which a work was created, the intention of the artist, the reception of the beholder (the AUDIENCE) to the work, and ultimately the meaning in the work of art.

The study of the "what" of subject matter is ICONOGRAPHY. ICONOLOGY has come to mean the study of the "why" of subject matter.

STYLE. Understandably, specialized terminology is used to describe style in art history. Expressed very broadly, style is the combination of form and content characteristics that make a work distinctive.

Representational and **nonrepresentational style** (also called NONOBJECTIVE) refer to whether the subject matter is or is not recognizable.

Linear describes the style in which an artist uses line as the primary means of definition. When shadows and shading or modeling and highlights dominate, the style may be called PAINTERLY. Architecture and sculpture may be linear or painterly.

Realistic, naturalistic, and **idealized** are often-found descriptions of style. REALISM is the attempt to depict objects as they are in actual, visible reality. NATURALISM is a style of depiction in which the physical appearance of the rendered image in nature is the primary inspiration. A work in a naturalistic style resembles the original but not with the same exactitude

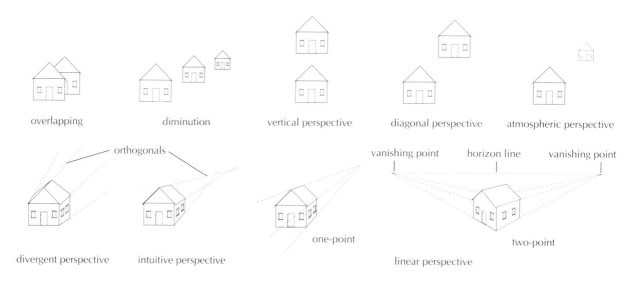

overlapping diminution vertical perspective diagonal perspective atmospheric perspective

orthogonals

vanishing point horizon line vanishing point

one-point two-point

divergent perspective intuitive perspective linear perspective

28. Pictorial devices for depicting recession in space

Among the simpler devices are OVERLAPPING, in which partially covered elements are meant to be seen as located behind those covering them, and DIMINUTION, in which smaller elements are meant to be perceived as being farther away than larger ones. In VERTICAL and DIAGONAL PERSPECTIVE, elements are stacked vertically or diagonally, with the higher elements meant to be perceived as deeper in space. Another way of suggesting depth is through ATMOSPHERIC PERSPECTIVE, which depicts objects in the far distance with less clarity than nearer objects, often in bluish gray hues, and treats the sky as paler near the horizon. For many centuries DIVERGENT PERSPECTIVE, in which forms widen slightly and lines diverge as they recede in space, was used by East Asian artists. INTUITIVE PERSPECTIVE, such as that in some late medieval European art, uses the opposite: forms become more narrow and lines converge the farther away they are from the viewer, approximating the optical experience of spatial recession. LINEAR PERSPECTIVE, also called SCIENTIFIC, MATHEMATICAL, ONE-POINT, or Renaissance perspective, is an elaboration and standardization of intuitive perspective and was developed in fifteenth-century Italy. It uses mathematical formulas to construct illusionistic images in which all elements are shaped by imaginary lines called ORTHOGONALS that converge in one or more VANISHING POINTS on a HORIZON LINE. Linear perspective is the system that most people in Euro-American cultures think of as perspective. Because it is the visual code they are accustomed to reading, they accept as "truth" the distortions it imposes, including FORESHORTENING, in which, for instance, the soles of the feet in the foreground are the largest element of a figure lying on the ground.

and literalness as a work in a realistic style. IDEALIZATION strives for perfection that is grounded in prevailing values of a culture. Classical Greek sculpture is an example of art that is both naturalistic and idealized. ABSTRACTION is the stylistic opposite of the last three styles, because the artist makes forms that do not depict observable objects—often with the intention of extracting the essence of an object or idea. Much prehistoric art is abstract in this way. EXPRESSIONISTIC style appeals to the subjective responses of the beholder, often through exaggeration of form and expression.

MEDIUM. What is meant by medium (here we have used the plural *mediums*, to distinguish the word from the press *media*) is the material from which a given object is made. Even broader than medium is the distinction between two-dimensional, three-dimensional, mixed-medium, and ephemeral arts.

Two-dimensional arts include painting, drawing, the graphic arts, and photography.

Three-dimensional arts are sculpture, architecture, and many ornamental and practical arts.

Mixed medium includes categories such as collage and assemblage, in which the two-dimensional surface is built up from elements that are not painted, such as pieces of paper or metal or garments.

Ephemeral arts include such chiefly modern categories as performance art, earthworks, cinema, video art, and computer art, all of which have a central temporal aspect in that the artwork is viewable for a finite period of time and then disappears forever, is in a constant state of change, or must be replayed to be experienced.

Painting includes wall painting and fresco, illumination (decoration of books with paintings), panel painting (paintings on wood panels), miniature painting, handscroll and hanging scroll painting, and easel painting.

Drawings may be sketches (quick visual notes for larger drawings or paintings); studies (more carefully drawn analyses of details or entire compositions); drawings as complete artworks in themselves; and cartoons (full-scale drawings made in preparation for work in another medium, such as fresco).

Graphic arts are the printed arts—images that are reproducible and that traditionally include woodcut, engraving, etching, drypoint, and lithography.

Still photographs are a two-dimensional art.

Sculpture is a three-dimensional work of art that is carved, modeled, or assembled. Carved sculpture is reductive in the sense that the image is created by taking material away.

TECHNIQUE

Lost-Wax Casting

The lost-wax casting process (also called *cire perdue*, the French term) has been used for many centuries. It probably started in Egypt. By 200 BCE the technique was known in China and ancient Mesopotamia and was soon after used by the Benin peoples in Africa. It spread to ancient Greece sometime in the sixth century BCE and was widespread in Europe until the eighteenth century, when a piece-mold process came to predominate. The usual metal is bronze, an alloy of copper and tin, or sometimes brass, an alloy of copper and zinc.

The progression of drawings here shows the steps used by Benin sculptors. A heat-resistant "core" of clay—approximating the shape of the sculpture-to-be (and eventually becoming the hollow inside the sculpture)—was covered by a layer of wax about the thickness of the final sculpture. The sculptor carved the details in the wax. Rods and a pouring cup made of wax were attached to the model. A thin layer of fine, damp sand was pressed very firmly into the surface of the wax model, and then model, rods, and cup were encased in thick layers of clay. When the clay was completely dry, the mold was heated to melt out the wax. The mold was then turned upside down to receive the molten metal, which for the Benin was brass, heated to the point of liquification. The cast was placed in the ground. When the metal was completely cool, the outside clay cast and the inside core were broken up and removed, leaving the cast brass sculpture. Details were polished to finish the piece of sculpture, which could not be duplicated because the mold had been destroyed in the process.

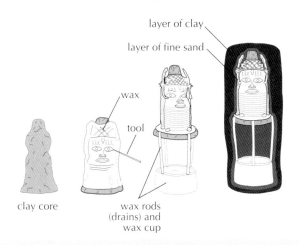
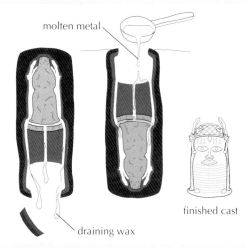

clay core

wax rods (drains) and wax cup

wax

tool

layer of clay

layer of fine sand

molten metal

draining wax

finished cast

Wood and stone sculpture, large and small, is carved sculpture because the material is not malleable. Modeled sculpture is considered additive, meaning that the object is built up from a material such as clay that is soft enough to be molded and shaped. Metal sculpture is usually cast (see "Lost-Wax Casting," above) or is assembled by welding or similar means of joining.

Sculpture is either FREESTANDING (sculpture in the round) or in RELIEF, which means projecting from the surface of which it is a part. Relief may be HIGH RELIEF, with parts of the sculpture projecting far off the background, or LOW RELIEF, in which the projections are only slightly raised. SUNKEN RELIEF, found mainly in Egyptian sculpture, is imagery carved into the surface, with the highest part of the relief being the flat surface.

Architecture is three-dimensional and highly spatial, and it is closely bound up with developments in technology and materials. An example of the relationship among technology, materials, and function is how space is spanned (see "Elements of Architecture," page 32).

Buildings are represented by a number of two-dimensional schematic drawings, including plans, elevations, sections, and cutaways (fig. 29). PLANS are imaginary slices through a building at approximately waist height. Everything below the slice is drawn as if looking straight down from above. ELEVATIONS are exterior sides of a building as if seen from a moderate distance but without any perspective dis-

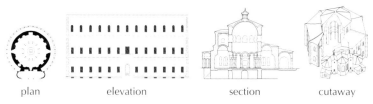

plan elevation section cutaway

29. Diagrammatic drawings of buildings

tortion. SECTIONS are imaginary vertical slices from top to bottom through a building that reveal elements "cut" by the slice. CUTAWAY DRAWINGS show both inside and outside elements from an oblique angle.

Other mediums. Besides painting, drawing, graphic arts, photography, sculpture, and architecture, works of art are made in the mediums of ceramic and glass, textile and stitchery, metalwork and enamel, and many other materials. Today anything—even "junk," the discards of society—can be turned into a work of art.

PERIOD. A word often found in art historical writing, *period* means the historical era from which a work of art comes. It is good practice not to use the words *style* and *period* interchangeably. Style is the sum of many influences and characteristics, including the period of its creation. An example of good usage is: "an American house from the Colonial period built in the Georgian style."

ELEMENTS OF ARCHITECTURE

Space-Spanning Construction Devices

Gravity pulls on everything, presenting great challenges to the need to cover spaces. The purpose of the spanning element is to transfer weight to the ground. The simplest space-spanning device is post-and-lintel construction, in which uprights are spanned by a horizontal element. However, if not flexible, a horizontal element over a wide span breaks under the pressure of its own weight and the weight it carries.

Corbeling, the building up of overlapping stones, is another simple method for transferring weight to the ground. Arches, round or pointed, span space. Vaults, which are essentially extended arches, move weight out from the center of the covered space and down through the corners. The cantilever is a variant of post-and-lintel construction. When concrete is reinforced with steel or iron rods, the inherent brittleness of cement and stone is then overcome because of metal's flexible qualities. The concrete can then span much more space and bear heavier loads. Suspension works to counter the effect of gravity by lifting the spanning element upward. Trusses of wood or metal are relatively lightweight spanners but cannot bear heavy loads. Large-scale modern construction is chiefly steel frame and relies on steel's properties of strength and flexibility to bear great loads. The balloon frame, an American innovation, is based in post-and-lintel principles and exploits the lightweight, flexible properties of wood.

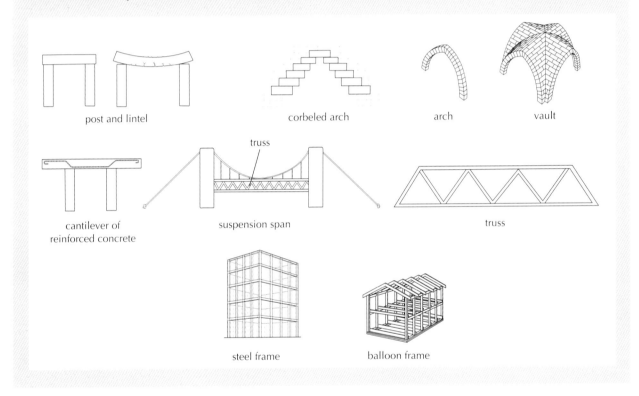

post and lintel corbeled arch arch vault

truss

cantilever of reinforced concrete suspension span truss

steel frame balloon frame

What Art History Is

Art history is a humanistic field of inquiry that studies visual culture. Increasingly, art history seeks to understand the role of visual culture in societies around the world and to learn more about the people and cultures who created the individual artworks through close yet multidimensional study of the art itself. Art history embraces many different approaches to visual culture. CONTEXTUAL ART HISTORY seeks to place and understand art as one expression of complex social, economic, political, and religious influences on the culture and the individuals within it. FORMALISM, or FORMAL ANALYSIS, examines and analyzes the formal elements of works of art, in and of themselves. The most traditional approach is CONNOISSEURSHIP, the almost intimate appreciation and evaluation of works of art for their intrinsic attributes, including genuineness and quality. Connoisseurship necessarily involves AESTHETICS, a branch of philosophy concerned with the nature of beauty and taste. This book combines contextual art history and formal analysis, while acknowledging other approaches.

Museums

When you visit a museum, you need no special preparation, but planning can enhance your enjoyment. Several museum resources can help you as you study the works of art there. Publications such as exhibition catalogs and museum handbooks have entries on the artworks. Postcards are an inexpensive way to take an image home.

Museum behavior is simple common sense: don't do anything that endangers the art or interferes with other people's enjoyment of it. In the galleries take a quick look around to get a sense of what is there before going back to look more carefully at individual works that attract you. You can be systematic or selective. When you approach a work of art, look at it and think about it before you read the label. You may not see the same works of art that you have studied in this book, but you will see pieces that relate to both the ideas and the artworks presented in *Art History*. Reading about art—whether in books, in catalogs, or on museum labels—should supplement, not substitute for, looking at works of art.

A BRIEF REVIEW OF THE EUROPEAN MIDDLE AGES

The Middle Ages, or medieval period, spans approximately 1,000 years in Europe, from the fifth to the fifteenth century. Medieval society arose after the collapse of the Western Roman Empire in 476, and the empire's vast road and water-supply networks, grandiose buildings, and places of learning quickly declined. This period of rapid change was marked by the spread of Christianity under the authority of the pope, the bishop of Rome. Christian clergy were almost the only people during this time who maintained the skills of reading and writing and undertook scholarly endeavors. The Church, as a result, had much influence on the arts.

As the migrating peoples of Euope settled down, they established kingdoms. For a time in the eighth and ninth centuries, Charlemagne, an astute and powerful ruler, united much of what are now France, Germany, Belgium, the Netherlands, and northern Italy into the Carolingian Empire, but his heirs soon divided the empire into separate kingdoms. From about 800 to 1000, Viking invaders from Scandinavia raided parts of Europe. Out of a conglomeration of mainly Germanic and northern Italian states and principalities arose a weak and often divided Holy Roman Empire in the late 900s, ruled by a series of emperors crowned by the pope.

In response to almost constant local warfare, people turned to local political, economic, and social structures for security. A new medieval way of life—combining vestiges of the old Roman Empire with Germanic traditions—expanded throughout Europe, especially after the tenth century. Powerful rulers, in order to obtain a trained local fighting force, promised tracts of land, called fiefs, to vassals, who in turn promised loyalty and military assistance to their lords. In time, wealthy vassals controlled enough land to offer some of it to their own vassals. Vassals and sub-vassals often attempted to make their fiefs hereditary, which gave rise to a complex legal and economic system of rights, obligations, and dependency known as feudalism.

Most people in agricultural medieval society lived a bleak life as serfs bound to the land, laboring in return for promises of protection, a share of the crops, and economic support from their lord. Manors, or huge estates, were almost self-sufficient units, since people could no longer depend upon the long-distance trade opportunities or large cities of an empire to provide them with goods, services, or courts of law. Life for most people was short, with the events of birth, marriage, and death marked by Christian religious ceremonies conducted by the local clergy.

Beginning in the early 600s, the new religion of Islam spread from Arabia westward across North Africa and then northward into Europe. From about 800 until final victory in 1492, Christian kings fought wars to reconquer the Iberian peninsula (modern Spain and Portugal) from the Muslims. Beginning in 1096, Christian kings also led or sent military expeditions known as the Crusades from Europe into the Middle East to reclaim the Holy Land from Muslim Arabs.

On medieval Europe's southeastern borders, the Byzantine Empire (the eastern part of the former Roman Empire) flourished with a complex blend of ancient Greek, Roman, Christian, and Middle Eastern traditions. The empire lasted until 1453 when its capital, Constantinople, fell to the Muslim Ottoman Turks. In 1054 the Christian Church had split into two parts, the Roman Catholic Church in western Europe, and the Eastern Orthodox Church in the Byzantine Empire, but the Crusades again brought the West into contact with the East and stimulated the flow of new ideas and new wealth from trade.

During the 1100s and 1200s this new wealth was channeled by taxes into huge building programs, making possible the soaring Gothic cathedrals with their brilliant stained-glass windows. These structures in growing towns gave work to architects, artists, stonemasons, sculptors, carpenters, craftworkers, and merchants. Within new town-centered universities students prepared for service in the Church or the government.

During the last few hundred years of the Middle Ages, the feudal system declined. In 1348 a bubonic plague, called the Black Death, struck Europe, killing more than 40 percent of the people. Growing royal power in England, France, and Spain meant a decline in the power of local nobles, who were further weakened by the Hundred Years' War (1337–1453) between England and France. Monarchs used their increased tax revenues to pay for standing armies rather than depend upon the doubtful loyalty of knights and the lessened security of castles. Medieval society was also weakened by disputes within the Church; at times in the 1300s there were two rival popes.

With the revival of urban life, merchants and craftsworkers demanded a greater say in political decisions. In the Italian city-states, in particular, wealthy merchants and rulers supported the renewed interest in ancient Greek and Roman texts, which inspired people to study language, poetry, history, and moral philosophy emphasizing harmony and balance in nature and the importance of individual achievement—ideas soon reflected in works of art and scholarship. After the mid-fifteenth century, printing with movable type made the spread of new knowledge faster and easier. By then the Middle Ages had given way to the Renaissance.

1400 1420 1440

Limbourg Brothers
Detail of seated woman,
February. 1413–16

Brunelleschi
Dome of Florence Cathedral
1417–36

Donatello
David
After 1428

Van Eyck
*Portrait of Giovanni Arnolfini (?)
and His Wife, Giovanna Cenami (?)*
1434

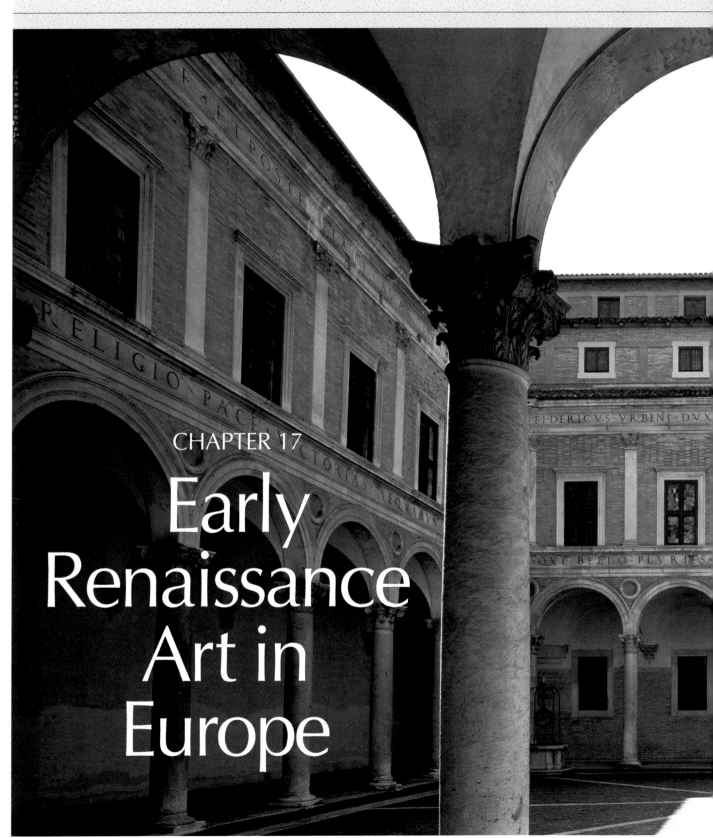

CHAPTER 17

Early Renaissance Art in Europe

Fouquet
*Étienne Chevalier
and Saint Stephen*
c. 1450

Alberti
Facade
Church of Sant'Andrea
Designed 1470

Verrocchio
Equestrian monument of
Bartolommeo Colleoni
c. 1481–96

Perugino
*Delivery of the Keys
to Saint Peter*
1482

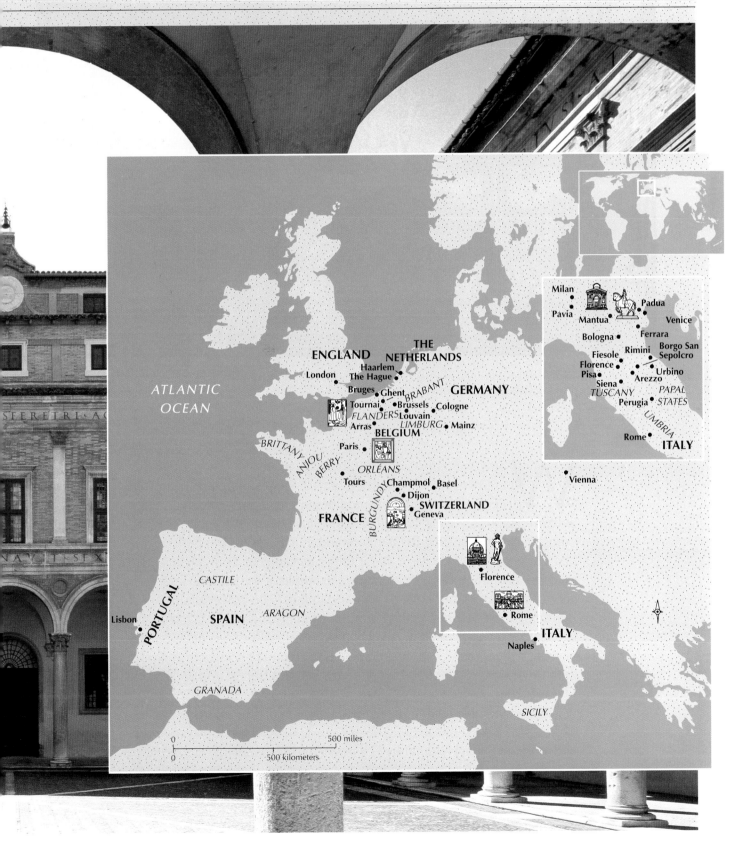

ATLANTIC
OCEAN

ENGLAND

THE
NETHERLANDS

London
Haarlem
The Hague
Bruges Ghent
BRABANT
GERMANY
Tournai Brussels
FLANDERS Louvain Cologne
Arras LIMBURG Mainz
BELGIUM

BRITTANY

ANJOU Paris
BERRY
ORLÉANS
Tours Champmol Basel
BURGUNDY Dijon
FRANCE Geneva SWITZERLAND

Lisbon
CASTILE
PORTUGAL
ARAGON
SPAIN
GRANADA

Florence

Rome

ITALY

Naples

SICILY

Vienna

Milan
Pavia
Mantua Padua
Venice
Bologna Ferrara
Fiesole Rimini Borgo San
Florence Sepolcro
Pisa Urbino
Siena Arezzo
TUSCANY PAPAL
Perugia STATES
UMBRIA
Rome
ITALY

0 500 miles
0 500 kilometers

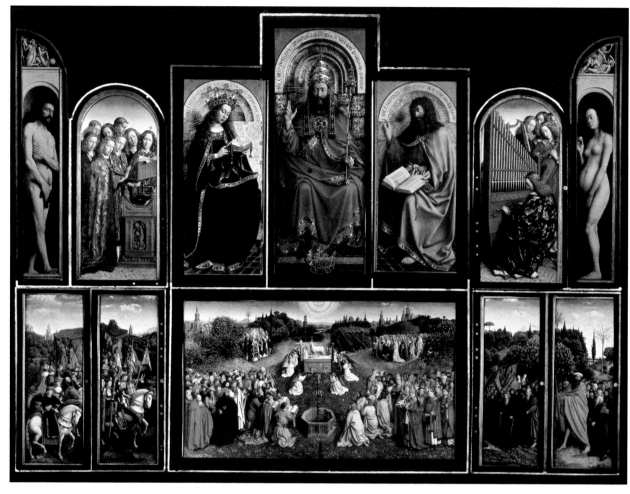

17-1. Jan and Hubert van Eyck. *Ghent Altarpiece* (open), Cathedral of Saint-Bavo, Ghent, Flanders (Belgium). 1432. Oil on panel, 11'5³⁄₄" x 15'1¹⁄₂" (3.5 x 4.6 m)

When Philip the Good of Burgundy entered Ghent in 1458, the entire Flemish city turned out. Townspeople made elaborate decorations and presented theatrical events—much as they did for religious festivals, feast days, and visits by other important dignitaries. Local artists designed banners and made sets for the performances, most of which were about religious subjects. That day in Ghent, an especially dramatic and fascinating example of the relationship between visual art and performance took place. The powerful duke of Burgundy was greeted by small groups standing absolutely frozen, like statues: to welcome him they had become *tableaux vivants* ("living pictures") dressed in costume and posed to re-create scenes from their town's most celebrated work of art, Jan and Hubert van Eyck's *Ghent Altarpiece* (fig. 17-1).

This remarkable centerpiece of worship, completed twenty-six years earlier, shows an enthroned figure of God, seated between the Virgin Mary and John the Baptist and flanked by angel musicians. Below is a depiction of the Communion of Saints, based on the passage in the Book of Revelation that describes the Lamb of God receiving the veneration of a multitude of believers (Revelation 14:1). The church fathers, prophets, martyrs, and other saints depicted were among those staged that day to greet Philip.

The fascination with this complex and beautiful altarpiece, reflected so early in the tableaux vivants, perhaps accounts for its survival through more than five centuries. During uprisings in the sixteenth century, the panels were twice removed from their frames and hidden in a church tower. Over later centuries, panels were separated and taken to various locations to protect them. In 1894, while in the royal collection in Berlin, the six smallest panels were split through the middle so that both painted sides could be displayed at the same time. After World War I, the altarpiece was reassembled at Ghent, but a thief made off with two panels in 1934. (One, at the far left, was never recovered but was replaced by a faithful copy.) During World War II, the altarpiece panels were moved from town to town for safekeeping. Finally, in 1950–1951, the whole *Ghent Altarpiece*, one of the most studied and respected works of the early Renaissance in Europe, was reconstituted in Ghent.

THE EMERGENCE OF THE RENAISSANCE

In Europe many developments that had begun in the late Middle Ages reached maturity in the fifteenth century. Basic to these changes was economic growth in the late fourteenth century that gave rise to a prosperous middle class in the Netherlands (which then included present-day Belgium), France, and Italy. Unlike the hereditary aristocracy that had dominated society during the Middle Ages, these merchants and bankers had attained their place in the world through personal achievement and were imbued with a spirit of self-confidence. In the early fifteenth century this newly rich middle class, like other people of means since the earliest civilizations, supported scholarship, literature, and the arts. Their generous patronage resulted in the explosion of learning and creation known as the Renaissance.

Renaissance is a French word for "rebirth." Although there have been other periods of economic and cultural rejuvenation in history, when people today speak of "the Renaissance," they mean this revival of certain ideals of Greek and Roman civilization, which arose and developed in the fifteenth century and spread throughout Europe in the sixteenth. This chapter considers the emergence of the Renaissance and its development during the fifteenth century. Sixteenth-century Renaissance art is covered in Chapter 18.

The intense interest in the classical past that characterized the fifteenth century did not develop suddenly in 1400. Scholars in the Middle Ages had already translated and written commentaries on the most important surviving books of antiquity. Since most of these texts were pre-Christian, the scholars who studied them became increasingly acquainted with a more secular outlook than was common among people of the Middle Ages. By the end of the fourteenth century, admiration of the ancient world had grown to such a point that humanists, as these scholars of antiquity were called, even began to use Latin texts as models for works of their own.

The Middle Ages, it is often said, was an "age of faith," a time when the goal of human existence was considered to be the salvation of the soul. Although the period produced wonderful examples of literature, poetry, history, and even science, intellectual life was largely concerned with theology and the reading of Scripture. To medieval people, despite their admiration for the accomplishments of the classical past, antiquity represented not a golden age to be revered and imitated but the unfortunate period before the coming of Christ. Thus, the humanists' admiration of the remarkable accomplishments of Greek and Roman civilization was a dramatic change. They regarded with wonder not only philosophers, poets, rhetoricians, and historians—of whom the Middle Ages also had many—but also mathematicians, astronomers, geographers, physicians, and naturalists, not to mention artists and architects. Perhaps more important, many classical writings exemplified a spirit of inquiry that tried to understand the natural world in a rational and scientific way. Renaissance scholars and artists all over Europe sought this same understanding.

In the art of northern Europe, where this survey of the Renaissance begins, interest in the natural world was manifested in detailed observation of nature. In manuscript painting, on wooden **panels**, and on canvas, artists depicted birds, plants, and animals with breathtaking accuracy. They observed that the sky is darker straight above than at the horizon, and they painted it that way. They described trees, shrubs, and even blades of grass with botanical precision. Enlarging on developments begun in the fourteenth century, artists accurately portrayed reflections in water and, in **volumetric** rendering, modeled the volumes of forms with light and shadow.

Along with the desire for accurate depiction came a new interest in particular personalities. Fifteenth-century portraits have astonishingly lifelike individuality, combining careful—sometimes even unflattering—description with an uncanny sense of vitality. In a number of religious paintings, even the saints and angels seem to be portraits. Indeed, individual personalities were important

Europe	1400–1450	1450–1500
France	Claus Sluter; Limbourg brothers; Joan of Arc burned at the stake	End of Hundred Years' War with England; René of Anjou; Mary of Burgundy Painter
Flanders	Robert Campin; Jan van Eyck; Rogier van der Weyden; Petrus Christus	Hugo van der Goes; Dirck Bouts; Geertgen tot Sint Jans; Hans Memling; Hunt of the Unicorn tapestry
Spain and Portugal	Beginning of European exploration of West Africa's coast	Nuño Gonçalvez; Isabella and Ferdinand unite Spanish peninsula; Diego de la Cruz; beginning of Europe's Atlantic slave trade; Columbus's voyages; Vasco da Gama discovers sea route to India
Germany	Holy Roman Empire; Konrad Witz	Gutenberg's Bible; E. S.'s engravings; Martin Schongauer
Italy	Nanni di Banco; Council of Constance restores papacy to Rome; Kingdom of Naples and Sicily and Papal States begin to dominate politically; Filippo Brunelleschi; Gentile da Fabriano; Masaccio; Jacopo della Quercia; Fra Angelico; Michelozzo di Bartolommeo; Medici academy for classical learning; Andrea del Castagno; Paolo Uccello	Jacopo Bellini; Leon Battista Alberti; Fra Filippo Lippi; Piero della Francesca; Donatello; Lorenzo de' Medici rules Florence; Antonio del Pollaiuolo; Andrea Mantegna; Andrea del Verrocchio; Domenico del Ghirlandaio; Sandro Botticelli; Perugino, restoration of Sistine Chapel begins; Gentile Bellini; Savonarola preaches against worldliness; Giovanni Bellini
World	Ming dynasty (China); Muromachi period (Japan); Inka Empire established (South America); Montezuma rules Aztec Empire (South America); Ottoman Turks defeat Crusaders; *The Arabian Nights* collected (Egypt)	Ottoman Turks conquer Constantinople; War of the Roses (England); Mosque of Qait Bey (Egypt); first printed book in English by William Caxton (Brussels); Ivan the Great rules Russia; John Cabot (England) reaches North America; Spanish Inquisition, world population less than 500 million

in every sphere. More names of artists were recorded during the fifteenth century, for example, than in the entire span from the beginning of the common era to the year 1400. A similar observation might be made in nearly every field.

One reason for this new emphasis on individuality was that humanism implied an interest not only in antiquity but also in human beings; humanists believed that people were both worthy and capable of determining their own destinies. This perspective contrasted sharply with the medieval view that humanity was irredeemably sinful and had value only through the infinite grace of God. Nevertheless, the rise of humanism did not signify a decline in the importance of Christian belief. In fact, an intense Christian spirituality continued to inspire and pervade most European art through the fifteenth century and long after.

Despite the enormous importance of Christian faith in the fifteenth century, the established Western Church was plagued with problems. Furthermore, militant Islam was expanding toward southeastern Europe. In 1453, the Ottoman Turks actually conquered Constantinople, the capital of the Byzantine Empire and the center of Eastern Christianity. From there they pushed westward into Greece and Serbia and ultimately lay siege to the northeastern coast of Italy. Within the Western Church, the hierarchy was being bitterly criticized for a number of its practices, including perceived indifference toward the needs of common people. Although these strains within the Western Church had little direct effect on fifteenth-century art, they exemplified the skepticism of the Renaissance mind. In the next century, these tensions would give birth to the Protestant Reformation.

FRENCH COURT ART AT THE TURN OF THE CENTURY

In the late Middle Ages the French monarchy, from its seat in Paris, began to emerge as the powerful center of a national state after centuries of weakness following the collapse of the Carolingian Empire. In the fourteenth and fifteenth centuries royal authority was still constrained by dukes and other nobles who controlled large territories outside the Paris region. Some of these nobles were at times powerful enough to pursue their own policies independent of the king. Many of the great dukes were members of the royal family, however, and their interests often united with those of the king. One strong centralizing

WOMEN ARTISTS IN THE LATE MIDDLE AGES AND THE RENAIS-SANCE Medieval and Renaissance women artists typically learned their trade from members of their families, because formal apprenticeships were not open to them. Surviving records of medieval French stone-cutting workshops, which were operated as family businesses, show that women were active in these businesses. Similarly, Jeanne de Montbaston and her husband, Richart, worked together as book **illuminators** under the auspices of the University of Paris in the fourteenth century. After Richart's death, Jeanne continued the workshop and, following the custom of the time, was sworn in as a *libraire* (publisher) by the university in 1353.

Convents trained women artists, some of them members of the order, others unaffiliated. One of the earliest examples of a signed work by a woman painter is a tenth-century manuscript of the *Apocalypse*, illustrated by a woman named Ende, who describes herself as "painteress and helper of God." Particularly remarkable is a twelfth-century collection of sermons decorated by a nun named Guda, who not only signed her work but also included a self-portrait, one of the earliest in Western art.

In the fifteenth century women could be admitted to the guilds in some cities, including the Flemish towns of Ghent, Bruges, and Antwerp. The fifteenth-century painter Agnes van den Bossche of Ghent, for example, learned her trade at home but went on to operate a painting workshop with her artist husband. After his death she became a free master of the painters' guild. A study of the painters' guild of Bruges has shown that by the 1480s one-quarter of its membership was female. Thus, while professional women artists were not the rule in medieval and Renaissance Europe, they were more common than is generally supposed today.

Particularly talented women were given commissions of the highest order. Bourgot, the daughter of the miniaturist Jean le Noir, illuminated books for a number of noble patrons, including Charles V of France and Jean, Duke of Berry. Christine de Pisan (1365–c. 1430), a well-known writer patronized by Philip the Bold of Burgundy and Queen Isabeau of France, described the work of an illuminator named Anastaise, "who is so learned and skillful in painting manuscript borders and miniature backgrounds that one cannot find an artisan . . . who can surpass her . . . nor whose work is more highly esteemed" (*Le Livre de la Cité des Dames*, I.41.4, translated by Earl J. Richards). Besides women pursuing painting as a profession, noblewomen, who were often educated in convents, also learned to draw and paint, skills that came to be considered part of the education of a woman of rank.

Here the anonymous illuminator of a French edition of a book by the Italian author Boccaccio entitled *Concerning Famous Women*, produced for Philip the Bold in 1403, shows Tha-

myris, an artist of antiquity, at work in her studio. She is depicted in a contemporary fifteenth-century room, painting an image of the Virgin and Child. At the right, an assistant grinds and mixes the colors Thamyris will need to complete her painting. The uptilted ground plane, the minute details of the setting, and the bright colors and patterns exemplify the International Gothic style of illumination favored by the French courts at the beginning of the fifteenth century.

Page with Thamyris, from Giovanni Boccaccio's *De Claris Mulieribus (Concerning Famous Women)*. 1402. Ink and tempera on vellum. Bibliothèque Nationale, Paris

factor was the threat of a common enemy, England. Claiming the French throne through inheritance, Edward III of England and his successors repeatedly invaded France between 1337 to 1453. This series of conflicts is known as the Hundred Years' War.

Just as the king held court in Paris, the most powerful of the dukes maintained courts in their own capitals. Through most of the fourteenth century, these centers had been arbiters of taste for most of Europe. From the last decades of the fourteenth century up to the 1420s, French court patronage was especially influential in northern Europe. The French king and his relatives the dukes of Anjou, Berry, Orléans, and Burgundy employed not only local artists but also gifted painters and sculptors from the Low Countries (present-day Belgium, Luxembourg, and the Netherlands). At the same time, many Dutch and Flemish artists migrated to France to work. Of major importance in the spread of new artistic ideas from the north were the construction and decoration of a

monastery at Champmol in what is now eastern France.

The French love of personal, intimate works of art set the tone for much of the art produced all over Europe in the International Gothic style, the prevailing manner of the late fourteenth century. The general characteristics of this style were charming or touching subjects, graceful poses, sweet facial expressions, and a concern for naturalistic details, including carefully rendered costumes and textile patterns, presented in a palette of bright and pastel colors with liberal touches of gold. The International Gothic style was so universally appealing that patrons throughout Europe continued to commission such works well into the fifteenth century, even as the new styles of the Renaissance took hold.

Manuscript Illumination

The French nobility were avid collectors of illustrated manuscripts, and in the late fourteenth century the

17-2. Paul, Herman, and Jean Limbourg. Page with *February, Très Riches Heures.* 1413–16. Musée Condé, Chantilly, France

The provenance, or ownership history, of this Book of Hours was unbroken up to 1530, when it passed at the death of Margaret of Austria, the regent of the Netherlandish provinces, to Jean Ruffaut, treasurer of the Holy Roman Empire. After that, it dropped out of sight until around 1850, when a French duke purchased it from an Italian collection. The duke identified its original owner as Jean, Duke of Berry, from the portrait on the *January* page of the book's calendar. Not until 1881, however, was the manuscript matched by art historian Léopold Delisle with an item in Jean's accounts, described as an incomplete but "very sumptuous hours [*très riches heures*] made by Paul and his brothers, very richly historiated and illuminated."

workshops of Paris were producing outstanding manuscripts for them. Religious texts were in great demand, as were secular writings such as herbals (encyclopedias of plants), health manuals, and works of history and literature, both ancient and contemporary.

The painters of Flanders, Holland, and other principalities of the Low Countries were increasingly influential in France at the beginning of the fifteenth century, and their fascination with creating an illusion of reality

began to have an impact on French **illumination**, the small-scale illustration of books in color, some of which was done by women (see "Women Artists in the Late Middle Ages and the Renaissance," page 615). The most famous Netherlandish illuminators of the time were three brothers, Paul, Herman, and Jean, commonly known as the Limbourg brothers. In the fifteenth century, people generally did not have family names but were instead known by their first names, often followed by a

reference to their place of origin or parentage. The name used by the three Limbourg brothers, for example, refers to their home region. (Similarly, Jan van Eyck means "Jan from [the town of] Eyck." This chapter uses the forms of artists' names as they most commonly appear in contemporary documents.)

The Limbourg brothers are first recorded as apprentice goldsmiths in Paris about 1390. About 1404, they entered the service of the duke of Berry, for whom they produced their major work, the so-called *Très Riches Heures* (*Very Sumptuous Hours*), between 1413 and 1416. For the calendar section of this Book of Hours—a selection of prayers and readings keyed to Church rituals—the Limbourgs created full-page paintings to introduce each month, with subjects alternating between peasant labors and aristocratic pleasures.

Like most European artists of the time, the Limbourgs showed the laboring classes in a light acceptable to aristocrats—that is, happily working for their benefit. But the Limbourgs also showed the peasants enjoying their own pleasures. Haymakers on the *August* page shed their clothes to take a swim in a stream, and *September* grape pickers pause to savor the sweet fruit they are gathering. In the *February* page (fig. 17-2), farm people relax cozily before a blazing fire. Although many country people at this time lived in hovels, this farm looks comfortable and well maintained, with timber-framed buildings, a row of beehives, a sheepfold, and woven fences. In the distance are a small village and church.

Most remarkably, the artists convey the feeling of cold winter weather: the breath of the bundled-up worker turning to steam as he blows on his hands, the leaden sky and bare trees, the soft snow covering the landscape, and the comforting smoke curling from the farmhouse chimney. The painting clearly shows several International Gothic conventions: the high placement of the **horizon line**, the point at which the earth and the sky appear to meet, and the missing front wall of the house. The muted palette is sparked with touches of yellow-orange, blue, and a patch of bright red on the man's turban at the lower left. The integration of human and animal figures and architecture into the landscape has been accomplished within the prevailing Gothic style, but on a more believable scale, with a landscape receding continuously from foreground to middleground to background. The only nonrealistic element is the elaborate calendar device, with the sun god and the zodiac symbols.

Painting and Sculpture for the Chartreuse de Champmol

One of the most lavish projects of Philip the Bold, the duke of Burgundy (ruled 1363–1404) and son of the French king, was a Carthusian monastery, or *chartreuse* ("charterhouse," in English). He founded it in 1385 at Champmol, near his capital at Dijon, and its church was intended to house his family's tombs. A Carthusian monastery was particularly expensive because Carthusians, unlike most monks, did not provide for themselves by farming or other physical work but were dedicated to prayer and solitary

17-3. Claus Sluter. Well of Moses, Chartreuse de Champmol, Dijon, France. 1395–1406. Limestone, height of figures 5'8" (1.69 m)

meditation. The order is in effect a brotherhood of hermits. Although the brothers were thus free to pray at all hours for the souls of Philip and his family, it also meant that they needed continuing financial support.

Philip commissioned the Flemish sculptor Jean de Marville to direct the production of the sculptural decoration of the monastery. At Jean's death in 1389, he was succeeded by his assistant Claus Sluter (documented from 1379; d. 1405/6), from Haarlem, in Holland. Although much of this splendid complex was destroyed 400 years later during the French Revolution, the quality of Sluter's work can still be seen on the Well of Moses, a monumental fountain at the center of the main cloister, which served as the order's cemetery (fig. 17-3). Begun in 1395, the fountain was unfinished at Sluter's death. Originally the base rose from its center to support a large, freestanding Crucifixion, which included figures of the Virgin Mary, Mary Magdalen, and John the Evangelist. Surrounding the base, which still survives, are nearly 6-foot-tall stone figures of Old Testament prophets and heroes who either foretold the coming of Christ or were in some sense his precursors: Moses (the ancient Hebrew prophet and lawgiver), David (king of Israel and an ancestor of Jesus), and the prophets Jeremiah, Zechariah, Daniel, and Isaiah.

Sluter depicted the Old Testament figures as distinct individuals physically and psychologically. Moses' sad old eyes blaze out from a memorable face entirely covered with a fine web of wrinkles. Even his horns—traditionally

17-4. Melchior Broederlam. *Annunciation and Visitation* (left); *Presentation in the Temple and Flight into Egypt* (right), wings of an altarpiece for Chartreuse de Champmol. 1394–99. Oil on panel, 5'5¾" x 4'1¼" (1.67 x 1.251 m). Musée des Beaux-Arts, Dijon

given to him because of a mistranslation in the Latin Bible—are wrinkled. A mane of curling hair and a beard cascade over his heavy shoulders and chest, and an enormous cloak envelops his body. Beside him stands David, in the voluminous robes of a medieval king, the personification of nobility. The drapery, with its deep folds creating dark pockets of shadow, is an innovation of Sluter's. While its heavy sculptural masses conceal the body beneath, its strong highlights and shadows visually define the body's volumes. With these vigorous, imposing, and highly individualized figures, Sluter transcended the limits of the International Gothic style and introduced a new Renaissance manner to northern sculpture.

Between 1394 and 1399, two Flemish artists working in different towns produced a large **altarpiece** for the Chartreuse de Champmol. This was a **triptych**, a work in three panels, hinged together side by side so that the two side panels, or **wings**, fold over the central one. Jacques de Baerze, a wood carver, executed the central panel in carved reliefs—figures or objects carved from the surrounding plane—while Melchior Broederlam painted the exteriors of the two large wings (fig. 17-4). Broederlam's subjects illustrate the Infancy of Christ. The events take place in a continuous landscape that fills the two panels, each scene with its own architectural or natural spatial setting for the solid, three-dimensional figures. In International Gothic fashion, the front walls of the structures have been removed and the floors tilted up to give clear views of the interiors. Outdoor elements have been

arranged to lead the eye up from the foreground and into the distance along a rising ground plane. Despite the imaginative architecture, fantasy mountains, miniature trees, and solid gold sky, the artist has created a sense of light and air around his figures.

On the left wing, in the *Annunciation,* the archangel Gabriel greets Mary with the news of her impending motherhood. A door leads into the dark interior of the tall pink rotunda meant to represent the Temple of Jerusalem, where, according to legend, Mary was an attendant prior to her marriage to Joseph. At the left is a tiny enclosed garden, a symbol of Mary's virginity. In the *Visitation,* just outside the temple walls, the now-pregnant Mary greets her older cousin Elizabeth, who is also pregnant and will soon give birth to John the Baptist. On the right wing, in the *Presentation in the Temple,* Mary and Joseph have brought the newborn Jesus to the temple for the Jewish purification rite, where the prophet Simeon takes him in his arms to bless him (Luke 2:25–32). At the far right, the Holy Family flees into Egypt to escape King Herod's order to kill all Jewish male infants. The family travels along treacherous terrain similar to that in the *Visitation* scene, an element that foretells the difficulties that lie ahead for the child. As with many medieval and Renaissance scenes of the Life of Christ, much of the detail comes not from the New Testament accounts but from other legendary writings. One such detail is the statue of the pagan god breaking and tumbling from its pedestal as the Christ Child approaches, visible at the upper right.

FLEMISH ART

Netherlandish painting of this period is called Flemish because its greatest exponents lived in that province of the Low Countries called Flanders (most of which is now part of modern Belgium, and a small part is in present-day France), although some artists' families had originally come from Brabant and Holland to the north or from nearby German states and France. Flanders, with its major seaport at Bruges, was the commercial power of northern Europe, rivaled in southern Europe only by the Italian city-states of Florence and Venice. The chief sources of Flemish wealth were the wool trade and the manufacture of fine fabrics. Powerful local guilds, or associations, oversaw nearly every aspect of their members' lives, and high-ranking guild members served on town councils and helped run city governments.

Artists who worked independently in their own studios without the sponsorship of an influential patron had to belong to a local guild. Experienced artists who moved from one city to another usually had to work as assistants in a local workshop until they met the requirements for guild membership. Different kinds of artists belonged to different guilds. Painters, for example, joined the Guild of Saint Luke, the guild of the physicians and pharmacists, because painters used the same techniques of grinding and mixing raw ingredients for their pigments and varnishes that physicians and pharmacists used to prepare salves and potions.

Civic groups, town councils, and wealthy merchants were important art patrons in the Netherlands, where the cities were self-governing, largely independent of the landed nobility. The diversity of clientele encouraged artists to experiment with new types of images, with outstanding results. Throughout most of the fifteenth century, the art and artists of the Netherlands were considered the best in Europe. The new Flemish style of painting was so admired in other countries that artists came from abroad to see the paintings of the major Flemish artists and eventually tried to emulate them. The dukes of Burgundy expanded their empire throughout nearly the entire Netherlands, and they provided stability for the arts to flourish there, as well as spreading the influence of Flemish arts throughout Europe. Only at the end of the fifteenth century did a general preference for the Netherlandish painting style give way to a taste for the new styles of art and architecture developing in Italy.

First-Generation Panel Painters

Although northern European artists painted on wood panels in the fourteenth century, too few remain to allow us to trace the emergence of the Flemish Renaissance style (see "Painting on Panel," below). Its origins are more evident in manuscript illumination of the late fourteenth century, when artists began to create full-page scenes set off with frames that functioned as windows looking into rooms or out onto landscapes with distant horizons. The panel paintings of the early fifteenth century developed logically from these works.

The most outstanding exponents of the new Flemish style were Robert Campin (documented from 1406; d. 1444), Jan van Eyck (c. 1370/90–1441), and Rogier van der Weyden (c. 1399–1464). Scholars have been able to piece together sketchy biographies for these artists from contracts, court records, account books, and mentions of their work by contemporaries. Reasonable attributions of a number of paintings have been made to each of them, but written evidence is limited, and signatures are rarely found on fifteenth-century paintings, owing in part to the custom of signing on the frames, which usually have been lost.

Only recently, for example, has Robert Campin been widely accepted as the artist formerly known as the Master of Flémalle, named for a pair of panel paintings once

TECHNIQUE

PAINTING ON PANEL

Painting pictures on wood has an ancient history, and wood **panels** were particularly favored by European painters and their patrons in the fifteenth century for works ranging from enormous **altarpieces** to small portraits. First the wood surface was prepared to make it smooth and nonabsorbent. After being sanded, the panel was coated—in Italy with **gesso**, a fine solution of plaster, and in northern Europe with a solution of chalk. These coatings soaked in and closed the pores of the wood. Fine linen was often glued down over the whole surface or over the joining lines on large panels made of two or more pieces of wood. The cloth was then also coated with gesso or chalk.

Once the surface was ready, the artist could paint on it with either a water-soluble color, called **tempera**, or **oil paint**. Italian artists favored tempera, using it almost exclusively for panel painting until the end of the fifteenth century. Northern European artists preferred the oil technique that Flemish painters so skillfully exploited at the beginning of the century. In some cases, wood panels were first painted with oil, then given fine detailing with tempera, a technique especially popular for small portraits.

Tempera had to be applied in a very precise manner, because it dried almost as quickly as it was laid down. Shading had to be done with careful overlying strokes in tones ranging from white and gray to dark brown and black. Because tempera is opaque—light striking its surface does not penetrate to lower layers of color and reflect back—the resulting surface was **matte**, or dull, and had to be varnished to give it a sheen. Oil paint, on the other hand, took much longer to dry, and while it was still wet, errors could simply be wiped away with a cloth. Oil could also be made translucent by applying it in very thin layers, called **glazes**. Light striking a surface built up of glazes penetrates to the lower layers and is reflected back, creating the appearance of glowing from within. In both tempera and oil the desired result in the fifteenth century was a smooth surface that betrayed no brushstrokes and somewhat resembled enamel.

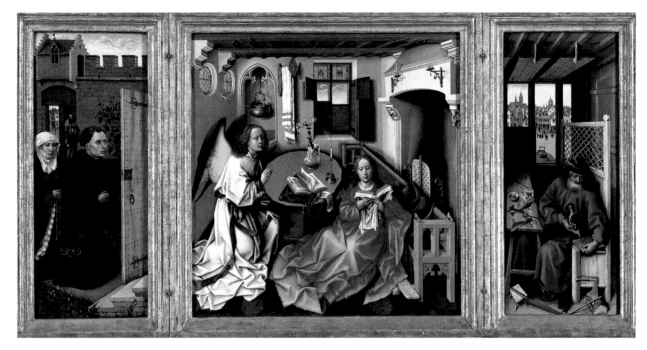

17-5. Robert Campin. *Mérode Altarpiece (Triptych of the Annunciation)* (open). c. 1425–28. Oil on panel, center 25¼ x 24⅞" (64.1 x 63.2 cm); each wing approx. 25⅜ x 10⅞" (64.5 x 27.6 cm). The Metropolitan Museum of Art, New York
The Cloisters Collection, 1956 (56.70)

thought to have come from the Abbey of Flémalle. Despite a lack of documentary evidence, stylistic analysis has convinced most art historians that Campin and the Master of Flémalle are the same artist. His paintings reflect the Netherlandish taste for narrative emphasis and a bold volumetric treatment of the figures reminiscent of the sculptural style of Claus Sluter.

About 1425–1428 Campin painted an altarpiece now known as the *Mérode Altarpiece* from the name of modern owners. Slightly over 2 feet tall and about 4 feet wide with the wings open, it probably was made for a small private chapel or altar (fig. 17-5). Campin portrayed the Annunciation inside a Flemish home and integrated common religious symbols into this contemporary setting. The lilies on the table, for example, which symbolize Mary's virginity, were a traditional element of Annunciation imagery (see fig. 17-4). Moreover, Flemish viewers would have recognized the vase carrying them as a **majolica** (glazed earthenware) pitcher, commonly used then for the ritual of the **Eucharist** (Communion). The hanging waterpot and white towel in the niche symbolize Mary's purity and her role as the vessel for the Incarnation of Christ. These objects are often referred to as "hidden" symbols because they are treated as a normal part of the scene, but their religious meanings would have been widely understood by contemporary people. Unfortunately, the precise meanings are not always clear today.

For example, the central panel does not portray the most commonly depicted moment: Gabriel's telling Mary that she will be the Mother of Christ. Instead, according to one interpretation, it shows the moment immediately following Mary's acceptance of her destiny, and her impregnation by the Holy Spirit is signified by the rush of wind that riffles the book pages and snuffs the candle.

The Incarnation (God assuming human form) is represented by the tiny figure at the upper left descending on a ray of light, carrying a cross. Having accepted the miraculous event, Mary, sitting humbly on the footrest of the long bench as a symbol of her submission to God's will, has returned to reading her Bible.

Another interpretation of the scene is that it represents the moment just prior to the Annunciation. In this view Mary is not yet aware of Gabriel's presence, and the rushing wind is the result of the angel's rapid descent into the room, where he appears before her half kneeling and raising his hand in salutation.

The complex treatment of light in the *Mérode Altarpiece* was an innovation of the Flemish painters. The strongest illumination comes from an unseen source at the upper left from in front of the **picture plane**, apparently the sun entering through the miraculously transparent wall that allows the viewer to observe the scene. Often the light is deliberately painted to look inconsistent in order to convey symbolic meaning. Here, a few rays enter the round window at the left as the vehicle for the Christ Child's descent. More light comes from the window at the rear of the room, and areas of reflected light can also be detected.

Campin maintained the convention of boxlike space typical of the International Gothic style; the abrupt recession of the bench toward the back of the room, the sharply uptilted floor and tabletop, and the disproportionate relationship between the figures and the architectural space create an inescapable impression of instability. In an otherwise intense effort to mirror the real world, this treatment of space may be a conscious remnant of medieval style, serving the symbolic purpose of visually detaching the religious realm from the world

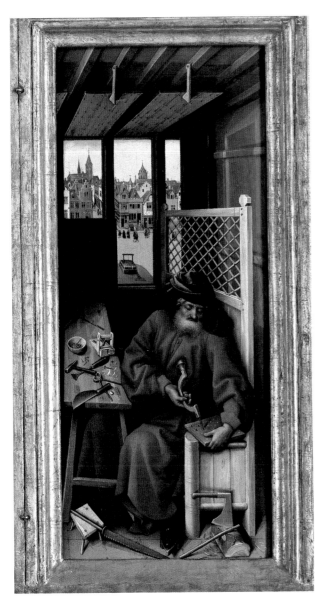

17-6. Robert Campin. *Joseph in His Carpentry Shop*, right wing of the *Mérode Altarpiece (Triptych of the Annunciation)*

The unusual attention given to Mary's husband, Joseph, is connected with the beginnings of a cult of devotion to him that resulted in his veneration by the end of the sixteenth century as an important saint in his own right. Unlike most earlier images of him as an aged, uncomprehending but kindly man, he is shown here as the well-dressed owner of a prosperous middle-class home. Moreover, his individuality and independence is stressed as a master craftsworker, creating wares in his urban shop surrounded by the tools of his trade.

of the viewers. Unlike figures by such International Gothic painters as the Limbourg brothers (see fig.17-2), the Virgin and Gabriel are massive rather than slender, and their abundant draperies increase the impression of their material weight.

Although in the biblical account Joseph and Mary were not married at the time of the Annunciation, this house clearly belongs to Joseph, shown in his carpentry shop on the right (fig. 17-6). A prosperous Flemish city can be seen through the shop window, with people going

about their business unaware of the drama taking place inside the carpenter's home. One clue indicates that this is not an everyday scene: the shop, displaying carpentry wares—mousetraps, in this case—should be on the ground floor, but its window opens from the second floor. The significance of the mousetraps would have been recognized by knowledgeable people in the fifteenth century as Saint Augustine's reference to Christ as the bait in a trap set by God to catch Satan. Joseph is drilling holes in a small board that may be a drainboard for wine making, symbolizing the central rite of the Church, the Eucharist.

Joseph's house opens onto a garden planted with a red-rose bush, which alludes to the Virgin and also to the Passion (the arrest, trial, and Crucifixion of Jesus). It has been suggested that the man standing behind the open entrance gate, clutching his hat in one hand and a document in the other, may be a self-portrait of the artist. Alternatively, the figure may represent an Old Testament prophet, since rich costumes like his often denoted high-ranking Jews of the Bible. Kneeling in front of the open door to the house is the donor of the altarpiece. Behind him is his wife, who was added slightly later—probably the couple married after the triptych was painted. The pair appears at first glance to be observing the Annunciation through the door, but their gazes are unfocused, and the garden where the donors kneel is unrelated spatially to the chamber where the Annunciation takes place, suggesting that the scene is a vision induced by their prayers. Such a presentation, often used by Flemish artists, allowed the donors of a religious work to appear in the same space and time, and often on the same scale, as the figures of the saints represented.

Campin's contemporary Jan van Eyck was a court painter to the duke of Burgundy. Nothing is known of Jan's youth or training, but he was born sometime between 1370 and 1390 in Maaseik, on the Maas (Meuse) River, now in Belgium on the present-day border between Belgium and the Netherlands. He was from a family of artists, including two brothers, Lambert and Hubert, and a sister, Margareta, whom sixteenth-century Flemish writers still remembered with praise. The earliest references to Jan are in 1422 in The Hague, where he was probably involved in the renovation of a castle. He was appointed painter to Philip the Good, the duke of Burgundy, in Bruges on May 19, 1425. His appointment papers stated that he had been hired because of his skillfulness in the art of painting, that the duke had heard about Jan's talent from people in his service, and that the duke himself recognized those qualities in Jan van Eyck. The special friendship that developed between the duke and his painter is a matter of record.

Although there are a number of preserved accounts of Jan's activities, the only reference to specific artworks is to two portraits of Princess Isabella of Portugal, which he painted in that country in 1429 and sent back to Philip in Flanders. Philip and Isabella were married in 1430. The duke alluded to Jan's remarkable technical skills in a letter of 1434–1435, saying that he could find no other painters equal to his taste or so excellent in art and

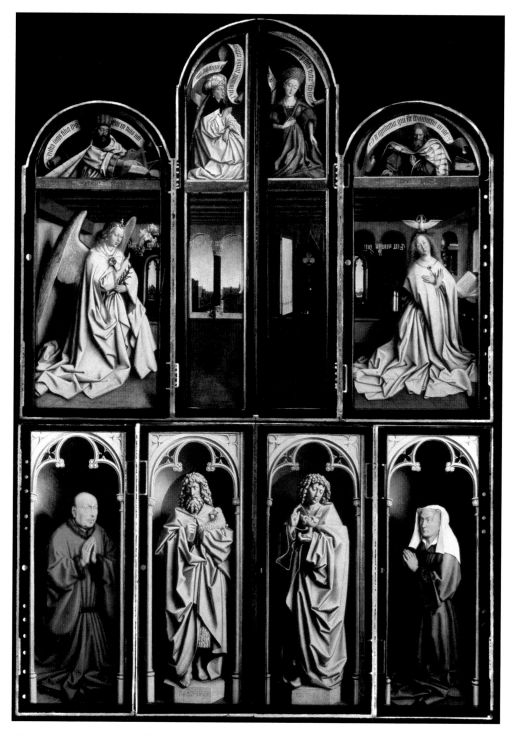

17-7. Jan van Eyck. *Ghent Altarpiece* (closed), Cathedral of Saint-Bavo, Ghent, Flanders (Belgium).
1432. Oil on panel, 11'5¾" x 7'6¾" (3.4 x 2.3 m)

science. Part of the secret of Jan's "science" was his tech-
nique of painting with oil on wood panel. So brilliant
were the results of his experiments that Jan has been
mistakenly credited with being the inventor of **oil paint-
ing**. Actually, the medium had been known for several
centuries, and medieval painters had used oil paint to
decorate stone, metal, and occasionally plaster walls.

For his paintings on wood panel, Jan built up the
images in transparent oil layers, a procedure called **glaz-
ing**. His technique permitted a precise, objective des-
cription of what he saw, with tiny, carefully applied

brushstrokes so well blended that they are only visible at
very close range. Other northern European artists of the
period worked in the oil medium, although oil and **tem-
pera** were still combined in some paintings, and tempera
was used for painting on canvas (see "Painting on Panel,"
page 619).

Jan's earliest known work, the *Ghent Altarpiece,* was
completed in 1432 for a wealthy official of Ghent and his
wife. The complexities of this altarpiece can be challeng-
ing intellectually and emotionally. The wing exteriors (fig.
17-7) present an Annunciation scene, with Gabriel and

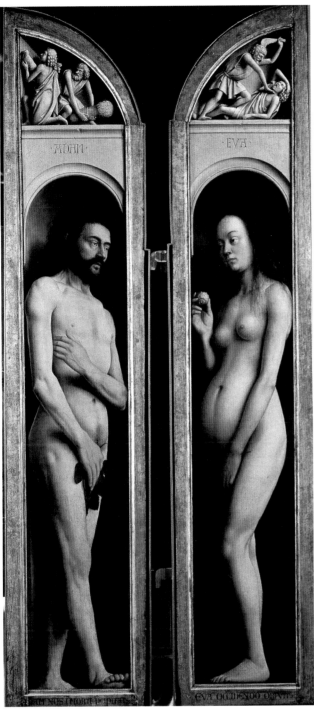

17-8. Jan van Eyck. *Adam* and *Eve,* details of the open *Ghent Altarpiece* (fig. 17-1)

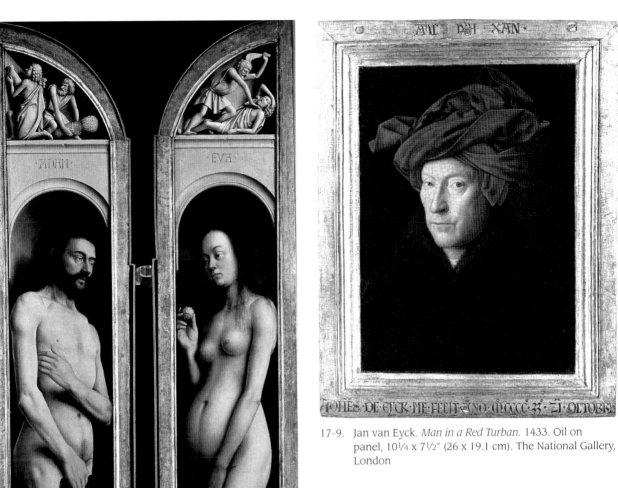

17-9. Jan van Eyck. *Man in a Red Turban.* 1433. Oil on panel, 10¼ x 7½" (26 x 19.1 cm). The National Gallery, London

the Virgin on opposite sides of a room overlooking out onto a city. In the panels above are pagan and Old Testament prophets who foretold the coming of Christ. Below, the donors are portrayed beside statues of the church's patron saints, John the Baptist and John the Evangelist.

The brilliantly painted interior of the altarpiece, which was only opened at Easter (see fig. 17-1), presents an enthroned figure of God, the Virgin Mary, John the Baptist, and angel musicians. The jewels and embroidery, meticulously re-created gem by gem and stitch by stitch, are superb examples of Jan's characteristic technique.

The nude figures of Adam and Eve on the outermost panels (fig. 17-8) contrast shockingly to the richly dressed figures between them. Above their heads, painted as if carved in stone, their son Cain kills his brother Abel, thus committing the first murder. This is the terrible consequence of the first couple's disobedience to God, a sin that can only be redeemed by the coming of Christ.

Below these figures is a panoramic Communion of Saints. Jan's technique is firmly grounded in the terrestrial world despite his visionary subject. The meadow and woods, painted leaf by leaf and petal by petal, and the distant city have been rendered from a careful observation of nature. Jan noted, for example, that the farther colors are from a viewer, the more muted they seem. He thus painted the more distant objects with a grayish or bluish cast and the sky paler toward the horizon, an effect called **atmospheric perspective** (see "Renaissance Perspective Systems," page 624).

The *Man in a Red Turban* of 1433 (fig. 17-9) is widely believed to be Jan's self-portrait, partly because of the strong sense of personality it projects, partly because the frame, signed and dated by him, also bears his personal motto, *Als ich chan* ("The best that I am capable of doing"). This motto, derived from classical sources, is a telling illustration of the humanist spirit of the age and the confident expression of an artist who knows his capabilities and is proud to display them.

If the *Man in a Red Turban* is, indeed, the face of Jan van Eyck, it shows us his physical appearance as if seen

RENAISSANCE PERSPECTIVE SYSTEMS

The increasingly human-centered world of the Renaissance was reflected in how artists depicted space. In the fourteenth century, fresco painters such as the Lorenzetti brothers and Giotto in Italy and northern manuscript illuminators such as Jean Pucelle pioneered the rendering of figures and objects within coherent settings that created the illusion of three-dimensional space. They used **intuitive perspective** to approximate the appearance of things growing smaller and narrowing in the distance (see fig. 17-4).

The humanists' scientific study of the natural world and their belief that "man is the measure of all things" led to the invention of a mathematical system based on proportions of a human male body to enable artists to represent the visible world in a convincingly **illusionistic** way. This system—known variously as **mathematical, linear**, or Renaissance **perspective**—was first demonstrated by the architect Filippo Brunelleschi about 1420. In 1436 Leon Battista Alberti codified mathematical perspective in his treatise *Della Pittura (On Painting)*, making a standardized, somewhat simplified method available to a larger number of draftspeople, painters, and relief sculptors.

For Alberti, the picture's surface was a flat plane that intersected the viewer's field of vision, which he saw as cone- or pyramid-shaped, at right angles. In Alberti's highly artificial system, a one-eyed viewer was to stand at a prescribed distance from a work, dead center, and remain there. From this fixed vantage point everything appeared to recede into the distance at the same rate, shaped by imaginary lines called **orthogonals** that met at a single **vanishing point**, often on the horizon. Orthogonals distort objects by **foreshortening** them, replicating the optical illusion that things grow smaller and closer together as they get farther away from us. Despite its limitations, mathematical perspective has the advantage of making the viewer feel a direct, almost physical connection to the pictorial space, which seems like an extension of real space. It creates a compelling, even exaggerated sense of depth.

Early Renaissance artists following Alberti's system relied on a number of mechanical methods. Many constructed devices with peepholes through which they sighted the figure or object to be represented. They used mathematical formulas that enabled them to translate three-dimensional forms onto the **picture plane**, which they overlaid with a grid to provide reference points. As Italian artists became more comfortable with mathematical perspective in the course of the fifteenth century, they came to rely less on peepholes and formulas, and be less fascinated with linear forms (such as tiled floors and buildings) that had been a hallmark of early Renaissance style. Many artists adopted multiple vanishing points, which gave their work a more relaxed, less tunnel-like feeling.

Meanwhile, in the North, artists such as Jan van Eyck continued to refine intuitive perspective, coupling it with **atmospheric**, or aerial, **perspective**. This technique—applied to the landscape scenes that were a northern specialty—was based on the observation that because of haze in the atmosphere, distant elements appear less distinct and become blue-gray, and that the sky becomes paler as it nears the horizon. Among southern artists, Leonardo da Vinci made extensive use of atmospheric perspective, while in the north, the German artist Albrecht Dürer adopted the Italian system of mathematical perspective toward the end of the fifteenth century.

Paolo Uccello. *The Deluge (Flood)*, fresco in Church of Santa Maria Novella, Florence. c. 1450. See figure 17-52. As the overlaid orthogonals show, Uccello missed perfect convergence in his one-point perspective organization of this painting.

in an enlarging mirror—every wrinkle and scar, the stubble of a day's growth of beard on the chin and cheeks, and the tiny reflections of light from a studio window in the pupils of the eyes. The image gives not only this man's outward features but a glimpse of his soul. The outward gaze of the subject is new in portraiture, and it suggests the increased sense of pride in personal achievement of the Renaissance individual. Although eye contact between portrait subject and viewer has been interpreted as the result of the painter looking into a mirror—and thus is unique to self-portraiture—many other examples exist in fifteenth-century northern European painting that are clearly not self-portraits.

Jan's best-known painting today is an elaborate portrait of a couple, traditionally identified as Giovanni Arnolfini and his wife, Giovanna Cenami (fig. 17-10). This fascinating work has been, and continues to be, subject to a number of interpretations, most of which suggest that it represents a wedding or betrothal. One remarkable detail is the artist's inscription below the mirror on the back wall: *Johannes de eyck fuit hic 1434* ("Jan van Eyck was here, 1434"). Normally, a work of art in fifteenth-century Flanders would have been signed "Jan van Eyck made this." The wording here specifically refers to a witness to a legal document, and indeed, two witnesses to the scene are reflected in the mirror, a man in

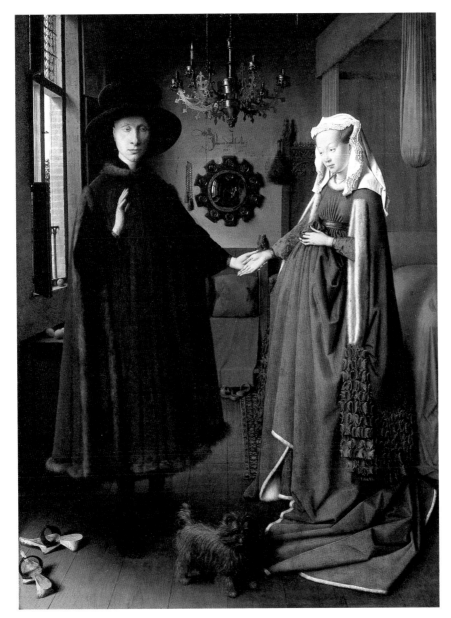

17-10. Jan van Eyck. *Portrait of Giovanni Arnolfini (?) and His Wife, Giovanna Cenami (?).* 1434. Oil on panel, 33 x 22½" (83.8 x 57.2 cm). The National Gallery, London

Odd though it may seem today, the fact that this event takes place in a bedroom is quite in keeping with the times, although somewhat unusual. A beautifully furnished room containing a large bed hung with rich draperies was a source of pride for its owners, and the bedroom was symbolic of marital happiness and pleasure. According to a later inventory description of this painting, the original frame (now lost) was inscribed with a quotation from Ovid, a Roman poet known for his celebration of romantic love.

a red turban—perhaps the artist—and one other. The man in the portrait, identified by early sources as a member of an Italian merchant family living in Flanders, the Arnolfini, holds the right hand of the woman in his left and raises his right to swear to the truth of his statements before the two onlookers. The fact that this takes place in a domestic setting, apparently the couple's bedroom, is unusual.

In the fifteenth century, a marriage was rarely celebrated with a religious ceremony. The couple signed a legal contract before two witnesses, after which the bride's dowry might be paid and gifts exchanged. If the painting indeed documents a wedding, the room where

the couple stands is their nuptial chamber, whose furnishings were often gifts from the groom to the bride. Recently, however, it has been suggested that, instead of a wedding, the painting might be a pictorial "power of attorney," by which the husband states that his wife may act on his behalf in his absence.

Whatever the painting represents, the artist has juxtaposed the secular and the religious in a work that seems to have several layers of meaning. On the man's side of the painting, the room opens to the outdoors, the external world in which men function, while the woman is silhouetted against the domestic interior, with its allusions to the roles of wife and mother. The couple is

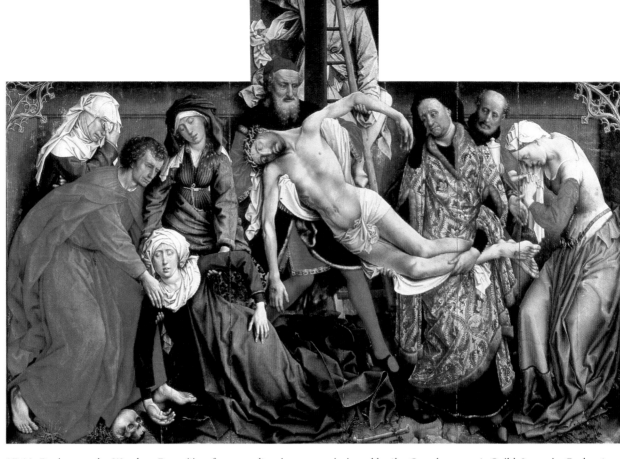

17-11. Rogier van der Weyden. *Deposition*, from an altarpiece commissioned by the Crossbowmen's Guild, Louvain, Brabant, Belgium. c. 1435. Oil on panel, 7'2⅝" x 8'7⅛" (2.2 x 2.62 m). Museo del Prado, Madrid

surrounded by emblems of wealth, piety, and married life. The convex mirror reflecting the entire room and its occupants is a luxury object described in many inventories of the time, but it may also symbolize the all-seeing eye of God, before whom the man swears his oath. The **roundels** decorating its frame depict the Passion of Christ, a reminder of Christian redemption.

Many other details have religious significance, suggesting the piety of the couple: the crystal prayer beads on the wall; the image of Saint Margaret, protector of women in childbirth, carved on the top of a high-backed chair next to the bed; and the single burning candle in the chandelier, which may be a symbol of Christ's presence. But the candle can also represent a nuptial taper or a sign that a legal event is being recorded. The fruits shown at the left, seemingly placed there to ripen in the sun, may allude to fertility in a marriage and also to the Fall of Adam and Eve and the Garden of Eden. The small dog may simply be a pet, but its rare breed—affenpinscher—suggests wealth and serves also as a symbol of fidelity.

One of the most mysterious of the major early Flemish artists is Rogier van der Weyden. Although his biography has been pieced together from documentary sources, not a single existing work of art bears his name

or has an entirely undisputed connection with him. He was thought at one time to be identical with the Master of Flémalle, but evidence now suggests that he studied under Robert Campin, which would explain the similarities in their painting styles. Even his relationship with Campin is not altogether certain, however. At the peak of his career, Rogier maintained a large workshop in Brussels, to which apprentices and shop assistants came from as far away as Italy to learn his style of painting. He died in 1464.

The work scholars used to establish the thematic and stylistic characteristics for Rogier's art is a large panel, more than 7 by 8 feet, depicting the Deposition (fig. 17-11). This is the central panel of an altarpiece that once had wings painted with the Four Evangelists—Matthew, Mark, Luke, and John—and Christ's Resurrection. The altarpiece was commissioned by the Louvain Crossbowmen's Guild sometime before 1443, the date of the earliest known copy after it by another artist.

The Deposition was a popular theme in the fifteenth century because of its dramatic, personally engaging character. The viewer could identify with the grief of Jesus' friends, who tenderly and sorrowfully remove his body from the Cross for final burial. Here Jesus' suffering

17-12. Rogier van der Weyden. *Last Judgment Altarpiece* (open). After 1443. Oil on panel, open 7'4⅝" x 17'11" (2.25 x 5.46 m). Musée de l'Hôtel-Dieu, Beaune, France

and death are made palpably real by the display of the lifesize corpse at the center of the composition. Rogier has arranged this figure in a graceful curve, echoed by the form of the fainting Virgin, thereby increasing the viewer's emotional identification with both the Son and the Mother. The artist's compassionate sensibility is especially evident in the facial expressions and hand gestures of the young John the Evangelist, who supports the Virgin at the left, and Jesus' friend Mary Magdalen, who wrings her hands in anguish at the right.

The removal of Jesus' body from the Cross is enacted on a shallow stage closed off by a wood backdrop that has been **gilded**, or covered with a thin overlay of gold. The solid, three-dimensional figures press forward toward the viewer's space, allowing no escape from their expressions of intense grief. Many scholars see Rogier's emotionality as a tie with the Gothic past, but it can also be interpreted as an example of fifteenth-century humanistic sensibility in its concern for individual expressions of emotion. Although united by their sorrow, the mourning figures react in personal ways.

Rogier's choice of color and pattern balances and enhances his composition. For example, the complexity of the gold brocade worn by Joseph of Arimathea, a secret disciple of Jesus whose new tomb was used for his burial, increases the visual impact of the right side of the panel, countering the larger number of figures at the left. The palette of subtle, slightly muted colors is sparked with red and white accents to focus the viewer's attention on the main subject. The whites of the winding cloth and the tunic of the youth on the ladder set off Jesus' pale body, as the white headdress and neck shawl emphasize the ashen face of Mary.

Most scholars believe that Rogier van der Weyden painted his largest and most elaborate work, the altarpiece of the *Last Judgment,* during the middle to final years of his career (fig. 17-12). Some date the altarpiece just prior to a trip he is believed to have made to Rome in 1450, perhaps inspired by the Last Judgments so common in medieval churches. Others, who see Italianate elements in it, believe that he designed it after his return. The tall, straight figure of the archangel Michael, dressed in a white robe and priest's cope, or cloak, dominates the center of the wide **polyptych** (multiple-panel work), weighing souls under the direct order of Christ, who sits on the arc of a giant rainbow above him. Twenty saints, seated on clouds halfway between earth and heaven, include the Virgin Mary and John the Baptist at either end of the rainbow, six apostles behind them on each side, and in the outermost ranks a king, a queen, and a pope. The solid gold background serves, as it did in medieval times, to signify events in the heavenly realm or in a time remote from that of the viewer.

The Last Judgment takes place on a narrow, barren strip of earth that runs across the bottom of all but the outer panels. Resurrected men and women climb out of their tombs, turning in different directions as if confused or led by instinct. The scale of justice held by Michael tips in an unexpected direction; instead of Good weighing more than Bad, the Saved Soul has become pure spirit and rises, while the Damned one sinks, weighed down by unrepented sins. Michael's role here seems to be one of simply providing a model (with tiny token figures, perhaps) against which the resurrected dead can measure their own worth and determine in which direction to go. Those moving to the right throw themselves into the flaming pit of hell; those moving to the left—notably far less numerous—are greeted by the archangel Gabriel at the shining Gothic-style Gate of Heaven.

In his portraiture, Rogier balanced a Flemish love of detailed individuality with a flattering **idealization** of the features of men and women. A prime example is the

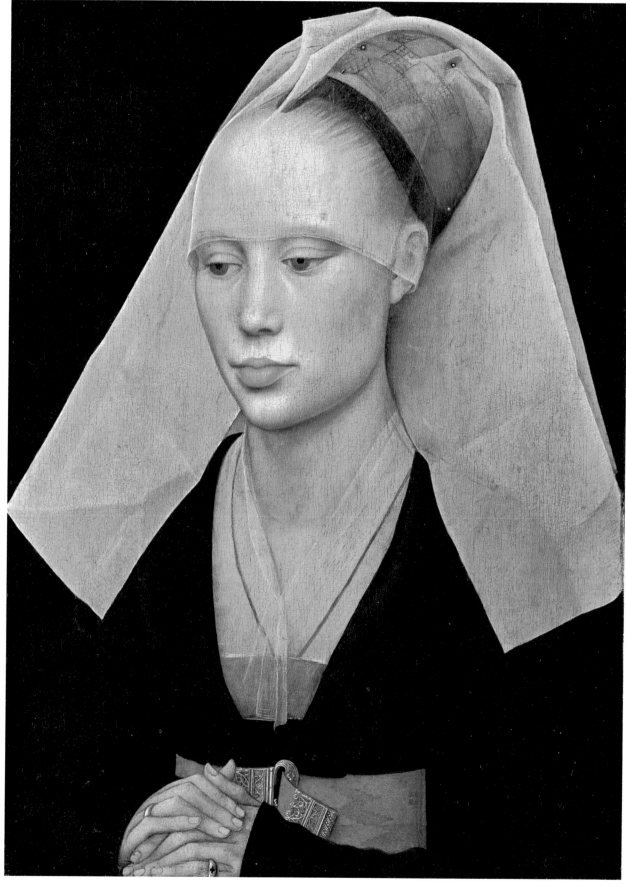

17-13. Rogier van der Weyden. *Portrait of a Lady.* c. 1460. Oil and tempera on panel, 14$\frac{1}{16}$ x 10$\frac{5}{8}$" (37 x 27 cm). National Gallery of Art, Washington, D.C.
Andrew W. Mellon Collection

17-14. Petrus Christus. *Saint Eloy (Eligius) in His Shop.* 1449. Oil on oak panel, 38⅝ x 33½" (98 x 85 cm). The Metropolitan Museum of Art, New York

Robert Lehman Collection, 1975 (1975.1.110)

Portrait of a Lady, dating about 1460 and scarcely larger than a sheet of legal-size paper (fig. 17-13). The woman's broad, square-jawed face, blunt nose, and full lips have been transformed through their precise regularity and smooth, youthful skin into a vision of exquisite but remote beauty. The long, almond-shaped eyes are a characteristic of both men and women in portraits attributed to Rogier, and the half-length pose that includes the woman's high waistline and clasped hands was popularized by him. He used it as well for images of the Virgin and Child that often formed **diptychs** (two-panel works) with small portraits of this type. Since the woman's hands are folded at her waist rather than raised in prayer, this was probably a secular portrait.

Second-Generation Panel Painters

The extraordinary achievements of Robert Campin, Jan van Eyck, and Rogier van der Weyden attracted many followers. In general, the work of this second generation of Flemish painters was simpler, more direct, and easier to understand than that of their predecessors. Nevertheless, these artists produced high-quality work of great emotional power, and they were in large part responsible for the rapid spread of the Flemish style through Europe. A number of the second-generation painters received their early training in the Dutch provinces, where local schools of painting had developed strong followings.

Petrus Christus (documented from 1444; d. c.1475) probably came from the duchy of Brabant (a region partly in present-day Belgium, partly in the modern Netherlands) to Bruges, where he became a citizen in 1444, three years after the death of Jan van Eyck. Because of their stylistic affinities, it was once speculated that Christus might have worked in Jan's shop, a notion that is now generally rejected. In fact, his work seems as much influenced by Rogier van der Weyden as by Jan. He may also have spent time in Italy, where a "Piero from Bruges" was active in the ducal court of Milan in 1457.

In 1449, Christus painted one of his most admired and influential works, *Saint Eloy (Eligius) in His Shop* (fig. 17-14). Eloy, a seventh-century ecclesiastic and a goldsmith and mintmaster for the French court, according to legend used his wealth to ransom Christian captives. Here he weighs a jeweled ring to determine its price, as a handsome couple looks on. Among the objects on the shelf behind him are a number of similar rings. This may be a specific betrothal or wedding portrait, or the couple may be idealized figures personifying marital love in general. Because Saint Eloy was a special patron of illegitimate children, the moral message could be that marriage and legitimate birth were to be prized, not disregarded in the pursuit of pleasure.

As in Jan's *Portrait of Giovanni Arnolfini(?) and His Wife, Giovanna Cenami(?)* (see fig. 17-10), a convex mirror extends the viewer's field of vision, in this instance

17-15. Dirck Bouts. *Wrongful Execution of the Count* (left), and companion piece, *Justice of Otto III* (right). 1470–75. Oil on panel, each 12'11" x 6'7½" (3.9 x 2 m). Musées Royaux des Beaux-Arts de Belgique, Brussels, Belgium

to the street outside, where two men, one holding a fal-con, look through the window. Whether or not the reflected image has symbolic meaning, the mirror had a practical value in allowing the goldsmith to note the approach of a potential customer. All figures are dressed in the height of Flemish fashion, which spread to the rest of Europe through the export of fine local fabrics. Thus, to the modern eye, the painting might be read as an advertisement for the goldsmith. The emphasis on every-day details is so strong that the presence of the saint seems more a pretext for a secular subject than a sign of religious meaning. In fact, this painting provided the for-mat for a long line of clearly secular pictures showing businesspeople in their shops, which persisted well into the sixteenth century.

An outstanding Haarlem painter who moved south to Flanders, Dirck Bouts (documented from 1457; d. 1475), became the official painter of Louvain in 1468. His mature style shows a strong debt to Jan van Eyck and, especially, Rogier van der Weyden, but not at the expense of his own clear-cut individuality. Bouts was an excellent storyteller, a master of direct narration rather than com-plex symbolism. His best-known works today are two remaining panels (fig. 17-15) from a set of four on the

subject of justice, a common theme in municipal build-ings. They were commissioned by the town council of Louvain for the city hall. Unfinished at Bouts's death, the panels were completed by his workshop. The subject of the panels was a fictional twelfth-century story about a real-life Holy Roman emperor. In a continuous narrative in the left panel, *Wrongful Execution of the Count*, the empress falsely accuses a count of a sexual impropriety. Otto tries and convicts the count, and he is put to death by beheading. In the right panel, *Justice of Otto III*, the widowed countess successfully endures a trial by ordeal to prove her husband's innocence. She kneels unscathed before the repentant emperor, holding her husband's head on her right arm and a red-hot iron bar in her left hand. In the far distance, the evil empress is punished by burning at the stake.

Dirck Bouts's work is especially notable for the spa-tial development of its outdoor settings. Carefully ad-justing the scale of his figures to the landscape and architecture, the artist created an illusion of space that recedes continuously and gradually from the picture plane back to the far horizon. For this effect, he employed devices such as walkways, walls, and winding roads along which characters in the scene are placed. Bouts's

17-16. Hans Memling. Saint Ursula reliquary. 1489. Painted and gilded oak, 34 x 36 x 13" (86.4 x 91.4 x 33 cm). Memling Museum, Hospital of Saint John, Bruges, Belgium

The reliquary was commissioned presumably by the two women dressed in white habits and black hoods worn by hospital sisters and depicted on the end of the reliquary not visible here. One hypothesis is that they are Jossine van Dudzeele and Anna van den Moortele, two administrators of the hospital, where the church-shaped chest has remained continuously for more than five centuries. The story of fourth-century Saint Ursula, murdered by Huns in Cologne after she returned from a visit to Rome, is told on the six side panels. Shown from the left: the pope bidding Ursula goodbye at the port of Rome; the murder of her female companions in Cologne harbor; and Ursula's own death. On the "roof" are roundels with musician angels flanking the Coronation of the Virgin. At the corners are carved saints, and on the end is Saint Ursula in the doorway of the "church," sheltering her followers under her mantle. In early stories, Ursula was accompanied on her trip by ten maidens. By the tenth century, however, she had become the leader of 11,000 women martyrs of all ages.

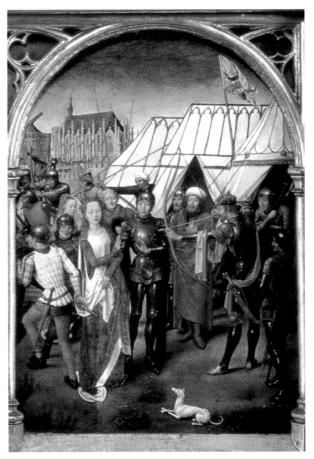

17-17. Hans Memling. *Martyrdom of Saint Ursula,* detail of the Saint Ursula reliquary. Panel 13³/4 x 10" (35 x 25.3 cm)

figures are extraordinarily tall and slender and have little or no facial expression. Bouts is credited as the inventor of a type of official group portrait in which individuals are integrated into a narrative scene with fictional or religious characters. Thus, the Louvain justice panels, with their distinctly individualized protagonists, may have been a vehicle for a group portrait of the town council.

By far the most successful of the second-generation Flemish-school painters was Hans Memling. His work exhibits the intellectual depth and virtuosity of rendering of his predecessors, but the psychology of his figures is one of exquisite composure. Memling was born in one

of the German states about 1430–1435. Considering his mature style of painting, he was probably young when he came to Flanders, and he may have worked in Rogier van der Weyden's Brussels workshop in the 1460s. Rogier remained the dominant influence on his art, and soon after this master's death in 1464, Memling moved to Bruges, where he worked until his death in 1494. One of the most important painters in Flanders, Memling had an international clientele, and his style was widely emulated both at home and abroad.

Among the works securely assigned to Memling is a large wooden **reliquary**, a container for sacred relics (remains), in the form of a Gothic-style chapel, completed in 1489 (fig. 17-16). It was commissioned by two sisters for the Hospital of Saint John in Bruges, now a museum of Memling's works, to hold bone fragments believed to be those of Saint Ursula and her companions. Six side panels relate the story of Ursula's martyrdom. According to legend, Ursula, the daughter of the Christian king of Brittany, in France, was betrothed to a pagan English prince. She requested a three-year delay in the marriage to travel with 11,000 virgin attendants to Rome, during which time her husband-to-be was to convert to Christianity. On the trip home, Ursula stopped in Cologne, which had been taken over by Huns, a nomadic people from Central Asia, whose warriors on horseback inspired fear throughout Europe. They murdered her companions, and, when Ursula rejected their chief's offer of marriage, they killed her as well, with an arrow through the heart (fig. 17-17). Although the

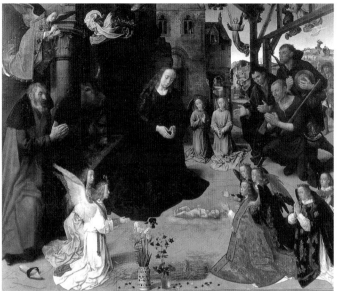

17-18. Hugo van der Goes. *Portinari Altarpiece* (open). c. 1474–76. Tempera and oil on panel, center 8'3½" x 10' (2.53 x 3.01 m); wings each 8'3½" x 4'7½" (2.53 x 1.41 m). Galleria degli Uffizi, Florence

events supposedly took place in the fourth century, Memling has set them in contemporary Cologne, where its Gothic cathedral, still under construction, looms in the background of the *Martyrdom of Saint Ursula* panel. Memling created this deep space as a foil for his idealized female martyr, with her aristocratic features, swaying pose, and elaborate draperies. Rather than a means of defining the body beneath it, the drapery has been represented for its own qualities of surface pattern and intricately sculpted folds.

In the paintings of Hugo van der Goes (c. 1440–1482), the intellectualism of Jan van Eyck and the emotionalism of Rogier van Weyden were brought together in an entirely new style. Hugo's major work was an exceptionally large altarpiece, more than 8 feet tall, commissioned by an Italian living in Bruges, Tommaso Portinari, who was branch manager of the Medici bank there (fig. 17-18). Painted in Flanders, probably between 1474 and 1476, the large triptych was transported to Italy and installed in 1483 in the Portinari family chapel in the Church of Saint Egidio, Florence. Tommaso, his wife, Maria Baroncelli, and their three eldest children are portrayed on the wing interiors, kneeling in prayer. With pointing gestures, their patron saints present them. On the left wing, looming larger than life behind Tommaso and his son Antonio, are their name saints, Thomas and Anthony. The younger son, Pigello, born in 1474, was apparently added after the original composition was set and has no patron saint. On the right wing, Maria and her daughter Margherita are presented by Saints Mary Magdalen and Margaret. The theme of the altarpiece is the Nativity of Christ, with the central panel representing the Adoration of the newborn Child by Mary and Joseph, a host of angels, and a few shepherds who have rushed in from the fields. In the middle ground of the wings are scenes that precede the Adoration in the central panel. Winding their way through the winter landscape are two groups headed for Bethlehem, Jesus' birth-

17-19. Hugo van der Goes. Detail of the foreground, central panel, *Portinari Altarpiece*

place. On the left wing Mary and Joseph travel to their native city to take part in a census ordered by the Roman ruler over the region. Near term in her pregnancy, Mary has dismounted from her donkey and staggers before it, supported by Joseph. On the right wing a servant of the Three Magi, who are coming to honor the awaited Savior, is asking directions from a poor man. The continuous landscape across the wings and central panel is the finest evocation of cold, gray, barren winter since the Limbourg brothers' *February* calendar page (see fig. 17-2).

Although the brilliant palette and meticulous accu-

racy recall Jan van Eyck, and the intense but controlled feelings suggest the emotional content of Rogier van der Weyden's works, the composition and interpretation of the altarpiece are entirely Hugo's. The monumental figures of Joseph, Mary, and the shepherds dominating the central panel are the same size as the patron saints on the wings; the Portinari family and the angels are small in comparison. Hugo uses color as well as the gestures and gazes of the figures to focus our eye on the center panel, where the mystery of the Incarnation takes place. Instead of lying swaddled in a manger or in his mother's arms, the Child rests naked and vulnerable on the barren ground with rays of light emanating from his body. The source of this image was the visionary writing of the Swedish mystic Bridget (declared a saint in 1391), composed about 1360–1370, which specifically mentions Mary kneeling to adore the Child immediately after giving birth.

Hugo's complex symbolism recalls Jan's *Ghent Altarpiece,* which was still in its original location in the Cathedral of Saint-Bavo. The setting of the central scene refers both to Jesus' birth and to his royal ancestry. Supporting the stable, where the traditional ox and ass observe the event, is a large Roman-style column against which Mary was believed to have leaned during the birth. In the background the ancient palace of King David is identified by his symbol, the harp, over the door, which may itself be a reference to the name Portinari ("gatekeepers"). The inscription above the harp has been interpreted to mean "Here Christ was born of the Virgin Mary."

The foreground still life of vases, flowers, and a sheaf of wheat has multiple meanings (fig. 17-19). The glass vessel is a Marian symbol (related to the Virgin Mary) that alludes to the entry of the Christ Child into the Virgin's womb without destroying her virginity, the way light passes through glass without breaking it. The glass holds more Marian emblems: three red carnations, which may refer to the Trinity of Father (God), Son (Jesus), and the Holy Ghost, as well as seven blue columbines symbolizing the Virgin's future sorrows. Scattered on the ground are violets, symbolizing humility. The majolica vase holds a red lily (for the blood of Christ) and three irises— white for purity and purple for Christ's royal ancestry. The iris, or "little sword," also refers to Simeon's prophetic words to Mary at the Presentation in the Temple, "And you yourself a sword will pierce so that the thoughts of many hearts may be revealed" (Luke 2:35). The vase is decorated with vines and grapes, alluding to the wine of Communion at the Eucharist, which represents the Blood of Christ. The wheat sheaf refers both to the location of the event at Bethlehem, which in Hebrew means "house of bread," and to the Host, or bread, at Communion, which represents the Body of Christ.

The central panel illustrates more than a historical Nativity scene; it is also an enactment of the Eucharist, the central rite of Christian worship. The angels wear attire appropriate to various roles at a High Mass—but the chief celebrant is missing, and it has been suggested that he is the Infant Christ himself. The exact moment in the liturgy may be indicated by the words *Sanctus, Sanctus, Sanctus* ("Holy, Holy, Holy") embroidered on

17-20. Geertgen tot Sint Jans. *Saint John the Baptist in the Wilderness.* c. 1490. Oil on panel, 16½ x 11" (42.3 x 27.1 cm). Staatliche Museen zu Berlin, Preussischer Kulturbesitz, Gemäldegalerie

the edge of the angel's vestment at the right, which are the first lines of a hymn that immediately precedes the Consecration of the Host. Hugo's artistic vision goes far beyond this formal religious symbolism. For example, the shepherds, who stand in unaffected awe before the miraculous event, are among the most sympathetically rendered images of common people to be found in the art of this period.

Toward the end of the fifteenth century, the Dutch-speaking northern Netherlands had grown to such political and cultural importance that its best artists no longer needed to travel south to Flanders and France to find work. Cross-influences among these regions continued, however. One of the most original Dutch painters to assimilate and transform Flemish achievements was Geertgen tot Sint Jans. His career was brief—from 1480 to about 1490—and he may have died at age twenty-eight. His name derives from his position as the "servant and painter" of a religious order in Haarlem called the Commandery of Saint John.

Geertgen's unique style, closely related to Hugo van der Goes's, is mystical, tender, and poetic, conveying an innocent, childlike charm even in such serious subjects as *Saint John the Baptist in the Wilderness* (fig. 17-20). John

has exiled himself with his identifying emblem, the lamb, to a lush woodland setting instead of the harsh desert where he is so often portrayed. As he rests his head on his hand and rubs one big foot on the other, his expression is less that of a religious zealot contemplating the terrible moral condition of the world than of a homesick sojourner.

Manuscript Illumination

The rise in popularity of panel painting in the fifteenth century did not diminish the production of richly illustrated books for wealthy patrons. Not surprisingly, developments in manuscript illumination were similar to those in panel painting, although in miniature. Each scene was a tiny image of the world rendered in microscopic detail. Complexity of composition and ornateness of decoration were commonplace, with the framed image surrounded by a fantasy of vines, flowers, insects, animals, shellfish, or other objects painted as if seen under a magnifying glass. Ghent and Bruges were major centers of this exquisite art, and one of the finest practitioners was an anonymous artist known as the Mary of Burgundy Painter from a Book of Hours traditionally thought to have been made for Mary, the daughter and only heir of Charles the Bold, the duke of Burgundy. The manuscript dates to sometime prior to Mary's early death in 1482 (fig. 17-21).

In the Book of Hours frontispiece, the painter has attained a new complexity in treating pictorial space; we look not only through the "window" of the illustration's frame but through another window in the wall of the room depicted in the painting. The young Mary of Burgundy appears twice: once seated in the foreground, reading from her Book of Hours, and again in the background in a vision inspired by her reading, kneeling with attendants before the Virgin and Child in a church. On the window ledge is an exquisite still life—a rosary, carnations, and a glass vase holding purple irises. The artist has skillfully executed the filmy veil covering Mary's hat, the transparent glass vase, and the bull's-eye panes of the window, circular panes whose center "lump" was formed by the glassblower's pipe. The spatial recession leads the eye into the far reaches of the church interior, past the Virgin and the gilded altarpiece in the sanctuary to two people conversing in the far distance at the left. In the "painting" within an illumination in a book only 5 by 7 inches in size, reality and vision have been rendered equally tangible, as if captured by a Jan van Eyck or a Robert Campin on a large panel.

Textiles and Tapestries

The importance of textiles in the fifteenth century cannot be overemphasized. Flemish artists of the period produced outstanding designs for tapestries, embroidery, and needlepoint. These designs exhibit many of the same concerns with the bulk of figures, the illusion of three-dimensional space, and naturalistic details that are seen in Flemish paintings.

17-21. Mary of Burgundy Painter. Page with *Mary at Her Devotions,* in *Hours of Mary of Burgundy.* Before 1482. 7½ x 5¼" (19.1 x 13.3 cm). Österreichische Nationalbibliothek, Vienna

A remarkable example is a sumptuous embroidered cope, or ceremonial cloak worn by high-ranking clergy on special occasions, now in the Treasury of the Golden Fleece in Vienna (fig. 17-22). Its surface is divided into compartments, with the standing figure of a saint in each one. At the top of the cloak's back, as if presiding over the standing saints, is an enthroned figure of Christ, flanked by scholar-saints in their studies. The designer of this remarkable piece of needlework was clearly familiar with contemporary Flemish painting, and the embroiderers were able to copy the preliminary drawings with great precision. The particular stitch used here consists of double gold threads tacked down with unevenly spaced colored silk threads to create an iridescent effect.

In the fifteenth and sixteenth centuries, Flemish tapestry making was considered the best in Europe. There were major weaving centers at Brussels, Tournai, and Arras, where intricately designed wall hangings were made on order for royal and aristocratic patrons, important church officials, and even town councils. Among the most common subjects were foliage and flower patterns, scenes from the lives of the saints, and themes from classical mythology and history. Tapestries provided both insulation and luxurious decoration for the stone walls of castles, churches, and municipal buildings. Often they were woven for specific places or for festive occasions such as weddings, coronations, and other public events.

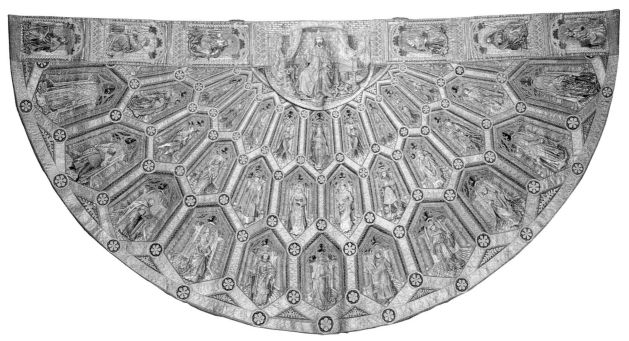

17-22. Cope, from the Treasury of the Golden Fleece. Flemish, mid-15th century. Cloth with gold and colored silk embroidery, 5'4⁹/₁₆" x 10'9⁵/₁₆" (1.64 x 3.3 m). Kunsthistorisches Museum, Vienna

The Order of the Golden Fleece was an honorary fraternity founded by Duke Philip the Good of Burgundy in 1430 with twenty-three knights chosen for their moral character and bravery. Religious services were an integral part of the meetings of the order, and opulent liturgical and clerical objects were created for the purpose. The insignia of the order was a gold ram skin, which hung as a pendant from the Collar of the Golden Fleece, given to each knight. These insignia were the property of the order and had to be returned at the death of the member. The gold ram referred to the Greek legend of Jason, who went off on his ship *Argo* to search for the Golden Fleece, the wool of a magical ram that had been sacrificed to Zeus.

Many were given as diplomatic gifts, and the wealth of individuals can often be judged from the number of tapestries listed in their household inventories.

One of the best-known tapestry suites (now in a museum in the United States) is the Hunt of the Unicorn, whose original five surviving pieces may have been made for Anne of Brittany, the young widow of the French king Charles VIII, to celebrate her marriage to King Louis XII of France on January 8, 1499. The first and seventh pieces, *Start of the Hunt* and *Unicorn in Captivity,* were added later. Unfortunately, following the French Revolution all wall hangings with royal insignia were ordered destroyed or the identifying marks cut off, as happened with this set. The unicorn, a mythological horselike animal with cloven hoofs, a goat's beard, and a single long twisted horn, appears in stories from ancient India, the Near East, and Greece. The creature was said to be supernaturally swift and, in medieval belief, could only be captured by a young virgin, to whom it came willingly. Thus, it became a symbol of the Incarnation, with Christ as the unicorn captured by the Virgin Mary, and also a metaphor for romantic love, suitable as a subject for wedding tapestries.

Each of the tapestry pieces exhibits a number of figures in a dense field with trees, flowers, and a distant view of a castle, as in the *Unicorn at the Fountain* (fig. 17-23). The letters *A* and *E*, hanging by a cord from the fountain, may be a reference to the first and last letters of Anne's name or the first and last letters of her motto, *À ma vie* ("By my life," a kind of pledge). The workshop that produced the Unicorn series is not known, although Brussels is a likely possibility. The unusually fine condition of the piece allows us to appreciate its rich coloration and the subtlety in modeling the faces, creating tonal variations in the animals' fur, and depicting reflections in the water.

Because of its religious connotations, the unicorn was an important animal in the medieval bestiary, an encyclopedia of real and imaginary animals, giving information of both moral and practical value. For example, the unicorn's horn (if ever found) was thought to be an antidote to poison. Thus, the unicorn is shown dipping its horn into the fountain's waters to purify them. Other woodland creatures included here have symbolic meanings as well. For example, lions, ancient symbols of power, represent valor, faith, courage, and mercy; the stag is a symbol of Christian resurrection and a protector against poisonous serpents and evil in general; and the gentle, intelligent leopard was said to breathe perfume. Not surprisingly, the rabbits symbolize fertility and the dogs fidelity. The pair of pheasants is an emblem of human love and marriage, and the goldfinch is another symbol of fertility. Only the ducks swimming away seem to have no known message.

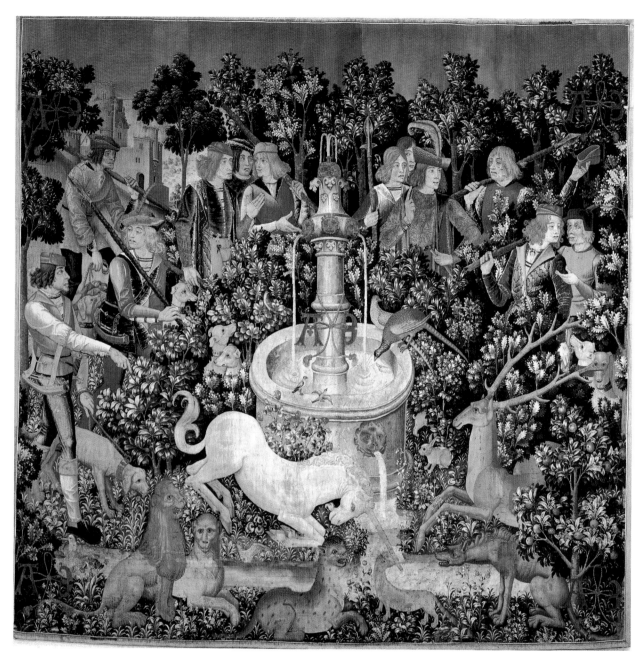

17-23. *Unicorn at the Fountain,* from the Hunt of the Unicorn tapestry series. c. 1498–1500. Wool, silk, and metal thread (13–21 warp threads per inch), 12'1" x 12'5" (3.68 x 3.78 m). The Metropolitan Museum of Art, New York

Gift of John D. Rockefeller, the Cloisters Collection (37.80.2)

The price of a tapestry depended on the threads used. Rarely was a fine, commissioned series woven only with wool; instead, tapestry producers enhanced it to varying degrees with silk, silver, and gold threads. The richest kind of tapestry was one made entirely of silk and gold. Because the silver and gold threads were real metal, people later damaged or even burned many tapestries in order to retrieve the precious materials. Few French royal tapestries survived the French Revolution as a result of this practice. Many existing works show obvious signs, however, that the metallic threads were painstakingly pulled out in order to preserve the tapestries.

The plants, flowers, and trees in the tapestry, identifiable from their botanically correct depictions, reinforce the theme of protective and curative powers. Each has both religious and secular meanings, but the theme of marriage, in particular, is referred to by the presence of such plants as the strawberry, a common symbol of sexual love; the periwinkle, a cure for spiteful feelings and jealousy; the pomegranate, for fertility; and the pansy, for remembrance. The trees include oak for fidelity, beech for nobility, holly for protection against evil, hawthorn for the power of love, and orange for fertility. The parklike setting with its prominent fountain is rooted in a biblical love poem, the Song of Songs (4:12, 13, 15-16): "You are an enclosed garden, my sister, my bride, an enclosed garden, a fountain sealed. You are a park that puts forth pomegranates, with all choice fruits. . . . You are a garden fountain, a well of water flowing fresh from Lebanon. Let my lover come to his garden and eat its choice fruits."

HISPANO-FLEMISH ART OF SPAIN AND PORTUGAL

Spanish and Portuguese painters quickly absorbed the new Flemish style to such an extent that the term *Hispano-Flemish* is applied to their works of the second half of the fifteenth century. Not only were Flemish paintings brought to Spain but Spanish artists went north to study the Flemish style and technique firsthand. Queen Isabella of Castile preferred Flemish painting above all other styles. Her marriage to Ferdinand of Aragon (1469) and their conquest of Granada from the Muslims (1492) effectively united the peninsula in what would later become modern Spain. By 1496, when their daughter Joanna married Philip, son and heir of Mary of Burgundy, the Flemish manner had replaced the earlier Spanish styles.

The marriage of Joanna and Philip was commemorated in an altarpiece, painted probably by Diego de la Cruz, the panels of which are now scattered, many to American collections. The strong impact of Flemish art is unmistakable in this painter's work, as in a panel depicting the Visitation (fig. 17-24).

Elizabeth and Mary embrace in front of the castlelike home of Elizabeth and her husband, Zechariah, a Temple priest. Zechariah sits on the porch in the background, reading, his dog nearby, while two cleaning women on the upstairs gallery are hard at work with mops and ladders, getting everything tidy for the arrival of a guest. The lush garden setting is filled with accurately portrayed plants and flowers, symbolizing Mary's virginity, purity, and humility, as well as foretelling the Passion of Christ, her yet-unborn son. Included are many plants having medicinal uses, known from herbals of the time, suggesting that Elizabeth's son, John the Baptist, and Mary's son, Jesus, were born to heal the ills of humanity.

A major artist connected with the court of Portugal, Nuño Gonçalvez, also assimilated much from the style of Jan van Eyck in his intensity of detail, monumental figures, and rich color treatments. He was especially renowned for his portraiture, closer to Dirck Bouts's and Hans Memling's than to Jan's, and for his virtuoso rendering of costumes and draperies. His only extant works are six panels from a large polyptych, whose central scene may have been carved. It was made for the Convent of Saint Vincent de Fora in Lisbon between 1471 and 1481. In one of the two largest panels (fig. 17-25),

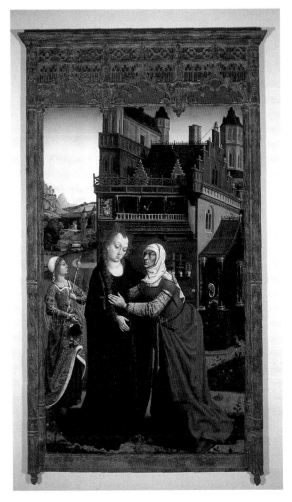

17-24. Diego de la Cruz (?). *Visitation,* panel from an altarpiece, Valladolid, Spain. 15th century. Oil on panel, 60 x 36⅞" (152.8 x 93.7 cm). Collection of the University of Arizona Museum of Art, Tucson
Gift of Samuel H. Kress Foundation (61.13.22)

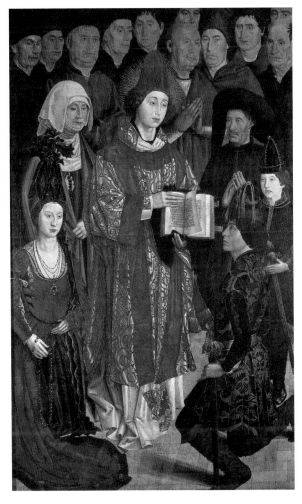

17-25. Nuño Gonçalvez. *Saint Vincent with the Portuguese Royal Family,* panel from the *Altarpiece of Saint Vincent.*
c. 1471–81. Oil on panel, 6'9¾" x 4'2⅝" (2.07 x 1.28 m). Museu Nacional de Arte Antiga, Lisbon

Vincent, magnificent in red and gold vestments, stands in a tightly packed group of people, with members of the royal family at the front and courtiers forming a solid block across the rear. With the exception of the idealized features of the saint, all are portraits; at the right King Alfonso V kneels before Vincent, while his young son and his deceased uncle, Henry the Navigator, look on. Alfonso and his son rest their hands on their swords; Henry's hands are tented in prayer. At the left are Alfonso's wife and mother, whose right hands are wrapped in rosary beads. The appearance of Vincent is clearly a vision, brought on by the intense prayer of the individuals around him. The altarpiece may have been created to commemorate a Portuguese crusade against the Muslims in Morocco undertaken in 1471 under Saint Vincent's standard.

FRENCH ART

During the fifteenth century, France was divided into feudal holdings that in theory were under royal rule. Many, however, were held by dukes who were richer and more powerful than the king himself. Throughout much of the century there were repeated struggles for power. When Charles VI died in 1422, the throne was claimed for the nine-month-old Henry VI of England through his mother, the French princess. The infant king's uncle, the duke of Bedford, then assumed control of the French royal territories as regent, with the support of the duke of Burgundy. The exile of the late French king Charles VI's son, Charles VII, inspired Joan of Arc to lead a crusade to return him to the French throne. Although Joan was captured, condemned on trumped-up charges, and burned at the stake in 1431, the revitalized French forces captured Paris in 1436, and by 1453 the English had finally been driven out. In 1461, Louis XI succeeded his father, Charles VII, on the throne and began a single-minded extension of royal power. He and his successors firmly established the power and wealth of the monarchy, and under their rule the French royal court again became a major source of patronage for the arts.

An outstanding court artist of the period, Jean Fouquet (c. 1420–c. 1481), was born in Tours and may have trained in Paris as an illuminator. He appears to have traveled to Italy about 1445 and is believed to be the artist who painted a portrait of Pope Eugene IV. By about 1450, he was a master in Tours, with commissions that included portraits of the restored king, Charles VII, his family, and his courtiers, as well as illustrations for manuscripts and designs for the tomb of Charles VII's successor. Fouquet's paintings on panels and in manuscripts exhibit great familiarity with contemporary Italian architectural decoration, but he was also fully aware of and strongly influenced by Flemish painting.

Among the court officials painted by Fouquet is Étienne Chevalier (fig. 17-26), the treasurer of France under Charles VII, on the left half of a diptych that portrays the Virgin and Child on the facing panel. According to an inscription, the painting was made to fulfill a vow made by Chevalier to the king's much-loved and respected mistress, Agnès Sorel, who died in 1450. Sorel,

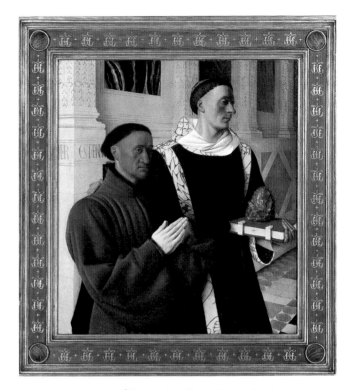

17-26. Jean Fouquet. *Étienne Chevalier and Saint Stephen,* left wing of the *Melun Diptych.* c. 1450. Oil on panel, 36½ x 33½" (92.7 x 85 cm). Staatliche Museen zu Berlin, Preussischer Kulturbesitz, Gemäldegalerie

whom contemporaries described as a highly moral, extremely pious woman, was probably the model for the Virgin, with her features taken from her death mask, which is still preserved.

Chevalier, who kneels in prayer with clasped hands and a meditative gaze, wears a houppelande, the voluminous costume of the time. Fouquet has followed the Flemish manner in depicting the courtier's ruddy features as carefully as the reflection in a mirror, and its accuracy is confirmed by other known portraits. Chevalier is presented to the Virgin by his name saint, Stephen (Étienne, in French), whose features are also distinctive enough to have been a portrait. According to legend and biblical accounts, Stephen was a deacon in the early Christian Church in Jerusalem and the first Christian martyr; he was stoned to death for preaching Christianity. The saint wears liturgical, or ritual, vestments and carries a large stone on a closed Gospel, a volume with the first four books of the New Testament. A trickle of blood can be seen on his tonsure, the shaved head adopted as a sign of humility by male members of some religious orders. The two figures are shown in a large hall decorated with marble paneling and classical **pilasters**, upright strips of wall masonry made to resemble columns, that have been gilded. Fouquet has arranged the figures in an unusual spatial setting, with the diagonal lines of the wall and uptilted tile floor receding toward an unseen focal point at the right. Despite his debt to Flemish realism and his nod to Italian architectural forms' **linear perspective**, Fouquet's somewhat austere style is uniquely his own.

1460
1400 1500

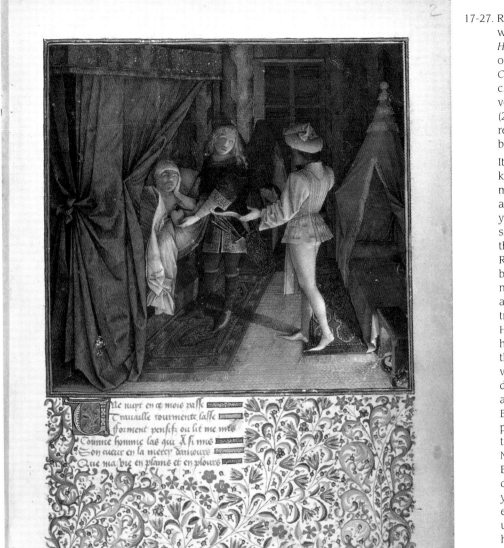

17-27. René Painter. Page with *René Gives His Heart to Desire*, in René of Anjou's *Livre du Cuer d'Amours Espris*. c. 1457–65. Tempera on vellum, 11³⁄₈ x 8¹⁄₈" (28.9 x 20.6 cm). Österreichische Nationalbibliothek, Vienna

It was not customary to keep records of works made by official court artists, who were paid yearly salaries or pensions rather than by the piece. At one time, René of Anjou was believed to have been not only a writer but also a painter who illustrated his own books. His accounts show, however, that during the time this manuscript was produced, the duke had in his employ an illuminator named Berthélemy van Eyck, perhaps a younger relation of Jan van Eyck. No clue is given to what Berthélemy painted during his twenty-five years in the duke's employ, but he worked under the close eye of his patron. An inventory of 1471–1472 records the fact that his workroom was just off René's own study.

The brother-in-law of Charles VII, René, the duke of Anjou, was a major figure in French culture of the fifteenth century, both as a patron and as a gifted writer. Among René's noted books is a romantic allegory, *Livre du Cuer d'Amours Espris* (*Book of the Heart Captured by Love*), completed in 1457. One of the earliest illustrated copies, completed about 1465, was created by a painter of original talents, probably at René's court. The René Painter exhibits a special ability to render difficult effects of illumination, as seen in the opening illustration, *René Gives His Heart to Desire* (fig. 17-27). The setting is the bedroom of the king, who is unable to sleep and is tormented by desire. The allegory begins with the king's heart being taken by Amour (Love) and given to Desire, who sets off to find the perfect object for the king's affections. In spite of the dim light, every detail of the chamber is clear, from the crisp white linens and velvet hangings on the beds to the oriental rugs and patterned wall design to a fifteenth-century nightlight—a candle burning under a wooden stand.

GERMAN ART

In the Holy Roman Empire, a loose confederation of primarily Germanic states that lasted until the early nineteenth century, two major stylistic strains of art existed simultaneously during the first half of the fifteenth century. One continued the International Gothic interest in prettiness, softness, and sweetness of expression. The other was an intense investigation and detailed description of the physical world. The major exponent of the latter style was Konrad Witz (documented from 1434; d. 1446), a native of what is now southern Germany who, like many artists, was drawn to Basel (in modern Switzerland), where the numerous church officials were a rich source of patronage. His career ended with his early death, probably from the plague. Witz's last large

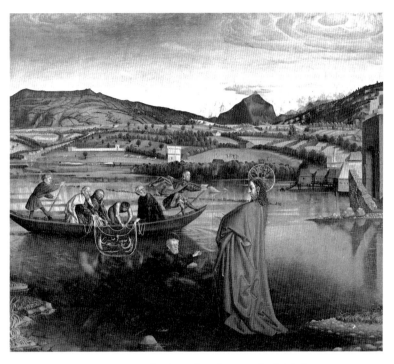

17-28. Konrad Witz. *Miraculous Draft of Fish*, from an altarpiece from the Cathedral of Saint Peter, Geneva, Switzerland. 1444. Oil on panel, 4'3" x 5'1" (1.29 x 1.55 m). Musée d'Art et d'Histoire, Geneva

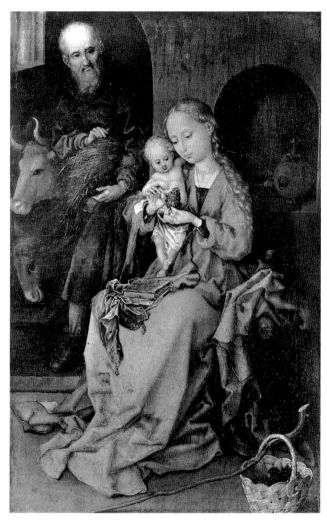

17-29. Martin Schongauer. *Holy Family.* 1480s. Oil on panel, 10¼ x 6¾" (26 x 15.9 cm). Kunsthistorisches Museum, Vienna

commission was an altarpiece dedicated to Saint Peter for the Cathedral of Saint Peter in Geneva, which he signed and dated in 1444 on the wing panels, the only parts of the altarpiece preserved today. In the *Miraculous Draft of Fish* (fig. 17-28), a scene from the life of Saint Peter, what ultimately engages our attention is the landscape setting. The painter has created an identifiable topographical portrayal of Lake Geneva, with its dark mountain rising on the far shore behind Jesus and the surrounding Alps shining in the distance. Witz records every nuance of light and water—the rippling surface, the reflections of boats, figures, and buildings, even the lake bottom. Peter's body and legs, visible through the water, are distorted by the refraction. The floating clouds above create shifting light and dark passages over the water. Witz, perhaps for the first time in European art, recorded nature in a way that approached a modern photograph.

Martin Schongauer (c. 1450–1491), an influential artist and printmaker of the second half of the fifteenth century, thoroughly absorbed Flemish ideas while maintaining elements of the German International Gothic style, favoring charming subjects and brilliant colors. A mature work, the tiny *Holy Family* (fig. 17-29) from the

1480s, disarms us with what appears at first glance to be a greater interest in describing the natural world than in symbolic content. Seated in a stable, the young Mary plucks grapes from a cluster to feed the Child, who leans casually against her shoulder with one arm clutching her neck. A woven wood basket of freshly picked grapes stands in the foreground, while Joseph brings in a sheaf of grain to feed the farm animals, an ox and an ass. Except for the rich robes of the Virgin, nothing would appear out of place in a scene of everyday farm life. But, as in Hugo van der Goes's Portinari panels (see fig. 17-18), the details allude to the Eucharist, with the grapes representing the wine, or Blood of Christ, and the sheaf of wheat the Host, or Body of Christ.

THE ITALIAN RENAISSANCE IN FLORENCE

In the late fourteenth century, as Italy recovered from the devastation in 1348 of the Black Death, Italian cities grew rich from international banking and cloth manufacture. In the fifteenth century, the Kingdom of Naples and Sicily and the Papal States—states in central Italy controlled by the pope—were the largest territories, but the most impor-

tant cultural centers were north of Rome at Florence, Pisa, Milan, Venice, and the smaller duchies of Mantua, Ferrara, and Urbino. Much of the power and art patronage was in the hands of wealthy families: the Medici in Florence, the Visconti and Sforza in Milan, the Gonzaga in Mantua, the Este in Ferrara, and the Montefeltro in Urbino. Cities grew in wealth and independence as people moved to them from the countryside in unprecedented numbers, and commerce became increasingly important. In some of the Italian states a noble lineage was no longer necessary for—nor did it guarantee—political and economic success. Now money conferred status, and a shrewd business or political leader could become very powerful.

Education was also an important factor. Merchants, lawyers, and courtiers needed a practical knowledge of mathematics, as well as skills in rhetoric and deportment. Schools also responded to humanist concerns by teaching Greek and Roman literature, poetry and music, history and classical philosophy, and physical education. In some ways they tried to emulate the ancient academies of Plato and Aristotle. During this period humanists put great emphasis on looking to classical antiquity for ideals of proportion as applied to architecture and the human body. They stressed the importance of the dignity of the individual.

Although most of the physical remains of classical antiquity were in Rome, Florence was the birthplace of the Italian Renaissance movement. Patronage of the arts in Florence was an important public activity with political overtones. As one Florentine merchant, Giovanni Rucellai, succinctly noted, he supported the arts "because they serve the glory of God, the honour of the city, and the commemoration of myself" (cited in Baxandall, page 2; see fig. 17-35).

The Medici of Florence were leaders in intellectual and artistic patronage, as they were in business practice. Cosimo de' Medici the Elder (1389–1464) founded his own academy devoted to the study of classical learning, especially the works of Plato and his followers, the Neoplatonists. Most basically, Neoplatonism is characterized by a sharp opposition between the spiritual (the ideal or Idea) and the carnal (Matter) that can be overcome by severe discipline and aversion to the world of the senses. The experience of transcending these opposites is a mystical, spiritual ecstasy. Writers, philosophers, and musicians dominated the Medici Neoplatonic circle. Few architects, sculptors, or painters were included, however, for although some artists had studied Latin or Greek, most had learned their craft in apprenticeships and thus were still considered little more than manual laborers. Nevertheless, interest in the ancient world rapidly spread beyond the Medici circle to artists and craftspeople, who sought to reflect the new interests of their patrons in their work. Gradually, artists began to see themselves as more than artisans, and society recognized their best works as achievements of a very high order.

Artists, like humanist scholars, looked to Classical antiquity for inspiration, studying surviving examples of ancient Roman architecture and sculpture. Because few examples of ancient Roman painting were known in the fifteenth century, Renaissance painters looked to Roman sculpture and literature for inspiration. Despite this interest in antiquity, fifteenth-century Italian painting and sculpture continued to be predominantly religious. Secular works were rare until the second half of the century, and even these were chiefly portraits. Allegorical and mythological themes also appeared in the latter decades as patrons began to collect art for their personal enjoyment. The male nude became an acceptable subject, mainly through the study of Classical figures as models for idealized Renaissance sculpture. Other than representations of Eve or an occasional allegorical or mythological figure, female nudes were rare until the end of the century.

Like their Flemish counterparts, Italian painters and sculptors moved gradually toward a greater precision in rendering the illusion of physical reality. They did so in a more analytical way than the Flemings had, however, with the goal of achieving anatomically correct but stylistically **idealized** figures—perfected, generic types—set within a rationally, rather than intuitively, defined space. Just as Italian architects applied abstract, mathematically derived design principles to their plans and elevations, painters and relief sculptors developed a rational system of linear perspective to achieve the illusion of continuously receding space (see "Renaissance Perspective Systems," page 624).

Architecture

Travelers from across the Alps in the mid-fifteenth century found Florence very different in appearance from the northern cities. Instead of church spires piercing the sky, the Florentine skyline was dominated, as it still is today, by the enormous mass of the cathedral dome rising above low houses, smaller churches, and the block-like palaces of the wealthy, all of which had minimal exterior decoration.

The major civic project of the early years of the fifteenth century was the still-unfinished cathedral, begun in the late thirteenth century and continued intermittently during the fourteenth century. As early as 1367, its architects had envisioned a very tall dome to span the huge interior space, but they lacked the engineering know-how to construct it. When interest in completing the cathedral was revived around 1407, the technical solution was proposed by a young sculptor-turned-architect, Filippo Brunelleschi (1377–1446). Brunelleschi's intended career as a sculptor had ended with his failure to win the 1402 competition to design new bronze doors for the Baptistry, which stands next to the Florence Cathedral. Brunelleschi declined a role as assistant on that project and traveled to Rome, probably with his sculptor friend Donatello, where he studied ancient Roman sculpture and architecture.

Brunelleschi, whose father had been involved in the original plans for the dome in 1367, advised constructing first a tall **drum**, or cylindrical base. The drum was finished in 1410, and in 1417 Brunelleschi was commissioned to

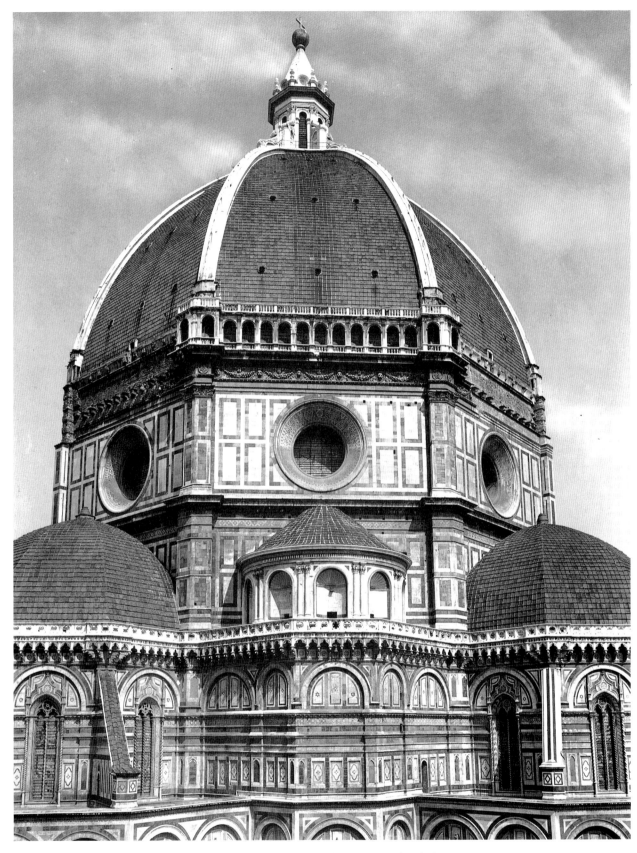

17-30. Filippo Brunelleschi. Dome of Florence Cathedral. 1417–36; lantern completed 1471

The cathedral dome was a source of immense local pride from the moment of its completion. Renaissance architect and theorist Leon Battista Alberti described it as rising "above the skies, large enough to cover all the peoples of Tuscany with its shadow" (cited in Goldwater and Treves, page 33). While Brunelleschi maintained the Gothic pointed-arch profile of the dome established in the fourteenth century, he devised an advanced construction technique that was more efficient, less costly, and safer than earlier systems. An arcaded gallery he planned to install at the top of the tall drum was never built, however. In 1507, Baccio d'Agnolo won a competition to design the gallery, using supports installed on the drum nearly a century earlier. The first of the eight sections, seen here, was completed in 1515.

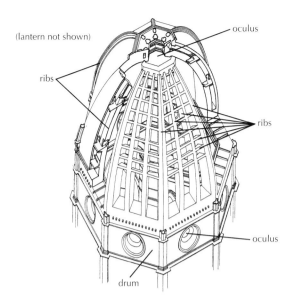

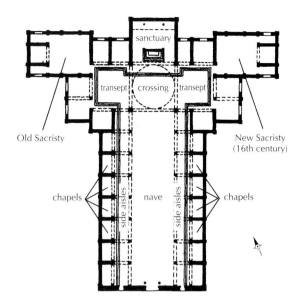

17-31. Cutaway drawing of Brunelleschi's dome, Florence Cathedral. (Drawing by P. Sanpaolesi)

17-32. Filippo Brunelleschi. Plan of the Church of San Lorenzo, Florence. c. 1421–46; plan includes later additions and modifications

design the dome itself (fig. 17-30). Work began in 1420 and was completed by 1471. A revolutionary feat of engineering, the dome is a double shell of masonry that combines Gothic and Renaissance elements. Gothic construction is based on the pointed arch, using stone shafts, or **ribs**, to support the **vault**, or ceiling. The octagonal outer shell is essentially a structure of this type, supported on ribs and in a pointed-arch profile; however, like Roman domes, it is cut at the top with an **oculus** (opening) and is surmounted by a **lantern**, a crowning structure made up of Roman architectural forms. The dome's 138-foot diameter would have made the use of **centering** (temporary wooden construction supports) costly and even dangerous. Therefore, Brunelleschi devised machinery to hoist building materials as needed and invented an ingenious system by which each portion of the structure reinforced the next one as the dome was built up **course**, or layer, by course. The reinforcing elements were vertical marble ribs and horizontal sandstone rings connected with iron rods, with the whole supported by oak staves and beams tying rib to rib (fig. 17-31). The inner and outer shells were also tied together internally by a system of arches. When completed, this self-buttressed unit required no external support to keep it standing.

The cathedral dome was a triumph of engineering and construction technique for Brunelleschi, who was a pioneer in Renaissance architectural design. Other commissions came quickly after the cathedral-dome project, and Brunelleschi's innovative designs were well received by Florentine patrons. From about 1421 to his death in 1446, Brunelleschi was involved in two projects for the Church of San Lorenzo. First, the architect designed a **sacristy** (a room where ritual attire and vessels are kept), completed in 1428 and called the old Sacristy, as a chapel and mausoleum for the Medici. He was then commissioned to rebuild the church itself. The precise history of this second project is obscured by intermittent construction and later alterations. Brunelleschi may have conceived the plans for the new church at the same time as he designed the sac-

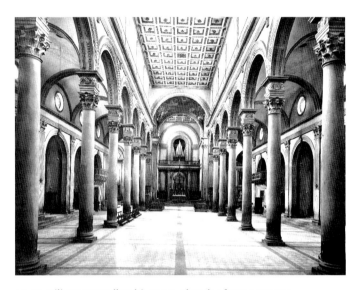

17-33. Filippo Brunelleschi. Nave, Church of San Lorenzo

risty in 1421 or perhaps as late as about 1425, after new foundations had been laid for the **transept** and **sanctuary**.

San Lorenzo is an austere **basilica-plan** church with elements of Early Christian design (fig. 17-32). The long **nave**, flanked by single side aisles opening into shallow side chapels, is intersected by a short transept with a square **crossing**. Beyond the crossing space facing the nave is a square sanctuary flanked by small chapels opening off the transept. Projecting out from the south transept is Brunelleschi's sacristy, today called the Old Sacristy to distinguish it from one built in the sixteenth century.

What is entirely new in San Lorenzo is its mathematical regularity and symmetry. To plan the church, Brunelleschi used a module—a basic unit of measure that could be multiplied or divided and applied to every element of the design. The result was a series of clear, rational interior spaces in harmony with each other and on a human scale.

Brunelleschi's modular system was also carried through in the proportions of the church's interior (fig. 17-33). Ornamental details were carved in *pietra serena*,

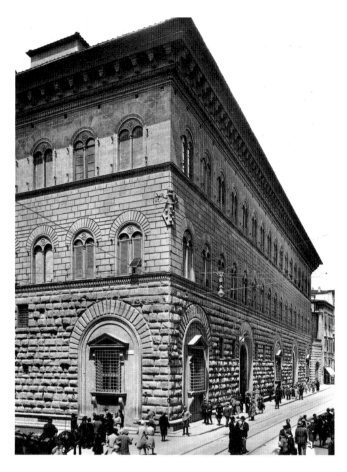

17-34. Michelozzo di Bartolommeo. Palazzo Medici-Riccardi, Florence. Begun 1444

Cosimo de' Medici the Elder's decision to build a new town palace was not just to provide more living space for his family. He also incorporated into the plans offices and storage rooms for conducting his business affairs. For the palace site, he chose the Via de' Gori at the corner of the Via Larga, the widest city street at that time. Despite his practical reasons for constructing a large residence and the fact that he chose simplicity and austerity over grandiosity in the exterior design, his detractors had a field day. As one exaggerated: "[Cosimo] has begun a palace which throws even the Colosseum at Rome into the shade."

a grayish stone that became synonymous with Brunelleschi's interiors. Below the plain **clerestory** (upper-story wall of windows) with its unobtrusive openings, the arches of the nave are carried on tall, slender **Corinthian** columns made even taller by the insertion of a favored Brunelleschian device, an **impost block** between the column capital and the springing of the round arches. The arcade is repeated in the outer walls of the side aisles in the arched openings to the chapels surmounted by arched **lunettes**. Flattened architectural forms in *pietra serena* articulate the wall surfaces, and each bay is covered by its own vaulted ceiling. The square crossing is covered by a hemispherical dome, the nave and transept by flat ceilings.

San Lorenzo was an experimental building combining old and new elements, but Brunelleschi's rational approach, unique sense of order, and innovative incorporation of Classical motifs were inspirations to later Renaissance architects, many of whom learned from his work firsthand by completing his unfinished projects.

Brunelleschi's role in the Medici palace (now known as the Palazzo Medici-Riccardi) in Florence, begun in 1444, is unclear. According to the sixteenth-century painter, architect, and biographer Giorgio Vasari, Brunelleschi's model for the palazzo, or palace, was rejected as too grand by Cosimo de' Medici the Elder, who later hired Michelozzo di Bartolommeo (1396–1474), whom most scholars have accepted as the designer of the building. In any case, the palace established a tradition for Italian town houses that, with interesting variations, remained the

norm for a century (fig. 17-34). The plain exterior was in keeping with political and religious thinking in Florence, which was strongly influenced by Christian ideals of poverty and charity. Like many other European cities, Florence had sumptuary laws, which forbid ostentatious displays of wealth—but they were often ignored. Under Florentine law, for example, private homes were limited to a dozen rooms; Cosimo, however, acquired and demolished twenty small houses to provide the site for his new residence.

Huge in scale (each story is more than 20 feet high), with fine proportions and details, the building was constructed around a central courtyard surrounded by a **loggia**, or covered gallery. On one side the ground floor originally opened through large, round arches onto the street. Although these arches were walled up in the sixteenth century and given windows designed by Michelangelo, they are still visible today. The facade of large, **rusticated** stone blocks—that is, with their outer faces left rough, typical of Florentine town house exteriors—was derived from fortifications. On the palace facade the stories are clearly set off from each other by the change in the stone surfaces from very rough at the ground level to almost smooth on the third. The Medici Palace inaugurated a new monumentality and regularity of plan in residential urban architecture.

By the middle of the fifteenth century, more artists had become students of the past, and a few humanists had ventured into the field of art theory and design. Leon Battista Alberti (1404–1472), a humanist-turned-

ELEMENTS OF ARCHITECTURE

The Renaissance Palace Facade

Wealthy and noble families in Renaissance Italy built magnificent city palaces. More than just being large and luxurious private homes, these palaces were designed (often by the best architects of the time) to look imposing and even intimidating.

The **facade**, or front face of a building, offers broad clues to what lies behind the facade: a huge central door suggests power; rough, **rusticated** stonework hints of strength and the fortifications of a castle; precious marbles or carvings connote wealth; a **cartouche**, perhaps with a family coat-of-arms, is an emphatic identity symbol.

Most Renaissance palaces used architectural elements derived from ancient Greek and Roman buildings—**columns** and **pilasters** in the Doric, Ionic, and/or Corinthian orders, decorated **entablatures**, and other such pieces—in a style known as **classicism**. The example illustrated here, the Palazzo Farnese in Rome, was built for the Farneses, one of whom, Cardinal Alessandro Farnese, became Pope Paul III in 1534. Designed by Antonio da Sangallo the Younger, Michelangelo, and Giacomo della Porta, this immense building stands at the head of and dominates a broad open public square, or **piazza**. The palace's three stories are clearly defined by two horizontal bands of stonework, or **stringcourses**. A many-layered **cornice** sits on the facade like a weighty crown. The **moldings**, cornice, and entablatures are decorated with classical **motifs** and with the lilies that form the Farnese family coat-of-arms.

The massive central door is emphasized by elaborate rusticated stonework (as are the building's corners, where the shaped stones are known as **quoins**), and is surmounted by a balcony suitable for ceremonial appearances by the owner, over which is set the cartouche with the Farnese arms. Windows are treated differently on each story: on the ground floor, the twelve windows sit on sturdy scrolled **brackets**, and the window heads are topped with **architraves**. The story directly above is known in Italy as the *piano nobile*, or first floor (Americans would call it the second floor), which contains the grandest—or "noble"—rooms. Its twelve windows are decorated with alternating triangular and arched **pediments**, supported by pairs of **engaged half columns** in the Corinthian order. The second floor (or American third floor) has thirteen windows, all with triangular pediments whose supporting Ionic half columns are set on brackets echoing those under the windows on the ground floor.

Renaissance city palaces, in general, were oriented inward, away·from the noisy streets. Many contained open courtyards (see fig. 17-59). Classical elements prevailed here, too. The courtyard of the Palazzo Farnese has a **loggia** fronted by an **arcade** at the ground level. Its Classical **engaged columns** and pilasters present all the usual parts: **pedestal**, **base**, **shaft**, and **capital**. The progression of orders from the lowest to the highest story mirrors the appearance of the orders in ancient Greece: Doric, Ionic, and Corinthian.

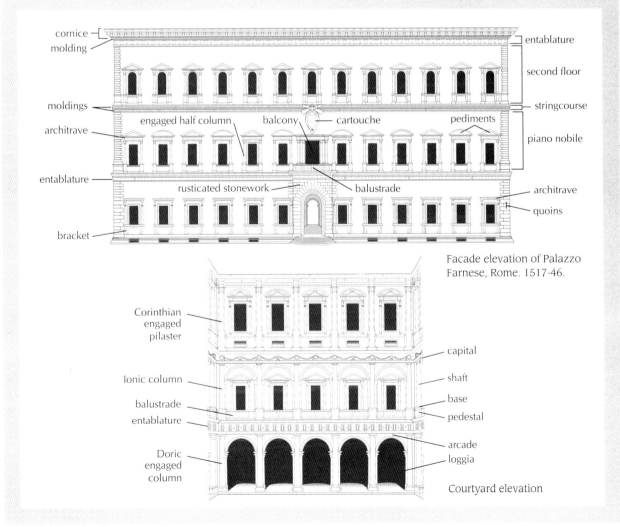

Facade elevation of Palazzo Farnese, Rome. 1517-46.

Courtyard elevation

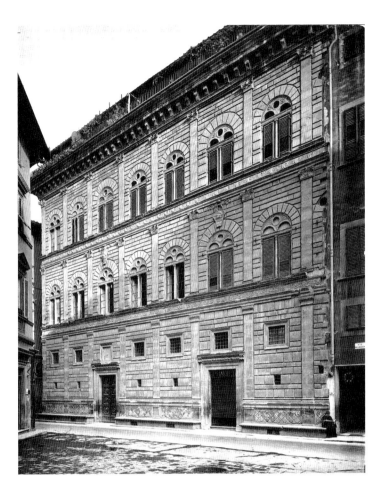

17-35. Leon Battista Alberti. Palazzo Rucellai, Florence. 1455–70

architect, wrote about his classical theories on art before he ever designed a building. Alberti studied at the universities of Padua and Bologna, then worked as a Latin scribe for Pope Eugene IV. This position, which involved diplomatic travel and thus put Alberti in contact with the best potential patrons in Italy, was critical to his later career as an architect. Alberti's various writings present the first coherent exposition of early Italian Renaissance aesthetic theory, including the Italian mathematical perspective system credited to Brunelleschi and ideal proportions of the human body derived from classical art. With Alberti began the gradual change in the status of the architect from a hands-on builder—and thus manual laborer—to an intellectual expected to know philosophy, history, and the classics as well as mathematics and engineering.

The relationship of the facade to the body of the building behind it was a continuing challenge for Italian Renaissance architects. Early in his architectural career, Alberti devised a facade—begun in 1455 but never finished—to be the unifying front for a planned merger of eight adjacent houses in Florence acquired by Giovanni Rucellai (fig. 17-35). Alberti's design, influenced in its basic approach by the Palazzo Medici, was a simple rectangular front suggesting a coherent, cubical three-story building capped with an overhanging **cornice**, a heavy, projecting horizontal molding at the top of the wall. The double windows under round arches were a feature of Michelozzo's Palazzo Medici, but other aspects of the facade were entirely new. Inspired by the ancient Colos-

seum in Rome, Alberti articulated the surface of the lightly rusticated wall with a horizontal-vertical pattern of pilasters and **architraves** that superimposed the **Classical orders**: **Doric** on the ground floor, **Ionic** on the second, and **Corinthian** on the third (see "Elements of Architecture," page 645). The Palazzo Rucellai provided a visual lesson for local architects in the use of classical elements and mathematical proportions, and Alberti's enthusiasm for classicism and his architectural projects in other cities were catalysts for the spread of the Renaissance movement.

Sculpture

In the early fifteenth century the two most important sculptural commissions in Florence were the new bronze doors for the Florence Cathedral Baptistry and the exterior decoration of the Church of Orsanmichele. Orsanmichele, once an open-arcaded market, was both the municipal granary and a shrine for the local guilds. After its ground floor was walled up near the end of the fourteenth century, each of the twelve niches on the outside of the building was assigned to a guild, which was to commission a large figure of its patron saint or saints for the niche.

Nanni di Banco (c. 1385–1421), son of a sculptor in the Florence Cathedral workshop, produced statues for three of Orsanmichele's niches in his short but brilliant career. The *Four Crowned Martyrs* was commissioned about 1410–1413 by the stone carvers and woodworkers'

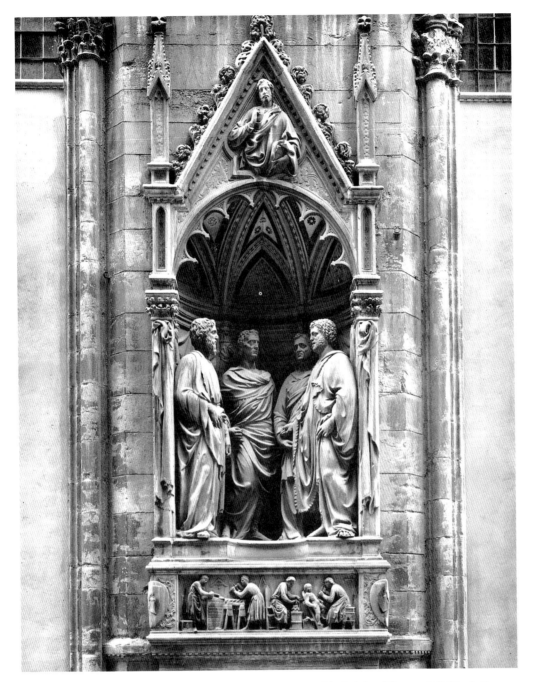

17-36. Nanni di Banco. *Four Crowned Martyrs.* c. 1410–13. Marble, height of figures 6' (1.83 m). Orsan-michele, Florence

guild, to which Nanni himself belonged (fig. 17-36). These martyrs, according to legend, were third-century Christian sculptors executed for refusing to make an image of a Roman god. Although the setting resembles a small-scale Gothic chapel, Nanni's figures—with their solid bodies, heavy, form-revealing togas, and stylized hair and beards—have the appearance of ancient Roman sculpture. Standing in a semicircle with two feet and some drapery protruding beyond the floor of the niche, the saints convey a sense of realism by their individual-ized features and the appearance that they are in conversation. In the relief panels below, showing wood-carvers and sculptors at work, the forms have a similar

solid vigor. Both figures and objects have been deeply undercut around their contours to cast shadows and enhance the illusion of three-dimensionality.

In 1402 a competition was held to determine who would provide bronze relief panels for a new set of doors for the north side of the Florence Baptistry of San Gio-vanni. The commission was awarded to Lorenzo Ghi-berti (1381?–1455), a young artist trained as a painter, at the very beginning of his career. His panels were such a success that he was awarded the commission for a final set of doors for the east side of the Baptistry in 1425. Those doors, installed in 1452, were reportedly said by Michelangelo to be worthy of being the Gates of Paradise

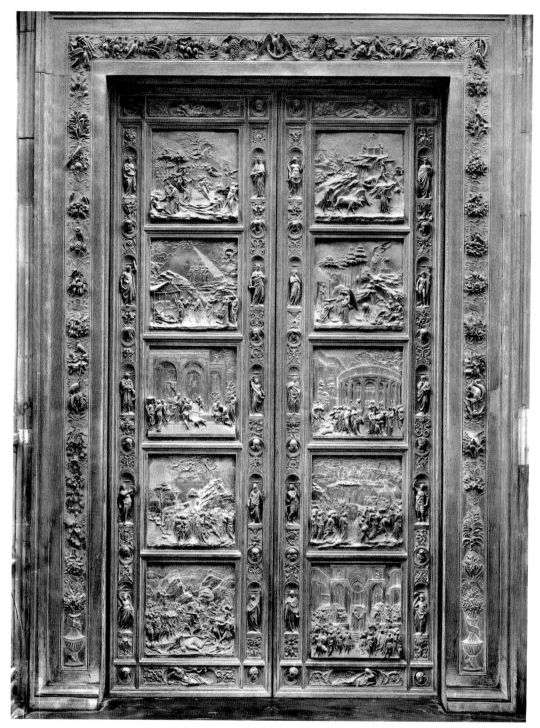

17-37. Lorenzo Ghiberti. Gates of Paradise (East Doors), Baptistry of San Giovanni,
Florence. 1425–52. Gilt bronze, height 15' (4.57 m). Museo dell'Opera del Duomo, Florence

The door panels contain ten Old Testament scenes from the Creation to the reign of Solomon.
The upper left panel depicts the Creation, Temptation, and Expulsion of Adam and Eve from Par-
adise. The murder of Abel by his brother Cain follows in the upper right panel, succeeded in the
same order by the great Flood and the drunkenness of Noah, Abraham sacrificing Isaac, the story
of Jacob and Esau (see fig. 17-38), Joseph sold into slavery by his brothers, Moses receiving the
Tablets of the Law, Joshua and the fall of Jericho, David and Goliath, and finally Solomon and
the Queen of Sheba. Ghiberti, whose bust portrait appears at the lower right corner of *Jacob and
Esau*, wrote in his *Commentaries* (c. 1450–55): "I strove to imitate nature as clearly as I could, and
with all the perspective I could produce, to have excellent compositions with many figures."

(fig. 17-37). The ten large, square reliefs were unified by
being completely gilded. Several panels were organized
by a system of linear perspective approximating the one
described by Alberti in his 1435 treatise on painting.

One panel (fig. 17-38) illustrates the Old Testament
story of the twin brothers Jacob and Esau, whose mother
tricked their father, Isaac, into giving his special blessing
to Jacob, the younger son, instead of to the rightful first-

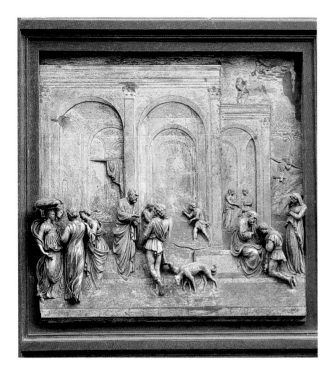

17-38. Lorenzo Ghiberti. *Jacob and Esau,* panel of the East Doors, Baptistry of San Giovanni. 1425–52. Gilt bronze, 31¼ x 31¼" (79.4 x 79.4 cm). Museo dell'Opera del Duomo, Florence

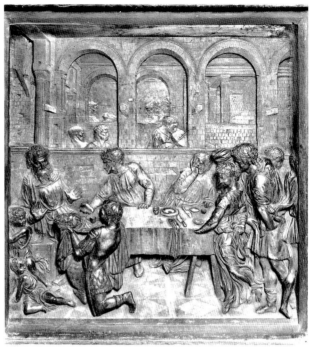

17-39. Donatello. *Feast of Herod,* panel of baptismal font, Siena Cathedral Baptistry. c. 1425. Gilt bronze, 23½ x 23½" (59.7 x 59.7 cm)

born Esau (Genesis 27). The incidents in the story, including the birth of the twins, take place in different parts of the same overall setting, as if they were one coherent event rather than a sequence of events. Space is organized by a series of arches leading the eye into the distance. Foreground figures, including the scene of blessing at the right, are grouped in the lower third of the panel in an uncrowded relationship with the sculpted architecture, while the other figures decrease gradually in size toward the background. In the panel, the depicted architecture, which, like Alberti's Rucellai facade (see fig. 17-35), suggests a Roman palace, illustrates the emerging antiquarian tone in Florentine art that would come to full flower in the second half of the fifteenth century. Such details as the conversational groupings of people, dogs sniffing the ground, and Esau climbing the hill with his bow provide immediacy.

The great genius of early Italian Renaissance sculpture was Donatello (Donato di Niccolò Bardi, c. 1386–1466), one of the most influential figures of the century in Italy. During his long and vigorous career, he pursued the goals of the emerging Renaissance movement in Florence but did not adhere rigidly to preconceived notions. Because he executed each commission as if it were a new experiment in expression, his sculpture is like an encyclopedia of types of work, with nearly every piece breaking new ground.

One of Donatello's innovations was a remarkably pictorial approach to relief sculpture. His reliefs have a low projection height, their space is organized by the use of linear perspective, and the forms on their background planes are delineated in shallowly cut lines, in effect drawn rather than sculpted. A fine example of Donatello's work in this style is the *Feast of Herod* (fig. 17-39), a gilded-bronze panel made for the baptismal font in the Siena Cathedral Baptistry about 1425. As in the relief sculpted below Nanni's *Four Crowned Martyrs* (see fig. 17-36), the contours of the foreground figures have been undercut to emphasize their mass, while figures beyond the foreground are in progressively lower relief. The lines of the brickwork and many other architectural features are incised rather than carved in depth. Anticipating Ghiberti's *Jacob and Esau* relief (see fig. 17-38), Donatello organized the scene with Classical architecture, but he did so systematically, around a focal point at the center of the panel. Nevertheless, he avoided the artificiality of precise geometric perspective by handling some peripheral areas more intuitively. The result is a spatial setting in relief sculpture as believable as that in an illusionistic painting.

In illustrating the biblical story of Salome's dance before her stepfather, Herod Antipas, and her morbid request to be rewarded with the head of John the Baptist on a platter (Mark 6:21–28), Donatello showed Herod's palace as a series of three receding chambers separated from each other by low walls and high, round arches. Although he established a **vanishing point**, the central point where the lines of the architecture converge, he placed the focus of action and emotion—the severed head of John the Baptist on a platter—in the left foreground, leaving the central axis of the composition empty. As a result, the eye is led past the foreground into the rooms beyond, where the beheading had previously taken place. Donatello demonstrates his mastery of inner emotion as well as physical presence by having each person react in a personal way to the presentation of the head.

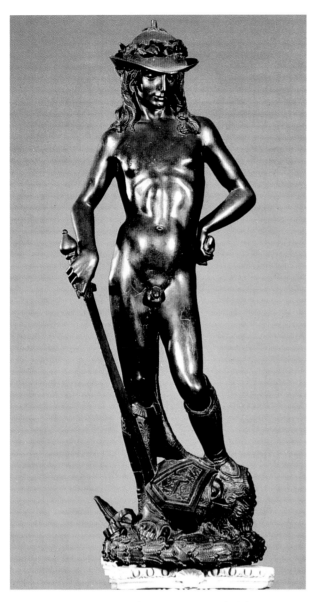

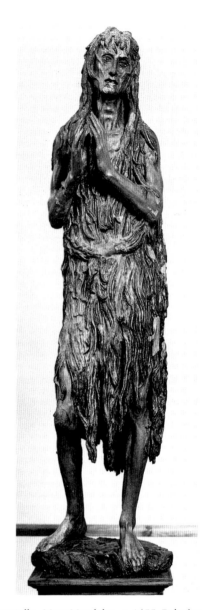

17-40. Donatello. *David.* After 1428. Bronze, height 5'2¹/4"
(1.58 m). Museo Nazionale del Bargello, Florence

17-41. Donatello. *Mary Magdalen.* c. 1455. Polychromy and
gilt on wood, height 6'2" (1.88 m). Museo dell'Opera
del Duomo, Florence

Donatello's *David* (fig. 17-40) is the earliest known lifesize freestanding bronze nude in European art since antiquity. It is first recorded in 1469 in the courtyard of the Medici Palace, where it stood on a base engraved with an inscription extolling Florentine heroism and virtue. This inscription supports the suggestion that it celebrated the triumph of the Florentines over the Milanese in 1428. Although the statue clearly draws on the Classical tradition of heroic nudity, this sensuous, adolescent boy in jaunty hat and boots has long piqued interest in the meaning of its conception. In one interpretation, the boy's angular pose, his underdeveloped torso, and the sensation of his wavering between childish interests and adult responsibility heighten his heroism in taking on the giant and outwitting him. With Goliath's severed head now under his feet, David seems to have lost interest in warfare and to be retreating into his dreams.

As Donatello's career drew to a close, his style underwent a profound change, becoming more emotionally expressive. His *Mary Magdalen* of about 1455 (fig. 17-41) shows the saint known for her physical beauty as an emaciated, vacant-eyed hermit in a ragged animal skin. Few can look at this figure without a wrenching reaction to the physical deterioration of aging and years of self-denial. Nothing is left for her but an ecstatic vision of the hereafter. Despite Donatello's total rejection of Classical form in this figure, the powerfully felt force of the Magdalen's personality makes this a masterpiece of Renaissance imagery.

In dramatic contrast to this pious rejection of worldly life are the self-laudatory portrait tombs by such artists as Desiderio da Settignano (c. 1430–1464), who executed the funerary monument for Carlo Marsuppini (fig. 17-42). A noted humanist and chancellor of Florence, Marsuppini wanted his tomb to match in format and decoration that of humanist Leonardo Bruni, also in the Church of Santa Croce. The **triumphal arch**, Corinthian pilasters, classical moldings, marble panels, and carved foliate designs recall the Bruni tomb and, along with the graceful hanging garlands, echo antique motifs. Desiderio's work is distinguished by its tall, elegant proportions and soft modeling. Marsuppini reclines as if napping on a

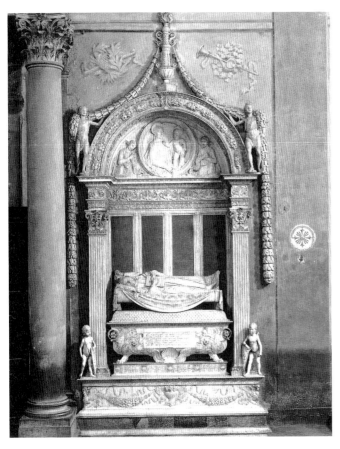

17-42. Desiderio da Settignano. Tomb of Carlo Marsuppini, Church of Santa Croce, Florence. c. 1454–64. White and colored marble, 20' x 11'9" (6.1 x 3.6 m)

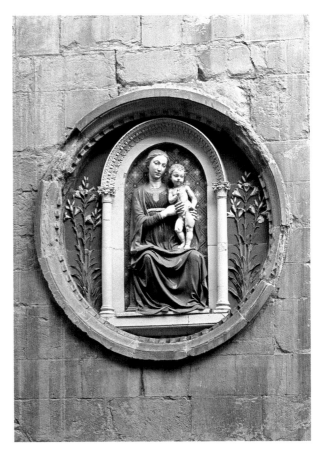

17-43. Luca della Robbia. *Madonna and Child with Lilies*, Orsanmichele, Florence. c. 1455–60. Enameled terra-cotta, tondo diameter approx. 6' (1.83 m)

couch atop an elegant sarcophagus with curved sides and spiraling foliate relief decoration. Desiderio's special talent for portraying children can be seen in the charming awkwardness of the young boys standing in front of the flanking pilasters.

Luca della Robbia (1399/1400–1482), although an accomplished sculptor in marble, specialized in glazed ceramic reliefs for architectural decoration. His workshop made molds so that a particularly popular work could be replicated many times. Luca favored a limited palette of clear blues, greens, and pale yellows with a great deal of white, as seen in his *Madonna and Child with Lilies* of 1455–1460, at Orsanmichele (fig. 17-43). The elegant and lyrical della Robbia style was continued by Luca's nephew Andrea and his children long after Luca's death.

Antonio del Pollaiuolo (c. 1432–1498), multitalented

17-44. Antonio del Pollaiuolo. *Hercules and Antaeus.* c. 1475. Bronze, height with base 18" (45.7 cm). Museo Nazionale del Bargello, Florence

Among the many courageous acts by which Hercules gained immortality was the killing of the evil Antaeus in a wrestling match by lifting him off the earth, which was the source of the giant's great physical power. Hercules had been attacked by Antaeus, the son of the earth goddess Ge (or Gaia), on his search for a garden that produced pure gold apples. Stealing the apples was one of the Twelve Labors assigned to Hercules by King Eurystheus, who promised to let the hero marry his daughter when all were completed. When the king went back on his word, Hercules killed him too.

and ambitious, was trained as a goldsmith and embroiderer but came to the Medici court about 1460 as a painter. His sculpture were mostly small bronzes, such as his *Hercules and Antaeus* of about 1475 (fig. 17-44). This

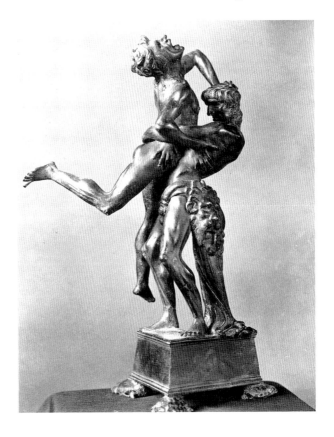

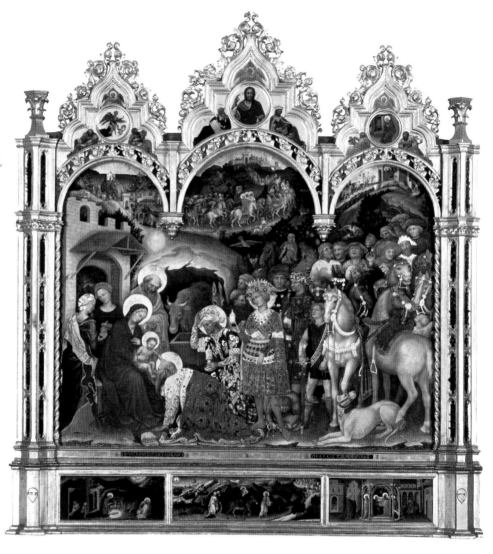

17-45. Gentile da Fabriano. *Adoration of the Magi*, altarpiece from the Sacristy of the Church of Santa Trinità, Florence. 1423. Oil on panel, 9'10" x 9'3" (3 x 2.85 m). Galleria degli Uffizi, Florence

study of complex interlocking figures has an explosive energy that can best be appreciated by viewing the sculpture from every angle. Statuettes of religious subjects were still popular, but humanist art patrons began to collect bronzes of Greek and Roman subjects like this one, reflecting their changing tastes.

Painting

Italian patrons generally commissioned murals and large altarpieces for their local churches and smaller panel paintings for their private chapels. Home decoration with panel paintings was uncommon until the latter part of the fifteenth century. Artists experienced in **fresco**, mural painting on wet plaster, were in great demand and traveled widely to execute wall and ceiling decorations. Italian panel painters showed little interest in oil painting, continuing to use tempera even for their largest works until the last decades of the century, when Venetians began to use the oil medium for major panel paintings.

The new Renaissance style in painting, with its solid, volumetric forms, perspectively defined space, and references to classical antiquity, did not immediately displace the International Gothic. One of the important painters who retained International Gothic elements in

their styles was Gentile da Fabriano (c. 1385–1427), who in 1423 completed the *Adoration of the Magi* (fig. 17-45), a large altarpiece for the Sacristy of the Church of Santa Trinità in Florence. Among the International Gothic elements are the steeply rising ground plane, graceful figural poses, brightly colored costumes and textile patterns, glinting gold accents, and naturalistic rendering of the details of the setting. But Gentile's landscape, with its endless procession of people winding from the far distance toward Bethlehem to worship the Christ Child, is broadly related to the near-contemporary *Ghent Altarpiece* (see fig. 17-1).

Gentile's skill in blending naturalistic and supernatural lighting effects is especially notable in his depiction of the nocturnal Nativity in the left panel of the **predella**, the section of the altarpiece below the main panel. As in Hugo van der Goes's *Portinari Altarpiece* (see fig. 17-18), Saint Bridget's written account of her visions was the source of the image of the Christ Child lying on the ground emitting rays of light while his mother adores him.

The most innovative of the early Italian Renaissance painters was Maso di Ser Giovanni di Mone Cassai (1401–1429?), nicknamed Masaccio ("big ugly Tom"). The exact chronology of his works is uncertain, and his fresco of the Trinity in the Church of Santa Maria Novella in

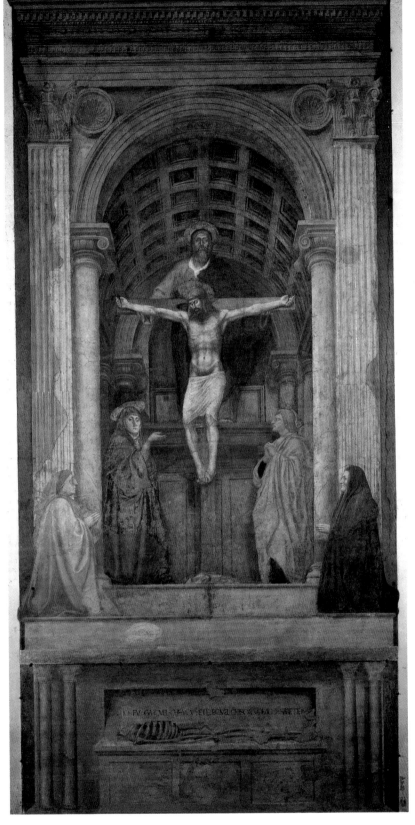

17-46. Masaccio. *Trinity with the Virgin, Saint John the Evangelist, and Donors*, fresco in the Church of Santa Maria Novella, Florence. c. 1425 (?). 21' x 10'5" (6.5 x 3.2 m)

Florence has been dated as early as 1425 and as late as 1428 (fig. 17-46). The Trinity fresco was meant to give the illusion of a stone funerary monument and altar table set below a deep **aedicula** (framed niche) in the wall. The praying donors in front of the pilasters are less than life-size, and the niche group is even smaller. The red robes of the male donor at the left signify that he was a member of the governing council of Florence.

Masaccio created the unusual **trompe l'oeil** ("fool-the-eye") effect of looking up into a barrel-vaulted niche through precisely rendered linear perspective. The eye level of an adult viewer determined the horizon line on which the vanishing point was centered, just above the base of the cross. The painting demonstrates Masaccio's intimate knowledge of both Brunelleschi's perspective experiments and his architectural style (see fig. 17-33,

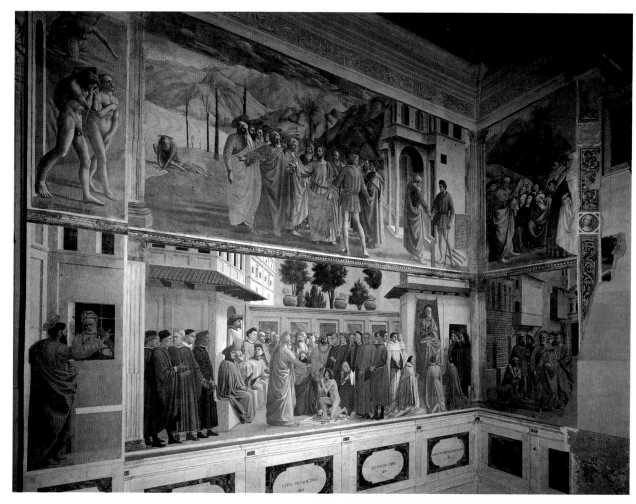

17-47. Interior of the Brancacci Chapel, Church of Santa Maria del Carmine, Florence, with frescoes by Masaccio and Masolino (c. 1423–28) and Filippino Lippi (c. 1482–84)

side aisle). The painted architecture is an unusual combination of Classical orders; on the wall surface Corinthian pilasters support a plain architrave below a cornice, while inside the niche Ionic columns support arches on all four sides (see "Elements of Architecture," page 645). The Trinity is represented by Jesus on the Cross, with the dove of the Holy Spirit poised in downward flight between his tilted halo and the head of God the Father, who stands behind the Cross on a high platform apparently supported on the rear columns. The "source" of the consistent illumination modeling the figures with light and shadow lies in front of the picture, casting reflections on the **coffers**, or sunken panels, of the ceiling. As in many scenes of the Crucifixion, Jesus is flanked by the Virgin Mary and John the Evangelist, but here they show no emotional reaction to the scene. Mary gazes calmly out at us, her raised hand presenting the Trinity. Below, on the sarcophagus, is a skeleton, a grim reminder that death awaits us all and that our only hope is redemption and life in the hereafter through Christian belief. The inscription above the skeleton reads: "I was once that which you are, and what I am you also will be."

Masaccio's brief six- or seven-year career reached its height in his collaboration with a painter known as

Masolino (c. 1400–1440/47) on the fresco decoration of the Brancacci Chapel in the Church of Santa Maria del Carmine in Florence (fig. 17-47). The chapel was originally dedicated to Saint Peter, and most frescoes illustrate events in his life. Masaccio's most innovative painting is the *Tribute Money* (fig. 17-48), completed about 1427, rendered in a continuous narrative of three scenes within one setting. The painting illustrates an incident in which a collector of the Jewish temple taxes (tribute money) demands payment from Peter, shown in the central group with Jesus and the other disciples (Matthew 17:24–27). Although Jesus opposes the tax, he instructs Peter to "go to the sea, drop in a hook, and take the first fish that comes up," which Peter does at the far left. In the fish's mouth is a coin worth twice the tax demanded, which Peter gives to the tax collector at the far right. The tribute story was particularly significant for Florentines because in 1427, to raise money for defense against military aggression, the city enacted a graduated tax, based on the ability to pay.

The *Tribute Money* is particularly remarkable for its integration of figures, architecture, and landscape into a consistent whole. The group of Jesus and his disciples forms a clear central focus, from which the landscape

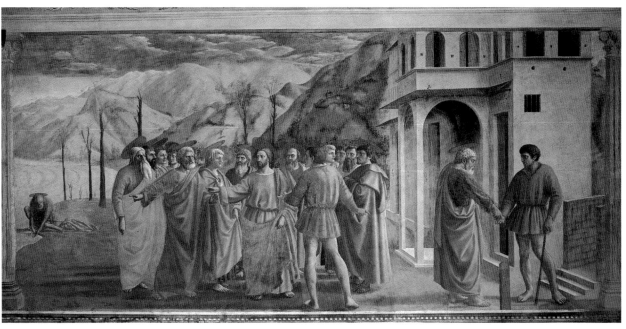

17-48. Masaccio. *Tribute Money*, fresco in the Brancacci Chapel. c. 1427. 8'1" x 19'7" (2.3 x 6 m)

Much valuable new information about the Brancacci Chapel frescoes was discovered during the course of a cleaning and restoration carried out between 1981 and 1991. Art historians now have a more accurate picture of how the frescoes were done and in what sequence, as well as which artist did what. One interesting discovery was that all of the figures in the *Tribute Money*, except those of the temple tax collector, originally had gold-leaf halos, several of which had flaked off. Rather than silhouette the heads against flat gold circles in the medieval manner, Masaccio conceived of the halo as a gold disk hovering in space above each head and subjected it to perspective foreshortening depending on the position of the figure.

seems to recede naturally into the far distance. To create this illusion Masaccio used linear perspective in the depiction of the house. The lines of the house converge on the head of Jesus, which Masaccio reinforced by diminishing the sizes of the barren trees and reducing Peter's size at the left. There is a second vanishing point for the steps and stone rail at the right. A recent cleaning of the fresco revealed that Masaccio also used atmospheric perspective in his intuitive rendering of the distant landscape, where mountains fade from grayish green to grayish white and the houses and trees on their slopes are loosely sketched.

Masaccio modeled the foreground figures with strong highlights and cast their long shadows on the ground toward the left, implying a light source at the far right, as if the scene were lit by the actual window in the rear wall of the Brancacci Chapel. Not only does the lighting give the forms sculptural definition, but the colors vary in tone according to the strength of the illumination. Masaccio used a wide range of hues—pale pink, mauve, gold, seafoam, apple green, peach—and a sophisticated color technique in which Andrew's green robe is shaded with red instead of darker green. Another discovery after the cleaning was that—allowing for the difference in mediums between rapidly applied water-based colors in fresco versus slow-drying oil—the wealth of linear detail is much closer to that of Masaccio's northern European contemporaries than previously thought. In contrast to Jan van Eyck's figure style, however, Masaccio's exhibits

an intimate knowledge of Roman sculpture.

Stylistic innovations take time to be fully accepted, and Masaccio's genius for depicting weight and volume, consistent lighting, and spatial integration was best appreciated by a later generation. Many important sixteenth-century Italian artists, including Michelangelo, studied and sketched from Masaccio's Brancacci Chapel frescoes. In the meantime, painting in Florence after Masaccio's death developed along lines somewhat different from that of the *Tribute Money*, as other artists experimented in their own ways with the illusion of a believably receding space.

Fra Angelico ("Brother Angel"), born Guido di Pietro (c. 1400–c. 1455), was known to his peers as Fra Giovanni da Fiesole and earned his nickname through his unusually pious nature. He is documented as a painter in Florence during the period 1417–1418 and took his vows as a Dominican monk in nearby Fiesole sometime between 1418 and about 1421. Considering the number of documented commissions he received, he must have had light religious responsibilities. One of his most extensive projects was the decoration of the Dominican Monastery of San Marco in Florence between 1435 and 1445. Fra Angelico went to work at the Vatican in Rome in 1445, and the frescoes at San Marco were completed by his assistants several years later.

Among the frescoes attributed entirely to Angelico by most scholars is the *Annunciation* in a monk's cell off the east corridor of the upper floor of the monastery

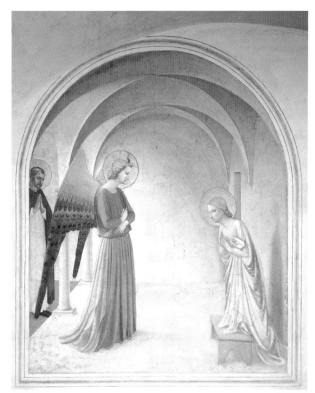

17-49. Fra Angelico. *Annunciation*, fresco in Cell No. 3, Monastery of San Marco, Florence. c. 1441–45. Image 6'1¹/₂" x 5'2" (1.87 x 1.57 m)

If an early legend is true, then Fra Angelico's humility lost him the opportunity to become a saint. He had left the completion of the San Marco frescoes to his assistants in 1445 to answer Pope Eugene IV's summons to Rome. The pope was looking for a new archbishop of Florence at the time, and the current vicar of San Marco, Antonino Pierozzi, was finally appointed to the post in January 1446. When Pierozzi was proposed for canonization in the early sixteenth century, several individuals testified that Pope Eugene's first choice for archbishop had been Fra Angelico, who declined it and suggested his Dominican brother Antonino.

(fig. 17-49). Nearly everything about the painting is in keeping with its location. The arched frame echoes the curvature of the cell wall, and the plain white interior of the illusionistic space appears almost to be a nichelike extension of the cell's space. Although the bottom edge of the painting is above normal eye level, the effect is that of looking through a window onto a scene taking place in a cloister portico. In the painting the ceiling is supported by the wall on one side and by slender Ionic columns on the other. The artist used minimal perspective indications: the edge of the porch, the base of the first column, the lines of the bench, and the angles where the ceiling planes come together. Gabriel and Mary are simplified figures enhanced with plain but glowing draperies whose folds are noticeably affected by gravity. The natural light falls from the left to model the forms, but a supernatural radiance lights Gabriel's hands and face, which ought to be in shadow, and creates a spotlight effect on the back wall. The scene is a vision within a vision; Saint Dominic appears at the left in prayer, giving rise to the vision of the Annunciation, while the whole may be seen as a vision of the resident monk.

Another painter who was a monk early in his career, Fra Filippo Lippi (c. 1406–1469), became an artist some years after joining the Carmelite order. According to his

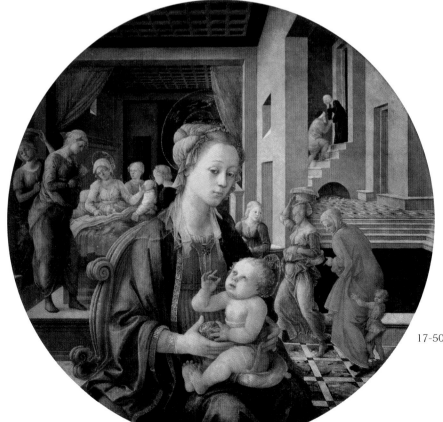

17-50. Fra Filippo Lippi. *Virgin and Child*. c. 1452. Oil on panel, diameter 53" (134.6 cm). Gallery, Palazzo Pitti, Florence

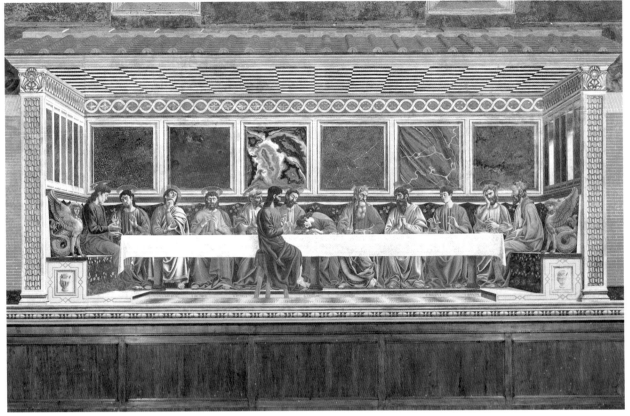

17-51. Andrea del Castagno. *Last Supper*, fresco in the Refectory, Monastery of Sant'Apollonia, Florence. 1447. Approx. 15' x 32' (4.6 x 9 m)

biographer, Vasari, Filippo began to paint after watching Masaccio at work in the Brancacci Chapel. Later, Filippo obtained permission to leave religious life and married. His son Filippino Lippi became a painter and eventually completed the Brancacci Chapel frescoes in 1481–1482.

Filippo mastered scientific perspective and the volumetric rendering of figures and objects while retaining a taste for International Gothic grace and charm. His half-length portrayals of the Madonna and Child were in great demand. Lippi's style is characterized by careful drawing, clean contours, and intense color, especially his greens, reds, and dark mauves. He tended to place the main subject of his paintings in the foreground before a deeply receding background of architecture or landscape with figures, thus creating a second level of visual interest. In a panel of about 1452 (fig. 17-50), the legend of Mary's birth is told in the background scenes. At the right in the distance, Mary's mother, Anna, greets her husband, Joachim, at the city gate with the news that they are to have a child; the birth takes place in the middle ground at the left.

Andrea del Castagno (c. 1417/19–1457) worked for a time in Venice before returning to Florence to execute his best-known work, *Last Supper*, painted in 1447 at the Monastery of Sant'Apollonia (fig. 17-51). Extending 32 feet across the end wall of the dining room and rising 15 feet high, the fresco gives the illusion of a raised alcove where Jesus and his disciples are eating their meal along with the monks. Rather than the humble "upper room" where the biblical event took place, the setting resembles

a royal audience hall with its sumptuous marble panels and inlays. The trompe l'oeil effect is aided by the creation of a focal point on the head and shoulders of the sleeping young disciple John. Some of the lines of the architecture converge here, while others merely come close; a few converge elsewhere. Thus, Andrea appears to have adjusted many of the perspectival elements intuitively to create a more believable spatial representation. The focus on the figure of John, traditionally the "disciple whom Jesus loved" (John 20:2), rather than on Jesus himself, may have been intended to enable the monks in this austere order, whose members rarely had contact with the outside world, to identify themselves with the saint.

In contrast to Andrea's approach to spatial illusion, Paolo Uccello (1397–1475) is noted today, as he was in his own time, for his absolute obsession with linear perspective. The story was told that he talked about it in his sleep to such an extent that his wife accused him of having a mistress named Perspective. Perhaps trained in Ghiberti's workshop and a member of the Florence painters' guild since 1414, Uccello worked also in Venice, Urbino, and Padua, where he may have studied Donatello's relief designs for Padua's Church of Sant'Antonio. These designs apparently influenced his frescoes on the Life of Noah, painted for the Florentine Church of Santa Maria Novella soon after his return from Padua in about 1447–1448.

Uccello used only two basic colors for his frescoes, ocher and *terra verde*, a green pigment that gave the cloister where the works are located its name, Chiostro

17-52. Paolo Uccello. *The Deluge (Flood)*, fresco in the Chiostro Verde, Church of Santa Maria Novella, Florence. c. 1450. 7' x 16'9" (2.13 x 5.11 m)

Verde (Green Cloister). *The Deluge (Flood)* of about 1450 (fig. 17-52) is a composite of two scenes organized and separated by a deep central plunge into space. At the left, Noah has closed up his oddly shaped vessel, already filled with male and female pairs of all the earth's creatures and his own family members. The people left behind react in panic as the waters rise. At the left, two men beat at the Ark with clubs, while other people cling to its sides, hoping to ride out the storm that whips clumps of foliage about them and threatens to break their grips. At the right, the ordeal is nearly over as Noah leans out of the Ark to see the dove he dispatched returning with a leafy sprig in its beak, a sign that it has found dry land. The waters between the two depictions of the Ark are filled with the dead and those too weak to struggle, but the figure appearing to stand on the water at the right has never been satisfactorily identified. Every geometric element in the composition has been subjected to perspectival rendering, from the two imposing views of the boat to the smallest details. Refer to page 624.

The most important Florentine painting workshop of the later fifteenth century was that of the painter known as Domenico del Ghirlandaio ("garland maker"), a nickname adopted by his father, a goldsmith noted for his floral designs. A specialist in narrative cycles, Ghirlandaio (1449–1494) incorporated the innovations of his predecessors into a visual language of great descriptive immediacy. He was familiar with examples of Flemish painting, seen in Florence after about 1450, which had considerable impact on his style, especially in portrai-

17-53. Domenico del Ghirlandaio. *A Man with His Grandchild.* c. 1480–90. Panel, 24³/₈ x 18¹/₈" (62 x 46.1 cm). Musée du Louvre, Paris

17-54. Sandro Botticelli. *Primavera.* c. 1482. Panel, 6'8" x 10'4" (2.03 x 3.15 m). Galleria degli Uffizi, Florence

ture. Instead of the more typical Italian full-profile format (see fig. 17-68), he adopted the three-quarter view and more relaxed pose of early-fifteenth-century Flemish painters, as in his portrait of a man and his grandchild of about 1480–1490 (fig. 17-53). Ghirlandaio painted this unknown man, whose nose is malformed as a result of a condition called rhinophyma, posthumously, using a deathbed sketch. Such an objective portrayal, recalling northern European portraiture, was a special talent of Ghirlandaio's.

Sandro Botticelli (1445–1510), one of the most poetic Renaissance painters, was a pupil of Filippo Lippi and also trained in the workshops of the sculptors and painters Pollaiuolo and Verrocchio. In his first mature phase he produced multifigured scenes with sculptural figures modeled by light from a consistent source, placed in deep landscape settings rendered with strict linear perspective. He was an outstanding portraitist who in his religious paintings often mingled recognizable contemporary figures with the saints and angels.

In 1481, after returning from Rome, where he had worked on frescoes for the Sistine Chapel, Botticelli entered a new phase of his career. He produced a series of secular paintings of mythological subjects inspired by contemporary Neoplatonic thought, including *Primavera,* or *Spring* (fig. 17-54), which may depict an ancient Roman spring festival, the Floralia. This work was commissioned about 1482 for the private collection of Lorenzo de' Medici, who had become ruler of Florence in 1469. Silhouetted and framed by an arching view through the

trees at the center of the canvas is Venus, the goddess of love. She is flanked on the right by Flora, a Roman goddess of flowers and fertility, and on the left by the Three Graces. Her son, Cupid, hovers above, playfully aiming an arrow at the Graces. At the far right is the wind god, Zephyr, in pursuit of the nymph Chloris, his breath causing her to sprout flowers from her mouth. At the far left, the messenger god, Mercury, uses his characteristic snake-wrapped wand, the caduceus, to dispel a patch of gray clouds drifting in Venus's direction. While breaking new ground in subject matter, Botticelli returned to his master Filippo Lippi for his charming ambience, graceful poses, and linear contours. The overall appearance of *Primavera* recalls Flemish tapestries, which were the height of fashion in Italy at the time. The decorative quality of the painting is deceptive, however, for it is a highly complex allegory, interweaving Neoplatonic ideas with esoteric references to classical sources.

Neoplatonic philosophers and poets conceived of Venus as having two natures, one terrestrial and the other celestial. The first ruled over earthly, human love and the second over universal love, making her a classical equivalent of the Virgin Mary. *Primavera* is recorded as having hung outside Lorenzo's bedroom around the time of his marriage, so it may have been intended as a painting on the nuptial theme of love and fertility in marriage. Venus, clothed in contemporary costume and wearing a marriage wreath on her head, here represents her terrestrial nature governing marital love. She stands in a grove of orange trees weighted down with lush fruit,

suggesting human fertility. Cupid embodies romantic desire, and as practiced in central Italy in ancient times, Flora's festival had definite sexual overtones.

Botticelli's later career was affected by a profound spiritual crisis. While he was composing his mythologies, a Dominican monk, Fra Girolamo Savonarola, had begun to preach impassioned sermons denouncing the worldliness of Florence. Many Florentines reacted with orgies of self-recrimination, and processions of weeping penitents wound through the streets. In the 1490s, Botticelli, too, fell into a state of religious fervor. In a dramatic gesture of repentance, he burned many of his earlier paintings and began to produce highly emotional, religious pictures. Finally, at the end of his life, he gave up painting altogether.

THE ITALIAN RENAISSANCE OUTSIDE FLORENCE

In the second half of the fifteenth century, the Renaissance began to expand from Florence to the rest of Italy, giving birth to a number of local styles. Renaissance ideas were often spread by artists who had trained or worked in Florence, and who then traveled to other cities to work, either temporarily or permanently—including Donatello (Padua, Siena), Alberti (Mantua, Rimini, and Rome), Piero della Francesca (Urbino, Ferrara, Rome), Uccello (Venice, Urbino, Padua), Giuliano da Sangallo (Rome), and Botticelli (Rome). Northern Italy embraced the new Renaissance styles swiftly, with the ducal courts at Mantua and Urbino taking the lead. The Republic of Venice and the city of Padua, which Venice had controlled since 1404, also emerged as innovative art centers in the last quarter of the century.

Architecture

The spread of Renaissance architecture outside Florence was due in significant part to Leon Battista Alberti, who traveled widely and expounded his views to potential patrons. As a result he undertook an unusual project in Rimini, fitting for an artist steeped in classical knowledge: to transform an existing medieval church, the Church of San Francesco, into a Renaissance "temple" honoring the local ruler, Sigismondo Malatesta, and his mistress Isotta degli Atti. Although the project, designed in 1450, was never completed, the partly altered exterior shell nevertheless provides an encyclopedia of Albertian architectural ideas (fig. 17-55). The facade, set in front of the original church wall, combines forms derived from a Classical temple front and a Roman triumphal arch such as the nearby Arch of Augustus. The high podium with the Corinthian order of attached columns and the **entablature** supporting a triangular **pediment** constitute the temple front. The triple arches, attached columns, roundels, and heavy projecting cornice carry the triumphal-arch motif. This layering and combining of motifs and references is typical of humanistic thinking and similar in concept to Botticelli's treatment of mythologies.

Another patron, the ruler of Mantua, in 1470 commissioned Alberti to enlarge the small Church of Sant'Andrea,

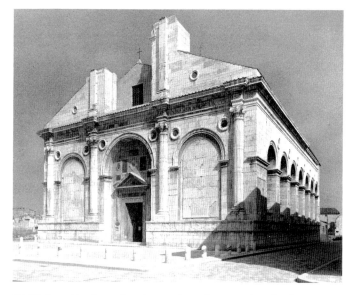

17-55. Leon Battista Alberti. Tempio Malatesta, Church of San Francesco, Rimini. Designed c. 1450

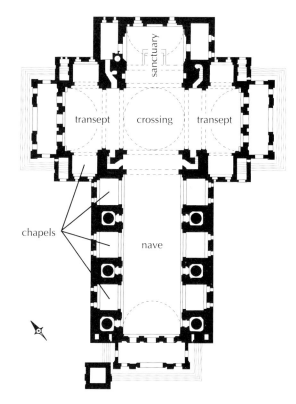

17-56. Leon Battista Alberti. Plan of the Church of Sant' Andrea, Mantua. Designed 1470

which housed a sacred relic believed to be the actual blood of Jesus. To satisfy his patron's desire for a sizable building to handle crowds coming to see the relic, Alberti proposed to build an "Etruscan temple." Work began on the new church in 1472, but Alberti died that summer. Construction went forward slowly, at first according to his original plan, but it was finally completed only at the end of the eighteenth century. Thus, it is not always clear which elements belong to Alberti's original design.

The **Latin-cross plan** (fig. 17-56)—a nave more than 55 feet wide intersected by a transept of equal width; a square, domed crossing; and a rectangular sanctuary on

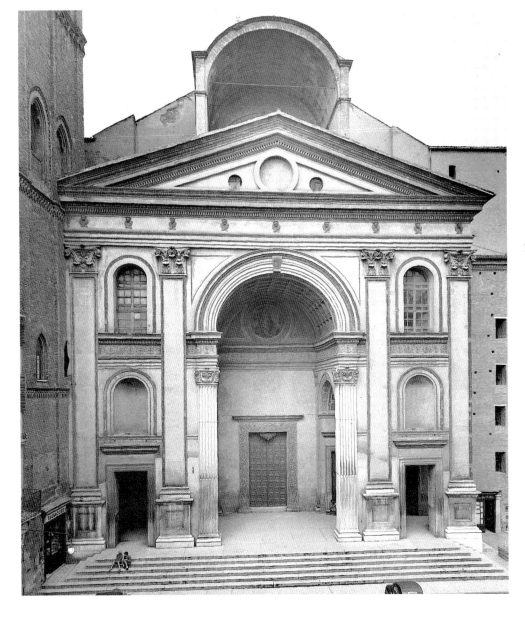

17-57. Leon Battista Alberti. Facade, Church of Sant'Andrea

axis with the nave—is certainly in keeping with Alberti's ideas. Alberti was responsible, too, for the barrel-vaulted chapels the same height as the nave and the low chapel niches carved out of the huge piers supporting the barrel vault of the nave. His dome, however, would not have been perforated and would not have been raised on a drum, as this one finally was.

Alberti's design for the facade of Sant'Andrea (fig. 17-57) echoes that of the Tempio Malatesta in Rimini in its fusion of temple front and triumphal arch, but the facade now has a clear volume of its own, which sets it off visually from the building behind. Two sets of colossal Corinthian pilasters articulate the porch face. Those flanking the barrel-vaulted triumphal-arch entrance are two stories high, whereas the others, raised on pedestals, run through three stories to support the entablature and pediment of the temple form. The arch itself has lateral barrel-vaulted spaces opening through two-story arches on the left and right.

Neither the simplicity of the plan nor the complexity of the facade hints at the grandeur of Sant'Andrea's interior (fig. 17-58). Its immense barrel-vaulted nave

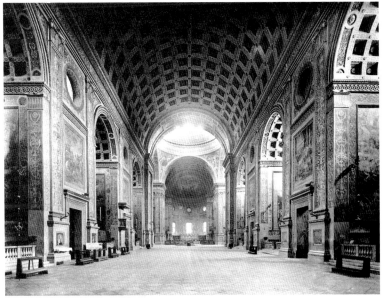

17-58. Leon Battista Alberti. Nave, Church of Sant'Andrea

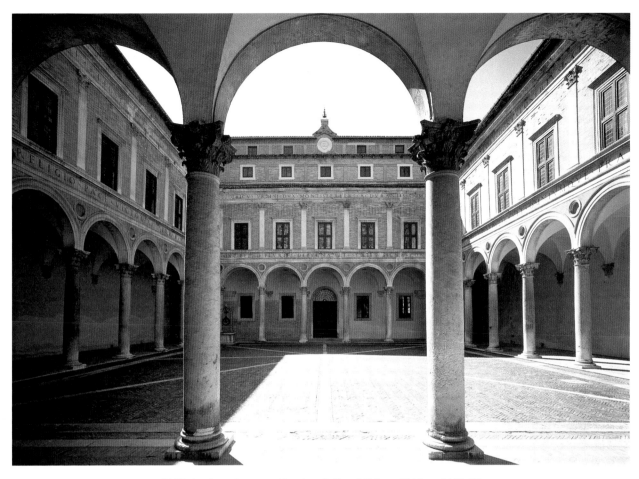

17-59. Luciano Laurana. Courtyard, Ducal Palace, Urbino. 1465–79

extended on each side by tall chapels was inspired by the monumental interiors of such ancient ruins as the Basilica of Constantine and Maxentius in the Roman Forum. In this clear reference to Roman imperial art Alberti created a building of such colossal scale and spatial unity that it affected architectural design for centuries.

The court of Urbino was an outstanding artistic center under the patronage of Federico da Montefeltro, who actively sought out the finest artists of the day to come to Urbino. In 1468, after failing to find a Tuscan to take over the construction of a new ducal palace (*palazzo ducale*) begun about 1450, Federico hired one of the assistants already involved in the project, Luciano Laurana, to direct the work. Among Laurana's major contributions were his closing the courtyard with a fourth wing and redesigning the courtyard facades (fig. 17-59). The result is a superbly rational solution to the problems of courtyard elevation design. The ground-level portico on each side has arches supported by columns; the corner angles are bridged with piers having engaged columns on the arcade sides and pilasters facing the courtyard. This arrangement avoided the awkward visual effect of two arches springing from a single column and gave the corner a greater sense of stability. The **Composite** capital (Corinthian with added Ionic **volutes**) was used, perhaps for the first time, on the ground level. Corinthian pilasters flank the windows in the story above, forming divisions that repeat the bays of the portico. (The two short upper

stories were added later.) The plain architrave faces were engraved with inscriptions identifying Federico and lauding his many humanistic virtues. Not visible in the illustration is an innovative feature that became standard in palace courtyard design: the monumental staircase from the courtyard to the main floor.

A fifteenth-century Florentine architect whose work was most important for developments in the sixteenth century was Giuliano da Sangallo (c. 1443–1516). From 1464 to 1472, he worked in Rome, where he produced a number of meticulous drawings after the city's ancient monuments, many of which are now lost and known today only from his work. Back in Florence, he became a favorite of Lorenzo the Magnificent, a great humanist and patron of the arts. Soon after completing a country villa for Lorenzo in the early 1480s, Giuliano submitted a model for a new church in Prato, near Florence, on which he began work in 1485. In 1484, a child had claimed that a painting of the Virgin on the wall of the town prison had come to life, and plans were soon made to remove the image and preserve it in a votive church (a church built as a special offering to a saint), to be named Santa Maria delle Carceri (Saint Mary of the Prisons).

Although the need to accommodate processions and the gathering of congregations made the long nave of a basilica almost a necessity for local churches, the votive church became a natural subject for Renaissance experimentation with the central plan. The existing tradition

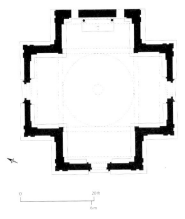

17-60. Giuliano da Sangallo. Plan of the Church of Santa Maria delle Carceri, Prato. Before 1485

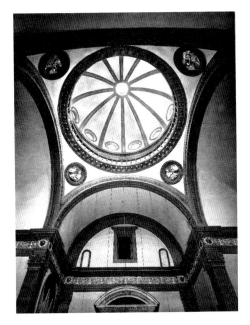

17-61. Giuliano da Sangallo. Interior view of dome, Church of Santa Maria delle Carceri. 1485–92

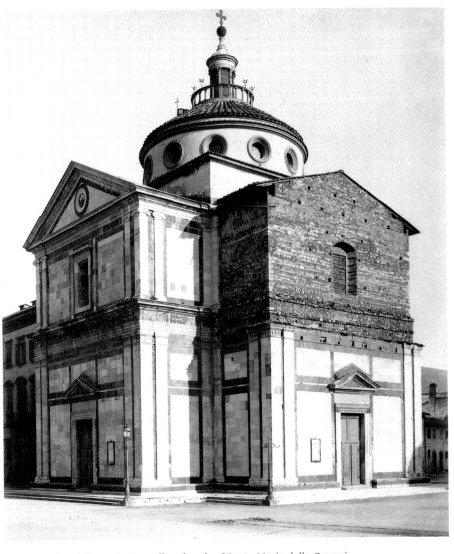

17-62. Giuliano da Sangallo. Church of Santa Maria delle Carceri

of **central-plan churches** extended back to the Early Christian **martyrium** (a round shrine to a martyred saint) and perhaps ultimately to the Classical **tholos**, or round temple. Alberti in his treatise on architecture had spoken of the central plan as an ideal, derived from the humanist belief that the circle was a symbol of divine perfection and that both the circle inscribed in a square and the cross inscribed in a circle were symbols of the cosmos. Thus, Giuliano's Church of Santa Maria delle Carceri, built on a Greek-cross plan, is one of the finest early Renaissance examples of humanist symbolism in architectural design (fig. 17-60). It is also the first Renaissance church with a true central plan; Brunelleschi's earlier experiment in the Old Sacristy of San Lorenzo, for example, was for an attached structure, and Alberti's Greek-cross plan was never actually built. Drawing on his knowledge of Brunelleschi's works, Giuliano created a square, dome-covered central space extended in each direction by arms whose length was one-half the width

of the central space. The arms are covered by barrel vaults extended from the round arches supporting the dome. Giuliano raised his dome on a short, round drum that increased the amount of natural light entering the church. He also articulated the interior walls and the twelve-ribbed dome and drum with *pietra serena* (fig. 17-61). The exterior of the dome is capped with a conical roof and a tall lantern in Brunelleschian fashion.

The exterior of the church (fig. 17-62) is a marvel of Renaissance clarity and order. The ground-floor system of slim Doric pilasters clustered at the corners is repeated in the Ionic order on the shorter upper level, as if the entablature of a small temple had been surmounted with a second smaller one. The church was entirely finished in 1494 except for installation of the fine green-and-white-marble veneer above the first story. In the 1880s, one section of the upper level was veneered; however, the philosophy of twentieth-century conservation requires that the rest of the building be left in rough stone, as it is today.

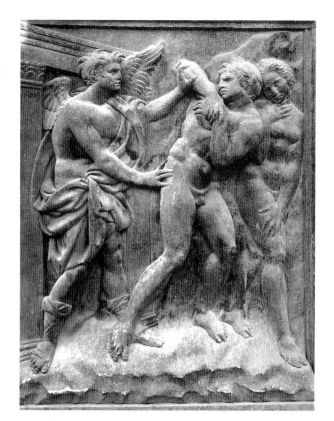

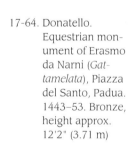

17-63. Jacopo della Quercia. *Expulsion of Adam and Eve*, panel in main portal, Church of San Petronio, Bologna. c. 1430. Stone, 34 x 27" (86.4 x 68.6 cm)

Sculpture

While Ghiberti and Donatello were forging the early Renaissance style in Florence, a sculptor in another part of Tuscany, Jacopo della Quercia of Siena (c. 1374–1438), was moving on a parallel path. Little is known of his early years, except for his participation in the 1402 competition for the Florence Baptistry doors. He seems to have worked principally in relief, and focusing on the human figure, he developed an active, monumental, idealized nude unlike any seen in Western art since classical antiquity. Between 1425 and 1438, Jacopo executed ten relief panels depicting the Genesis story of Adam and Eve in this new figural style for the Church of San Petronio in Bologna. In the *Expulsion of Adam and Eve* (fig. 17-63), of about 1430, the sculptor demonstrated no interest in adapting figures to settings in natural proportional relationships, as did his Florentine counterparts. Instead, the physical presence of the muscular figures dominates the relief, with just enough landscape detail to provide a sense of place. The drama is revealed through exaggerated poses, gestures, and gazes. These massive figures in emphatically active poses had little immediate influence on Italian sculpture, but in the sixteenth century, sculptors recognized and responded to their power.

Some of the best Renaissance sculpture in northern Italy was produced by artists trained in Florence. In 1443,

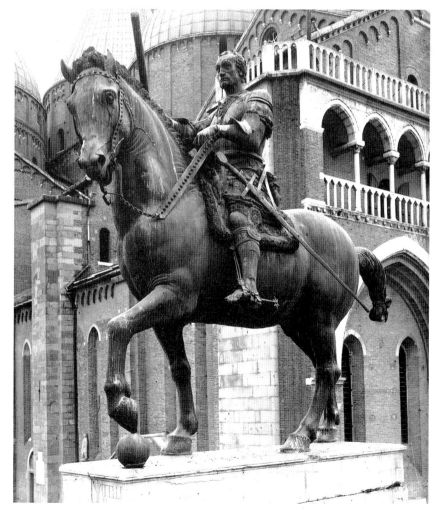

17-64. Donatello. Equestrian monument of Erasmo da Narni (*Gattamelata*), Piazza del Santo, Padua. 1443–53. Bronze, height approx. 12'2" (3.71 m)

for example, Donatello was called to Padua to execute an equestrian statue commemorating the Venetian general Erasmo da Narni, nicknamed Gattamelata ("Calico Cat") (fig. 17-64). Donatello's sources for this statue were two surviving Roman bronze equestrian portraits, one (now lost) in the north Italian city of Pavia, the other of the emperor Marcus Aurelius, which the sculptor certainly saw and probably sketched during his youthful stay in Rome. Donatello's monument, installed on a high base in front of the Church of Sant'Antonio, was the first large-scale bronze equestrian portrait since antiquity. Viewed from a distance, this man-animal juggernaut seems capable of thrusting forward at the first threat. Seen from up close, however, the man's sunken cheeks, sagging jaw, ropey neck, and stern but sad expression suggest a war machine now grown old and tired from the constant need for military vigilance and rapid response. Such expressionism was a recurring theme in Donatello's portrayals.

During the decade that he remained in Padua, Donatello executed other commissions for the Church of Sant'Antonio, including a bronze crucifix and reliefs for the high altar. His presence in the city introduced Renaissance ideas to northeastern Italy and gave rise to a new Paduan school of painting and sculpture.

In the early 1480s the Florentine painter and sculptor Andrea del Verrocchio (1435–1488) was commissioned to produce an equestrian memorial to another Venetian general, Bartolommeo Colleoni (d. 1475), this time in Venice itself. In contrast to the tragic overtones communicated by Donatello's *Gattamelata*, the impression conveyed by the tense forms of Verrocchio's equestrian monument (fig. 17-65) is one of vitality and brutal energy. The general's determination is clearly expressed

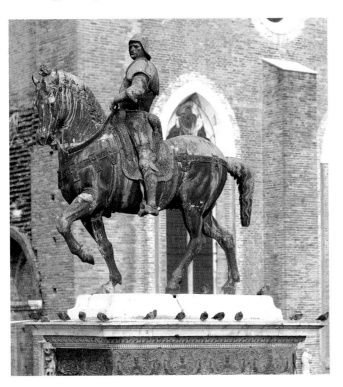

17-65. Andrea del Verrocchio. Equestrian monument of Bartolommeo Colleoni, Campo Santi Giovanni e Paolo, Venice. c. 1481–96. Bronze, height approx. 13' (4 m)

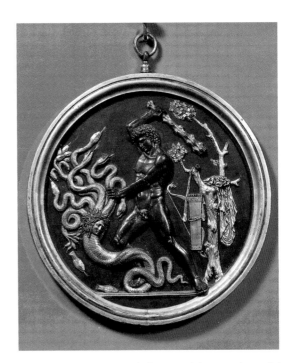

17-66. Antico (Pier Jacopo Alari Bonacolsi). *Hercules and the Hydra.* 1495–98. Gilt bronze, diameter 12¼" (29 cm). Museo Nationale del Bargello, Florence

in his clenched jaw and staring eyes. The taut muscles of the horse, fiercely erect posture of the rider, and complex interaction of the two make this image of will and domination one of the most compelling monuments of late-fifteenth-century sculpture.

The enthusiasm of European collectors in the latter part of the fifteenth century for small bronzes contributed to the spread of classical taste. Many sculptors, especially those trained as goldsmiths, began to cast small copies after well-known Classical sculpture. Some artists executed their own designs *all'antica* ("in the antique style") as well. Although there were outright forgeries of antiquities at this time, works in the antique manner made by such sculptors as Pier Jacopo Alari Bonacolsi (c. 1460–1528) were intended simply to appeal to a cultivated humanist taste. Bonacolsi, who worked in Mantua, was so admired for such sculpture that he was nicknamed "Antico."

On a large bronze relief medallion more than a foot in diameter produced about 1495–1498, Antico represented *Hercules and the Hydra* (fig. 17-66), which shows the hero killing a multiheaded water serpent. Using the skills he had learned as a goldsmith, Antico often enriched his bronzes by gilding or inlaying details in gold and silver. A typical piece, like the one shown here, exhibits satin-smooth, glowing flesh contrasting with fine, realistic details and areas of glittering texture. This mythological scene is enlivened with naturalistic touches, such as the gnarled tree trunk, the carefully observed quiver and bow, and the exquisitely rendered scales of the hydra.

Painting

Piero della Francesca (c. 1406/12–1492) had worked in Florence in the 1430s before settling down in his native

17-67. Piero della Francesca. *Discovery and Testing of the True Cross*, fresco in the Church of San Francesco, Arezzo. 1454–58. 11'8⅜" x 6'4" (3.56 x 1.93 m)

According to legend, Helena was aided by a young Jerusalem Jew named Judas in finding Christ's Cross, whose location had been handed down in his family over the 270 years since the Crucifixion. After being thrown into a well and starved, he led Helena and her companions to the hill of Golgotha (Calvary), where they tore down a temple to Venus and excavated the crosses of Jesus and the two thieves executed with him (at the left). Judas also helped test the crosses. The "true" one was identified when its touch brought back to life a recently deceased man being carried to his tomb (at the right).

Borgo San Sepolcro, a Tuscan hill town under papal control. Piero was well acquainted with current thinking in art and art theory: Brunelleschi's system of spatial illusion and linear perspective, Masaccio's powerful modeling of forms and atmospheric perspective, and especially Alberti's theoretical treatises. Piero was one of the few practicing artists who wrote about his own theories. Not surprisingly, in his treatise on perspective he emphasized geometry and the volumetric construction of forms and spaces in his work to an unprecedented degree.

Piero continued to receive important commissions requiring him to stay in other cities for long periods of time. From about 1454 to 1458 he was in Arezzo, where he decorated the sanctuary of the Church of San Francesco with a cycle of frescoes illustrating the Legend of the True Cross. (Helena, mother of the first Christian Roman emperor, Constantine, went to Jerusalem in the early fourth century and supposedly discovered the "True Cross" of Jesus' Crucifixion.) The finding and testing of the Cross are illustrated in a single scene (fig. 17-67).

Piero reduced his figures to cylindrical and ovoid shapes and painted the clothing and other details of the setting with muted colors. His analytical modeling and perspective projection resulted in a highly believable illusion of space around his monumental figures. The **foreshortening** of figures and objects—shortening the

lines of forms seen head-on in order to align them with the overall perspective system—such as the cross at the right, and the anatomical accuracy of the revived youth's nude figure are particularly remarkable. Unlike many of his contemporaries, Piero gave his figures no expression of human emotion. Of special note in Piero's composition are the inclusions of Classical architecture, which convert ancient Jerusalem into a Renaissance city. Behind the crowd at the right stands an elegant building whose facade reflects Alberti's principles and recommendations for ideal architecture: an even number of vertical elements, an odd number of openings, and decoration with panels of veined marble framed in plain marble or stone.

Piero's commissions took him later to the court of Federico da Montefeltro at Urbino, for whom he painted a pair of pendant, or companion, portraits in 1472–1473 of Federico and his recently deceased wife, Battista Sforza (fig. 17-68). In the traditional Italian fashion, the figures are portrayed in strict profile, as remote from the viewer as icons. The profile format also allowed for an accurate recording of Federico's likeness without emphasizing two disfiguring scars—the loss of his right eye and the bridge of his nose—from a sword blow. His good left eye is shown, and the angular profile of his nose seems like a distinctive familial trait. Typically, Piero

 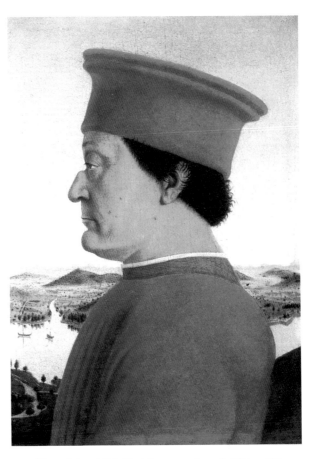

17-68. Piero della Francesca. *Battista Sforza* (left) and *Federico da Montefeltro* (right). 1472–73. Oil on panel, each 18¹/₂ x 13" (47 x 33 cm). Galleria degli Uffizi, Florence

emphasized the underlying geometry of the forms, rendering the figures with an absolute stillness. Dressed in the most elegant fashion, Battista and Federico are silhouetted against a distant view of the Tuscan hills. The portraits may have been hinged as a diptych, since the landscape appears continuous across the two panels. The influence of Flemish art is strong in careful observation of Battista's jewels and in the intuitive, well-observed use of atmospheric perspective, with the landscape features becoming lighter and paler as they recede. Piero has also used another northern European device in the harbor view near the center of Federico's panel: the water narrows into a river and leads the eye into the distant landscape.

Andrea Mantegna (1431–1506) of Padua was one of the most influential of the fifteenth-century Renaissance painters who were born and worked outside Florence. An artistic prodigy, Mantegna entered the painters' guild at the age of fifteen. The greatest influence on the young artist was the sculptor Donatello, who arrived in Padua in 1443 for a decade of work there. In his early twenties when Donatello left, Mantegna had fully absorbed the sculptor's Florentine linear-perspective system, which he pushed to its limits with experiments in radical perspective views and the foreshortening of figures. In 1459 Mantegna went to work for Ludovico Gonzaga, the ruler of

Mantua, and he continued to work for the Gonzaga family for the rest of his life, except for trips to Florence and Pisa in the 1460s and to Rome in 1488–1490. In Mantua, the artist became a member of the humanist circle, whose interests in classical literature and archeology he shared. He often signed his name using Greek letters.

Mantegna's mature style is characterized by the virtuosity of his use of perspective, his skillful integration of figures into their settings, and his love of individualization and naturalistic details. This style is exemplified in the frescoes of the Camera Picta ("Painted Room") of Gonzaga's ducal palace, a tower chamber with a lake view, which Mantegna decorated between 1465 and 1474. On the domed ceiling, the artist painted a tour-de-force of radical perspective called *di sotto in sù* ("seen from directly below"), which began a long-lasting tradition of illusionistic ceiling painting (fig. 17-69). The room appears to be open to a cloud-filled sky through a large oculus in a simulated marble- and mosaic-covered vault. On each side of a precariously balanced planter, three young women and an exotically turbaned African man peer over a marble **balustrade** into the room below. A fourth young woman in a veil looks dreamily upward. Joined by a large peacock, several **putti** play around the balustrade.

On two adjacent walls Mantegna created a continuous narrative illustrating aristocratic family life as well

17-69. Andrea Mantegna. Fresco on the ceiling of the Camera Picta, Ducal Palace, Mantua. 1474

as a fascinating moment in Church history (fig. 17-70). Above the fireplace, which is incorporated into the painted scene, he produced a group portrait of Ludovico, his wife, Barbara von Hohenzollern, some of their children, and a few courtiers. Ludovico, seated at the far left, has just read a letter announcing the imminent arrival from Rome of their son Francesco, who had gone there to be made

a cardinal at the age of thirteen; the young cardinal's arrival is shown on the adjoining wall. Mantegna painted recognizable portraits of the Gonzaga family and rendered the costumes and architectural setting with customary realism, but the landscape views are of imaginary hill towns rather than the flat plain around Mantua.

The establishment of Rome as a Renaissance center

17-70. Andrea
Mantegna.
*Gonzaga
Family*,
wall of the
Camera
Picta

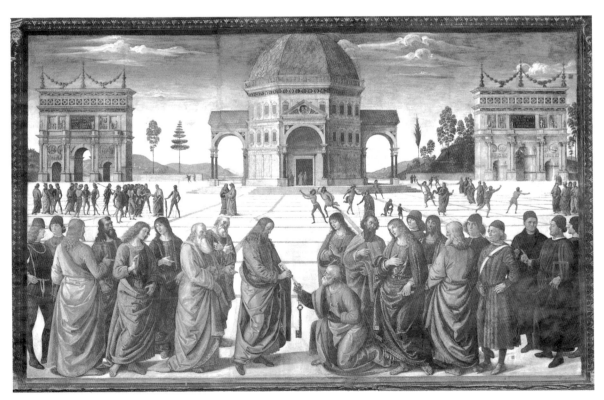

17-71. Pietro Perugino. *Delivery of the Keys to Saint Peter*,
fresco in the Sistine Chapel, Vatican, Rome. 1482.
11'5¹/₂" x 18'8¹/₂" (3.48 x 5.70 m)

of the arts was greatly aided by Pope Sixtus IV's decision
to call to the city the best artists he could find to decorate
the walls of his newly built Sistine Chapel. In the early fif-
teenth century, a schism in the Western Church ended,
and the papacy was firmly reestablished in Rome. This
event had precipitated the need to restore not only the
Vatican but the whole city as a center worthy of the papal
court. Among those who went to Rome was Pietro Van-
nucci, called Perugino (c. 1445–1523), from near the
town of Perugia in Umbria. Perugino had been working
in Florence since 1472 and left there in 1481 to travel to
Rome to work on the Sistine wall frescoes. His contri-
bution, *Delivery of the Keys to Saint Peter* (fig. 17-71),

Modern eyes accustomed to gigantic parking lots
would not find a large open space in the middle of a
city extraordinary, but in the fifteenth century this
great piazza was purely the product of artistic imagi-
nation. A real piazza this size would have been very
impractical. In summer sun or winter wind and rain,
such spaces would have been extremely unpleasant
for a pedestrian population, but, more important, no
city could afford such extravagant use of valuable
land within its walls.

17-72. Jacopo Bellini. *Flagellation.* c. 1450. Leadpoint drawing on parchment, 16¾ x 11¼" (42.6 x 28.6 cm). Musée du Louvre, Cabinet des Dessins, Paris

portrayed the event that provided biblical support for the supremacy of papal authority, Christ's giving the keys to the kingdom of heaven (Matthew 16:19) to the apostle Peter, the first bishop of Rome.

Delivery of the Keys is a remarkable work in carefully studied linear perspective that reveals much about Renaissance ideas and ideals. In a light-filled piazza whose banded paving stones provide a geometric grid for perspectival recession, the figures stand like chess pieces on the squares, scaled to size according to their distance from the picture plane and modeled by a consistent light source from the upper left. Horizontally, the composition is divided between the lower frieze of massive figures and the band of widely spaced buildings above. Vertically, it is divided by the open space at the center between Christ and Peter and by the symmetrical architectural forms on each side of this central axis. The carefully calibrated scene is softened by the subdued colors, the distant idealized landscape and cloudy skies, and the variety of the figures' positions.

Perugino's painting is, among other things, a representation of Alberti's ideal city, described in his treatise on architecture as having a "temple" (that is, a church) at the very center of a great open space raised on a dais and separate from any other buildings that might obstruct its view. His ideal church had a central plan, illustrated here as a domed octagon.

In the last quarter of the fifteenth century, Venice emerged as a major artistic center of Renaissance painting. From the late 1470s on, Venetian painters embraced the oil medium for both panel and canvas painting. The most important Venetian artists of this period were two brothers, Gentile (c. 1429–1507) and Giovanni (c. 1430–1516) Bellini. Beginning with their father, Jacopo (active c. 1423–1470), the Bellinis were central figures in Venetian art. Andrea Mantegna was also part of this circle, for he had married Jacopo's daughter in 1453. Jacopo, who had worked for a short time in Florence, was also a theorist who produced books of drawings in which he experimented with linear perspective. An experimental perspective study with a very low vanishing point and steeply plunging **orthogonals**—lines receding from the **picture plane** to converge on a vanishing point— survives in a *Flagellation* of about 1450 from Jacopo's sketchbook (fig. 17-72). His reputation as a painter is overshadowed in modern thinking by the achievements of his sons.

Gentile Bellini, a diplomat as well as a painter, received a number of important commissions, including fresco cycles for the ducal palace and various other public and private buildings in Venice. Many of his paintings celebrate the daily life of the city in large, multifigured narrative scenes, such as the *Procession of the Relic of the True Cross before the Church of San Marco* of 1496

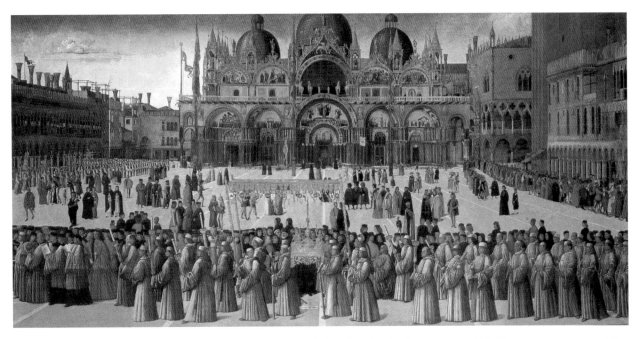

17-73. Gentile Bellini, *Procession of the Relic of the True Cross before the Church of San Marco.* 1496. Oil on canvas, 10'7" x 14' (3.23 x 4.27 m). Galleria dell'Accademia, Venice

(fig. 17-73). This work on canvas depicts a contemporary historical event: in 1444, during a procession in which a relic of the True Cross was carried through Venice's Piazza San Marco, a miraculous healing occurred, which was attributed to the relic. This accurately detailed cityscape is an early example of the topographical views that would one day be bought by wealthy tourists as souvenirs of their travels.

For almost sixty years, Giovanni Bellini's virtuosity as an artist amazed and attracted patrons. *Virgin and Child Enthroned with Saints Francis, John the Baptist, Job, Dominic, Sebastian, and Louis of Toulouse* (fig. 17-74), painted about 1478–1479 for the Ospedale of San Giobbe (Saint Job), exhibits a dramatic perspectival view up into a vaulted apse. Certainly Giovanni knew his father's perspective drawings well, and he may also have been influenced by his brother-in-law Mantegna's early experiments in radical foreshortening and the use of a low vanishing point. In Giovanni's painting, the vanishing point for the rapidly converging lines of the architecture lies at the center, on the feet of the lute-playing angel. Also, the

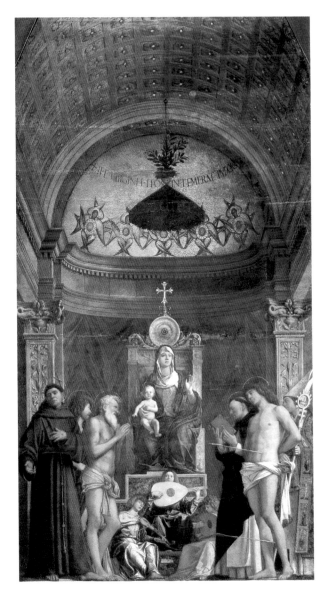

17-74. Giovanni Bellini. *Virgin and Child Enthroned with Saints Francis, John the Baptist, Job, Dominic, Sebastian, and Louis of Toulouse,* from the chapel for the Ospedale of San Giobbe, Venice. c. 1478–79. Panel, 15'4" x 8'4" (4.67 x 2.54 m). Galleria dell'Accademia, Venice

Art historians have given a special name, *sacra conversazione* ("holy conversation"), to this type of composition showing saints, angels, and sometimes even the painting's donors in the same pictorial space with the enthroned Virgin and Child. Despite the name, no conversation or other interaction between the figures takes place in a literal sense. Instead, the individuals portrayed are joined in a mystical communion occurring outside of time, in which the viewer is invited to share.

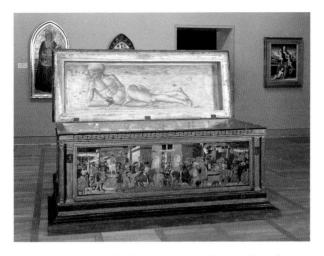

17-75. Florentine School. *Cassone*. c. 1460. Length 6'8⁷/₁₀"
(2.05 m). Statens Museum for Kunst, Copenhagen

pose of Saint Sebastian, his body pierced by arrows, at the right recalls a famous *Saint Sebastian* by Mantegna. Giovanni has placed his figures in a Classical architectural interior with a coffered barrel vault, reminiscent of Masaccio's *Trinity* (see fig. 17-46). The gold mosaic with its identifying inscription and stylized angels, reminiscent of the art of the Byzantine Empire in the eastern Mediterranean, recalls the long tradition of Byzantine-inspired painting and mosaics produced in Venice.

Although Giovanni's career covered nearly all of the second half of the fifteenth century, many of his greatest paintings were produced in the first decades of the sixteenth. While his work is often discussed with that of Leonardo da Vinci in the sixteenth century, it seems fit-

ting to end our consideration of the first phase of Renaissance painting in Italy with Giovanni Bellini as an important and influential bridge to the future.

INTERIOR ARTS, PRINTS, AND BOOKS

The Italian craft artists, too, were inspired by new Renaissance ideas. As the creators of luxury goods for an educated clientele, they came into direct contact with humanistic ideas and increased interest in classical antiquity. Particularly in the domain of home furnishings and interior decorations, the field was open for ambitious experiments in new subjects, treatments, and techniques.

Perfect objects for painted decoration were *cassoni* (singular, *cassone*, "chest") used for storing linens, fabrics, and clothing, which were often presented to couples at the time of their marriage. Few such chests survive intact today, often because the painted sections were cut out and sold as individual pictures by art dealers. Although religious subjects are found, especially on chests to store church linens and vestments, the *cassone* painters preferred mythological and historical subjects, allegorical or symbolic inventions, and occasionally, scenes of everyday life. An extremely elegant *cassone* by an unknown artist, possibly made as a bride's chest about 1460 in Florence, is painted on both the front panel and the inner side of the lid (fig. 17-75). The reclining male nude on the lid, which may have some symbolic meaning, perhaps as a fertility image, has an immediacy and sensuality suggesting a study from a live model. The front panel, framed by carved

17-76. *Studiolo* of Federico da Montefeltro, Ducal Palace, Urbino. 1470s. Intarsia, height 7'3" (2.21 m)

Corinthian pilasters and columns, is a panoramic view of a city filled with figures. Although the subject comes from the legendary history of Rome, the setting and costumes are of the fifteenth century.

The development of linear perspective was a strong inducement for the creation of trompe l'oeil effects in painting, but the designers of **intarsia** (wood inlay) carried it to its ultimate expression. During the reconstruction of the palace at Urbino, Federico da Montefeltro commissioned the intarsia decoration of the walls of his *studiolo*, a room for his private collection of fine books and art

objects (fig. 17-76). The trompe l'oeil design gave the small room illusionistic pilasters, carved cupboards with latticed doors, niches with statues, paintings, and built-in tables. A large window looks out onto an elegant marble loggia with a distant view of the countryside through its arches, and the shelves, cupboards, and tables are filled with all manner of fascinating things—scientific instruments, books, even the duke's armor hanging like a suit in a closet. All of this scene was inlaid in wood on flat surfaces with scrupulously applied linear perspective and foreshortening that would have been the envy of Paolo Uccello.

TECHNIQUE

WOODCUTS AND ENGRAVINGS ON METAL

Woodcuts are made by drawing on the smooth surface of a block of wood that has a fine grain, such as fruit wood, then cutting away all the areas around the lines with a sharp tool called a gouge, leaving the lines in **high relief**. When the block's surface is inked and a piece of paper pressed down hard on it, the ink on the relief areas is transferred to the paper to create a reverse image. The linear effects can be varied by using thicker and thinner lines, and shading can be achieved by making the lines closer or farther apart. Other techniques—such as punching, **cross-hatching**, and flicking out short strokes with the gouge—also create pictorial interest. In the fifteenth century the images were generally left in black and white or painted by hand, although a few artists experimented with adding colors during the inking of the block and using more than one block with one or two colors printed over the black-and-white image.

Engraving on metal requires a technique called **intaglio**, in which the lines are cut into the plate with tools called gravers or **burins**, while the surface remains flat. The engraver carefully scrapes any metal piled up beside the line, then burnishes any scratches left on the plate to give a clean, sharp image. Ink is applied over the whole plate and forced down into the lines, after which the surface of the plate is carefully wiped clean. The ink in the lines prints onto a sheet of paper pressed hard against the metal plate.

Both woodblocks and metal plates could be used repeatedly to make nearly identical images. If the lines of the block or plate wore down, the artists could repair them. Printing large numbers of identical prints of a single version, called an **edition**, was usually a team effort

in a busy workshop. One artist would make the drawing. Sometimes it was made directly on the block or plate with ink, in reverse of its printed direction, sometimes on paper to be transferred in reverse onto the plate or block by another person, who then cut the lines. Others would ink and print the images. Prints often were inscribed with the names and occupations (usually given in Latin, and frequently abbreviated) of those who carried out these various tasks. The following are some of the most common inscriptions (Hind, volume 2, page 26):

Sculpsit (*sculp., sc.*), *sculptor*: engraved or cut, engraver or cutter
Incidit (*incid., inc.*), *incisor*: engraved or cut, engraver or cutter
Fecit (*fec., f.*): literally "made"; engraved or cut, engraver or cutter
Excudit (*excud., exc.*): printed, or published
Impressit (*imp.*): printed
Pinxit (*pinx.*), *pictor*: painted, painter
Delineavit (*delin.*), *delineator*: drew, draftsperson
Invenit (*inv.*), *inventor*: designed, designer

In the illustration of books, the plates or blocks would be reused to print later editions and even adapted for use in other books. A set of blocks or plates for illustrations was a valuable commodity often sold by one workshop to another. Early in publishing, there were no copyright laws, and many entrepreneurs simply had their workers copy book illustrations onto woodblocks and cut them for their own publications.

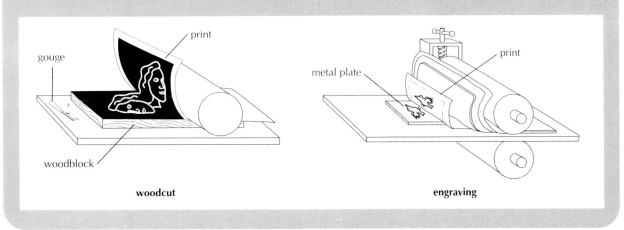

woodcut **engraving**

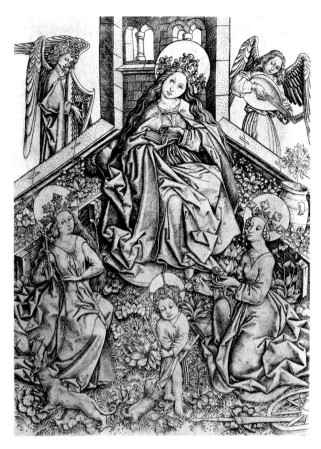

17-77. E. S. Engraver. *Virgin and Child in a Garden with Saints Margaret and Catherine* (or *Large Enclosed Garden*). c. 1461. Engraving, plate 8⅝ x 6⅜" (21.9 x 16.2 cm). Bibliothèque Nationale, Paris

European Printmaking and Book Printing

Printmaking emerged in Europe with the availability of locally manufactured paper at the end of the fourteenth century. Paper had been made in China as early as the second century CE, and small amounts were imported into Europe from the eighth century on. The first European paper was made in the twelfth century, but until the fourteenth century paper was rare and expensive. By the turn of the fifteenth century, however, commercial paper mills in nearly every European country were turning out large supplies that made it fairly inexpensive to use paper in a variety of ways, including for printing. Designs carved in relief on woodblocks had long been used to print on cloth, but the printing of images and texts on paper and the production of books in multiple copies of a single **edition**, or version, rather than copying each book by hand, emerged in the fifteenth century. Soon both handwritten and printed books were illustrated with printed images.

The Single-Sheet Print. Single-sheet woodcuts and engravings were made in large quantities in the early decades of the fifteenth century (see "Woodcuts and Engravings on Metal," page 673). In the beginning, woodcuts were often made by woodworkers with no training in drawing, but very quickly artists began to draw images for them to cut from the block. Engravings, on the other

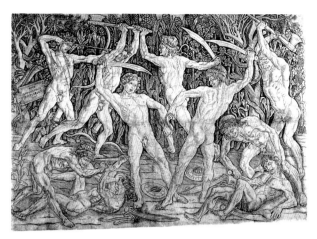

17-78. Antonio del Pollaiuolo. *Battle of the Nudes.* c. 1465–70. Engraving, 15⅛ x 23¼" (38.3 x 59 cm). Cincinnati Art Museum, Ohio
Bequest of Herbert Greer French. 1943.118

hand, seem to have developed from the metalworking techniques of goldsmiths and armorers. When paper became relatively plentiful around 1400, these artisans began to take impressions of the designs they were engraving on metal by rubbing the lines with lampblack and pressing paper over them.

Simply executed woodcut devotional images became popular early in the century, and they were sold as souvenirs to pilgrims at holy sites. Images for private devotion were also engraved, and in the hands of an experienced goldsmith the resulting images were often highly detailed, such as the *Virgin and Child in a Garden with Saints Margaret and Catherine* of about 1461 (fig. 17-77), by "E. S.," an artist known only from the engravings that carry this signature. More than 300 engravings by E. S. still exist, ranging in subject from grotesque alphabets to elaborate, symbolic representations of the Virgin. The artist worked in southern Germany, Switzerland, and eastern France from about 1450 to the late 1460s, producing extremely complex works in a style recalling that of Robert Campin, using a delicate line and fine **cross-hatched** shading. This charming scene in an enclosed garden, symbolic of virginity, could almost be that of a queen and her ladies-in-waiting watching over a playing child while listening to lute and harp music. But the figures are the Virgin Mary, the Christ Child, and Saints Margaret with her leashed dragon and Catherine with her wheel.

Not all prints were made for religious purposes, or even for sale. Some artists seem to have made them as personal studies, in the manner of drawings, or for use in their shops as models. The Florentine goldsmith and sculptor Antonio del Pollaiuolo may have intended his only known—but highly influential—print, *Battle of the Nudes,* an engraving done about 1465 to 1470, as a study in composition involving the human figure in action (fig. 17-78). The naked men fighting each other ferociously against a tapestrylike background of foliage seem to have been drawn from a single model in a variety of poses, many of which were taken from classical

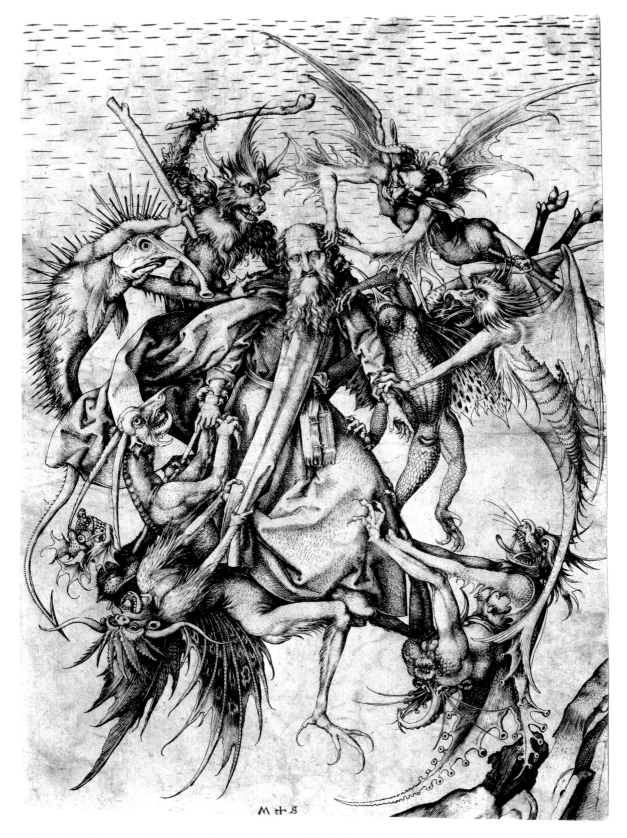

17-79. Martin Schongauer. *Temptation of Saint Anthony*. c. 1480–90. Engraving, 12¼ x 9" (31.1 x 22.9 cm). The Metropolitan Museum of Art, New York

Rogers Fund, 1920 (20.5.2)

sources. Like the artist's *Hercules and Antaeus* (see fig. 17-44), much of the engraving's fascination lies in how it depicts muscles of the male body reacting under tension.

The German painter Martin Schongauer, who learned engraving from his goldsmith father, was an immensely skillful printmaker who excelled in drawing and the difficult technique of shading from deep blacks to faintest grays. One of his best-known prints today is the *Temptation of Saint Anthony*, engraved about 1480 to 1490 (fig. 17-79). Schongauer illustrated the original biblical

17-80. Page with *Pilgrims at Table,* Prologue to *Canterbury Tales,* by Geoffrey Chaucer, published by William Caxton, London, 1484 (second edition; first with illustrations). Woodcut, 4¹/₁₆ x 4⁷/₈" (10.2 x 12 cm). The Pierpont Morgan Library, New York
PML 693

Chaucer (c. 1342–1400) included in his *Tales* two extremely complex and engaging women, Dorigen and Alice, the Wife of Bath. Dorigen appeared in the Franklin's Tale as a good woman who refused to accept society's advice that she kill herself if her virtue were threatened. Alice, on the other hand, was one of the thirty people who joined her host in making a pilgrimage to the shrine of Saint Thomas à Becket, each one telling a story to entertain the others along the way. Some critics see the Wife of Bath as an example for good women to avoid, but Chaucer put words in the lively Alice's mouth that are well understood by many women today.

meaning of temptation, expressed in the Latin word *tentatio,* as a physical assault rather than a subtle inducement. Wildly acrobatic, slithery, spiky demons lift Anthony up off the ground to torment and terrify him in midair. The engraver intensified the horror of the moment by condensing the action into a swirling vortex of figures beating, scratching, poking, tugging, and no doubt shrieking at the stoical saint, who remains impervious to all by reason of his faith.

The Illustrated Book. The explosion of learning in Europe in the fifteenth century precipitated experiments in faster and cheaper ways of producing books than by hand-copying them. The earliest printed books were

block books, for which each page of text, with or without illustrations, was cut in relief on a single block of wood. **Movable-type printing**, in which individual letters could be locked together, inked, and printed onto paper by a mechanical press, was first achieved in the workshop of Johann Gutenberg in Mainz, Germany. More than forty copies of Gutenberg's Bible, printed in 1456, still exist. With the invention of this fast way to make a number of identical books, the intellectual and spiritual life of Europe—and with it the arts—changed forever. As early as 1465, two German printers were working in Italy, and by the 1470s there were presses in France, Flanders, Holland, and Spain.

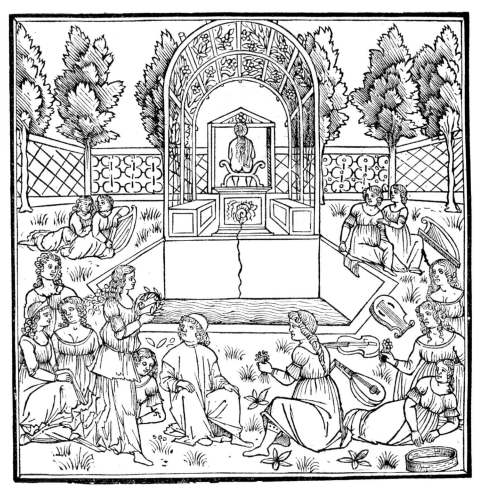

17-81. Page with *Garden of Love, Hypnerotomachia Poliphili*, by Fra Francesco Colonna, published by Aldo Manuzio (Aldus Manutius), Venice, 1499. Woodcut, image 5⅛ x 5⅛" (13.5 x 13.5 cm). The Pierpont Morgan Library, New York
PML 373

England got its first printing press in 1481 as the result of a second career launched by a former English cloth merchant, William Caxton (active 1441–1491?). Caxton lived for thirty years in Bruges, where he came in contact with the humanist community, as well as local book-printing ventures. In his spare time, he translated into English Raoul le Fevre's *Histories of Troy,* which became the first book printed in that language. In 1476 Caxton moved back to London, where he established the first English publishing house. He printed eighty books in the next fourteen years, including works by the four-teenth-century English author Geoffrey Chaucer. In the second edition of Chaucer's *Canterbury Tales,* published in 1484, Caxton added woodblock illustrations by an un-known artist (fig. 17-80). The assembled pilgrims, whose individual stories make up the *Tales,* appear in the Pro-logue seated around a table, ready to dine. Although technically simple, this woodcut and its companions are effective, original compositions.

Another famous early book was *Hypnerotomachia Poliphili* (*The Love-Dream Struggle of Poliphilo*). This charming romantic allegory tells of the wanderings of Poliphilo through exotic places in search of his lost love, Polia—much in the manner of René of Anjou's *Livre du Cuer d'Amours Espris* (see fig. 17-27). The book, written in the 1460s or 1470s by Fra Francesco Colonna, was published in 1499 by the noted Venetian printer Aldo Manuzio (Aldus Manutius). Many historians of book printing consider Aldo's *Hypnerotomachia* to be the most beautiful book ever produced, from the standpoint of type and page design. The woodcut illustrations in the *Hypnerotomachia,* such as the *Garden of Love* (fig. 17-81), incorporate linear perspective and pseudoclassical struc-tures that would influence future architects.

Although woodcuts, constantly refined and increas-ingly complex, would remain a popular medium of book illustration for centuries to come, methods for illustrating books with engravings soon emerged. The potential of these new techniques for printing illustrated books in Europe at the end of the 1400s held great promise for the spread of knowledge and ideas in the following century. The new empirical frame of mind that characterized the fifteenth century gave rise in the sixteenth century to an explosion of inquiry and new ways of looking at the world.

1500 1520 1540

Leonardo
*The Last
Supper*
1495–98

Michelangelo
David
1501–4

Bosch
Detail,
*Garden of
Delights*
1500–5

Clouet
Francis I
1525–30

Holbein the Younger
Henry VIII
1540

Bramante
Tempietto
1502

Grünewald
Crucifixion, from
Isenheim Altarpiece
c. 1510–15

Pontormo
Entombment
1525–28

CHAPTER 18

Renaissance Art in Sixteenth-Century Europe

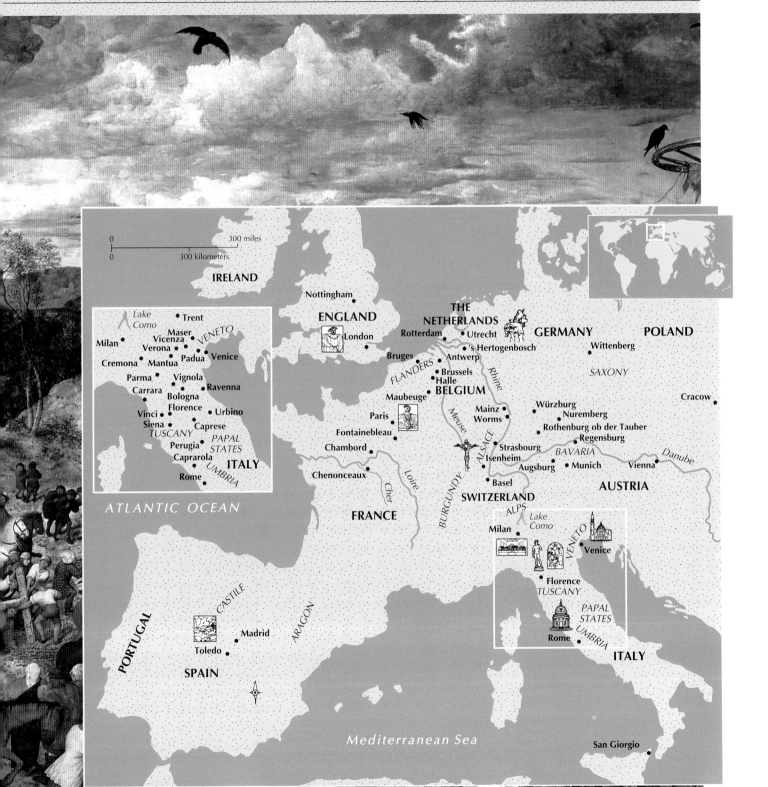

1560 1580 1600

Palladio
San Giorgio Maggiore
1566

El Greco
View of Toledo
1609

IRELAND

Nottingham

ENGLAND

London

**THE
NETHERLANDS**

Rotterdam Utrecht **GERMANY** **POLAND**

's Hertogenbosch

Bruges Antwerp Wittenberg

FLANDERS Brussels *SAXONY*

Halle

BELGIUM Cracow

Maubeuge

Paris Mainz Würzburg Nuremberg

Worms Rothenburg ob der Tauber

Fontainebleau Regensburg

Chambord Strasbourg *BAVARIA* *Danube*

Isenheim

Chenonceaux Augsburg Munich Vienna

Basel

FRANCE **SWITZERLAND** **AUSTRIA**

ALPS

Milan *Lake Como*

VENETO

Venice

Florence

TUSCANY

*PAPAL
STATES*

Rome *UMBRIA*

ITALY

ATLANTIC OCEAN

CASTILE

Madrid

Toledo *ARAGON*

PORTUGAL

SPAIN

Mediterranean Sea San Giorgio

Inset map (Italy):

Lake Como Trent

Milan Maser *VENETO*

Vicenza

Verona Padua Venice

Cremona Mantua

Parma Vignola

Carrara Ravenna

Bologna

Vinci Florence Urbino

Siena Caprese

TUSCANY *PAPAL
STATES*

Perugia

Caprarola *UMBRIA*

Rome **ITALY**

Scale:
0 300 miles
0 300 kilometers

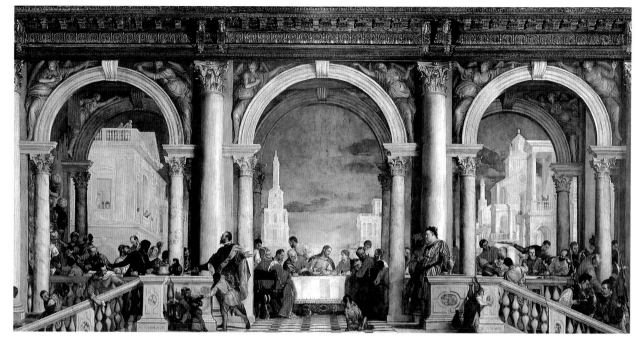

18-1. Veronese. *Feast in the House of Levi*, from the Monastery of Santi Giovanni e Paolo, Venice. 1573. Oil on canvas, 18'3" x 42' (5.56 x 12.8 m). Galleria dell'Accademia, Venice

Jesus among his disciples at the Last Supper was a popular image during the sixteenth century. But when the highly esteemed painter Veronese in 1573 revealed an enormous canvas that seemed at first glance to depict this scene, the people of Venice were shocked (fig. 18-1). Jesus, indeed, is in the center of the painting, with his followers, but some viewers were offended by Veronese's grandiose portrayal of the subject, filled with splendor and pageantry; others, by the impiety of placing near Jesus a host of extremely unsavory characters. They were so offended, in fact, that Veronese was called before the Inquisition to explain his reasons for including such extraneous details as a man picking his teeth, scruffy dogs, a parrot, and foreign soldiers. The subject, indeed, originally may have been intended to be the Last Supper—the Inquisitors certainly thought so, although Veronese claimed it depicted the Feast in the House of Simon, a small dinner shortly before Jesus' final entry into Jerusalem. From the record of the inquiry, Veronese boldly justified his actions by saying: "We painters take the same license the poets and the jesters take. . . . I paint pictures as I see fit and as well as my talent permits" (cited in Holt, volume 2, pages 68, 69). This statement was a quite-unheard-of stance at that time, and his defense fell on unsympathetic ears. He was told to change the painting.

Accordingly, Veronese changed the picture's title so that it referred to another banquet, given by the tax collector Levi, whom Jesus had called to follow him. Thus, the "buffoons, drunkards . . . and similar vulgarities" (cited in Holt, volume 2, page 68) remained, and Veronese noted his new source—Luke, Chapter 5—on the balustrade. In that Gospel one reads that "Levi gave a great banquet for him [Jesus] in his house, and a large crowd of tax collectors and others were at table with them" (Luke 5:29). In changing the declared subject of the painting, Veronese also had modest revenge on the Inquisitors: when Jesus was criticized for associating

with such people, he replied, "I have not come to call the righteous to repentance but sinners" (Luke 5:32).

The Inquisitors who under the direction of the Church were scrutinizing works of art for heretical or profane suggestions, the painter who brashly defended his art, the very size and medium and style of the painting itself—all were products of the extraordinarily rich, inspiring, and unpredictable sixteenth century.

EUROPE IN THE SIXTEENTH CENTURY

The sixteenth century in Europe was an age of ferment—social, intellectual, religious, and geographic—that transformed European culture. The humanism of the fourteenth and fifteenth centuries, with its medieval roots and its often uncritical acceptance of the authority of classical texts, slowly gave way to a new spirit of discovery that led scholars to investigate the natural world around them, to conduct scientific and mechanical experiments, and to explore lands in Africa, Asia, and the Americas previously unknown to Europeans. Travel became more common than before, both within Europe and beyond it, and new ideas spread through the publication in translation of ancient and contemporary texts. An explosion of information, aided by the rapid growth of book printing, not only broadened the horizons of educated Europeans but also enabled more people to learn to read. Much more than in earlier centuries, artists and their work became mobile, traveling from city to city and from one country to another, and artistic styles became less regional and more international.

At the start of the sixteenth century, England, France, and Portugal were national states under strong monarchs. With the succession to the throne of the Habsburg Philip II in 1556, a united Spain soon became the strongest power in Europe, with vast territories in Asia, the Americas, Italy, and Flanders. Germany was divided into dozens of free cities and hundreds of territories ruled by nobles and princes. These territories ranged in size from a few square miles to large and powerful states like Saxony and Bavaria. But all the German states acknowledged the overlordship of the Habsburg Holy Roman emperors. Italy, also divided into many small states, was a diplomatic and military battlefield, where Spain, France, Venice, and the papacy warred against each other in shifting alliances for much of the century. The popes themselves behaved like secular princes. They used diplomacy and military force to regain their control over the Papal States in central Italy and in some cases to establish their families as hereditary rulers at the expense of local authorities. This behavior was expensive, and the popes' incessant demands for money aggravated the religious dissent that had long been developing, especially north of the Alps, and contributed greatly to the rise of Protestantism.

The political maneuvering of Pope Clement VII (papacy 1523–1534) led to a clash with the Holy Roman Emperor Charles V, based in Germany. As a result, in May 1527 the imperial army attacked Rome, beginning a six-month orgy of killing, looting, and burning. The Sack of Rome, as it is called, damaged irreparably the humanistic confidence of the Renaissance. On a more practical level, many artists simply left Rome for good.

The Effects of the Reformation on Art

The Church had witnessed many dissident movements in its history. Some of these movements had led to great controversy and outright war. But in the end, the unity of the Church and its authority had always prevailed. In the sixteenth century this unity broke down. The sixteenth-century reformers (hence this movement is called the Reformation) not only challenged Church teaching over specific beliefs and religious practices but denied the very basis of the pope's—and thus the Church's—authority. These reformers, called Protestants because they "protested" against the practices and beliefs of the Catholic Church, succeeded in permanently breaking away from Rome for a variety of reasons. One cause of their success was the support they enjoyed from powerful rulers in Germany and Scandinavia who saw the Protestant movement as a way of enhancing their own wealth and power. Another factor was the easier availability of the printed word, which allowed scholars throughout Europe to debate religious matters among themselves and to influence many people who were already dissatisfied with the Church. Two important reformers in the early sixteenth century were themselves Catholic priests and trained theologians, Desiderius Erasmus of Rotterdam (1466?–1536) and Martin Luther (1483–1546). The wide circulation of Luther's writings—especially his German translation of the Bible and his works maintaining that salvation came through faith alone—led eventually to the establishment of a Protestant church in Germany and Scandinavia.

By the end of the sixteenth century, some form of Protestantism prevailed in much of Europe. By the 1560s only Italy, Spain, Ireland, Poland, and Portugal were still entirely Catholic, although France reaffirmed its allegiance to the Roman Catholic Church in the late 1570s after decades of religious civil war. Southern Germany, the Rhineland, Austria, and Hungary also remained predominantly Catholic.

One tragic consequence of the Reformation was the destruction of religious art. In some areas, Protestant zealots smashed sculpture and stained-glass windows

PARALLELS

Europe	1500–1550	1550–1600
Italy	Michelangelo's *David*; Bramante's Tempietto; Pope Julius II; Leonardo's *Mona Lisa*; rebuilding of Saint Peter's; Giorgione's *Tempest*; Michelangelo's Sistine frescoes; Raphael's *School of Athens*; Pope Leo X; Mannerism emerges; Pope Clement VII; Sack of Rome; Machiavelli's *The Prince*; Michelangelo's *Last Judgment*; Pope Paul III; Titian's *Isabella d'Este*; Bronzino's *Ugolino Martelli*; Roman Inquisition introduced; Council of Trent begins; Michelangelo takes over rebuilding of Saint Peter's	Vasari's *Lives* of artists; Palladio's San Giorgio and Villa Rotonda; Pope Pius IV; Pope Gregory XIII; Veronese's *Feast in the House of Levi*; Pope Sixtus V; first completely sung opera
France	King Francis I; Château of Chenonceaux; Clouet's *Francis I*; Fontainebleau begun; Reformation in France; Lescot's Cour Carré	Montaigne's *Essays;* reaffirms allegiance to Catholic Church
Netherlands	Bosch's *Garden of Delights*	Brueghel the Elder's *Return of the Hunters*; Dutch war of independence and establishment of Dutch Republic
Germany	University of Wittenberg founded; Dürer's *Adam and Eve*; Grünewald's *Isenheim Altarpiece*; Luther's "95 Theses" launches Reformation in Germany; landscape painting develops; Holy Roman Emperor Charles V; Dürer's *Four Apostles*	University of Würzberg founded; Holy Roman Emperor Ferdinand I
England	King Henry VIII; More's *Utopia*; England breaks with Rome; Holbein the Younger's *Henry VIII*; King Edward VI	Queen Mary restores Catholicism briefly; Queen Elizabeth I; Drake circumnavigates world; Smythson's Wollaton Hall; Raleigh explores present-day North Carolina and Virginia; Marlowe's *Tamburlaine the Great*; England destroys the Spanish Armada; Shakespeare's early plays; Spenser's *Faerie Queene*; Bacon's *Essays*
Spain	Spanish Inquisition continues to burn heretics at the stake; Columbus's final voyages to Americas; Ponce de León claims Florida; Cortés conquers Mexico; Magellan circumnavigates world; Pizarro conquers Inkas; Ignatius Loyola founds Jesuit Order	King Philip II of Spain and ruler of Netherlands, Americas, Milan, Burgundy, and Naples and Sicily; Herrera's El Escorial; El Greco's *Burial of Count Orgaz*
World	Ming dynasty (China); first African slaves in the West Indies; Montezuma II rules Aztec empire (Mexico); Copernicus (Poland) states that Earth revolves around the Sun; Ottomans take Cairo; Europeans expelled from China; Mughal dynasty founded in India; Portuguese reach Japan; Tsar Ivan the Terrible (Russia)	Sultan Suleyman I (Turkey); Akbar the Great (India); Oda Nobunaga rules Japan from Kyoto; first kabuki company, established by a woman (Japan); Hideyoshi unifies Japan; Tsar Boris Godunov (Russia)

and whitewashed religious paintings to rid the churches of what they considered to be idolatrous images. With the sudden loss of the market for religious images in the newly Protestant countries, many artists turned to portraiture and other secular subjects, including moralizing depictions of human folly and weaknesses, much as reformers such as Erasmus had done in writing. The popularity of these themes stimulated a free market for which artists created works of their own invention and sold them through dealers or by word of mouth.

During the Council of Trent (1545–1563), the Roman Catholic hierarchy formulated a program to counter the Protestant Reformation. Part of their program included a set of guidelines for religious art. Traditional images of Christ and the saints would continue to be venerated in churches, but they were to be scrutinized carefully for heresy, profanity, or any other quality that might justify Protestant criticism. Moreover, bishops and priests were to educate laypeople not to view images as having any intrinsic power. Although these rules limited what could be expressed in Christian art and led to the destruction of some works, over time they encouraged artistic creation.

The Changing Status of Artists

Sixteenth-century artists have left a considerable record of their activities, including diaries, notebooks, and letters. In addition, contemporary writers reported on everything from artists' physical appearances to their personal reputations. Giorgio Vasari's famous *Lives of the Most Excellent Italian Architects, Painters, and Sculptors* first appeared in 1550. Clearly, sixteenth-century society valued artists highly and rewarded them well, not only with choice commissions and generous gifts but even by elevating some of them to noble rank. Painters and sculptors hired dealers to sell their art, invested in moneymaking schemes, and ran other businesses on the side, especially in the Protestant countries. The sale of prints by or based on the works of popular artists was a means by which reputations and styles became widely known, and artists of stature were sought-after international celebrities. With their new fame and independence, the most successful artists could decide which commissions to accept, reject, or leave unfinished—even if the patron was a pope or an emperor.

During this period, theorists increasingly came to regard the conception of a painting, sculpture, or work of architecture as a liberal rather than a manual art. The artist, it was recognized, could express as much through painted, sculptural, and architectural forms as the poet or writer could with words or the musician through melody. The belief that artists were individual creative geniuses became a widespread myth—one that is still with us today. Some historians have suggested that the new status of artists in the sixteenth century worked against the participation of women in the visual arts, for, it was believed, genius was reserved to men. Yet there were women artists active in Europe despite numerous obstacles to their entering any profession. A few had achieved international renown, traveling widely to fulfill commissions and accepting appointments that required relocating themselves and their families permanently.

ITALIAN ART

By the turn of the sixteenth century, the Renaissance movement was the dominant artistic force in Italy, and its ideas were spreading rapidly to the rest of Europe, especially through the patronage of foreign courts. The early phase of sixteenth-century Italian art—with its self-confident humanism, its admiration of classical forms, and its dominating sense of stability and order—was once called the High Renaissance, usually roughly dated from 1500 to 1520. In time, many outstanding younger artists trained in Florence and northern Italy worked not only in other Italian cities but also in Spain, France, Germany, and the Netherlands. They interpreted Renaissance forms in their own ways, developing a number of local and personal styles that characterize the Late Renaissance, generally referring to the period after 1520.

As the fortunes of the ruling families of Florence and Milan fluctuated sharply because of political struggles, Rome became the most active artistic and intellectual center in Italy, with the popes and the noble Roman families as the most-generous patrons. The election of Pope Julius II in 1503 began a resurgence of the power of the papacy and a beautification of the city of Rome. During the ten years of his reign, he fought wars and formed alliances to consolidate his power. Julius's vision included rebuilding Rome and the Vatican, the pope's residence there, for which he enlisted the artists Bramante, Raphael, and Michelangelo. Thus Rome became the center of a program of revitalization and the development of a new Christian art based on classical forms and principles.

Painting in Florence and Northern Italy

Florence, considered the cradle of the Italian Renaissance since Vasari called it so, had developed its own style of classicism, which affected painters beyond its borders. The fifteenth-century frescoes in the Brancacci Chapel (Chapter 17), for example, inspired young sixteenth-century artists, who came to study Masaccio's solid, monumental figures and eloquent facial features, poses, and gestures (see fig. 17-47). Michelangelo's youthful sketches of the chapel frescoes clearly show the importance of Masaccio's influence on his mature style in both sculpture and painting.

At the turn of the sixteenth century, two major changes took place in Italian painting: The use of **tempera** gave way to the more flexible oil technique, and commissions from private sources increased. Many wealthy patrons in Italy and other European countries became avid collectors of paintings, as well as small bronzes, antiquities, and even minerals and fossils.

Leonardo da Vinci. A fiercely debated topic in Renaissance Italy was the question of which art was superior to others. Leonardo da Vinci (1452–1519) insisted on the supremacy of painting as the best and most complete means of creating an illusion of the natural world. Born in

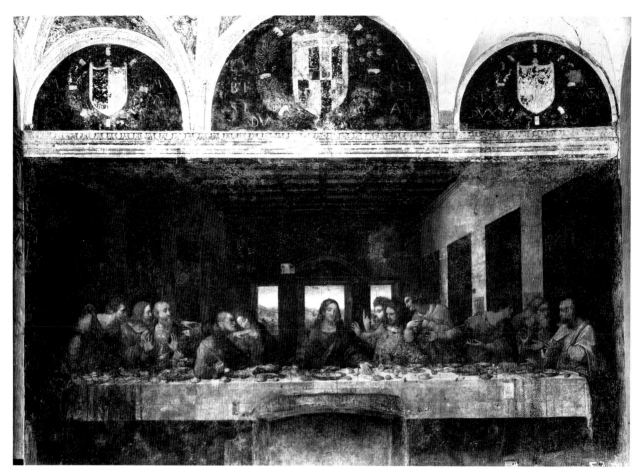

18-2. Leonardo. *The Last Supper*, wall painting in the Refectory, Monastery of Santa Maria delle Grazie, Milan, Italy. 1495–98. Tempera and oil on plaster, 15'2" x 28'10" (4.6 x 8.8 m)

Instead of painting in fresco, Leonardo devised an experimental technique for this mural. Hoping to achieve the freedom and flexibility of painting on panel, he worked directly on dry intonaco—a thin layer of smooth plaster—with an oil tempera paint, whose formula is unknown. The result was disastrous. Within a short time, the painting began to deteriorate, and by the middle of the sixteenth century its figures could be seen only with difficulty. In the seventeenth century, the monks saw no harm in cutting a doorway through the lower center of the composition. Since then the work has barely survived, despite many attempts to halt its deterioration and restore its original appearance. The painting narrowly escaped complete destruction in World War II, when the refectory was bombed to rubble around its heavily sandbagged wall. The most recent restoration began in 1979.

the Tuscan village of Vinci, Leonardo was twelve or thirteen when his family moved to Florence. He was apprenticed in the shop of the painter and sculptor Verrocchio, where he was employed until about 1476. After a few years on his own, Leonardo traveled to Milan in 1482 or 1483 to work for the Sforza court. In fact, Leonardo spent much of his time in Milan on military and civil engineering projects, including an urban renewal plan for the city.

At Duke Lodovico Sforza's request, Leonardo painted one of the defining monuments of Renaissance art, *The Last Supper,* in the dining hall of the Monastery of Santa Maria delle Grazie in Milan between 1495 and 1498 (fig. 18-2). Leonardo's vision of the event takes place in a large chamber whose **one-point perspective** is defined by a **coffered** ceiling and four pairs of tapestries hanging on its walls. Its stagelike space recedes from a long table, placed parallel to the **picture plane**, to three windows on the back wall. Seated behind and at the two ends of this table are Jesus and his disciples. Jesus' outstretched arms form a pyramid at the center, and the disciples are

grouped in threes on each side. On one level, the scene is a narrative, showing the moment when Jesus tells his companions that one of them will betray him. They react with shock, disbelief, and horror. Judas, clutching his money bag in the shadows to the left of Jesus, has recoiled so suddenly that he has upset the salt dish, a bad omen. On the narrative level, the picture offers a study of human emotions, with the disciples modeled on real people Leonardo knew. He is said to have found his Judas, for example, in the thieves' quarter of Milan.

On another level, the Last Supper is presented as a symbolic evocation of transcendental truth. Breaking with traditional representations of the subject, such as the one by Andrea del Castagno (see fig. 17-51), Leonardo placed Judas in the first triad to the left of Jesus, along with the young John the Evangelist and the elderly Peter, rather than isolating him on the opposite side of the table. Judas, Peter, and John were each to play essential roles in Jesus' mission: Judas, to set in motion the events leading to Jesus' sacrifice; Peter, to lead the

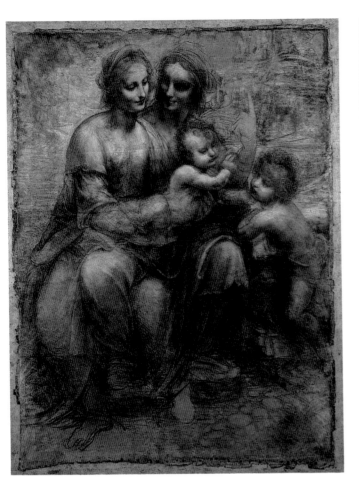

18-3. Leonardo. *Virgin and Saint Anne with the Christ Child and the Young John the Baptist*. c. 1500–1. Charcoal heightened with white on brown paper, 54 7/8 x 39 7/8" (139 x 101 cm). The National Gallery, London

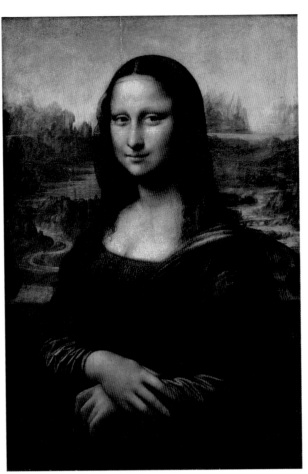

18-4. Leonardo. *Mona Lisa*. c. 1503–6. Oil on panel, 30 1/4 x 21" (76.8 x 53.3 cm). Musée du Louvre, Paris

Church after Jesus' death; and John, the visionary, to foretell the Second Coming and the Last Judgment in the Apocalypse. By arranging the disciples and architectural elements into four groups of three, Leonardo incorporated a medieval tradition of numerical symbolism related to the Trinity, the Virtues (in medieval philosophy, there were three Theological and four Cardinal Virtues), the four elements (earth, air, fire, and water), and the four seasons. Thus the painting's meaning, beyond the immediate narrative subject, is symbolic and is not restricted to a particular time.

This sense of timelessness is reinforced by the painting's careful geometry, the convergence of its perspective lines, and the stability of its pyramidal forms. The calm of Jesus' demeanor in the midst of the general commotion also contributes to this effect. These qualities of stability, calm, and a sense of timeless order, coupled with the already established Renaissance forms modeled on those of classical sculpture, characterize the art of the Renaissance at the beginning of the sixteenth century.

Leonardo left Milan in 1498 and resettled in Florence. In about 1500, he produced a drawing for a painting of the *Virgin and Saint Anne with the Christ Child and the Young John the Baptist* (fig. 18-3). Drawn in black charcoal with white highlights on brown paper, this large sheet (roughly 4'7" high) is clearly the full-scale model, called a **cartoon**, for a major painting, but no known finished work can be associated with it. Mary sits on the knee of her mother, Anne, and turns to the right to hold the Christ Child, who strains away from her to reach toward his cousin, the young John the Baptist. Leonardo created the illusion of high relief by modeling the figures with strongly contrasted light and shadow, called **chiaroscuro** (Italian for "light-dark"). Carefully placed highlights create a circular movement rather than a central focus, which retains the individual importance of each figure while also making each of them an integral part of the whole. This effect is emphasized by the complex interaction of the exquisitely tender facial expressions, particularly those of Saint Anne and the Virgin.

Between 1503 and 1506, Leonardo painted his renowned *Mona Lisa* (fig. 18-4), which he kept with him for the rest of his life. The subject was twenty-four-year-old Lisa Gherardini del Giocondo, the wife of a prominent merchant in Florence. The solid pyramidal form of her half-length figure is silhouetted against distant mountains, whose desolate grandeur reinforces the mysterious atmosphere of the painting. Mona Lisa's facial expression

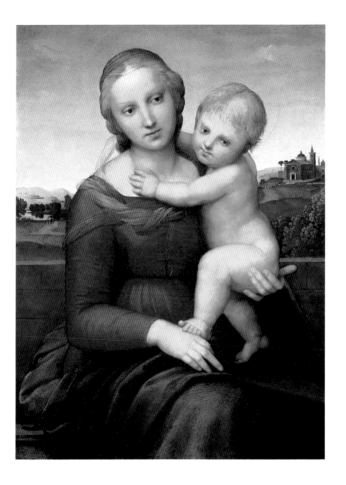

18-5. Raphael. *The Small Cowper Madonna*. c. 1505. Oil on panel, 23³⁄₈ x 17³⁄₈" (59.5 x 44.1 cm). National Gallery of Art, Washington, D.C.
Widener Collection

has been called enigmatic because her gentle smile is not accompanied by the warmth one would expect to see in her eyes. The contemporary fashion for plucked eyebrows and a shaved hairline to increase the height of the forehead adds to her arresting appearance. Perhaps most unsettling is the bold and slightly flirtatious way in which her gaze has shifted sideways toward the right to look straight out at the viewer. The implied challenge of her direct stare, combined with her apparent serenity and inner strength, has made the *Mona Lisa* one of the best-known works in the history of art.

For Leonardo color was secondary to the depiction of sculptural volume, which he achieved through his virtuosity in highlighting and shading. He also unified his compositions by covering them with a thin, lightly tinted varnish, which resulted in a smoky overall haze called **sfumato**. Because early evening light is likely to produce a similar effect naturally, he considered dusk the finest time of day and recommended that painters set up their studios in a courtyard with black walls and a linen sheet stretched overhead to reproduce the twilight of dusk.

Leonardo's fame as an artist is based on only a few known works. Unlike his humanist contemporaries, he was not particularly interested in classical literature or archeology. Instead, his great passions were mathematics and the natural world, and he compiled volumes of detailed drawings and notes on anatomy, botany, geology, meteorology, architectural design, and mechanics. Although he lived for a time in the Vatican at the invitation of Pope Leo X, there is no evidence that he produced any art during his stay. In 1517 he accepted Francis I's invitation to resettle in France as an adviser on architecture. He lived there until his death in 1519.

Raphael. In 1504 Raphael Sanzio (1483–1520) arrived in Florence from his native Urbino. Raphael had studied in Perugia with the leading artist of that city, Perugino (see fig. 17-71). Raphael was quickly successful in Florence, especially for his paintings of the Virgin and Child, such as *The Small Cowper Madonna* (named for a modern owner) of about 1505 (fig. 18-5). Raphael was already a superb painter, but he must have studied the work of Leonardo and Michelangelo to achieve the simple grandeur of these monumental figures' shapes, uncomplicated naturalistic draperies, and rich, concentrated colors. The forms of *The Small Cowper Madonna* are modeled solidly but softly by clear, even lighting that pervades the outdoor setting. Raphael painted at least seventeen Madonnas, several portraits, and a number of other works in the three or four years he spent in Florence, but his greatest achievements were to come in the dozen years he spent in Rome, discussed later.

Correggio. In his brief but prolific career, Correggio (Antonio Allegri, c. 1489/99–1534), produced most of his work for patrons in Parma and Mantua in north-central Italy. Correggio's great work, *Assumption of the Virgin* (fig. 18-6), a fresco painted about 1520–1524 in the dome of the Cathedral of Parma, distantly recalls the ceiling by Andrea Mantegna in the Gonzaga ducal palace (see fig. 17-69). Leonardo clearly influenced Correggio's use of softly modeled forms, spotlighting effects of illumination,

18-6. Correggio. *Assumption of the Virgin*, fresco in main dome interior, Parma Cathedral, Parma, Italy. c. 1520–24. Diameter of base of dome 35'10" x 37'11" (10.93 x 11.56 m)

and a slightly hazy overall appearance. Correggio also assimilated elements from Raphael's work in developing his highly personal style, which inspired artists for the next three centuries. In the *Assumption,* the architecture of the dome seems to dissolve, and the viewer is drawn up into the swirling vortex of heavenly beings accompanying the Virgin. The sensuous flesh and clinging draperies of individual figures are drawn with great attention. This, combined with their warm colors, tends to obscure the subject, which is the miraculous transporting of the Virgin directly to heaven at the moment of her death. The viewer's strongest impression is of a powerful, spiraling upward motion, as if the artist hoped to convey the spiritual essence of the Assumption. Illusionistic painting directly

derived from this work would become a hallmark of ceiling decoration in the following century.

Sculpture in Florence and Northern Italy

Florence nurtured many of the major talents of the sixteenth century. Michelangelo, the greatest of these, specialized in marble work. Leonardo da Vinci is also documented as an accomplished sculptor, and he received several important commissions early in his career, although only a few sketches and contemporary descriptions of them survive today. In the second half of the century, the Leoni family, based in Milan, became favorites of the Austrian Habsburgs, whose commissions

18-7. Michelangelo. *Pietà*, from Old Saint Peter's. c. 1500. Marble, height 5'8½" (1.74 m).
Saint Peter's, Vatican, Rome

for numerous statues in bronze and marble kept their studios constantly occupied. Religious sculpture was in greatest demand, but portraits were very popular, and statues and reliefs decorated homes, gardens, and courtyard fountains. Although freestanding statues in public places were still rare in most of Italy, sculpted public fountains would have a long history.

Michelangelo. Michelangelo Buonarroti (1475–1564) was born in the Tuscan town of Caprese and grew up in Florence. At the age of thirteen he was apprenticed to the painter Domenico del Ghirlandaio, in whose workshop he learned the rudiments of fresco painting and studied drawings of classical monuments. After approximately a year, Michelangelo joined the household of Lorenzo the Magnificent, where he came into contact with the Neoplatonic philosophers in Lorenzo de' Medici's circle and was given the opportunity to study sculpture with Bertoldo di Giovanni, a pupil of Donatello. Bertoldo's sculptures were primarily in bronze, and Michelangelo later

claimed that he had taught himself to carve marble by studying the Medici collection of classical statues.

After Lorenzo died in 1492, Michelangelo traveled to Venice and Bologna, then returned to Florence, where he fell under the spell of the charismatic preacher Fra Girolamo Savonarola. The preacher's execution for heresy in 1498 had a traumatic effect on Michelangelo, who said in his old age that he could still hear the sound of Savonarola's voice.

By nature, Michelangelo was an intense man who alternated between periods of depression and frenzied activity. He was difficult and often arrogant, yet he was devoted to his friends and helpful to young artists. He believed that his art was divinely inspired; later in life, he became deeply absorbed in religion and dedicated himself chiefly to religious works.

Michelangelo's major early work was a *Pietà* of about 1500, commissioned by a French cardinal and installed as a tomb monument in Old Saint Peter's in the Vatican (fig. 18-7). **Pietàs**—works in which the subject is the Vir-

18-8. Michelangelo. *David*. 1501–4. Marble, height 13'5"
(4.09 m). Galleria dell'Accademia, Florence

Michelangelo's most famous sculpture was cut from
an 18-foot-tall marble block already partially carved
by another sculptor during the 1460s. After studying
the block carefully and deciding that it could be
salvaged, Michelangelo made a small model in wax,
then sketched the contours of the figure as they
would appear from the front on one face of the mar-
ble. Then, according to his friend and biographer
Vasari, he chiseled in from the drawn-on surface, as if
making a figure in very high relief. The completed
statue took four days to move on tree-trunk rollers
down the narrow streets of Florence from Michelan-
gelo's workshop to its location outside the Palazzo
Vecchio. In 1837, the statue was replaced by a copy to
scale and moved into the museum of the Florence
Academy.

gin supporting and mourning the body of the dead
Jesus—had long been popular in northern Europe but
were rare in Italian art at the time. Michelangelo traveled
to the marble quarries at Carrara in central Italy to select
the block from which to make this large work, a practice
he was to follow for nearly all of his sculpture. The choice
of the stone was important because he envisioned the
statue as already existing within the marble and needing

only to be "set free" from it. He later wrote in his Sonnet
15 (1536–1547): "The greatest artist has no conception
which a single block of marble does not potentially con-
tain within its mass, but only a hand obedient to the mind
can penetrate to this image."

Michelangelo's *Pietà* is a very young Virgin of heroic
stature holding the lifeless, smaller body of her grown
son. The seeming inconsistencies of age and size are
countered, however, by the sweetness of expression, the
finely finished surfaces, and the softly modeled forms.
Michelangelo's compelling vision of beauty is meant to
be seen up close from directly in front of the statue and
on the statue's own level, so that the viewer can look
into Jesus' face. The sculpture is signed prominently on
the diagonal strap across the Virgin's breast. The twenty-
five-year-old artist is said to have done this after the
statue was finished, stealing into the church at night
to provide the answer to the many questions about its
creator.

In 1501 Michelangelo accepted a commission for a
statue of the biblical David (fig. 18-8) for an exterior but-
tress of the Florence Cathedral. When it was finished in
1504, the *David* was so admired that the Florentine city
council placed it in the square next to the seat of Flor-
ence's government. Although Michelangelo's *David*
embodies the athletic ideal of antiquity in its muscularity,
the emotional power of its facial expression and con-
centrated gaze are entirely new. Unlike Donatello's
bronze *David* (see fig. 17-40), this is not a triumphant
hero with the head of the giant Goliath under his feet.
Instead, slingshot over his shoulder and a rock in his right
hand, Michelangelo's David frowns and stares into
space, seemingly preparing himself psychologically for
the danger ahead. Here the male nude implies, as it had
in classical antiquity, heroic or even divine qualities. No
match for his opponent in experience, weaponry, or
physical strength, David represents the power of right
over might. He was a perfect emblematic figure for the
Florentines, who twice drove out the powerful Medici
and reinstituted short-lived republics in the early years of
the sixteenth century.

Upon the election of Giovanni de' Medici as Pope Leo
X, the pope and his cousin commissioned a facade for the
Medici family Church of San Lorenzo in Florence. Michel-
angelo was made chief architect for the project, but in
1519, after about three years of preliminary construction,
Leo asked Michelangelo to work instead on a new funer-
ary chapel inside the church for the duke of Urbino, who
had just died, as well as for three other dukes. The Medici
Chapel, called the New Sacristy, was an innovative varia-
tion on the Old Sacristy by Filippo Brunelleschi at the
other end of the transept of the Church of San Lorenzo
(see fig. 17-32). Construction went forward slowly and
intermittently because of Leo's death in 1521 and ongo-
ing political struggles in Florence. In 1534, detested by the
new duke of Florence and fearing for his life, Michelan-
gelo returned to Rome, where he lived for the rest of his
life. Others completed the sacristy by 1559, using marble
Michelangelo had selected, but they left the Medici wall
tombs as they were at his departure.

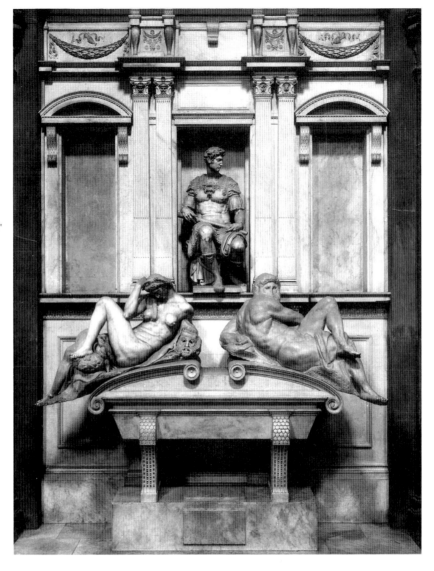

18-9. Michelangelo. Tomb of Giuliano de' Medici. 1519–34. Marble, height 22'9" x 15'3" (6.94 x 4.65 m). Medici Chapel (New Sacristy), Church of San Lorenzo, Florence

Each monument consists of an idealized portrait of the deceased seated in a niche above a pseudoclassical sarcophagus (fig. 18-9). Balanced precariously on the sarcophagus tops are male and female figures representing the Times of Day. Their positions would not seem so unsettling had reclining figures of river gods been installed below them, as originally planned, to complete the encircling effect. The Medici are shown in armor, which may designate them as "Christian soldiers." Here, Giuliano, Duke of Nemours, represents the Active Life. His sarcophagus figures are allegories of Night and Day, according to Michelangelo's notes: "Day and Night speak, and say: We with our swift course have brought the Duke Giuliano to death." Night is accompanied by her symbols: a star and crescent moon on her tiara; poppies, which induce sleep; and an owl under the arch of her leg. The huge mask at her back may allude to Death, since Sleep and Death were said to be the children of Night. According to Vasari, Michelangelo left a small piece of marble for the figure of a mouse, which, like Time, nibbles away at earthly things, but it was never carved. The portraits of the deceased, facing each other on opposite walls, are flanked by paired pilasters and empty niches meant to have been filled with allegorical figures. Finally, the walls of the sacristy are articulated with Brunelleschian *pietra serena* pilasters and architraves in the Corinthian order. The figures of the dukes are finely finished, but the Times of Day are notable for their contrasting patches of rough and polished marble, a characteristic of the artist's mature work that some Michelangelo specialists call his ***nonfinito*** ("unfinished") quality, suggesting that he had begun to view his artistic creations as symbols of human imperfection (see fig. 18-19). Indeed, Michelangelo's poetry often expressed his belief that humans could achieve perfection only in death.

Jacopo Sansovino. Michelangelo's closest competitor in Florence was the sculptor Jacopo Tatti (1486–1570), who took the last name of his teacher Andrea Sansovino. Renaissance sculptors experimented increasingly with three-dimensional works that could be viewed satisfactorily from any angle. One strategy to achieve this effect was to incorporate a second figure facing in a different direction from the main one to give visual interest from the sides and back, as in Jacopo's *Bacchus* (fig. 18-10). Jacopo based his work on a statue of Bacchus, the god of wine, by Michelangelo, which he had seen on a visit to Rome in 1505. The wine god stands in **contrapposto**— his weight supported by one leg while the other remains relaxed—holding up a drinking cup in one hand while a boy-satyr crouches behind him. The youthful, innocent Bacchus is so full of buoyant spirits that he hoists his cup high above his head.

18-10. Jacopo Sansovino. *Bacchus*. 1511. Marble, height 57" (146 cm). Museo Nazionale del Bargello, Florence

18-11. Leone Leoni. *Charles V Triumphing over Fury*. 1549–55. Bronze, height to top of head 5'8" (1.74 m). Museo del Prado, Madrid

About this time, around 1511, Jacopo competed unsuccessfully for the commission to design the new San Lorenzo facade; later his bid for a role in the creation of its sculpture was rejected by Michelangelo. He returned to Rome but fled the 1527 sack of the city. He resettled in Venice, where he was appointed city architect and remained until his death.

Leone Leoni. Born near Lake Como in northern Italy, Leone Leoni (1509–1590) traveled widely, working on commissions in Venice, Padua, Brussels, and Madrid, where his son Pompeo, also a sculptor, was born. By 1542, Leone had settled in Milan, where he produced major works in bronze, many for patrons in other cities or abroad. He worked in Milan for a brother of Pope Pius IV and later became a favorite of Emperor Charles V and his son Philip II of Spain. Elevated to the nobility, the artist became rich from his sculpture, architectural designs, and goldsmith work.

One of Leone's most dramatic works is the lifesize bronze *Charles V Triumphing over Fury* (fig. 18-11), cast for the emperor between 1549 and 1555. Here Leone cre-

ated a Herculean image wearing armor that was cast separately and can be removed to reveal a heroic nude. Although the face is recognizably a portrait of the emperor, the features have been idealized to convey an impression of regal strength, experience, and wisdom.

Commissions from the Habsburgs were so numerous that Leone and his son Pompeo could do little more than design and supervise their execution. Pompeo also acted as his father's agent at various courts and ultimately moved permanently to Spain.

Painting in Rome

In the late fifteenth century the popes had begun to repair the physical decay of Rome and the Vatican. One project was the building and decoration of the Sistine Chapel, the pope's private chapel, for which a number of notable painters from Umbria and Tuscany had come to the city (see fig. 17-71). Although Rome produced few native artists in either the fifteenth or the sixteenth century, the many patrons, painters, and sculptors from other cities living there attracted artists from across Europe.

18-12. Raphael. *School of Athens*, fresco in the Stanza della Segnatura, Vatican, Rome. 1510–11. 19 x 27' (5.79 x 8.24 m)

Raphael gave many of the figures in his imaginary gathering of philosophers the features of his friends and colleagues. Plato, standing immediately to the left of the central axis and pointing to the sky, was said to have been modeled after Leonardo da Vinci, and Euclid, shown inscribing a slate with a compass at the lower right, was a portrait of Raphael's friend the architect Donato Bramante. Michelangelo, who was at work on the Sistine ceiling only steps away from the *stanza* where Raphael was painting his fresco, is shown as the solitary figure at the lower left, leaning on a block of marble and sketching, in a pose reminiscent of the figures of sibyls and prophets on his great ceiling. Raphael's own features are represented on the second figure from the far right, as the face of a young man listening to a discourse by the astronomer Ptolemy.

Raphael. Raphael left Florence in about 1508 for Rome, where Pope Julius II put him to work almost immediately decorating the papal apartments. Raphael's most outstanding achievement in these rooms (*stanze*, singular *stanza*) was the *School of Athens* (fig. 18-12), painted about 1510–1511 for the pope's library. The painting seems to summarize the ideals of the Renaissance papacy in its grand conception of harmoniously arranged forms and rational space, as well as the calm dignity of its figures. Indeed, the warrior and pragmatist Julius II was a very learned man who may not have actually devised the subjects painted but certainly approved them.

In the *School of Athens,* viewed through a trompe l'oeil arch decorated with a **Greek-key pattern** (an ornamental pattern in which small, straight lines intersect at right angles), Plato and Aristotle command center stage. At the left Plato gestures upward to the heavens as the ultimate source of his philosophy, while Aristotle, with his outstretched hand, palm down, seems to emphasize the importance of gathering empirical knowledge from

observing the material world. Looking down from niches in the walls are Apollo, the Greek and Roman god of sunlight, rationality, poetry, and music, carrying a lyre, and Minerva, the Roman goddess of wisdom. Around Plato and Aristotle are mathematicians, naturalists, astronomers, geographers, and other philosophers. Some debate while others demonstrate their theories to onlookers. The scene, flooded with a clear, even light from a single source, takes place in an immense barrel-vaulted interior possibly inspired by the new design for Saint Peter's, which was being rebuilt on a plan by the architect Donato Bramante. The grandeur of the building is matched by the monumental dignity of the philosophers themselves, each of whom is a distinct physical and intellectual presence. These striking individuals are organized into a dynamic unity by the sweeping arcs of the composition and the variety and energy of the poses and gestures.

Raphael's talents were also put to use by Julius II's successor, Leo X (papacy 1513–1521), whom Raphael

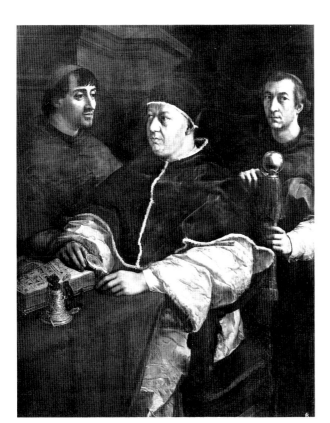

18-13. Raphael. *Leo X with Cardinals Giulio de' Medici and Luigi de' Rossi.* c. 1518. Oil on panel, 5'5⅝" x 3'10⅞" (1.54 x 1.19 m). Galleria degli Uffizi, Florence

served as the director of all archeological and architectural projects in Rome. Raphael's portrait of Leo X of about 1518 (fig. 18-13) depicts the pope as a great collector of books, and indeed, Leo was probably already planning a new Medici library in Florence (see fig. 18-46). Leo's driving ambition was the advancement of the Medici family, and Raphael's painting is, in effect, a dynastic group portrait. Facing the pope at the left is his cousin Giulio, Cardinal de' Medici; behind him stands Luigi de' Rossi, another relative he had made cardinal. Dressed in splendid brocades and enthroned in a velvet chair, the pope looks up from a richly illuminated fourteenth-century manuscript he has been examining with a magnifying glass. Raphael lovingly depicted the contrasting textures and surfaces in the picture, including the visual distortion caused by the magnifying glass on the book page. In this telling detail, as in the reflection of the window and in Raphael's self-portrait, which are in the polished brass knob on the pope's chair, Raphael acknowledges his debt—despite great stylistic differences—to the fifteenth-century Flemish artist Jan van Eyck and his followers (Chapter 17).

At about the same time, Raphael was working for Leo on designs for ten tapestries on themes from the Acts of the Apostles to cover the **dado** (lower wall) below the fifteenth-century wall paintings, or **murals**, in the Sistine Chapel. The first tapestry in the series was the *Miraculous Draft of Fishes,* combined with Christ's calling of his apostles (fig. 18-14). Tapestries, which were produced for

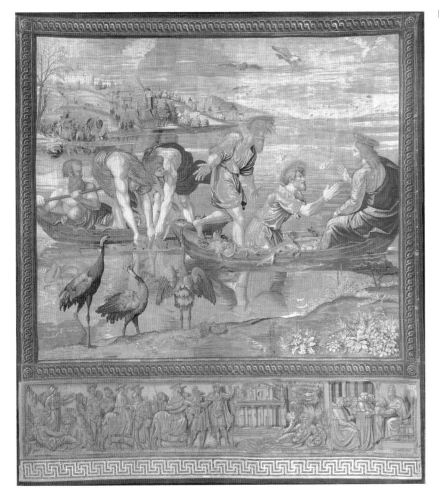

18-14. Shop of Pieter van Aelst, Brussels, after Raphael's cartoon. *Miraculous Draft of Fishes*, from the Acts of the Apostles series; lower border, two incidents from the life of Giovanni de' Medici, later Pope Leo X. Woven 1517, installed 1519 in the Sistine Chapel. Wool and silk with silver-gilt threads, 15'11⅚" x 14'5⅚" (4.90 x 4.41 m). Musei Vaticani, Pinacoteca, Rome

Raphael's Acts of the Apostles cartoons were used as the models for several sets of tapestries woven in the van Aelst shop, including one for Francis I of France. In 1630 the Flemish painter Peter Paul Rubens discovered seven of the ten original cartoons in the home of a van Aelst heir and convinced his patron, Charles I of England, to buy them. Still part of the royal collection today, they are exhibited at the Victoria and Albert Museum in London. After being dispersed after the Sack of Rome in 1527, later returned, and dispersed again during the Napoleonic wars, the original Sistine tapestries were purchased by a private collector in 1808 and returned to the Vatican as a gift that year. They are now displayed in the Raphael room of the Vatican Painting Gallery.

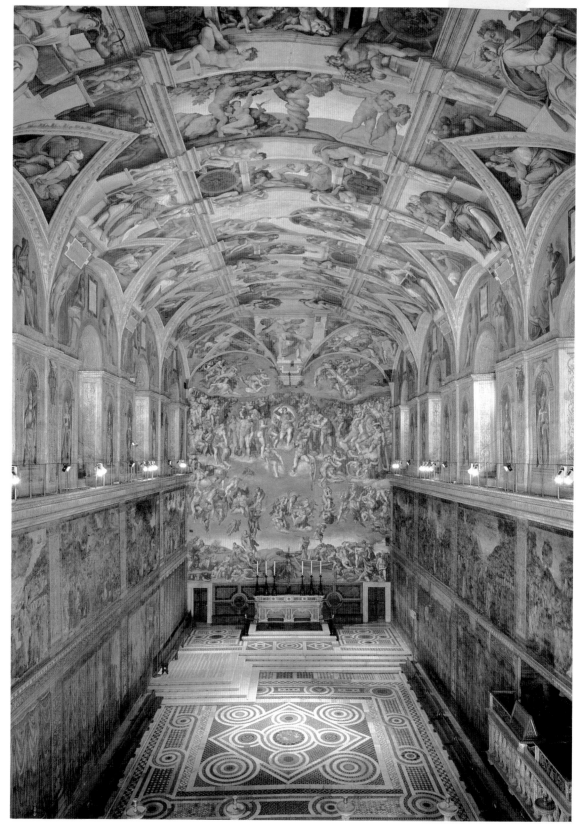

18-15. Interior, Sistine Chapel, Vatican, Rome. Built 1475–81

Named after its builder, Pope Sixtus (Sisto) IV, the chapel is slightly over 130 feet long and about $43^{1}/_{2}$ feet wide, approximately the same measurements recorded in the Old Testament for the Temple of Solomon. The floor mosaic was recut from the colored stones used in the floor of an earlier papal chapel. The plain walls were painted in fresco between 1481 and 1483 with scenes from the life of Moses and the life of Christ by Perugino, Botticelli, Ghirlandaio, and others. Below these are trompe l'oeil painted draperies, where Raphael's tapestries illustrating the Acts of the Apostles once hung (see fig. 18-14). Michelangelo's famous ceiling frescoes begin with the lunette scenes above the windows (see fig. 18-16). On the wall above the altar is his *Last Judgment* (see fig. 18-17).

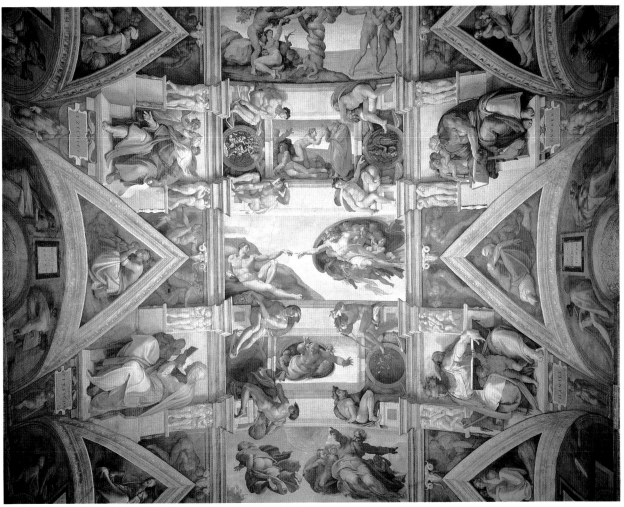

18-16. Michelangelo. Sistine Ceiling. Top to bottom: *Expulsion* (center); *Creation of Eve* with *Ezekiel* (left) and *Cumaean Sibyl* (right); *Creation of Adam*; *God Gathering the Waters* with *Persian Sibyl* (left) and *Daniel* (right); and *God Creating the Sun, Moon, and Planets*. Frescoes on the ceiling, Sistine Chapel. 1508–12

Italian patrons in the workshops of France and Flanders, were extremely expensive at this time. Raphael and his assistants made full-size, detailed charcoal cartoons, then painted over the 11-by-15-foot sketch with glue-based watercolors in hues the weavers had to match. The cartoons were then sent to Brussels, where they were used to make the actual tapestries. Today, the Sistine Chapel dado is painted with trompe l'oeil draperies (see fig. 18-15), and the tapestries in the papal collection are used only occasionally.

Raphael died after a brief illness in 1520, at the age of thirty-seven. In view of his study of Rome's ancient past, his burial in the ancient Pantheon, which had long been converted into a Christian church, has great poignancy.

Michelangelo. Julius II saw Michelangelo as his equal in personal strength and dedication and thus as an ideal collaborator in the artistic aggrandizement of the papacy. Despite Michelangelo's contractual commitment to the Florence Cathedral for statues of the apostles, in 1505 Julius arranged for him to come to Rome. The sculptor's first undertaking was the pope's tomb, but this commission was set aside in 1506 when Julius ordered Michelangelo to redecorate the ceiling of the Sistine Chapel (fig. 18-15).

Julius's initial directions for the ceiling were fairly simple. He wanted a decoration of trompe l'oeil "stucco" coffers to replace the original blue, star-spangled ceiling. Later he wanted the Twelve Apostles seated on thrones to be painted in the triangular **spandrels**, the areas of the walls between the **lunettes** framing the chapel windows. When Michelangelo objected to the limitations of Julius's plan, the pope told him to paint whatever he liked on the ceiling. This he presumably did, although it is unlikely that a commission of this importance would have had no supervision from the pope, and it probably also involved an adviser in theology. Whatever their source, the frescoes are a pictorial declaration of papal authority, derived from the Bible.

First, the artist painted an illusionistic, marblelike architectural framework on the vault of the chapel (fig. 18-16). Running completely around the ceiling is a painted **cornice**, with prominent projections supported by short pilasters sculpted with the figures of nude baby boys, called **putti**. Set among these projections are figures of various Old Testament prophets and Classical sibyls (female prophets) who were believed to have foretold Jesus Christ's birth. Seated on the cornice projections are heroic figures of nude young men, called *ignudi*

THE SISTINE CEILING RESTORATION

The cleaning of the frescoes on the walls of the Sistine Chapel, done in the 1960s and 1970s, was so successful that in 1980 a single lunette from Michelangelo's ceiling decoration was cleaned as a test. Underneath layers of soot and dust was found color so brilliant and so different from the long-accepted dusky appearance of the ceiling that conservators summoned their courage and proposed a major restoration. In early 1981 a plan was set to begin cleaning the entire ceiling. The work was completed in the winter of 1989, and the *Last Judgment* over the altar was completed in the spring of 1994.

Although the restorers proceeded with great caution and frequently consulted with other experts in the field, the cleaning created a serious controversy. The greatest fear was that the work was moving ahead too rapidly for absolute safety. There was also great concern that the ceiling's final appearance might not resemble its original state. Some scholars, convinced that Michelangelo had reworked the surface of the fresco after it had dried to soften and tone

Michelangelo. *Libyan Sibyl*, Sistine Chapel, Vatican, Rome. 1511–12. On the left, the fresco before cleaning; on the right, as it appears today

down the colors, feared that cleaning would remove these finishing touches. Nevertheless, the breathtaking colors of the Sistine Ceiling fresco that the cleaning revealed forced scholars to almost completely revise their understanding of the art of Michelan-

gelo and the development of sixteenth-century Italian painting. We will never know for certain if some subtleties were lost in the cleaning, and only time will tell if this restoration has prolonged the life of Michelangelo's great work.

(singular, *ignudo*), assuming a variety of poses and holding sashes attached to large gold medallions. Rising behind the *ignudi*, shallow bands of stone span the center of the ceiling and divide it into compartments. The scenes in these compartments depict the Creation, the Fall, and the Flood, as told in Genesis. The narrative sequence begins over the altar and ends near the chapel entrance. God's earliest acts of creation are therefore closest to the altar, while the Creation of Eve at the center of the ceiling introduces the imperfect actions of humanity: the Temptation, the Fall, the Expulsion from Paradise, and God's eventual destruction of all people except Noah and his family by the Flood.

The steep sides of the triangular spandrels, which contain paintings of the ancestors of Jesus, support mirror-image nudes in reclining and seated poses. At the apex of each spandrel-triangle is a *bucranium*, or ox skull, a **motif** (a repeated figure in a design) that appears in ancient Roman paintings and reliefs.

According to discoveries during the most recent restoration (see "The Sistine Ceiling Restoration," above), Michelangelo worked on the ceiling in two main stages, beginning in the late summer or fall of 1508 and moving from the chapel's entrance toward the altar, in reverse of the narrative sequence. The first half of the ceiling up to the Creation of Eve was unveiled in August 1511, and the second half in October 1512. Perhaps the most familiar scene is the Creation of Adam. Here Michelangelo

depicts the moment when God charges the languorous Adam with the spark of life. As if to echo the biblical text, Adam's heroic body and pose mirror those of God, in whose image he has been created. Directly below Adam is an *ignudo* grasping a bundle of oak leaves and giant acorns, which refer to Julius's family name (della Rovere, or "of the oak"), and possibly also to a passage in the Old Testament prophecy of Isaiah (61:3), "They will be called oaks of justice, planted by the Lord to show his glory."

A quarter of a century later, Michelangelo again went to work in the Sistine Chapel, this time on the *Last Judgment,* painted between 1536 and 1541 on the 48-by-44-foot end wall where the chapel altar was located (fig. 18-17). Michelangelo, now entering his sixties, had complained of feeling old for years, yet he accepted this important and demanding task, which took him two years to complete.

Abandoning the clearly organized medieval conceptions of the Last Judgment, in which the Saved are neatly separated from the Lost, Michelangelo painted a writhing swarm of resurrected humanity. At the left the dead are dragged from their graves and pushed up into a vortex of figures around Christ, who wields his arm like a sword of justice. Despite the efforts of several saints to save them at the last minute, the rejected souls are plunged toward hell on the right, leaving the Elect and still-unjudged in a dazed, almost uncomprehending state. To the right of Christ's feet is Saint Bartholomew,

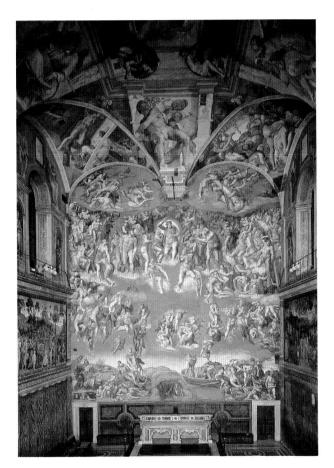

18-17. Michelangelo. *Last Judgment*, fresco in the Sistine Chapel. 1536–41

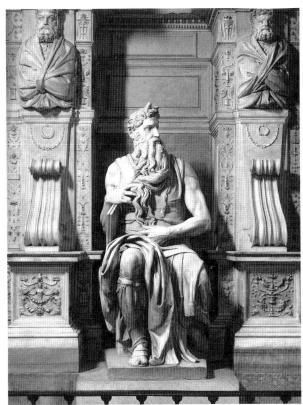

18-18. Michelangelo. *Moses*, Tomb of Julius II. c. 1513–15. Marble, height 7'8¹/₂" (2.35 m). Church of San Pietro in Vincoli, Rome

Princes of the Church, like their secular counterparts, often arranged for their burial and funerary monuments themselves, knowing that their heirs might have other priorities. Although Pope Julius II's immediate survivors ordered an even larger and more costly tomb than Julius himself had commissioned from Michelangelo, during the three decades following his death the projected size and opulence of the monument steadily diminished. In the end the pope was buried not in Saint Peter's in the Vatican, as he had wished, but elsewhere, and a few salvaged statues and reliefs were mounted with some new pieces by Michelangelo's assistants in a commemorative monument against a wall of the della Rovere family church. In this final setting the pope's small reclining image was greatly overshadowed by the only statue there made for the original tomb, Michelangelo's superb figure of *Moses*.

who in legend was martyred by being skinned alive, holding his flayed skin, the face of which is painted with Michelangelo's own distorted features. On the lowest level of the mural, directly above the altar, is the gaping, fiery Hellmouth, toward which Charon propels his craft on the River Styx, which encircles the underworld. The painting remains today, in the spirit of its original conception, a grim and constant reminder to the celebrants of the Mass—the pope and his cardinals—that ultimately they will be judged for their deeds.

Sculpture in Rome

Rome's sixteenth-century sculptors were perhaps too overwhelmed by the many ancient monuments surrounding them to synthesize their own classical styles. Florence still dominated sculpture, lending its geniuses on a regular basis to Roman patrons and projects and to the next generation of artists as mentors. Most papal sculpture commissions were given to Michelangelo, despite his reputation for being difficult and frequently failing to complete what he had started.

Michelangelo. Michelangelo's first papal sculpture commission, the tomb of Julius II, was to plague him and his patrons for forty years. In 1505 he presented his first designs to the pope for a large freestanding rectangular structure. With levels on three steps set back from each

other, culminating in the pope's sarcophagus and having more than forty statues and reliefs in marble and bronze, it was to be installed in the new Saint Peter's that Julius was planning to build. After a year of preliminary work on the tomb, Michelangelo left Rome for Florence in a fit of anger on the day before the laying of the cornerstone for the new Saint Peter's. He later explained that Julius himself had decided to halt the tomb project and divert the money to building the church. After Julius died in 1513, his heirs offered the sculptor a new contract for a more elaborate tomb and a larger payment. At this time, between 1513 and 1515, Michelangelo created *Moses* (fig. 18-18), the only sculpture from the original design to be incorporated into the final, much-reduced monument

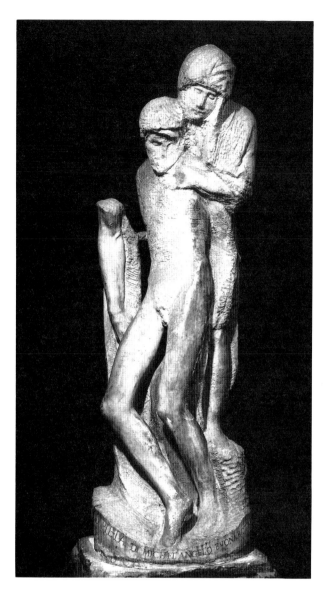

18-19. Michelangelo. *Pietà* (known as the *Rondanini Pietà*). 1555–64. Marble, height 5'3³⁄₈" (1.61 m). Castello Sforzesco, Milan

Shortly before his death in 1564, Michelangelo resumed work on this sculpture group, which he had begun some years earlier. He cut down the massive figure of Jesus, merging the figure's now elongated form with that of the Virgin, who seems to carry her dead son upward toward heaven.

to Julius II. No longer an actual tomb—Julius was buried elsewhere—the pope's monument was installed in 1545, after decades of wrangling, in the Church of San Pietro in Vincoli, Rome.

In the original design, the *Moses* would have been one of four equally large seated figures at the corners of the second level. These were to be prominent but subordinate to the group above, depicting the pope supported by angels atop a sarcophagus. Above them were to be a large standing Madonna and Child flanked by saints. In the final configuration, however, the eloquent figure of Moses becomes the focus of the monument and an allegorical representative of the long-dead pope.

Michelangelo was seventy when the monument of Pope Julius was finally installed. His last days up to his death in 1564 were occupied by an unfinished composition now known, from the name of a modern owner, as the *Rondanini Pietà* (fig. 18-19). Dismissed by some as an oddity with no more than biographical relevance, the *Rondanini Pietà* is the final artistic expression of a lonely, disillusioned, and physically debilitated man who struggled to end his life as he had lived it—working with his mind and his hands. In his youth, the stone had released the *Pietà* in Saint Peter's as a perfect, exquisitely finished

VITRUVIUS The Roman architect and engineer Marcus Vitruvius Pollio lived and wrote in the first century BCE, during the reign of Augustus Caesar, to whom he dedicated his ten-volume *De Architectura* (*On Architecture*). Beginning in the fifteenth century this treatise was a fundamental resource for Italian humanistic investigations into the principles of ancient Roman architecture. In the sixteenth century it was widely published in translation and reached a large audience across Europe. The ten books covered not only the architecture of Vitruvius's time but also such diverse subjects as the education of an architect, materials and mechanical aids for construction, astrology and astronomy, and ways to find water. Vitruvius's chapter "On Symmetry" (Book III) in-spired Leonardo da Vinci to create his well-known diagram for drawing the ideal male figure, called the *Vitruvian Man*. As Vitruvius wrote: "For if a man be placed flat on his back, with his hands and feet extended, and a pair of compasses centered at his navel, the fingers and toes of his two hands and feet will touch the circumference of a circle described therefrom. And just as the human body yields a circular outline, so too a square figure may be found from it. For if we measure the distance from the soles of the feet to the top of the head, and then apply that measure to the outstretched arms, the breadth will be found to be the same as the height" (Book III, Chapter 1, Section 2). Leonardo has added his own observations in the reversed writing he always used for his notebooks.

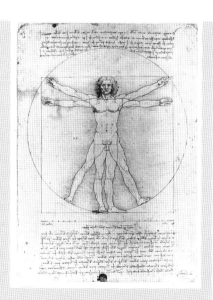

Leonardo da Vinci. *Vitruvian Man*. c. 1490. Ink, approx. 13¹⁄₂ x 9⁵⁄₈" (34.3 x 24.5 cm). Galleria dell'Accademia, Venice

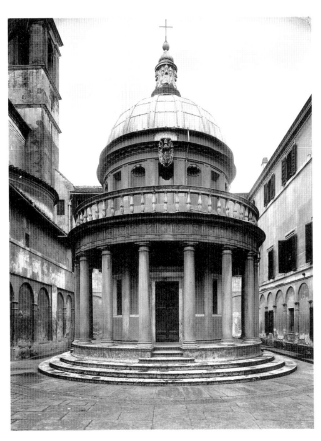

18-20. Donato Bramante. Tempietto, Church of San Pietro in Montorio, Rome. 1502

work (see fig. 18-7), but this block resisted his best efforts to shape it. The ongoing struggle between artist and medium is nowhere more apparent than in this moving example of Michelangelo's *nonfinito* creations.

Architecture in Rome and Its Environs

Benefiting from the achievements of fifteenth-century pioneers and inspired by studying the monuments of antiquity, the Renaissance architects who worked in Rome developed ideals comparable to those of contemporary painters and sculptors. The first-century Roman architect and engineer Vitruvius's ten-volume work on classical architecture (see "Vitruvius," page 698) continued to be an important source for sixteenth-century Italian architects. It inspired several encyclopedias of Renaissance architecture and practical manuals on classical style, as did Giacomo da Vignola, discussed below. Whereas religious architecture was a major source of commissions, some of the best opportunities for innovation were urban palaces and large country villas.

Donato Bramante. Born near Urbino and trained as a painter, Donato Bramante (1444–1514) turned to architectural design early in his career. Little is known of his activities until about 1481, when he became attached to the Sforza court in Milan, where he would have known Leonardo da Vinci. In 1499 Bramante settled in Rome, but work came slowly. The architect was nearing sixty when he was commissioned in 1502 to design a small

shrine over the spot where the apostle Peter was believed to have been crucified (fig. 18-20). The Tempietto ("little temple") has been admired since it was built as a nearly perfect Renaissance interpretation of the principles of Vitruvius. Without copying any specific ancient monument but perhaps inspired by the remains of a small round temple in Rome, Bramante designed the shrine, only 15 feet in diameter, with a stepped base and a Doric **peristyle** (continuous row of columns). Vitruvius had advised that the Doric order be used for temples to gods of particularly forceful character. The first story of the shrine is topped by a tall **drum**, or circular wall, supporting a hemispheric dome (no longer original) recalling ancient Roman round tombs. Especially notable is the sculptural effect of the building's exterior, with its deep wall niches creating contrasts of light and shadow, its Doric frieze of carved papal emblems, and its elegant **balustrade** (carved railing).

Shortly after Julius II's election as pope in 1503, he commissioned Bramante to renovate the Vatican Palace, and in 1506 Julius appointed him chief architect of a project to replace Saint Peter's Basilica in the Vatican, the site of Peter's tomb. Construction had barely begun when Julius died in 1513; Bramante himself died in 1514 without leaving a comprehensive plan or model that a successor could complete. After a series of popes and architects and various revisions, the new Saint Peter's was still nowhere near completion when Michelangelo took over the project in 1546 (see "Saint Peter's Basilica," page 701).

Michelangelo. After Michelangelo settled in Rome in 1534, a rich and worldly Roman noble was elected as Pope Paul III (papacy 1534–1549). He surprised his electors by his vigorous pursuit of reform within the Church, including in 1545 the Council of Trent, which brought together conservative and reform factions. He also began renovation of several important sites in Rome and the upgrading of papal properties. Among the projects in which he involved Michelangelo was remodeling the Campidoglio (Capitol), a public square atop the Capitoline Hill, once the citadel of Republican Rome. The buildings covering the irregular site had fallen into disrepair, and the pope saw its renovation as a symbol of both his spiritual and his secular power.

Scholars still debate Michelangelo's role in the Capitoline project, although some have connected the granting of Roman citizenship to him in 1537 with his taking charge of the work. Preserved accounts mention the artist by name on only two occasions, however. In 1539 his advice was taken on reshaping the base for the ancient Roman statue of Marcus Aurelius. In 1563 payment was made "to execute the orders of master Michelangelo Buonarroti in the building of the Campidoglio." Michelangelo's comprehensive plan for what is surely among the most beautiful urbanrenewal projects of all time is documented in prints identified as having been done from Michelangelo's plan and model for the new Campidoglio (fig. 18-21). The Piazza del Campidoglio today closely resembles the conception recorded in these prints only a few years after Michelangelo's death, although the square and buildings were not finished

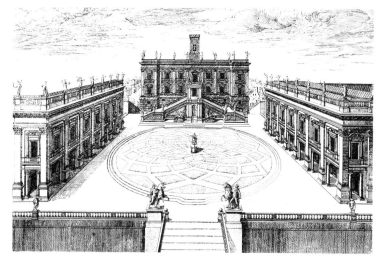

18-21. Étienne Dupérac. *Piazza del Campidoglio, Rome*, engraving after design of Michelangelo. 1569. Gabinetto Nazionale delle Stampe, Rome

Flanking the entrance to the piazza are the so-called *Dioscuri*, two ancient Roman statues moved to the Capitol by Paul III, along with the bronze *Marcus Aurelius*, an imperial Roman equestrian statue, which was installed at the center of the slightly sunken ovoid fronting the buildings. At the back of the square is the Palazzo Senatorio, whose double-ramp grand staircase is thought to have been designed by Michelangelo. At the right is the Palazzo dei Conservatori, with a new facade designed by the sculptor, and facing it, the Palazzo Nuovo, which was built in the seventeenth century to match the Conservatori. Today, air pollution so threatens the monuments that some have been brought indoors.

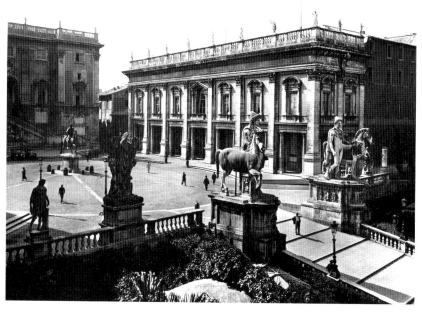

18-22. Michelangelo. Facade of the Palazzo dei Conservatori, Piazza del Campidoglio, Rome. c. 1563

until the seventeenth century, and Michelangelo's exquisite star design in the pavement was not installed until the twentieth century.

In 1537 the city council (the Conservatori) allotted funds to renovate the Palazzo dei Conservatori (fig. 18-22), which contained its offices and meeting rooms. Although only three bays of the new facade were finished by the time of Michelangelo's death in 1564, his repeating vertical elements were continued on the Conservatori facade and on the so-called Palazzo Nuovo facing it across the piazza (see fig. 18-21). The framework of the facade is formed by colossal Composite order pilasters raised on tall pedestals and supporting a wide architrave below the heavy cornice. Each ground-level bay opens into the deep portico through Ionic columns supporting their own architraves. On the main level above, although a wide central window was added later, the original

design called for identical bays, each with a narrow central window and a balcony flanked by **engaged columns** supporting **segmental pediments**. The horizontal orientation of the building is emphasized by the plain architrave below the balustrade of the roof and is then picked up below in the broken architrave above the portico.

Ever since the laying of the cornerstone for the new Saint Peter's by Julius II in 1506, Michelangelo had been well aware of the efforts of its architects, from Bramante to Raphael to Antonio da Sangallo. When Paul III offered the post to Michelangelo in 1546, he gladly accepted. By this time, the seventy-one-year-old sculptor was not just confident of his architectural expertise; he demanded the right to deal directly with the pope rather than through the committee of construction deputies. Michelangelo further shocked the deputies—but not the pope—by tearing down or canceling those parts of Sangallo's design

SAINT PETER'S BASILICA The history of Saint Peter's in Rome is an interesting case of the effects of individual and institutional conceits on the practical congregational needs of a major religious monument. The original church was built in the fourth century CE by Constantine, the first Christian Roman emperor, to mark the grave of the apostle Peter, the first bishop of Rome and therefore the first pope. Because this site was considered one of the holiest in the world, Constantine's architect had to build a monumental structure both to house Saint Peter's tomb and to accommodate the large crowds of pilgrims who came to visit it. To provide a platform for the church, a huge terrace was cut into the side of the Vatican Hill, in the midst of a cemetery across the Tiber River from the city. Here Constantine's architect erected a **basilica**, a type of Roman building used for law courts, markets, and other public gatherings. Like most basilicas, Saint Peter's had a long central chamber, or **nave**, with flanking side aisles set off by **colonnades**, and an **apse**, or large niche-like recess, set into the wall opposite the main door. To allow large numbers of visitors to approach the shrine a new feature was added: a **transept**, or long rectangular area at right angles to the nave. The rest of the church was, in effect, a covered cemetery, carpeted with the tombs of believers who wanted to be buried near the grave of the apostle. In front of the church was a walled forecourt, or **atrium**. When it was built, Constantine's basilica, as befitted an imperial commission, was one of the largest buildings in the world (interior length 368 feet; width 190 feet), and for more than a thousand years it was the most important pilgrim shrine in Europe.

In 1506 Pope Julius II (papacy 1503–1513) made the astonishing decision to demolish the Constantinian basilica, which had fallen into disrepair, and to replace it with a new building. That anyone, even a pope, had the nerve to pull down such a venerated building is an indication of the extraordinary sense of assurance of the age—and of Julius himself. To design and build the new church, the pope appointed Donato Bramante, who had only a few years earlier designed the Tempietto, a small, round, domed shrine at the site of Saint Peter's martyrdom (see fig. 18-20). Bramante envisioned the new Saint Peter's as a grander version of the Tempietto: a central-plan building, in this case a Greek cross (one with four arms of equal length) crowned by an enormous dome. This design was intended to continue the ancient Roman tradition of domed temples and round martyria, which had been revived by Filippo Brunelleschi in Florence Cathedral (fig. 17-30). In Renaissance thinking, the central plan and dome also symbolized the perfection of God.

The deaths of both pope and architect in 1513–1514 put a temporary halt to the project. Successive plans by the painter Raphael, the architect Antonio da Sangallo, and others changed the Greek cross to a Latin cross (one with three shorter arms and one long one) in order to provide the church with a full-length nave. However, when Michelangelo was appointed architect in 1546, he returned to the Greek-cross plan. Michelangelo simplified Bramante's design to create a single, unified space covered with a hemispherical dome. The dome was finally completed some years after Michelangelo's death by the Baroque architect Giacomo della Porta, who retained Michelangelo's basic design but gave the dome a taller and slimmer profile.

By the early seventeenth century the needs of the basilica had changed. During the Counter-Reformation the Church emphasized congregational worship, so more space was needed for people and processions. Moreover, it was felt that the new church should more closely resemble Old Saint Peter's and should extend over roughly the same area, including the ground covered by the atrium. In 1606, therefore, more than a hundred years after Julius II had initiated the project, Pope Paul V commissioned the architect Carlo Maderno to change Michelangelo's Greek-cross plan to a Latin-cross plan. Maderno extended the nave to its final length of slightly over 636 feet and added a Baroque facade (see fig. 19-3), thus completing Saint Peter's as it is today. Later in the seventeenth century the sculptor and architect Gianlorenzo Bernini monumentalized the square in front of the basilica by surrounding it with a great colonnade (see fig. 19-5).

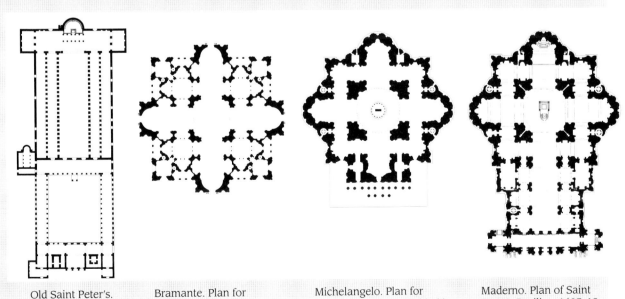

Old Saint Peter's. Early 4th century

Bramante. Plan for New Saint Peter's. 1506

Michelangelo. Plan for New Saint Peter's. 1546–64

Maderno. Plan of Saint Peter's Basilica. 1607–12

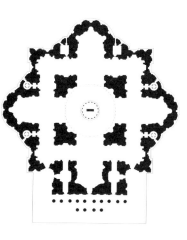

18-23. Michelangelo.
Plan for New
Saint Peter's,
Vatican, Rome.
c. 1546–64

that he found without merit. Ultimately, Michelangelo transformed the central-plan church (fig. 18-23) into a vast organic structure, in which the architectural elements work cohesively together like the muscles of a torso. Seventeenth-century additions and renovations dramatically changed the original plan of the church and the appearance of its interior, but Michelangelo's Saint Peter's can still be seen in the contrasting forms of the flat

18-24. Michelangelo. Saint Peter's Basilica, Vatican. c. 1546–64 (dome completed 1590 by Giacomo della Porta). View from the southwest

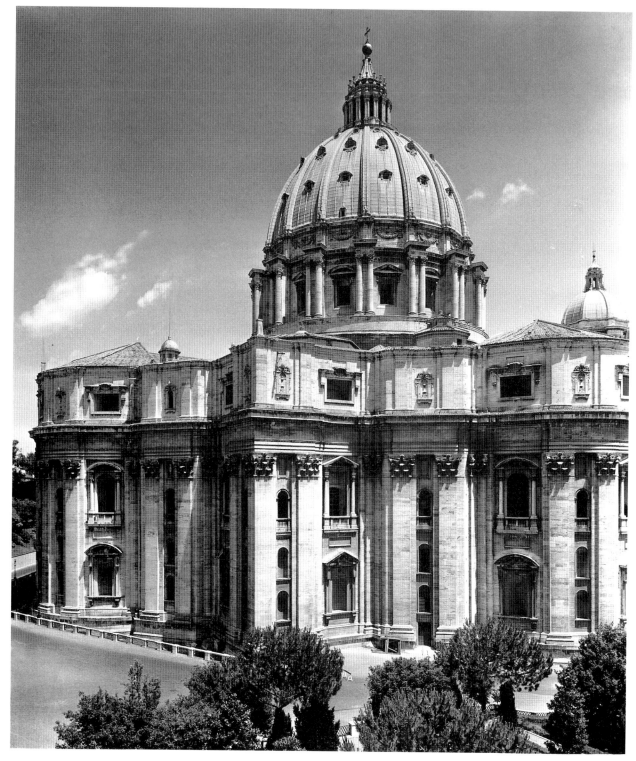

18-25. G.D. Falda. Cutaway view of the Villa Farnese, engraving from the *Cours d'Architecture* by A. C. Vaviler, published by Nicolas Langois, Paris, 1691. Bibliothèque Nationale, Paris

18-26. Vignola. Villa Farnese. 1559–73. Courtyard view

and angled walls and the three **hemicycles** (semicircular structures), whose colossal pilasters, **blind windows** (having no openings), and niches form the sanctuary of the church (fig. 18-24). The level above the heavy entablature was later given windows of a different shape. How Michelangelo would have built the great dome is not known; most scholars believe that he would have made it hemispherical. The dome that was actually erected, by Giacomo della Porta in 1588–1590, retains Michelangelo's basic design: a segmented dome with regularly spaced openings, resting on a high drum with pedimented windows between paired columns, and surmounted by a tall lantern reminiscent of Bramante's Tempietto. Della Porta's major changes were raising the dome height, narrowing its segmental bands, and changing the shape of its openings.

Vignola. Michelangelo designed the most prestigious buildings of sixteenth-century Rome, but there were far too much money, ambition, and demand for architectural skill for him to monopolize the field. One young artist who helped meet that demand was Giacomo Barozzi (1507–1573), called Vignola after his native town. He worked in Rome in the late 1530s surveying ancient Roman monuments and providing illustrations for an edition of Vitruvius, then worked from 1541 to 1543 in

France with Francesco Primaticcio at the Château of Fontainebleau. After Vignola returned, he secured the patronage of the Farnese family, for whom he designed and supervised the building of the Villa Farnese at Caprarola from 1558 until his death.

At Caprarola, Vignola used the fortress built there by Antonio da Sangallo the Younger as a foundation (podium) for his five-sided building. Unlike medieval castle builders, who had taken advantage of the natural contours of the land in their defenses, Renaissance architects imposed geometric forms on the land. Recently developed artillery made the high walls of medieval castles easy targets, so Renaissance engineers built horizontal rather than vertical structures against long-distance firepower. Wide bastions at the outer points of such fortresses provided firing platforms for the defenders' cannons.

Vignola's building rises in three stories around a circular courtyard (fig. 18-25). He decorated the external faces with an arrangement of circles, ovals, and rectangles, just as he had advised in his book *The Rule of the Five Orders of Architecture*, published in 1562. The building was vaulted throughout, and the interior was lighted with evenly spaced windows. The courtyard appears to have only two stories, but a third story of small service rooms is screened by an open, balustraded terrace (fig. 18-26).

THE ITALIAN RENAISSANCE SECRET GARDEN A special feature of Italian Renaissance palaces and villas was the secret garden, a hidden retreat created expressly for the enjoyment of its owners. Secret gardens became very popular in the hot Italian climate as places for intimate conversation and private contemplation, enhanced by the sound of water, the aromas and visual beauty of flowers and boxwood, and often amusing sculpture. Amid clipped hedges and fountains, the nobility could enjoy moments of privacy away from the prying eyes and idle gossip of their courtiers.

Italian architects were great designers of gardens. Alberti, for example, wrote that gardens should have walls as "Defense against Malice," but that they should also be on hillsides to catch the breezes and provide views of the countryside. With classical Renaissance taste, he recommended that plantings be in circles and squares and trees be planted in straight lines. Vignola, one of the greatest of all garden designers, combined formal gardens having fountains and geometric planting with mazes, cascades of water, woods, grottoes, and secret gardens. The grottoes were artificial caves complete with pools, cascades of water, slimy artificial moss, and statues. One of Vignola's most ingenious ideas was a fountain constructed as a stone banquet table, with water running through a trough in the center to cool bottles of wine.

The first and second stories are ringed with galleries, and like the Palazzo Medici-Riccardi in Florence (see fig. 17-34) the ground level is **rusticated**. On the second level, Ionic half columns form a triumphal-arch motif, and rectangular niches topped with blind arches echo the arched niches of the first-floor arcade. Behind the palace, formal gardens extended beyond the moat (see "The Italian Renaissance Secret Garden," page 703).

Painting in Venice

In the sixteenth century, although Venice remained an important economic and political center, its wealth declined relative to the great monarchies of France and Spain. Venice's chiefs of state, the doges, and the republic's prosperous merchants nevertheless patronized local artists enthusiastically. Venetian painters, beginning with the Bellini family in the late fifteenth century (see figs. 17-73, 17-74), developed a distinctive style and technique. They used the oil medium for painting on both canvas and wood panel (see "Painting on Canvas," below). Oil paint was particularly suited to the brilliant color and lighting effects of Venice's four major sixteenth-century painters: Giorgione, Titian, Tintoretto, and Veronese.

Giorgione and Titian. The careers of Giorgione (Giorgio da Castelfranco, c. 1477–1510), and Titian (Tiziano Vecelli, c. 1478?–1576), were closely bound together. Giorgione's period of activity was brief, and most scholars accept only four or five paintings as entirely by his hand. Nevertheless, his importance to Venetian painting is critical. His early life and training are undocumented, but his work suggests that he studied with Giovanni Bellini. There is also a hint of inspiration from Leonardo da Vinci's subtle lighting system and mysterious, intensely observed landscapes.

Giorgione's most famous work, called today *The Tempest* (fig. 18-27), was painted shortly before his death from the plague in 1510. The figures and setting are so unusual that our interest is piqued simply to try to understand what is happening in the picture. At the right a woman is seated on the ground, nude except for the end of a long piece of white material thrown over her shoulders. Her nudity seems maternal rather than erotic as she turns to nurse the baby sitting at her side on the cloth-covered ground. Across the dark, rock-edged spring stands a man wearing the costume of a German mercenary soldier. His head is turned toward the woman, but he appears to have paused for a moment before continuing to turn toward the viewer. Between them, a spring feeds a lake surrounded by a village of substantial houses, and in the far distance a bolt of lightning splits the darkening sky.

X rays of the painting show that the woman on the right was originally balanced on the left by another woman shown stepping into the spring and thus that Giorgione decided to alter his composition while he was still at work on it. This change seems to rule out any specific story as its subject matter. Some scholars have theorized that Giorgione approached his work as many modern-day artists do, by developing subjects in response to personal, private impulses, which he then expressed through his paintings.

Although *The Tempest* may have been painted purely for personal reasons, most of Giorgione's known works were of traditional subjects, produced on commission for clients: portraits, altarpieces, and frescoes to decorate the exterior walls of Venetian buildings. When given the commission in 1507 to paint the exterior of the Fondaco dei Tedeschi, the warehouse and offices of German merchants in Venice, Giorgione hired Titian as an assistant. Everything about Titian's life and career up to that time is

TECHNIQUE

PAINTING ON CANVAS

Although few good examples survive, canvas paintings—chiefly in **tempera** on linen—were common in the late fifteenth century. From contracts and payment accounts, most of these paintings appear to have been decorations for private homes. Many may have served as inexpensive substitutes for tapestries, but records show that small, framed pictures of various subjects were also common. There are also instances of copies made on canvas of religious works for the patrons who had commissioned the originals for a church. Canvas paintings were clearly considered less important and less expensive than frescoes until the Venetians began to exploit the technique of painting with **oils** on canvas in the late fifteenth century.

A recent scientific study of Titian's paintings reveals that he ground his pigments much finer than earlier panel painters had. The complicated process by which he produced many of his works began with a charcoal drawing on the prime coat of lead white that was used to seal the pores and smooth the surface of the rather coarse Venetian canvas. The artist then built up the forms with fine glazes of color laid on with brushes, sometimes in as many as ten to fifteen layers. Because patrons customarily paid for paintings according to the painting's size and how richly the paint was applied, thinly painted works may reflect the patron's finances rather than the artist's choice of technique.

The use of large canvas paintings instead of frescoes for wall decoration developed in Venice, then spread elsewhere. Painting on canvas allowed greater flexibility to artists, who could complete the work in their studios and then carry the rolls of canvas to the location where they were to be installed. Because oils dried slowly, errors could be corrected and changes made easily during the work. Thus, the flexibility of the canvas support, coupled with the radiance and depth of oil-suspended color pigments, eventually made oil painting on canvas the almost universally preferred medium.

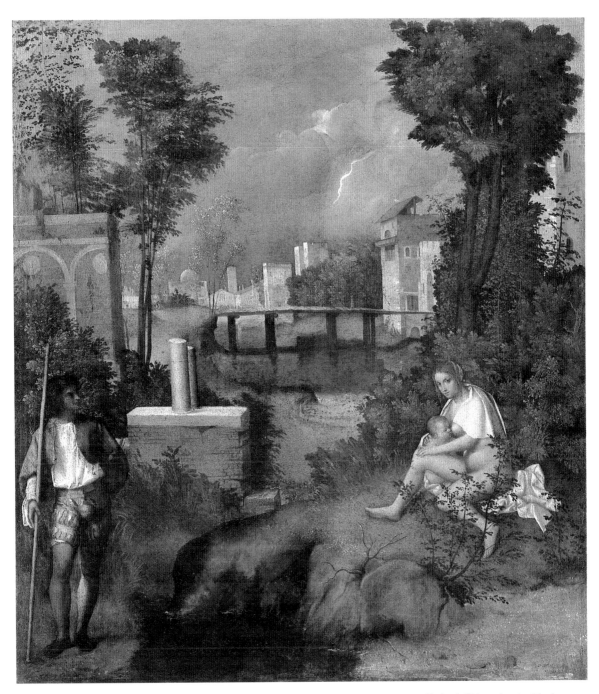

18-27. Giorgione. *The Tempest*. c. 1510. Oil on canvas, 31 x 28³/₄" (79.4 x 73 cm). Galleria dell'Accademia, Venice

Recent literature offers many attempts to explain this enigmatic picture, a number of which are so well reasoned that any of them might be a solution to the mystery. However, the subject of the painting, which has so preoccupied twentieth-century art historians, seems not to have particularly intrigued sixteenth-century observers, one of whom described the painting matter-of-factly in 1530 as a small landscape in a storm with a gypsy woman and a soldier.

obscure, including his age, which was given at his death in 1576 as 103 (now considered erroneous). He supposedly began an apprenticeship as a mosaicist, then studied painting under Gentile and Giovanni Bellini. His first documented work, the Fondaco frescoes, completed in 1508, has been destroyed except for a fragment of a Giorgionesque female nude preserved in the Accademia museum of Venice. Whatever Titian's work was like before that time, he had completely absorbed Giorgione's style by the time the artist died two years later and Titian completed

Giorgione's work. Having built on the success of the Fondaco frescoes, Titian was made official painter to the Republic of Venice when Giovanni Bellini died in 1516.

In 1529, Titian, who was well known outside the republic, began a long professional relationship with Emperor Charles V, who vowed to let no one else paint his portrait. Shortly after being elevated by Charles to noble rank in 1533, Titian was commissioned to paint the portrait of Isabella d'Este (see "Women Patrons of the Arts," see page 706). Isabella was past sixty when

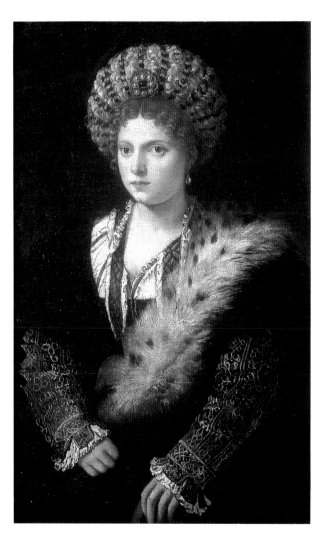

18-28. Titian. *Isabella d'Este*. 1534–36. Oil on canvas,
40¹/₈ x 25³/₁₆" (102 x 64.1 cm). Kunsthistorisches
Museum, Vienna

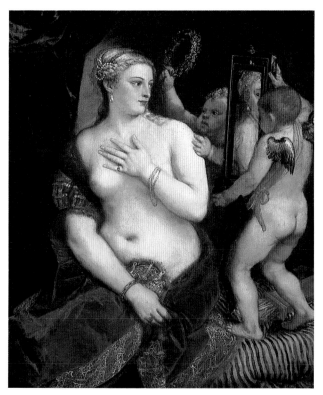

18-29. Titian. *Venus with a Mirror*. c. 1555. Oil on canvas,
49 x 41¹/₂" (124.5 x 105.5 cm). National Gallery of Art,
Washington, D.C.

Andrew W. Mellon Collection

X rays of this painting reveal that Titian reused a hori-
zontal canvas on which he had first painted a double
portrait of a man and woman. Turning the canvas
from horizontal to vertical, he then covered the por-
traits with a Venus clothed in a white filmy garment.
Finally he painted the painting we see today. Evidently
he was particularly pleased with the way he had
painted the red velvet and fur garment drawn across
Venus's lap, for that element survived from the earli-
est of the three paintings on the canvas, in which it
was the man's coat.

Titian portrayed her in 1534–1536 (fig. 18-28), but she
asked to appear as she had in her twenties. A true magi-
cian of portraiture, Titian was able to satisfy her wish by
referring to an early portrait by another artist while also
conveying the mature Isabella's strength, self-confidence,

and energy. No photograph can convey the vibrancy of
Titian's paint surfaces, which he built up in layers of indi-
vidual brushstrokes in pure colors, chiefly red, white, yel-
low, and black. According to a contemporary, Titian
could make "an excellent figure appear in four brush-

WOMEN PATRONS OF THE ARTS In the sixteenth century many wealthy women, from both the aristocracy and the merchant class, were enthusiastic patrons of the arts. Two English queens, the Tudor half sisters Mary I and Elizabeth I, glorified their combined reigns of half a century with the aid of court artists, as did most sovereigns of the period. The Habsburg princesses Margaret of Austria and Mary of Hungary presided over brilliant humanist courts when they were regents of the Netherlands. But

perhaps the Renaissance's greatest woman patron of the arts was the marchesa of Mantua, Isabella d'Este (1474–1539), who gathered painters, musicians, composers, writers, and literary scholars around her. Married to Francesco II Gonzaga at age fifteen, she had great beauty, great wealth, and a brilliant mind that made her a successful diplomat and administrator. A true Renaissance woman, her motto was the epitome of rational thinking—"Neither Hope nor Fear." An avid reader and collector of manuscripts and books, while

still in her twenties she sponsored an edition of Virgil. She also collected ancient art and objects, as well as works by contemporary Italian artists such as Botticelli, Mantegna, Perugino, Correggio, and Titian. Her *grotto*, or cave, as she called her study in the Mantuan palace, was a veritable museum for her collections. The walls above the storage and display cabinets were painted in fresco by Mantegna, and the carved wood ceiling was covered with mottos and visual references to Isabella's impressive literary interests.

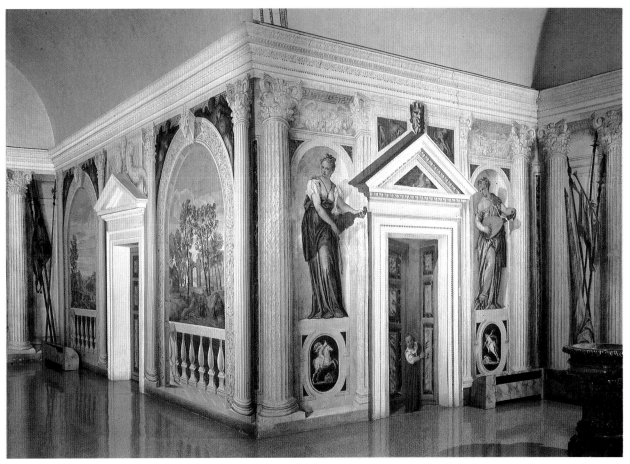

18-30. Veronese. Trompe l'oeil fresco, main reception hall, Villa Barbaro, Maser, Venetia, Italy. c. 1561

strokes." His technique was admirably suited to the creation of female nudes, whose flesh seems to glow with an incandescent light. Charles V's son Philip II of Spain was so fond of Titian's nudes that he had a special room built to enjoy them in private. Typical of such paintings is *Venus with a Mirror* (fig. 18-29), of about 1555. The sensuous quality of these works suggests that Titian was as inspired by flesh-and-blood beauty as by any source from mythology or the history of art.

As in his portraits, Titian has played the textures—velvet, fur, flesh, hair, gold, silver, and pearls—against each other with such virtuosity that they dominate the image. The goddess of love at first appears to be admiring herself in a mirror held by one cupid while another holds a wreath over her head. But, as the viewer's gaze follows hers to the mirror image, it becomes apparent that Venus is not looking at herself; instead, she appears to scrutinize a viewer who is gazing at her voluptuous form. Titian evidently painted this canvas for himself, for he kept it in his home until his death.

Veronese. The paintings of Veronese (Paolo Caliari, 1528–1588), called Veronese after his home town of Verona, are nearly synonymous today with the popular image of Venice as a splendid city of pleasure and pageantry sustained by a nominally republican government and great mercantile wealth. His elaborate architectural settings and costumes, still lifes, anecdotal vignettes, and other everyday details unconnected with the main subject proved immensely appealing to Venetian patrons.

Much of Veronese's work was wall and ceiling paintings, often for monasteries and convents. Between 1559 and 1561, however, he decorated the interior of a villa built in nearby Maser by the architect Palladio. Among these works are the fanciful, trompe l'oeil murals in the main reception hall (fig. 18-30). The only real architectural forms here, other than the plain wall surfaces, are the doorframes and the heavy classical cornice below the point where the **cove ceiling** (a ceiling that is concave) meets the wall. Below this, a trompe l'oeil cornice is supported by Composite order columns. At the left, the wall appears to be a **loggia**, or gallery, opening onto distant landscape views through carved arches whose projecting **keystones** (central stones) are decorated with ram's heads. At the right, painted "statues" of female musicians stand in niches above an inlaid marble dado. A charming surprise is a little girl peeking out from behind double doors.

Veronese's most famous work is the religious painting of 1573 now called *Feast in the House of Levi* (see fig. 18-1), painted for the Dominican Monastery of Santi Giovanni e Paolo, Venice. At first glance the true subject of this painting seems to be architecture, with the users of the space secondary to it. The house is represented by an enormous loggia entered through colossal triumphal arches. Beyond the loggia an imaginary city of white marble gleams in the distance. The size of the canvas allowed Veronese to make his figures realistically proportional to the architectural setting without losing their substance. He also maintained visual balance by giving the figures exaggerated, theatrical gestures and poses.

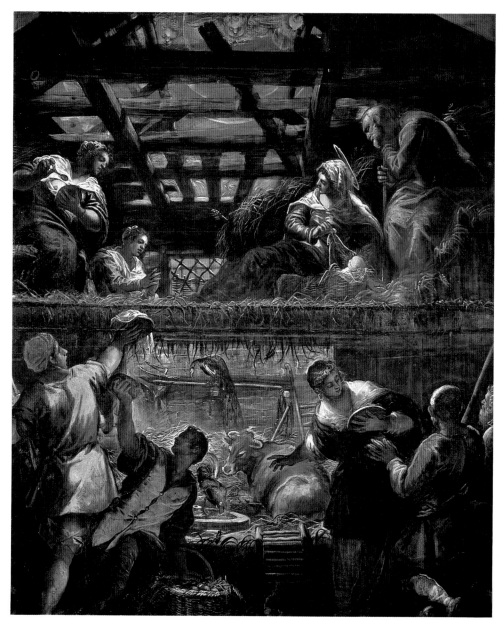

18-31. Tintoretto. *Nativity*. 1577–81. Oil on canvas, 17'9" x 14'4" (5.41 x 4.37 m). Sala Grande, Scuola Grande di San Rocco, Venice

Tintoretto, who ran a large workshop, often developed a composition by creating a small-scale model like a miniature stage set, which he populated with wax figures. He then adjusted the positions of the figures and the lighting until he was satisfied with the entire scene. Using a grid of horizontal and vertical threads placed in front of this model, he could easily sketch the composition onto squared paper for his assistants to recopy onto a large canvas. His assistants also primed the canvas, blocking in the areas of dark and light, before the artist himself, now free to concentrate on the most difficult passages, finished the painting. This efficient working method allowed Tintoretto's shop to produce a large number of paintings in all sizes.

Tintoretto. The fourth great painter of the Venetian Renaissance, Jacopo Robusti (1518–1594), called Tintoretto, worked in a style that developed from, and exaggerated, the techniques of Titian. Tintoretto ("little dyer"), nicknamed for his father's trade, was reportedly apprenticed in Titian's shop. His goal, declared on a sign in his studio, was to combine his master's color with the drawing ability of Michelangelo. The speed with which Tintoretto drew and painted was the subject of comment in his own time and of legends thereafter, and indeed, his

brilliance and immediacy were often derided in the past as carelessness. Certainly his rapid brushwork contrasted dramatically with Titian's meticulous strokes. Nevertheless, Tintoretto's visibly dynamic technique, strong colors, and bright highlights created a pictorial mood of intense spirituality that appealed to many Venetian patrons.

Like Veronese, Tintoretto often received commissions to decorate huge interior spaces. A particularly fine canvas is his *Nativity* (fig. 18-31), painted for the main hall of the Scuola Grande di San Rocco in 1577–1581. The

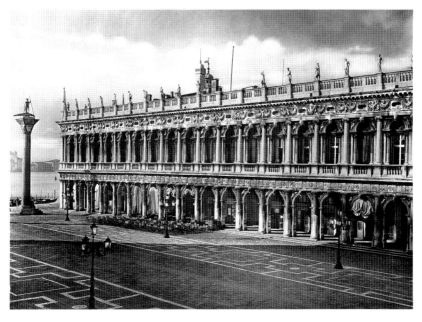

18-32. Jacopo Sansovino. Library of San Marco, Piazza San Marco, Venice. 1536

dramatic lighting of the figures in their darkened setting is reminiscent of Leonardo's *Virgin and Saint Anne* (see fig. 18-3). Like Leonardo, Tintoretto moves the viewer's eye in a circular orbit around his composition, which he staged elaborately in a two-story stable. On the lower level are farm animals and kneeling peasants, who might be looking up at a lifesize Christmas scene. On the second level, the Holy Family is adored by two women bearing gifts, probably the midwives traditionally thought to have assisted at Jesus' birth. The rafters open to a red-orange sky swimming with cherubs, who gaze down at the scene. Like Veronese, Tintoretto has given his figures broad theatrical poses that enhance the emotional impact of the scene.

Tintoretto may have seemed to paint so rapidly because he organized a large workshop, which included other members of his family. Of his eight children, four became artists. His oldest child, Marietta Robusti, worked with him as a portrait painter, and two or perhaps three of his sons also joined the shop. Another daughter, famous for her needlework, became a nun. Marietta, in spite of her fame and many commissions, stayed in her father's shop until she died, at the age of thirty. So skillfully did she capture her father's style and technique that today art historians cannot be certain which paintings are hers.

Architecture in Venice and the Veneto

The Sack of Rome in 1527 benefited other Italian cities when artists fled for their livelihoods, if not for their lives. Venice had long been a vital Renaissance architectural center with its own traditions, but the field was empty when the Florentine sculptor Jacopo Sansovino arrived there from Rome. As a result, Sansovino became the most important architect of the mid-sixteenth century in Venice. The second half of the century was dominated by Andrea Palladio, a brilliant artist from the Veneto,

the mainland region ruled by Venice. Palladio brought Venetian Renaissance architecture to its grand conclusion with his villas, palaces, and churches.

Jacopo Sansovino. Soon after settling in Venice, Sansovino was appointed to renovate the Piazza San Marco, the great square in front of the Church of San Marco. In 1536 he created a model for a new library on the south side of the **piazza**, or open square (fig. 18-32), inspired by such classical structures as the Colosseum in Rome, which featured regular bays of superimposed orders. The flexibility of this design, with identical modules that can be repeated indefinitely, is reflected in the history of the Library of San Marco. It was opened after the first seven bays were completed at the end of 1546. Then, between 1551 and 1554, seven more bays were added, and in 1589, nearly two decades after the architect's death, more bays were added to provide office space.

Drawing upon his earlier experience as a sculptor, Sansovino enriched the facade with elaborate spandrel figures and a frieze of putti and garlands. The roofline balustrade surmounted at regular intervals by statues elegantly emphasizes the horizontal orientation of the building. Although Michelangelo never saw the library, he reinterpreted the same classical elements in his own powerful manner on the new facade of the Palazzo dei Conservatori in Rome (see fig. 18-22). The library also had a great impact on a young architect from Vicenza, Andrea Palladio, who proclaimed it "the richest and most ornate" building since antiquity.

Palladio. Probably born in Padua, Palladio (Andrea di Pietro, 1508–1580) began his career as a stonecutter. After moving to Vicenza, he was hired by the noble humanist scholar and amateur architect Giangiorgio Trissino. Trissino made him a protégé and nicknamed him Palladio, a name derived from Pallas, the Greek goddess of wisdom, and the fourth-century Roman writer

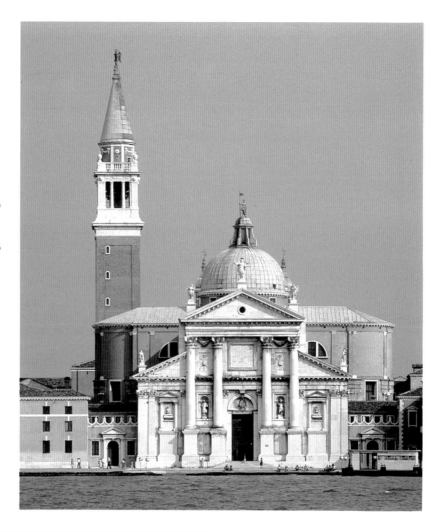

18-33. Palladio. Church of San Giorgio Maggiore, Venice. Begun 1566

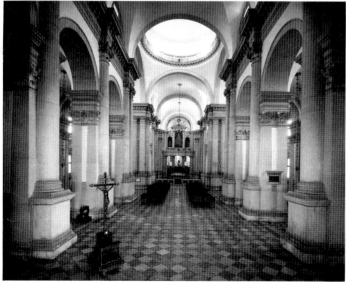

18-34. Palladio. Nave, Church of San Giorgio Maggiore

Palladius. Palladio learned Latin at Trissino's small academy and accompanied his benefactor on three trips to Rome, where Palladio made drawings of Roman monuments. Over the years he became involved in several publishing ventures, including a guide to Roman antiquities, an illustrated edition of Vitruvius, and books on architecture that for centuries were valuable resources for architectural design.

By 1559, when he settled in Venice, Palladio was one of the foremost architects of Italy. About 1566 he undertook a major architectural commission: the monastery Church of San Giorgio Maggiore on the Venetian islet of San Giorgio (fig. 18-33). His design for the Renaissance facade to the traditional basilica-plan elevation—a wide lower level fronting the nave and side aisles, surmounted by a narrower front for the nave clerestory—is the height of ingenuity. Inspired by Leon Battista Alberti's solution for Sant'Andrea in Mantua (see fig. 17-57), Palladio created the illusion of two temple fronts of different heights and widths, one set inside the other. At the center, colossal columns on high pedestals, or bases, support an entablature and pediment that front the narrower clerestory level of the church. The lower "temple front," which covers the triple-aisle width and slanted side-aisle roofs, consists of pilasters supporting an entablature and pediment running behind the columns of the taller clerestory front. Palladio retained Alberti's motif of the triumphal-arch entrance. Although the facade was not built until after the architect's death, his original design was followed.

The interior of San Giorgio (fig. 18-34) is a fine example of Palladio's harmoniously balanced geometry, expressed here in strong verticals and powerful arcs. The tall engaged columns and shorter pairs of pilasters of the

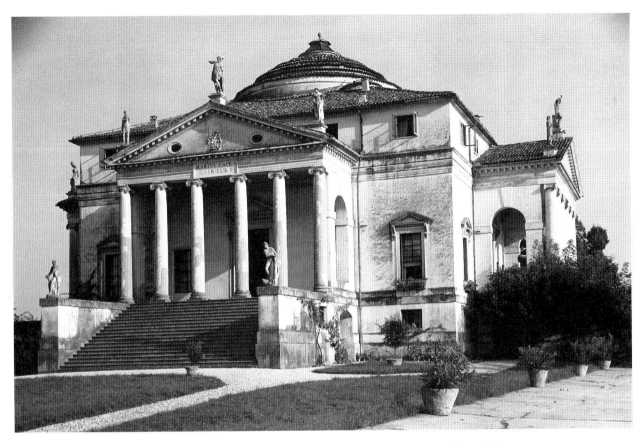

18-35. Palladio. Villa Rotonda (Villa Capra), Vicenza, Venetia, Italy. 1566–69

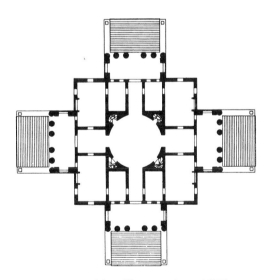

18-36. Palladio. Plan of the Villa Rotonda. c. 1550?

Palladio was a scholar and an architectural theorist as well as a designer of buildings. His books on architecture provided ideal plans for country estates, using proportions derived from ancient Roman structures. Despite their theoretical bent, his writings were often more practical than earlier treatises. Perhaps his early experience as a stonemason provided him with the knowledge and self-confidence to approach technical problems and discuss them as clearly as he did theories of ideal proportion and uses of the Classical orders. By the eighteenth century Palladio's *Four Books of Architecture* had become part of the library of most educated people. Thomas Jefferson had one of the first copies in America.

nave arcade echo the two levels of orders on the facade, thus unifying the exterior and interior of the building.

Palladio's diversity can best be seen in numerous villas built early in his career. In 1550 he started his most famous villa, just outside Vicenza (fig. 18-35). Although most rural villas were working farms, Palladio designed this one as a retreat for relaxation. To afford views of the countryside, he placed an Ionic order porch on each face of the building, with a wide staircase leading up to it. The main living quarters are on the second level, and the lower level is reserved for the kitchen and other utility rooms. Upon its completion in 1569, the villa was dubbed the Villa Rotonda because it had been inspired by another rotonda (round hall), the Roman Pantheon. After its purchase in 1591 by the Capra family, it became known as the Villa Capra. The villa plan (fig. 18-36) shows the geometrical clarity of Palladio's conception: a circle inscribed in a small square inside a larger square, with symmetrical rectangular compartments and identical rectangular projections from each of its faces. The use of a central dome on a domestic building was a daring innovation that effectively secularized the dome. The Villa Rotonda was the first of what was to become a long tradition of domed country houses, particularly in England and the United States.

18-37. Rosso Fiorentino. *Dead Christ with Angels.* 1524–27. Oil on panel, 52½ x 41" (133.5 x 104.1 cm). Museum of Fine Arts, Boston

Charles Potter King Fund

ITALIAN MANNERISM

The term *Mannerism* comes from the Italian *maniera*, a term used in the sixteenth century to mean charm, grace, or even playfulness and suggesting art concerned with formal beauty for its own sake rather than idealized nature according to Renaissance conventions. In the seventeenth century and later, many critics used the word disparagingly for work they considered superficial, overly ornate, frivolous, or lacking in serious intent. Later, nineteenth-century scholars adopted Mannerism as a convenient category for any sixteenth-century art that did not fit stylistically into the classical Renaissance style.

For this discussion, Mannerism is considered the stylistic movement that emerged at about the same time as the classical Renaissance but had its own aims, rhythms, and sources of influence, which often allowed artistic scope for considerable experimentation and individual expression. Mannerism, which was stimulated and supported by court patronage, arose in Florence and Rome before 1520 first in painting, then in other mediums, and was spread to other locations when the artists traveled. The major Mannerist artists—Rosso Fiorentino, Pontormo, Parmigianino, Bronzino, Giulio Romano, and Primaticcio—were admirers of and were inspired by the great leaders of the earlier generation, Leonardo da Vinci, Raphael, and Michelangelo.

Any attempt to define Mannerism as a single style is futile, but certain characteristics were common: extraordinary virtuosity; sophisticated, elegant compositions; and fearless manipulations or distortions of accepted conventions of form. Paintings often exhibited irrational spatial development and figures with elongated proportions, exaggerated poses, and enigmatic gestures and facial expressions. Some artists favored obscure, unsettling, and oftentimes erotic imagery; unusual color use and juxtapositions; and unfathomable main subjects or secondary scenes. Mannerist sculpture generally exhibited the same characteristics as figural painting, especially in distorted, exaggerated body forms and poses. The sculptors also tended to prefer small size, the use of precious metals, and exquisite technical execution. Mannerist architecture involved defiance of the conventional applications of the Classical orders and reversals of the expected uniformity and rationality of elevation design, rather than structural innovations.

18-38. Pontormo. *Entombment.* 1525–28. Oil on panel, 10'3" x 6'4" (3.12 x 1.93 m). Capponi Chapel, Church of Santa Felicità, Florence

Painting

Mannerism as a style that is clearly differentiated from the classical Renaissance approach began in painting in the second decade of the sixteenth century. In Rome Raphael had already moved in a distinctly Mannerist direction in the last of his decorations in the Vatican before his death in 1520, and in Florence the first wave of Mannerist painters was already emerging. Some scholars have connected their ambiguous, unsettling new tendencies with the famine, plague, and constant war that then troubled Italy. Others have seen, instead, a formal relationship between the new painting styles and the aesthetic theories that began to appear at this time.

An early leader of the Mannerist movement was the Florentine painter known as Rosso Fiorentino (1495–1540), who later carried his style to the renovation of the Château of Fontainebleau. Rosso's *Dead Christ with Angels,* of about 1524–1527, painted while he was working in Rome, exhibits many general Mannerist characteristics (fig. 18-37). The figure of Jesus fills the picture plane and seems to press forward into the viewer's space, its exaggerated **Z** shape providing an odd combination of contortion and almost erotic grace. All traces of the final tortured moments of the Crucifixion have been eliminated. The beautiful candle-bearing angels with curly golden hair and exquisitely colored costumes are a vivid and disturbing contrast to the enormous corpse, which they effortlessly support on a colorful shroud. Although the scene has been traditionally identified as a Deposition, it has also been interpreted as the first moment of Resurrection in the tomb, with Christ's eyes just beginning to flicker open. Supporting this hypothesis are the claustrophobic spacelessness of the painting that seems to deny the material world, the unmarked flesh of the Savior, whose wounds seem to have disappeared, and a mood that has no trace of mourning or despair.

Rosso's contemporary, with whom he may have worked in Florence in 1512, Jacopo da Pontormo (1494–1557), was a highly regarded religious painter and a favorite of the Medici ruling family. Pontormo's *Entombment* (fig. 18-38) was painted about 1525–1528 for the Church of Santa Felicità in Florence. Like Rosso's painting, its subject is ambiguous. The rocky ground and cloudy sky give only the faintest sense of location in space, which is immediately confused by the arrangement of the

18-39. Parmigianino. *Madonna with the Long Neck.* c. 1535. Oil on panel, 7'1" x 4'4" (2.16 x 1.32 m). Galleria degli Uffizi, Florence

figures, who are either levitating or standing on a ring of boulders in the rocky terrain. Pontormo seems to have chosen a moment just after Jesus' removal from the Cross, when the youths who have lowered him have paused to regain their composure. The large green bundle of cloth below Jesus apparently represents the shroud brought for his entombment. The emotional atmosphere of the scene is expressed in a range of facial expressions, odd poses, drastic shifts in scale, and unusual costumes, but perhaps most poignantly in the dramatic use of color. The palette is predominantly blue and pink with accents of olive green, gray, scarlet, and creamy white. The overall tone of the picture is set by the color treatment of the crouching youth, whose bright pink torso is shaded in iridescent, pale gray-green.

When Parmigianino (Francesco Mazzola, 1503–1540) arrived in Rome from his native Parma in 1524, the strongest influence on his work had been Correggio, who had completed major works in Parma before the younger artist's departure. While in Rome, Parmigianino met Mannerists Rosso Fiorentino and Giulio Romano, and he also studied Raphael and Michelangelo. His genius was to assimilate what he saw into his own distinctive style of Mannerism with none of the nervous, sharply unsettling qualities of Rosso's or Pontormo's works. Three years later, he was captured and imprisoned briefly during the 1527 Sack of Rome, after which he went first to Bologna, then to Parma, where he lived until his death. Dating from 1535 is an unfinished painting known as the *Madonna with the Long Neck* (fig. 18-39). The elongated figure of the Madonna, whose massive legs and lower torso contrast with her narrow shoulders and long neck, was clearly conceived to resemble the large metal vase inexplicably being carried by the youth at the left. The Madonna's neck also seems to echo the very tall white columns placed, equally mysteriously, in the middle distance. The painting has been interpreted as an abstract conception of beauty in which the female body is compared to the forms of Classical columns and vases, an aesthetic ideal illustrated by Raphael in his later *stanze* paintings. Like Rosso and Pontormo, Parmigianino presents a common religious image in a manner calculated to unsettle viewers. Are the young people at the left grown-up cherubs or wingless angels? Is the man with the scroll at the right an architect or an Old Testament prophet, perhaps Isaiah, who foretold the birth of Christ? There may be some truth in the explanation given by the theorist Celio Calcagnini (d. 1541): Mannerist taste is admiration for things "that are beautiful just because they are deformed, and thus please by giving displeasure" (cited in Shearman, page 156).

Bronzino (Agnolo Tori, 1503–1572), who got the nickname "Copper-Colored" because of his dark complexion, was born near Florence. He became Pontormo's assistant about 1522. He established his own workshop in 1530 but continued to work with Pontormo occasionally on large projects until the older artist's death. In 1540 Bronzino became court painter to the Medici. Although he was a versatile artist who produced altarpieces, fresco decorations, and tapestry designs over his long career, he is best known today for his portraits in the courtly Mannerist style. *Ugolino Martelli,* of about 1535 (fig. 18-40), demonstrates Bronzino's characteristic portrayal of his subjects as intelligent, aloof, elegant, and self-assured. Bronzino's virtuosity in rendering costumes and settings sometimes dominates his compositions, creating a rather cold and formal effect. On the other hand, the calm, self-contained demeanor of his subjects admirably conveys a sense of the force of their personalities, and the wealth and elegance suggested in these portraits were highly prized by his patrons.

Northern Italy, more than any other part of the peninsula, produced a number of gifted woman artists. Sofonisba Anguissola (1528–1625), born into a noble family in Cremona, was unusual in that she was not the daughter of an artist. Her father gave his six daughters the same humanistic education as his one son, and he encouraged them all to pursue careers in literature, music, and especially painting. Anguissola's proud father consulted Michelangelo about her artistic talents in 1557, asking for a drawing that she might copy and return to be

18-40. Bronzino. *Ugolino Martelli*. c. 1535. Oil on panel, 44¹/₈ x 33¹/₂" (102 x 85 cm). Staatliche Museen zu Berlin, Preussischer Kulturbesitz, Gemäldegalerie

critiqued. Michelangelo not only obliged but also set another task for young Anguissola; she was to send him a drawing of a crying boy. Her sketch of a girl comforting a small boy, wailing because a crayfish is biting his finger, so impressed Michelangelo that he gave it as a gift to his closest friend, who later presented it, along with a drawing by Michelangelo, to Cosimo I de' Medici.

Giorgio Vasari wrote admiringly of the Anguissola sisters' painting, especially a work by Sofonisba that portrayed two of her sisters playing chess while a younger

18-41. Sofonisba
Anguissola.
*The Sisters of the
Artist and Their
Governess.* 1555.
Oil on canvas,
27⁹/₁₆ x 37"
(70 x 94 cm). Na-
rodowe Museum,
Poznan, Poland

18-42. Lavinia
Fontana. *Noli
Me Tangere.*
1581. Oil on
canvas,
47³/₈ x 36⁵/₈"
(120.3 x 93
cm). Galleria
degli Uffizi,
Florence

child and a governess watch (fig. 18-41). Painted in 1555, this canvas anticipates later highly popular group portraits of people engaged in everyday activities. There is a faint echo of Leonardo da Vinci's style in the facial expressions, the softly modeled forms, and the smoky unifying tone of the painting.

In 1560, Sofonisba accepted the invitation of the queen of Spain to become an official court painter, a post she held for twenty years. In a 1582 Spanish inventory, Sofonisba is described as "an excellent painter of portraits above all the painters of this time," extraordinary

praise in a court that patronized Titian and Antonis Mor, discussed later. Unfortunately, most of Sofonisba's Spanish works were lost in a seventeenth-century palace fire.

Another northern Italian, Lavinia Fontana (1552–1614), learned to paint from her father, a Bolognese follower of Raphael. By the 1570s, she was a highly respected painter of narrative as well as of portraits, the more usual field for women artists of the time. Her success was so well rewarded, in fact, that her husband, the painter Gian Paolo Zappi, eventually gave up his own artistic career to care for their large family and help

Lavinia with such technical aspects of her work as framing. This situation would not have been very unusual in Bologna, which boasted some two dozen women painters as well as a number of women scholars who lectured at the university in a variety of subjects, including law. While still in her twenties, Lavinia painted the *Noli Me Tangere* of 1581 (fig. 18-42), illustrating the biblical story of Christ revealing himself for the first time following his Resurrection to Mary Magdalen (Mark 16:9, John 20:17). The Latin title of the painting means "Don't touch me," Christ's words when she moved to embrace him, explaining that he now existed in a new form somewhere between physical and spiritual. Christ's costume refers to the passage in the Gospel of John, which says that the Magdalen at first mistook Christ for a gardener.

In 1603, Lavinia moved to Rome as an official painter to the papal court. She also soon came to the attention of the Habsburgs, who paid large sums for her work. In 1611, she was honored with a commemorative medal portraying her in a bust as a dignified, elegantly coiffed woman on one side and as an intensely preoccupied artist with rolled-up sleeves and wild, uncombed hair on the other.

Sculpture

Probably the most influential sculptor in Italy in the second half of the sixteenth century was the Flemish artist Jean de Boulogne, better known by his Italian name, Giovanni da Bologna (1529–1608). Born in Flanders, he settled by 1557 in Florence, where both the Medici family and the sizable Netherlandish community there were his patrons. Not only did he influence a later generation of Italian sculptors, but he also spread the Mannerist style to the north through artists who came to study his work.

Although greatly influenced by Michelangelo, Giovanni's distinctive style was generally more concerned with graceful forms and poses, as in his gilded bronze *Astronomy,* or *Venus Urania,* of about 1573 (fig. 18-43). Beginning with a Classical prototype of Venus, Giovanni designed the statuette to be seen from any viewpoint rather than from the front only, a much more difficult task for a single figure than for a group, such as Sansovino's *Bacchus* (see fig. 18-10). Straining the limits of the human body, the sculptor twisted Venus's upper torso and arms to the far right and extended her neck in the opposite direction, so that her chin was over her right shoulder. The elaborate coiffure of tight ringlets and the detailed textural engraving of the drapery contrast strikingly with the smooth, gleaming flesh of Venus's body. The figure's identity is suggested by the astronomical device on the base of the **plinth**. Following common practice for cast-metal sculpture, this statuette was replicated in Giovanni's shop several times for various patrons.

18-43. Giovanni da Bologna. *Astronomy,* or *Venus Urania.* c. 1573. Bronze gilt, height 15¼" (38.8 cm). Kunsthistorisches Museum, Vienna

Architecture

Mannerist architecture referred to Classical conventions only to reject them. An important early exponent of architectural Mannerism was Raphael's student Giulio Romano. While Giulio remained attached to the Classical

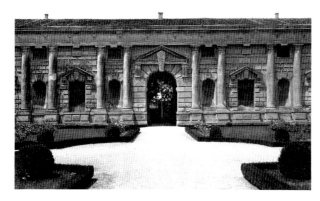

18-44. Giulio Romano. Palazzo del Tè, Mantua. 1525–32.
Courtyard facade

modes, he brought a studied playfulness to his building designs and interior decoration. Giulio's inventive use of traditional forms would inspire later architects.

Giulio Romano. After Raphael's death in 1520, Giulio Romano (1492–1546) completed his unfinished painted works and began the fresco decoration of the last Vatican *stanza*. In 1524, however, he accepted an offer from

the ruling Gonzaga family to become their court artist in Mantua, where he spent the rest of his life. He carried out a number of architectural commissions there, but the only well-preserved example is the Palazzo del Tè (fig. 18-44), built on a small nearby island between 1525 and 1532. A country villa rather than a palace, it was used for entertaining, which allowed an opportunity for fanciful architectural treatment.

The basic plan is a conventional Renaissance conception: a one-story square building with four wings enclosing a central court. However, the inside face of the east wing, illustrated here, looks more like a fortress than a porticoed Renaissance-style courtyard (see fig. 18-26). Giulio has used the Doric order, but with typically Mannerist variations. The columns, resting on bases, form with the entablature a projecting screen in front of the rusticated stucco wall. Rather than being evenly spaced, the columns flank a large arched entrance and wall niches of two different sizes. The building's windows are small rectangles that seem to float just under the architrave. The oddest features are the dropped **triglyphs** (three-grooved blocks) on the architrave at the center of each expanse of space between the columns. The sophisticated Mannerist wit of these irregularities would have been apparent only to viewers familiar with Classical architectural theory.

In the interior, Giulio created illusions that everyone could quickly appreciate. In the Sala dei Giganti ("Room

18-45. Giulio Romano. *Fall of the Giants*, fresco in the Sala dei Giganti, Palazzo del Tè. 1530–32

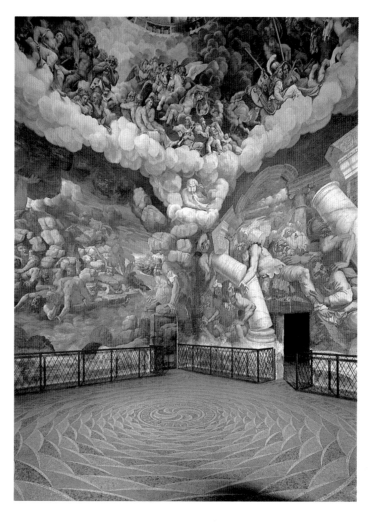

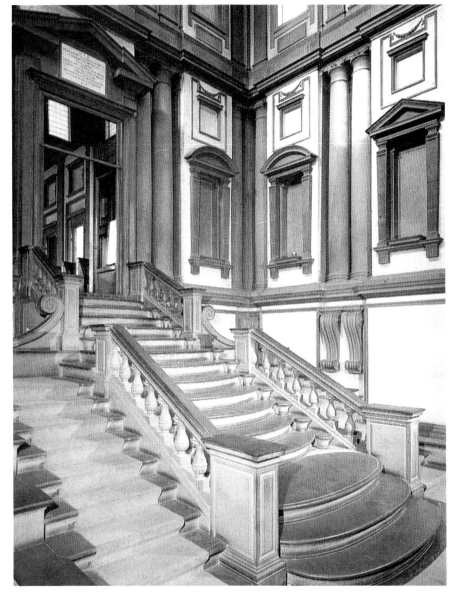

18-46. Michelangelo. Vestibule of the Laurentian Library, Monastery of San Lorenzo, Florence. 1524–33; staircase completed 1559

of the Giants"), he used the entire space—walls, ceiling, and floor—to create the effect that the viewer was in the midst of the mythological battle of the gods and Giants (fig. 18-45). The ceiling depicts the palace of Jupiter floating on a ring of billowing clouds. From its safety, the king of the gods hurls down thunderbolts on the Giants, who are crushed by falling buildings and rocks crashing down from the mountains. In its original form, the room had a fireplace made to look as though its stones were also crumbling and a floor paved with stones cut to mask the division between it and the illusionistic wall paintings.

Michelangelo. Another important work of Mannerist architecture is Michelangelo's entry hall for the Laurentian Library in Florence. Built above the monastery's dormitories, the large, rectangular reading room is reached by a grand staircase in a vestibule off the main cloister (fig. 18-46). In its final realization, Michelangelo's staircase, completed in 1559, was a remarkable Mannerist conception. The spatial proportions are somewhat unsettling: a tall room with the floor space taken up almost entirely by a staircase cascading like a waterfall, with a

central flight of large oval steps flanked by narrower flights of rectangular ones. According to Michelangelo's instructions, seats were placed at intervals along the outer edges of the stair, and the side ramps end and join the main flight just short of the door. Paired columns are embedded in the walls on the second-floor level instead of supporting an entablature; enormous volute brackets, capable of bearing great weight, are simply attached to the wall, supporting nothing. Michelangelo at one point described this project as "a certain stair that comes back to my mind as in a dream," and the strange and powerful effects do indeed suggest a dreamlike imagining brought to physical reality.

THE FRENCH COURT

Italy had experienced the military power of French kings since the end of the fifteenth century, and the French kings had experienced the aesthetic power of Italian Renaissance art. The greatest French patron of Italian artists was Francis I (b. 1494; ruled 1515–1547), despite his constant wars against Holy Roman Emperor Charles V to expand French territory.

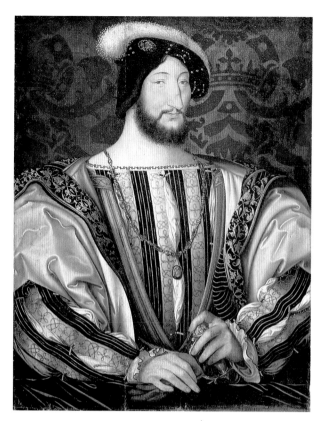

18-47. Jean Clouet. *Francis I*. 1525–30. Oil and tempera on panel, 37¾ x 29⅛" (95.9 x 74 cm). Musée du Louvre, Paris

Painting

Before the arrival of Italian painters at Francis I's court, the Flemish-born artist Jean Clouet (d. 1540) had found great favor as the king's portraitist. Clouet's origins are obscure, but he was in France as early as 1509, and in 1530 he moved to Paris as principal court painter. Clouet probably painted Francis's official portrait soon after the king's release from imprisonment in Spain by Charles V (fig. 18-47). His distinctive features have been softened but not completely idealized, for his thick neck seems at odds with his delicately worked costume of silks, satin, velvet, jewels, and gold embroidery. In its format and grandeur of presentation, Clouet's portrayal has its roots in the portrait tradition established at the French court by Jean Fouquet (see fig. 17-26). Some scholars have questioned the attribution of this particular painting to Clouet because of its stiffness, but this may simply be a court convention for official portraits. Artists generally made rapid sketches then painted a prototype for the

18-48. Primaticcio. Stucco and wall painting, Chamber of the duchess of Étampes, Château of Fontainebleau. 1540s

Primaticcio worked on the decoration of Fontainebleau from 1532 until his death in 1570. During that time, he also commissioned and imported a large number of copies and casts made from original Roman sculpture, including the *Apollo Belvedere* in the Vatican gardens, the newly discovered *Laocoön*, and even the relief decoration on the Column of Trajan. These works provided an invaluable visual source for the northern artists employed on the project.

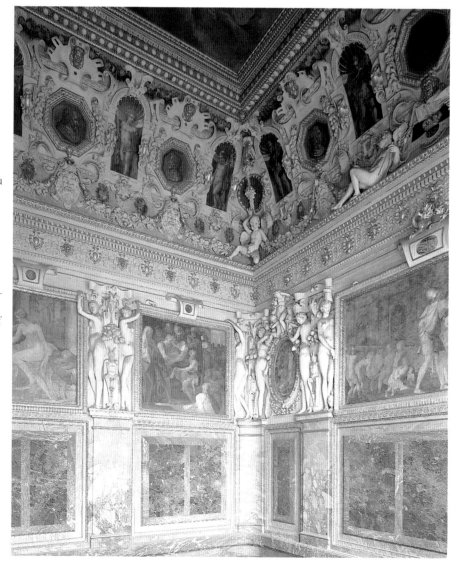

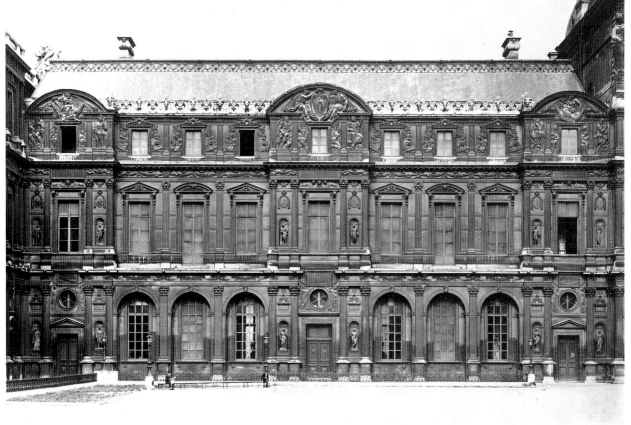

18-49. Pierre Lescot. West wing of the Cour Carré, Palais du Louvre, Paris. Begun 1546

official portrait, which, upon approval, was the model for numerous replicas for diplomatic and family purposes.

Architecture and Its Decoration

At the beginning of the sixteenth century, with the enthusiasm of French royalty for things Italian and the widening distribution of Italian books on architecture, the Italian Renaissance style began to appear in French construction. Builders of elegant rural palaces, called **châteaux**, were quick to introduce Italianate decoration on otherwise Gothic buildings, but French architects soon adapted Classical principles of building design as well.

Immediately upon his ascent to the throne in 1515, Francis I showed his desire to "modernize" the French court by acquiring the versatile talents of Leonardo da Vinci, who moved to France in 1516 and was actively involved in the design of the Château of Chambord in the Loire Valley in western France up to his death in 1519. But it was not until 1526, after Francis's military defeat by Charles V and a long imprisonment in Madrid, that the king began a major renovation of royal properties.

Having chosen as his primary residence the medieval hunting lodge at Fontainebleau, Francis began transforming it in 1526 into a grand palace. Most of the exterior structure was altered or destroyed by later renovations, but parts of the interior decoration, mainly the work of artists and artisans from Italy, have been preserved and restored. The first artistic director at Fon-

tainebleau, the Mannerist painter Rosso Fiorentino (see fig. 18-37), arrived in 1530. In 1540 he was succeeded by his colleague Francesco Primaticcio, from Mantua, where the latter had worked with Giulio Romano.

Following ancient tradition, the king maintained an official mistress—Anne, the duchess of Étampes, who was in residence at Fontainebleau. Among Primaticcio's first projects was the redecoration, in the 1540s, of Anne's bedroom (fig. 18-48), which has survived nearly intact. The artist combined the arts of woodworking, stucco relief, and fresco painting in his complex but light-hearted and graceful interior design. The lithe figures of his stucco nymphs with their long necks and small heads recall Parmigianino's painting style (see fig. 18-39), and their spiraling postures and bits of clinging drapery are playfully sexual. The wall surface is almost overwhelmed with garlands, mythological figures, and Roman architectural ornament, yet the visual effect is extraordinarily confident and joyous. The first School of Fontainebleau, as this Italian phase of the palace decoration is called, established a tradition of Mannerism in painting and interior design that spread to other centers in France and the Netherlands.

In 1546 Francis I began to renovate the royal palace in Paris, the Louvre, by replacing its central block with a courtyard. He appointed the architect Pierre Lescot (c. 1510–1578) to build a new wing along the west side of this square court, or Cour Carré, as it came to be called (fig. 18-49). Lescot's appointment was an innovation,

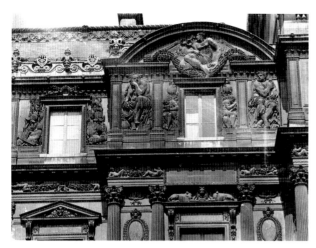

18-50. Jean Goujon. *Archimedes and Euclid, with Allegorical Figures*, detail of the sculptural decoration of the west wing of the Cour Carré. 1548–49

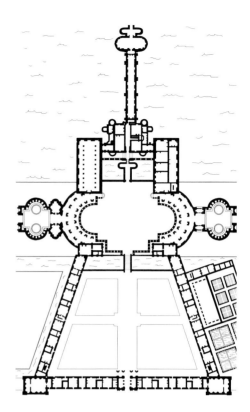

18-51. Plan of the Château of Chenonceaux, with projected additions and formal gardens, Loire Valley

because he was a well-educated man who came not from the building trades but from the study of painting and mathematics. He was thus a French counterpart to such Italian architects as Bramante, Raphael, and Leonardo. The exterior elevation of the wing today does not reflect Lescot's original plan, but rather significant alterations he made during the course of the work. In 1549, to accommodate a grand ballroom, Lescot moved the staircase from a single projecting bay, or **frontispiece**, at the center of the wing to the north end. He built another frontispiece for it there and balanced this with a third projection at the south end, thus creating the triple vertical divisions of the courtyard face. The frontispiece, which had its own roof, was derived from earlier sixteenth-century château designs. A second major change occurred during construction of the king's apartment on the south end of the building. A fourth story with large Gothic windows overlooking the Seine River was added there and disguised by an added level on the courtyard face. Lescot created this by adding about 3 feet to the height of the frontispieces and continuing this across the whole wing. Lescot designed an identical south face for the Cour Carré.

Apparently, Lescot had not visited Italy before 1556, so his Louvre design drew on native French traditions and classical elements learned from books. The result has been acknowledged as the first original French Renaissance design. Although Lescot's Cour Carré embodies classical ideals of balance and regularity and incorporates antique architectural detailing, it would never be mistaken for an Italian Renaissance building. The integration of sculptural reliefs into the facade design was original and entirely French in conception although not in sculptural style (fig. 18-50). The reliefs were the work of Jean Goujon (c.1510–1568?), whose elongated figures and elegant poses, as shown in *Archimedes and Euclid, with Allegorical Figures*, were clearly influenced by Italian Mannerism, but they are integrated into the architecture in the French Gothic tradition.

One of the finest examples of Italian Renaissance influence on French architectural design is the Château

of Chenonceaux, developed in three phases during the sixteenth century (fig. 18-51). The original residential block (fig. 18-52 at the left) was built between about 1515 and 1522, using the foundations of a mill built out over the Cher River to create one of the earliest château designs reflecting classical principles of geometric regularity and symmetry. Rooms are arranged on each side of a wide central hall that originally ended in a large window overlooking the river. The château also introduced to French architecture a form of the Italian straight-ramp staircase.

Later, the foremost French Renaissance architect, the Roman-trained Philibert de l'Orme (d. 1570), designed a gallery and bridge extending the rest of the way across the river (fig. 18-52). The extension was completed about 1581 on a new three-story design, probably devised by the Italian-trained architect Jean Bullant (c. 1510–c. 1578). The extension incorporated contemporary Italianate window treatments, wall moldings, and cornices that harmonized almost perfectly with the forms of the original turreted building. Chenonceaux remains today one of the most important—and beautiful—examples of classical influence on French Renaissance architecture.

Craft Arts

Italian craftspeople began to move north after the end of the fifteenth century, and the Fontainebleau treasury includes some of the finest work of the Florentine goldsmith and sculptor Benvenuto Cellini (1500–1571). Cellini worked from just before 1540 to 1545 at Fontainebleau, where he made the famous *Saltcellar of Francis I* (fig.

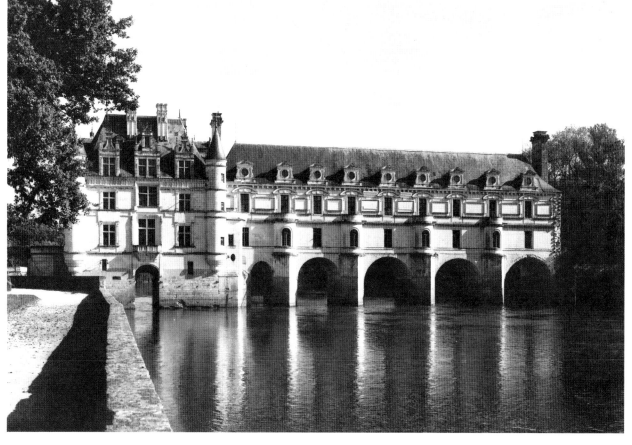

18-52. Château of Chenonceaux. 1515–22, 1556–59, and 1576–81

This château, first acquired by Francis I, was a favorite of his grandson Henry III (ruled 1574–1589). Henry III and his mother, Catherine de' Medici, who had inherited the property, delighted in throwing lavish parties here with costumed young men and women emerging from the woods to greet guests, while singers and musicians entertained from boats on the river.

18-53). This utilitarian table piece, dated about 1539–1543, was transformed into an elegant sculptural ornament through the artist's fanciful imagery and superb execution in gold and enamel. The Roman sea god, Neptune, representing the source of salt, sits next to a tiny boat-shaped container that carries the seasoning, while a personification of the Earth guards the plant-derived pepper. The Seasons and the Times of Day on the base refer to both daily meal schedules and festive seasonal celebrations. The two main figures, their poses mirroring each other with one bent and one straight leg, lean away from each other at impossible angles yet are connected and visually balanced by glances and gestures. Their supple, elongated bodies and small heads reflect the Mannerist conventions of Parmigianino and Primaticcio.

Although Italians were prominent at the French court, native French craft artists also attracted royal patronage. Among these was the ceramicist Bernard Palissy (c. 1510–c. 1590), called the "Huguenot potter" because of his Protestant faith. In 1563 Palissy was appointed "inventor of rustic figurines" and created in the garden of the Tuileries in Paris a make-believe earthenware grotto, decorated entirely with ceramic rocks, shells, crumbling statues, water creatures, a cat stalking birds, ferns, and garlands of fruits and vegetation. In creating his ceramic forms, he reportedly made casts from

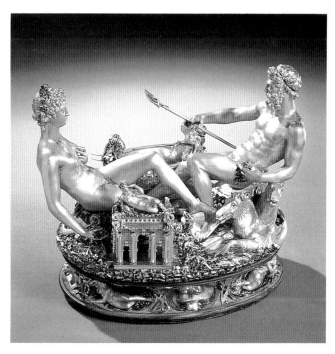

18-53. Benvenuto Cellini. *Saltcellar of Francis I.*
1539–43. Gold with enamel, 10¼ x 13⅛" (26 x 33.3 cm). Kunsthistorisches Museum, Vienna

18-54. Attributed to Bernard Palissy. Oval plate in "style rustique." 1570–80/90(?). Polychromed tin and glazed earthenware, length 20½" (52 cm). Musée du Louvre, Paris

actual creatures and natural elements. From 1570 until 1576, during a period of persecution of Protestants in Paris, Palissy was exiled. He was permitted to return to Paris to teach but was arrested again in 1588 and died in prison around 1590, about the time that his Tuileries grotto was destroyed. He is known today for his distinctive ceramic platters decorated in high relief with plants, flowers, reptiles, water creatures, and insects (fig. 18-54). Existing examples are best called Palissy-style works, however, because their originality is nearly impossible to prove. His designs were copied into the seventeenth century, and pieces in his style are still made today.

NETHER-LANDISH ART

Sixteenth-century art in the Netherlands followed several different directions. While some artists capitalized on styles of the late fifteenth century, others looked back for models to earlier Flemish painters. A few artists, perhaps the best known today, were such individualists that they must be considered unique. Virtually all Netherlandish artists must have been well aware of developments in Italian art, and many responded without losing their northern identity. The term *Romanist* generally indicates that the Netherlandish painters had contact either personally or through a teacher with prevailing Italian art styles of the sixteenth century. Here we include under Romanist both those influenced by Italian Renaissance styles and those who were drawn to Italian Mannerism. The term *Mannerist* also is applied to certain types of native Netherlandish art that do not fit easily into Renaissance categories.

Painting

Although the Roman Catholic Church continued to commission works of art, unpredictable religious controversies in the Netherlands led artists to seek private patrons. An enormous market flourished for small paintings of secular subjects that were both decorative and interesting conversation pieces for homes. Certain subjects were so popular later in the century that some artists became specialists, producing variations on a particular theme rapidly, with the help of assistants.

Hieronymous Bosch. With the work of Hieronymous Bosch (c. 1450–1516), we enter a world of fantastic imagination associated with medieval art. Bosch's career was spent in the town whose name he adopted, 's Hertogenbosch, near the Maas (Meuse) River on the German border. Bosch's religious devotion is certain. His range of painting subjects, rendered with great technical virtuosity, shows that he was well educated and well read; he was also a hydraulic engineer who designed fountains and civic waterworks.

Paintings such as his triptych *Garden of Delights* (fig. 18-55) are challenging and unsettling. Modern critics have called the painter everything from madman to scholar, from mystic to social critic. There are many interpretations of the *Garden,* but a few broad conclusions can be drawn with certainty. The subject of the overall work is Sin—that is, the Christian belief in human beings' natural state of sinfulness and their inability to save themselves from its consequences. The triptych tells the story of the religious past and future of humanity, from the Creation of the World on the wing exteriors (not shown in fig. 18-55) and the Creation of Adam and Eve on the left wing to the Last Judgment on the right. The fact that only the Damned in Hell are shown in the Judgment scene supports a conclusion that the work cautions that Damnation is the natural outcome of a life lived in ignorance and folly. In the center panel (fig. 18-56), which illustrates those activities that condemn humanity, it seems that greed, jealousy, and murder are less threatening to human salvation than seemingly harmless diversions such as games, romance, music, and even art.

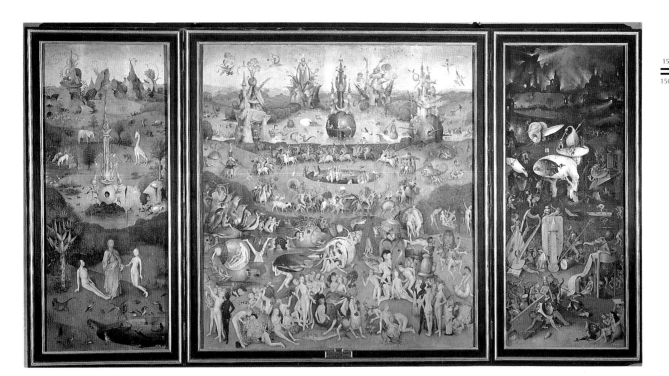

1520
1500 1600

18-55. Hieronymus Bosch. *Garden of Delights*. c. 1505–15. Oil on panel, center panel 7'2½" x 6'4¾" (2.2 x 1.95 m); each wing 7'2½" x 3'2" (2.19 x 0.96 m). Museo del Prado, Madrid

"The world upside down," a common folk expression in the sixteenth-century Netherlands, may represent part of the meaning of this enigmatic painting. Even the triptych format that the artist chose may be an understated irony. Before the Reformation, the altarpiece had been synonymous with religious imagery in northern Europe, but this work was commissioned by an aristocrat for his Brussels town house. As a secular work, the *Garden of Delights* may well have inspired lively discussion and even ribald comment, much as it does today in its museum setting. Despite—or perhaps because of—its bizarre subject matter, the triptych was copied in 1566 to make tapestry versions, one for a cardinal (now in El Escorial) and another for Francis I. At least one painted copy was made as well. Bosch's original triptych was acquired during the revolt of the Netherlands and sent in 1568 to Spain, where it entered the collection of Philip II.

18-56. Hieronymus Bosch. Detail of the center panel, *Garden of Delights*

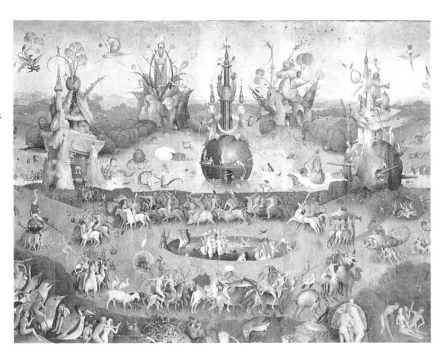

One interesting interpretation of the central panel proposes that it is a parable on human salvation in which the process sought to turn common metals into gold parallels Christ's power to convert human dross into spiritual gold. The alchemical process merged, or "married," two opposite elements (possibly symbolized here by male and female) through distillation to form an entirely new element. The bizarre fountain at the center of the lake in the middle distance (fig. 18-56) can be seen as an alchemical "marrying chamber" complete with alembics, the glass vessels for collecting the vapors of distillation. The figure standing on its head may allude to "turning upside

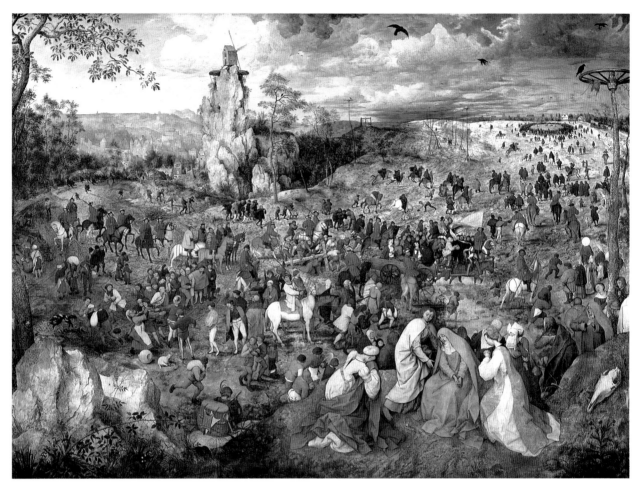

18-57. Pieter Brueghel the Elder. *Carrying of the Cross.* 1564. Oil on panel, 4'³⁄₄" x 5'7" (1.23 x 1.70 m). Kunsthistorisches Museum, Vienna

down," the alchemical expression for distillation, also referred to as "play," which may explain the playful attitudes of even the most grotesque creatures in the picture.

Whatever Bosch's intentions were—and they must have been far more complex than an alchemical allegory—they were unknown to one art critic, who wrote in about 1600 that the triptych was called "The Strawberry Plant" because it resembled the "vanity and glory and the passing taste of strawberries or the strawberry plant and its pleasant odor that is hardly remembered once it has passed." Luscious fruits—strawberries, cherries, grapes, and pomegranates—appear everywhere in the *Garden*, serving as food, as shelter, and even as a boat. Therefore, the subject of Sin is reinforced by the suggestion that life is as fleeting and insubstantial as the taste of a strawberry.

Pieter Brueghel the Elder. So popular did the works of Hieronymus Bosch remain after his death that, nearly half a century later, the young painter Pieter Brueghel (c. 1525–1569) was able to earn a great deal of money by imitating his work. Fortunately, Brueghel's talents went far beyond those of an ordinary copyist. Nothing is known of his early training, but shortly after entering the Antwerp Guild in 1551, he spent time in Bologna and Rome, where he studied Michelangelo's Sistine ceiling and other works in the Vatican.

Brueghel maintained a shop in Antwerp from 1554 until 1563, when he moved to Brussels. His style and choices of subjects found great favor with local scholars, merchants, and bankers, who appreciated his beautifully painted, artfully composed works, which reflected contemporary social, political, and religious conditions. Brueghel's inspiration came from visiting country fairs, where he sketched the farmers and townspeople who became the focus of his paintings, whether religious or secular. No artist had ever depicted Flemish farmers so vividly and sympathetically while also exposing their faults and foolishness, an ability that earned the solidly middle-class artist the nickname of "Peasant" Brueghel. Nevertheless, Brueghel's characters were not unique individuals but well-observed types whose universality makes them familiar even today.

Although Brueghel is not strictly speaking a Mannerist, he specialized in an unsettling Manneristic approach to composition. The main subject of the picture is often deliberately hidden or disguised by being placed in the distance or amid a teeming crowd of figures, as in the *Carrying of the Cross* (fig. 18-57), painted in Brussels in 1564. At first glance, the group of large figures near the picture plane at the lower right seems to be the true subject, but they are in fact secondary to the main event: Jesus carrying his Cross to Golgotha. To find him, the viewer must visually enter the painting and search for the

1560
1500 1600

18-58. Pieter Brueghel the Elder. *Return of the Hunters.* 1565. Oil on panel, 3'10½" x 5'3¾" (1.18 x 1.61 m). Kunsthistorisches Museum, Vienna

main action, while being constantly distracted by smaller dramas going on among others who mill about the large open field, surging with the crowd this way and that, part of the public circus going on around the dire events central to the painting.

Brueghel's panoramic scene is carefully composed to attract our eye and guide it in swirling, circular orbits that expand, contract, and intersect. Part of this movement is accomplished by the careful spotting of the bright red coats of the guards trying to control the crowd. The figure of Jesus is finally discovered at the center of the painting where the vertical and horizontal axes intersect. The landscape recedes skillfully and apparently naturally toward the distant horizon, except for the tall rock outcropping near the center with a wooden windmill on top. The exaggerated shape of the rock is a convention of sixteenth-century northern European landscapes, but the enigmatic windmill suggests the ambiguities of Italian Mannerism.

Cycles, or series, of paintings on a single allegorical subject—such as the Five Senses, the Times of Day, and the Seasons—were frequently commissioned as decorations for elegant Netherlandish homes. Brueghel's *Return of the Hunters* (fig. 18-58) of 1565 is one of a cycle of six panels, each representing two months of the year. In this November-December scene, Brueghel has captured the atmosphere of the damp, cold winter with its early nightfall in the same way that his compatriots the Limbourgs did 150 years earlier in the *February* calendar illustration for the duke of Berry (see fig. 17-2). In contrast to much Renaissance and Mannerist art, the *Hunters* appears neutral and realistic. The viewer seems to hover with the hawks slightly above the ground, looking down first on the busy foreground scene, then across the valley to the snow-covered village and frozen ponds. The main subjects of the painting, the hunters, have their backs turned and do not reveal their feelings as they slog stoically through the snow, trailed by their dogs. They pass an inn at the left, where a worker moves a table by the door to receive the pig others are singeing in a fire before butchering it. But this is clearly not an accidental image,

a slice of everyday life faithfully reproduced, for the forms of the composition are carefully calculated. The sharp diagonals, both on the picture plane and as lines receding into space, are countered by the pointed gables and roofs at the lower right as well as by the jagged mountain peaks linking the valley and the skyline along the right edge. Their rhythms are deliberately slowed and stabilized by a balance of vertical tree trunks and horizontal rectangles of water frozen-over in the distance.

As a depiction of Flemish life, this scene represents a relative calm before the storm. Two years after it was painted, the anguished struggle of the northern provinces for independence from Spain began. Pieter the Elder died young in 1569, leaving two children, Pieter the Younger and Jan, both of whom became successful painters in the next century.

Romanists and Specialists. A major change in the sixteenth-century Netherlands was the development of stronger, more-affluent art centers, such as Utrecht, in the north. Despite the long struggle for independence from Spain, which led seven northern Protestant provinces to found the United Provinces in 1579 and eventually divided the Netherlands along religious lines, people nevertheless found the resources to patronize artists.

The first Netherlandish Romanist was the Flemish painter Jan Gossaert (c. 1478–c. 1533), who later called himself Mabuse after his native city, Maubeuge. In about 1507 he entered the service of Philip, an illegitimate son of the duke of Burgundy. Gossaert's only visit to Italy was a trip with his patron a year later, during which he made drawings of antique sculpture and architecture. Philip, an avid arts patron, brought the Venetian painter and engraver Jacopo de' Barbari to his court in 1509, and Gossaert collaborated with him in late 1515 on a series of mythological paintings. From 1517 to 1524, Gossaert worked for Philip and other Burgundian patrons in Utrecht, then opened his own shop.

Gossaert's painting style went through several phases, and he seems to have responded in different ways

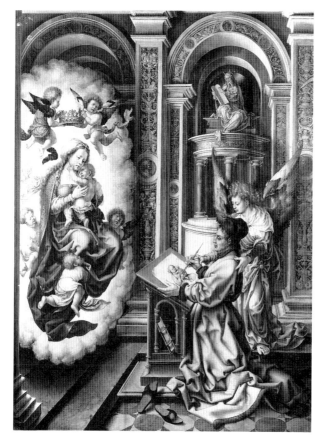

18-59. Jan Gossaert. *Saint Luke Painting the Virgin*. 1520. Oil on panel, 43³/₈ x 32¹/₄" (110.2 x 81.9 cm). Kunsthistorisches Museum, Vienna

his specialty or his pictorial format, which recalls the depiction of the goldsmith-saint Eloy in 1449 by Petrus Christus (see fig. 17-14). Such paintings were popular conversation pieces; even the satirized subjects themselves apparently bought and displayed them.

Caterina van Hemessen (1528–1587) of Antwerp developed an illustrious international reputation. She had learned to paint from her father, the Flemish Mannerist Jan Sanders van Hemessen, with whom she collaborated on large commissions, but her quiet realism and skilled rendering had roots in Renaissance Romanism. Her portraits typically depict the subject in three-quarter view, carefully including background elements that could be shown perspectively, such as the easel in her *Self-Portrait* (fig. 18-61). To maintain the focus on the foreground subject, Caterina painted the portrait backgrounds in an even dark color, on which she identified her subject and the subject's age, and signed and dated the work. Here, the inscription reads: "I Caterina van Hemessen painted myself in 1548. Her age 20." In delineating her own features, Caterina presented a serious young person without personal vanity yet seemingly already self-assured about her artistic abilities. During her early career, spent in Antwerp, she became a favored court artist to Mary of Hungary, regent of the Netherlands and sister of Emperor Charles V, for whom she painted not only portraits but also religious works. In 1554 Caterina married the organist of Antwerp Cathedral, and they accompanied Mary to Spain after she ceased to be regent in 1556. Unfortunately, Caterina's Spanish works have not survived or have been attributed to others.

GERMANY AND THE HOLY ROMAN EMPIRE

Through carefully calculated dynastic marriages and some good luck, the Habsburg Holy Roman Emperor Charles V (ruled 1519–1556), also known as Charles I of Spain, ruled over lands from the North Sea to the Mediterranean. Charles was a Roman Catholic throughout his life, but he also was forced to accommodate the German Protestant Reformation. Tired of the strain of government and prematurely aged, he abdicated in 1556 and retired to a monastery, where he died two years later. After his death, Habsburg domains were divided. His son Philip II became the king of Spain, the Netherlands, and the Americas, as well as ruler of Milan, Burgundy, and the Kingdom of Naples and Sicily. Charles's brother Ferdinand I succeeded him as Holy Roman Emperor. The Habsburg dynasty lasted into the twentieth century.

From the last decades of the fifteenth century up to the 1520s, the arts flourished in Austria, Germany, and the German-speaking regions of Switzerland and Alsace. After that, religious upheavals and **iconoclastic** (image-smashing) purges of religious images began to take a toll. Religious strife was intimately bound up with social and political problems, and some artists found their careers at an end because of their sympathies for rebels and reformers. Others left their homes to seek patronage abroad because of their support for the Roman Catholic Church.

according to the patron or the subject of his works. Only briefly did he work in the strongly Mannerist style of his *Saint Luke Painting the Virgin* (fig. 18-59) of about 1520. The subject, taken from legend, shows Luke painting a portrait of the Virgin and Child as they appeared to him in a vision. The Evangelist kneels in an imaginary church before a lectern that acts as his easel. In the niche beyond is a statue of the horned Moses seated and holding the Tablets of the Law atop a high round pedestal. The angel looking over Luke's shoulder holds his right hand as if guiding his work. Although the imaginary classical architecture was derived from Italian sources, the decorative folds of Luke's robe are typical of late Gothic drapery, echoing those of Veit Stoss's *Saint Roche* (see fig. 18-75). Luke's vision of the Virgin as the Queen of Heaven surrounded by an aura also has much in common with Grünewald's visionary scene on the *Isenheim Altarpiece* (see fig. 18-63).

An outstanding "specialist" painter, Marinus van Reymerswaele (c. 1493–after 1567), was apprenticed in Antwerp in 1509 to a glass painter. Later, he organized and ran a well-regarded shop that mainly produced secular panel paintings featuring a class of universally despised members of society—money lenders, tax collectors, and greedy, cold-hearted landlords. The *Banker and His Wife* (fig. 18-60), painted in 1538, is known in at least four copies, and no fewer than twenty-five variants presenting the subject as a tax collector have been preserved. Reymerswaele was not the inventor of either

1540
1500 1600

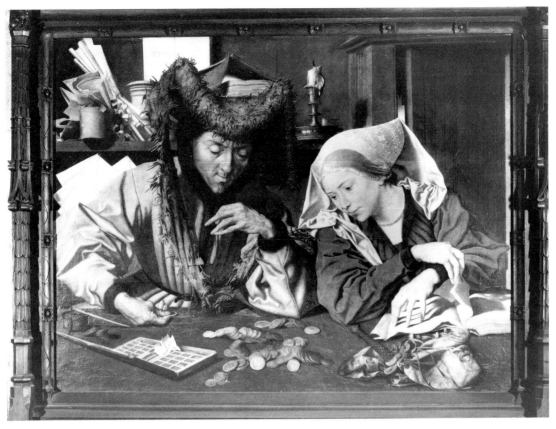

18-60. Marinus van Reymerswaele. *Banker and His Wife.* 1538. Oil on panel, 33³/₄ x 45⁷/₈" (85.7 x 116.5 cm). Museo Nazionale del Bargello, Florence

18-61. Caterina van Hemessen. *Self-Portrait.* 1548. Oil on panel, 12¹/₄ x 9¹/₄" (31.1 x 23.5 cm). Öffentliche Kunstsammlung, Basel, Switzerland

Painting and Printmaking

The first decades of the sixteenth century were dominated in German art by two very different artists, Matthias Gothardt, known as Matthias Grünewald (c. 1480–1528), and Albrecht Dürer (1471–1528). Grünewald's unique style expressed the continuing currents of medieval German mysticism and emotionalism, while Dürer's intense observation of the natural world represented the scientific Renaissance interest in empirical observation, perspective, and a reasoned canon of human proportions. Both artists sympathized with religious reforms, which affected their later lives, and their deaths in 1528 occurred just as the Protestant Reformation gained political power in Germany. Their successors were forced to make drastic efforts to survive in the radically different German market.

Matthias Grünewald. As an artist in the court of the archbishop of Mainz, Grünewald worked as an architect and hydraulic engineer as well as a painter, a common combination at the time. The work for which Grünewald is best known today, the *Isenheim Altarpiece* (figs. 18-62, 18-63), created between 1510 and 1515, illustrates the same intensity of religious feeling that motivated reformers like Martin Luther. It was created for the Abbey of Saint Anthony in Isenheim, whose hospital specialized in the care of patients with skin diseases, including the plague and leprosy. Not only did the altarpiece commemorate a major saint, the fourth-century Egyptian Anthony the Hermit, but it was thought to be able to heal

18-62. Matthias Grünewald. *Isenheim Altarpiece*, closed, from the Community of Saint Anthony, Issenheim, Alsace, France. Main body: *Crucifixion*; predella: *Lamentation*; side panels: Saints Sebastian and Anthony Abbot. c. 1510–15. Oil on panel, main body 9'9¹/₂" x 10'9" (2.97 x 3.28 m), predella 2'5¹/₂" x 11'2" (0.75 x 3.4 m). Musée Unterlinden, Colmar, France

those who looked upon it. In fact, viewing the altarpiece was part of the medical care given to the sick who entered the hospital. The altarpiece is no longer mounted in its original frame, but it is, nevertheless, monumentally impressive in size and complexity. The main inner section and supporting platform, or **predella**, are of sculpted wood figures. Grünewald painted one set of fixed wings and two sets of movable ones, plus one set of small wings for the predella, so that the altarpiece could be exhibited in different configurations depending upon the Church calendar.

On normal weekdays, when the altarpiece was closed, viewers saw a shocking image of the Crucifixion in a darkened landscape, a Lamentation below it on the predella, and lifesize figures of Saints Sebastian and Anthony Abbot standing like statues on trompe l'oeil pedestals on the fixed wings (see fig. 18-62). Grünewald represented in the most horrific detail the tortured body of Jesus covered with gashes from being beaten and pierced by the thorns used mockingly to form a crown for his head. Not only do his ashen color, open mouth, and blue lips indicate that he is dead, but he also appears

already to be decaying, an effect enhanced by the palette of putrescent greens, yellows, and purplish red. A ghost-like Virgin Mary has collapsed in the arms of an emaciated John the Evangelist, and Mary Magdalen has fallen in anguish to her knees; her clasped hands with outstretched fingers seem to echo Jesus' straining, cramping fingers in rigor mortis. At the right, John the Baptist points at Jesus and repeats his prophecy, "He shall increase." The Baptist and the lamb holding a cross and bleeding from its breast into a golden chalice allude to the Christian rites of Baptism and the Eucharist. In the predella below, Jesus' bereaved mother and friends prepare his body for burial, a scene that must have been familiar indeed in the hospital. On the fixed wings, the martyred Saint Sebastian and the hermit Saint Anthony serve as models for a life of Christian devotion and as intercessors for the sick and the dying.

In contrast, the altarpiece when first opened displays Christian events of great joy—the Annunciation, the Nativity, and the Resurrection—expressed in vivid red and gold accented with high-keyed pink, lemon, and white (see fig. 18-63). Unlike the murky darkness of the

18-63. Matthias Grünewald. *Isenheim Altarpiece*, first opening. Left to right: *Annunciation*, *Virgin and Child with Angels*, *Resurrection*. c. 1510–15. Oil on panel, center panel 9'9½" x 10'9" (2.97 x 3.28 m), each wing 8'2½" x 3'½" (2.49 x 0.92 m)

Crucifixion, the inner scenes are illuminated with clear natural daylight, phosphorescent auras and halos, and the glitter of stars in a night sky. Fully aware of contemporary Renaissance formal achievements, Grünewald created the illusion of three-dimensional space and volumetric figures, and he abstracted, simplified, and idealized the forms. Unlike Italian Renaissance painters, his aim was to strike the heart rather than the intellect and to evoke sympathy rather than to create visual grandeur. Underlying this deliberate attempt to arouse an emotional response in the viewer is a complex, religious symbolism, undoubtedly the result of close collaboration with his monastic patrons.

The Annunciation on the left wing illustrates a special liturgy called the Golden Mass, which celebrated the divine motherhood of the Virgin and included a staged reenactment of the angel's visit to her. There were also readings from the story of the Annunciation (Luke 1:26–38) and the Old Testament prophecy of the Savior's birth (Isaiah 7:14–15), which is inscribed in Latin on the pages of the Virgin's open book. The event takes place as reenacted in the Mass.

The central panels show the heavenly and earthly realms joined in one space. In a variation on the northern visionary tradition, the new Mother adores her miraculous Child while envisioning her own future as the Queen of Heaven amid angels and cherubs. Grünewald illustrated a range of ethnic types in the heavenly realm, as well as three distinct types of angels seen in the foreground—young, mature, and a feathered hybrid with a birdlike crest on its human head. Perhaps this was intended to emphasize the global dominion of the Church, whose missionary efforts were expanding as a result of the European exploration and discovery of new territories. The panel is also filled with symbolic and narrative imagery related to the Annunciation. For example, the Virgin and Child are surrounded by Marian symbols: the enclosed garden, the white towel on the tub, and the clear glass cruet behind it, which signify Mary's virginity; the waterpot next to the tub, which alludes both to purity and to childbirth; and the fig tree at the left, suggesting the Virgin Birth, since figs were thought to bear fruit without pollination. The bush of red roses at the right alludes not only to Mary but also to the Passion of Christ, thus recalling the Crucifixion on the

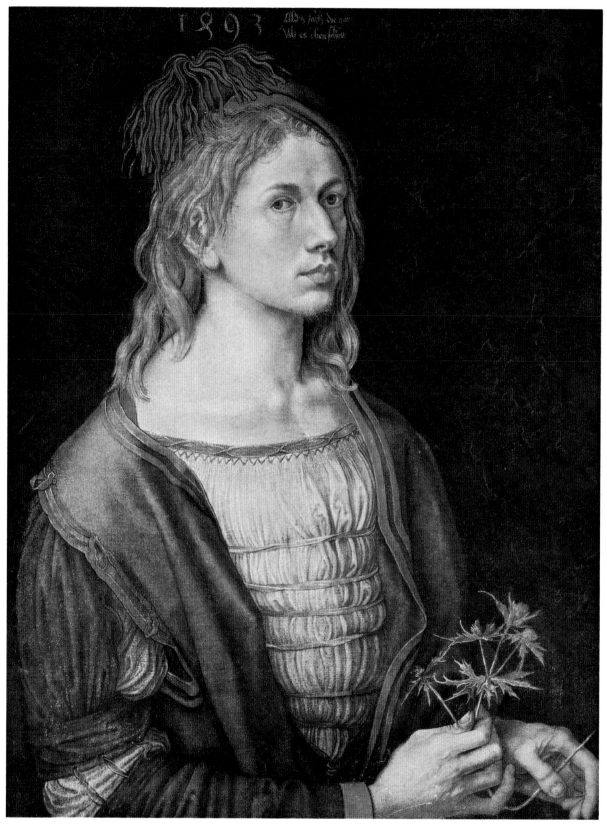

18-64. Albrecht Dürer. *Self-Portrait with a Sprig of Eryngium*. 1493. Parchment on linen, 22¼ x 17½" (54 x 44.5 cm). Musée du Louvre, Paris

outer wings and providing a transition to the Resurrection on the right wing. There, the shock of Christ's explosive emergence from his stone sarcophagus tumbles the guards about, and his new state of being—no longer material but not yet entirely spiritual—is vibrantly evident in his dissolving, translucent figure.

Grünewald's personal identification with the struggles of the peasants in the social and religious turmoil of the 1520s damaged his artistic career. After actively supporting the peasants, who, because of economic and religious oppression, rose up against their feudal overlords in the Peasants' War in 1525, he left Mainz and spent his

last years in Halle, whose ruler was the chief protector of Martin Luther and a longtime patron of Grünewald's contemporary Albrecht Dürer.

Albrecht Dürer. Much is known about the life, personality, and thinking of Albrecht Dürer. Studious, analytical, observant, and meticulous but as self-absorbed and difficult as Michelangelo, Dürer was one of eighteen children of a Nuremberg goldsmith. Nuremberg at that time was a free imperial city with strong business, trade, and publishing interests. The city had an active group of humanists and internationally renowned artists and artisans who exported many works, especially large altarpieces. After an apprenticeship in painting, stained-glass design, and especially the making of woodcuts, in the spring of 1490 Dürer traveled to extend his education and gain experience as an artist. Dürer worked until early 1494 in Basel, Switzerland, providing drawings for woodcut illustrations for books published there. While in Basel, Dürer painted a self-portrait, probably for his upcoming marriage. Originally painted with oil on **vellum** but transferred later to linen canvas, the *Self-Portrait with a Sprig of Eryngium* (fig. 18-64) is inscribed: "1493. My affairs will go as it is written in the stars." The sprig the young artist holds was believed to have aphrodisiac properties and thus symbolized romantic love and betrothal. Although the pleated silks and satins are worn casually and contrast with his unkempt hair and large, capable hands, Dürer's lifelong interest in stylish clothing is already apparent here. Already, too, the artist was devoted to meticulously documenting his subjects' features in a manner that also revealed their personalities.

Not long after his marriage in 1494, Dürer traveled to Italy seeking patrons among the large, rich community of German merchants then living in Venice. Dürer's travels are documented by a series of fresh, freely executed watercolors of the Alpine landscape, such as the *Wehlsch Pirg (Italian Mountain)*, probably painted in 1495 (fig. 18-65). The artist's interest in **atmospheric perspective** is clear from the tonal variations of the blues and greens in the distant, moisture-laden air.

Back in Nuremberg, the young artist continued to experience a slow market for his work. To bolster his income, Dürer began to publish his own prints, and ultimately it was these prints, not his paintings, that made his fortune. His first major publication was the Book of Revelation, or Apocalypse, which appeared simultaneously in German and Latin editions in 1497–1498 and consisted of a woodcut title page and fourteen full-page illustrations with the text printed on the back of each. The best-known of the woodcuts is the *Four Horsemen of the Apocalypse* (fig. 18-66) based on figures in Revelation 6:1–8: a crowned rider armed with a bow, on a white horse (Conquest); a rider with a sword, on a red horse (War); a rider with a set of scales, on a black horse (Plague and Famine); and a rider on a sickly pale horse (Death).

The artist probably did not cut his own woodblocks but rather employed a skilled carver who followed his drawings faithfully. Dürer's dynamic whirlpool of figures shows affinities with *Temptation of Saint Anthony* (see fig.

18-65. Albrecht Dürer. *Wehlsch Pirg (Italian Mountain)*. c. 1495. Watercolor and gouache, 8¼ x 12¼" (21 x 31.1 cm). Ashmolean Museum, Oxford

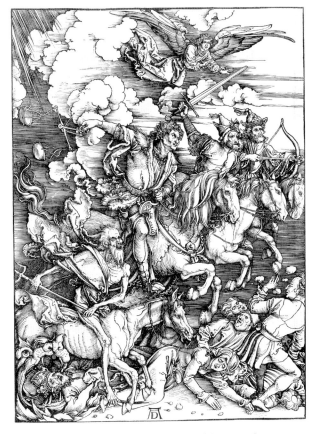

18-66. Albrecht Dürer. *Four Horsemen of the Apocalypse*, from *The Apocalypse*. 1497–98. Woodcut, 15½ x 11⅛" (39.4 x 28.3 cm). The Metropolitan Museum of Art, New York
Gift of Junius S. Morgan, 1919 (19.73.209)

17-79), by Martin Schongauer, whom he admired, and he adapted for woodcut Schongauer's technique for shading on the engraved plate, using a complex pattern of lines that model the forms with highlights against the tonal ground. His fifteenth-century training is evident in his meticulous attention to detail, decorative cloud and drapery patterns, and the foreground filled with large, active figures.

Perhaps as early as the summer of 1494, Dürer had begun to experiment with engravings, cutting the plates himself with artistry equal to Schongauer's. His growing

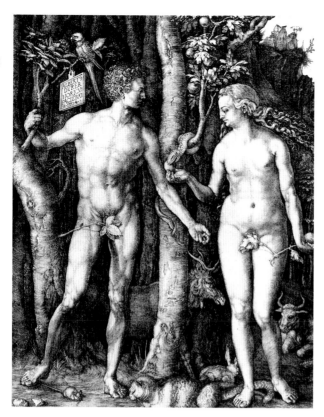

18-67. Albrecht Dürer. *Adam and Eve*. 1504. Engraving,
9⅞ x 7⅝" (25.1 x 19.4 cm). Philadelphia Museum
of Art

Purchased: Lisa Nora Elkins Fund

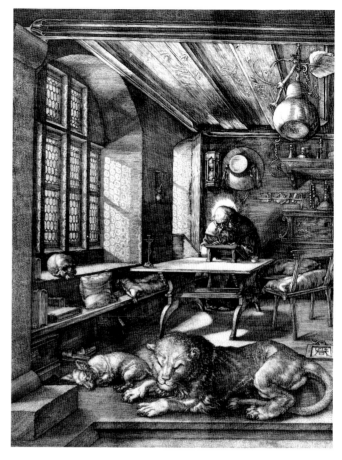

18-68. Albrecht Dürer. *Saint Jerome in His Study*. 1514.
Engraving, 9⅝ x 7⅜" (24.5 x 18.7 cm). The British
Museum, London

The books and pillows on the windowsill and the
carefully positioned slippers below them create a mar-
velous study in receding forms in this engraving. The
print also offers a study of light streaming in through
the bull's-eye glass panes, projecting its harmonious
pattern of circular and rectangular forms. In many
ways this is an engraver's showpiece, demonstrating
the artist's skill at implying a sense of color and tex-
ture by black line alone.

interest in Italian art and theoretical investigations is
reflected in his 1504 engraving *Adam and Eve* (fig. 18-67),
which represents his first documented use of a canon of
ideal human proportions. His nudes were based on
Roman copies of Greek gods, probably seen as prints or
small sculpture in the antique manner that had become
so popular among European collectors by 1500. As ide-
alized as the human figures may be, the flora and fauna
are recorded with typically northern European micro-
scopic detail. Dürer embedded the landscape with sym-
bolic content related to the medieval theory that after
Adam and Eve disobeyed God, they and their descen-
dants became vulnerable to imbalances in body fluids
that altered human temperament: An excess of black bile
from the liver produced melancholy, despair, and greed;
yellow bile caused anger, pride, and impatience; phlegm
in the lungs resulted in a lack of emotion, lethargy, and
disinterest; and an excess of blood made a person un-
usually optimistic but also compulsively interested in
pleasures of the flesh.

These four human temperaments, or personalities,
are symbolized here by the melancholy elk, the choleric
cat, the phlegmatic ox, and the sensual rabbit. The mouse
is a symbol of Satan, whose earthly power, already man-
ifest in the Garden of Eden, was capable of bringing per-
fect human beings to a life of woe through their own bad
choices. The parrot may symbolize false wisdom, since it
can only repeat mindlessly what is said to it. Dürer's pride
in his engraving can be seen in the prominence of his sig-
nature—a placard bearing his full name and date hung on
a branch of the Tree of Life.

Dürer's familiarity with Italian art was greatly en-
hanced by a second, more leisurely trip over the Alps in
1505–1506. Thereafter, he seems to have resolved to
reform the art of his own country by publishing theoretical
writings and manuals that discussed Renaissance prob-
lems of perspective, ideal human proportions, and the
techniques of painting. In his engraving *Saint Jerome in His
Study* of 1514 (fig. 18-68), despite the limitations of his
monochromatic medium, he integrated the rigid Italian
one-point perspective system with the sensitive, natural-
istic lighting effects of fifteenth-century northern Euro-
pean painting. Dürer displayed his technical ability in the
carefully arranged furnishings and objects forming indi-
vidual still-life groups. Yet the overwhelming message
conveyed is not one of technical achievement but of a
deeply felt joy in intellectual activity.

The contribution of Saint Jerome, a late-fourth/
early-fifth-century scholar noted for his Latin translation
of the Bible, was the subject of some controversy. More-
radical reformers venerated him for his rejection of

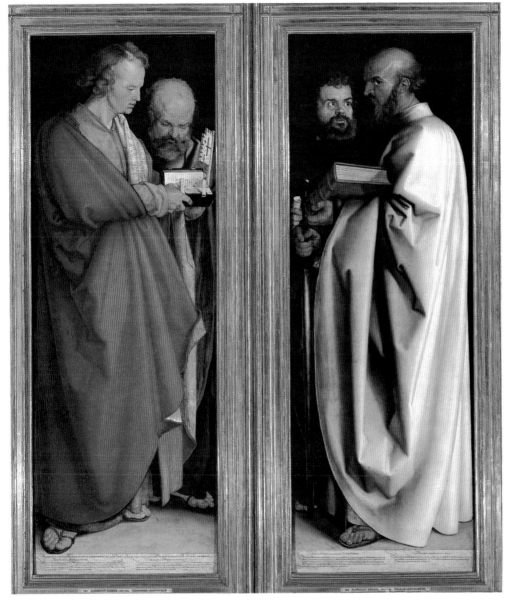

18-69. Albrecht Dürer. *Four Apostles*, 1526. Oil on panel, each panel 7'¹/₂" x 2'6" (2.14 x 0.76 m). Alte Pinakothek, Munich

worldly pleasures. Others, especially humanists, admired above all his scholarship. Dürer's image is clearly the humanist's. Jerome is surrounded by a reading stand, lamps, pens, and other writing equipment. The cardinal's hat on the wall reminds us that he had put aside worldly ecclesiastical power to bring the Scriptures to ordinary people. His emblem, the lion, asleep next to a little dog in the foreground, recalls Jerome's charity to animals and the story of his removing a thorn from a lion's paw, thus gaining the lifelong devotion of the beast. The hanging hourglass and the skull on the windowsill are **vanitas** symbols, reminders of the futility and brevity of human life. The large gourd, which in the biblical story of Jonah grew one night and died the next (Jonah 4:6–7), is another symbol of the fleeting nature of human life.

Dürer admired the writings of Martin Luther and had hoped to engrave a portrait of him, as he had other important Reformation thinkers. In 1526 the artist openly professed his belief in Lutheranism in a pair of inscribed panels commonly referred to as the *Four Apostles* (fig. 18-69). The paintings depict John, Peter, Paul, and Mark the Evangelist in an arrangement possibly intended to create an acceptable Protestant imagery. On the left panel, the elderly Peter, the first pope, seems to shrink behind the young John, Luther's favorite evangelist. On the right panel, Mark is nearly hidden behind Paul, whose teachings and epistles were greatly admired by the Protestants. Dürer presented the panels to the city of Nuremberg, which had already adopted Lutheranism as its official religion. Long inscriptions below the figures (not legible here) warn the viewer not to be led astray by "false prophets" but to heed the words of the New Testament. Excerpts from the letters of Peter, John, and Paul, and the Gospel of Mark, are from Luther's German translation of the New Testament.

Luther, an avowed pacifist, never supported the destruction of religious art, and Dürer's gift to Lutheran Nuremberg was surely meant to demonstrate that a Protestant art was possible. Earlier, the artist had written: "For a Christian would no more be led to superstition by a picture or effigy than an honest man to commit murder because he carries a weapon by his side. He must indeed be an unthinking man who would worship picture, wood, or stone. A picture therefore brings more good than harm, when it is honourably, artistically, and well made" (cited in Snyder, page 347).

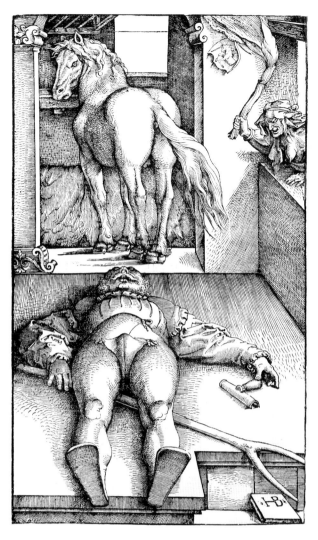

18-70. Hans Baldung Grien. *Stupefied Groom*. 1544. Woodcut, image 13¹⁵/₁₆ x 7⁷/₈" (33.8 x 19.8 cm). Staatliche Museen zu Berlin, Preussischer Kulturbesitz, Kupferstichkabinett

Hans Baldung Grien, Lucas Cranach the Elder, and Albrecht Altdorfer.

Dürer's most successful pupil and lifelong friend, Hans Baldung (c. 1484–1545), received the nickname Grien, possibly from his habit of wearing green clothing while an apprentice from about 1503 to 1509. Baldung Grien, from a highly educated German family, spent most of his adult life in Strasbourg. Having specialized at first in religious altarpieces and stained glass, the artist adapted to the advent of Protestantism in Strasbourg in the late 1520s by painting portraits, classical subjects, and small Madonnas for private clients. He also benefited from the sale of his woodcuts, including the enigmatic *Stupefied Groom* (fig. 18-70), made in 1544, the year before his death. The scene shows a sturdy cavalry horse looking back at a groom, who is lying unconscious (or dead) on a barn floor as an old woman with a firebrand looks on from the window. The woman seems to have frightened the horse, which reacted by kicking the groom who was currying him. Baldung Grien's earlier prints included images of witches, as well as of wild horses symbolizing the baser human instincts, so this picture could have been intended as a moral lesson on the power of evil. The preliminary study for the print shows an even more radically foreshortened

18-71. Lucas Cranach the Elder. *Martin Luther as Junker Jörg*. c. 1521. Oil on panel, 20½ x 13⁵/₈" (52.1 x 34.6 cm). Kunstmuseum, Weimar, Germany

male figure and no grooming equipment, so the perspective study may have been the focus around which the artist then built his picture.

Another of Dürer's friends, Lucas Cranach the Elder (1472–1553), had moved his workshop to Wittenberg in 1504, after a number of years in Vienna. In addition to the humanist milieu of its university, Wittenberg also offered the patronage of the Saxon court. Appointed court painter in 1505, Cranach created all manner of works, including woodcuts, altarpieces, and many portraits. Cranach was Martin Luther's favorite painter, and one of the most interesting among Cranach's roughly fifty portraits of Luther is *Luther as Junker Jörg* (fig. 18-71). It was painted after the reformer's excommunication by Pope Leo X in early 1521—and after a meeting of princes and rulers of the German states of the Holy Roman Empire, held in the city of Worms in the spring of 1521, had declared Luther's ideas heresy and Luther himself an outlaw to be captured and handed over to Emperor Charles V. Smuggled out of Worms by Saxon agents, Luther returned to Wittenberg wearing a black beard and moustache, disguised as a knight named Jörg, or George. As his religious commissions dwindled, Cranach's later work tended to be portraits, hunting scenes, and mythological subjects.

Landscape, with or without figures, was an important new category of imagery after the Reformation. Among the most accomplished German landscape painters of the period was Albrecht Altdorfer (c. 1480–1538), who spe-

18-72. Albrecht Altdorfer. *Danube Landscape.* c. 1525. Oil on panel, 12 x 8³⁄₄" (30.5 x 22.2 cm). Alte Pinakothek, Munich

cialized in portraying the Danube River Valley. He probably received his early training in Bavaria from his painter father, then became a citizen in 1505 of the city of Regensburg, located in the Danube River Valley, where he remained for the rest of his life. In addition to civic construction projects, Altdorfer executed many paintings, often combining religious and historical subjects in magnificent wooded Danube landscapes. The artist's varied talents are barely hinted at by the single work illustrated here, his *Danube Landscape* of about 1525 (fig. 18-72), a

18-73. Hans Holbein the Younger. *Artist's Wife and Children*. 1528/29. Tempera on paper on limewood, 30⅛ x 25¼" (79.5 x 65.5 cm). Öffentliche Kunstsammlung, Basel, Switzerland

fine example of pure landscape painting without a narrative subject or human figures, unusual for the time. A small work on vellum laid down on a wood panel, the *Landscape* seems to be a minutely detailed view of the natural terrain, but a close inspection reveals an inescapable picturesqueness—far more poetic and mysterious than Dürer's scientifically observed views of nature—in the low mountains, gigantic lacy pines, neatly contoured shrubberies, and fairyland castle with red-roofed towers at the end of a winding path. The eerily glowing yellow-white horizon below roiling gray and blue clouds in a sky that takes up more than half the composition suggests otherworldly scenes.

Hans Holbein the Younger. A talent for portrait painting was important for nearly all German artists from the 1520s, but Hans Holbein the Younger eventually owed his entire livelihood to it. Born in Augsburg in 1497 (d. 1543), the son of a painter of altarpieces, Holbein worked for a time in Basel, Switzerland, traveled to Italy in 1518–1519, then returned to Switzerland. He received

portrait and religious commissions but also capitalized on the growing popularity of fresco decorations for house facades. After the humanist scholar Erasmus of Rotterdam settled in Basel in 1521, Holbein became his portraitist and close friend. The Protestant religion spread to Basel in 1522, and by 1526 religious problems there had greatly escalated. Holbein left with letters of introduction from Erasmus to humanist friends in Antwerp and London, where he received lucrative portrait commissions before returning home in 1528.

Although Holbein had officially become a Protestant by 1532, harassment from the reformers sent him once again, with letters from Erasmus, to England. Before leaving Basel, however, he painted a portrait of his wife and two children (fig. 18-73), perhaps meant to be paired with a self-portrait placed on the right. The pyramidal composition and monumental figures of *Artist's Wife and Children* immediately recall a Raphael *Madonna and Child* (see fig. 18-5), but the power of Holbein's work lies in the unidealized, beloved features of his subjects. His wife is already suffering from the eye disease that would eventually blind

18-74. Tilman Riemenschneider. *Last Supper*, center of the *Altarpiece of the Holy Blood*, Sankt Jakobskirche, Rothenburg ob der Tauber, Germany. c. 1499–1505. Limewood, height of tallest figure 39" (99.1 cm); height of altar 29'6" (9 m)

her, and the children seem on the verge of tears as they look out to the far right, perhaps at a painting of their father. Distilled in this work is the sense of hopelessness that prompted the artist to leave his family again. He had every intention of returning to Basel from England, as he had earlier, but Holbein, while serving Henry VIII as court painter, died of the plague in London in 1543.

Sculpture

Fifteenth-century German sculpture was closely related to that of France and Flanders, but in the sixteenth century it began slowly but persistently to show the influence of the Italian Renaissance and Mannerist styles. Although German sculptors worked in every medium, they produced some of their finest and most original work in this period in limewood, from the linden or limetree, which grew abundantly in central and southern Germany. Generally wood images had been gilded and painted until Tilman Riemenschneider (active 1483–1531) introduced a natural wood finish.

Riemenschneider, from about 1500 on, ran the largest workshop in Würzburg, which included specialists in every medium of sculpture; he also was politically active in the city's government. Riemenschneider's work attracted patrons from other cities, and in 1501 he signed a contract for one of his major creations, the *Altarpiece of the Holy Blood*, for the Sankt Jakobskirche (Church of Saint James) in Rothenburg ob der Tauber, where a relic said to be a drop of Jesus' blood was preserved. The construction was to be nearly 30 feet high and made entirely of limewood. A specialist in wood shrines began work on the frame in 1499, and Riemenschneider later provided the figures. The relative value of their contributions can be judged from the fact that the frame carver received fifty florins and Riemenschneider sixty.

The main scene of the altarpiece is the *Last Supper* (fig. 18-74). Like his Italian contemporary Leonardo da Vinci (see fig. 18-2), Riemenschneider depicted the moment of Jesus' revelation that one of his followers would betray him. Unlike Leonardo, Riemenschneider composed his group with Jesus off-center at the left and the

18-75. Veit Stoss. *Saint Roche*, Church of Santissima
Annunziata, Florence. c. 1510–20. Limewood,
height 5'7" (1.7 m)

18-76. Peter Flötner. Apollo Fountain. 1532. Bronze, height
without base 30" (76.2 cm). Germanisches National-
museum, Nuremberg

figures of his disciples packed around him. Judas, at center stage, looks pathetic as he holds the money bag to which he will soon add the thirty pieces of silver he received for his betrayal. As the event is described in John 13:21–30, the apostles look puzzled by the news that a traitor is among them, and Jesus extends a morsel of food to Judas, signifying that he is the one destined to set in motion the events leading to Jesus' death. The youngest apostle, John, is asleep with his head on the table, following a medieval tradition derived from John 13:23, where "one of his disciples, the one whom Jesus loved" is described as "reclining at Jesus' side." One of the figures in front points down toward the predella, where the Crucifixion is depicted.

Riemenschneider's style is characterized by large heads, prominent features, and elaborate hair treatments with thick wavy locks and deeply drilled curls. The muscles, tendons, and raised veins of the hands and feet are especially lifelike, as are the sharp cheekbones, sagging jowls, baggy eyes, and slim figures of Jesus and his followers. Riemenschneider's studio workers copied either from drawings or from other carved examples, including different modes of drapery rendering. Rather than creating individual portrayals, Riemenschneider simply repeated this limited number of types. Here, the deeply hollowed folds and active patterning of the drapery create strong highlights and dark shadows that unify the figural composition and the intricate carving of the framework. The scene is set in a three-dimensional space with actual benches for the figures to rest on and windows at

the rear glazed with real bull's-eye glass. Natural light from the church's windows illuminates the scene with constantly changing effects, according to the time of day and weather. Despite his enormous production of religious images for churches, Riemenschneider's career ended when his support of the 1525 Peasants' War led to a fine and imprisonment just six years before his death.

Veit Stoss (c. 1438–1533), of Nuremberg, spent his career from 1477 to 1496 mainly in Cracow, Poland, where he became wealthy from his sculpture, architectural commissions, and financial investments. Upon returning to Nuremberg, he began to specialize in limewood sculpture, probably because commissions in other mediums were already dominated by established artists. Unlike Riemenschneider, he ran a small operation whose output was characterized by an easily recognizable, personal style expressing an obvious taste for German realism. Stoss's unpainted limewood works show a special appreciation for the wood itself, which he exploited for its inherent colorations, grain patterns, and range of surface finishes.

One statue in this vein is his lifesize *Saint Roche* of about 1510–1520 (fig. 18-75), first documented in 1523 in the Church of Santissima Annunziata in Florence, where it remains today. Stoss's style is often described as calligraphic because it suggests decorative lettering in the flowing linear **S** curves, swirls, and flourishes so evident in the drapery patterning. Like Riemenschneider, Stoss favored elaborate locks of hair and deeply cut drapery folds, which often contributed to dramatic effects of

lighting. His approach to physical features varied according to the subject, from minutely detailed realism to smooth, idealized countenances for women saints and the young. Images such as the *Saint Roche,* the patron saint for protection against the plague, soon afterward became prime objects of disdain and destruction in the north, but Stoss managed to ride out the rising tide of religious iconoclasm.

Among the earliest German sculptors to respond with enthusiasm to the Italian Renaissance movement was Peter Flötner (1486/95–1546). A Swiss native, Flötner became a Nuremberg citizen in 1523, on the eve of the disruptions that made his career a concentrated struggle for survival. Stylistic changes in his work suggest that he may have traveled to Italy about 1530, just before the creation of the cast-bronze Apollo Fountain (fig. 18-76). Many northern artists had access to Italian prints, however, and Flötner may have studied Italian engravings. His use of mythological subjects, such as this idealized sun god–archer, was a perfect means of making the transition from religious patronage, the main source of earlier sculpture commissions, to secular and civic markets. He created several classical fountains and filled gaps between large commissions by producing small sculptural works for home decoration, designs for goldsmiths, and popular prints.

18-77. Hans Holbein the Younger. *Henry VIII.* c. 1540. Oil on panel, 32½ x 29½" (82.6 x 75 cm). Galleria Nazionale d'Arte Antica, Rome

Holbein used the English king's great size to advantage for this official portrait, enhancing Henry's majestic figure with embroidered cloth, fur, and jewelry to create one of the most imposing images of power in the history of art. Although in the sixteenth century gluttony was considered "the English vice," the laying of a stupendous feast at every court meal was an expression of English royal superiority. Even Henry's illegitimate son, the six-year-old duke of Richmond, is recorded as having had set before him as an evening meal soup, boiled meat, mutton, roasted rabbits, roasted birds of different types, various vegetables and fruits, breads, and alcoholic beverages. The young duke's caretakers were then charged with distributing what must have been the considerable leftovers to the beggars at the gate.

ENGLAND AND THE ENGLISH COURT

England, in contrast to continental Europe, was economically and politically stable enough to sustain bountiful arts during the Tudor dynasty in the sixteenth century. Henry VIII (ruled 1509–1547) was known for his love of music, but he also competed with the elegant courts of Francis I and Charles V in the visual arts. Although direct contacts with Italy became difficult after Henry's break with the Roman Catholic Church in 1534, the Tudors so favored Netherlandish, German, and French artists that a vigorous native school of painters did not emerge until the eighteenth century. English architects fared better, developing their own style, which incorporated classical features but was generally independent of direct Italian influence. Nevertheless, the first architectural manual in English, published in 1563, was written by John Shute, who had spent time in Italy. Also available were stylebooks and treatises by Flemish, French, and German architects, as well as a number of books on architectural design by the Italian architect Sebastiano Serlio.

Court Painters

A remarkable record of the appearance of the Tudor monarchs survives in portraiture. Hans Holbein the Younger, who had worked for the humanist circle around Sir Thomas More during his first visit to London from 1526 to 1528, was appointed court painter to Henry VIII about four years after he returned to England in 1532. One of Holbein's official portraits of Henry at age thirty-nine (fig. 18-77), according to the inscription on the dark

background, was painted about 1540, although the dress and appearance of the king had already been established in an earlier prototype based on sketches of the king's features. Henry's huge frame—he was well over 6 feet tall and had a 54-inch waist in his maturity—is covered by the latest style of dress, a short puffed-sleeved cloak of heavy brocade trimmed in dark fur, a narrow, stiff white collar fastened at the front, and a doublet slit to expose his silk shirt and encrusted with gemstones and gold braid. Henry was quite vain and was so fascinated with Francis I that he attempted to emulate and surpass the French king's appearance (see fig. 18-47). After Francis had set a new style by growing a beard, Henry also grew one after about 1517, as shown in this portrait.

Holbein was not the highest-paid painter in Henry VIII's court. That status belonged to a Flemish woman named Levina Bening Teerling, who worked in England

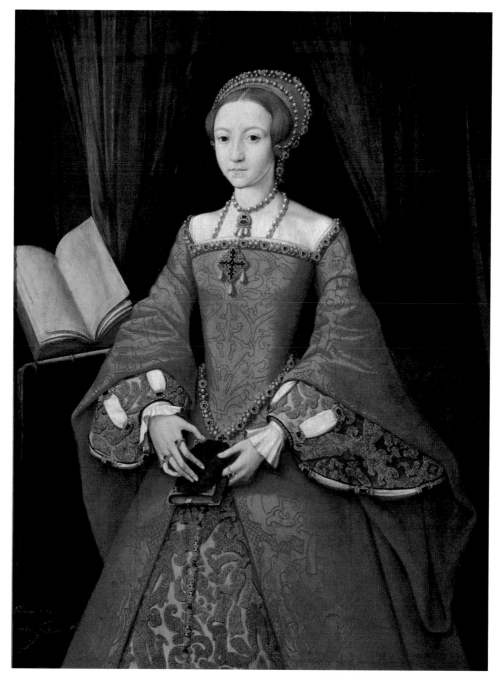

18-78. Attributed to Levina Bening Teerling. *Elizabeth I as a Princess*. c. 1559. Oil on oak panel, 42³/₄ x 32¹/₄" (108.5 x 81.8 cm). The Royal Collection, Windsor Castle, Windsor, England

for thirty years. The disappearance of her work is an art-historical mystery. At Henry's invitation to become "King's Paintrix," she arrived in London in 1545 from Bruges, accompanied by her husband. She maintained her court appointment until her death around 1576 in the reign of Elizabeth I. Because Levina was the grand-daughter and daughter of Flemish manuscript illumina-tors, she is assumed to have painted mainly miniature portraits or scenes on vellum and ivory. One lifesize portrait frequently attributed to her, but by no means securely, is that of Elizabeth Tudor as a young princess (fig. 18-78), painted around 1559. Elizabeth wears an adaptation of the so-called French hood popularized by her mother, Anne Boleyn. The pearled headcap is set

back to expose the hair around her face, while the rest of the hood falls on her shoulders at the back. Her brocaded outer dress, worn over a rigid hoop, is split to expose an underskirt of cut velvet. Although her features are soft-ened by youth and no doubt idealized as well, the princess's long, high-bridged nose and the unusual full-ness below her small lower lip give her a distinctive appearance. The prominently displayed books were no doubt included to signify Elizabeth's well-known love of learning.

About the time Elizabeth sat for this portrait in 1559, her twelve-year-old half brother, the Protestant Edward VI, was king, and her half sister, Mary Tudor, was next in line for the throne. But Mary was a Catholic and Edward

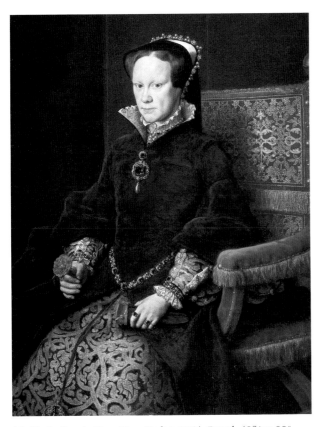

18-79. Anthonis Mor. *Mary Tudor*. 1554. Panel, 42⅞ x 33"
(108.9 x 83.8 cm). Museo del Prado, Madrid

After Mary Tudor's accession to the English throne,
the Scottish Protestant Reformation leader John Knox,
royal chaplain under her brother Edward VI, fled into
exile in Switzerland. In 1558 he published *The First
Blast of the Trumpet against the Monstrous Regiment of
Women*, expressing his view that it was against God's
law for a woman to hold supreme political power. The
English, however, had little problem with female rule,
and public objections to it were rare, perhaps because
of a strongly held belief in hereditary descent. Queen
Mary I came to be known in history, however, as
"Bloody Mary" for her zealous attempt to reestablish
the Roman Catholic Church in England. During her
reign of less than five years, 280 heretics were burned
at the stake, compared with 81 during the long reign
of her father, Henry VIII, and only 4 in the more than
forty-four years that her half sister Elizabeth I was on
the throne.

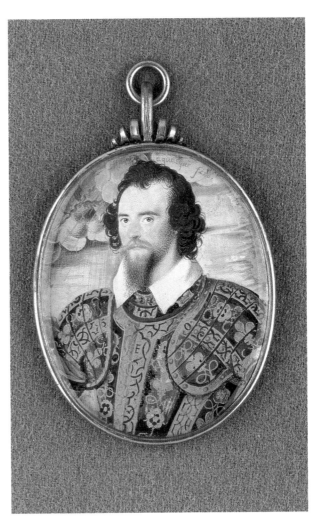

18-80. Nicholas Hilliard. *George Clifford, 3rd Earl of Cumber-
land (1558–1605)*. c. 1585–89. Watercolor on vellum
on card, oval 2¾ x 2³⁄₁₆" (7.1 x 5.8 cm). The Nelson-
Atkins Museum of Art, Kansas City, Missouri
Gift of Mr. and Mrs. John W. Starr through the Starr
Foundation. F58-60/188

and his advisers were Protestants. Therefore, at Edward's
death in 1553, the regent tried to proclaim Edward's
cousin, Lady Jane Grey, successor to the throne. The
thirty-seven-year-old Mary, every bit as iron-willed and
ferocious as her father, Henry VIII, called for the people's
support and rallied over 40,000 armed volunteers, who
put her on the throne within two weeks. Queen Mary
quickly reinstated Catholic practice, and in July 1554 she
married the future King Philip II of Spain.

In her marriage portrait by the internationally re-
nowned painter Anthonis Mor (1512/25–1575), brought
to London by Philip, Mary I is shown with strong, unre-
fined features and a bold, self-assertive look (fig. 18-79).
She holds a pink Tudor rose, which symbolizes that the

Tudors were the heirs of two earlier English dynasties—
the houses of York, whose symbol was the white rose,
and of Lancaster, whose symbol was the red rose. Mor's
skill at portraying the textures of elegant materials is bal-
anced by his ability to use a dynamic pose and engaging
expression to portray a real, even if somewhat idealized,
human being.

In 1570, while Levina Teerling was still active at Eliz-
abeth's court (ruled 1558–1603), Nicholas Hilliard (1547–
1619) arrived in London from southwest England to pur-
sue a career as a jeweler, goldsmith, and painter of
miniatures. Hilliard never received a court appointment
but worked instead on commission, creating miniature
portraits of the queen and court notables, including
George Clifford, third earl of Cumberland (fig. 18-80).
This former admiral was a regular participant in the
tilts (jousts) and festivals celebrating the anniversary of
Elizabeth I's ascent to the throne. In Hilliard's miniature,
Cumberland wears a richly engraved and gold-inlaid suit
of armor, forged for his first appearance in 1583 at the

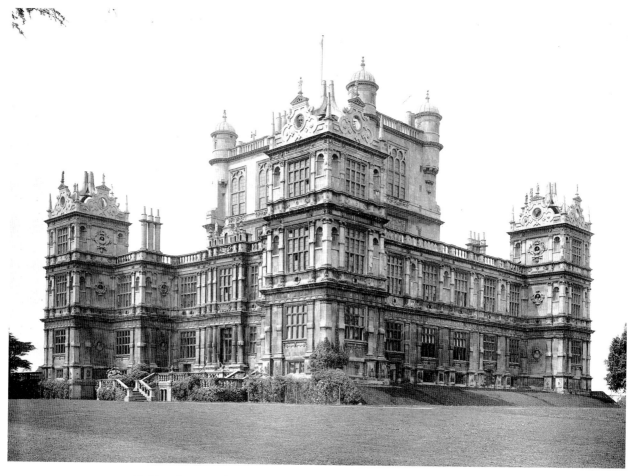

18–81. Robert Smythson. Wollaton Hall, Nottinghamshire, England. 1580–88

WHAT THE QUEEN'S CHAMPION WORE AT THE TILTS

The medieval tradition of tilting competitions at English festivals and public celebrations continued during Renaissance times. Perhaps the most famous of these, the Accession Day Tilts, were held annually to celebrate the anniversary of Elizabeth I's coronation. The gentlemen of the court, dressed in armor made especially for the occasion, rode their horses from opposite directions, trying to strike each other with long lances. Each pair of competitors galloped past each other six times, and the judges rated their performances the way boxers are given points today. Breaking of a competitor's lance was comparable to a knockout.

The elegant armor worn by George Clifford, third earl of Cumberland, at the Accession Day Tilts has been preserved in a nearly complete state in the collection of the Metropolitan Museum of Art in New York.

In honor of the queen, the armor's surface was decorated with engraved Tudor roses and capital *E*s back to back. As the Queen's Champion from 1590 on, Clifford also wore her jeweled glove attached to his helmet as he met all comers in the courtyard of Whitehall Palace in London.

Made by Jacob Halder in the royal armories at Greenwich, the 60-pound suit of armor is recorded in the sixteenth-century *Almain Armourers Album* along with its "exchange pieces." These allowed the owner to vary his appearance by changing mitts, side pieces, or leg protectors, and also provided backup pieces if one piece were damaged.

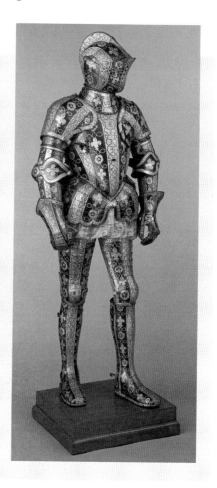

Armor of George Clifford, 3rd Earl of Cumberland, made in the royal workshop at Greenwich, England. c. 1580–85. Steel and gold, height 5'9½" (1.77 m). The Metropolitan Museum of Art, New York
Munsey Fund, 1932 (32.130.6)

18-82. Plan of Wollaton Hall (drawn by Giroux, after John Thorpe)

tilts (see "What the Queen's Champion Wore at the Tilts," opposite). Hilliard had a special talent for giving his male subjects an appropriate air of courtly jauntiness and depicting them in extravagant costumes and hairstyles without making them appear foolish. Cumberland, a man of about thirty with a stylish beard, moustache, and curled hair, is humanized by his direct gaze and unconcealed receding hairline. Cumberland's motto, "I bear lightning and water," is inscribed on a stormy sky, with a lightning bolt in the form of a caduceus (the symbolic staff with two entwined snakes), one of his emblems.

Architecture

In the years after his 1534 break with the Roman Catholic Church, Henry VIII, as the newly declared head of the Church of England, dissolved the monastic communities in England, seized their land, and sold or gave it to favored courtiers. Many properties were bought by speculators who divided and resold them. To increase support for the Tudor dynasty, Henry and his successors created a new nobility by granting titles to rich landowners and officials. To display their wealth and status, many of these newly created aristocrats embarked on extensive building projects after about 1550. They built lavish country residences, which sometimes surpassed the French châteaux in size and grandeur.

The first English architect of the Renaissance period known at present by name was Robert Smythson (c. 1535–1614), who was commissioned in 1580 to build Wollaton Hall near Nottingham. The classical principles that Smythson applied to his basic design, as well as the superimposed orders on the pilasters flanking the windows and capping the corners (fig. 18-81), undoubtedly

drew on the books of Sebastiano Serlio, perhaps the greatest source of Italian architectural ideas outside Italy. The solid square plan of Wollaton Hall (fig. 18-82) is both geometric and symmetrical: a two-story central block with identical three-story pavilions at each corner. Smythson's confident design is visible in his bold and effective integration of nonclassical elements into the elevation. Although conforming to a classical symmetry of design on all four exterior faces, the building also brings together huge, rectangular glazed windows, Flemish **gables** disguising the pavilion roofs, and a castlelike keep rising from the central block, complete with arched double windows and corner turrets.

SPAIN AND THE SPANISH COURT

Philip II, the only son of Charles V and Isabella of Portugal, preferred Spain as his permanent residence and Madrid as his capital. His long reign as king, from 1556 to 1598, saw the zenith of Spanish power. Under Philip's direction, Spain halted the advance of Islam in the Mediterranean and secured control of most of the Americas. Despite enormous effort and wealth, however, Philip could not suppress the revolt of the northern Netherlands, and his navy, the famous Spanish Armada, was destroyed by the English in 1588. From an early age, Philip was a serious art collector: for more than half a century he patronized and supported artists in Spain and abroad.

Architecture

Philip built El Escorial, the great monastery-palace complex outside Madrid, seen here in a detail from a painting (fig. 18-83), partly to comply with his father's direction to construct a "pantheon" in which all Spanish kings might be buried and partly to house his court and government. The basic plan was a collaboration between Philip and Juan

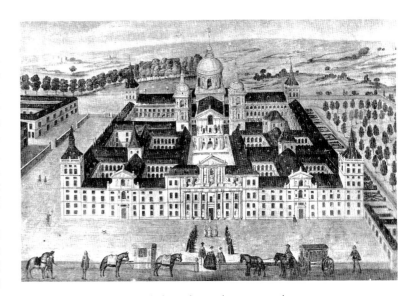

18-83. Juan Bautista de Toledo and Juan de Herrera. El Escorial, Madrid. 1563–84. 625 x 520' (205 x 160 m). Detail from an anonymous 18th-century painting

Bautista de Toledo, Michelangelo's supervisor at Saint Peter's from 1546 to 1548. Summoned from Italy by the king in 1559, Juan Bautista provided a design that reflected his indoctrination with Bramantean classical principles in Rome. The king himself dictated the severity of the design, and El Escorial's grandeur comes from its great size, excellent masonry, and fine proportions. The complex comprises not only the royal residence but the Royal Monastery of San Lorenzo and a church whose crypt served as the royal burial chamber; many people's visions were involved in its creation. From Juan Bautista's death in 1567 until 1569, an Italian architect directed the project. In 1572 Juan Bautista's original assistant, Juan de Herrera, was appointed architect and immediately changed the design, adding second stories on all wings and breaking the horizontality of the main facade with a central frontispiece that resembled superimposed temple fronts. Before beginning the church, Philip solicited the advice of Italian architects, including Vignola and Palladio, and the final design was a composite of ideas that Philip approved and Herrera carried out. Although not a replica of any Italian design, the church embodies Italian classicism in its geometric clarity and symmetry and the use of superimposed orders on the temple-front facade.

Sculpture

Philip's conservative tastes in architecture were countered by his commissions and purchase of lavish paintings and sculpture to glorify his reign and adorn the interior of El Escorial. He provided so much work for the Leoni, the Milanese family of sculptors discussed earlier, that Pompeo Leoni (c. 1533–1608) finally moved to Madrid. Among his works are lifesize bronze portrait statues of Philip II and his family, placed inside the church as funerary and dynastic monuments (fig. 18-84). The group kneels in prayer facing the main altar in the Doric order gallery overlooking the sanctuary, just above a private oratory, or chapel, where the family actually worshiped. Directly opposite is a similar family group around Charles V. Shown with Philip are his wives Maria of Portugal, Elizabeth of Valois, and Anna of Austria, and his son by Maria, Don Carlos. Mary Tudor is conspicuously not among them, possibly because Philip's Armada had been destroyed by her sister and successor, Elizabeth I.

Painting

The most famous painter in Spain in the last quarter of the sixteenth century was the Greek painter Kyriakos (Domenikos) Theotokopoulos (1541–1614), who arrived in 1577 after working for ten years in Italy. El Greco (the Greek), as he is called, was trained as an icon painter in the Byzantine manner in his native Crete, then under Venetian rule. In about 1566 he went to Venice and entered Titian's shop, but he must also have closely studied the paintings of Tintoretto and Veronese. From about 1570 to 1577, he worked in Rome, apparently without finding sufficient patronage. Probably encouraged by Spanish church officials he met in Rome, El Greco immigrated to Spain and settled in Toledo, where he soon was given major commissions. He appar-

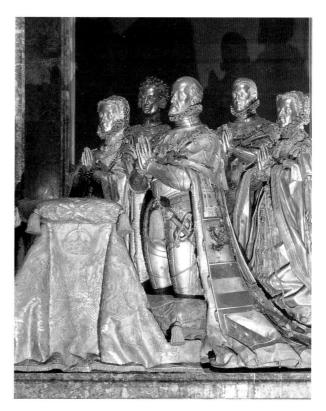

18-84. Pompeo Leoni. *Philip II and His Family*, private chapel of the royal family, El Escorial, Madrid. 1591–98. Bronze, lifesize

ently hoped for a court appointment, but Philip II disliked the one large painting he had commissioned from the artist for El Escorial and never gave him work again.

Toledo was an important cultural center, and El Greco soon joined the circle of humanist scholars who dominated its intellectual life. An intense religious revival was also under way in Spain, expressed not only in the poetry of the Spanish mystics but in the impassioned preaching of Ignatius Loyola (c. 1491–1556), the founder of a new religious order called the Society of Jesus, or Jesuits. El Greco's style, rooted in Byzantine religious art but strongly reflecting Tintoretto's Venetian love of rich color and loose brushwork, was the ideal vehicle to express in paint the intense spirituality of the two great Spanish mystics, Teresa of Ávila (1515–1582) and her follower John of the Cross (1542–1591), both later canonized.

In 1586, the artist was commissioned by the Orgaz family to paint a large canvas illustrating a legend from the fourteenth century, the *Burial of Count Orgaz* (fig. 18-85). The count had been a great benefactor of the Church, and at his funeral Saints Augustine and Stephen were said to have appeared and lowered his body into his tomb as his soul simultaneously was seen ascending to heaven. In El Greco's painting the miraculous burial takes place slightly off-center in the foreground, while Orgaz's tiny ghostly soul is lifted by an angel along the central axis through the heavenly hosts toward the enthroned Christ at the apex of the canvas. Depicting the legend also allowed El Greco to paint a group portrait of the local aristocracy and religious notables, who fill up the space around the burial scene. El Greco placed his eight-year-old

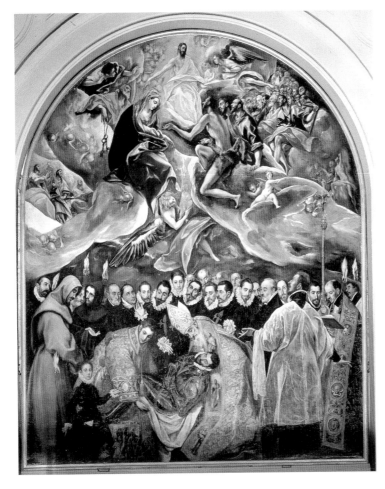

18-85. El Greco. *Burial of Count Orgaz*, Church of Santo Tomé, Toledo, Spain. 1586. Oil on canvas, 16' x 11'10" (4.88 x 3.61 m)

son at the lower left next to Saint Stephen and signed the painting on the boy's white kerchief. El Greco may have put his own features on the man just above the saint's head, the only one who looks straight out at the viewer.

In composing the painting, El Greco used a Mannerist device reminiscent of Rosso and Pontormo, filling up the pictorial field with figures and eliminating specific reference to the spatial setting (see figs. 18-37, 18-38). He has distinguished between earth and heaven by creating a separate light source above in the figure of Christ, who sheds an otherworldly luminescence quite unlike the natural light below. The two realms are connected, however, by the descent of the light from heaven to strike the priestly figure in the alb, a long-sleeve white vestment, at the lower right.

Late in his life, El Greco commemorated Toledo in *View of Toledo*, a topographical cityscape transformed by a stormy sky and a narrowly restricted palette of greens and grays into a mystical illusion (fig. 18-86). This conception is very different from Altdorfer's peaceful, idealized *Danube Landscape* of nearly a century earlier (see fig. 18-72). If any precedent comes to mind, it is the lightning-rent sky and pre-storm atmosphere in Giorgione's *Tempest* (see fig. 18-27). In El Greco's painting the geography and architecture of Toledo seem to have been overridden by the artist's mental state and desire to convey his emotions.

The emotionalism and dramatic light effects of El Greco's work would be echoed by painters in early-seventeenth-century, or early Baroque, styles in Europe. The drive to discover all that could be learned about nature and the world continued and intensified, but the way this fascination was expressed transformed the arts.

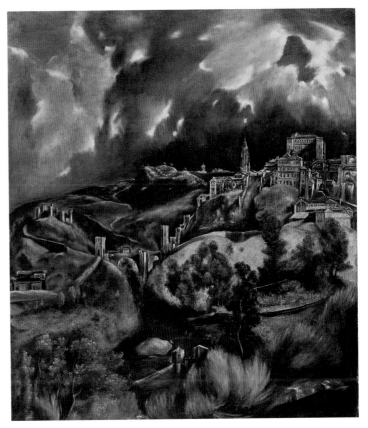

18-86. El Greco. *View of Toledo*. 1612. Oil on canvas, 47¾ x 42¾" (121 x 109 cm). The Metropolitan Museum of Art, New York

The H. O. Havemeyer Collection. Bequest of Mrs. H. O. Havemeyer, 1929 (29.100.6)

1575 CE 1625

Velázquez
*Water Carrier
of Seville*
c. 1619

Whitehall
Banqueting House
1619–22

Van Dyck
Charles I at the Hunt
1635

Leyster
Self-Portrait
1635

Saint Peter's Square
1656–57

CHAPTER 19

Baroque, Rococo, and Early American Art

Parson Capen House
1683

Rigaud
Louis XIV
1701

Asam
*Angel Kneeling
in Adoration*
1732

Fragonard
The Meeting
1771–73

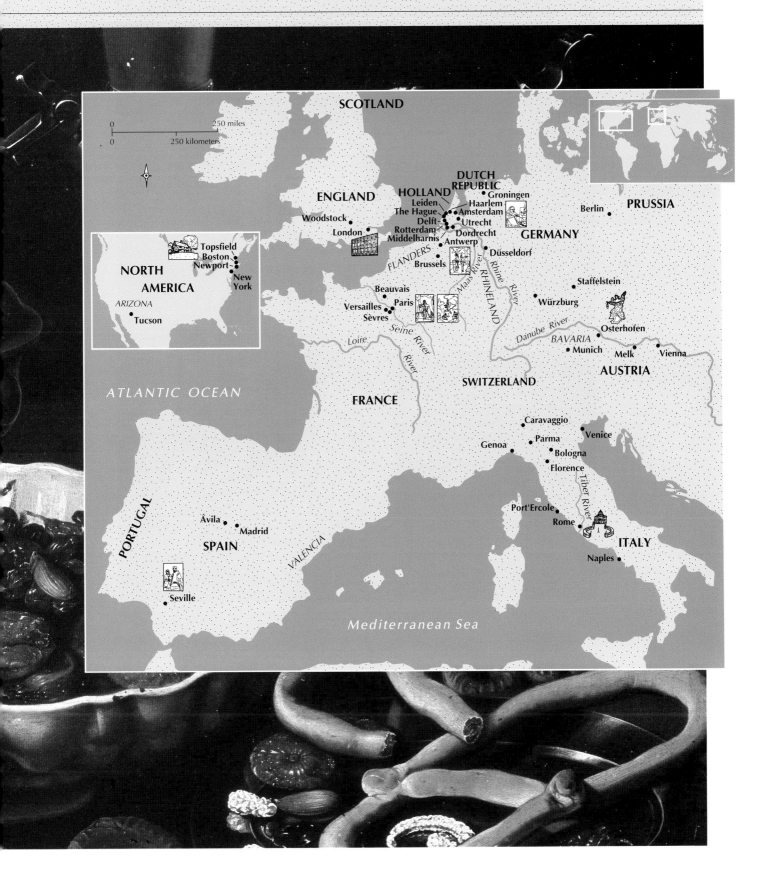

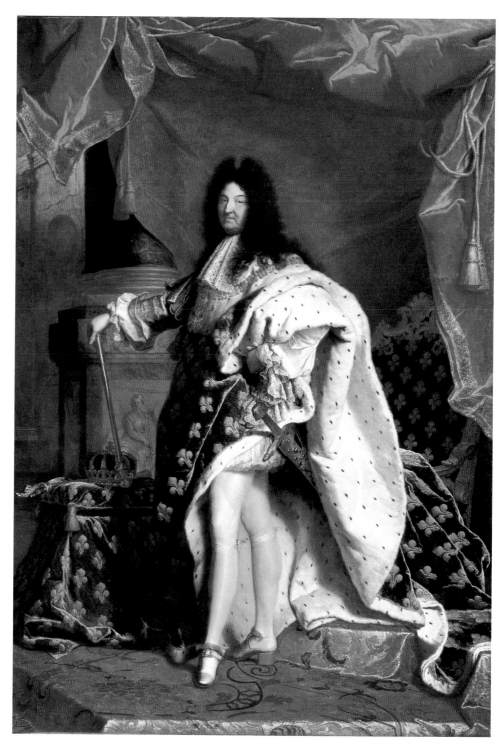

19-1. Hyacinthe Rigaud. *Louis XIV.* 1701. Oil on canvas, 9'2" x 7'10¾" (2.79 x 2.4 m). Musée du Louvre, Paris

I n Hyacinthe Rigaud's 1701 portrait of Louis XIV, the richly costumed monarch known as le Roi Soleil ("the Sun King") is presented to us by an unseen hand that pulls aside a huge billowing curtain (fig. 19-1). Showing off his elegant legs, of which he was quite proud, the sixty-three-year-old French monarch poses in an elaborate robe of state, decorated with gold fleurs-de-lis and white ermine, and he wears the red-heeled

built-up shoes he had invented to compensate for his shortness. At first glance, the face under the huge wig seems almost incidental to the overall grandeur. Yet the directness of Louis XIV's gaze makes him movingly human, despite the pompous pose and the distracting magnificence that surrounds him. Rigaud's genius in portraiture was always to capture a good likeness while idealizing his subjects' less attractive features and giving minute attention to the virtuoso rendering of textures and materials of the costume and setting.

Rigaud had a workshop that produced between thirty and forty such portraits a year. From his meticulous business records, we know the cost of his materials, the salaries of his employees, and the prices he charged. His portraits, for example, varied in price according to whether the entire figure was painted from life or Rigaud merely added a portrait head to a stock figure placed in a composition he had designed but his workshop had executed.

Rigaud's long career spanned a time of great change in Western art. Not only did new manners of representation emerge, but where art had once been under the patronage of the Church and the aristocracy, a kind of broad-based commercialism arose that was reflected not only by Rigaud's "mass-produced" portraits but also by the thousands of still-life painters producing works for the many households that could now afford them. These artistic changes of the seventeenth and eighteenth centuries, the Baroque period, took place in a cultural context in which individuals and organizations were grappling with the effects of religious upheaval, economic growth, political turbulence, and a dramatic explosion of scientific knowledge.

THE BAROQUE PERIOD

By the seventeenth century, Protestantism was already established firmly and irrevocably in much of northern Europe. The permanent division within Europe between Roman Catholicism and Protestantism had a critical effect on European art. In response to the Protestant Reformation of the early sixteenth century, the Roman Catholic Church had embarked in the 1550s on a program of renewal known as the Counter-Reformation. As part of the program, the Church used art to encourage piety among the faithful and to persuade those it regarded as heretics to return to the fold. Counter-Reformation art was intended to be both doctrinally correct and visually and emotionally appealing so that it could influence the largest possible audience. Both the Catholic Church and the Catholic nobility supported ambitious building and decoration projects to achieve these ends.

There was also a variety of civic projects—buildings, sculpture, and paintings—undertaken to support numerous political positions throughout Europe, and private patrons continued to commission works of art. Economic growth in most European countries helped create a large, affluent middle class eager to build and furnish fine houses and even palaces. By the late seventeenth century, Colonial America, both North and South, was also prospering and had eager buyers for art of every type and quality. The art produced in the American colonies was closely related to, although generally distinct from, that of Europe. In both Europe and America, building projects ranged from enormous churches and palaces to stage sets for plays and ballets, while painting and sculpture varied from large religious works and history paintings to portraits, still lifes, and **genre**, or scenes of everyday life. At the same time, scientific advances forced Europeans to question how they viewed the world. Of great importance was the growing understanding that the Earth was not the center of the universe but was a planet revolving around the Sun. In the eighteenth century, scientific literature became so abundant that the period has been called the Age of Enlightenment.

Within this cultural climate Baroque and Rococo art

PARALLELS

Europe and North America	1575–1675	1675–1775
Italy	Il Gesù; Pope Sixtus V; Farnese Ceiling; Gianlorenzo Bernini; first completely sung opera; Francesco Borromini; Caravaggio's *Entombment*; Maderno's facade of Saint Peter's; Galileo constructs and improves telescope; Reni's *Aurora*; Pope Urban VIII	Vivaldi's *Four Seasons*; Pope Clement XIV bans Jesuits
France	King Henri IV; Nicolas Poussin; Claude Lorrain; King Louis XIII (Marie de' Medici as regent); French Royal Academy founded; Descartes's *Principles of Philosophy*; wars with Spain end; King Louis XIV; Molière's *Le Misanthrope*; Louvre facade begun; enlargement of Versailles begun	Jean-Antoine Watteau; Jean-Siméon Chardin; François Boucher; Honoré Fragonard; chinoiserie design; Voltaire's *Candide*; Clodion's Rococo sculpture
Spain	Spain annexes Portugal; Jusepe de Ribera; Francisco de Zurbarán; Diego Velázquez; King Philip IV; expulsion of majority of Muslims	King Philip V; War of Spanish Succession; Churrigueresque style emerges
Flanders	Habsburg rule; Spanish Habsburg rule; Jan Brueghel; Peter Paul Rubens	
Netherlands	Frans Hals; Dutch Republic proclaims independence; Rembrandt van Rijn; Judith Leyster; landscape painting emerges; Jan Vermeer; Spain recognizes independence of Dutch Republic; genre painting emerges; Leeuwenhoek uses microscope	
England	Drake circumnavigates globe; Mary, Queen of Scots, executed; defeat of the Spanish Armada; Marlowe's *Dr. Faustus*; Spenser's *Faerie Queene*; Bacon's *Essays*; Shakespeare's *Macbeth*; King James Bible; Donne's *Holy Sonnets*; Jones introduces Palladianism; First English Civil War; Parliament restores monarchy; plague kills 75,000 people in London; Great Fire in London; Milton's *Paradise Lost*	Wren rebuilds Saint Paul's Cathedral; Newton's *Principia*; Locke's *Essay Concerning Human Understanding*; union of England and Scotland as Great Britain; Swift's *Gulliver's Travels*; Handel's *Messiah*; British Museum founded; Watts develops steam engine; Cook's Pacific voyages
Germany/Austria	University of Würzburg founded; Thirty Years' War begins and spreads throughout Europe; Andreas Schlüter	Bach's *Brandenburg* Concerti; Asam's Rococo sculpture; Cuvilliés's Rococo architecture; Tiepolo's Residenz frescoes; Mozart's first symphony
North America	Spain founds St. Augustine, Fla.; Raleigh colonizes Roanoke Island, N.C.; first French settlement in Nova Scotia; English settlement of Jamestown, Va.; timber architecture in Northeast and Spanish-style mission design in Southwest; first enslaved Africans arrive in Virginia; Pilgrims at Plymouth Rock; Harvard University founded; European settlers wage wars with Native Americans	Pueblo peoples rise up against Spanish; French Huguenots arrive in North America; witchcraft trials in Salem, Mass.; John Singleton Copley; Boston Tea Party; Palladian-style architecture; Seven Years' War; First Continental Congress issues Declaration of Rights and Grievances; Second Continental Congress names George Washington commander-in-chief
World	Hideyoshi unites Japan; first printing in Peru; Christians banned in Japan; Portugal explores East Africa; Tsar Boris Godunov (Russia); Japanese capital moved to Edo (Tokyo); Taj Mahal (India); Qing dynasty (China)	Peter the Great (Russia); Moscow University founded; Afghanistan conquers Persia; coffee first planted in Brazil; Hermitage Museum founded (Russia); Catherine the Great (Russia)

arose and thrived. The term *baroque* is derived from the Portuguese word *barroco*, literally "large, irregularly shaped pearl." For a while, the word came to suggest something that was heavily ornate, complex, strange, or even in bad taste. In the late nineteenth century, critics first applied the word to the art of Europe and some European colonies in the Americas from the late 1500s to the late 1700s—that is, from the end of the Renaissance to the emergence of Neoclassicism and Romanticism (Chapter 26), now broadly known as the Baroque period. The term *rococo* was coined by critics who combined *barroco* and the French word *rocaille* ("stone debris"), a rock-and-shell ornament used extensively in decoration, to describe the ornate, fanciful, and often playful artwork and architectural decoration that became fashionable in France in the 1720s and spread throughout Europe. Rococo was a light, refined style that emerged late in the Baroque period. Although both *baroque* and *rococo* were originally derogatory terms, the high quality of Baroque and Rococo art is accepted today without question. Whereas Rococo has been described as a style, when theorists have tried to define the characteristics of a single Baroque style the task has proved virtually impossible, given the roughly two centuries and immense geographical expanse over which Baroque art flourished. Nevertheless, there are four stylistic features that are evident in much of Baroque art: emotionalism, naturalism, classicism, and tenebrism. **Emotionalism** here refers to the powerful and immediate emotional response that many seventeenth- and eighteenth-century works were deliberately meant to evoke in the viewer: astonishment, horror, sorrow, piety, and intense empathy. **Naturalism**, the use of elements from everyday life in seemingly unposed or informal arrangements, both as contexts for religious or historical subjects and as principal subjects in themselves, was also widespread in Baroque art. **Classicism**, meaning here the adherence to Renaissance ideals and principles of composition, was especially favored in Rome, in the central Italian city of Bologna, and in France. Emotionalism, naturalism, and classicism often coexisted in the same work, and many of the best examples of Baroque art combine all three elements. Finally, **tenebrism**, which is the use of **chiaroscuro**, or strong light-and-shadow effects, was a pictorial device found in all the arts across Europe. Above all, in the seventeenth and eighteenth centuries the quality most admired in a work of art was great technical skill. Artists achieved spectacular technical virtuosity. The leading artists were in complete control of their craft, and their delight in pure skill permeated their studios and workshops.

Finally, the role of the viewer changed, and the expectation of active involvement in the artwork increased. The work of art reached out in every direction physically and emotionally to draw the viewers into its orbit. Whereas Renaissance painters and patrons had been fascinated with the visual possibilities of perspective and of the fact that the beholder could look *into* a spatial illusion, seventeenth- and eighteenth-century artists regarded viewers as *participants* in the work of art and architecture. Compositions include the world beyond the frame or the piece

of sculpture, the space where the viewer stands. For example, Gianlorenzo Bernini's *David* of 1623 (see fig. 19-10) hurls a rock at the unseen giant Goliath, who seems positioned behind the viewer. Similarly, late Baroque churches and palaces break the bounds of orderly spatial units and offer instead a theater of surprise.

Not only was physical connection between the artwork and the viewer desirable but so was emotional and intellectual involvement. Horrifying scenes of martyrdoms and moments of a mystic's ecstatic religious union with God were turned by artists into opportunities for the beholder's vicarious participation in emotional, often religious, drama. In all these areas of virtuosity, artists and architects of the European Baroque were performing theatrically, so to speak, for a broad range of ecclesiastical and secular clients.

ROMAN BAROQUE

The patronage of the papal court and the Roman nobility dominated much of Italian art from the late sixteenth to the late seventeenth century. Major architectural projects were undertaken in Rome during this period, both to glorify the Church and to improve the city. Pope Sixtus V (papacy 1585–1590) had begun the renewal by cutting long, straight avenues between important churches and public squares, replacing some of Rome's crooked medieval streets. Sixtus also began to renovate the Vatican and its library, completed the dome of Saint Peter's Basilica (Chapter 18), built splendid palaces, and reopened one of the ancient aqueducts to stabilize the city's water supply. Several of Sixtus V's successors, especially Urban VIII (papacy 1623–1644), were also vigorous patrons of art and architecture.

Architecture and Its Decoration

A major program of the Counter-Reformation was to embellish the Church with splendid architecture, some of which was so extravagant that the Vatican treasury was nearly bankrupted. In contrast to the Renaissance ideal of the **central-plan church**, Counter-Reformation thinking called for churches with long, wide **naves** to accommodate large congregations and the processional entry of the clergy at the Mass. Although in the sixteenth century the decoration of new churches was generally modest, even austere, seventeenth- and eighteenth-century taste favored opulent and spectacular visual effects to heighten the spiritual involvement of worshipers.

The Church of Il Gesù. The Society of Jesus, or Jesuit order—organized in 1539 by the Spanish noble Ignatius of Loyola—commissioned the Italian architect Giacomo Barozzi, known as Giacomo da Vignola (1507–1573; see figs. 18-25 and 18-26), to design its headquarters church in Rome. The simplicity and functionality of the Church of Il Gesù (Jesus), completed after Vignola's death by Giacomo della Porta in 1584, influenced church design for more than a century. Vignola's plan included a large nave, but the church's short **transepts** and the great

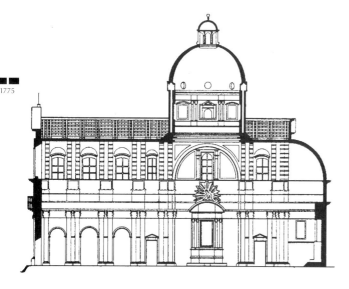

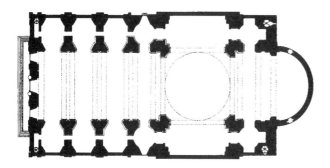

19-2. Plan and section of the Church of Il Gesù, Rome. Begun on Vignola's design in 1568; facade completed by della Porta c. 1575–84

height of its vault created a visual effect close to that of a domed, central-plan church of the Renaissance (fig. 19-2).

Especially influential was the facade (fig. 19-3), also by Vignola but altered by della Porta during construction. The general design had been established by Renaissance architects: paired **colossal orders** (**columns** or **pilasters** extending through two or more stories) visually tying together the first and second stories; a second order superimposed on the third story; and large **volutes** (scroll forms) to ease the transition between the wide lower levels and the narrow third level by masking the sloping roofs of the side aisles. Two important aspects of the facade design were new: centrality and verticality. Centrality was achieved by emphasizing the central axis of the building's main entrance. This was done by gradually moving the orders on the lower level forward, from the relatively flat pilasters at the corners to the **engaged half columns** at the center; by crowning the central door with a double **pediment**—a triangle or similar form used to surmount an entrance—and by enlarging the central window on the level above. Verticality was stressed by the intrusion of the double pediment into the level above it. An emphasis on centrality and verticality was to become a hallmark of Baroque church-facade design (see "Elements of Architecture," page 755).

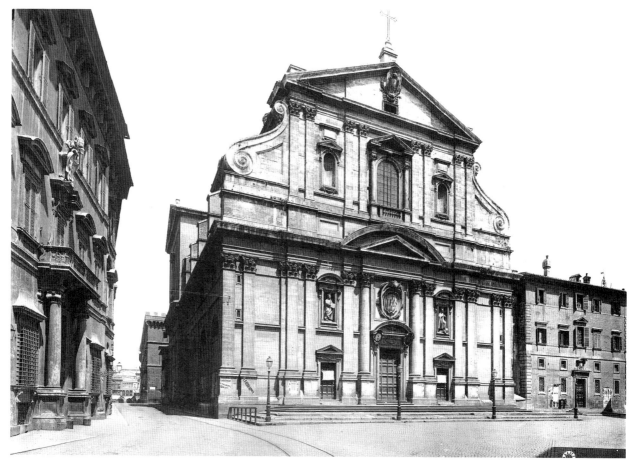

19-3. Giacomo da Vignola and Giacomo della Porta. Facade of the Church of Il Gesù

ELEMENTS OF ARCHITECTURE

Baroque and Rococo Church Facades

The two facades featured here demonstrate the shift of taste in architecture—from classicistic to expressionistic—between the beginning of the Baroque and the end of the Rococo. At one end of the spectrum is Giacomo da Vignola's and Giacomo della Porta's Roman Baroque facade for Il Gesù of about 1575–1584, which, like Renaissance and Mannerist buildings, is still firmly grounded in the clean articulation and vocabulary of classical architecture. At the other end is Pedro de Ribera's portal for the Hospicio de San Fernando (now a municipal museum) in Madrid, which was designed about 150 years later, in 1722. Ribera's portal is Rococo taken to extremes, in which there is nearly a meltdown of heavily encrusted, highly elaborated ornament in the **Churrigueresque** style.

Il Gesù's facade employs the **colossal order** and at the same time uses huge **volutes** to soften and aid the transition from the wide lower stories to the narrower upper level. Verticality is also stressed by the large double **pediment** that rises from the wide **entablature** and pushes into the transition zone between stories; by the repetition of triangular pedimental forms (above the **aedicula** window and in the crowning **gable**); by the push-up effect of the volutes; and most obviously by the massing of upward-moving forms at the center of the facade. **Cartouches**, **cornices**, and **niches** provide concave and convex rhythms across the middle zone.

The sandstone portal ensemble of the Hospicio is as much like a painting as architecture gets, and although the architect used classical elements (among them **cornices**, **brackets**, **pedestals**, volutes, **finials**, **swags**, and niches) and organized them symmetrically, the parts run together in a wild profusion of theatrical hollows and projections, large forms (such as the **broken pediment** at the roofline), and small details.

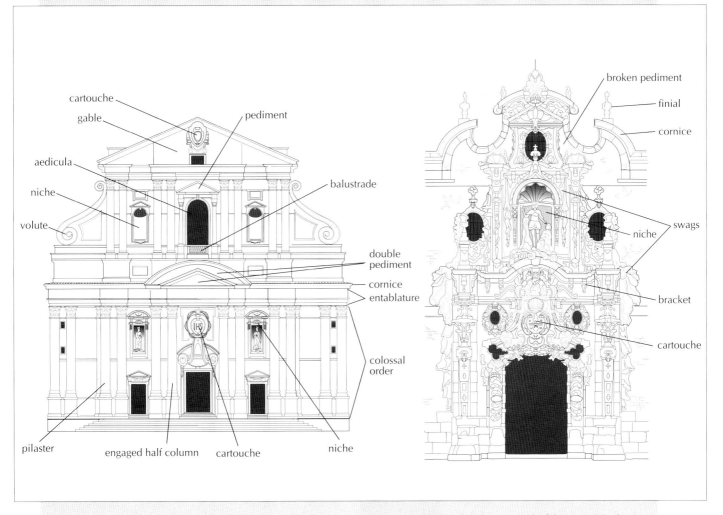

Giacomo da Vignola and Giacomo della Porta. Facade elevation of the Church of Il Gesù, Rome. c. 1575–84

Pedro de Ribera. Portal of the Hospicio de San Fernando, Madrid. 1722

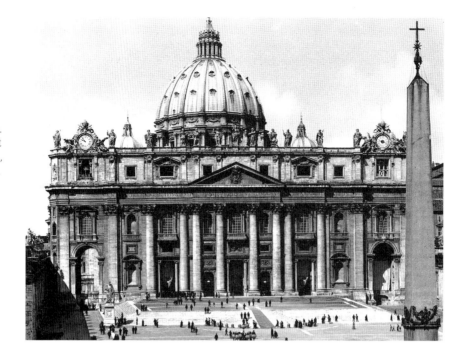

19-4. Carlo Maderno. Facade of Saint Peter's Basilica, Vatican, Rome. 1607–15

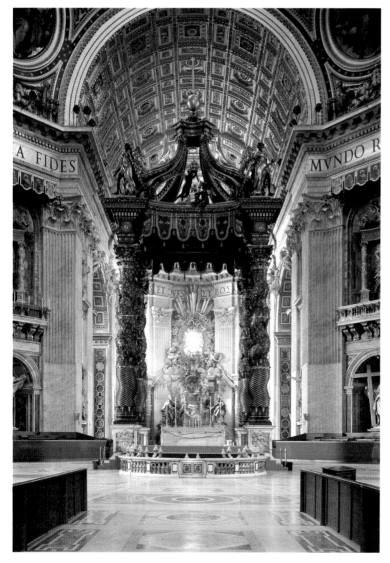

19-5. Gianlorenzo Bernini. *Baldacchino.* 1624–33. Gilt bronze, height approx. 100' (30.48 m). Chair of Peter. 1657–66. Gilt bronze, marble, stucco, and glass. Pier decorations. 1627–41. Gilt bronze and marble. Crossing, Saint Peter's Basilica, Vatican, Rome

Saint Peter's Basilica in the Vatican. Half a century after Michelangelo had returned Saint Peter's Basilica to Bramante's original vision of a central-plan building (see fig. 18-23), Pope Paul V (papacy 1605–1621) commissioned Carlo Maderno (1556–1629) to provide the church with a longer nave and a new facade (fig. 19-4). The construction was begun in 1607, and everything but the facade bell towers was completed by 1615. In essence, Maderno took the concept of the Gesù facade and enhanced its scale befitting the most important church of the Catholic world. Like that of Il Gesù, Saint Peter's facade is "stepped out" in three planes: from the corners to the doorways flanking the central entrance area, then the entrance area, then the central doorway itself (see "Saint Peter's Basilica," page 701). Similarly, the colossal orders connecting the first and second stories take the form of flat pilasters at the corners but are fully round columns flanking the doorways. These columns support a continuous **entablature** that also steps out—following the columns—as it moves toward the central door, which is surmounted by a triangular pediment. Similar to the Gesù facade, the pediment provides a vertical thrust, as does the superimposition of pilasters on the relatively narrow attic story above the entablature.

When Maderno died in 1629, he was replaced as Vatican architect by his collaborator of five years, Gianlorenzo Bernini (1598–1680). Bernini was born in Naples, but his family had moved to Rome about 1605. Taught by his father, Gianlorenzo was already a proficient marble sculptor by the age of eight. Part of his training involved sketching the Vatican collection of ancient sculpture, such as *Laocoön and His Sons* (see fig. 9), as well as the many examples of Renaissance painting in the papal palace. Throughout his life, Bernini admired antique art and considered himself a classicist. His fusion of classicism and emotionalism came to epitomize the Baroque style.

When Urban VIII was elected pope in 1623, he unhesitatingly gave the young Bernini the demanding task of designing an enormous cast-bronze **baldachin**, or canopy, for the main altar of Saint Peter's. The resulting

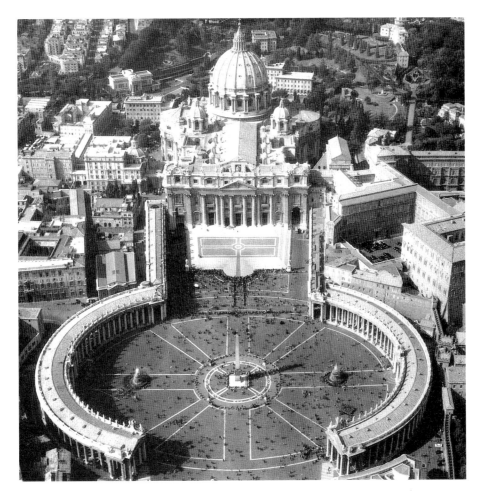

19-6. Gianlorenzo Bernini. Saint Peter's Square, Vatican, Rome. Designed c. 1656–57

Perhaps only a Baroque artist of Bernini's talents could have unified the many artistic periods and styles that come together in Saint Peter's Basilica. The visitor today sees not a piecing together of parts made by different builders at different times, starting with Bramante's original design for the building in the sixteenth century, but rather encounters a triumphal unity of all the parts in one coherent whole.

Baldacchino (fig. 19-5), which stands about 100 feet high, exemplifies the Baroque tendency to combine architecture and sculpture, and sometimes painting as well, so that a work cannot be precisely categorized as being in one medium or another. Begun in 1624, the *Baldacchino* was completed in 1633. The twisted columns decorated with spiraling parallel grooves and winding bronze vines were derived from Early Christian remains of the fourth-century church known as Old Saint Peter's. The fanciful **Composite capitals**, combining elements of both the Ionic and the Corinthian orders, support an entablature with a crowning element topped with an orb (a sphere representing the universe) and a cross, symbolizing the reign of Christ. Figures of angels and **putti** decorate the entablature, which is hung with tasseled panels in imitation of a cloth canopy. These symbolic elements—both architectural and sculptural—not only mark the site of the tomb of Saint Peter but also serve as a monument to Urban VIII and his family, the Barberini, whose emblems—including honeybees and suns on the tasseled panels, and laurel leaves on the climbing vines—are prominently displayed.

Between 1627 and 1641 Bernini and several other sculptors, again combining architecture and sculpture, rebuilt Bramante's crossing piers as giant **reliquaries**. Statues of Saints Helena, Veronica, Andrew (visible at left in fig. 19-5), and Longinus (by Bernini himself, 1629–1638) stand in **niches** below alcoves containing their relics. Visible through the *Baldacchino*'s columns on the back wall of the church is another reliquary, the gilded stone, bronze, and **stucco** encasement made by Bernini between 1657 and 1666 for the ancient wooden throne thought to have been used by Saint Peter as the first bishop of Rome. The Chair of Peter symbolized the direct descent of Christian authority from Peter to the current pope, a belief rejected by Protestants and therefore deliberately emphasized in Counter-Reformation Catholicism. The chair is carried by four theologians and lifted further by a surge of gilded clouds moving upward toward an explosion of angels, putti, and gilt-bronze rays of light bursting forth from a stained-glass panel depicting a dove (representing the Holy Spirit), lit from a window. The light penetrating the church from this window, reflected back by the gilding, is in effect part of the sculpture. Similarly, the flickering of candles during evening services, reflected and multiplied by the bronze, is incorporated into this masterpiece.

At approximately the same time that he was at work on the Chair of Peter, Bernini designed and supervised the building of a **colonnade** to enclose Saint Peter's Square (fig. 19-6). The space of the open square that he

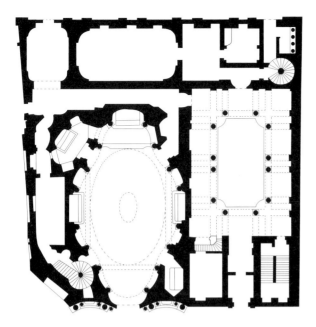

1625
1575 1775

19-7. Francesco Borromini. Plan of the Church of San Carlo alle Quattro Fontane, Rome. Begun 1638

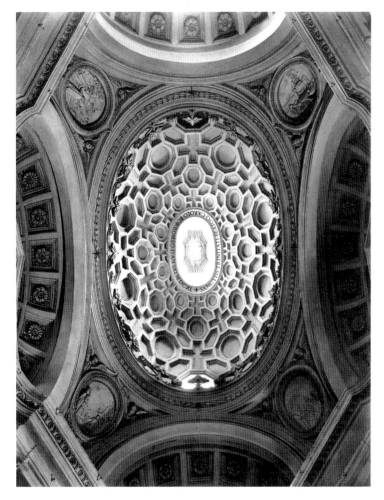

19-8. Francesco Borromini. Dome interior, Church of San Carlo alle Quattro Fontane. 1638–45

had to work with was irregular, and an Egyptian **obelisk**—a four-sided, tapered shaft ending in a pyramid—and two fountains already in it had to be incorporated into the overall plan. Bernini's remarkable design frames the square with two enormous curved **porticoes**, or covered walkways, supported by Doric columns. These are connected to two straight porticoes that lead up a slight incline to the two ends of the church facade. Bernini spoke of his conception as representing the "motherly arms of the church," reaching out to the world. He intended to build a third section of the colonnade closing the side of the square facing the church so that pilgrims, after crossing the Tiber River bridge and passing through narrow streets, would suddenly emerge into the enormous open space before the church. Encountered this way, the great church, colonnade, and square with its towering obelisk and monumental fountains would have been an awe-inspiring vision.

The Church of San Carlo alle Quattro Fontane.

When young Francesco Borromini (1599–1667), a nephew of the architect Carlo Maderno, arrived in Rome in 1619 from northern Italy, he entered his uncle's workshop. Later, he worked under Bernini's supervision on the decoration of Saint Peter's, and some details of the *Baldacchino* are now attributed to him.

In 1634 Borromini received his first independent commission, to design the Church of San Carlo alle Quattro Fontane (Saint Charles at the Four Fountains). From 1638 to 1641 he planned and constructed the body of this small church, although he was not given the commission for its facade until 1665. Unfinished at Borromini's death in 1667, the church was, nevertheless, completed according to his design.

San Carlo stands on a narrow lot with one corner cut off to make room for one of the four fountains that give the church its name. To fit this site, Borromini created an elongated interior space with undulating walls, set into the irregular shell of the building (fig. 19-7). The powerful sweep of the curves of these walls creates an unexpected feeling of movement, as if the walls were actually heaving in and out. Robust pairs of columns support a massive entablature, over which an oval dome seems to float (fig. 19-8), as light as air. The **coffers** (inset panels in geometric shapes) filling the interior of the dome form an eccentric honeycomb of crosses, elongated hexagons, and octagons. These coffers decrease sharply in size as they approach the **apex**, or highest point, so that the dome appears to be inflating. Such devices make a visitor to the church feel as if it were a living, breathing organism.

It is difficult today to appreciate how audacious Borromini's design for this small church was. In it he abandoned the modular system of planning taken for granted by every architect since Brunelleschi (see figs. 17-32, 17-33) and worked instead from an overriding geometrical scheme. Moreover, his treatment of the architectural elements as if they were malleable was unprecedented. Borromini's contemporaries understood immediately what an extraordinary innovation the church represented;

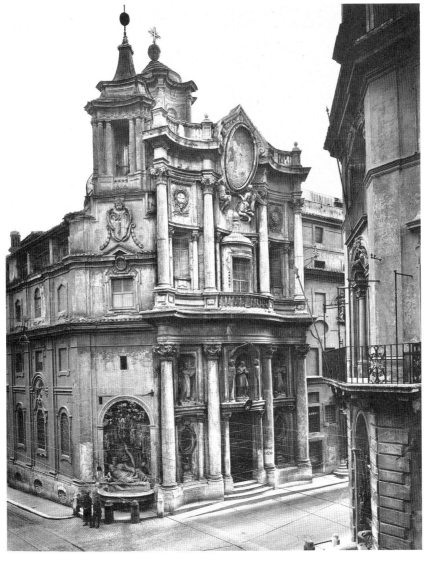

19-9. Francesco Borromini. Facade, Church of San Carlo alle Quattro Fontane. 1665–67

the monks who had commissioned it received requests for plans from visitors from all over Europe. Although Borromini's invention had little influence on the architecture of classically minded Rome, it was widely imitated in northern Italy and beyond the Alps.

Two decades later, Borromini's design for the facade of the same church (fig. 19-9) was as innovative as his plan for its interior had been. He turned the building's front into an undulating, sculpture-filled screen punctuated with large columns and deep niches, which create effects of light and shadow somewhat like those of a painting in chiaroscuro. Borromini also gave his facade a strong vertical thrust in the center by placing over the tall doorway a statue-filled niche, then an empty niche covered with a pointed canopy, then a giant **cartouche** (an oval or circular decorative element) held up by angels undercut so deeply that they appear to hover in front of the wall. The entire facade is crowned with a **balustrade**, or railing held up by decorative posts, that peaks sharply at the center. Like the interior of the church, Borromini's facade had little effect on the work of Roman architects, but it, too, was enthusiastically imitated in northern Italy and especially in northern and eastern Europe.

Bernini's Sculpture

Bernini became famous first as a sculptor and continued to work in that medium throughout his career, for both the papacy and private clients. His *David* (fig. 19-10), made for the nephew of Pope Paul V in 1623, introduced a new type of three-dimensional composition that intrudes forcefully on the viewer's space. Inspired by Annibale Carracci's athletic figures on the Farnese Ceiling, such as a Giant preparing to heave a boulder (see fig. 19-15, far end), Bernini's *David* bends at the waist and twists far to one side, ready to launch the fatal rock. Unlike Michelangelo's composed youth (see fig. 18-8), this more mature David, with his lean, sinewy body, is all tension and determination, a frame of mind emphasized by his ferocious expression, tightly clenched mouth, and straining muscles. Bernini's energetic, centrifugal figure activates its surrounding space by implying the presence of an unseen adversary somewhere behind the viewer, who is compelled to witness the action that is about to occur.

Among Bernini's many innovations was his approach to portrait sculpture. According to one of his biographers, it was Bernini's custom to follow his subjects' daily

19-10. Gianlorenzo Bernini. *David*. 1623. Marble, height 5'7"
(1.7 m). Galleria Borghese, Rome

19-12. Gianlorenzo Bernini. Cornaro Chapel, Church of Santa
Maria della Vittoria, Rome. 1642–52

19-11. Gianlorenzo Bernini. *Costanza Bonarelli*. c. 1635.
Marble, height 28⅜" (72 cm). Museo Nazionale del
Bargello, Florence

rounds, sketching them in various activities, trying to capture a "speaking likeness." His remarkable marble portraits do, indeed, seem to transcend their medium, not only in representing flesh, hair, and clothing in a lifelike way, but also in seeming to represent a given moment in time, communicating more immediacy and naturalness than anything done in the Renaissance or in ancient times. One of Bernini's most striking portraits of this type was a bust of Costanza Bonarelli, the wife of one of his shop assistants, who was both his model and his lover. Produced about 1635, it is a superb example of Baroque naturalism (fig. 19-11). Costanza appears unaware of being portrayed. Her open collar, slightly turned head, disheveled hair, and parted lips all contribute to this effect and to the sense that we are seeing not just her outward appearance but her vivid character as well.

Even after Bernini's appointment as Vatican architect in 1629, his large workshop enabled him to accept outside commissions. One was the decoration of the funerary chapel of Cardinal Federigo Cornaro in the Church of Santa Maria della Vittoria (fig. 19-12), which Bernini carried out from 1642 to 1652. Bernini covered the walls of the tall, shallow chapel with colored marble panels, crowned with a projecting **cornice** supported

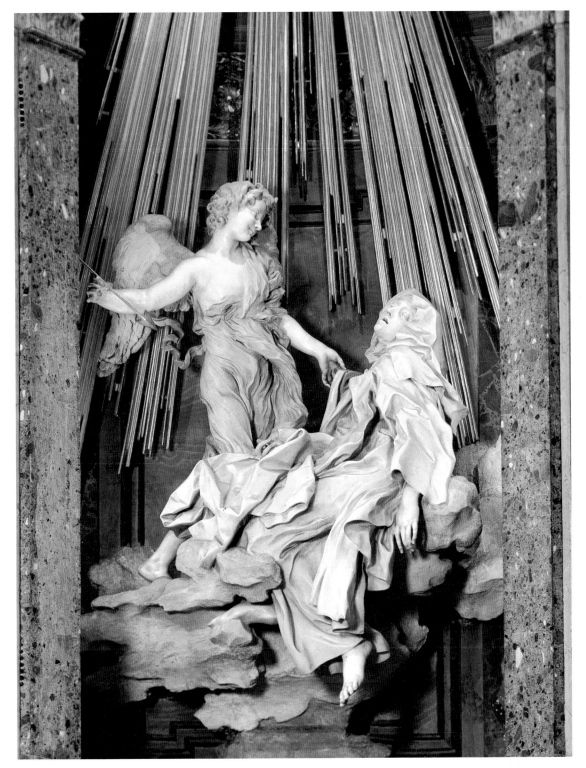

19-13. Gianlorenzo Bernini. *Saint Teresa of Ávila in Ecstasy.* 1645–52. Marble, height of the group 11'6" (3.5 m). Cornaro Chapel, Church of Santa Maria della Vittoria

with marble pilasters. Above the cornice on the back wall, the curved ceiling surrounding the window appears to dissolve into a painted vision of clouds and angels. Kneeling on what appear to be balconies are portrait statues of Federigo, his deceased father, and six cardinals of the Cornaro family. Unlike the bronze portrait statues of the Spanish royal family in Philip II's funerary church at El Escorial (see fig. 18-84), Bernini's figures are active, informally posed "speaking likenesses." Two are reading from their prayer books; others converse; and one leans out from his seat, apparently to look at someone entering the chapel.

The chapel is dedicated to Saint Teresa of Ávila, Spain. Framed by columns in a huge oval niche above the altar, Bernini's marble group *Saint Teresa of Ávila in Ecstasy* (fig. 19-13), created between 1645 and 1652, represents a

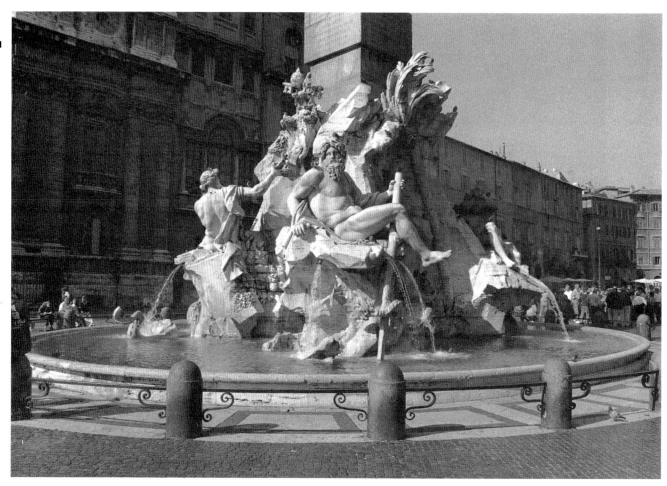

19-14. Gianlorenzo Bernini. Four Rivers Fountain. 1648–51. Travertine and marble. Piazza Navona, Rome

vision described by the saint, in which an angel pierced Teresa's body repeatedly with an arrow, transporting her to a state of religious ecstasy, a sense of oneness with God. The saint and the angel, who seem to float upward on moisture-laden clouds, are cut from a heavy mass of solid marble held in place by metal bars sunk deep into the chapel wall. Bernini's skill at capturing the movements and emotions of these figures is matched by his virtuosity in simulating different textures and colors in the pure white medium of marble; the angel's gauzy, clinging draperies seem silken in contrast with Teresa's heavy woolen robe. Yet Bernini effectively used the configuration of the garment's folds to convey the swooning, sensuous body beneath, even though only Teresa's face, hands, and bare feet are actually visible. The descending rays of light are of gilt bronze, but actual light also illuminates the scene from the window above. Bernini's complex, theatrical interplay of the various levels of illusion in the chapel, which invites the beholder to identify with Teresa's emotion, was imitated by sculptors throughout Europe.

Bernini is at his most exciting in his fountain designs, such as that of the Four Rivers Fountain for Rome's Piazza Navona (fig. 19-14), a **piazza**, or open square, that was a popular site for festivals and celebrations. The history of the project gives an idea of the effects of politics

on art in the seventeenth century. The fountain was commissioned by Pope Innocent X (papacy 1644–1655), whose family had built a palace on the piazza. Bernini, who had been publicly disgraced in 1646 when a bell tower he had begun for Saint Peter's threatened to collapse, was not invited to compete for the fountain's design. The contest was won by Francesco Borromini, who originated the Four Rivers theme and brought in the water supply for the fountain in 1647. With the collusion of a papal relative, however, the pope saw Bernini's design. Pope Innocent X was so impressed that Bernini took over work on the fountain the next year. Executed in marble and **travertine**, a porous stone that is less costly and more easily worked than marble, the fountain was completed in 1651. In the center is a rocky hill covered with animals and vegetation, from which flow the four great rivers of the world, each representing a continent: the Ganges (Asia, facing out); the Nile (Africa, right); the Danube (Europe, left); and the Rio de la Plata (the Americas, not visible in the figure). The central rock formation supports an Egyptian obelisk topped by a dove, the emblem of the pope's family. The installation of the obelisk—which weighs many tons—over the hidden collecting pool that feeds the rivers was a technical marvel that did much to reverse Bernini's disgrace over the bell-tower incident.

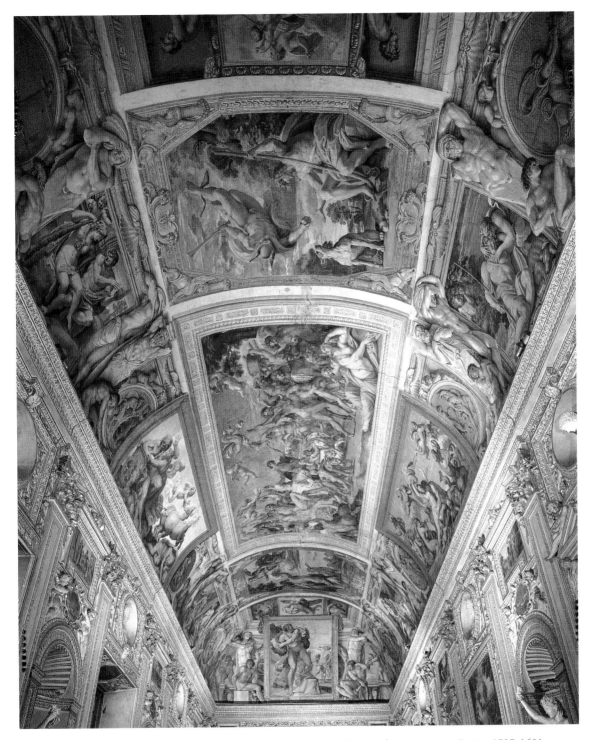

19-15. Annibale Carracci. Farnese Ceiling, fresco in main gallery, Palazzo Farnese, Rome. 1597–1601

Illusionistic Ceiling Painting

Baroque ceiling decoration went far beyond Andrea Mantegna's early Renaissance prototype in the Gonzaga ducal palace at Mantua (see fig. 17-69) or even Michelangelo's Sistine Ceiling (see fig. 18-16). Many Baroque ceiling projects were done entirely in **trompe l'oeil** painting, but some were complex constructions combining architecture, painting, and stucco sculpture. These grand illusionistic projects were carried out on the domes and vaults of churches, civic buildings, palaces, and villas.

The major monument of early Baroque classicism was a ceiling painted for the Farnese family in the last years of the sixteenth century. In 1597, to celebrate the wedding of Duke Ranuccio Farnese of Parma, the family decided to redecorate the **galleria** (great hall) of their immense Roman palace. The commission was given to Annibale Carracci (1560–1609), a noted painter and the cofounder of an art academy in Bologna. Annibale was assisted by his brother Agostino (1557–1602), who also worked briefly in Rome. The Farnese Ceiling (fig. 19-15) is an exuberant tribute to earthly love, expressed in

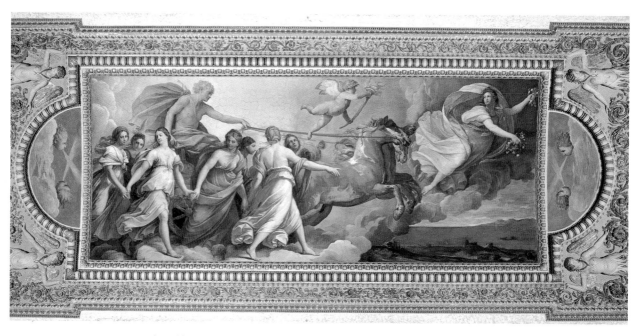

19-16. Guido Reni. *Aurora*, ceiling fresco in Casino Rospigliosi, Rome. 1613–14

mythological scenes. Its primary image, set in the center of the vault, is *The Triumph of Bacchus and Ariadne*, a joyous procession celebrating the wine god Bacchus's love for Ariadne, a woman whom he rescued after her lover abandoned her on an island. Carracci's illusionistic ceiling is a trompe l'oeil assemblage of framed paintings, stone sculpture, bronze medallions, and *ignudi* (nude youths) in an architectural framework, all clearly inspired by Michelangelo's Sistine Ceiling. The figure types, true to their source, are heroic and muscular and are drawn with precise anatomical accuracy. But instead of Michelangelo's cool illumination and intellectual detachment, the Farnese Ceiling glows with a warm light that recalls the work of the Venetian painters Titian and Veronese and seems buoyant with optimism. The ceiling was highly admired and became famous almost immediately. The Farnese family, proud of the gallery, were generous in allowing young artists to sketch the figures there, so that Carracci's masterpiece influenced Italian classicism well into the following century.

The most important Italian Baroque classicist after Annibale Carracci was the Bolognese artist Guido Reni (1575–1642), who briefly studied at the Carracci academy in 1595. Shortly after 1600 he made his first trip to Rome, where he worked intermittently before returning to Bologna in 1614. In 1613–1614 Reni decorated the ceiling of a garden house at a palace in Rome with his most famous work, *Aurora* (fig. 19-16). The fresco emulates

the illusionistic framed mythological scenes on the Farnese Ceiling, although Reni made no effort to relate its space to that of the room. Indeed, *Aurora* appears to be a framed oil painting incongruously attached to the ceiling. The composition itself, however, is Baroque classicism at its most lyrical. Apollo is shown driving the sun chariot, escorted by Cupid and the Seasons and led by the flying figure of Aurora, goddess of the dawn. The measured, processional staging and idealized forms seem to have been derived from an antique relief, and the precise drawing owes much to Annibale Carracci. But the graceful figures, the harmonious rhythms of gesture and drapery, and the intense color are all Reni's own.

Pietro Berrettini (1596–1669), called Pietro da Cortona after his hometown, carried the development of the Baroque ceiling in another direction altogether. Trained in Florence, the young artist was commissioned in the early 1630s by the Barberini family of Pope Urban VIII to decorate the ceiling of the audience hall of their Roman palace. Pietro's great fresco there, *Triumph of the Barberini* (fig. 19-17), became a model for a succession of Baroque illusionistic ceilings throughout Europe. Its subject is an elaborate **allegory**, or symbolic representation, of the virtues of the papal family. Just below the center of the vault, seated at the top of a pyramid of clouds and figures personifying Time and the Fates, Divine Providence gestures toward three giant bees surrounded by a huge laurel wreath (both Barberini emblems) carried by Faith,

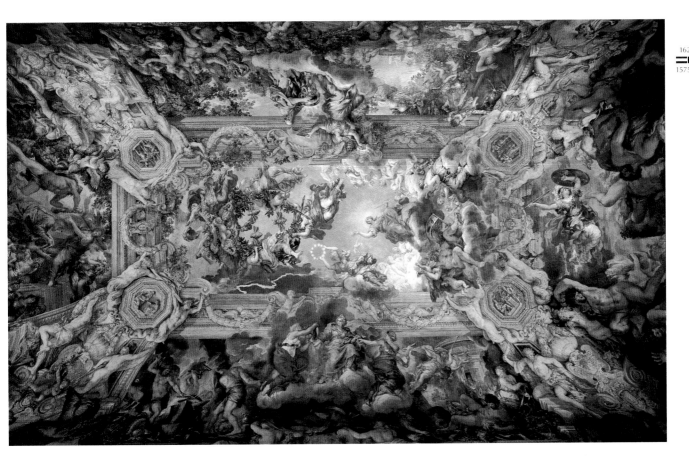

19-17. Pietro da Cortona. *Triumph of the Barberini*, ceiling fresco in the Gran Salone, Palazzo Barberini, Rome. 1633–39

Hope, and Charity. Immortality offers a crown of stars, while other symbolic figures present the crossed keys and the triple-tiered crown of the papacy. Around these figures are scenes of Roman gods and goddesses, who demonstrate the pope's virtues by triumphing over the vices.

Pietro, like Annibale Carracci, framed his mythological scenes with painted architecture, but in contrast to Annibale's neat separations and careful framing, Pietro partly concealed his setting with an overlay of shells, masks, garlands, and figures, which unifies the vast illusionistic space. Instead of Annibale's warm, nearly even light, Pietro's sporadic illumination, with its bursts of brilliance alternating with deep shadows, fuses the ceiling into a dense but unified whole.

Perhaps the ultimate illusionistic Baroque ceiling is *Triumph of the Name of Jesus* (fig. 19-18), which fills the vault of Il Gesù (see fig. 19-3). Originally, in the 1560s, Giacomo da Vignola had designed an austere interior for Il Gesù, but when the church was renovated a century later the Jesuits commissioned a religious allegory to cover the plain ceiling of the nave. The **fresco** was painted between 1676 and 1679 by Giovanni Battista Gaulli (1639–1709), also called Baciccia. Gaulli, who came to Rome from Genoa in 1657, had worked in his youth for Bernini, from whom he absorbed a Baroque taste for drama and for combining mediums. The elderly Bernini, who worshiped daily at Il Gesù, may well have offered his personal advice

to his former assistant, and Gaulli was certainly familiar with other illusionistic paintings in Rome as well, including Pietro da Cortona's Barberini ceiling.

Gaulli's astonishing creation went beyond anything that had preceded it in unifying architecture, sculpture, and painting. Every element is dedicated to the illusion that clouds and angels have floated down through an opening in the church's vault into the upper reaches of the nave. The figures are projected as if seen from below, and the whole composition is focused off-center on the golden aura around the letters *IHS*, a Greek abbreviation for "Jesus." The subject is, in fact, a Last Judgment, with the Elect rising joyfully toward the name of God and the Damned plummeting through the ceiling toward the nave floor. The sweeping inclusion in the work of the space of the nave, the powerful and exciting appeal to the viewer's emotions, and the nearly total unity of visual effect have never been surpassed.

Painting on Canvas

In painting, the Baroque classicism exemplified by Carracci's Farnese Ceiling and Guido Reni's *Aurora* was the logical development of mature Renaissance styles with roots in classical antiquity. A more naturalistic tendency was introduced by Carracci's younger contemporary Michelangelo Merisi (1573–1610), known as Caravaggio after his birthplace in northern Italy, who arrived in Rome in 1593.

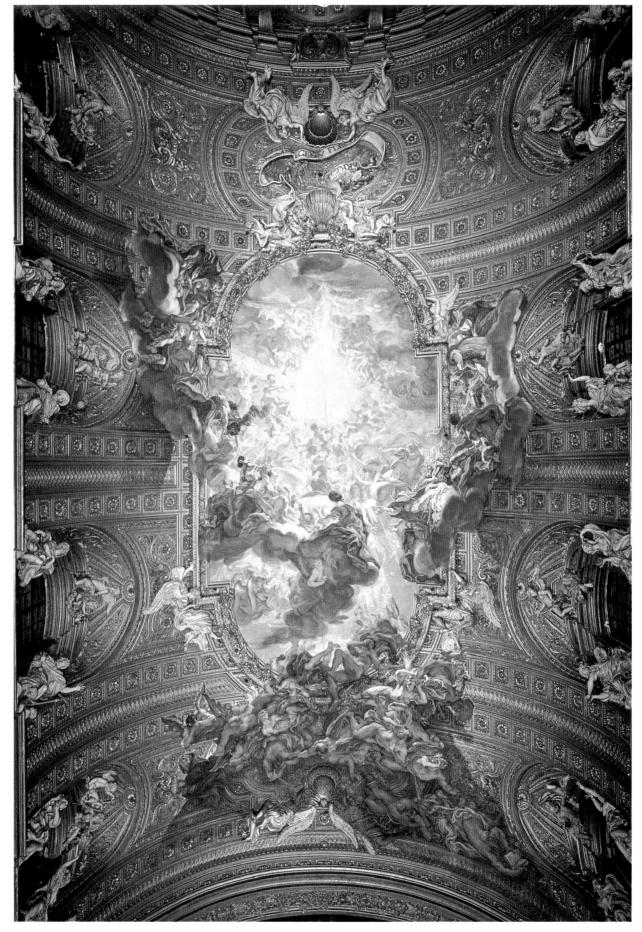

19-18. Giovanni Battista Gaulli. *Triumph of the Name of Jesus,* ceiling fresco with stucco figures in the vault of the Church of Il Gesù, Rome. 1676–79

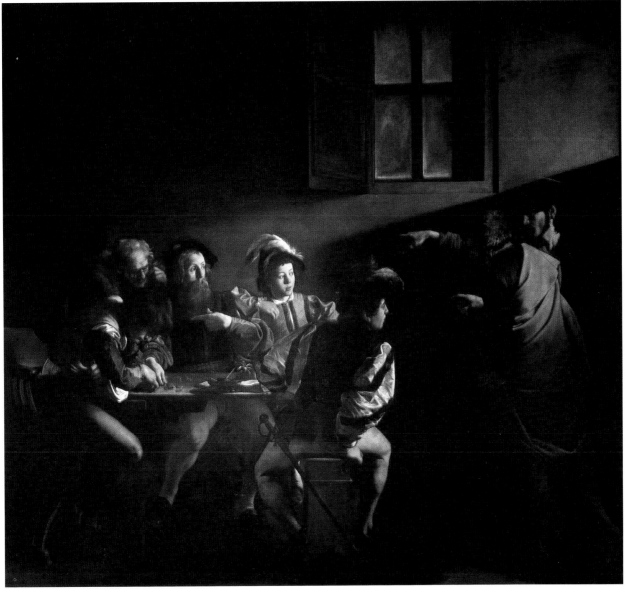

19-19. Caravaggio. *Calling of Matthew*, in the Contarelli Chapel, Church of San Luigi dei Francesci, Rome. c. 1599–1602. Oil on canvas, 11'1" x 11'5" (3.4 x 3.5 m)

At first Caravaggio painted for a small circle of sophisticated Roman patrons. His subjects from this period include still lifes and low-life scenes featuring fortune-tellers, cardsharps, and street urchins dressed as musicians or mythological figures. The figures in these pictures tend to be large, brightly lit, and set close to the picture plane. Most of his commissions after 1600 were religious, and reactions to them were mixed. On occasion his powerful, sometimes brutal, naturalism was rejected by patrons as unsuitable to the subject's dignity.

Caravaggio's approach has been likened to the preaching of Filippo Neri, later canonized as Saint Philip Neri (1515–1595), a priest and noted mystic of the Counter-Reformation who founded a Roman religious group called the Congregation of the Oratory. Philip Neri, called the Apostle of Rome, focused his missionary efforts on the people there, for whom he strove to make Christian history and doctrine understandable and meaningful. Caravaggio, too, interpreted his religious subjects directly and dramatically, combining intensely observed forms, poses, and expressions with strong effects of light and color. The forms tend to emerge from dark backgrounds into a strong light, often falling from a single source outside the painting.

One of Caravaggio's earliest religious commissions, the *Calling of Matthew* (fig. 19-19), was painted around 1599–1602 for the private chapel of the Cointrel family (Contarelli in Italian) in the French community's church in Rome. The painting depicts the biblical story of Jesus' calling the Roman tax collector Matthew to join his apostles (Matthew 9:9–13). Matthew sits at a table, counting out gold coins for a boy at the left, surrounded by overdressed young men in plumed hats, velvet doublets, and satin shirts. Nearly hidden behind another figure at the right, the gaunt-faced Jesus points dramatically at Matthew, a gesture that is repeated by the tax collector's

19-20. Caravaggio. *Entomb-
ment*, painted for the
Vittrice Chapel, Church
of Santa Maria in
Vallicella, Rome.
c. 1603. Oil on canvas,
9'10⅛" x 6'7¹⁵/₁₆"
(3 x 2.03 m). Musei
Vaticani, Pinacoteca,
Rome

The *Entombment* was
one of many paintings
confiscated from
Rome's churches and
taken to Paris during
the French occupation
by Napoleon's troops
in 1798 and 1808–1814.
It was one of the few to
be returned after 1815
through the negotia-
tions of Pius VII and
his agents, who were
assisted greatly by
the Neoclassical sculp-
tor Antonio Canova, a
favorite of Napoleon.
The decision was
made not to return the
works to their original
churches and chapels
but rather to assemble
them in a gallery
where the general
public could enjoy
them. Today Caravag-
gio's painting is one
of the most important
in the collections of the
Vatican Museums.

surprised response of pointing to himself and again by
the descent of the raking light that enters the painting
from a high, unseen source at the right. For all of his nat-
uralism, Caravaggio also used antique and Renaissance
sources. Jesus' outstretched arm, for example, recalls
God's gesture giving life to Adam in Michelangelo's *Cre-
ation of Adam* on the Sistine Ceiling (see fig. 18-16), now
restated as Jesus' command to Matthew to enter a new
life as his disciple.

The emotional power of Baroque naturalism com-
bined with a solemn, classical monumentality is embod-
ied in Caravaggio's *Entombment* (fig. 19-20), painted in
about 1603 for a chapel in Santa Maria in Vallicella, the
church of Saint Philip Neri's Congregation of the Oratory.
With almost physical force, the size and immediacy of
this painting strike the viewer, whose perspective is from
within the burial pit into which Jesus' lifeless body is to
be lowered. The figures form a large off-center triangle,
within which angular elements are repeated: the project-
ing edge of the stone slab; Jesus' bent legs; the akimbo

arm, bunched coat, and knock-kneed stance of the man
on the right; and even the spaces between the spread fin-
gers of the raised hands. The Virgin and Mary Magdalen
barely intrude on the scene, which, through the careful
placing of the light, focuses on the dead Jesus, the sturdy-
legged laborer supporting his body at the right, and the
young Saint John at the triangle's apex.

Despite the great esteem in which Caravaggio was
held as an artist, his violent temper repeatedly got him
into trouble. During the last decade of his life he was fre-
quently arrested, generally for minor offenses: throwing
a plate of artichokes at a waiter, carrying arms illegally,
or street brawling. In 1606, however, he killed a man in
a fight over a tennis match and had to flee Rome. He
went first to Naples, then to Malta, finding work in both
places. The Knights of Malta awarded him the cross of
their religious and military order in July 1608, but in Octo-
ber he was imprisoned for insulting one of their number,
and he had to flee again. The aggrieved knight's agents
tracked him to Naples in the spring of 1610 and severely

19-21. Artemisia Gentileschi. *La Pittura*, a self-portrait. 1630. Oil on canvas, 38 x 29" (96.5 x 73.7 cm). The Royal Collection, Windsor Castle, Windsor, England

wounded him; the artist recovered and fled north to Port'Ercole, where he died of a fever on July 18, 1610, at age thirty-six. Despite his tragic and violent personal history, Caravaggio's naturalism and lighting influenced nearly every important European artist of the seventeenth century.

One of Caravaggio's most successful Italian followers was Artemisia Gentileschi (1593–c.1653), whose international reputation helped spread the style of Caravaggio outside Rome. Born in Rome, Artemisia first studied and worked under her father, himself a follower of Caravaggio. In 1616 she moved to Florence, where she worked for the grand duke of Tuscany and was elected, at the age of twenty-three, to the Florentine Academy of Design. In 1638 Artemisia went to England to assist her ill father, who was working for King Charles I. She eventually settled in Naples.

In 1630 she painted *La Pittura*, an allegorical self-portrait (fig. 19-21). The image of a woman with palette and brushes, richly dressed, and wearing a gold necklace with a mask pendant comes from a popular sourcebook for such images, the *Iconologia* by Cesare Ripa, which maintains that the mask imitates the human face, as painting imitates nature. The gold chain symbolizes "the continuity and interlocking nature of painting, each man learning from his master and continuing his master's achievements in the next generation" (cited in Tufts, page 61). Thus, Artemisia's self-portrait not only commemorates her profession but also pays tribute to her father.

FRENCH BAROQUE

The early seventeenth century was a difficult period in France, marked by almost continuous foreign and civil wars. The assassination of King Henri IV in 1610 left France in the hands of the queen, Marie de' Medici, as regent for her nine-year-old son, Louis XIII (ruled 1610–1643). When Louis came of age, the brilliant and unscrupulous Cardinal de Richelieu became chief minister and set about increasing the power of the Crown at the expense of the French nobility. The death of Louis XIII again left France with a child king, the five-year-old Louis XIV (ruled 1643–1715). His mother, Anne of Austria, became regent, with the assistance of another powerful minister, Cardinal Mazarin. At Mazarin's death in 1661, Louis XIV (see fig. 19-1) began his long personal reign, assisted by an able and ingenious minister, Jean-Baptiste Colbert.

An absolute monarch whose reign was the longest in European history, Louis XIV expanded royal art patronage, making the French court the envy of every ruler in Europe. In 1635 Cardinal Richelieu founded the French Royal Academy to compile a definitive dictionary and grammar of the French language. In 1648 the Royal Academy of Painting and Sculpture was founded, which, as reorganized by Colbert in 1663, maintained strict control over the arts (see "Quarrel of the Ancients and the Moderns," page 785). Although it was not the first European arts academy, none before it had exerted such dictatorial authority—an authority that lasted in France until the late nineteenth century. Membership in the Academy assured

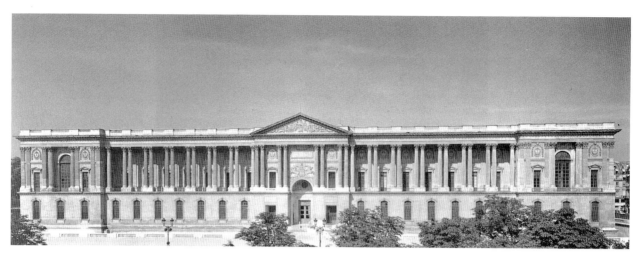

19-22. Louis Le Vau, Claude Perrault, and Charles Le Brun. East front, Palais du Louvre, Paris. 1667–70

an artist of royal and civic commissions and financial success, but many talented artists did well outside it.

Palace Architecture and Its Decoration

French architecture developed along classical lines in the second half of the seventeenth century under the influence of François Mansart (1598–1666) and Louis Le Vau (1612–1670). When the Royal Academy of Architecture was founded in 1671, its members developed guidelines for architectural design based on the belief that mathematics was the true basis of beauty. Their chief sources for ideal models were the books of Vitruvius (see "Vitruvius", page 698), Vignola (see figs. 18-26, 19-3), and Palladio (see fig. 18-35).

In early 1664 Colbert invited Bernini to submit designs for the new east facade of the Palais du Louvre being built to house royal apartments. In June 1665, Bernini came to Paris to discuss a design he had sent from Rome but was instead put to work sculpting a marble bust of the king. Bernini's third Louvre design, completed while he was in Paris, was accepted, and when he left for Rome in October the facade foundations were under way. When Bernini's assistant returned to Paris in 1666 to supervise the work, however, a group of French architects, outraged that such an important commission should go to a foreigner, succeeded in halting it.

Colbert appointed a design council that included the architect Louis Le Vau, the painter Charles Le Brun (1619–1690), and Claude Perrault (1613–1688), a physician and mathematician turned architect, who later published an edition of Vitruvius. The final model for the facade, which was constructed between 1667 and 1670, was divided into five units, with projecting blocks in the center and at each end. On the central block was a triangular pediment, suggesting a classical temple front, with long Corinthian colonnades on each side. The resulting facade was both grand and dignified, its somewhat austere forms softened by the rippling waves of light and shade cast by the rows of paired columns (fig. 19-22). The king was so pleased with this design that, despite the added expense, he had it repeated on the other palace faces. This elegant variation on the Roman temple front was the first great monument of French Baroque classicism in architectural design.

Once the design for the Louvre east front had been settled, the king turned his attention in 1668 to enlarging the small château built by Louis XIII at nearby Versailles, to which Louis XIV eventually moved his entire court. The designers of the palace and garden complex at Versailles—Le Vau, Le Brun, and André Le Nôtre (1613–1700), who planned the gardens—had already worked together on a magnificent château and gardens at Vaux-le-Vicomte for Nicolas Fouquet, the king's finance minister. The king was said to be so jealous of that beautiful country house that he not only had Fouquet imprisoned for life (the real reason was Fouquet's massive stealing from the royal treasury) but also deliberately set out to surpass the Vaux château in the design of Versailles (fig. 19-23). For both political and sentimental reasons, the old Versailles château was left standing, and the new building went up around it. This project consisted of two phases: the first additions by Le Vau, begun in 1668; and an enlargement completed after Le Vau's death by his successor, Jules Hardouin-Mansart, from 1670 to 1685.

In the hands of Le Nôtre, the terrain around the palace became an extraordinary work of art and a visual delight for its inhabitants. The garden designer's neatly contained stretches of lawn and broad, straight vistas seemed to stretch to the horizon, while the formal gardens at the rear of the palace (see the lower part of fig. 19-23) became an exercise in precise geometry. Broad intersecting paths separate reflecting pools and planting beds, called embroidered **parterres** for their colorful flower patterns. The entire layout, which includes mock grottoes (caves) and theaters, is accented by fountains, stone sculpture, and trimmed shrubs and small trees. From these gardens, a series of terraces descends to controlled, shaped, wooded areas and the mile-long Grand Canal. Classically harmonious and restful in their symmetrical, geometric

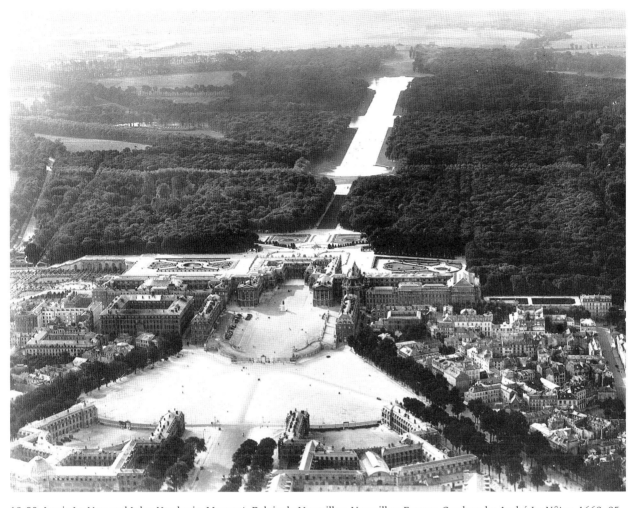

1675
1575 1775

19-23. Louis Le Vau and Jules Hardouin-Mansart. Palais de Versailles, Versailles, France. Gardens by André Le Nôtre. 1668–85

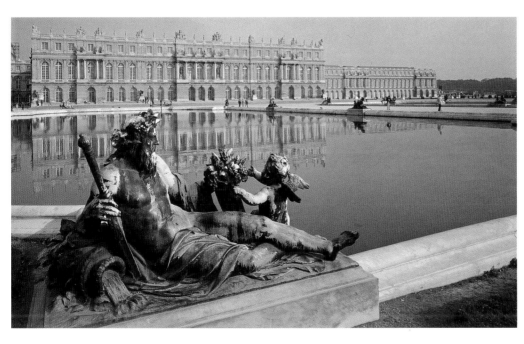

19-24. Louis Le Vau and Jules Hardouin-Mansart. Central block of the garden face, Palais de Versailles

design, the Versailles gardens are Baroque in their vast size and extension into the surrounding countryside.

Le Vau's successor, Hardouin-Mansart, was responsible for the addition of the long lateral wings and the renovation of Le Vau's central block on the garden side to match these wings (fig. 19-24). The three-story elevation has a lightly **rusticated** ground floor, a main floor lined with enormous arched windows separated by Ionic pilasters, an attic level whose rectangular windows are also flanked by pilasters, and a flat, terraced roof. The overall design is a sensitive balance of horizontals and verticals relieved by a restrained overlay of regularly

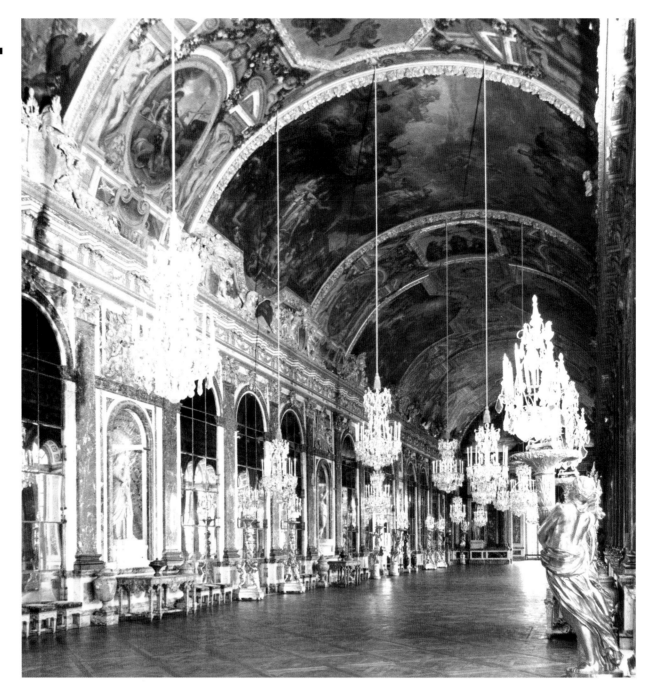

19-25. Jules Hardouin-Mansart and Charles Le Brun. Hall of Mirrors, Palais de Versailles. Begun 1678

In the seventeenth century, mirrors and clear window glass were enormously expensive. To furnish the Hall of Mirrors, hundreds of glass panels of manageable size had to be assembled into the proper shape and attached with "glazing bars," which became part of the decorative pattern of the vast room.

spaced projecting blocks with open, colonnaded porches.

In his renovation of Le Vau's original garden face in the center block, Hardouin-Mansart enclosed the previously open gallery on the main level, which is about 240 feet long. Architectural symmetry was achieved by lining the interior wall opposite the windows with Venetian glass mirrors—extremely expensive in the seventeenth century—the same size and shape as the arched windows, thus creating the famed Hall of Mirrors (fig. 19-25). The mirrors reflect the natural light from the windows and give the impression of an even larger space. In a tribute to Carracci's Farnese Ceiling (see fig. 19-15), Le

Brun decorated the vaulted ceiling with paintings glorifying the reign of Louis XIV. Le Brun had studied in Italy in 1642, where he came under the influence of the classical style of his compatriot Nicolas Poussin, discussed later in this chapter. Stylistically, Le Brun tempered the more exuberant Baroque ceiling decorations he had seen in Rome with Poussin's classicism to create spectacular decorations. The underlying theme for the design and decoration of the palace was the glorification of the king as Apollo the Sun God, with whom Louis was identified as the Sun King. Louis XIV thought of the duties of kingship, including its pageantry, as a solemn performance, so it

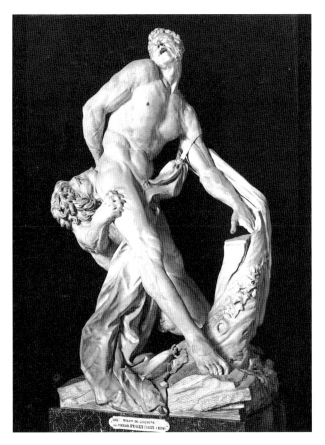

19-26. Pierre Puget. *Milo of Crotona*. 1671–82. Marble, height 8'10½" (2.71 m). Musée du Louvre, Paris

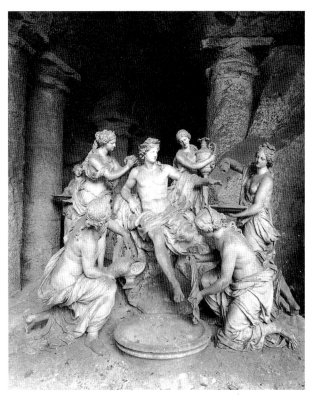

19-27. François Girardon. *Apollo Attended by the Nymphs of Thetis,* from the Grotto of Thetis, Palais de Versailles, Versailles, France. c. 1666–72. Marble, lifesize. Original setting destroyed in 1684; reinstalled in a different configuration in 1778

was most appropriate that Rigaud's portrait of him shows him presented on a raised, stagelike platform, with a theatrical curtain (see fig. 19-1). Versailles was the splendid stage on which this grandiose drama was played.

Sculpture

In the seventeenth century, French taste in sculpture tended to favor classicizing works, whose inspiration was drawn from antiquity and from the Italian Renaissance. One exception to this was the sculpture of Pierre Puget (1620–1694), who had worked as a painter from 1640 to 1643 with Pietro da Cortona on several projects, including the Barberini Palace in Rome. After his return to France, Puget began to produce sculpture. In 1671 Louis XIV's minister Colbert commissioned him to provide three pieces for Versailles, one of which was his famous *Milo of Crotona* (fig. 19-26), completed in 1682 for the gardens.

Milo was a renowned wrestler of ancient Greece who won the Olympic Games six times. His legendary reputation for great strength was similar to that of the mythical hero Hercules. But instead of showing the athlete at a moment of triumph, Puget chose to illustrate the hero's agony before his tragic death. Having caught his hand in a tree stump that he was trying to uproot, Milo was attacked and killed by wild animals. Recalling Bernini's *David* (see fig. 19-10), every muscle of the figure's idealized physique strains against the entrapping stump, while his anguished facial expression communicates something of the passion

of Bernini's *Saint Teresa of Ávila in Ectasy* (see fig. 19-13).

A highly favored sculptor much more in tune with classical taste, François Girardon (1628–1715) had studied the monuments of classical antiquity in Rome in the 1640s. After working with Le Vau and Le Brun at Vaux-le-Vicomte and the Louvre, he made a considerable contribution to the decoration of Versailles. In keeping with the palace's repeated identification of Louis XIV with Apollo, he created the group *Apollo Attended by the Nymphs of Thetis* (fig. 19-27), executed in about 1666–1672, to be displayed in a classical arched niche in the Grotto of Thetis, a sea nymph beloved by Apollo. The original grotto was destroyed in 1684 and was replaced by the present cave-like setting in 1778. The visitor looks into Thetis's under-sea grotto at the Sun God, who rests from his day's journey across the heavens while nymphs wash his tired body. All these idealized figures are based on Classical prototypes; the hair and features in particular reflect Roman sculpture.

Painting

French seventeenth-century painting was much affected by what was happening in Italian art. The lingering Mannerism of the sixteenth century gave way as early as the 1620s to Baroque classicism and **Caravaggism**—the use of strong **chiaroscuro** and raking light, and the placement of large-scale figures in the foreground. These Italianate styles found royal favor, and native French artists also established successful personal idioms. The painters

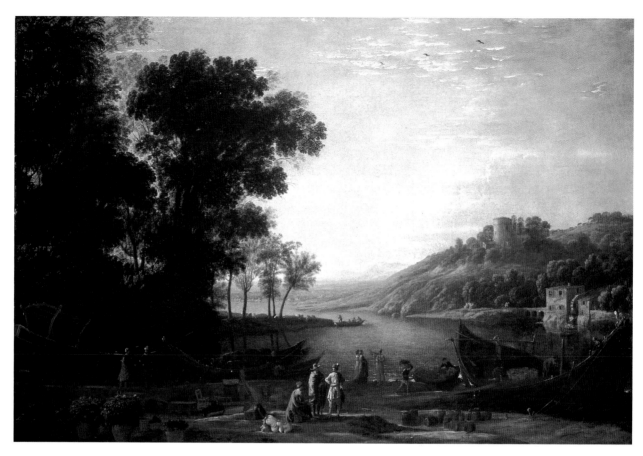

19-28. Claude Lorrain. *Landscape with Merchants.* c. 1630. Oil on canvas, 38¼ x 56½" (97.2 x 143.6 cm). National Gallery of Art, Washington, D.C.

Samuel H. Kress Collection

Claude Gellée, called Claude Lorrain, or simply Claude (1600–1682), and Nicolas Poussin (1594–1665) worked for French patrons and significantly influenced other French artists, although they both pursued their careers in Italy. Claude and Poussin were classicists in that neither left nature as he found it but instead organized natural elements and figures into idealized compositions. Both were influenced by Annibale Carracci and somewhat by Venetian painting, yet each evolved an unmistakable personal style that conveyed an entirely different mood from that of their sources and from each other.

Claude went to Rome in 1613 and studied with a specialist in harbor paintings, which inspired his later enthusiasm for that subject. He dedicated himself to painting landscapes and harbor views with small figures that activated the space and provided a narrative subject. He was fascinated with light, and his works are often studies of the effect of the rising or the setting sun on colors and the atmosphere. His working method included making many sketches from nature, which he then referred to while composing in his studio. A favorite and much imitated device was to place one or two large objects in the foreground—a tree, building, or hill—past which the viewer's eye enters the scene and proceeds, often by zigzag paths, into the distance.

In his *Landscape with Merchants* (fig. 19-28) of about 1630, Claude presents an idyllic scene in which elegant

gentlemen proffer handsome goods to passersby as the sun rises on a serene world. Past the framing device of huge trees in the left foreground, the eye moves unimpeded into the open middle ground over gleaming water to arrive at a mill and waterwheel, then on to a hilltop tower illuminated by the rising sun. Along the shore is a walled city, luminous in the early morning haze. Pale blue mountains provide a final closure in the far distance.

Poussin, like Claude an important history painter, also created landscapes with small figures, but his effect is different. His *Landscape with Saint John on Patmos*, from 1640 (fig. 19-29), appears orderly and admirably arranged; Poussin has also created a consistent perspective progression from the picture plane back into the distance through a clearly defined foreground, middle ground, and background. These zones are marked by alternating sunlight and shade, as well as by their architectural elements, which imitate ancient Roman ruins or medieval or Renaissance buildings. Unlike some of Poussin's landscapes of identifiable sites, this is a Greek island with both real and imaginary architecture. In the middle distance are a ruined temple and an obelisk, while the round building in the distant city is Hadrian's Tomb from Rome. Precisely placed trees, hills, mountains, water, and even clouds take on a solidity of form that seems almost as structural as architecture. The reclining saint and his eagle, the symbol of Saint John, seem almost

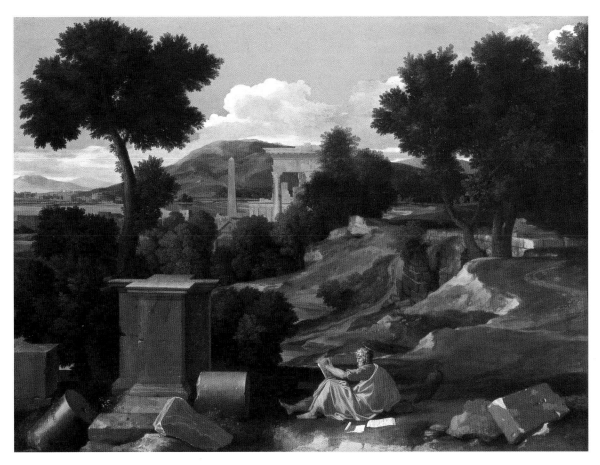

19-29. Nicolas Poussin. *Landscape with Saint John on Patmos.* 1640. Oil on canvas, 40 x 53½" (101.8 x 136.3 cm).
The Art Institute of Chicago
A. A. Munger Collection, 1930.500

incidental to this perfect landscape. The subject of Poussin's painting is in effect the balance and order of nature rather than the story of Saint John the Evangelist.

One of Caravaggio's most important followers in France, Georges de La Tour (1593–1652), received major royal and ducal commissions and became court painter to King Louis XIII in 1639. La Tour may have traveled to Italy in 1614–1616, and in the 1620s he almost certainly visited the Netherlands, where Caravaggio's style was being enthusiastically emulated. Like Caravaggio, Georges de La Tour filled the foreground of his canvases with monumental figures, but in his work, Caravaggio's detailed naturalism has given way to a simplified setting and a light source within the picture so intense that it often seems to be the real subject of the painting. In his **nocturne** (night scene) *The Repentant Magdalen* (fig. 19-30), the light emanates from a candle. The hand acts as a device to establish a foreground plane, and the compression of the figure within the pictorial space leads to a sense of intimacy. The light is the unifying element of the painting and the essential conveyor of its mood. Many details of the painting have been hidden by darkness, but the essence of the forms remains, presenting a timeless image of spirituality and mystery.

19-30. Georges de La Tour. *The Repentant Magdalen.*
c. 1640. Oil on canvas, 44½ x 36½" (113 x 92.7 cm).
National Gallery of Art, Washington, D.C.
Alisa Mellon Bruce Fund

19-31. Antoine Le Nain. *The Village Piper*. 1642. Oil on copper, 8³⁄₈ x 11¹⁄₂" (21.3 x 29.2 cm). The Detroit Institute of Arts
City of Detroit Purchase

19-32. Pedro de Ribera. Portal of the Hospicio de San Fernando, Madrid. 1722

Something of this same feeling of timelessness pervades the paintings of the Le Nain brothers, Antoine (c. 1588–1648), Louis (c. 1593–1648), and Mathieu (1607–1677). Although the brothers were working in Paris by about 1630, little else is known about their lives and careers. Because they collaborated closely with each other, art historians have only recently begun to distinguish their individual styles. They did produce some history paintings, but their specialty was genre imbued with a strange sense of foreboding and enigmatic meaning. *The Village Piper* (fig. 19-31) of 1642, by Antoine Le Nain, is typical of the brothers' work. Peasant children gather around the figure of a flute player. The simple homespun garments and undefined setting turn the painting into a study in neutral colors and rough textures, with soft young faces that contrast with the old man, who seems lost in his simple music.

Hyacinthe Rigaud (1659–1743), trained by his painter-father, won the Royal Academy's prestigious Prix de Rome in 1682, which would have paid his expenses for study at the Academy's villa in Rome. Rigaud, however, rejected the prize and opened his own Paris studio. After painting a portrait of Louis XIV's brother in 1688, he became a favorite of the king himself. One of his best-known portraits—one representing the height of royal propaganda—is the one of the Sun King painted in 1701 with which we opened the chapter (see fig. 19-1). Rigaud, whose magnificent portraits so influenced later French portraitists, was far removed from both the classicizing and the Caravaggesque influences at work on the other French artists discussed above.

SPANISH BAROQUE

Spain's Habsburg kings in the seventeenth century—Philip III, Philip IV, and Charles II—presided over the decline of the Spanish empire. Agriculture, industry, and trade all suffered, and there were repeated local rebellions, culminating in 1640, when Portugal reestablished its independence. The Dutch Republic was an increasingly serious threat to Spanish trade and colonial possessions, and what had seemed an endless flow of gold and silver from the Americas diminished, as precious-metal production in Bolivia and Mexico declined. Nevertheless, seventeenth-century writers and artists produced much of what is considered the greatest Spanish literature and art, and the century is often called the Spanish Golden Age.

Architecture

After the severity of the sixteenth-century El Escorial (see fig. 18-83), Spanish architects returned to the lavish decoration that had characterized their art since the fourteenth century. The profusion of ornament typical of later Moorish and Gothic architecture in Spain swept back into fashion in the work of a family of architects and sculptors named Churriguera. The style, known as **Churrigueresque**, found its most exuberant expression in the work of eighteenth-century architects such as Pedro de Ribera (c. 1638–1742) and in the architecture of colonial Mexico and Peru. Ribera's 1722 facade for the Hospicio de San Fernando is typical (see "Elements of Architecture," page 755). The street facade is a severe brick structure with an extraordinarily exuberant architectural scheme for the portal, where the sculptural decoration is concentrated (fig. 19-32). Like a huge altarpiece, the portal soars upward, breaking through the roofline into **segmental** (semicircular) and triangular pediments and a dramatic **broken pediment**. The structural forms of classical architecture are transformed into projecting and receding layers overlaid with foliage. Carved curtains loop back as if to

19-33. Juan Sánchez Cotán. *Still Life with Quince, Cabbage, Melon, and Cucumber.* c. 1602. Oil on canvas, 27¹⁄₈ x 33¹⁄₄" (68.8 x 84.4 cm). San Diego Museum of Art

Gift of Anne R. and Amy Putnam

reveal the doorway and the central niche, which holds the figure of the hospital's patron saint. The sophistication of the composition and carving becomes apparent when the portal is compared to its North and South American counterparts (see fig. 19-91).

Painting

The primary influence on Spanish painting in the fifteenth and sixteenth centuries had been the art of Flanders. Late in the sixteenth century, Spanish artists developed a significant interest in **still lifes**—paintings of artfully arranged objects—rendered with intense attention to detail. Juan Sánchez Cotán (1561–1627) was one of the earliest painters of pure still life in Spain. His *Still Life with Quince, Cabbage, Melon, and Cucumber* (fig. 19-33) of about 1602 is a prime example of the characteristic Spanish trompe l'oeil rendering of an artificially composed still life. Cotán's composition plays off the irregular, curved shapes of the fruits and vegetables against the angular geometry of the setting. His precisely ordered subjects, suspended from strings in a long arc from the upper left to the lower right, are set in a strong light against an impenetrable dark background. This highly artificial arrangement exemplifies a Spanish fascination with spatial ambiguity; it is not clear whether the seemingly airless space is a wall niche or a window ledge, or why these objects have been arranged in this way.

Caravaggio's most important early follower in Spanish-ruled Naples was Jusepe (José) de Ribera (1591–1652), called Lo Spagnoletto ("the Little Spaniard"). Over time, however, his Caravaggesque tenebrism gave way to more traditional illumination. After studying in Valencia and then Rome, he settled in Naples before 1620. Many of his paintings went to patrons in Spain, where they reinforced and spread the taste for Caravaggism.

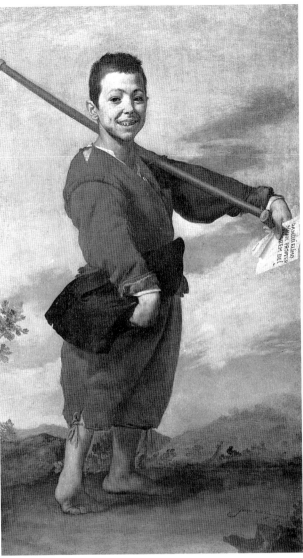

19-34. Jusepe de Ribera. *Boy with a Clubfoot.* 1642/52 (?). Oil on canvas, 5'4¹⁄₂" x 3'¹⁄₄" (1.64 x 0.92 m). Musée du Louvre, Paris

The street urchin in Ribera's *Boy with a Clubfoot* (fig. 19-34), of 1642 or 1652 (?), shows courageous optimism despite physical deformity. The boy stands silhouetted against the sky, jauntily balancing his crutch on his shoulder like a military standard. The low horizon line, sweeping vista, and rolling clouds of the setting, as well as the boy's cocky pose and direct gaze, are familiar conventions of heroic portraiture. They emphasize his spirited independence, natural vitality, and love of life. But for all its immediacy, the painting clearly embodies a moralizing theme and may even have been intended as an allegory of Charity. The paper that the boy holds bears an inscription in Spanish, which in translation is "Give me alms, for the love of God."

Diego Rodríguez de Silva y Velázquez (1599–1660), the greatest painter to emerge from the Caravaggesque school of Seville, entered its painters' guild in 1617. Like Ribera, he, too, was influenced at the beginning of his career by Caravaggesque tenebrism and naturalism.

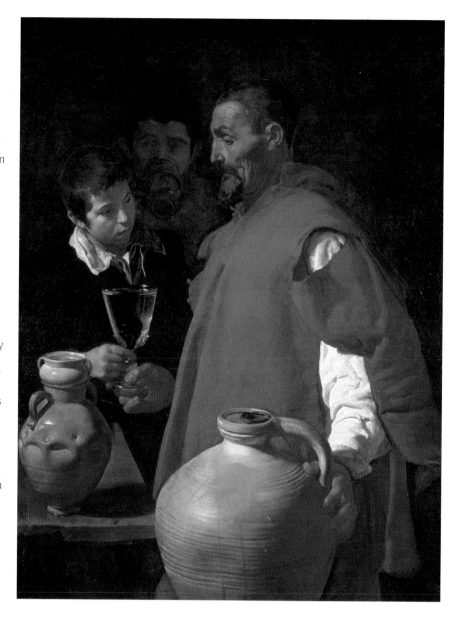

19-35. Diego Velázquez. *Water Carrier of Seville*. c. 1619. Oil on canvas, 41¹⁄₂ x 31¹⁄₂" (105.3 x 80 cm). Wellington Museum, London

In the oppressively hot climate of Seville, Spain, where this painting was made, water vendors walked the streets selling their cool liquid from large clay jars like the one in the foreground. In this scene the clarity and purity of the water is proudly attested to by its seller, who offers the customer a sample poured into a glass goblet. The jug contents were usually sweetened by the addition of a piece of fresh fruit or a sprinkle of aromatic herbs.

During his early years, he painted figural works set in taverns, markets, or kitchens, showing still lifes of various foods and kitchen utensils. Velázquez was devoted to studying and sketching from life, and the model for the superb *Water Carrier of Seville* (fig. 19-35), of about 1619, was a well-known Sevillian water seller. Like Sánchez Cotán, Velázquez arranged the elements of his paintings with almost mathematical rigor. The objects and figures allow the artist to exhibit his virtuosity in rendering sculptural volumes and contrasting textures illuminated by dramatic natural light, which reacts to the surfaces: reflecting off the **glazed** waterpot at the left and the matte-, or dull-, finished jug in the foreground; being absorbed by the rough wool and dense velvet of the costumes; and reflecting, being refracted, and passing through the clear glass and the waterdrops on the jug's skin.

In 1623 Velázquez moved to Madrid, where he became court painter to young King Philip IV (ruled 1621–1665), a comfortable position that he maintained until his death in 1660. The artist's style evolved subtly but significantly over his long career. The Flemish painter Peter Paul Rubens, during a 1628–1629 diplomatic visit to

the Spanish court, convinced the king that Velázquez should visit Italy, which Velázquez did in 1629–1631 and again in 1649–1651, thus being exposed to Italian painting of that time.

Although complex compositions were characteristic of many Velázquez paintings, perhaps his most striking and enigmatic work is the enormous multiple portrait, nearly 10¹⁄₂ feet tall and 9 feet wide, known as *Las Meninas,* or *The Maids of Honor* (fig. 19-36). Painted in 1656, near the end of the artist's life, this painting continues to reveal its creator's complex conception. Like Caravaggio's *Entombment* (see fig. 19-20), it draws the viewer directly into its action, for the viewer is standing, apparently, in the space occupied by King Philip and his queen, whose reflections can be seen in the large mirror on the back wall. The central focus, however, is on the couple's five-year-old daughter, the Infanta (Princess) Margarita, surrounded by her attendants, most of whom are identifiable portraits.

A cleaning of *Las Meninas* in 1984 revealed much about Velázquez's methods. He used a minimum of underdrawing, building up his forms with layers of loosely

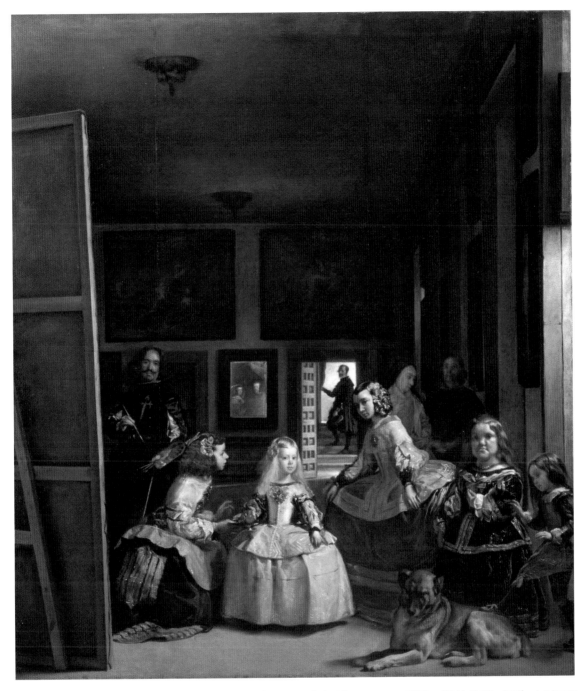

19-36. Diego Velázquez. *Las Meninas (The Maids of Honor)*. 1656. Oil on canvas, 10'5" x 9'1/2" (3.18 x 2.76 m). Museo del Prado, Madrid

applied paint and finishing off the surfaces with dashing highlights in white, lemon yellow, and pale orange. Veláz-quez tried to depict the optical properties of light rather than using it to model volumes in the classical manner. While his technique captures the appearance of light on surfaces, at close inspection his forms dissolve into a maze of individual strokes of paint (fig. 19-37).

In a sense, it does not matter whether the painting is meant to depict the king and queen while the others look on or to capture the royal pair stepping into the artist's stu-dio just as he is taking a break from painting the Infanta. Throughout his life Velázquez had sought acclaim for him-self and for his art. No matter what its real subject is, *Las Meninas* shows him at the peak of his good fortune, as an

19-37. Diego Velázquez. Detail of *Las Meninas (The Maids of Honor)*

19-38. Francisco de Zurbarán. *Saint Serapion.* 1628. Oil on canvas, 47¹/₂ x 40³/₄" (120.7 x 103.5 cm). Wadsworth Atheneum, Hartford, Connecticut

Ella Gallup Sumner and Mary Catlin Sumner Collection

intimate of the royal family itself. Later, when he was rewarded for his long service by being made a member of the Order of the Knights of Santiago (Saint James), he added the red cross of the order to his black courtier's costume.

Francisco de Zurbarán (1598–1664) is closely associated with the monastic orders for whom he executed his major commissions. Little is known of his early years before 1625, but he was greatly influenced by the Caravaggesque taste prevalent in Seville. From it he evolved his own distinctive style incorporating a Spanish taste for abstract design, as in his 1628 *Saint Serapion* (fig. 19-38). Serapion was a member of the thirteenth-century Mercedarians, a Spanish order founded to rescue the Christian prisoners of the Spanish Moors. The work portrays his martyrdom after he had allowed himself to be exchanged for Christian captives. The dead man's pallor, his rough hands, and the coarse ropes contrast sharply with the off-white of his creased Mercedarian habit, its folds carefully arranged in a pattern of highlights and varying depths of shadow. The only colors are the red and gold of the insignia on a straight pin, carefully placed to hold back the outer mantle and reveal the simple tunic underneath. The effect of this composition, almost timeless in its stillness, is that of a tragic still life.

FLEMISH BAROQUE

After a period of relative autonomy from 1598 to 1621 under a Habsburg regent, Flanders returned to direct Spanish rule and remained predominantly Catholic. Antwerp, the capital city and major arts center, gradually recovered from the turmoil of the sixteenth century, and artists of great talent flourished there, establishing international reputations that brought them important commissions from foreign patrons.

Painting

Peter Paul Rubens (1577–1640), whose painting has become synonymous with Flemish Baroque, was born in Germany, where his father, a Protestant, had fled from his native Antwerp to escape religious persecution. In 1587, after her husband's death, Rubens's mother and her children returned to Antwerp and to Catholicism. After a youth spent in poverty, Rubens decided in his late teens to become an artist. He was accepted into the Antwerp painters' guild at age twenty-one, a testament to his energy, intelligence, and determination.

Because he lacked money to set up his own studio, Rubens worked for two years in the shop of his teacher, Otto van Veen. In 1600 he left for Italy, taking with him a pupil, whose father may have paid for the trip. While he was in Venice his work came to the attention of an agent for the duke of Mantua, and Rubens was offered a court post. His activities on behalf of the duke over the next eight years did much to prepare him for the rest of his long and stupendously successful career. Other than designs for court entertainments and occasional portraits, the duke never acquired a single original work of art by Rubens. Instead, he had him copy famous paintings in collections all over Italy to add to the ducal collection. Rubens was free, however, to accept other commissions if they did not interfere with the duke's commands.

Rubens visited every major Italian city, went to Madrid as the duke's emissary, and spent two extended periods in

19-39. Peter Paul Rubens. *The Raising of the Cross*, painted for the Church of Saint Walpurga, Antwerp, Belgium. 1609–10.
Oil on canvas, center panel 15'1⅞" x 11'1½" (4.62 x 3.39 m); each wing 15'1⅞" x 4'11"(4.62 x 1.52 m). Cathedral of Our Lady, Antwerp

Rome, where he studied the great works of Roman antiquity and the Italian Renaissance. From 1605 to 1607, he shared quarters in Rome with his older brother Philip, providing illustrations from Classical sculpture for a book Philip was writing on Roman society. While in Italy, Rubens showed great interest in the work of two contemporaries, Caravaggio and Annibale Carracci. In 1606 he accepted a commission from the Oratorians to paint an altarpiece for the main altar of Santa Maria in Vallicella, where he certainly would have seen Caravaggio's *Entombment* (see fig. 19-20). Hearing of Caravaggio's death in 1610, Rubens encouraged the duke to buy the artist's painting *Death of the Virgin*, which had been rejected by the patron because of the shocking realism of its portrayal of the Virgin's dead body. Later, he arranged the purchase of a Caravaggio painting by an Antwerp church.

Rubens returned to Antwerp in 1608, fully expecting to go back to Italy. Once home, however, he decided to remain, and he accepted employment from the Habsburg governors of Flanders, and shortly afterward, he married. Rubens's first major commission in Antwerp was a large canvas **triptych** for the main altar of the Church of Saint Walpurga, *The Raising of the Cross* (fig. 19-39), painted in 1609–1610. Unlike earlier triptychs, where the side panels contained related but independent images, the wings here extend the action of the central scene and surrounding landscape across the vertical framing. At the center, Herculean figures strain to haul upright the

wooden cross with Jesus already stretched upon it. At the left, the followers of Jesus join in mourning, and at the right, indifferent soldiers supervise the execution. Culminating in this work are all the drama and intense emotion of a Caravaggio and the virtuoso technique of Annibale Carracci, transformed and reinterpreted according to Rubens's own unique ideal of thematic and formal unity. The heroic nude figures, dramatic lighting effects, dynamic diagonal composition, and intense emotions show his debt to Italian art, but the rich colors and surface realism, with minute attention given to varied textures and forms, belong to his native Flemish tradition.

Rubens had created a powerful, expressive visual language that was as appropriate for the secular rulers who engaged him as it was for the Catholic Church. Moreover, his intelligence, courtly manners, and personal charm made him a valuable and trusted courtier to his royal patrons, who included Philip IV of Spain, Queen-Regent Marie de' Medici of France, and Charles I of England. In 1630, while Rubens was in England on a peace mission, Charles I knighted him and commissioned him to decorate the ceiling of the new royal Banqueting House at Whitehall Palace, London (see fig. 19-63).

In 1621 Marie de' Medici, regent for her young son, Louis XIII, asked Rubens to paint the story of her life, to glorify her role in ruling France and also to commemorate the founding of the new Bourbon royal dynasty. In twenty-one paintings Rubens portrayed Marie's life and

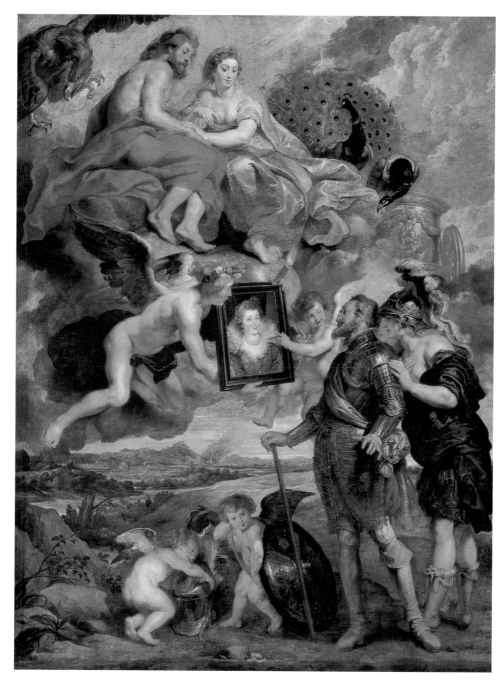

19-40. Peter Paul Rubens. *Henri IV Receiving the Portrait of Marie de' Medici*. 1621–25. Oil on canvas, 12'11⅛" x 9'8⅛" (3.94 x 2.95 m). Musée du Louvre, Paris

political career as one continuous triumph overseen by the gods. In fact, Marie and her husband, Henri, appear as Roman gods themselves.

In the painting depicting the royal engagement (fig. 19-40), Henri IV falls in love at once with Marie's portrait, shown to him by Cupid and Hymen, the god of marriage, as the supreme Roman god, Jupiter, and his wife, Juno, look down from the clouds. Henri, wearing his steel breastplate and silhouetted against a landscape in which the smoke of the battle lingers in the distance, is encouraged by a personification of France to abandon war for love, as putti play with the rest of his armor. The sustained visual excitement of these enormous canvases makes them not only important works of art but political propaganda of the highest order.

For all the grandeur of his commissioned paintings, Rubens was a sensitive, innovative painter, as the works he created for his own pleasure clearly demonstrate. One of his greatest joys was his country home, the Château of Steen, a working farm with gardens, fields, woods, and streams. Steen furnished subjects for several pastoral paintings, such as *Landscape with Rainbow* (fig. 19-41), of about 1635. The atmosphere after a storm is nearly palpable, with the sun breaking through clouds and the air still moisture laden, as farmworkers resume their labors. These magnificent landscapes had a significant impact on later painting.

Steen was in no sense a retirement home, and Rubens continued to produce large commissions for clients all over Europe. He employed dozens of assistants, many

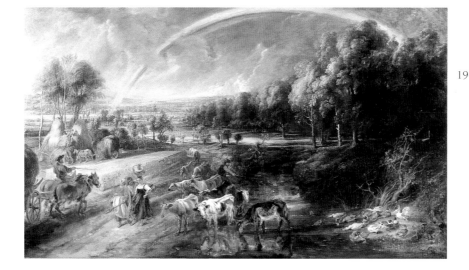

19-41. Peter Paul Rubens. *Landscape with Rainbow.* c. 1635. Oil on panel, 4'5³/₄" x 7'9¹/₈" (1.36 x 2.36 m). Wallace Collection, London

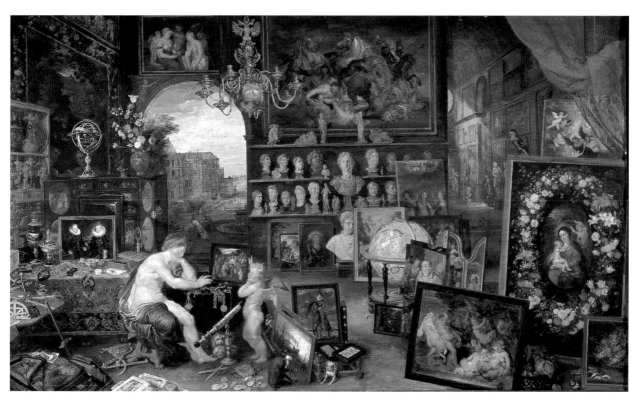

19-42. Jan Brueghel. *Sight*, from Allegories of the Five Senses. c. 1617–18. Oil on panel, 5'9¹/₄" x 8'7¹⁵/₁₆" (1.76 x 2.64 m). Museo del Prado, Madrid

of whom were, or became, important painters in their own right. Using workshop assistants was standard practice for a major artist, but Rubens was particularly methodical, training or hiring specialists in costumes, still lifes, landscapes, portraiture, and animal painting who together could complete a work from Rubens's detailed sketches.

One of his collaborators was Jan Brueghel (1568–1625), son of Pieter Brueghel the Elder and a highly regarded landscape and flower painter. Jan was called Velvet Brueghel, perhaps because of his love of elegant dress. Rubens and Jan may have met at the Antwerp Guild of Saint Luke, which the Brussels-born Jan entered in 1597 after working for a time in Italy. Among Jan's famous works are Allegories of the Five Senses, one of which, *Sight* (fig. 19-42), was painted about 1617-1618. Jan's arched setting

is filled with an encyclopedic display of beautiful things that appeal to the eye, including every sort of artwork, from Classical sculpture and rich decorative objects to paintings. Through the open arch is a peacock, its tail full of eyes, a fitting emblem for this particular sense.

The paintings in *Sight* are replicas of actual works, many of which are identifiable, but the large religious painting reproduced at the right is of special significance. The original *Virgin and Child in a Garland of Flowers* was a joint production, with the flowery wreath painted by Jan and the figures by Rubens. Already an extremely popular genre among Netherlandish artists at the end of the sixteenth century, still-life paintings of cut-flower arrangements were produced by the hundreds throughout the Baroque period.

19-43. Anthony Van Dyck. *Charles I at the Hunt.* 1635. Oil on canvas, 8'11" x 6'11" (2.75 x 2.14 m). Musée du Louvre, Paris

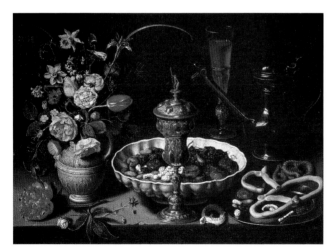

19-44. Clara Peeters. *Still Life with Flowers, Goblet, Dried Fruit, and Pretzels.* 1611. Oil on panel, 19¾ x 25¼" (50.2 x 64.1 cm). Museo del Prado, Madrid

Typical of Dutch breakfast pieces, this painting features a pile of pretzels among the elegant tablewares. The word *pretzel*, which comes from the Latin *pretiola*, meaning "small reward," was given to this salty, twisted bread because it was invented by southern German monks to reward children who had learned their prayers. The twisted shape represented the crossed arms of a child praying. Following a long-established Netherlandish tradition, the artist included a portrait of herself in a reflection on the covered goblet at the center and again in the multiple reflections on the pewter pitcher in the right background.

Another of Rubens's collaborators, Anthony Van Dyck (1599–1641), had an illustrious though short career, mainly as a portraitist. Son of an Antwerp silk merchant, he was listed as a pupil of the dean of Antwerp's Guild of Saint Luke at age ten. He had his own studio and roster of pupils at age sixteen but was not made a member of the guild until 1618, the year after he began his association with Rubens as a painter of heads. The necessity for blending his work seamlessly with that of Rubens affected Van Dyck's technique, but his artistic character was expressed in the elegance and aristocratic refinement of his own work. After a trip to the

English court of James I (ruled Great Britain 1603–1625) in 1620, Van Dyck traveled to Italy and worked as a portrait painter to the nobility for seven years before returning to Antwerp. In 1632, he returned to England as the court painter to Charles I, by whom he was knighted and given a studio, a summer home, and a large salary.

Van Dyck's many portraits of the royal family provide a sympathetic record of their features, especially those of King Charles. In *Charles I at the Hunt* (fig. 19-43) of 1635, Van Dyck was able, by clever manipulation of the setting, to portray the king truthfully and yet as a quietly impos-

 BAROQUE, ROCOCO, AND EARLY AMERICAN ART

QUARREL OF THE ANCIENTS AND THE MODERNS

When the French Royal Academy of Painting and Sculpture was established in 1648, its academicians considered ancient art the absolute standard by which to judge contemporary work. After the reorganization of the Academy in 1663 under Jean-Baptiste Colbert, students at the Academy school were instructed chiefly by drawing casts of Roman sculpture. They attended compulsory lectures on classical art theory.

In the 1680s, however, younger members of the Academy began to rebel against this rigid program. Charles Perrault, brother of architect Claude Perrault, who helped design the east facade of the Louvre (see fig. 19-22), published two tracts in which he argued that artists of his own century had made great advances on the ancients, even surpassing them in some respects. Modern artists could draw on new styles and utilize linear perspective, which was unknown to the Greeks and Romans. The result was a series of papers and debates, which came to be known as the Quarrel of the Ancients and the Moderns.

Parallel to the quarrel ran another, which debated the value of color versus drawing in painting. The Academy's position was that in painting, drawing was superior to color because drawing appealed to the mind, while color appealed to the senses. Many younger members of the Academy, however, had come to admire the vivid colors of Titian, Veronese, and Rubens. Their position was that the principal aim of painting is to deceive the eye and that color achieves this deception more convincingly than drawing.

The defenders of the Academy position were called *poussinistes* in honor of the artist Nicolas Poussin (who by this time had been dead for six years), because his work was thought to embody perfectly the classical principles of subject and design. The partisans of color were called *rubénistes*, because of their admiration for the color of Rubens. Since these disputes attacked the most cherished academic orthodoxies, the fact that they happened at all caused the Academy's authority to be eroded, and by the end of the century the views of the *rubénistes* came to be generally accepted.

The portraitist and critic Roger de Piles (1635–1709), though not a member of the Academy, took a lively interest in the debate, publishing his views in a series of pamphlets, in which he defended the primacy of color and particularly praised the work of Rubens. In *The Principles of Painting*, de Piles evaluated the most important painters on a scale of 0 to 20 in what he considered the Four Principal Parts of Painting: composition, drawing, color, and expression. He gave no score higher than 18, for no mortal artist could achieve "sovereign perfection," that is, 20 (cited in Holt, volume 2, pages 183–87). Few people today would rank Michelangelo below Primaticcio or give Rembrandt and Caravaggio a 6 in drawing!

The Best-Known Painters	Composition	Drawing	Color	Expression
Albrecht Dürer	8	10	10	8
Giovanni Bellini	4	6	14	0
Annibale Carracci	15	17	13	13
Leonardo	15	16	4	14
Michelangelo	8	17	4	8
Caravaggio	6	6	16	0
Parmigianino	10	15	6	6
Veronese	15	10	16	3
Poussin	15	17	6	15
Primaticcio	15	14	7	10
Raphael	17	18	12	18
Rembrandt	15	6	17	12
Rubens	18	13	17	17
Titian	12	15	18	6
Van Dyck	15	10	17	13

ing figure. Dressed casually for the hunt and standing on a bluff overlooking a distant view, Charles is shown as being taller than his pages and even than his horse, since its head is down and its heavy body is partly off the canvas. The viewer's gaze is diverted from the king's delicate and rather short frame to his pleasant features, framed by his jauntily cocked cavalier's hat. As if in decorous homage, the tree branches bow gracefully toward him, echoing the circular lines of the hat.

A contemporary of Van Dyck in Antwerp who did not work for Rubens, Clara Peeters (1594–after 1657), an early still-life specialist, was a prodigy whose career seems to have begun before she was fourteen. She married in Antwerp and was a guild member there, but she may have previously spent time in Holland. Of some fifty paintings now attributed to her, many are of the type called **breakfast pieces**, showing a table set for a meal of bread and fruit. As in her *Still Life with Flowers, Goblet, Dried Fruit, and Pretzels* (fig. 19-44) of 1611, Peeters arranged rich tableware and food against neutral, almost black backgrounds, the better to emphasize the fall of light over the contrasting surface textures. The pretzels, piled high on the pewter tray, are a particularly interesting Baroque element, with their complex multiple curves. The luxurious goblet and bowl contrast with the simple pewterware, as do the flowers with the pretzels.

SCIENCE AND ART IN THE SEVENTEENTH CENTURY

Francis Bacon (1561–1626) in England and René Descartes (1596–1650) in France established a new scientific method of studying the world by insisting on scrupulous objectivity and logical reasoning. Bacon proposed that facts be established by observation and tested by controlled experiments. Descartes argued for the deductive method of reasoning, in which a conclusion was arrived at logically from basic premises, the most fundamental of which was "I think, therefore I am." Descartes even used logic to prove the existence of God. Seventeenth-century scientists continued to believe that God had created matter, the basis of all things, and that their discoveries simply amplified human understanding of Creation, and this added to God's glory. Church authorities, however, often disagreed.

In 1543 the Polish scholar Nicolaus Copernicus (1473–1543) published *On the Revolutions of the Heavenly Spheres*, which contradicted the long-held view that the Earth is the center of the universe (the Ptolemaic theory) by arguing instead that the Earth and other planets revolve around the Sun. The Church viewed the Copernican theory as a challenge to its doctrines and put *On the Revolutions of the Heavenly Spheres* on its Index of Prohibited Books in 1616. At the beginning of the seventeenth century Johannes Kepler (1571–1630), the court mathematician and astronomer to Holy Roman Emperor Rudolf II, demonstrated that the planets revolve around the Sun in elliptical orbits. Kepler noted a number of interrelated dynamic geometric patterns in the universe, the overall design of which he believed was an expression of Divine order.

Galileo Galilei (1564–1642), an astronomer, mathematician, and physicist, was the first to develop a new invention, the telescope, as a tool for observing the heavens. His findings provided further confirmation of the Copernican theory, and after the teaching of that theory was prohibited by the Church, Galileo was tried for heresy by the Inquisition. Under duress, he publicly rejected his views, although at the end of his trial, according to legend, he muttered, "Nevertheless it [the Earth] does move." As the first person to see the craters of the moon through a telescope, Galileo began the exploration of space that would culminate in the first human steps on the moon in 1969.

The new seventeenth-century science turned to the study of the very small as well as to the vast reaches of space. Here the new technology included the microscope, developed by the Dutch lens maker and amateur scientist Anton van Leeuwenhoek (1632–1723). Although embroiderers, textile inspectors, manuscript illuminators, and painters already used magnifying glasses in their work, Leeuwenhoek perfected grinding techniques and increased the power of his lenses far beyond what was required for these uses. Ultimately, he was able to study the inner workings of plants and animals and even see microorganisms. Early scientists learned to draw or depended on artists to draw the images revealed by the microscope for further study and publication. Not until the discovery of photography in the nineteenth century could scientists communicate their discoveries without an artist's help.

DUTCH BAROQUE

The Dutch struggle for independence continued until Spain recognized Dutch sovereignty in 1648. During this period the Dutch Republic, as the northern Netherlands was officially known, managed not only to maintain its hard-won independence but also to prosper.

The Hague was the capital city and the preferred residence of the ruling princes of the House of Orange, but Amsterdam was the true center of power, owing to its sea trade and the enterprise of its merchants, who made the city an international commercial center. Historically, the princes of Orange had not been enthusiastic patrons of the arts, although the situation distinctly improved under Prince Frederick Henry (ruled 1625–1647). Nevertheless, Dutch artists found many eager patrons among the prosperous middle class in Amsterdam, Leiden, Haarlem, Delft, and Utrecht.

Painting and Prints

The art popular in the seventeenth-century Netherlands shows that the Dutch delighted in depictions of themselves and their country's landscape, cities, and domestic life, not to mention beautiful and interesting objects. In addition, the Dutch, a well-educated people, were fascinated by history, mythology, the Bible, new scientific discoveries, commercial expansion abroad, and colonial exploration (see "Science and Art in the Seventeenth Century," above). Many paintings show a continuation of the tradition of Netherlandish art, established in the time of Robert Campin and Jan van Eyck (Chapter 17), in which common objects carried underlying symbolic or moralizing meanings.

Portraits. Dutch Baroque portraiture took many forms, ranging from single portraits in sparsely furnished settings to allegorical depictions of people in elaborate costumes with appropriate symbols. Although the accurate portrayal of settings, costumes, and facial features was the most important gauge of a portrait's success, Dutch painters consistently went beyond pure description to idealize their subjects and to convey a sense of their personalities. Group portraiture that documented the membership of corporate organizations was a Dutch specialty. These large canvases filled with numerous individuals, who shared the cost of the commission, challenged painters to present a coherent, interesting composition that, nevertheless, gave equal attention to each individual portrait.

Frans Hals (c. 1581/85–1666), the leading painter of Haarlem, studied with the Flemish Mannerist Karel van Mander, but little is certain about Hals's work before 1616. He had by then developed a style grounded in the Netherlandish love of realism and inspired by the Caravaggesque style, yet it was far from slavish to either one. Like Velázquez, he tried to re-create the optical effects of light on the shapes and textures of objects. He painted boldly, with slashing strokes and angular patches

of paint that coalesce, when seen at a distance, into solid forms over which a flickering light seems to move. In Hals's hands this seemingly effortless technique suggests a boundless joy of life.

In his unusual painting *Catharina Hooft and Her Nurse* (fig. 19-45) of about 1620, he captured the vitality of an instantaneous gesture and a fleeting moment in time. While the portrait records for posterity the great pride of the parents in their child and their wealth, it is much more than a study of rich fabrics, laces, and expensive toys. Hals depicts the heartwarming delight of the child, who seems to be acknowledging the viewer as a loving family member while her doting nurse tries to distract her with an apple.

In contrast to this intimate individual portrait are Hals's official group portraits, such as his *Officers of the Haarlem Militia Company of Saint Adrian* (fig. 19-46), of

19-45. Frans Hals. *Catharina Hooft and Her Nurse.* c. 1620. Oil on canvas, 33³/4 x 25¹/2" (85.7 x 64.8 cm). Staatliche Museen zu Berlin, Preussischer Kulturbesitz, Gëmaldegalerie

19-46. Frans Hals. *Officers of the Haarlem Militia Company of Saint Adrian.* c. 1627. Oil on canvas, 6' x 8'8" (1.83 x 2.67 m). Frans Halsmuseum, Haarlem

Hals painted at least six group portraits of civic-guard organizations, including two for the Company of Saint Adrian. The company, made up of several guard units, was charged with the military protection of Haarlem whenever it was needed. Officers came from the upper middle class and held their commissions for three years, whereas the ordinary guards were tradespeople and craftworkers. Each company was organized like a guild under the patronage of a saint. When the men were not on war alert, the company functioned as a fraternal order, holding archery competitions, taking part in city processions, and maintaining an altar in the local church. (See also fig. 19-48.)

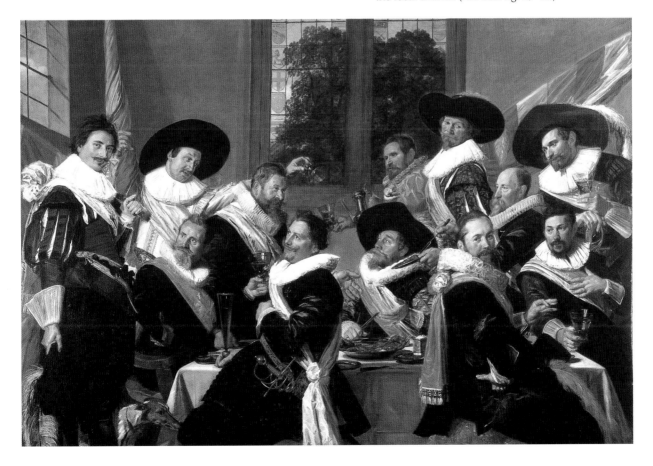

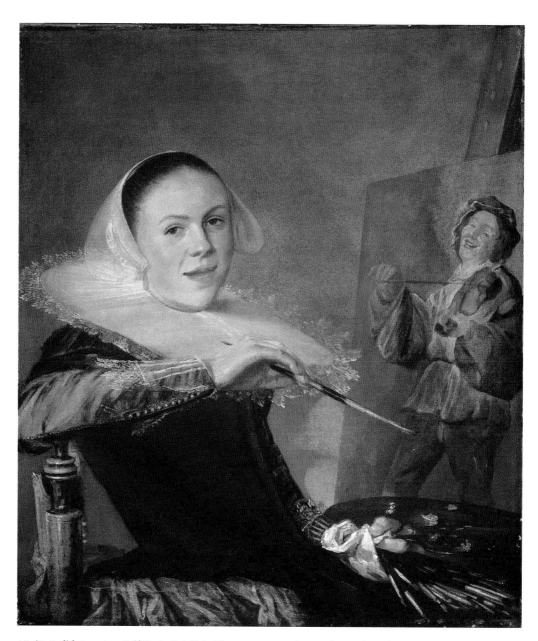

19-47. Judith Leyster. *Self-Portrait.* 1635. Oil on canvas, 29½ x 25¾" (74.9 x 65.4 cm). National Gallery of Art, Washington, D.C.
Widener Collection

about 1627. Less imaginative artists had arranged their sitters in neat rows to depict every face clearly. Hals's dynamic composition turned the group portrait into a lively social event, even while maintaining a strong underlying geometry of diagonal lines—gestures, banners, and sashes—balanced by the stabilizing perpendiculars of table, window, tall wineglass, and striped banner. The black suits and hats make the white ruffs and sashes of pink, orange, blue, and green even more brilliant.

The most successful of Hals's contemporaries to adopt his almost boisterous early manner was Judith Leyster (c. 1609–1660). In fact, one painting long praised as one of Hals's finest works was recently discovered to be by Leyster when a cleaning revealed her distinctive signature, the monogram *JL* with a star, in reference to her surname, Leysterre ("Pole Star"), which her family took from the name of their Haarlem brewery.

Although almost nothing is known of her early years, in 1628–1629 she was with her family in Utrecht, where she very likely encountered artists who had traveled to Italy and fallen under the spell of Caravaggio. Leyster's work shows clear echoes of her exposure to these Utrecht *Caravaggisti,* who had enthusiastically adopted the Italian master's naturalism, the dramatic tenebrist lighting effects, the large figures pressed into the foreground plane, and, especially, the theatrically presented everyday or low-life themes. In 1631 Leyster signed as a witness at the baptism in Haarlem of one of Frans Hals's children, which has led to the probably incorrect conclusion that she was Hals's pupil. Leyster may have worked in his shop, however, since she entered Haarlem's Guild of Saint Luke only in 1633. Membership allowed her to take pupils into her studio, and her competitive relationship with Frans Hals around that time is made clear by

TECHNIQUE

ETCHING AND DRYPOINT

Etching with acid on metal was used to decorate armor and other metal wares before it became a printmaking medium. The earliest etchings were made in Germany in the early 1500s, and even Albrecht Dürer experimented with the technique briefly by etching a few plates. These early etchings were made on iron, which tended to produce a ragged, fuzzy line. When printmakers began to work on copper with slow-acting acids, they produced a cleaner, more reliable image. Rembrandt was the first artist to popularize etching as a major form of artistic expression.

In the etching process, a plate, or metal sheet, is coated on both sides with an acid-resistant varnish that dries hard without being brittle. Then, instead of laboriously cutting the lines of the desired image directly into the plate, the artist draws through the varnish with a sharp needle to expose the metal. The plate is then covered with acid, which eats into the metal exposed by the drawn lines. By controlling the time the acid stays on different parts of the plate, the artist can make fine, shallow lines or heavy, deep ones. The varnish covering the plate is removed before an impression is taken. If a change needs to be made, the lines can be "erased" with a sharp metal scraper. Finally, accidental scratches are eliminated by burnishing (polishing). Not surprisingly, a complex image with a wide range of tones requires many steps.

Another technique for registering images on a metal plate is called **drypoint**. A sharp needle is used to scratch lines in the metal, but there are two major differences in technique between the process of **engraving** and that of drypoint (see "Woodcuts and Engravings on Metal," page 673). The engraving tool, or **burin**, is held straight and throws up equal amounts of metal, called burr, on both sides of the line, but the drypoint needle is held at a slight slant and throws up most of the burr on one side. Also, in engraving the metal burr is scraped off and the plate polished to yield a clean, sharp groove to hold the ink for printing. In drypoint the burr is left in place, and it, rather than the groove, holds the ink. Thus, under magnification, drypoint lines are white, with ink on both sides, but their rich black appearance when printed is impossible to achieve with engraving or etching. Unfortunately, drypoint burr is fragile, and only a few prints—a dozen or fewer—can be made before it flattens and loses its character. Rembrandt's earliest prints were pure etchings, but later he enriched his prints with drypoint to achieve greater tonal richness.

Like engraving, etching and drypoint use a printing technique called **intaglio**. After the desired image has been etched or scratched into the metal printing surface, printing ink is applied over the whole plate and forced down into the lines; then the surface of the plate is carefully wiped clean. Just as in the engraving process, the ink in the lines prints onto a sheet of paper pressed firmly against the metal plate.

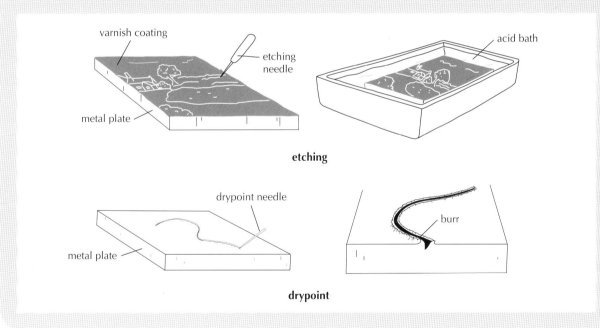

varnish coating
etching needle
metal plate
acid bath

etching

drypoint needle
metal plate
burr

drypoint

the complaint she lodged against him in 1635 for luring away one of her apprentices.

Leyster is known primarily for her informal scenes of daily life, which often carry an underlying moralistic theme. In her lively *Self-Portrait* (fig. 19-47) of 1635, the artist has paused momentarily in her work to look back, as if the viewer has just entered the room. Her elegant dress and the fine chair in which she sits are symbols of her success as an artist whose popularity was based on the very type of painting under way on her easel. Her subject, a man playing a violin, may be a visual pun on the painter with palette and brush. So that the viewer would immediately see the difference between her painted portrait and the painted painting, she varied her technique, executing the image on her easel more loosely. The narrow range of colors sensitively dispersed in the composition and the warm spotlighting are typical of Leyster's mature style.

19-48. Rembrandt van Rijn. *Captain Frans Banning Cocq Mustering His Company (The Night Watch).* 1642. Oil on canvas (cut down from the original size), 11'11" x 14'4" (3.63 x 4.37 m). Rijksmuseum, Amsterdam

The most important painter working in Amsterdam in the seventeenth century was Rembrandt van Rijn (1606–1669), now revered as one of the great artists of all time. Rembrandt was one of nine children born in Leiden to a miller and his wife. Rembrandt was sent to the University of Leiden in 1620 at age fourteen, but within a few months he dropped out to study painting. From 1621 to about 1624 he was apprenticed to a Leiden artist, then worked briefly in the Amsterdam studio of the history painter Pieter Lastman. Back in Leiden by 1625, Rembrandt soon developed a large following as a painter of religious pictures. In 1631 or 1632 he returned to Amsterdam to work in the studio of the art dealer Hendrick Van Uylenburgh. Although the dealer may have sold Rembrandt's original paintings, copies were also made from them for sale by a stable of artists whom Van Uylenburgh employed for this purpose.

In Amsterdam, Rembrandt broadened his repertoire to include mythological paintings, landscapes, and figure studies, but his primary source of income was portraiture. His work quickly attracted the interest of the secretary to Prince Frederick Henry, whose favorite artist was Peter Paul Rubens. Knowing this, Rembrandt studied Rubens's work and incorporated some of his compositional ideas in a series of paintings for the prince on the subject of the Passion of Christ (c. 1632–c. 1640).

Prolific and popular with Amsterdam clientele, Rembrandt ran a busy studio producing works that sold for high prices. His large workshop and the many pupils who imitated his manner have made it difficult for scholars to define his body of work, and many paintings formerly attributed to him have recently been assigned to other artists. Rembrandt's mature work reflected his new environment, his study of science and nature, and the broad-

ening of his artistic vocabulary by the study of Italian Renaissance art, chiefly from engraved copies. In 1639 he purchased a large house, which he filled with art and an enormous supply of studio props, such as costumes, weapons, and stuffed animals.

In 1642 Rembrandt was one of several artists commissioned by a wealthy civic-guard company to create large group portraits of its members for its new meeting hall. The result, *Captain Frans Banning Cocq Mustering His Company* (fig. 19-48), is considered one of Rembrandt's finest works. Because of the dense layer of grime and darkened varnish on it and its dark background architecture, this painting was once thought to be a night scene and was therefore called *The Night Watch.* After recent cleaning and restoration it now exhibits a natural golden light that sets afire the palette of rich colors—browns, blues, olive green, orange, and red—around a central core of lemon yellow in the costume of a lieutenant. To the dramatic group composition, showing a company forming for a parade in an Amsterdam street, Rembrandt added several colorful but seemingly unnecessary figures. While the officers stride purposefully forward, the rest of the men and several mischievous children mill about. The young girl at the left, carrying a chicken and wearing a money pouch, and the boy firing a blank rifle at the lieutenant's fancy plumed hat are so unusual that attempts have been made to find symbolic or ironic meaning in them. From the earliest days of his career, however, Rembrandt was devoted to sketching people he encountered in the streets. These figures may simply add lively touches of interesting local color to heighten the excitement of the scene.

Rembrandt was second only to Albrecht Dürer (Chapter 18) in his enthusiasm for printmaking as an important art form with its own aesthetic qualities and expressiveness. His interest focused on **etching**, a relatively minor medium at the time, in which the picture is created with acid on metal plates. His earliest line etchings date from 1627. About a decade later he began to experiment with additions in the **drypoint** technique, in which the artist uses a sharp needle to scratch shallow lines in a plate (see "Etching and Drypoint," page 789). Because etching and drypoint allow the artist to work directly on the plate, the style of the finished print has the relatively free and spontaneous character of a drawing. Rembrandt's commitment to the full exploitation of the medium is indicated by the fact that he alone carried the creative process through from the preparation of the plate to its inking and printing, and he constantly experimented with the technique, with methods of inking, and with papers for printing.

Although he is best known for his narrative prints on religious, mythological, and historical subjects, Rembrandt found that patrons enjoyed having their portraits etched. Other than his family, his subjects were exclusively well-to-do middle-class men, several of whom posed in Rembrandt's studio in the same high-back chair with lion's-head finials that appears in his portrait *Jan Lutma, Goldsmith* (fig. 19-49) of 1656. The print was created by etching a dense, intricate web of **cross-hatched** lines, then enriching small areas by hand with

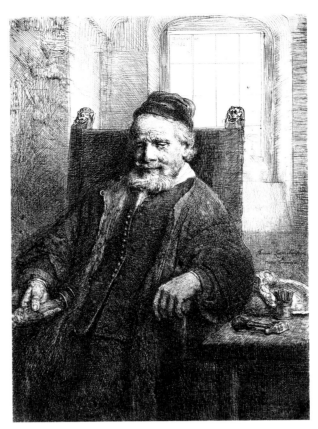

19-49. Rembrandt van Rijn. *Jan Lutma, Goldsmith.* 1656. Etching and drypoint, 7³⁄₄ x 6" (19.6 x 16 cm). Museum of Fine Arts, St. Petersburg, Florida

Gift of Margaret Acheson Stuart

the drypoint needle, whose soft burr created a velvety black when inked and printed. Lutma's profession is indicated by the goldsmith's mallet, a jar of punches, a basin on the table, and a statuette held in his right hand. The translation of the inscription in Latin above the table is "Jan Lutma Goldsmith, born in Groningen."

Rembrandt painted many self-portraits, in which one can trace the evolution of his style. By 1659 his past tribulations, including the death in childbirth of his wife, seem to have deepened his sensitivity to the human condition, for these images of himself became more searching and, like many of his paintings of other subjects, expressed a personal, internalized spirituality new in the history of art (fig. 19-50). Here, the half-length figure and the setting merge in a rich, luminous chiaroscuro, with the face and clasped hands emerging out of the darkness. A few well-placed brushstrokes suggest the physical tension in the fingers and the weariness of soul in the deep-set eyes. Mercilessly analytical, the portrait depicts the furrowed brow, sagging flesh, and prematurely aged face (he was only fifty-three) of one who has suffered deeply but retained his dignity.

Although continually plagued by financial problems, Rembrandt remained a popular artist and teacher, painting ever more brilliantly in a unique manner that distilled a lifetime of study and contemplation of life and human personalities. Among his late achievements is *The Jewish*

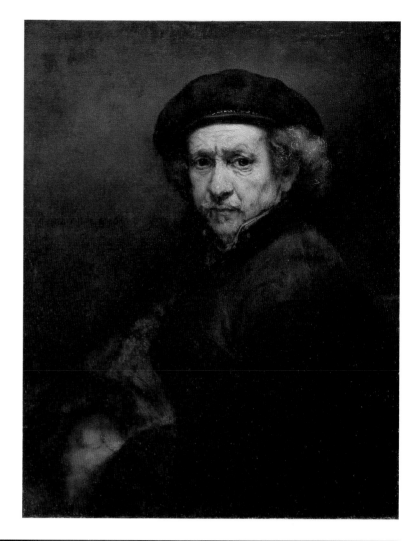

19-50. Rembrandt van Rijn. *Self-Portrait.* 1659. Oil on canvas, 33¼ x 26" (84 x 66 cm). National Gallery of Art, Washington, D.C.
Andrew W. Mellon Collection

19-51. Rembrandt van Rijn. *The Jewish Bride.* c. 1665. Oil on canvas, 3'11¾" x 5'5½" (1.21 x 1.65 m). Rijksmuseum, Amsterdam

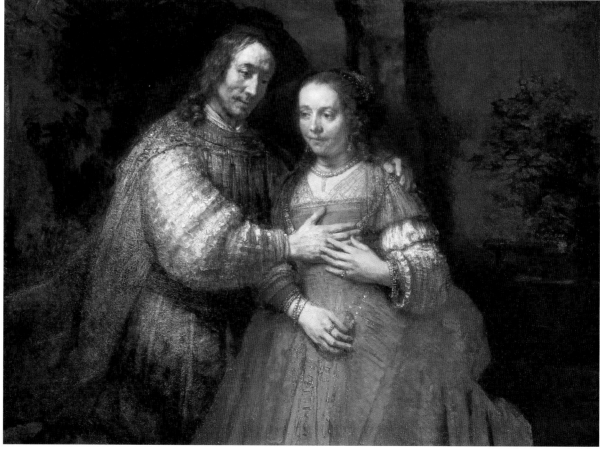

792 Baroque, Rococo, and Early American Art

19-52. Aelbert Cuyp. *Maas at Dordrecht.* c. 1660. Oil on canvas, 3'9¼" x 5'7" (1.15 x 1.70 m). National Gallery of Art, Washington, D.C.
Andrew W. Mellon Collection

Bride (fig. 19-51) of about 1665. This wedding portrait of the Jewish poet Don Miguel de Barrios and his wife, Abigael de Pina, was probably meant to refer to the marriage of Isaac and Rebecca or some other loving biblical couple. The groom's tender gesture of touching his bride's breast is an ancient symbol of fertility. Over the twenty years since the execution of *Captain Frans Banning Cocq Mustering His Company*, the artist's facility with brush and paint had not weakened. The monumental figures emerge from the same type of dark architectural background, perhaps a garden wall and portico, with the warm light suffusing the scene and setting the reds and golds of their costumes aglow. In comparison with Jan van Eyck's emotionally neutral *Portrait of Giovanni Arnolfini (?) and His Wife, Giovanna Cenami (?)* of the early fifteenth century (see fig. 17-10), where the meaning of the picture relied heavily on its symbolic setting, the significance of *The Jewish Bride* is emotional, conveyed by loving expressions and gestures.

Landscapes and Seascapes. The Dutch loved the landscapes and vast skies of their own country, but those who painted them were not slaves to nature as they found it. The artists were never afraid to remake a scene by rearranging, adding, or subtracting to give their compositions formal organization or a desired mood. Starting in the 1620s, view painters generally adhered to a convention in which little color was used beyond browns, grays, and beiges. After 1650, they tended to be more individualistic in their styles, but nearly all brought a broader

range of colors into play. One continuing **motif** was the emphasis on cloud-filled expanses of sky dominating a relatively narrow horizontal band of earth below.

From a family of artists, Aelbert Cuyp (1620–1691) of Dordrecht specialized early in his career in view painting. Cuyp first worked in the older, nearly monochromatic convention for recording the Dutch countryside and waterways. About 1645, his style evolved to include a wider range of colors, while also moving toward more idealized scenes drenched with a warm golden light, such as his *Maas at Dordrecht* (fig. 19-52), painted about 1660. This dramatic change has been attributed to Cuyp's contact with Utrecht painters who were influenced by contemporary landscape painting in Italy, especially the works of the French expatriate Claude Lorrain (see fig. 19-28). Unlike the Italian and French preference for religious, historical, or other narrative themes expressed through the figures inhabiting the landscape, Cuyp and other Dutch painters tended to represent nature for its own sake, even as they idealized it. The wide, deep harbor of the Maas River at Dordrecht was always filled with cargo ships and military vessels. A contemporary record mentions a fleet of ships with some 30,000 men in the harbor in 1646. If there is any symbolic meaning here, it might express Cuyp's pride in Dordrecht's contribution to the Dutch Republic's prosperity, independence, and peaceful life.

The Haarlem landscape specialist Jacob van Ruisdael (1628/29–1682) was especially adept at both the invention of dramatic compositions and the projection of moods in

19-53. Jacob van Ruisdael. *The Jewish Cemetery*. 1655–60. Oil on canvas, 4'6" x 6'2½" (1.42 x 1.89 m). The Detroit Institute of Arts
Gift of Julius H. Haass in memory of his brother Dr. Ernest W. Haass

19-54. Meindert Hobbema. *Avenue at Middelharnis*. 1689. Oil on canvas, 40¾ x 55½" (104 x 141 cm). The National Gallery, London

his canvases. His *The Jewish Cemetery* (fig. 19-53) of 1655–1660 is a thought-provoking view of silent tombs, crumbling ruins, and stormy landscape, with a rainbow set against dark, scudding clouds. Ruisdael was greatly concerned with spiritual meanings, which he expressed in his choice of such environmental factors as the time of day, the weather, the appearance of the sky, or the abstract patterning of sun and shade. Here the tombs, ruins, and fallen and blasted trees suggest an allegory of transience. The somewhat melancholy mood is mitigated by the rainbow, a traditional symbol of renewal.

Ruisdael's popularity drew many pupils to his workshop, the most successful of whom was Meindert Hobbema (1638–1709), who studied with him from 1657 to 1660. Although there are many similarities with Ruisdael's style in Hobbema's earlier paintings, his mature work moved away from the melancholy and dramatic moods of his master. Hobbema's love of the peaceful, orderly beauty of the civilized Dutch countryside is exemplified by one of his best-known paintings, *Avenue at Middelharnis* (fig. 19-54). In contrast with the broad horizontal orientation of many Dutch landscapes, Hobbema's composition draws the viewer into the picture and down the rutted, sandy road toward the distant village of Middelharnis as convincingly and compellingly as if the artist were a student of Italian Renaissance perspective.

Genre Painting. Dutch genre paintings of contemporary life were categorized in their own time by such descriptive titles as the "merry company," "garden party,"

19-55. Gerard Ter Borch. *The Suitor's Visit.* c. 1658. Oil on canvas, 32½ x 29⅝" (80 x 75 cm). National Gallery of Art, Washington, D.C.
Andrew W. Mellon Collection

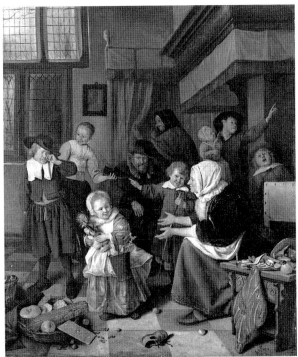

19-56. Jan Steen. *The Feast of Saint Nicholas.* c. 1660–65. Oil on canvas, 32¼ x 27¾" (82 x 70.5 cm). Rijksmuseum, Amsterdam

and "picture with little figures." Scholars of this period have noted that many of these works contain symbolic objects that suggest underlying meanings. Many of these messages seem to be admonitory, warning against alcoholism, gambling, or sexual promiscuity. The artists probably meant for their works to be understood on more than one level, a long tradition in Netherlandish painting. Where religious symbolism had dominated earlier works, Baroque artists painted chiefly for private patrons, who seem to have wanted paintings to be instructive as well as beautiful. Recent scholarship has found clues to the meaning of Dutch genre paintings in the emblem books that were popular at the time. These books were illustrated catalogs of allegorical or symbolic images, each one generally accompanied by a moralizing verse. Although these books tell a great deal about the meanings of Dutch genre painting, they can be confusing. In an emblem book published in 1618, one of the best-known compilers of emblems gave different common meanings for each image, depending upon whether the approach was moralizing, religious, or "romantic."

Before he began to specialize in genre pictures about 1650, Gerard Ter Borch (1617–1681) was highly regarded for his battle scenes and portraits. He was renowned for his exquisite rendition of lace, velvet, and, especially, satin, a skill well demonstrated in a work traditionally known as *The Suitor's Visit* (fig. 19-55), painted about 1658. It shows a well-dressed man bowing gracefully to an elegant woman in a sumptuously furnished room in which another woman plays the lute. The painting appears to represent a prosperous gentleman paying a call on a lady of equal social status, possibly to propose marriage. The dog in the painting and the musician seem

to be simply part of the scene. We are already familiar with the dog as a symbol of fidelity, and stringed instruments were said to symbolize, through their tuning, the harmony of souls and thus, possibly, a loving relationship. However, Ter Borch's scene has also been interpreted as showing a guest arriving at a luxurious house of prostitution. Supporting this view is the woman's low-cut neckline, which would have been considered improperly revealing for most social occasions in the seventeenth-century Netherlands. Moreover, the dog symbolizes sexual appetite as well as fidelity, and lute playing in the Netherlands was almost always associated with erotic activity.

The genre paintings of Jan Steen (1626–1679), whose larger brushstrokes contrast with the meticulous treatment of Ter Borch, used scenes of everyday life to portray moral tales, illustrate proverbs and folk sayings, or make puns to amuse the spectator. Steen was influenced early in his career by Frans Hals. His work in turn influenced a **school**, or circle of artists working in a related style, of Dutch artists who emulated his style and subjects. To support his family, Steen worked in a brewery for several years, and from 1670 until his death he kept a tavern in Leiden.

Jan Steen's paintings of children are especially remarkable, for he captured not only their childish physiques but also their fleeting moods and expressions, as in *The Feast of Saint Nicholas* (fig. 19-56) of about 1660–1665. Paintings like this suggest why today the Dutch phrase "Jan Steen's household" is used to describe a disorganized or untidy home. Here members of a family with seven children have gathered to celebrate the feast with a pile of sweets and toys for the children. Most

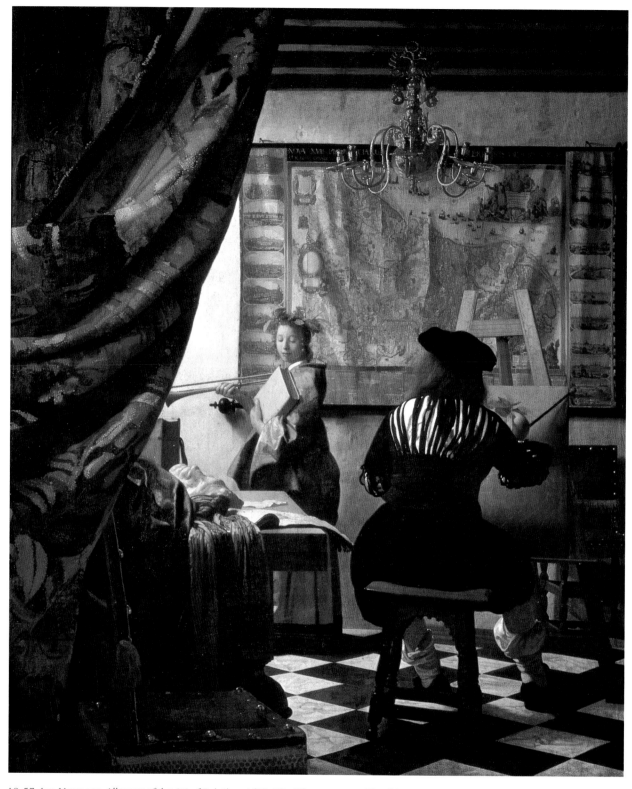

19-57. Jan Vermeer. *Allegory of the Art of Painting*. 1670–75. Oil on canvas, 52 x 44" (132 x 112 cm). Kunsthistorisches Museum, Vienna

of the children have found gifts in their shoes, except the unhappy boy at the left, who found his shoe filled with switches. To make matters worse, his younger sister and brother are having a good laugh at his expense. Meanwhile, the acquisitive little girl at the center has gathered up all the toys, including a Saint Nicholas doll, and is resisting her mother's coaxing gesture to share them with the others. A helpful oldest son distracts an infant and another child by pointing at something above their heads, while the father of the noisy brood looks on. In the shadows at the rear corner of the room, the children's grandmother or nurse smiles broadly and beckons with her finger, perhaps to soothe the crying boy with something she has been saving for him behind the draperies. In the work of many Netherlandish artists, children's activities were used to caricature adult foolishness. Thus, Steen's painting may be an admonishment for people to rise above childish greed and jealousy. Whatever the

case, *The Feast of Saint Nicholas* presents a fascinating view of Dutch life.

Perhaps the greatest of the Dutch genre painters was Jan (Johannes) Vermeer (1632–1675) of Delft. An innkeeper and art dealer who painted only for local patrons, Vermeer entered the Delft artists' guild in 1653. Meticulous in his technique, with a unique compositional approach and painting style, Vermeer produced few works. Of the fewer than forty canvases securely attributed to him, most are of a similar type—quiet, low-key in color, and asymmetrical but strongly geometric in organization. They are frequently enigmatic scenes of women in their homes, alone or with a servant, who are occupied with some cultivated activity, such as writing, reading letters, or playing a musical instrument. Vermeer also produced history paintings, views of Delft, and pictures of men and women together in the manner of Gerard Ter Borch, whom he knew.

Vermeer also painted at least two allegorical works, one of which is the *Art of Painting* (fig. 19-57), the title by which it was listed in documents after his death. The exact date of the painting is unknown; it may be as early as 1662–1665 or as late as 1670–1675. In 1662 Vermeer was elected an officer of the Guild of Saint Luke in Delft and probably was involved in the decoration of its guildhall with allegories of Painting, Sculpture, and Architecture. Also, scholars have noted connections with allegorical descriptions found in Cesare Ripa's emblem book *Iconologia*, which had been translated into Dutch by 1644. On the table at the left in Vermeer's painting is a large stone mask, which refers to painting's imitation of life. The model's laurel-leaf crown, book, and trumpet identify her as Clio, the Muse of History. The Muses, nine goddesses associated with Apollo, were thought by the ancient Greeks to inspire the arts, including the writing of history. The old-fashioned costume worn by the painter and the map on the wall, which shows the Netherlands as it had been in the previous century, may express nostalgia for the past. The Dutch were accomplished cartographers, and Dutch genre artists frequently used maps symbolically in their paintings. In the lower border of the map is the artist's signature, "I Ver-Meer." By setting his subject far from the picture plane and framing it in a doorway, Vermeer has removed his figures psychologically from the viewer. He thus endows them with a timeless stability that is reinforced by the geometry of the painting, in which every object seems carefully placed to achieve an overall balance, by the quiet atmosphere, and by the clear, even light.

A type of genre picture that achieved great popularity in the Baroque period was the **architectural interior**. These interior views seem to have been painted for their own special beauty, just as exterior views of the land, cities, and harbors were. The Rotterdam portrait and history painter Emanuel de Witte (c. 1617–1692) specialized in this type of work after moving to Delft in 1640 and after settling permanently in Amsterdam in 1652. Although many of his interiors were composites of features from several locations combined in one idealized architectural view, de Witte also painted faithful portraits of actual buildings. One of these is his *Portuguese Synagogue, Am-*

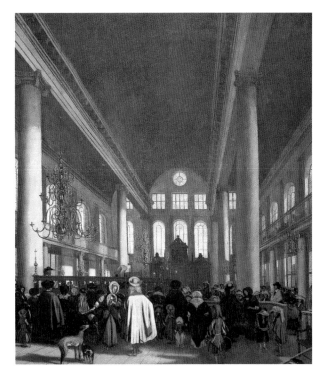

19-58. Emanuel de Witte. *Portuguese Synagogue, Amsterdam.* 1680. Oil on canvas, 43¹/₂ x 39" (110.5 x 99.1 cm). Rijksmuseum, Amsterdam

sterdam (fig. 19-58) of 1680. The synagogue is shown here as a rectangular hall divided into one wide central aisle with narrow side aisles, each covered with a wooden barrel vault resting on lintels supported by columns. De Witte's shift of the viewpoint slightly to one side has created an interesting spatial composition, and strong contrasts of light and shade add dramatic movement to the simple interior. The caped figure in the foreground and the dogs provide a sense of scale for the architecture and add human interest.

Today, the painting is interesting both as a record of seventeenth-century synagogue architecture and as evidence of Dutch religious tolerance in an age when Jews were often persecuted. Ousted from Spain and Portugal in the late fifteenth and early sixteenth centuries, many Jews had settled first in Flanders and then in the Netherlands. The Sephardic (Spanish) and Portuguese Jews in Amsterdam enjoyed religious and personal freedom, and their synagogue was considered one of the outstanding sights of the city.

Still Lifes and Flower Pieces. The term *still life* for paintings of artfully arranged objects on a table comes from the Dutch *stilleven*, a word coined about 1650. The Dutch were so proud of their artists' still-life paintings that they presented one to the French queen Marie de' Medici when she made a state visit to Amsterdam. As with genre pictures, still-life paintings often carried allegorical or moralizing connotations. A common type was the *vanitas*, whose elements reminded viewers of the transience of life, material possessions, and even art.

Still-life paintings consisting predominantly of cut-flower arrangements are often referred to as **flower pieces**. Significant advances were made in botany during

THE DUTCH ART MARKET Visitors to the Netherlands in the seventeenth century noted the great popularity of art, not just among aristocrats but also among merchants and working people. Peter Mundy, an English traveler, wrote in 1640: "As For the art off Painting and the affection off the people to Pictures, I thincke none other goe beeyond them, there having bin in this Country Many excellent Men in thatt Facullty, some att presentt, as Rimbrantt, etts. [etc.] All in generall striving to adorne their houses, especially the outer or street roome, with costly peeces, Butchers and bakers not much inferiour in their shoppes, which are Fairely sett Forth, yea many tymes blacksmithes, Coblers, etts., will have some picture or other by their Forge and in their stalle. Such is the generall Notion, enclination and delight that these Countrie Native[s] have to Paintings" (cited in Temple, page 70).

This taste for art stimulated a free market for paintings that functioned like other commodity markets. Without Church patronage and with limited civic and private commissions, artists had to compete to capture the interest of their public by painting on speculation. Naturally, specialists in particularly popular types of images were likely to be financially successful, and what most Dutch patrons wanted were paintings of themselves, their country, their homes, and scenes of the life around them. It was hard to make a living as an artist, and many artists had other jobs, such as tavern keeping and art dealing, to make ends meet. In some cases, the artist was more entrepreneur than art maker, running a "stable" of painters who made copy after copy of original works to sell. Forgery was not unknown, either. The painter Jan Vermeer, a connoisseur of Italian art, was called to court at The Hague in 1672 to examine a group of paintings sold by a Dutch dealer to the Elector of Brandenburg as works by Titian, Raphael, and Michelangelo. Vermeer's judgment was that they were not Italian, "but, on the contrary, great pieces of rubbish and bad paintings" (cited in Blankert, page 17).

The market for engravings and etchings, both for original compositions and for copies after paintings, was especially active in the Netherlands. One copperplate could produce hundreds of impressions, and worn-out plates could be reworked and used again. Although most prints sold for modest prices, Rembrandt's etching *Christ Healing the Sick* (1649) was already known in 1711 as the "Hundred-Guilder Print," because of the then-unheard-of price that one patron had paid for an impression of it.

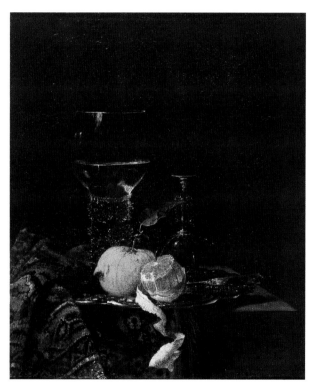

19-59. Wilhelm Kalf. *Still Life with Lemon Peel*. 1659. Oil on canvas, 20 x 17" (50.8 x 43.1 cm). Stichting Vrienden van het Mauritshuis, The Hague

the Baroque period through the application of orderly scientific methods, and objective observation was greatly improved by the invention of the microscope in 1674. The Dutch Republic was also a major importer, grower, and exporter of exotic flowers, especially tulips, which appear in nearly every flower piece in dozens of exquisite variations.

Wilhelm Kalf (1619–1693) of Rotterdam, an excellent painter of breakfast pieces, specialized in table settings of a rich and exotic character. This kind of painting was popular in the second half of the seventeenth century, and Kalf helped supply the thriving art market (see "The Dutch Art Market," above). In his *Still Life with Lemon Peel* (fig. 19-59) of 1659, Kalf depicts the surface textures of Chinese porcelain, gold, silver, brass, crystal, and an Oriental rug, which Dutch owners generally used to cover fine wood furniture. The half-peeled lemon—an expensive fruit in the Netherlands at the time—with its peel spiraling down implies that the unseen diner suddenly left the table. Thus, the "interrupted-meal" still life has been interpreted as a *vanitas* reminding the viewer that Death can come in the midst of pleasure. Citrus fruits also had sexual implications, and a half-peeled lemon often appears in depictions of houses of prostitution. One of the greatest pleasures of such paintings is the artist's virtuosity in rendering the subtle contrasts among the lemon's opaque, oily rind, its soft white pith, and the taut, transparent skin of the interior of the fruit.

Before the invention of photography, scientific investigations relied entirely on drawn and painted illustrations, and researchers hired artists to accompany them on field trips. Anna Maria Sibylla Merian (1647–1717) was unusual in making noteworthy contributions as both researcher and artist. German by birth and Dutch by training, Merian was once described by a Dutch contemporary as a painter of flowers, fruit, birds, worms, flies, mosquitoes, spiders, "and other filth." At the time, it was believed that insects emerged spontaneously from the soil, but Merian's research on the life cycles of insects proved otherwise, findings she published in 1679 and 1683 as *The Wonderful Transformation of Caterpillars and (Their) Singular Plant Nourishment*. In 1699 Amsterdam subsidized

19-60. Anna Maria Sibylla Merian. Plate 9 from *Dissertation in Insect Generations and Metamorphosis in Surinam.* 1719. Hand-colored engraving, 18⅞ x 13" (47.9 x 33 cm). National Museum of Women in the Arts, Washington, D.C. Gift of Wallace and Wilhelmina Holladay

Merian's research on plants and insects in the Dutch colony of Surinam in South America, whose results were published as *Dissertation in Insect Generations and Metamorphosis in Surinam*, illustrated with sixty large plates engraved after her watercolors. Each plate is scientifically precise, accurate, and informative, presenting insects in various stages of development along with the plants they live on (fig. 19-60).

The Dutch tradition of flower painting peaked in the long career of Rachel Ruysch (1663–1750) of Amsterdam. Her flower pieces were highly prized for their sensitive, free-form arrangements and their unusual and beautiful color harmonies. During her seventy-year career spanning the two Baroque centuries, she became one of the most sought-after and highest-paid still-life painters in Europe. In her *Flower Still Life* (fig. 19-61), painted after

19-61. Rachel Ruysch. *Flower Still Life.* After 1700. Oil on canvas, 30 x 24" (76.2 x 61 cm). The Toledo Museum of Art, Ohio
Purchased with funds from the Libbey Endowment. Gift of Edward Drummond Libbey

Flower painting was a much-admired specialty in the seventeenth-century Netherlands. Such paintings were almost never straightforward depictions of actual fresh flowers. Instead, artists made color sketches of fresh examples of each type of flower and studied scientifically accurate color illustrations in botanical publications. Using their sketches and notebooks, in the studio they could compose bouquets of perfect specimens of a variety of flowers that could never be found blooming at the same time. In fifteenth-century painting, flowers carried religious symbolism, especially in conjunction with images of the Virgin Mary. Baroque flower paintings were less specifically symbolic, but the short life of blooming flowers was a poignant reminder of the fleeting nature of beauty and human life.

1700, Ruysch placed the container at the center of the canvas's width, then created an asymmetrical floral arrangement of pale oranges, pinks, and yellows rising from lower left to top right of the picture, offset by the strong diagonal of the tabletop. To further balance the painting, she placed highlighted blossoms and leaves against the dark left half of the canvas and silhouetted them against the light wall area on the right. Ruysch often emphasized the beauty of curving flower stems and enlivened her compositions with interesting additions, such as casually placed pieces of fruit or insects, in this case a large gray moth (lower left) and two snail shells.

ENGLISH BAROQUE

England and Scotland came under the same rule in 1603 with the ascent of James VI of Scotland to the English throne as James I (ruled 1603–1625). James increased the royal patronage of British artists, especially in literature and architecture. William Shakespeare's *Macbeth*, featuring the king's legendary ancestor Banquo, was written in tribute to the new royal family and performed at court in December 1606. James's son Charles I (ruled 1625–1649) was also an important collector and patron of painting.

Unfortunately, religious and political tensions resulted in civil wars beginning in 1642 that cost Charles his throne and his life in 1649. Much of the rest of the Baroque period in England was politically uneasy, with a succession of republican and monarchical rulers, ending with the first three Hanoverian kings, George I, II, and III, who together ruled until 1802.

Architecture

In the early seventeenth century the architect Inigo Jones (1573–1652) introduced into England Renaissance classicism, an architectural design based on the style of the Renaissance architect Andrea Palladio (Chapter 18). Jones had studied Palladio's work in Venice, and Jones's copy of Palladio's *Four Books of Architecture* has been preserved, filled with notes in his hand. Jones was appointed surveyor-general in 1615 and was commissioned to design the Queen's House in Greenwich and the Banqueting House for the royal palace of Whitehall.

The Whitehall Banqueting House (fig. 19-62), built in 1619–1622 to replace an earlier one destroyed by fire, was used for court ceremonies and entertainments such as popular masques (see "The English Court Masque,"

THE ENGLISH COURT MASQUE

James I and his successor, Charles I, were fond of dance-dramas called masques, an important form of performance in early Baroque England. Inspired by Italian theatrical entertainments, the English masque combined theater, music, and dance in a spectacle in which professional actors, courtiers, and even members of the royal family participated. The event was more than extravagant entertainment, however; the dramas also glorified the monarchy. The entertainment began with an antimasque in which actors described a world torn by dissension and vice. Then, to the accompaniment of theatrical effects designed to amaze the spectators, richly costumed lords and ladies of the court appeared in the heavens to vanquish Evil. A dance sequence followed, symbolizing the restoration of peace and prosperity.

Inigo Jones, the court architect, was frequently called on to produce awe-inspiring special effects—storms at sea, blazing hells, dazzling heavens, and other wonders. To meet these demands, Jones revolutionized English stage design. He abandoned the Shakespearean theater, where viewers sat on the stage with the actors, and devised a **proscenium arch** that divided the audience from the stage action. He then created a bi-level stage with an upper area, where celestial visions could take place, and a main lower area, which was equipped with sliding shutters to permit rapid set changes. Jones achieved remarkable effects of deep space using linear perspective to decorate the shutters and the back cloth. His stagecraft is known today from the many working drawings he made, such as the design shown here, which he made for the last scene in court poet Thomas Carew's *Coelum Britannicum*, performed in 1634. This masque, which glorified the union of England and Scotland under James I and Charles I, ended with the appearance in clouds over the royal palace of personifications of Religion, Truth, Wisdom, Concord, Reputation, and Government.

Inigo Jones. *A Garden and a Princely Villa*, sketch for set design for *Coelum Britannicum*, by Thomas Carew. Performed February 18, 1634. Pen and brown ink with green distemper wash, 16⅝ x 21" (43.7 x 56.5 cm). Devonshire Collection, Chatsworth, England

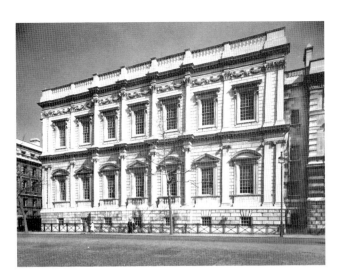

19-62. Inigo Jones. Banqueting House, Whitehall Palace, London. 1619–22

page 800). The west front shown here, consisting of two upper stories with superimposed Ionic and Composite orders raised over a plain basement level, exemplifies the understated elegance of Jones's interpretation of Palladian design. On the two upper stories, pilasters flank the end **bays** (vertical divisions), and engaged columns provide a subtle emphasis to the three bays at the center. These vertical elements are repeated in the balustrade along the roofline. A rhythmic effect was created in varying window treatments from triangular and segmental (semicircular) pediments on the first level to cornices with volute (scroll-form) brackets on the second. The sculpted garlands just below the roofline add an unexpected decorative touch, as does the use of a different-color stone—pale golden, light brown, and white—for each story.

Despite the two stories presented on the exterior, the interior of the Whitehall Banqueting House (fig. 19-63) is

1625
1575 1775

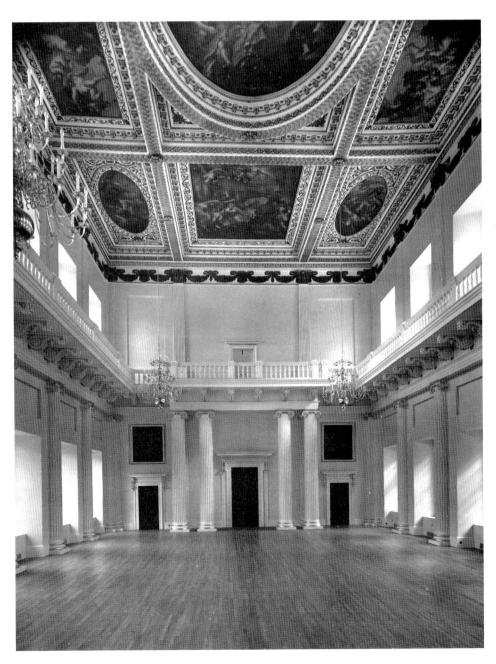

19-63. Inigo Jones. Interior, Banqueting House, Whitehall Palace. Ceiling paintings by Peter Paul Rubens. 1630–35

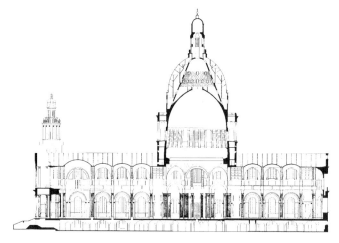

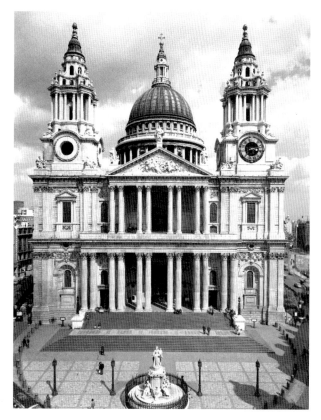

19-64. Christopher Wren. Saint Paul's Cathedral, London. 1675–1709

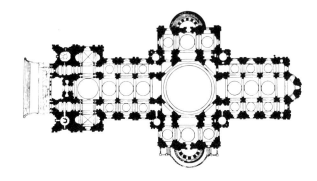

19-65. Plan and section of Saint Paul's Cathedral

actually one large hall with a balcony on the upper level and antechambers at each end. (The entrance is on the short side.) Ionic pilasters suggest a colonnade but do not impinge on the ideal, double-cube space measuring 55 by 110 feet by 55 feet high. In 1630 Charles I commissioned Peter Paul Rubens to decorate the ceiling. Jones had divided the flat ceiling into nine compartments, for which Rubens painted canvases glorifying the reign of James I. Installed in 1635, the paintings show a series of royal triumphs ending with the king carried to heaven in clouds of glory. So proud was Charles of the result that, rather than allow the smoke of candles and torches to harm the ceiling decoration, he moved the evening entertainments to an adjacent pavilion.

English architecture after 1660 was dominated by Christopher Wren (1632–1723), who built more than fifty Baroque churches. Wren began his professional career in 1659 as a professor of astronomy; architecture was a sideline until 1665, when he traveled to France to further his education. While there, he met with French architects and with Bernini, who was in Paris to consult on his designs for the Louvre. Wren returned to England with architectural books, engravings, and a greatly increased admiration for French classical Baroque design. In 1669, he was made surveyor-general, the position once held by Inigo Jones, and in 1673 he was knighted.

After the Great Fire of 1666 demolished central London, Wren was continuously involved in its rebuilding for the rest of the century and beyond. His major project was the rebuilding of Saint Paul's Cathedral (fig. 19-64), carried out from 1675 to 1709, after attempts to salvage the burned-out medieval church failed. Like Saint Peter's Basilica in the Vatican, Saint Paul's has a long nave, short transepts with semicircular ends, and a domed crossing. Like Brunelleschi's dome for the Florence Cathedral, Wren's dome for Saint Paul's has an interior masonry vault with an **oculus** and an exterior sheathing of lead-covered wood (fig. 19-65). As in the two Italian churches, the dome of Saint Paul's is crowned by a tall **lantern**, to which a brick cone rises from the inner oculus to admit light to the interior. The dome itself is plainly derived from Bramante's Tempietto, Church of San Pietro in Montorio, Rome (see fig. 18-20). On the main west front of Saint Paul's, two stages of paired Corinthian columns—a tribute to the east front of the Louvre—support a sculpted pediment. The deep-set porches and the columned pavilions atop the towers create dramatic areas of light and shadow, recalling the facade of Borromini's Church of San Carlo alle Quattro Fontane (see fig. 19-9). The huge size of the cathedral and its triumphant verticality, complexity of form, and chiaroscuro effects make it a major monument of the English Baroque.

John Vanbrugh (1664–1726), like Wren, came late to architecture. His heavy, angular style was utterly unlike Wren's, but it was well suited to buildings intended to express power and domination, in which Vanbrugh specialized. Perhaps his most important achievement was Blenheim Palace (fig. 19-66), built from 1705 to 1721. Blenheim's enormous size and symmetrical plan, with double wings reaching out to encompass the surrounding terrain (fig. 19-67), was strongly influenced by Versailles (see fig. 19-23). Instead of the refinement of detail to be found there, however, Blenheim's classical forms, including the

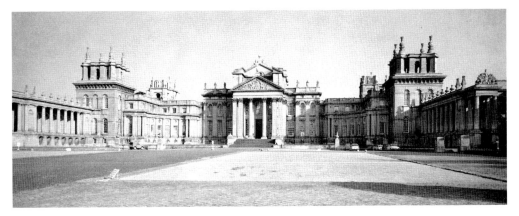

19-66. John Vanbrugh. Blenheim Palace, Wood-stock, Oxford-shire, England. 1705–21

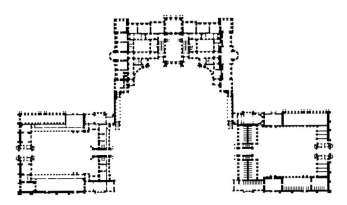

19-67. John Vanbrugh. Plan of Blenheim Palace

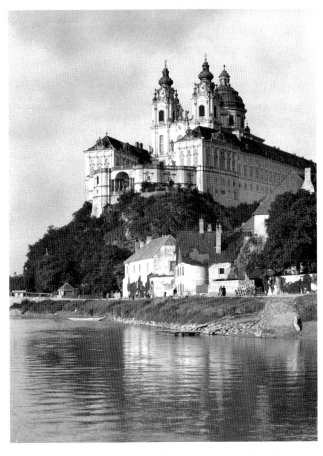

19-68. Jakob Prandtauer. Benedictine Monastery Church, Melk, Austria. 1702–36

temple-front exterior entrance, are large and rugged. They are also combined with the expansive **glazed** windows characteristic of English palace design since the sixteenth century (see fig. 18-81). The angular exterior, with its towering statues and pinnacles, casts shadows across the central block, creating a dramatic chiaroscuro effect.

GERMAN AND AUSTRIAN BAROQUE

In the seventeenth and eighteenth centuries the Habsburg emperors ruled their vast territories from Vienna, but the rest of German-speaking Europe remained divided by politics and religion into small principalities. Individual rulers decided on the religion of their territory, with Catholicism prevailing in southern and western Germany, including Bavaria and the Rhineland, and in Austria, while the north was Lutheran. Because of the devastating effects of the seventeenth-century religious wars, the Baroque style did not flourish in Germany and Austria until the eighteenth century, and then primarily under the patronage of Catholic prince-bishops.

Architecture

Eighteenth-century church architecture in Catholic Germany looked to Italian Baroque developments, which were then added to German medieval forms, such as the **westwork**, a tall west front, and bell towers. With these elements German Baroque architects gave their churches an especially strong vertical emphasis. Important secular projects were also undertaken, as princes throughout Germany began building smaller versions of Louis XIV's palace and garden complex at Versailles.

One of the most imposing Baroque buildings is the Benedictine Monastery Church at Melk, built high on a promontory above the Danube River in Austria (fig. 19-68). The architect, Jakob Prandtauer (1660–1726), oversaw its construction from 1702 to 1736 on a site where there had been a Benedictine monastery since the eleventh century. Seen from the river, the monastery appears to be a huge twin-towered church. But the complex also includes two long (1,050 feet) parallel wings flanking the church, one of which contains the

19-69. Andreas Schlüter. *Frederick William, the Great Elector (of Brandenburg)*. 1697–1703. Bronze equestrian group, over-lifesize. Schloss Charlottenburg, Berlin

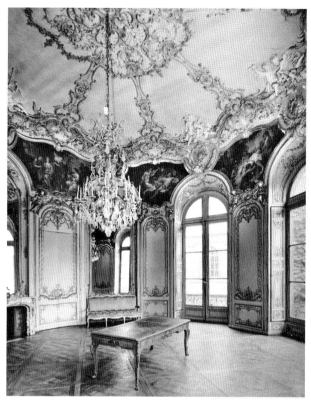

19-70. Germain Boffrand. Salon de la Princesse, Hôtel de Soubise, Paris. 1732

monastery's library. The wings are joined at the basement level by a section with a curving facade that descends from the cliff, forming a terrace overlooking the river in front of the church. Large windows and open galleries take advantage of the river view, while colossal pilasters and high bulbous-domed towers stress the verticality of the building by extending the vertical elements to a considerable height. The Melk monastery, as an ancient foundation enjoying imperial patronage, was expected to provide lodging for traveling princes and other dignitaries. Its grand and palacelike appearance was appropriate to this function.

Sculpture in Germany

Many Baroque German rulers wanted equestrian monuments of themselves. A representative example is a work by Andreas Schlüter (1664–1714), *Frederick William, the Great Elector (of Brandenburg)*, created in 1697–1703 in Berlin, the capital of Prussia (fig. 19-69). The statue commemorates the Great Elector (ruled 1640–1688) for restoring the Prussian military and improving his dominions' finances. The work is an over-lifesize bronze, set on a high podium, with its base surrounded by chained captives. Frederick's head is flung back, his hair cascading behind him like a lion's mane, as he calmly holds in check his powerful mount, with its thick neck, bulging eyes, and flaring nostrils. In contrast to the ferocity of the horse, the prince's calm demeanor suggests the cool rationality of enlightened rule. The dramatic pose of horse and rider

gives Frederick William a heroic presence, while the utter subjection of the chained captives, to whom the Great Elector seems to be oblivious, makes this an icon of absolute, unapologetic secular power. A representation of this kind greatly contrasts with the Rococo representation that developed shortly afterward in France and quickly spread to Germany and the rest of Europe.

THE ROCOCO STYLE

The Rococo style is characterized by pastel colors, delicately curving forms, dainty figures, and a light-hearted mood. It represents a lighter, more specialized phase of Baroque. The Rococo manner may be seen partly as a reaction at all levels of society, even among kings and bishops, against the "grand manner" of art identified with the formality and rigidity of seventeenth-century court life. The movement toward a lighter, more charming manner began in French architectural decoration at the end of Louis XIV's reign (d. 1715) and quickly spread across Europe. The duke of Orléans, regent for the boy-king Louis XV (ruled 1715–1774), made his home in Paris, and the rest of the court—delighted to escape Versailles—also moved there and built elegant town houses (in French, *hôtels*). The layout, furniture, and decor were designed for these smaller rooms, which became the settings for intimate and fashionable intellectual gatherings and entertainments, called salons, that were hosted by accomplished, educated women of the upper class whose names are still known today—Mesdames de

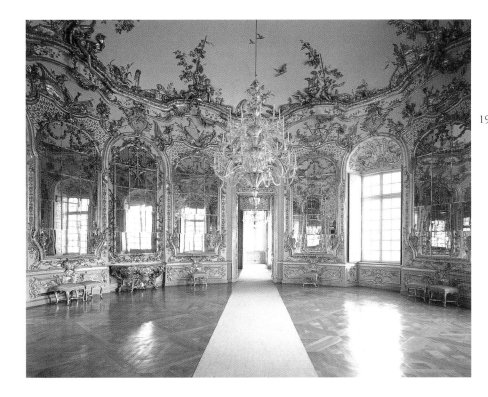

19-71. François de Cuvilliés the Elder. Mirror Room, Amalienburg, Nymphenburg Park, outside Munich, Germany. 1734–39

Staël, de La Fayette, de Sévigné, and du Châtelet, among others. The Salon de la Princesse in the Hôtel de Soubise in Paris, designed by Germain Boffrand beginning in 1732, is typical of the delicacy and lightness seen in French Rococo *hôtel* design of the 1730s (fig. 19-70). Interior designs for palaces and churches built on traditional Baroque plans were also animated by the Rococo spirit, especially in Germany and Austria. In occasional small-scale buildings the Rococo style was also successfully applied to architectural planning.

Architecture and Its Decoration in Germany and Austria

Typical Rococo elements in architectural decoration were arabesques, **S** shapes, **C** shapes, reverse **C** shapes, volutes, and naturalistic plant forms. The glitter of silver or gold against expanses of white or pastel color, the visual confusion of mirror reflections, delicate ornament in sculpted stucco, carved wood panels called **boiseries**, and inlaid wood designs on furniture and floors were all part of the new look. In residential settings, pictorial themes were often taken from classical love stories, and sculpted ornaments were rarely devoid of putti, cupids, and clouds.

The spread of the Parisian taste for Rococo architectural decoration to Germany is traditionally ascribed to the Flemish-born architect François de Cuvilliés the Elder (1695–1768), who spent almost all of his life in the service of the rulers of Bavaria. Cuvilliés studied in Paris from 1720 to 1724 and fully absorbed the new Rococo style, then returned to Munich. One of the finest examples of his style is the Amalienburg (fig. 19-71), a pavilion for royal relaxation at Nymphenburg Park outside Munich, built in 1734–1739. The main salon, or Mirror Room, is a fantasy of sculpted silver-leafed stucco on a blue background, naturalistically depicting vines, trees, flowers, fruits, urns, baskets, and musical instruments intermingled with peacocks, putti, and reclining classical figures. The doors, window alcoves, and **dadoes** are covered with *boiseries*, and the plants that appear above the undulating cornice suggest that the domed ceiling, paler blue than the walls, is actually the sky, where birds and butterflies soar.

A major late Baroque architectural project influenced by the new Rococo style was the Residenz, a splendid palace created for the prince-bishop of Würzburg from 1719 to 1744 by Johann Balthasar Neumann (1687–1753). One of Neumann's great triumphs of planning and decoration is the oval Kaisersaal, or Imperial Hall (fig. 19-72). Although the clarity of the plan, the size and proportions of the marble columns, and the large windows recall the Hall of Mirrors at Versailles, the decoration of the Kaisersaal, with its white-and-gold color scheme and its profusion of delicately curved forms, embodies the Rococo spirit. Here one can see the earliest development of Neumann's aesthetic of interior design that culminated in his final project, the Church of the Vierzehnheiligen (see fig. 19-74).

Neumann's collaborator on the Residenz was a brilliant Venetian painter, Giovanni Battista Tiepolo (1696–1770), who began to work there in 1750. Venice in the early eighteenth century had surpassed Rome as an artistic center, and Tiepolo was acclaimed internationally for his confident and optimistic expression of the illusionistic fresco painting pioneered by such sixteenth-century Venetians as Veronese (see fig. 18-30).

Tiepolo's work in the Kaisersaal—three scenes glorifying the twelfth-century crusader-emperor Frederick Barbarossa, who had been a patron of the bishop of

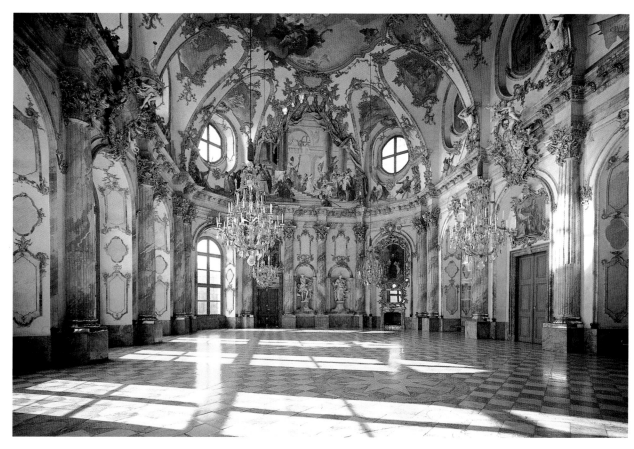

19-72. Johann Balthasar Neumann. Kaisersaal (Imperial Hall), Residenz, Würzburg, Bavaria, Germany. 1719–44. Fresco by Giovanni Battista Tiepolo. 1751–52

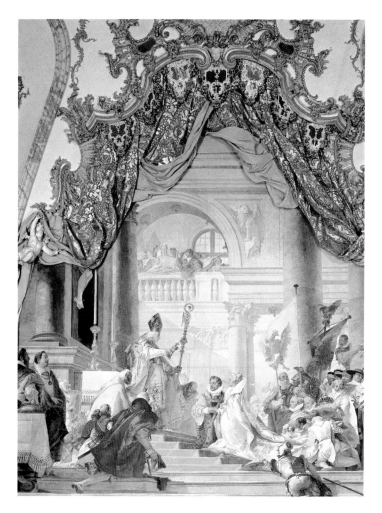

Würzburg—is a superb example of his architectural painting. *The Marriage of the Emperor Frederick and Beatrice of Burgundy* (fig. 19-73) is presented as if it were theater, with painted and gilded stucco curtains drawn back to reveal the sumptuous costumes and splendid setting of an imperial wedding. Like Veronese's grand conceptions (see fig. 18-1), Tiepolo's spectacle is populated with an assortment of character types, presented in dazzling light and sun-drenched colors with the assured hand of a virtuoso. Against the opulence of their surroundings, these heroic figures behave with the utmost decorum and, the artist suggests, nobility of purpose.

Rococo decoration in Germany was as often religious as secular. One of the many opulent Rococo church interiors still to be seen in Germany and Austria is that of the Church of the Vierzehnheiligen (Fourteen Auxiliary Saints) near Staffelstein (fig. 19-74), which was begun by Neumann in 1743 but was not completed until 1772, long after his death. The grand Baroque facade gives little hint of the overall plan, which is based on six interpenetrating oval spaces of varying sizes around a dominant domed ovoid center (fig. 19-75). The plan, in fact, recalls Borromini's double-shell design of the Church of San Carlo alle Quattro Fontane (see fig. 19-7). On the interior of the nave (fig. 19-76), the Rococo love of undulating surfaces and overlays of decoration creates a visionary

19-73. Giovanni Battista Tiepolo. *The Marriage of the Emperor Frederick and Beatrice of Burgundy,* fresco in the Kaisersaal (Imperial Hall), Residenz. 1751–52

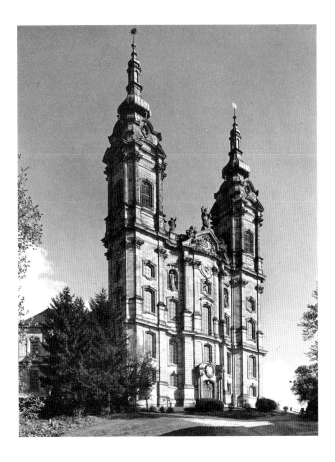

19-74. Johann Balthasar Neumann. Church of the Vierzehn-heiligen, near Staffelstein, Germany. 1743–72

In the center of the nave of the Church of Vierzehn-heiligen (Fourteen Auxiliary Saints) an elaborate shrine was built over the spot where, in the fifteenth century, a shepherd had visions of the Christ Child surrounded by saints. The saints came to be known as the Holy Helpers because they assisted people in need.

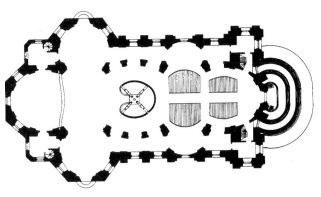

19-75. Johann Balthasar Neumann. Plan of the Church of the Vierzehnheiligen. c. 1743

world where flat wall surfaces scarcely exist. Instead, the viewer is surrounded by clusters of pilasters and engaged columns interspersed with two levels of arched openings to the side aisles and large clerestory windows illuminating the gold and white of the interior. The foliage of the fanciful capitals is repeated here and there in arabesques, wreaths, and the ornamented frames of the irregular panels that line the vault. What Neumann had begun in the Kaisersaal at Würzburg was brought to full fruition here in the ebullient sense of spiritual uplift carried by the complete integration of architecture and decoration.

Sculpture in Germany and France

Rococo sculpture style was introduced in small tabletop works on themes of fantasy and erotic love, consisting often of single figures or groups of satyrs, nymphs, cupids, Venuses, and Bacchantes (female attendants of Bacchus, the Roman wine god). Although marble and bronze were used, the less formal mediums of gilded wood, painted porcelain, and plain terra-cotta were especially popular. Over time, larger statues were also done in the Rococo manner.

From a Bavarian family of artists, Egid Quirin Asam (1692–1750) went to Rome in 1712 with his father, a

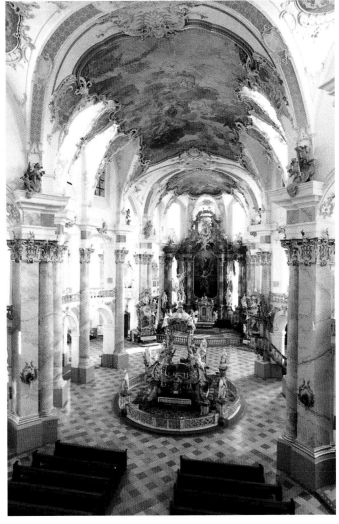

19-76. John Balthasar Neumann. Interior, Church of the Vierzehnheiligen. 1743–72

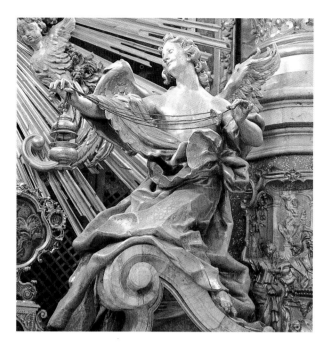

19-77. Egid Quirin Asam. *Angel Kneeling in Adoration*, part of a tabernacle on the main altar, Convent Church, near Osterhofen, Germany. c. 1732. Limewood with gilding and silver leaf, height 6'4" (2 m)

fresco painter, and his brother, Cosmas Damian (1686–1739). There, they studied Bernini's works and the illusionistic ceilings of Annibale Carracci and others. Back in Bavaria, Egid completed an apprenticeship with a Bavarian sculptor in 1716. The brothers both undertook architectural commissions, and they often collaborated on interior decoration in the Italian Baroque manner, to which they soon added lighter, more fantastic elements in the French Rococo style. Cosmas specialized in fresco painting and Egid in stone, wood, and stucco sculpture. The Rococo spirit is clearly evident in Egid's *Angel Kneeling in Adoration* (fig. 19-77), a detail of a tabernacle made about 1732 for the main altar of a church for which Cosmas provided the altarpiece. Sculpted of limewood and covered with silver leaf and gilding, the over-lifesize figure swings a censer and appears to have landed in a half-kneeling position on a large bracket. Bernini's angel in the Cornaro Chapel (see fig. 19-12) was the inspiration for Asam's figure, but the Bavarian artist has taken the liveliness of pose to an extreme, and the drapery, instead of revealing the underlying forms, swirls about in an independent decorative pattern.

In the last quarter of the eighteenth century, French art generally moved away from Rococo style and toward the classicizing styles that would end in Neoclassicism, but one sculptor who clung to Rococo up to the threshold of the French Revolution in 1789 was Claude Michel, known as Clodion (1738–1814). His major output consisted of playful, erotic tabletop sculpture, mainly in uncolored terra-cotta. Typical of Clodion's Rococo designs is the terra-cotta model he submitted to win a 1784 royal commission for a large monument to the invention of the hot-air balloon (fig. 19-78). Although Clodion's enchanting piece may today seem out of keeping with a

19-78. Clodion. *The Invention of the Balloon.* 1784. Terra-cotta model for a monument, height 43½" (110.5 cm). The Metropolitan Museum of Art, New York
Rogers Fund and Frederick R. Harris Gift, 1944 (44.21ab)

Up to the French Revolution, Clodion had a long career as a sculptor in the exuberant, precious Rococo manner seen in this work commemorating the 1783 invention of the hot-air balloon. During the austere revolutionary period of the First Republic (1792–1795), however, he became one of the few Rococo artists to adopt successfully the more acceptable Neoclassical manner (Chapter 26). In 1806 he was commissioned by Napoleon to provide the relief sculpture for two Paris monuments, the Vendôme Column and the Carrousel Arch near the Louvre.

technological achievement, hot-air balloons then were elaborately decorated with painted Rococo scenes, gold braid, and tassels. Clodion's balloon, decorated with bands of classical ornament, rises from a columnar launching pad in billowing clouds of smoke, assisted at the left by a puffing wind god with butterfly wings and heralded at the right by a trumpeting Victory. A few putti are stoking the fire basket that provided the hot air on which the balloon ascended as a host of others gathers reeds for fuel and flies up toward them.

19-79. Jean-Antoine Watteau. *The Pilgrimage to Cythera.* 1717. Oil on canvas, 4'3" x 6'4½" (1.3 x 1.9 m). Musée du Louvre, Paris

Painting in France

The emergence of the Rococo style in painting is marked by the career of the French artist Jean-Antoine Watteau (1684–1721), considered one of the greatest artists of the eighteenth century. For a time, he worked for a decorator of interiors, where he learned to paint charming shepherds and shepherdesses framed in arabesques, garlands, and vines. In 1717 he was elevated to full membership in the Royal Academy of Painting and Sculpture on the basis of a painting for which there was no established category. The academicians created a new category for it, called the **fête galante**, or elegant outdoor entertainment. The work he submitted, *The Pilgrimage to Cythera* (fig. 19-79), depicted a dreamworld event in which an assortment of beautifully dressed adults and children are setting out for, or perhaps taking their leave from, the mythological island of love. The flourishing landscape, which has all the reality of a painted theater backdrop, would never soil the characters' exquisite satins and velvets, nor would a summer shower ever threaten them. This idyllic vision, with its overtones of wistful melancholy, had a powerful attraction in early-eighteenth-century Paris and soon charmed the rest of Europe.

Tragically, Watteau died from tuberculosis when still in his thirties. During his final illness, while living with the art dealer Edme-François Gersaint, he painted a signboard for Gersaint's shop (fig. 19-80). The dealer later wrote, implausibly, that Watteau had completed the painting in about a week, working only in the mornings because of his failing health. When the sign was installed, it was greeted with almost universal admiration, and Gersaint sold it shortly thereafter.

The painting shows an art gallery—not, in fact, Gersaint's—filled with paintings from the Venetian and Netherlandish schools that Watteau admired. Indeed, the glowing satins and silks of the women's gowns are an homage to artists like Gerard Ter Borch (see fig. 19-55). In certain respects the composition restages an established Dutch Baroque image, the **cabinet piece**, a portrait of a connoisseur's private collection. The visitors to the gallery are elegant ladies and gentlemen, at ease in these surroundings and apparently knowledgeable about paintings. Thus, they create an atmosphere of aristocratic sophistication. At the left a woman in shimmering pink satin steps across the threshold. Ignoring her companion's outstretched hand, she is distracted by the two porters packing an order for delivery. While one holds a mirror, the other carefully lowers into the wooden case a portrait of Louis XIV, which may be a reference to the name of Gersaint's shop, Au Grand Monarque ("At the Sign of the Great King"). It also suggests the passage of time, for Louis had died in 1715. A number of other elements in the work also gently suggest transience. On the right the clock positioned directly over the king's portrait, surmounted by an allegorical figure of Fame and sheltering a pair of lovers, is a traditional **memento mori**, a reminder of mortality. The figures on it suggest that both love and fame are subject to the depredations of time.

19-80. Jean-Antoine Watteau. *The Signboard of Gersaint*. c. 1721. Oil on canvas, 5'4" x 10'1" (1.62 x 3.06 m). Stiftung Preussiche Schlössen und Gärten Berlin-Brandenburg, Schloss Charlottenburg

One of the most beautiful signboards ever created, Watteau's painting was designed to be placed under the canopy of Au Grand Monarque ("At the Sign of the Great King"), an art gallery in Paris belonging to the artist's friend and dealer, Edme-François Gersaint. Gersaint, one of the most successful dealers in eighteenth-century France, introduced the English idea of selling paintings by catalog. These systematic listings of works for sale gave the name of the artist and the title, medium, and dimensions of each work of art. The shop depicted on the signboard is not Gersaint's, the layout of which is known from contemporary documents, but an ideal gallery visited by elegant and cultivated patrons. The sign was so admired that Gersaint sold it only fifteen days after it was installed. Later it was cut in half down the middle and each piece framed separately, which resulted in the loss of some canvas along the sides of each section.

Well-established *vanitas* emblems are the straw, so easily destroyed, and the young woman gazing into the mirror (set next to a vanity case on the counter), for mirrors and images of young women looking at their reflections in them were time-honored symbols of the fugitive nature of human life. Watteau, dying, certainly knew how ephemeral life is, and no artist ever expressed the fragility of human happiness with greater delicacy.

Pastel, a new medium for finished works of art, soon became popular among Rococo artists and their patrons. Working with pastel chalks—made of chalk as a base, pulverized pigment, and weak gum water as a binder—allowed for a rapid, sketchlike technique in color, to capture fleeting impressions and moods. One of the most admired practitioners was the Venetian artist Rosalba Carriera (1675–1757), a former miniaturist and pattern-maker for lace, whose pastels earned her an honorary membership in Rome's Academy of Saint Luke in 1705. Watteau already knew and admired her work, for he had written to her in 1719 asking for a sample of it. In return she had sent a letter whose envelope she decorated with a sketch of the goddess Juno with a peacock. When Carriera arrived in Paris in 1720, Watteau was in London, but the two met after his return, and in the final months before his death in 1721, she did his portrait in pastel (fig. 19-81). Having been made a member of the Royal Acad-

19-81. Rosalba Carriera. *Jean-Antoine Watteau.* 1721. Pastel on paper, 14⁷/₁₆ x 9¹/₁₆" (36.6 x 23 cm). Städelsches Kunstinstitut, Graphische Sammlung, Frankfurt

19-82. François Boucher. *Le Déjeuner (Luncheon)*. 1739. Oil on canvas, 32⅛ x 25¾" (81.5 x 65.5 cm). Musée du Louvre, Paris

as a studio assistant to her husband. The other was Louis XV's mistress, Madame de Pompadour, who became his major patron and supporter. Pompadour was an amateur artist herself and took lessons from Boucher in print-making. After Boucher received his first royal commission in 1735, he worked almost continuously to decorate the royal residences at Versailles and Fontainebleau. In 1755 he was made chief inspector at the Gobelins Tapestry Manufactory, and he provided designs to it and to the Sèvres porcelain and Beauvais tapestry manufactories, all of which produced furnishings for the king. Boucher apparently did not meet Louis XV in person until he was made First Painter to the King in 1765. Only five years later, Boucher was found dead in his studio, having died suddenly while working at his easel.

Boucher produced extravagant compositions featuring beautiful nudes and chubby-cheeked boys and girls. But this artist of solid technique and great imagination also created magnificent portraits, breathtaking landscapes, tapestry designs, and scenes of daily life, such as his 1739 *Le Déjeuner (Luncheon)*. This painting looks almost like a family portrait, showing a mother with her two young children, the children's nurse, and an attentive butler serving coffee (fig. 19-82). A distant echo of Dutch family-life pictures (see fig. 19-56), *Le Déjeuner* is a catalog of contemporary French middle-class life in its depiction of the costumes, the Rococo *boiseries*, candle sconces, console, and parquet floor. Even the doll and pull toy the little girl has brought to the room provide interesting details for the modern viewer.

The work of Boucher's contemporary and friend in Paris, Jean-Siméon Chardin (1699–1779), could hardly have been more different from Boucher's courtly Rococo style. A painter whose output was limited essentially to still lifes and quiet domestic scenes in the Dutch manner, Chardin tended to work on a small scale, meticulously and slowly. His still lifes consisted of a few simple objects that were to be enjoyed for their subtle differences of shape and texture, not for any virtuoso performance, complexity of composition, or moralizing content.

In the 1730s Chardin began to focus on simple, mildly touching scenes of everyday middle-class life. He was one of the first European artists to treat the lives of women and children with sympathy and to honor the dignity of women's work in his portrayals of young mothers, governesses, and kitchen maids. Ironically, these simple domestic scenes appealed to aristocrats and even to royalty, who bought so many of them that Chardin was kept busy simply making copies of his popular compositions.

One of his most popular subjects was a half-length portrayal of a young boy blowing soap bubbles (fig. 19-83), which he painted many times for different patrons. In this version, the boy leaning out the window is entirely self-absorbed in blowing a larger and larger bubble, as a smaller boy watches in anticipation. Even such a simple concept as soap-bubble blowing may have a hidden meaning. The boy enjoys a pleasurable pursuit as time wastes away, and the soap bubble itself is a traditional symbol of the fragile, fleeting nature of human life; therefore, the painting has been interpreted as a type of *vanitas*.

emy of Painting and Sculpture in 1720, Carriera is credited with introducing French artists to the pastel medium for portraiture, so admirably suited to Rococo style and taste. She returned to Italy in 1721 and enjoyed an illustrious career until failing eyesight made it impossible for her to work.

The artist most closely associated today with the height of the Rococo phase in Paris was François Boucher (1703–1770), who was a student of Watteau despite never having met him. In 1721 Boucher, the son of a minor painter, entered the workshop of an engraver to support himself as he attempted to win favor at the Academy. The young man's facility with the engraving needle drew the attention of a devotee of Watteau, who hired him to reproduce Watteau's paintings in his collection, an event that firmly established the direction of Boucher's career.

Having won the Prix de Rome in 1724, Boucher used the money to study at the French Academy in Rome from 1727 to 1731. Although Boucher later dismissed much of Italian Renaissance and Baroque art, his work reveals that he learned a great deal from earlier artists, even as he moved in an entirely different stylistic direction.

Back in Paris, Boucher became an academician, and soon his life and career were intimately bound up with two women. The first was his artistically talented wife, Marie-Jeanne Buseau, who was a frequent model as well

19-83. Jean-Siméon Chardin. *Soap Bubbles*. c. 1745. Oil on canvas, 36⅝ x 29⅜" (93 x 74.6 cm). National Gallery of Art, Washington, D.C.
Gift of Mrs. John W. Simpson

When the mother of young Honoré Fragonard (1732–1806) brought her son to Boucher's studio around 1747–1748, the busy court artist recommended that the boy first study the basics of painting with Chardin. Within a few months, Fragonard returned with some small paintings done on his own, and Boucher gladly welcomed him as an apprentice-assistant at no charge to his family. Boucher encouraged the boy to enter the competition for the Prix de Rome, which Fragonard won in 1752.

Upon his return to Paris in 1761 Fragonard was still uncertain about his professional direction and spent another four years experimenting, mainly with landscape painting. In 1765 he was finally accepted into the Royal Academy. His reception piece drew high critical praise and was sent to be copied in a tapestry. On the brink of a potentially illustrious career as a court painter, Fragonard suddenly turned his back on the path to official success and began catering to the tastes of an aristocratic clientele. He also filled the vacuum left by Boucher's death in 1770 as a decorator of interiors.

Fragonard's great work is a group of fourteen canvases commissioned around 1771 by Madame du Barry, Louis XV's last mistress, to decorate her château. These marvelously free and seemingly spontaneous visions of lovers seem to explode in color and luxuriant vegetation. *The Meeting* (fig. 19-84) shows a secret encounter between a young man and his sweetheart, who looks back anxiously over her shoulder to be sure she has not been followed and clutches the letter arranging the tryst. The

19-84. (opposite) Honoré Fragonard. *The Meeting*, from The Loves of the Shepherds. 1771–73. Oil on canvas, 10'5¼" x 7'5⅝" (3.18 x 2.15 m). The Frick Collection, New York

rapid brushwork and creamy application that distinguish Fragonard's technique are at their freest and most lavish here. However, Madame du Barry rejected the paintings and commissioned another set in the fashionable Neoclassic style. Her view of Fragonard's manner as passé showed that the Rococo world was, indeed, ending. Fragonard's ravishing visions became outmoded, and his last years were spent living on a small pension and the generosity of his highly successful pupil Marguerite Gérard (1761–1837), who was his wife's younger sister.

Even while Fragonard was still painting erotic Rococo fantasies, a strong new reaction had begun among critics, who urged a return to seriousness and moral content in art. Jean-Baptiste Greuze (1725–1805) was a specialist in genre pictures on the subject of sin and redemption. Greuze entered the Royal Academy as a genre painter in 1775 with a painting titled *A Father Explaining the Bible to His Children*. Although his paintings are, indeed, outwardly moralizing, they often express a Rococo eroticism, as in his *Broken Eggs* (fig. 19-85) of 1756. Here, a shamefaced young woman is scolded by her mother for having broken some of the eggs she has brought into the house in a basket. An equally uncomfortable young man stands awkwardly in the background. Like the Dutch paintings that influenced Greuze profoundly, this work carries a second implied meaning: The broken eggs symbolize the loss of the young woman's sexual innocence, a meaning reinforced by her languorous pose and exposed bosom.

19-85. Jean-Baptiste Greuze. *Broken Eggs*. 1756. Oil on canvas, 28¾ x 37" (73 x 94 cm). The Metropolitan Museum of Art, New York
Bequest of William K. Vanderbilt, 1920 (20.55.8)

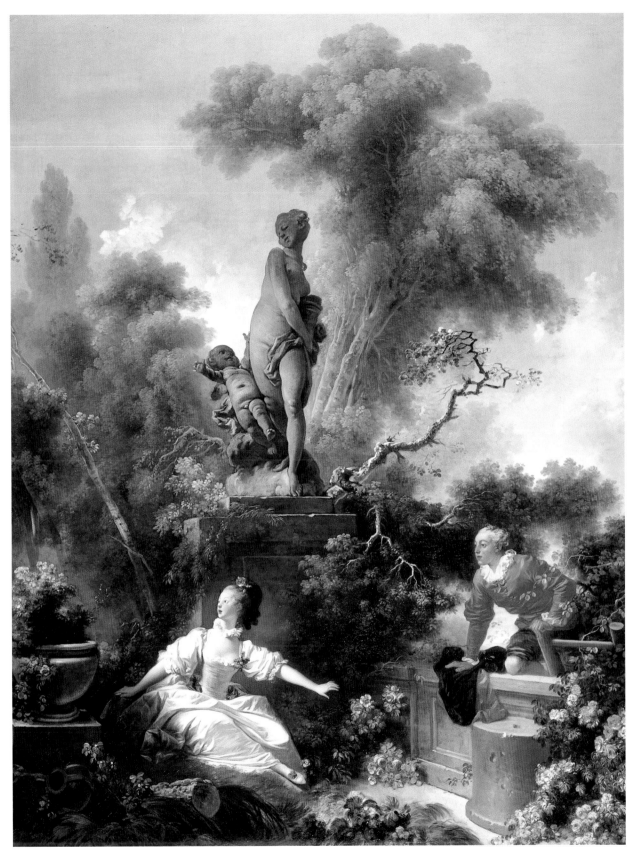

Craft Arts in France and England

A study of French Rococo art would be incomplete without the exquisite design of household furnishings. Various royal manufactories led the way in promoting the lively Rococo style in everything from chairs, consoles, and wall hangings to **porcelain** and silverware. Inspired by Chinese art and decoration, but fully Rococo in style, was the type of craft design referred to as **chinoiserie**. An excellent example of this decorative fantasy is a tapestry from a six-piece suite done from designs by Boucher, *La Foire Chinoise* (*The Chinese Fair*). Ten sets of the suite

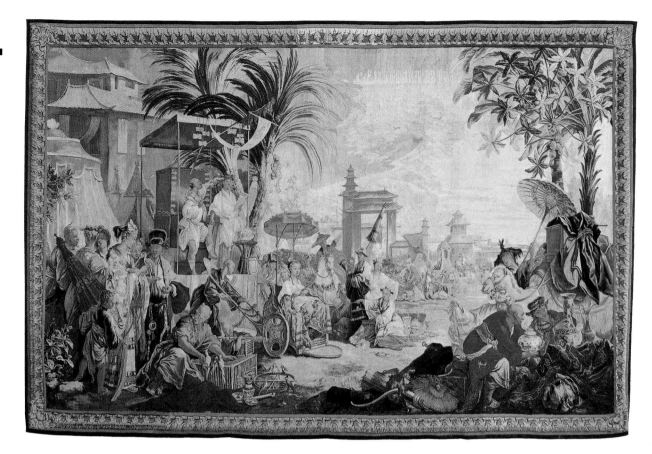

19-86. After a cartoon by François Boucher. *La Foire Chinoise (The Chinese Fair).* Designed 1743; woven 1743–75 at Beauvais, France. Tapestry of wool and silk, approx. 11'11" x 18'2" (3.63 x 5.54 m). The Minneapolis Institute of Arts
The William Hood Dunwoody Fund

were woven between 1743 and 1775, most of them for the king (fig. 19-86). The artist used his imagination freely to invent a scene in a country he had never visited and probably knew little about beyond the decorations of imported Chinese porcelains. Boucher's goal was to create a mood of liveliness and exotic charm rather than an authentic depiction of China.

French chinoiserie design directly influenced the work of a major goldsmith, Elizabeth Godfrey (c. 1700–c. 1758), one of several outstanding women craft artists working in London at the time. The daughter of an immigrant French Protestant silversmith, Elizabeth married twice, both times to goldsmiths. Elizabeth first registered her personal mark, used to identify works from her shop, at the death of her first husband in 1731. During her subsequent marriage to Benjamin Godfrey, she apparently worked under his mark, but at his death in 1741 she again registered her own. At about this time Elizabeth responded to the new wave of French taste in England in creating Rococo designs, such as her tea caddies of 1755 (fig. 19-87). Made to hold a choice of black or green tea, the shapes of the caddies have been totally disguised with **C** shapes, spiral scrolls, swags, volutes, and convex side panels containing enchanting little chinoiseries that depict the planting and gathering of tea. Even the jar openings and lids are arched vertically

with concave sides, and the lid knobs are sculpted tangles of exotic birds.

Europeans, especially Germans, had created their own version of hard-paste, or true, porcelain, of the type imported from China (see "The Secret of Porcelain," page 843). But many wares continued to be made in imitation of Chinese porcelain using soft paste, a cheaper clay mix containing ground glass, which can be fired at lower temperatures. A major production center of soft paste in France was the Royal Porcelain Factory at Sèvres, whose name today is synonymous with fine porcelain. Typical of its elegant creations for the court and other patrons able to afford such luxury items is a soft-paste potpourri jar in the shape of a boat (fig. 19-88), dated 1758, which is displayed on a base created for it. This rare technical masterpiece of sculpting and enamel painting is also a prime illustration of the Rococo taste for curved lines. In a typical blend of realistic detail and utter fantasy, the boat has gilded rope rigging and a rope ladder leading to the crow's nest at the top of the mast, which is wrapped in a fine silken length of cloth embroidered with the royal fleurs-de-lis. The portholes are actually open to the interior to allow the odor of the potpourri (aromatic herbs, rose petals, cinnamon bark, and the like) to escape. In emulation of Chinese vase decoration, the side of the boat is painted with birds and blossoms.

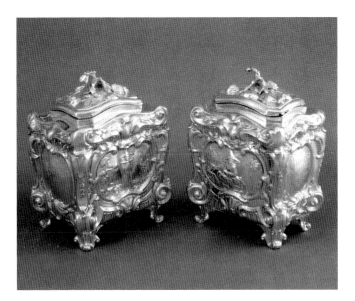

19-87. Elizabeth Godfrey. Tea caddies, from London. 1755. Silver, height approx. 5½" (14 cm). National Museum of Women in the Arts, Washington, D.C.

Silver Collection assembled by Nancy Valentine, purchased with funds donated by Mr. and Mrs. Oliver Grace and family

Godfrey created her intricate Rococo designs by the repoussé technique, a manner of embossing metal by delicately beating it over forms with small mallets from inside the container. Although made in London, the style of these pieces was derived from French Rococo designs of the type called chinoiserie. This term refers to fanciful Chinese-style figures and settings used as decorations on porcelains, furniture, silver vessels, and even large tapestries.

In the seventeenth and eighteenth centuries the art of Colonial America reflected the tastes of the European countries that ruled the colonies, mainly England and Spain. Not surprisingly, much of the colonial art was done by immigrant artists, and styles often lagged behind the European mainstream. Colonial life was still hard in the 1600s, and few could afford to think of fine houses and art collections. Puritans, for example, needed only the simplest functional buildings for their religious activities. By contrast, in the pre-Revolutionary decades of the eighteenth century the American colonies had become more affluent, and Americans had a greater sense of permanence and pride of place. Easier and more frequent travel between the continents contributed to the spread of European styles, although not necessarily the most current, because of the generally conservative, austere tastes of the settlers. Architecture responded more quickly than sculpture, painting, and craft arts in the development of native styles. Unfortunately but understandably, native artists of outstanding talent often found it advantageous to resettle in Europe.

Architecture

Architecture in the eastern British North American colonies can be divided generally into two types: derivations of European provincial timber construction with medieval roots, and the Palladian classical style that arrived from England about the middle of the eighteenth century. In the Southwest, Spanish styles dominated the building of mission-church complexes.

Wood, so easily obtained in the Northeast, was used to create the same kinds of houses and churches then being built in rural England, Holland, or France, depending on the colonists' home provinces. In seventeenth-century New England, for example, many buildings reflected the contemporary English style so appropriate to the severe North American winters—**half-timber construction** with steep roofs, massive central fireplaces and chimneys, overhanging upper stories, and small windows with tiny panes of glass. Building techniques were in a time-honored tradition; space between the boards of a wooden frame were filled with **wattle and daub** (woven branches packed with clay) or brick in more expensive homes. Instead of leaving this half-timber construction exposed as was common in Europe, colonists usually weatherproofed it with horizontal plank siding, called **clapboard**. One of the few well-preserved examples is the Parson Capen House in Topsfield,

19-88. Potpourri jar, from Sèvres Royal Porcelain Factory, France. 1758. Soft-paste porcelain with polychrome and gold decoration, vase without base 14¾ x 13¾ x 6⅞" (37.5 x 34.6 x 17.5 cm). The Frick Collection, New York

19-89. Parson Capen House, Topsfield, Massachusetts. 1683

19-90. Peter Harrison. Redwood Library, Newport, Rhode Island. 1749

19-91. Mission San Xavier del Bac, near Tucson, Arizona. 1784–97. Arizona Historial Society, Tucson
(Ash #41446)

Massachusetts (fig. 19-89), built in 1683. The earliest homes generally consisted of a single "great room" and fireplace, but the Capen House has two stories, each with two rooms flanking the central fireplace and chimney, affording more privacy to its occupants. The main fireplace hearth was the center of domestic life, where all the cooking was done and the firelight provided illumination for reading, sewing, or game playing.

The Palladian style, introduced into England by Inigo Jones in the seventeenth century (see fig. 19-62), continued to be popular in England and came to the British North American colonies in the mid-eighteenth century. One of the earliest examples, the work of English-born architect Peter Harrison, is the Redwood Library (fig. 19-90), built in Newport, Rhode Island, in 1749. The fusion of the temple front with a colossal Doric order and

19-92. *Mrs. Freake and Baby Mary.* c. 1674. Oil on canvas, 42¼ x 36¼" (108 x 92.1 cm). Worcester Museum of Art, Worcester, Massachusetts

Gift of Mr. and Mrs. Albert W. Rice

a lower facade with a triangular pediment is not only typically Palladian (see fig. 18-33); it is, in fact, a faithful replica of a design by Palladio in his *Fourth Book of Architecture*. The elegant simplicity of this particular design made it a favorite of English architects for small pleasure buildings on the grounds of estates.

In the Spanish colonial Southwest, the builders of one of the finest examples of mission architecture, San Xavier del Bac near Tucson, Arizona (fig. 19-91), looked to Spain for its inspiration. The foundations were begun by the Jesuit priest Eusebio Kino in 1700, using stone quarried locally by Native Americans of the Pima nation. The desert site had already been laid out with irrigation ditches, and Father Kino wrote in his reports that there would be running water in every room and workshop of the new mission, but the building never proceeded. Instead, Kino's vision was realized by the Spanish Franciscan missionary and master builder Juan Bautista Velderrain (d. 1790), who came to the mission in 1776. Velderrain in his letters spoke of his labors for God and the king of Spain—at that time Charles III, who established royal control over Spanish churches and ousted the Jesuit order from Spain. Thus, Father Kino's Jesuit mission site had been turned over to the Franciscans in 1768.

The huge church, 99 feet long with a domed crossing and flanking bell towers, was unusual for the area in being built of brick and mortar rather than **adobe**, made of earth and straw. The basic structure was finished by the time of Velderrain's death in 1790, and the exterior

decoration was completed by 1797 under the supervision of his successor. It is generally accepted that the Spanish artists executing the elaborate exterior, as well as the fine interior paintings and sculpture, were from central Mexico. Nearly thirty artists were living there in 1795. Although the San Xavier facade is far from a copy, the focus on the central entrance area, created by a combination of Spanish Churrigueresque decoration and sinuous Rococo lines and spirals, is clearly in the tradition of the earlier eighteenth-century work of Pedro de Ribera in Madrid (see fig. 19-32). The mission was dedicated to Saint Francis Xavier, whose statue once stood at the apex of the portal decoration. In the niches are statues of four female saints tentatively identified as Lucy, Cecilia, Barbara, and Catherine of Siena. Hidden in the sculpted mass is one humorous element: a cat confronting a mouse, which inspired a local Pima saying: "When the cat catches the mouse, the end of the world will come" (cited in Chinn and McCarty, page 12).

Painting

Painting and sculpture had to wait for more settled and affluent times in the colonies. For a long time carved or engraved tombstones were the only sculpture. Portraits done by itinerant "face painters," also called **limners**, have a charm and sincerity that appeal to the modern eye. The anonymous painter of *Mrs. Freake and Baby Mary* (fig. 19-92), dated about 1674, seems to have

19-93. John Smibert. *Dean George Berkeley and His Family (The Bermuda Group)*. 1729. Oil on canvas, 5'9¹/2" x 7'9"
(1.77 x 2.4 m). Yale University Art Gallery, New Haven, Connecticut
Gift of Isaac Lathrop of Plymouth, Massachusetts

known Dutch portraiture, probably through engraved copies that were imported and sold in the colonies. Even though its painter was clearly self-taught and lacked skills in illusionistic, three-dimensional composition, the spirit of the Freake portrait has much in common with Frans Hals's *Catharina Hooft and Her Nurse* (see fig. 19-45), especially in the care given to minute details of costuming and the focus on large figures in the foreground space. Maternal pride in an infant and hope for her future are universals that seem to apply to little Mary as well as to Catharina, even though their worlds were far apart.

As patronage for portrait paintings grew with the wealth of the colonies, a few traditionally trained European artists immigrated to satisfy the market. Probably the first such artist of stature to arrive was John Smibert (1688–1751), a Scot who had studied in London and spent considerable time in Italy. He came to the colonies in 1728 with one of his patrons, George Berkeley, to be the art professor at the college Berkeley was planning to found in Bermuda. In 1729, while Berkeley and his entourage were in Newport, Rhode Island, to complete their arrangements for the project, Smibert took the opportunity to paint a group portrait, *Dean George Berkeley and His Family,* commonly called *The Bermuda Group* (fig. 19-93). Berkeley at the right dictates to a richly dressed man at the table, while Berkeley's wife and child and another couple listen, and Smibert himself appears at the far left.

Smibert's debt to Flemish painting, which was still favored in the English court at the time, is obvious in the balanced but asymmetrical arrangement of figures and the great attention paid to representing textures of the costumes and the pattern of the Oriental rug on the table. The men's features are individualized likenesses, but the women's are idealized according to a convention of female beauty current in English portraiture—ovoid heads with large, plain features, columnlike necks, and tastefully exposed bosoms. The Bermuda project never went forward, and Smibert settled in Boston, working as a portrait painter, art-supply dealer, and printseller. The native Boston artists imitated his rich foreground settings against distant landscape views, his asymmetrical composition, and, especially, his conventions for female beauty.

Among Smibert's friends was Peter Pelham, an English immigrant painter-engraver, who married a Boston widow with a tobacco shop in 1748. Pelham's stepson John Singleton Copley (1738–1815) grew up to be America's first native artist of genius. Copley's sources of inspiration were meager—Smibert's followers and his stepfather's engravings—but his work was already drawing attention when he was fifteen. Young Copley's canny instincts for survival in the colonial art world included an intuitive understanding of the psychology of his middle-class Puritanical clientele. They valued not only his excellent technique, which equaled that of European artists, but also his ability to dignify them while recording their features with unflinching realism.

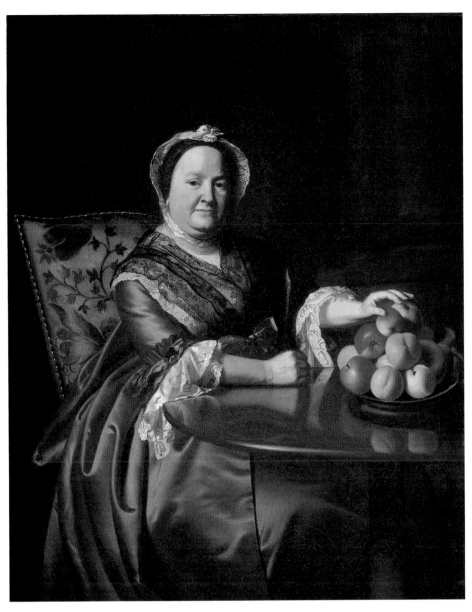

19-94. John Singleton Copley. *Mrs. Ezekiel Goldthwait (Elizabeth Lewis).* 1771. Canvas,
50³/₈ x 40¹/₄" (128 x 102.2 cm). Museum of Fine Arts, Boston
Bequest of John T. Bowen in memory of Eliza M. Bowen, 1941

An example of his mature Boston style is *Mrs. Ezekiel Goldthwait (Elizabeth Lewis)* (fig. 19-94), painted in 1771. Elizabeth Goldthwait was well known for her fine home and gracious dinner parties, but she was also a successful agriculturist whose orchards must have supplied the lush fruits she caresses, as if offering one to the viewer. She is shown in a lace-trimmed silk dress, surrounded by such luxuries as a damask-covered chair and mirror-polished mahogany table. Despite her obvious prosperity, Mrs. Goldthwait's open, amiable features, strong thick wrists, and large capable hands show a lack of vanity and a commitment to hard work that seem to personify the spirit of Puritan New England.

Copley's talents so outdistanced those of his colonial contemporaries that the artist aspired to a larger reputation. In 1766 he had sent a portrait of his half brother, *Boy with a Squirrel,* to an exhibition in London. The critical response was rewarding, and a colonial expatriate from Philadelphia encouraged Copley to study in Europe. At that time, he was kept from following the advice by family ties. But in 1773, revolutionary struggles hit close to home. Colonists dressed as Native Americans boarded a ship carrying tea and threw the cargo into Boston Harbor to protest the British East India Company's monopolistic selling of tea to a select few wholesalers—one of whom was Copley's father-in-law. Copley's failed attempts at negotiation between the Boston tea merchants and the company had ended with the Boston Tea Party. In June 1774 Copley sailed for Europe, where he visited London and Paris, then Italy. While there, he received word of the increasingly dangerous atmosphere in the colonies and urged his family to flee to England. Except for his widowed mother, all were reunited in London in 1775, the eve of the American Revolution. Copley spent the rest of his life in London and appears again in Chapter 26.

The Bodhisattva Avalokiteshvara
12th century

CHAPTER 20

Art of India after 1100

Taj Mahal
c. 1632–48

Gandhi Bhavan
1959–61

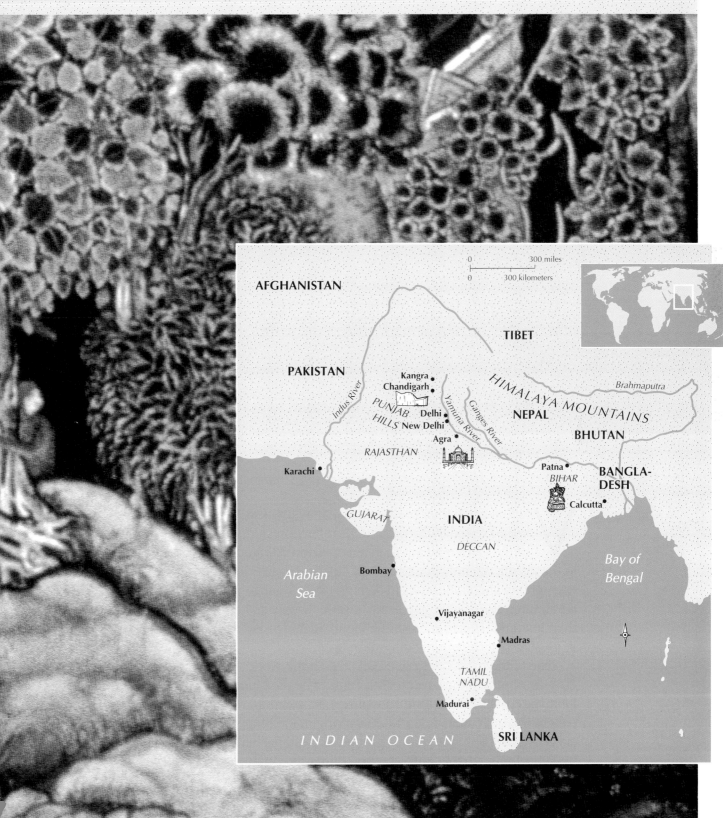

AFGHANISTAN

TIBET

PAKISTAN

Kangra
Chandigarh

HIMALAYA MOUNTAINS

Brahmaputra

PUNJAB
HILLS

Delhi

Yamuna River

Ganges River

NEPAL

BHUTAN

New Delhi

Agra

RAJASTHAN

Patna

BIHAR

BANGLA-
DESH

Karachi

Calcutta

GUJARAT

INDIA

DECCAN

Arabian
Sea

Bombay

Bay of
Bengal

Vijayanagar

Madras

TAMIL
NADU

Madurai

SRI LANKA

INDIAN OCEAN

0 300 miles
0 300 kilometers

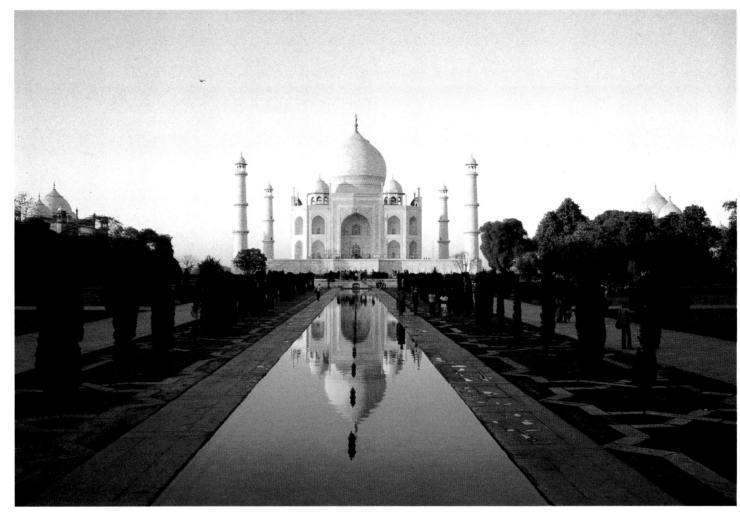

20-1. Taj Mahal, Agra, India. Mughal period, Mughal, reign of Shah Jahan, c. 1632–48

Visitors catch their breath. Ethereal, weightless, the building barely seems to touch the ground. Its reflection shimmers in the pools of the garden meant to evoke a vision of paradise as described in the Koran, the holy book of Islam. Its facades are delicately inlaid with inscriptions and arabesques in semiprecious stones—carnelian, agate, coral, turquoise, garnet, lapis, and jasper. Above, its luminous, white-marble dome reflects each shift in light, flushing rose at dawn, dissolving in its own brilliance in the noonday sun.

One of the most celebrated buildings in the world, the Taj Mahal (fig. 20-1) was built in the seventeenth century by the Mughal ruler Shah Jahan as a mausoleum for his favorite wife, Mumtaz-i-Mahal, who died in childbirth. A dynasty of Central Asian origin, the Mughals were the most successful of the many Islamic groups that established themselves in India beginning in the tenth century. Under their patronage, Persian and Central Asian influences mingled with older traditions of the South Asian subcontinent, adding yet another dimension to the already ancient and complex artistic heritage of India.

LATE MEDIEVAL PERIOD

By 1100 India was already among the world's oldest civilizations (see "Foundations of Indian Culture," below). The art that survives from its earlier periods is almost exclusively sacred, most of it inspired by the three principal religions: Hinduism, Buddhism, and Jainism. At the start of the Late Medieval period, which extends roughly from 1100 to 1526, these three religions continued as the principal focus for Indian art, even as invaders from the northwest began to establish the new religious culture of Islam.

Buddhist Art

After many centuries of prominence, Buddhism had been in decline as a cultural force in India since the seventh century. By the Late Medieval period, the principal Buddhist centers were concentrated in the northeast, in the kingdom ruled by the Pala dynasty. There, in great monastic universities that attracted monks from as far away as China, Korea, and Japan, was cultivated a form of Buddhism known as tantric (Vajrayana) Mahayana. The

practices of tantric Buddhism, which included techniques for visualizing deities, encouraged the development of **iconographic** images such as the gilt bronze sculpture of the **bodhisattva** Avalokiteshvara in figure 20-2. Bodhisattvas are beings who are well advanced on the path to buddhahood (enlightenment), the goal of Mahayana Buddhists, and who have vowed out of compassion to help others achieve enlightenment. Avalokiteshvara, the bodhisattva of greatest compassion, whose vow is to forgo buddhahood until all others become buddhas, became the most popular of these saintly beings in India and in East Asia.

Characteristic of bodhisattvas, he is distinguished in art by his princely garments, unlike a buddha, who wears a monk's robes. Avalokiteshvara is specifically recognized by the lotus flower he holds and by the presence in his crown of his "parent" buddha, in this case Amitabha, buddha of the Western Pure Land. Other marks of Avalokiteshvara's extraordinary status are the third eye (symbolizing the ability to see in miraculous ways) and the wheel on his palm (signifying the ability to teach the Buddhist truth).

FOUNDATIONS OF INDIAN CULTURE

The earliest civilization on the Indian subcontinent flourished toward the end of the third millennium BCE along the Indus River in present-day Pakistan. Remains of its expertly engineered brick cities have been uncovered, together with works of art that intriguingly suggest spiritual practices and reveal artistic traits known in later Indian culture.

The abrupt demise of the Indus Valley civilization during the mid-second millennium BCE coincides with (and may be related to) the arrival from the northwest of a semi-nomadic warrior people known as the Indo-European Aryans. Over the next millennium they were influential in formulating the new civilization that gradually emerged. The most important Aryan contributions to this new civilization included the Sanskrit language and the sacred texts called the Vedas. The evolution of Vedic thought under the influence of indigenous Indian beliefs culminated in the Upanishads, whose mystical, philosophical texts took shape sometime after 800 BCE.

The Upanishads teach that the material world is illusory; only Brahman, the universal soul, is real and eternal. We—that is, our individual souls—are trapped in this illusion in a relentless cycle of birth, death, and

rebirth. The ultimate goal of religious life is to liberate ourselves from this cycle and to unite our individual soul with Brahman.

Buddhism and Jainism are two of the many religious communities that developed in the climate of Upanishadic thought. Buddhism is based on the teachings of Shakyamuni Buddha, who lived in central India about 500 BCE; Jainism was shaped about the same time around the followers of the spiritual leader Mahavira. Both religions acknowledged the cyclical nature of existence and taught a means of liberation from it, but they rejected the authority, rituals, and social strictures of Vedic religion. Whereas the Vedic religion was in the hands of a hereditary priestly class, Buddhist and Jain communities welcomed all members of society, a fact that gave them great appeal. The Vedic tradition eventually evolved into the many sects collectively known as Hinduism.

Politically, India has generally been a mosaic of regional dynastic kingdoms, but from time to time, empires emerged that unified large parts of the subcontinent. The first was the Maurya dynasty (c. 322–185 BCE), whose great king Ashoka patronized Buddhism. From this time Buddhist doctrines spread widely and its artistic traditions were established.

In the first century CE the Kushans, a Central Asian people, created an empire extending from present-day Afghanistan down into central India. Buddhism prospered under Kanishka, the most powerful Kushan king, and spread into Central Asia and to East Asia. At this time, under the evolving thought of Mahayana Buddhism, traditions first evolved for depicting the image of the Buddha in art.

Later, under the Gupta dynasty (c. 320–500 CE) in central India, Buddhist art and culture reached their high point. However, Gupta monarchs also patronized the Hindu religion, which from this time grew to become the dominant Indian religious tradition, with its emphasis on the great gods Vishnu (the Creator), Shiva (the Destroyer), and the Goddess—all with multiple forms.

During the long Medieval period, which lasted from about 650 to 1526 CE, numerous regional dynasties prevailed, some quite powerful and long-lasting. During the early part of this period, to roughly 1100, Buddhism continued to decline as a cultural force, while artistic achievement under Hinduism soared. Hindu temples, in particular, developed monumental and complex forms that were rich in symbolism and ritual function, with each region of India producing its own variation.

20-2. *The Bodhisattva Avalokiteshvara*, from Kurkihar, Bihar, Central India. Pala dynasty. Late Medieval period, 12th century. Gilt-bronze, height 10" (25.5 cm). Patna Museum, Patna

20-3. Detail of a leaf with *The Birth of Mahavira*, from the *Kalpa Sutra*. Late Medieval period, western Indian school (probably Gujarat), c. 1375–1400. Gouache on paper, 3⅜ x 3" (8.5 x 7.6 cm). Prince of Wales Museum, Bombay

Avalokiteshvara is shown here in the posture of relaxed ease known as the royal pose. One leg angles down; the other is drawn up onto the lotus seat, itself considered an emblem of spiritual purity. His body bends gracefully, if a bit stiffly, to one side. The chest scarf and lower garment cling to his body, fully revealing its shape. Delicate floral patterns enliven the textiles, and closely set parallel folds provide a wiry, linear tension that contrasts with the hard but silken surfaces of the body. Linear energy continues in the sweep of the tightly pleated hem emerging from under the right thigh, the sinuous lotus stalks on each side, and the fluttering ribbons of the elaborate crown. A profusion of details and varied textures creates an ornate effect—the lavish jewelry, the looped hair piled high and cascading over the shoulders, the ripe blossoms, the rich layers of the lotus seat. Though still friendly and human, the image has become rather formalized. The features of the face, where we instinctively look for a human echo, are treated quite abstractly, and despite its reassuring smile, the statue's expression remains somewhat remote. Through richness of ornament and tension of line, this style expresses the heightened power of a perfected being.

With the fall of the Pala dynasty to Turkic invaders in 1199, the last centers of Buddhism in northern India collapsed, and the monks dispersed, mainly into Nepal and Tibet. From that time, Tibet has remained the principal stronghold of Tantric Buddhist practice and its arts.

The artistic style perfected under the Palas, however, became an influential international style throughout East and Southeast Asia.

Jain Art

The Jain religion traces its roots to a spiritual leader called Mahavira (d. 526 BCE), whom it regards as the final in a series of twenty-four saviors known as pathfinders, or *tirthankaras*. Devotees seek through purification to become worthy of rebirth in the heaven of the pathfinders, a zone of pure existence at the zenith of the universe. Jain monks live a life of austerity, and even laypersons avoid killing any living creature.

As Islamic, or Muslim, territorial control over northern India expanded, non-Islamic religions resorted to more private forms of artistic expression, such as illustrating their sacred texts, rather than public activities, such as building temples. In these circumstances, the Jains of western India, primarily in the region of Gujarat, created many stunningly illustrated manuscripts, such as this *Kalpa Sutra*, which explicates the lives of the pathfinders (fig. 20-3). Produced during the late fourteenth century, it is one of the first Jain manuscripts on paper rather than palm leaf, which had previously been used.

With great economy, the illustration, inserted between blocks of Sanskrit text, depicts the birth of Mahavira. He is shown cradled in his mother's arms as she reclines in her

Years	Period	India	World
c. 1100–1526	**Late Medieval period**	Hinduism, Buddhism, Jainism coexist; Pala dynasty in northeast; Buddhist monastic universities in northeast; Turkic invaders defeat Pala dynasty; Buddhism in India declines; Vijayanagar Hindu kingdom in South India resists Islamic forces; Nayaks' Hindu temple complexes	**c. 1100–1600** Mound-building cultures (North America); Oxford and Cambridge (England) and the University of Paris (France) founded; Kamakura period (Japan); Magna Carta (England); Hundred Years' War between England and France; Black Death in Europe; Ming dynasty (China); Great Schism in Roman Catholic Church (Italy, France); Columbus's voyages (Spain); Protestant Reformation
c. 1526–18th century	**Mughal period**	Babur first Mughal emperor; Rajput kingdoms and schools; *Gita Govinda*; Emperor Akbar; imperial Mughal school workshops; *Hamza-nama*; Emperor Jahangir; Emperor Shah Jahan; Taj Mahal; Mughal Empire unified; British East India Company; Kangra school	**c. 1600–1800** First permanent English colony in North America; Thirty Years' War in Europe; union of England and Scotland as Great Britain; James Watt develops steam engine (Scotland); Declaration of Independence (United States); French Revolution; Napoleon's conquests (France)
c. 18th century–present	**Modern period**	British Empire includes India; New Delhi made capital city; India achieves independence	**c. 1800–c. 1950** Simón Bolívar founds independent Venezuela (South America); Monroe Doctrine (United States); Mexico becomes a republic; Canada united; Italy united; Civil War (United States); Sino-Japanese War; Spanish-American War; Wright brothers make first flight (United States); Einstein's theory of relativity (Germany); World War I; Russian Revolution; League of Nations; Spain becomes a republic; World War II; United Nations established; People's Republic of China founded

bed under a canopy connoting royalty, attended by three ladies-in-waiting. Decorative pavilions and a shrine with peacocks on the roof suggest a luxurious palace setting. Everything appears two-dimensional against the brilliant red or blue ground. Vibrant colors and crisp outlines impart an energy to the painting that suggests the arrival of the divine in the mundane world. Transparent garments with variegated designs reveal the swelling curves of the figures, whose alert postures and gestures convey a sense of the importance and excitement of the event. Strangely exaggerated features, such as the protruding eyes, contribute to the air of the extraordinary. With its angles and tense curves, the drawing is closely linked to the aesthetics of Sanskrit calligraphy, and the effect is as if the words themselves had suddenly flared into color and image.

Hindu Art

During the Early Medieval period Hinduism had become the dominant religious tradition of India. With the increasing popularity of Hindu sects came the rapid development of Hindu temples. Spurred by the ambitious building programs of wealthy rulers, well-formulated regional styles had evolved by about 1000 CE. The most spectacular structures of the era were monumental, with a complexity and grandeur of proportion unequaled even in later Indian art.

During the Late Medieval period this emphasis on monumental individual temples gave way to the building of vast **temple complexes** and more moderately scaled yet more richly ornamented individual temples. These

20-4. Outer *gopura* of the Minakshi-Sundareshvara Temple, Madurai, Tamil Nadu, South India. Nayak dynasty. Late Medieval period, mostly 13th to mid-17th centuries

developments took place largely in the south of India, for temple building in the north virtually ceased with the consolidation of Islamic rule there from the beginning of the thirteenth century. The mightiest of the southern Hindu kingdoms was Vijayanagar (c. 1350–1565), whose rulers successfully countered the southward progress of Islamic forces for more than 200 years. Viewing themselves as defenders and preservers of Hindu faith and culture, Vijayanagar kings lavished donations on sacred shrines. Under the patronage of the Vijayanagar and their successors, the Nayaks, the principal monuments of later Hindu architecture were created.

The enormous temple complex at Madurai, one of the capitals of the Nayaks, is an example of this late, fervent expression of Hindu faith. Founded around the thirteenth century, it is dedicated to the goddess Minakshi (the local name for Parvati, the consort of the god Shiva) and to Sundareshvara (the local name for Shiva himself). The temple complex stands in the center of the city and is the focus of Madurai life. At its heart are the two oldest shrines, one to Minakshi and the other to Sundareshvara. Successive additions over the centuries gradually expanded the complex around these small shrines and came to dominate the visual landscape of the city. The most dramatic features of this and similar "temple cities" of the south were the thousand-pillar halls, large ritual-bathing pools, and especially entrance gateways, called **gopuras**, which tower above the temple site and the surrounding city like modern skyscrapers (fig. 20-4).

Gopuras proliferated as a temple city grew, necessitating new and bigger enclosing walls, and thus new gateways. Successive rulers, often seeking to outdo their predecessors, donated taller and taller *gopuras*. As a result, temple cities often have their tallest structures at the periphery rather than for the central temples, which are sometimes totally overwhelmed. The temple complex at Madurai has eleven *gopuras*, the largest well over 100 feet tall.

Formally, the *gopura* has its roots in the **vimana**, the pyramidal tower characteristic of the seventh-century southern temple style. As the *gopura* evolved, it took on the graceful concave silhouette shown here. The exterior is embellished with thousands of sculpted figures, evoking a teeming world of gods and goddesses. Inside, stairs lead to the top for an extraordinary view.

MUGHAL PERIOD

Islam first touched the South Asian subcontinent in the eighth century, when Arab armies captured a small territory near the Indus River. Later, beginning around 1000, Turkic factions from Central Asia, relatively recent converts to Islam, began military campaigns into North India, at first purely for plunder, then seeking territorial control. From 1206, various Turkic dynasties ruled portions of the subcontinent from the northern city of Delhi. These sultanates, as they are known, constructed forts, mausoleums, monuments, and **mosques**. Although these early dynasties left their mark, it was the Mughal dynasty that made the most inspired and lasting contribution to the art of India.

The Mughals, too, came from Central Asia. Babur (ruled 1494–1530), the first Mughal emperor, empha-

TECHNIQUE

INDIAN PAINTING ON PAPER

Before the fourteenth century most painting in India had been made on walls or palm leaves. With the introduction of paper, techniques were adapted from Persia, and over the ensuing centuries Indian artists produced jewel-toned paintings of surpassing beauty on paper.

Painters usually began their training early. As young apprentices, they learned to make brushes and grind pigments. Brushes were made from the curved hairs of a squirrel's tail, arranged to taper from a thick base to a single hair at the tip. Paint came from mineral and vegetable pigments, ground to a paste with water, then bound with a solution of gum from the acacia plant. Blue was made from lapis lazuli, pale green from malachite. Paper, too, was made by hand. Fibers of cotton and jute were crushed to a pulp, poured onto a woven mat, dried, and then burnished with a smooth piece of agate, often to a glossy finish.

Artists frequently worked from a collection of sketches belonging to a master painter's **atelier**. Sometimes sketches were pricked with small, closely spaced holes and wet color daubed over the holes to transfer the drawing to a blank sheet beneath. The dots were connected into outlines, and the painting began. First, the painter applied a thin **wash** of a chalk-based white, which sealed the surface of the paper while allowing the underlying sketch to show through. Next, outlines were filled with thick washes of brilliant, opaque, unmodulated color. When the colors were dry, the painting was laid face down on a smooth marble surface and burnished with a rounded agate stone, rubbing first up and down, then side to side. The indirect pressure against the marble polished the pigments to a high luster. Then outlines, details, and modeling—depending on the style—were added with a fine brush.

Sometimes certain details were purposely left for last, such as the eyes, which were said to bring the painting to life. Along more practical lines, gold and raised details were applied when the painting was nearly finished. Gold paint, made from pulverized, 24-karat **gold leaf** bound with acacia gum, was applied with a brush and burnished to a high shine. Raised details such as the pearls of a necklace were made with thick, white chalk-based paint, with each pearl a single droplet hardened into a tiny raised mound.

sized his Turkic heritage, though he had equally impressive Mongol ancestry. After some initial conquests in Central Asia, he amassed an empire stretching from Afghanistan to Delhi, which he conquered in 1526. Akbar (ruled 1556–1605), the third ruler, extended Mughal control over most of North India, and under Akbar and his two successors, Jahangir and Shah Jahan, northern India was generally unified as the Mughal Empire by 1658.

Mughal Painting

Probably no one had more control over the solidification of the Mughal Empire and the creation of Mughal art than the emperor Akbar. A dynamic, humane, and just leader, Akbar was an avid enthusiast of religious discourse and the arts, especially painting. He created an imperial **atelier** (workshop) of painters, which he placed under the direction of two artists from the Persian court. Learning from these two masters, the Indian painters of the atelier soon transformed Persian styles into the more vigorous, naturalistic styles that mark the Mughal school (see "Indian Painting on Paper," above).

One of the most famous and extraordinary works produced in Akbar's atelier is an illustrated manuscript of the *Hamza-nama*, a Persian classic about the adventures of Hamza, uncle of the Prophet Muhammad. Painted on cotton cloth, each illustration is more than 2½ feet high. The entire project gathered 1,400 illustrations into twelve volumes and took fifteen years to complete.

One illustration shows Hamza's spies scaling a fortress wall and surprising some men as they sleep (fig. 20-5). One man climbs a rope; another has already beheaded a figure in yellow and lifts his head aloft—realistic details are never avoided in paintings from the Mughal atelier. The receding lines of the architecture,

20-5. Page with *Hamza's Spies Scale the Fortress*, from the *Hamza-nama*, North India. Mughal period, Mughal, reign of Akbar, c. 1567–82. Gouache on cotton, 30 x 24" (76 x 61 cm). Museum of Applied Arts, Vienna

20-6. Abul Hasan and Manohar. Page with *Jahangir in Darbar*, from the *Jahangir-nama*, North India. Mughal period, Mughal, reign of Jahangir, c. 1620. Gouache on paper, 13⅝ x 7⅝" (34.5 x 19.5 cm). Museum of Fine Arts, Boston
Frances Bartlett Donation of 1912 and Picture Fund

20-7. Taj Mahal, Agra, India. Mughal period, Mughal, reign of Shah Jahan, c. 1632-48

Inside, the Taj Mahal evokes the *hasht behisht*, or "eight paradises," a plan named for the eight small chambers that ring the interior—one at each corner and one behind each iwan. In two stories (for a total of sixteen chambers), the rooms ring the octagonal central area, which rises the full two stories to a domed ceiling that is lower than the outer dome. In this central chamber, surrounded by a finely carved octagonal openwork marble screen, are the exquisite inlaid cenotaphs of Shah Jahan and his wife, whose actual tombs lie in the crypt below.

viewed from a slightly elevated vantage point, provide a reasonably three-dimensional setting. Yet the sense of depth is boldly undercut by the richly variegated geometric patterns of the tilework, which are painted as though they had been set flat on the page. Contrasting with the flat geometric patterns are the large human figures, whose rounded forms and softened contours create a convincing sense of volume. The energy exuded by the figures is also characteristic of painting under Akbar—even the sleepers seem active. This robust, naturalistic figure style is quite different from the linear style seen earlier in Jain manuscripts (see fig. 20-3) and even from the Persian styles that inspired Mughal paintings.

Nearly as prominent as the architectural setting with its vivid human adventure is the sensuous landscape in the foreground, where monkeys, foxes, and birds inhabit a grove of trees that shimmer and glow against the darkened background like precious gems. The treatment of the gold-edged leaves at first calls to mind the patterned geometry of tilework, yet a closer look reveals a skillful naturalism born of careful observation. Each tree species is carefully distinguished—by the way its trunk grows, the way its branches twist, the shape and veining of its leaves, the silhouette of its overall form. Pink and blue rocks with lumpy, softly outlined forms add still further interest to this painting, whose every inch is full of intriguing elements.

Painting from the reign of Jahangir (ruled 1605–1627) presents a different tone. Like his father, Jahangir admired painting and, if anything, paid even more attention to his atelier. Indeed, he boasted that he could recognize the hand of each of his artists even in collaborative paintings, which were common. Unlike Akbar, however, Jahangir preferred the courtly life to the adventurous one, and paintings produced for him reflect his subdued and refined tastes and his admiration for realistic detail.

One such painting is *Jahangir in Darbar* (fig. 20-6). The work, probably part of a series on Jahangir's reign, shows the emperor holding an audience, or *darbar*, at court. Jahangir himself is depicted at top center, seated on a balcony under a bright red canopy. Members of his court, including his son, the future emperor Shah Jahan,

stand somewhat stiffly to each side. The audience, too, is divided along the central axis, with figures lined up in profile or three-quarter view. In the foreground, an elephant and a horse complete the symmetrical format.

Jahangir insisted on fidelity in portraiture, including his own in old age. The figures in the audience are a medley of portraits, possibly taken from albums meticulously kept by the court artists. Some represent people known to have died before Jahangir's reign, so the painting may represent a symbolic gathering rather than an actual event. Standing out amid the bright array of garments is the black robe of a Jesuit priest from Europe. Both Akbar and Jahangir were known for their interest in things foreign, and many foreigners flocked to the courts of these open-minded rulers. The scene is formal, the composition static, and the treatment generally two-dimensional. Nevertheless, the sensitively rendered portraits and the fresh colors, with their varied range of pastel tones, provide the aura of a keenly observed, exquisite ideal reality that marks the finest paintings of Jahangir's time.

Mughal Architecture

Mughal architects were heir to a 300-year-old tradition of Islamic building in India. The Delhi sultans who preceded them had great forts housing government and court buildings. They also introduced two fundamental Islamic structures, the mosque and the tomb, along with construction based on the arch and the dome. (Indian architecture had been based primarily on **post-and-lintel construction**.) In turn, they drew freely on Indian architecture, borrowing both decorative and structural elements to create a variety of hybrid styles. They especially benefited from the centuries-old Indian virtuosity in stone carving and masonry. The Mughals followed in this tradition, synthesizing Indian, Persian, and Central Asian elements for their forts, palaces, mosques, tombs, and **cenotaphs** (tombs or monuments to someone whose remains are actually somewhere else). Mughal architectural style culminated in the most famous of all Indian Islamic structures, the Taj Mahal (figs. 20-1 and 20-7).

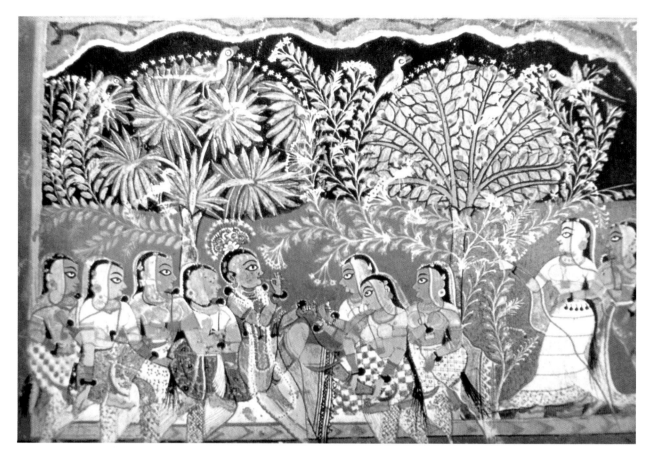

20-8. Page with *Krishna and the Gopis*, from the *Gita Govinda*, Rajasthan, India. Mughal period, Rajput, c. 1525–50. Gouache on paper, 4⅞ x 7½" (12.3 x 19 cm). Prince of Wales Museum, Bombay

The lyrical poem *Gita Govinda*, by the poet-saint Jayadeva, was probably written in eastern India during the latter half of the twelfth century. The episode illustrated here occurs early in the relation of Radha and Krishna, which in the poem is a metaphor for the connection between humans and god. The poem traces the progress of their love through separation, reconciliation, and fulfillment. Intensely sensuous imagery characterizes the entire poem, as in the final song, when Krishna welcomes Radha to his bed (Narayana is the name of Vishnu in his role as cosmic creator):

Leave lotus footprints on my bed of tender shoots, loving Radha!
Let my place be ravaged by your tender feet!
 Narayana is faithful now. Love me Radhika!

I stroke your feet with my lotus hand—you have come far.
Set your golden anklet on my bed like the sun.
 Narayana is faithful now. Love me Radhika!

Consent to my love. Let elixir pour from your face!
To end our separation I bare my chest of the silk that bars your breast.
 Narayana is faithful now. Love me Radhika!

(Translated by Barbara Stoller Miller)

The Taj Mahal is sited on the bank of the Yamuna River at Agra, in northern India. Built between 1632 and 1648, it was commissioned as a **mausoleum** for his wife by the emperor Shah Jahan (ruled 1628–1658), who is believed to have taken a major part in overseeing its design and construction.

Visually, the Taj Mahal never fails to impress (see fig. 20-1). As visitors enter through a monumental, hall-like gate, the tomb looms before them across a spacious garden set with long reflecting pools. Measuring some 1,000 by 1,900 feet, the garden is unobtrusively divided into quadrants planted with trees and flowers and framed by broad walkways and stone inlaid in geometric patterns. In Shah Jahan's time, fruit trees and cypresses—symbolic of life and death, respectively—lined the walkways, and fountains played in the shallow pools. One can imagine

the melodies of court musicians that wafted through the garden. Truly, the senses were beguiled in this earthly evocation of paradise.

Set toward the rear of the garden, the tomb is flanked by two smaller structures not visible here, one a mosque and the other, its mirror image, a resting hall. They share a broad base with the tomb and serve visually as stabilizing elements. Like the entrance hall, they are made mostly of red sandstone, rendering even more startling the full glory of the tomb's white marble. The tomb is raised higher than these structures on its own marble platform. At each corner of the platform, a **minaret**, or slender tower, defines the surrounding space. The minarets' three levels correspond to those of the tomb, creating a bond between them. Crowning each minaret is a *chattri*, or pavilion. Traditional embellishments of Indian palaces, *chattris* quickly passed into the vocabulary of Indian Islamic architecture, where they appear prominently. Minarets occur in architecture throughout the Islamic world; from their heights, the faithful are called to prayer.

A lucid geometric symmetry pervades the tomb. It is basically square, but its **chamfered**, or sliced-off, corners create a subtle octagon. Measured to the base of the **finial** (the spire at the top), the tomb is almost exactly as tall as it is wide. Each facade is identical, with a central **iwan** flanked by two stories of smaller iwans. (A typical feature of eastern Islamic architecture, an iwan is a vaulted opening with an arched portal.) By creating voids in the facades, these iwans contribute markedly to the building's sense of weightlessness. On the roof, four octagonal *chattris*, one at each corner, create a visual transition to the lofty, bulbous dome, the crowning element that lends special power to this structure. Framed but not obscured by the *chattris*, the dome rises more gracefully and is lifted higher by its **drum** than in earlier Mughal tombs, allowing the swelling curves and lyrical lines of its beautifully proportioned, surprisingly large form to emerge with perfect clarity.

The pristine surfaces of the Taj Mahal are embellished with utmost subtlety. The sides of the platform are carved in relief with a **blind arcade** motif, and carved relief panels of flowers adorn the base of the building. The portals are framed with verses from the Koran inlaid in black marble, while the **spandrels** are decorated with floral arabesques inlaid in colored semiprecious stones, a technique known by its Italian name, *pietra dura*. Not strong enough to detract from the overall purity of the white marble, the embellishments enliven the surfaces of this impressive yet delicate masterpiece.

Rajput Painting

Outside of the Mughal strongholds at Delhi and Agra, much of northern India was governed regionally by local Hindu princes, descendants of the so-called Rajput warrior clans, whom the Mughals allowed to keep their lands in return for allegiance. Like the Mughals, Rajput princes frequently supported painters at their courts, and in these settings, free from Mughal influence, a variety of strong, indigenous Indian painting styles were perpetuated.

The Hindu devotional movement known as bhakti, which had done much to spread the faith in the south from around the seventh century, experienced a revival in the north beginning in the Late Medieval period. As it had earlier in the south, bhakti inspired an outpouring of poetic literature, this time devoted especially to Krishna, the popular human incarnation of the god Vishnu. Most renowned is the *Gita Govinda*, a cycle of rhapsodic poems about the love between God and humans expressed metaphorically through the love between the young Krishna and the cowherd Radha.

The illustration here is from a manuscript of the *Gita Govinda* produced in the region of Rajasthan about 1525–1550 (fig. 20-8). The blue god Krishna sits in dalliance with a group of cowherd women. Standing with her maid and consumed with love for Krishna, Radha peers through the trees, overcome by jealousy. Her feelings are indicated by the cool blue color behind her, while the crimson red behind the Krishna grouping suggests passion. The curving stalks and bold patterns of the flowering vines and trees express not only the exuberance of springtime, when the story unfolds, but also the heightened emotional tensions of the scene. Birds, trees, and flowers are brilliant as fireworks against the black, hilly landscape edged in an undulating white line. As in the Jain manuscript earlier (see fig. 20-3), all the figures are of a single type, with plump faces in profile and oversized eyes. Yet the resilient line of the drawing gives them life, and the variety of textile patterns provides some individuality. The intensity and resolute flatness of the scene seem to thrust all of its energy outward, irrevocably engaging the viewer in the drama.

Quite a different mood pervades *Hour of Cowdust*, a work from the Kangra school in the Punjab Hills, foothills of the Himalaya north of Delhi (fig. 20-9). Painted around 1790, some 250 years later than the previous work, it shows the influence of Mughal naturalism on the later schools of Indian painting. The theme is again Krishna. Wearing his peacock crown, garland of flowers, and yellow garment—all traditional iconography of Krishna-Vishnu—he returns to the village with his fellow cowherds and their cattle. All eyes are upon him as he plays his flute, said to enchant all who heard it. Women with water jugs on their heads turn to look; others lean from windows to watch and call out to him. We are drawn into this charming village scene by the diagonal movements of the cows as they surge through the gate and into the courtyard beyond. Pastel houses and walls create a sense of space, and in the distance we glimpse other villagers going about their work or peacefully sitting in their houses. A rim of dark trees softens the horizon, and an atmospheric sky completes the aura of enchanted naturalism. Again, all the figures are similar in type, this time with a perfection of proportion and a gentle, lyrical movement that complements the idealism of the setting. The scene embodies the sublime purity and grace of the divine, which as in so much Indian art is evoked into our human world to coexist with us as one.

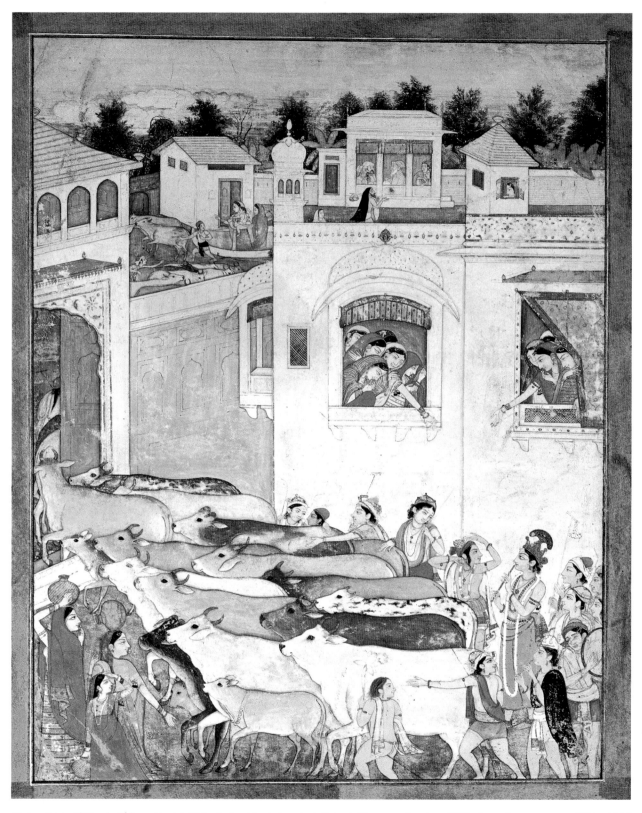

20-9. *Hour of Cowdust*, from Punjab Hills, India. Mughal period, Rajput, Kangra school, c. 1790. Gouache on paper, 10³⁄₄ x 8¹⁄₂"
(27.2 x 21.5 cm). Museum of Fine Arts, Boston
Denman W. Ross Collection

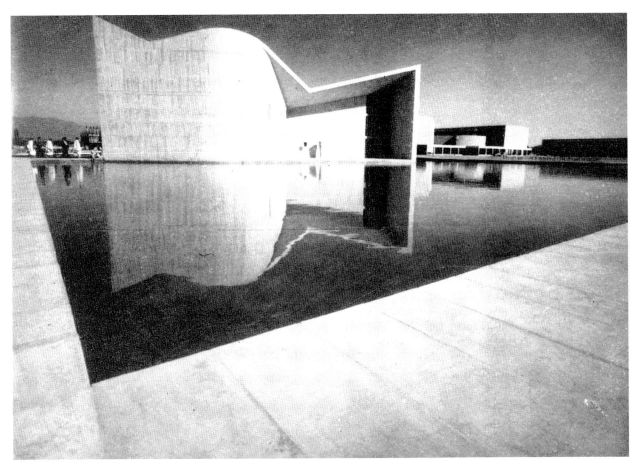

20-10. B. P. Mathur and Pierre Jeanneret. Gandhi Bhavan, Punjab University, Chandigarh, North India. Modern period, 1959–61

MODERN PERIOD

By the time *Hour of Cowdust* was painted, India's regional princes had reasserted themselves, and the vast Mughal Empire had shrunk to a small area around Delhi. At the same time, a new power, Britain, was making itself felt, inaugurating a markedly different period in Indian history. First under the mercantile interests of the British East India Company in the seventeenth century, and then under the direct control of the British government as a part of the British Empire in the eighteenth, India was brought forcefully into contact with the West and its culture.

The political concerns of the British Empire extended even to the arts, especially architecture. Over the course of the nineteenth century, the great cities of India, such as Calcutta, Madras, and Bombay, took on a European aspect as British architects built in the revivalist styles favored in England (Chapter 26). During the late nineteenth and early twentieth centuries, architects made an effort to incorporate Indian, usually Mughal, elements into their work. But the results were superficial or overly fantastic and consisted largely of adding ornamental forms such as *chattris* to fundamentally European buildings. The most telling imperial gesture came in the 1920s with the construction of a new, Western-style capital city at New Delhi.

At the same time that the British were experimenting with Indian aesthetics, Indian artists were infusing into their own work Western styles and techniques. One example of this new synthesis is the Gandhi Bhavan at Punjab University in Chandigarh, in North India (fig. 20-10). Used for both lectures and prayer, the hall was designed in the late 1950s by Indian architect B. P. Mathur in collaboration with Pierre Jeanneret, cousin of the French modernist architect Le Corbusier (Chapter 29), whose version of the International Style had been influential in India. The Gandhi Bhavan's three-part, pinwheel plan, abstract sculptural qualities, and fluid use of planes reflect the modern vision of the International Style. Yet other factors speak directly to India's heritage. The merging of sharp, brusque angles with lyrical curves recalls the linear tensions of the ancient Sanskrit alphabet. The pools surrounding the building evoke Mughal tombs, some of which were similarly laid out on terraces surrounded by water, as well as the ritual-bathing pools of Hindu temples. Yet the abstract style is free of specific religious associations.

The irregular stone structure, its smooth surfaces punctuated by only a few apertures, shimmers in the bright Indian sunlight like an apparition of pure form in our ordinary world. Caught between sky, earth, and water, it fittingly evokes the pulsating qualities of a world seen as imbued with divine essence, the world that has always been at the heart of Indian art.

1280 CE 1400 1500 1600

Ni Zan
The Rongxi Studio
1372

Ming porcelain flask
c. 1425–35

▲ YUAN DYNASTY 1280–1368 ▲ MING DYNASTY 1368–1644

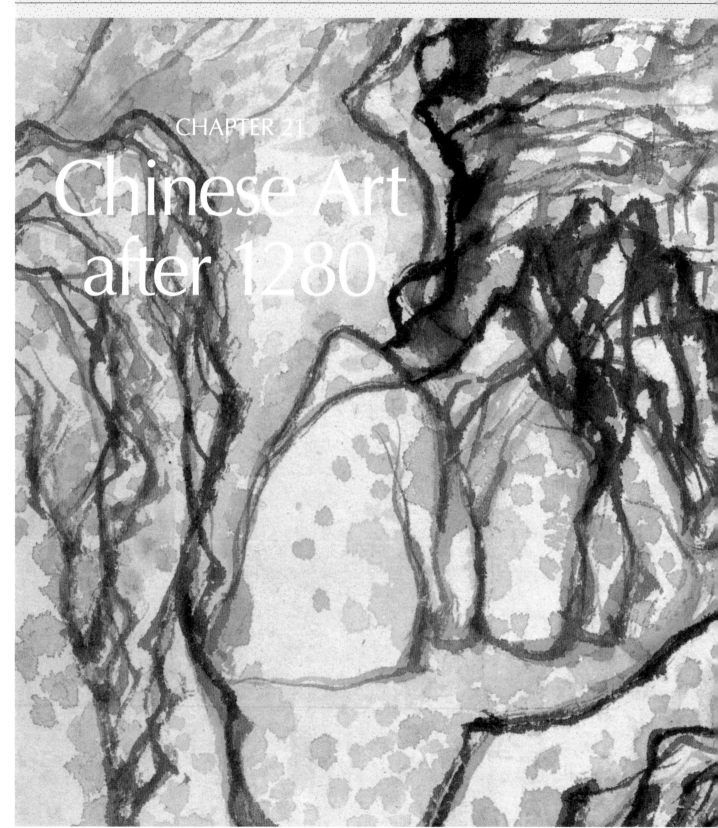

CHAPTER 21

Chinese Art after 1280

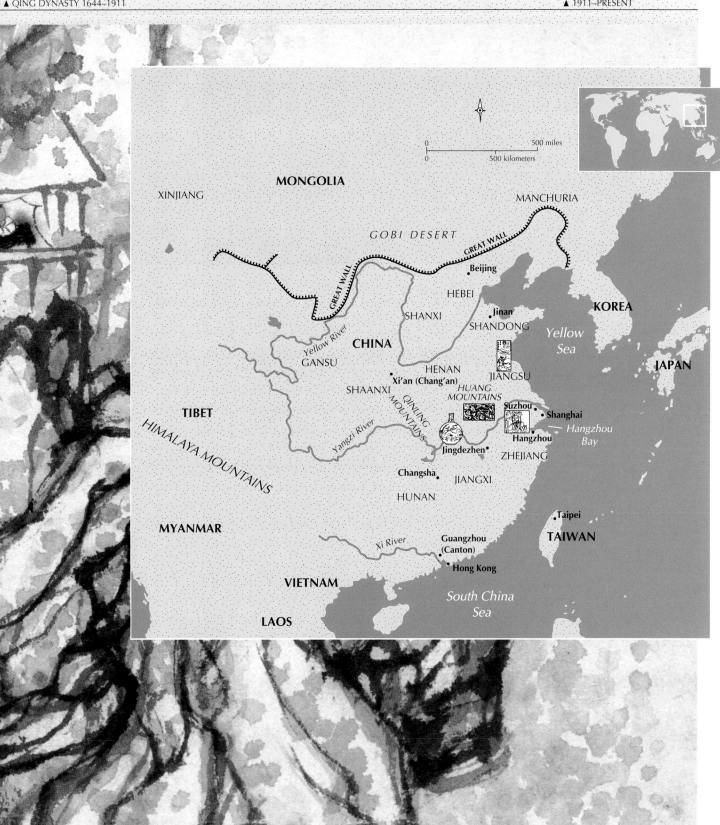

Shitao
Landscape
c. 1700

Wu Guanzhong
Pine Spirit
1984

▲ QING DYNASTY 1644–1911

MODERN PERIOD
▲ 1911–PRESENT

XINJIANG

MONGOLIA

MANCHURIA

GOBI DESERT

GREAT WALL

GREAT WALL

• Beijing

HEBEI

KOREA

SHANXI

• Jinan

SHANDONG

Yellow Sea

Yellow River

CHINA

GANSU

HENAN

JAPAN

• Xi'an (Chang'an)

JIANGSU

HUANG MOUNTAINS

SHAANXI

QINLING MOUNTAINS

Suzhou •

• Shanghai

TIBET

Yangzi River

Jingdezhen •

Hangzhou •

Hangzhou Bay

ZHEJIANG

HIMALAYA MOUNTAINS

Changsha •

JIANGXI

HUNAN

• Taipei

MYANMAR

Xi River

Guangzhou (Canton) •

TAIWAN

VIETNAM

Hong Kong •

South China Sea

LAOS

0 — 500 miles
0 — 500 kilometers

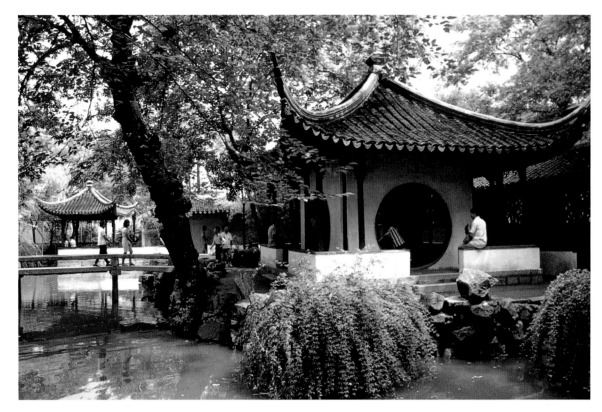

21-1. Garden of the Cessation of Official Life, Suzhou, Jiangsu. Ming dynasty, early 16th century

Early in the sixteenth century, an official in Beijing, frustrated after serving in the capital for many years without promotion, returned to his home near Shanghai. Taking an ancient poem, "The Song of Leisurely Living," for his model, he began to build a garden. He called his retreat the Garden of the Cessation of Official Life (fig. 21-1) to indicate that he had exchanged his career as a bureaucrat for a life of leisure. By leisure, he meant that he could now dedicate himself to calligraphy, poetry, and painting, the three arts dear to scholars in China.

The scholar class of imperial China was a phenomenon unique in the world, the product of an examination system designed to recruit the finest minds in the country for government service. First instituted during the Tang dynasty (618–907), the civil service examinations were excruciatingly difficult, but for the tiny percentage that passed at the highest level, the rewards were prestige, position, power, and wealth. During the Song dynasty (960–1279) the examinations were expanded and regularized, and more than half of all government positions came to be filled by scholars.

Steeped in the classic texts of philosophy, literature, and history, China's scholars—known as literati—shared a common bond in education and outlook. Their lives typically moved between the philosophical poles of Confucianism and Daoism (see "Foundations of Chinese Culture," opposite). Following the former, they became officials to fulfill their obligation to the world; pulled by the latter, they retreated from society in order to come to terms with nature and the universe: to create a garden, to write poetry, to paint.

Under a series of remarkably cultivated emperors, the literati reached the height of their influence during the Song dynasty. Their world was about to change dramatically, however, with lasting results for Chinese art.

FOUNDATIONS OF CHINESE CULTURE

Chinese culture is distinguished by its long and continuous development. Between 7000 and 2000 BCE a variety of Neolithic cultures flourished across China. Through long interaction these cultures became increasingly similar, and they eventually gave rise to the three Bronze Age dynastic states with which Chinese history traditionally begins: the legendary Xia, the Shang (c. 1700–1100 BCE), and the Zhou (1100–221 BCE).

The Shang developed a culture of splendor and violence. Society was stratified, and the ruling group maintained its authority in part by claiming power as shamans, intermediaries between the human and spirit worlds. Shamanistic practices are responsible for the earliest known examples of Chinese writing—bones inscribed with questions to and answers from the spirit world. Under the Zhou a feudal society developed, with nobles related to the king ruling over numerous small states. During the latter part of the Zhou dynasty, states began to vie for supremacy through intrigue and increasingly ruthless warfare. The collapse of social order inspired China's first philosophers, who largely concerned themselves with the pragmatic question of how to bring about a stable society.

In 221 BCE rulers of the state of Qin triumphed over the remaining states, unifying China as an empire for the first time. The Qin created the mechanisms of China's centralized bureaucracy, but their rule was harsh and the dynasty was quickly overthrown. During the ensuing Han dynasty (206 BCE–220 CE), China at last knew peace and prosperity. Confucianism was made the official state ideology, in the process assuming the form and force of a religion. Developed from the thought of Confucius (551–479 BCE), one of the many philosophers of the Zhou, Confucianism is an ethical system for the management of society based on establishing correct relationships among people. Providing a counterweight was Daoism, which also came into its own during the Han dynasty. Based on the thought of Laozi, a possibly legendary contemporary of Confucius, and the philosopher Zhuangzi (369–286 BCE), Daoism is a kind of nature mysticism that seeks to harmonize the individual with the Dao, or Way, of the Universe. Confucianism and Daoism have remained central to Chinese thought—the one addressing the public realm of duty and conformity, the other the private world of individualism and creativity.

Following the collapse of the Han dynasty, China experienced a long period of disunity (220–589 CE). Invaders from the north and west established numerous kingdoms and dynasties, while a series of six precarious Chinese dynasties held sway in the south. Buddhism, which had begun to filter over trade routes from India during the Han dynasty, now spread widely. The period also witnessed the economic and cultural development of the south (all previous dynasties had ruled from the north).

China was reunited under the Sui dynasty (589–618 CE), which quickly overreached itself and fell to the Tang (618–907 CE), one of the most successful dynasties in Chinese history. Strong and confident, Tang China fascinated and, in turn, was fascinated by the cultures around it. Caravans streamed across Central Asia to the capital, Chang'an, then the largest city in the world. Japan and Korea sent thousands of students to study Chinese culture, and Buddhism reached the height of its influence before a period of persecution signaled the start of its decline.

The mood of the Song dynasty (960–1279 CE) was quite different. The martial vigor of the Tang gave way to a culture of increasing refinement and sophistication, and Tang openness to foreign influences was replaced by a conscious cultivation of China's own traditions. In art, landscape painting emerged as the most esteemed genre, capable of expressing both philosophical and personal concerns. With the fall of the north to invaders in 1126, the Song court set up a new capital in the south, which became the cultural and economic center of the country.

THE MONGOL INVASIONS

At the beginning of the thirteenth century the Mongols, a nomadic people from the steppelands north of China, began to amass an empire. Led at first by Jenghiz Khan (c. 1162–1227), then by his sons and grandsons, they swept westward into central Europe and overran Islamic lands from Central Asia through present-day Iraq. To the east, they quickly captured northern China, and in 1279, led by Kublai Khan, they conquered southern China as well. Grandson of the mighty Jenghiz, Kublai proclaimed himself emperor of China and founder of the Yuan dynasty (1280–1368).

The Mongol invasions were traumatic, and their effect on China was long lasting. During the Song dynasty, China had grown increasingly reflective. Rejecting foreign ideas and influences, intellectuals focused on defining the qualities that constituted true "Chineseness." They drew a clear distinction between their own people, whom they characterized as gentle, erudite, and sophisticated, and the "barbarians" outside China's borders, whom they believed to be crude, wild, and uncultured. Now, faced with the reality of barbarian occupation, China's inward gaze intensified in spiritual resistance. For centuries to come, long after the Mongols had gone, leading scholars continued to seek intellectually more challenging, philosophically more profound, and artistically more subtle expressions of all that could be identified as authentically Chinese.

YUAN DYNASTY

The Mongols established their capital in the northern city now known as Beijing. The cultural centers of China, however, remained the great cities of the south, where the Song court had been located for the previous 150 years. Combined with the tensions of Yuan rule, this separation of China's political and cultural centers created a new situation in the arts.

1280

1280 1980

Years	Period	China	World
1280–1368	**Yuan dynasty**	Kublai Khan, emperor of China, founds Yuan dynasty; Marco Polo in China; Zhao Mengfu's *Autumn Colors on the Qiao and Hua Mountains*	**1280–1400** Book arts flourish in France and England; Gothic style emerges (France); Aztec Empire (Mexico); Hundred Years' War between England and France; Black Death in Europe; Great Schism in Christian Church; Golden Pavilion (Japan)
1368–1644	**Ming dynasty**	Ni Zan's *The Rongxi Studio*; Black Death kills 30 percent of Chinese population; Forbidden City rebuilt; Garden of the Cessation of Official Life; Shen Zhou's *Poet on a Mountain Top*; Dong Qichang's *The Qingbian Mountains*	**1400–1700** Chaucer's *Canterbury Tales* (England); Van Eyck's *Ghent Altarpiece* (Flanders); Inka Empire (South America); Ghiberti's *Gates of Paradise* (Italy); Gutenberg's Bible (Germany); Columbus's voyages (Spain); Michelangelo's *David*; Leonardo's *Mona Lisa*; Michelangelo's Sistine Ceiling (Italy); Protestant Reformation in Europe; Mughal period (India); Baroque style in Europe; Peter Paul Rubens (Flanders); Hideyoshi unites Japan; Rembrandt van Rijn (Netherlands); English colonize North America; Age of Enlightenment begins in Europe
1644–1911	**Qing dynasty**	Individualist painters; Wang Hui's *A Thousand Peaks and Myriad Ravines*; Shitao's *Landscape*; Sino-Japanese War	**1700–1900** Union of England and Scotland as Great Britain; John Singleton Copley (North America); Declaration of Independence (North America); French Revolution; Romanticism and Neoclassicism arise; Mexico becomes a republic; Realism arises in Europe; Marx and Engels's *Communist Manifesto*; Darwin's *Origin of Species*; Italy united; Civil War (United States); Dominion of Canada formed; Impressionism and Post-Impressionism arise
1911–present	**Modern period**	First republic established by Sun Yat-Sen (Sun Yixian); People's Republic of China (Communist) established; Wu Guanzhong's *Pine Spirit*	**1900–1950** Fauve painters emerge (France); German Expressionist movement arises; Cubism (France); World War I; Civil War (Russia); League of Nations founded; World War II; United Nations established

Throughout most of Chinese history, the imperial court had set the tone for artistic taste; artisans attached to the court produced architecture, paintings, gardens, and objects of jade, lacquer, ceramic, and silk especially for imperial use. Over the centuries, painters and calligraphers gradually moved higher up the social scale, for these "arts of the brush" were often practiced as well by scholars and even emperors, whose high status reflected positively on whatever interested them. With the establishment of an imperial painting academy during the Song dynasty, painters finally achieved a status equal to that of court officials. For the literati, painting came to be grouped with **calligraphy** and poetry as the trio of accomplishments suited to members of the cultural elite.

21-2. Zhao Mengfu. Section of *Autumn Colors on the Qiao and Hua Mountains*. Yuan dynasty, 1296. Handscroll, ink and color on paper, 11¼ x 36¾" (28.6 x 93.3 cm). National Palace Museum, Taipei, Taiwan

But while the literati elevated the status of painting by virtue of practicing it, they also began to develop their own ideas of what painting should be. Not having to earn an income from their art, they cultivated an amateur ideal in which personal expression counted for more than "mere" professional skill. They created for themselves a status as artists totally separate from and superior to professional painters, whose art they felt was inherently compromised, since it was done to please others, and impure, since it was tainted by money.

The conditions of Yuan rule now encouraged a clear distinction between court taste, ministered to by professional artists and artisans, and literati taste. The Yuan continued the imperial role as patron of the arts, commissioning buildings, murals, gardens, paintings, and decorative arts. Western visitors such as the Italian Marco Polo were impressed by the magnificence of the Yuan court (see "Marco Polo," above). But scholars, profoundly alienated from the new government, took no notice of these accomplishments, and thus nothing was written about them. Nor did Yuan rulers have much use for scholars, especially those from the south. The civil service examinations were abolished, and the highest government positions were bestowed, instead, on Mongols and their foreign allies. Scholars now tended to turn inward, to search for solutions of their own and to try to express themselves in personal and symbolic terms.

Typical of this trend is Zhao Mengfu (1254–1322), a descendant of the imperial line of Song. Unlike many scholars of his time, he eventually chose to serve the Yuan government and was made a high official. A painter, calligrapher, and poet, all of the first rank, Zhao was especially known for his carefully rendered paintings of horses. But he also cultivated another manner, most famous in his landmark painting, *Autumn Colors on the Qiao and Hua Mountains* (fig. 21-2).

Zhao painted this work for a friend whose ancestors came from Jinan, the present-day capital of Shandong province, and the painting supposedly depicts the landscape there. Yet the mountains and trees are not painted in the accomplished naturalism of Zhao's own time but rather in the archaic yet oddly elegant manner of the earlier Tang dynasty. The Tang dynasty was a great era in Chinese history, when the country was both militarily strong and culturally vibrant. Through his painting Zhao evoked a feeling of nostalgia, not only for his friend's distant homeland but also for China's past.

This educated taste for the "spirit of the antiquity" became an important aspect of **literati painting** in later periods. Also typical of literati taste are the unassuming brushwork, the subtle colors sparingly used (many literati paintings forgo color altogether), the use of landscape to convey personal meaning, and even the intended audience—a close friend. The literati did not paint for

TECHNIQUE

FORMATS OF CHINESE PAINTING

Aside from the large wall paintings that typically decorated palaces, temples, and tombs, most Chinese paintings were done in ink and water-based colors on silk or paper. Finished works were generally mounted on silk as a **handscroll**, a **hanging scroll**, or an **album**.

An album comprises a set of paintings of identical size mounted in an accordion-fold book. (A single painting from an album is called an **album leaf**.) The paintings in an album are usually related in subject, such as various views of a famous site or a series of scenes glimpsed on one trip.

Album-size paintings might also be mounted as a handscroll, a horizontal format generally about 12 inches high and anywhere from a few feet to dozens of feet long. More typically, however, a handscroll would be a single continuous painting. Handscrolls were not meant to be displayed all at once, the way they are commonly presented today in museums. Rather, they were unrolled only occasionally, to be savored in much the same spirit as we might put a favorite film in the VCR. Placing the scroll on a flat surface such as a table, a viewer would unroll it a foot or two at a time, moving gradually through the entire scroll from right to left, lingering over favorite details. The scroll was then rolled up and returned to its box until the next viewing.

Like handscrolls, hanging scrolls were not displayed permanently but were taken out for a limited time—a day, a week, a season. Unlike a handscroll, however, the painting on a hanging scroll was viewed as a whole, unrolled and put up on a wall, with the roller at the lower end acting as a weight to help the scroll hang flat. Although some hanging scrolls are quite large, they are still fundamentally intimate works, not intended for display in a public place.

Creating a scroll was a time-consuming and exacting process. The painting was first backed with paper to strengthen it. Next, strips of paper-backed silk were pasted to the top, bottom, and sides, framing the painting on all four sides. Additional silk pieces were added to extend the scroll horizontally or vertically, depending on the format. The assembled scroll was then backed again with paper and fitted with a half-round dowel, or wooden rod, at the top (of a hanging scroll) or right end (of a handscroll), with ribbons for hanging and tying, and with a wooden roller at the other end. Hanging scrolls were often fashioned from several patterns of silk, and a variety of piecing formats were developed and codified. On a handscroll, a painting was generally preceded by a panel giving the work's title and often followed by a long panel bearing **colophons**—inscriptions such as poems in praise of the work or comments by its owners over the centuries.

colophon panel title panel

handscroll

label

front back

hanging scroll

public display but for each other. They favored small formats such as **handscrolls**, **hanging scrolls**, or **album leaves** (book pages), which could easily be taken to show to friends or to share at small gatherings (see "Formats of Chinese Painting," above).

Of the considerable number of Yuan painters who took up Zhao's ideas, several became models for later generations. One such was Ni Zan (1308–1374), whose most famous surviving painting is *The Rongxi Studio* (fig. 21-3). Done entirely in ink, the painting depicts the lake

region in Ni's home district. Mountains, rocks, trees, and a pavilion are sketched with a minimum of detail using a dry brush technique—a technique in which the brush is not fully loaded with ink but rather about to run out, so that white paper "breathes" through the ragged strokes. The result is a painting with a light touch and a sense of simplicity and purity. Literati styles were believed to reflect the painter's personality. Ni's spare, dry style became associated with a noble spirit, and many later painters adopted it or paid homage to it.

Ni Zan was one of those eccentrics whose behavior has become legendary in the history of Chinese art. In his early years he was one of the richest men in the region, the owner of a large estate. His pride and his aloofness from daily affairs often got him into trouble with the authorities. His cleanliness was notorious. In addition to washing himself several times daily, he also ordered his servants to wash the trees in his garden and to clean the furniture after his guests had left. He was said to be so unworldly that late in life he gave away most of his possessions and lived as a hermit in a boat, wandering on rivers and lakes.

Whether these stories are true or not, they were important elements of Ni's legacy to later painters, for Ni's life as well as his art served as a model. The painting of the literati was bound up with certain views about what constituted an appropriate life. The ideal, as embodied by Ni Zan and others, was of a brilliantly gifted scholar whose spirit was too fine-tuned for the "dusty world" of government service and who thus preferred to live as a recluse, or as one who had retired after having become frustrated by a brief stint as an official.

MING DYNASTY

The founder of the next dynasty, the Ming (1368–1644), came from a family of poor uneducated peasants. As he rose through the ranks in the army, he enlisted the help of scholars to gain power and solidify his following. Once he had driven the Mongols from Beijing and firmly established himself as emperor, however, he grew to distrust intellectuals. His rule was despotic, even ruthless. Throughout the nearly 300 years of Ming rule, most emperors shared his attitude, so although the civil service examinations were reinstated, scholars remained alienated from the government they were trained to serve.

21-3. Ni Zan. *The Rongxi Studio.* Yuan dynasty, 1372. Hanging scroll, ink on paper, height 29³⁄₈" (74.6 cm). National Palace Museum, Taipei, Taiwan

The idea that a painting is not done to capture a likeness or to satisfy others but is executed freely and carelessly for the artist's own amusement is at the heart of the literati aesthetic. Ni Zan once wrote this comment on a painting: "What I call painting does not exceed the joy of careless sketching with a brush. I do not seek formal likeness but do it simply for my own amusement. Recently I was rambling about and came to a town. The people asked for my pictures, but wanted them exactly according to their own desires and to represent a specific occasion. [When I could not satisfy them,] they went away insulting, scolding, and cursing in every possible way. What a shame! But how can one scold a eunuch for not growing a beard?" (cited in Bush and Shih, page 266).

Court and Professional Painting

The contrast between the luxurious world of the court and the austere ideals of the literati continued through the Ming dynasty. A typical example of Ming court taste is *Hundreds of Birds Admiring the Peacocks*, a large painting on silk by Yin Hong, an artist active during the late fifteenth and early sixteenth centuries (fig. 21-4). A pupil of some well-known courtiers, Yin most probably served in the court at Beijing. The painting is an example of the birds-and-flowers **genre**, which had been popular with artists of the Song academy. Here the subject takes on symbolic meaning, with the homage of the birds to the peacocks representing the homage of court officials to

21-4. Yin Hong. *Hundreds of Birds Admiring the Peacocks*. Ming dynasty, c. late 15th–early 16th centuries. Hanging scroll, ink and color on silk, 7'10½" x 6'5" (2.4 x 1.96 m). The Cleveland Museum of Art
Purchase from the J. H. Wade Fund, 74.31

the emperor. The decorative style goes back to Song academy models as well, although the large format and multiplication of details are traits of the Ming.

The preeminent professional painter in the Ming period was Qiu Ying (1494–1552), who lived in Suzhou, a prosperous southern city. He inspired generations of imitators with exceptional works, such as a long handscroll known as *Spring Dawn in the Han Palace* (fig. 21-5). The painting is based on Tang dynasty depictions of women in the court of the Han dynasty (206 BCE–220 CE). While in the service of a well-known collector, Qiu Ying had the opportunity to study many Tang paintings, whose artists usually concentrated on the figures, leaving out the background entirely. Qiu's graceful and elegant figures—

although modeled after those in Tang works—are portrayed in a setting of palace buildings, engaging in such pastimes as chess, music, calligraphy, and painting. With its antique subject matter, refined technique, and flawless taste in color and composition, *Spring Dawn in the Han Palace* brought professional painting to a new high point.

Gardens and Decorative Arts

Qiu Ying painted to satisfy his patrons in Suzhou. The cities of the south were becoming wealthy, and newly rich merchants collected paintings, antiques, and art objects. The court, too, was prosperous and patronized the arts on a lavish scale. In such a setting, the decorative arts thrived.

21-5. Qiu Ying. Section of *Spring Dawn in the Han Palace*. Ming dynasty, first half of the 16th century. Handscroll, ink and color on silk, 1' x 18'¹³⁄₁₆" (0.30 x 5.7 m). National Palace Museum, Taipei, Taiwan

21-6. Porcelain flask with decoration in blue underglaze. Ming dynasty, c. 1425–35. Palace Museum, Beijing

Dragons have featured prominently in Chinese folklore from earliest times—Neolithic examples have been found painted on pottery and carved in jade. In Bronze Age China, dragons came to be associated with powerful and sudden manifestations of nature, such as wind, thunder, and lightning. Bronze Age shamans appealed to dragons to learn the weather. At the same time, dragons also became associated with superior beings such as virtuous rulers and sages. With the emergence of China's first firmly established empire during the Han dynasty, the dragon was appropriated as an imperial symbol, and it remained so throughout Chinese history. Dragon sightings were duly recorded and considered auspicious. Yet even the Son of Heaven could not monopolize the dragon. During the Tang and Song dynasties the practice arose of painting pictures of dragons to pray for rain, and for Chan (Zen) Buddhists, the dragon was a symbol of sudden enlightenment.

Like the Song dynasty before it, the Ming has become famous the world over for its exquisite ceramics, especially **porcelain** (see "The Secret of Porcelain," below). The imperial **kilns** in Jingdezhen, in Jiangxi province, became the most renowned center for porcelain not only in all of China but eventually in all the world. Particularly noteworthy are the blue-and-white wares produced there during the ten-year reign of the ruler known as the Xuande emperor (ruled 1425–1435), such as the flask in figure 21-6. The subtle shape, the refined yet vigorous decoration of dragons writhing in the sea, and the flawless **glazing** embody the high achievement of Ming artisans.

Chinese furniture, made mainly for domestic use, reached the height of its development in the sixteenth

THE SECRET OF PORCELAIN Marco Polo, it is said, was the one who named a new type of ceramic he found in China. Its translucent purity reminded him of the smooth whiteness of the cowry shell, *porcellana* in Italian. **Porcelain** is made from kaolin, an extremely refined white clay, and petuntse, a variety of the rock-mineral feldspar. When properly combined and fired at a sufficiently high temperature, the two materials fuse into a glasslike, translucent ceramic that is far stronger than it looks.

Porcelaneous stoneware, fired at lower temperatures, was known in China by the seventh century, but true porcelain emerged during the Song dynasty. To create blue-and-white porcelain such as the flask in figure 21-6, blue pigment was made from cobalt oxide, finely ground and mixed with water. The decoration was painted directly onto the unfired porcelain vessel, then a layer of white glaze was applied over it. (In this technique, known as **underglaze**, the decoration is painted beneath the glaze.) After firing, the piece emerged from the kiln with a clear blue design set sharply against a snowy white background.

Entranced with the exquisite properties of porcelain, European potters tried for centuries to duplicate it. The technique was finally discovered in 1708 by Johann Friedrich Böttger in Dresden, Germany, who tried—but failed—to keep it a secret.

21-7. Armchair. Ming dynasty, l6th–17th century. Huanghuali wood (rosewood), 39³/₈ x 27¹/₄ x 20" (100 x 69.2 x 50.8 cm). The Nelson-Atkins Museum of Art, Kansas City, Missouri

and seventeenth centuries. Characteristic of Chinese furniture, the chair in figure 21-7 is constructed without the use of glue or nails. Instead, pieces fit together based on the principle of the **mortise-and-tenon joint**, in which a projecting element (tenon) on one piece fits snugly into a cavity (mortise) on another. Each piece of the chair is carved, as opposed to being bent or twisted, and the joints are crafted with great precision. The patterns of the wood grain provide subtle interest unmarred by any painting or other embellishment. The style, like that of Chinese architecture, is one of simplicity, clarity, symmetry, and balance. The effect is formal and dignified but natural and simple—virtues central to the Chinese view of proper human conduct as well.

The art of landscape gardening also reached a high point during the Ming dynasty, as many literati surrounded their homes with gardens. The most famous gardens were created in the southern cities of the Yangzi River (Chang Jiang) delta, especially Suzhou. The largest surviving garden of the era is the Garden of the Cessation of Official Life, with which this chapter opened (see fig. 21-1). Although modified and reconstructed many times through the centuries, it still reflects many of the basic ideas of the original Ming owner. About a third of the 3-acre garden is devoted to water through artificially created brooks and ponds. The landscape is dotted with pavilions, kiosks, libraries, studios, and corridors. Many of the buildings have poetic names, such as Rain Listening Pavilion and Covered Bridge of Small Flying Rainbow.

21-8. The Forbidden City, now the Palace Museum, Beijing. Mostly Ming dynasty. View from the southwest

GEOMANCY, COSMOLOGY, AND CHINESE ARCHITECTURE

Geomancy is a form of divination that looks for signs in the topography of the earth. In China it has been known from ancient times as *feng shui*, or "wind and water." Still practiced today, *feng shui* assesses *qi*, the primal energy that is believed to flow through creation, to determine whether a site is suitably auspicious for building. *Feng shui* also advises on improving a site's *qi* through landscaping, planting, creating waterways, and building temples and pagodas.

One important task of *feng shui* in the past was selecting auspicious sites for imperial tombs. These were traditionally set in a landscape of hills and winding paths, protected from harmful spiritual forces by a hill to the rear and a winding waterway crossed by arched bridges in front. *Feng shui* was also called on to find and enhance sites for homes, towns, and, especially, imperial cities. The Forbidden City, for example, is "protected" by a hill outside the north wall and a bow-shaped watercourse just inside the entrance.

The layout of imperial buildings was as important as their site and reflected ancient principles of cosmology—ideas about the structure and workings of the universe. Since the Zhou dynasty (1100–221 BCE) the emperor had ruled as the Son of Heaven. If he was worthy and right-acting, it was believed, then all would go well in nature and the cosmos. But if he was not, cosmic signs, natural disasters, and human rebellions would make it clear that Heaven had withdrawn his dynasty's mandate to rule—traditional histories explained the downfall of a dynasty in just these terms.

Architecture played a major role in expressing this link between imperial and cosmic order. As early as Zhou times, cities were oriented on a north-south axis and built as a collection of enclosures surrounded by a defensive wall. The first imperial city of which we have any substantial knowledge, however, is Chang'an, the capital of the Tang (Tang dynasty, 618–907 CE). Chang'an was a walled city laid out on a rectangular grid measuring 5 miles by 6 miles. At the north end was an imperial enclosure. The palace within faced south, symbolic of the emperor looking out over his city and, by extension, his realm. This orientation was already traditional by Tang times. Chinese rulers—and Chinese buildings—had always turned their backs to the north, from whence came evil spirits. Confucius even framed his admiration for one early Zhou ruler by saying that all he needed to do to govern was to assume a respectful position and face south, so attuned was he to Heaven's way.

A complex of government buildings stood in front of the imperial compound, and from them a 500-foot-wide avenue led to the city's principal southern gate. The city streets ran north-south and east-west. Each of the resulting 108 blocks was like a miniature city, with its own interior streets, surrounding walls, and gates that were locked at night. Two large markets to the east and west were open at specified hours. Such was the prestige of China during the Tang dynasty that the Japanese modeled their imperial capitals at Nara (built in 710 CE) and Heian (Kyoto, built in 794 CE) on Chang'an, though without the surrounding walls.

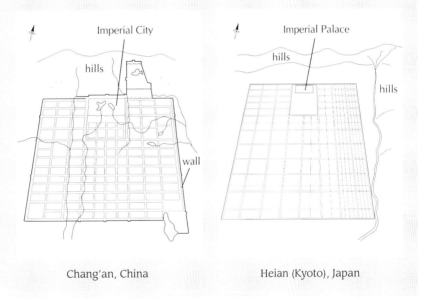

Chang'an, China

Heian (Kyoto), Japan

Architecture and City Planning

Centuries of warfare and destruction have left very few Chinese architectural monuments intact. The most important remaining example of traditional Chinese architecture is the Forbidden City, the imperial palace compound in Beijing, whose principal buildings were constructed during the Ming dynasty (fig. 21-8).

The basic plan of Beijing was the work of the Mongols, who laid out their capital city according to traditional Chinese principles. City planning began in China in the early seventh century with Chang'an (present-day Xi'an), the capital of the Sui and Tang emperors (see "Geomancy, Cosmology, and Chinese Architecture," above). The walled city of Chang'an was laid out on a rectangular grid, with even-ly spaced streets that ran north-south and east-west. At the northern end stood a walled imperial complex.

Beijing, too, was developed as a walled, rectangular city with streets laid out in a grid. The palace enclosure occupied the center of the northern part of the city, which was reserved for the Mongols. Chinese lived in the southern third of the city. Later Ming and Qing emperors preserved this division, with officials living in the northern or Inner City, and commoners living in the southern or Outer City. Under the third Ming emperor, Yongle (ruled 1402–1424), the Forbidden City was rebuilt as we see it today.

The approach to the Forbidden City was impressive, and it was meant to be. Visitors entered through the Meridian Gate, a monumental **U**-shaped gate (at the right in fig. 21-8). Inside the Meridian Gate a broad courtyard is crossed

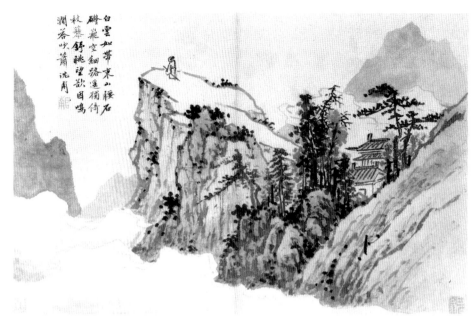

21-9. Shen Zhou. *Poet on a Mountain Top*, leaf from an album of landscapes; painting mounted as part of a handscroll, Ming dynasty, c. 1500. Ink and color on paper, 15¼ x 23¾" (38.1 x 60.2 cm). The Nelson-Atkins Museum of Art, Kansas City, Missouri

Purchase, Nelson Trust (46-51/2)

The poem at the upper left reads:

> White clouds like a belt encircle the mountain's waist
> A stone ledge flying in space and the far thin road.
> I lean alone on my bramble staff and gazing contented into space
> Wish the sounding torrent would answer to your flute.
> (Translated by Richard Edwards, cited in *Eight Dynasties
> of Chinese Paintings*, page 185)

The style of the calligraphy, like the style of the painting, is informal, relaxed, and straightforward—qualities that were believed to reflect the artist's character and personality.

by a bow-shaped waterway that is spanned by five arched marble bridges. At the opposite end of the courtyard is the Gate of Supreme Harmony, opening onto an even larger courtyard that houses three ceremonial halls raised on a broad platform. First is the Hall of Supreme Harmony, where, on the most important state occasions, the emperor was seated on his throne, facing south. Beyond is the smaller Hall of Central Harmony, then the Hall of Protecting Harmony. Behind these vast ceremonial spaces, still on the central axis, is the inner court, again with a progression of three buildings, this time more intimate in scale. In its balance and symmetry the plan of the Forbidden City reflects ancient Chinese beliefs about the harmony of the universe, and it emphasizes the emperor's role as the Son of Heaven, whose duty was to maintain the cosmic order from his throne in the middle of the world.

Literati Painting

In the south, especially in the district of Suzhou, literati painting remained the dominant trend. One of the major literati figures from the Ming period is Shen Zhou (1427–1509), who had no desire to enter government service but spent most of his life in Suzhou. He studied the Yuan painters avidly and tried to recapture their spirit in such works as *Poet on a Mountain Top* (fig. 21-9). Although the style of the painting recalls the freedom and simplicity of Ni Zan (see fig. 21-3), the motif of a poet surveying the landscape from a mountain plateau is Shen's creation.

In earlier landscape paintings, human figures were typically shown dwarfed by the grandeur of nature. Travelers might be seen scuttling along a narrow path by a stream, while overhead towered mountains whose peaks conversed with the clouds and whose heights were inaccessible. Here, the poet has climbed the mountain and dominates the landscape. Even the clouds are beneath him. Before his gaze, a poem hangs in the air, as though he were projecting his thoughts. The painting reflects Ming philosophy, which held that the mind, not the physical world, was the basis for reality. With its perfect synthesis of poetry, calligraphy, and painting, and its harmony of mind and landscape, *Poet on a Mountain Top* represents the very essence of literati painting.

The ideas underlying literati painting found their

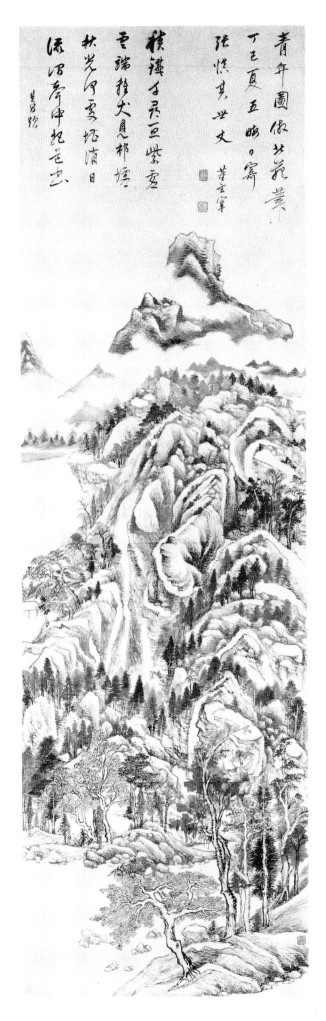

most influential expression in the writings of Dong Qichang (1555–1636). A high official in the late Ming dynasty, Dong Qichang embodied the literati tradition as poet, calligrapher, and painter. He developed a view of Chinese art history that divided painters into two opposing schools, northern and southern. The names have nothing to do with geography—a painter from the south might well be classed as northern—but reflect a parallel Dong drew to the northern and southern schools of Chan (Zen) Buddhism in China. The southern school of Chan, founded by the eccentric monk Huineng (638–713), was unorthodox, radical, and innovative; the northern school was traditional and conservative. Similarly, Dong's two schools of painters represented progressive and conservative traditions. In Dong's view the conservative northern school was dominated by professional painters whose academic, often decorative style emphasized technical skill. In contrast, the progressive southern school preferred ink to color and free brushwork to meticulous detail. Its painters aimed for poetry and personal expression. In promoting this theory, Dong gave his unlimited sanction to literati painting, which he positioned as the culmination of the southern school, and he fundamentally influenced the way the Chinese viewed their own tradition.

Dong Qichang summarized his views on the proper training for literati painters in the famous statement "Read ten thousand books and walk ten thousand miles." By this he meant that one must first study the works of the great masters, then follow "heaven and earth," the world of nature. These studies prepared the way for a transformation to self-expression through brush and ink, the goal of literati painting. Dong's views rested on an awareness that a painting of scenery and the actual scenery are two very different things. The excellence of a painting does not lie in its degree of resemblance to reality—that gap can never be bridged—but in its expressive power. The expressive language of painting is inherently abstract and lies in its nature as a construction of brushstrokes. For example, in a painting of a rock, the rock itself is not expressive; rather, the brushstrokes that add up to "rock" are expressive.

With such thinking Dong brought painting close to the realm of calligraphy, which had long been considered the highest form of artistic expression in China. More than a thousand years before Dong's time, a body of critical terms and theories had evolved to discuss calligraphy in light of the formal and expressive properties of brushwork and composition. Dong introduced some of these terms—ideas such as opening and closing, rising and falling, and void and solid—to the criticism of painting.

Dong's theories are fully embodied in his painting *The Qingbian Mountains* (fig. 21-10). According to Dong's

21-10. Dong Qichang. *The Qingbian Mountains.* Ming dynasty, 1617. Hanging scroll, ink on paper, 21'8" x 7'4³/₈" (6.72 x 2.25 m). The Cleveland Museum of Art
Leonard C. Hanna, Jr., Bequest, 80.10

own inscription, the painting was based on a work by the tenth-century artist Dong Yuan. Dong Qichang's style, however, is quite different from the masters he admired. Although there is some indication of foreground, middle ground, and distant mountains, the space is ambiguous, as if all the elements were compressed to the surface of the picture. With this flattening of space, the trees, rocks, and mountains become more readily legible in a second way, as semiabstract forms made of brushstrokes.

Six trees diagonally arranged on a boulder define the extreme foreground and announce themes that the rest of the painting repeats, varies, and develops. The tree on the left, with its outstretched branches and full foliage, is echoed first in the shape of another tree just across the river and again in a tree farther up and toward the left. The tallest tree of the foreground grouping anticipates the high peak that towers in the distance almost directly above it. The forms of the smaller foreground trees, especially the one with dark leaves, are repeated in numerous variations across the painting. At the same time, the simple and ordinary-looking boulder in the foreground is transformed in the conglomeration of rocks, ridges, hills, and mountains above. This double reading, both abstract and representational, parallels the work's double nature as a painting of a landscape and an interpretation of a traditional landscape painting.

The influence of Dong Qichang on the development of Chinese painting of later periods cannot be overstated. Indeed, nearly all Chinese painters since the early seventeenth century have reflected his ideas in one way or another.

QING DYNASTY

In 1644, when the armies of the Manchu people to the northeast of China marched into Beijing, many Chinese reacted as though the world had come to an end. However, the situation turned out to be quite different from the Mongol invasions three centuries earlier. The Manchu had already adopted many Chinese customs and institutions before their conquest. After gaining control of all of China, they showed great respect for Chinese tradition. In art, all the major trends of the late Ming dynasty continued almost without interruption into the Manchu, or Qing, dynasty (1644–1911).

Orthodox Painting

Literati painting was by now established as the dominant tradition; it had become orthodox. Scholars followed Dong Qichang's recommendation and based their approach on the study of past masters, and they painted large numbers of works in the manner of Song and Yuan artists as a way of expressing their learning, technique, and taste.

The grand, symphonic composition *A Thousand Peaks and Myriad Ravines* (fig. 21-11), painted by Wang Hui (1632–1717) in 1693, exemplifies all the basic elements of Chinese landscape painting: mountains, rivers,

waterfalls, trees, rocks, temples, pavilions, houses, bridges, boats, wandering scholars, fishers—the familiar and much loved cast of actors from a tradition now many centuries old. At the upper right corner, the artist has written:

> Moss and weeds cover the rocks and mist hovers
> over the water.
> The sound of dripping water is heard in front of the
> temple gate.
> Through a thousand peaks and myriad ravines the
> spring flows,
> And brings the flying flowers into the sacred caves.

> In the fourth month of the year 1693, in a hotel in the capital, I painted this based on a Tang dynasty poem in the manner of [the painters] Dong [Yuan] and Ju [ran].

> (Translated by Chu-tsing Li)

This inscription shares Wang Hui's complex thoughts as he painted this work. In his mind were both the lines of the Tang dynasty poet Li Cheng, which offered the subject, and the paintings of the tenth-century masters Dong Yuan and Juran, which inspired his style. The temple the poem asks us to imagine is nestled on the right bank in the middle distance, but the painting shows us the scene from afar, as when a film camera pulls slowly away from some small human drama until its actors can barely be distinguished from the great flow of nature. Giving viewers the experience of dissolving their individual identity in the cosmic flow had been a goal of Chinese landscape painting since its first era of greatness during the Song dynasty.

All the Qing emperors of the late seventeenth and eighteenth centuries were painters themselves. They collected literati painting, and their conservative taste was shaped mainly by artists such as Wang Hui. Thus literati painting became an academic style and ended up within the court after all.

Individualists

In the long run, the Manchu conquest was not a great shock for China as a whole. But its first few decades were both traumatic and dangerous for those who were loyal—or worse, related—to the Ming. Some committed suicide, while others sought refuge in monasteries or wandered the countryside. Among them were several painters who expressed their anger, defiance, frustration, and melancholy in their art. They took Dong Qichang's idea of painting as an expression of the artist's personal feelings very seriously and cultivated highly original styles. These painters have become known as the individualists.

One of the individualists was Shitao (1642–1707), a descendant of the first Ming emperor who took refuge in Buddhist temples when the dynasty fell. In his later life he brought his painting to the brink of abstraction in such

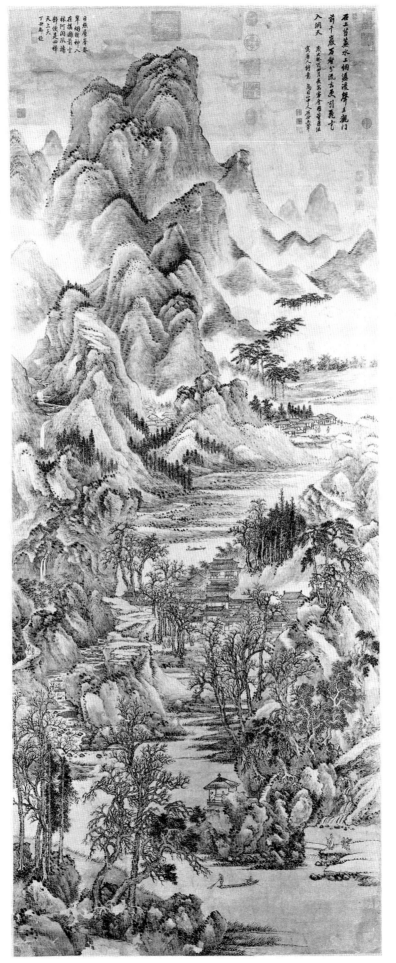

21-11. Wang Hui. *A Thousand Peaks and Myriad Ravines.* Qing dynasty, 1693. Hanging scroll, ink on paper, 8'2¹/₂" x 3'4¹/₂" (2.54 x 1.03 m). National Palace Museum, Taipei, Taiwan

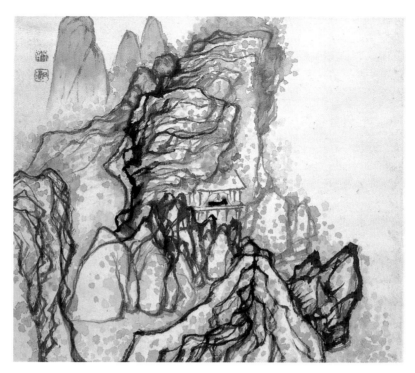

21-12. Shitao. *Landscape*, leaf from an album of landscapes. Qing dynasty, c. 1700. Ink and color on paper, 9¹/₂ x 11" (24.1 x 28 cm)
Collection C. C. Wang family

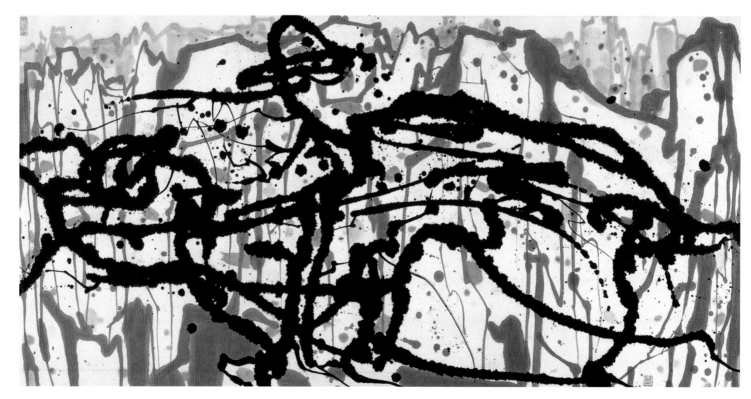

21-13. Wu Guanzhong. *Pine Spirit*. 1984. Ink and color on paper, 2'3⁵/₈" x 5'3¹/₂" (0.70 x 1.40 m). Spencer Museum of Art, University of Kansas, Lawrence
Gift of the E. Rhodes and Leonard B. Carpenter Foundation

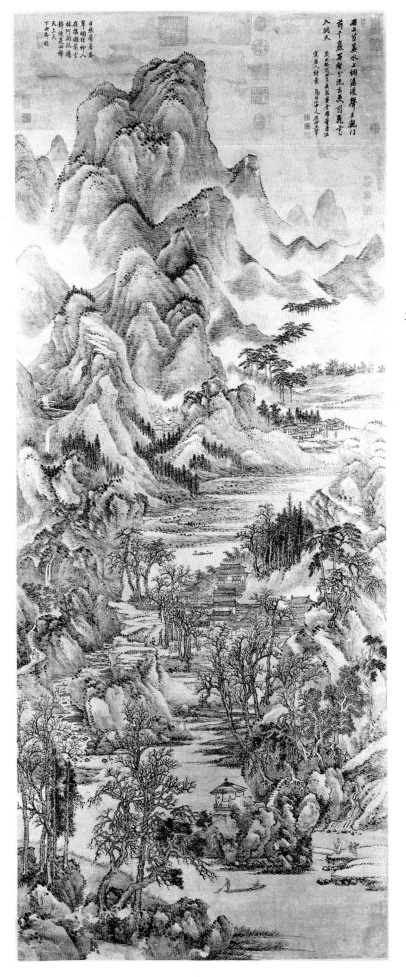

21-11. Wang Hui. *A Thousand Peaks and Myriad Ravines.* Qing dynasty, 1693. Hanging scroll, ink on paper, 8'2¹/₂" x 3'4¹/₂" (2.54 x 1.03 m). National Palace Museum, Taipei, Taiwan

CHINESE ART AFTER 1280

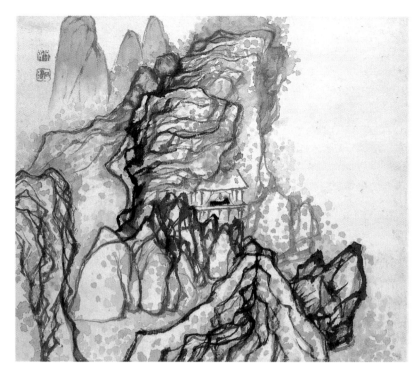

21-12. Shitao. *Landscape*, leaf from an album of landscapes. Qing dynasty,
c. 1700. Ink and color on paper, 9½ x 11" (24.1 x 28 cm)
Collection C. C. Wang family

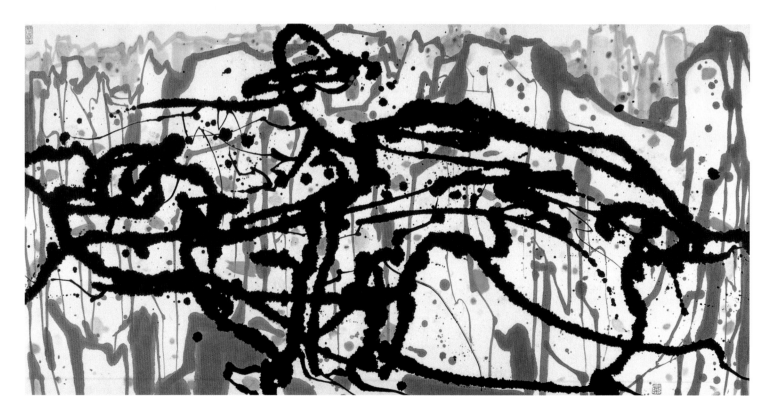

21-13. Wu Guanzhong. *Pine Spirit*. 1984. Ink and color on paper, 2'3⅝" x 5'3½" (0.70 x 1.40 m). Spencer Museum of Art,
University of Kansas, Lawrence
Gift of the E. Rhodes and Leonard B. Carpenter Foundation

works as *Landscape* (fig. 21-12). A monk sits in a small hut, looking out onto mountains that seem to be in turmoil. Dots, used for centuries to indicate vegetation on rocks, here seem to have taken on a life of their own. The rocks also seem alive—about to swallow up the monk and his hut. Throughout his life Shitao continued to identify himself with the fallen Ming, and he felt that his secure world had turned to chaos with the Manchu conquest.

THE MODERN PERIOD

In the mid- and late nineteenth century China was shaken from centuries of complacency by a series of crushing military defeats by Western powers and Japan. Only then did the government finally realize that these new rivals were not like the Mongols of the thirteenth century. China was no longer at the center of the world, a civilized country surrounded by "barbarians." Spiritual resistance was no longer enough to solve the problems brought on by change. New ideas from Japan and the West began to filter in, and the demand arose for political and cultural reforms. In 1911 the Qing dynasty was overthrown, ending 2,000 years of imperial rule, and China was reconceived as a republic.

During the first decades of the twentieth century Chinese artists traveled to Japan and Europe to study Western art. Returning to China, many sought to introduce the ideas and techniques they had learned and explored ways to synthesize the Chinese and the Western traditions. After the establishment of the present-day Communist government in 1949, individual artistic freedom was curtailed as the arts were pressed into the service of the state and its vision of a new social order. After 1979, however, cultural attitudes began to relax, and Chinese painters again pursued their own paths.

One artist who emerged during the 1980s as a leader in Chinese painting is Wu Guanzhong (b. 1919). Combining his French artistic training and Chinese background, Wu Guanzhong has developed a semiabstract style to depict scenes from the Chinese landscape. His usual method is to make preliminary sketches on site, then, back in his studio, to develop them into free interpretations based on his feeling and vision. An example of his work, *Pine Spirit*, depicts a scene in the Huang (Yellow) Mountains (fig. 21-13). The technique, with its sweeping gestures of paint, is clearly linked to Abstract Expressionism, an influential Western movement of the post–World War II years (Chapter 29); yet the painting also claims a place in the long tradition of Chinese landscape as exemplified by such masters as Shitao.

Like all aspects of Chinese society, Chinese art has felt the strong impact of Western influence, and the question remains whether Chinese artists will absorb Western ideas without losing their traditional identity. Interestingly, landscape remains the most popular subject, as it has been for more than a thousand years. Using the techniques and methods of the West, China's painters still seek spiritual communion with nature through their art as a means to come to terms with human life and the world.

1400 CE

1500

1600

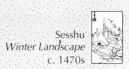

Sesshu
Winter Landscape
c. 1470s

Himeji Castle
1601–9

MOMOYAMA PERIOD
▲ 1568–1603

▲ MUROMACHI PERIOD 1392–1568

▲ EDO PERIOD 1603–1853

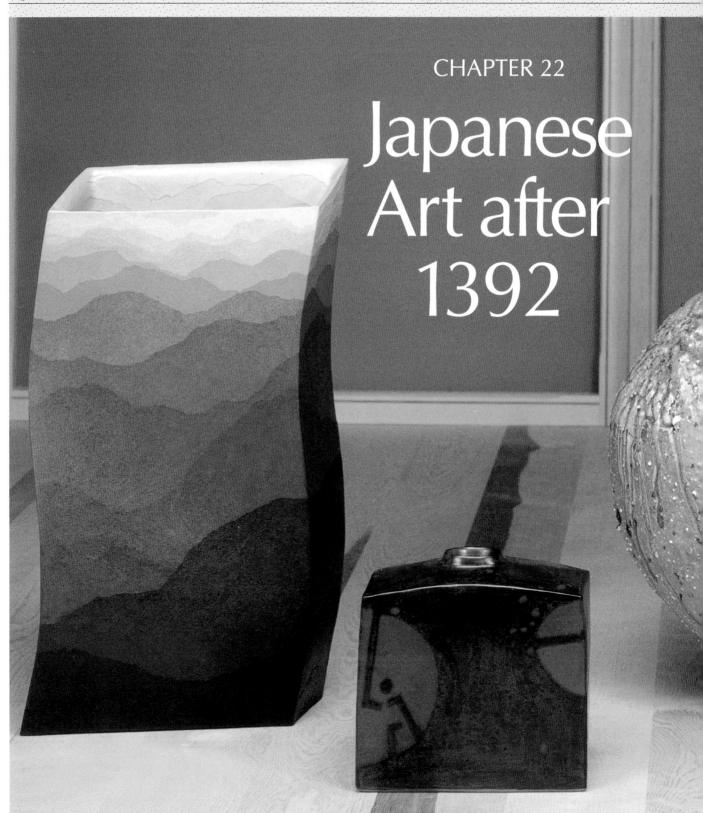

CHAPTER 22

Japanese Art after 1392

Hakuin
Bodhidharma Meditating
18th century

Fujii
Untitled '90
1990

▲ MEIJI AND MODERN PERIODS 1853–PRESENT

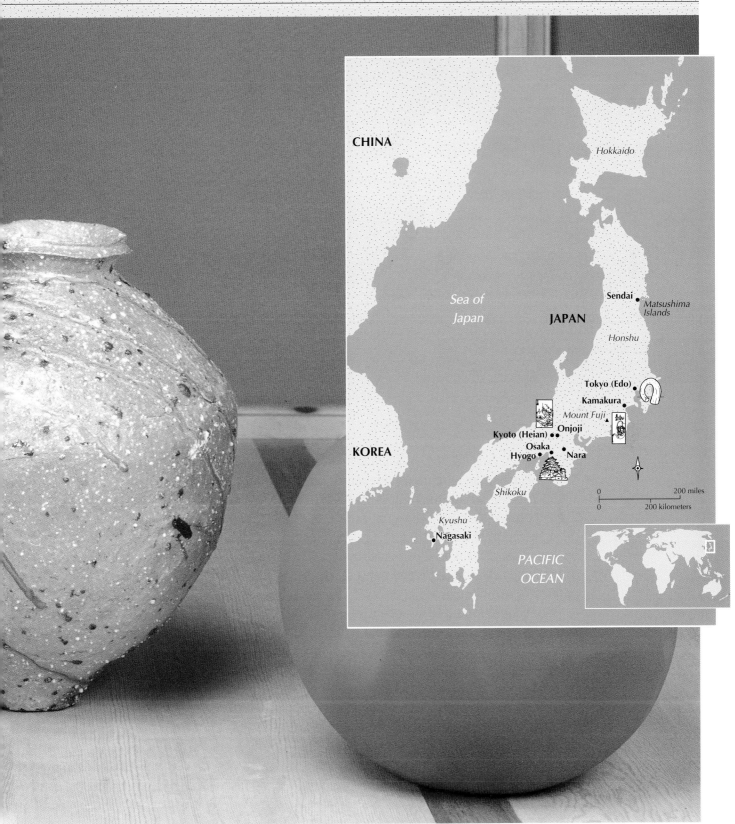

CHINA

Hokkaido

*Sea of
Japan*

JAPAN

Sendai
*Matsushima
Islands*

Honshu

Tokyo (Edo)

Kamakura

Mount Fuji ▲

KOREA

Kyoto (Heian) Onjoji

Osaka

Hyogo Nara

Shikoku

Kyushu

Nagasaki

PACIFIC
OCEAN

0 200 miles
0 200 kilometers

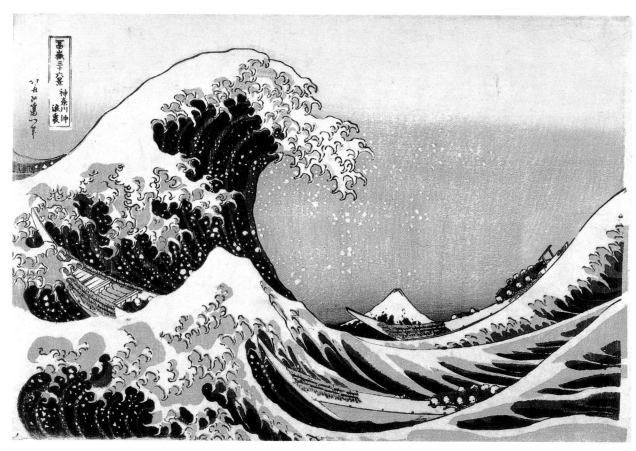

22-1. Katsushika Hokusai. *The Great Wave.* Edo period, c. 1831. Polychrome woodblock print on paper, 9⅞ x 14⅝"
(25 x 37.1 cm). Honolulu Academy of Arts, Honolulu, Hawaii
James A. Michener Collection (HAA 13, 695)

The great wave rears up like a dragon with claws of foam, ready to crash down on the figures huddled in the boat below. Exactly at the point of imminent disaster, but far in the distance, rises Japan's most sacred peak, Mount Fuji, whose slopes, we suddenly realize, swing up like waves and whose snowy crown is like foam—comparisons the artist makes clear in the wave nearest us, caught just at the moment of greatest resemblance.

If one were forced to choose a single work of art to represent Japan, at least in the world's eye, it would have to be this woodblock print, popularly known as *The Great Wave*, by Katsushika Hokusai (fig. 22-1). Taken from his series called *Thirty-Six Views of Fuji*, it has inspired countless imitations and witty parodies, yet its forceful composition remains ever fresh.

Today, Japanese prints are collected avidly around the world, but in their own day they were barely considered art. Produced by the hundreds for ordinary people to buy, they were the fleeting souvenirs of their era, one of the most fascinating in Japanese history. Not until the twentieth century would the West experience anything like the pluralistic cultural atmosphere, where so many diverse groups participate in and contribute to a common culture, as the one that produced *The Great Wave*.

MUROMACHI PERIOD

By the year 1392 Japanese art had already developed a long and rich history (see "Foundations of Japanese Culture," below). Beginning with prehistoric pottery and tomb art, then expanding through cultural influences from China and Korea, Japanese visual expression reached high levels of sophistication in both religious and secular arts. Very early in the tradition, elements of a particularly Japanese aesthetic made themselves felt. These characteristics include a love of natural materials, a taste for asymmetry, a sense of humor, and a tolerance for qualities that may seem paradoxical or contradictory—characteristics that continued to distinguish Japanese art, appearing and reappearing in ever changing guises.

Toward the end of the twelfth century the political and cultural dominance of the emperor and his court gave way to rule by warriors, or samurai, under the leadership of the shogun, the emperor's general-in-chief. In 1392 the Ashikaga family gained control of the shogunate and moved their headquarters to the Muromachi district in Kyoto. They reunited northern and southern Japan and retained their grasp on the office for more than 150 years. The Muromachi period after the reunion (1392–1568) is also known as the Ashikaga era.

The Muromachi period is especially marked by the ascendance of Zen Buddhism, whose austere ideals particularly appealed to the highly disciplined samurai. While Pure Land Buddhism, which had spread widely during the latter part of the Heian period (794–1185), remained popular, Zen, patronized by the samurai, became the dominant cultural force in Japan.

FOUNDATIONS OF JAPANESE CULTURE

With the end of the last Ice Age roughly 15,000 years ago, rising sea levels submerged the lowlands connecting Japan to the Asian landmass, creating the chain of islands we know today as Japan. Not long afterward, early Paleolithic cultures gave way to a Neolithic culture known as Jomon (12,000–300 BCE), after its characteristic cord-marked pottery. During the Jomon period, a notably sophisticated hunter-gatherer culture developed. Agriculture supplemented hunting and gathering by around 5000 BCE, and rice cultivation began some 4,000 years later.

A fully settled agricultural society emerged during the Yayoi period (300 BCE–300 CE), accompanied by hierarchical social organization and more-centralized forms of government. As people learned to manufacture bronze and iron, use of those metals became widespread. Yayoi architecture, with its unpainted wood and thatched roofs, already reveals the Japanese affinity for natural materials and clean lines, and the style of Yayoi granaries in particular persisted in the design of shrines in later centuries. The trend toward centralization continued during the Kofun period (300–552 CE), an era characterized by the construction of large royal tombs following Korean practice. Veneration of leaders grew into the beginnings of the imperial system that has lasted to the present day.

The Asuka era (552–646 CE) began with a century of profound change as elements of Chinese civilization flooded into Japan, initially through the intermediary of Korea. The three most significant Chinese contributions to the developing Japanese culture were Buddhism (with its attendant art and architecture), a system of writing, and the structures of a centralized bureaucracy. The earliest extant Buddhist temple compound in Japan—the oldest currently existing wooden building in the world—dates from this period.

The arrival of Buddhism also prompted some formalization of Shinto, the loose collection of indigenous Japanese beliefs and practices. Shinto is a shamanistic religion that emphasizes ceremonial purification. Its rituals include the invocation and appeasement of spirits, including those of the recent dead. Many Shinto deities are thought to inhabit various aspects of nature, such as particularly magnificent trees, rocks, and waterfalls, and living creatures such as deer. Shinto and Buddhism have in common an intense awareness of transience, and as their goals are complementary—purification in the case of Shinto, enlightment in the case of Buddhism—they have generally existed comfortably alongside each other to the present day.

The Nara period (646–794 CE) takes its name from Japan's first permanently established imperial capital. During this time the founding works of Japanese literature were compiled, among them an important collection of poetry called the *Manyoshu*. Buddhism advanced to become the most important force in Japanese culture. Its influence at court grew so great as to become worrisome, and in 794 the emperor moved the capital from Nara to Heian-kyo (present-day Kyoto), far from powerful monasteries.

During the Heian period (794–1185), an extremely refined court culture thrived, embodied today in an exquisite legacy of poetry, calligraphy, and painting. An efficient method for writing the Japanese language was developed, and with it a woman at the court wrote the world's first novel, *The Tale of Genji*. Esoteric Buddhism, as hierarchical and intricate as the aristocratic world of the court, became popular.

The end of the Heian period was marked by civil warfare as regional warrior (samurai) clans were drawn into the factional conflicts at court. Pure Land Buddhism, with its simple message of salvation, offered consolation to many in these troubled times. In 1185 the Minamoto clan defeated their arch rivals, the Taira, and their leader, Minamoto Yoritomo, assumed the position of shogun (general-in-chief). While paying respects to the emperor, Minamoto Yoritomo kept actual military and political power to himself, setting up his own capital in Kamakura. The Kamakura era (1185–1392) began a tradition of rule by shogun that lasted in various forms until 1868.

■■■■■■■
1400 2000

Years	Period	Japan	World
1392–1568	Muromachi	Ashikaga shogunate; capital in Muromachi district, Kyoto; ascendance of Zen Buddhism; Ikkyu's calligraphy; ink painting flourishes under Shubun, Bunsei, and Sesshu; Ryoan-ji garden; Kano school founded	**1400–1550** Black Death kills 30 percent of Chinese population; Chaucer's *Canterbury Tales* (England); Forbidden City rebuilt (China); Jan van Eyck's *Ghent Altarpiece* (Flanders); Inka Empire (South America); Ghiberti's *Gates of Paradise* (Italy); Gutenberg's Bible (Germany); Columbus's voyages (Spain); Spanish Inquisition; Michelangelo's *David*, Sistine Ceiling (Italy); Leonardo's *Mona Lisa* (Italy); Protestant Reformation in Europe; Spanish conquest of Aztec Empire (Mexico)
1568–1603	Momoyama	Oda Nobunaga shogunate; Westerners arrive; tea ceremony conceived by Sen no Rikyu; Kano school thrives; Toyotomi Hideyoshi shogunate; Himeji Castle	**1550–1600** Mughal period (India); William Shakespeare born (England); Baroque style emerges in Europe; Peter Paul Rubens (Flanders)
1603–1868	Edo	Tokugawa Ieyasu shogunate; period of isolation from foreigners; samurai officials; neo-Confucianism arises; Tawaraya Sotatsu and Rimpa school; Zen Buddhism revival; Maruyama-Shijo school; ukiyo-e; Nanga, or Southern, school; kabuki prints; Hokusai's *Thirty-Six Views of Fuji*; Hiroshige's *Fifty-Three Stations of the Tokaido* isolationism ends; capital at Edo (Tokyo)	**1600–1850** Rembrandt van Rijn (Netherlands); English colonize North America; Qing dynasty (China); Age of Enlightenment in Europe; Union of England and Scotland as Great Britain; James Watt develops steam engine; Declaration of Independence (United States); French Revolution; Romanticism and Neoclassicism arise in Europe; Mexico becomes a republic; Realism arises
1868–present	Meiji and Modern	Meiji Restoration of emperor; blending of foreign and native styles and traditions in art	**1850–present** Italy united; Civil War (United States); Dominion of Canada formed; Impressionism and Post-Impressionism arise; Sino-Japanese War; Chinese republic established by Sun Yat-Sen; World War I; Civil War (Russia); League of Nations; World War II; United Nations established; People's Republic of China; breakup of Soviet Union

Ink Painting

Several forms of visual art flourished during the Muromachi period, but **ink painting**—monochrome painting in black ink and its diluted grays—reigned supreme. Muromachi ink painting was heavily influenced by the aesthetics of Zen, yet it also marked a shift away from the earlier Zen painting tradition. As Zen moved from an oppositional "outsider" sect to the chosen sect of the ruling group, the fierce intensity of earlier masters gave way to a more subtle and refined approach. And whereas earlier Zen

artists had concentrated on rough-hewn depictions of Zen figures such as monks and teachers, now Chinese-style landscapes became the most important theme.

The monk-artist Shubun (active 1414–1463) is regarded as the first great master of the ink landscape. Unfortunately, no works survive that can be proven to be his. Two landscapes by Shubun's pupil Bunsei (active c. 1450–1460) have survived, however. In the one shown here (fig. 22-2), the foreground reveals a spit of rocky land with an overlapping series of motifs—a spiky pine tree, a craggy rock, a poet seated in a hermitage, and a

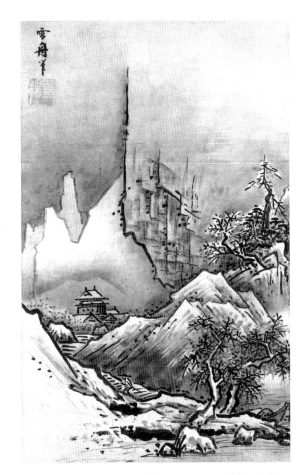

22-3. Sesshu. *Winter Landscape.* Muromachi period, c. 1470s. Ink on paper, 18¼ x 11½" (46.3 x 29.3 cm). Tokyo National Museum

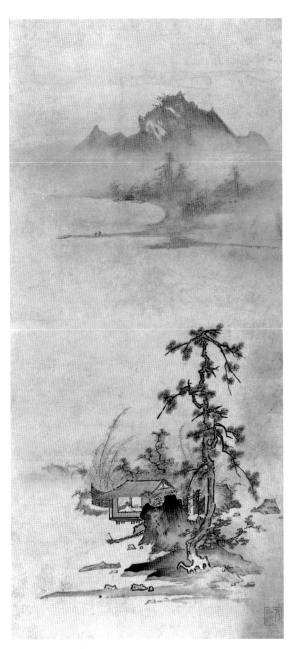

22-2. Bunsei. *Landscape.* Muromachi period, mid-15th century. Hanging scroll, ink and light colors on paper, 28¾ x 13" (73.2 x 33 cm). Museum of Fine Arts, Boston
Special Chinese and Japanese Fund

brushwood fence holding back a small garden of trees and bamboo. In the middleground is space—emptiness, the void.

We are expected to "read" the empty paper as representing water, for subtle tones of gray ink suggest the presence of a few people fishing from their boats near the distant shore. The two parts of the painting seem to echo each other across a vast expanse, just as nature echoes the human spirit in Japanese art. The painting illustrates well the pure, lonely, and ultimately serene spirit of the Zen-influenced poetic landscape tradition.

Ink painting took on a different spirit at the turn of the sixteenth century. By then, temples were asked for so many paintings that they formed **ateliers** staffed by monks who specialized in art rather than religious ritual

or teaching. Some painters even found they could survive on their own as professional artists. Nevertheless, many of the leading masters remained monks, at least in name, including the most famous of them all, Sesshu (1420–1506). Although he lived his entire life as a monk, Sesshu devoted himself primarily to painting. Like Bunsei, he learned from the tradition of Shubun, but he also had the opportunity to visit China in 1467. Sesshu traveled extensively there, viewing the scenery, stopping at Zen monasteries, and seeing whatever Chinese paintings he could. He does not seem to have had access to works by contemporary **literati** masters such as Shen Zhou (see fig. 21-9) but saw instead the works of professional painters. Sesshu later claimed that he learned nothing from Chinese artists, but only from the mountains and rivers he had seen. When Sesshu returned from China, he found his homeland rent by the Onin Wars, which devastated the capital of Kyoto. Japan was to be torn apart by further civil warfare for the next hundred years. The refined art patronized by a secure society in peacetime was no longer possible. Instead, the violent new spirit of the times sounded its disturbing note, even in the peaceful world of landscape painting.

This new spirit is evident in Sesshu's *Winter Landscape,* which makes full use of the forceful style that he developed (fig. 22-3). A cliff descending from the mist seems to cut the composition in half. Sharp, jagged brushstrokes delineate a series of rocky hills, where a

22-4. Ikkyu. *Calligraphy Pair,* from Daitoku-ji, Kyoto. Muro-machi period, c. mid-15th century. Ink on paper, each 10'2⅞" x 1'4½" (3.12 x 0.42 m)

lone figure makes his way to a Zen monastery. Instead of a gradual recession into space, flat overlapping planes seem to slice the composition into crystalline facets. The white of the paper is left to indicate snow, while the sky is suggested by tones of gray. The few trees cling desperately to the rocky land, and the harsh chill of winter is boldly expressed.

A third important artist of the Muromachi period was a monk named Ikkyu (1394–1481). A genuine eccentric and one of the most famous Zen masters in Japanese history, Ikkyu derided the Zen of his day, writing, "The temples are rich but Zen is declining, there are only false teachers, no true teachers." Ikkyu recognized that success was distorting the spirit of Zen. Originally, Zen had been a form of counterculture for those who were not

22-5. Stone and gravel garden, Ryoan-ji, Kyoto. Muromachi period, c. 1480

The American composer John Cage once exclaimed that every stone at Ryoan-ji was in just the right place. He then said, "[A]nd every other place would also be just right." His remark is thoroughly Zen in spirit. There are many ways to experience Ryoan-ji. For example, we can imagine the rocks as having different visual "pulls" that relate them to one another. Yet there is also enough space between them to give each one a sense of self-sufficiency and permanence.

satisfied with prevailing ways. Now, however, Zen monks acted as government advisers, teachers, and even leaders of merchant missions to China. Although true Zen masters were able to withstand all outside pressures, many monks became involved with political matters, with factional disputes among the temples, or with their reputations as poets or artists. Ikkyu did not hesitate to mock what he regarded as "false Zen." He even paraded through the streets with a wooden sword, claiming that his sword would be as much use to a samurai as false Zen to a monk.

Ikkyu was very involved in the arts, although he treated them with extreme freedom. His calligraphy, which is especially admired, has a spirit of spontaneity. To write out the classic Buddhist couplet "Abjure evil, practice only the good," he created this pair of single-line scrolls (fig. 22-4). At the top of each scroll, Ikkyu began with standard script, in which each stroke of a character is separate and distinct. As he moved down the columns he grew more excited and wrote in increasingly cursive script, until finally his frenzied brush did not leave the paper at all. This calligraphy displays the intensity that is the hallmark of Zen.

Ryoan-ji

One of the most renowned Zen creations in Japan is the "dry garden" at the temple of Ryoan-ji in Kyoto (fig. 22-5). There is a record of a famous cherry tree at this spot, so the completely severe nature of the garden may have come about some time after its original founding in the late fifteenth century. Nevertheless, today the garden is celebrated for its serene sense of space and emptiness. Fifteen rocks are set in a long rectangle of raked white gravel. Temple verandas border the garden on the north and east sides, while clay-and-tile walls define the south and west. Only a part of the larger grounds of Ryoan-ji, the garden has provoked so much interest and curiosity that there have been numerous attempts to "explain" it. Some people see the rocks as land and the gravel as sea. Others imagine animal forms in certain of the rock groupings. However, perhaps it is best to see the rocks and gravel as . . . rocks and gravel. The asymmetrical balance in the placement of the rocks and the austere beauty of the raked gravel have led many people to meditation.

The Muromachi period is the only time when an entire culture was strongly influenced by Zen, and the results were mixed. On one hand, works such as Ryoan-ji were created that continue to inspire people to the present day. On the other, the very success of Zen led to a certain secularization and professionalization that artists such as Ikkyu found intolerable.

MOMOYAMA PERIOD

The civil wars sweeping Japan laid bare the basic flaw in the Ashikaga system, which was that samurai were primarily loyal to their own feudal lord, or daimyo, rather than to the central government. Battles between feudal clans grew more frequent, and it became clear that only a daimyo powerful and bold enough to unite the entire country could control Japan. As the Muromachi period drew to a close, three leaders emerged who would change the course of Japanese history.

The first of these leaders was Oda Nobunaga (1534–1582), who marched his army into Kyoto in 1568, signaling the end of the Ashikaga family as a major force in Japanese politics. A ruthless warrior, Nobunaga went so far as to destroy a Buddhist monastery because the monks refused to join his forces. Yet he was also a patron of the most rarefied and refined arts. Assassinated in the midst of one of his military campaigns, Nobunaga was succeeded by the military commander Toyotomi Hideyoshi (1536/37–1598), who soon gained complete power in Japan. He, too, patronized the arts when not leading his army, and he considered culture a vital adjunct to his rule. Hideyoshi, however, was overly ambitious. He believed that he could conquer both Korea and China, and he wasted much of his resources on two ill-fated invasions. A stable government finally emerged in 1600 with the triumph of a third leader, Tokugawa Ieyasu (1543–1616), who established his shogunate in 1603. But despite its turbulence, the era of Nobunaga and Hideyoshi, known as the Momoyama period (1568–1603), was one of the most creative eras in Japanese history.

Architecture

Today the very word *Momoyama* conjures up images of bold warriors, luxurious palaces, screens shimmering with **gold leaf**, and magnificent ceramics. The Momoyama period was also the era when Europeans first made an impact in Japan. A few Portuguese explorers had arrived at the end of the Muromachi era in 1543, and traders and missionaries were quick to follow. It was only with the rise of Nobunaga, however, that Westerners were able to extend their activities beyond the ports of Kyushu, Japan's southernmost island. Nobunaga welcomed foreign traders, who brought him various products, the most important of which were firearms.

European muskets and cannons soon changed the nature of Japanese warfare and even influenced Japanese art. In response to the new weapons, monumental fortified castles were built in the late sixteenth century. Some were eventually lost to warfare or torn down by victorious enemies, and others have been extensively altered over the years. One of the most beautiful of the surviving castles is Himeji, not far from the city of Osaka (fig. 22-6). Rising high on a hill above the plains, Himeji has been given the name White Heron. To reach the upper fortress, visitors must follow angular paths beneath steep walls, climbing from one area to the next past stone ramparts and through narrow fortified gates, all the while feeling as though lost in a maze, with no sense of direction or progress. At the main building, a further climb up a series of narrow ladders leads to the uppermost chamber. There, the foot-sore visitor is rewarded with a stunning 360-degree view of the surrounding countryside. The sense of power is overwhelming.

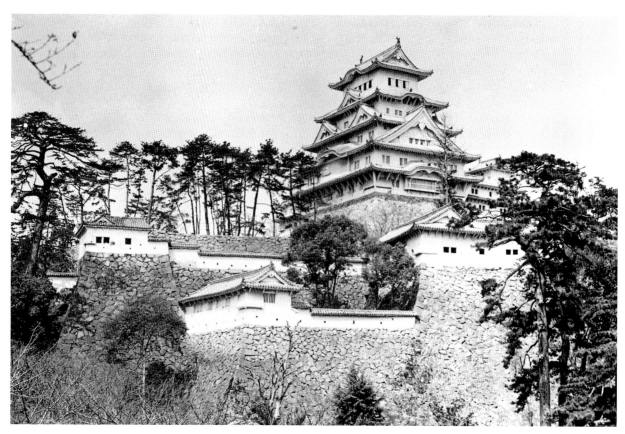

22-6. Himeji Castle, Hyogo, near Osaka. Muromachi period, 1601–9

Decorative Painting

Castles such as Himeji were sumptuously decorated, offering artists unprecedented opportunities to work on a grand scale. Large murals on **fusuma**—paper-covered sliding doors—were particular features of Momoyama design, as were folding screens with gold-leaf backgrounds, whose glistening surfaces not only conveyed light within the castle rooms but also vividly demonstrated the wealth of the warrior leaders. Temples, too, commissioned large-scale decorative paintings for their rebuilding projects after the devastation of the civil wars.

The Momoyama period produced a number of artists who were equally adept at decorative **golden screens** and broadly brushed fusuma paintings. Daitoku-ji, a celebrated Zen monastery in Kyoto, has a number of subtemples that are virtual treasure troves of Japanese art. One, the Juko-in, possesses fusuma by Kano Eitoku (1543–1590), one of the most brilliant painters from the Kano school, a professional school of artists that was patronized by government leaders for several centuries. Founded in the Muromachi period, the Kano school combined training in the ink-painting tradition with new skills in decorative subjects and styles. The illustration here shows two of the three walls of fusuma panels painted when the artist was in his mid-twenties (fig. 22-7). To the left, the subject is the familiar Kano school theme of cranes and pines, both symbols of long life; to

the right is a great gnarled plum tree, symbol of spring. The trees are so massive they seem to extend far beyond the panels. An island rounding both walls of the far corner provides a focus for the outreaching trees. Ingeniously, it belongs to both compositions at the same time, thus uniting them into a single organic whole. Eitoku's vigorous use of brush and ink, his powerfully jagged outlines, and his dramatic compositions all hark back to the style of Sesshu, but the bold new sense of scale in his works is a leading characteristic of the Momoyama period.

Tea

Japanese art is never one-sided. Along with castles, golden screens, and massive fusuma paintings there was an equal interest during the Momoyama period in the quiet, the restrained, and the natural. This was expressed primarily through the tea ceremony.

"Tea ceremony" is an unsatisfactory way to express *cha no yu,* the Japanese ritual drinking of tea, but there is no counterpart in Western culture, so this phrase has come into common use. Tea itself had been introduced to Japan from the Asian continent hundreds of years earlier. At first tea was molded into cakes and boiled. However, the advent of Zen in the late Kamakura period (1185–1392) brought to Japan a different way of preparing tea, with the leaves crushed into powder and then whisked in bowls with hot water. Tea was used by Zen

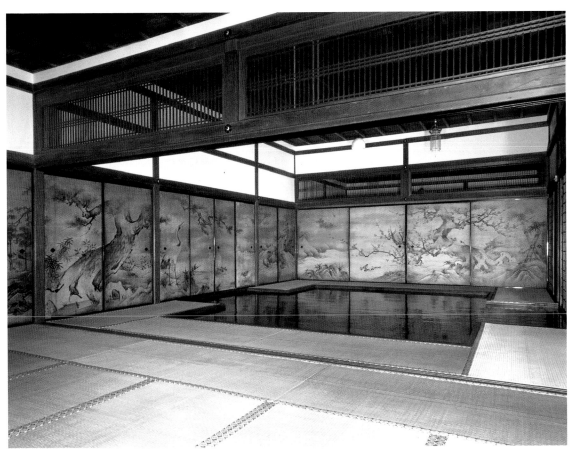

22-7. Kano Eitoku. Fusuma depicting pine and cranes (left) and plum tree (right), from the central room of the Juko-in, Daitoku-ji, Kyoto. Momoyama period, c. 1563–73. Ink and gold on paper, height 5'9⅛" (1.76 m)

monks as a slight stimulant to aid meditation, and it also was considered a form of medicine.

The most famous tea master in Japanese history was Sen no Rikyu (1521–1591). Sen no Rikyu conceived of the tea ceremony as an intimate gathering in which a very few people would enter a small rustic room, drink tea carefully prepared in front of them by their host, and quietly discuss the tea utensils or a Zen scroll hanging on the wall. He did a great deal to establish the aesthetic of modesty, refinement, and rusticity that permitted the tearoom to serve as a respite from the busy and sometimes violent world outside. A traditional tearoom is quite small and simple. It is made of natural materials such as bamboo and wood, with mud walls, paper windows, and a floor covered with **tatami** mats—mats of woven straw. One tearoom that preserves Rikyu's design is named Tai-an (fig. 22-8). Originally built in 1582, it is distinguished by its tiny door (guests must crawl to enter) and its alcove, or *tokonoma*, where a Zen scroll or a simple flower arrangement may be displayed. At first glance, the room seems symmetrical. But the disposition of the tatami mats does not match the spacing of the *tokonoma*, providing a subtle undercurrent of irregularity. A longer look reveals a blend of simple elegance and rusticity. The walls seem scratched and worn with age, but the tatami are replaced frequently to keep them clean and fresh. The mood is quiet; the light is muted and diffused through three small paper windows. Above all, there is a

22-8. Sen no Rikyu. Tai-an tearoom, Myoki-an Temple, Kyoto. Momoyama period, 1582

sense of spatial clarity. All nonessentials have been eliminated, so there is nothing to distract from focused attention. The tearoom aesthetic became an important element in Japanese culture, influencing secular architecture through its simple and evocative form (see "Elements of Architecture," page 862).

ELEMENTS OF ARCHITECTURE
Shoin Design

Of the many expressions of Japanese taste that reached great refinement in the Momoyama period, *shoin* architecture has had perhaps the most enduring influence. *Shoin* are upper-class residences that combine a number of traditional features in more-or-less standard ways, always asymmetrically. These features are wide verandas; wood posts as framing and defining decorative elements; woven straw **tatami** mats as floor and ceiling covering; several shallow alcoves for prescribed purposes; **fusuma** (sliding doors) as fields for painting or textured surfaces; and **shoji** screens—translucent, rice-paper–covered wood frames. The *shoin* illustrated here was built in 1601 as a guest hall, called Kojo-in, at the great Onjo-ji monastery. Tatami, shoji, alcoves, and asymmetry are still seen in Japanese interiors today.

In the original *shoin*, one of the alcoves would contain a hanging scroll, an arrangement of flowers, or a large painted screen. Seated in front of that alcove, called ***tokonoma***, the owner of the house would receive guests, who could contemplate the object above the head of their host. Another alcove contained staggered shelves, often for writing instruments. A writing space fitted with a low writing desk was on the veranda side of a room, with shoji that could open to the outside.

The architectural harmony of *shoin,* like virtually all Japanese buildings, was based on the mathematics of proportions and on the proportionate disposition of basic units, or modules. The modules were the **bay**, reckoned as the distance from the center of one post to the center of another, and the tatami. Room area in Japan is still expressed in terms of the number of tatami mats, so that, for example, a room is described as a seven-mat room. Although varying slightly from region to region, the size of a single tatami is about 3 feet by 6 feet.

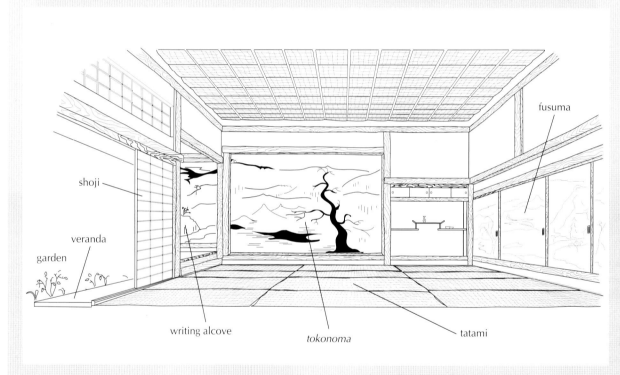

Guest Hall, Kojo-in, Onjo-ji monastery, Shiga prefecture. Momoyama period, 1601

EDO PERIOD

Three years after Tokugawa Ieyasu gained control of Japan, he proclaimed himself shogun. His family's control of the shogunate was to last for over 250 years, a span of time known as the Edo period (1603–1868) or the Tokugawa era.

Under the rule of the Tokugawa family, peace and prosperity came to Japan at the price of an increasingly rigid and often repressive form of government. The problem of potentially rebellious daimyo was solved by ordering all feudal lords to spend either half of each year or every other year in the new capital of Edo (present-day Tokyo), where their wives and children were sometimes required to live permanently. Zen Buddhism was sup-

planted as the prevailing intellectual force by a form of neo-Confucianism, a philosophy formulated in Song dynasty China that emphasized loyalty to the state. More drastically, Japan was soon closed off from the rest of the world by its suspicious government. Japanese were forbidden to travel abroad, and with the exception of small Chinese and Dutch trading communities on an island off the southern port of Nagasaki, foreigners were not permitted in Japan.

Edo society was officially divided into four classes. Samurai officials constituted the highest class, followed by farmers, artisans, and finally merchants. As time went on, however, merchants began to control the money sup-

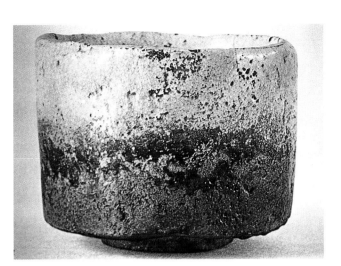

22-9. Hon'ami Koetsu. Teabowl, called *Mount Fuji*. Edo period, early 17th century. Raku ware, height 3³/₈" (8.5 cm). Sakai Collection, Tokyo

A specialized vocabulary grew up to allow connoisseurs to discuss the subtle aesthetics of tea. A favorite term was *sabi*, which summoned up the particular beauty to be found in stillness or even deprivation. *Sabi* was borrowed from the critical vocabulary of poetry, where it was first established as a positive ideal by the early-thirteenth-century poet Fujiwara Shunzei. Other virtues were *wabi*, conveying a sense of great loneliness or a humble (and admirable) shabbiness, and *shibui*, meaning plain and astringent.

ply, and in Japan's increasingly mercantile economy they soon reached a high, if unofficial, position. Reading and writing became widespread at all levels of society. Many segments of the population—samurai, merchants, intellectuals, and even townspeople—were now able to patronize artists, and a pluralistic cultural atmosphere developed unlike anything Japan had experienced before.

Tea

The rebuilding of temples continued during the first decades of the Edo period, and for this purpose government officials, monks, and wealthy merchants needed to cooperate. The tea ceremony was one way that people of different classes could come together for intimate conversations. Every utensil connected with tea, including the waterpot, the kettle, the bamboo spoon, the whisk, the tea caddy, and, above all, the teabowl came to be appreciated for their aesthetic qualities, and many works of art were created for use in *cha no yu*.

The age-old Japanese admiration for the natural and the asymmetrical found full expression in tea ceramics. Korean bowls made by humble farmers for their rice were suddenly considered the epitome of refined taste. Tea masters even went so far as to advise rural potters in Japan to create imperfect shapes. But not every misshapen bowl would be admired. An extremely subtle sense of beauty developed that took into consideration such factors as how well a teabowl fit into the hands, how subtly the shape and texture of the bowl appealed

to the eye, and who had previously used and admired it. For this purpose, the inscribed box became almost as important as the ceramic that fit within it, and if a bowl had been given a name by a leading tea master, it was especially treasured by later generations.

One of the finest teabowls extant is named *Mount Fuji* after Japan's most sacred peak (fig. 22-9). (Mount Fuji itself is depicted in figure 22-1.) An example of **raku** ware—a hand-built, low-fired ceramic developed especially for use in the tea ceremony—the bowl was crafted by Hon'ami Koetsu (1558–1637), a leading cultural figure of the early Edo period. Koetsu was most famous as a calligrapher, but he was also a painter, **lacquer** designer, poet, landscape gardener, connoisseur of swords, and potter. With its small foot, straight sides, slightly irregular shape, and crackled texture, this bowl exemplifies tea taste. In its rough exterior we seem to sense directly the two elements of earth and fire that create pottery. Merely looking at it suggests the feeling one would get from holding it, warm with tea, cupped in one's hands.

Rimpa School

One of Koetsu's friends was the painter Tawaraya Sotatsu (active c. 1600–1640), with whom he collaborated on several magnificent handscrolls. Sotatsu is considered the first great painter of the Rimpa school, a grouping of artists with similar tastes rather than a formal school such as the Kano school. Rimpa masters excelled in decorative designs of strong expressive force, and they frequently worked in several mediums.

Sotatsu painted some of the finest golden screens that have survived. The splendid pair here depict the celebrated islands of Matsushima near the northern city of Sendai (fig. 22-10). Working in a boldly decorative style, the artist has created asymmetrical and almost abstract patterns of waves, pines, and island forms. On the screen to the right, mountainous islands echo the swing and sweep of the waves, with stylized gold clouds in the upper left. The screen on the left continues the gold clouds until they become a sand spit from which twisted pines grow. Their branches seem to lean toward a strange island in the lower left, composed of an organic, amoebalike form in gold surrounded by mottled ink. This mottled effect was a specialty of Rimpa school painters.

As one of the "three famous beautiful views of Japan," Matsushima was often depicted in art. Most painters, however, emphasized the large number of pine-covered islands that make the area famous. Sotatsu's genius was to simplify and dramatize the scene, as though the viewer were passing the islands in a boat on the roiling waters. Strong, basic mineral colors dominate, and the sparkling two-dimensional richness of the gold leaf contrasts dramatically with the three-dimensional movement of the waves.

The second great master of the Rimpa school was Ogata Korin (1658–1716). Korin copied many designs after Sotatsu in homage to the master, but he also originated many remarkable works of his own, including colorful golden screens, monochrome scrolls, and paintings

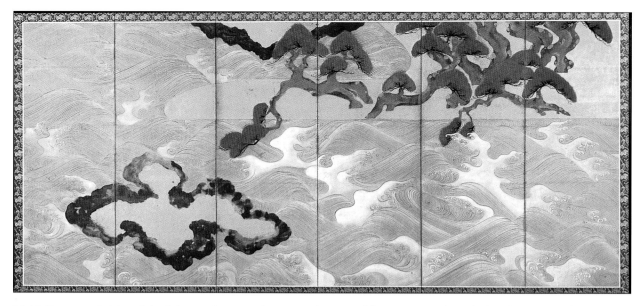

22-10. Tawaraya Sotatsu. Pair of six-panel screens, known as the Matsushima screens. Edo period, 17th century. Ink, mineral colors, and gold leaf on paper; each screen 4'9⁷⁄₈" x 11'8¹⁄₂" (1.52 x 3.56 m). Freer Gallery of Art, Smithsonian Institution, Washington, D.C. (06.231; 06.232)

The six-panel screen format was a triumph of scale and practicality. Each panel consisted of a light wood frame surrounding a latticework interior covered with several layers of paper. Over this foundation was pasted a high-quality paper, silk, or gold-leaf ground, ready to be painted by the finest artists. Held together with ingenious paper hinges, a screen could be folded for preservation or transportation, resulting in a mural-size painting light enough to be carried by a single person, ready to be displayed as needed.

in glaze on his brother Kenzan's pottery. He also designed some highly prized works in lacquer (see "Lacquer," below). One famous example (fig. 22-11) is a writing box, a lidded container designed to hold tools and materials for calligraphy (see "Inside a Writing Box," opposite). Korin's design for this black lacquer box sets a

motif of irises and a plank bridge in a dramatic combination of mother-of-pearl, silver, lead, and gold lacquer. For Japanese viewers the decoration immediately recalls a famous passage from the tenth-century *Tales of Ise*, a classic of Japanese literature. A nobleman poet, having left his wife in the capital, pauses at a place called Eight

TECHNIQUE

LACQUER

Lacquer is derived form the sap of the lacquer tree, *Rhus verniciflua*. The tree is indigenous to China, where examples of lacquerware have been found dating back to the Neolithic period. Knowledge of lacquer spread early to Korea and Japan, and the tree came to be grown commercially throughout East Asia.

Gathered by tapping into a tree and letting the sap flow into a container, in much the same way as maple syrup, lacquer is then strained to remove impurities and heated to evaporate excess moisture. The thickened sap can be colored with vegetable or mineral dyes and lasts for several years if carefully stored. Applied in thin coats to a surface such as wood or leather, lacquer hardens into a smooth, glasslike, protective coating that is waterproof, heat and acid resistant, and airtight. Lacquer's practical qualities made it ideal for storage containers and vessels for food and drink. In Japan the leather scales of samurai armor were coated in lacquer, as were leather saddles. In China, Korea, and Japan the decorative potential of lacquer was brought to exquisite perfection in the manufacture of expensive luxury items.

The creation of a piece of lacquer is a painstaking process that can take a sequence of specialized craftsworkers several years. First, the item is fashioned of wood and sanded to a flawlessly smooth finish. Next, a layer of lacquer is built up. In order to dry properly, lacquer must be applied in extremely thin coats. (If the lacquer is applied too thickly, the lacquer's exterior surface dries first, forming an airtight seal that prevents the lacquer below from ever drying.) Optimal temperature and humidity are also essential to drying, and craftsworkers quickly learned to control them artificially. Up to 30 coats of lacquer, each dried and polished before the next is brushed on, are required to build up a substantial layer.

Many techniques were developed for decorating lacquer. Particularly in China, lacquer was often applied to a thickness of up to 300 coats, then elaborately carved in low relief—dishes, containers, and even pieces of furniture were executed in carved lacquer. In Japan and Korea, **inlay** with mother-of-pearl and precious metals was brought to a high point of refinement. Japanese artisans also perfected a variety of methods known collectively as **maki-e** ("sprinkled design") that embedded flaked or powdered gold or silver in a still-damp coat of lacquer—somewhat like a very sophisticated version of the technique of decorating with glitter on glue.

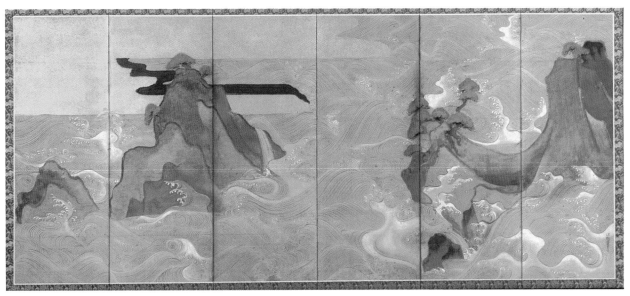

Bridges, where a river branches into eight streams, each covered with a plank bridge. Irises are in full bloom, and his traveling companions urge the poet to write a *tanka*—a five-line, thirty-one-syllable poem—beginning each line with a syllable from the word *ka·ki·tsu·ba·ta* ("iris"). The poet responds (substituting *ha* for *ba*):

> *Ka*ragoromo
> *kit*sutsu narenishi
> *tsu*ma shi areba
> *ha*rubaru kinuru
> *ta*bi o shi zo omou.

> When I remember
> my wife, fond and familiar
> as my courtly robe,
> I feel how far and distant
> my travels have taken me.

(Translated by Stephen Addiss)

22-11. Ogata Korin. Lacquer box for writing implements. Edo period, late 17th–early 18th century. Lacquer, lead, silver, and mother-of-pearl, 5⅝ x 10¾ x 7¾" (14.2 x 27.4 x 19.7 cm). Tokyo National Museum

INSIDE A WRITING BOX The interiors of the writing box shown in figure 22-11 is fitted with compartments for holding an ink stick, an ink stone, brushes, an eye-dropper, and paper—tools and materials not only for writing but also for **ink painting**.

Ink sticks are made by burning wood or oil inside a container. Soot deposited by the smoke is collected, bound into a paste with resin, heated for several hours, kneaded and pounded, then pressed into small stick-shaped or cake-shaped molds to harden. Molds are often carved to produce an ink stick (or ink cake) decorated in low relief. The tools of writing and painting are also beautiful objects in their own right.

Fresh ink is made for each writing or painting session by grinding the hard, dry ink stick in water against a fine-grained stone. A typical ink stone has a shallow well at one end sloping up to a grinding surface at the other. The artist fills the well with water, transferring it from a waterpot. The ink stick, held vertically, is dipped into the well to pick up a small amount of water, then is rubbed in a circular motion firmly on the grinding surface. The process is repeated until enough ink has been prepared. Grinding ink is viewed as a meditative task, time for collecting one's thoughts and concentrating on the painting or calligraphy ahead.

Brushes are made from animal hairs set in a simple bamboo or hollow-reed handle. Brushes taper to a fine point that responds with great sensitivity to any shift in pressure. Although great painters and calligra-phers eventually develop their own style of holding and using the brush, all begin by learning the basic position for writing. The brush is held vertically, grasped firmly between the thumb and first two fingers, with the fourth and fifth fingers often resting against the handle for more subtle control.

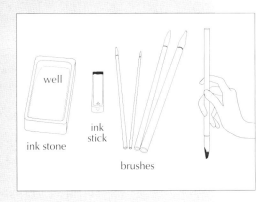

well
ink stone
ink stick
brushes

The poem brought tears to all their eyes, and the scene became so famous that any painting of a group of irises, with or without a plank bridge, immediately calls it to mind.

Nanga School

Rimpa artists such as Sotatsu and Korin are considered quintessentially Japanese in spirit, both in the expressive power of their art and in their use of poetic themes from Japan's past. Other painters, however, responded to the new Confucian atmosphere by taking up some of the ideas of the literati painters of China. These painters are grouped together as the Nanga, or Southern, school. Nanga was not a school in the sense of a professional workshop or a family tradition. Rather, it took its name from the Southern school of amateur artists described by the Chinese literati theorist Dong Qichang (Chapter 21). Educated in the Confucian mold, Nanga masters were individuals and often individualists, creating their own variations of literati painting from unique blendings of Chinese models, Japanese aesthetics, and personal brushwork. They were often experts at calligraphy and poetry as well as painting, but one, Uragami Gyokudo (1745–1820), was even more famous as a musician, an expert on a seven-string Chinese zither called the *qin.* Most instruments are played for entertainment or ceremonial purposes, but the *qin* has so deep and soft a sound that it is played only for oneself or a close friend. Its music becomes a kind of meditation, and for Gyokudo it opened a way to commune with nature and his own inner spirit.

Gyokudo was a hereditary samurai official, but midway through his life he resigned from his position and spent seventeen years wandering through Japan, absorbing the beauty of its scenery, writing poems, playing music, and beginning to paint. During his later years Gyokudo produced many of the strongest and most individualistic paintings in Japanese history, although they were not appreciated by people during his lifetime. *Geese Aslant in the High Wind* is a leaf from an album Gyokudo painted in 1817, three years before his death (fig. 22-12). The creative power in this painting is remarkable. The wind seems to have the force of a hurricane, sweeping the tree branches and the geese into swirls of action. The greatest force comes from within the land itself, which mushrooms out and bursts forth in peaks and plateaus as though an inner volcano were erupting.

The style of the painting derives from the Chinese literati tradition, with layers of calligraphic brushwork building up the forms of mountains, trees, and the solitary human habitation. But the inner vision is unique to Gyokudo. In his artistic world, humans do not control nature but can exult in its power and grandeur. Gyokudo's art may have been too strong for most people in his own day, but in our violent century he has come to be appreciated as a great artist.

Zen

Deprived of the support of the government and samurai officials, Zen initially went into something of a decline

22-12. Uragami Gyokudo. *Geese Aslant in the High Wind.* Edo period, 1817. Ink and light colors on paper, 12³/₁₆ x 9⁷/₈" (31 x 25 cm). Takemoto Collection, Aichi

during the Edo period. In the early eighteenth century, however, it was revived by a monk named Hakuin Ekaku (1685–1769), born in a small village not far from Mount Fuji, who resolved to become a monk after hearing a fire-and-brimstone sermon in his youth. For years he traveled around Japan seeking out the strictest Zen teachers. After a series of enlightenment experiences, he eventually became an important teacher himself.

In his later years Hakuin turned more and more to painting and calligraphy as forms of Zen expression and teaching. Since the government no longer sponsored Zen, Hakuin reached out to ordinary people, and many of his paintings portray everyday subjects that would be easily understood by farmers and merchants. The paintings from his sixties have great charm and humor, and by his eighties he was creating works of astonishing force. Hakuin's favorite subject was Bodhidharma, the semilegendary Indian monk who had begun the Zen tradition in China (fig. 22-13). Here he has portrayed the wide-eyed Bodhidharma during his nine years of meditation in front of a temple wall in China. Intensity, concentration, and spiritual depth are conveyed by broad and forceful brushstrokes. The inscription is the ultimate Zen message, attributed to Bodhidharma himself: "Pointing directly to the human heart, see your own nature and become Buddha."

Hakuin's pupils followed his lead in communicating their vision through brushwork. The Zen figure once again became the primary subject of Zen painting, and the painters were again Zen masters rather than primarily artists.

22-14. Nagasawa Rosetsu. *Bull and Puppy.* Edo period, 18th century. One of a pair of six-panel screens, ink and gold wash on paper, 5'7¼" x 12'3" (1.70 x 3.75 m). Los Angeles County Museum of Art

Joe and Etsuko Price Collection

22-13. Hakuin Ekaku. *Bodhidharma Meditating.* Edo period, 18th century. Ink on paper, 49½ x 21¾" (125.7 x 55.3 cm). On extended loan to the Spencer Museum of Art, University of Kansas, Lawrence

Hakuin had his first enlightenment experience while meditating upon the koan (mysterious Zen riddle) about *mu.* One day a monk asked a Chinese Zen master, "Does a dog have the buddha nature?" Although Buddhist doctrine teaches that all living beings have buddha nature, the master answered, "*Mu,*" meaning "has not" or "nothingness." The riddle of this answer became a problem that Zen masters gave their students as a focus for meditation. With no logical answer possible, monks were forced to go beyond the rational mind and penetrate more deeply into their own being. Hakuin, after months of meditation, reached a point where he felt "as though frozen in a sheet of ice." He then happened to hear the sound of the temple bell, and "it was as though the sheet of ice had been smashed." Later, as a teacher, Hakuin invented a koan of his own that has since become famous: "What is the sound of one hand clapping?"

Maruyama-Shijo School

Zen paintings were given away to all those who wished them, including poor farmers as well as artisans, merchants, and samurai. Many merchants, however, were more concerned with displaying their increasing wealth than with spiritual matters, and their aspirations fueled a steady demand for golden screens and other decorative works of art. One school that arose to satisfy this demand was the Maruyama-Shijo school, formed in Kyoto by Maruyama Okyo (1733–1795). Okyo had studied Western-style "perspective pictures" in his youth, and he was able in his mature works to incorporate shading and perspective into a decorative style, creating a sense of volume that was new to East Asian painting. Okyo's new style proved very popular in Kyoto, and it soon spread to Osaka and Edo (present-day Tokyo) as well. The subjects of Maruyama-Shijo painting were seldom difficult to understand. Instead of legendary Chinese themes, Maruyama-Shijo painters portrayed the birds, animals, hills, trees, farmers, and townsfolk of Japan. Although highly educated people might make a point of preferring Nanga painting, Maruyama-Shijo works were perfectly suited to the taste of the emerging upper middle class.

The leading pupil of Okyo was Nagasawa Rosetsu (1754–1799), a painter of great natural talent who added his own boldness and humor to the Maruyama-Shijo tradition. Rosetsu delighted in surprising his viewers with odd juxtapositions and unusual compositions. One of his finest works is a pair of screens, the left depicting a bull and a puppy (fig. 22-14). The bull is so immense that it fills almost the entire six panels of the screen and still cannot be contained at the top, left, and bottom. The puppy, white against the dark gray of the bull, helps to emphasize the huge size of the bull by its own smallness. The puppy's relaxed and informal pose, looking happily right out at the viewer, gives this powerful painting a humorous touch that increases its charm.

TECHNIQUE

JAPANESE WOODBLOCK PRINTS

Ukiyo-e ("pictures of the floating world" as these **woodblock prints** are called in Japanese) represent the combined expertise of three people: the artist, the carver, and the printer. Coordinating and funding the endeavor was a publisher, who commissioned the project and distributed the prints to stores or itinerant peddlers, who would sell them.

The artist supplied the master drawing for the print, executing its outlines with brush and ink on tissue-thin paper. Colors might be indicated, but more often they were understood or decided on later. The drawing was passed on to the carver, who pasted it facedown on a hardwood block, preferably cherry wood, so that the outlines showed through the paper in reverse. A light coating of oil might be brushed on to make the paper more transparent, allowing the drawing to stand out with maximum clarity. The carver then cut around the lines of the drawing with a sharp knife, always working in the same direction as the original brushstrokes. The rest of the block was chiseled away, leaving the outlines standing in relief. This block, which reproduced the master drawing, was called the **key block**. If the print was to be **polychrome**, having multiple colors, prints made from the key block were in turn pasted facedown on blocks that would be used as guides for the carver of the color blocks. Each color generally required a separate block, although both sides of a block might be used for economy.

Once the blocks were completed, the printer took over. Paper for printing was covered lightly with animal glue (gelatin). A few hours before printing, the paper was lightly moistened so that it would take ink and color well. Water-based ink or color was brushed over the block, and the paper placed on top and rubbed with a smooth, padded device called a *baren*, until the design was completely transferred. The key block was printed first, then the colors one by one. To ensure that the colors printed exactly within the outlines, each block was carved with two small marks called **registration marks**, in exactly the same place in the margins, outside of the image area—an **L** in one corner, and a straight line in another. By aligning the paper with these marks before letting it fall over the block, the printer ensured that the colors would be placed correctly. One of the most characteristic effects of later Japanese prints is a grading of color from dark to pale. This was achieved by wiping some of the color from the block before printing, or by moistening the block and then applying the color gradually with an unevenly loaded brush—a brush loaded on one side with full-strength color and on the other with diluted color.

An early 20th-century woodblock showing two women cutting and inking blocks

In earlier centuries, when works of art were created largely under aristocratic or religious patronage, Rosetsu's painting might have seemed too down-to-earth. In the Edo period, however, the taste for art had spread so widely through the populace that no single group of patrons could control the cultural climate. Everyday subjects like farm animals were painted as often as Zen subjects or symbolic themes from China. In the hands of a master such as Rosetsu, plebeian subject matter could become simultaneously delightful and monumental, equally pleasing to viewers with or without much education or artistic background.

Ukiyo-e: Pictures of the Floating World

Not only did newly wealthy merchants patronize painters in the middle and later Edo period, but even artisans and tradespeople could purchase works of art. Especially in the new capital of Edo, bustling with commerce and cultural activities, people savored the delights of their peaceful society. Buddhism had long preached that pleasures were fleeting; the cherry tree, which blossoms so briefly, became the symbol for the transience of earthly beauty and joy. Commoners in the Edo period did not dispute this transience, but they took a new attitude: Let's enjoy it to the full as long as it lasts. Thus the Buddhist phrase *ukiyo* ("floating world") became positive rather than negative.

There was no world more transient than that of the pleasure quarters, set up in specified areas of every major city. Here were found restaurants, bathhouses, and brothels. The heroes of the day were no longer famous samurai or aristocratic poets. Instead, the admired were swashbuckling actors and beautiful courtesans. These paragons of pleasure soon became immortalized in paintings, and because paintings were often too expensive for common people, in **woodblock prints** known as **ukiyo-e**, "pictures of the floating world" (see "Japanese Woodblock Prints," above).

At first prints were made in black and white, then colored by hand when the public so desired. The first artist to design prints to be printed in many colors was Suzuki Harunobu (1724–1770). His exquisite portrayals of feminine beauty quickly became so popular that soon every artist was designing multicolored *nishiki-e* ("brocade pictures").

22-15. Suzuki Harunobu. *Geisha as Daruma Crossing the Sea.* Edo period, mid-18th century. Color woodcut, 10⅞ x 8¼" (27.6 x 21 cm). Philadelphia Museum of Art

Gift of Mrs. Emile Geyelin, in memory of Anne Hampton Barnes

One print that displays Harunobu's charm and wit is *Geisha as Daruma Crossing the Sea* (fig. 22-15). Harunobu has portrayed a young woman in a red cloak crossing the water on a reed, a clear reference to one of the legends about Bodhidharma, known in Japan as Daruma. To see a young woman peering ahead to the other shore, rather than a grizzled Zen master staring off into space, must have greatly amused the Japanese populace. There was also another layer of meaning in this image because geishas, or courtesans, were sometimes compared to Buddhist teachers or deities in their ability to bring ecstasy, akin to enlightenment, to humans. Harunobu's print suggests these meanings, but it also succeeds simply as a portrait of a beautiful woman, with the gently curving lines of drapery suggesting the delicate feminine form beneath.

The second great subject of ukiyo-e were the actors of the new form of popular theater known as kabuki. Because women had been banned from the stage after a series of scandalous incidents, male actors took both male and female roles. Much as people today buy posters of their favorite sports or music stars, so, too, in the Edo period people clamored for images of their feminine and masculine ideals.

During the nineteenth century, landscape joined courtesans and actors as a major theme—not the idealized landscape of China, but the actual sights of Japan. The two great masters of landscape prints were Utagawa Hiroshige (1797–1858) and Katsushika Hokusai

(1760–1849). Hiroshige's *Fifty-Three Stations of the Tokaido* and Hokusai's *Thirty-Six Views of Fuji* became the most successful sets of graphic art the world has yet known. The blocks were printed and printed again until they were worn out. They were then recarved, and still more copies were printed. This process continued for decades, and thousands of prints from the two series are still extant.

The Great Wave (see fig. 22-1) is the most famous of the scenes from *Thirty-Six Views of Fuji.* Hokusai was already in his seventies, with a fifty-year career behind him, when he designed this image. Such was his modesty that he felt that his Fuji series was only the beginning of his creativity, and he wrote that if he could live until he was 100, he would finally learn how to become an artist.

When seen in Europe and America, these and other Japanese prints were immediately acclaimed, and they strongly influenced late-nineteenth- and early-twentieth-century Western art (Chapter 28). ***Japonisme***, or "japonism," became the vogue, and Hokusai and Hiroshige became as famous in the West as in Japan. Indeed, their art was taken more seriously in the West; the first book on Hokusai was published in France, and it has been estimated that by the early twentieth century more than 90 percent of Japanese prints had been sold to Western collectors. Only within the past fifty years have Japanese museums and connoisseurs fully realized the stature of this "plebeian" form of art.

THE MEIJI AND MODERN PERIODS

Pressure from the West for entry into Japan mounted dramatically in the mid-nineteenth century, and in 1853 the policy of national seclusion was ended. Resulting tensions precipitated the downfall of the Tokugawa shogunate, however, and in 1868 the emperor was formally restored to power, an event known as the Meiji Restoration. The court moved from Kyoto to Edo, which was renamed Tokyo, meaning "Eastern Capital."

The Meiji period marked a major change for Japan. After its long isolation Japan was deluged by the influx of the West. Western education, governmental systems, clothing, medicine, industrialization, and technology were all adopted rapidly into Japanese culture. Teachers of sculpture and oil painting were imported from Italy, while adventurous Japanese artists traveled to Europe and America to study.

Japan has always been a country where people have been eager to be up-to-date while at the same time preserving the heritage of the past. Even in the hasty scrambling to become a modern industrialized country, Japan did not lose its sense of tradition, and traditional arts continued to be created even in the days of the strongest Western influence. In modern Japan, artists must choose whether to work in an East Asian style, a Western style, or some combination of the two. Just as Japanese art in earlier periods had both Chinese style and native traditions, so Japanese art of the twentieth century has both Western and native aspects.

Perhaps the most lively contemporary art is ceramics. Japan remains a country where there is widespread appreciation for pottery. Many people still practice the traditional arts of the tea ceremony and flower arranging, both of which require ceramic vessels, and most people would like to own at least one fine ceramic piece. In this atmosphere potters can earn a comfortable living by making art ceramics, an opportunity that does not occur in other countries. Some ceramists continue to create raku teabowls and other traditional wares, while others experiment with new styles and new techniques. Figure 22-16 shows the work of four contemporary potters, from left to right, Miyashita Zenji (b. 1939), Morino Hiroaki (b. 1934), Tsujimura Shiro (b. 1947), and Ito Sekisui (b. 1941).

Miyashita Zenji, who lives in Kyoto, spends a great deal of time on each piece. He creates the initial form by constructing an undulating shape out of pieces of cardboard, then builds up the surface with clay of many different colors, using torn paper to create irregular shapes. When fired, the varied colors of the clay seem to form a landscape, with layers of mountains leading up to the sky. Miyashita's work is modern in shape, yet also traditional in its evocation of nature.

Morino Hiroaki's works are often abstract and sculptural, without any functional use. He has also made vases, however, and they showcase his ability to create designs in glaze that are wonderfully quirky and playful. His favorite colors of red and black bring out the asymmetrical strength of his compositions, the products of a lively individual artistic personality.

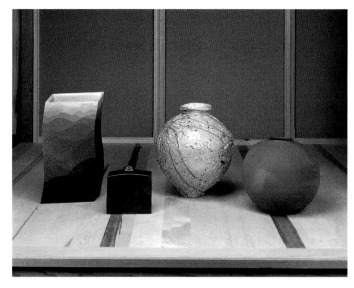

22-16. From left: Miyashita Zenji, Morino Hiroaki, Tsujimura Shiro, Ito Sekisui. Four ceramic vessels. Modern period, after 1970. Spencer Museum of Art, University of Kansas, Lawrence
Gift of the Friends of the Art Museum/Helen Foresman Spencer Art Acquisition Fund

Tsujimura Shiro lives in the mountains outside Nara and makes pottery in personal variations on traditional shapes. He values the rough texture of country clay and the natural ash glaze that occurs with wood firing, and he creates jars, vases, bowls, and cups with rough exteriors covered by rivulets of flowing green glaze that are often truly spectacular. Tsujimura's pieces are always functional, and part of their beauty comes from their suitability for holding food, flowers, or tea.

Ito Sekisui represents the fifth generation of a family of potters. Sekisui demonstrates the Japanese love of natural materials by presenting the essential nature of fired clay in his works. The shapes of his bowls and pots are beautifully balanced with simple clean lines; no ornament detracts from their fluent geometric purity. The warm tan, orange, and reddish colors of the clay reveal themselves in irregularly flowing and changing tones created by allowing different levels of oxygen into the kiln when firing.

These four artists represent the high level of contemporary ceramics in Japan, which is supported by a broad spectrum of educated and enthusiastic collectors and admirers. There is also strong public interest in contemporary painting, prints, calligraphy, textiles, lacquer, architecture, and sculpture.

One of the most adventurous and original sculptors currently working is Chuichi Fujii. Born into a family of sculptors in wood, Fujii found himself as a young artist more interested in the new materials of plastic, steel, and glass. However, in his mid-thirties he took stock of his progress and decided to begin again, this time with wood. At first he carved and cut into the wood, but he soon realized that he wanted to allow the material to express its own natural spirit, so he devised an ingenious new technique that preserved the individuality of each

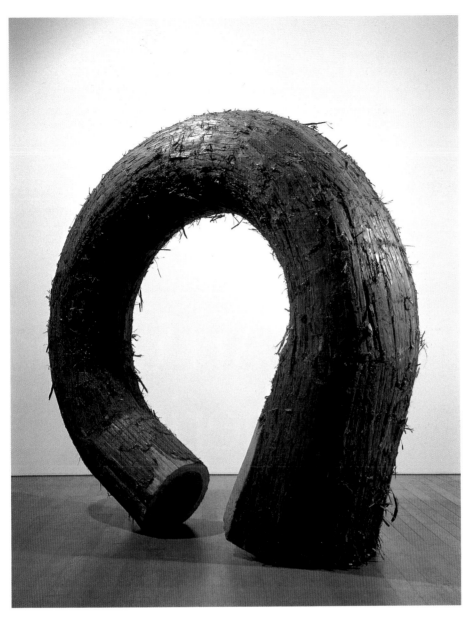

22-17. Chuichi Fujii. *Untitled '90.* Modern period, 1990. Cedar wood, height 7'5½"(2.3 m). Hara Museum of Contemporary Art, Tokyo

log while making of it something new. As Fujii explains it, he first studies the log in order to come to terms with its basic shape and decide how far he can "push to the limit the log's balancing point with the floor" (Howard N. Fox, *A Primal Spirit: Ten Contemporary Japanese Sculptors.* Exh. cat., Los Angeles County Museum of Art, 1990, page 63). Next, he inserts hooks into the log and runs wires between them. Every day he tightens the wires, very gradually, over a period of months, pulling the log into a new shape. When he has bent the log tree trunk to the shape he envisioned, Fujii makes a final cut and sees whether his sculpture will stand. If he has miscalculated, he discards the work and begins again.

Here, Fujii has created a circle, one of the most basic forms in nature but never before seen in such a thick tree trunk (fig. 22-17). The work strongly suggests the *enso,* the circle that Zen monks painted to express the universe, the all, the void, the moon—and even a tea cake. Yet Fujii does not try to proclaim his links with Japanese culture. He says that while his works may seem to have some connections with traditional Japanese arts, he is not conscious of them. He acknowledges, however, that people carry their own cultures inside them, and he claims that all Japanese have had "the experience of sensing with their skin the fragrance of a tree. Without saying it, the Japanese understand that a tree has warmth; I believe it breathes air, it cries" (Fox, page 63).

Fujii's sculpture testifies to the depth of an artistic tradition that has continued to produce visually exciting works for 14,000 years. He has achieved something entirely new, yet his work also embodies the love of asymmetry, respect for natural materials, and dramatic simplicity encountered throughout the history of Japanese art. Whatever the future of art in Japan, these principles will undoubtedly continue to lead to new combinations of tradition and creativity.

The Moon Goddess,
Coyolxauhqui
Aztec
15th century

Silver llama statue
Inka
15th century

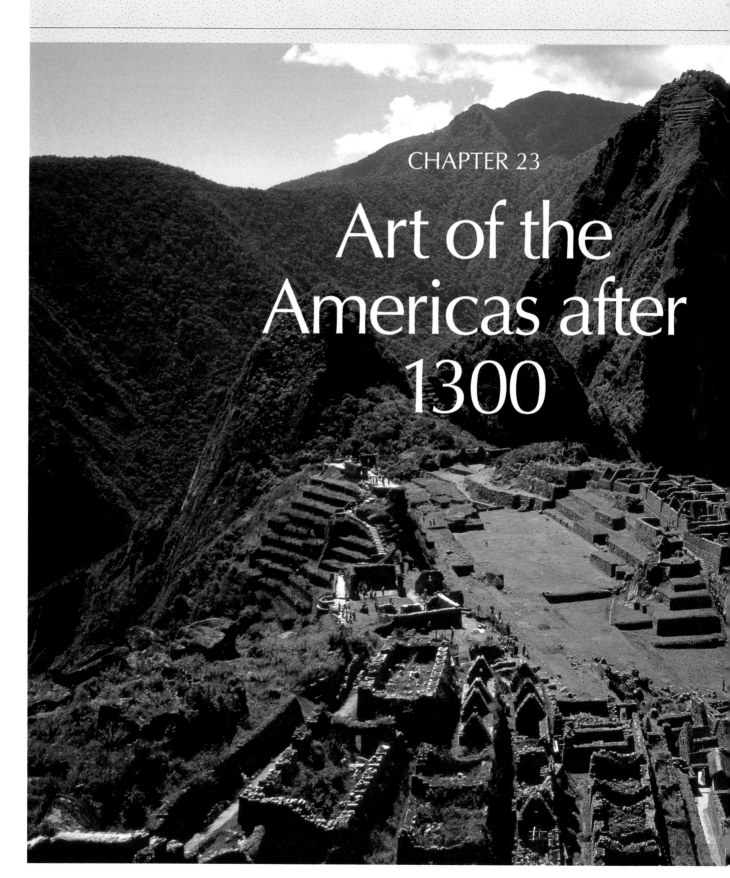

CHAPTER 23

Art of the Americas after 1300

1700 1800 1900 2000

Taos Pueblo
Tewa
c. 1700

Hide painting
Mandan
1797–1805

Partition screen
Tlingit
c. 1840

Martinez
Blackware jar
c. 1942

Bering Strait

NORTH

AMERICA

Hudson
Bay

NORTHWEST COAST

ROCKY MOUNTAINS

Queen
Charlotte
Islands

PACIFIC
OCEAN

Danger Cave

GREAT PLAINS

Mississippi River

Missouri River

EASTERN
WOODLANDS

Santa Fe

SOUTHWEST

UNITED STATES

ATLANTIC
OCEAN

MEXICO

Gulf of
Mexico

THE
YUCATAN

CUBA

Mexico City

AZTEC EMPIRE

GUATEMALA

NEW MEXICO

Santa Clara
Pueblo
San Ildefonso
Pueblo

Taos Pueblo

Santa Fe

VALLEY OF
MEXICO

Tula

Teotihuacan

Mexico City
(Tenochtitlan)

Lake
Texcoco

Malinalco

MEXICO

Quito

ECUADOR

PERU

Wari

Saqsawaman

INKA

Amazon River

Machu Picchu
Cuzco

Urubamba River

SOUTH

AMERICA

Lake Titicaca

BOLIVIA

ANDES MOUNTAINS

INKA EMPIRE

PACIFIC
OCEAN

Santiago

CHILE

ARGENTINA

0 1000 miles
0 1000 kilometers

TIERRA DEL FUEGO

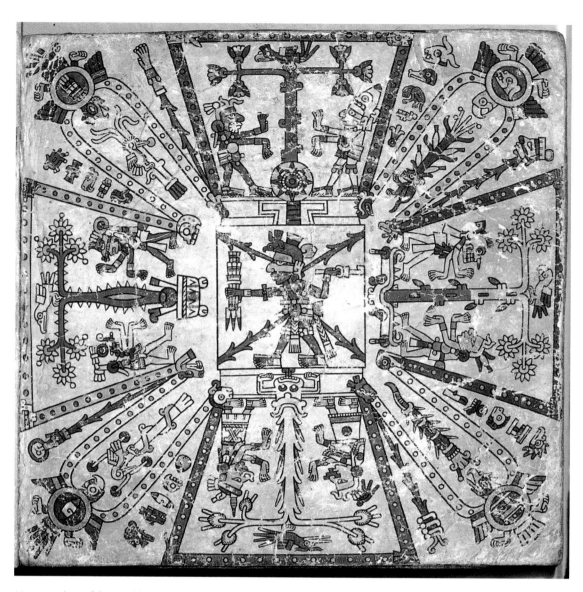

23-1. A view of the world, detail from *Codex Fejervary-Mayer*. Aztec or Mixtec, c. 1400–1521. Paint on animal hide, each page 6⁷⁄₈ x 6⁷⁄₈" (17.5 x 17.5 cm), total length 13'3" (4.04 m). The National Museums and Galleries on Merseyside, Liverpool, England

Early in November 1519, the army of the Spanish conquistador Hernán Cortés beheld for the first time the great Aztec capital of Tenochtitlan. The shimmering city, which seemed to be floating on the water, was built on islands in the middle of Lake Texcoco in the Valley of Mexico, linked by broad causeways to the mainland. One of Cortés's companions later recalled the wonder the Spanish felt at that moment: "When we saw so many cities and villages built on the water and other great towns and that straight and level causeway going towards [Tenochtitlan], we were amazed . . . on account of the great towers and [temples] and buildings rising from the water, and all built of masonry. And some of our soldiers even asked whether the things that we saw were not a dream" (cited in Berdan, page 1).

The startling mirage that Cortés's soldiers saw was indeed real, a city of stone built on islands—a city that held many treasures and many mysteries. Much of the period before the conquistadores' arrival still remains enigmatic, but a rare manuscript that survived the Spanish Conquest depicts the preconquest worldview of peoples of Mexico at that

time, though it is uncertain whether the manuscript originated with the Aztec or their rivals the Mixtec. At the center of the image here is the ancient fire god Xiuhtecutli (fig. 23-1). Radiating from him are the four directions—each associated with a specific color—as well as a deity and a tree with a bird in its branches. In each corner, to the right of a **U**-shaped band, is an attribute of the god Tezcatlipoca, an omnipotent, primal deity, the "smoking mirror" who could see everything—in the upper right a head, in the upper left an arm, in the lower left a foot, and in the lower right bones. Streams of blood flow from these attributes to the fire god in the center. Such images are filled with important, symbolically coded information—even the dots refer to the number of days in one aspect of the Mesoamerican calendar—and they were integral parts of the culture of the Americas.

INDIGENOUS AMERICAN ART

When the first European explorers and conquerors arrived, the Western Hemisphere was already inhabited from the Arctic Circle to Tierra del Fuego by peoples with long and complex histories and rich and varied cultural traditions (see "Foundations of Civilization in the Americas," below). This chapter focuses on the arts of the indigenous peoples of Mesoamerica, Andean South America, and North America just prior to and in the wake of their encounter with an expansionist Europe.

Although art was central to their lives, the peoples of the Americas set aside no special objects as "works of art." For them, everything had a function. Some objects were essentially utilitarian and others had ritual uses and symbolic associations, but people drew no distinctions between art and other aspects of material culture or between the fine arts and the decorative arts. Understanding Native American art thus requires an understanding of the cultural context in which it was made, a context that in many cases has been lost to time or to the disruptions of the European conquest. Fortunately, art history and archeology have recently contributed to the recovery of at least some of that lost context.

MEXICO AND SOUTH AMERICA

Two great empires—the Aztec in Mexico and the Inka in South America—rose to prominence in the fifteenth century at about the same time that European adventurers began to explore the oceans in search of new trade routes to Asia. In the encounter that followed, the Aztec and Inka Empires were destroyed.

FOUNDATIONS OF CIVILIZATION IN THE AMERICAS

Humans first entered the Western Hemisphere sometime between 12,000 and 30,000 years ago by way of a land bridge in the Bering region that connected Asia and North America during the last Ice Age. By 11,000 years ago they had spread over both North and South America. In many regions they developed a settled, agricultural way of life. In Mesoamerica, in the Andean region of South America, and for a time in what is now the southeastern United States, they developed hierarchical, urban societies with monumental architecture and elaborate artistic traditions.

Mesoamerica extends from north of the Valley of Mexico into Central America. The civilizations that arose there shared a number of features, including writing, a complex calendrical system, a ritual ball game, and several deities and religious beliefs. Their religious practices included blood and human sacrifice. The earliest Mesoamerican civilization, that of the Olmec, flourished between 1200 and 400 BCE. Maya civilization arose around the beginning of the Common Era in southern Mesoamerica and endured until the Spanish Conquest. Its initial focus, during the Classic period (250–900 CE), was in the southern Yucatan but then shifted to the northern Yucatan. The Classic period Maya developed Mesoamerica's most sophisticated writing and calendrical systems. The Valley of Mexico was dominated during the Classic period by the city of Teotihuacan, which exerted widespread influence throughout Mesoamerica. The Toltec established a state north of the Valley of Mexico that endured from about 1000 to 1200. The Aztec Empire emerged in the Valley of Mexico beginning in the thirteenth and fourteenth centuries. By the end of the fifteenth century the Inka Empire controlled the entire Andean region from north of Quito in modern Ecuador to Santiago in modern Chile.

In North America the people of what is now the southeastern United States adopted a settled way of life by around the end of the second millennium BCE and began building monumental earthworks as early as 1300 BCE. The people of the American Southwest developed a settled, agricultural way of life during the first millennium CE. By around 750 CE the Anasazi—the forebears of the modern Pueblo peoples—began building multistoried, apartmentlike structures with many specialized rooms.

PARALLELS

Years	Americas Cultural Centers	Americas	World
c. 1300–1525	Aztec Empire	Capital of Tenochtitlan founded; empire expands through alliances, marriages, conquest; conquered by the Spanish under Cortés	**1300–1500** Hundred Years' War between England and France; Black Death in Europe; Ming dynasty (China); Great Schism in Christian Church; Gutenberg's Bible; Columbus's voyages (Spain); Spanish Inquisition
c. 1300–1537	Inka Empire	Capital of Cuzco flourishes; strong government and religious hierarchy; empire expands to length of 2,600 miles; government control of agriculture; public-works, military, and agricultural production mandatory; extensive roads and storehouses; assassination of Atahualpa and conquest by the Spanish under Pizarro	**1500–1700** Michelangelo's *David* (Italy); Leonardo's *Mona Lisa* (Italy); Michelangelo's Sistine Ceiling (Italy); Protestant Reformation in Europe; Mughal period (India); William Shakespeare born (England); Baroque style emerges in Europe; Peter Paul Rubens (Flanders); Hideyoshi unites Japan; Rembrandt van Rijn (Netherlands); Qing dynasty (China)
c. 1300–	Eastern Woodlands	Hunting and agricultural communities; birch-bark canoes; pottery; Iroquois confederation; quillwork; beadwork; English settle Jamestown, Va.; French settle Quebec, Canada; trading; European encroachment on Native American lands; Indian Removal Act; Trail of Tears	**1700–1800** Union of England and Scotland as Great Britain; British Museum founded; James Watt develops steam engine (Scotland); French Revolution; Age of Enlightenment in Europe
c. 1300–	Great Plains	Groups in permanent villages pursue agriculture while nomadic groups hunt buffalo; tepees; hunting groups increase after Spanish introduce horses; Spanish introduce firearms; Prairie style incorporates elements from Eastern Woodlands	
c. 1300–	Northwest Coast	Extended family groups living in communal timber dwellings; fishing; dugout canoes; wood carving, weaving, and basketry; arrival of European fur traders	
c. 1300–	Southwest	Pueblo dwellers cultivate crops; Navajos establish semisedentary agricultural and herding groups; weaving, painting, sand painting; Spanish settle Sante Fe; Pueblo peoples rise up against Spanish	

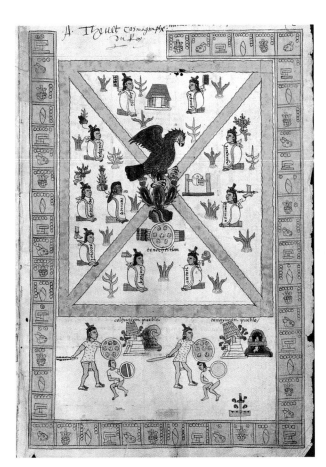

23-2. *The Founding of Tenochtitlan*, page from *Codex Mendoza*. Aztec, 16th century. Ink and color on paper, 8⁷/₁₆ x 12⁶/₁₆" (21.5 x 31.5 cm). The Bodleian Library, Oxford

MS. Arch Selden. A.1.fol. 2r

The Aztec Empire

The people who lived in the remarkable city that Cortés found were then rulers of much of Mexico. Their rise to such power had been recent and swift. Only 400 years earlier, according to their own legends, they had been a nomadic people living on the shores of the mythological Lake Aztlan somewhere to the northwest of the Valley of Mexico, where present-day Mexico City is located. They called themselves the Mexica, hence the name *Mexico.* The term *Aztec* derives from Aztlan.

At the urging of their patron god, Huitzilopochtli, the Aztec began a long migration away from Lake Aztlan, arriving in the Valley of Mexico in the thirteenth century. Driven from place to place, they eventually ended up in the marshes on the edge of Lake Texcoco. There they settled on an island where they had seen an eagle perching on a prickly pear cactus *(tenochtli),* a sign that Huitzilopochtli told them would mark the end of their wandering. They called the place Tenochtitlan. The city, like Venice, grew on a collection of islands linked by canals.

Through a series of alliances and royal marriages, the Aztec gradually rose to prominence, emerging less than a century before the arrival of Cortés as the head of a powerful alliance and the dominant power in the valley. Only then did they begin the aggressive expansion

that brought them tribute from all over Central Mexico and transformed Tenochtitlan into the glittering capital that so impressed the invading Spanish.

Aztec society was divided into roughly three classes: an elite of rulers and nobles, a middle class of professional merchants and luxury artisans, and a lower class of farmers and laborers. The luxury artisans were known as *Toltecca,* reflecting Aztec admiration for the earlier Toltec civilization, which had fallen in the thirteenth century. Commoners and elite alike received rigorous military training.

Aztec religion was based on a complex pantheon that combined the Aztec deities with more ancient ones that had long been worshiped in Central Mexico. According to Aztec belief, the gods had created the current universe at the ancient city of Teotihuacan. Its continued existence depended on human actions, including rituals of bloodletting and human sacrifice. The end of each round of fifty-two years in the Mesoamerican calendar was a particularly dangerous time, requiring a special fire-lighting ritual. Sacrificial victims sustained the sun god in his daily course through the sky. Huitzilopochtli, son of the earth mother Coatlicue and the Aztec patron deity associated with the sun and warfare, also required sacrificial victims so that he could, in a regular repetition of the events surrounding his birth, drive the stars and the moon from the sky at the beginning of each day. The stars were his half brothers, and the moon, Coyolxauhqui, was his half sister. When Coatlicue conceived Huitzilopochtli by inserting a ball of feathers into her chest as she was sweeping, his jealous siblings conspired to kill her. When they attacked, Huitzilopochtli emerged from her body fully grown and armed, drove off his brothers, and destroyed his half sister, Coyolxauhqui.

Most Aztec books were destroyed in the wake of the Spanish Conquest, but the work of Aztec scribes appears in several documents created for Spanish administrators after the conquest. The first page of the *Codex Mendoza,* prepared for the Spanish viceroy in the sixteenth century, can be interpreted as an idealized representation of both the city of Tenochtitlan and its sacred ceremonial precinct (fig. 23-2). An eagle perched on a prickly pear cactus—the symbol of the city—fills the center of the page. Waterways divide the city into four quarters, which are further subdivided into wards, as represented by the seated figures. The victorious warriors at the bottom of the page represent Aztec conquests.

The focal point of the sacred precinct—probably symbolized in figure 23-2 by the temple or house at the top of the page—was the Great Pyramid, a 130-foot-high stepped double pyramid with dual temples on top, one of which was dedicated to Huitzilopochtli and the other to Tlaloc, the god of rain and fertility. Two steep staircases led up the west face of this structure from the plaza in front of it. Sacrificial victims climbed these stairs to the Temple of Huitzilopochtli at the summit, where several priests threw them over a stone and another quickly cut open their chests and pulled out their still-throbbing hearts. Their bodies were then rolled down the stairs and dismembered. Thousands of severed heads were said to have been kept

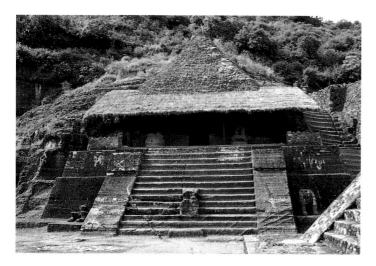

23-3. Rock-cut sanctuary, Malinalco, Mexico. Aztec, 15th century; modern thatched roof

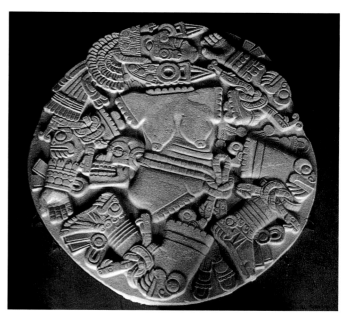

23-4. *The Moon Goddess, Coyolxauhqui.* Aztec, 15th century. Stone, diameter 11'6" (3.5 m)

This disk was discovered accidentally in 1978 by workers from a utility company who were excavating at a street corner in central Mexico City.

on a skull rack in the plaza, represented in figure 23-2 by the rack with a single skull to the right of the eagle. During the winter rainy season the sun rose behind the Temple of Tlaloc, and during the dry season it rose behind the Temple of Huitzilopochtli. The double temple thus united two natural forces, sun and rain, or fire and water. During the spring and autumn equinoxes, the sun rose between the two temples, illuminating the Temple of Quetzalcoatl, the feathered serpent, an ancient creator god associated with the calendar, civilization, and the arts.

Like other Mesoamerican peoples, the Aztec intended their temples to resemble mountains. They also carved shrines and temples directly into the mountains surrounding the Valley of Mexico. A steep flight of stairs leads up to one such temple carved into the side of a mountain at Malinalco (fig. 23-3). The formidable entrance, which resembles the open mouth of the earth monster, leads into a circular room (the thatched roof is modern). If the temple itself is a mountain, surely this space is a symbolic cave, the womb of the earth. A pit for blood sacrifices opens into the heart of the mountain. Stylized eagle and jaguar skins carved into a semicircular bench around the interior are symbols of two Aztec military orders, suggesting that members of those orders performed rites here.

Sculpture of serpents and serpent heads on the Great Pyramid in Tenochtitlan associated it with the "Hill of the Serpent," where Huitzilopochtli slew the moon goddess Coyolxauhqui. A huge circular relief of the dismembered goddess once lay at the foot of the temple stairs, as if the enraged and triumphant Huitzilopochtli had cast her there like a sacrificial victim (fig. 23-4). Her torso is in the center, surrounded by her head and limbs. A rope around her waist is attached to a skull. She has bells on her cheeks

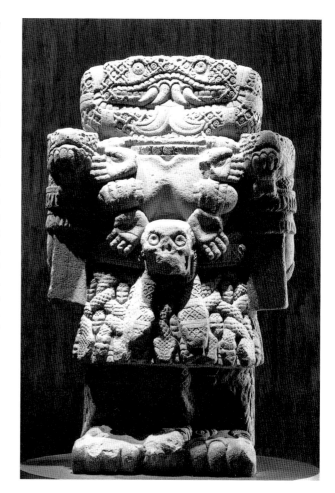

23-5. *The Mother Goddess, Coatlicue.* Aztec, 15th century. Stone, height 8'6" (2.65 m). Museo Nacional de Antropología, Mexico City

and balls of down in her hair. She wears a magnificent headdress and has distinctive ear ornaments composed of disks, rectangles, and triangles. The sculpture is two-dimensional in concept with a deeply cut background.

The Spanish built their own capital, Mexico City, over the ruins of Tenochtitlan and built a cathedral on the site of Tenochtitlan's sacred precinct. An imposing statue of Coatlicue, mother of Huitzilopochtli, was found near the cathedral during excavations there in the late eighteenth century (fig. 23-5). One of the conquistadores described seeing such a statue covered with blood inside the Temple of Huitzilopochtli, where it would have stood high above the vanquished Coyolxauhqui. Coatlicue means "she of the serpent skirt," and this broad-shouldered figure with clawed hands and feet has a skirt of twisted snakes. A pair of serpents, symbols of gushing blood, rise from her neck to form her head. Their eyes are her eyes; their fangs, her tusks. The writhing serpents of her skirt also form her body. Around her stump of a neck hangs a necklace of sacrificial offerings—hands, hearts, and a dangling skull. Despite the surface intricacy, the sculpture's simple, bold, and blocky forms create a single visual whole. The colors with which it was originally painted would have heightened its dramatic impact.

The Inka Empire

At the beginning of the sixteenth century the Inka Empire was one of the largest states in the world, rivaling China in size. It extended more than 2,600 miles along western South America, encompassing most of modern Peru, Ecuador, Bolivia, and northern Chile and reaching into modern Argentina. Like the Aztec Empire, its rise had been recent and swift.

The Inka called their empire the Land of the Four Quarters. At its center was their capital, Cuzco, "the navel of the world," located high in the Andes Mountains. The initial history of the Inka people is obscure. The Cuzco region had been under the control of the earlier Wari Empire, and the Inka state was probably one of many small competing kingdoms that emerged in the highlands in the wake of the Wari collapse. In the fifteenth century the Inkas began suddenly and rapidly to expand, and they subdued most of their vast domain—through conquest, alliance, and intimidation—by 1500. To hold their linguistically and ethnically diverse empire together, the Inka relied on an overarching state religion, a hierarchical bureaucracy, and various forms of labor taxation, in which the payment was a set amount of time spent performing tasks for the state. Agricultural lands were divided into three categories: those for the gods, which supported priests and religious authorities; those for the ruler and the state; and those for the local population itself. As part of their labor tax, people were required to work the lands of the gods and the state for part of each year. In return the state provided them with gifts through their local leaders and sponsored lavish ritual entertainments. Men served periodically on public-works projects—building roads and terracing hillsides, for example—and in the army. The Inka also moved about

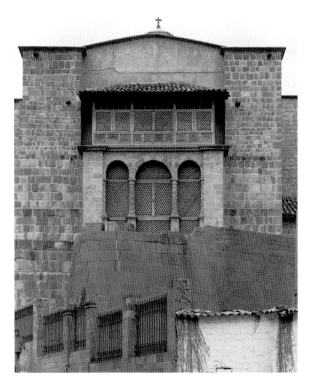

23-6. Walls of the Temple of the Sun, below the Church of Santo Domingo, Cuzco, Peru. Inka, 15th century

The curving lower wall formed part of the Inka Temple of the Sun, also known as the Golden Enclosure or Court of Gold.

whole subject communities to best exploit the resources of their empire. Ranks of storehouses at Inka administrative centers assured the state's ability to feed its armies and supply the people working for it. No Andean civilization ever developed writing, but the Inka kept detailed accounts on knotted and colored cords.

To move their armies around and speed transport and communication within their empire, the Inka built nearly 15,000 miles of roads. These varied from 50-foot-wide thoroughfares to 3-foot-wide paths. In common with other Native American civilizations, the Inka had no wheeled vehicles. Travelers went on foot, and llamas were used as pack animals. Stairways helped travelers negotiate steep mountain slopes, and rope suspension bridges allowed them to cross river gorges. The main road on the Pacific coast, a desert region, had walls to protect it from blowing sand. All along the roads, the Inkas built administrative centers, storehouses, and roadside lodgings. These lodgings—more than a thousand have been found—were spaced a day's journey apart. A relay system of waiting runners could carry messages between Cuzco and the farthest reaches of the empire in about a week.

Cuzco, a capital of great splendor and magnificence, was home to the Inka, as the ruler of the Inka Empire was called, and the extended ruling group. The city, which may have been laid out to resemble a giant puma, was a showcase of the finest Inka masonry, some of which can still be seen in the modern city. The walls of its most magnificent structure, the Temple of the Sun, served as the foundation for the Spanish colonial Church of Santo Domingo (fig. 23-6). Within the Temple of the Sun was a room adorned

ELEMENTS OF ARCHITECTURE

Inka Masonry

Working with the simplest of tools—mainly heavy stone hammers—and using no mortar, Inka builders created stonework of great refinement and durability: roads and bridges that linked the entire empire, built-up terraces for growing crops, and structures both simple and elaborate. At Machu Picchu (fig. 23-7), all buildings and terraces within its 3-square-mile extent were made of granite, the hard stone occurring at the site. Commoners' houses and some walls were constructed of irregular stones that were carefully fitted together. Some walls and certain domestic and religious structures were erected using squared-off, smooth-surfaced stones laid in even rows. At a few Inka sites, the stones were boulder-size: up to 27 feet tall.

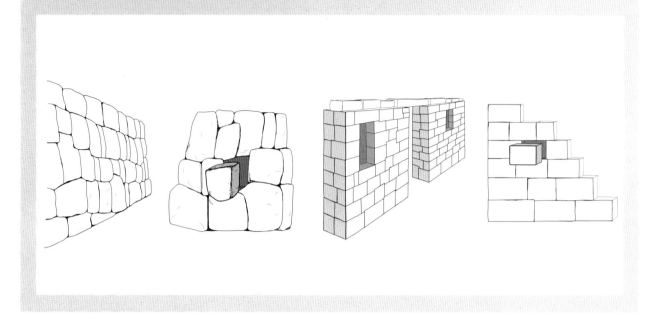

with gold dedicated to the sun and another adorned with silver dedicated to the moon.

Inka masonry has survived earthquakes that have destroyed or seriously damaged later structures. Fine Inka masonry consisted of either rectangular blocks, as in figure 23-6, or irregular polygonal blocks. Both were ground so that adjoining blocks fit tightly together without mortar (see "Elements of Architecture," above). The blocks might be slightly **beveled** so that the stones had a pillowed form and each block retained its identity, or they might, as in figure 23-6, be smoothed into a continuous flowing surface in which the individual blocks form part of a seamless whole. Inka structures had gabled, thatched roofs. Doors, windows, and niches were trapezoid shaped, narrower at the top than the bottom. The effort expended on building by the Inka was prodigious. The temple fortress of Saqsawaman in Cuzco, for example, was reputed to have occupied 30,000 workers for many decades.

Machu Picchu, one of the most spectacular archeological sites in the world, provides an excellent example of Inka architectural planning (fig. 23-7). At 9,000 feet above sea level, it straddles a ridge between two high peaks in the eastern slopes of the Andes and looks down on the Urubamba River. Stone buildings occupy terraces around central plazas, and narrow agricultural terraces descend into the valley. The site lies near the eastern limits of the empire, suggesting that it may have been a frontier outpost. Its temples and carved sacred stones suggest that it also had an important religious function.

The production of fine textiles is of ancient origin in the Andes, and textiles were one of the primary forms of wealth for the Inka. One kind of labor taxation was to require the manufacture of fibers and cloth, and textiles as well as agricultural products filled Inka storehouses. Cloth was a fitting offering for the gods, so fine garments were draped around golden statues, and entire images were constructed of cloth. Garments also carried important symbolic messages. Their patterns and designs were not simply decorative but indicated, among other things, a person's ethnic identity and social rank. Each square in the tunic shown in figure 23-8 represents a miniature tunic, but the meaning of the individual patterns is not yet completely understood. The four-part motifs may refer to the Land of the Four Quarters. The checkerboard pattern designated military officers and royal escorts. The meaning of the diagonal key motif is not known, but it is often found on tunics with horizontal border stripes.

The Spanish who conquered the Inka Empire were far more interested in the Inka's vast quantities of gold and silver objects than in cloth. Whatever they could find, they melted down to enrich themselves and the royal coffers of Spain. The Inka, in contrast, valued gold and silver not as precious metals in themselves but because they saw in them symbols of the sun and the moon. They are said to have called gold the "sweat of the sun" and silver the "tears of the moon." Some small figures, buried as offerings, escaped the conquerors' treasure hunt. The small llama shown in figure 23-9 was found near Lake Titicaca.

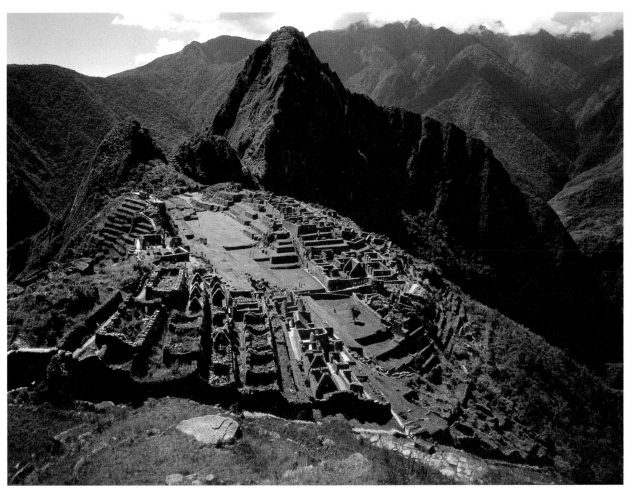

23-7. Machu Picchu, Peru. Inka, 15th–16th centuries

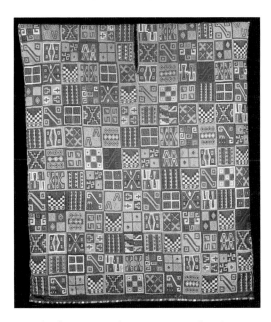

23-8. Tunic, from Peru. Inka, c. 1500. Wool and cotton,
35⅞ x 30" (91 x 76.5 cm). Dumbarton Oaks Research
Library and Collections, Washington, D.C.

Textile patterns and colors were standardized, like
European heraldry or the uniforms of today's sports
teams, to convey information at a glance.

23-9. Llama, from Bolivia or Peru, found near Lake Titicaca,
Bolivia. Inka, 15th century. Cast silver with gold and
cinnabar, 9 x 8½ x 1¾" (22.9 x 21.6 x 4.4 cm). Ameri-
can Museum of Natural History, New York

Trans. #5003

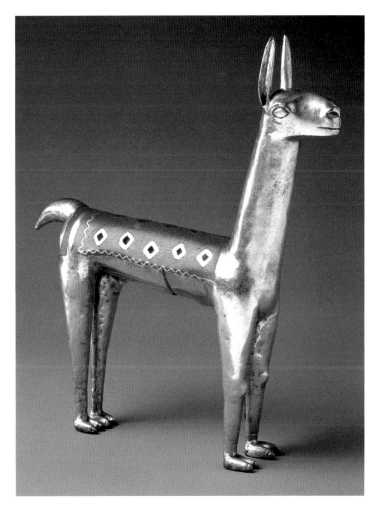

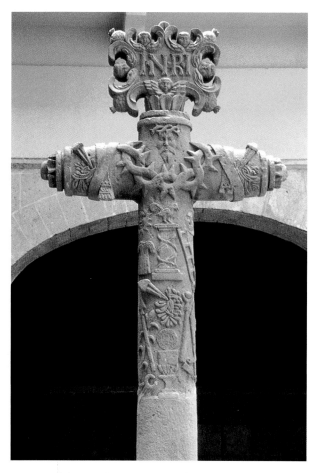

23-10. Atrial cross, from Mexico. Before 1556. Stone, height 11'3" (3.45 m). Chapel of the Indians, Basilica of Guadalupe, Mexico City

The llama had a special connection with the sun, with rain, and with fertility. In Cuzco a llama was sacrificed to the sun every morning and evening. A white llama was kept in the capital as the symbol of the Inka. Dressed in a red tunic and wearing gold jewelry, this llama passed through the streets during April celebrations. According to Spanish commentators, these processions included lifesize gold and silver images of llamas, people, and gods.

The Aftermath of the Spanish Conquest

Hernán Cortés arrived off the coast of Mexico from the Spanish colony in Cuba in 1519. Within two years, after forging alliances with the Aztec's enemies, he had succeeded in taking Tenochtitlan. Over the next several years Spanish forces subdued much of the rest of Mexico and established it as a colony of Spain. In 1532 Francisco Pizarro, following Cortés's example, led an expedition to the land of the Inka. Hearing that the Inka ruler Atahualpa, freshly victorious in the war of succession that followed the death of his father, was progressing south from the city of Quito to Cuzco, Pizarro pressed inland to intercept him. He and his men seized Atahualpa, held him for a huge ransom in gold, then treacherously strangled him. They marched on Cuzco and seized it in 1533. The conquest was followed by a period of disorder,

with Inka rebellions and struggles among the conquistadores themselves, that did not end until about 1550. In both Mexico and Peru the Native American populations declined sharply after the conquest because of the exploitative policies of the conquerors and the ravages of diseases they imported, like smallpox, against which the indigenous people had no immunity.

In the wake of the conquest, Roman Catholicism spread throughout Spanish America, and local beliefs and practices were suppressed. Native American temples were torn down, and churches erected in their place. The work of conversion in the sixteenth century fell to the Franciscan, Dominican, and Augustinian religious orders. Several missionaries were so appalled by the conquerors' treatment of the people they called Indians that they petitioned the Spanish king to improve their condition.

In the course of Native Americans' conversion to Roman Catholicism, their symbolism was to some extent absorbed into Christian symbolism. This process can be seen in the huge early colonial **atrial crosses**, so called because they were located in church atriums, where large numbers of converts gathered for education in their new faith. Early chroniclers wrote that the crosses were decorated with flowers and that children gathered around them for instruction. Missionaries recruited Native American sculptors to carve these crosses. One sixteenth-century atrial cross, now in the Basilica of Guadalupe in Mexico City, suggests pre-Hispanic sculpture in its stark form and rich surface symbols, even though the individual images were probably copied from illustrated books brought by the missionaries (fig. 23-10). The work is made from two large blocks of stone that are entirely covered with low-relief images known as the Arms of Christ, the "weapons" Christ used to defeat the devil. Jesus' Crown of Thorns hangs like a necklace around the cross bar, and with the Holy Shroud, which also wraps the arms, it frames the image of the Holy Face (the cloth with which Veronica wiped Jesus' face). Blood gushes forth where huge nails pierce the ends of the cross. Symbols of regeneration, such as winged **cherub** heads and pomegranates, surround the inscription at the top of the cross.

The cross itself suggests an ancient Mesoamerican symbol, the World Tree or Tree of Life, and the image of blood sacrifice resonates with indigenous beliefs. Like the statue of Coatlicue (see fig. 23-5), the cross is composed of many individual elements that seem compressed to form a shape other than their own. The dense low relief combines into a single massive form. Traditional Christian imagery in a simplified form is clearly visible in the work, although it may not yet have had much meaning or emotional resonance for the artists who put it there.

In 1531 Native American converts gained their own patron saint when the Virgin Mary appeared as a Native American to a Native American named Juan Diego. She is said to have asked that a church be built on a hill where the Aztec mother goddess had once been worshiped. As evidence of this vision, Juan Diego brought flowers that the Virgin had caused to bloom, wrapped in a cloak, to the archbishop. When he opened his bundle, the cloak

bore the image of a dark-skinned Virgin Mary, standing on the moon and clothed with the sun, an image known as the Woman of Revelations. The site of the vision was renamed Guadalupe, after Our Lady of Guadalupe in Spain, and became a venerated pilgrimage center. In 1754 the pope declared the Virgin of Guadalupe to be the patron of the Americas.

NORTH AMERICA

The Europeans who settled America north of Mexico were drawn not by gold and silver but by land. As colonists settled what was to become the United States and Canada, claiming land for their towns, farms, and plantations, they dispossessed the people already living there. European explorers and settlers had little interest in Native American arts. Much of it was small, portable, fragile, and impermanent; its symbolic language was misunderstood; and until recently its aesthetic quality was unappreciated.

Eastern Woodlands and the Great Plains

When European settlement began, forests covered eastern North America from Hudson Bay to the Gulf of Mexico and from the Atlantic coast to the Mississippi River and Missouri River watersheds. Between this Eastern Woodlands region and the Rocky Mountains to the west lay an area of prairie grasslands now known as the Great Plains.

The Native American peoples of the Eastern Woodlands supported themselves by a combination of hunting and agriculture. They lived in villages and cultivated corn, squash, and beans. They used flexible and waterproof birch bark to construct their homes and to make the extremely functional river and lake craft known as the canoe. After the arrival of the Europeans, they exchanged furs for such useful items as metal kettles and needles, cloth, and beads. In the sixteenth century one Eastern Woodlands group, the Iroquois, formed a sophisticated and powerful confederation of Native American nations in the Northeast that played a prominent military and political role until after the American Revolution.

Before the coming of the Europeans, two differing ways of life developed on the Great Plains, one nomadic—dependent for food, clothing, and shelter on the region's great migrating herds of buffalo—and the other sedentary and agricultural. The introduction of the horse to the prairies by Spanish explorers in the late seventeenth century transformed Plains life. Horses—and, later, firearms—made buffalo hunting vastly more efficient than before and attracted more people to the nomadic way of life.

As European settlers on the eastern seaboard began to turn forests into farms, they put increasing pressure on the Eastern Woodlands peoples, depriving them of their lands and forcing them westward. This steady encroachment reached a climax when the U.S. Congress passed the Indian Removal Act of 1830, which forced many eastern groups to resettle west of the Mississippi River. Just one of the consequences of this law was the infamous 1838–1839 "Trail of Tears," the forced march of the Cherokee to Oklahoma from their towns and farms in

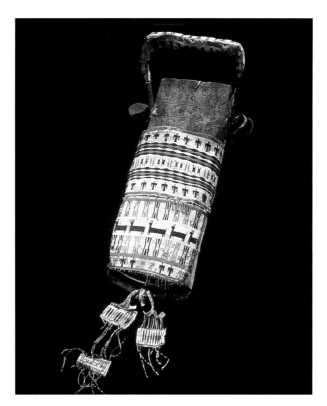

23-11. Baby carrier, from the Upper Missouri River area. Eastern Sioux, 19th century. Board, buckskin, porcupine quill, length 31" (78.8 cm). Smithsonian Institution Libraries, Washington, D.C.

Georgia. The resulting interaction of Eastern Woodlands artists with one another and with Plains artists led to the emergence of the Prairie style among numerous groups.

One distinctively Eastern Woodlands medium that found its way into the Plains was **quillwork** embroidery. Quillwork involved soaking porcupine and bird quills to soften them, dyeing them, and then working them into rectilinear, ornamental surface patterns on deerskin clothing and on birch-bark artifacts like baskets and boxes. A Sioux legend recounts how a mythical ancestor, Doublewoman ("double" because she was both beautiful and ugly, benign and dangerous), appeared to a woman in a dream and taught her the art of quillwork. As this legend suggests, quillwork was a woman's art form. The Sioux baby carrier shown in figure 23-11 is richly decorated with symbols of protection and well-being, including bands of antelopes in profile and thunderbirds with their heads turned and tails outspread. The thunderbird was an especially beneficent symbol, thought to be capable of protecting against both human and supernatural adversaries.

Another medium associated with the Eastern Woodlands groups that was adopted by the Plains peoples was **beadwork**. Eastern Woodlands peoples had long made wampum, belts of cylindrical purple and white beads made from clam shells or the center spirals of conch shells. The Iroquois and Delaware used wampum to keep records and exchanged it to conclude treaties. Decorative beadwork, on the other hand, did not become commonplace until after the European contact. It initially

23-12. Shoulder bag, from Kansas. Delaware, c. 1860. Wool fabric, cotton fabric and thread, silk ribbon, and glass beads, 23 x 7¾" (58.5 x 19.8 cm). The Detroit Institute of Arts
Founders Society Purchase (81.216)

mimicked the patterns and colors of quillwork and in the nineteenth century began to replace quillwork in some places. In the late eighteenth century Native American artists began to acquire European colored glass beads, and in the nineteenth century they favored tiny seed beads from Venice and Bohemia. In a process known as **reintegration**, they began to adapt European needlework techniques and patterns and the design of European garments into their own work. Some of the functional aspects of those garments were transformed into purely decorative motifs; a pocket, for example, would be replaced by an area of beadwork in the *form* of a pocket.

An example of beadwork is the shoulder bag from Kansas, made around 1860 by a Delaware woman, shown in figure 23-12. In contrast to the rectilinear patterns of quillwork, the bag is covered with curvilinear plant motifs. White lines outline brilliant pink and blue leaf-shaped forms, heightening the intensity of the colors, and colors alternate within repeated patterns that have no consistent foreground or background.

The nomadic Plains peoples developed a light, portable dwelling known as a **tepee** (fig. 23-13), which was well designed to withstand the wind, dust, and rain of the prairies. The framework of a tepee consisted of a

23-13. Blackfoot women raising a tepee. Photographed c. 1900. Montana Historical Society, Helena

stable frame of three or four long poles, filled out with about twenty additional poles, in a roughly egg-shaped plan. The framework was covered with hides (or, later, with canvas) to form an almost conical structure that leaned slightly in the direction of the prevailing west wind. The hides were specially prepared to make them flexible and waterproof. A typical tepee required about eighteen hides, the largest about thirty-eight hides. The opening at the top served as a smoke hole for the central hearth. The flap-covered door and smoke hole usually faced east, away from the wind. An inner lining covered the lower part of the walls and the perimeter of the floor

to protect the occupants from drafts. When packed to be dragged by a horse, the tepee served as a platform for transporting other possessions as well. When the Blackfeet gathered in the summer for their ceremonial Sun Dance, they formed their hundreds of tepees into a circle a mile in circumference. The Sioux encamped in two half circles—one for the sky people and one for the earth people—divided along an east-west axis.

Tepees were the property and responsibility of women, who raised them at new encampments and lowered them when the group moved on. Blackfeet women could set up their huge tepees in less than an hour. Women painted, embroidered, quilled, and beaded tepee linings, backrests, clothing, and equipment. The patterns with which tepees were decorated, as well as their proportions and colors, varied from Native American nation to nation. In general, the bottom was covered with a group's traditional motifs and the center section with personal images.

Plains men recorded their exploits in symbolic and narrative form in paintings on tepee linings and covers and on buffalo-hide robes. The earliest known painted buffalo-hide robe illustrates a battle fought in 1797 between the Mandan of North Dakota and their allies against the Sioux (fig. 23-14). The painter, trying to capture the full extent of a conflict in which five nations took part, shows a party of warriors in twenty-two separate episodes. Their leader appears with a pipe and wears an elaborate eagle-feather headdress. The party is armed with bows and arrows, lances, clubs, and flintlock rifles. The lively stick figures of the warriors have rectangular torsos and tiny round heads. Details of equipment and emblems of rank—headdresses, sashes, shields, feathered

23-14. Battle-scene hide painting, from North Dakota. Mandan, 1797–1805. Tanned buffalo hide, dyed porcupine quills, and black, red, green, yellow, and brown pigment, 7'10" x 8'6" (2.44 x 2.65 m). Peabody Museum of Archaeology, Harvard University, Cambridge, Massachusetts (99-12-10/53121)

This robe, collected by Meriwether Lewis and William Clark on their 1803–1806 expedition into western lands acquired by the United States in the Louisiana Purchase, is the earliest documented example of Plains painting. The robe was one of a number of Native American artworks that Lewis and Clark sent to President Thomas Jefferson. Jefferson displayed the robe in the entrance hall of his home at Monticello, Virginia.

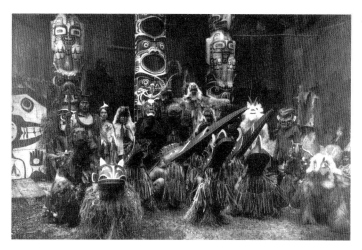

23-15. Edward S. Curtis. Hamatsa dancers, Kwakiutl, Canada. Photographed 1914

The photographer Edward S. Curtis (1868–1952) devoted thirty years to documenting the lives of Native Americans. This photograph shows participants in a film he made about the Kwakiutl. For the film, his Native American informant and assistant, Richard Hunt, borrowed family heirlooms and commissioned many new pieces from the finest Kwakiutl artists. Most of the pieces are now in museum collections. The photograph shows carved and painted posts, masked dancers (including those representing cannibal birds), a chief at the left (holding a speaker's staff and wearing a cedar neck ring), and spectators at the right.

lances, powder horns for the rifles—are accurately depicted. Horses are shown in profile with stick legs and C-shaped hooves. Some have clipped manes, others have flowing manes. The figures stand out against the light-colored, almost white background of the buffalo hide. Lines were pressed into the hide, and black, red, green, yellow, and brown pigments added. A strip of colored porcupine quills runs down the spine. The robe would have been worn draped over the shoulders of the powerful warrior whose deeds it commemorates. As he moved, the painted horses and warriors would have come alive, transforming him into a living representation of his exploits.

The Northwest Coast

From southern Alaska to northern California, the Pacific coast of North America is a region of unusually abundant resources. Its many rivers fill each year with salmon returning to spawn. Harvested and dried, the fish could sustain large populations throughout the year. The peoples of the Northwest Coast—among them the Tlingit, the Haida, and the Kwakiutl—exploited this abundance to develop a complex and distinctive way of life in which the arts played a central role.

Northwest Coast peoples lived in extended family groups in large, elaborately decorated communal houses made of massive timbers and thick planks. Family groups claimed descent from a mythic animal or animal-human ancestor. Social rank within and between related families was based on genealogical closeness to the mythic ancestor. Chiefs, who were in the most direct line of descent from the ancestor, administered a family's spiritual and material resources. Chiefs validated their status and garnered prestige for themselves and their families by holding ritual feasts in which they gave valuable gifts to the invited guests. Shamans, who were sometimes also chiefs, mediated between the human and spirit worlds. A family derived its name and the right to use certain animals and spirits as totemic emblems, or crests, from its mythic ancestor. These emblems appeared prominently in Northwest Coast art, notably in carved house crests and the tall, freestanding poles erected to memorialize dead chiefs.

23-16. Grizzly bear house-partition screen, from the house of Chief Shakes of Wrangell, Canada. Tlingit, c. 1840. Cedar, native paint, and human hair, 15 x 8' (4.57 x 2.74 m). Denver Art Museum

The participants who danced in Northwest Coast ceremonies wore elaborate costumes and striking carved wooden masks. Among the most elaborate masks were those used by the Kwakiutl in their Winter Dance for initiating new members into the shamanistic Hamatsa society (fig. 23-15). The dance reenacted the taming of Hamatsa, a people-eating spirit, and his three attendant bird spirits. Magnificent carved and painted masks transformed the dancers into Hamatsa and the bird attendants, who searched for victims to eat. Strings allowed the dancers to manipulate the masks so that the beaks opened and snapped shut with spectacular effect.

23-17. Chilkat blanket. Tlingit, before 1928. Mountain-goat wool and shredded cedar bark, 4'7¹/₈" x 5'3³/₄" (1.40 x 1.62 m). American Museum of Natural History, New York

Trans. #3804

Carved and painted house-partition screens separated a chief's quarters from the rest of a communal house. The screen shown in figure 23-16 came from the house of Chief Shakes of Wrangell (d. 1916), whose family crest was the bear. The image of a rearing grizzly painted on the screen is itself made up of smaller bears and bear heads that appear in its ears, eyes, nostrils, joints, paws, and body. The images within the image enrich the monumental symmetrical design. The oval door opening is a symbolic vagina; passing through it reenacts the birth of the family from its ancestral spirit.

Blankets and other textiles produced by the Chilkat Tlingit had great prestige throughout the Northwest Coast (fig. 23-17). Chilkat men created the patterns, which they drew on boards, and women did the weaving. The blankets are made from shredded cedar bark wrapped with mountain-goat wool. The weavers did not use looms; instead, they hung **warp** threads from a rod and twisted colored threads back and forth through them to make the pattern. The ends of the warp formed the fringe at the bottom of the blanket.

The small face in the center of the blanket shown here represents the body of a stylized creature, perhaps a sea bear or a standing eagle. On top of the body are the creature's large eyes; below it and to the sides are its legs and claws. Characteristic of Northwest painting and weaving, the images are composed of two basic elements: the **ovoid**, a slightly bent rectangle with rounded corners, and the **formline**, a continuous, shape-defining line. Here, subtly swelling black formlines define structures with gentle curves, ovoids, and rectangular **C** shapes. When the blanket was worn, its two-dimensional forms would have become three-dimensional, with the dramatic central figure curving over the wearer's back and the more intricate side panels crossing over his shoulders and chest.

The contemporary Canadian Haida artist Bill Reid (b. 1920) has sought to sustain and revitalize the traditions of Northwest Coast art in his work. Trained as a wood carver, painter, and jeweler, Reid revived the art of carving dugout canoes and totem poles in the Haida homeland of Haida Gwaii—"Islands of the People"—known on maps today as the Queen Charlotte Islands. Late in life he began to create large-scale sculpture in bronze. With their black patina, these works recall traditional Haida carvings in argillite, a shiny black stone. One of them,

23-18. Bill Reid. *The Spirit of Haida Gwaii.* Haida, 1991.
Bronze, approx. 13 x 20' (4 x 6 m). Canadian Embassy,
Washington, D.C.

The Spirit of Haida Gwaii, now stands outside the Canadi-
an Embassy in Washington, D.C. (fig. 23-18). This sculp-
ture, which Reid views as a metaphor for modern
Canada's multicultural society, depicts a collection of fig-
ures from the natural and mythic worlds struggling to
paddle forward in a canoe. The dominant figure in the
center is a shaman in a spruce-root basket hat and
Chilkat blanket holding a speaker's pole, a staff that gives
him the right to speak with authority. In the prow, the
place reserved for the chief in a war canoe, is the Bear.
The Bear faces backward rather than forward, however,
and is bitten by the Eagle, with formline-patterned wings.
The Eagle, in turn, is bitten by the Seawolf. The Eagle and

the Seawolf, together with the man behind them, never-
theless continue paddling. In the stern, steering the
canoe, is the Raven, the trickster in Haida mythology. The
Raven is assisted by Mousewoman, the traditional guide
and escort of humans in the spirit realms. On the other
side, not visible here, are the Bear mother and her twins,
the Beaver, and the Dogfish Woman. According to Reid,
the work represents a "mythological and environmental
lifeboat," where "the entire family of living things . . .
whatever their differences, . . . are paddling together in
one boat, headed in one direction."

The Southwest

The Native American peoples of the southwestern United
States include, among others, the Pueblo (village-
dwelling) groups and the Navajo. The Pueblo groups are
heirs to the ancient Anasazi and Hohokam cultures,
which developed a settled, agricultural way of life around
the beginning of the Common Era. The Anasazi built the
many large, multistoried, apartmentlike villages and cliff
dwellings whose ruins are found throughout northern
Arizona and New Mexico. The Navajo, who moved into
the region more recently—in about the eleventh century
or later—developed a semisedentary way of life based on
agriculture and, after the introduction of sheep by the
Spanish, sheepherding. Both groups have succeeded in
maintaining many of their traditions despite first Spanish
and then Anglo-American encroachments. Their arts
reflect the adaptation of traditional forms to new tech-
nologies, new mediums, and the influences of the dom-
inant American culture that surrounds them. Such
adaptations are seen among various groups and in all
mediums (see "Basketry," below).

TECHNIQUE

BASKETRY

Basketry involves weaving reeds, grasses, and
other materials to form containers. In North
America the earliest evidence of basketwork, found in
Danger Cave, Utah, dates to as early as 8400 BCE. Over the
subsequent centuries Native American women, notably
in California and the Southwest, developed basketry into
an art form that combined utility with great beauty.

There are three principal basket-making techniques:
coiling, twining, and **plaiting**. Coiling involves sewing
together a spiraling foundation of rods with some other
material. Twining involves sewing together a vertical
warp of rods. Plaiting involves weaving strips over and
under each other.

The coiled basket shown here was made by the
Pomo of California. According to Pomo legend, the earth
was dark until their ancestral hero stole the sun and
brought it to earth in a basket. He hung the basket first
just over the horizon, but, dissatisfied with the light it
gave, he kept suspending it in different places across the
dome of the sky. He repeats this process every day, which
is why the sun moves across the sky from east to west.
In the Pomo basket the structure of coiled willow and
bracken fern root produces a spiral surface into which
the artist worked sparkling pieces of clamshell, trade

beads, and the soft tufts of woodpecker and
quail feathers. The underlying basket, the glit-
tering shells, and the soft, moving feathers make this an
exquisite container. Such baskets were treasured pos-
sessions, cremated with their owners at death.

Wedding basket. Pomo, c. 1877. Willow, bracken fern
root, clamshell, trade beads, woodpecker and quail
feathers, height 5½" (14 cm), diameter 12" (36.5 cm).
Philbrook Museum of Art, Tulsa, Oklahoma
Clark Field Collection

23-19. Laura Gilpin. Taos Pueblo, Tewa, Taos, New Mexico. Photographed 1947. Amon Carter Museum, Forth Worth, Texas

Laura Gilpin Collection (neg. # 2528.1)

The Pueblos. Some Pueblo villages today, like those of their Anasazi forebears, consist of multistoried, apartmentlike dwellings of considerable architectural interest. One of these, Taos Pueblo, shown here in a mid-twentieth-century photograph, is located in north-central New Mexico (fig. 23-19). The northernmost of the surviving Pueblo communities, Taos once served as a trading center between Plains and Pueblo peoples. It burned in 1690 but was rebuilt about 1700 and has often been modified since. Its great "houses," multifamily dwellings, stand on either side of Taos Creek, rising in a stepped fashion to form a series of roof terraces. The houses border a plaza that opens toward the neighboring mountains. The plaza and roof terraces are centers of communal life and ceremony.

Pottery traditionally was a woman's art among Pueblo

peoples, whose wares were made by **coiling** and other handbuilding techniques, then fired at low temperature in wood bonfires. One of the best-known twentieth-century Pueblo potters is Maria Montoya Martinez (1887–1980) of San Ildefonso Pueblo. Inspired by prehistoric **blackware** pottery that was unearthed at nearby archeological excavations, she and her husband, Julian Martinez (1885–1943), developed a distinctive new ware decorated with **matte** (nongloss) black forms on a lustrous black background (fig. 23-20). The Martinezes achieved the ware's black color through creating an oxygen-poor atmosphere by smothering vessels with horse manure and wood ash near the end of a firing. They achieved the lustrous surface areas by polishing the matte areas with a fine shale paste that they discovered in 1918. Their decorative patterns were inspired by both traditional Pueblo imagery and the then-fashionable Euro-American Art Deco style.

In the 1930s Anglo-American art teachers and dealers worked with Native Americans of the Southwest to create a distinctive "Indian" style in several mediums—including jewelry, pottery, weaving, and painting—that would appeal to tourists and collectors. A leader in this effort was Dorothy Dunn, who taught painting in the Santa Fe Indian School, a government high school, from 1932 to 1937. Dunn inspired her students to create a painting style that combined the outline drawing and flat colors of folk art, the decorative qualities of Art Deco, and "Indian" subject matter. The success of the style made painting a viable occupation for young Native American artists.

Pablita Velarde (b. 1918), a 1936 graduate of Dorothy Dunn's school, was only a teenager when one of her paintings was selected for exhibition at the Chicago

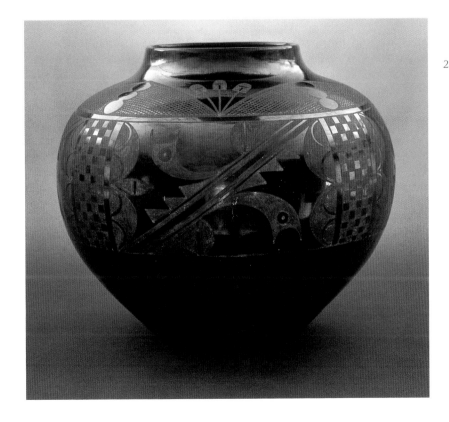

23-20. Maria Montoya Martinez and Julian Martinez. Blackware storage jar, from San Ildefonso Pueblo, New Mexico. Hopi, c. 1942. Ceramic, height 18³/₄" (47.6 cm), diameter 22¹/₂" (57.1 cm). Museum of Indian Arts and Culture/ Laboratory of Anthropology, Museum of New Mexico, Santa Fe

NAVAJO NIGHT CHANT

This chant accompanies the creation of a sand painting during a Navajo curing ceremony. It is sung toward the end of the ceremony and indicates the restoration of inner harmony and balance.

In beauty (happily) I walk.
With beauty before me I walk.
With beauty behind me I walk.
With beauty below me I walk.
With beauty above me I walk.
With beauty all around me I walk.

It is finished (again) in beauty.
It is finished in beauty.

(cited in Washington Mathews, *American Museum of Natural History Memoir*, no. 6, New York, 1902, page 145)

23-21. Pablita Velarde. *Koshares of Taos*, from Santa Clara Pueblo, New Mexico. 1946–47. Watercolor, 13⅞ x 22⅜" (35.3 x 56.9 cm). Philbrook Museum of Art, Tulsa, Oklahoma

23-22. Hosteen Klah. *Whirling Log Ceremony*, sand-painting tapestry by Mrs. Sam Manuelito. Navajo, c. 1925. Wool, 5'5" x 5'10" (1.69 x 1.82 m). Heard Museum, Phoenix, Arizona

World's Fair in 1933. Velarde, from the Santa Clara Pueblo in New Mexico, began to document Pueblo ways of life as her work matured. *Koshares of Taos* (fig. 23-21) illustrates a moment during a ceremony celebrating the winter solstice when koshares, or clowns, have taken over the plaza from the kachinas—the supernatural counterparts of animals, natural phenomena like clouds, and geological features like mountains—who are central to traditional Pueblo religion. Kachinas become manifest in the human dancers who impersonate them during the winter solstice ceremony, as well as in the small figures known as kachina dolls that are given to children. Velarde's painting combines bold, flat colors and a simplified decorative line with European perspective to produce a kind of Art Deco abstraction.

The Navajos. Navajo women are renowned for their skill as weavers. According to Navajo mythology, the universe itself is a kind of weaving, spun by Spider Woman out of sacred cosmic materials. Spider Woman taught the art of weaving to Changing Woman (a mother earth figure who constantly changes through the seasons), who in turn taught it to Navajo women. The earliest Navajo blan-

kets have simple horizontal stripes, like those of their Pueblo neighbors, and are limited to the white, black, and brown colors of natural sheep's wool. Over time, the weavers developed finer techniques and introduced more intricate patterns. In the mid-nineteenth century they began unraveling the fibers from commercially manufactured and dyed blankets and reusing them in their own work. By 1870–1890 they were weaving spectacular blankets that were valued as prestige items among the Plains peoples as well as Euro-American collectors.

Another traditional Navajo art, sand painting, is the exclusive province of men. Sand paintings are made to the accompaniment of chants by shaman-singers in the course of healing and blessing ceremonies and have great sacred significance (see "Navajo Night Chant," above). The paintings depict mythic heroes and events; as ritual art they follow prescribed rules and patterns that ensure their power. To make them, the singer dribbles pulverized colored stones, pollen, flowers, and other natural colors over a hide or sand ground. The rituals are intended to restore harmony to the world. The paintings are not meant for public display and are destroyed by nightfall of the day on which they are made.

23-23. Jaune Quick-to-See Smith. *Trade (Gifts for Trading Land with White People)*. Salish-Cree-Shoshone, 1992. Oil and collage on canvas, 5' x 14'2" (1.56 x 4.42 m). Chrysler Museum, Norfolk, Virginia

Courtesy Steinbaum Krauss Collection, New York City

In 1919 a respected shaman-singer named Hosteen Klah began to incorporate sand-painting images into weavings, breaking with the traditional prohibition against making them permanent. Many Navajos took offense at Klah both for recording the sacred images and for doing so in a woman's art form, but the works were ultimately accepted because of his great skill and prestige. Klah's *Whirling Log Ceremony* sand-painting, shown here in a tapestry (fig. 23-22), depicts a part of the Navajo creation myth in which the Holy People divide the world into four parts, create the Earth Surface People (humans), and bring forth corn, beans, squash, and to-bacco, the four sacred plants. The Holy People surround the image, and a male-female pair of humans stands in each of the four quarters defined by the central cross. The guardian figure of Rainbow Maiden encloses the scene on three sides. The open side represents the east. Like all Navajo artists, Hosteen Klah hoped that the excellence of the work would make it pleasing to the spirits. Recently, singers have started making permanent sand paintings on boards for sale, but they always introduce slight errors in them to render them ceremonially harmless.

CONTEMPORARY NATIVE AMERICAN ART

Many Native American artists today are seeking to move beyond the occasionally self-conscious revival of traditional forms to a broader art that acknowledges and mediates among the complex cultural forces shaping their lives. One exemplar of this trend is Jaune Quick-to-See Smith (b. 1940), who was raised on Flatrock Reservation in Montana and traces her descent to the Salish of the Northwest Coast, the Shoshone of southern California,

and the Cree, a northern woodlands and plateau people. Quick-to-See Smith described the multiple influences on her work this way: "Inhabited landscape is the continuous theme in my work. Pictogram forms from Europe, the Amur, the Americas; color from beadwork, parfleches, the landscape; paint application from Cobra art, New York expressionism, primitive art; composition from Kandinsky, Klee, or Byzantine art provide some of the sources for my work. Study of the wild horse ranges, western plants and animals, and ancient sites feed my imagination and dreams. This is how I reach out and strike new horizons while I reach back and forge my past" (*Women of Sweetgrass*, page 97).

During the United States' quincentennial celebration of Columbus's arrival in the Americas—in her words, the beginning of "the age of tourism"—Quick-to-See Smith created paintings and collages of great formal beauty that also confronted viewers with their own, perhaps unwitting, stereotypes (fig. 23-23). In *Trade (Gifts for Trading Land with White People)*, a stately canoe floats over a richly colored and textured field, which on closer inspection proves to be a dense collage of newspaper clippings from local Native American newspapers. Wide swatches and rivulets of red, yellow, green, and white cascade over the newspaper collage. On a chain above the painting is a collection of both Native American cultural artifacts—tomahawks, beaded belts, feather headdresses—and American sports memorabilia for teams with names like the Atlanta Braves, the Washington Redskins, and the Cleveland Indians that many Native Americans find offensive. Surely, the painting suggests, Native Americans could trade these goods to retrieve their lost lands, just as European settlers traded trinkets with Native Americans to acquire the lands in the first place.

Mimis and Kangaroo
Aborigine
16,000–7000 BCE

Pottery fragment
Lapita
1200–1100 BCE

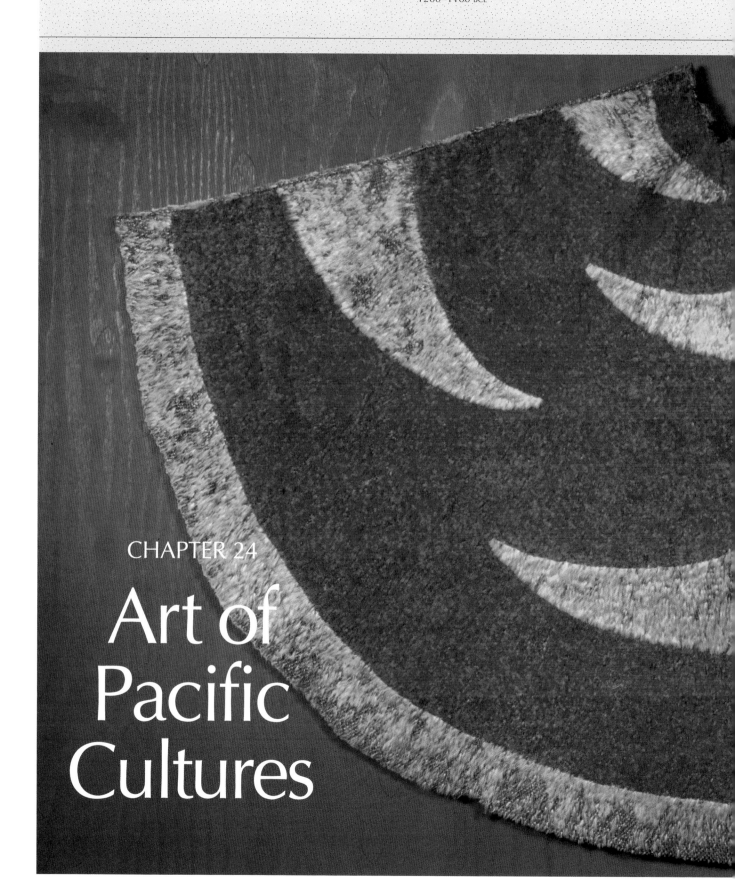

CHAPTER 24

Art of
Pacific
Cultures

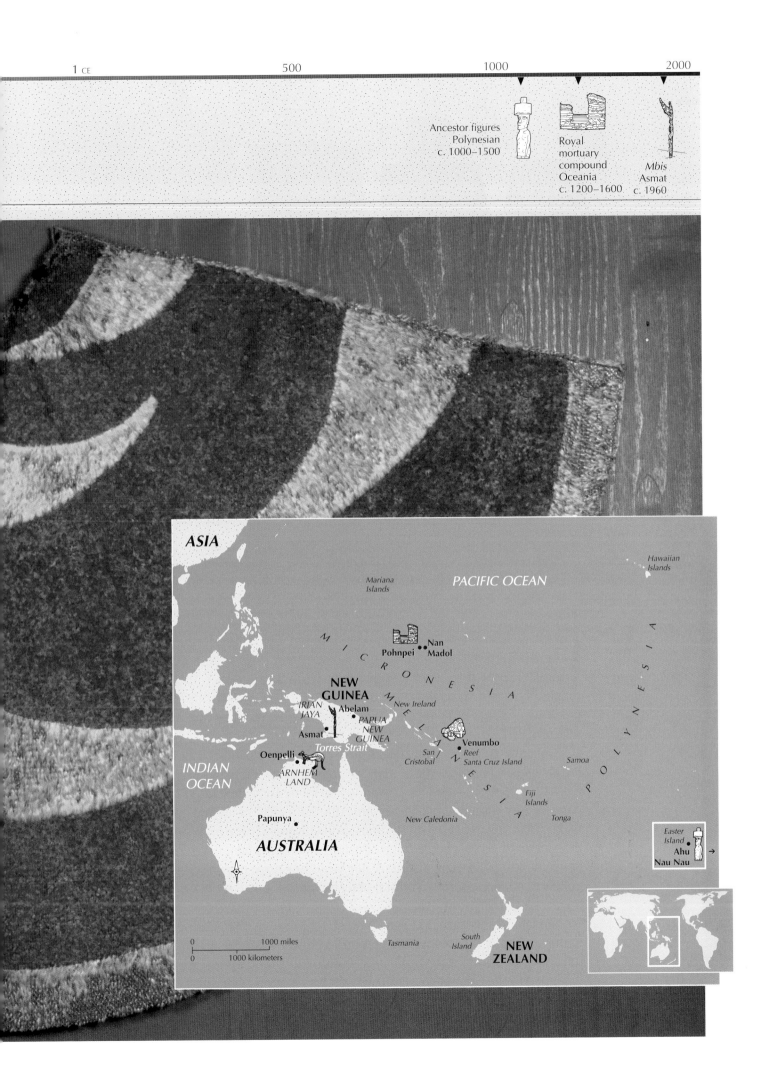

Ancestor figures
Polynesian
c. 1000–1500

Royal
mortuary
compound
Oceania
c. 1200–1600

Mbis
Asmat
c. 1960

ASIA

Hawaiian Islands

Mariana Islands

PACIFIC OCEAN

M I C R O N E S I A

Pohnpei • Nan
Madol

NEW
GUINEA

*IRIAN
JAYA* ■ Abelam

M
E
L
A
N
E
S
I
A

New Ireland

P
O
L
Y
N
E
S
I
A

Asmat *PAPUA
NEW
GUINEA*

Venumbo
Reef

Oenpelli
Torres Strait

*San
Cristobal* *Santa Cruz Island*

Samoa

*ARNHEM
LAND*

INDIAN
OCEAN

*Fiji
Islands*

Papunya •

New Caledonia

Tonga

AUSTRALIA

*Easter
Island* •
Ahu
Nau Nau →

0 1000 miles
0 1000 kilometers

Tasmania

*South
Island*

NEW
ZEALAND

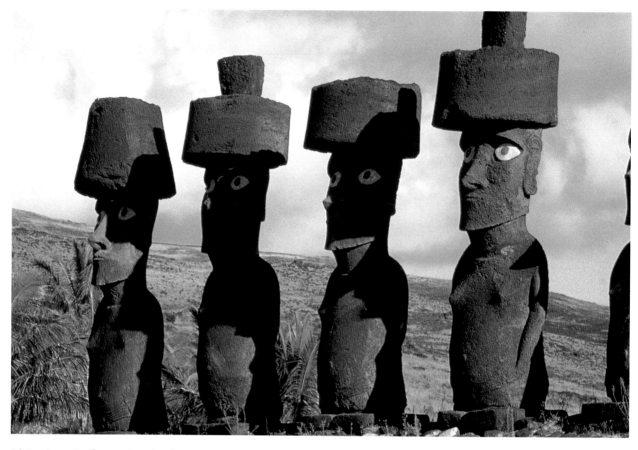

24-1. Ancestor figures (*moai*)? Ahu Nau Nau, Easter Island, Polynesia. c. 1000–1500, restored 1978. Volcanic stone (tufa), average height approx. 36' (11 m)

In an effort to preserve the culture and landscape of Easter Island, the Chilean government has made its archeological sites into a national park. Some of the huge stone figures have been re-erected and restored with their coral and stone eyes and their red tufa topknots in place. Some of the topknots are as tall as 9 feet.

I n the middle of the Great Ocean, in a region where no one ever passes, there is a mysterious and isolated island; there is no land in the vicinity and, for more than eight hundred leagues in all directions, empty and moving vastness surrounds it. It is planted with tall, monstrous statues, the work of some now-vanished race, and its past remains an enigma" (Pierre Loti, *L'Île de Pâques*, 1872).

The early travelers who successfully reached the islands that lie in the Pacific Ocean found far more than the mysterious, "monstrous" statues of Easter Island (fig. 24-1). Those islands that came to be described as simple paradises by romantic European and American visitors, in fact, support widely differing ecosystems, peoples, and cultures. There, over many thousands of years, people have developed complex belief systems that have encouraged a rich, visionary life. And they have expressed their beliefs in concrete form—in ritual objects, masks, and the enrichment of their material environment.

Nineteenth-century explorers who sought that vastness using the earliest maps of the region, about a hundred years old, found only an uncertain location for the unknown "continent" that mapmakers believed extended to the South Pole. For them, as for us, maps helped to create a view of the world and establish their place in it. European medieval maps, for example, placed Jerusalem in the center, while later cartographers

focused on Rome. Westerners are so accustomed to thinking of a world grid originating at an observatory in Greenwich, England, or to imagining a map with the United States as the center of the world that other images are almost inconceivable. From a Northern Hemisphere point of view the great landmasses of Australia, New Guinea, and New Zealand become lands "down under," sliding off under the globe, remote from "our" world. But a simple shift of viewpoint—or a map in which the vast Pacific Ocean forms the center of a composition—suddenly marginalizes the Americas, and Europe disappears altogether.

THE PEOPLING OF THE PACIFIC

On a map with the Pacific Ocean as its center, only the peripheries of the great landmasses of Asia and the Americas appear. This immense, watery region consists of four cultural-geographic areas: Australia, Melanesia, Micronesia, and Polynesia. *Australia* includes the island continent as well as the island of Tasmania to the southeast. *Melanesia* (a term meaning "black islands," a reference to the dark skin color of its inhabitants) includes New Guinea and the string of islands that extends eastward from it as far as Fiji and New Caledonia. *Micronesia* ("small islands"), to the north of Melanesia, is a region of small islands, including the Marianas. *Polynesia* ("many islands") is scattered over a huge, triangular region defined by New Zealand in the south, Easter Island in the east, and the Hawaiian Islands to the north. The last region on earth to be inhabited by humans, Polynesia covers some 7.7 million square miles, of which fewer than 130,000 square miles are dry land—and most of that is New Zealand. Melanesia and Micronesia are also known as Near Oceania, and Polynesia as Far Oceania.

Australia, Tasmania, and New Guinea formed a single continent during the last Ice Age, which began some 2.5 million years ago. Some 50,000 years ago, when the sea level was about 330 feet lower than it is today, people had moved into this continent from Southeast Asia, making at least part of the journey over open water. Some 27,000 years ago they were settled on the large islands north and east of New Guinea as far as San Cristóbal, but they ventured no farther for another 25,000 years. By about 4000 BCE—possibly as early as 7000 BCE—the people of Melanesia were raising pigs and cultivating taro, a plant with edible rootstocks. As the glaciers melted, the sea level rose, flooding low-lying coastal land. By around 4000 BCE a 70-mile-wide waterway, now called the Torres Strait, separated New Guinea from Australia, whose people retained a hunting and gathering way of life into the twentieth century.

The settling of the rest of the islands of Melanesia and the westernmost islands of Polynesia—Samoa and Tonga—coincided with the spread of the seafaring Lapita culture, named for a site in New Caledonia, after about 1500 BCE. The Lapita people were farmers and fisherfolk who lived in often large coastal villages, probably cultivated taro and yams, and produced a distinctive style of pottery. They were skilled shipbuilders and navigators and engaged in interisland trade. Over time the Lapita culture lost its widespread cohesion and evolved into various local forms. Polynesian culture apparently emerged in the eastern Lapita region on the islands of Tonga and Samoa. Around the beginning of the first millennium CE, daring Polynesian seafarers, probably in double-hulled sailing canoes, began settling the scattered islands of Far Oceania and eastern Micronesia. Voyaging over open water, sometimes for thousands of miles, they reached Hawaii and Easter Island after about 500 CE and settled New Zealand by about 800/900–1200 CE.

In this vast and diverse region the arts of the Pacific display enormous variety and are generally closely linked to a community's ritual and religious life. In this context the visual arts were often just one strand in a rich weave that also included music, dance, and oral literature.

AUSTRALIA

The aboriginal inhabitants of Australia, or Aborigines, were nomadic hunter-gatherers closely attuned to the varied environments in which they lived until European settlers disrupted their way of life. The Aborigines had a complex social organization and a rich mythology that was vividly represented in the arts. As early as 18,000 years ago they were painting images on rocks and caves in western Arnhem Land, which is on the northern coast of Australia. One such painting contains a later image superimposed on an earlier one (fig. 24-2). The earlier painting is of skinny,

24-2. *Mimis and Kangaroo*, prehistoric rock art, Oenpelli, Arnhem Land, Australia. Older painting 16,000–7000 BCE. Red and yellow ocher and white pipe clay

PARALLELS

Years	Pacific Cultures	World
c. 50,000–20,000 BCE	People from Southeast Asia migrate to Australia, New Guinea, and nearby islands	Paleolithic hunter-gatherers migrate to New World; *Woman from Willendorf* (Austria)
c. 16,000–1500 BCE	*Mimis* cave paintings in Australia; x-ray style painting in Australia; plants and pigs domesticated	Lascaux cave paintings (France); first pottery vessels (Japan); plants and animals domesticated (Near East, Southeast Asia, Americas); metallurgy (Near East); first writing (Sumer, China, India); Great Pyramids at Giza (Egypt); Stonehenge (England)
c. 1500 BCE–c. 500 CE	Lapita culture spreads through Melanesia	Olmec civilization (Mexico); Rome's legendary founding (Italy); birth of Siddhartha Gautama, founder of Buddhism (Nepal); crucifixion of Jesus (Jerusalem); Maya civilization (Central America)
c. 500–1500 CE	Hawaii and Easter Island settled; Easter Island *moai* figures; Polynesian seafarers settle Far Oceania; monumental structures at Nan Madol in Micronesia	Birth of Muhammad, founder of Islam (Arabia); first Viking colony in Greenland; Marco Polo in China; Ottoman Empire (Asia Minor); Aztec Empire (Mexico); Black Death in Europe; Ming dynasty (China); Great Schism in Christian Church; Inka Empire (South America); Renaissance begins in Europe; Gutenberg's Bible (Germany); Columbus's voyages (Spain)
c. 1500–1900 CE	Captain James Cook explores New Zealand, Australia, and Easter Island; first British settlement in Australia; quilting introduced in Hawaii; Australia becomes British dependency; Peruvian slave hunters decimate Easter Island population	Protestant Reformation in Europe; Mughal period (India); Hideyoshi unites Japan; English colonize North America; Qing dynasty (China); union of England and Scotland as Great Britain; Declaration of Independence (United States); French Revolution; Mexico becomes a republic; Italy is united; Darwin's *Origin of Species*; Civil War (United States); Dominion of Canada is formed
c. 1900 CE–present	Abelam *tamberan* houses in Papua New Guinea; Asmat *mbis* sculpture in Irian Jaya; *malanggan* ceremonies in New Ireland; Confederation of Australia	World War I; World War II; United Nations established; People's Republic of China founded; breakup of the Soviet Union

sticklike humans that the Aborigines call *mimis* (ancestral spirits). Superimposed over the *mimis* is a kangaroo rendered in the distinctive **x-ray style**, in which the artist drew important bones and internal organs—including the spinal column, other bones, the heart, and the stomach—over the silhouetted form of the animal. In the picture shown here, all four of the kangaroo's legs have been drawn, and the ears have been placed symmetrically on top of its head. In some images both eyes appear in the head, which is shown in profile. The x-ray style was still prevalent in western Arnhem Land when European settlers arrived in the nineteenth century.

Bark paintings from northeastern Arnhem Land are entirely filled with elaborate narrative compositions in delicate striping and **cross-hatching**. The Aborigines do not reveal the full meaning of these works to outsiders, but in general they depict origin myths from the Dream Time, when, according to their beliefs, the world and its inhabitants were created. The paintings and the rituals associated with them provide a way to restore contact with the Dream Time. The myths and rituals also explain the origin of important features of the landscape, of climatic phenomena like the monsoon season, and of aboriginal social groupings: In the beginning, the world was

24-4. Fragments of a large Lapita jar, from Venumbo, Reef Santa Cruz Island, Solomon Islands, Melanesia. c. 1200–1100 BCE. Clay, height of human face approx. 1½" (4 cm)

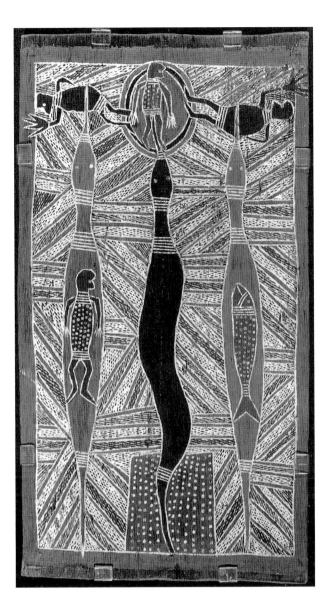

24-3. Mawalan Marika. *The Wawalag Sisters and the Rainbow Serpent.* 1959. Ochers on eucalyptus bark, 18³⁄₄ x 10¹⁄₈" (48 x 26 cm). Collection, Art Gallery of Western Australia, Perth

The sisters dance outside their home in an attempt to escape the Rainbow Serpent's wrath. The serpent slithers out of his hole at the bottom of the bark. It has already devoured a human and a fish.

flat, but animals and the ancestral beings shaped it into mountains, sand hills, creeks, and water holes. Animals became the totemic ancestors of human groups, and the places associated with them became sacred sites. In one origin myth depicted in a bark painting by Mawalan Marika (1908–1967), the first humans, the Wawalag Sisters (seen at the top of figure 24-3), walked about with their digging sticks, singing, dancing, naming things, and populating the land with their children. But they offended the Rainbow Serpent, a symbol of the monsoon rains that bring both fertility and destruction. The serpent swallowed the sisters and designated the place where their descendants were to perform the Wawalag rituals.

Aboriginal artists have continued to work in time-honored and ritually sanctioned ways, and their explana-

tions of their work provide insight into the meaning of prehistoric images. Paintings in ocher and clay on eucalyptus bark, created in a ritual context, were used to help maintain and transmit cultural traditions from generation to generation. These paintings reduced complex stories and ideas to essentials and served as memory aids that elders could elaborate upon. Aboriginal artists today may paint with **acrylic** paint on canvas instead of with ocher, clay, and charcoal on rock and eucalyptus bark, but their imagery has remained relatively constant.

MELANESIA

Exceptional seafarers spread the Lapita culture throughout the islands of Melanesia beginning around 1500 BCE. They brought with them the plants and animals that colonizers needed for food, thus spreading agricultural practices through the islands. They also carried with them the distinctive ceramics whose remnants today enable us to trace the extent of their travels. Lapita potters, probably women, produced dishes, platters, bowls, and jars. Sometimes they covered their wares with a red **slip**, and they often decorated them with bands of **incised** and stamped geometric patterns—dots, lines, and hatching—heightened with white lime. Most of the decoration was entirely geometric, but some was figurative. The human face that appears on one example (fig. 24-4) is among the earliest representations of a human being in Oceanic art. Over time Lapita pottery evolved into a variety of regional styles in Melanesia, but in western Polynesia, the heartland of Polynesian culture and the easternmost part of the Lapita range, the making of pottery ceased altogether by between 100 and 300 CE.

In Melanesia, as in Australia, the arts were intimately involved with belief and provided a means for communicating with supernatural forces. Rituals and ritual arts were primarily the province of men, who devoted a great

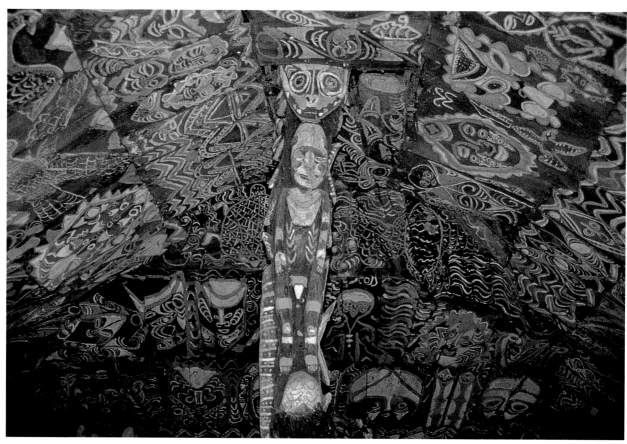

24-5. Detail of *tamberan* house, Sepik River, Papua New Guinea, New Guinea. Abelam, 20th century. Carved and painted wood, with ocher pigments on clay ground

deal of time to both. In some societies most of the adult male population were able to make ritual objects. Although barred from ritual arts, women gained prestige for themselves and their families through their skill in the production of other kinds of goods. To be effective, ritual objects had to be well made, but they were often allowed to deteriorate after they had served their ceremonial function.

Papua New Guinea

New Guinea, the largest island in Melanesia (and at 1,500 miles long and 1,000 miles wide, the second largest island in the world), is today divided between two countries. The eastern half of the island is part of the present-day nation of Papua New Guinea; the western half is Irian Jaya, a province of present-day Indonesia. Located near the equator and with mountains that rise to 16,000 feet, the island's diverse environments range from tropical rain forest to grasslands to snow-covered peaks.

The Abelam, who live in the foothills of the mountains on the north side of Papua New Guinea, raise pigs and cultivate yams, taro, bananas, and sago palms. In traditional Abelam society, people live in extended families or clans in hamlets. A hamlet includes sleeping houses, cooking houses, storehouses for yams, a central space for rituals, and a special men's ceremonial struc-

ture called a *tamberan* house. Wealth among the Abelam is measured in pigs, but men gain status from participation in a yam cult that has a central place in Abelam society and in the **iconography** of its art and architecture. The yams that are the focus of this cult—some of which reach an extraordinary 12 feet in length—are associated with clan ancestors and the potency of their growers. Village leaders renew their relationship with the forces of nature that yams represent during the Long Yam Festival, which is held at harvest time and involves processions, masked figures, singing, and the ritual exchange of the finest yams.

Tamberan houses, which play a central role in these rituals, shelter *tamberans,* images and objects associated with the yam cult and with clan identity, keeping them hidden from women and uninitiated boys. Men gather in these structures to organize rituals, to conduct community business, and, in the past, to plan raids. The prestige of a hamlet is linked to the quality of its *tamberan* house and the size of its yams. Constructed on a frame of poles and rafters and roofed with split cane and thatch, *tamberan* houses have been as much as 280 feet long and more than 40 feet wide. The ridgepole is set at an angle, making one end higher than the other, and the roof extends forward in an overhanging peak that is braced by a carved pole (fig. 24-5). The entrance facade is thus a large, in-folded triangular form, elaborately painted and

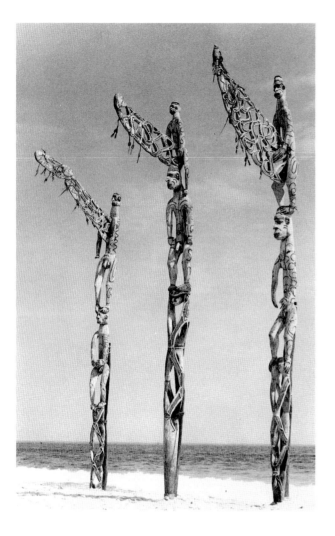

24-6. Asmat ancestral spirit poles (*mbis*), Faretsj River, Irian Jaya, Indonesia, New Guinea. c. 1960. Wood, paint, palm leaves, and fiber, height approx. 18' (5.48 m). The Metropolitan Museum of Art, New York

The Michael C. Rockefeller Memorial Collection, Gift of Nelson A. Rockefeller and Mrs. Mary C. Rockefeller, 1965 (1978.412. 1248-50)

(fig. 24-6). The poles are known as *mbis*, and the rituals surrounding them, intended to reestablish the balance between life and death, are known as *mbis* ceremonies. After *mbis* ceremonies, the poles are abandoned and allowed to deteriorate.

Mbis house the souls of the recent dead and stand in front of the village men's house, where the souls can observe the rituals. In the past, once the poles had been carved, villagers would organize a headhunting expedition so that they could place an enemy head in a cavity at the base of each pole. The abstract shapes of the spaces for enemy heads represent the roots of the banyan tree. Above the base are figures representing tribal ancestors supporting figures of the recent dead. The bent pose of the figures associates them with the praying mantis, one symbol of headhunting; another symbol of headhunting is birds breaking open nuts. The large, lacy phalluses emerging from the figures at the top of the poles symbolize male fertility, and the surface decoration suggests tattoos and scarification (patterned scars), common body ornamentation in Melanesia.

New Ireland

The people of the central part of the island of New Ireland, which is one of the large easternmost islands of the nation of Papua New Guinea, are known for their *malanggan* ceremonies, elaborate funerary rituals for which they make striking painted carvings and masks. *Malanggans* involve an entire community as well as its neighbors and serve to validate social relations and property claims.

Because preparations are costly and time consuming, *malanggans* are often delayed for several months or even years after a death and might commemorate more than one person. Although preparations are hidden from women and children, everyone participates in the actual ceremonies. Arrangements begin with the selection of trees to be used for the *malanggan* carvings. In a ceremony marked by a feast of taro and pork, the logs are cut, transported, and ritually pierced. Once the carvings are finished, they are dried in the communal men's house, polished, and then displayed in a *malanggan* house in the village *malanggan* enclosure. Here the figures are painted and eyes made of sea snail shell are inserted. The works displayed in a *malanggan* house include figures on poles and freestanding sculpture representing ancestors and the honored dead, as well as masks and ritual dance equipment. They are accorded great respect for the duration of the ceremony, then allowed to decay.

Another ritual, the *tatanua* dance, assures male power, and men avoid contact with women for six weeks beforehand. *Tatanua* masks, worn for the dance, represent

carved. A lintel with carved heads representing ancestors divides the triangular facade into two parts. The lower section is covered by woven rattan panels. The upper section, fully two-thirds of the facade's height, is covered with detachable panels that are painted in red, ocher, white, and black with the faces of a clan's ancestral spirits. The Abelam believe the paint itself has magical qualities. The effectiveness of the images depends in part on accurate reproduction, and master painters direct the work of younger initiates. Regular, ritual repainting revitalizes the images and ensures their continued potency. Every stage in the construction of a *tamberan* house is accompanied by ceremonies, which are held in the early morning while women and uninitiated boys are still asleep. The completion of a house is celebrated with elaborate fertility rituals and an all-night dance. Women participate in these inaugural ceremonies and are allowed to enter the new house, which is afterward ritually cleansed and closed to them.

Irian Jaya

The Asmat, who live in the grasslands on the southwest coast of Irian Jaya, were known in the past as warriors and headhunters. They believe that a mythic hero carved their ancestors from trees, and to honor the dead they erect memorial poles covered with elaborate sculpture

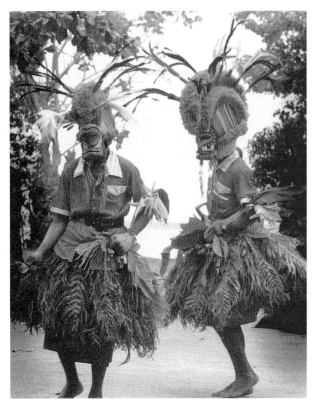

24-7. Dancers wearing *tatanua* masks, Pinikindu Village, central New Ireland, Papua New Guinea, New Guinea. 1979. Masks: wood, vegetable fibers, trade cloth, and pigments, approx. 17 x 13" (43 x 33 cm)

24-8. Royal mortuary compound, Nan Madol, Pohnpei, Federated States of Micronesia. c.1200/1300–c.1500/1600. Basalt blocks, wall height up to 25' (7.62 m)

the spirits of the dead (fig. 24-7). The helmetlike masks are carved and painted with simple, repetitive motifs such as ladders, zigzags, and stylized feathers. The paint is applied in a ritually specified order: first lime white for magic spells; then red ocher to recall the spirits of those who died violently; then black from charcoal or burned nuts, a symbol of warfare; and finally yellow and blue from vegetable materials. The magnificent crest of plant fiber is a different color on the right and the left sides, perhaps a reflection of a lost hairstyle in which the hair was cut short and left naturally black on one side and dyed yellow and allowed to grow long on the other. The contrasting sides of the masks allow dancers to present a different appearance by turning from side to side. A good performance of the *tatanua* dance is considered a demonstration of strength, while a mistake can bring laughter and humiliation.

MICRONESIA

Over the centuries the people of Oceania erected monumental stone architecture and carvings in a number of places. In some cases, in Polynesia for example, widely scattered structures share enough characteristics to suggest that they spring from a common origin. Others

appear to be unique. The site of Nan Madol, on the southeast coast of Pohnpei in Micronesia, is the largest and one of the most remarkable stone complexes in Oceania. Together with a similar, smaller complex on another island nearby, it is also apparently without precedent.

Pohnpei, where today the Federated States of Micronesia's capital city of Palikir is located, is a mountainous tropical island with cliffs of prismatic basalt. By the thirteenth century CE the island's inhabitants were evidently living in a hierarchical society ruled by a powerful chief with the resources to harness sufficient labor for a monumental undertaking. Nan Madol, which covers some 170 acres, consists of 92 small artificial islands set within a network of canals. Most of the islands are oriented northeast-southwest, receiving the benefit of the cooling prevailing winds. Seawalls and breakwaters 15 feet high and 35 feet thick protect Nan Madol from the ocean. Openings in the breakwaters allowed canoes access to the ocean and allowed seawater to flow in and out with the tides and regularly to flush clean the canals. The islands and structures of Nan Madol are built of prismatic basalt "logs" stacked in alternating **courses** (rows or layers). Through ingenious technology the logs were split from their source by alternately heating the base of a

1500 BCE

1500 BCE 2000 CE

basalt cliff with fire and dousing it with water. Nan Madol at one time was home to as many as 1,000 people, but it was deserted by the time Europeans discovered it in the nineteenth century.

The royal mortuary compound, which once dominated the southeast side of Nan Madol (fig. 24-8), has walls rising in subtle upward and outward curves to a height of 25 feet. To achieve the sweeping, rising lines, the builders increased the number of stones in the **header** courses (the courses with the ends of the stones laid toward the face of the wall) relative to the **stretcher** courses (the courses with the lengths of the stones laid parallel to the face of the wall) as they came to the corners and entryways. The plan of the structure consists simply of rectangles within rectangles: outer walls, interior walls, and a tomb in the center. Visitors arriving at the entrance on the west side and disembarking on the landing there would have stepped up from level to level as they passed through two sets of enclosing walls to an inner courtyard and a small, cubical tomb.

POLYNESIA The settlers of the far-flung islands of Polynesia quickly developed distinctive cultural traditions but also retained linguistic and cultural affinities that reflect their common origin. Traditional Polynesian society was generally far more stratified than Melanesian society, and Polynesian art objects served as important indicators of rank and status. Reflecting this function, they tended to be more permanent than art objects in Melanesia, and they often were handed down as heirlooms from generation to generation. European colonization had a profoundly disruptive effect on society and art in Polynesia, as elsewhere in Oceania. Ironically, a major factor contributing to that impact was the very high regard these outsiders felt for the art they found. The result was that European artists and collectors admired Polynesian art and purchased it avidly, but in so doing they totally altered the context in which much of it was produced (see "Paul Gauguin on Oceanic Art," above).

Easter Island

Easter Island, the most remote and isolated island in Polynesia, is also the site of Polynesia's most impressive sculpture. Stone temples, or *marae,* with stone altar platforms, or *ahu,* are common and are found throughout Polynesia. Most of the *ahu* are built near the coast, parallel to the shore. About 900 CE, Easter Islanders began to erect huge stone figures on *ahu,* perhaps as memorials to dead chiefs. Nearly 1,000 of the figures, called *moai,* have been found, including some unfinished in the quarries where they were being made. Carved from tufa, a yellowish brown volcanic stone, most are about 36 feet tall, but one unfinished figure measures almost 70 feet. In 1978 several figures were restored to their original condition, with red tufa topknots on their heads and white coral eyes with stone pupils (see fig. 24-1). The heads have deep-set eyes under a prominent browridge; a long, concave, pointed nose; a small mouth with pursed lips; and an angular chin. The extremely elongated earlobes have parallel engraved lines that suggest ear ornaments. The figures have schematically indicated breastbones and pectorals, small arms with hands pressed close to the sides, but no legs.

Easter Islanders stopped erecting *moai* around 1500 and apparently entered a period of warfare among themselves, possibly because overpopulation was straining the island's available resources. Most of the *moai* were knocked down and destroyed during this period. The island's indigenous population, which may at one time have consisted of as many as 10,000 people, was nearly eradicated in the nineteenth century by Peruvian slave traders, who lured inhabitants to the beaches with trading goods, then captured and exported about 1,000 of them. Missionaries secured the freedom of the approximately 100 who survived diseases in Peru, but only 15 lived through the trip home. The smallpox and tuberculosis they brought with them precipitated an epidemic that left only about 600 inhabitants alive on Easter Island.

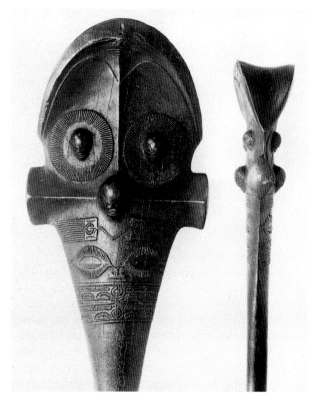

24-9. War club, from Marquesas Islands, Polynesia. Early
19th century. Ironwood, length approx. 5' (1.52 m).
Peabody Essex Museum, Salem, Massachusetts

24-10. Skirt originally belonging to Queen Kamamalu,
Hawaii. 1823–24. Paper mulberry (wauke) bark,
stamped patterns, 12'3" x 5'6" (3.77 x 1.7 m). Bishop
Museum, Honolulu

Gift of Evangeline Priscilla Starbuck, 1927 (C.209)

Marquesas Islands

Warfare was common in Polynesia and involved hand-to-hand combat. Warriors dressed to intimidate and to convey their rank and status, so weapons, shields, and regalia tended to be especially splendid creations. A 5-foot-long ironwood war club from the Marquesas Islands (fig. 24-9) is lavishly decorated, with a Janus-like double face at the end. More faces appear within these faces. The high arching eyebrows frame sunburst eyes whose pupils are tiny faces. Other patterns seem inspired by human eyes and noses. The overlay of low relief and engraved patterns suggests tattooing, a highly developed art in Polynesia (see fig. 24-12).

Hawaiian Islands

Until about 1200 CE the Hawaiian Islands remained in contact with other parts of Polynesia, but thereafter they were isolated until the English explorer Captain James Cook landed there in 1778. Hawaiian society, divided into several independent chiefdoms, was rigidly stratified. By 1810 one ruler, Kamehameha I (c. 1758–1819), had consolidated the islands into a unified kingdom. The influence of United States missionaries and economic interests increased during the nineteenth century, and Hawaii's traditional religion and culture declined. The United States annexed Hawaii in 1898, and the territory became a state in 1959.

Decorated bark cloth and featherwork, found elsewhere in Polynesia, were highly developed in Hawaii. Bark cloth, commonly known as **tapa** (*kapa* in Hawaii), is made by pounding together moist strips of the inner bark of certain trees, particularly the mulberry tree. The clothmakers, usually women, used mallets with incised patterns that left impressions in the cloth. Like a watermark in paper, these impressions can be seen when the cloth is held up to the light. Fine bark cloth was dyed and decorated in red or black with repeated geometric patterns laboriously made with tiny bamboo stamps. One favorite design consists of parallel rows of **chevrons** printed close together in sets or spaced in rows. The cloth could also be worked into a kind of **appliqué**, in which a layer of cutout patterns, usually in red, was beaten onto a light-colored backing sheet. The traditional Hawaiian women's dress consisted of a sheet of bark cloth worn wrapped around the body either below or above the breasts. The example shown here (fig. 24-10) belonged to Queen Kamamalu. Such garments were highly prized and were considered to be an appropriate diplomatic gift. The queen took bark-cloth garments with

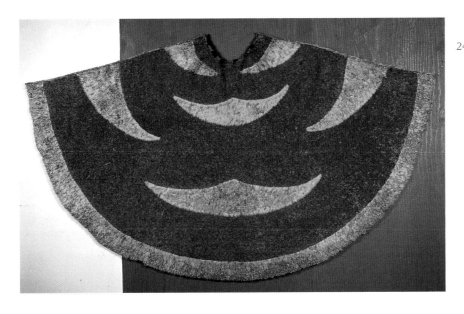

24-11. Feather cloak, known as the Kearny Cloak, Hawaii. c. 1843. Red, yellow, and black feathers, olona cordage, and netting, length 55¾" (143 cm). Bishop Museum, Honolulu

Hawaiian chiefs wore feather cloaks into battle, making them prized war trophies as well as highly regarded diplomatic gifts. King Kamehameha III (ruled 1824–1854) presented this cloak to Commodore Lawrence Kearny, commander of the U.S. frigate *Constellation*.

her when she and King Kamehameha II made a state visit to London in 1823.

The Hawaiians prized featherwork even more highly than fine bark cloth. Feather cloaks, helmets, capes, blankets, and garlands (leis) conveyed special status and prestige, and only wealthy chiefs could command the resources to make them. Tall feather pompons (*kahili*) mounted on long slender sticks symbolized royalty. And the images of the gods that Hawaiian warriors carried into battle were made of light, basketlike structures covered with feathers. Feather garments, made following strict ritual guidelines, consisted of bundles of feathers tied in overlapping rows to a foundation of plant-fiber netting. Yellow feathers, which came from the Hawaiian honey eater bird, were extremely valuable because one bird produced only seven or eight suitable feathers. Some 80,000 to 90,000 honey eaters were used to make King Kamehameha I's full-length royal cloak. Lesser men had to be satisfied with short capes. Cloaks and capes hung funnel-like from the wearer's shoulders, creating a sensuously textured and colored abstract design. The typical cloak was red (the color of the gods) with a yellow border and sometimes a narrow decorative neckband. The symmetrically arranged geometric decoration in the example shown here (fig. 24-11) falls on the wearer's front and back; the paired crescents on the edge join when the garment is closed to match the forms on the back. Captain Cook, impressed by the "beauty and magnificence" of Hawaiian featherwork, compared it to "the thickest and richest velvet" (*Voyage*, 1784, volume 2, page 206; volume 3, page 136).

New Zealand

New Zealand was the last part of Polynesia to be settled. The first inhabitants had arrived by about the tenth century, and their descendants, the Maori, numbered in the hundreds of thousands by the time of European contact in the seventeenth and eighteenth centuries. Captain Cook, before he landed in Hawaii, led a British scientific

ART AND SCIENCE: THE FIRST VOYAGE OF CAPTAIN COOK The ship *Endeavour,* under the command of Captain James Cook, a skilled geographer and navigator, sailed from Plymouth, England, in August 1768 on a scientific expedition to the Pacific Ocean. On board—in addition to a research team of astronomers, botanists, and other scientists—were two artists, Sydney Parkinson (1745?–1771), a young Scottish botanical drafter, and Alexander Buchan, a painter of landscape and portraits. At that time drawings and paintings served science the way photographs and documentary films and videotapes do today, recording, as Cook wrote, "a better idea . . . than can be expressed by word . . ." (*Journal*, 1773).

The *Endeavour* sailed west to Brazil, then south around South America's Cape Horn, and westward across the Pacific Ocean to Tahiti, where Buchan died. The ship went on to explore New Zealand, Tasmania, Australia, and the Great Barrier Reef before returning to England in July 1771, by sailing westward and around Africa's southern tip, the Cape of Good Hope.

Parkinson, frequently working with decaying specimens in cramped quarters on rough seas or plagued by insects, completed more than 1,300 drawings and paintings. His watercolors of plants are especially outstanding. Although he could not replace Buchan as a portrait painter, he did make a few sketches and wash drawings of people, among them drawings of the Maori that provide valuable evidence of their traditional way of life (see fig. 24-12). He died on the return journey, on January 21, 1771. In addition to fulfilling his duties as expedition artist, Parkinson, like the other expedition members, had kept a journal, which was later published.

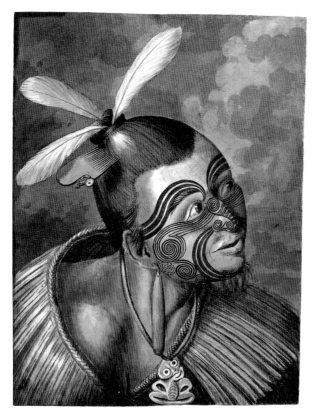

24-12. Sydney Parkinson. Portrait of a Maori. 1769. Wash drawing, 15½ x 11⅝" (39.37 x 29.46 cm), later engraved and published as plate XVI in Parkinson's *Journal*, 1773. The British Library, London Add MS 23920 f.55

expedition to the Pacific that explored the coast of New Zealand in 1769. Sydney Parkinson (1745?–1771), an artist on the expedition, documented aspects of Maori life and art at the time (see "Art and Science: The First Voyage of Captain Cook," page 903). An unsigned drawing by Parkinson (fig. 24-12) shows a Maori with facial tattoos (*moko*) wearing a headdress with feathers, a comb, and a hei-tiki (a carved pendant of a human figure).

Combs similar to the one in the drawing can still be found in New Zealand. The long ear pendant is probably made of greenstone, a form of jade found on New Zealand's South Island that varies in color from off-white to very dark green. The Maori considered greenstone to have supernatural powers. The hei-tiki hanging on a cord around the man's neck would have been among his most precious possessions. Such tiki figures, which represented legendary heroes or ancestor figures, gained power from their association with powerful people. The tiki in this illustration has an almost embryonic appearance, with its large tilted head, huge eyes, and seated posture. Some tiki had large eyes of inlaid shell.

The art of tattoo was widespread and ancient in Oceania; bone tattoo chisels have even been found in Lapita sites. Maori men generally had tattoos on the face and on the lower body between the waist and the knees. Women were tattooed around the mouth and on the chin. The typical design of facial tattoos, like the striking one shown here, consisted of broad, curving parallel lines from nose to chin and over the eyebrows to the ears. Small spiral patterns adorned the cheeks and nose. Additional spirals or other patterns were added on the forehead and chin and in front of the ears. A formal, bilateral symmetry controlled the design. Maori men considered their *moko* designs to be so personal that they sometimes signed documents with them. Ancestor carvings in Maori meetinghouses also have distinctive *moko*. According to Maori mythology, tattooing, as well as weaving and carving, was brought to them from the underworld, the realm of the Goddess of Childbirth. *Moko* might thus have a birth-death symbolism that links the living with their ancestors.

The Maori are especially known for their wood carving, which is characterized by a combination of massive underlying forms with delicate surface ornament. This art form found expression in small works like the hei-tiki in Parkinson's drawing as well as in the sculpture that adorned storehouses and meetinghouses in Maori hilltop villages. The meetinghouse in particular became a focal point of local tradition under the influence of one built in 1842–1843 by Raharuhi Rukupo as a memorial to his brother (fig. 24-13). Rukupo, who was an artist, diplomat, warrior, priest, and early convert to Christianity, built the house with a team of eighteen wood carvers. Although they used European metal tools, they worked in the technique and style of traditional carving with stone tools. They finished the carved wood by rubbing it with a combination of red clay and shark-liver oil to produce a rich, brownish red color.

The whole structure symbolizes the sky father. The ridgepole is his backbone, the rafters are his ribs, and the slanting **bargeboards**—the boards attached to the projecting end of the **gable**—are his outstretched enfolding arms. His head and face are carved at the peak of the roof. The curvilinear patterns on the rafters were made with a silhouetting technique. Artists first painted the rafters white, then outlined the patterns, and finally painted the background red or black, leaving the patterns in white. Characteristically Maori is the *koru* pattern, a curling stalk with a bulb at the end that is said to resemble the young tree fern.

Relief figures of ancestors—Raharuhi Rukupo included a portrait of himself among them—cover the support poles, wall planks, and the lower ends of the rafters. The ancestors, in effect, support the house. They were thought to take an active interest in community affairs and to participate in the discussions held in the meetinghouse. Like the hei-tiki in figure 24-12, the figures have large heads. Flattened to fit within the building planks and covered all over with spirals, parallel and hatched lines, and tattoo patterns, they face the viewer head on with glittering eyes of blue-green inlaid shell. Their tongues stick out in defiance from their grimacing mouths, and they squat in the posture of the war dance.

Lattice panels made by women fill the spaces between the wall planks. Because ritual prohibitions, or taboos, prevented women from entering the meetinghouse, they worked from the outside and wove the panels from the back. They created the black, white, and

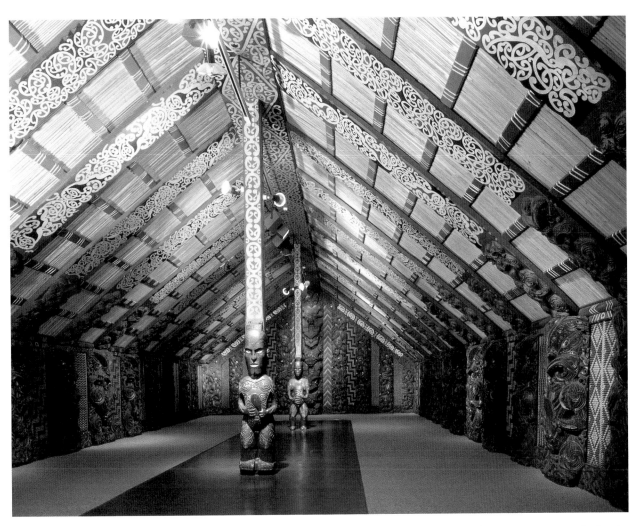

24-13. Raharuhi Rukupo, master carver. Te-Hau-ki-Turanga (Maori meetinghouse), from Manutuke Poverty Bay, New Zealand. 1842–43, restored in 1935. Wood, shell, grass, flax, and pigments. The Museum of New Zealand Te Papa Tongarewa, Wellington, New Zealand

Neg. B18358

orange patterns from grass, flax, and flat slats. Each pattern has a symbolic meaning: Chevrons represent the teeth of the monster Tamsha, steps represent the stairs of Heaven climbed by the hero-god Tashaki, and diamonds represent the flounder.

Considered a national treasure by the Maori, this meetinghouse was restored in 1935 by Maori artists from remote areas still working in traditional methods, and moved to the Museum of New Zealand.

RECENT ART IN OCEANIA

Many contemporary artists in Oceania, in a process anthropologists call **reintegration**, have responded to the impact of European culture by adapting traditional themes and subjects to new mediums and techniques. The work of a Hawaiian quilt maker and an Australian aboriginal painter provide two examples of the striking and challenging results of this process.

Missionaries introduced fabric patchwork and quilting to the Hawaiian Islands in 1820, and Hawaiian women were soon making distinctive, multilayered stitched quilts. Over time, as cloth became increasingly available, the new arts replaced bark cloth in prestige,

and today they are held in high esteem. Quilts are brought out for display and given as gifts to mark holidays and rites of passage such as weddings, anniversaries, and funerals. They are also important gifts for establishing bonds between individuals and communities.

Royal Symbols, by Deborah (Kepola) U. Kakalia, is a luxurious quilt with a two-color pattern reminiscent of bark-cloth design (fig. 24-14). It combines heraldic imagery from both Polynesian and European sources to communicate the artist's proud sense of cultural identity. The crowns, the rectangular feather standards (*kahili*) in the corners, and the boldly contrasting red and yellow colors—derived from traditional featherwork—are symbols of the Hawaiian monarchy, even though the crowns have been adapted from those worn by European royalty. The *kahili* are ancient Hawaiian symbols of authority and rule, and the eight arches arranged in a cross in the center symbolize the uniting of Hawaii's eight inhabited islands into a single Christian kingdom. The quilt's design, construction, and strong color contrasts are typically Hawaiian. The artist created the design the way children create paper snowflakes, by folding a piece of red fabric into eight triangular layers, cutting out the pattern,

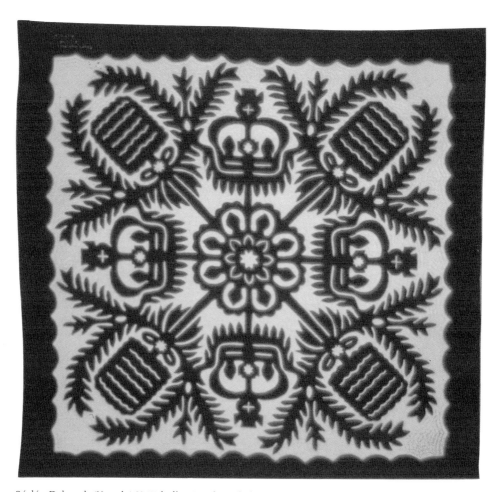

24-l4. Deborah (Kepola) U. Kakalia. *Royal Symbols*. 1978. Quilt (*tifaifai*) of cotton fabric and batting, appliqué, and contour quilting, 6'6¼" x 6'4½" (1.98 x 1.96 m). Joyce D. Hammond Collection

and then unfolding it. The red fabric was then sewn onto a yellow background with a technique known as contour stitching, in which the quilter follows the outlines of the design layer with parallel rows of tiny stitches. This technique, while effectively securing the layers of fabric and batting together, also creates a pattern that quilters liken to breaking waves.

In Australia, Aborigine artists have adopted canvas and acrylic paint for rendering imagery traditionally associated with more ephemeral mediums like bark, sand, and body painting. Under the influence of an art teacher named Geoff Bardon, who introduced them to the new mediums, a group of Aborigines expert in **sand painting**—an ancient ritual art form that involves creating large colored designs on the ground—formed an art cooperative in 1971 in Papunya, in central Australia. Their success in transforming their transient, ritual form into a salable commodity encouraged community elders to allow others, including women, to try their hand at painting, which soon became an economic mainstay for many aboriginal groups in the region.

Sand paintings consist of red and yellow ochers, seeds, and feathers arranged on the earth in dots and other symbolic patterns that convey tribal lore to young initiates. Clifford Possum Tjapaltjarri, a founder of the Papunya cooperative who gained an international reputa-

tion after an exhibition of his paintings in 1988, works with his canvases on the floor, using traditional patterns and colors, as well as touches of blue. The superimposed layers of concentric circles and undulating lines and dots in a painting like *Man's Love Story* (fig. 24-15) create an effect of shifting colors and lights. The painting seems entirely abstract, but it actually conveys a complex narrative involving two mythical ancestors. One of these men came to Papunya in search of honey ants; the white **U** shape on the left represents him seated in front of a water hole with an ants' nest, represented by the concentric circles. His digging stick lies to his right, and white sugary leaves lie to his left. The straight white "journey line" represents his trek from the west. The second man, represented by the brown-and-white **U**-shape form, came from the east, leaving footprints, and sat down by another water hole nearby. He began to spin a hair string (a string made from human hair) on a spindle (the form leaning toward the upper right of the painting) but was distracted by thoughts of the woman he loved, who belonged to a kinship group into which he could not marry. When she approached, he let his hair string blow away (represented by the brown flecks below him) and lost all his work. Four women (the dotted **U** shapes) from the group into which he could marry came with their digging sticks and sat around the two men. Rich symbolism fills other areas of

24-15. Clifford Possum Tjapaltjarri. *Man's Love Story*. 1978. Papunya, Northern Territory, Australia. Synthetic polymer paint on canvas, 6'11¾" x 8'4¼" (2.15 x 2.57 m). Art Gallery of South Australia, Adelaide

Visual Arts Board of the Australia Council Contemporary Art Purchase Grant, 1980

the painting: The white footprints are those of another ancestral figure following a woman, and the wavy line at the top is the path of yet another ancestor. The black, dotted oval area indicates the site where young men were taught this story. The long horizontal bars are mirages. The wiggly shapes represent caterpillars, and the dots represent seeds, both forms of food.

The point of view of this work may be that of someone looking up from beneath the surface of the earth rather than down from above. Possum first painted the landscape features and the impressions left on the earth by the figures—their tracks, direction lines, and the U-shaped marks they left when sitting. Then, working carefully, dot by dot, he captured the vast expanse and

shimmering light of the arid landscape. The painting's resemblance to modern Western painting styles like Abstract Expressionism, **gestural** painting, or Color Field painting (Chapter 29) is accidental. Possum's work remains deeply embedded in the mythic, narrative traditions of his people. Although few artifacts remain from prehistoric times on the Pacific islands, throughout recorded history artists such as Possum have worked with remarkable robustness, freshness, and continuity. They have consistently created arts that express the deepest meanings of their culture despite the incursions of peoples from the Americas and from Europe, who were, at about the same time, "discovering" the classic arts of another continent, Africa.

Bwami mask
Lega
early 20th century

Spirit spouse
Baule
early 20th century

Kanaga mask
Dogon
early 20th century

Ekpo mask
Anang Ibibio
late 1930s

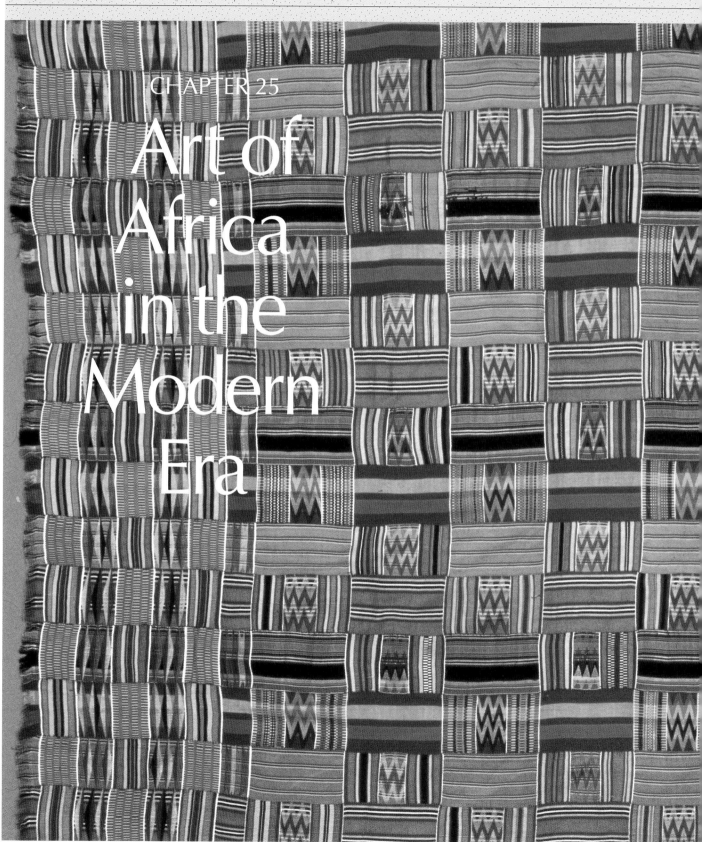

CHAPTER 25

Art of Africa in the Modern Era

Finial
Ashanti
20th century

Twin figures
Yoruba
20th century

Odundo
Asymmetrical
angled piece
1990–91

Mediterranean Sea

ALGERIA

LIBYA

EGYPT

Cairo

Nile

Red Sea

ARABIA

Mecca

S A H A R A

MALI

SONGHAY

Timbuktu

Dakar

Mopti

Djenné

Dossi

Niger River

River

SUDAN

BURKINA
FASO

NIGERIA

SIERRA
LEONE

CÔTE
D'IVOIRE

GHANA

BENIN

Nok

Kumasi

Ilorin

Ife

Abeokuta

Benin

Ikot Ekpene

KENYA

SOMALIA

Abidjan

CAMEROON

Nairobi

Rio
Muni

GABON

Zaire (Congo) River

Kinshasa

ZAIRE

ATLANTIC
OCEAN

Zambezi River

Great Zimbabwe

MADAGASCAR

INDIAN
OCEAN

0 800 miles

0 800 kilometers

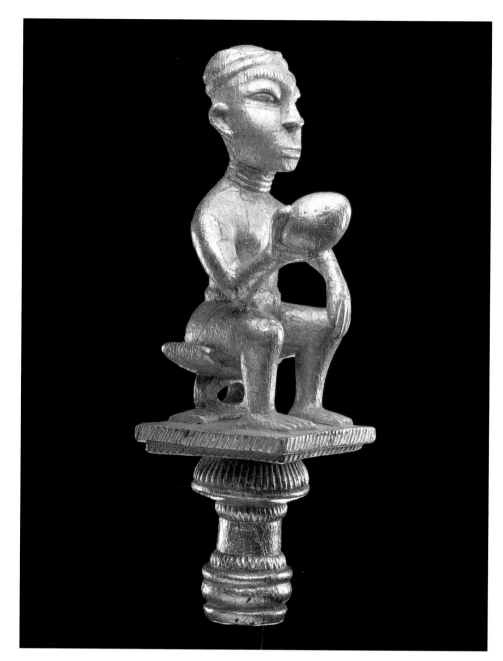

25-1. Finial of a spokesperson's staff (*okyeame poma*), from Ghana. Ashanti culture, 20th century. Wood and gold, height 11¼" (28.57 cm). Musée Barbier-Mueller, Geneva

Political power is like an egg, says an Ashanti proverb. Grasp it too tightly and it will shatter in your hand; hold it too loosely and it will slip from your fingers. Whenever the *okyeame*, or spokesperson, for one twentieth-century Ashanti ruler was conferring with that ruler or communicating the ruler's words to others, he held before their eyes a staff with this symbolic caution on the use and abuse of power prominently displayed on the gold-leaf–covered **finial** (fig. 25-1).

If we are to attempt to understand African art such as this staff on its own terms, we must first restore it to life. As with the art of so many periods and societies, we must take it out of the glass cases of the museums where we usually encounter it and imagine the artwork playing its vital role in a human community.

TRADITIONAL AND CONTEMPORARY AFRICA

The second largest continent in the world, Africa is a land of enormous diversity. Geographically, it ranges from enormous deserts to tropical rain forest, from flat grasslands to spectacular mountains and dramatic rift valleys. Human diversity in Africa is equally impressive. More than 1,000 languages have been identified, grouped by scholars into five major linguistic families. Various languages represent unique cultures, with their own history, customs, and art forms.

Before the nineteenth century, the most important outside influence in Africa had been the religious culture of Islam, which spread gradually and largely peacefully through much of West Africa and along the East African coast (see "Foundations of African Cultures," below). The modern era, in contrast, begins with the European exploration and subsequent colonization of the African continent, developments that brought traditional African societies into sudden and traumatic contact with the "modern" world that Europe had largely created.

European ships first visited sub-Saharan Africa in the fifteenth century. For the next several hundred years, however, European contact with Africa was almost entirely limited to coastal areas, where trade, including the tragic slave trade, was carried out. During the nineteenth century, as the slave trade was gradually eliminated, European explorers began to investigate the unmapped African interior. They were soon followed by Christian missionaries, whose reports greatly fueled popular interest in the continent. Drawn by the potential wealth of Africa's natural resources, European governments began to seek territorial concessions from African rulers. Diplomacy soon gave way to force, and toward the end of the century, competition among rival powers fueled the so-called scramble for Africa, when European governments raced to lay claim to whatever portion of the continent they were powerful

1900 2000

FOUNDATIONS OF AFRICAN CULTURES

Africa was the site of one of the great civilizations of the ancient world, that of Egypt, which arose along the fertile banks of the Nile River over the course of the fourth millennium BCE and lasted for some 3,000 years. Egypt's rise coincided with the emergence of the Sahara, the largest desert in the world, from the formerly lush grasslands of northern Africa. Some of the oldest known African art, images inscribed and painted in the mountains of the central Sahara beginning around 8000 BCE, bears witness to this gradual transformation as well as to the lives of the pastoral peoples who once lived in the region.

As the grassland dried, its populations most likely migrated in search of pasture and arable land. Many probably made their way to the Sudan, the broad band of savanna south of the Sahara. During the sixth century BCE, knowledge of iron smelting spread across the Sudan, enabling larger and more complex societies to emerge. One such society was the iron-working Nok culture, which arose in present-day Nigeria around 500 BCE and lasted until about 200 CE. **Terra-cotta** figures created by Nok artists are the earliest known sculpture from sub-Saharan Africa.

Farther south in present-day Nigeria, a remarkable culture developed in the city of Ife, which rose to prominence around 800 CE. There, from roughly 1000 to 1400, a tradition of naturalistic sculpture in bronze and terra-cotta flourished, focused on exquisitely modeled memorial heads—possibly actual portraits—of rulers. Ife was, and remains, the sacred city of the Yoruba people, two of whose modern-era sculpture are included in this chapter (figs. 25-3 and 25-10). According to legend, Ife artists brought the techniques of bronze casting to the kingdom of Benin to the southeast. From 1400 through the nineteenth century Benin artists in the service of the court created numerous works in bronze, at first in the naturalistic style of Ife, then becoming increasingly stylized and elaborate.

With the Arab conquest of North Africa during the seventh and eighth centuries, Islamic travelers and merchants became regular visitors to the Sudan. Largely through their writings, we know of the powerful West African empires of Ghana, Mali, and Songhay, which flourished successively from the fourth through the sixteenth centuries along the great bend in the Niger River. All three empires grew wealthy by controlling the flow of African gold and forest products into the lucrative trans-Sahara trade. During their time, such fabled West African cities as Mopti, Djenné, and Timbuktu arose, serving not only as commercial hubs but also as prominent centers of Islam, which became an important cultural force in Africa.

Peoples along the coast of East Africa, meanwhile, had participated since before the Common Era in a maritime trade network that ringed the Indian Ocean and extended east to the islands of Indonesia. Over the course of time, trading settlements arose along the coastline, peopled by Arab, Persian, and Indian merchants as well as Africans. By the thirteenth century these settlements had become important cities, and a new language, Swahili, had developed from the longtime mingling of Arabic with local African languages. Peoples of the interior organized extensive trade networks to funnel goods to these ports, and large-scale political formations grew up around the control of the interior trade. From 1000 to 1500 many of these interior routes were controlled by the Shona people from a site called Great Zimbabwe. The extensive stone ruins of the palace compound there once stood in the center of this city of some 10,000 at its height. With the decline of Great Zimbabwe, control of the southeastern trade network passed to the Mwene Mutapa and Kami empires a short distance to the north.

Numerous cities and kingdoms, often of great wealth and opulence, greeted the astonished eyes of the first European visitors to Africa at the end of the fifteenth century.

PARALLELS

Years	Africa	World
1880–1912	European colonization of all of continent except Ethiopia creates boundaries unrelated to cultural and language groups	Sino-Japanese War; Alfred Nobel's prizes for peace, science, and literature established (Sweden); Spanish-American War; Russo-Japanese War; Albert Einstein's special theory of relativity
1950–1975	European powers begin granting independence to territories in Africa; Egypt becomes republic; Organization of African Unity founded; first successful human heart transplant; severe drought spreads south of the Sahara	Korean War begins; French defeated at Dien Bien Phu (Vietnam); Federal Republic of West Germany established; European Common Market established; first human orbits the earth (Soviet Union); first astronauts land on the moon (United States)
1975–present	Political and social upheaval spreads throughout continent; Namibia gains independence; apartheid in South Africa legally dismantled; AIDS and famine resulting from droughts take heavy tolls	Nuclear nonproliferation treaty signed by fifteen nations; Muslim leaders take control of Iran; Soviet Union invades Afghanistan; Indira Gandhi assassinated (India); discovery of AIDS virus reported (United States, France); first Islamic woman prime minister elected (Pakistan); breakup of Soviet Union

enough to take. By 1914 virtually all of Africa had fallen under colonial rule.

In the years following World War I, nationalistic movements arose across Africa. Their leaders generally did not advocate a return to earlier forms of political organization but rather demanded the transformation of colonial divisions into Western-style nation-states governed by Africans. From 1945 through the mid-1970s one colony after another gained its independence, and the present-day map of modern African nations took shape.

Change has been brought about by contact between one people and another since the beginning of time. And art in Africa has both affected and been affected by such contacts. During the early twentieth century the art of traditional African societies played a pivotal role in revitalizing the Western tradition. The formal inventiveness and expressive power of African sculpture were sources of inspiration for European artists trying to rethink strategies of representation. Many contemporary African artists, especially those from major urban centers, have come of age in the postcolonial culture that mingles European and African elements. Drawing easily on the influences from many cultures, both African and non-African, today's artists have established a firm place in the lively international art scene along with their European, American, and Asian counterparts, and their work is shown as readily in Paris, Tokyo, and Los Angeles as it is in the African cities of Abidjan, Kinshasa, and Dakar.

Many traditional societies persist, both within and across contemporary political borders. From the time of the first European explorations and continuing through the colonial era, quantities of art from traditional African societies were shipped back to Western museums. At first these were not art museums but museums of natural history or ethnography, where the works were exhibited as curious artifacts of "primitive" cultures. Toward the end of the nineteenth century, however, profound changes in Western thinking about art gradually led more and more people to appreciate the inherent **aesthetic** qualities of traditional African "artifacts" and finally to embrace them fully as art. Art museums began to collect African art more seriously and methodically, both in Africa and in the West. Together with the living arts of traditional peoples today, these collections afford us a rich sampling of African art in the modern era.

Traditional African art plays a vital role in the spiritual and social life of the community. It is used to express Africans' ideas about their relation to their world and as a tool to help them survive in a difficult and unpredictable environment. This chapter explores African art in light of how it addresses some of the fundamental concerns of human existence. Because African art must be considered within its cultural and social contexts, in this chapter we look at works of art within various broad contexts rather than by geographical region or time frame.

CHILDREN AND THE CONTINUITY OF LIFE

Among the most fundamental of human concerns is the continuation of life from one generation to the next. In traditional societies children are especially important, for not only do they represent the future of the family and the community, but they are also a form of "social security," guaranteeing that parents will have someone to care for them when they are old.

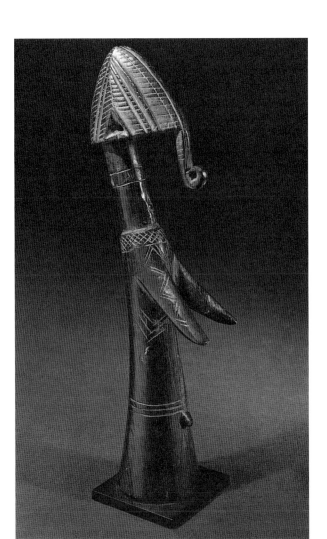

25-2. Doll (*biiga*), from Burkina Faso. Mossi culture, mid-20th century. Wood, height 11¼" (28.57 cm). Collection Thomas G. B. Wheelock

In the often harsh and unpredictable climates of Africa, human life can be fragile. In some areas half of all infants die before the age of five, and the average life expectancy may be as low as forty years. In these areas women may bear many children in hopes that a few will survive into adulthood, and failure to have children is a disaster for a wife, her husband, and her husband's lineage. It is very unusual for a man to be blamed as the cause of infertility, so women who have had difficulty bearing children appeal with special offerings or prayers, often involving the use of art.

The Mossi people of Burkina Faso, in West Africa, carve a small wooden figure called *biiga*, or "child," as a plaything for little girls (fig. 25-2). The girls feed and

25-3. Twin figures (*ere ibeji*), from Nigeria. Yoruba culture, 20th century. Wood, height 7⅞" (20 cm). The University of Iowa Museum of Art, Iowa City

The Stanley Collection

As with other African sculpture, patterns of use result in particular signs of wear. The facial features of *ere ibeji* are often worn down or even obliterated by repeated feedings and washings. Camwood powder applied as a cosmetic builds to a thick crust in areas that are rarely handled. Even the blue indigo dye regularly applied to the hair eventually builds to a thin layer.

bathe the figures and change their clothes, just as they see their mothers caring for younger siblings. At this level the figures are no more than simple dolls. Like many children's dolls around the world, they show ideals of mature beauty, including elaborate hairstyles, lovely clothing, and developed breasts. The *biiga* shown here wears its hair just as little Mossi girls do, with a long lock projecting over the face. (A married woman, in contrast, wears her lock in back.)

Other aspects of the doll, however, reveal a more complex meaning. The elongated breasts recall the practice of stretching by massaging to encourage lactation, and they mark the doll as the mother of many children. The scars that radiate from the navel mimic those applied to Mossi women following the birth of their first child. Thus, although the doll is called a child, it actually represents the ideal Mossi woman, one who has achieved the goal of providing children to continue her husband's lineage.

Mossi girls do not outgrow their dolls as one would a childhood plaything. When a young woman marries, she brings the doll with her to her husband's home to serve as an aid to fertility. If she has difficulty in bearing her first child, she carries the doll on her back just as she would a baby. When she gives birth, the doll is placed on a new, clean mat just before the infant is placed there, and when she nurses, she places the doll against her breast for a moment before the newborn receives nourishment.

In all societies everywhere, the death of a child is a traumatic event. Many African peoples believe that a dead child continues its life in a spirit world. The parents' care and affection may reach it there, often through the medium of art. The Yoruba people of Nigeria have one of the highest rates of twin births in the world. The birth of twins is a joyful occasion, yet it is troubling as well, for twins are more delicate than single babies, and one or both may well die. When a Yoruba twin dies, the parents consult a diviner, a specialist in ritual and spiritual practices, who may tell them that an image of a twin, or *ere ibeji*, must be carved (fig. 25-3).

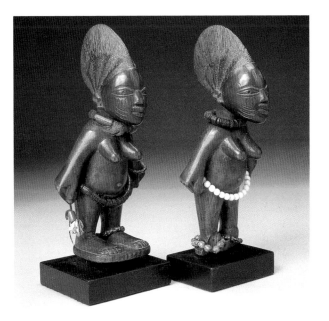

The mother cares for the "birth" of this image by sending the artist food while the figure is being carved. When the image is finished, she brings the artist gifts. Then, carrying the figure as she would a living child, she dances home accompanied by the singing of neighborhood women. She places the figure in a shrine in her bedroom and lavishes care upon it, feeding it, dressing it with beautiful textiles and jewelry, anointing it with cosmetic oils. The Yoruba believe that the spirit of a dead twin thus honored may bring its parents wealth and good luck.

The figures here represent female twins. They may be the work of the Yoruba artist Akiode, who died in 1936. Akiode belonged to the school of Esubiyi, an artist who worked in the Itoko quarter of the city of Abeokuta in southwestern Nigeria. Like most objects that Africans produce to encourage the birth and growth of children, the figures emphasize health and well-being. They have beautiful, glossy surfaces, rings of fat as evidence that they are well fed, and the marks of mature adulthood that will one day be achieved. They represent hope for the future, for survival, and for prosperity.

INITIATION

Eventually, an adolescent must leave behind the world of children and take his or her place in the adult world. In contemporary Western societies, initiation into the adult world is extended over several years and punctuated by numerous rites, such as graduating from high school, being confirmed in a religion, earning a driver's license, and reaching the age of majority. All of these steps involve acquiring the spiritual and worldly knowledge Western society deems necessary and accepting the corresponding responsibilities. In other societies, initiation is more concentrated, and the acquisition of knowledge may be supplemented by physical tests and trials of endurance to prove that the candidate is equal to the hardships of adult life.

The Bwa people of central Burkina Faso initiate young men and women into adulthood following the onset of puberty. The initiates are first separated from younger playmates by being "kidnapped" by older relatives, though their disappearance is explained in the community by saying that they have been devoured by wild beasts. The initiates are stripped of their clothing and made to sleep on the ground without blankets. Isolated from the community, they are taught about the world of nature spirits and about the wooden masks that represent them.

The initiates have watched these masks in performance every month for their entire lives. Now, for the first time, they learn that the masks are made of wood and are worn by their older brothers and cousins. They learn of the spirit each mask represents, and they memorize the story of each spirit's encounter with the founding ancestors of the clan. They learn how to construct costumes from hemp to be worn with the masks, and they learn the songs and instruments that accompany the masks in performance. Only the boys wear each mask in turn and learn the dance steps that express the character and personality it represents. Returning to the community, the initiates display their new knowledge in a public ceremony. Each boy performs with one of the masks, while the girls sing the accompanying songs. At the end of the mask ceremony the young men and young women rejoin their families as adults, ready to marry, to start farms, and to begin families of their own.

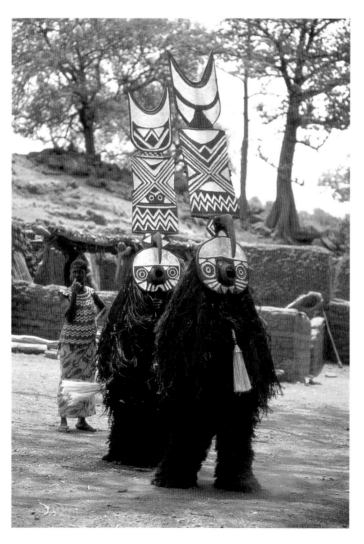

25-4. Two masks in performance, from Dossi, Burkina Faso. Bwa culture, 1984. Wood, mineral pigments, and fiber, height approx. 7' (2.13 m)

Note: The Bwa have been making and using such masks since well before Burkina Faso achieved its independence in 1960. We might assume their use is centuries old, but in this case, the masks are a comparatively recent innovation. The elders of the Bwa family who own these masks state that they, like all Bwa, once followed the cult of the spirit of Do, who is represented by masks made of leaves. In the last quarter of the nineteenth century the Bwa were the targets of slave raiders from the north and east. Their response to this new danger was to acquire wooden masks from their neighbors, for such masks seemed a more effective and powerful way of communicating with spirits who could help them. Thus, faced with a new form of adversity, the Bwa sought a new tradition to cope with it.

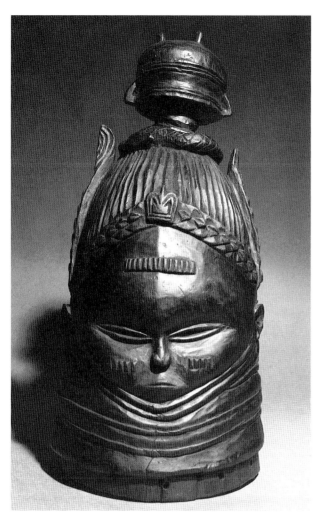

Among the Mende people of Sierra Leone, in West Africa, the initiation of young girls into adulthood is organized by a society of older women called Sande. The initiation culminates with a ritual bath in a river, after which the girls return to the village to meet their future husbands. At the ceremony the Sande women wear black gloves and stockings, black costumes of shredded raffia fibers that cover the entire body, and black masks called *nowo* (fig. 25-5).

With its high and glossy forehead, plaited hairstyle decorated with combs, and creases of abundance around the neck, the mask represents the Mende ideal of female beauty. The meanings of the mask are complex. One scholar has shown that the entire mask can be compared to the chrysalis of a certain African butterfly, with the creases in particular representing the segments of the chrysalis. Thus, the young woman entering adulthood is like a beautiful butterfly emerging from its ugly chrysalis. The comparison extends even further, for just as the butterfly feeds on the toxic sap of the milkweed to make itself poisonous to predatory birds, so the medicine of Sande is believed to protect the young women from danger. The creases may also refer to concentric waves radiating outward as the mask emerges from calm waters to appear among humankind, just as the initiates rise from the river to take their place as members of the adult community.

A ceremony of initiation may accompany the achievement of other types of membership as well. Among the Lega people, who live in the dense forests between the headwaters of the Zaire River and the great lakes of East Africa, the political system is based on a voluntary association called *bwami*, which comprises six levels or grades. Some 80 percent of all male Lega belong to *bwami*, and all aspire to the highest grade. Women can belong to *bwami* as well, although not at a higher grade than their husbands.

Promotion from one grade of *bwami* to the next takes many years. It is based not only on a candidate's character but also on his or her ability to pay the initiation fees, which increase dramatically with each grade. No candidate for any level of *bwami* can pay the fees alone, but all must depend on the help of relatives to provide the necessary cowrie shells, goats, wild game, palm oil, clothing, and trade goods. Candidates who are in conflict with their relatives will never be successful in securing such guarantees and thus will never achieve their highest goals. The ambitions of the Lega to move from one level of *bwami* to the next encourage a harmonious and well-ordered community, for all must stay on good terms if they are to advance. The association promotes a lifelong growth in moral character and an ever-deepening understanding of the relationship of the individual to the community.

Bwami initiations are held in the plaza at the center of the community in the presence of all members. Dances and songs are performed, and the values and ideals of the appropriate grade are explained through proverbs and sayings. These standards are illustrated by natural or crafted objects, which are presented to the initiate as signs of membership. At the highest two levels of *bwami*, such objects include masks and sculpted figures.

25-5. *Nowo* mask, from Sierra Leone. Mende culture, 20th century. Wood, height 18⅞" (48 cm). The Baltimore Museum of Art

Most Bwa masks depict spirits that have taken an animal form, such as crocodile, hyena, hawk, or serpent. Others represent spirits in human form. Among the most spectacular masks, however, are those crowned with a tall, narrow plank (fig. 25-4), which are entirely **abstract** and represent spirits that have taken neither human nor animal form. The graphic patterns that cover these masks are easily recognized by the initiated. The white crescent at the top represents the quarter moon, under which the initiation is held. The white triangles below represent bull roarers—sacred sound makers that are swung around the head on a long cord to re-create spirit voices. The large central **X** represents the scar that every initiated Bwa wears as a mark of devotion. The horizontal zigzags at the bottom represent the path of ancestors and symbolize adherence to ancestral ways. That the path is difficult to follow is clearly conveyed. The curving red hook that projects in front of the face is said to represent the beak of the hornbill, a bird associated with the supernatural world and believed to be an intermediary between the living and the dead. Through abstract patterns, the mask conveys a message about the proper moral conduct of life with all the symbolic clarity and immediacy of a traffic signal.

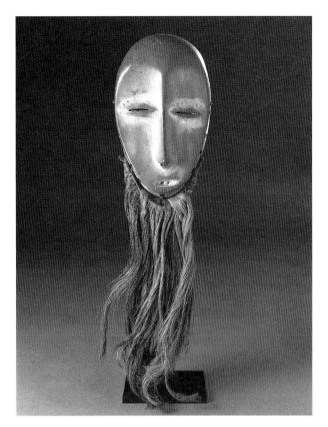

25-6. *Bwami* mask, from Zaire. Lega culture, early 20th century. Wood and kaolin, height 7⅝" (19.3 cm). The University of Iowa Museum of Art, Iowa City
The Stanley Collection

The mask in figure 25-6 is associated with *yananio*, the second highest grade of *bwami*. Typical of Lega masks, the head is fashioned as an oval into which is carved a concave, heart-shaped face with narrow, raised features. The masks are often colored white with clay and fitted with a beard made of hemp fibers. Too small to cover the face, they are displayed in other ways—held in the palm of a hand, for example, or attached to a thigh. Each means of display recalls a different value or saying, so that one mask may convey a variety of meanings. For example, held by the beard and slung over the shoulder, this mask represents "courage," for it reminds the Lega of a disastrous retreat from an enemy village during which many Lega men were slain from behind.

THE SPIRIT WORLD

Why does one child fall ill and die while its twin remains healthy? Why does one year bring rain and a bountiful crop, while the next brings drought and famine? All people everywhere confront such fundamental and troubling questions. For traditional African societies the answers are often felt to lie in the workings of spirits. Spirits are believed to inhabit the fields that produce crops, the river that provides fish, the forest that is home to game, the land that must be cleared in order to build a new village. A family, too, includes spirits—those of its ancestors as well as those of children yet unborn. In the blessing or curse of these myriad surrounding spirits lies the difference between success and failure in life.

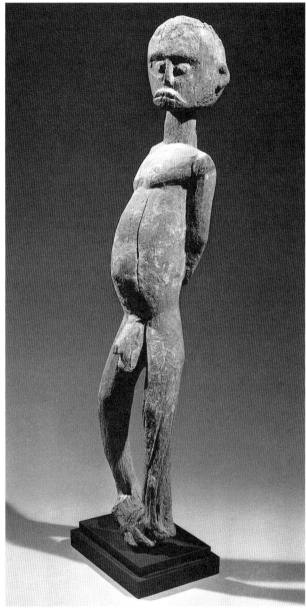

25-7. Spirit figure (*boteba*), from Burkina Faso. Lobi culture, 19th century. Wood, height 30¹¹/₁₆" (78 cm). Collection Kerchache, Paris

To communicate with these all-important spirits, African societies usually rely on a specialist in ritual—the person known elsewhere in the world as priest, minister, rabbi, pastor, imam, or shaman. Whatever his or her title, the ritual specialist serves as an essential link between the supernatural and human worlds, opening the lines of communication through such techniques as prayer, sacrifice, offerings, magic, and divination. Each African people has its own name for this specialist, but for simplicity we can refer to them all as diviners. Art often plays an important role in dealings with the spirit world, for art can make the invisible visible, giving identity and personality to what is abstract and intangible.

To the Lobi people of Burkina Faso, the spirits of nature are known as *thila* (singular, *thil*), and they are believed to control every aspect of life. Indeed, their power is so pervasive that they may be considered the true rulers of the community. Lobi houses may be widely scattered

over miles of dry West African savanna. These houses are considered a community when they acknowledge the same *thil* and agree to regulate their society by its rules, called *zoser*. Such rules bear comparison to those binding many religious communities around the world and may include a prohibition against killing or eating the meat of a certain animal, sleeping on a certain type of mat, or wearing a certain pattern or cloth. Totally averse to any form of kingship or centralized authority, the Lobi have no other system of rule but *zoser*.

Thila are normally believed to be invisible. When adversity strikes, however, the Lobi may consult a diviner, who may prescribe the carving of a wooden figure called a *boteba* (fig. 25-7). A *boteba* gives a *thil* physical form. More than simply a carving, a *boteba* is thought of as a living being who can see, move, and communicate with other *boteba* and with its owner. The owner of a *boteba* can thus address the spirit it gives form to directly, seeking its protection or aid.

Each *thil* has a particular skill that its representative *boteba* conveys through pose or expression. A *boteba* carved with an expression of terrible anger, for example, represents a *thil* whose skill is to frighten off evil forces. The *boteba* in figure 25-7 is carved in the characteristic Lobi pose of mourning, with its hands clasped tightly behind its back and its head turned to one side. This *boteba* mourns so that its owner may not be saddened by misfortune. Like a spiritual decoy, it takes on the burden of grief that might otherwise have come to the owner. Shrines may hold dozens of *boteba* figures, each one contributing its own unique skill to the family or community.

Among the most potent images of power in African art are the *nkisi*, or spirit, figures made by the Kongo and Songye peoples of Zaire. The best known of these are the large wooden *nkonde*, which bristle with nails, pins, blades, and other sharp objects (fig. 25-8). A *nkisi nkonde* begins its life as a simple, unadorned wooden figure that may be purchased from a carver at a market or commissioned by a diviner on behalf of a client who has encountered some adversity or who faces some important turning point in his or her life. Drawing on vast knowledge, the diviner prescribes certain magical/medicinal ingredients, called *bilongo*, that will help the client's problem. These *bilongo* are added to the figure, either mixed with white clay and plastered directly onto the body or suspended in a packet from the neck or waist.

The *bilongo* transform the *nkonde* into a living being with frightful powers, ready to attack the forces of evil on behalf of a human client. *Bilongo* ingredients are drawn from plants, animals, and minerals, and may include human hair, nail clippings, and other materials. Each ingredient has a specific role. Some bring the figure to life by embodying the spirit of an ancestor or a soul trapped by a malevolent power. Others endow the figure with specific powers or focus the powers in a particular direction, often through metaphor. For example, the Kongo admire the quickness and agility of a particular species of mouse. Tufts of this mouse's hair included in the *bilongo* act as a metaphor for quickness, ensuring that the *nkisi nkonde* will act rapidly when its powers are activated.

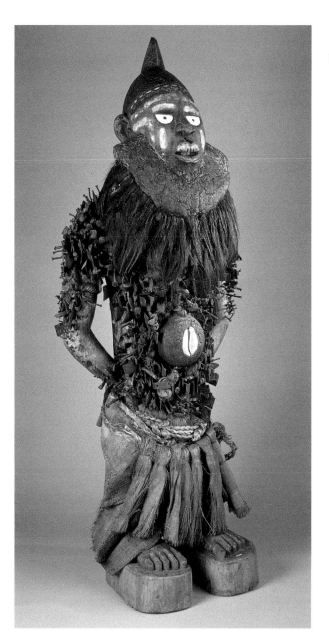

25-8. Power figure (*nkisi nkonde*), from Zaire. Kongo culture, 19th century. Wood, nails, pins, blades, and other materials, height 44" (111.7 cm). The Field Museum, Chicago
Acquisition A109979 ᶜ

Nkisi nkonde provide a dramatic example of the ways in which African sculpture are transformed by use. When first carved, the figure is "neutral," with no particular significance or use. Magical materials applied by a diviner transform the figure into a powerful being, at the same time modifying its form. Each client who activates that power further modifies the statue. While the object is empowered, nails may also be removed as part of a healing or oath-taking process. And when the figure's particular powers are no longer needed, the additions may all be stripped away to be replaced with different magical materials that give the same figure a new function. The result is that many hands play a role in creating the work of art we see in a museum. The person we are likely to label as the "artist" is only the initial creator. Many others modify the work, and in their hands the figure becomes a visual document of the history of the conflicts and afflictions that have threatened the community.

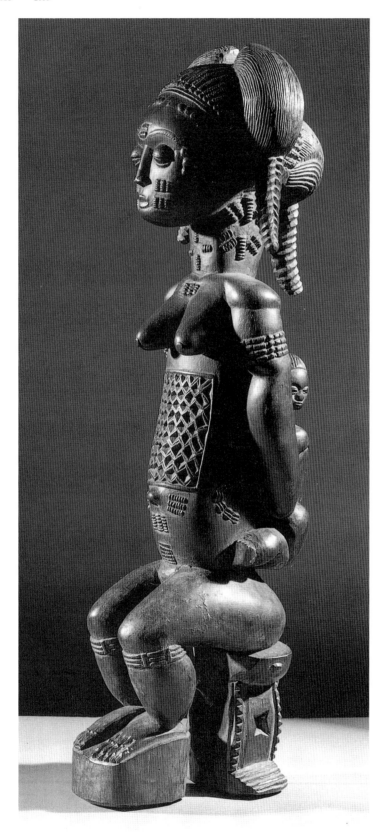

25-9. Spirit spouse (*blolo bla*), from Côte d'Ivoire. Baule culture, early 20th century. Wood, height 17⅛" (43.5 cm). University Museum, University of Pennsylvania, Philadelphia

To activate the powers, clients drive in a nail or other pointed object to get the *nkonde's* attention and prick it into action. A *nkisi nkonde* may serve many private and public functions. Two warring villages might agree to end their conflict by swearing an oath of peace in the presence of the *nkonde* and then driving a nail into it to seal the agreement. Two merchants might agree to a partnership by driving two small nails into the figure side by side and then make their pact binding by wrapping the nails together with a stout cord. Someone accused of a crime might swear his innocence and drive in a nail, asking the *nkonde* to destroy him if he lied. A mother might invoke the power of the *nkonde* to heal her sick children. The objects driven into the *nkonde* may also operate metaphorically. For example, the Kongo use a broad blade called a *baaku* to cut into palm trees, releasing sap that will eventually be fermented into palm wine. The word *baaku* derives from the word *baaka*, which means both "extract" and "destroy." Thus tiny replicas of *baaku* driven into the *nkonde* are believed to destroy those who use evil power.

The word *nkonde* shares a stem with *konda*, meaning "to hunt," for the figure is quick to hunt down a client's enemies and destroy them. The *nkonde* here stands in a pose called *pakalala*, a stance of alertness like that of a wrestler challenging an opponent in the ring. Other *nkonde* figures hold a knife or spear in an upraised hand, ready to strike or attack.

Some African peoples conceive of the spirit world as a parallel realm in which spirits may have families, attend markets, live in villages, and possess personalities complete with faults and virtues. The Baule people in Côte d'Ivoire believe that each of us lived in the spirit world before we were born. While there, we had a spirit spouse, whom we left behind when we entered this life. A person who has difficulty assuming his or her gender-specific role as an adult Baule—a man who has not married or achieved his expected status in life, for example, or a woman who has not borne children—may dream of his or her spirit spouse.

For such a person, the diviner may prescribe the carving of an image of the spirit spouse (fig. 25-9). A man has a female figure (*blolo bla*) carved; a woman has a male figure (*blolo bian*) carved. The figures display the most admired and desirable marks of beauty so that the spirit spouses may be encouraged to enter and inhabit them. Spirit spouse figures are broadly naturalistic, with swelling, fully rounded musculature and careful attention to details of hairstyle, jewelry, and scarification patterns. They may be carved standing in a quiet, dignified pose or seated on a traditional throne. The throne contributes to the status of the figure and thus acts as an added incentive for the spirit to take up residence there. The owner keeps the figure in his or her room, dressing it in beautiful textiles and jewelry, washing it, anointing it with oil, feeding it, and caressing it. The Baule hope that by caring for and pleasing their spirit spouse a balance may be restored that will free their human life to unfold smoothly.

While nature spirits are often portrayed in African art, major deities are generally considered to be far

sought him out to ask him to restore order on earth, they found him sitting beneath a palm tree. Olodumare refused to return, although he did consent to give humanity some tools of divination so that they could learn his will indirectly.

The Yoruba have a sizable pantheon of lesser gods, or *orisha*, who serve as intermediaries between Olodumare and his creation. One that is commonly represented in art is Eshu, also called Elegba, the messenger of the gods. Eshu is a trickster, a capricious and mischievous god who loves nothing better than to throw a wrench into the works just when everything is going well. The Yoruba acknowledge that all humans may slip up disastrously (and hilariously) just when it is most important not to, and thus all must recognize and pay tribute to Eshu.

Eshu is associated with two eternal sources of human conflict, sex and money, and is usually portrayed with a· long hairstyle, because the Yoruba consider long hair to represent excess libidinous energy and unrestrained sexuality. Figures of Eshu are usually adorned with long strands of cowrie shells, a traditional African currency. Shrines to Eshu are erected wherever there is the potential for encounters that lead to conflict, especially at crossroads, in markets, or in front of banks. Eshu's followers hope that their offerings will persuade the god to spare them the pitfalls he places in front of others.

Eshu is intriguingly ambivalent and may be represented as male or female, as a young prankster or a wise old man. The dance staff here beautifully embodies the dual nature of Eshu (fig. 25-10). To the left he is depicted as a boy blowing loud noises on a whistle just to annoy his elders—a gleefully antisocial act of defiance. To the right he is shown as a wise old man, with wrinkles and a beard. The two faces are joined at the hair, which is drawn up into a long phallic knot. The heads crown a dance wand meant to be carried in performance by priests and followers of Eshu, whose bodies the god is believed to enter during worship.

LEADERSHIP

As in societies throughout the world, art in Africa is also used to identify those who hold power, to validate their right to kingship or their authority as representatives of the family or community and to communicate the rules for moral behavior that must be obeyed by all members of the society.

The gold-and-wood spokesperson's staff with which this chapter opened is an example of the art of leadership (see fig. 25-1). It belongs to the culture of the Ashanti peoples of Ghana, in West Africa, and was probably carved in the 1960s or 1970s by Kojo Bonsu. The son of Osei Bonsu, a famous carver who died in 1977, Kojo Bonsu lives in the Ashanti city of Kumasi and continues to carve prolifically. Gold was a major source of power for the Ashanti, who traded it first via intermediaries across the Sahara to the Mediterranean world, then later directly to Europeans on the West African coast. Along with other peoples of the region, the Ashanti have used gold for jewelry as well as for objects reserved for the use of rulers, such as the staff.

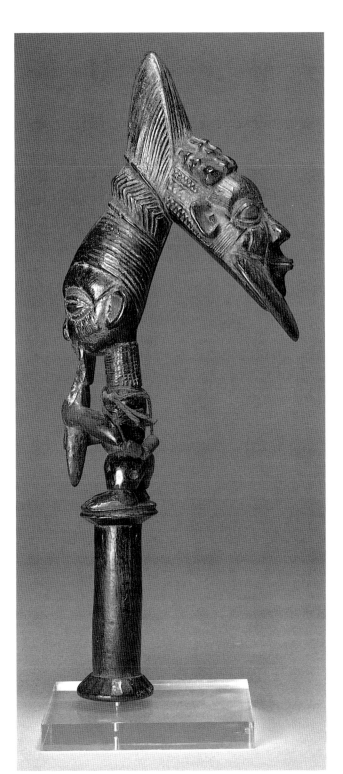

25-10. Dance staff depicting Eshu, from Nigeria. Yoruba culture, 20th century. Wood, height 17" (43.2 cm). The University of Iowa Museum of Art, Iowa City
The Stanley Collection

removed from the everyday lives of humans and are thus rarely depicted. Such is the case with Olodumare, also known as Olorun, the creator god of the Yoruba people of southwestern Nigeria. According to Yoruba myth, Olodumare withdrew from the earth when he was insulted by one of his eight children. When the children later

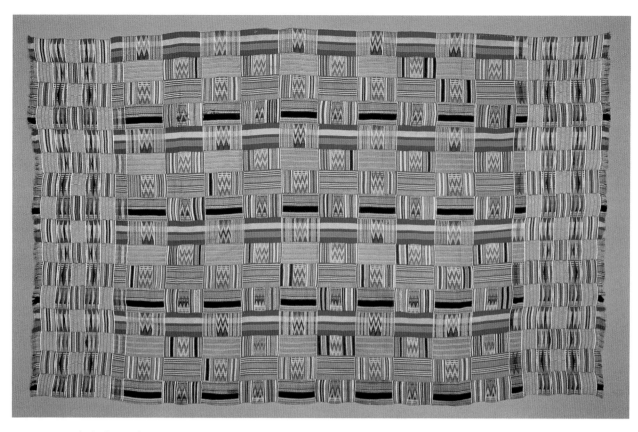

25-11. *Kente* cloth, from Ghana. Ashanti culture, 20th century. Silk, 6'10⁹/₁₆" x 4'3⁹/₁₆" (2.09 x 1.30 m). National Museum of African Art and National Museum of Natural History, Washington, D.C.
Purchased with funds provided by the Smithsonian Collections Acquisition Program, 1983–85, EJ 10583

The Ashanti are also renowned for the beauty of their woven textiles, called **kente** (fig. 25-11). Ashanti weavers work on small, light, horizontal looms that produce long, narrow strips of cloth. They begin by laying out the long **warp** threads in a brightly colored pattern. Today the threads are likely to be rayon. Formerly, however, they were silk, which the Ashanti produced by unraveling Chinese cloth obtained through European trade. **Weft** threads are woven through the warp to produce complex patterns, including double weaves in which the front and back of the cloth display different patterns. The long strips produced by the loom are then cut to size and sewn together to form large rectangles of finished *kente* cloth.

The *kente* cloth here began with a warp pattern that alternates red, green, and yellow. The pattern is known as *oyokoman ogya da mu*, meaning "there is a fire between two factions of the Oyoko clan," and refers to the civil war that followed the death of the Ashanti king Osai Tutu in about 1730. Traditionally, only the king of the Ashanti was allowed to wear this pattern. Other complex patterns were reserved for the royal family or members of the court. Commoners who dared to wear a restricted pattern were severely punished. In present-day Ghana the wearing of *kente* and other traditional textiles has

25-12. Portrait figure (*ndop*) of Shyaam a-Mbul a-Ngwoong, from Zaire. Kuba culture, mid-17th century. Wood, height 21³/₈" (54.5 cm). Museum of Mankind, London

25-13. Ekpo mask, from Nigeria. Anang Ibibio culture, late 1930s. Wood, height 23⅝" (60 cm). Musée Barbier-Mueller, Geneva

This mask embodies many characteristics the Ibibio find repulsive or frightening, such as swollen features, matte black skin, and large, uneven teeth. The pair of skulls atop the head are potent death imagery. The circular scar on the forehead and the ropelike headband indicate membership in the diviner's cult, *idiong*, whose members were particularly feared for their supernatural power. The mask is in the style of the Otoro clan from the Ikot Abia Osom area near the city of Ikot Ekpene.

ing mancala, a game he is said to have introduced to the Kuba. Icons of other kings include an anvil for a king who was a skilled blacksmith, a slave girl for a king who married beneath his rank, and a rooster for a twentieth-century king who was exceptionally vigilant.

Kuba *ndop* figures also feature carved representations of royal regalia, including a wide belt of cowrie shells crossing the torso. Below the cowries is a braided belt that can never be untied, symbolizing the ability of the wearer to keep the secrets of the kingdom. Cowrie-shell bands worn on the biceps are called *mabiim*. Commoners are allowed to wear two bands; the royal family wear nine. The brass rings depicted on the forearms may be worn only by the king and his mother. The ornaments over each shoulder are made of cloth-covered cane. They represent hippopotamus teeth, and they reflect the prestige that accrues to a hunter of that large animal. Finally, all of the Kuba king figures wear a distinctive cap with a projecting bill. The bill reminds the Kuba of the story of a dispute that arose between the sons of their creator god in which members of one faction identified themselves by wearing the blade of a hoe balanced on their heads.

Not all African peoples centralized power in a single ruler. Most of the peoples of southeastern Nigeria, for example, depended on a council of male elders or on a men's voluntary association to provide order in the life of the community. The Anang Ibibio people of Nigeria were formerly ruled by a men's society called Ekpo. Ekpo expressed its power in part through art, especially large, dark, purposely frightening masks (fig. 25-13). In most rituals involving masks, it is "the mask," not the person wearing it, who takes the action. Such masks were worn by the younger members of the society when they were sent out to punish transgressors. Accompanied by assistants bearing torches, the mask would emerge from the Ekpo meetinghouse at night and proceed directly to the guilty person's house, where a punishment of beating or even execution might be meted out. The identity of the executioner was concealed by the mask, which identified him as an impersonal representative of Ekpo in much the same way that a uniform makes it clear that a police officer represents the authority of the state.

been encouraged, and patterns are no longer restricted to a particular person or group.

The Kuba people of central Zaire have produced elaborate and sophisticated political art since at least the seventeenth century. Kuba kings were memorialized by portrait sculpture called *ndop* (fig. 25-12). While the king was alive, his *ndop* was believed to house his double, a counterpart of his soul. After his death the portrait was believed to embody his spirit, which was felt to have power over the fertility both of the land and of his subjects. Together, the twenty-two known *ndop* span almost 400 years of Kuba history.

Kuba sculptors did not try to capture a physical likeness of each king. Indeed, several of the portraits seem interchangeable. Rather, each king is identified by an icon, called *ibol*, carved as part of the dais on which he is seated. The *ibol* refers to a skill for which the king was noted or an important event that took place during his lifetime. The *ndop* in figure 25-12 portrays the seventeenth-century king Shyaam a-Mbul a-Ngwoong, founder of the Kuba kingdom. Carved on the front of his dais is a board for play-

DEATH AND ANCESTORS

In the traditional African view, death is not an end but a transition—the leaving behind of one phase of life and the beginning of another. Just as ceremonies marked the initiation of young men and women into the community of adults, so they mark the initiation of the newly dead into the community of spirits. Like the rites of initiation into adulthood, death begins with a separation from the community, in this case the community of the living. A period of isolation and trial follows, during which the newly dead spirit may, for example, journey to the land of ancestors. Finally, the deceased is reintegrated into a community, this time the community of ancestral spirits. The memory of the deceased may be preserved among the living, and his or her spirit may be

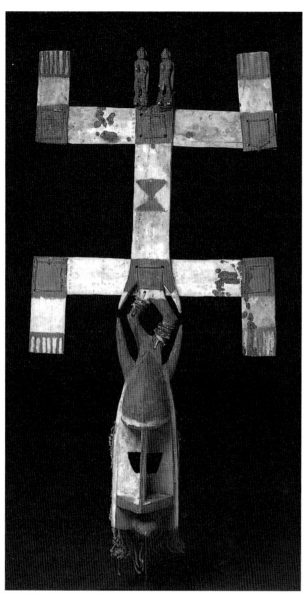

25-14. *Kanaga* mask, from Mali. Dogon culture, early 20th century. Wood, height 45¼" (115 cm). Musée Barbier-Mueller, Geneva

appealed to for intercession on their behalf with nature spirits or to prevent the spirits of the dead from using their powers to harm.

Among the Dogon people of Mali, in West Africa, the period of mourning following the death of an elder is brought to an end by a ceremony called *dama*, meaning "forbidden" or "dangerous." During *dama*, masks perform in the public square to the sound of gunfire to drive the soul of the deceased from the village. Among the most common masks is the *kanaga*, whose rectangular face supports a superstructure of planks that depict a crocodile or lizard with splayed legs (fig. 25-14).

If the deceased was a man, men from the community later engage in a mock battle on the roof of his home and participate in ritual hunts; if the deceased was a woman, the women of the community smash her cooking vessels on the threshold of her home. These portions of *dama* are reminders of human activities the deceased will no longer engage in. An elaborate *dama* commissioned by a wealthy

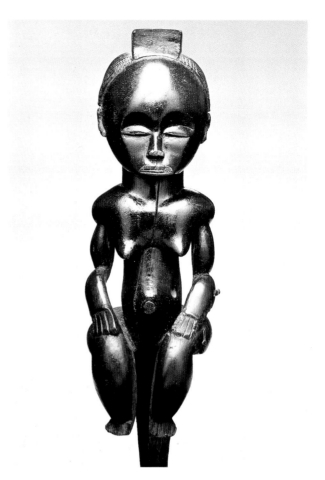

25-15. Reliquary guardian (*nlo byeri*), from Gabon. Fang culture, 19th century. Wood, height 16⅞" (43 cm). Musée Dapper, Paris

family may last as long as six days and include the performance of as many as 100 masks. Because a *dama* is so costly, it may be performed for several deceased elders, both male and female, at the same time.

The Fang people, who live near the Atlantic coast from southern Cameroon through Rio Muni and into northern Gabon, follow an ancestral religion in which the long bones and skulls of ancestors who have performed great deeds are collected after burial and placed together in a cylindrical bark container called *nsekh o byeri*. Deeds thus honored include killing an elephant, being the first to trade with Europeans, bearing an especially large number of children, or founding a particular lineage or community. On top of the container the Fang place a wooden figure called *nlo byeri*, which represents the ancestors and guards their relics from malevolent spirit forces (fig. 25-15). *Nlo byeri* are carved in a naturalistic style, with carefully arranged hairstyles, fully rounded torsos, and heavily muscled legs and arms. Frequent applications of cleansing and purifying palm oil produce a rich, glossy black surface.

The strong symmetry of the statue is especially notable. The layout of Fang villages is also symmetrical, with pairs of houses facing each other across a single long street. At each end of the street is a large public meetinghouse. The Fang immigrated into the area they now occupy during the early nineteenth century. The

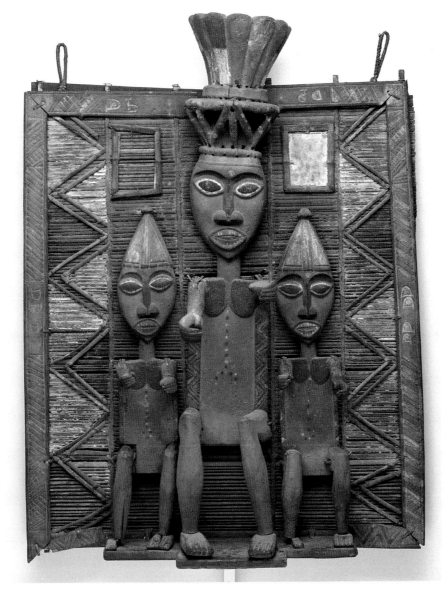

25-16. Ancestor screen (*duen fobara*), from Abonnema village, Nigeria. Kalabari group, Ijo culture, 19th century. The Minneapolis Institute of Arts

experience was disruptive and disorienting, and Fang culture thus emphasizes the necessity of imposing order on a disorderly world. Many civilizations have recognized the power of symmetry to express permanence and stability (see, for example, the Forbidden City in Beijing, China, fig. 21-8).

Internally, the Fang strive to achieve a balance between the opposing forces of chaos and order, male and female, pure and impure, powerful and weak. They value an attitude of quiet composure, of reflection and tranquillity. These qualities are embodied in the powerful symmetry of the *nlo byeri* here, which communicates the calm and wisdom of the ancestor while also instilling awe and fear in those not initiated into the Fang religion.

Among the most complex funerary art in Africa are the memorial ancestral screens made during the nineteenth century by the Ijo people of southeast Nigeria (fig. 25-16). The Ijo live on the Atlantic coast, and with their great canoes formerly mediated the trade between European ships anchored offshore and communities in the interior of Nigeria. During that time groups of Ijo men organized themselves into economic associations called

canoe houses, and the heads of canoe houses had much power and status in the community. When the head of a canoe house died, a screen such as the one in figure 25-16 was made in his memory. The Ijo call these screens *duen fobara*, meaning "foreheads of the dead." (The forehead were believed to be the seat of power and the source of success.) The screens are made of wood and cane that were joined, nailed, bound, and pegged together. The assembly technique is unusual, because most African sculpture is carved from a single piece of wood.

Although each screen commemorates a specific individual, the central figure was not intended as a physical likeness. Instead, as is common in Africa, identity was communicated through attributes of status, such as masks, weapons, or headdresses that the deceased had the right to wear or display. The central figure of the example here wears a hat that distinguishes him as a member of an important men's society called *peri*. He is flanked by assistants, followers, or supporters of the canoe house, who are portrayed on a smaller scale. All three figures originally held weapons or other symbols of aggressiveness and status. Other extant screens include

25-17. Spirit mask in performance, from Côte d'Ivoire. Guro culture, early 1980s. Polychrome wood, height approx. 18" (45.72 cm)

smaller heads attached to the top of the frame, perhaps wearing masks that the deceased had commissioned, and representations of the severed heads of defeated enemies at the feet of the figures.

Memorial screens were placed in the ancestral altars of the canoe house, where they provided a dwelling for the spirit of the dead, who was believed to continue to participate in the affairs of the house after his death, ensuring its success in trade and war.

CONTEMPORARY ART

The photograph in this chapter of the Bwa masks in performance (see fig. 25-4) was taken in 1984. Even as you read this chapter, new costumes are being made for this year's performance, in which the same two masks will participate. Many traditional communities continue their art in contemporary Africa. But these communities do not live as if in a museum, re-creating the forms of the past as though nothing had changed. As new experiences pose new challenges or offer new opportunities, art changes with them.

Perhaps the most obvious change in traditional African art has been in the adaptation of modern materials to traditional forms. The Guro people of Côte d'Ivoire, for example, continue to commission delicate masks dressed with costly textiles and other materials. But now they paint them with oil-based enamel paints, endowing the traditional form with a new range and brilliance of color (fig. 25-17). The Guro have also added inscriptions in French and depictions of contemporary figures to sculptural forms that have persisted since before the colonial period. Other peoples have similarly made use of European textiles, plastics, metal, and even Christmas tree ornaments to enhance the visual impact of their art. Some Yoruba have used photographs and even brightly colored imported plastic children's dolls in place of the traditional *ere ibeji*, the images of twins shown in figure 25-3.

Throughout the colonial period and especially during the years following World War II, Europeans established schools in Africa to train talented artists in the mediums and techniques of European art. In the postcolonial era numerous African artists have studied in Europe and the United States, and many have become known internationally through exhibits in galleries and museums.

One such artist is Ouattara (b. 1957), represented here by *Nok Culture* (fig. 25-18). Ouattara's background exemplifies the fertile cross-cultural influences that shape the outlook of contemporary urban Africans. Born in Côte d'Ivoire, he received both formal French schooling and traditional African spiritual schooling. His father practiced both Western-style surgery and traditional African heal-

25-18. Ouattara. *Nok Culture*. 1993. Acrylic and mixed mediums on wood, 9'8¹/₂" x 6'7³/₄" (2.96 x 2.03 m). Collection of the artist

ing. At nineteen Ouattara moved to Paris to absorb at first-hand the modern art of Europe. He currently lives and works in New York, Paris, and Abidjan. In paintings such as *Nok Culture*, Ouattara draws on his entire experience, synthesizing Western and African influences.

Nok Culture is dense with allusions to Africa's artistic and spiritual heritage. Its name refers to a culture that thrived in Nigeria from about 500 BCE to 200 CE and whose naturalistic **terra-cotta** sculpture are the earliest known figurative art from sub-Saharan Africa. Here, thickly applied paint has built up a surface reminiscent of the painted adobe walls of rural architecture. Tonalities of earth browns, black, and white appear frequently in traditional African art, especially in textiles. The conical horns at the upper corners evoke the ancestral shrines common in rural communities as well as the buttresses of West African adobe mosques. The **motif** of concentric circles at the center of the composition looks much like the traditional bull-roarer sound maker used to summon spirits. Suspended in a window that opens into the painting is a lesson board of the type used by Muslim students in Koranic schools. On the board appear Arabic writing, graphic patterns from African initiation rituals, and symbols from the Christian, ancient Egyptian, and mystical Hebrew traditions—a vivid if cryptic evocation of the many spiritual currents that run together in Africa.

Another art that has brought contemporary African artists to international attention is ceramics. Traditionally, most African pottery has been made by women. In some West African societies, potters were married to black-smiths, both husband and wife making products that take raw ingredients from the earth and transform them by fire. These couples lived apart from the community both physically and socially, respected for their skills yet feared for the intimate contact they had with the powers of earth and fire.

Today, making pottery has enabled many women from traditional communities to attain a measure of economic independence. In Nigeria it is not uncommon to see large trucks stopped at a potters' village, loading up pots to be transported to distant markets. The women do not usually share their pottery income with the male head of the family but keep it to buy food for themselves and their children. In one large pottery community in Ilorin, a northern city of the Yoruba people in Nigeria, women have subcontracted the dreary and physically demanding tasks of gathering raw clay and fuel to local men so that they can concentrate on forming their wares, for which there is a great demand. In this way they control much of the local economy.

Nourished by this long tradition, some women have achieved broader recognition as artists. One is Magdalene Odundo (b. 1950), whose work displays the flawless surfaces of traditional Kenyan pottery (fig. 25-19). Indeed, she forms her pots using the same coiling technique that her Kenyan relatives use. Like Ouattara,

Odundo draws her inspiration from a tremendous variety of sources, both African and non-African. In the workshops she presents at colleges and art schools she shows hundreds of slides of pottery. She begins with images of Kenyan potters and pottery, then quickly moves on to pottery from the Middle East, China and Japan, and ancient North and South America. Odundo works in England, teaches in Europe and the United States, and shows her art through a well-known international dealer. Yet the power of traditional African forms is abundantly evident in the elegant pot illustrated here.

The painter Ouattara probably speaks for most contemporary artists around the world when he says, "[M]y vision is not based only on a country or a continent, it's beyond geography or what you see on a map, it's much more than that. Even though I localize it to make it understood better, it's wider than that. It refers to the cosmos" (cited in McEvilley, page 81). In his emphasis on the inherent spirituality of art, Ouattara voices what is most enduring about the African tradition.

25-19. Magdalene Odundo. *Asymmetrical Angled Piece*. 1991. Reduced red clay, height 17" (43.18 cm). Collection of Werner Muensterberger

1725 1755 1785

Boyle
Chiswick House
1724–29

Patterson and Washington
Mount Vernon
1758–86

Pigalle
Portrait of Diderot
1777

Fuseli
*The
Nightmare*
1781

David
*Oath of
the Horatii*
1784–85

Langhans
Brandenburg
Gate
1788–91

CHAPTER 26

Neoclassicism and Romanticism in Europe and the United States

Goya
Third of May, 1808
1814–15

anova
*Maria Paulina Borghese
s Venus Victrix*
808

Barye
*Lion Crushing
a Serpent*
1833

Bingham
*Fur Traders Descending
the Missouri*
c. 1845

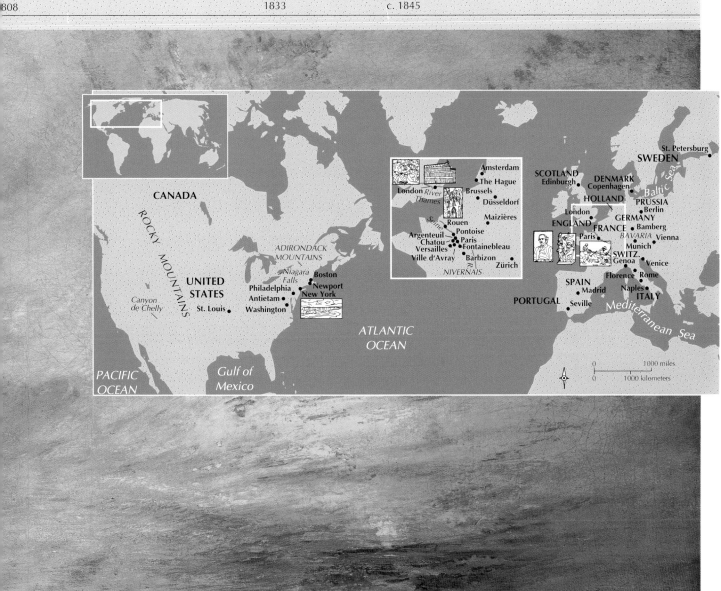

St. Petersburg

SWEDEN

SCOTLAND
Edinburgh

DENMARK
Copenhagen

Baltic Sea

HOLLAND

PRUSSIA
Berlin

CANADA

Amsterdam
The Hague
Brussels
Düsseldorf
Maizières

London *River Thames*

London

GERMANY
Bamberg
BAVARIA
Vienna
Munich

ENGLAND
FRANCE

ROCKY MOUNTAINS

ADIRONDACK
MOUNTAINS

Seine
Rouen
Argenteuil
Chatou
Versailles
Ville d'Avray

Pontoise
Paris
Fontainebleau
Barbizon

Paris

SWITZ.
Venice

UNITED
STATES

Niagara
Falls
Philadelphia
Antietam
St. Louis

Boston
Newport
New York

NIVERNAIS

Zürich

Genoa
Florence Rome

SPAIN
Madrid

Naples
ITALY

Canyon
de Chelly

Washington

ATLANTIC
OCEAN

PORTUGAL

Seville

Mediterranean Sea

PACIFIC
OCEAN

Gulf of
Mexico

0 1000 miles
0 1000 kilometers

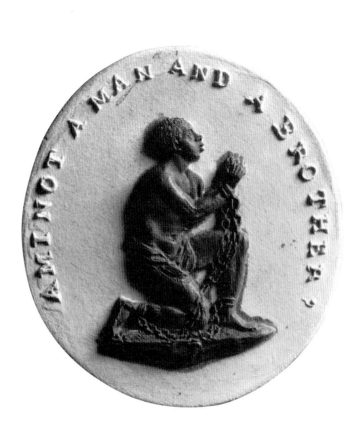

26-1. William Hackwood, for Josiah Wedgwood. *"Am I Not a Man and a Brother?"* 1787. Black-and-white jasperware, 1⅜ x 1⅜" (3.5 x 3.5 cm). Trustees of the Wedgwood Museum, Barlaston, Staffordshire, England

For two centuries the name *Wedgwood* has been synonymous with exquisitely made English ceramics. The man who first gave his name to these fine ceramics, Josiah Wedgwood, had begun to work in his family's pottery business at age nine, and through sheer inventiveness and superlative taste he transformed ceramics in England from an industry to a popular art. Wedgwood became the maker of a cream-colored earthenware that quickly gained wide popularity and was known as Queen's ware, in honor of England's Queen Charlotte, and he created a dinner service for Catherine the Great of Russia.

But there was another side to Wedgwood. He established a village named Etruria for his employees and cared deeply about their living conditions. Wedgwood was also active in the international effort to halt the African slave trade and abolish slavery. To publicize the abolitionist cause, he asked the sculptor William Hackwood to design an emblem for the British Committee to Abolish the Slave Trade, formed in 1787. The compelling image created by Hackwood, a small white-and-black medallion, was carved in relief in the likeness of a black African man kneeling in chains, with the legend "Am I Not a Man and a Brother?" (fig. 26-1). Wedgwood sent copies of the medallion to Benjamin Franklin, the president of the Philadelphia Abolition Society, and to others in the abolitionist movement. In the nineteenth century the women's suffrage movement in the United States adapted the image by representing a woman in chains with the motto "Am I Not a Woman and a Sister?"

A work of art as explicitly political as this was highly unusual in the eighteenth century, although not unique. There were artists in both Europe and America who responded to the tumultuous social and political changes with powerful and courageous works of art.

REVOLUTION AND ENLIGHTENMENT

In the eighteenth century, growing dissatisfaction with the political system in Great Britain, France, and Colonial America led to sweeping changes. In Britain the king's prerogatives gradually came to be exercised by a cabinet responsible to Parliament, while in North America thirteen of Britain's colonies successfully revolted against George III. The monarchy in France was also overthrown in armed revolution. As political power was shifting from the Crown and the nobility, the Industrial Revolution was bringing a new prosperity to the middle classes.

Despite the republican fervor of the French Revolution, which began in 1789, the revolutionary government did not endure. After a series of political upheavals, General Napoleon Bonaparte established himself first as dictator (First Consul) in 1799, then in 1804 as Emperor Napoleon I. Napoleon's subsequent military conquests redrew the map of Europe and radically altered its political life.

These enormous changes reflected an attitude, which developed during the eighteenth century, that valued scientific inquiry both into the natural world and into human life and society. Reason became the touchstone for evaluating nearly every civilized endeavor, including philosophy, art, and politics. By extension, nature, which was thought to embody reason, was also evoked to corroborate the correctness—and goodness—of everything from political systems to architectural designs. It was generally believed that people are inherently reasonable and that if given an opportunity and if their ignorance were dispelled they would choose what is reasonable and good. These beliefs led cultural historians to call the eighteenth century the Age of Enlightenment, or the Age of Reason.

Two of the most influential theorists of the Enlightenment were the French philosopher and critic Denis Diderot (1713–1784) and the Swiss philosopher Jean-Jacques Rousseau (1712–1778). Diderot published criticism of the Royal Academy's biennial Salon exhibitions

1725 1875

ACADEMY EXHIBITIONS

During the seventeenth century the French government founded a number of royal **academies** for the support and instruction of students in literature, painting and sculpture, music, dance, and architecture. In 1667 the Royal Academy of Painting and Sculpture began to mount occasional exhibitions of the members' recent work. These exhibitions came to be known as **Paris Salons** because they were held in the Salon d'Apollon ("Salon of Apollo") in the Palais du Louvre. After a reorganization of the Royal Academy in 1737 the Salons were held every other year, with a jury of members selecting the works that would be shown. As the only public art exhibitions of any importance in Paris, the Salons were enormously influential in establishing officially approved styles and in molding public taste, and they helped consolidate the Royal Academy's dictatorial control over the production of fine art.

In England the Royal Academy of Arts was quite different. Although chartered by King George III in 1768, it was a private institution independent of any interference from the Crown. It had only two functions, to operate an art school and to hold two annual exhibitions, one of art of the past and another of contemporary art, which was open to any exhibitor on the basis of merit alone. The Royal Academy continues to function in this way to the present day.

In France the Revolution of 1789 brought a number of changes to the Royal Academy. In 1791 the jury system was abolished as a relic of the monarchy, and the Salon was democratically opened to all artists. In 1793 all of the royal academies were disbanded and in 1795 reconstituted as the newly founded Institut de France, which was to administer the art school—the École des Beaux-Arts—and sponsor the Salon exhibitions. The number of would-be exhibitors was soon so large that it became necessary to reintroduce some screening procedure, and so the jury system was revived.

In 1816, with the return of the monarchy after the defeat of Napoleon I at Waterloo, the division of the Institut dedicated to painting and sculpture was renamed the Académie des Beaux-Arts, and thus the old Academy was in effect restored. During the following years this new Academy exerted enormous influence over artistic matters, just as the old one had in the past. As time went on, increasing numbers of artists began to protest its control of the Salons. In response to the growing dissatisfaction, Emperor Napoleon III established the Salon des Refusés ("Salon of the Rejected Ones") in 1863 to exhibit work that had not been accepted by the Academy's jury. The opening of an officially sanctioned alternate exhibition greatly changed the artistic climate of Paris, encouraging increasing numbers of independent exhibitions and, ultimately, breaking the absolute dominance of the Academy.

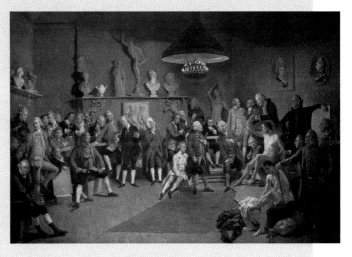

Johann Zoffany. *Academicians of the Royal Academy.* 1771–72. Oil on canvas, 47½ x 59½" (120.6 x 151.2 cm). The Royal Collection, Windsor Castle, Windsor, England

■■■■■■
1725 1875

Culture Center	1725–1800	1800–1875
Italy	Excavations of Pompeii and Herculaneum; Winckelmann distinguishes Greek and Roman styles in painting and sculpture; Antonio Canova; Neoclassicism emerges	
Britain	Lord Burlington promotes Neoclassical architecture; Hogarth's Marriage à la Mode; British landscape and genre paintings increase; British Empire in India; history paintings gain popularity; James Watt develops steam engine; Joshua Reynolds's Grand Manner portraits; romance of science paintings; Copley exhibits at London Society of Artists; George III charters Royal Academy of Art; Angelica Kauffmann and Mary Moser named to Royal Academy; Josiah Wedgwood perfects jasperware; Britain recognizes American independence; Gainsborough's portraits; Romantic literary movement	United Kingdom of Great Britain and Ireland established; Constable's *White Horse*; Houses of Parliament redesigned; Turner's *Fighting "Téméraire"*
France	Grand Manner emerges; Jean-Jacques Rousseau's *Émile* and *Le Contrat Social*; David's *Oath of the Horatii*; Vigée-Lebrun's portraits of Marie Antoinette; French Revolution; David's *Death of Marat*; Napoleon First Consul; Neoclassicism in France at its peak	Napoleon I of First Empire; Ingres's *Large Odalisque*; Romanticism emerges; royal restoration of Louis XVIII; Géricault's *Raft of the "Medusa"*; Charles X; Delacroix's *The Twenty-eighth of July: Liberty Leading the People*; Revolution of 1830; Louis Philippe; Rude's *La Marseillaise*; Napoleon III of Second Empire
Germany	King Frederick William II of Prussia; Langhans's Brandenburg Gate; Mozart's *Don Giovanni*	Beethoven's Ninth Symphony; Marx and Engels's *Communist Manifesto*
Spain	King Charles III; King Charles IV	Goya's *Third of May, 1808*; King Joseph Bonaparte; King Ferdinand VII installed by British
United States	Georgian style; Boston Tea Party; Declaration of Independence; Federal style; George Washington president	Thomas Jefferson president; Latrobe initiates Greek Revival style; Louisiana Purchase from France doubles U.S. territory; Audubon's *The Birds of America*; Cole's *The Oxbow*; Texas annexed; Oregon acquired; California gold rush; Stowe's *Uncle Tom's Cabin*; South Carolina secedes; Civil War begins; slavery abolished; Abraham Lincoln assassinated; first transcontinental railroad
World	Qing dynasty continues (China); Catherine the Great (Russia); Hermitage Museum founded (Russia)	Mexico becomes a republic; South African Republic established; Crimean War between Turkey and Russia; Italy is united; Dominion of Canada is formed

(see "Academy Exhibitions," page 929) in the popular press, decrying what he considered the empty pomposity of the Baroque period and the frivolity of the Rococo style, calling instead for an edifying art that would glorify virtue. To forge this new artistic expression, artists sought models in classical antiquity, the Renaissance, and even the Baroque period. Raphael and Poussin were held in high esteem, but by far the most influential artist was Michelangelo. Michelangelo's art was heroic, serious, and certainly edifying, and it reflected unparalleled virtuosity. Many late-eighteenth-century artists felt the need to come to terms with his example, often by deliberate imitation.

Another manifestation of the eighteenth-century spirit of inquiry that profoundly affected both art and literature was the development of **historicism**, or the consciousness of history. Literate people increasingly valued accurate descriptions of historical events, which resulted in greater accuracy in the depiction of not only classical subjects but also Gothic, Romanesque, and various Asian styles.

Around 1750 Rococo tendencies in art and architecture, responding to the general longing for a noble and serious mode of expression, gave way to a restrained and formal style of representation referred to as the **Grand Manner**. This term encompassed not only the new style but also the more restrained modes of seventeenth-century classicism, the monumental stillness of Greek sculpture, and the dignified gravity of Roman painting. Thus, the Grand Manner was not a radical change but essentially a shift toward greater reserve and formality. It was an important change, however, for it signaled a movement toward true Neoclassicism.

The theoretical basis for the specifically classical style called Neoclassicism emerged in Rome in the 1760s. It was stimulated in part by new discoveries in excavations of Pompeii and Herculaneum, Roman cities buried by the first-century eruption of Mount Vesuvius. The leaders of the Neoclassic movement were German and British expatriates, primarily the German archeologist and art critic Johann Winckelmann (1717–1768), the German painter Anton Raphael Mengs (1728–1779), and the Scottish artist and archeologist Gavin Hamilton (1723–1798). Winckelmann was the movement's main propagandist, and although he never visited Greece himself, his ideas influenced nearly every artist who worked in Rome during the 1750s and 1760s, whether Italian or foreign. Winckelmann was the first antiquarian, or scholar of antiquities, to distinguish between Greek and Roman styles of architecture and sculpture, and he considered the Greek superior. As a result, artists in Rome began to emulate Classical models more closely, particularly those thought to be Greek. The Neoclassicism that developed in Rome was characterized by Classical subject matter, formal dependence on antique sources, heroic nudity in sculpture, and the use of pure line in painting and drawing. These qualities were generally accompanied by an underlying moralism that exalted the virtues associated by the moderns with Republican Rome: moral incorruptibility, patriotism, and courage.

In the late eighteenth century the French artist Jacques-Louis David developed a distinctively Neoclassical painting style by bringing together his study of Classical sculpture in Rome and of academic realism at the Royal Academy, one of a number of **academies**—official societies of learned persons founded to advance the arts—established in Europe during this period. The first public showing of this work, in 1781, was enthusiastically received, and Diderot declared the young man a genius.

Despite the dominance of classicism in the second half of the eighteenth and early nineteenth centuries, much art of that period was imaginative and "irrational"—a strain of expression called Romanticism because many of its themes were taken from medieval "romances"—novellas, stories, and poems in Romance (Latin-derived) languages. Thus, the term *Romantic* suggests something fantastic or novelistic, perhaps set in a remote time or place, and a spirit of poetic fancy or even melancholy. Many paintings and sculpture combined elements of Neoclassicism and Romanticism. Indeed, because Neoclassical and Romantic art are both characterized by "remoteness in time or place," it can even be argued that the overriding impulse in European and American art from roughly 1725 to 1875 was Romanticism and that Neoclassicism was simply one of its subcategories. In fact, Neoclassicism itself embodies many contradictions, and some Neoclassic art exhibits such clearly "Romantic" qualities as eroticism, violence, and expressive formal distortions. Many artists also moved from one style to another, perhaps painting in a very Baroque vein for one work, then in a Neoclassic manner for another.

THE GRAND TOUR

From the late 1600s until well into the nineteenth century, one feature of the education of young gentlemen (and, occasionally, gentlewomen) of northern Europe and the American colonies that had great influence on European art was the grand tour. Generally accompanied by a tutor and an entourage of servants, wealthy travelers visited the cultural sights of primarily France and Italy for several years as a way of enhancing a classical education. Typically, the tour began with visits to the Louvre and the Royal Academy in Paris, then proceeded to southern France to see a number of well-preserved Roman monuments, followed by a passage to Italy through the Alps, considered the ultimate in **sublime** scenery. In Italy the principal points of interest were Venice, Florence, Rome, and Naples, whose **picturesque** settings, magnificent art, and exciting social life led many tourists to stay for months. All these cities had large expatriate communities, where a traveler from the north could feel at home.

The grand tour was influential for several reasons. As art collecting and **connoisseurship** (the study of styles and quality in art) came to be considered proper aristocratic pastimes, many important Italian paintings and antique statues were acquired for private collections in northern Europe. The sights of the grand tour also had a profound effect on those artists who traveled. Not surprisingly, Italian artists responded to this rich and

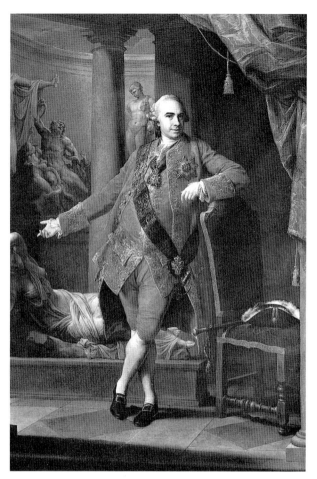

26-2. Pompeo Batoni. *Portrait of Count Razoumowsky.* 1766. Oil on canvas, 9'9½" x 6'5" (2.99 x 2.07 m). Collection Count Razoumowsky, Vienna

cultivated foreign clientele. In Rome the portraits of Pompeo Batoni (1708–1787) were considered the pinnacle of urbanity and refinement, and visiting foreigners besieged him with commissions. A full-length painting of the Russian Count Razoumowsky (fig. 26-2), president of the St. Petersburg Academy of Science, is typical of Batoni's Grand Manner portraits. The count, in an embroidered velvet coat sparkling with imperial decorations, is portrayed as a cultivated visitor to the papal collection of antique sculpture, his somewhat studied gestures and relaxed but dignified demeanor marking him as a model of cosmopolitan nobility.

Travelers on the grand tour also enthusiastically bought **vedute** (Italian for "views"; singular, **veduta**), paintings of the cities they visited. The Venetian artist Giovanni Antonio Canal, called Canaletto (1697–1768), became so popular among British clients that his dealer arranged for him to work from 1746 to 1755 in England, where he painted views of London and the surrounding countryside, giving impetus to a school of English **landscape painting**.

In 1762 George III purchased Canaletto's *Santi Giovanni e Paolo and the Monument to Bartolommeo Colleoni* (fig. 26-3), painted probably in 1735–1738. The Venetian square is shown as if the viewer were in a gondola on a

26-3. Canaletto. *Santi Giovanni e Paolo and the Monument to Bartolommeo Colleoni.* c. 1735–38. Oil on canvas, 18⅜ x 30⅞" (46 x 78.4 cm). The Royal Collection, Windsor Castle, Windsor, England

26-4. Giovanni Paolo Panini. *View of the Piazza del Popolo, Rome*. 1741. Oil on canvas, 38 x 52¾" (96.6 x 134 cm). The Nelson-Atkins Museum of Art, Kansas City, Missouri
Purchase: Acquired through the Generosity of an Anonymous Donor (F79-3)

nearby canal. Immediately to the right is a perspectival plunge down the street into the distance. Many of Canaletto's views, like this one, are topographically correct; in others he rearranged the buildings to tighten the **composition** (the way the parts of the painting were put together), even occasionally adding features to produce a **capriccio** ("caprice"), or mixture of pleasing motifs.

In Rome the view painter Giovanni Paolo Panini (c. 1692–1765), like Canaletto, specialized in painting his city's sights and was especially favored by French patrons. His views, too, are sometimes topographically correct and sometimes imaginary, with actual ruins placed in fantasy settings. His *View of the Piazza del Popolo, Rome* (fig. 26-4) of 1741 is a faithful view of a Roman square from above, which a visitor today might see from a tall building.

Giovanni Battista Piranesi (1720–1778), another artist catering to Rome's foreign clientele, became one of the most successful publishers of prints in the eighteenth century. Trained in Venice as an architect, Piranesi went to Rome in 1740. After studying etching, he began in 1743 to produce portfolios of prints, and in 1761 he established his own publishing house. Piranesi is best known for his views of ancient Roman ruins, such as *The Arch of Drusus* (fig. 26-5), published in a portfolio of etchings called *Le Antichità Romane* (*Roman Antiquities*) in

26-5. Giovanni Battista Piranesi. *The Arch of Drusus.* 1748. Etching, 14⁷/₁₆ x 28¾" (37 x 73 cm). Published in *Le Antichità Romane* (later retitled *Arco Trionfali*), Rome, 1748. The Pierpont Morgan Library, New York
PML 12601

Piranesi's children carried on his publishing business after his death. Encouraged by Napoleon's officials, his sons Francesco and Piero moved the operation in 1799 to Paris, where between 1800 and 1807 they made and sold restrikes (posthumous impressions) of all of their father's etchings. Later Piranesi's plates were purchased by the Royal Printing House in Rome and reprinted again.

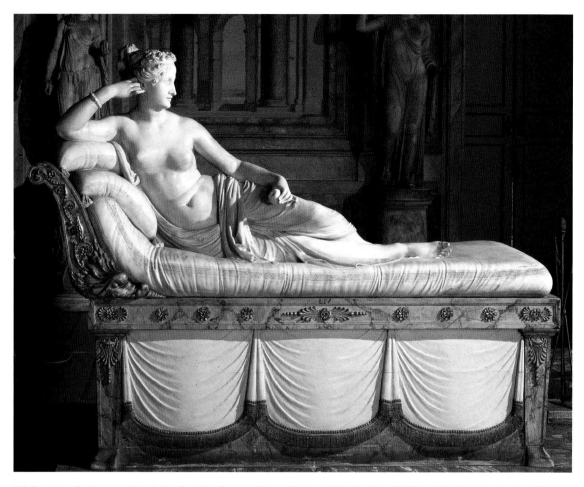

26-6. Antonio Canova. *Maria Paulina Borghese as Venus Victrix*. 1808. Marble, 5'2⅞" x 6'6¾" (1.6 x 2 m). Galleria Borghese, Rome

Paulina Borghese was a younger sister of Napoleon Bonaparte. The widow of a French general, in 1803 she married Prince Camillo Borghese, a member of the old nobility of Rome. Prince Borghese remained a firm supporter of his brother-in-law, serving as his governor of Piedmont in 1807.

1748. Although Piranesi was deeply in sympathy with the antiquarianism of Winckelmann and the Neoclassicists, the poetry of his vision, with its dramatic shadows, wild growths of trees and vines, picturesque figures, colossal sense of scale, and his monuments' aura of crumbling majesty, reveals an early Romantic sensibility. Piranesi's imaginative evocation of antiquity is one of many intersections of the Neoclassic and Romantic impulses.

ITALY Although Rome was the cradle of the Neoclassic movement, few Italian artists were stylistic innovators. In the second half of the eighteenth century, however, sculptors in Rome began to assimilate the new classicism, which in turn influenced many foreign artists who had come to the city to study and work.

Antonio Canova

In the late eighteenth century the foremost Neoclassical artist in Italy—and, indeed, in Europe—was the sculptor Antonio Canova (1757–1822). Born into a family of stonemasons near Venice, Canova settled in Rome in 1781 after traveling to Naples to see the Greek temples at Paestum and the excavations at Pompeii and Hercula-

neum in 1779–1780. Canova rapidly achieved such renown that critics compared him with Michelangelo. Every serious collector hoped to own one of his pieces, including Catherine the Great of Russia, whose invitation to her court the sculptor politely declined.

Napoleon, too, became a patron. One of Canova's most admired works is a portrait of the emperor's sister, *Maria Paulina Borghese as Venus Victrix* (fig. 26-6), completed in 1808. The princess is shown as an idealized, partially nude goddess reclining on an elaborately carved Neoclassical couch, her calm facial expression suggesting divine detachment. In one hand she holds an apple, an allusion to the golden apple awarded by the Trojan prince Paris to Aphrodite (the Greek name of Venus) for her beauty. Canova's sculpture is a study in delicately calibrated contrasts. The rounded forms of the goddess's body are set off by crisp folds of drapery, the softness of her skin by the rough texture of her hair, and the lustrous off-white finish that Canova gave his marbles by the veined gray-lavender stone and gilded details of the couch. Canova is said to have finished his surfaces by candlelight so that no subtlety would be lost, which enabled him to produce the almost miraculously delicate shading evident in this work. Although carved fully in the

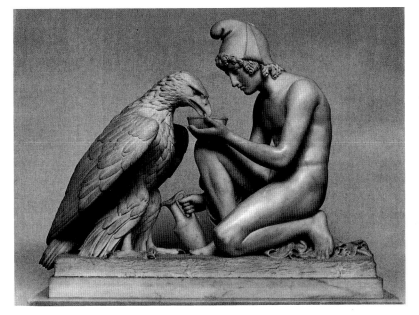

26-7. Bertel Thorvald-
sen. *Ganymedes
with Jupiter's
Eagle.* 1817.
Marble, lifesize.
Thorvaldsens
Museum,
Copenhagen

round, the figure is meant to be seen from one side, as if it were a relief sculpture. Canova's interest in line here is characteristic of his style and of the Neoclassic style in general after 1800.

Bertel Thorvaldsen

After studying for five years at the Royal Academy of Sculpture in Copenhagen, the Danish sculptor Bertel Thorvaldsen (1768/1770–1844) arrived in Rome on March 3, 1797, a day he thereafter considered his birthday. By the early nineteenth century his reputation was second only to Canova's in Neoclassic sculpture. The work of the two sculptors is quite different. Thorvaldsen left his marbles stark white, whereas Canova preferred an off-white finish; Thorvaldsen's proportions were heavier, his cutting sharper, and his surfaces harder. He maintained a large workshop—with about forty assistants by 1820—that inculcated his severe Neoclassic style in the young sculptors who came to Rome to study, including many Americans. A particularly fine example of Thorvaldsen's work is a statue of *Ganymedes with Jupiter's Eagle* (fig. 26-7), of 1817. Like most Neoclassic sculpture after 1800, this piece presents the carefully articulated profile of a line drawing, and many of its effects—such as the precise cutting of feathers and hair and the dry, spare treatment of muscle and drapery—tend to be linear.

BRITAIN In the early eighteenth century the British theorists Colin Campbell (d. 1729) and Jonathan Richardson the Elder (1665–1745), like Diderot later in France, called for a reform in art because of the moral decay and disillusionment they found in government, in Britain's case those of George I (ruled 1714–1727) and George II (ruled 1727–1760). Like Diderot, Campbell and Richardson believed that art should promote and support "civic humanism," or public virtue and integrity, and for this they favored a restrained **classical** style.

Later in the century there were nonclassical developments in Britain, as well. The term *Romantic*, originally invented to denote a literary preoccupation with nature that lasted from around 1790 to 1830, was extended to cover painting in the same vein. The subject of most Romantic painting in Britain, like British Romantic poetry, was the country's landscape and everyday life. Like the poetry, these paintings often suggested melancholy, loss, and disillusionment. Indeed, in contrast to the Enlightenment point of view, the Romantic sensibility both in Britain and on the Continent considered nature not "reasonable" or idyllic but poetically lonely, eerie, thrilling, or even terrifying.

Two terms common in Romantic art criticism were ***picturesque*** and **sublime**. In 1757, for example, the British philosopher and diplomat Edmund Burke distinguished the familiar, comprehensible, and reassuring as the beautiful (or the picturesque), while subjects that evoked a strong emotional reaction were sublime. Thus, pleasant country views or rural **genre** scenes (episodes of everyday life) were called picturesque, and more awe-inspiring subjects were considered sublime. The art of Michelangelo was quintessentially sublime. Dramatic landscape features, such as towering mountains, thundering waterfalls, rocky crags, dismal forests, crumbling ruins, or erupting volcanoes, were inherently sublime, especially if portrayed to emphasize their extremes. Paintings of historical and literary subjects might also be sublime if they were presented dramatically.

Architecture and Decoration

In Britain Vitruvius (first century BCE) and Palladio (sixteenth century CE) were major inspirations for architecture during most of the eighteenth century, although British architects, like their seventeenth-century predecessor Inigo Jones (see fig. 19-62), often integrated Baroque, Rococo, or more modern elements into their **Palladian** buildings. Early in the century Richard Boyle,

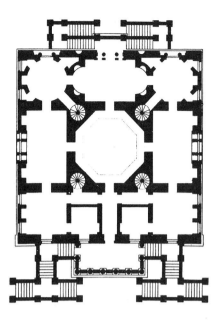

26-8. Richard Boyle, Lord Burlington. Plan of Chiswick House, West London. 1724

third earl of Burlington (1695–1753), promoted classicism in English architecture. He made two trips to Italy, including one dedicated to the study of Palladio's architecture. The best-preserved of Burlington's works is his residence at Chiswick, West London, designed in 1724. The building's plan (fig. 26-8) shares the mathematical rationale and symmetry of Palladio's Villa Rotonda (see fig. 18-36), although its central core is octagonal rather than round and there are only two entrances on opposite sides, one with a porch designed to look like a Classical temple. Chiswick's **elevation** is characteristically Palladian, with a main floor resting on a basement, and tall rectangular windows with triangular **pediments**, but Burlington introduced a staircase on each side of the porch rather than a single steep flight at the center (fig. 26-9). The result is a lucid evocation of Palladio's design, whose few but crisp details seem perfectly suited to the refined proportions of the whole. It is hard to believe that only twenty years separate this exquisite building from the rugged angularity of Blenheim Palace (see fig. 19-66).

In Rome Burlington had persuaded an English expatriate, William Kent (1685–1748), to return to London as his collaborator. Kent designed first Chiswick's interior, then the grounds, in a style that became known throughout Europe as the "English landscape garden." Kent's garden, in contrast to the regularity and rigid formality

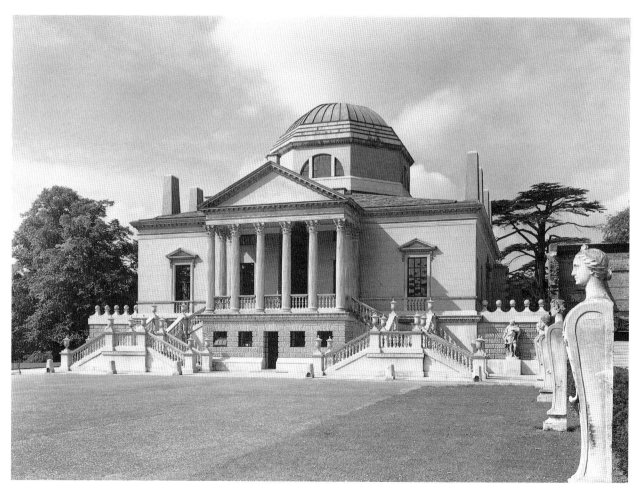

26-9. Richard Boyle, Lord Burlington. Chiswick House. 1724–29. Interior decoration (1726–29) and new gardens (1730–40) by William Kent

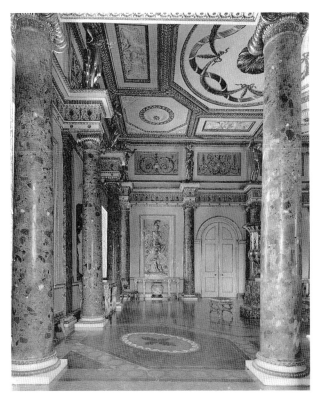

26-10. Robert Adam. Anteroom, Syon House, Middlesex, England. 1760–69

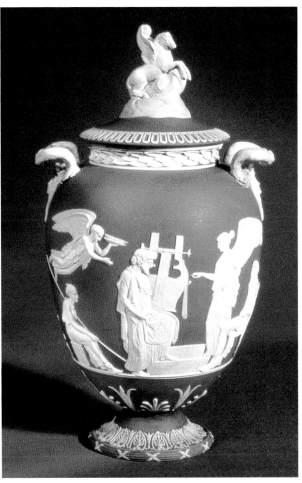

26-11. Josiah Wedgwood. Vase, made at the Wedgwood Etruria factory, Staffordshire, England. 1786. White jasper body with a mid-blue dip and white relief, height 18" (45.7 cm). Relief of *The Apotheosis of Homer* by John Flaxman, Jr., after a Greek vase in the British Museum. 1778. Trustees of the Wedgwood Museum, Barlaston, Staffordshire

of Baroque gardens (see fig. 19-23), featured winding paths, a lake with a cascade, irregular plantings of shrubs, and other effects imitating the appearance of the natural rural landscape. To Kent and Burlington, such a garden, far from seeming at odds with the pristine classicism of the house, was "natural" and "reasonable," and thus in perfect accord with it.

Kent's interior designs and furniture remained highly ornate. For the finest Neoclassical interior design the wealthy turned to the Scots Robert Adam (1728–1792) and his brothers. On tour in Rome, Robert Adam became enthralled with the remains of classical antiquity and even hired other artists to sketch and paint Roman architectural monuments for him. His fascination with Roman architecture and its decoration profoundly affected his style after he returned to London in 1758. In about 1760 Hugh Percy, first duke of Northumberland, commissioned Adam to renovate the interior of his country estate, Syon House, near London. The anteroom, a square chamber between the entrance hall and the dining room, remains today a prime example of Adam's brilliance in interior design (fig. 26-10). The opulent colored marbles, gilded relief panels and statues, spirals, garlands, rosettes, and heavily carved, gilded moldings are profuse yet are restrained by the strong geometric order imposed on them and by the visual relief of plain wall and ceiling surfaces. Adam's great gift was the seeming effortlessness with which he combined a variety of classical motifs into elegant designs perfectly scaled for a British interior.

Another medium influenced by classicism was ceramics, especially the wares of Josiah Wedgwood (1730–1795), who invented several new wares early in

his career. In 1768 he started a pottery factory that he named Etruria after the red-and-black "Etruscan" (actually Greek) vases being excavated in Italy. This production-line shop had several divisions, each with its own **kilns** (firing ovens) and workers trained in individual specialties.

In 1774–1775 Wedgwood perfected a fine-grained, unglazed, colored pottery, which he named jasperware. At first he made the new ware only in white, blue, and blue green; later he invented a method to add other colors by dipping. Jasperware was used for ornamental works that imitated Greek vases and Roman cameo-glass vessels and medallions (see fig. 26-1). An important example is a dark blue urn decorated in white relief with a scene of *The Apotheosis of Homer* (fig. 26-11), designed by the sculptor John Flaxman, Jr. (1755–1826). Flaxman, who was only fifteen when his work was first exhibited at the Royal Academy, worked for Wedgwood as a designer from 1775 to 1787. Later he studied in Italy, where he became a leading Neoclassic sculptor. He also became famous for illustrating classical literary works with line drawings, which were engraved and widely published. These drawings, like

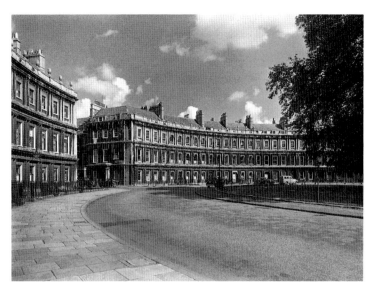

26-12. John Wood the Elder and John Wood the Younger.
The Circus, Bath, England. 1754–58

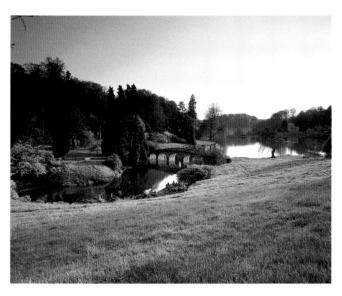

26-13. Henry Flitcroft and Henry Hoare. The Park
at Stourhead, Wiltshire, England. Laid out 1743;
executed 1744–65, with continuing additions

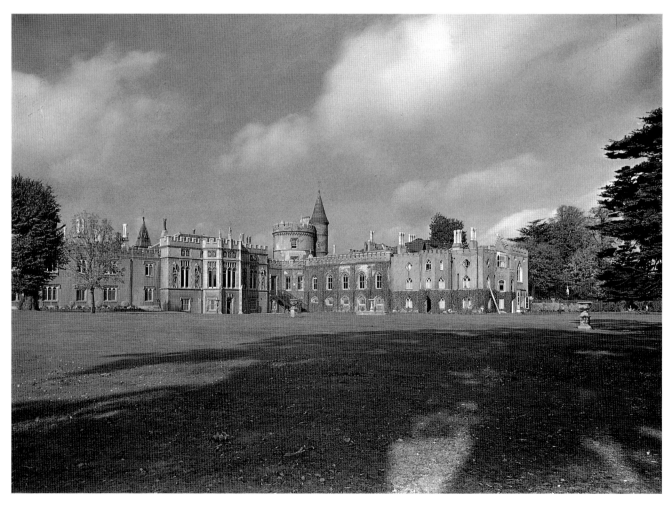

26-14. Horace Walpole and others. Strawberry Hill, Twickenham, England. 1749–77

26-15. Richard Bentley.
Holbein Chamber,
Strawberry Hill.
After 1754

his designs for Wedgwood, exemplify the late-eighteenth-century Neoclassic tendency toward linear images set against empty backgrounds.

A remarkable phenomenon of eighteenth-century British art and letters was the Provincial Enlightenment, so called because the ideas of innovative artists from outside London, like Josiah Wedgwood, influenced developments in the capital, rather than the other way around. One of these innovators was John Wood the Elder (c. 1704–1754), who dreamed of turning into a new Rome his native Bath—a spa town in the west near Wales originally built by the Romans in the first century, where well-to-do people came to "take the waters." On a large property near the town center, Wood began in 1727 to lay out a public meeting place, sports arena, and gymnasium. Much of his plan was never carried out, but in 1754 he began building the Circus (fig. 26-12), an elegant housing project that was completed in 1758 by his son, John Wood the Younger (d. 1782). The Circus was a circle of thirty-three town houses, all sharing a single three-story facade modeled on the exterior of the Roman Colosseum, with an attic to house the servants' quarters, and steeply pitched roofs and large chimneys as a concession to English winters. In 1764 Wood the Younger began another housing project in Bath, a semicircle of houses called the Royal Crescent, also following a Roman theme. Like the Circus, the Royal Crescent has a single classical exterior elevation, in this case a row of colossal Ionic columns, surmounted with a roofline balustrade. The Woods' elegant Circus and Royal Crescent, with their handsome yet modestly scaled classical fronts, were imitated enthusiastically in London and other British and American cities well into the nineteenth century.

The British were fascinated with sculpting artificial vistas. Following William Kent's lead, **landscape architecture** flourished in the hands of such designers as Lancelot ("Capability") Brown and Henry Flitcroft. In 1743 the banker Henry Hoare redid the grounds of his estate at Stourhead in Wiltshire (fig. 26-13) with the assistance of Flitcroft, a protégé of Burlington. The resulting gardens at Stourhead carried William Kent's

ideas much further. Stourhead is, in effect, an exposition of the picturesque, with orchestrated views dotted with Greek and Roman temples, grottoes, copies of antique statues, and such added delights as a rural cottage, a Chinese bridge, a Gothic cross, and a Turkish tent. In the view illustrated here a replica of the Pantheon in Rome is visible across a carefully placed lake, whose undulating shoreline resembles an irregular Rococo ornament. The repeated evocation at Stourhead of the past and the exotic, suggesting poetic contemplation of the passage of time and the decay of civilizations, is quintessentially Romantic.

A Romantic spirit informed the work of Horace Walpole, an aristocratic man of letters, in remodeling his Strawberry Hill house in Twickenham (fig. 26-14), near London. Working with friends and professional architects, including Robert Adam, he devoted nearly thirty years (1749–1777) to converting the house into a neo-Gothic mansion, one of the early monuments of the Gothic Revival style. The house's sprawling asymmetry and its many medievalizing touches, such as fireplaces and wall ornaments copied from Gothic tombs and choir screens, epitomize the Romantic sensibility. Among the fanciful rooms was the architect Richard Bentley's Holbein Chamber (fig. 26-15), a Gothic Revival fantasy as elegant as any classical Adam interior. Although the Gothic style was admired for its romantic ruins and haunted castles and the like, Walpole aptly described the interior of Strawberry Hill as "pretty and gay." Indeed, the house's playful charm has much in common with such joyful Rococo pleasure pavilions as the Amalienburg (see fig. 19-71), which antedates it by only a few years.

The medieval revival in architecture was not a passing fancy. After Parliament's Westminster Palace burned in 1834, entries in the competition to design the new Houses of Parliament were required to be in English Gothic or Elizabethan style, evoking England's history. The commission was granted to Charles Barry (1795–1860) and Augustus Welby Northmore Pugin (1812–1852), who began construction in 1836. Barry was responsible for the basic plan of the buildings, while Pugin designed the

26-16. Charles Barry and Augustus Welby Northmore Pugin. Houses of Parliament, London. 1836–60.
Royal Commission on the Historical Monuments of England, London

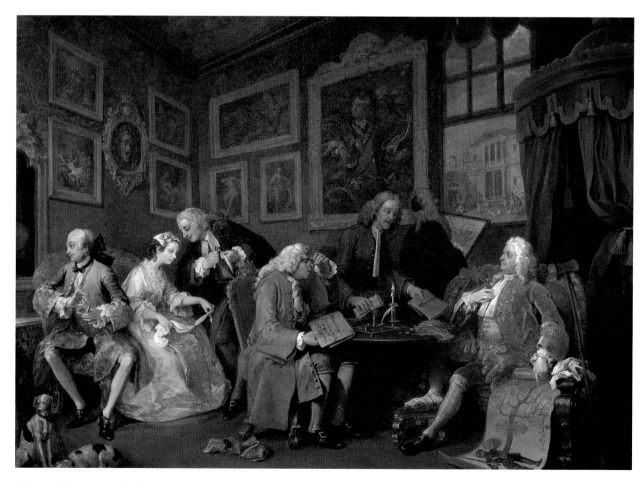

26-17. William Hogarth. *The Marriage Contract,* from Marriage à la Mode. 1743–45. Oil on canvas, 28 x 36" (71.7 x 92.3 cm).
The National Gallery, London

Gothic decoration (fig. 26-16). Pugin had had many earlier commissions for churches, for which the Gothic style was especially popular. The plan of the Houses of Parliament building is actually classical, with two vast halls for the House of Commons and the House of Lords symmetrically flanking the main entrance. Offices, committee rooms, and libraries surround these two chambers. The exterior is elaborated with a splendid array of Gothic spires, **turrets**, and towers, including that of the House of Lords at the left and the clock tower known as Big Ben at the right.

Painting

When the newly prosperous middle classes began to buy art, they wanted portraits of themselves. But taste was also developing for other subjects, such as moralizing satire and caricature, ancient and modern history, the British landscape and people, and scenes from English literature.

The Satiric Spirit. Satiric essays, songs, and cartoons provided social commentary on and criticism of eighteenth-century Britain. Perhaps the most important satirist of the century was the engraver William Hogarth (1697–1764). In 1721 Hogarth began to produce original prints lampooning current events. Shrewd and somewhat puritanical, he was particularly drawn to English social conventions. About 1731, Hogarth began illustrating moralizing tales of his own invention in sequences of four to six paintings that he then reproduced in prints. Sold in sets, the prints were like acts in a play telling a story of sin and its consequences. The Harlot's Progress, the tale of a country girl lured into prostitution in London, was quickly followed by The Rake's Progress, a story of male debauchery and decline. Financially successful from engraving, Hogarth also hoped to be a painter, but despite his considerable gifts, he was not a success and gave up painting after 1745.

Between 1743 and 1745, Hogarth painted a series for engraving called Marriage à la Mode. The opening scene (fig. 26-17) shows a marriage contract being drawn up between the daughter of a rich merchant and the son of the bankrupt earl of Squanderfield. The middle-class bride will become a viscountess by the stroke of her father's pen, and the penniless young lord will enjoy his wife's generous dowry and future inheritance, but a bad end to this loveless marriage is already predicted. While the bride listens intently to the blandishments of the lawyer, Silvertongue, the groom admires himself in the mirror and takes a pinch of snuff. The dogs at his feet, suggesting his lazy and decadent character, are chained together in an allusion to the upcoming marriage. The old earl rests one gouty foot on a velvet cushion and displays the family tree springing from the side of his first noble forebear, while on the table is a large pile of gold coins and bank notes furnished by the bride's father, whose dedication to making money has enabled him to buy his daughter a title.

Hogarth's contempt is not directed only at the actors in this drama. The earl's house is hung floor to ceiling with paintings in the Grand Manner, which the artist personally abhorred, and through the window the viscount's new Palladian mansion can be seen under construction.

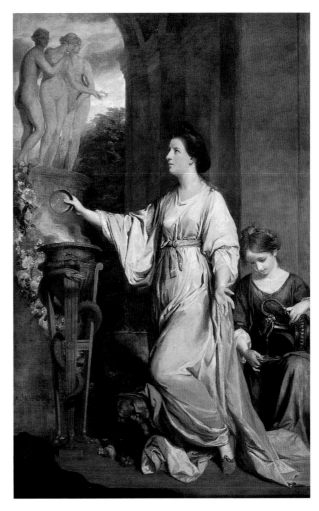

26-18. Joshua Reynolds. *Lady Sarah Bunbury Sacrificing to the Graces*. 1765. Oil on canvas, 7'10" x 5' (2.42 x 1.53 m). The Art Institute of Chicago
Mr. and Mrs. W. W. Kimball Collection, 1922. 4468

The architect at the window checking his plan against the progress of the building is an unflattering reference to Lord Burlington and his architecture (see fig. 26-9).

In his book *Analysis of Beauty* (1753), Hogarth praised social satire as equal to the highest artistic effort, because it was both difficult to do and useful to society. He also wrote that art should be accessible to ordinary people in public exhibitions and should be understandable in subject matter and treatment—a point of view that some of his contemporaries strongly criticized.

Portraits in the Grand Manner. The outstanding British Grand Manner portrait artist was Sir Joshua Reynolds (1723–1792). Although he came from a clerical family, he was the antithesis of the moralistic Hogarth. After studying Renaissance painting in Italy, he settled in London in 1753 and worked vigorously to educate artists and patrons to appreciate classical **history painting**. He was never a popular history painter, but his portraits, which resonate with high-minded seriousness, were immensely successful. Often presented in historical settings and costumes, his subjects personify the quiet authority of the traditional Grand Manner.

Lady Sarah Bunbury Sacrificing to the Graces (fig. 26-18), of 1765, portrays a Roman priestess sacrificing to the

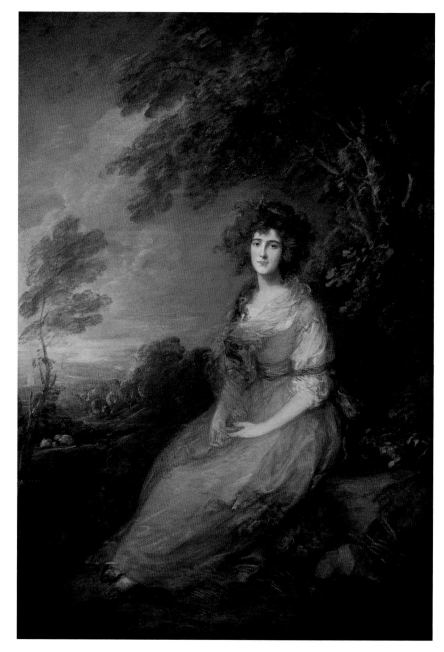

26-19. Thomas Gainsborough. *Portrait of Mrs. Richard Brinsley Sheridan.* 1785–87. Oil on canvas, 7'2½" x 5'½" (2.2 x 1.54 m). National Gallery of Art, Washington, D.C.
Andrew W. Mellon Collection

Three Graces, who appear as marble statues atop a high **plinth**. As if echoing the Graces, the canvas is divided into three sections with arched openings on each side of a wide pier, and the foreground elements are grouped in a large triangle. Reynolds monumentalized his subject by dropping the viewer's eye-level and placing Lady Sarah above the kneeling servant and the tripod of burning incense. There is even a suggestion of classical sculpture in her emphatic **contrapposto**, a stance Reynolds also adopted for heroic male portraits.

Reynolds was determined to cultivate a class of patron who not only bought art on the grand tour but also collected work at home. He helped convince George III to charter the Royal Academy of Arts in 1768, and he was its first president, until 1790. Knighted in 1769, Reynolds

was appointed painter to the king in 1784. Not only was he the most important portraitist in Britain, he also profoundly influenced British art through his lectures at the Academy (subsequently published), in which he argued that art could be mastered by following prescribed rules derived from exemplary models of the past, especially Michelangelo.

Reynolds's younger contemporary Thomas Gainsborough (1727–1788) established his reputation as a portraitist early. In 1759 he and his wife moved to Bath, which was attracting the rich and noble in large numbers. For this clientele the artist developed an elegant and relaxed portrait style. In 1768 he was elected a founding member of the Royal Academy and in 1774 moved permanently to London. In 1785–1787 Gainsborough,

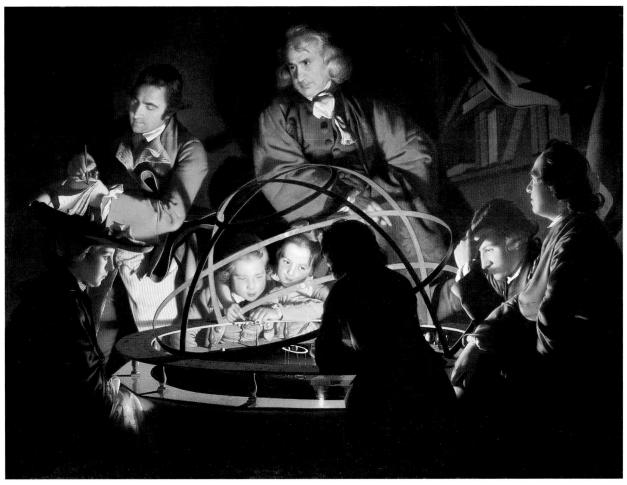

26-20. Joseph Wright. *A Philosopher Giving a Lecture on the Orrery.* 1766. Oil on canvas, 4'10" x 6'8" (1.47 x 2.03 m).
Derby Museum and Art Gallery, Derby, England

using light, rapid brushstrokes in a delicate **palette** (selection of colors), painted a portrait of Mrs. Richard Brinsley Sheridan (fig. 26-19), a professional singer who had married a celebrated wit and playwright. He also created superb landscape paintings, evident in the feathery, windblown trees in the background. Although Gainsborough's portraits incorporated many Grand Manner elements popularized by Reynolds, they are painted with the freshness and immediacy of sketches, and their light palette and elegant figures in graceful, informal poses have a decidedly Rococo flavor.

The Romance of Science. Joseph Wright of Derby (1734–1797) from about 1765 had experimented with such nocturnal light effects as moonlight and candlelight, and he painted several carefully observed views of Mount Vesuvius erupting at night. One of his best candlelight scenes is *A Philosopher Giving a Lecture on the Orrery* (fig. 26-20), which shows a group of enthralled observers of a mechanical model of the solar system, with a lamp to represent the sun. Wright was Romantically fascinated with science and industry, and he depicted scientific experiments and factory scenes with

IRON AS A BUILDING MATERIAL Technology, the properties of a material, and engineering skills in large part determine form and often produce an unintended and revolutionary new aesthetic. In 1779 Abraham Darby III completed a bridge over the Severn River at Coalbrookdale in England. The bridge was a functional structure in the new industrial environment where factories and workers' housing filled the valley. The bridge's importance lies in the fact that it is the first use of structural metal on a large scale. Iron replaced the heavy, hand-cut, stone **voussoirs** used to construct earlier bridges. Five pairs of cast-iron, semicircular arches form a strong, economical, 100-foot span. The light, space, movement, and skeletal structure desired by builders since the twelfth century at last were possible.

a brilliant **tenebrism** (use of shadow) reminiscent of the work of Georges de La Tour (see fig. 19-30). Wright's paintings are a remarkable combination of Baroque style and contemporary subject matter.

Innovations in construction technology and materials (see "Iron as a Building Material," page 943) enabled architects and engineers to build new kinds of structures whose designs both contributed to and reflected the Romantic fascination with science during this period.

History Painting. European academies had long considered history painting, with subjects drawn from classical literature, the Bible, and mythology, as the highest form of artistic endeavor, but British patrons were reluctant to purchase such works from native artists. Instead, they favored Italian paintings bought on the grand tour or acquired through agents in Italy. Thus, the arrival in London in 1766 of the Italian-trained Swiss history painter Angelica Kauffmann (1741–1807) was a great impetus to those artists in London aspiring to success as history painters. She was welcomed immediately into Joshua Reynolds's inner circle. In 1768 Kauffmann was one of two women artists named among the founding members of the Royal Academy (see "Women and the Academies in the Eighteenth Century," below); the other, Mary Moser (1744–1819), was also of Swiss heritage.

Kauffmann had assisted her father on church murals and was already accepting portrait commissions at age fifteen. Then, in a highly unusual move, she embarked on an independent career as a history painter. She first encountered the new classicism in Rome, in the circle of Johann Winckelmann, whose portrait she painted in 1763, and where she was elected to the Academy of Saint Luke. Kauffmann's style of painting figures was not derived from Renaissance models but was based loosely on the figure types found in Roman wall paintings in the excavations of Pompeii and Herculaneum. Her lyrical classicism is typified by *Zeuxis Selecting Models for His Picture of Helen of Troy* (fig. 26-21) of about 1765, which

26-21. Angelica Kauffmann. *Zeuxis Selecting Models for His Picture of Helen of Troy*. c. 1765. Oil on canvas, 32⅛ x 44⅛" (81.6 x 112.1 cm). The Annmary Brown Memorial, Brown University, Providence, Rhode Island

illustrates a paradigm of classical idealization: the Greek painter Zeuxis seeks the most beautiful features of many women in order to paint a perfect image of Helen of Troy. The woman picking up a brush at the right is thought to be Kauffmann's self-portrait. In England Kauffmann married the painter Antonio Zucchi, who was working for Robert Adam, and she, too, provided paintings for Adam's projects and decorated ceramics and furniture in the Neoclassical style.

Kauffmann's devotion to history painting was shared by her American friend Benjamin West (1738–1820), who, after studying art in Philadelphia, traveled to Italy in 1759 and became a pupil of Anton Raphael Mengs and met Winckelmann, then settled permanently in London in 1763. West acted with generosity and encouragement toward fellow Colonial artists, and his studio became a veritable "American academy" abroad. A founder of the Royal Academy, West exhibited at its 1770 Salon his

WOMEN AND THE ACADEMIES IN THE EIGHTEENTH CENTURY Although several women were made members of the European academies of art before the eighteenth century, their inclusion amounted to little more than honorary recognition of their achievements. In France, Louis XIV had proclaimed in the founding address of the Royal Academy that its intention was to reward all worthy artists, "without regard to the difference of sex," but this resolve was not put into practice. Only seven women were awarded the title of academician between 1648 and 1706, the year the Royal Academy declared itself closed to women. Nevertheless, four women had been admitted to the Academy by 1770, when the men became worried that women members would become "too numerous" and declared four women members to be the limit for any one time, noting, however, that the Academy was not obliged to maintain that number. Young women were not admitted to the Academy school or allowed to compete for Academy prizes, both of which were nearly indispensable for professional success.

Women fared even worse at London's Royal Academy. After the Swiss painters Mary Moser and Angelica Kauffmann were named as founding members in 1768, no other women were elected until 1922, and then only as associates. Johann Zoffany's 1771–1772 portrait of the London academicians shows the men grouped around a nude male model, along with the Academy's study collection of Classical statues and plaster copies (see page 929). Propriety prohibited the presence of women in this setting, so Zoffany painted their portraits on the wall. In more formal portraits of the Academy, however, the two women were included.

26-22. Benjamin West. *Death of General Wolfe.* 1770. Oil on canvas, 4'11½" x 7' (1.51 x 2.14 m). The National Gallery of Canada, Ottawa

Gift of the Duke of Westminster, 1918

While West was still working on this canvas, George III made it clear that he would not buy such a painting showing British heroes in modern dress. Joshua Reynolds, president of the Royal Academy, called on West at his studio and begged him not to continue this aberration of "taste." When the painting was exhibited at the Academy in 1770, Reynolds apologized for his error in judgment, and George III commissioned a replica from West after he learned that the original had been purchased by Lord Grovesnor. West painted four more replicas but made the largest amount of money by far in royalties from an engraving after the painting.

remarkable history painting *Death of General Wolfe* (fig. 26-22). West's re-creation of a recent historical event as though it were happening before the viewer's eyes shocked contemporaries but was well received. General Wolfe had been killed in 1759 in a battle with the French for control of Quebec during the Seven Years' War. West depicted Wolfe in his red uniform dying in the arms of his comrades, although contemporary accounts record that Wolfe died in a field tent with only two or three men around him. Thus, even though West's painting is powerfully naturalistic, it is not "factual," nor was it meant to be. The Grand Manner intended to convey not an anecdotal report of the battle but a larger truth about the valor of the fallen hero, the loyalty of the British soldiers, and the justice of their cause. West included a figure of a Native American to locate the action in North America and to provide an "objective" observer of Wolfe's death. The dramatic illumination increases the emotional intensity of the scene, as do the poses of Wolfe's attendants, arranged to suggest a Lamentation over the dead Christ. The rhetorical power of the work so strongly impressed

the great Shakespearean actor David Garrick that he is said to have enacted an impromptu interpretation of the dying Wolfe in front of the painting at the Academy's exhibition hall. West also painted scenes of antiquity in a strong Neoclassic style, typifying an eighteenth-century tendency for artists to work in more than one manner.

At the 1766 exhibition of the London Society of Artists, the organization that preceded the Royal Academy, West had seen and admired a painting by a young American, who was in fact the most important portrait painter in the British colonies at the time, John Singleton Copley (1738–1815). After corresponding with Copley and arranging his membership in the Society of Artists, West encouraged him to travel to Italy and invited him to visit London as well. Copley arrived in England in 1774, then journeyed on to Italy. With the coming of the American Revolution, Copley's family fled to London, where the artist joined them and remained for the rest of his life.

After coming to England, Copley abandoned his colonial portrait style (see fig. 19-94) for a career as a history painter. One of his most celebrated paintings was

26-23. John Singleton Copley. *Watson and the Shark*. 1778. Oil on canvas, 6'1/2" x 7'6¼" (1.84 x 2.29 m). National Gallery of Art, Washington, D.C.
Ferdinand Lammot Belin Fund

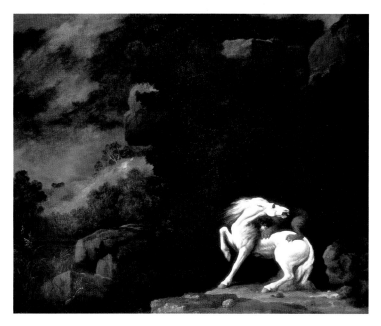

26-24. George Stubbs. *Lion Attacking a Horse*. 1770. Oil on canvas, 40⅛ x 50¼" (102 x 128 cm). Yale University Art Gallery, New Haven, Connecticut
Gift of the Yale University Art Gallery Associates

Watson and the Shark (fig. 26-23), painted in 1778 to commemorate Brook Watson's escape from a shark attack in the harbor of Havana, Cuba. Following the example of West, Copley staged the event with intense drama, depicting the terrifying moment when the shark was closing in for the kill. The background for the classical pyramid of figures is a distant view of Havana, with Morro Castle at the right. In what looks like an eighteenth-century version of the biblical story of Jonah and the Whale, the ferocious creature rushes on Watson, shown as an idealized nude with his hair trailing in the water. The harpooner has raised his spear, and the sailor at the center risks being thrown into the shark-infested waters in his effort to balance the weight of his mates leaning forward to rescue Watson, but their outstretched hands have not yet reached the youth. Each figure in the boat is a careful study of emotion and action.

West and Copley belonged to a generation of Americans who sought their fortunes in Europe, where they believed they could find a more cultivated patronage than in America. The next generation of American artists who traveled abroad, however, were able to earn their livings in the United States or to work in Europe for American patrons, as improving economic conditions and political stability after the American Revolution made the arts an important part of life in the United States.

The Sublime. The notion of the sublime can be applied to a type of painting that can be called **literary illustration**, although the artists' own imaginations significantly affected the form and style of their works, even to the point of devising original subjects of a literary character. Many who practiced in this style were British.

George Stubbs (1724–1806) combined a meticulous study of comparative anatomy with a considerable imaginative gift. Stubbs, who first specialized in portraiture, began to study equine (horse) anatomy and dissected a number of horse cadavers to prepare drawings for his *Anatomy of a Horse,* which he published in 1766. In the meantime, he painted individual and group portraits of clients on their country estates with their horses, though he was more adept at depicting animals than people.

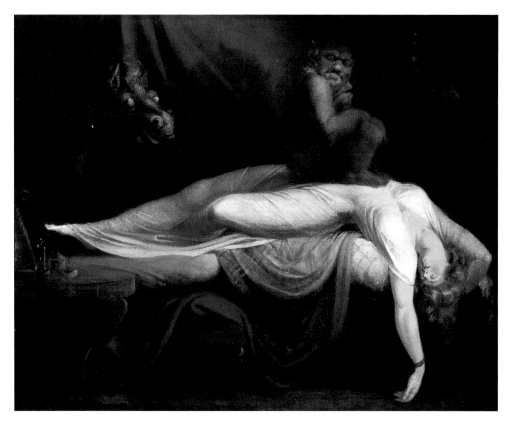

26-25. John Henry Fuseli. *The Nightmare.* 1781. Oil on canvas, 40 x 50" (111 x 127 cm). The Detroit Institute of Arts
Founders Society purchase with funds from Mr. and Mrs. Bert L. Smokler and Mr. and Mrs. Lawrence A. Fleischman

Fuseli was not popular with the English critics. One writer said Fuseli's 1780 entry in the London Royal Academy exhibition "ought to be destroyed," and Horace Walpole called another painting in 1785 "shockingly mad, mad, mad, madder than ever." Even after achieving the highest official acknowledgment of his talents, Fuseli was called the Wild Swiss and Painter to the Devil. But the public appreciated his work, and *The Nightmare,* exhibited at the Academy in 1782, was repeated in at least six versions, all of which were sold to commercial engravers for reproduction in prints. One of these prints would one day hang in the office of the Austrian psychoanalyst Sigmund Freud, who believed that dreams were manifestations of the dreamer's repressed desires.

A subject that Stubbs first depicted about 1762, then repeated in paintings and original prints, was a horse being frightened or attacked by a lion (fig. 26-24). This violent motif is so uncharacteristic of his work as a whole that it has been suggested that the artist actually witnessed such an attack on a trip to North Africa or perhaps saw a sculpture of a lion killing a horse among the antiquities in Rome. However, Stubbs probably made drawings of a lion kept as a curiosity by his patron, Lord Shelburne. In *Lion Attacking a Horse,* the sublime theme of nature's cruelty is underscored by the dark, craggy landscape setting for the terrible moment when the horse tries in vain to dislodge its attacker. Stubbs's work of this type anticipated the fascination of the French Romanticists with animal subjects half a century later.

A contemporary of Stubbs, John Henry Fuseli (1741–1825), a highly educated Swiss minister, arrived in London in 1764 and quickly became a member of the city's intellectual elite. After two visits to Italy he returned to England to pursue a career as a painter. Although Fuseli was knowledgeable about classical principles and was particularly influenced by Michelangelo, his unusual style seems to have originated in his own psyche. His usual approach was to illustrate scenes from literary

works—including Norse myths, Dante, Shakespeare, Milton, contemporary writers, and even his own poetry—but one of his best-known works, *The Nightmare* (fig. 26-25), painted in 1781, was instead a personal expression of the experience of awaking from a terrible dream with the sensation that something heavy has been pressing on one's chest. In this dark fantasy of night terrors, Fuseli combined the irrational and the erotic, two persistent subthemes in most of his works. The creature sitting on the woman's abdomen is an incubus, a demon from folklore who was believed to steal upon sleeping women and have sexual intercourse with them, a subject Fuseli also painted. Adding to the interest of this canvas today is a portrait on the reverse. She is Anna Landolt, with whom Fuseli fell passionately in love on a visit to Zürich in 1779.

Fuseli's friend William Blake (1757–1827) also drew subjects for his paintings from literary sources, mainly the Bible, Milton, Shakespeare, and his own poetry and prose. His imagery and figural style were greatly influenced by his love of Michelangelo, whom he knew from reproductions and whose images he transformed with his idiosyncratic mysticism. Throughout his life Blake experienced hallucinatory states of mind. Even as a young child, he told his family that he saw angels walking in the fields and a tree

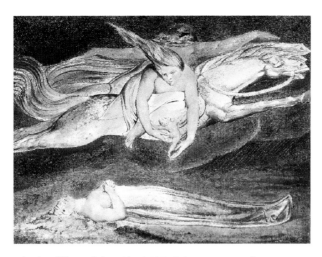

26-26. William Blake. *Pity*. 1795. Color monotype in tempera touched with pen, black ink, and watercolor, 15³/₄ x 20⁷/₈" (40 x 53 cm). The Metropolitan Museum of Art, New York

Gift of Mrs. Robert W. Goelet, 1958 (58.603)

glittering with angels' wings. Blake was apprenticed to an engraver at the age of seven, then later briefly attended the Royal Academy school, where he developed a strong dislike of Reynolds and his **formalist** ideas. One of his most compelling creations was the spirit Urizen ("your Reason"), representing rationalist thought, which Blake believed encumbered creative vision. Although he painted in **tempera**, an egg-based paint, on wood panel, Blake's reputation is based mainly on his **monoprints** (single-

impression prints), hand-colored and drawn over with ink. The sale of these and his self-illustrated books of poems and the fees for engravings done of other artists' works provided his modest living.

In 1795 Blake created the large painted print *Pity* (fig. 26-26), inspired by a passage from Shakespeare's *Macbeth*. Regarding his plan to assassinate the Scottish king Duncan, Macbeth says: "And Pity, like a naked new-born babe, / Striding the blast, or heaven's cherubin, hors'd / Upon the sightless couriers of the air, / Shall blow the horrid deed in every eye, / That tears shall drown the wind" (act 1, scene 7, lines 21–25). The passage was only a touchstone for Blake, who added the horizontal floating form of a woman with bared breasts. A planet's orbit has been interposed between her and the enormous, windblown **cherub** above, who gently retrieves the naked baby. This type of eroticized imagery seems to have been taken up by Blake in response to Fuseli's works. The two men met about 1779, and Fuseli hired Blake not long after to make prints of his paintings. They remained friends until Blake became a complete recluse in the last decade of his life.

Sublime and Romantic effects soon made their appearance in landscape painting as well. The two great masters of English Romantic landscape were John Constable (1776–1837) and Joseph Mallord William Turner (1775–1851), who, championed by Fuseli and others, profoundly influenced later landscape painting, especially in France.

The son of a well-to-do miller, Constable later claimed that the landscape of his youth had made him a

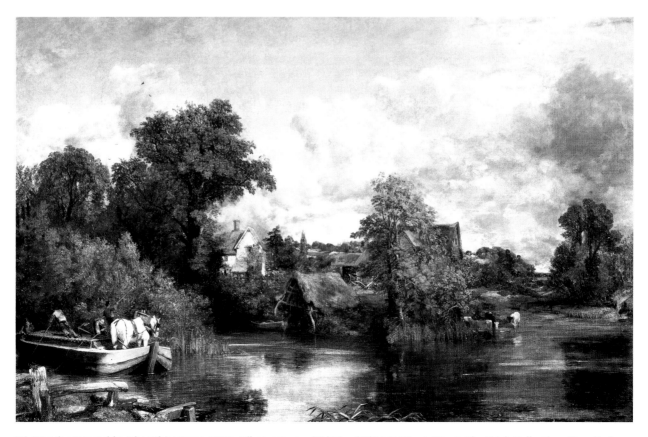

26-27. John Constable. *The White Horse*. 1819. Oil on canvas, 4'3³/₄" x 6'2¹/₈" (1.31 x 1.88 m). The Frick Collection, New York

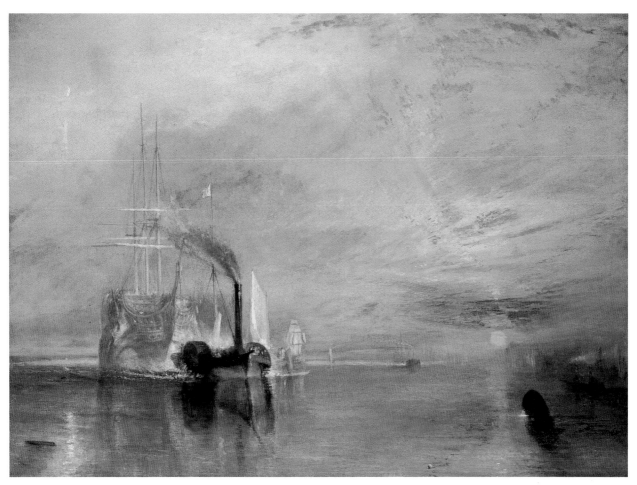

26-28. Joseph Mallord William Turner. *The Fighting "Téméraire," Tugged to Her Last Berth to Be Broken Up.* 1838. Oil on canvas, 35¼ x 48" (89.5 x 121.9 cm). The National Gallery, London

painter before he ever picked up a brush. He continuously found inspiration in rural southern England, and he credited such seventeenth-century Netherlandish artists as Ruisdael, Rembrandt, and especially Rubens with teaching him about landscape painting. In a lecture, he said of Rubens's *Landscape with Rainbow* (see fig. 19-41): "More than the rainbow itself, I mean dewy light and freshness, the departing shower, with the exhilaration of the returning sun, effects which Rubens, more than any other painter, has perfected on canvas" (cited in Emmons, page 161). Constable went to work in 1795 for a London engraver, who discouraged his aspirations and sent him home. In 1800 he returned to London and entered the Royal Academy school, but he received little official recognition and was not made an **academician**, or member of the Royal Academy, until 1829, five years after he had been discovered by French connoisseurs and patrons (see "Academy Exhibitions," page 929).

Constable's *The White Horse* of 1819 (fig. 26-27) draws on the artist's intense observation of every facet of the natural landscape, recorded in sketches he made on walking tours. He detested what he called "cold, trumpery stuff" and "bravura" in other landscape painters' work, by which he meant Romantic effects of drama and grandeur. He preferred to portray the landscape and the mundane activities taking place in it without suggestions of underlying cosmic or philosophical meaning.

Turner was an exceptional creator of moods, light, and drama. After only two years of study in the Royal Academy school, one of his **watercolors**—the only medium he worked in until 1796—was accepted at the Royal Academy's annual exhibition of 1790. At the age of twenty-seven he was elected a full academician, and he later became a professor in the Royal Academy school. First turning to Claude and Poussin for inspiration—both in composition and in the handling of color and atmosphere—Turner imbued his early works with a pleasant, picturesque quality not far removed from Constable's. But as his personal style matured, the phenomena of colored light and atmospheric movement became the true subjects of his paintings. To the academicians his works increasingly looked like sketches or the preliminary underpainting of unfinished canvases, but to his admirer Constable they were "golden visions, glorious and beautiful," painted with "tinted steam." Between 1819 and 1840 Turner made four trips to Italy, where he was most affected by the technique and coloration of Venetian Renaissance paintings and by Venice's own watery brilliance and glowing atmosphere.

Turner's *The Fighting "Téméraire," Tugged to Her Last Berth to Be Broken Up* (fig. 26-28) of 1838 is both a history painting and a study in the optical effects of the setting sun over water. The *Téméraire* had been the second-ranking British ship in the Battle of Trafalgar in 1805, a

great British naval victory over the combined fleets of Spain and Napoleon's France. Some thirty-three years later, however, the ship was ready for the scrap heap, and Turner watched from a ferry as it was towed away to be destroyed. Some have interpreted the scene as a symbol of the passing of the old order. But the narrative content is entirely overwhelmed by light and color; the glowing red sun reflecting off the water creates, instead, a sense of apotheosis for the dying ship. Turner's painting style continued to develop toward his ultimate near-abstract style, which some critics consider the finest phase of his work.

FRANCE

Neoclassicism and Romanticism in France are closely tied to its turbulent history. The Revolution of 1789, the reign of Emperor Napoleon I (ruled 1804–1814, 1815), and, later, that of Emperor Napoleon III (ruled 1852–1870) all espoused Neoclassicism. Similarly, much of the art of the Romantic artists of the nineteenth century also had political associations.

Changes in artistic taste were evident as early as 1749, when Louis XV's mistress, Madame de Pompadour, sent her brother to Italy to report firsthand on the archeological finds at Pompeii and Herculaneum and on the new ideas current in Roman art circles. When the young man was later made marquis de Marigny and subsequently appointed director of royal buildings, he encouraged French architects to embrace the Neoclassic principles that were to dominate French art through the next century. Young painters and sculptors studying at the French Academy in Rome also responded to the new classicizing movement there and brought its ideas back to Paris. But, as in England, stylistic change was more gradual in painting and sculpture than in architecture. The peak of French Neoclassicism came under Napoleon I, who hoped to make his empire a modern version of imperial Rome.

During the thirty-three-year restoration of the monarchy (1815–1848), Romanticism emerged as a strong parallel strain in French painting and sculpture. Unlike Neoclassicism, the Romantic style was not embraced by the restored kings but instead became identified with a type of social commentary in which the dramatic presentation was intended to stir public emotions, especially in the work of its chief exponents, Théodore Géricault and Eugène Delacroix.

Neoclassical Architecture

Classicism in architectural design was revived in a new, modern spirit in the second half of the eighteenth century under the dictates of the marquis de Marigny. He challenged the profession to avoid what he did *not* want— neither "modern chicory" (fussy detail) nor an "austere antique." Aiming for something in between, French architects worked with cubical masses and purity of geometric form both in the refined classicism they adopted for private buildings and in more severe large-scale Neoclassical religious and civic architecture.

26-29. Jacques-Germain Soufflot. Panthéon (Church of Sainte-Geneviève), Paris. 1755–92

This building, popularly known as the Paris Panthéon, has a strange history. Before it was completed, the revolutionary government in control of Paris confiscated all religious properties to raise desperately needed public funds. Instead of selling Sainte-Geneviève, however, they voted in 1791 to make it the Temple of Fame for the burial of heroes of Liberty. Under Napoleon I the building was resanctified as a Catholic church and was again used as such under King Louis Philippe (ruled 1830–1848) and Napoleon III (ruled 1852–1870). Then it was permanently designated a nondenominational lay temple. In 1851 the building was used as a physics laboratory. Here the French physicist Jean-Bernard Foucault suspended his famous pendulum on the interior of the high crossing dome and by measuring the path of the pendulum's swing proved his theory that Earth rotates on its axis in a clockwise motion. In 1995 the ashes of Marie Curie, who with her husband won the Nobel Prize for chemistry in 1911, were moved into this "memorial to the great men of France," making her the first woman to be enshrined here for her accomplishments.

Jacques-Germain Soufflot (1713–1780), who accompanied Marigny on his Italian tour in 1749, was an early convert to Neoclassicism in architecture. His major work, controversial with critics at the time, was the Church of Sainte-Geneviève (figs. 26-29, 26-30), which was begun in 1755 but not completed until 1792. After the Revolution it was renamed the Temple of Fame, dedicated to French heroes, but it became known as the Paris Panthéon. The building is a **central-plan** Greek cross, with a tall dome and a deep Corinthian order porch with a triangular pediment at the main entrance. The dome, raised on a high **drum**, recalls Wren's dome of Saint Paul's in London (see fig. 19-64), but the building's

26-30. Jacques-Germain Soufflot. Section and plan of the Panthéon

26-31. Claude-Nicolas Ledoux. Pavillon du Madame du Barry, Château de Louveciennes. c. 1771. Engraving of the facade. British Architectural Library, RIBA, London

severe, monumental geometry is typical of French Neoclassical public architecture.

Claude-Nicolas Ledoux (1736–1806), early in his career, built a number of Paris town houses in a pristine Neoclassical style. When Louis XV gave his mistress Madame du Barry, successor to the deceased Madame de Pompadour, a small château, she commissioned Ledoux to design a pavilion for entertaining (fig. 26-31) that is a model of classicism, with its simple cubic volumes, Ionic order, and flat, **balustraded** roofline. Du Barry also commissioned Fragonard to create a suite of paintings (see fig. 19-84), but she later rejected them in favor of Neoclassic canvases by Joseph-Marie Vien. Ledoux also designed a series of customhouses on various roads into Paris that remain today as monuments to the architect's heavy, austere classicism.

Étienne-Louis Boullée (1728–1799), like Ledoux, designed private residences in the Neoclassic style. He is chiefly remembered today, however, for drawings for visionary projects that were considerably beyond eighteenth-century technology. In these designs, made between 1780 and 1790 and rediscovered in the twentieth century, Boullée worked in an abstract style derived from classical models that seems ultramodern, even utopian. His Cenotaph for Isaac Newton (fig. 26-32), designed in 1784, is based on round Roman monumental tombs, which were stepped and planted with trees. What would have been a hemispherical dome in a Roman tomb has been projected into a gigantic sphere. The interior was to have been empty, except for Newton's sarcophagus, with illumination provided by hundreds of small holes piercing the sphere's fabric to represent the starry heavens.

Neoclassical Sculpture

Early in the eighteenth century, French sculpture continued in the Grand Manner. Jean-Baptiste Pigalle (1714–1785), whose restrained, yet forceful, style represents this tradition at its best, continued to work within it almost to the end of the century. After studying in Rome, Pigalle became a favorite sculptor of Madame de Pompadour. His grandest and most ambitious work was the *Monument to the Maréchal de Saxe* that he designed in 1753 for

26-32. Étienne-Louis Boullée. Exterior and cross section of the Cenotaph for Isaac Newton (never built). 1784. Ink and wash drawings, 15½ x 25½" (39.4 x 64.8 cm). Bibliothèque Nationale, Paris

26-33. Jean-Baptiste Pigalle. *Monument to the Maréchal de Saxe*. Designed 1753.
Marble, lifesize figures. Church of Saint Thomas, Strasbourg, France

the Church of Saint Thomas in Strasbourg (fig. 26-33). Maurice de Saxe was a military hero and a much-loved royal cousin, but because he was a Protestant, he could not be buried with the royal family after his death in 1750. To honor him suitably, Pigalle rebuilt the choir of the church so that the enormous tomb could fill it and broke new windows through the walls for spotlighting effects. The result is one of the great monuments of French sculpture.

The marshal general of France is shown in full uniform, descending the steps of his pyramidal tomb toward a coffin held open by a stooped figure of Death. On the steps are heraldic animals representing the defeated enemies of France, whose personification tearfully tries to intervene on the general's behalf, while Hercules, representing the armies of France, weeps. Despite the forceful drama of this scene and the almost symphonic interplay of forms and motifs, perhaps what is most moving about this work is its intense naturalism. De Saxe stands in proud isolation, staring scornfully into the face of Death, whose horror and mystery are represented with un-

flinching directness. It would be difficult to conceive of a more poignant tribute to courage and nobility.

Pigalle's portraits embraced the informality of the Rococo spirit, always maintaining a profoundly sympathetic naturalism. A fine example is his *Portrait of Diderot* (fig. 26-34) of 1777. Here is the intellectual vigor, the energetic spirit of inquiry, the impassioned curiosity that made Diderot such a quintessential champion of the Enlightenment. Nevertheless, the subject's unsmiling dignity shows Pigalle to be still a Baroque artist, perhaps its last.

Jean-Antoine Houdon (1741–1828) developed Pigalle's naturalistic tendencies into an art of a more relaxed, more spontaneous sensibility. He lived in Italy from 1764 to 1769 after winning the **Prix de Rome**, a competitive prize that enabled young French artists to study in Rome for five years. There he absorbed Winckelmann's theories and established his reputation as a sculptor before returning to Paris. After executing a **bust,** or statue of the head and upper torso, of Benjamin Franklin in 1778, Houdon was commissioned in 1784 by the Virginia legislature to portray its native son, George Washington

26-34. Jean-Baptiste Pigalle. *Portrait of Diderot.* 1777. Bronze, height 16½" (42 cm). Musée du Louvre, Paris

26-35. Jean-Antoine Houdon. *George Washington.* 1788–92. Marble, height 6'2" (1.9 m). State Capitol, Richmond, Virginia

(fig. 26-35). Houdon traveled to the United States in 1785 to make a cast of Washington's features and a bust in plaster, then executed the lifesize marble figure in Paris for the State Capitol in Richmond. Although in contemporary dress, Washington is portrayed in an imposing stance typical of painted portraits in the Grand Manner, with his left hand resting on a fasces, an ancient Roman symbol of authority consisting of wooden rods and an axe tied together, attached to which are a sword of War and a plowshare of Peace. But despite the dignity of the presentation, Washington is shown as a man very much at ease, a person of considered action and good sense, and above all, of gentlemanly approachability.

Painting

In the mid-eighteenth century many French artists began to work in a classicizing mode, which was first revealed in a new feeling of sobriety in subject matter and treatment, then later evolved into a clearly defined Neoclassical style. But not all artists were interested in classicism. Portraiture, particularly at court, was often relaxed, elegant, and urbane rather than severe or academic. In the late eighteenth century, however, the history painter Jacques-Louis David, inspired by Roman and Greek sculpture, developed a true Neoclassical painting style, in which his numerous pupils and followers continued to work well into the nineteenth century. Around the turn of the nineteenth century, Romantic elements began to appear in

French art, and even David's pupils were known to temper their Neoclassical style with Romantic subjects or treatments. The acknowledged leaders of the new movement were Théodore Géricault and Eugène Delacroix, whose works exemplify not only Romantic subjects and meanings but an **anticlassical** painting style as well.

Women Painters at Court. Two important women portraitists, Adélaïde Labille-Guiard (1749–1803) and Marie-Louise-Élisabeth Vigée-Lebrun (1755–1842), found favor early in their careers at the court of Louis XVI. Members of the Paris Academy of Saint Luke before its disbanding in 1777 by royal decree, both women were elected in 1783 to the Royal Academy, where they joined Marie Thérèse Reboul (1729–1805) and Anne Vallayer-Coster (1744–1818) as the four women academicians allowed at the time. Critics viewing the portraits by Vigée-Lebrun and Labille-Guiard at their debut in the 1783 biennial **Paris Salon** praised both artists highly, and in the years just before the French Revolution both women had similar careers and patronage—mainly royal and aristocratic but also including middle-class intellectuals, artists, writers, and actors. Both survived the political turmoil of 1789–1794 and continued their careers under the new regimes or outside France.

Labille-Guiard showed great drawing talent early in life and was apprenticed at fourteen to a painter of miniatures. She studied and specialized in pastels until 1780, when she began painting oil portraits as well. In

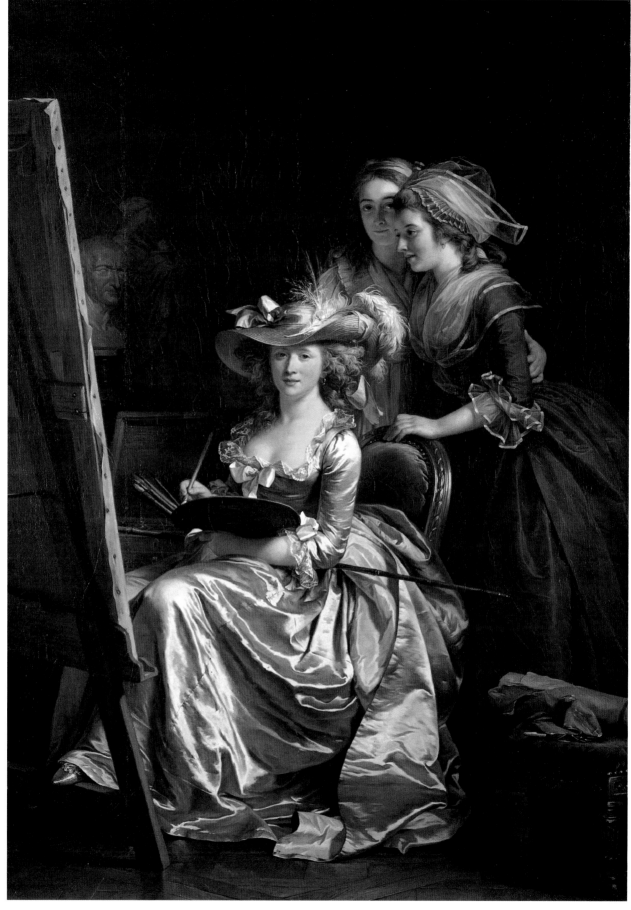

26-36. Adélaïde Labille-Guiard. *Self-Portrait with Two Pupils, Mademoiselle Marie Gabrielle Capet (1761–1818) and Mademoiselle Carreux de Rosemond (died 1788)*. 1785. Oil on canvas, 6'11" x 4'11½" (2.11 x 1.51 m). The Metropolitan Museum of Art, New York

Gift of Julia A. Berwind, 1953 (53.225.5)

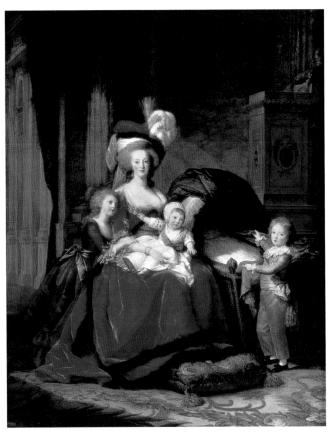

26-37. Marie-Louise-Élisabeth Vigée-Lebrun. *Portrait of Marie Antoinette with Her Children.* 1787. Oil on canvas, 9'1/4" x 7'5/8" (2.75 x 2.15 m). Musée National du Château de Versailles, Versailles, France

As the favorite painter to the queen, Vigée-Lebrun escaped from Paris with her daughter on the eve of the Revolution of 1789 and fled to Rome. After a very successful self-exile working in Italy, Austria, Russia, and England, the artist finally resettled in Paris in 1804 at the invitation of Napoleon I and again became popular with French art patrons. Over her long career, she painted about 800 portraits in a vibrant style that changed little over the decades.

Labille-Guiard's *Self-Portrait with Two Pupils* (fig. 26-36) of 1785, the three women pose in front of an easel in an allusion to the Three Graces. The portrait bust is of the artist's father, sculpted by a family friend. Labille-Guiard was committed to the education of women artists and petitioned successfully in 1790 to end the restriction on the number of women admitted to the Royal Academy.

Vigée-Lebrun's reputation paralleled Labille-Guiard's. The daughter of a professor at the Academy of Saint Luke, she entered its school at age fourteen. She exhibited in the Saint Luke's 1774 Salon, along with Labille-Guiard, and received her first court patronage in 1776. In 1779 she became painter to Queen Marie Antoinette. Initially refused membership in the Royal Academy because her husband, Lebrun, was an art dealer, she later had to combat gossip that she had been admitted only because of pressure from the court.

Vigée-Lebrun painted more than twenty portraits of Marie Antoinette, including one in 1787 of the queen with her children (fig. 26-37), made in the hope that the queen's depiction as a devoted mother would counter her public image as immoral, extravagant, and conniving. In a poignant touch, the little dauphin—the eldest son and heir to a throne he would never ascend—points to the empty cradle of a recently deceased infant. The princess leans affectionately against her mother, who holds the infant Louis Charles on her lap. Even though the French upper classes routinely used wet nurses and governesses, the image of a loving mother surrounded by numerous children represented an ideal in the work of many Neoclassic artists. The portrait thus identified the queen as a sister to women everywhere, united with them in sacred motherhood (see "Jean-Jacques Rousseau on Educating Children," below). The image here also alluded to the well-known allegory of Abundance, suggesting the peace and prosperity of society under the king's rule.

But the king's rule was rapidly coming to an end. One summer afternoon in 1789, a Parisian mob stormed the Bastille, a notorious prison; early that autumn a Parisian

JEAN-JACQUES ROUSSEAU ON EDUCATING CHILDREN Although he never married and he placed his own children in orphanages, the French-Swiss philosopher Jean-Jacques Rousseau (1712–1778) formulated a behavioral program of childhood education that affected all French schools after the Revolution of 1789. His essay on education, *Émile, ou de l'Éducation* (*Emile, or Regarding Education*), was written at the same time as his well-known political tract *Le Contrat Social* (*The Social Contract*), in which he argued that all people were equal and inherently good and that rulers held their positions only by the consent of the people they governed. *Émile*, which contained a preliminary outline restating the theory of the social contract, was published in Paris in May 1762. Believing that children were inherently good until society corrupted them and broke their naturally independent, inquisitive spirits, Rousseau advised mothers to breast-feed their babies themselves, dress them in loose clothing with no bonnet, wash them in unheated water, give them freedom to crawl about, and never to rock them, which Rousseau considered harmful. As boys grew, they were to be taught to value nature, human liberty, and personal valor and virtue. This environment would inevitably produce a citizen committed to political freedom and civic duty. Girls were to be educated only as needed for their futures as wives and mothers. Once married, women were to stay at home, out of the public eye, caring for their households and children, which Rousseau saw as "the manner of living that nature and reason prescribe for the sex" (Richard and Richard, pages 457–458). The *Contrat Social* became the basis for the French Constitution, and *Émile* a manual for the country's public education programs.

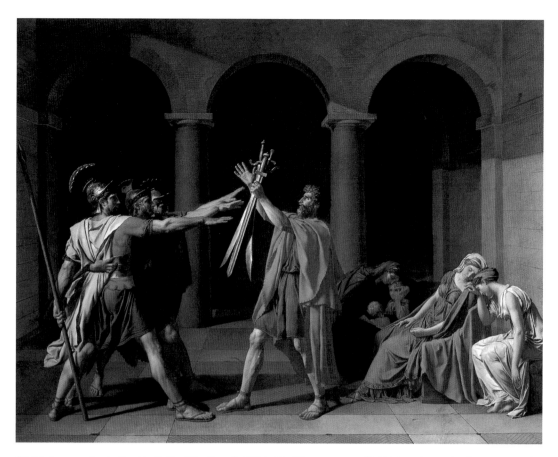

26-38. Jacques-Louis David. *Oath of the Horatii*. 1784–85. Oil on canvas, 10'8¼" x 14' (3.26 x 4.27 m). Musée du Louvre, Paris

crowd marched to Versailles and forced the royal family to move to Paris. The monarchy was doomed; the king and queen were beheaded in 1793, and their one surviving son, Louis Charles, died two years later in prison.

Jacques-Louis David. More than any other artist, Jacques-Louis David (1748–1825) is identified today with the French Revolution, even though his first patronage and early successes came from the court of Louis XVI. David had prepared for a career as an architect, but when he insisted on becoming a painter, he was **apprenticed** to Joseph-Marie Vien—that is, contracted to work for Vien while he learned his art. David also worked briefly for Fragonard on interior decoration (now lost) for one of Ledoux's Paris town houses, but after winning the Prix de Rome in 1774, David accompanied Vien to Italy.

Back in Paris, David exhibited at the 1781 Salon, where his work elicited Diderot's highest praise. Louis XVI, as part of a program to decorate his palaces with history paintings, in 1783 commissioned from David *Oath of the Horatii* (fig. 26-38). This work, which David painted in Rome so that he might be in close communion with the Classical past, would be the first major expression of his mature Neoclassic style.

As early as 1781 the artist had considered painting this duel to the death, fought by three Roman brothers (the Horatii) and three brothers from nearby Alba (the Curatii) to settle a dispute between their native cities. David's sources for the story may have included a play he

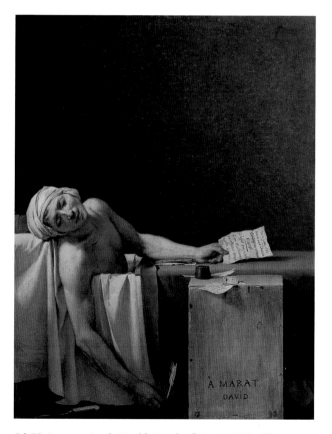

26-39. Jacques-Louis David. *Death of Marat*. 1793. Oil on canvas, 5'5" x 4'2½" (1.65 x 1.28 m). Musées Royaux des Beaux-Arts de Belgique, Brussels

saw in late 1782. Somewhat surprisingly, he depicted an incident that is not actually part of the story in any known source: the three Horatii taking an oath to fight to the death for Rome. The meaning of the finished painting—the value of putting patriotic duty above personal interests and even family obligations—is expressed with such clarity and power that it created a sensation when David exhibited it in Rome and Paris in early 1785. The three brightly dressed Horatii and their father are spotlighted in a shallow, stagelike space in front of a darkened portico, whose three arches organize the composition. Standing at the center, the father, Horatius, administers the oath to his sons. Fired with patriotism, the energetic young men with their glittering swords are a powerful contrast to the swooning women already mourning the tragedy to come. Ignored by her husband and sons, the wife of Horatius embraces her grandchildren, while her daughter Camilla, who is betrothed to one of the Curatii, and her daughter-in-law Sabina, a Curatii herself, weep together, knowing that whatever the outcome of the battle, they will inevitably lose someone dear to them.

Painted for a royal commission, David's *Oath of the Horatii* was fully within the tradition of chivalric self-sacrifice. Heroic subjects from Roman history were later extolled by leaders of the French Revolution as examples of republican virtue, so it is tempting to read revolutionary warnings into David's work of the 1780s. But the artist's political radicalism did not emerge until some years after the picture was painted, and it seems unlikely that he intended any overt antimonarchist statement at this point. It should be said, however, that David almost certainly shared in the general desire for moral renewal, and his impassioned paintings of Roman virtue helped to feed revolutionary fervor.

In 1793 the radical Jacobin party came to power. The Jacobins drafted a new constitution, abolished the monarchy—and also slavery in the French colonies—and proclaimed the year 1793 Year I. As an elected deputy to the National Convention, David became propaganda minister and director of public festivals. Possibly at his instigation, the Royal Academies were abolished as the last refuge of the aristocracy; they were reconstituted two years later, however, as the Institut de France.

In 1793 the Jacobins commissioned from David a tribute to one of their leaders, Jean-Paul Marat, who had been assassinated that year. Marat, a radical pamphleteer and revolutionary firebrand, had been responsible in part for the 1792 riots in which Jacobins had killed hundreds of helpless prisoners. A young woman named Charlotte Corday d'Armont heard accounts of these atrocities and decided that Marat was a monster who should be destroyed. Marat, who took long daily medicinal baths for a skin ailment, wrote and received visitors while sitting in his bathtub. It was there that Charlotte

Corday, pretending to be an informant about enemies of the Revolution, stabbed him to death.

In his *Death of Marat* (fig. 26-39), David combined naturalistic immediacy with a strong Neoclassical clarity in a manner that also recalls Caravaggio in its spare setting, dramatic lighting, and forceful intrusion into the viewer's space. The slumped figure of the dead revolutionary deliberately evokes images of the dead Jesus, a suggestion reinforced by the single wound under Marat's collarbone. Thus, like West's *Death of General Wolfe* (see fig. 26-22), David's painting reenacts a contemporary event using the visual language of Christian imagery and Baroque realism.

The fall from power of the Jacobin party eventually brought Napoleon Bonaparte to power. Made commander of French forces in Italy in 1796, Napoleon rose through his spectacular military successes there and in Austria and returned to Paris in 1797 to wide public acclaim. Napoleon agreed to sit for a portrait for David, but after three hours of posing, the general became impatient, and the portrait was never completed. Nevertheless, David kept the sketch in his studio and proclaimed to everyone that "Bonaparte is my hero." In November 1799 Napoleon was declared First Consul—in effect, dictator—and the government was reorganized.

In May 1800 Napoleon and his army returned to northern Italy, an event that David commemorated in his *Napoleon Crossing the Saint-Bernard* (fig. 26-40). As with the *Death of Marat*, the painting treats contemporary history in an idealized Grand Manner, portraying what was

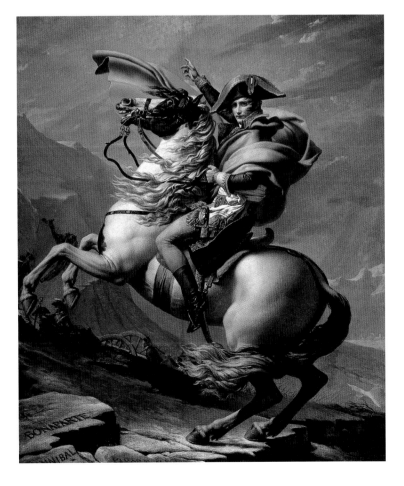

26-40. Jacques-Louis David. *Napoleon Crossing the Saint-Bernard*. 1800–01. Oil on canvas, 8'11" x 7'7" (2.7 x 2.3 m). Musée National du Château de la Malmaison, Rueil-Malmaison, France

actually an uneventful trip as a thrilling drama. Napoleon charges up the mountain slope past rocks incised with his name and those of the heroes who had preceded him, Hannibal and Charlemagne, while a strong wind whips his cloak and the horse's mane and tail into a passionate frenzy. Here, Napoleon—actually quite a small man— seems to tower over the figures of his soldiers, who are hauling a cannon up the steep trail.

Napoleon appointed David his chief painter in 1803 and, after assuming the title of emperor in 1804, promoted him to chief imperial painter and made him a baron. When Napoleon fell from power, David moved to Brussels, where he was quickly surrounded by admirers and patrons. He died there in 1825 without ever returning to Paris.

David's Pupils. Among David's first pupils was Anne-Louis Girodet-Trioson (1767–1824), whose mature style, which anticipated Romanticism, David considered a betrayal of his teachings. Winner of the Prix de Rome in 1789, Girodet remained in Italy from 1790 to about 1796. Upon his return he held his own in competition with David and his fellow students and later gained favor with Napoleon.

Girodet favored mythological and literary subjects, but he also painted portraits in a proto-Romantic style. In his 1797 *Portrait of Jean-Baptiste Belley* (fig. 26-41), a

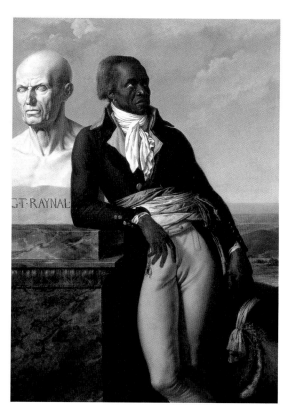

26-41. Anne-Louis Girodet-Trioson. *Portrait of Jean-Baptiste Belley.* 1797. Oil on canvas, 5'2½" x 3'8½" (1.59 x 1.13 m). Musée National du Château de Versailles, Versailles, France

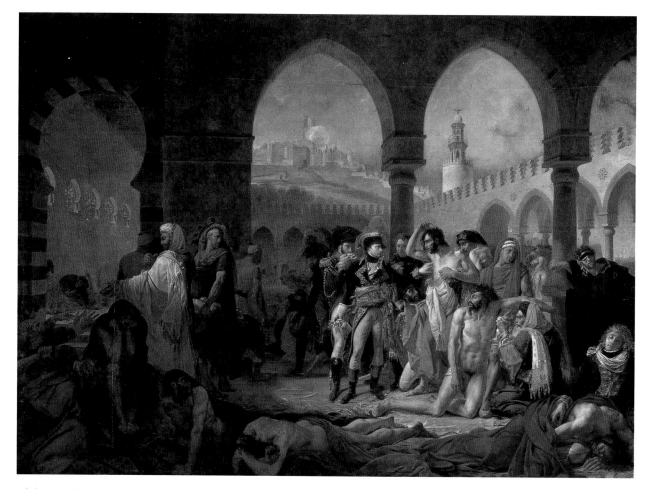

26-42. Antoine-Jean Gros. *Napoleon in the Plague House at Jaffa.* 1804. Oil on canvas, 17'5" x 23'7" (5.32 x 7.2 m). Musée du Louvre, Paris

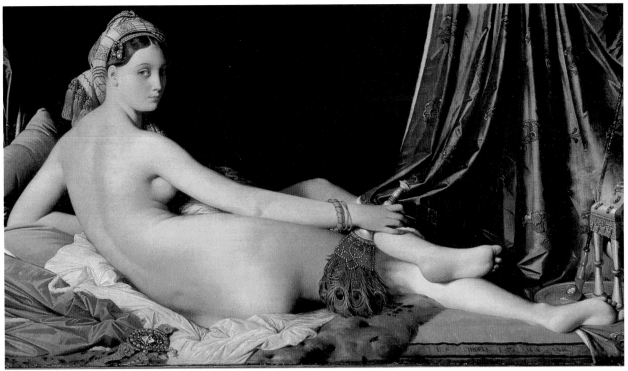

26-43. Jean-Auguste-Dominique Ingres. *Large Odalisque*. 1814. Oil on canvas, approx. 2'10" x 5'4" (0.88 x 1.62 m). Musée du Louvre, Paris

respected diplomat from the French-ruled colony of Saint-Domingue (now Haiti), he combined a casual but elegant pose inspired by classical sculpture and realistic features with an allusion to events related to his subject's past. Belley, a tall man with a distinctive African appearance, leans on a pedestal holding a bust of the abbot Guillaume Raynal, the French philosopher-historian who wrote a book attacking European policies toward the peoples of the Caribbean. Raynal, who had had to flee France as a result, was later extolled as a champion of human rights. The inclusion of his bust in Belley's portrait set the historical tone of the picture and also commemorated Raynal's death the year before. Unfortunately, Napoleon reestablished slavery in the islands.

Antoine-Jean Gros (1771–1835), who began to work in David's studio in 1783 at age twelve, eventually vied with his master for commissions from Napoleon. He also went further than Girodet in his embrace of Romanticism. Gros traveled with Napoleon in Italy in 1796–1797 as an appraiser of artworks to be confiscated and sent back to Paris, a practice David deplored. Later Gros became an official chronicler of Napoleon's military campaigns. His *Napoleon in the Plague House at Jaffa* (fig. 26-42) of 1804 portrayed the emperor as a near-divine ruler courageously touching one of his soldiers who was ill from an infectious disease. The gesture recalls the medieval belief that monarchs could, by their touch, cure scrofula, a form of tuberculosis of the lymph glands or bones. Gros's heroic fiction hides a terrible truth: Napoleon subsequently ordered the sick soldiers to be poisoned because they were an impediment to his campaign. There are a number of Romantic elements in the painting: the exotic loca-

tion, the smoky red sky seen through the dark Moorish arches, and the moving image of the dead and dying.

Jean-Auguste-Dominique Ingres (1780–1867) thoroughly absorbed his teacher David's Neoclassical vision but reinterpreted it in a new manner. Inspired by Raphael rather than by antique art, Ingres emulated the Renaissance artist's precise drawing, formal **idealization**, classical composition, and graceful lyricism. Ingres won the Prix de Rome in 1801 and lived in Italy from 1806 to 1824; he returned to Italy to serve as director of the French Academy in Rome from 1835 to 1841. As a teacher and theorist, Ingres became the most influential artist of his time, helping to formulate the taste of his own generation and using his academic position to suppress other artistic styles.

Painted in Rome in 1814, Ingres's *Large Odalisque* (fig. 26-43), despite its cool and precise treatment, is in many respects anticlassical. The exotic subject—an **odalisque**, who is any woman living in the women's quarter of a Turkish house (*oda*)—allowed the artist to paint a full nude, but the odd distortions of her body seem akin to Mannerist art of the late sixteenth century. To make this figure conform to his idiosyncratic aesthetic, Ingres has given her several extra vertebrae and tiny, boneless feet scarcely capable of supporting her weight. Surrounded by exotic paraphernalia, Ingres's cool, languorous woman personifies an elegant eroticism reminiscent of Canova's *Maria Paulina Borghese as Venus Victrix* (see fig. 26-6). She remains forever aloof as part of a remote and imaginary world.

A superb portraitist, Ingres could capture a true likeness while creating a Grand Manner impression. His

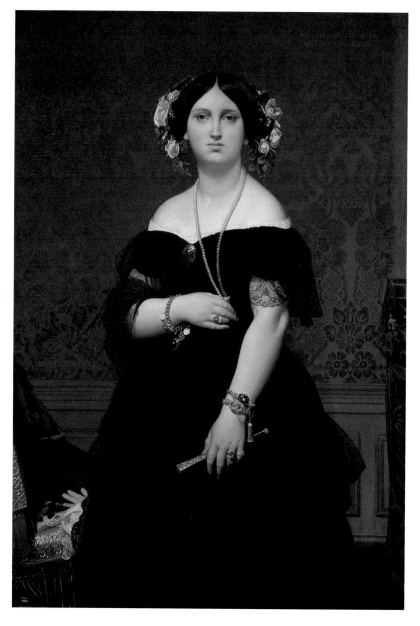

26-44. Jean-Auguste-Dominique Ingres. *Madame de Moitessier.* 1851. Oil on canvas, 57¾ x 39½" (146.7 x 100.3 cm). National Gallery of Art, Washington, D.C.

Samuel H. Kress Collection

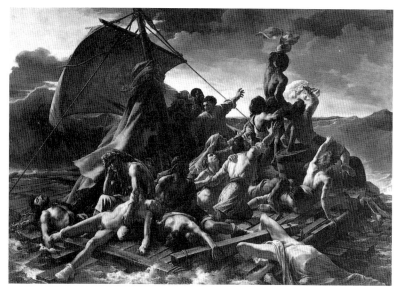

26-45. Théodore Géricault. *Raft of the "Medusa."* 1818–19. Oil on canvas, 16'1" x 23'6" (4.9 x 7.16 m). Musée du Louvre, Paris

Madame de Moitessier (fig. 26-44), painted in 1851, conveys a monumental presence through the subject's confident pose, authoritative eye contact with the viewer, and rich costume. Here, as in the *Large Odalisque*, the emphasis on clearly defined contours and carefully drawn details exemplifies Ingres's belief in the superiority of drafting over color.

The Romanticism of Géricault and Delacroix.

Romanticism, already anticipated in French painting in Napoleon's reign, flowered during the royal restoration that lasted from 1815 to 1848. French artists not only drew upon literary sources but also added the distinctive new dimension of social criticism. Romantic painting was characterized by loose, fluid brushwork, strong colors, complex compositions, dramatic contrasts of light and dark, and expressive poses and gestures. These qualities represent a return to the Baroque, but Romanticism is very much a modern art movement in that artists were free to choose from a variety of subjects, styles, and techniques as their inspiration dictated.

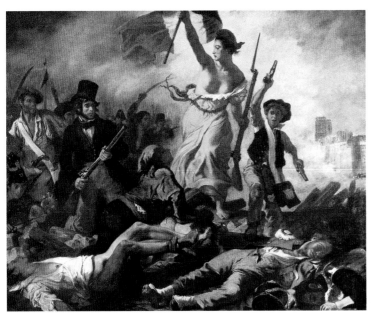

26-46. Eugène Delacroix. *The Twenty-eighth of July: Liberty Leading the People.* 1830. Oil on canvas, 8'6" x 10'7" (2.59 x 3.25 m). Musée du Louvre, Paris

Delacroix painted this patriotic allegory after watching the three-day Revolution of 1830 fought in the streets near his studio. Critics did not appreciate the picture when it was exhibited at the 1831 Salon, but the new royal government of "Citizen King" Louis Philippe bought it for a high price. Hung in the painting gallery of the Palais du Luxembourg, it began to annoy the king, however, and was returned after a few months to Delacroix, who gave it to his Aunt Félicité. When the Revolution of 1848 ended the monarchy and established the Second Republic, the painting was returned to the State and exhibited at the 1848 Salon.

Théodore Géricault (1791–1824) began his career painting works inspired by Napoleon's military campaigns. In 1818–1819 Géricault found the subject for his major work, *Raft of the "Medusa"* (fig. 26-45). When the French ship *Méduse* foundered off the African coast in July 1816, during a shipboard celebration marking the crossing of the equator, the commander ordered 149 passengers and crew onto a small raft attached by a rope to a lifeboat holding the ship's officers. The towline either broke or was deliberately cut to save the lifeboat, and the raft tossed about on stormy seas for nearly two weeks before it was found, with only fifteen survivors. The wreck of the *Méduse* became a scandal involving the elderly, incompetent aristocratic commander appointed by the government.

Géricault researched the subject thoroughly, starting with the study of a widely circulated pamphlet in which two survivors gave a horrifying account of insanity and cannibalism. He visited hospitals and morgues to sketch the dying and dead, and he launched a raft in the ocean to observe how it rode the waves. In his studio he used live models, one of whom was the painter Delacroix, who appears as the corpse lying facedown at the center of the canvas. The Romantic subject of human tragedy and injustice is illustrated with indignant compassion, but Géricault's academic training underlies the painting's organization as a series of interlocking triangles. The outstretched arms of the victims lead the viewer's eye up to the climactic figure of an African held aloft to wave a red-and-white cloth to attract the attention of a ship that is only a speck on the horizon. Like so many Neoclassic and Romantic artists, Géricault was powerfully influenced by Michelangelo; the writhing movements of the monumental, idealized male bodies in his painting reflect Michelangelo's *Last Judgment* (see fig. 18-17). To disguise the implied criticism of the government, Géricault had to change the painting's title to an anonymous "shipwreck" for the 1819 Salon. Failing to find a buyer, he followed a trend of the time and began exhibiting the enormous canvas to the public for a fee. In 1820 he took

the painting to England, where it created a sensation. Despite its controversial subject and realistic detail, *Raft of the "Medusa"* was a sufficiently heroic and universal image for the painting to be purchased by the French government shortly after Géricault's death at thirty-two.

Eugène Delacroix (1798–1863) followed his friend as the inspirational leader of the Romantic movement. His social conscience was expressed mainly in works that conveyed a dramatic concern for personal and political liberty. But he had an equally consuming interest in literary drama, such as Shakespeare's plays, and in all manner of exotic subjects remote in time or place. Delacroix's political sympathies were republican throughout the royal restoration. In commemorating the Revolution of 1830 with his painting *The Twenty-eighth of July: Liberty Leading the People* (fig. 26-46), he created an image that became a widely recognized symbol of liberation. In that fierce but brief uprising, Parisians had forced the abdication of Charles X. Delacroix showed the contemporary event as an allegory in which the rebels are urged on by a monumental figure of Liberty with "powerful breasts and robust charm," as she was described in a popular French song. The motley group of fighters, seemingly oblivious to the dead and dying over whose bodies they charge, includes a twelve-year-old boy who killed a royal soldier before being badly wounded himself. Delacroix seems to have taken the visual drama of Géricault's *Raft of the "Medusa"* and combined it with the fervent patriotic spirit of David's *Oath of the Horatii* (see fig. 26-38).

A trip to North Africa in 1832 made a deep impression on Delacroix and provided him with enough sketches of exotic subjects to feed his pictorial imagination for the rest of his life. A particularly fruitful resource for his work back in Paris was a series of quick watercolor sketches that he had made during a secret visit to an Algerian harem. One result of this adventure was his *Women of Algiers* of 1834 (fig. 26-47). Drawing with brilliant color and laying down his intense tones with loaded brushes in short strokes, the artist re-created on canvas a vision of his afternoon with the odalisques, whom he described

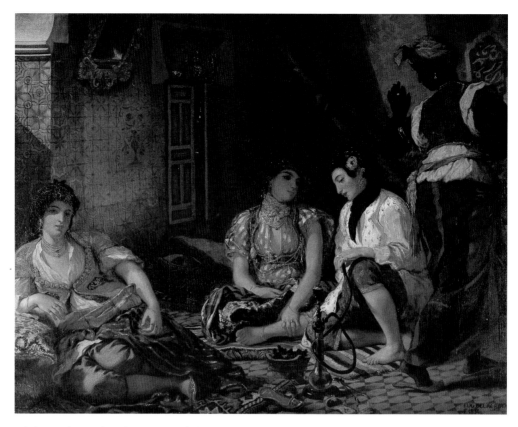

26-47. Eugène Delacroix. *Women of Algiers.* 1834. Oil on canvas, 5'10⁷/₈" x 7'6¹/₈" (1.8 x 2.29 m). Musée du Louvre, Paris

as "tame gazelles." Delacroix was particularly impressed not only by the exoticism but also by the dignity of the North Africans, who seemed to him to have a nobility like that of the ancient Greeks and Romans.

Romantic Sculpture

Neoclassicism prevailed throughout the Napoleonic period, but by the fall of Napoleon in 1815, a new approach to sculpture emerged that paralleled Romanticism in painting. A renowned sculptor in this mode, François Rude (1784–1855), arrived in Paris at the height of Napoleon's reign. A fervent supporter of the emperor, he fled to Brussels when his hero first fell from power in 1814. When Rude returned to Paris in 1827, his early Neoclassical style gave way to a taste for high drama and violently active poses, as seen in his major work, *Departure of the Volunteers of 1792* (fig. 26-48), popularly called *The Marseillaise* in reference to France's revolutionary anthem. Executed between 1833 and 1836, this relief decorates the base of one of the most prominent public monuments of Paris, the Neoclassical Arc de Triomphe at the Place de l'Étoile, commissioned by Napoleon. The sculpture commemorates the volunteer army that halted a Prussian invasion in 1792–1793 which aimed to restore the rule of Louis XVI. The soldiers, dressed in Roman battle gear or heroically nude, are urged forward by the lunging figure of the Goddess of Liberty, brandishing a sword. The compression of the gesticulating figures and the forward surge of activity convey an unprecedented

feeling of passion and excitement in a sculptural group.

Antoine-Louis Barye (1796–1875), like Rude, was trained as a Neoclassical sculptor. Influenced by Géricault and Delacroix, he was praised by critics for his entry in the 1831 Salon of a bronze figure of a tiger devouring a hare. Barye closely studied the wild animals in Paris's zoo, where his friend Delacroix occasionally joined him on sketching trips. Barye's *Lion Crushing a Serpent* (fig. 26-49) of 1833 is one of his many compositions involving a powerful animal and its weaker prey. Characteristic of his Romantic approach is the theme of Nature's cruelty expressed through a dynamic composition and an intense naturalism in the anatomically correct rendering of the animals. His work exploits the expressive possibilities and dark tonalities of bronze particularly well. In demand internationally, Barye was a favorite sculptor of Napoleon III during the Second Empire (1852–1870).

GERMANY King Frederick William II of Prussia (ruled 1786–1797), like Napoleon, found in Neoclassicism the perfect style for his regime. Frederick William thought of himself as a philosopher-king, personifying not only power and severity but also intelligence and discipline, and Neoclassicism seemed to embody precisely those attributes. At his direction the royal architect Karl Gotthard Langhans (1732–1808) built the Brandenburg Gate (fig. 26-50) as a monumental entrance to one of the main boulevards of Berlin, the Prussian capital. Almost certainly familiar with the Vitruvian

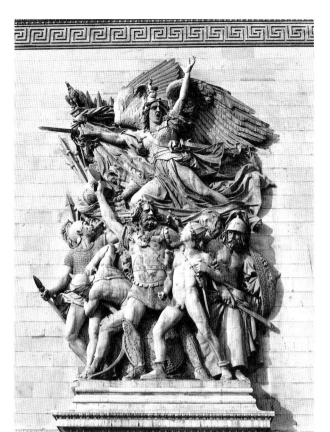

26-49. Antoine-Louis Barye. *Lion Crushing a Serpent.* 1833. Bronze, height 5'10" (1.8 m). Musée du Louvre, Paris

Barye's dramatic animal sculpture in the Romantic vein attracted many American patrons. After his death they joined together to raise money through exhibits of his works in New York and Paris to commission a public memorial to the sculptor. The result was Square Barye, a park in the heart of Paris on the southeast tip of an island in the Seine River behind Nôtre-Dame Cathedral. To mark the site, a large marble monument was created by reproducing several of Barye's best-known works, including this one.

26-48. François Rude. *Departure of the Volunteers of 1792 (The Marseillaise).* 1833–36. Limestone, height approx. 42' (12.8 m). Arc de Triomphe, Place de l'Étoile, Paris

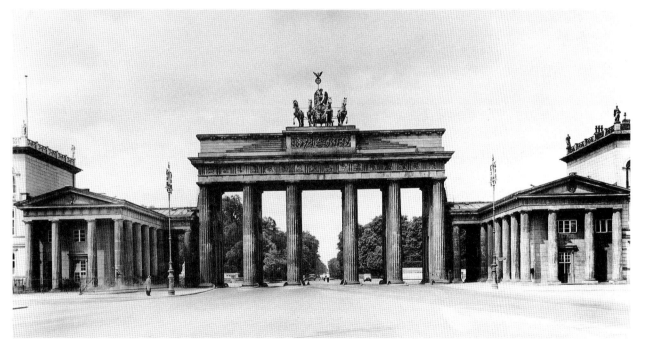

26-50. Karl Gotthard Langhans. Brandenburg Gate, Berlin. 1788–91

conception of the austere and heavily proportioned Doric as being the most masculine order, Langhans took as his model for the project the Propylaia, the Doric gateway to the Acropolis in Athens built in the fifth century BCE. Thus, the Brandenburg Gate was the first classical monument in Germany to be modeled on a Greek rather than a

Roman example. Langhans's severe Doric style was continued well into the nineteenth century in Germany by his pupils.

Other artists turned to aspects of the Middle Ages as inspiration for a national German art. Neo-Gothic castles and churches asserted traditional German values as

26-51. Caspar David Friedrich. *Cloister Graveyard in the Snow.* c. 1817–19. Oil on canvas, 47⅝ x 66⅞" (121 x 169.9 cm). Former collection of Staatliche Museen zu Berlin, Preussischer Kulturbesitz, Nationalgalerie. Destroyed in World War II

Neoclassicism gave way to Romanticism. The work of the painter Caspar David Friedrich (1774–1840) represents the brooding melancholy that characterizes German Romanticism. Friedrich, like the sculptor Thorvaldsen (see fig. 26-7), attended the Royal Academy in Copenhagen, then he settled permanently in Dresden in 1798. His early work was almost exclusively monochromatic: pen-and-ink sketches, **sepia** (dark brown ink) drawings, and **etchings**. Friedrich began to paint in oils in 1807, but even then confined himself to a restrained palette. His precise execution often depends on light, fog, snow, or some other blanketing element to unify his haunting compositions, which frequently seem to express loneliness and dejection. Friedrich's mature work uses a poetic and symbolic vocabulary, fusing images of religion, nature, and death to express his intense obsession with the impermanence of human life.

Cloister Graveyard in the Snow (fig. 26-51) of about 1817–1819 shows a snow-covered forest landscape, where bare-headed monks move in procession past crumbling gravestones in the foreground, through the portal of a ruined church, and toward an altar. In the background is the hulking remnant of the church's choir, which seems to hover over the scene like a presiding spirit. The lonely grandeur of the snow-covered landscape and the rugged building, as well as the sheer indecipherability of the event taking place contribute to the eerie fascination this painting often evokes. With characteristic precision, Friedrich based the architecture on sketches he had made of a ruined Cistercian monastery near the Baltic Sea. He is known to have considered bare-limbed oak trees as emblems of the pre-Christian world, which suggests that this desolate forest with its ruined Gothic choir and liturgical procession may be intended as an elegy on loss and the transience of human life and society.

SPAIN In eighteenth-century Spain, patrons looked to foreign artists, such as Giovanni Battista Tiepolo (see fig. 19-73), who spent his last nine years in

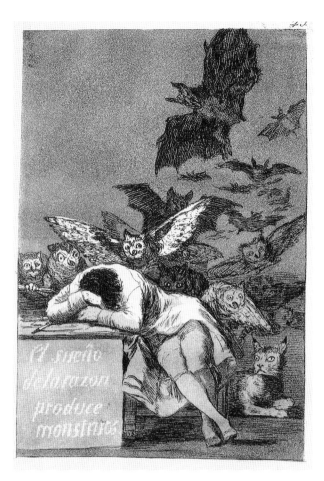

26-52. Francisco Goya. *The Sleep of Reason Produces Monsters,* No. 43 from *Los Caprichos* (The Caprices). 1796–98, published 1799. Etching and aquatint, 8½ x 6" (21.6 x 15.2 cm). The Hispanic Society of America, New York

After printing about 300 sets of this series of 80 prints, Goya advertised them for sale in February 1799 in two Madrid newspapers. When only 27 sets had been sold after four years, in 1803 Goya made a gift of the plates and the remaining sets to the Royal Printing Office, in return for which his nineteen-year-old son, Francisco Xavier, was granted a yearly stipend to further his education.

Madrid, to fill major commissions. Not until late in the century did a native painter emerge whose achievements were comparable to those of Velázquez. Francisco Goya y Lucientes (1746–1828), in fact, learned as much from Velázquez as from his own teachers by making etchings after Velázquez's paintings. He also studied the paintings and etchings of Rembrandt, whom he considered his other great inspiration. During the first half of his long career, however, Goya chiefly produced formal portraits and Rococo genre pictures, including sixty-three full-scale tapestry designs for the Royal Manufactory in Madrid, painted in a light palette that clearly shows the influence of Tiepolo. Around 1800, however, Goya's study of Velázquez and Rembrandt began to be expressed in his work in a darker tonality, freer brushwork, and dramatic presentation. His style continued to develop in this direction for the rest of his career.

In 1799 Goya published his first suite of etchings, *Los Caprichos* (The Caprices), which exhibit a new bitterness

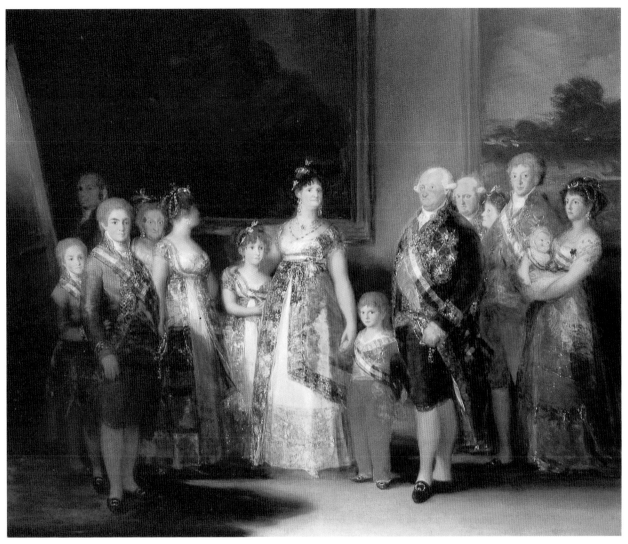

26-53. Francisco Goya. *Family of Charles IV.* 1800. Oil on canvas, 9'2" x 11' (2.79 x 3.36 m). Museo del Prado, Madrid

in his outlook. Setting the tone for eighty etchings is the print originally intended as its **frontispiece**, *The Sleep of Reason Produces Monsters* (fig. 26-52). Although the text published with the print sounds a hopeful note ("Imagination abandoned by reason produces impossible monsters; united with her, she is the mother of the arts and the source of their wonders"), the images are an angry attack on contemporary Spanish manners and morals that makes Hogarth's satire (see fig. 26-17) seem tame by comparison. Goya did not share the Enlightenment faith in the ultimate rationality and goodness of humanity. On the contrary, he believed that the violence, greed, and foolishness of his society had to be examined mercilessly if it were to be changed in any way. Each *Capricho* depicts a dramatic moment, emphasized by strongly contrasting areas of light and shadow, provided by the stark, unprinted paper and shading in gray and black.

Goya's paintings and prints were admired for their dazzling technical execution, even by critics who might otherwise have been offended by the searching realism and astute psychological penetration of his best work. Appointed court painter to Charles III in 1786, Goya was elevated to principal painter under Charles IV (ruled

1788–1808). The one portrait that he made of Charles IV and his extended family in 1800 (fig. 26-53) is an enigmatic homage to Velázquez's *Las Meninas* (see fig. 19-36). In a clear allusion to that portrait, Goya placed himself at work at his easel in a room of the palace, with the royal family gathered about him. But instead of the grave dignity of Velázquez's king and queen and the playful charm of their daughter, a chill foreboding seems to grip Goya's royal family. Charles IV appears almost catatonic, and the rest of the group is strangely quiet and apprehensive before the artist's—and the viewer's—pitiless scrutiny. Even the future Ferdinand VII, presumably at the height of his youth and vigor, shares in the general paralysis, and his fiancée at his side is shown, curiously, with her face averted. Despite the clear allusion to *Las Meninas,* Goya's glittering encrustation of paint recalls the surface of Rembrandt's *Jewish Bride* (see fig. 19-51) rather than the flickering brushwork of Velázquez. What the artist thought about painting this disturbing image can only be surmised, but it, too, seems touched by the bitterness shown in Goya's earlier *Caprichos.*

Spain, with its extensive American territories and strategic location at the entrance to the Mediterranean

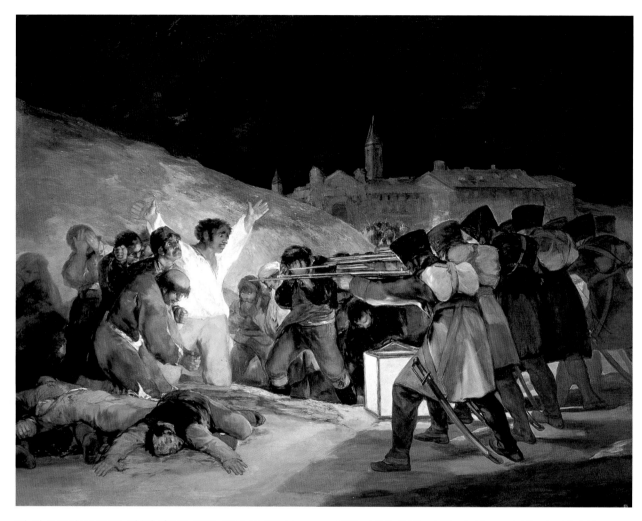

26-54. Francisco Goya. *Third of May, 1808.* 1814–15. Oil on canvas, 8'9" x 13'4" (2.67 x 4.06 m). Museo del Prado, Madrid

Sea, soon attracted Napoleon's interest. In 1808 he occupied the country, forced Charles IV to abdicate, and installed his brother, Joseph Bonaparte, as king. At first many Spaniards welcomed the new regime, hoping for much-needed political reform. However, many of the hoped-for reforms outraged conservatives and Spanish nationalists, and there were continuous bloody revolts, which the French ruthlessly put down.

Charles IV's son Ferdinand VII, imprisoned in France by Napoleon, was returned to power in 1814. Goya quickly made overtures to him, painting two works commemorating the first popular uprising in Madrid in support of the royal family. In *Third of May, 1808* (fig. 26-54), Goya depicted the summary execution of a group of rebels. Although he had probably not seen any of the rebellion at firsthand, he sketched the site of the execution and would have heard many descriptions of it. The violent gestures of the terrified rebels and the almost mechanized efficiency of the firing squad seem to be scenes from a nightmare. The man in the white shirt, confronting his faceless killer with outstretched arms suggesting the crucified Jesus, is an image of particular horror and pathos.

Ferdinand VII's reactionary reign was disastrous for Spain. The king abolished the constitution and reinstated the Inquisition. Goya joined a community of Spanish exiles in France, where he died four years later.

THE UNITED STATES

The United States emerged from the War of Independence from Britain with sufficient resources, technology, and entrepreneurism to move into the forefront of the industrialized world. The country's territory was doubled by the purchase from France in 1803 of Louisiana, a vast expanse that reached from the Gulf of Mexico northward to what is now Canada and from the Mississippi River northwestward to present-day Oregon. As explorers spoke glowingly of opportunities in the West, Americans began migrating to California and the Pacific Northwest. When gold was discovered in California in 1848, the migration became a flood. The transcontinental railroad completed in 1869 made the journey considerably easier, and by the 1890s the frontier had disappeared.

Architecture

At the end of the eighteenth century, classicism was still the prevailing style for architecture in the United States, especially for major public buildings. Only in the mid-nineteenth century did Romanticism, in the form of Romanesque and Gothic **revivalism**, begin to appear in American architecture as the new rich built replicas of medieval castles and European mansions.

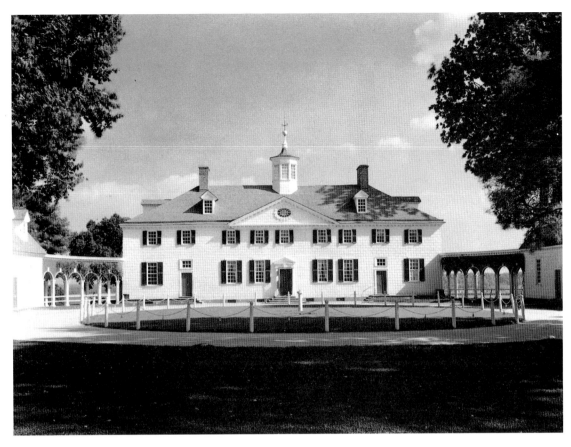

26-55. James Patterson and George Washington. Mount Vernon, Fairfax County, Virginia. 1758–86

Perhaps the most famous old house in North America is Mount Vernon. George Washington, with a 1754 lease, acquired Mount Vernon, his family's estate in Fairfax County, Virginia, and in 1758 began enlarging the small farmhouse on the property. Work on the mansion was interrupted during the War of Independence, and the house was finally completed in 1786. Mount Vernon (fig. 26-55) is a Georgian building, the style named for the kings of England and inspired by English country houses and the Renaissance villas of Palladio (see fig. 18-35). Although Mount Vernon is constructed of wood, the siding on the outside is designed to look like stone. The elevation is simple and symmetrical, with a triangular pediment suggesting a Roman temple front. Curving **arcades** link this central block with the outbuildings, including the kitchen.

The large dining room at Mount Vernon (fig. 26-56), called simply the "new room" by the Washingtons, was decorated by John Rawlins and Richard Thorpe in 1786–1787. Its decoration belongs to the Federal phase of American architecture, which spanned the period from the end of the American Revolution in 1783 to the 1820s. In the Federal period there was a move toward archeologically correct decorative details prompted by the excavations going on in Italy. In some buildings the motifs came directly from Roman sources, but in others, such as the dining room, they were derived from the work of Robert Adam (see fig. 26-10). Rawlins and Thorpe created a graceful and intimate effect using recognizable classical elements such as the triumphal-arch, or Pal-

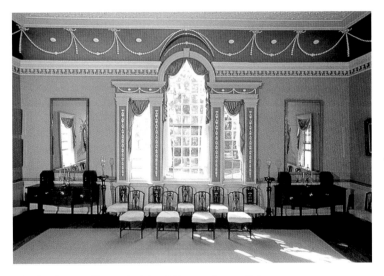

26-56. John Rawlins and Richard Thorpe. Large dining room, Mount Vernon. 1786–87

ladian, window, with its high arch supported on **pilasters**. The pilasters are decorated with a design of modified Roman lamp forms, and the walls are articulated with simple moldings and delicate beaded garlands. The ceiling, which has been enriched with **stucco** (plaster) moldings, strongly recalls Adams' designs.

Thomas Jefferson, political leader and principal author of the Declaration of Independence, believed fervently in architecture as a means of expressing the ideals of the newly independent United States and in Neoclassic

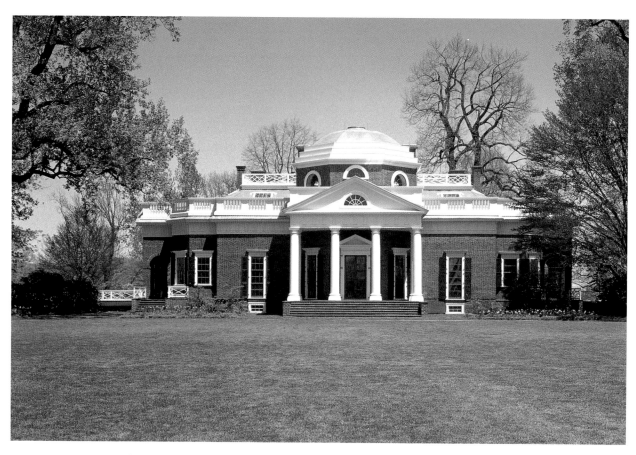

26-57. Thomas Jefferson. Monticello, Charlottesville, Virginia. 1770–84, 1796–1806

as the style appropriate for the new national capital, Washington, D.C. The product of a classical education, Jefferson was also an amateur architect of great knowledge and imagination. Not surprisingly, his designs for Virginia's State Capitol at Richmond and the library and academic buildings of the University of Virginia at Charlottesville (1817–1826) copied Roman temples. In true Enlightenment spirit, Jefferson intended these buildings to be not only handsome but also instructive, helping to encourage in students a spirit of inquiry and, more practically, to provide examples for the study of classical architecture.

Jefferson's first attempts at architectural design were at his home, Monticello, near Charlottesville, Virginia (fig. 26-57). In his enthusiasm he continually altered its design. He began in 1770 with a Palladian structure with superimposed Doric and Ionic orders on the two stories, but by the time the building was completed in 1806, he had transformed it into a Neoclassical design of his own creation—part Roman temple, part Palladian villa, reminiscent of Chiswick House (see fig. 26-9). On the exterior he simplified and unified the facade by using a single story of the Doric order, with its frieze continued from the porch around the walls of the building. A balustrade acts as a screen to disguise the upper level. The materials are red brick with wooden trim painted white and columns formed of bricks covered with stucco and painted white. The central block of the house contains a reception hall on the main level and a ballroom above, whose walls form the octagonal drum supporting the dome.

CAPITOL OF THE U.S. AT WASHINGTON.

26-58. William Thornton and Benjamin Henry Latrobe. U.S. Capitol, Washington, D.C. c. 1808. Engraving by T. Sutherland, 1825. New York Public Library
I. N. Phelps Stokes Collection

While Jefferson was president (1801–1809), he was advised on renovations of the unfinished President's Palace (the original White House) in Washington, D.C., by Benjamin Henry Latrobe (1764–1820), who had immigrated from England in 1796. Jefferson appointed Latrobe surveyor of public buildings in 1803, which gave Latrobe the major responsibility for completing the U.S. Capitol. The basic Capitol plan and exterior design (fig. 26-58) were the work of William Thornton (1759–1828), a physician and amateur architect from the British West Indies, who had won an open competition for it in 1792.

26-59. Benjamin Henry Latrobe. U.S. Capitol. Corncob capital sculpted by Giuseppe Franzoni, 1809

Praised by George Washington for its "grandeur, simplicity, and convenience," the plan resembled a domed Roman temple inserted between two wings of equal size containing on one side the House of Representatives and on the other the smaller Senate chamber and committee rooms. Thornton's elevation, which Latrobe retained, featured a **rusticated** (rough-stone) basement, a temple-front entrance reached by a straight flight of steps, and over the central section, a round dome on an octagonal drum. The Capitol was partially burned during the British attack on Washington in 1814 and had to be rebuilt.

A committed classicist, Latrobe believed that Greek principles and sources, not Roman ones, were more appropriate for a democracy. Although Latrobe worked in the Federal period, he is credited with initiating the

26-60. James Renwick, Jr. Smithsonian Institution, Washington, D.C. 1848–55. Smithsonian Institution Archives, Washington, D.C.

Greek Revival, which became the principal public building style in the United States for the next century. Today Latrobe's ingenuity can be seen in the decoration of the Capitol interior. Determined to find new symbolic forms within the classical mode, he created a variation on the Corinthian order in which ears of corn (fig. 26-59) and tobacco plants were substituted for the acanthus leaves on Greek capitals. Latrobe resigned in 1817, and the Capitol was completed under Charles Bulfinch (1763–1844), the first American-born architect to work on the building. By 1850 the U.S. Congress had grown to 62 senators and 232 representatives, and a major renovation of the Capitol was undertaken that brought the building closer to its present appearance.

The Greek Revival style became a dominant force in nineteenth-century American architecture, but many architects and patrons preferred the parallel revival of Romanesque and Gothic styles. A well-known example, the Smithsonian Institution (fig. 26-60), was built between 1848 and 1855 by James Renwick, Jr. (1818–1895), to house the new scientific and cultural organization established in Washington, D.C., by the English scientist and philanthropist James Smithson. Renwick was the century's foremost designer of neomedieval churches, such as Grace Church (1845) and Saint Patrick's Cathedral (1858–1888), both in New York City. At the Smithsonian he combined elements from Romanesque and Gothic styles into an imaginative gathering of red-brick towers, **crenellations**, and chimneys. Like the Houses of Parliament in London (see fig. 26-16), the building has an irregular skyline that disguises a symmetrical plan for its exhibition galleries, laboratories, library, auditorium, and offices.

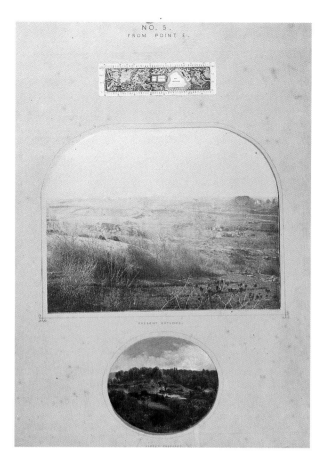

26-61. Frederick Law Olmsted and Calvert Vaux. Greensward Presentation Sketch No. 5, for Central Park, New York City, before and after. 1858. Oil painting and photograph mounted on board, 28½ x 21" (72.4 x 53.3 cm). The Municipal Archives, New York

26-62. Thomas Crawford. *Charles Sumner.* 1842. Marble, 27 x 14 x 10⅜" (68.6 x 35.5 x 26.4 cm). Museum of Fine Arts, Boston
Bequest of Charles Sumner

Originally, an inventive landscape setting was planned for the Smithsonian, and although it was never completed, interest in landscape architecture and in practical gardening was growing in America. The most successful landscape architect of nineteenth-century America was Frederick Law Olmsted (1822–1903). In 1857 he was appointed superintendent of New York's Central Park, which was already under construction through the efforts of the New York writer and publisher William Cullen Bryant. A practical man and a believer in the unaltered beauties of nature, Bryant had envisioned the project as a few winding paths cut through the woods with some water from the aqueduct to the main Manhattan reservoir spilling over the rocks here and there. Olmsted, however, was a great admirer of the eighteenth-century landscape gardens of England, and he accepted an offer of collaboration from the English landscape architect Calvert Vaux (1824–1895) to prepare a new design for the park for an announced competition. Their detailed presentation, called Greensward (fig. 26-61), easily won the competition. Each page of the presentation contained at the top the overall plan of the long rectangular parkland, at the center a black-and-white photograph of the specific area outlined on the plan, and at the bottom a detailed sketch of its proposed "after" appearance. The park as it exists today still essentially reflects the Olmsted-Vaux project.

American Sculptors in Italy

After the American Revolution the demand for monumental sculpture in marble and bronze grew significantly in the United States. At first patrons looked to European Neoclassical sculptors like Houdon and Canova, but soon American sculptors were given opportunities to study and work abroad for their American patrons. As it was for painting, Italy was the wellspring of Neoclassical inspiration in sculpture, and it was also the source of the materials and skilled workers needed to assist in the execution of large commissions. The first sculptors from the United States began arriving in Italy around 1825, and by the 1840s they were flocking to the American artists' colonies in Rome and Florence. (After visiting the large American colony in Rome, Nathaniel Hawthorne was inspired to make these expatriate sculptors the protagonists of his novel *The Marble Faun,* published in 1860.)

Thomas Crawford (1813–1857) settled in Rome at age twenty-two. There he studied with the Danish Neoclassical sculptor Bertel Thorvaldsen (see fig. 26-7) and quickly developed a solid reputation with both European and American patrons. One of Crawford's early patrons was the Bostonian Charles Sumner (fig. 26-62), who sat for his portrait bust in Rome in 1842. Crawford modeled his subject in the classical manner as an idealized nude with smooth skin and a conventional hair treatment, yet

26-64. Harriet Hosmer. *Beatrice Cenci*. 1856. Marble,
2'4 x 5'2" (0.71 x 1.57 m). The St. Louis Mercantile
Library Association, St. Louis, Missouri

26-63. Hiram Powers. *The Greek Slave*. 1843. Marble, height
5'5½" (1.68 m). Yale University Art Gallery, New
Haven, Connecticut

Olive Louise Dann Fund

In time-honored tradition, the creation of a large
marble statue was rarely carried through from begin-
ning to end by the artist who conceived it. By delegat-
ing the more time-consuming processes of execution
to specialists, artists were able to accept and carry
out more commissions, including replicas of popular
works. *The Greek Slave* exists in seven authentic ver-
sions produced in Powers's Florence workshop. This
statue put Powers in such demand that he was able
to charge the then-unheard-of price of $4,000 for
each of its six replicas. Unlike many artists, Powers
earned a reputation as a hard-headed businessperson;
when his patrons did not pay for their portrait busts,
he would display them on a shelf in his shop under a
large sign with the word *Delinquent.*

the modish sideburns and distinctive realism of the facial
features identify it as a fully modern work. At the time
Sumner was only twenty-eight and on the grand tour, but
he later served in the U.S. Senate, where he was a fiery
opponent of slavery. Among Crawford's later commis-
sions were bronze doors for the U.S. Capitol and the
Armed Liberty statue adorning its dome.

The "Yankee stonecutter," as Hiram Powers (1805–
1873) liked to call himself, was raised in Cincinnati, Ohio,

where as a young man he repaired lifesize wax figures
used in historical displays at the Western Museum in
Cincinnati. The director of the museum, following the
advice of the English writer Frances Trollope, put Powers
to work on a series of displays illustrating Dante's *Inferno*.
Encouraged by Trollope, who remained a lifelong friend,
Powers undertook with a local sculptor his only formal
training. A Cincinnati art patron paid Powers's way to
Europe for study, and he settled permanently in 1837 in
Florence. There he created his most famous work, *The
Greek Slave* (fig. 26-63), exhibited first in London in 1845
and then in New York in 1846, where long lines of people
paid 25 cents each to view the work. The subject of this
first fully nude female figure by an American sculptor had
great appeal in Europe at the time, for it represented
Greece held captive by Turkey before the Greeks had
gained their independence in 1832. Powers was later to
say that the image came to him in a dream, but the figure
actually emulates a common type of antique Venus that
he could easily have seen in Italian collections. The statue
became internationally famous when it was exhibited in
the American section of the first World Exposition, held
in London's Crystal Palace in 1851. After it was bought by
an English duke, orders for replicas poured in, the cele-
brated poet Elizabeth Barrett Browning wrote a sonnet
about it, and Powers's reputation was made.

Another American sculptor who worked in Italy was
Harriet Hosmer (1830–1908), who first came to Rome in
1852. Hosmer had studied with a Boston sculptor and had
taken anatomy classes in a St. Louis medical school be-
fore leaving for Europe. In Rome she became the pupil of
the English Neoclassical sculptor John Gibson. When her
father's financial problems ended his ability to support
her, she made a small marble of Shakespeare's character
Puck sitting on a toadstool, the sales of which brought her
about $50,000, a tremendous sum at a time when skilled
American artisans earned about $400 to $500 a year.
Soon she was receiving commissions from both Euro-
pean royalty and American clients. Among her many
idealized works is her *Beatrice Cenci* (fig. 26-64) of 1856.
Beatrice, the daughter of a Roman nobleman, conspired

26-65. Anne Whitney. *Roma*. 1869. Bronze, height 26⅝"
(67.6 cm). Davis Museum and Cultural Center,
Wellesley College, Wellesley, Massachusetts
Gift to the College by the Class of 1886 (1891.1)

26-66. Edmonia Lewis. *Hagar*. 1875. Marble, 52⅝ x 15¼ x 17"
(136.2 x 39.1 x 43.59 cm). National Museum of African
Art, Smithsonian Institution, Washington, D.C.

with her mother and brothers to murder her tyrannical father. At Beatrice's trial, her lawyer defended her on the grounds that she had been a victim of attempted incest, but she was nevertheless convicted and beheaded in 1599. Unlike Powers's *The Greek Slave*, whose untouchable aloofness owes much to the example of Thorvaldsen, Hosmer's vision of Beatrice, asleep in her cell after exhausting herself in prayer, is emphatically sensuous. The contrasts of flesh, hair, and drapery folds strongly recall the work of Canova (see fig. 26-6).

Besides Hosmer, other American women sculptors forged careers in Italy. Anne Whitney (1821–1915) worked intensely for the two causes that dominated her life, feminism and the fight against slavery, and she used her art to express her views on social problems. Little is known about her early career as a sculptor, but she was already an accomplished artist when she arrived in Rome in 1867. Her allegorical bronze statue *Roma* (fig. 26-65) so irritated the modern Romans that the statue was moved to Florence. Instead of the traditional triumphant goddess, Whitney's *Roma* (*Rome*) is represented as a weary, depressed, aging woman, with the decline of the empire told in a series of images along the hem of her classical costume. After completing this figure, Whitney returned to the United States, where she taught sculpture at Wellesley College, in Massachusetts, and received commissions for important public monuments.

Edmonia Lewis (1845–1890), who arrived in Rome the same year as Whitney, was the daughter of a Chippewa

moccasin maker and an African American. She attended Oberlin College in Ohio on scholarship from 1856 to 1859, but in her senior year two of her white friends were poisoned, and Lewis was charged with their murder. Defended by John Mercer Langston (who was later a professor of law, a diplomat, and a member of Congress), Lewis was acquitted. She went to Boston with an introduction to the abolitionist William Lloyd Garrison, who arranged for her to study with a Neoclassical sculptor. In 1862 she sculpted a bust of the white colonel Robert Gould Shaw after seeing him and his famed African American Fifty-fourth Massachusetts Regiment on their way to fight in the Civil War. The sale of plaster replicas of the Shaw portrait earned her enough money to travel to Europe in 1867. Settling in Rome, Lewis quickly drew important patrons for her portrait busts and idealized works on African and Native American themes. In 1873 she reportedly received two $50,000 commissions. That same year she visited San Francisco, where five of her statues were on exhibit, and did not return to Rome until 1885. One of her important works on a biblical subject, *Hagar* (fig. 26-66), was made on this American sojourn, in 1875.

Hagar was the Egyptian concubine of the biblical patriarch Abraham, given to him by his childless wife, Sarah, so that he might have a son. When Hagar's son Ishmael was in his teens, Sarah gave birth to Isaac. Jealous of her husband's other family, Sarah demanded that Abraham drive them into the desert to survive as best they could. When Hagar and her son were dying from

26-67. John James Audubon. *Common Grackle,* for *The Birds of America.* 1825. Watercolor, graphite, and selective glazing, 23⁷⁄₈ x 18¹⁄₂" (61.22 x 47.44 cm). New-York Historical Society

To create Audubon's *The Birds of America* (1827–38), his watercolors, like this one of grackles, were copied by the London printmaker Robert Havell using the aquatint process. Broad areas of neutral color were inked on the plates and the rest added by hand on the prints themselves. This bird encyclopedia was Audubon's first successful business venture. The cost to him of the first issue was $100,000, and 2,000 sets were eventually sold at $1,000 each. Between 1840 and 1844, before his health and eyesight began to fail, he supervised the production of *Birds* with reduced-size illustrations.

26-68. George Catlin. *Buffalo Bull's Back Fat, Head Chief, Blood Tribe.* 1832. Oil on canvas, 29 x 24" (73.7 x 60.9 cm). National Museum of American Art, Smithsonian Institution, Washington, D.C.

thirst, an angel led her to a well and foretold that her son Ishmael's descendants would be a great nation (Genesis 16:1–16; 18:1–21). In Lewis's conception Hagar is shown standing with her hands clasped in gratitude for her rescue, an overturned water pitcher at her foot. Her hair is swept back, and her tunic is pressed against her as if from a rush of wind from the angel's wings, while her eyes seem to gaze into the distance, as if she were seeing a vision. The bravery suggested by her erect stance and the touching simplicity of her gesture make this one of the most moving works of American Neoclassicism.

Painting the American Scene

Although many American painters, like the architects and sculptors, looked to Europe for their inspiration in the early nineteenth century, others found everything they needed in their native landscape and took pride in the American scene. These artists tended to paint their subjects with a detailed realism combined with an idyllic aura that suggested peace and limitless abundance.

Before the advent of photography, artists played an important role in the development of knowledge about the natural world. John James Audubon (1785–1851) set out to make accurate drawings of the birds of America, reproduce them in prints, and publish hand-colored impressions of them in portfolios. Audubon had come from his native Saint-Domingue (Haiti) at age seventeen to oversee family property near Philadelphia, but he was a poor manager and decided about 1822 to work on a bird encyclopedia, for which he solicited subscriptions from patrons in advance. Traveling and sketching from Florida to Labrador and southwest to Texas, he completed 435 bird studies in detailed watercolors. Audubon combined close observation with an artist's eye for design to convey, often whimsically and a bit dramatically, the birds' natural habitats. In his *Common Grackle* (fig. 26-67), these beautiful and fearless birds are shown assaulting ears of corn.

George Catlin (1796–1872) was one of the first artists to travel west of the Mississippi in search of Native American subjects for his paintings. A lawyer and self-taught artist, Catlin was working as a portrait painter in Philadelphia when a delegation of Western Native American chiefs visited the city. Inspired by their visit, Catlin in 1832 traveled to the West and lived with forty-eight different Native American groups. In 1839 he brought East an "Indian Gallery," consisting of 200 scenes of Native American village life and hunting forays, 310 portraits of chiefs, and a collection of Native American art and artifacts.

Among the striking portraits was that of *Buffalo Bull's Back Fat, Head Chief, Blood Tribe* (fig. 26-68). The title is Catlin's translation of this Blackfoot chief's name, which

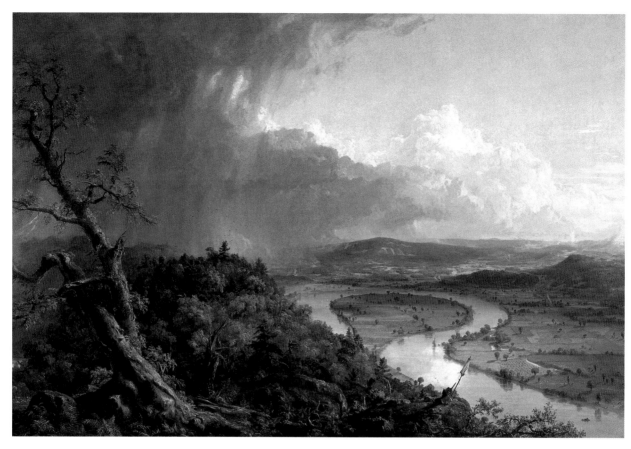

26-69. Thomas Cole. *The Oxbow*. 1836. Oil on canvas, 4'3½" x 6'4" (1.31 x 1.94 m). The Metropolitan Museum of Art, New York
Gift of Mrs. Russell Sage, 1908 (08.228)

refers to the hump of fat on a male buffalo's back. Catlin described in his notes how the man's deerskin costume was made and decorated. The seams on the sleeves were covered from shoulder to wrist with decorations in porcupine quills and a fringe of black human hair taken from the heads of Back Fat's opponents in battle. The pipe, made by the chief himself, had a carved red-stone bowl and a long stem wrapped with braided porcupine quills. Through lectures, articles, and the exhibition of the Indian Gallery, Catlin attempted to educate the public about the dignity, beauty, and independence of the Native American peoples. When the U.S. government refused to set up a museum for his collections, Catlin took them on tour to England and France.

The French poet Charles Baudelaire admired Catlin's Native American portraits, and the French painter Rosa Bonheur made a pencil-and-watercolor copy after *Back Fat*. In 1841 Catlin's *Letters and Notes on the Manners, Customs, and Conditions of the North American Indians,* with 300 illustrations, was published in London, and in 1845, the artist issued a suite of twenty-five hand-colored **lithographs** (prints made from impressions produced by a flat stone) with accompanying texts, called Catlin's North American Indian Portfolio. Other artists painted Romantic scenes of exotic and entirely imaginary Native American subjects, but Catlin's work was distinguished by its great realism and authenticity and is still an invaluable anthropological source.

Thomas Cole (1801–1848), called in his own time the father of American landscape painting, emigrated from England at age seventeen. He began in 1820 to work as an itinerant **limner**, or portrait painter, walking through the countryside with his paints and brushes on his back, finding commissions where he could. His real interest, however, was sketching and painting the landscape. He arrived in New York City in 1825 and placed three of his landscapes of the Catskill Mountains in the window of a framer's shop. The paintings soon drew the attention of several influential New Yorkers, who purchased Cole's paintings. With his career under way, Cole found a patron to finance a trip to Europe from 1829 to 1831. In England Cole was impressed by Turner's early landscapes but not by his later, more abstract ones. In Italy he admired the work of Raphael and other Renaissance painters, and he was also profoundly affected by the ruins of classical antiquity, which he viewed as a vast and tragic symbol of the transience of human life and achievements. Such sights later inspired his series The Course of the Empire (1833–1837?), in which he traced the same landscape view from its primeval state to its architectural peak under the Roman Empire to its final state of desolation. Cole took occasional breaks from his work on the Course to go on sketching trips, one of which resulted in a painting now called *The Oxbow* (fig. 26-69). When it was first

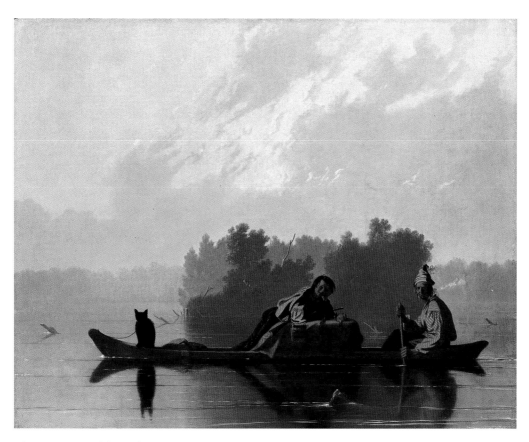

26-70. George Caleb Bingham. *Fur Traders Descending the Missouri*. c. 1845. Oil on canvas, 29 x 36"
(73.7 x 91.4 cm). The Metropolitan Museum of Art, New York
Morris K. Jesup Fund, 1933 (33.61)

exhibited, in 1836, it was identified as a spectacular bend in the Connecticut River. To Cole ancient geological formations such as this constituted America's "antiquities," which he already recognized as being threatened with destruction by urbanization and industrial development. But even Cole, who still roamed on foot in search of picturesque landscape views, found the train the most convenient way to get from New York to his favorite haunts in the Catskills. His stirring landscapes of the immense Hudson River valley were the first of a tradition of painting that came to be known as the Hudson River School. Just as Catlin recorded the daily lives of the vanishing Native Americans, in such paintings as *The Oxbow* Cole commemorated the moment when the wilderness was giving way to cultivated fields and cattle.

George Caleb Bingham (1811–1879), the first major painter to live and work west of the Mississippi River, like Cole began his career as an itinerant portrait painter. He also sketched and painted scenes of everyday life along the river and eventually abandoned portrait painting. In 1838 he went to New York, where he exhibited his work at the new National Academy of Design.

With his *Fur Traders Descending the Missouri* (fig. 26-70), painted in about 1845, Bingham began an association with the newly formed American Art-Union in New York. As a way to promote American painters, the union purchased works for a flat fee, then reproduced prints to be sold by subscription. A lottery was held for the paintings themselves, which allowed people of modest means to own original works of art. *Fur Traders Descending the Missouri*, which Bingham sold to the union for $25, is an idyllic scene of a French trapper and his son with their pet bear cub and cat in a dugout canoe, gliding through the early morning stillness with only faint ripples on the water marking their passage. The still-hidden sun tinges the clouds with rosy gold, and morning mists shroud the river landscape in mystery. Despite the overt peacefulness of the scene, there is an underlying ominousness. Branches and rocks sticking up out of the water are reminders of the everyday hazards river boaters faced, and the mysterious black shape of the chained bear mirrored in the glassy water surface produces an eerie effect reminiscent of the demon in Fuseli's *The Nightmare* (see fig. 26-25). Later in life, Bingham became heavily involved in local politics and drew subjects for his paintings from that experience.

The same forces that brought about the Neoclassic and Romantic movements also helped bring them to an end: the spirit of inquiry that subjected so much of traditional life and culture to rational analysis; the desire to edify humanity and to improve the world; and growing out of these, a new sense of the value of the individual. These impulses, coupled with the turbulent history of revolution in America and Europe in the late eighteenth and early nineteenth centuries, gave birth to the modern age.

1820 1830 1840 1850

Courbet
The Stone Breakers
1849

Paxton
Crystal Palace
London
1850–51

CHAPTER 27

Realism to Impressionism in Europe and the United States

1860	1870	1880	1890

Church
Niagara
1857

Nadar. *Portrait of Charles Baudelaire*
1863

Carpeaux
The Dance
1867–68

Rossetti
La Pia de' Tolomei
1868–69

Monet
Rouen Cathedral
1894

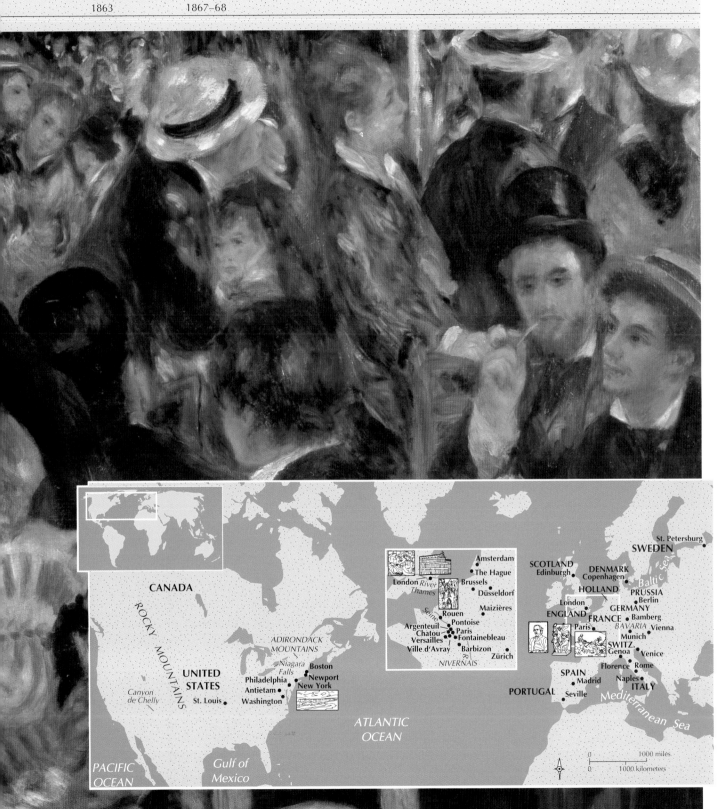

CANADA

ROCKY MOUNTAINS

UNITED STATES

ADIRONDACK MOUNTAINS

Niagara Falls

Boston
Newport
New York

Philadelphia
Antietam

Washington

St. Louis

Canyon de Chelly

PACIFIC OCEAN

Gulf of Mexico

ATLANTIC OCEAN

Amsterdam
The Hague
Brussels
Düsseldorf
Maizières
Rouen
Pontoise
Argenteuil
Paris
Chatou
Fontainebleau
Versailles
Ville d'Avray
Barbizon
Zürich
NIVERNAIS

London
River Thames
Seine

SCOTLAND
Edinburgh

DENMARK
Copenhagen

Baltic Sea

SWEDEN

St. Petersburg

HOLLAND

PRUSSIA
Berlin

ENGLAND
London

GERMANY
FRANCE
Paris

BAVARIA
Bamberg
Vienna
Munich

SWITZ.
Genoa
Venice
Florence
Rome
Naples

SPAIN
Madrid

PORTUGAL
Seville

ITALY

Mediterranean Sea

0 1000 miles
0 1000 kilometers

27-1. Sir Joseph Paxton. Crystal Palace, London. 1850–51. Iron and glass. Lithograph, The Mansell Collection, London

Early in 1850, a British royal commission announced a design competition for a massive temporary edifice to house the London Great Exhibition, a showcase of advances in industry and technology, which Queen Victoria and her husband, Prince Albert, wanted to open the following year in London's Hyde Park. By June it was evident that none of the 245 entries could possibly be completed in time. Ten days before the commission was to submit its own plan for a domed brick shed—which would also have required additional time—one of the commissioners met Joseph Paxton, a professional gardener who had recently designed a number of impressive greenhouses. Paxton agreed to submit a design, scale drawings, and cost sheet for an exhibition hall that was, in effect, a greatly enlarged greenhouse.

The commissioners, relieved but unenthusiastic, accepted his plan, and the structure was completed in the extraordinarily brief span of just over six months (fig. 27-1). The triple-tiered edifice, dubbed a "crystal palace" by a journalist for a humor magazine, was the largest space ever enclosed up to that time—1,848 feet long, covering more than 18 acres, and providing for almost a million square feet of exhibition space. The central vaulted transept—based on the new railway stations and, like them, meant to echo imperial Roman architecture—rose 108 feet to accommodate a row of elms dear to Prince Albert.

Although everyone agreed that the Crystal Palace was a technological marvel, most architects and critics did not consider it to be legitimate architecture. Some observers, however, were more forward-looking. One visitor called it "a revolution in architecture from which a new style will date." And indeed it was an expression of the positivism that would dominate this period.

THE POSITIVIST AGE

The second half of the nineteenth century has been called the positivist age, an age of faith in the positive consequences of what can be achieved through the close observation of the natural and human realms. The term *positivism* was used by the French philosopher Auguste Comte (1798–1857) during the 1830s to describe what he saw as the final stage in the development of philosophy, in which all knowledge would derive from science and scientific methods. One of the founders of sociology, Comte intended to bring to the study of human society the same scientific rigor that was advancing fields like physics, biology, astronomy, and chemistry. Comte's faith that science and its objective methods could solve all human problems was not novel; the idea of human progress had been gradually maturing since its first tentative expression by the Enlightenment thinkers of the late eighteenth century. Comte's achievement was to clarify this idea and give it a name. In the second half of the century, the term *positivism* came to be applied widely to any expression of the new emphasis on objectivity.

In the visual arts the positivist spirit is most obvious, perhaps, in the widespread rejection of Romantic subjectivism and imagination in favor of the accurate and apparently objective description of the ordinary, observable world, a change especially evident in painting. Although some historians, for quite valid reasons, call this new emphasis on descriptive accuracy naturalism, we employ the term *realism* because this was the label used around 1850 by the artists and critics who pioneered the development (see "Realist Criticism," page 994).

Positivist thinking is evident not simply in the growth of realism but also in the full range of artistic developments of the period after 1850—from the highly descriptive style of academic art, with its realistic figures and elements, to the Impressionist emphasis on the phenomenon of light; and from the development of photography to the application of new technologies in architecture.

■■■■■■■■
1820 1890

PARALLELS

Years	Events
1820–1829	Beethoven's Ninth Symphony (Germany); Niépce makes first positive-image photographs (France); Audubon's *The Birds of America* (United States)
1830–1839	Slavery abolished in British Empire; Hokusai's *Hundred Views of Mount Fuji* (Japan); Cole's *The Oxbow* (United States); Houses of Parliament redesigned (England); first daguerreotype made (France)
1840–1849	Talbot publishes first book illustrated with photographs (England); Labrouste's Bibliothèque Sainte-Geneviève (France); Marx and Engels's book *Communist Manifesto* (Germany); revolt in Paris establishes French Second Republic; Pre-Raphaelite Brotherhood established in England; Seneca Falls Women's Rights Convention (United States); Courbet's *The Stone Breakers* (France)
1850–1859	Paxton's Crystal Palace (England); Stowe's novel *Uncle Tom's Cabin* (United States); Melville's novel *Moby-Dick* (United States); Napoleon III emperor of France; South African Republic established; Thoreau's book *Walden* (United States); Whitman's poetry collection *Leaves of Grass* (United States); Millet's *The Gleaners* (France); Flaubert's novel *Madame Bovary* (France); Darwin's book *Origin of Species* (England); Dickens's novel *A Tale of Two Cities* (England); Italy is united
1860–1869	Civil War (United States); serfdom abolished in Russia; Hugo's novel *Les Misérables* (France); Manet's *Le Déjeuner sur l'Herbe* (France); Tolstoy's novel *War and Peace* (Russia); Dostoyevsky's novel *Crime and Punishment* (Russia); Brooklyn Bridge begun (United States); Dominion of Canada is formed; Meiji Restoration of emperor (Japan); revolution in Spain; first transcontinental railroad in United States
1870–1879	Franco-Prussian War; Third Republic in France; first Impressionist art exhibition (France); Tchaikovsky's Piano Concerto No. 1 (Russia); Renoir's *Moulin de la Galette* (France); Alexander Graham Bell patents telephone (United States); William Morris promotes Arts and Crafts Movement (England); Muybridge's *Galloping Horse* (United States); Edison invents phonograph and electric lightbulb (United States)
1880–1890	Major European colonization of Africa begins; Hertz discovers and produces radio waves (Germany); Eastman's box camera (United States)

27-2. John Augustus Roebling and Washington Augustus Roebling. Brooklyn Bridge, New York. 1867–83

27-3. Henri Labrouste. Reading Room, Bibliothèque Sainte-Geneviève, Paris. 1843–50

TECHNOLOGICAL PROGRESS

The positivist faith that technological progress was the key to human progress spawned a long succession of world's fairs devoted to advances in industry and technology. The first of these fairs, the London Great Exhibition of 1851, introduced new building techniques that ultimately contributed to the abandonment in the twentieth century of **historicism**—the use of historically based styles—in architecture. The revolutionary modular construction of the Crystal Palace (see fig. 27-1), created for the London Great Exhibition by Joseph Paxton (1801–1865), featured a structural skeleton of cast iron that held iron-framed glass panes measuring 49 by 30 inches, the largest size that could then be mass-produced. Prefabricated wooden ribs and bars supported the panes.

Engineering

Bridge designers had pioneered the use of cast iron as a building material—the first cast-iron bridge had been erected in England in 1776–1779 (see "Iron as a Building Material," page 943)—as well as the use of wrought iron and then steel, the results of new refining processes. The most famous early steel bridge, the Brooklyn Bridge (fig. 27-2), was constructed between 1869 and 1883 to link the burgeoning borough of Manhattan in New York City to the growing city of Brooklyn (which eventually became another borough of New York City). The designer, John Augustus Roebling (1806–1869), a German-born civil engineer, had written his university thesis on the suspension bridge at Bamberg, Germany, one of the first built in Europe. In 1841, ten years after emigrating to the United States, he invented twisted-wire cable, a considerable structural advance over the wrought-iron chains then being used for suspension bridges. In 1867, after designing and supervising the construction of a number of innovative suspension bridges in the eastern United States, Roebling was appointed chief engineer for the long-proposed Brooklyn–Manhattan bridge, whose main span

would be the longest in the world at that time. He died in 1869 of complications from a work-related accident just as construction was to begin, and the project was completed by his engineer son, Washington Augustus Roebling (1837–1926), who had assisted his father in earlier projects.

The bridge roadbed, nearly 6,000 feet long, hangs beneath a web of stabilizing and supporting steel-wire cables (the heaviest of which is 16 inches in diameter) suspended from two massive masonry towers that rise 276 feet above the water. The roadbed and cables are purely functional, with no decorative adornment, but the granite towers feature projecting cornices over pointed-arch roadbed openings. These historicist elements allude both to Gothic cathedrals and to Roman triumphal arches. Rather than military victories, however, Roebling's arches celebrate the triumphs of modern engineers while paying homage to those of their ancient Roman forebears.

Architecture

A less religious attitude toward technological progress can be seen in the first attempt to incorporate structural iron into architecture proper, the Bibliothèque Sainte-Geneviève (fig. 27-3), a library in Paris designed by Henri Labrouste (1801–1875). Conventionally trained at the École des Beaux-Arts and employed as one of its professors, Labrouste was something of a radical in his desire to reconcile the École's conservative design principles with the technological innovations being developed by industrial engineers. Apparently reluctant to promote this goal in his teaching, he clearly pursued it in his practice.

Because of the Bibliothèque Sainte-Geneviève's educational function, Labrouste wanted the building to suggest the course of both learning and technology. The window arches on the exterior have panels with the names of 810 important contributors to Western thought from its religious origins to the positivist present, arranged chronologically from Moses to the Swedish chemist Jöns Jacob Berzelius. The exterior's stripped-down Renaissance

style reflects the belief that the modern era of learning dates from that period. The move from outside to inside subtly outlines the general evolution of architectural techniques. The exterior of the library features the most ancient of permanent building materials, cut stone, which was then considered the only "noble" construction material, that is, suitable for a serious building. The columns in the entrance hall are solid masonry with cast-iron decorative elements. In the main reading room, however, cast iron plays a structural role. Slender iron columns—cast to resemble the most ornamental Roman **order**, the Corinthian—support two parallel **barrel vaults**. The columns are set on tall concrete pedestals, reminding the attentive viewer that modern construction technology rests on the accomplishments of the Romans, who developed concrete. The design of the delicate floral cast-iron **ribs** in the vaults is borrowed from the Renaissance architectural vocabulary.

Academic architects more typically used iron only as an internal support for conventional materials, as is the case with the Opéra, the Paris opera house (fig. 27-4), designed by Charles Garnier (1825–1898) and built as part of the transformation of Paris begun in the 1850s by Napoleon Bonaparte's nephew, Napoleon III. Elected president of the Second Republic in 1848 and declared emperor in 1852, Napoleon III ruled France until 1870. He inaugurated a controversial program to modernize Paris and promote greater prosperity for its upper and middle classes. The plan, drawn up by Georges-Eugène Haussmann (1809–1891)—who was given the title of baron in 1857 for his administrative work in transforming Paris—included new sewer and water systems, improved railroad lines, parks, and a network of straight, wide boulevards to facilitate business, the flow of traffic, and military action against any threatened insurrections. The Opéra was to be a focal point, located at the intersection of several major boulevards in a chic section of downtown Paris full of banks, businesses, and the new department stores for which the city became famous.

Garnier was a graduate of the École des Beaux-Arts and one of the architects helping Baron Haussmann realize his plans for Paris. Garnier's design for the Opéra was selected in a competition announced in 1860 for a new building to replace the city's dilapidated existing opera house. He won the competition despite the Empress Eugénie's objection that his proposal fitted no recognizable style. To her charge that it was "neither Louis XIV, nor Louis XV, nor Louis XVI," Garnier retorted, "It is Napoleon III." The massive facade, featuring a row of paired columns above an **arcade**, is essentially a heavily ornamented, Baroque version of the Louvre (see fig. 19-22), an association meant to suggest the continuity of French greatness and to flatter Emperor Napoleon III by comparing him favorably with King Louis XIV. The luxuriant treatment of form, in conjunction with the building's primary function as a place of entertainment, was intended to celebrate the devotion to wealth and pleasure that characterized Napoleon III's reign. The ornate architectural style is also appropriate for the most elaborate of all musical forms, the opera.

27-4. Charles Garnier. The Opéra, Paris. 1861–74

27-5. Charles Garnier. Grand staircase, the Opéra

The inside of what some critics called the "temple of pleasure" (fig. 27-5) was even more opulent, with its neo-Baroque sculptural groupings, heavy, gilded decoration, and lavish mix of expensive, **polychromed** materials. The highlight of the interior was not the spectacle on stage so much as that on the great, sweeping Baroque staircase where the various members of the Paris elite—

27-6. Jean-Baptiste Carpeaux. *The Dance*. 1867–68. Plaster, height c. 15' (7.1 m). Musée de l'Opéra, Paris

from old nobility to newly wealthy industrialists—could display themselves, the men in black tailcoats accompanying women in bustles and long trains. As Garnier himself said, the purpose of the Opéra was to fulfill the most basic of human desires: to hear, to see, and to be seen.

FRENCH ACADEMIC ART One of the large sculptural groups on the entranceway of the Opéra is *The Dance* (fig. 27-6) by Jean-Baptiste Carpeaux (1827–1875). Carpeaux, who had studied at the École des Beaux-Arts under the Romantic sculptor François Rude (see fig. 26-48), had previously worked in both Romantic and Rococo styles. Dramatic and somber themes, however, were considered inappropriate to the new atmosphere of the capital, and in the years after about 1850 there was a marked decline in Romantic themes in French art and literature. Carpeaux's sculptural subjects, drawn from the eighteenth century, were better suited to the new taste for lighthearted pleasure. In *The Dance* a winged personification of Dance, a slender male carrying a tambourine, leaps up joyfully in the midst of a compact, entwined group of mostly nude female dancers, reflecting the theme of uninhibited Dionysian revelry. When the group was unveiled in 1869, it

was criticized as indecent, and it almost was removed—not because of the general theme or the nudity of any of the figures or even the presence of a satyr, a mythological creature known for its lascivious appetites, which is discreetly hidden behind the women, but because the figures seemed so shockingly lifelike. To Parisians used to smooth, generalized nudes, Carpeaux's figures appeared simply naked.

Ironically, the basis of Carpeaux's treatment can be found in the time-honored practices of academic teaching. Students at the Academy began their training in figure drawing by copying two-dimensional pictures of Classical and Renaissance sculpture. Later, after drawing from plaster casts of such sculpture, they were finally allowed to study live models, both men and women posed like Classical sculpture. The emphasis in this last phase was on exact delineation; every individual nuance of knee, hand, and face was rendered with extreme care. The point was to develop technical skill and knowledge of the human form. When artists finally began making actual paintings, they were expected to recall their earlier immersion in Classical art and "correct"—generalize—ordinary nature according to its higher ideal. Until the reign of Napoleon III, they had largely done so.

Carpeaux's unwillingness to idealize physical details was symptomatic of a major shift in French academic art in the second half of the nineteenth century. Although the influence of photography on the taste of the period has sometimes been cited as the probable cause of this change, both photography and the new exactitude in academic art were simply manifestations of the increasingly positivist values of the era. These values were particularly evident among the bankers and businesspeople who came to dominate French society and politics in the years after 1830. As patrons, these practical leaders of commerce were generally less interested in art that idealized than in art that brought the ideal down to earth.

The effect of this new taste on academic art is nowhere more evident than in the case of Adolphe-William Bouguereau (1825–1905), who became one of the richest and most powerful painters in France in the late nineteenth century by catering to bourgeois taste. At the beginning of his career, in the middle to late 1850s, Bouguereau specialized in Romantic themes of death and suffering. By the early 1860s, however, he realized that these themes were not compatible with period taste. He later explained: "I soon found that the horrible, the frenzied, the heroic does not pay, and as the public of today prefers Venuses and Cupids and I paint to please the public, it is to Venus and Cupid I chiefly devote myself" (cited in Zafran, page 55).

Bouguereau gave the public not only the subjects it wanted but also the factual detail it loved. In *Nymphs and a Satyr* (fig. 27-7), for example, four young and voluptuous wood nymphs attempt to drag a reluctant satyr into the water. The slight smile on his face and the lack of real struggle on his part suggest that this is good-natured teasing. The painting's power depends less on the subject than on the way Bouguereau was able to make it seem palpable and "real" for the spectator through a

27-7. Adolphe-William Bouguereau. *Nymphs and a Satyr.*
1873. Oil on canvas, 9'3⅜" x 5'10⅞" (2.6 x 1.8 m).
Sterling and Francine Clark Art Institute,
Williamstown, Massachusetts

heightened depiction of texture and appearance. In order
to produce a persuasive satyr Bouguereau made careful
anatomical studies of horses' ears and of the hindquar-
ters of goats. Bouguereau makes the scene not only real
but accessible. The figure on the right appears to back
toward the viewer, so the viewer's world and the world
of the painting seem continuous. The viewer is invited to
step in and join the figures in their romp.

A positivist taste for descriptive accuracy is also
evident in the academic history painting of the period.
In *Death of Caesar* (fig. 27-8), for example, Jean-Léon
Gérôme (1824–1904) attempted an objective and arche-
ologically correct re-creation of the event. In order to
avoid Romantic emotionalism Gérôme chose to depict
not the moment of the assassination but instead the sud-
den calm that follows as the conspirators rush out to
announce their action to the city. Gérôme wanted us to
observe a historical event as it might have occurred, not
to identify with its protagonists. To this end he combined
an impeccably descriptive style with a reporter's concern
for the facts. He carefully researched the building where
Caesar died, the Theater of Pompey, in order to situate it

27-8. Jean-Léon Gérôme. *Death of Caesar.* 1859. Oil on canvas, 33⅝ x 57¼" (86.2 x 146.8 cm). Walters Art Gallery, Baltimore
Gérôme was one of the leading antagonists of innovative art forms. As a member of the Salon jury during the last four
decades of the nineteenth century, he skillfully opposed the acceptance of much of the new art, especially that of the
Impressionists, which he considered "the disgrace of French art." In 1884 he fought the installation of the Manet memo-
rial exhibition at the École, and in 1895–1897 he led the fight against the acceptance by the government of an important
bequest of Impressionist works.

27-9. Louis-Ernest Barrias. *The First Funeral*. 1878–83. Marble, height 7'11" (2.4 m). Musée du Petit Palais, Paris

27-10. Gustave Moreau. *Oedipus and the Sphinx*. 1864. Oil on canvas, 6'9¹/4" x 3'5¹/4" (2.1 x 1.1 m). The Metropolitan Museum of Art, New York
Bequest of William H. Herriman

properly. From historical accounts he learned that the conspirators gave Caesar a petition scroll to distract him, that he knocked over a chair during the assassination, and that he struggled to the base of the statue of Pompey, which he grasped with his bloodied hands before succumbing. All this is reflected in Gérôme's painting. In applying the lessons of realism to history painting Gérôme was completing a shift of emphasis well under way in the work of certain academic artists of the second quarter of the century, men such as his own teacher, Paul Delaroche (1797–1856), who began to think of history more as a set of objective facts than as something from which to learn moral lessons. Jacques-Louis David, too, had sought archeological accuracy, for example in *Oath of the Horatii* (see fig. 26-38), but not as an end in itself.

Moral lessons continued to be contained in much academic art of the period, but they were more implicit than explicit, more a matter of confirming existing social attitudes than of improving them. *The First Funeral*, by Louis-Ernest Barrias (1841–1905), is indicative of this trend (fig. 27-9). A marble version of a plaster model that won Barrias a medal of honor at the **Paris Salon** of 1878, this statue shows a grieving Adam and Eve burying their son Abel after he had been killed by his jealous brother Cain. There is no mention of such a funeral in the Bible;

the scene is based instead on medieval biblical commentaries that claimed Adam and Eve grieved for a hundred years. The work is typical of much academic art of the period in the way it combines sentimentality and a conservative social message. The idealized body of Eve, who is usually presented in academic sculpture of the period as a fallen seducer, here bends gently and sadly over her lifeless son, her tender feeling evoking and foreshadowing the Virgin Mary's grief over the death of Jesus. Looking down on the scene is Adam, whose muscular body is to be taken as an outward sign of his greater emotional containment. Like David in *Oath of the Horatii*, Barrias contrasts female "emotionalism" with male stoic "rationalism," thereby reinforcing gender stereotypes of the late nineteenth century.

The works of Gustave Moreau (1826–1898) also

depict men as rational and self-controlled. Nineteenth-century academic art came to be deprecated in the twentieth century, but Moreau's reputation endured, partly because of his interest in probing the nature of the relations between men and women. Unlike Bouguereau, he did not abandon Romantic themes to appeal to popular taste. His early work was influenced by Delacroix. About 1860 he became preoccupied with a dramatic theme that would also concern many other late-nineteenth- and early-twentieth-century artists and writers: the confrontation between a male hero and an alluring femme fatale determined to destroy him.

Moreau's first statement of this theme was *Oedipus and the Sphinx* (fig. 27-10), which he produced for the Salon of 1864. The painting's subject, taken from ancient Greek mythology, had been popular among Romantics and other academics. It involves an episode in the tragic life of Oedipus in which he saves the city of Thebes from the tyranny of the sphinx, a winged creature that was part lion, part woman. The sphinx required a yearly human sacrifice from the city and would leave only when someone correctly answered her riddle: What walks on four legs in the morning, two at noon, and three in the evening? She killed anyone who gave a wrong answer, as was the fate of those whose grisly remains lie in the foreground of Moreau's painting. Oedipus, however, gives the correct answer, which is "man," who crawls in infancy (morning), walks on two legs as an adult (noon), and walks with a stick in old age (evening). Earlier depictions of the story generally showed Oedipus at the decisive moment, giving the answer, but Moreau presents a calm and self-possessed hero determinedly staring down a transfixing woman-animal who looks up into his eyes. Unlike the original myth, which celebrates the victory of human rationality over the irrational forces of nature, Moreau emphasizes instead what he sees as a gendered conflict: in his notes on the painting Moreau said it pitted moral idealism against sensual desire.

EARLY PHOTOGRAPHY

Another expression of the new, positivist interest in descriptive accuracy—one that had a profound impact on the arts—was the development of photography. Photography as we know it emerged around 1850, but since the late Renaissance, artists and others had been seeking a mechanical method for exactly recording or rendering a scene. One device that emerged for this purpose was the **camera obscura** (Latin for "dark chamber"), which consists of a darkened room or box with a lens on one side. Light passes through the lens, projecting an exact image of the outside scene on the opposite wall or side. An artist can trace the image, and in the sixteenth century several artists and theoreticians offered practical advice on how to use the camera obscura to do so. By the eighteenth century a small, portable camera obscura, or camera, had become standard equipment for many landscape painters in particular. Photography developed essentially as a way to fix, that is, to make permanent, the images produced by a camera obscura on light-sensitive material.

The first to make a permanent picture by the action of light was Joseph-Nicéphore Niépce (1765–1833), one of the many "gentlemen inventors" in the West in the eighteenth and early nineteenth centuries. In 1796 he and his brother Claude tried unsuccessfully to record camera images on chemically treated surfaces. About twenty years later Joseph resumed those experiments in an attempt to find an easier and less cumbersome substitute for another recently invented reproductive process, **lithography** (see "Lithography," below). His success in copying translucent **engravings** by attaching them to pewter plates covered with a kind of light-sensitive asphalt used by etchers led Niépce to try this substance in the camera. Using metal and glass plates covered with this substance, called bitumen, he succeeded around 1826 in making the first positive-image photographs of views from a window of his estate at

TECHNIQUE

LITHOGRAPHY

Aloys Senefelder invented **lithography** in Bavaria, Germany, in 1796 and registered for an exclusive right to the process the following year. Lithography is a planographic process—that is, the printing is done from a flat surface. It was the first wholly new printing process to be introduced since the fifteenth century, when the **intaglio**, or **incising**, process was developed. Lithography, still popular today, is based on the natural antagonism between oil and water. The artist draws on a flat surface—traditionally, fine-grained stone—with a greasy, crayonlike instrument. The stone's surface is wiped with water, then with an oil-based ink. The ink adheres to the greasy but not to the damp areas. A sheet of paper is laid face down on the inked stone, which is passed through a flatbed press. A scraper applies light pressure from above as the stone and paper pass under it, transferring ink from stone to paper, thus making lith-ography a direct method of creating a printed image. Francisco Goya, Honoré Daumier, and Henri de Toulouse-Lautrec exploited the medium to great effect.

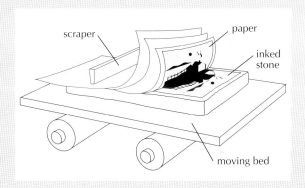

27-11. Joseph-Nicéphore Niépce. *View from His Window at Le Gras*. 1826. Heliograph, 6½ x 7⅞" (17 x 20 cm). Gernsheim Collection, University of Texas, Austin

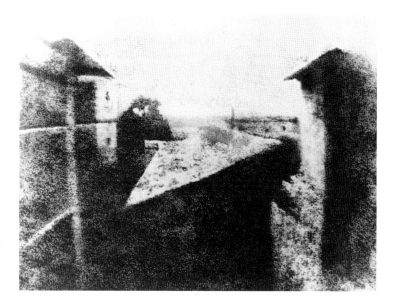

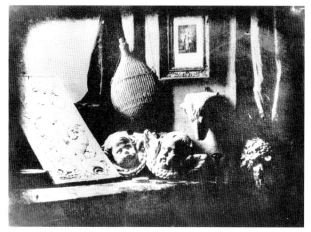

27-12. Louis-Jacques-Mandé Daguerre. *The Artist's Studio*. 1837. Daguerreotype, 6½ x 8½" (16.5 x 21.6 cm). Société Française de Photographie, Paris

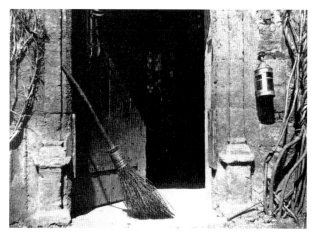

27-13. William Henry Fox Talbot. *The Open Door*. 1843. Salt-paper print from a calotype negative. Science Museum, London
Fox Talbot Collection

Le Gras, France. Only one of his **heliographs** (or "sun drawings") survives (fig. 27-11). This view of the outbuildings on Niépce's estate required an exposure of about eight hours, which explains why sunlight is evident on the inside portions of the taller buildings on both left and right. The image was fixed simply by cleaning the asphalt from the plate after exposure.

While seeking financial help in the development of his discovery, Niépce met Louis-Jacques-Mandé Daguerre (1787–1851), a Parisian painter who was also experimenting in creating images for his **diorama** (a popular theater built for the display of huge, dramatically lit, illusionistic paintings on semitransparent fabric). Working with a lens maker, Daguerre had developed an improved camera. In 1829 Daguerre and Niépce formed a partnership. After Niépce's death in 1833, Daguerre continued their research using copper plates coated in iodized silver, long known to be light-sensitive. In 1835 he left one of the plates he had been working on in a cupboard. When he returned several days later, he was amazed to find an image on it. Through a process of elimination, he deter-

mined that the vapor of a few drops of spilled mercury from a broken thermometer had produced the effect. Thus Daguerre discovered that an exposure to light of only twenty to thirty minutes would produce a latent image on one of his silvered plates treated with iodine fumes, which could then be made visible through an after-process involving mercury vapor. By 1837 he had developed a method of fixing the image by bathing the plate in a strong solution of common salt after exposure.

The inventor's first such picture, or **daguerreotype**, was a still life of plaster casts, a wicker-covered bottle, a framed drawing, and a curtain (fig. 27-12). Through its subject the work makes the earliest claim for photography as an art form. Although many of the objects, including the bottle, seem to have been included for their textures, the drawing and sculpture identify the process with the realm of art. Specifically, Daguerre suggests that this is a naturalistic, not an expressive, art form. The work is a still life, considered by the Academy a legitimate form but a minor one because it was thought to involve the technical skills of a copyist more than the imaginative ones of a history

TECHNIQUE

HOW PHOTOGRAPHY WORKS

A camera is essentially a lightproof box with a hole, called an aperture, which is usually adjustable in size and which regulates the amount of light that strikes the film. The aperture is covered with a lens, which focuses the image on the film, and a shutter, a kind of door that opens for a controlled amount of time, to regulate the length of time that the film is exposed to light—usually a small fraction of a second. Modern cameras also have a viewer that permits the photographer to see virtually the same image that the film will "see."

Photography is based on the principle that certain substances are sensitive to light and react to light by changing **value**. In modern black-and-white photography, silver halide crystals (silver combined with iodine, chlorine, or other halogens) are suspended in a gelatin base to make an emulsion that coats the film (in early photography, before the invention of plastic, a glass plate was used with a variety of emulsions). The film is then exposed. Light reflected off objects enters the camera and strikes the film. Pale objects reflect more light than do dark ones. The silver in the emulsion collects most densely where it is exposed to the most light, producing a "negative" image on the film. Later, when the film is placed in a chemical bath (developed), the silver deposits turn black, as if tarnishing. The more light the film receives, the denser the black tone created.

A positive image is created from the negative in a darkroom: the film negative is placed over a sheet of paper that, like the film, has been treated to be light-sensitive, and light is directed through the negative onto the paper. Multiple positive prints may be made from a single negative.

Color photography works on much the same principle as black-and-white: a light-sensitive emulsion reacts to exposure by changing color. Most color film uses a complicated process based on color theory—the concept that three **primary colors** (red, yellow, and blue) can be combined to make up all the **hues** the eye sees. (Thus, the discovery of color theory that was so important to the Neo-Impressionists was of equal importance to the invention of color photography.) The resulting negative does not reverse black and white values, but "reverses" the primary colors to their **complements**. Originally, this meant that three separate emulsions on the film, each sensitive to a different primary color, had to be developed, using many chemicals, bleaches, and dyes in the darkroom. Other, later film processes simplified this function. Some color processes are now quite direct and mechanized; others require complex chemistry and much handwork in the darkroom.

painter. At the time, still life was most strongly identified with the work of the seventeenth-century Dutch naturalists, whom Daguerre here implies were his forebears in the search for verisimilitude. They, too, often used curtains to help display the objects they copied.

The 1839 announcement of Daguerre's invention prompted the English scientist William Henry Fox Talbot (1800–1877) to publish the results of his own work on what he called the **calotype** (from the Greek term for "beautiful image"). Talbot's process, even more than Daguerre's, became the basis of modern photography because, unlike Daguerre's, which produces a single, positive image, Talbot's calotype is a negative image from which an unlimited number of positives can be printed. In his book *The Pencil of Nature* (issued in six parts, 1844–1846), the first to be illustrated with photographs, Talbot describes the evolution of his process from the first experiments, in the mid-1830s, using paper impregnated with silver chloride. At first, engravings, pieces of lace, and leaves were copied in negative by laying them on this paper and exposing them to light. By the summer of 1835 he was using this chemically treated paper in both large and small cameras. Then, in 1840, he discovered, independently of Daguerre, that latent images resulting from exposure to the sun for short periods of time could be developed chemically. Applying the technique he had earlier used with engravings and leaves, he was able to make positive prints from the calotype negatives.

One of the calotypes hand-pasted into *The Pencil of Nature* was *The Open Door* (fig. 27-13). The subject, like many by Talbot, is rural. As with a number of his contemporaries, he seems to have been distressed by the growing industrialization of Britain. His photograph is a nostalgic evocation of an agrarian way of life that was fast disappearing. The viewer is invited into an old, time-worn cottage in whose doorway Talbot has placed a sturdy broom, the handle carefully positioned to parallel the shadows on the door. This is the kind of traditional, handcrafted broom that mass production was beginning to make obsolete, but the use of photography itself also suggests that something made by mechanical means could have a genuine value, comparable to that of the handmade. Talbot's "soliloquy of the broom," as his mother called it, gives evidence of his conviction that photography might offer a creative artistic outlet for those, like himself, without the manual talent to draw or paint.

The final step in the development of early photography was taken in 1851 by Frederick Scott Archer, a British sculptor and photographer, who was one of many in Western Europe trying to find a way to make silver nitrate adhere to glass. The result would be a glass negative, from which countless positive proofs could be made. Archer's solution was collodion, a combination of guncotton, ether, and alcohol used in medicinal bandages. He found that a mixture of collodion and silver nitrate, when wet, needed only a few seconds' exposure to light to create an image. Although the wet-collodion process was more cumbersome than earlier techniques, it quickly replaced them because of its greater speed and the sharper tonal subtleties it produced. Moreover, it was universally available because Archer, unlike Daguerre and Talbot, generously refused to patent his invention. Thus the era of modern photography was launched (see "How Photography Works," above).

27-14. Oscar Rejlander. *The Two Paths of Life.* 1857. Combination albumen print, 16 x 31" (41 x 79.5 cm). The Royal Photographic Society, London

Once a practical photographic process had been invented, the question became how to use it. Those in the sciences agreed on its value for recording data, but artists were less certain how to take advantage of it. For some, like Delacroix, who occasionally worked from photographs instead of a live model, it was a cost-saving convenience. A number of critics argued that it could popularize fine art by making cheap reproductions of famous works available to the masses. For the academic painter Delaroche, however, photography represented a serious threat. He responded to Daguerre's invention in 1839 by declaring, "From this moment, painting is dead!" Although some artists in the ensuing years may have continued to feel uneasy about photography, it was soon clear that it threatened only one kind of painting: portraiture (see fig. 2, page 17). And even there, it was used mostly as a cheap, democratic substitute for the brand of expensive, high-society portraiture that continued undiminished into the twentieth century. The real issue was whether photography, taken on its own terms, could be a new art form.

Among the first photographers to argue for its artistic legitimacy was Oscar Rejlander (1813–1875) of Sweden, who had studied painting and sculpture at the Academy in Rome. In 1841 Rejlander settled in England. He first took up photography in the early 1850s as an aid for painting but was soon attempting to create photographic equivalents of the painted and engraved moral allegories so popular in Britain since the time of Hogarth (see fig. 26-17). In 1857 he produced his most famous work, *The Two Paths of Life* (fig. 27-14), by combining thirty negatives. This allegory of good and evil, work and idleness, was loosely based on Raphael's *School of Athens* (see fig. 18-12). At the center an old sage ushers two young men into life. The serene youth on the right turns toward personifications of Religion, Charity, Industry, and other virtues, while his counterpart eagerly responds to the enticements of pleasure. The figures on the left Rejlander described as personifications of "Gambling, Wine, Licentiousness and other Vices, ending in Suicide, Insanity, and Death." In the lower center, with a drapery over her head, is the hopeful figure of "Repentance." Although Queen Victoria purchased a copy of *The Two Paths of Life* for her husband, it was not generally well received as art. One typical response was that "mechanical contrivances" could not produce works of "high art," a criticism that would continue to be raised against photography.

Another pioneer of photography as art was Julia Margaret Cameron (1815–1879), who received her first camera as a gift from her daughters when she was forty-eight. Cameron's work was more personal and less dependent on existing forms than Rejlander's. Although she did numerous portraits of her family and of strangers whose faces she found interesting, Cameron's principal subjects were the great men of British arts, letters, and sciences, many of whom had long been family friends.

Like all of Cameron's portraits, that of the famous British historian Thomas Carlyle is slightly out of focus (fig. 27-15). Cameron produced this blurred effect deliberately, consciously rejecting the sharp stylistic precision of popular portrait photography, which she felt accentuated the merely physical attributes and neglected a subject's inner character. By blurring the details she sought to call attention to the light that suffused her subjects—a metaphor for creative genius—and to their thoughtful, often inspired expressions. Carlyle's concentrated expression is so intense that the dramatic lighting of his hair, face, and beard almost seems to emanate from within. In her autobiography Cameron said: "When I have had such men before my camera my whole soul has endeavored to do its duty towards them in recording faithfully the greatness of the inner as well as the features of the outer man." This sense of picturing both what was seen and what was not seen accorded with her larger goals for photography.

With regard to her medium Cameron said: "My aspirations are to ennoble Photography and to secure for it the character and uses of High Art by combining the real and ideal." To this end, she showed her portraits at the major European photographic exhibitions of the period, which were many.

An even more ambitious conception of photography was pursued by the most famous French practitioner of the time, known as Nadar (1820–1910). Born Gaspard-Félix Tournachon, he began his career as a drama critic. After a variety of other jobs and enthusiasms he worked as a caricaturist. He became interested in photography in 1849 as a tool to help him with a project called the Panthéon-Nadar, a series of four lithographs that was to include the faces of all the well-known Parisians of the day. He quickly saw the documentary potential of the photograph and opened a portrait studio in 1853. His thriving studio, which at one point had twenty-six employees, became a meeting place for many of the great intellectuals and artists of the period. The first exhibition of Impressionist art was held there in 1874.

Nadar was a realist in the tradition inaugurated by Daguerre. He embraced photography because of its ability to record people and their surroundings exactly. As part of a heroic effort to produce a comprehensive and factual portrait of his era, in 1858 he took successful aerial photographs of Paris, the first of their kind, from a hot-air balloon. In 1863 he built a balloon called *The Giant* that could carry about fifty passengers and was equipped with a darkroom. At the other extreme he made numerous photographs of the catacombs and sewers of Paris. He also produced a series on typical Parisians. Finally, Nadar attempted to photograph all the leading figures of French culture, among them the poet Charles Baudelaire (fig. 27-16). As can be seen in the portrait of Baudelaire, Nadar eschewed the use of props and avoided formal poses in favor of informal ones determined, like their facial expressions, by the sitters themselves. His goal was not so much an interpretation as a factual record of a sitter's characteristic appearance and demeanor. The drawn expression on Baudelaire's face, for example, tells much about him. The year this photograph was taken, 1863, Baudelaire published "The Painter of Modern Life," a newspaper article in which he called on artists to provide an accurate and insightful portrait of the times. The idea may have come from Nadar, who had been trying to do just that for some time.

27-15. Julia Margaret Cameron. *Portrait of Thomas Carlyle.* 1863. Silver print, 10 x 8" (25.4 x 20.3 cm). The Royal Photographic Society, London

27-16. Nadar. *Portrait of Charles Baudelaire.* 1863. Silver print.

Although Baudelaire never wrote about the photographic work of his friend Nadar, he was highly critical of the vogue for photography and of its influence on the visual arts. In his Salon review of 1859 he said: "The exclusive taste for the True . . . oppresses and stifles the taste of the Beautiful. . . . In matters of painting and sculpture, the present-day *Credo* of the sophisticated is this: 'I believe in Nature . . . I believe that Art is, and cannot be other than, the exact reproduction of Nature. . . .' A vengeful God has given ear to the prayers of this multitude. Daguerre is his Messiah."

SCHOOL, FOLLOWER OF, AND OTHER TERMS OF ATTRIBUTION

In art history the word *school* has several meanings. Artists whose work is related by period, **style**, and place are linked by the term *school,* as in "Barbizon School." *School of* is sometimes used for works that are not attributable to a known artist but that show strong stylistic similarities to him or her, for example, "school of Rubens." When a term such as *Sienese school* is used, it means that the work shows traits common in the art from Siena during the period being discussed. *Follower of* most often suggests a second-generation artist working in a variant style of the named artist. *Workshop of* is an attribution appropriate to the centuries when the guild system was in place in Europe and implies that a work was created by an artist or artists trained in the workshop of an established artist. *Attributed to,* like a question mark next to an artist's name, means that there is some uncertainty as to whether the work is by that artist.

FRENCH NATURALISM AND REALISM AND THEIR OUTGROWTHS

Realistic figure painting of the late nineteenth century shared with photography an allegiance to factual accuracy. The descriptive approach to scenes of daily life emerged in France out of the tradition of Romantic naturalism, which itself gained a new respectability and popularity after about 1850. The kind of work produced in the 1830s and 1840s by the Barbizon School—a group centered in the village of Barbizon on the edge of the Fontainebleau Forest, painting landscapes and rural scenes that academic jurors and conservative critics had attempted to bar from the Salons—was now embraced by the Parisian art world (see *"School, Follower of,* and Other Terms of Attribution," above). One reason for this critical shift was the radically changed conditions of Parisian life. Between 1831 and 1851 the city's population doubled, and thereafter Haussmann's renovations completed its transformation from a collection of small neighborhoods to a modern, crowded, noisy, and fast-paced metropolis. To those living in this new environment, the image of a peaceful and contented country life began to have increasing appeal.

Another factor in the new acceptance of rural landscapes, especially those featuring farm workers, was the widespread uneasiness over the political and social effects of the Revolution of 1848 and its aftermath. This revolution began in February of that year when Parisian workers overthrew the monarchy and established the Second Republic (1848–1851). Its founders' socialist goals, including collective ownership of means of production and distribution, were abandoned when conservative factions won elections that summer, and fear of further disruptions continued to trouble many. These people found solace in images of the seemingly unchanging and traditional life of the countryside.

One naturalist landscape painter who saw his reputation soar after 1850 was Jean-Baptiste-Camille Corot (1796–1875). Corot had been trained in the 1820s to accept the academic distinction between the heroic landscape—an idealized and carefully finished composite with a subject from the Bible or classical history—and the rural landscape, a direct record of an ordinary country scene. The heroic landscape, because it required learning and imagination as well as technical skill, was considered the higher and nobler of the two. Although Corot produced heroic landscapes for the Salons, like his younger friends the Barbizon painters he found the rural scenes more satisfying and congenial. After 1850 he began to enjoy critical and financial success with paintings of a dreamy subjectivity as well as more naturalistic works, such as *Sèvres-Brimborion, View toward Paris* (fig. 27-17).

Corot painted *Sèvres-Brimborion* in his Paris studio from studies he made in a small town southwest of Paris near Ville d'Avray, where he spent many of his summers. Throughout his career Corot liked to set viewers on such country roads, inviting them to follow in their imaginations the slow, peaceful pace of the other travelers, all of them enveloped in a haze of pleasant weather. The quiet mood is underscored by the harmony of browns, blues, and greens (achieved by mixing a little off-white with each color) and by the apparently casual application of the paint. The picture's slow tempo and emotional tranquillity offer a sharp contrast to city life, subtly suggested by the Paris skyline barely visible in the distance.

One of the most popular French painters to address the taste for rural landscapes was Rosa Bonheur (1822–1899). Her success in what was then a male domain owed much to the socialist convictions of her parents, who belonged to a radical utopian sect founded by the Comte de Saint-Simon, which believed not only in the equality of women but in a female Messiah. Of women Bonheur said in her *Reminiscences* (published posthumously in 1910): "I am persuaded that the future belongs to us." Her father, a drawing teacher, provided most of her artistic training.

Although she did a few Barbizon-like landscapes in the early 1840s, Bonheur was from the first dedicated to a realistic depiction of the farm animals she loved. This commitment to rural subjects was partly the result of her aversion to Paris, where she had been raised. To record farm animals accurately, she read zoology books and made detailed studies in the countryside and in slaughterhouses. Because these settings were rugged, she often wore men's clothing, for which she had to get police permission.

Although Bonheur received some critical praise for her animal portraits in the 1840s, her success dates from the Salon of 1848, where she showed eight paintings and won a first-class medal. As a result, the government commissioned a work from her, *Plowing in the Nivernais: The Dressing of the Vines* (fig. 27-18). This monumental painting features one of her favorite animals, the ox, engaged

27-17. Jean-Baptiste-Camille Corot. *Sèvres-Brimborion, View toward Paris*. 1864. Oil on canvas, 16¼ x 24½"
(41.3 x 61.6 cm). The George A. Lucas Collection of the Maryland Institute, College of Art, on extended loan to the
Baltimore Museum of Art

27-18. Rosa Bonheur. *Plowing in the Nivernais: The Dressing of the Vines*. 1849. Oil on canvas, 5'9" x 8'8" (1.8 x 2.6 m). Musée
d'Orsay, Paris

Bonheur was often compared with the writer George Sand, a contemporary woman who adopted a male name as well
as male dress. Sand devoted several of her novels to the humble life of farmers and peasants. Critics at the time noted
that *Plowing in the Nivernais* may have been inspired by a passage in Sand's *The Devil's Pond* (1846) that begins: "But
what caught my attention was a truly beautiful sight, a noble subject for a painter. At the far end of the flat ploughland,
a handsome young man was driving a magnificent team [of] oxen."

27-19. Jean-François Millet. *The Gleaners*. 1857. Oil on canvas, 33 x 44" (83.8 x 111.8 cm). Musée d'Orsay, Paris

27-20. Gustave Courbet. *The Stone Breakers*. 1849. Oil on canvas, 5'3" x 8'6" (1.6 x 2.6 m). Formerly Gemäldegalerie, Dresden. Present whereabouts unknown; possibly destroyed during World War II

in a time-honored rural activity. The powerful beasts, anonymous workers, and fertile soil offer a reassuring image of the continuity of agrarian life. The stately movement of people and animals reflects the kind of carefully balanced compositional schemes taught in the Academy and echoes scenes of processions found in Classical art. The painting's compositional harmony—expressed in the way the shape of the hill is answered by and continued in the general profile of the four white oxen and their handler on the right—as well as its stylistic illusionism, pleasant landscape, and conservative theme were very appealing to the taste of the times, in England and the United States as well as in France. Bonheur became so famous that in 1865 she received France's highest award, membership in the Legion of Honor, becoming the first woman to be awarded its Grand Cross.

The most renowned of the French rural realists, Jean-François Millet (1814–1875), actually grew up on a farm. After moving to Paris to study in 1837 he went through a difficult period. His teacher, an academician, considered him nearly unteachable, and Millet intensely disliked the city. He stayed on until after the Revolution of 1848, however, becoming a painter of the female nude. The Revolution's preoccupation with ordinary people seems to have led Millet to focus on peasant life, which had been only a marginal concern in his early work, and his support of the Revolution earned him a state commission that allowed him to leave Paris and settle in the village of Barbizon. After moving to Barbizon in 1849, he devoted himself almost exclusively to the difficulties and simple pleasures of rural existence.

Perhaps the most famous of his mature works is *The Gleaners* (fig. 27-19), which shows three women gathering grain at harvesttime. The warm colors and slightly hazy atmosphere are soothing, but the scene is one of extreme poverty. Gleaning, or the gathering of the grains left over after the harvest, was a form of relief offered the rural poor. It required hours of backbreaking work to gather the scant reward of enough wheat to produce a single loaf of bread. When the painting was shown in 1857, a number of critics thought Millet was attempting to rekindle the sympathies and passions of 1848, especially because he was known to have supported the Revolution. Yet Millet's intentions were actually quite conservative. An avid reader of the Bible, he saw in such scenes the fate of humanity, condemned since the Expulsion of Adam and Eve from the Garden of Eden to earn its bread by the sweat of its brow. Despite his brief enthusiasm for the Revolution Millet was neither a revolutionary nor a reformer but a fatalist who found exemplary the peasant's heroic acceptance of the human condition. To suggest the timeless nature of the scene, Millet generalized, even monumentalized, his figures, making them not specific individuals but representatives of their class. To avoid the unique and the idiosyncratic, Millet rarely studied from nature.

Millet, who disliked change, was also drawn to scenes like that of *The Gleaners* because they evoked an enduring way of life. He purposefully omitted from his paintings any evidence of the technological improvements recently introduced in French agriculture. He chose instead to emphasize those tools, like the rake and the hoe, that had served humanity from time immemorial. Like Talbot, he was nostalgic for the preindustrial past.

Gustave Courbet (1819–1877) was also inspired by the events of 1848 to turn his attention to the poor and ordinary. Trained around 1840 at an independent Paris studio, Courbet had until the Revolution devoted himself primarily to narcissistic images of himself in flattering portraits and romantic roles. The street fighting of 1848, however, seems to have radicalized him, as it did some of his close friends. He told one newspaper in 1851 that he was "not only a Socialist but a democrat and a Republican: in a word, a supporter of the whole Revolution." Courbet proclaimed his new political commitment in three large paintings he submitted to the Salon of 1850–1851.

One of these, *The Stone Breakers* (fig. 27-20), shows

27-21. Honoré Daumier. *The Third-Class Carriage*. c. 1862. Oil on canvas, 25³/₄ x 35¹/₂" (65.4 x 90.2 cm). The National Gallery of Canada, Ottawa

two men preparing the small stones used for roadbeds. Courbet describes the painting and its origins in a letter:

> [N]ear Maizières, I stopped to consider two men breaking stones on the highway. It is rare to encounter the most complete expression of poverty, so an idea for a picture came to me. . . . I made an appointment with them for the next day at my studio. On the one side is an old man, seventy. . . . On the other side is a young fellow . . . in his filthy tattered shirt. . . . Alas, in labor such as this, one's life begins that way, it ends the same way.

Despite its subject, the painting is not an obvious piece of political propaganda. By hiding the faces of his two protagonists, Courbet makes it difficult for the viewer to identify with them and their plight. He objectified the pair, treating them simply as two more facts in a painting that emphasizes the appearance, texture, and weight of things. This impersonal treatment and the reference in his letter to the sad course of a laborer's life have led many to speculate that Courbet's work is less a political statement than an expression of conservative fatalism akin to Millet's. In 1866 one of Courbet's own friends questioned his intention: "Did you mean to make a social protest out of those two men bent under the inexorable compulsion of Toil? I see in them, on the contrary, a

poem of gentle resignation, and they inspire in me a feeling of pity." Courbet responded, "But that pity springs from the injustice, and that is how I stirred up, not deliberately, but simply by painting what I saw, what they call the social question" (cited in Lindsay, page 60).

Like his other offerings to the Salon of 1850–1851, *The Stone Breakers* testifies to Courbet's respect for ordinary people. In French art before 1848 such people had been shown only in small, modestly scaled paintings. Monumental canvases had been reserved for heroic subjects and for pictures of the powerful (see "Realist Criticism," page 994). In his three large Salon paintings Courbet implicitly claimed that humble men and women were worthy of respect. *The Stone Breakers* also reveals the artist's fondness for depicting stone. Rocky landscapes, usually without human presence, would become his favorite subject. His use of impasto (thickly applied paint), which he often laid on with a palette knife, seems intended to convey the rugged materiality of nature that he so loved.

Partly for convenience, Courbet, Millet, Bonheur, and the other county-life realists who emerged in the 1850s are sometimes referred to as "the generation of 1848." Because of his sympathy with working-class people, the somewhat older Honoré Daumier (1808–1879) is also grouped with this generation. Unlike Courbet and the others, however, Daumier often depicted urban scenes, as in *The Third-Class Carriage* (fig. 27-21). The painting

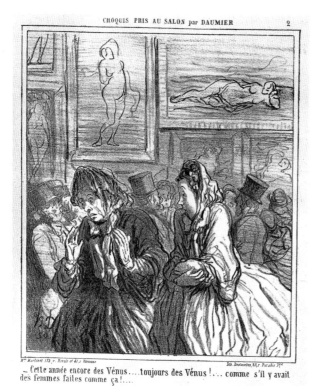

CHÓQUIS PRIS AU SALON par DAUMIER 2

– Cette année encore des Vénus....toujours des Vénus !... comme s'il y avait
des femmes faites comme ça !....

27-22. Honoré Daumier. *This Year, Venuses Again . . .
Always Venuses!* No. 2 of the sketches made at the
Salon, from *Le Charivari*, May 10, 1864

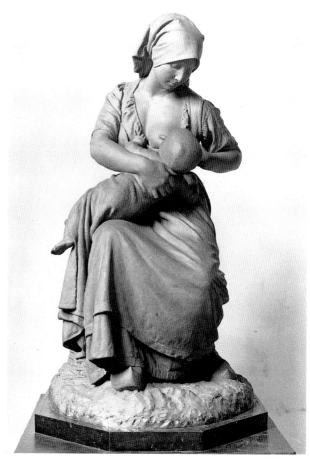

27-23. Aimé-Jules Dalou. *Breton Woman Nursing Her Child.*
1873. Terra-cotta, height 49¾" (126 cm). Victoria and
Albert Museum, London

REALIST CRITICISM

The critical insistence that art should focus not on historical, biblical, or literary themes but on the realities of contemporary life was a major factor in the rise of artistic Realism in France after 1848. A French utopian socialist, the Comte de Saint-Simon (1760–1825), was largely responsible for this view. Saint-Simon, like both Auguste Comte and Karl Marx after him, believed that the laws of human society could be discovered by science and used to construct what he called the "golden age of humanity." Art would contribute significantly to this process, according to Saint-Simon, by preparing the public to accept the changes advocated by the new social scientists. Saint-Simon's *Opinions* (1825) contains a fictional dialogue between such a scientist and an artist in which the latter says: "It is we, artists, who will serve you as avant-garde [vanguard]: the power of the arts is in fact most immediate. . . .

When we wish to spread new ideas among [people], we inscribe them on marble or in canvas."

Saint-Simon's view of art's function was quickly embraced by a number of liberal critics. One of them, Gustave Planche (1808–1857), first applied the word *realism* to art in 1833. For Planche and for others prior to about 1860, Realism meant a combination of contemporary subjects and socialist intentions. The leading realist critic of the era was probably Théophile Thoré (1807–1869), who during the 1830s and 1840s advised artists to reject as irrelevant to the present the subjects and formulas of the past. He also insisted that art must have a moral dimension.

The ideas of Thoré, Planche, and other realist critics were much discussed by a group of younger critics, artists, poets, and writers who gathered at a Paris beer hall in the years just prior to the Revolution of 1848. Among the regulars were Courbet and the fledgling art and literary

critic known as Champfleury (1821–1889; born Jules-François-Félix Husson). Courbet's first defender, Champfleury later helped the artist write his so-called Realist Manifesto. When two of Courbet's thirteen submissions were rejected by the jury for the Universal Exposition of 1855, Courbet withdrew and organized a private exhibition for which he and Champfleury wrote a brief catalog introduction. In it Courbet said, "To know in order to be able to create, that was my idea. To be in a position to translate the customs, the ideas, the appearance of my epoch, according to my own estimation; to be not only a painter, but a man as well; in short, to create living art—this is my goal."

In this manifesto both Courbet and Champfleury were apparently renouncing the political and moral associations long carried by the term *realism* in favor of the apolitical and individualistic conception that would prevail among the critics and artists of the following generation.

depicts the interior of one of the large, horse-drawn buses that transported Parisians along Baron Haussmann's new boulevards. Daumier places the viewer in the poor section of the bus, opposite a serene grandmother, her daughter, and her two grandchildren. Their intimacy and unity (Daumier has arranged them in a pyramid shape) are in sharp contrast to the separateness of the upper- and middle-class passengers whose heads appear behind them. The work could be seen as a commentary on urban alienation, which would become an important topic in art after 1880.

As *The Third-Class Carriage* suggests, Daumier had a genuine affection for working-class people. A political liberal like Courbet, he had been greatly affected by the Revolution of 1830. Then a student at the Academy, Daumier began producing antimonarchist and prorepublican caricatures in leftist journals. He was soon obliged to focus on social and cultural themes, rather than strictly political ones, however, because of stringent censorship laws. His biting satires of the bourgeoisie and of academic art helped usher in the new taste for realism. *This Year, Venuses Again . . . Always Venuses!* (fig. 27-22), for example, humorously contrasts academic standards of ideal female beauty with two quite ordinary women visiting the Salon. One of them turns away from a wall of academic nudes with the comment, "This year, Venuses again . . . always Venuses! As if there really were women built like that!"

One of the artists who carried the concerns of the generation of 1848 into the later part of the century was the sculptor Aimé-Jules Dalou (1838–1902). Encouraged by Carpeaux, Dalou studied sculpture at the Academy. He enjoyed considerable success in the 1860s for works essentially made for the market. His more personal work emerged in the context of the Commune of 1871, the short-lived socialist government established in Paris after the defeat of the French in the Franco-Prussian War and the abdication of Napoleon III. Like his friend Courbet, Dalou actively supported the Commune. At this time he produced the first of his realist sculpture, a lifesize figure of an embroiderer. When the leaders of the Commune were driven from power, Dalou, like Courbet, was forced into exile. Until the amnesty of 1879–1880 he lived in England, where he specialized in scenes of people engaged in everyday pursuits. Many of these works were later used for **porcelain** figurines issued in large editions.

One of Dalou's favorite themes can be seen in *Breton Woman Nursing Her Child* (fig. 27-23). This work delighted the British public when it was exhibited in 1873, possibly because Dalou's concern for common people and occurrences resulted in imagery that supported a conservative view then prevalent that the home is a woman's "natural" domain.

Following the French lead, artists of other Western European nations also embraced realism in the period after 1850. Among them was the German painter Wilhelm Leibl (1844–1900). Trained at the Munich Academy, Leibl was a fairly conventional academician until Courbet's visit in 1869 to the Munich International Exhibition, where some of his paintings were on display. Inspired by

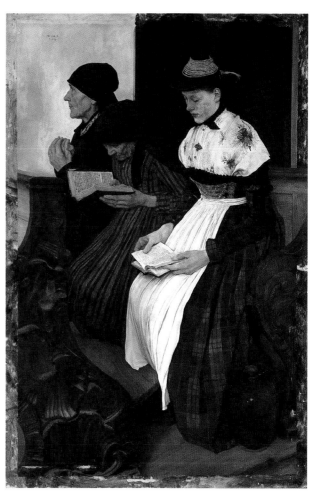

27-24. Wilhelm Leibl. *Three Women in a Village Church.* 1878–81. Oil on wood, 44½ x 30⅜" (113 x 77 cm). Kunsthalle, Hamburg

About this painting, Leibl wrote to his mother in 1879: "Here in the open country and among those who live close to nature, one can paint naturally. . . . It takes great staying power to bring such a difficult, detailed picture to completion in the circumstances. Most of the time I have literally taken my life in my hands in order to paint it. For up to now the church has been as cold as a grave, so that one's fingers get completely stiff. Sometimes, too, it is so dark that I have the greatest difficulty getting a clear enough view of the part on which I am working. . . . Several peasants came to look at it just lately, and they instinctively folded their hands in front of it. . . . I have always set greater store by the opinion of simple peasants than by that of so-called painters."

Courbet's work, and on his advice, Leibl went to Paris to familiarize himself with its realist currents. After Leibl's return to Germany he lived in Munich for several years before moving to rural Bavaria, in southern Germany, where he dedicated himself to peasant subjects.

Leibl's best-known painting is *Three Women in a Village Church* (fig. 27-24), which was based on countless sittings by villagers he used as models. The work features a young woman, whose fresh beauty stands in sharp contrast to the weathered faces of the women next to her. The contrast is emphasized by the different backgrounds

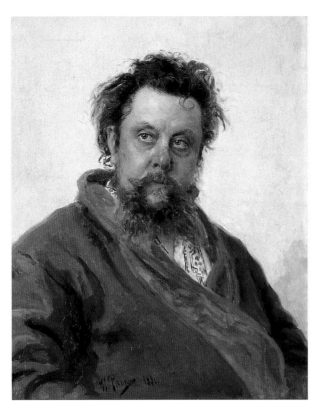

27-25. Ilya Repin. *The Composer Moussorgsky*. 1881. Oil on canvas, 27¹/₄ x 22¹/₂" (69.9 x 57.7cm). Tretyakov Gallery, Moscow

sidered to be an authentic Russian culture rooted in the traditions of the peasantry. This movement developed in reaction to the Western European customs that had long predominated among the Russian aristocracy. Since the late eighteenth century, for example, French had been spoken at court and among Russia's educated elite.

Ilya Repin (1844–1930), who attended the St. Petersburg Academy and won a scholarship to study in Paris, joined the Wanderers on his return to Russia in 1878. His work included genre scenes, history paintings, and portraits of other leading figures in the arts. His portrait of Modest Moussorgsky, one of a group of composers incorporating Russian folk melodies into their symphonic music, shows him with tousled hair and a rugged demeanor, a man of the people rather than a slick sophisticate in the Western mold (fig. 27-25).

ART IN THE UNITED STATES

Art in the United States at mid-century, like Russian art after the emancipation of the serfs, was marked by the tension between an academic tradition imported from Western Europe and an unbroken American tradition of realism. In the case of the United States, however, the tension was not recent. The advocates of realism had long considered it distinctively American and democratic; others, in contrast, saw the academic ideal as a link to a higher Western European culture.

behind the older women and the young woman. The work is more than a reverie on youthful beauty, however. It also extols the conservative customs and values of Bavarian peasants, as embodied in the traditional dress and ardent piety of the three women. Carrying on the practices of her elders, the young woman represents the enduring strength of those customs and values. Even the elaborately carved pews, which seem to date from the Baroque period, suggest a faithfulness to the past. The scene is rendered with a minute care that owes more to the example of Hans Holbein (figs. 18-73, 18-77) and Jan Vermeer (fig. 19-57) than to that of Courbet. Leibl thereby demonstrates his own devotion to time-honored artistic standards threatened by innovation and change.

In Russia, too, realism developed in relation to a new concern for the peasantry. In 1861 the czar abolished serfdom, emancipating Russia's peasants from the virtual slavery they had endured on the large estates of the aristocracy. Two years later a group of painters inspired by the emancipation declared allegiance to both the peasant cause and freedom from the St. Petersburg Academy of Art, which had controlled Russian art since 1754. Rejecting what they considered the idealized, "art for art's sake" aesthetics of the Academy, the members of the group dedicated themselves to a socially useful realism. Committed to bringing art to the people in traveling exhibitions, they called themselves the Wanderers. By the late 1870s, members of the group, like their counterparts in music and literature, were also becoming active in a broad nationalistic movement to reassert what they con-

Sculpture

In the years immediately before and after the Civil War, sculpture, especially in marble, remained the essential medium for those committed to "high," or European, culture. A new generation of sculptors continued the European Neoclassical tradition established in Rome by Antonio Canova (see fig. 26-6) and brought to the United States in the second quarter of the nineteenth century by artists like Thomas Crawford and Hiram Powers (Chapter 26). Most members of this new generation studied in Rome, but a few, including Erastus Dow Palmer (1817–1904), had no formal training. A carpenter from upstate New York, Palmer had begun making small cameo portraits around 1845 and had moved to large-scale marble figures by the early 1850s. He achieved his greatest popular success in 1859, when he exhibited *The White Captive* (fig. 27-26). The work, which places a realistic head on a classically idealized body, was displayed alone in a room carefully illuminated by gaslight that warmed the marble to a semblance of flesh. This theatrical presentation, reminiscent more of Daguerre's diorama than of the Paris Salon, was typical of the way Americans saw art in this period.

Painting and Photography

In contrast to the late Neoclassicism prevalent in sculpture, during the years before the Civil War American landscape painters shifted from the Romantic tradition of Thomas Cole (see fig. 26-69) toward a more factual natu-

27-26. Erastus Dow Palmer. *The White Captive.* 1857–59. Marble, height 5'6" (1.68 m). The Metropolitan Museum of Art, New York

Gift of Hamilton Fish

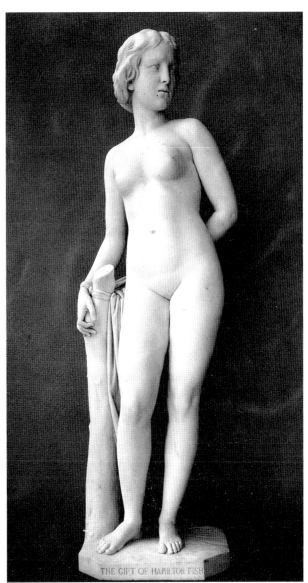

ralism. This transition is particularly evident in the work of Frederick Edwin Church (1826–1900), Cole's only student. Like Cole, Church favored the grand spectacles of nature, such as Niagara Falls (fig. 27-27). In its epic aspirations Church's *Niagara* remains Romantic in conception, but its Romanticism is tempered by a scientific eye. Church's cool coloring and precise rendering reflect the influence of Alexander von Humboldt, a German naturalist who advocated a factual approach to the study of landscape as a prerequisite for grasping nature's grandeur, not an end in itself. The painting's magnificent spectacle, precarious vantage point, and huge scale were designed to generate grand emotions. Its subject also sparked considerable nationalistic pride. Niagara Falls was one of those august places that exemplified to Americans the greatness of their nation. By including a rainbow over the falls, a traditional symbol of divine approval, Church clearly meant to appeal to the public's preconceptions about their national destiny. Drawn by its combination of naturalism, lofty emotion, and nationalism, people flocked to see the painting in New York City in 1857 and, despite a twenty-five cent fee, on its national tour in 1859. More than 1,100 visitors to the 1857 exhibition ordered colored reproductions of *Niagara*.

One of them, John Frederick Kensett (1816–1872), was a landscape painter with an even more naturalistic approach to the Romanticism of his predecessors. Trained as an engraver, Kensett toured and studied in Europe between 1840 and 1847. After his return he traveled in the United States, making detailed records of the beautiful

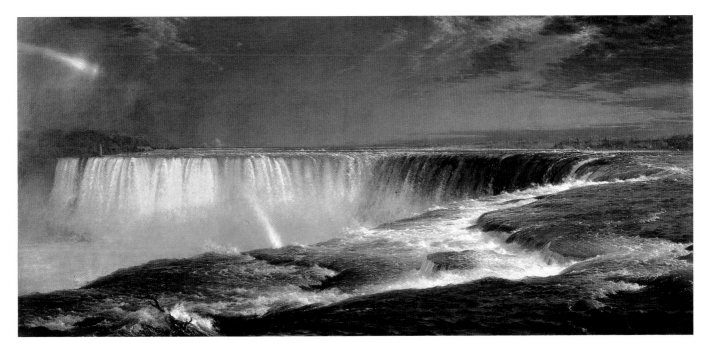

27-27. Frederick Edwin Church. *Niagara.* 1857. Oil on canvas, 3'6½" x 7'6½" (1.1 x 2.3 m). The Corcoran Gallery of Art, Washington, D.C.

27-28. John Frederick Kensett. *Beacon Rock, Newport Harbor*. 1857. Oil on canvas, 22½ x 36"
(57.2 x 91.4 cm). National Gallery of Art, Washington, D.C.
Gift of Frederick Sturges, Jr.

scenery of the Northeast and West. He and a group of his contemporaries, including Fitz Hugh Lane (1804–1865), Martin Johnson Heade (1819–1904), and Worthington Whittredge (1820–1910), have together come to be known as the Luminists because of the radiant light that suffuses the atmosphere in their landscapes.

Characteristic of Kensett's work in its combination of the documentary with the metaphorical is *Beacon Rock, Newport Harbor* (fig. 27-28). The painting, which shows the entrance to the Rhode Island city's harbor, employs a three-part spatial arrangement that derives ultimately from the seventeenth-century French Baroque painter Claude Lorrain (see fig. 19-28). From a narrow foreground plane, where the viewer stands, the eye moves around a large mass that establishes the middle ground to the elements of the far distance. But whereas Claude and his later imitators composed ideal landscapes to fit this format, Kensett has accommodated the format to the topographical facts. For example, the harmony of human and nature signaled in the Claudian tradition by Arcadian herders is here indicated by the people in boats that Kensett actually observed on the site. Nevertheless, the scene's tranquil noonday light, which looks naturalistic to the twentieth-century eye, must be seen in the context of the mid-nineteenth century's insistence on metaphorical readings of the landscape. Kensett, like his predecessors, seems to have considered light to be evidence of the divine. Unlike his predecessors, however, he shunned the theatrical handling of such metaphors and a preoccupation with their narrative implications. In *Beacon Rock* Kensett makes no claims about the future of the United States. He simply records a single, blessed moment.

In retrospect we know that Kensett's luminous calm was about to be broken by a terrible storm. Four years after he painted *Beacon Rock*, the Civil War erupted. This conflict lasted four bloody years (1861–1865) and cost nearly 620,000 lives, more than all other United States wars combined. It generated intense national and international interest, attracting not only journalists and artists but also practitioners of the new medium of photography. Inspired by the pioneering documentary work of a handful of British war photographers in the middle to late 1850s, more than 300 American and foreign photographers eventually entered the battle zone with passes from the U.S. government.

The first photographer at the front was Mathew B. Brady (1823–1896), who ran large portrait studios in New York City and Washington, D.C. When the war broke out, he used his friendship with the influential government officials whose portraits he had made to obtain permission to take a team of photographers and a darkroom wagon to the front, where they endured considerable hardship and danger. After Brady himself was almost killed in an early battle he left the actual photographing to his twenty assistants. Brady's Photographic Corps amassed more than 7,000 negatives documenting every aspect of the war except the actual fighting, because the cameras were still too slow for action scenes.

The most memorable images by Brady and his assistants were taken immediately after battles, before the dead could be buried. An example is *Confederate Dead Gathered for Burial, Antietam, September 1862* (fig. 27-29), by Brady's most acclaimed assistant, Alexander Gardner (1821–1882). Lying in a neat, wedge-shaped pile are the corpses of some of the more than 10,000 Confederate soldiers who had fallen in that battle. The grim evidence of carnage in such works made a powerful impression on the American public, cutting through the conventional glamour of war in a way that even Francisco Goya had been unable to do (Chapter 26).

After the war the nation tried to heal its wounds in a variety of ways. In both North and South, public sculpture

27-29. Alexander Gardner. *Confederate Dead Gathered for Burial, Antietam, September 1862*. Albumen silver print. Library of Congress, Washington, D.C.

An 1862 editorial in the *New York Times* on the Antietam photographs commented that Mathew Brady and his assistants "bring home to us the terrible reality . . . of the war. If [they have] not brought bodies and laid them in our door yards . . . [they have] done something very like it."

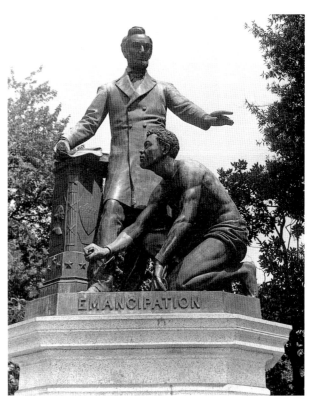

27-30. Thomas Ball. *The Emancipation Group*. 1874. Bronze, over-lifesize. Lincoln Park, Washington, D.C.

was commissioned not only to commemorate the dead and provide an outlet for grief but to provide satisfactory explanations for the epic sacrifice. One of the most popular subjects in the North was Abraham Lincoln, shown either alone or freeing slaves, as in Thomas Ball's bronze sculpture *The Emancipation Group* (fig. 27-30). Ball (1819–1911), a self-trained sculptor who moved to Italy in 1854, produced this and a number of similarly naturalistic commemorative monuments in his Florence studio. The work shows President Lincoln in contemporary dress, with his 1863 Emancipation Proclamation in one hand, blessing with the other a man who, his wrist chains of enslavement just broken, is about to rise a free person. Lincoln was the perfect subject for such explanatory sculpture because his assassination immediately following the war was seen as its final tragedy and epitomizing symbol. For Northerners, at least, his personal sacrifice in the name of a great moral cause personified that of the nation as a whole.

Among the most important factors in the nation's recovery from the war was the massive westward expansion that soon came to preoccupy its citizens. This expansion into the so-called wilderness between the eastern seaboard and California—already occupied by Native Americans—was justified as the nation's Manifest Destiny, a term coined in 1845. To help open up territory, the U.S. government sponsored a number of exploratory surveys into the West, and many Civil War photographers, toughened by combat and looking for fresh subjects, accompanied them.

One of those photographers was Timothy H. O'Sullivan (1840–1882), who had trained in Brady's portrait studios and worked for him during the war. As his most famous photograph, *Ancient Ruins in the Cañon de Chelley, Arizona*, makes clear, O'Sullivan's landscapes are more a personal expression of awe than they are documentary records (fig. 27-31). Taken on a government geological

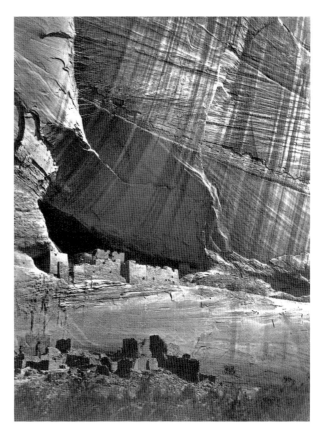

27-31. Timothy H. O'Sullivan. *Ancient Ruins in the Cañon de Chelley, Arizona*. 1873. Albumen print. National Archives, Washington, D.C.

27-32. Albert Bierstadt. *The Rocky Mountains, Lander's Peak*. 1863. Oil on canvas, 6'1¼" x 10'¾" (1.86 x 3 m). The Metropolitan Museum of Art, New York
Rogers Fund

27-33. Winslow Homer. *Snap the Whip*. 1872. Oil on canvas, 22¼ x 36½" (55.9 x 91.4 cm). The Butler Institute of American Art, Youngstown, Ohio

survey of the Southwest, this landscape view is virtually without precedent. The canyon wall, 700 feet high, fills the image, giving the viewer no clear vantage point and scant visual relief. The bright, raking sunlight across the rock face reveals little but the cracks and striations formed over countless eons. The image suggests not only the immensity of geological time but humanity's insignificant place within it. Like the Classical ruins that were a popular theme in European art and poetry, the eleventh-to-fourteenth century Anasazi ruins suggest

the inevitable passing of all civilizations. For O'Sullivan, whose Romantic pessimism was surely fueled by the Civil War, the four puny humans standing in this majestic yet barren place would have reinforced the message of human futility and insignificance.

The paintings of Albert Bierstadt (1830–1902) impart a more optimistic view of the Western landscape. Born in Germany and raised in the United States, Bierstadt studied at the Düsseldorf Academy in the mid-1850s. In 1858–1859, just before the Civil War, he accompanied an expedition of U.S. Army engineers, led by Colonel Frederick Lander, mapping an overland route from St. Louis to the Pacific Ocean. Working from his sketches of this pristine territory, especially the Rocky Mountains, he produced a series of paintings that made his fame. The first of these, *The Rocky Mountains, Lander's Peak* (fig. 27-32), sold for $25,000, the highest price an American painting had yet brought—more than forty times what a skilled carpenter or mason then earned per year. The huge canvas, intended for Eastern audiences only slightly familiar with Native Americans and even less familiar with the Rockies, combines a documentary approach to Native American life in the tradition of George Catlin (see fig. 26-68) with an epic, composite landscape in the tradition of Frederick Edwin Church (see fig. 27-27). The painting is more than a geography lesson, however. As in the work of Church and Cole, it conveys an implicit historical narrative. From the Native American encampment in the foreground, with its apparent associations to the Garden of Eden, the eye is drawn into the middle ground by the light on the waterfall, then up to Lander's Peak. To audiences that accepted the concept of a divinely sanctioned Manifest Destiny, the work's spatial progression must have seemed to map out their nation's westward and upward course. The painting seems virtually to beckon them into this paradise to displace the Native Americans already inhabiting it.

The myth of America as the new Eden, challenged by the war, also reasserted itself in genre painting and sculpture. One of those who specialized in reassuring scenes of American innocence was the painter Winslow Homer (1836–1910). Homer began his artistic career in 1857 as a free-lance illustrator for popular periodicals such as *Harper's Weekly* and *Ballou's Pictorial*. *Harper's* sent him to cover the Civil War in 1862. His quiet scenes of life behind the lines could hardly be more different from the harsh photographs by Gardner and others. In 1866–1867 he spent ten months in France, where the realist art he saw may have inspired him to begin painting rural subjects when he returned.

About 1870 Homer began painting scenes based on frequent forays from his New York City home to upstate New York villages. Works like *Snap the Whip* (fig. 27-33), with its depiction of boys playing outside a one-room schoolhouse in the Adirondack Mountains on a glorious day in early fall, evoke the innocence of childhood and the imagined charms of a preindustrial America for an increasingly urbanized audience. Many of these paintings were reproduced as wood engravings for illustrated books and magazines. Homer apparently shared his

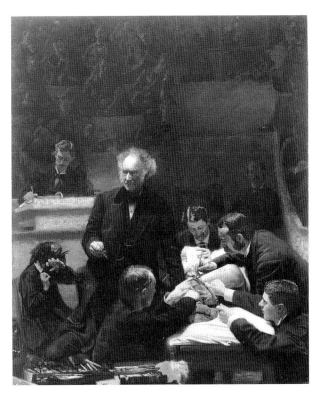

27-34. Thomas Eakins. *The Gross Clinic*. 1875. Oil on canvas, 8' x 6'5" (2.44 x 1.98 m). Jefferson Medical College of Thomas Jefferson University, Philadelphia

In 1876 Eakins joined the staff of the Pennsylvania Academy of the Fine Arts, where he taught anatomy and figure drawing. He disapproved of the academic technique of drawing from plaster casts. In an interview in 1879 he said, "At best, they are only imitations, and an imitation of an imitation cannot have so much life as an imitation of nature itself." He added that "The Greeks did not study the antique . . . the draped figures in the Parthenon pediment were modeled from life, undoubtedly." Eakins introduced the study of the nude model, which shocked many in staid Philadelphia society. In 1886 he was given the choice of changing his teaching policies or resigning. He chose the latter.

audience's nostalgia for a more carefree past, and the paintings seem to have reminded him of his own active, outdoor childhood in Cambridge, Massachusetts, then still an almost-rural suburb of Boston. In one of them a boy signs the painter's initials on a schoolhouse wall.

Another famous American realist to emerge after the Civil War, Thomas Eakins (1844–1916), completely renounced such artistic pleasantries. Trained at the Pennsylvania Academy of the Fine Arts, he, too, went to Europe in 1866, studying for three years at the French École des Beaux-Arts under Jean-Léon Gérôme. He then spent six months in Spain, encountering the works of Diego Velázquez and José Ribera, whose profound realism came as a revelation to him. After he returned to Philadelphia in 1870 he specialized in frank portraits and genre scenes whose lack of conventional charm generated little popular interest.

One work that did attract attention, *The Gross Clinic* (fig. 27-34), was severely criticized. The painting shows

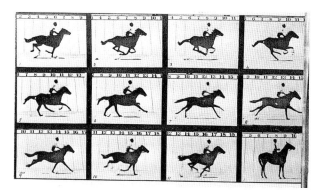

27-35. Eadweard Muybridge. *Galloping Horse*. 1878. Wet-plate photography

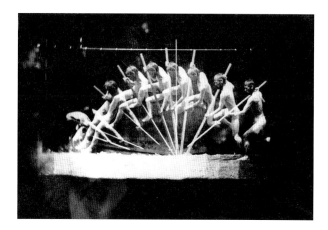

27-36. Thomas Eakins. *The Pole Vaulter*. 1884. Multiple-exposure photograph. The Metropolitan Museum of Art, New York

Gift of Charles Bregler

Dr. Samuel Gross performing an operation at the Jefferson Medical College, which commissioned the work. Ranged behind him are young medical students, to whom he turns to make a point. The representatives of science—a young medical student, the doctor, and his helpers—are all highlighted. This dramatic use of light, borrowed, like the theme, from paintings of anatomy lessons by Rembrandt, is not meant to stir emotions but to make a point: From the darkness of ignorance and fear modern science is bringing forth the light of knowledge. The light in the center falls not on the doctor's face but on his forehead—on his mind.

Most observers found the work's bluntness offensive, in particular the details of the operation and the blood on the doctor's hand. Refused exhibition space in the art section of the 1876 Philadelphia Centennial, the painting was shown, instead, at the army's hospital display.

Eakins was chosen to paint *The Gross Clinic* because he often attended the doctor's lectures—he included a portrait of himself among the students in the painting—and even wrote a scientific paper on muscles. His interest in anatomy led him in turn to photography, which he used both as an aid for painting and as a tool for studying the body in motion. He made a number of studies with Eadweard Muybridge (1830–1904), a pioneer in motion photography.

The English-born Muybridge, who was born Edward James Muggeridge but changed his name to what he thought was its original Anglo-Saxon form, set up shop as a bookseller in San Francisco in 1852. He began taking landscape photographs in the 1860s and by the end of the decade was directing photographic surveys of the California coast for the U.S. government. In 1872 railroad owner and former California governor Leland Stanford bet a friend $25,000 that a running racehorse has all four feet off the ground at some point in its stride, and he hired Muybridge to settle the issue. Muybridge's initial studies, for which he developed a fast new shutter, were promising but inconclusive, so Stanford asked him to continue working on the problem. After a number of interruptions, including his own trial for murder and his eventual acquittal, Muybridge succeeded in 1878 in proving Stanford's contention (fig. 27-35).

Galloping Horse was produced by twelve cameras, with shutter speeds, according to Muybridge, of "less than two-thousandth part of a second." The cameras, spaced 27 inches apart, were triggered by electric switches attached to fine black threads stretched across the track. In order to maximize the amount of light, the ground was covered with powdered lime and a white screen was set up along the rail, its linear divisions corresponding to the spacing of the cameras. When Eakins saw this photograph in 1879, he began a correspondence with Muybridge that eventually led to their collaboration under a contract from the University of Pennsylvania. With Muybridge's less than enthusiastic assistance Eakins devised a revolving disk for use over the camera lens that would permit a series of superimposed yet distinguishable images to be taken on one plate. The results are seen in such works as *The Pole Vaulter* (fig. 27-36).

ART IN ENGLAND In 1848 seven young artists formed the Pre-Raphaelite Brotherhood to counter what they considered the misguided practices of contemporary British art. Instead of the Raphaelesque conventions taught at the Royal Academy, the Pre-Raphaelites advocated the naturalistic approach of certain early Renaissance masters, especially those of northern Europe. They advocated as well a moral approach to art, in keeping with a long tradition in Britain established by Hogarth (see fig. 26-17).

The combination of didacticism and realism that characterized the first phase of the movement is best represented in the work of one of its leaders, William Holman Hunt (1827–1910), for whom moral truth and visual accuracy were synonymous. Typical of this academically trained artist is *The Hireling Shepherd* (fig. 27-37). The landscape portions of the composition were painted outdoors, an innovative approach at the time. Space was left for the figures, who were painted in his London studio. The work depicts a paid farmhand neglecting his duties to discuss with a woman a death's-head moth that he holds in his left hand. Meanwhile, some of his employer's sheep are wandering into an adjacent field, where they may die or become sick from eating green corn. Hunt later explained that he meant to

satirize pastors who spend time discussing theological questions he deemed to have no value rather than tending to their flock. The painting is also a moral lesson on the perils of temptation, with the woman cast as a latter-day Eve. She feeds an apple—a symbolic reference to the Fall of humankind from the state of grace—to the lamb on her lap, and she distracts the shepherd from his duty.

The other major members of the group, John Everett Millais (1829–1896) and Dante Gabriel Rossetti (1828–1882), were less inclined to this sort of moralizing and by 1852 had broken with Hunt, which led to the dissolution of the group. In 1857 Rossetti, son of an exiled Italian poet, met two young Oxford students, William Morris (1834–1896) and Edward Burne-Jones (1833–1898), while working on a mural at the university. Their shared interest in the Middle Ages inaugurated the second, unofficial phase of Pre-Raphaelitism. Despite Hunt's protests, critics continued to identify Rossetti with the term, which is now more equated with his later work and that of his Oxford friends than with Hunt and the original group.

Morris's wife, Jane Burden, became Rossetti's favorite model. Her particular blend of physical beauty and sad, aloof spirituality perfectly suited Rossetti's vision of the

27-37. William Holman Hunt. *The Hireling Shepherd*. 1851. Oil on canvas, 30⅛ x 43⅛" (76.4 x 109.5 cm). Manchester City Art Gallery, England

Middle Ages and lent itself to his yearning for the spiritual beauty he found lacking in the present.

After he and Burden became lovers, sometime in the 1860s, his images of her took on an added biographical dimension. *La Pia de' Tolomei* (fig. 27-38) uses an incident from Dante's *Purgatory* to articulate the artist's own

27-38. Dante Gabriel Rossetti. *La Pia de' Tolomei*. 1868–69. Oil on canvas, 41½ x 47½" (105.4 x 119.4 cm). Spencer Museum of Art, University of Kansas, Lawrence

27-39. William Morris. *Queen Guinevere*. 1858. Oil on canvas, 27 7/8 x 19 3/4" (71.8 x 50.2 cm). Tate Gallery, London

27-40. Bedstead, illustration from *The Art Journal Illustrated Catalogue of the Great Exhibition*, London, 1851

unhappy romantic situation. La Pia ("Pious One"), locked up by her husband in a castle, was soon to die. The rosary and devotional in front of her refer to the piety from which she takes her name. The stakes wrapped in the banner of her husband on the ramparts suggest her captivity. The sundial and ravens apparently allude to her impending death. Her continuing love for her husband, whose freshly read letters lie under the devotional, is symbolized by the evergreen ivy behind her. However, the luxuriant fig leaves that surround her, traditionally associated with the Fall, have no source in Dante's tale. Rossetti personalizes the tale in other ways, showing her fingering her wedding ring, a captive not so much of her husband as of her marriage.

Jane Burden also appears in the only painting ever produced by William Morris, *Queen Guinevere* (fig. 27-39). Ironically, given later events in Morris's and Burden's lives, Guinevere was the unhappy wife of King Arthur, in love with the king's friend and most famous knight of his Round Table, Sir Lancelot. Morris chose the subject not for the story, however, but essentially as an excuse for depicting medieval objects and dress. Morris made the work only at Rossetti's prompting, for he was less interested in painting than in the kinds of handcrafts displayed in *Queen Guinevere*. Morris's interest in handcrafts developed in the context of a widespread reaction against the gaudy design of industrially produced goods that began with the Crystal Palace exhibition of 1851.

The elaboration of decorative elements at the expense of function and good taste, as was evident in the objects on display, like the bed shown here (fig. 27-40), distressed many, including the event's organizers. Prince Albert and his associates sought to improve industrial products through the teaching of better design principles, but a number of critics—led by writer, artist, and art critic John Ruskin—were convinced that industrialism itself was the problem. Morris became the leader of this faction soon after his marriage to Burden in 1859. Unable to find satisfactory furnishings for their new home, Morris, with the help of a number of friends, designed and made them himself. He then founded a decorating firm, Morris, Marshall & Faulkner (later changed to Morris & Company), to produce a full range of medieval-inspired objects. Morris designed for a variety of materials, including cloth. *Bird Woolen* (fig. 27-41) is typical of his fabric design in its use of flattened motifs consistent with the two-dimensional medium. The organic subjects, the decorative counterparts to those of naturalistic landscape painting, were meant to provide relief from modern urban existence.

Morris promoted and inspired what became known as the Arts and Crafts Movement. His aim was to benefit not just a wealthy few but society as a whole. As he said in the lectures he began delivering in 1877, "What business have we with art at all unless we can share it?" A socialist, Morris meant to eliminate the machine not only because he found its products ugly but also because of its deadening influence on the worker. With craftwork, he maintained, the laborer gets as much satisfaction as the consumer. Unlike his Pre-Raphaelite friends, who wished to escape into idealizations of the Middle Ages, Morris saw in that era the model for economic and social reform.

27-41. William Morris. *Bird Woolen* double cloth, designed for the drawing-room tapestry for Kelmscott House, Hammersmith. 1878. Victoria and Albert Museum, London

27-42. James McNeill Whistler. *Black Lion Wharf*. 1859. Etching, 5⅞ x 8⅞" (15 x 22.6 cm). The Metropolitan Museum of Art, New York

Harris Brisbane Dick Fund

A copy of this work can be seen on the wall in Whistler's most famous painting, the portrait of his mother.

Not all of those who participated in the revival of the decorative arts were committed to improving the conditions of modern life, however. Many, including the American expatriate James McNeill Whistler (1834–1903), saw in the Arts and Crafts revival simply another way to satisfy an elitist taste for beauty. After failing out of West Point in the early 1850s Whistler studied art in Paris, where he came under the influence of Courbet. His first important works were **etchings**, which he had learned to make while employed in the U.S. government's Coastal Survey Department in Washington, D.C. Typical of his early work is *Black Lion Wharf* (fig. 27-42), a realistic scene of life along the

THE PRINT REVIVAL

During the Romantic period a number of artists, including Théodore Géricault and Eugène Delacroix, had used the new medium of lithography, invented in the mid-1790s, to produce fine art prints (see "Lithography," page 985). But as a result of the more prolific use of lithography by newspaper caricaturists such as Honoré Daumier (see fig. 27-23), the medium soon became identified with the popular arts.

Delacroix, Camille Corot, and Jean-François Millet had also produced the occasional **etching**, an art form at that time employed almost exclusively to produce cheap reproductions of well-known works (see "Etching and Drypoint," page 789). The Barbizon artist Charles-Émile Jacque (1813–1894), who as a student had studied and copied etchings by Rembrandt and other Dutch artists of the seventeenth century, was the first to devote himself more fully to the medium. Inspired partly by the work of Jacque and partly by the amateur example of his brother-in-law, Francis Seymour Haden, James McNeill Whistler turned to etching in 1858, just before moving to England. Whistler's early work may be said to have inaugurated a great age of etching. The interest it generated convinced an amateur French etcher and printer, Alfred Cadart, to organize the Society of Etchers in 1862. Cadart, who was also a print dealer, conceived the society partly as a way to bring before the public the kind of innovative work rejected by the Salon jury and partly as a way to protest the growth and influence of photography. The Romantic poet and critic Théophile Gautier said in his preface to the first volume of etchings Cadart issued:

In these times when photography fascinates the vulgar by the mechanical fidelity of its reproductions, it is needful to assert an artistic tendency in favor of free fancy and picturesque mood. The necessity of reacting against the positivism of the mirrorlike apparatus has made many a painter take to the etcher's needle; and the gathering of these men of talent, annoyed at seeing the walls crowded with monotonous and soul-less pictures, has given birth to the "Society of Etchers."

Included in the inaugural volume of etchings were works by forty-eight artists, among them Corot, Charles Daubigny, Édouard Manet, Alphonse Legros (who had introduced Manet to etching in 1861), Francis Seymour Haden, and C.R. (for Carolus Rex, the king of Sweden). The critical response to Cadart's early annuals was so positive that even the conservative organizers of the Salon decided to dedicate an entire room to the etching at the exhibition of 1866.

Philippe Burty, who later coined the term *japonisme*, commented that the show of that year should be called the Salon of the Etchers. Cadart's efforts established a solid foundation for a tradition that eventually included the work of Edgar Degas, Mary Cassatt, and a host of French artists. Cadart also contributed to the spread of etching when he helped form the French Etching Club in New York City in 1866. By the middle of the 1870s, however, general interest in etching had begun to decline.

27-43. Édouard Manet. *Le Déjeuner sur l'Herbe (The Luncheon on the Grass)*. 1863. Oil on canvas, 7' x 8'10" (2.13 x 2.64 m). Musée d'Orsay, Paris

River Thames. Although inspired by Courbet, Whistler's etching shows little of that artist's interest in either the solid tangibility of things or in the social or human significance of work. Because of its horizontal emphasis and the absence of a strong focal point, the eye scans the etching's registers, making a quick survey of its picturesque details before passing on and out of the frame. This approach to composition anticipates the French Impressionists. The work is important, too, because of Whistler's crucial early place in the print revival of the later nineteenth century (see "The Print Revival," page 1005).

Black Lion Wharf was produced soon after Whistler had moved to London early in 1859, partly to separate himself from Courbet and his influence. The new vogue for the arts of Japan helped fuel in him a growing dissatisfaction with realism (see *"Japonisme,"* page 1008). Whistler had been one of the first to collect Japanese art when it became available in curio shops in London and Paris after the 1854 reopening of that nation to the West. The simplified, elegant forms and subtle chromatic harmonies of Japanese art (Chapter 22) had a profound influence on his art in the early 1860s. In 1864 he exhibited three paintings that signaled his new direction. One of them, *Rose and Silver: The Princess from the Land of Porcelain* (see fig. 22, page 26, showing the Peacock Room Whistler later designed to house it), shows a woman

posed amidst a collection of Asian arts. The work is Whistler's answer to the medieval costume pieces of the Pre-Raphaelites (see fig. 27-39). What Whistler saw in Japanese objects was neither a preferable world nor a way to reform European decorative arts, but rather a model for painting. As the work's main title declares, Whistler attempted to create a formal and coloristic harmony similar to that of the objects displayed in the room. Thus, delicate organic shapes are shown against a rich orchestration of colors featuring silver and rose. By leaving his wet brushmarks visible, Whistler emphasized the paint itself over the depicted subject. In a remark that says more about his own commitments than about those of the Japanese, he later commented: "Japanese art is not merely the incomparable achievement of certain harmonies of color; *it is the negation, the immolation, the annihilation of anything else."*

Whistler's insistence on art as an antidote to the ugliness of modern life was shared by a number of influential British writers and critics, including Walter Pater (1839–1894) and Oscar Wilde (1854–1900). By the late 1870s this view and its manifestation in artworks like those of Whistler and Rossetti had come to be known as Aestheticism. Aestheticism became so popular in the 1880s that young men and women displayed their devotion to its tenets by carrying peacock feathers.

ARTISTIC ALLUSIONS IN MANET'S ART

Manet had in his studio a copy by Henri Fantin-Latour of the *Pastoral Concert*, a work in the Louvre then attributed to Giorgione, now attributed to Titian. It is plain that in painting *Le Déjeuner sur l'Herbe* (see fig. 27-43) he took inspiration from the *Pastoral Concert*, making a modernized reply to its theme of ease in nature.

At the same time, in preparing his composition Manet directly adapted a group of river gods and nymphs from an engraving by Marcantonio Raimondi, based on Raphael's *The Judgment of Paris*—an image that, in turn, looked back to Classical reliefs. Manet's allusion to the engraving was apparently quite clear to some observers at the time; in reviewing the Salon at which the *Déjeuner* was exhibited, the critic Ernest Chesneau specifically noted this borrowing and objected to it.

In making these two references to artworks from the Renaissance, Manet's painting addresses not only the ostensible subject, figures in a landscape. Just as important, it also addresses the history of art and helps define Manet's relationship to it by encouraging the viewer to compare Manet's painting with the works that inspired it. To a viewer who has in mind the traditional perspective and the rounded modeling of forms of the two Renaissance works, the stark lighting of Manet's nude and the flat, cutout quality of his figures become all the more shocking. Thus, by openly referring to these exemplary works of the past, Manet emphasized his own radical innovations.

Titian. *Pastoral Concert* (formerly attributed to Giorgione). c. 1509–10. Oil on canvas, 43¼ x 54⅜" (109.9 x 138.1 cm). Musée du Louvre, Paris

Marcantonio Raimondi. Detail of engraving after Raphael's *The Judgment of Paris*. c. 1520. The Metropolitan Museum of Art, New York
Rogers Fund, 1919

IMPRESSIONISM

While British artists were moving away from the naturalism advocated by the original Pre-Raphaelite Brotherhood, their French counterparts were pushing the traditions of Courbet, Corot, and the Barbizon painters into new territories. Instead of themes of the working classes and the country, the generation that matured around 1870 was generally devoted to subjects of leisure, the upper-middle class, and the city. Although many of these artists specialized in paintings of the country, the point of view they adopted was usually that of a city person there on holiday.

Édouard Manet

The leader of this loosely knit group was Édouard Manet (1832–1883). Born into an upper-middle-class Parisian family, Manet studied in the early 1850s with the painter Thomas Couture (1815–1879), an academician with progressive leanings. Manet often quarreled with Couture and some of his models, however, because he wanted the models to adopt more naturalistic poses and because he thought that during the summer months studies might be done outdoors, under natural light. Manet's realist inclinations were at first overshadowed by his fondness for Velázquez and the current vogue for Spanish themes; his commitment to realism emerged in the early 1860s, largely as a result of his close friendship with the poet Baudelaire. In "The Painter of Modern Life," Baudelaire called for an artist who would be the painter of contemporary manners, "the painter of the passing moment and of all the suggestions of eternity that it contains." Manet seems to have responded to this call.

JAPONISME In his *Portrait of Émile Zola*, painted in gratitude for the writer's defense of his work, Édouard Manet included a Japanese screen and a portrait of a sumo wrestler by Kuniaki II, a nineteenth-century Japanese printmaker. These items probably say more about Manet's interest in Japanese art than they do about Zola's taste. In particular, the reductive design principle evident in Japanese woodblock prints and their tendency to flatten form probably inspired similar features in some of Manet's early works. On the wall next to the Kuniaki portrait is a print after one of Manet's own paintings that was severely criticized for just these qualities.

Manet's interest in Japanese prints and decorative arts was part of a widespread fascination with Japan and its art that swept across the West in the last half of the nineteenth century. The vogue began shortly after the U.S. Navy forcibly opened Japan to Western trade and diplomacy in 1854. By the late 1850s Japanese lacquers, fans, bronzes, hanging scrolls, kimonos, ceramics, illustrated books, and **ukiyo-e** prints (images of the "floating world," the realm of geishas and popular entertainment) were beginning to appear in Western European specialty shops, art galleries, and even some department stores. French interest in Japan and its arts reached such proportions by 1872 that the art critic Philippe Burty gave it a name: *japonisme*.

Japanese art profoundly influenced Western painting, printmaking, applied arts, and eventually architecture. Although the tendency toward simplicity, flatness, and the decorative evident in much painting and graphic art in the West between roughly 1860 and 1900 is probably the most characteristic result of that influence, its impact was extraordinarily diverse. What individual artists took from the Japanese depended on their own interests. Thus, James McNeill Whistler, for example, found encouragement for his decorative conception of art (see fig. 22, page 26) while Edgar Degas discovered both realistic subjects and interesting compositional arrangements (see fig. 27-48). Those interested in the reform of late-nineteenth-century industrial design, on the other hand, found in Japanese objects both a technical excellence and a smooth elegance lacking in the West. There were even some, like Vincent van Gogh, who saw in the spare harmony of Japanese art and wares evidence of an idyllic society, which they considered a model for the West (Chapter 28). Perhaps the most strongly influenced were the new printmakers, like Mary Cassatt, who, lacking a strong tradition of their own, often thought of themselves more as part of the Japanese tradition than the Western.

Édouard Manet. *Portrait of Émile Zola*. c. 1868. Oil on canvas, 57⅛ x 44⅞" (145.3 x 113.8 cm). Musée d' Orsay, Paris

Le Déjeuner sur l'Herbe (The Luncheon on the Grass) (fig. 27-43), one of Manet's most famous and controversial paintings, reflects his Baudelairean program. When the jury for the official Salon of 1863 turned down nearly 3,000 works, including Manet's, a storm of protest erupted, prompting Napoleon III to order an exhibition of the refused work called the Salon des Refusés ("Salon of the Rejected Ones"). In that exhibition *Le Déjeuner sur l'Herbe* provoked a critical avalanche that was a mixture of shock and bewilderment.

Manet was no doubt surprised by both the moral outrage and the puzzlement, because he thought his basic intention—which, according to a close friend, was to make a modern version of a highly respectable painting in the Louvre, Giorgione's *Pastoral Concert* (now attributed to Titian)—would be fairly obvious (see "Artistic Allusions in Manet's Art," page 1007). Even with this information, however, what Manet intended by his radical remake of the *Pastoral Concert* remains unclear and a matter of considerable debate. One contested theory sees in the work a portrayal of alienation, not unlike Daumier's *Third-Class Carriage* (see fig. 27-22). The figures in Manet's painting are distant in both their physical and their psychological relationships. Although the man on the right seems to gesture toward his companions, the other man gazes off absently while the nude turns her attention away from them and to the viewer. Moreover, the look she gives us makes us conscious of our role as outside observer; we, too, are estranged. Manet's rejection of warm colors for a scheme of cool blues and greens plays an important role, as do his flat, sharply outlined figures, which seem starkly lit because of the near absence of modeling. The figures are not integrated with their natural surroundings, as in the Titian, but seem to stand out sharply against them, as if seated before a painted backdrop.

Manet may have intended to make a modern version of the popular Renaissance theme of sacred and profane love, a contrast between the higher spiritual love and that of the flesh. Several details in the picture suggest as much. For example, the man on the right makes a curious hand gesture, with his thumb pointing to the clothed woman in the stream and his index finger pointing to the nude. Above the woman in the water, itself a symbol of purity, is a bird, traditionally associated with the spirit. In the lower-left corner, next to the nude's discarded garments, is a frog, often an emblem of the flesh. With these hints, perhaps, Manet fulfills Baudelaire's mandate giving us not only "the passing moment" of a contemporary picnic but "all the suggestions of eternity that it contains." It is worth noting in this regard that the "duality of man," which would include the conflict between the

sacred and the profane, is one of Baudelaire's central concerns in "The Painter of Modern Life."

Claude Monet

While Manet was attempting to paint modern life without breaking entirely with the great art of the past, most of his slightly younger associates sought a completely fresh and unmediated vision. The leader in this quest was Claude Monet (1840–1926). Although Monet studied in the Paris studio of an academician, his real training came at the hands of Barbizon landscape painters such as Charles Daubigny (1817–1878) and a number of lesser-known naturalists associated with them, Eugène Boudin (1824–1898) and Johan Jongkind (1819–1891) in particular. From the latter pair he learned how to transcribe directly his visual sensations of nature. Whereas the Barbizon landscape painters had conceived nature essentially as a "site"—that is, a place—Monet learned to approach it largely as a "sight," something to stimulate the eye.

His early commitment to this conception of landscape painting is evident in *The River* (fig. 27-44). Painted directly from nature at one of the small towns along the Seine River outside Paris, *The River* shows a young woman enjoying the scenery. Monet, unconcerned with who she is and what she might be feeling, treats her simply as another of the color patches that make up the landscape. The most important of these are found in the broken reflections in the water of the town and sky. Monet, less interested in the village than he is in its reflection, chose a view that largely obscures the village behind a screen of trees.

Monet was more interested in the shifting play of light on the surface of the object and the light's effect on the eye than the actual depiction of physical objects. One of the painters he later befriended remembers him offering this advice:

> "When you go out to paint, try to forget what objects you have before you—a tree, a house, a field, or whatever. Merely think, Here is a little square of blue, here an oblong of pink, here a streak of yellow, and paint it just as it looks to you, the exact color and shape, until it gives your own naive impression of the scene before you."
>
> He [Monet] said he wished he had been born blind and then had suddenly gained his sight so that he could have begun to paint in this way without knowing what the objects were that he saw before him. He held that the first real look at the *motif* was likely to be the truest and most unprejudiced one. (cited in Janson, page 908)

Two important ideas are expressed here. One is that a quickly painted oil sketch most accurately records a landscape's general appearance. This view had been a part of academic training since the late eighteenth century, but such sketches were considered merely one part of the preparation for a finished work. In essence, Monet attempted to raise these traditional "sketch aesthetics" to the same level as a completed painting. As a result, the major criticism directed against him was that his paintings

27-44. Claude Monet. *The River*. 1868. Oil on canvas, 32⅛ x 39⅝" (81.6 x 100.6 cm). The Art Institute of Chicago
Potter Palmer Collection

27-45. Claude Monet. *Monet's House at Argenteuil*. 1873. Oil on canvas, 23¾ x 28⅞" (60.3 x 73.3 cm). The Art Institute of Chicago
Mr. and Mrs. Martin A. Ryerson Collection

were not "finished." The second idea, that art benefits from a naive vision untainted by intellectual preconceptions, was a part of both the naturalist and the realist traditions, from which his work evolved. Both Corot and Courbet had expressed a similar desire to regain the unprejudiced vision of the child. Monet could never achieve such a childlike vision, however. Despite his stated objective he looked at the world largely through the eyes of an upper-middle-class tourist, as can be seen in *The River*. One factor in Monet's enormous popularity is the way he implicitly puts the viewer in the position of someone on holiday enjoying a beautiful scene. As one critic remarked, Monet never painted weekdays. The son of a grocer, he had an ardent desire to rise in society that is often reflected in his work. *Monet's House at Argenteuil* (fig. 27-45), a somewhat

27-46. Camille Pissarro. *A Cowherd on the Route du Chou, Pontoise.* 1874. Oil on canvas, 21⅝ x 36¼" (55.5 x 93 cm).
The Metropolitan Museum of Art, New York
Gift of Edna H. Sachs

later work than *The River*, is an example. On one level the painting is simply a feast for the eye. In his search for ways to capture the shimmering appearance of sunlight in a world of constant flux, Monet around 1870 largely eliminated dark colors from his palette and progressively reduced his brushwork from broad planes to smaller strokes and touches. Compared with *The River*, Monet's *House at Argenteuil* is thus both a more scrupulous record of nature's appearance and a more dazzling display of its visual delights.

Monet's *House at Argenteuil* is hardly a "pure" vision, however, for beneath its surface is a scene eloquent with **iconographic** implications. It was painted in the garden of his new residence in one of Paris's burgeoning suburbs. Although he continued to borrow money from friends and patrons, his growing success allowed him to rent this fairly substantial and impressive property. His wife, in the doorway, and daughter, in the yard, are extremely well dressed, indicating not only their new station but that the day is a special one, probably a Sunday or holiday. More than an innocent vision, then, the painting records Monet's social aspirations and thereby locates the viewer, too, as the satisfied and idle proprietor of this beautiful and charming French home.

Monet's financial situation was far from secure, however. An economic boom that had buoyed art prices and sales in the early 1870s was waning, prompting Monet to revive an idea he and friends had considered in the late 1860s, the formation of an independent society to exhibit and market their art. In 1874 thirty artists exhibited 165 works in Nadar's studio. One of Monet's entries, *Boulevard des Capucines, Paris* (see fig. 25, page 28), is a view from the studio's window. Hoping to avoid being falsely identified with a single philosophy or movement, they called themselves a Corporation [Société Anonyme] of Artists, Painters, Sculptors, and Engravers. One critic, however, inspired by Monet's *Impression, Sunrise* (1872), titled his review "Exhibition of Impressionists," and the term *Impressionist* was quickly adopted as a convenient, if not entirely accurate, label for all those who participated in the 1874 show and the seven subsequent exhibitions Monet and his circle organized between 1874 and 1886.

Camille Pissarro

The oldest member of the group, Camille Pissarro (1830–1903), began his career under the influence of Corot's naturalism. In 1864 and 1865 Pissarro exhibited at the Salon as a "pupil of Corot," but the two had a falling-out shortly thereafter as a result of Pissarro's growing interest in the way Courbet opposed light and dark masses. The dark, Courbet-influenced phase of Pissarro's career gave way to an early Impressionist phase in 1870. In that year he and Monet were both living in London, having fled there to escape the Franco-Prussian War. Influenced by John Constable, J. M. W. Turner, and other British landscape painters, they worked closely together, dedicating themselves, as Pissarro later recalled, to "plein air [outdoor], light and fugitive effects." The result, for both painters, was a lightening of color and a loosening of paint handling. After the Franco-Prussian War, Monet and Pissarro returned to France, where they continued to work together on occasion for mutual inspiration.

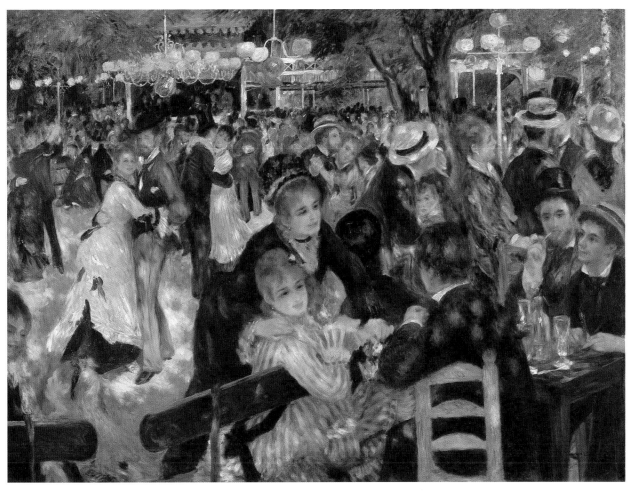

27-47. Pierre-Auguste Renoir. *Moulin de la Galette*. 1876. Oil on canvas, 4'3½" x 5'9" (1.31 x 1.75 m). Musée d'Orsay, Paris

Pissarro's particular brand of Impressionism had stronger ties to the naturalism of Corot and the Barbizon painters than that of any of his younger colleagues. Reflecting these influences, after his return to France Pissarro settled in Pontoise, a small village not far from Argenteuil but decidedly more agrarian. The works he produced there in the 1870s, such as *A Cowherd on the Route du Chou, Pontoise* (fig. 27-46), are typically Impressionist in their high-keyed color, short brushstrokes, and direct appeal to the eye, but the narrow range of soft greens and blues is closer to Corot than to Monet. An important feature of the painting, the woman with the cow, demonstrates Pissarro's adherence to the previous generation's conception of the landscape as a place where peasants live and work, not simply a vacationer's source of visual pleasure.

Pierre-Auguste Renoir

More typical of the Impressionists in his proclivity for scenes of upper-middle-class recreation is Pierre-Auguste Renoir (1841–1919). The son of a tailor, Renoir met Monet at the École des Beaux-Arts after enrolling in 1862. Despite his early predilection for figure painting in a softened, Courbet-like mode, the affable Renoir was encouraged by his more forceful friend Monet to follow his lead in the creation of pleasant, light-filled land-

scapes painted outdoors. By the mid-1870s Renoir was combining Monet's lessons in the rendering of natural light with his own taste for the figure.

Moulin de la Galette (fig. 27-47), for example, features dancers dappled in bright afternoon sunlight. The Moulin de la Galette (the "Pancake Mill"), in the section of Paris called Montmartre, was an old-fashioned Sunday afternoon dance hall, which during good weather made use of its open courtyard. Renoir has glamorized its normally working-class clientele by replacing them with his young artist friends and their models. Typical of Renoir's work of the period, these attractive members of the middle class are shown in attitudes of relaxed congeniality, smiling, dancing, and chatting. The innocence of their flirtations is underscored by the children in the lower left. The lack of tension in their relations is emphasized by the relaxed informality of the composition itself. The painting is knit together not by figural arrangement but by the overall mood, the sunlight falling through the trees, and by the way Renoir's soft brushwork weaves his blues and purples through the crowd and across the canvas. This idyllic image of a carefree age of innocence, a kind of paradise, nicely encapsulates Renoir's essential notion of art: "For me a picture should be a pleasant thing, joyful and pretty—yes pretty! There are quite enough unpleasant things in life without the need for us to manufacture more" (cited in Hanson, page 38).

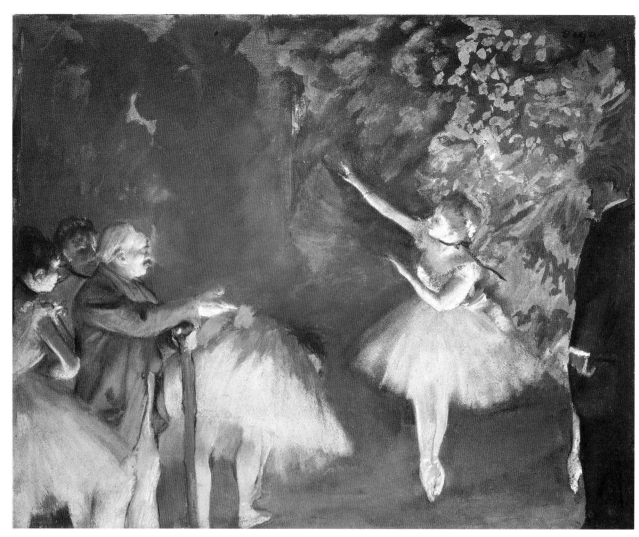

27-48. Edgar Degas. *Ballet Rehearsal*. c. 1874. Gouache and pastel over monotype, 21¾ x 26¾" (55.3 x 68 cm). The Nelson-Atkins Museum of Art, Kansas City, Missouri
Acquired through the Kenneth A. and Helen F. Spencer Foundation Acquisition Fund

Edgar Degas

The Impressionist whose work most severely tests the legitimacy of the label is Edgar Degas (1834–1917). The son of a Parisian banker, Degas was closer to Manet than to the other Impressionists in age and social background. He entered the École des Beaux-Arts in 1855 but soon became dissatisfied with its conservatism and left to study on his own. His friendship with Manet, whom he met in 1862, and with the realist critics in his circle, turned him gradually toward the depiction of contemporary life. After a period during which he specialized in psychologically probing portraits of friends and relatives, he turned his attention in the 1870s to a range of Paris amusements, including the music hall, opera, ballet, circus, and racetrack. Although a few of these works record the sadder aspects of the times, Degas began to think of art less as a mirror held up to the world than as a lofty form of entertainment that employed realistic elements. The very subjects of his work suggest something of this.

The best known of his themes is the ballet, an entertainment that played an important role in upper-middle-class social life at that time. Although he sometimes painted performances, Degas's main interest was in scenes of the work that preceded them. From a collection of carefully observed, realistic studies of individual dancers and striking groupings, Degas arranged, in effect, his own visual choreography. *Ballet Rehearsal* (fig. 27-48), for example, is not a factual record of something seen but a careful contrivance, inspired partly by Japanese prints (see "*Japonisme*," page 1008), and was intended to delight the eye. In this respect Degas's pictorial intentions are generally consistent with those of his Impressionist colleagues. But unlike their works, which depend on colored light and the principle of regularity and agreement, his paintings rely on a combination of unusual figural groupings and sharply differing bodily attitudes. *Ballet Rehearsal* is built around the counterpoint between the static, aging, and earthbound ballet master and the dynamic, ethereal beauty of the student he observes. The tightly compacted and darkly silhouetted group around him, which includes a flatfooted and awkwardly bending dancer, provides additional visual foils for the open, airy, and more conventionally beautiful elements on the right. The man at the right margin, who also contrasts with the dancer, is included largely to balance the overall composition. Finally,

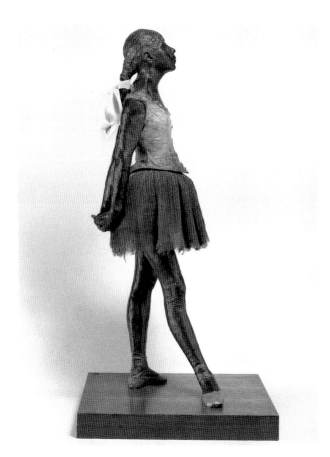

27-49. Edgar Degas. *Little Dancer Fourteen Years Old*. 1880–81. Bronze with gauze tutu and satin hair ribbon, height 39¹/₂" (100.3 cm). The Norton Simon Museum, Pasadena, California

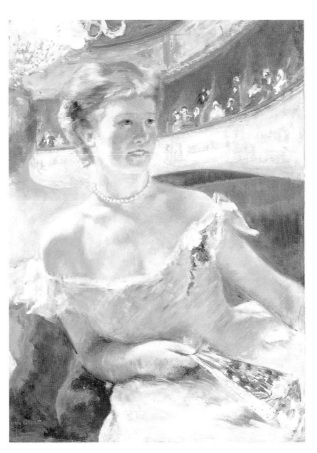

27-50. Mary Cassatt. *Lydia in a Loge, Wearing a Pearl Necklace*. 1879. Oil on canvas, 31⁵/₈ x 23" (80.3 x 58.4 cm). Philadelphia Museum of Art
Bequest of Charlotte Dorrance Wright

the whole is pulled together and further embellished by the unusual stage lighting from below and by the touches of blue and red in the curtain and costumes. The colorful sashes and black throat ribbons that enliven this and so many of his rehearsal scenes were Degas's inventions.

Although Degas's works most directly address the spectator's eye, they also evoke an empathetic sense of movement. The perceived difference between the ballet master and the lead dancer in *Ballet Rehearsal* is more than purely visual. Degas makes it possible for us to intuit something of what it might feel like to be his subjects as they rest, twist, bend, stretch, or elevate on point. His acute sensitivity to bodily feeling apparently led him during the 1870s to begin experimenting in the more tactile medium of sculpture. After his death about 150 small clay figures of ballerinas, bathers, and horses were found in his studio. These had been made not for exhibition and sale but for purposes of study.

Degas exhibited only one piece of sculpture during his lifetime, a piece in wax of a young dancer, which he showed at the 1881 Impressionist exhibition. After his death this work, called *Young Dancer Fourteen Years Old* (fig. 27-49), was cast in bronze. The original was done in the hyperrealistic mode now identified with wax museums. The figure was adorned with actual slippers, a gauze skirt, and a silk bodice. The real hair on her head was tied in a cloth ribbon. In the bronze cast all that

remains of this extreme verisimilitude is the cloth skirt and hair ribbon. The young girl stands with her arms clasped behind her. She pulls back her shoulders, stretching her upper chest, while turning the foot of her extended leg. Because her head is up and her eyes closed, her mind appears fully preoccupied with the purely physical sensations her complex pose entails.

Mary Cassatt

Another artist who showed with the Impressionists was the American expatriate Mary Cassatt (1845–1926). After studying at the Pennsylvania Academy of the Fine Arts in Philadelphia between 1861 and 1865, Cassatt moved to Paris, where she lived for most of the rest of her life. The realism of the figure paintings she exhibited at the Salons of the early and middle 1870s attracted the attention of Degas, who invited her to participate in the fourth Impressionist exhibition, in 1879. Although she, like Degas, rejected the Impressionist label, her distaste for what she called the tyranny of the Salon jury system made her one of the group's staunchest supporters. Cassatt focused her work on the world to which she had access, the domestic and social life of well-off women.

One of the two paintings she exhibited in 1879 was *Lydia in a Loge, Wearing a Pearl Necklace* (fig. 27-50). The

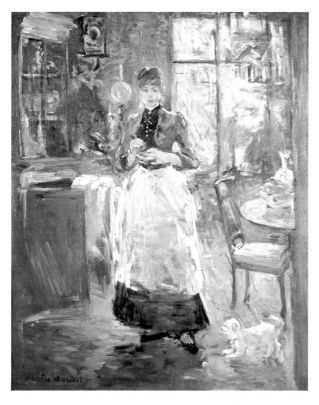

27-51. Berthe Morisot. *In the Dining Room*. 1886. Oil on canvas, 24¹/₈ x 19³/₄" (61.3 x 50.2 cm). National Gallery of Art, Washington, D.C.
Chester Dale Collection

glasses trained not on the stage but on the crowd around them, scanning it for other elegantly dressed socialites. As Garnier had noted, his new Opéra (see fig. 27-5) was designed partly as an appropriate backdrop for just the kind of display in which Lydia is here engaged.

Berthe Morisot

Berthe Morisot (1841–1895) also was a prominent French Impressionist artist. Unlike Cassatt, who seems to have decided early on to be a professional, Morisot came to this decision only after a considerable period of painting in the amateur role that was conventional for women at that time (see "The Tradition of the Amateur Artist," below). Morisot and her sister, Edma, studied with a minor drawing master in 1857. Admirers of the Barbizon painters, Berthe and Edma then studied with Corot for three years, beginning in 1860. The sisters showed in the five Salons between 1864 and 1868, the year they met Manet. In 1869 Edma married, and, following the traditional course, gave up painting to devote herself to domestic duties. Berthe, on the other hand, continued painting after her 1874 marriage to Manet's brother, Eugène. In the same year she joined the Impressionists, against the advice of Manet, who thought their independent society misguided, and she showed in all but one of their subsequent exhibitions.

Under the influence of Manet and the Impressionists Morisot adopted a looser, more **painterly** style to replace the Corot-influenced style in which she had been working. Like Cassatt, she focused on women and domestic scenes, such as that of *In the Dining Room* (fig. 27-51). Through this subject matter she sought to demonstrate that women had a unique vision, which, she said, was "more delicate than that of men." Her touch, although vigorous, is lighter than that of her male colleagues, and her colors are gentler, with a tendency to pastels. The brushwork of *In the Dining Room* calls attention to the act of painting itself. Both the subject and the style of *In the Dining Room* subtly insist that women be taken serious-

model for the painting was Cassatt's sister, who had recently come to live with her. The painting's bright and luminous color, fluent brushwork, and urban subject were no doubt chosen partly to demonstrate her solidarity with her new associates. Renoir had exhibited a very similar image of a woman at the opera in 1874. *Lydia in a Loge* is an attempt to capture a glamorous aspect of Parisian social life. Reflected in the mirror behind Lydia are other women and men in their boxes, some with opera

THE TRADITION OF THE AMATEUR ARTIST

Amateur describes artists, women and men, who draw and paint for their own pleasure (and sometimes because of social expectations), not to make a living from their art. The tradition of the amateur artist is long and honorable; only in our century has the word *amateur* acquired some negative connotations.

Jean-Jacques Rousseau, writing in France at the end of the eighteenth century, was highly influential in prescribing educational goals that fostered amateur artists, especially women (see "Jean-Jacques Rousseau on Educating Children," page 955).

For at least 200 years, as part of their preparation for married life, European women of the upper classes were usually tutored in drawing and watercolor—both mediums being portable and needing little equipment. The depiction of family, friends, vignettes of daily life, and scenes from their travels was accepted by both men and women as an effective and virtuous way for women to sharpen and cultivate sensibilities that would make them "accomplished" women (and, it was assumed, wives and mothers). While in the nineteenth century in particular women were expected to give up their art after marriage, those who continued to pursue it could do so as amateurs—that is, as artists who

painted or drew or sculpted as a pastime, not as an occupation—and still be considered "respectable" according to the strict social codes of the period.

It is against this backdrop that women such as Rosa Bonheur (see fig. 27-17), Mary Cassatt, and Berthe Morisot (and many others whose works, ignored for so long, have recently begun to be discussed) came forward as professional artists, earning their living from their work. In France and England many women artists, amateur and professional, showed their work in official exhibitions. In 1855, for example, 133 works by women were included in the Paris Salon.

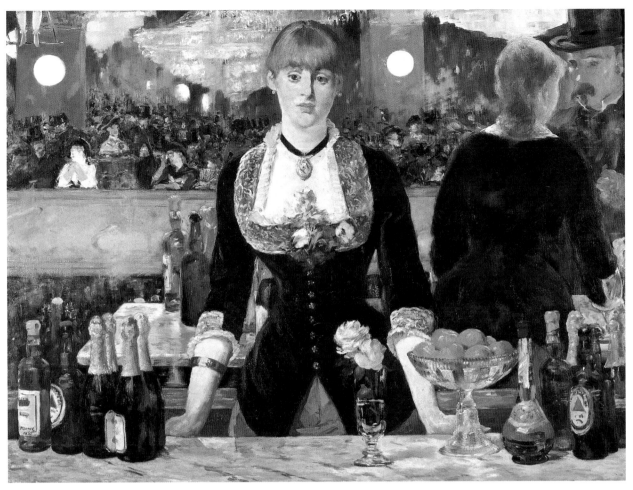

27-52. Édouard Manet. *A Bar at the Folies-Bergère*. 1881–82. Oil on canvas, 37³/₄ x 51¹/₄" (95.9 x 130 cm). Courtauld Institute Galleries, London
Home House Collection

ly for their work. Morisot sought an equality for women that she felt men refused to cede. Late in life she commented: "I don't think there has ever been a man who treated a woman as an equal, and that's all I would have asked, for I know I'm worth as much as they" (cited in Higonnet, page 19).

Later Impressionism

Many Impressionists, including Morisot, continued throughout their careers to work in the manner they developed around 1870. In the years after 1880, however, some began to reconsider their earlier approaches or make important adjustments to them.

Even before what historians now call the crisis of Impressionism, Manet was quietly objecting to its essentially cheerful terms. During the 1860s Manet had engaged in a dialogue with the art of the past, as his *Le Déjeuner sur l'Herbe* (see fig. 27-43) attests. After about 1870 he embraced his younger colleagues' brighter palette, and he seems to have adopted as well their more direct approach to modern life. But behind his apparent participation in the Impressionist movement lay a commitment, conscious or not, to use their essentially optimistic interpretation of modern life as the new foil for his more pessimistic one.

The last major painting of Manet's career, *A Bar at the Folies-Bergère* (fig. 27-52), for example, contradicts the happy aura of works such as *Monet's House at Argenteuil* (see fig. 27-45), *Moulin de la Galette* (see fig. 27-47), and *Lydia in a Loge* (see fig. 27-50). The painting features one of the barmaids at the Folies-Bergère, a large nightclub with a series of bars arranged around a theater that offered what would later in America be called vaudeville acts. Reflected in the mirror behind the barmaid is part of the elegant crowd, many identifiable as Manet's friends, watching a trapeze act. (The legs of one of the performers can be seen in the upper left.) On the bar itself Manet has placed an assortment of objects, from champagne bottles to tangerines and flowers, that characterize the pleasures for which the place was famous.

The items on the bar are associated not only with the place but with the barmaid herself, whose hips, strong neck, and closely combed golden hair are echoed in the champagne bottles. Her demeanor, however, refutes these associations. Manet puts the viewer directly in front of her, in the position of her customer. She neither smiles at this customer, as her male patrons and employers expected her to do, nor gives the slightest hint of recognition. She appears instead to be self-absorbed and downcast. Her reflection and that of her customer in the

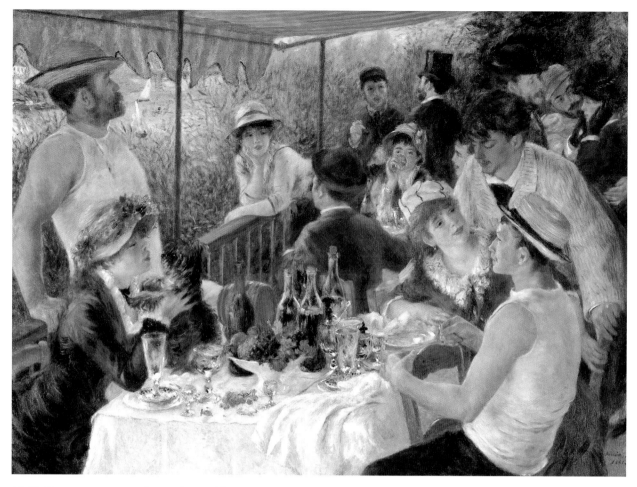

27-53. Pierre-Auguste Renoir. *Luncheon of the Boating Party*. 1881. Oil on canvas, 4'3" x 5'8" (1.3 x 1.7 m). The Phillips Collection, Washington, D.C.

mirror behind her and to the right, in contrast, tells a different story. There, she leans toward the patron, whose intent gaze she appears to meet; the physical and psychological distance between them has vanished. Exactly what Manet meant to suggest by this juxtaposition has been much debated. One possibility is that he wanted to contrast poignantly the longing for happiness and intimacy with the disappointing reality of ordinary existence.

What many of the Impressionists themselves found objectionable in their earlier art was not its truth value but its lack of permanence. One of the first to reject Impressionism for something that could compete with the classic art of the past was Renoir. The shift in his work is first signaled in *Luncheon of the Boating Party* (fig. 27-53), the last in a series of works he produced at Chatou on the theme of boating. The village on the Seine just outside Paris had become a favorite site for those Parisians interested in the new vogue for rowing. Here, Renoir depicts a group of rowers, in short sleeves and straw hats (known as boaters), and their friends on the terrace of the popular Restaurant Fournaise, located on the island that divided the Seine at Chatou. The company has gathered on this glorious summer day for refreshments and for the company of other beautiful young men and women. The painting, which again features an assortment of male artist friends and female models, is the suburban equivalent of *Moulin de la Galette* (see fig. 27-47).

Despite the fundamental similarity of conception and the persistent combination of sensual brushwork and lush color, *Luncheon of the Boating Party* differs from earlier works such as *Moulin de la Galette* in two fundamental respects. First, the elements, especially the figures, are more solidly and conventionally defined. The arm of the male seated in the foreground, for example, has a descriptive clarity and solidity not seen in Renoir's work since the late 1860s. Second, the composition, too, is more conservative. Beneath the apparent informality is a variation on the traditional pyramidal structure advocated by the academies. A small triangle whose apex is the woman leaning on the rail is set within a larger, somewhat looser one that culminates in the two men in the rear. Thus, instead of a moment quickly scanned in passing (an impression), Renoir creates a more stable and permanent scene.

The direction signaled by this work was confirmed and further encouraged by Renoir's subsequent visit to Italy in late 1881 and early 1882. In particular, the paintings by Raphael that he saw there made him reconsider his commitment to contemporary themes. Renoir became convinced that, unlike the enduring themes of Renaissance art, his records of modern life were too bound to their time to maintain the interest of future viewers. He therefore began to focus on the nude, a subject more difficult to locate in a particular time and place.

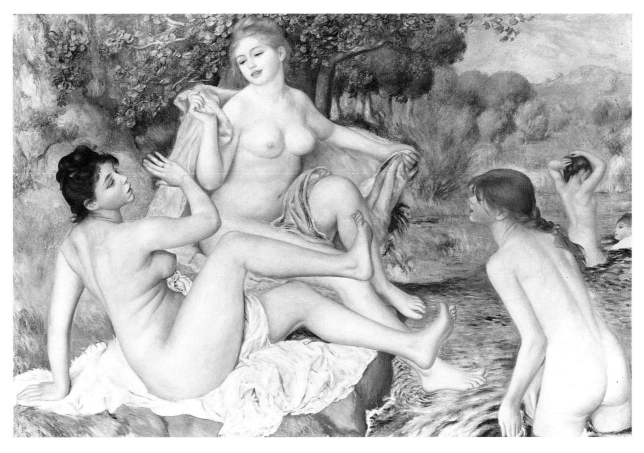

27-54. Pierre-Auguste Renoir. *Bathers*. 1887. Oil on canvas, 3'10 3/8" x 5'7 1/4" (1.18 x 1.71 m). Philadelphia Museum of Art
Mr. and Mrs. Carroll S. Tyson Collection

The first of these was *Bathers* (fig. 27-54). The stable, pyramidal grouping of three female bathers was based on a seventeenth-century sculpture by François Girardon at Versailles (see fig. 19-27). This source clearly indicates Renoir's new commitment to the classical tradition of the female nude that originated in the Hellenistic period and was first adopted by French artists during the reign of Louis XIV. The work is perhaps closer to Bouguereau's *Nymphs and a Satyr* (see fig. 27-7) than to *Moulin de la Galette*, although the nudes are certainly more innocent than those in Bouguereau's work.

The women are shown from three different views—front, back, and side—a convention that had been established in countless paintings of the Three Graces. Their chiseled contours also reflect a move toward academicism. Only the more loosely brushed landscape, the high-keyed colors, and the women themselves, who could be contemporary Parisians on the banks of the Seine, prevent the painting from being a wholesale rejection of Impressionism.

Cassatt, too, in the period after 1880 moved toward a firmer handling of form and more classic subjects. The shift is most apparent in her new focus on the theme of mother and child. In *Maternal Caress* (fig. 27-55), for

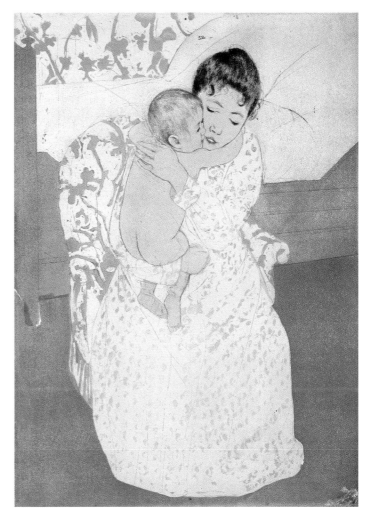

27-55. Mary Cassatt. *Maternal Caress*. 1891. Drypoint, soft-ground etching, and aquatint, 14 3/4 x 10 3/4" (37.5 x 27.3 cm). National Gallery of Art, Washington, D.C.
Rosenwald Collection

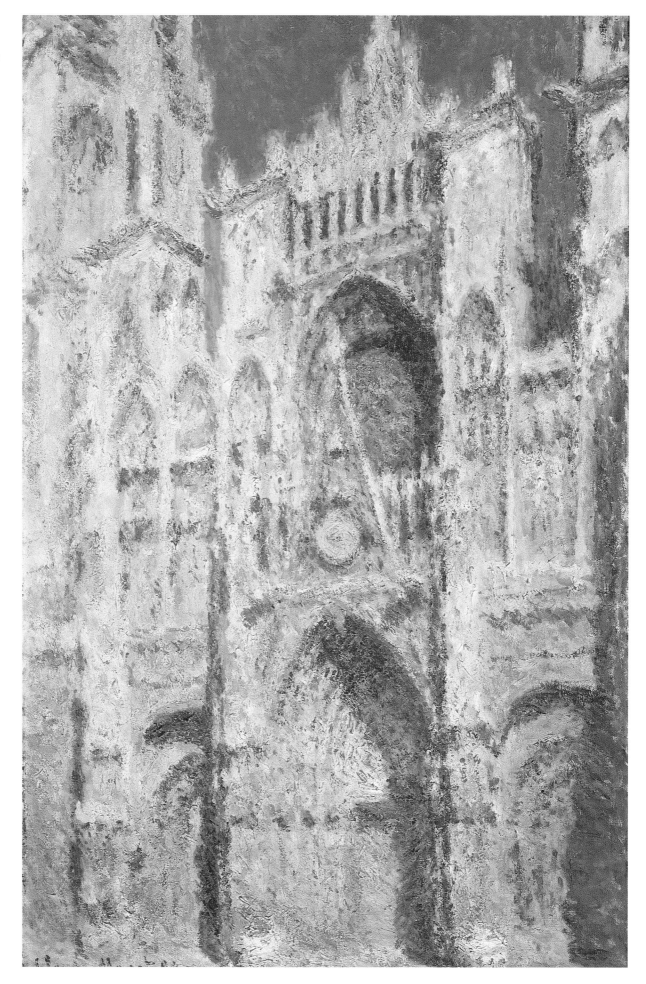

27-56. (opposite) Claude Monet. *Rouen Cathedral: The Portal (in Sun)*. 1894. Oil on canvas, 39¼ x 26" (99.7 x 66 cm). The Metropolitan Museum of Art, New York

Theodore M. Davis Collection, bequest of Theodore M. Davis

example, one of the many colored prints she produced in her later career, we see her sensitive response to the tradition of the Madonna and Child. Apparently fresh from the bath, the plump infant shares a tender moment with its adoring mother. Their intimacy is underscored by the subtle harmony of apricots and browns. Even the pairing of decorative patterns reinforces the central theme.

These patterns, like the work's simple contours and sharply sloping floor, derive from Japanese prints. Works such as *Maternal Caress* appear to be Cassatt's Western answer to the work of Japanese printmakers such as Utamaro (see fig. 7, page 19). As such, they apparently aim at not only the timeless but the universal. Like Renoir, she, too, moved far from her early commitment to depicting only contemporary moments.

Even Monet, who at first appeared immune to the growing crisis of Impressionism, eventually responded to it in the choice of some of his themes. During the 1880s he continued to record the transitory appearance of nature's more beautiful sites. In 1890 he appeared to take his brand of Impressionism even further with two series devoted to single themes, one to the haystack and the other to the poplars along a riverbank. Each painting concentrates on the light effects observable at a single instant in time. The two series thus seem to insist that

time is but a collection of unique moments with little relation to one another. Monet, however, may have been exploring not only the singular beauty of each isolated moment, but also the underlying continuities that link them. The poplar, for example, known as the Tree of Liberty during the French Revolution, had strong and enduring associations in France. The graceful **S** curves that dominate the paintings likewise have their counterparts in French Rococo art of the eighteenth century, which was then undergoing a revival.

Monet's apparent desire to place Impressionism within the great traditions of French art is most evident in a third series of paintings, this one devoted to the play of light over the variegated facade of Rouen Cathedral (fig. 27-56). The subject is unusual for Monet. Although he painted it with dazzling colors, the stony surface of the cathedral, unlike a row of poplars, actually has little color. Monet apparently chose the subject not for its coloristic appeal but for its iconographic associations. The building symbolizes the continuity of human institutions such as the Church and the enduring presence of the divine. And like the Rococo, the Gothic style of the cathedral originated in France in the Paris region. In effect, *Rouen Cathedral: The Portal (in Sun)* seems to argue that beneath the shimmering, insubstantial veneer of shifting appearances is a complex web of durable and expanding connections. Thus, while Renoir, Cassatt, and others were moving away from Impressionism, Monet was apparently trying to place it in a more enduring, coherent context. This pattern of rejection and reform is evident, as well, in the works of the next generation of French artists, the Post-Impressionists.

1880 1890 1900 1910

Rodin
Burghers of Calais
1884–86

van Gogh
The Starry Night
1889

Munch
The Scream
1893

Picasso
*Les Demoiselles
d'Avignon*
1907

Gilb
Woolworth Build
1911–

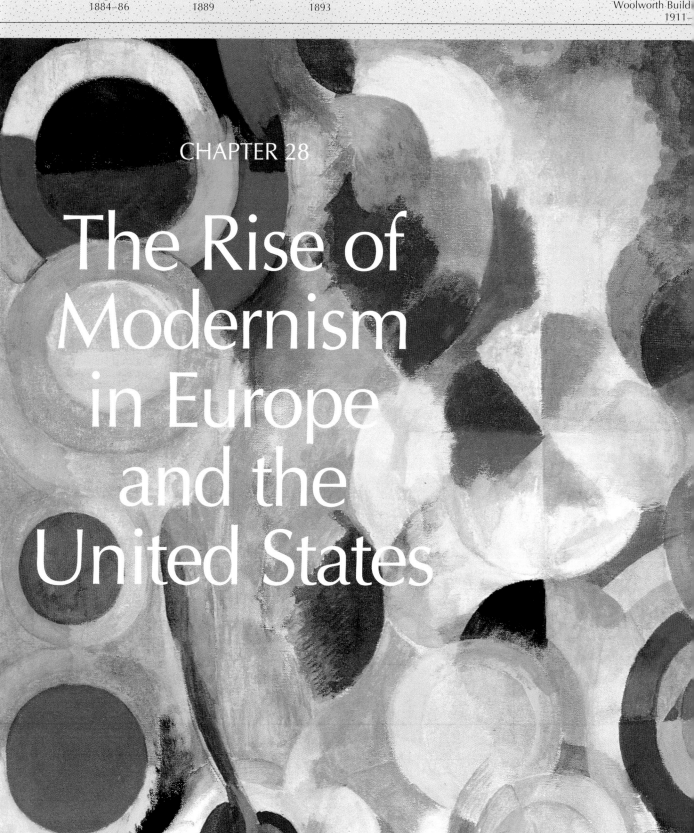

CHAPTER 28

The Rise of Modernism in Europe and the United States

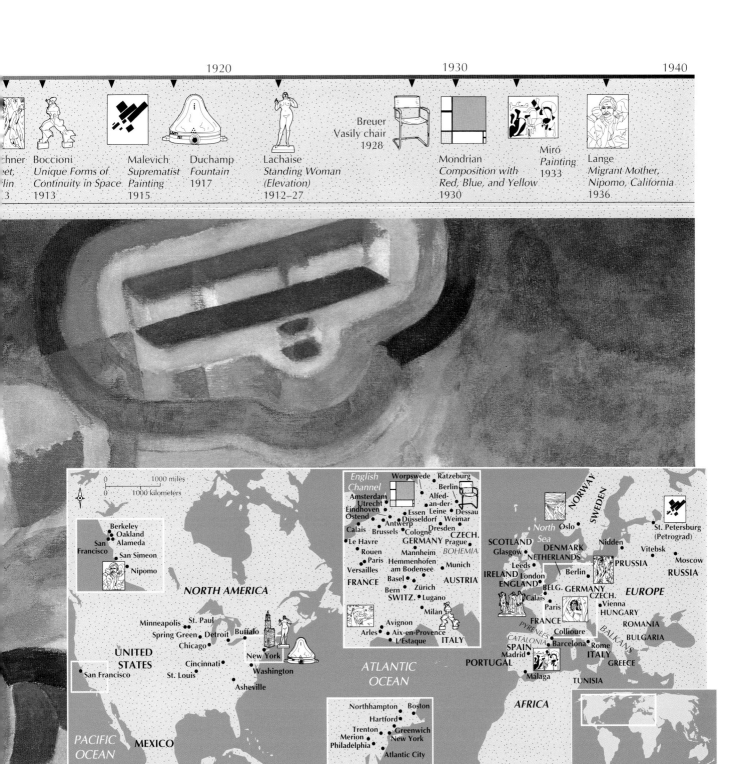

chner
et,
lin
3

Boccioni
*Unique Forms of
Continuity in Space*
1913

Malevich
*Suprematist
Painting*
1915

Duchamp
Fountain
1917

Lachaise
*Standing Woman
(Elevation)*
1912–27

Breuer
Vasily chair
1928

Mondrian
*Composition with
Red, Blue, and Yellow*
1930

Miró
Painting
1933

Lange
*Migrant Mother,
Nipomo, California*
1936

Map labels:

0 — 1000 miles
0 — 1000 kilometers

Berkeley
Oakland
Alameda
San Francisco
San Simeon
Nipomo

NORTH AMERICA

Minneapolis St. Paul
Spring Green Detroit Buffalo
Chicago
UNITED
STATES
San Francisco Cincinnati
St. Louis
New York
Washington
Asheville

PACIFIC
OCEAN

MEXICO

Mexico City

ATLANTIC
OCEAN

Northhampton Boston
Hartford
Trenton Greenwich
Merion New York
Philadelphia
Atlantic City

English
Channel
Worpswede Ratzeburg
Berlin
Amsterdam Alfed-
Utrecht an-der-
Eindhoven Essen Leine Dessau
Ostend Antwerp Düsseldorf Weimar
Calais Brussels Cologne Dresden
Le Havre GERMANY Prague CZECH.
Rouen Mannheim BOHEMIA
Paris Hemmenhofen Munich
Versailles am Bodensee
FRANCE Basel AUSTRIA
Bern Zürich
SWITZ. Lugano
Milan
Avignon
Arles Aix-en-Provence ITALY
L'Estaque

NORWAY
SWEDEN
North Oslo
Sea Nidden
SCOTLAND DENMARK
Glasgow NETHERLANDS
Leeds Berlin
IRELAND London PRUSSIA
ENGLAND BELG. GERMANY
Calais CZECH.
Paris Vienna
FRANCE HUNGARY
PYRENEES Collioure ROMANIA
CATALONIA Barcelona BULGARIA
SPAIN Madrid ITALY Rome
PORTUGAL GREECE
Málaga TUNISIA

St. Petersburg
(Petrograd)
Vitebsk
Moscow
RUSSIA
EUROPE
BALKANS

AFRICA

28-1. Marcel Duchamp.
 Fountain. 1917.
 Porcelain plumbing
 fixture and enamel
 paint, height 24⅝"
 (62.23 cm). Photo-
 graph by Alfred
 Stieglitz. Philadelphia
 Museum of Art
 Louise and Walter
 Arensberg Collection

As the American Society of Independent Artists prepared for its first annual exhibition, in 1917, its members were committed to a large, unjuried show. Any artist who paid six dollars could enter a work in its exhibition. But members of the society were stunned, some even outraged, when a work titled *Fountain*, signed "R. Mutt" and accompanied by the entry fee, turned out to be a urinal mounted in such a way as to be seen from above (fig. 28-1).

In fact, *Fountain* was submitted by Marcel Duchamp, a founding member of the society and chair of the hanging committee, among other reasons, to see just how open the members really were. Duchamp, who strongly believed that art is a matter of what the head creates, not what the hand makes, bought the fixture made by the J. L. Mott Iron Works, signed it "R. Mutt," and submitted it under that name. Because some members of the society considered it gross, offensive, and even indecent, the work was refused. The decision did not surprise Duchamp.

Fountain was more than a cynical vexation, however. In a small journal he helped found, Duchamp published a letter on the Mutt case refuting the immorality charge and wryly noting: "The only works of Art America has given are her plumbing and her bridges." In a more serious vein, he added: "Whether Mr. Mutt with his own hands made the fountain or not has no importance. He CHOSE it. He took an ordinary article of life, placed it so that its useful significance disappeared under the new title and point of view—and created a new thought for that object" (cited in Harrison and Wood, page 248).

Confronted by *Fountain* and other jarringly innovative works, viewers who had previously debated standards for judging the aesthetic quality of works of art found themselves challenged even to define the term *art*.

28-2. Paul Cézanne. *The Battle of Love.* c. 1880. Oil on canvas, 14 7/8 x 18 1/2" (37.8 x 47 cm). National Gallery of Art, Washington, D.C.

Gift of Averell W. Harriman in memory of Marie N. Harriman

WHAT IS MODERNISM?

The years between 1880 and the outbreak of World War II in 1939 witnessed a dizzying proliferation of different styles and artistic movements in Western European art and architecture. These various tendencies, often consciously at odds with one another, are nevertheless traditionally grouped under a common label, *modernism*. Like the word *Romanticism*, the term *modernism* is a disputed one, with neither an authoritative definition nor an entirely agreed-upon time frame. The most useful way to think of modernism, perhaps, is to consider it a collection of artistic and architectural tendencies that shared two general but fundamental characteristics. Artists and architects are here considered modernists if their work exhibits at least one of these.

The first modernist characteristic was a commitment to progressive formal innovation. In general, each generation of modernists attempted to develop the most original aspects of the styles initiated by its immediate predecessors, in the belief that it was thereby advancing or culminating the mainstream, that is, the central, dominant line of artistic innovation (see "The Idea of the Mainstream," page 1110). Because there were often competing notions of what the mainstream was, the fields of art and architecture were multifaceted and constantly changing. The second modernist characteristic was the belief that art could address the problems of modern life. Modernists disagreed, however, on what those problems were and how best to respond to them. In short, modernism should perhaps be considered the sum of the various competing expressions of artists and architects who, despite their very real differences, nevertheless shared a fundamental set of beliefs about art and the world.

An analysis of the career of the French painter Paul Cézanne (1839–1906), generally considered one of the pioneers of modernism, provides a good introduction to some of the basic issues, complexities, and difficulties of the art of this era. Cézanne's early work from around 1870 dealt with a number of violently Romantic themes in a purposefully dark, rough style. Then, under the guidance of one of the Impressionists, Camille Pissarro, Cézanne in 1872 turned outward to the direct transcription of his encounter with nature.

Cézanne's move toward Impressionism, however, did not resolve the psychological conflicts that had generated his tumultuous early work, as can be seen in those rare instances after 1872 when he returned to erotic themes. *The Battle of Love* of about 1880 (fig. 28-2), for example, shows the naked followers of Bacchus, the Roman god of wine, engaged in a violent orgy. Throughout the picture, women are under attack, sometimes by what appear to be other women. Short, brisk brushstrokes and the quick, scalloped rhythms of the cloud and body contours convey the agitation of this unusual scene. Here, the painting style developed by the Impressionists to record optical sensations has been used, instead, to record emotion. Because its effect is nervous rather than violent, the viewer might justifiably conclude that the brushwork has less to do with the aggressive feelings of the combatants than with the artist's own edgy response to sexual issues.

The potential that the quick, loose Impressionist brushstroke had to reveal the inner state of the artist—in the same way a seismograph records earthquakes—would be more fully developed by other painters, such as Vincent van Gogh. Cézanne's commitment to the continuing evolution of Impressionism took a different, although equally radical, form: a movement toward **abstraction**, or **nonrepresentational** art. Many historians have identified the "progress" of modernism in its shift away from the representation of specific things, whether imaginary or real, in favor of an emphasis on the intrinsic characteristics of an artistic medium itself. In painting, this shift meant simply an increasing concern with colored

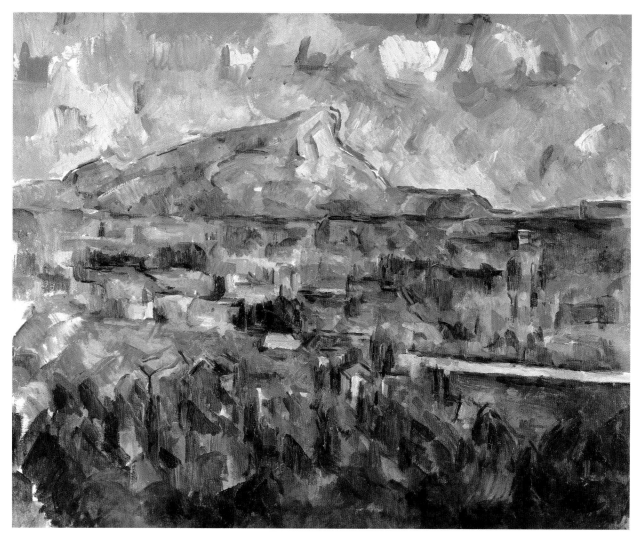

28-3. Paul Cézanne. *Mont Sainte-Victoire.* 1904–6. Oil on canvas, 25¹/₂ x 32" (65 x 81 cm). Private collection, Pennsylvania

After receiving a considerable inheritance upon the death of his father in 1886, Cézanne returned to his hometown, Aix-en-Provence, in the south of France, to avoid the distractions of Paris and its cultural debates. In 1901–1902 he built a studio in the countryside with a large window facing Mont Sainte-Victoire, to facilitate painting the subject that increasingly had come to preoccupy him.

paint and its two-dimensional canvas support. The frankly acknowledged paint surfaces of Cézanne's mature works and his growing disregard for the depiction of specific landscape features, which culminates in late paintings such as *Mont Sainte-Victoire* (fig. 28-3), were major steps in the move toward the completely nonrepresentational art that emerged in the second decade of the twentieth century. Again, it was the Impressionists who had opened this door when they shifted attention away from the subject matter itself to the painted record of how it appears to the viewer.

Although it is tempting to see in *Mont Sainte-Victoire* evidence of Cézanne's ultimate rejection of Impressionist aesthetics for an interest in the paint itself, this and works like it remained firmly grounded in the understanding of the individual brush mark as a record of the artist's immediate "sensation" of nature. What Cézanne apparently objected to in Impressionism was not its theory but its application. He rejected Monet's early preoccupation with nature's sensual surface for what he

referred to in his notebooks as "the concrete study of nature," by which he seems to have meant the investigation of its deeper truths as revealed through experience. Judging from his paintings, Cézanne saw in nature not only its shifting, ever-changing surface but also the solidity and constancy that lay beneath it. This is perhaps what Cézanne meant when he said, "I want to make of Impressionism something solid and durable, like the art of the museums." Cézanne's brushwork reveals the tension between nature's stability and instability. In the middle section of *Mont Sainte-Victoire*, for example, the solid, rectangular strokes, generally applied according to a rigid grid of vertical and horizontal lines, nevertheless form dynamic and irregular contours. Thus, Cézanne was able to define through paint his sense of the essential, or abstract, characteristics of nature behind the changing specifics of appearance.

Cézanne's late work is characterized by a number of such opposites held in tension. He often subtly disrupted his symmetrical and pyramidal compositions by tipping

PARALLELS

Years	Events
1880–1889	Major European colonization of Africa begins; Rodin wins competition for *Burghers of Calais* (France); steel first used in building construction (United States); Neo-Impressionists emerge (France); Seurat's *A Sunday Afternoon on the Island of La Grande Jatte* (France); Richardson's Marshall Field Warehouse (United States); Eastman's box camera (United States); Eiffel Tower (France); Art Nouveau emerges (France); van Gogh's *The Starry Night* (France)
1890–1899	Riis's *How the Other Half Lives* (United States); Roman School of classicists (France); James's book *The Principles of Psychology* (United States); Sullivan's Wainwright Building (United States); McKim, Mead, and White's Boston Public Library; Gropius's facade for Fagus Factory (Germany); Horta's Tassel House (Belgium); World's Columbian Exposition in Chicago; Sino-Japanese War; anti-academic Secession movement begins in France; Hunt's Biltmore estate (United States); Olympic Games reestablished (Greece); Spanish-American War; World of Art group forms in St. Petersburg (Russia); Freud's book *The Interpretation of Dreams* (Austria) and advent of psychoanalysis
1900–1909	Stieglitz organizes Photo-Secession group later known as 291 (United States); Wright brothers' first powered flight (United States); Russo-Japanese War; Fauves named (France); Die Brücke formed (Germany); Golden Fleece group forms in Moscow (Russia); Picasso's *Les Demoiselles d'Avignon* (France); Braque's *Houses at L'Estaque* inspires term *Cubism* (France); Ford's Model T automobile (United States); Ashcan School forms (United States); Braque and Picasso develop Analytic Cubism (France); Futurism emerges (Italy)
1910–1919	Union of South Africa formed; Wright's Taliesin (United States); Kandinsky organizes Der Blaue Reiter (Germany); Braque and Picasso evolve Synthetic Cubism (France); Cubo-Futurism emerges (Russia); Balkan Wars; Republic of China established by Sun Yat-Sen; Gilbert's Woolworth Building (United States); Armory Show launches modernism in the United States; World War I; Sant'Elia's *Manifesto of Futurist Architecture* (Italy); Malevich's *Suprematist Painting* (Russia); Wright's Imperial Hotel in Tokyo (Japan); Einstein's general theory of relativity (Germany); Dada movement begins in Switzerland; de Stijl emerges in the Netherlands; Russian Revolution; Purism emerges (France); worldwide influenza epidemic kills 20 million people; Gropius establishes Bauhaus (Germany)
1920–1929	Census shows more people living in urban than rural United States; League of Nations; Harlem Renaissance (United States); women citizens granted the right to vote in the United States; Constructivist movement (Russia); Leger's *Three Women* (France); Le Corbusier's design for a Contemporary City of Three Million Inhabitants (France); Eliot's poem *The Waste Land* (England); Joyce's novel *Ulysses* (Ireland); Breton's "Manifesto of Surrealism" (France); Griffith's film *America* (United States); Rietveld's Shröder House (Netherlands); Hitler publishes *Mein Kampf* (Germany); John Scopes convicted of teaching evolution in public school (United States); Morgan's San Simeon estate (United States); Hemingway's novel *The Sun Also Rises* (United States); Lindbergh makes first solo trans-Atlantic flight (United States); American Scene Painting emerges; Eisenstein's film *Ten Days That Shook the World* (Russia); Kellogg-Briand Pact, signed by 62 nations, attempts to end war; Mead's book *The Coming of Age in Samoa* (United States); Rivera's murals for the Mexico City Ministry of Education; dirigible *Graf Zeppelin* circles the globe (Germany); stock-market crash in United States signals worldwide economic depression; Woolf's essay *A Room of One's Own* (England); Museum of Modern Art founded (United States)
1930–1939	Mondrian's *Composition with Red, Blue, and Yellow* (Netherlands); Regionalist painters emerge (United States); Huxley's novel *Brave New World* (England); Social Realism in art instituted by Stalin (Russia); Hitler takes dictatorial power in Germany; Malraux's novel *Man's Fate* (France); Stein's *The Autobiography of Alice B. Toklas* (United States); Lange's *Migrant Mother, Nipomo, California*, photographed for Farm Securities Administration (United States); Roosevelt establishes Federal Arts Program (United States); Mitchell's novel *Gone with the Wind* (United States); Spanish Civil War; American Abstract Artists group forms; Renoir's film *The Grand Illusion* (France); Carlson invents xerography (United States); Nazis launch anti-Jewish campaign throughout Germany; Miller's novel *Tropic of Capricorn* (United States); Steinbeck's novel *Grapes of Wrath* (United States); Kahlo's *Two Fridas* (Mexico); Krasner's *Red, White, Blue, Yellow, Black* (United States); World War II

individual elements or placing them unexpectedly, revealing the tension between stability and instability. Heightening this tension is the juxtaposition of warm colors like red and yellow, which appear to come forward, with cool colors like blue, which appear to recede. And there is a spatial tension between two and three dimensions arising from the contradiction between the presumed depth and distance of the features depicted in a painting—the mountain in *Mont Sainte-Victoire*, for example—and the flat painted surface the viewer actually sees.

In the final analysis the exact source and meaning of the unresolved tensions that characterize Cézanne's entire mature output remain unknown. Yet the underlying resemblance between the nervous excitement of *The Battle of Love* and the more contained energy of *Mont Sainte-Victoire* raises an obvious question: To what extent did Cézanne's personal feelings contribute to his findings about nature? Or, phrased differently, did Cézanne merely discover in the external world confirmation of his own conflicted nature?

What makes these questions different from those asked about earlier art is the idiosyncratic nature of both Cézanne's quest and the visual vocabulary he employed to articulate it. By trying to express himself in an innovative and novel fashion, he made it more difficult for both the public and historians to interpret his work. Even Cézanne doubted whether his works could be fully understood by those accustomed to the conventional language of earlier representational art. This would become the chief difficulty, in fact, with much modernist art. In striving to frame universal truths in their own very personal ways, many modernists would, ironically, risk losing the ability to communicate their ideas clearly and well to a wide audience.

POST-IMPRESSIONIST ART

Cézanne, because of the way his work developed out of the Impressionist style of the 1870s, is considered a Post-Impressionist, a term that has two distinct meanings. Narrowly defined, it refers to five painters—Cézanne, Henri de Toulouse-Lautrec (1864–1901), Georges Seurat (1859–1891), Paul Gauguin (1848–1903), and Vincent van Gogh (1853–1890)—who assimilated much from Impressionism but in the end moved beyond its collective aesthetic principles to develop five quite different styles. In this sense, Post-Impressionism, unlike Impressionism, is not a true ism at all but a catchall term for the work of these five artists. Broadly defined, *Post-Impressionist* refers to the period when these five artists were either active or still influential. In this sense the term encompasses the entire generation of innovators, including sculptors and photographers as well as painters, whose principal work falls between about 1880 and 1910.

Auguste Rodin

The most important sculptor of the Post-Impressionist era, as it has been broadly defined, is Auguste Rodin (1840–1917), whose career dates from the mid-1860s but whose work has little in common with that of the five painters of Post-Impressionism narrowly defined. Rodin was rejected three times by the École des Beaux-Arts, but after an 1875 trip to Italy, where he saw the dramatic art of Michelangelo, he began to produce intensely muscular figures in unconventional poses, works that were attacked by the academic critics but were increasingly admired by the general public.

Rodin's status as the leading sculptor in France was confirmed in 1884, when he won a competition for *Burghers of Calais* (fig. 28-4), commissioned to commemorate an event from the Hundred Years' War. In 1347 King Edward III of England had besieged Calais but offered to spare the city if six leading citizens (or burghers)—dressed only in sackcloth with rope halters and carrying the keys to the city—would surrender themselves to him for execution. Rodin shows the six volunteers marching out to what they assume will be their deaths.

The Calais commissioners were not pleased with Rodin's conception of the work because they imagined calm, idealized heroes. Instead, Rodin presented ordinary-looking men in various attitudes of resignation and despair. He expressively lengthened their arms, greatly enlarged their hands and feet, and changed the light fabric he knew they wore into a much heavier one, showing not only how they may have looked but how they must have felt as they forced themselves to take one difficult step after another. Nor were the commissioners pleased with Rodin's plan to display the group at close to ground level. Rodin felt that the usual placement of such figures on a high pedestal suggested that only higher, superior humans are capable of heroic action. By placing the figures at street level, or close to it, Rodin hoped to convey to viewers that ordinary people, too, are capable of noble acts.

In its focus on great historical events that address human themes, Rodin's work looks back to a long tradition that began with the Greeks. *Burghers of Calais* is thus not typical of the art produced during the Post-Impressionist era or later. Although the sculptors and painters who followed him absorbed many of Rodin's specific stylistic innovations, their works increasingly responded to contemporary life rather than the past.

Documenting Modern Life

By 1880 the impact of industrialization on the West was becoming clear. Although modern technology had produced new and unheard-of levels of material well-being, it had also created a new set of human problems. Some involved the hardships of industrial working conditions, while others were connected with the growth of massive industrial cities. The separation of these new cities from nature was thought by many to have terrible psychological consequences. When people moved to the urban centers to find work, their old family and community ties were often strained or broken, and they found themselves surrounded by strangers, feeling alienated and alone.

One common response to these problems was simply to document them, an activity already begun in the preceding era by artists like Honoré Daumier. The Post-

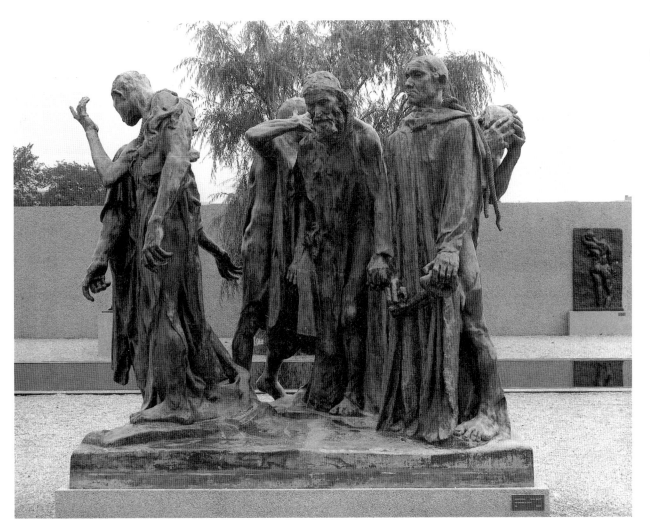

28-4. Auguste Rodin. *Burghers of Calais.* 1884–86. Bronze, 6'10¹/₂" x 7'11" x 6'6" (2.1 x 2.4 x 2 m). Hirshhorn Museum and Sculpture Garden, Smithsonian Institution, Washington, D.C.

Impressionist most identified with this current is Henri de Toulouse-Lautrec. Born a count in a small French town, Toulouse-Lautrec had a passion for drawing as a child. Medical problems drastically stunted his growth and so affected his face that he often drooled. Because of his appearance, he was not welcome in his own family.

In 1882 Toulouse-Lautrec moved permanently to Paris, where he entered the studio of an academic painter. He was soon drawn to the art of the Impressionists, especially that of Edgar Degas. He also discovered Montmartre, a part of Paris devoted to entertainment and inhabited by many who were on the fringes of society. From the late 1880s he dedicated himself to documenting this fascinating realm in individual **caricatures**—drawings that exaggerate the characteristic features of a subject for satirical effect—and in naturalistic scenes. He recorded his observations both in the posters for which he became famous (see "Posters and Prints of the 1890s," page 1028) and in paintings.

Typical of such works is *At the Moulin de la Galette* (fig. 28-5), a conscious remake of Pierre-Auguste Renoir's earlier painting of the popular dance hall (see fig. 27-47), which Toulouse-Lautrec had recently seen in an exhibition. Clearly, Toulouse-Lautrec wished to contradict the optimistic terms of the earlier work and of

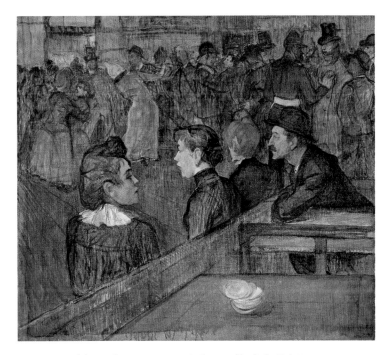

28-5. Henri de Toulouse-Lautrec. *At the Moulin de la Galette.* 1889. Oil on canvas, 35¹/₂ x 39¹/₄" (90.2 x 99.7 cm). The Art Institute of Chicago
Mr. and Mrs. Lewis L. Coburn Memorial Collection

POSTERS AND PRINTS OF THE 1890S

A second phase in the late-nineteenth-century print renaissance began around 1890 and lasted well into the next decade. (On the first phase, see "The Print Revival," page 1005.) Although this one, too, was centered in Paris, the medium was **chromolithography.** The artist largely responsible for it was a poster designer, Jules Chéret (1836–1932). After seventeen years working as a lithographic technician, in 1866 Chéret opened his own printing firm in Paris, where he produced a variety of commercial work, from menus to posters. He specialized in color **lithography,** a technique that he greatly helped to perfect (see "Lithography," page 985). His clever theater and café posters of the late 1860s and 1870s attracted the attention of both collectors and critics. In 1880 Joris-Karl Huysmans advised his readers to ignore the paintings and prints at the Salon and to turn, instead, to the "astonishing fantasies of Chéret" that could be found on any street.

In 1884 two histories of the French poster were published. Two years later, Henri Beraldi's *Les Graveurs du XIXe siècle* (*The Printmakers of the Nineteenth Century*) included a section devoted to Chéret's posters. In that year, too, the print dealer Edmond Sagot began listing posters, particularly those by Chéret, among his offerings. Other print dealers soon followed his lead, and by the end of the decade the poster vogue was in full flower not only in France but throughout the West. A number of talented and ambitious young artists turned their attention to designing them, including Alexandre Steinlen, Eugène Grasset, Alphonse Mucha, Will Bradley, Maxfield Parrish, Ethel Reed, John Sloan, Maurice Prendergast, and the Beggarstaff brothers. The most famous poster artist was Henri de Toulouse-Lautrec, who produced thirty between 1891 and his death in 1901.

Japanese prints influenced not only Toulouse-Lautrec's posters but those of many others as well. Another important influence came from Art Nouveau, which helped fuel the poster craze with its commitment to beautifying the urban environment.

One result of the poster phenomenon inaugurated by Chéret was a renewed interest in artistic lithography, especially in color. As André Mellerio stated in his 1898 book on the subject, "Chéret's posters opened up a new path—a path which the print happily followed" (cited in Cate and Hitchings, page 80). The year before, Mellerio had started a journal that implicitly made the same point, *L'Estampe et l'Affiche* (*The Print and the Poster*). Toulouse-Lautrec's first poster, for example, inspired a larger commitment to the lithographic print. A number of other famous artists also participated in this development, largely through the urgings of the art dealer Ambroise Vollard. Beginning in 1896 Vollard organized two annual editions of prints similar to those produced two decades earlier by Cadart. In 1896 he published an edition of twenty-four and the following year one containing thirty-two. Vollard's artists included Henri de Toulouse-Lautrec, Paul Cézanne, Pierre-Auguste Renoir, James McNeill Whistler, Paul Gauguin, Camille Pissarro, Pierre Bonnard, and Édouard Vuillard.

Vollard also contributed significantly to the renewed interest in book illustration, a genre neglected since the days of Édouard Manet. He asked a number of the artists just mentioned, as well as Marc Chagall and Georges Rouault later, to provide original lithographs for books. The best known of the English book illustrators was Aubrey Beardsley, whose work combined influences from Whistler, the second phase of the Pre-Raphaelite movement, and Japanese prints to form a beautifully "unnatural" style.

Impressionism in general. Whereas Renoir painted idealized, pretty young women and handsome young men, Toulouse-Lautrec depicts the sadder reality of such places. The happy couples in the back of the Toulouse-Lautrec work are only foils for the four lonely, dispirited figures in the front. The diagonal rail, similar to the one found in the Renoir painting, here creates a barrier between the sexes. Moreover, the rail and foreground table separate the viewer from the foreground figures, thus reinforcing the viewer's outside position. In these ways the painting reveals the artist's sensitivity to a new kind of loneliness: the modern feeling of alienation.

Another medium, photography, was ideally suited to recording the problems of modern life. One who contributed importantly to its rich documentary tradition was Eugène Atget (1857–1927), an actor who turned to photography in the early 1890s to earn a living. The Paris business he opened in 1892 specialized in providing artists with photographs on which they would base their

28-6. Eugène Atget. *Magasin, Avenue des Gobelins.*
1925. Albumen-silver print, 9½ x 7" (24.1 x 17.8 cm).
The Museum of Modern Art, New York
Abbott-Levy Collection. Partial gift of Shirley C. Burden

28-7. Eugène Atget. *Pontoise, Place du Grand-Martroy.* 1902. Albumen-silver print, 7 x 9³/₈" (17.8 x 23.8 cm). The Museum of Modern Art, New York

Abbott-Levy Collection. Partial gift of Shirley C. Burden

Atget's interest in the France of earlier times was part of a larger current in French culture that had been made manifest by the publication of Victor Hugo's medieval tale, *The Hunchback of Nôtre-Dame* (1831). Nostalgia for the premodern era was significantly heightened by Baron Haussmann's renovations of Paris in the 1850s and 1860s (Chapter 27). In the late nineteenth century, local groups throughout the city were organized to preserve what remained of the past, and a number of publications appeared documenting those buildings and sites that dated from between the Middle Ages and the Revolution of 1789.

compositions. By the end of the 1890s, however, Atget had begun to make, purely for himself, two kinds of photographs: nostalgic images of "old France" and pictures of the new age that threatened it.

A fine example of the latter type is *Magasin, Avenue des Gobelins* (fig. 28-6), which shows the seventeenth-century Gobelins tapestry works reflected in the window of a men's clothing store. The age-old methods of making fabrics by hand are thus contrasted with the modern industrial techniques that produced the cloth in the window. Price labels on the cloth and suits remind us that in factory production, price—not quality—is what matters. The mannequins themselves may well represent Atget's view of modern industrial humanity: anonymous, interchangeable, soulless, and wearing a price tag.

Artistic Alternatives to Modern Life

Magasin, Avenue des Gobelins is less typical of Atget than are his works that fondly record premodern France. These photographs of an older world are less exercises in nostalgia than countermoves against the encroachment of the new age. In most of his work Atget sought an image of a stable, unchanging world that would provide an imaginary escape from the increasingly noisy, unstable world of modernity. *Pontoise, Place du Grand-Martroy* (fig. 28-7), for example, shows the kind of small-town square that had been a center for community life in Renaissance and post-Renaissance Europe. Around the

square are the various small, family-run businesses— *boulangerie* ("bakery"), *sabotier* ("wooden-shoe maker"), *patisserie* ("pastry shop")—that served community needs long before big department stores began to appear in the late nineteenth century.

The square is formally stabilized on two sides by balancing architectural masses and symbolically stabilized by the church at the rear. The church represents both the personal security that belief can provide and a major force for social cohesion. Between the fall of Rome and the advent of the industrial age, Christianity had largely organized the life of western Europe, but its centrality was now being threatened by science, technology, and commerce. Atget, whether intentionally or not, shows an awareness of that threat.

In this, Atget was not alone. One important aspect of modernist art and architecture was the search for visual forms that would give psychological relief from the troubling conditions of a rapidly changing and increasingly complicated world. The painter Pierre-Cécile Puvis de Chavannes (1824–1898) was an important early contributor to this tradition. Puvis began his career as a Romantic painter, but partly because his early works were refused by the **Paris Salon** jury during the 1850s, in 1859 he adopted a **classical** mode. His inspiration came from the so-called Parnassian poets, who were then attempting to escape from the modern present into an idealized antiquity. By the late 1860s municipal buildings had become a major source of commissions for Puvis's large

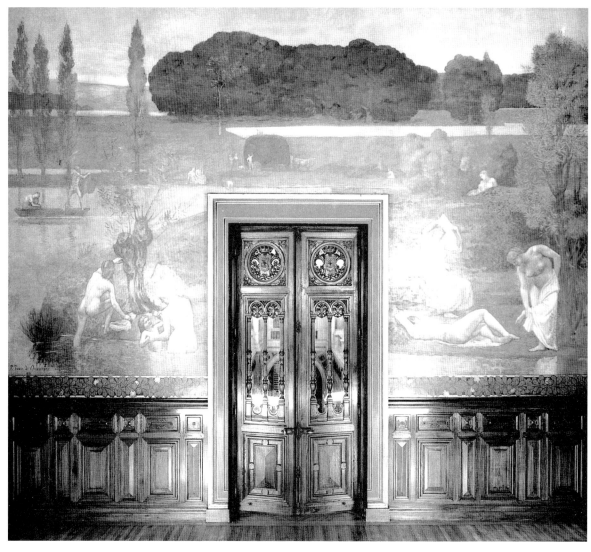

28-8. Pierre-Cécile Puvis de Chavannes. *Summer.* 1889–93. Oil on canvas, applied to wall. Hôtel de Ville, Paris

classical murals. Because the great popularity of such works dates from the early 1880s, Puvis, like Rodin, is usually grouped with the Post-Impressionists.

A good example of Puvis's canvas murals (he never learned the fresco technique) is *Summer* (fig. 28-8), set, like all his classical views, 2,000 years earlier in an idealized France after the arrival of Greek-Roman civilization. Against a simple agrarian background a scene of a family bathing suggests both a dignified pace of life and the notion that the larger community was composed of happy family units. To the right of the door, three indolent bathers, meant to resemble classical statuary in color and texture, anchor the scene both formally and psychologically. Puvis's lovely park is populated by sculpture; the marblelike figures create a static, timeless quality. The sense of tranquil unreality is further enhanced by the way he has simplified his forms and softly muted his colors.

Puvis's murals contributed to a new wave of classicism in French arts and letters, which included Renoir's *Bathers* (see fig. 27-54). During the 1890s the literary classicists called themselves l'École Romane ("the Roman School"). The major sculptor of this broad artis-

tic movement was Aristide Maillol (1861–1944), who during the 1880s trained as a painter at the École des Beaux-Arts. Late in the decade, he became a member of a group of young artists who greatly admired Puvis's murals. He first adapted Puvis's style to the making of tapestry, but because his eyesight became strained by such work, he turned to creating small sculpted pieces.

Maillol's reputation dates from 1905, when the exhibition of *The Mediterranean* (fig. 28-9) received widespread popular and critical acclaim. The large, relaxed female bather almost seems to have escaped from one of Puvis's murals. The smooth, simplified modeling—so different from the tense, tortured surfaces of Rodin's work—combines with the stable triangular arrangement of the figure to emphasize its psychological calm. As the title indicates, the bather personifies the ideal of the classical Mediterranean world established by Puvis and the Roman School of literature.

The year Maillol exhibited *The Mediterranean*, Constantin Brancusi (1876–1957), who had trained as a sculptor in a Romanian school for arts and crafts, enrolled in the École des Beaux-Arts. Early in 1907, Rodin hired him as an assistant, but Brancusi left after just two

<!-- timeline top right -->

1900
1880 1940

28-9. Aristide Maillol. *The Mediterranean.* 1902–5. Bronze, height including base 41" (104 cm). The Museum of Modern Art, New York
Gift of Stephen C. Clark

28-10. Constantin Brancusi. *Magic Bird.* 1908–12. White marble, height 22" (55.8 cm), on three-part limestone pedestal, height 5'10" (1.78 m), of which the middle part is the *Double Caryatid* (c. 1908), overall 7'8" x 12³⁄₄" x 10⁵⁄₈" (237 x 32 x 27 cm). The Museum of Modern Art, New York
Katherine S. Dreier Bequest

months, to avoid being overshadowed by the well-known sculptor. The rough surfaces of Brancusi's first works in France reflect Rodin's influence, but by the end of the decade, he had completely rejected Rodin's style for one that emphasized formal and conceptual simplicity. Behind this change stood the ancient Greek philosophy of Plato, who had held that all creatures and things are imperfect imitations of perfect models, or Ideas.

Brancusi's quest for the timeless essence of things is most completely expressed in *Magic Bird* (fig. 28-10). The piece is formed of two separate sections. The lower, limestone section has three parts, the middle one showing two rough-hewn figures (one of which has its face buried in the other's shoulder) representing the imperfect world of ordinary human existence. The top section, carved in pure white marble, is a symbol of the higher world of Ideas: the simplified form of a bird in flight.

The bird was apparently inspired by Russian-born composer Igor Stravinsky's 1910 ballet score *The Firebird*, which premiered in Paris. The ballet features a beautiful bird with magical powers that reminded Brancusi of the many Romanian folktales of the *pasarea maiastra*, or magic bird, able to heal the sick and restore sight to the blind. Unlike the magic birds of those tales, which always have dazzling plumage, the beauty of Brancusi's bird is in its utter simplicity. Brancusi tried to eliminate all unnecessary details in his search for the Platonic ideal of "birdness" itself. The bird also represents what many people believe the modern urban mind seeks and needs: the primal simplicity underlying nature. Brancusi's *Magic Bird* may not provide a healing force, but it does offer a satisfying artistic antidote to modern complexity.

As was often the case with modern artists, Brancusi longed for the way of life of his homeland but felt a greater need for the company of sophisticated urban artists and

28-11. Ernst Barlach. *Seated Woman.* 1907. Bronze, 8 x 7¹⁄₂" (20.3 x 18 cm), diameter 4³⁄₄" (12 cm). Ernst und Hans Barlach Lizenzverwaltung, Ratzeburg, Germany

writers. Quite the opposite was true for the German sculptor Ernst Barlach (1870–1938), who in 1916 moved to a small town to be closer to the "backward but healthy primitivism" he admired. Barlach produced graceful decorative figures until 1906, when on a visit to Russia he was deeply moved by the humble lives of the peasants. Typical of Barlach's early mature style is *Seated Woman* (fig. 28-11), a small bronze model for a work he intended to carve in

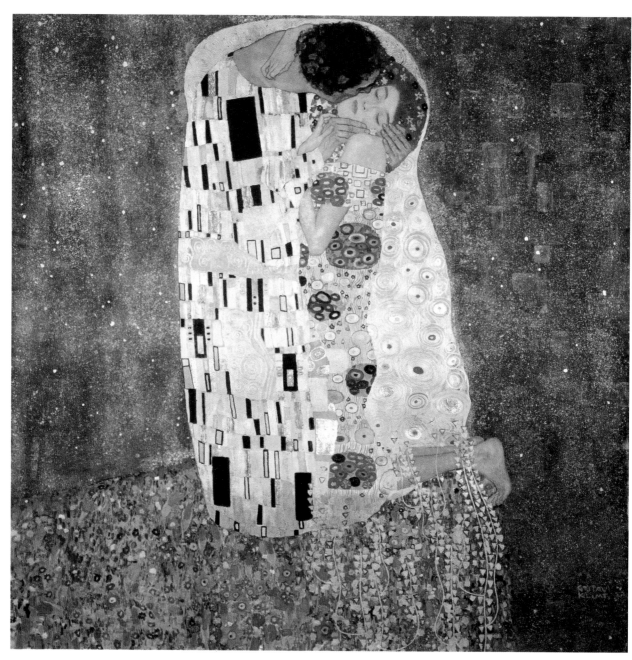

28-12. Gustave Klimt. *The Kiss*. 1907–8. Oil on canvas, 5'10¾" x 6' (1.8 x 1.83 m). Österreichische Galerie, Vienna

The Secession was part of a reaction by younger European artists against the conservative society in which they were raised. The generational revolt was also expressed in politics, literature, and the sciences. Sigmund Freud, the founder of psychoanalysis, may be considered part of this larger cultural movement, one of whose major aims was, according to the architect Otto Wagner, "to show modern man his true face."

wood. The handling of detail is simple, in keeping with the life of its farm woman subject. The pyramidal shape of the whole and the almost symmetrical arrangement of details give her a monumental stability, which is reinforced by the columnar striations of her skirt. The small but erect head makes her appear, despite her poverty, proud and confident. Like Maillol's *The Mediterranean* (see fig. 28-9), *Seated Woman* personifies and celebrates an entire way of life.

The very sophistication and ornate beauty that Barlach rejected became for Gustave Klimt (1862–1918), the leading Austrian painter of the period, the chosen avenue of escape from modern life. Klimt, whose father was a

goldsmith, trained for a career as a historical-scene painter for public buildings. During the mid-1890s he participated in the French-inspired revolt against academic standards in art and architecture known as the Secession. Klimt was the center of one faction, dedicated to an art that would offer refuge from the ordinary through highly decorative and artificial beauty.

Between 1907 and 1908 Klimt perfected what is called his golden style, shown in *The Kiss* (fig. 28-12). A man and woman—perhaps Klimt and his mistress—embrace in an aura of golden light. The representational elements here are subservient to the decorative ones.

28-13. Odilon Redon. *The Marsh Flower, a Sad and Human Face* (plate 2 from *Homage to Goya*). 1885. Lithograph, 10⅞ x 8" (27.5 x 20.3 cm). The Museum of Modern Art, New York

Abby Aldrich Rockefeller Purchase Fund

aging and in decline. Redon's image suggests that nations flower and wilt like plants but also expresses hope for regeneration. That the face glows with a radiant light suggests not only the power of the imagination over the darkness of despair but Redon's larger hope that his "suggestive art," akin to music, would reverse the French decline and promote "the supreme elevation and expansion of our personal life" (cited in Chipp, page 117). Redon's art thus participates in the broad artistic endeavor actually to change the world. Many historians consider this effort, and not the stress on formal innovation, the essential core of modernism.

The Avant-Garde

During the middle to late 1880s French art witnessed the birth of the **avant-garde** tradition. The term, originally a military one meaning "vanguard," was used in 1825 by a French socialist to refer to those artists whose propagandist art would prepare people to accept the social changes he and his colleagues envisioned (see "Realist Criticism," page 994). The idea of producing a socially revolutionary art had attracted such artists as Courbet (see fig. 27-20), but the real popularity of this notion dates from the Post-Impressionist era.

One of the first in his generation apparently to think of himself in these terms was Georges Seurat (1859–1891). Seurat trained at the École des Beaux-Arts, but after his graduation he devoted his energies to "correcting" Impressionism, which he found both intellectually shallow and too improvisational. In the mid-1880s he gathered around him a circle of young artists who became known as the Neo-Impressionists. The work that made his reputation and became the centerpiece of the new movement was *A Sunday Afternoon on the Island of La Grande Jatte* (fig. 28-14).

Seurat took a typical Impressionist subject, weekend leisure activities, and gave it an entirely new handling. An avid reader of scientific color theory, he applied his paint in small dots of pure color in the belief that when they are "mixed" in the eye—as opposed to being mixed on the palette—the resulting colors would be more luminous. His scientific approach to painting does not work in practice, however, because his dots of color are large enough to remain separate to the eye. Other aspects of his rational approach to expression were also problematic. He thought, for example, that upward-moving lines (like the coastline shown here) and warm, bright colors created "happy" paintings. Many viewers, however, find the stiff formality of his figures inconsistent with such a mood, which has led to controversy about the work.

From its first appearance the painting has been subject to a number of conflicting interpretations. Contemporary accounts of the island indicate that on Sundays it was noisy, littered, and chaotic. By painting it the way he did, Seurat may have intended to show how tranquil it should be. In doing this, was Seurat merely criticizing the Parisian middle class, or was he trying to establish a social ideal—a model for a more civilized way of life in the modern city? The key to Seurat's ideal, perhaps, is shown

The complex play of the jewel-like shapes and colors and the dazzling surface can distract the viewer from the human drama of the scene. For example, the position of the man's head actually forces the woman's head uncomfortably against her shoulder. And the marked difference between them, also evident in their hands, is further played out in the forms that decorate their garments: angular shapes dominate those worn by the male, whereas only a few such shapes are found amid the rounded forms of the woman's garment. What at first appears a single unit is in fact two separate and very distinct beings in a somewhat forced embrace. That they kneel dangerously close to the edge of a precipice further unsettles the initial impression.

Odilon Redon (1840–1916), a French painter and **graphic artist**, developed still another response to the modern world. He considered his visionary works his "revenge on an unhappy world." Examples such as *The Marsh Flower, a Sad and Human Face* (fig. 28-13) are not purely fanciful but express certain of the larger ideas of his era. Growing in a dark, featureless marsh, a scene probably inspired by the landscape of his youth, is a plant whose flowers are sad, lonely faces. Specifically, this work expresses the pessimism that swept France in the years after the Germans had defeated them in the Franco-Prussian War of 1870–1871. Many felt that France was

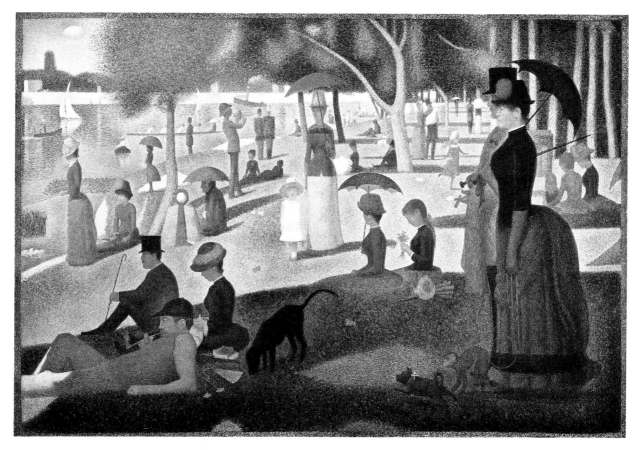

28-14. Georges Seurat. *A Sunday Afternoon on the Island of La Grande Jatte.* 1884–86. Oil on canvas, 6'9½" x 10'1¼"
(2.07 x 3.08 m). The Art Institute of Chicago
Helen Birch Bartlett Memorial Collection

Although the painting is highly stylized and carefully composed, it has a strong basis in factual observation. Seurat spent months visiting the island, making small studies, drawings, and oil paintings of the light and the people he found there. All of the characters in the final painting, including the woman with the monkey, were based on his observations at the site.

in the composure of the central figures in the work, the mother and child who stand as the still point around which the others move. The child, in particular, is a model of self-restraint. She may even represent Seurat's sense of the progress of human evolution, as obliquely suggested by the contrasting presence of the monkey in the right foreground.

Whereas Seurat seems to have felt that people were not civilized enough, the French painter Paul Gauguin (1848–1903) held the opposite view. Gauguin, whose mother was part French and part Peruvian Indian, had spent five years in the early 1850s with his family in Peru before they returned to France. He led an apparently conventional existence until the age of thirty-seven, when he quit his job as a Paris stockbroker and left his wife and five children to pursue a full-time painting career. Gauguin so loathed the instinctually restrained and money-oriented modern world that in 1891 he moved to Tahiti, an island in the South Pacific Ocean, in the belief that he could return to what he called Eden.

The first picture he painted there was *Ia Orana Maria (We Hail Thee Mary)* (fig. 28-15). The new Mary, a strong Polynesian woman holding an utterly contented Christ Child, stands in sharp contrast to the crucified Christs

and mourning Marys that dominated the Catholicism Gauguin knew and had sometimes painted in the late 1880s. In Tahiti he wrote an essay arguing that what was needed was Adam and Eve's blissful ignorance before the Temptation. Among the supposedly childlike Tahitians (as he and other Europeans then imagined them— Tahiti at that time was a French-controlled colony), he thought he could reenter the Garden of Paradise. The warm, rich colors and decorative patterns underscore the message that life in this supposedly uncivilized world is sweet and harmonious. The chief argument, however, is made through the fruit on the table. Like Adam and Eve before the Fall, people here need simply to pick the fruit off the trees. The fruit is put within the viewer's easy reach, as well. As in all of Gauguin's Tahitian works, we, too, are invited to leave a sorry industrial society and enjoy the fruits of Eden.

Among the artists in Gauguin's circle before his departure for Tahiti was the Dutch painter Vincent van Gogh (1853–1890). The oldest surviving son of a Protestant minister, after failing at a number of attempts to find a life's work, in 1880 he moved to Brussels to attend the Academy. His dark Dutch period ended in 1886, when he moved to Paris. There he was influenced by the work of

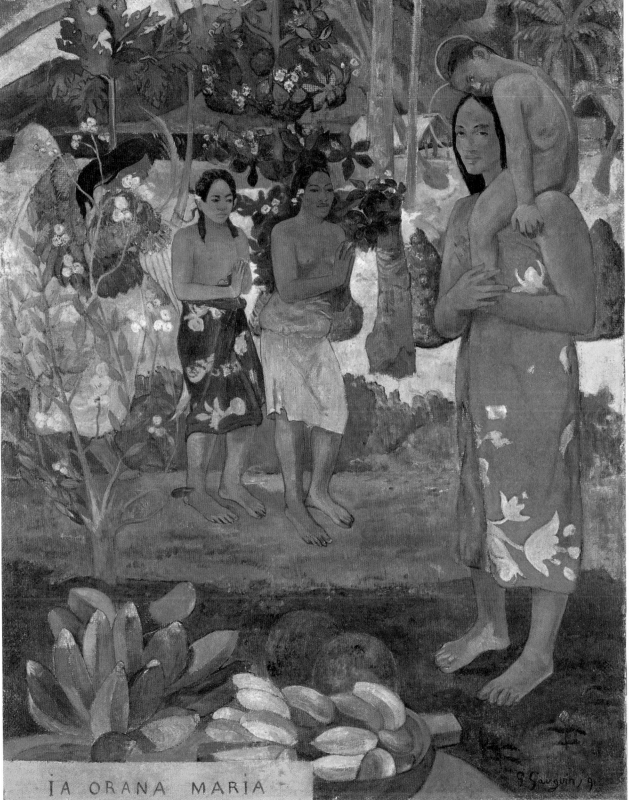

28-15. Paul Gauguin. *Ia Orana Maria (We Hail Thee Mary)*. c. 1891–92. Oil on canvas, 44³/₄ x 34¹/₂" (113.7 x 87.7 cm).
The Metropolitan Museum of Art, New York

Bequest of Samuel A. Lewisohn, 1951

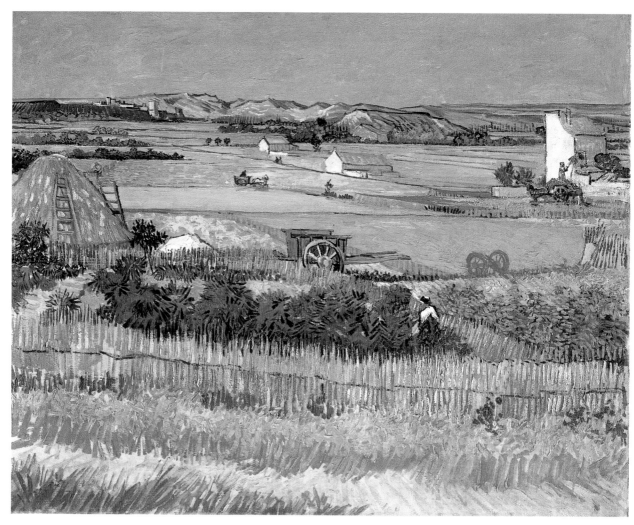

28-16. Vincent van Gogh. *Harvest at La Crau (The Blue Cart).* 1888. Oil on canvas, 28½ x 36¼" (72.5 x 92 cm). Rijksmuseum, Vincent van Gogh, Amsterdam

the Impressionists and Neo-Impressionists and met Gauguin. Van Gogh shared Gauguin's preference for simple, preindustrial life, and they planned to move to the south of France and establish a commune of like-minded artists. In the spring of 1888, van Gogh moved to Arles, where Gauguin was to join him.

The works van Gogh produced in his Arles period, such as *Harvest at La Crau (The Blue Cart)* (fig. 28-16), were strongly influenced by the Neo-Impressionist interest in **complementary colors**, pairs of colors that optically balance each other, such as blue and orange. But unlike Seurat and his followers, who applied these colors in small dots, van Gogh, inspired by Japanese prints (see "Japanese Woodblock Prints," page 868), juxtaposed large color areas. Van Gogh felt that the combination of Japanese forms and Neo-Impressionist colors effectively expressed the quiet, harmonious life of this rural community. Although the lively brushwork in the foreground foliage adds vitality to the scene, the insistent repetition of horizontal forms effectively dampens that effect and contributes to the calmness of the whole.

Works such as *Harvest at La Crau (The Blue Cart)* function less to provide an escape from the industrial city than to point the way back to a simpler agrarian life.

Although van Gogh's later work is meant to do this, too, it changed in both style and function at the beginning of 1889. Late in 1888, Gauguin finally arrived in Arles, but constant quarrels led to a violent confrontation in which van Gogh threatened Gauguin with a razor. After Gauguin fled, van Gogh turned the implement on himself and cut off the lobe of his right ear. This was the first of a series of psychological crises that led to his eventual suicide in July 1890. During the last year and a half of his life van Gogh's heightened emotional state was recorded in a series of paintings that contributed significantly to the emergence of the **expressionistic** tradition, in which the intensity of an artist's feelings overrides fidelity to the actual appearance of things.

Expressionism

One of the earliest and most famous examples of Expressionism is *The Starry Night* (fig. 28-17), which van Gogh painted from the window of his cell in a mental asylum. Above the quiet town is a sky pulsating with celestial rhythms and ablaze with exploding stars—clearly not a record of something seen but of what van Gogh felt. One explanation for the intensity of van Gogh's feelings in this

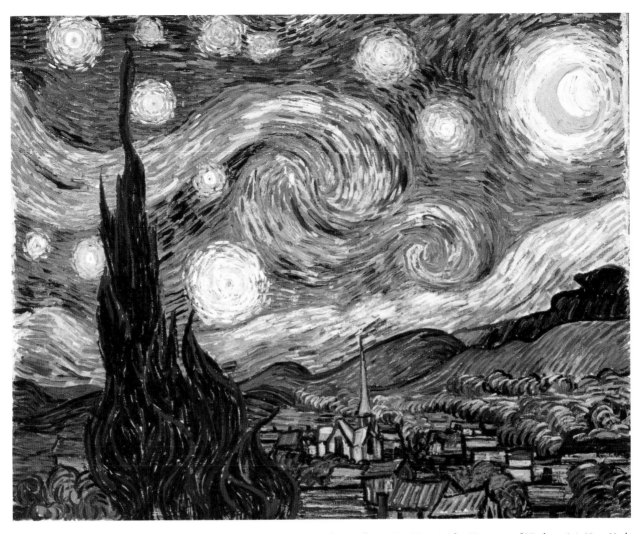

28-17. Vincent van Gogh. *The Starry Night.* 1889. Oil on canvas, 28³/₄ x 36¹/₂" (73 x 92 cm). The Museum of Modern Art, New York
Acquired through the Lillie P. Bliss Bequest

case focuses on the then-popular theory that after death people journeyed to a star, where they continued their lives. Contemplating immortality in a letter, van Gogh wrote: "Just as we take the train to get to Tarascon or Rouen, we take death to reach a star." The idea is given visible form in this painting by the cypress tree, a traditional symbol of both death and eternal life, which dramatically rises to link the terrestrial with the stars. The brightest star is actually Venus, which is associated with love. Is it possible that the picture's extraordinary excitement also expresses van Gogh's euphoric hope of gaining the companionship that had eluded him on Earth?

Whether modern artists have faced greater emotional difficulties than those from earlier ages is a matter of conjecture. What cannot be denied is that a great many artists of this period assumed that the chief function of art was to express their intense feelings to the world. The Belgian painter and printmaker James Ensor (1860–1949) was such an artist. Except for his four years at the Brussels Academy, Ensor spent his entire life in the coastal resort town of Ostend. Although his sense of isolation was sharpened by the hostile reception to both his early naturalistic and his later expressionistic art, it was

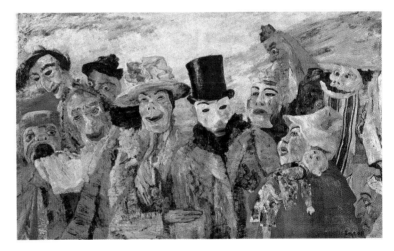

28-18. James Ensor. *The Intrigue.* 1890. Oil on canvas, 35¹/₂ x 59" (90.3 x 150 cm). Koninklijk Museum voor Schone Kunsten, Antwerp

apparently formed by his experiences with the ordinary tourists and townspeople of Ostend, as works such as *The Intrigue* (fig. 28-18) clearly attest. The painting shows a crowd of masked revelers celebrating Mardi Gras, one of the main holiday events in Ostend. Their grotesque

28-19. Edvard Munch. *The Scream.* 1893. Tempera and casein on cardboard, 36 x 29" (91.3 x 73.7 cm). Nasjonal-galleriet, Oslo

masks, rather than hiding the wearers' true identities, are here used to reveal them. Mouths hang open stupidly or smile without warmth. Eyes stare absently into space or focus menacingly on the viewer. The luminous colors oddly increase the sense of caricature, as does the crude handling of form. The rough paint is both expressive and expressionistic: its lack of subtlety well characterizes the subjects, while its almost violent application directly records Ensor's feelings toward them.

The Norwegian painter and printmaker Edvard Munch (1863–1944) dealt with problems of a different kind. When he was five, he witnessed his mother's death from tuberculosis. In 1875 he nearly died of the same disease. Three years later, his favorite sister hemorrhaged to death just as his mother had. As an artist, he was rejected for his frank treatments of death and sex not only by viewers with no particular interest in art but by progressive artists and critics as well. The members of the Berlin Secession, who invited him to show his work in 1892, were so shocked by it they closed the exhibition.

Munch's personal and professional anxiety in the aftermath of this rejection found expression in his most famous work, *The Scream* (fig. 28-19). Munch recorded

the painting's genesis in his diary: "One evening I was walking along a path; the city was on one side, and the fjord below. I was tired and ill. . . . I sensed a shriek passing through nature. . . . I painted this picture, painted the clouds as actual blood." In the painting itself, however, the figure is on a bridge and the scream emanates from him. Although he vainly attempts to shut out its sound by covering his ears, the scream fills the landscape with clouds of "actual blood." The overwhelming anxiety that sought release in this primal scream was chiefly a dread of death, as the sky and the skull-like head of the figure suggest, but the setting of the picture should also remind us that Munch suffered from a fear of open spaces.

Another painter of intense feelings was the Austrian Egon Schiele (1890–1918). Schiele's father died insane when Egon was fourteen. After a brief period of experimentation with the decorative style of Vienna's most famous artist, Gustave Klimt (see fig. 28-12), Schiele began to specialize in erotic paintings and drawings of women. In 1912 he was jailed briefly for allowing neighborhood children to see some of this work. Even before this traumatic event, Schiele revealed in an extraordinary series of self-portraits a deep ambivalence toward the

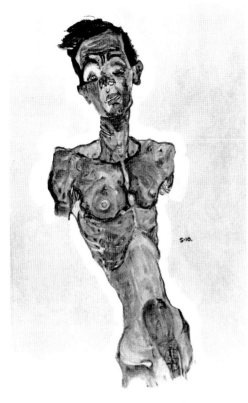

28-20. Egon Schiele. *Self-Portrait Nude.* 1910. Gouache, watercolor, and black crayon with white, 17⅝ x 13⅜" (44.7 x 34 cm). Private collection
Courtesy Galerie St. Étienne, New York

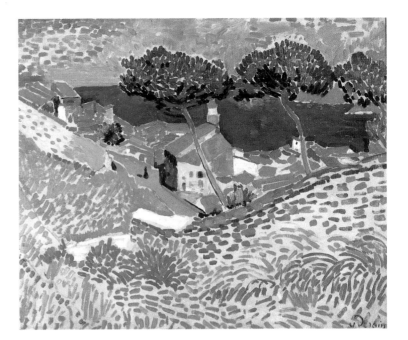

28-21. André Derain. *View of Collioure.* 1905. Oil on canvas, 26 x 32⅜" (66 x 82.3 cm). Museum Folkwang, Essen, Germany

sexual themes of many of his works. One of these, *Self-Portrait Nude* (fig. 28-20), presents an image of both physical and psychological suffering. The body is emaciated, the sad record of long victimization; the skin is raw, as if flayed.

EXPRESSIONISTIC MOVEMENTS

In the years just before and after 1910 the expressionistic approach pioneered by Ensor, Munch, and van Gogh, in particular, was developed in the work of three artists' groups. The first of these groups to emerge was the Fauves.

The Fauves

In the fall of 1905 a French critic, Louis Vauxcelles, referred to a loosely affiliated group of young painters as *fauves* ("wild beasts"), a term that caught the spirit of the work of the leading members of their circle, André Derain (1880–1954), Maurice de Vlaminck (1876–1958), and Henri Matisse (1869–1954). For some years, these artists had been trying to advance the colorist tradition in modern French painting, which they dated from the work of Eugène Delacroix (see figs. 26-46, 26-47) and which included that of the Impressionists, Neo-Impressionists, and Gauguin. Before leaving for a summer painting trip to Collioure, a seaside resort and port on the Mediterranean near the Spanish border, Derain and Matisse (along with Vlaminck) had seen a van Gogh retrospec-

tive exhibition. In works from that summer, like Derain's *View of Collioure* (fig. 28-21), the two artists combined the dynamic brushwork of van Gogh with the pure colors they had been experimenting with since about 1900. These bold **primary colors** (red, yellow, and blue), often applied directly from the tube, produced an explosive effect—"like sticks of dynamite," Derain said. Here, for the first time, the intensity of color is heightened by the exciting rhythms of the brush. As in almost all Fauve painting, Derain in *View of Collioure* shows little concern for the appearance of his subject. He is interested simply in recording the complete complex of sensations it produces in him.

Derain and Matisse sought to communicate a raw intensity of experience, what one of their favorite writers, the German philosopher and poet Friedrich Nietzsche, called "a new taste, a new appetite, a new gift of seeing colors, of hearing sounds, of experiencing emotions." This ideal was a response not only to the perception that modern times were dull and drab but to the pessimistic view that the French were an aging people with a declining capacity for life. The Fauves were part of an important strain in early-twentieth-century France that sought to reverse that downward direction and regenerate the nation.

For Gauguin, the ideal had been the "primitive" and the child (see fig. 28-15). For the Fauves, it was simply the child. We see this not in their subjects but in their styles, especially that of Vlaminck. Unlike Derain and Matisse,

28-22. Maurice de Vlaminck. *Landscape near Chatou.* 1906. Oil on canvas, 23⅞ x 29" (60.6 x 73.7 cm). Stedelijk Museum, Amsterdam

28-23. Henri Matisse. *The Woman with the Hat.* 1905. Oil on canvas, 31¾ x 23½" (80.6 x 59.7 cm). San Francisco Museum of Modern Art

Bequest of Elise S. Haas

Vlaminck was self-taught and proud of it. In works like *Landscape near Chatou* (fig. 28-22), he shows even less concern than van Gogh, his major inspiration, with looking sophisticated. The strong colors have been crudely applied with a stiff, broad brush. "I try to paint with my heart and my loins, not bothering about style," he once said. Vlaminck practiced this approach because he envied and wished to regain the child's fresh vision of the world.

A similar insistence on directness was one factor in the paintings produced in 1905 by the leading Fauve, Henri Matisse. Matisse's early work was largely inspired by Impressionism and Neo-Impressionism. The works he showed in the fall of 1905 culminated this early experimental phase. Among them was *The Woman with the Hat* (fig. 28-23), an image of his wife, Amélie, who until recently had supported the family with the proceeds from her millinery shop. She looks at the artist with wide, sad eyes, and her mouth is slightly turned down. This highly revealing presentation is surprising in a painting Matisse considered an exercise in immediate sensation. Although Matisse never quite succumbed to Vlaminck's example, the rapid, unrefined paint handling suggests their affinity. These were precisely the qualities that incensed the critics, who considered this work simply a bad preliminary sketch. Matisse himself soon came around to something like this view. In 1908 he published an essay, "Notes of a Painter," in which he rejected his Fauve approach for a more thoughtful and soothing one:

> Often when I sit down to work I begin by noting my immediate and superficial color sensations. Some years ago this first result was often enough for me. . . . [But now] I prefer to continue working on it so that later I may recognize it as a work of my mind. There was a time when I never left my paintings hanging on the wall because they reminded me of moments of nervous excitement. . . . Nowadays, I try to put serenity into my pictures and work at them until I feel that I have succeeded.

One of the first of Matisse's post-Fauve works is *The Joy of Life* (fig. 28-24), which he painted in his studio during the winter of 1905–1906. Despite the spontaneous sketch he began with, the finished painting is not a quick response to something seen. Like Cézanne's *The Battle of Love* (see fig. 28-2), it treats the hedonistic pursuits of the followers of Bacchus. But unlike Cézanne's scene, Matisse's is completely untroubled. These uninhibited, naked revelers dance, make love, commune with nature, or simply stretch out in their idyllic glade by the Mediterranean. The banquet of luscious colors comes from the developments of the previous summer at Collioure, but all traces of nervous intensity have been removed. The brushwork is now soft and careful, subservient to the pure sensuality of the color. The only movement is in the long, flowing curves of the trees and the bodily contours. These undulating rhythms, in combination with the relaxed poses of the two reclining women at the center, establish the "serenity" that Matisse wanted to characterize his work from this point.

In "Notes of a Painter" Matisse explains the purpose of his new emphasis: "What I dream of is an art . . . devoid of troubling or depressing subject matter . . . which might be for every mental worker, be he businessman or writer, like . . . a mental comforter, something like a good armchair in which to rest." Here Matisse signals his allegiance to the side of modernist art that sought relief from the stress of modern life. According to one biographer, Matisse himself was sometimes "madly anxious" and well understood the temporary peace art could provide.

28-24. Henri Matisse. *The Joy of Life*. 1905–6. Oil on canvas. 5'8¹⁄2" x 7'9³⁄4" (1.74 x 2.38 m). The Barnes Foundation, Merion, Pennsylvania

> During an illness in his youth, Matisse was given a box of paints by his mother, a moment that he recalled as fundamental to his later concerns as a painter: "When I started to paint, I felt transported into a kind of paradise. . . . In everyday life, I was usually bored and vexed by the things that people were always telling me I must do. Starting to paint, I felt gloriously free, quiet and alone." The reference to paradise, in particular, suggests that his mature paintings, such as *The Joy of Life,* are not concerned simply with the escapist Western myth of Arcadia but with painting itself as an ideal realm.

Die Brücke

The German counterpart to Fauvism was Die Brücke ("The Bridge"), which formed in the same year the Fauves were named. In 1905 three architecture students at the Dresden Technical College—Karl Schmidt-Rottluff (1884–1976), Erich Heckel (1883–1970), and Ernst Ludwig Kirchner (1880–1938)—decided to take up painting and form a brotherhood. For the next eight years they lived and worked together. Their collective name was taken from a passage in Nietzsche's *Thus Spake Zarathustra* (1883) in which the prophet Zarathustra speaks of contemporary humanity's potential to be the evolutionary "bridge" to a more perfect specimen of the future, the *Übermensch* ("beyond man," but usually translated as "superman").

In their art, however, the group demonstrated little interest in advancing the evolutionary process. Their paintings, sculpture, and graphics suggest, instead, a Gauguinesque yearning to return to imaginary origins. Among their favorite motifs were women living harmoniously in nature. Typical is Schmidt-Rottluff's *Three Nudes—Dune Picture from Nidden* (fig. 28-25), which shows three simplified female nudes formally integrated with their landscape. The style is purposefully simple and

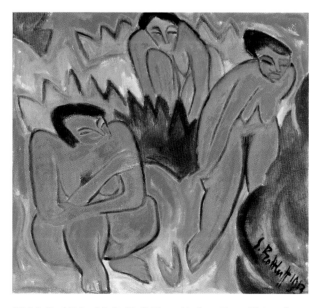

28-25. Karl Schmidt-Rottluff. *Three Nudes—Dune Picture from Nidden*. 1913. Oil on canvas, 38⁵⁄8 x 41³⁄4" (98 x 106 cm). Staatliche Museen zu Berlin, Preussischer Kulturbesitz, Nationalgalerie

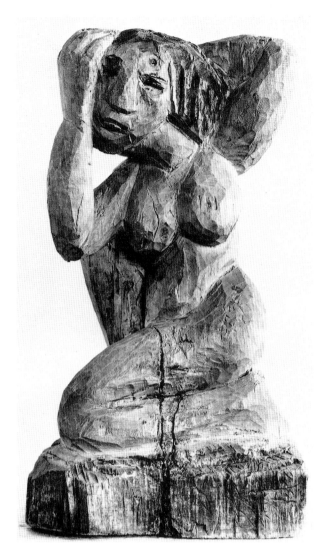

28-26. Erich Heckel. *Crouching Woman.* 1912. Painted linden wood, 11⅞ x 6¾ x 3⅞" (30 x 17 x 10 cm). Estate of Erich Heckel, Hemmenhofen am Bodensee, Germany

direct, in keeping with the painting's evocation of the prehistoric. Instead of the graceful contours of Matisse's erotic nudes in *The Joy of Life*, Schmidt-Rottluff gives his larger, lumbering subjects thick, inelegant outlines. Although both artists nostalgically look back, one looks to the golden age of Greece whereas the other seems more interested in Europe's Neolithic past.

The two artists also share a vocabulary of simple, flattened shapes of pure color mostly inspired by the same stylistic sources. Around 1905, when Derain and Vlaminck were discovering African art in Paris's shops and in its natural history museum, their German counterparts were studying African and Oceanic sculpture in their ethnographic museums. This interest led Die Brücke artists to make their own "primitive" sculpture. Heckel's *Crouching Woman* (fig. 28-26) is crudely carved in wood not only to emulate its non-European sources but to revive what the group considered the more honest methods of German Gothic artists. In turning to wood they were rejecting the classical tradition of both marble and

bronze. What they sought was not sophisticated beauty but unsophisticated strength, as the actions and features of the woman suggest. In this work the medium itself suggests the desire to return to nature that is depicted in Schmidt-Rottluff's *Three Nudes*.

During the summers Die Brücke artists actually did return to nature. They visited the remotest areas of northern Germany, such as Nidden. But in 1911 they moved to Berlin, preferring to imagine the simple life rather than live it. Ironically, the images they made of cities, especially Berlin, offer powerful arguments against living there. Kirchner's *Street, Berlin* (fig. 28-27), for example, forcefully demonstrates the isolation that can occur in cities. Although physically close, the well-dressed men and women are psychologically distant. And instead of becoming a larger formal unit, they are presented as a series of independent vertical elements, an accumulation of isolated individuals, not a tight-knit community. The angular, brittle shapes and the sharp contrast of predominantly cool colors formally underscore the message.

What made it possible for modernists like Kirchner to endure such conditions was their collective belief that they lived not in Berlin or Paris or New York but in bohemia, a cultural space uncontaminated by the ordinary conditions of those cities. The term *bohemian* was originally used during the 1830s in Paris to describe certain Gypsies (the Romany people, wrongly thought to have originated in Bohemia, a region of central Europe) who lived within a modern urban environment while maintaining a separate cultural identity. The term was then applied to young artists and writers who wanted the advantages of a cultural center without its crass, materialist, "bourgeois" (or middle-class) trappings. They were opposed to the new mass-produced things, like the ready-to-wear suits in Atget's *Magasin, Avenue des Gobelins* (see fig. 28-6), which they considered both shoddy and ugly, as well as to what they believed to be the bourgeoisie's appalling lack of interest in the life of the spirit and the mind.

By 1900 these new bohemians in various European centers were committed as well to resisting both the social fragmentation of the modern city and what they considered the puritanism of bourgeois life. Like Gauguin, many bohemians were attracted to the ideal of so-called primitive culture, imagining in it not only a less alienated society but also a more natural sexuality, free of inhibitions and learned restraints. But unlike Gauguin, who decided to return to what he thought of as a precivilized existence, the artists of Die Brücke attempted to "primitivize" bohemia. Uninhibited sexuality was often featured in one major subject of their art: the life of their studios.

In Kirchner's *Girl under a Japanese Umbrella* (fig. 28-28), for example, the viewer is put in the position of the artist as he gazes at his half-naked model. What are we to make of the bold brushstrokes, crude contours, and intense colors used to paint her? Do the partially parted lips, flared nostrils, and twisting torso suggest an independent creature whose passion challenges the artist rather than a passive sex object? The painting behind her of women in a landscape expresses her vital,

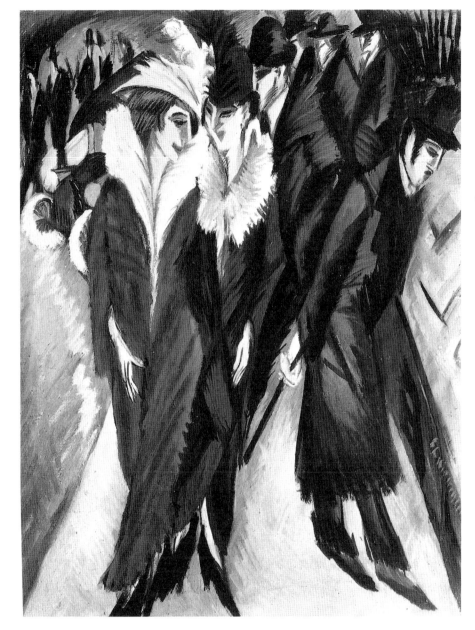

28-27. Ernst Ludwig Kirchner. *Street, Berlin.* 1913. Oil on canvas, 47½ x 37⅞" (120.6 x 91 cm). The Museum of Modern Art, New York
Purchase

"natural" attitude. The umbrella she holds is also suggestive of the Japanese **ukiyo-e** prints then in vogue in Europe, which often featured geishas (see fig. 22-15).

Such images conceive of women in terms of male desire, and Die Brücke artists restricted women to this role. Although they often depicted themselves and their male friends reading, writing, painting, and playing chess, they almost never showed women engaged in such pursuits. The brotherhood may have been antibourgeois in most respects, but its attitudes toward women were utterly conventional.

The women who participated in the modernist enterprise, although tolerated, were rarely treated as equals.

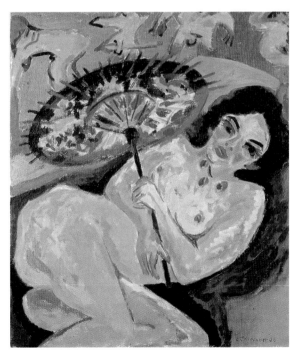

28-28. Ernst Ludwig Kirchner. *Girl under a Japanese Umbrella.* c. 1909. Oil on canvas, 36¼ x 31½" (92 x 80 cm). Kunstsammlung Nordrhein-Westfalen, Düsseldorf
Collection Dr. Frederic Bauer Davo

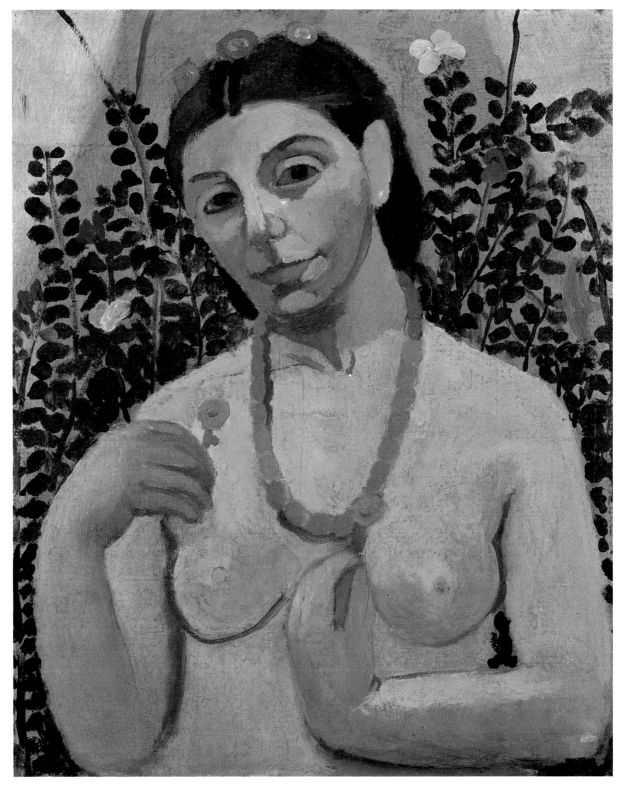

28-29. Paula Modersohn-Becker. *Self-Portrait with an Amber Necklace.* 1906. Oil on canvas, 24 x 19¾" (61 x 50 cm). Öffentliche Kunstsammlung, Kunstmuseum, Basel, Switzerland

One such woman was Paula Modersohn-Becker (1876–1907). In 1896 she enrolled in the Berlin School of Art for Women, where she was allowed to study the female nude and, on occasion, the partially dressed male models. In 1897 Modersohn-Becker moved to Worpswede in northern Germany, one of the many charming and rustic European villages that became famous artists' retreats, where she married a leading painter working in the Barbizon-related style (Chapter 27) identified with the town.

She quickly became dissatisfied with the naturalistic approach to rural life, which she said was not broad enough. Between 1900 and her death in 1907 she made four trips to Paris in order to assimilate the leading developments in Post-Impressionist painting. In particular,

28-30. Käthe Schmidt Kollwitz. *The Outbreak,* from the Peasants' War. 1903. Etching. Staatliche Museen zu Berlin, Preussischer Kulturbesitz, Kupferstichkabinett

she found amenable the formal simplicity developed by Gauguin and his circle. Inspired by such examples, she evolved at the end of her life a very personal approach to painting the women of Worpswede, including herself.

Modersohn-Becker's *Self-Portrait with an Amber Necklace* (fig. 28-29), for example, features greatly simplified shapes and crude outlines similar to those used in Schmidt-Rottluff's *Three Nudes—Dune Picture from Nidden* (see fig. 28-25). Avoiding the intense color in that work, however, Modersohn-Becker employed a muted palette of browns and blues. These colors combine with the soft layering of her paint to produce a formal effect similar to the gentle expression on her face. Emphasis is given to the figure's relationship with nature. The artist presents herself against a screen of flowering plants wearing only a necklace. In her large, somewhat awkward hands she tenderly holds the kind of little flower that also decorates her hair.

Another German who was an important artist of this period is Käthe Schmidt Kollwitz (1867–1945). Raised in a socialist household, she also studied at the Berlin School of Art for Women and at a similar school in Munich. In 1891 she married a doctor who shared her leftist political views, and they settled in a working-class neighborhood of Berlin. Art for her was a political tool, and to reach as many people as possible, she preferred printmaking to other forms. Although she made a number of effective self-portraits, the main subject of her art is the poor, oppressed worker.

Using a stark graphic style, Kollwitz attempted not only to win sympathy for working-class people but to inspire them and her viewers to action on their behalf. Between 1902 and 1908 she produced the Peasants' War series, seven etchings that depict events in a rebellion of German peasants in the sixteenth century. The most important of the seven, and the first completed, was *The Outbreak* (fig. 28-30). Here Kollwitz shows the peasants' built-up fury from years of mistreatment exploding in mass action against their oppressors. No longer single individuals, the tired and worn figures join in a powerful wedge. To the artist's contemporaries, the work is thus a lesson in the power of group action. In the front, with her back to us, is Black Anna, the leader of the revolt, who raises her hands to signal the attack. Kollwitz said that she modeled the figure of Anna after herself.

Der Blaue Reiter

The last of the important pre–World War I expressionist groups to come out of the crucible of late-nineteenth-century painting was formed in Munich around the Russian painter Vasily Kandinsky (1866–1944), who was born and raised in Moscow. In 1895 Kandinsky saw a Monet painting whose color so moved him that he decided to give up his law professorship in Moscow and devote himself fully to art. The following year he moved to Munich to study art because of the research being done there on the effects of color and form on the human psyche. During the first decade of the new century he traveled often to Paris and other European centers to familiarize himself with the latest artistic developments. The wealth of expressionist work he encountered convinced him that a new artistic era had begun. The development of his own style in this period depended not only on the contemporary art he saw but on the folk art and children's art he collected. In 1911 he organized Der Blaue Reiter ("The Blue Rider"), a group of nine artists who shared his interest in the power of color. Der Blaue Reiter was more diverse than the Fauves or Die Brücke, and its name says more about Kandinsky's aims than those of his colleagues.

"Der Reiter" was the popular name for the image of Saint George, mounted and slaying a dragon, that appeared on the Moscow city emblem. According to a long tradition revived around 1900, Moscow would be the new capital of the world during the millennium, the thousand years of Christ's reign on earth that would follow the Apocalypse, as prophesied by Saint John the Divine. Millennial and apocalyptic imagery appears often in Kandinsky's art in the years just prior to World War I. In

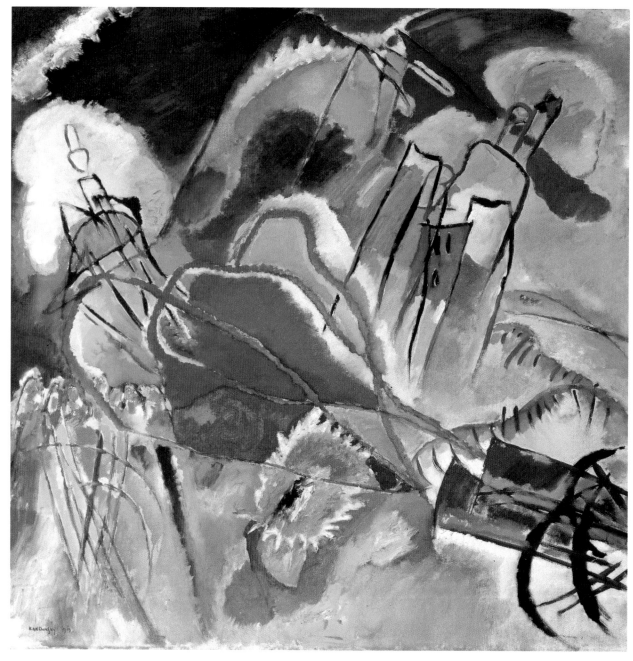

28-31. Vasily Kandinsky. *Improvisation No. 30 (Warlike Theme)*. 1913. Oil on canvas, 43¼ x 43¼" (109.9 x 109.9 cm). The Art Institute of Chicago

Arthur Jerome Eddy Memorial Collection

The traditional Russian idea that Moscow would be the "third Rome" was central to Kandinsky's art prior to World War I. The first center of Christianity had been Rome itself. The second Rome, according to Russian Orthodox tradition, had been Constantinople, the capital of the Christian world until 1453, when the Muslim Turks conquered it. The third and final Rome would be Moscow, according to the vision of a sixteenth-century monk, whose descriptive letter to the grand prince of Moscow led the prince's successor, Ivan the Terrible, to assume the title *czar*, Russian for "Caesar."

Improvisation No. 30 (Warlike Theme) (fig. 28-31), the firing cannons in the lower right combine with the intense reds, blackened sky, and precariously leaning mountains to suggest a scene from the end of the world. Such paintings, sometimes thought to reflect fear of the coming war, are, instead, ecstatic visions of the destructive prelude to the Second Coming of Christ. The schematic churches on top of the mountains are based on the churches of the Kremlin, Moscow's central district, and thus symbolize the coming Russian millennium.

Kandinsky never expected his viewers to understand his symbolism, nor did he think they needed to understand it. He intended, instead, to influence them directly through the sheer force of color. As he explained it: "[C]olor directly influences the soul. Color is the keyboard, the eyes are the hammers, the soul is the piano with many strings. The artist is the hand that plays, touching one key or another purposively, to cause vibrations in the soul" (cited in Chipp, pages 154–155). In essence, Kandinsky believed that his "largely unconscious" color improvisations would awaken the spiritual capacity and "urge" of one spectator after another and thus inaugurate "a great

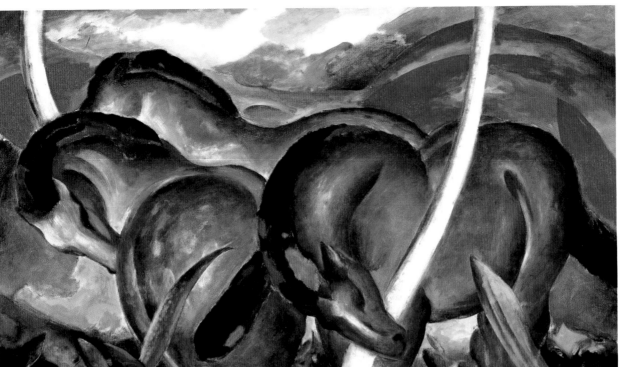

28-32. Franz Marc. *The Large Blue Horses.* 1911. Oil on canvas, 3'5³/₈" x 5'11¹/₄" (1.05 x 1.81 m). Walker Art Center, Minneapolis
Gift of T. B. Walker Collection, Gilbert M. Walter Fund, 1942

spiritual epoch." Kandinsky, then, was "der Reiter" who would prepare the way for the Second Coming.

Der Blaue Reiter was blue because Kandinsky and the group's cofounder, Franz Marc (1880–1916), considered blue the color of the male principle of spirituality. Marc, a man of gloomy disposition, was born and trained in Munich. Over the course of his career he moved from naturalism to expressionism, a process that culminated in 1910 when he met Kandinsky and became a member of his circle. Some years earlier Marc had turned to animals as subjects for his work. In *The Large Blue Horses* (fig. 28-32), he shows three horses, each defined by the same colors and shapes, in a tight, homogeneous unit. The fluid neck contours of the two horses in front, echoed in the shape of the third animal, reflect the harmony of their collective existence. With their billowing curves and graceful arabesques, the horses are also shown in perfect harmony with their surroundings. The simple but strong colors reflect the uncomplicated intensity of their experience as Marc enviously imagined it.

The third major artist associated with Der Blaue Reiter was Paul Klee (1879–1940), who was born near Bern, Switzerland, to a musical family. He married a pianist and until his final illness played the violin for an hour every morning. Although he was included in the second Blaue Reiter exhibition, in 1912, his involvement with the group was never more than tangential. It was not Blaue Reiter but a 1914 trip to Tunisia that inspired his interest in the expressive potential of color. "Color and I are one," he wrote in his diary while there.

On his return Klee painted a series of watercolors based on his memories of North Africa, among them *Hammamet with Its Mosque* (fig. 28-33). The play between

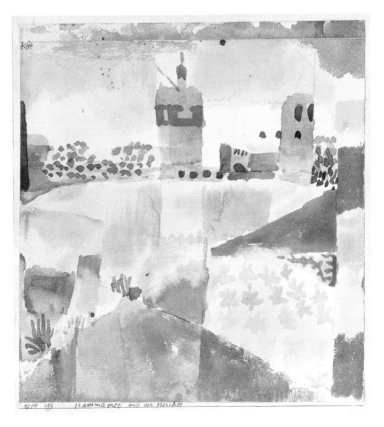

28-33. Paul Klee. *Hammamet with Its Mosque.* 1914. Watercolor and pencil on two sheets of laid paper mounted on cardboard, 8¹/₈ x 7⁵/₈" (20.6 x 19.7 cm). The Metropolitan Museum of Art, New York
The Berggruen Klee Collection, 1984

geometrical composition and irregular brushstrokes in this watercolor is reminiscent of Cézanne's work, which Klee had recently seen. The luminous colors and delicate **washes**, or applications of dilute watercolor, result in a gently shimmering effect that is more than a record of something seen under a hot sun. The subtle modulations of red across the bottom, especially, are positively melodic. Klee seems to have wanted to use color the way a musician would use sound, not to describe appearances but to evoke subtle nuances of feeling. That this had for Klee a spiritual dimension is suggested by the mosque presiding over the picture. Klee's spirituality of pure color links his work with Kandinsky's and Marc's. What differentiates it is the absence of any trace of a preconceived intellectual program. Though Klee, too, was a prolific theorist, his art was not meant to illustrate his ideas but rather to explore complicated and difficult-to-verbalize imaginative experiences. That it usually eludes translation into clear and certain concepts is, for many, the essence of its appeal.

CUBISM

Hammamet with Its Mosque reflects the influence of the most radical, innovative, and influential ism of twentieth-century art, Cubism. The complete flattening of space and the use of independent facets or blocks of color in Klee's painting derive from the Cubist paintings he had recently seen in Paris. Cubism was the joint invention of two men, Pablo Picasso (1881–1973) and Georges Braque (1882–1963). Their achievement was built upon the foundation of Picasso's early work.

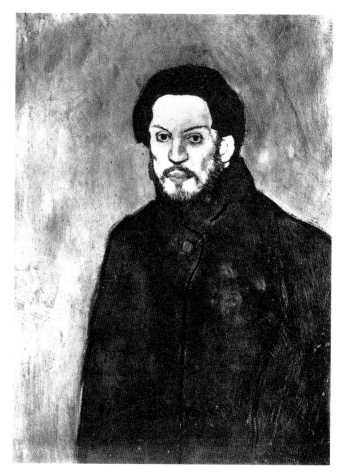

28-34. Pablo Picasso. *Self-Portrait.* 1901. Oil on canvas, 31⅞ x 23⅝" (81 x 60 cm). Musée Picasso, Paris

Picasso's Early Art

Picasso was born in Málaga, Spain, where his father taught in the School of Fine Arts. His talent was evident at an early age, and at fifteen he entered the Barcelona Academy. A year later, he was admitted as an advanced student to the Academy in Madrid. Picasso's involvement in the avant-garde began at the end of the 1890s, when he moved back to Barcelona and joined a group of young writers and artists interested in both progressive art and politics. Beginning in 1900 he made frequent extended visits to Paris and moved there early in 1904.

During this time Picasso was drawn to the socially conscious tradition in nineteenth-century French painting that included Honoré Daumier (see fig. 27-22) and Toulouse-Lautrec (see fig. 28-5). In what is known as his Blue Period, he painted the outcasts of Paris in weary poses and a coldly expressive blue. Two factors seem to have been at work in these paintings. The first was Picasso's political sensitivity to those he considered the victims of modern society, which would eventually lead him to join the Communist Party. The second was his own unhappiness, which appears clearly in his 1901 *Self-Portrait* (fig. 28-34). The painter's sallow complexion and hollow cheeks reveal his familiarity with cold, hunger, and disappointment. Whether his mood at this time colored his perception of the world or merely sharpened his political sensitivity to the suffering of others is a much debated point.

In 1904 Picasso's personal circumstances greatly improved. By the end of the year he had a large circle of supportive friends, and his work had attracted the attention of several important collectors. His works from the end of 1904 and the beginning of 1905, known collectively as the Rose Period because of the introduction of that color into his still predominantly blue palette, show the last vestiges of his earlier despair.

Between early 1905 and the winter of 1906–1907, Picasso's art went through an extraordinary and complex transformation. Wanting to produce art of greater formal and psychological strength, he began to study classical sculpture at the Louvre. Picasso's interest in classical art coincided with a new flowering of the Roman School that followed a Puvis retrospective late in 1904, the exhibition of Maillol's *The Mediterranean* (see fig. 28-9) in 1905, and an Ingres retrospective the same year. Despite his initial attraction to this kind of art, Picasso soon rejected it because of its association with French nationalism. Ever since Louis XIV had resisted the influence of the Italian Baroque in the seventeenth century (Chapter 19), French critics and historians considered a taste for classical balance to be deeply rooted in the national character. The works of Puvis, Ingres, and Maillol, in line with this tradition, were seen as quintessentially French. In response, the young Picasso began to cultivate his own ethnic identity.

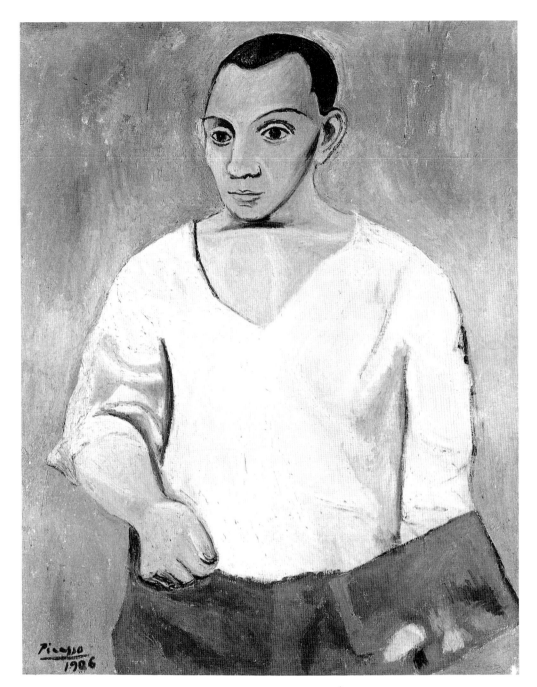

28-35. Pablo Picasso. *Self-Portrait with Palette.* 1906. Oil on canvas, 36¼ x 28¾" (92 x 73 cm). Philadelphia Museum of Art
A. E. Gallatin Collection

In 1906 the Louvre installed a newly acquired collection of sculpture from the Iberian region (the region of modern Spain and Portugal) that dated to the sixth and fifth centuries BCE. Inspired by these archaic figures, which had been excavated in the province of his birth, Picasso spent the summer of 1906 rediscovering his roots in a small village in the Spanish Pyrenees. The ancient Iberian figures, which he identified with the stoic dignity of the Pyrenean villagers, became the chief influence on his work for the next several years. Another important influence came from Gauguin's "primitive" sculpture, which Picasso also studied at this time. The Gauguin connection allowed Picasso to develop his Spanish identity while simultaneously contributing to a major current in modernist art.

The Iberian influence appears clearly in *Self-Portrait with Palette*, painted in 1906 (fig. 28-35). The frail, sensitive young man of the earlier self-portrait has become strong and self-contained. The simple sculptural modeling of the head lends firmness and certainty to his calm expression. Accentuated by heavy outlines, the powerful upper body and strong right arm, which ends in a fist, add a sense of newfound psychological strength. Picasso pointedly shows himself without a brush in his fist, making a statement as much about himself as a man as about himself as an artist.

Picasso's Iberian period culminated in 1907 in *Les Demoiselles d'Avignon* (fig. 28-36). The painting is Picasso's response to Matisse's *Joy of Life* (see fig. 28-24),

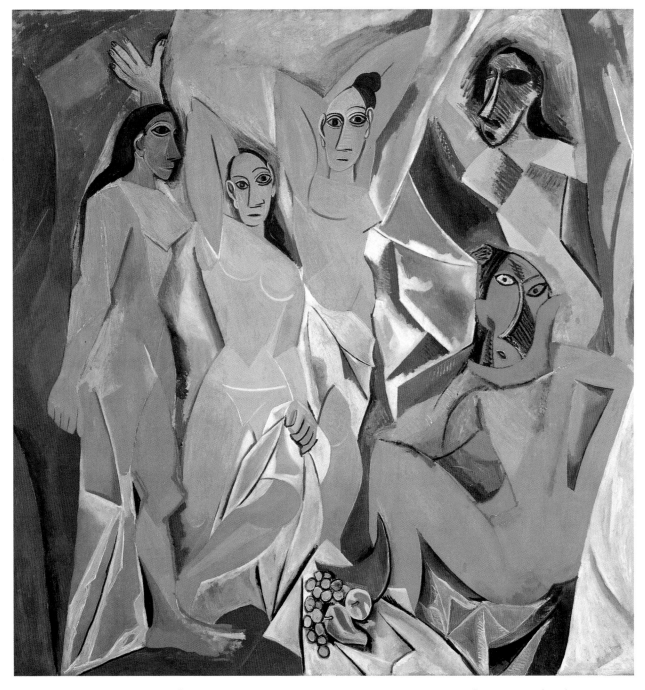

28-36. Pablo Picasso. *Les Demoiselles d'Avignon.* 1907. Oil on canvas, 8' x 7'8" (2.43 x 2.33 m). The Museum of Modern Art, New York
Acquired through the Lillie P. Bliss Bequest

exhibited the year before, and to the French classical tradition that stood behind it, which to Picasso was embodied in Ingres's harem paintings exhibited in a 1905 retrospective. Picasso began by substituting the bordello for the harem. The term *demoiselles* is a euphemism for prostitutes, and Avignon refers not to the French town but to the red-light district of Barcelona. In a preliminary study for the painting (fig. 28-37), Picasso had included two men with the five women. The man on the left holding a book seems to be a student. Other studies suggest

28-37. Pablo Picasso. Study for *Les Demoiselles d'Avignon.* 1907. Pastel on paper, 18¼ x 30" (47.6 x 63.7 cm). Kunstmuseum, Kupferstichkabinett, Basel, Switzerland

that the seated man is a sailor. Picasso may have meant to contrast the contemplative life of the student with the active life of the sailor. His decision to eliminate the men was probably based on a number of considerations. For one, the allegory they suggest detracts from the central issue of sexuality. For another, their confrontation with the women on display makes the viewer a mere onlooker. In the final painting the viewer is a participant: the women now pose for and look directly at us.

Picasso made a number of other changes. The women in the sketch are conventionally rendered in soft curves, but the only "feminine" curve in the finished painting is the line of the inner arm and breast of the central figure. Elsewhere, there are either sharp curves or angles. Picasso's central pair raise their arms in a conventional gesture of open accessibility, contradicted by their hard, piercing gazes and firm mouths. In working out his theme Picasso completely transformed the conventional masculine fantasy of easy access to willing women into a hostile confrontation. Even the fruit displayed in the foreground, a traditional symbol of female sexuality, seems hard and dangerous. Picasso flattened the figures and transformed the entire space into a turbulent series of sharp curves and angles, conveying what one art historian has called "a tidal wave of aggression."

Les Demoiselles d'Avignon was also conceived in opposition to Ingres's *Large Odalisque* (see fig. 26-43) and, in fact, to the entire Western tradition of erotic imagery since the Renaissance. Women, Picasso asserts, are not the gentle and passive creatures men would like them to be. In remarks to a friend about the African masks he used for the faces of the two *demoiselles* on the right, Picasso spoke of the work's purpose:

> Men had made those masks . . . as a kind of mediation between themselves and the unknown hostile forces that surrounded them, in order to overcome their fear and horror by giving [them] a form and image. And that moment I realized that . . . painting isn't an aesthetic operation; it's a form of magic designed as a mediator between this . . . hostile world and us, a way of seizing the power by giving form to our terrors as well as our desires. (cited in Gilot and Lake, page 266)

When Picasso showed the finished work to his friends, they were horrified. Matisse, for example, accused Picasso of making a joke of modern art and threatened to break off their friendship. Only one artist, Georges Braque, eventually responded positively, and he saw in *Les Demoiselles d'Avignon* a potential that Picasso probably had not fully intended. Picasso had set out to produce a stunningly innovative painting that would put him in control of the Parisian avant-garde, but he used broken and flattened forms to express his view of women, not consciously to break with the Western pictorial tradition that had been in place since the early-fourteenth-century painter Giotto. It was this formal revolution that Braque responded to in the work, however, and quickly set out, with Picasso's help, to develop.

28-38. Georges Braque. *Houses at L'Estaque.* 1908. Oil on canvas, 36¼ x 23⅝" (92 x 60 cm). Kunstmuseum, Bern, Switzerland
Collection Hermann and Magrit Rupf-Stiftung

28-39. D. H. Kahnweiler. Photograph of houses at L'Estaque. 1909

Analytic Cubism

Georges Braque was born a year after Pablo Picasso, near Le Havre, France, where he trained to become a house decorator, like his father and grandfather. In 1900 he moved to Paris to complete his apprenticeship but by 1902 had enrolled in one of the city's private academies.

The fledgling painter was so impressed by the Fauves' exhibition of 1905 that he joined them, but he soon grew tired of expressionism. The Cézanne retrospective that he saw in the fall of 1907 established his future course. He later said that exhibition was "more than an influence, it was an initiation." His interest in altered form and compressed space, kindled by Cézanne, was sharpened by Picasso's *Demoiselles*. Picasso, Braque observed, had flattened space and taken liberties with form much as Cézanne had in his late landscapes (see fig. 28-3).

Picasso's radical painting seems to have emboldened Braque to make his own advances on what he saw as Cézanne's late direction. In *Houses at L'Estaque* (fig. 28-38), painted in 1908 in one of Cézanne's favorite locales, we see the emergence of early Cubism. Inspired by Cézanne's example, Braque has reduced nature's many colors to its essential browns and greens. A comparison of the painting with a photograph of the site taken the following year by Braque's dealer (fig. 28-39) shows that the artist also eliminated detail to emphasize basic geometric forms. The houses have been arranged approximately into a pyramid and reduced to a kind of Platonic "houseness." Those in the distance have been pushed closer to the foreground, so the viewer looks *up* the canvas more than into it. In short, Braque simplified and reorganized the scene. The painting is less a Cézannesque study of nature than an attempt to translate nature's complexity into an independent, aesthetically satisfying whole; that is, the painting seems not so much a landscape as an arrangement of form and color meant to gratify a classical taste.

Houses at L'Estaque was put on view in Picasso's studio. Matisse said the avant-garde "considered it as something quite new, about which there were many discussions." Matisse explained to the puzzled critic Vauxcelles, who had coined the term *Fauvism*, that Braque made the painting out of "small cubes." When the critic later described the painting in print using that term, the name *Cubism* was born.

Picasso found in Braque's painting the artistic direction he had seemed to lack since the disastrous private showings of *Les Demoiselles d'Avignon*. By the end of 1908 the two artists had begun an intimate working relationship that lasted until Braque went off to war in 1914. During this period Picasso and Braque visited each other's studio almost every evening to see what the other had done during the day. The two were engaged in a difficult quest for a new conception of painting as, first and foremost, an arrangement of form and color on a two-dimensional surface. This arduous journey would require both Picasso's audacity and Braque's sense of purpose.

The move toward abstraction begun in Braque's landscapes in 1908 continued in the series of moderately scaled still lifes the two artists produced over the next two and a half years. The result of this series is the gradual elimination of space and subject matter. In Braque's *Violin and Palette* (fig. 28-40), the process is well under way. The still-life items are not arranged on a table in **illusionistic** depth but parallel to the picture plane in a shallow space. Using the **passage** technique developed by Cézanne, in which shapes closed on one side are open

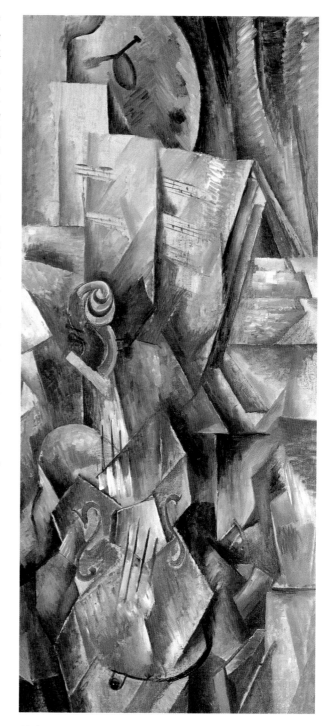

28-40. Georges Braque. *Violin and Palette.* 1909–10. Oil on canvas, 36⅛ x 16⅞" (91.8 x 42.9 cm). Solomon R. Guggenheim Museum, New York

on another so that they can merge with adjacent shapes, Braque has attempted to knit the various elements together into a single shifting surface of forms and colors. In some areas of the painting, the right most noticeably, these formal elements have lost not only their natural spatial relations but their identities as well. Where representational motifs remain—the violin, for example—Braque has fragmented them in order to facilitate their integration into the whole.

28-41. Georges Braque. *Fox.* 1912. Drypoint, printed in brown, 21½ x 15" (54.8 x 38 cm). The Museum of Modern Art, New York

Gift of Abby Aldrich Rockefeller

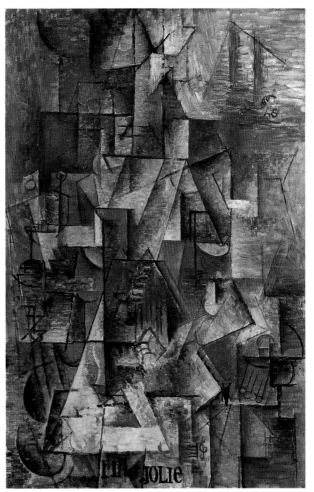

28-42. Pablo Picasso. *Ma Jolie.* 1911–12. Oil on canvas, 39⅜ x 25¾" (100 x 65.4 cm). The Museum of Modern Art, New York

Acquired through the Lillie P. Bliss Bequest

In 1923, Picasso said, "Cubism is no different from any other school of painting. The same principles and the same elements are common to all. The fact that for a long time Cubism has not been understood . . . means nothing. I do not read English, [but] this does not mean that the English language does not exist, and why should I blame anyone . . . but myself if I cannot understand [it]?" (cited in Chipp, page 264).

What Braque was aiming at in the work is indicated by the subjects that remain: the palette, sheet music, and violin. In identifying the palette with the musical elements, Braque reveals his new conception of painting. As their close friend the critic and poet Guillaume Apollinaire wrote in 1912, during these years the two were "moving toward an entirely new art which will stand, with respect to painting as envisaged heretofore, as music stands to literature. It will be pure painting, just as music is pure literature" (cited in Chipp, page 222). Just as the musician arranges sounds to make music, so Braque arranged forms and colors to make art. Braque and, to a somewhat lesser extent, Picasso felt that subject matter could sometimes be just as incidental to art as it is to symphonic music.

Braque's and Picasso's paintings of 1909 and 1910 initiated what is known as Analytic Cubism because of the way the artist took objects like the violin in *Violin and Palette* and broke them down into parts as if to analyze them. The works of 1911 and early 1912 are also grouped under the Analytic label, although in these the artists took a different approach to the breaking up of forms. Instead of simply fracturing an object, Picasso and Braque picked it apart and rearranged its elements. The process by which they worked is most clearly evident in etchings such as Braque's *Fox* (fig. 28-41). Braque began,

as they always did, by setting up a still life on a table in the studio. This one included playing cards among the usual bottles and books. Rather than copy these motifs, Braque proceeded to take from them various shape elements (curves, angles, and lines) and areas of shadow seen from various vantage points, which he then carefully assembled on the surface of his work in a pyramidal fashion. "The goal," as Braque said, "is not the *reconstitution* of an anecdotal fact, but the *constitution* of a pictorial fact." His concern for a classical balance is also evident in the even distribution of these elements on both sides of the central axis and in the frequent use of **T**-square elements aligned with the paper edge. The "pictorial fact" in *Fox*, as in all the works from this period, is defined not by subject but by the subtle nuance of formal harmonies organized in a classical fashion.

Picasso's *Ma Jolie* (fig. 28-42) was also the product of a careful reworking of a studio motif. Remnants of the

subject from which he worked, a woman holding a zither or guitar, are evident throughout the painting, but a search for clues that might allow one to reconstruct that subject would be misguided. The subject provided little more than the raw material for a particular formal arrangement. It is not a painting of a woman, or of a place, or of an event, but a painting pure and simple—or as Apollinaire said, "pure painting." Again, Picasso has suggested a musical analogy: he has painted in a G clef, and the words at bottom, *Ma Jolie*, were the title of a popular song. These references suggest that the viewer should approach the painting the way one would a musical composition, either by simply enjoying the arrangement of its elements or by analyzing it, but not by asking what it represents.

Throughout the painting, Picasso has maintained a subtle tension between order and disorder. For example, the shifting effect of the surface, a delicately patterned texture of grays and browns, is given regularity through the use of short, horizontal brushstrokes. Similarly, with the linear elements, although many irregular curves and angles are to be found, strict horizontals and verticals dominate. The combination of horizontal brushwork and right angles firmly establishes a grid that effectively counteracts the surface flux. Moreover, the repetition of certain diagonals and the relative lack of details in the upper left and upper right create a pyramidal shape. Thus, what at first may seem a random assemblage of lines and muted colors turns out to be well organized. The aesthetic satisfaction of such a work depends on the way chaos seems to resolve itself into order.

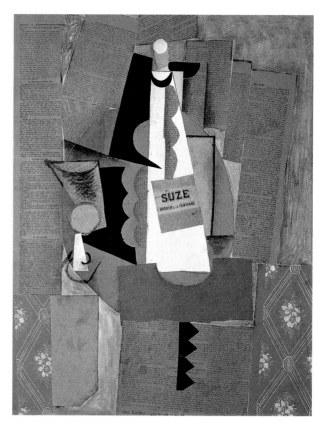

28-43. Pablo Picasso. *Glass and Bottle of Suze.* 1912. Pasted paper, gouache, and charcoal, 25¾ x 19¾" (65.4 x 50.2 cm). Washington University Gallery of Art, St. Louis, Missouri

University Purchase, Kende Sale Fund, 1946

Synthetic Cubism

In works like *Ma Jolie*, Picasso and Braque were on the brink of complete **formalism**. (This term, which carries a host of meanings, is used here to refer to a kind of abstract art that is completely preoccupied with formal elements like line, shape, and color.) Having reached this brink, they retreated, and in the spring of 1912 they began to create works with more clearly discernible subjects. Rather than rendering subjects naturalistically, however, they suggested them. This second major phase of Cubism is known as Synthetic Cubism because of the way the artists created motifs by combining simpler elements, as in a chemical synthesis. Picasso's *Glass and Bottle of Suze* (fig. 28-43), like most of the works he and Braque created from 1912 to 1914, is a **collage**, a work composed of separate elements pasted together. At the center is a combination of newsprint and construction paper cut and assembled to suggest a tray or round table upon which are a glass and a bottle of liquor with an actual label. Around this arrangement, Picasso has pasted larger pieces of newspaper and wallpaper. The elements together evoke not only a place—a bar—but an activity there: the viewer alone with a newspaper, enjoying a quiet drink. The tranquillity of the scene is suggested by the harmony of the browns, grays, and blues and by the classical pyramidal composition of the central elements.

The refuge from daily bustle that both art and quiet bars can provide was a central theme in the Synthetic Cubist works produced by Braque and Picasso. The two artists, however, used different types of newspaper clippings. Braque's clippings deal almost entirely with musical and artistic events. Picasso, signaling a renewed interest in the personal and social themes that had concerned him before his association with Braque, often included references to political events that would soon shatter the peaceful pleasures these works feature.

In *Glass and Bottle of Suze*, for example, the newspaper clippings deal with the First Balkan War of 1912–1913, which contributed to the mounting tensions that resulted in World War I. *Glass and Bottle of Suze* includes graphic descriptions of the war's victims, which are placed upside down in the collage, just possibly to suggest a world turned on its head. The clippings also include a report of a meeting in France of about 50,000 pacifists from all over Europe hoping to prevent "a general European war." Picasso's collage may record his uneasy response to the political events, or conversely, the clippings may simply document the problems from which bohemian bars and art itself provided a safe, if temporary, refuge.

In addition to collage, Picasso produced a number of Synthetic Cubist sculpture, such as *Mandolin and Clarinet* (fig. 28-44). Composed of wood scraps, the sculpture sug-

28-44. Pablo Picasso. *Mandolin and Clarinet.* 1913.
Construction of painted wood with pencil marks,
22⅝ x 14⅛ x 9" (58 x 36 x 23 cm). Musée Picasso,
Paris

28-45. Jacques Lipchitz. *Man with a Guitar.* 1915.
Limestone, 38¼ x 10½ x 7¾" (97.2 x 26.7 x 19.7 cm).
The Museum of Modern Art, New York
Mrs. Simon Guggenheim Fund (by exchange)

gests two musical instruments at right angles to one
another. The scrap wood and unfinished surfaces call
attention to the everyday world of the workers and crafts-
people with whom both Picasso and Braque identified
themselves at the time. The result is a fascinating in-
tegration of the fabricating techniques of the ordinary
workplace with the high-art aesthetics of Cubism.

Responses to Cubism

As the various phases of Cubism emerged from the stu-
dios of Braque and Picasso, it became clear to the art
world that something of great significance was happen-
ing. The radical innovations of the new style confused
and upset the public and most critics, but the avant-
garde saw in them the future of art.

French Responses. Some artists put these innovations
into the service of a less radical art, as can be seen in the
Cubist-inspired sculpture of Jacques Lipchitz (1891–1964).
Lipchitz, who came to Paris from Russia in 1909, met
Picasso in 1913. The influence of both Analytic and Syn-
thetic Cubism can be seen in his work of the period before
and during World War I. *Man with a Guitar* (fig. 28-45), for
example, is in the Synthetic Cubist mode. Like Picasso in
Mandolin and Clarinet, Lipchitz assembled curvilinear and
angular shapes, in this case to approximate a figure hold-

ing a guitar. The hole at the center of the work is wittily
used to suggest both the sound hole of the guitar and the
figure's navel. The piece aims simply to create a pleasant
arrangement of shifting but ultimately stable forms.

At the other end of the spectrum was the radical
painting of Robert Delaunay (1885–1941), who attempted
to take a monochromatic, static, and antisocial Analytic
Cubism into a new, wholly different direction. By 1904
Delaunay had become a landscape painter, first in the
Impressionist mode, then, after 1905, in the Fauvist vein.
His insistence on the spirituality of color, which recom-
mended him to Der Blaue Reiter, was first evident in the
series of paintings of a Gothic church interior he did in
1909.

Beginning in 1910 he attempted to fuse Fauvist color
with Analytic Cubist form in a series of works dedicated
to modern technology. One of these, *Homage to Blériot*
(fig. 28-46), is a tribute to the French pilot who in 1909
was the first to fly across the English Channel. One of
Louis Blériot's early airplanes, somewhat like the less-
advanced one the Wright brothers used in 1903, is shown
in the upper right, just above the Eiffel Tower. The air-
plane and the Eiffel Tower were powerful symbols of both
technological and social progress in this period. The
crossing of the channel was considered evidence of a
new, unified world without frontiers and national antag-
onisms. The arrangement of brightly colored circular

28-46. Robert
 Delaunay.
 *Homage to
 Blériot.* 1914.
 Tempera
 on canvas,
 8'2½" x 8'3"
 (2.5 x 2.51 m).
 Kunstmuse-
 um, Basel,
 Switzerland .
 Emanuel
 Hoffman
 Foundation

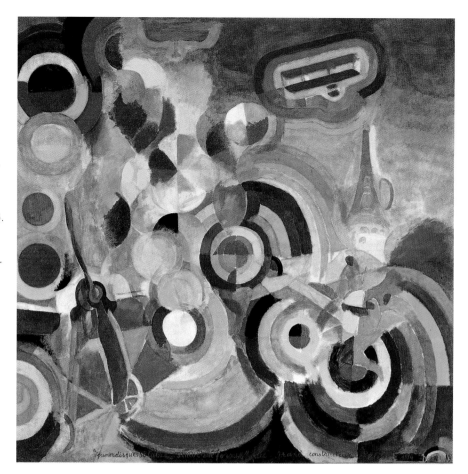

THE FUTURIST MANIFESTO On February 20, 1909, the Italian poet and publisher Filippo Tommaso Marinetti, who liked to think of himself as "the caffeine of Europe," published in the French newspaper *Le Figaro* "The Foundation and Manifesto of Futurism." The **manifesto** opens with a long, detailed description of a late-night automobile accident caused by

two cyclists, wavering in front of me like two equally persuasive but contradictory arguments. . . . What a nuisance! Auff! . . . I stopped short and—disgusting—was hurled, wheels in the air, into a ditch. . . .

Oh! maternal ditch, almost to the top with muddy water! Fair factory drainage ditch! I avidly savored your nourishing muck. . . . When I got out from under the upturned car—torn, filthy, and stinking—I felt the red-hot iron of joy pass over my heart!

After this preamble, Marinetti declares:

1. We intend to glorify the love of danger . . . the strength of daring. . . .

3. Literature having up to now glorified thoughtful immobility . . . and slumber, we wish to exalt the aggressive movement, the feverish insomnia, running, the perilous leap, the cuff, and the blow.

4. We declare that the splendor of the world has been enriched with a new form of beauty, the beauty of speed. A race-automobile . . . which seems to rush over exploding powder is more beautiful than the *Victory of Samothrace.* . . .

7. There is no more beauty except in struggle. No masterpiece without the stamp of aggressiveness. . . .

9. We will glorify war—the only true hygiene of the world—militarism, patriotism, the destructive gesture of [the] anarchist, the beautiful Ideas which kill, and the scorn of woman.

10. We will destroy museums, libraries, and fight against moralism, feminism, and all utilitarian cowardice.

11. We will sing the great masses agitated by work, pleasure, or revolt; we will sing the multicolored and polyphonic surf of revolutions in modern capitals. . . .

It is in Italy that we hurl this overthrowing and inflammatory declaration, with which today we found Futurism, for we will free Italy from her numberless museums which cover her with countless cemeteries. . . .

To admire an old picture is to pour our sentiment into a funeral urn instead of hurling it forth in violent gushes of action and productiveness. . . .

Therefore welcome the kindly incendiarists with the carbon fingers! Here they are! . . . Away and set fire to the bookshelves! . . .

The oldest among us are thirty; we have thus at least ten years in which to accomplish our task. When we are forty, let others—younger and more daring men—throw us into the wastepaper basket like useless manuscripts!

those of divinity, Delaunay meant to suggest that progress is part of God's divine plan. The ecstatic painting is thus a synthesis not only of Fauvist color and Cubist form but of conservative religion and modern technology as well.

Critics labeled Delaunay's art Orphism to suggest its affinities with Orpheus, the legendary Greek poet whose lute playing charmed wild beasts. Delaunay preferred to think of his work in terms of simultaneity, a vague and complicated concept he developed with his wife, the Russian-born artist Sonia Delaunay-Terk (née Sonia Terk, 1885–1979), that centered on a faith in the great unity of opposites.

Terk had moved to Paris in 1905 after a short period of study in Germany. By 1907 she was producing simplified portraits and figure studies using a Fauvist palette. After her marriage to Delaunay, in 1910, she produced work very similar to his both in style and in theme. In 1913, for example, she made a painting celebrating Paris's newly installed electric streetlights. Her work has received less attention than his partly because she worked in the applied arts, with fabrics in particular. Following the birth of their son in 1911, she made him a patchwork quilt, like those produced by Russian peasant women, out of pieces of colored fabric. The quilt seems to have come as a revelation for both Delaunays. It helped Robert develop a series of nonrepresentational works in 1912, and it led Sonia to design other utilitarian objects, especially clothing. In 1914 she designed the "simultaneous dress" (fig. 28-47) to wear at the dance hall where the Delaunays and their friends met every week. The simple, formfitting dress is made of brightly colored patches arranged dynamically. A spinning solar form like those found in *Homage to Blériot* decorates the front. By applying motifs from their forward-looking paintings to clothing, she was attempting to bring to daily life the dynamic and progressive rhythms that she and her husband felt were invigorating the modern era.

Italian Responses. Another of the twentieth century's isms, Futurism, emerged on February 20, 1909, when a controversial Milanese literary magazine editor, Filippo Marinetti, published his "Foundation and Manifesto of Futurism" in a Paris newspaper. An outspoken attack against everything old, dull, "feminine," and safe, Marinetti's **manifesto** promoted the exhilarating "masculine" experiences of warfare and reckless speed (see "The Futurist Manifesto," opposite). Although the stated aim of Futurism was to free Italy from its past, the deeper purpose was to promote a new taste for heightened experience.

In 1909 a number of artists and poets gathered around Marinetti in Milan to create art forms for a modernized and revitalized Italy. Prominent among the artists was the sculptor and painter Umberto Boccioni (1882–1916), who had followed his training in Rome with extensive European travel. In 1907 he settled in Milan, the industrial center of Italy, where he applied a modified Neo-Impressionist technique to modern subjects. After joining Marinetti he helped draft two manifestos of Futurist painting in 1910 and wrote one on sculpture in 1912.

His major sculptural work was *Unique Forms of*

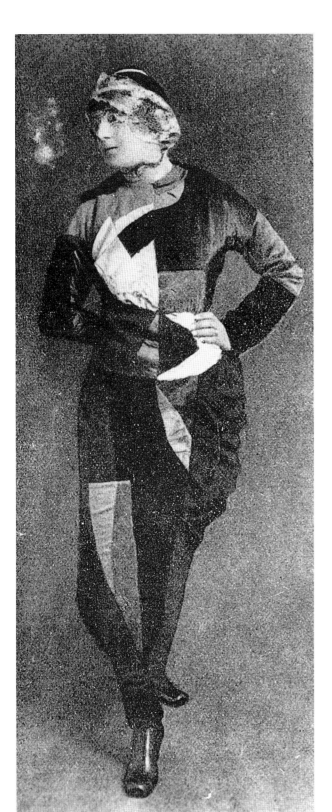

28-47. Sonia Delaunay-Terk, photographed wearing a "simultaneous dress" of her own design at the Bal Bullier, Paris. 1914

forms that fills the canvas is more than an expressionistic record of Delaunay's excitement at this prospect. The circular shapes, which suggest both the movement of the propeller on the left and the blazing sun, are meant to evoke as well the great **rose windows** of Gothic cathedrals. By combining images of progressive science with

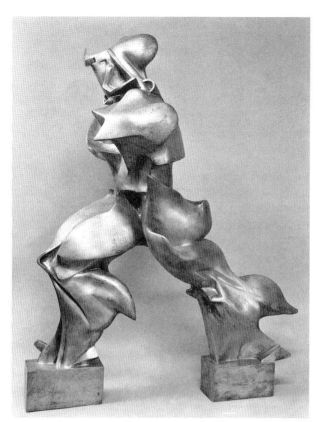

28-48. Umberto Boccioni. *Unique Forms of Continuity in Space*. 1913. Bronze, 43⅞ x 34⅞ x 15¾" (111 x 89 x 40 cm). The Museum of Moden Art, New York
Acquired through the Lillie P. Bliss Bequest

Boccioni and the Futurist architect Antonio Sant'Elia (see fig. 28-74) were both killed in World War I. The Futurists had ardently promoted Italian entry into the war on the side of France and England. After the war Marinetti's movement, still committed to nationalism and militarism, supported the rise of fascism under Benito Mussolini, although a number of the original members of the group rejected their youthful values.

Continuity in Space (fig. 28-48). The bronze sculpture depicts a powerful nude figure in full stride. The formal vocabulary of exaggerated muscular curves and countercurves was inspired by early Analytic Cubist still lifes and figure studies that he had seen in Paris in 1911. But whereas the Cubists had broken forms to integrate their compositions, here Boccioni dynamically stretches and swells them to express the figure's power and speed. In contrast to the Cubist taste for order and stability, this work revels in movement and change. The figure personifies the new Italian envisioned by the group, a powerful male rushing headlong into the future.

Boccioni's paintings celebrate the modern industrial city. *States of Mind: The Farewells* (fig. 28-49), for exam-

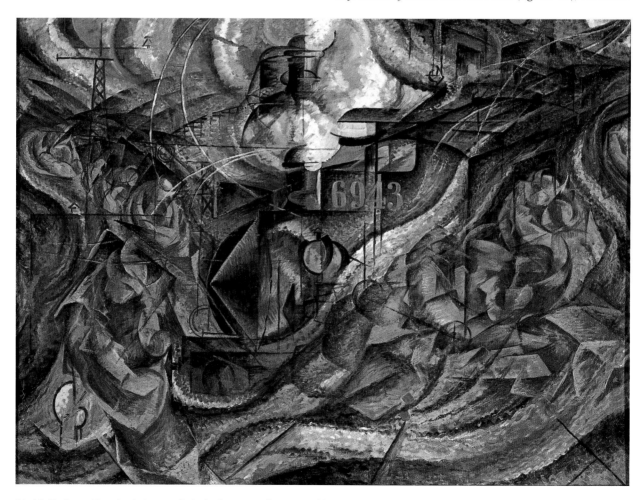

28-49. Umberto Boccioni. *States of Mind: The Farewells*. 1911. Oil on canvas, 27⅞ x 37⅞" (70.7 x 96 cm). The Museum of Modern Art, New York
Gift of Nelson A. Rockefeller

28-50. Giacomo Balla. *Dynamism of a Dog on a Leash (Leash in Motion)*. 1912. Oil on canvas, 35³/₄ x 43³/₈" (91 x 110 cm). Albright-Knox Art Gallery, Buffalo, New York

George F. Goodyear Bequest

28-51. Anton Giulio Bragaglia. *Greetings!* 1911. From *Fotodinamismo Futurista*, Rome, 1913

ple, immerses the viewer in the crowded, exciting chaos of a train station. At the center, with numbers emblazoned on its front, is a powerful steam locomotive. Pulsing across the top of the work is a series of bright curves meant to suggest radio waves emanating from the steel tower in the left rear. Adding to the complexity of the tightly packed surface are the longer, more fluid rhythms that seem to pull a crowd of metallic figures from beneath the tower down and across the work. The figures are actually a single couple shown moving through space and time. Although their simplified, blocky forms were borrowed from Analytic Cubism, their sequential arrangement was inspired by time-lapse photography. Boccioni wanted to convey more than a purely physical sense of such a place. He wanted, as well, to suggest the variety of sounds, smells, and emotions that filled the train station and made it the very epitome of the noisy urban existence he and his colleagues so loved.

The time-lapse photography (or **chronophotography**) of Eadweard Muybridge (see fig. 27-35) and Étienne-Jules Marey also provided the formal vocabulary for another of the Futurists, the Roman painter Giacomo Balla (1871–1958). Entirely self-taught, he worked first in a naturalistic manner and then in the modified Neo-Impressionist mode he introduced to his former student, Boccioni. In 1910 he signed the Futurist painting manifesto written in Milan. His paintings such as *Dynamism of a Dog on Leash (Leash in Motion)* (fig. 28-50) exhibit the less aggressive side of Futurism. The work, which condenses a series of time-lapse photographs into a single image, charmingly shows the excited movements of a dachshund and its owner out for a stroll. The painting expresses the group's love of movement but does so without any of the force or violence characteristic of its rhetoric.

Futurism found its own chronophotographer in Anton Giulio Bragaglia (1890–1960), who began his career in the fledgling movie industry of Rome in 1906. He

turned to photography in 1910, partly as a result of reading the various Futurist manifestos. By the following year he had evolved his own brand of Futurist photography, which he called Photodynamism. He produced photographs like *Greetings!* (fig. 28-51) by leaving the camera's shutter open while his subjects moved. The polite subject is in keeping with the less published side of Futurist production. Bragaglia also made photographs more consistent with the values outlined in Marinetti's manifesto, which ultimately helped produce Italian fascism.

Russian Responses. Since the time of Peter the Great (ruled 1682–1725), Russia's ruling classes had turned to Western Europe for cultural models. Throughout the eighteenth and nineteenth centuries, for example, French had been the official language of the Russian court and the educated elite. Until two wealthy young men, Aleksandr Benois (1870–1960) and Serge Diaghilev (1872–1929), began championing them, however, the leading-edge developments in Western European art in the late nineteenth century had been of little interest to Russian artists, writers, and critics. Benois and Diaghilev wanted not just to import Western innovations into Russia but also to make Russia for the first time a center of innovation that would contribute significantly to Western European culture. In 1899 they launched a magazine, *World of Art*, dedicated to international art, literature, and music. In the following year the World of Art group held the first in a series of international art exhibitions, which included works by Degas, Monet, Whistler, and Puvis de Chavannes. Following the group's desire to contribute to Western culture, Diaghilev took an exhibition of contemporary Russian art to Paris in 1906. Three years later he brought the Ballets Russes to the French capital, where it enjoyed enormous success.

The activities of the World of Art group, which was centered in Russia's capital, St. Petersburg, inspired the

28-52. Natalia Goncharova. *Haycutting.* 1910. Oil on canvas,
38⅝ x 46¼" (98 x 117 cm). Private collection

28-53. Natalia Goncharova. *Aeroplane over Train.* 1913.
Oil on canvas, 21⅝ x 32⅞" (55 x 83.5 cm). Kazan-skil
Muzej, Russia

formation of a similar group in Moscow, the Golden
Fleece. In 1906 it launched an art magazine by that name
and in 1908 organized a major exhibition of Russian and
French art, which included works by Rodin, Maillol,
Toulouse-Lautrec, Gauguin, Cézanne, Matisse, Derain,
and Braque. This exhibition had a complicated effect on
the city's young artists, as is evident in the work of
Natalia Goncharova (1881–1962), one of many women in
Russia's avant-garde.

By the early 1900s Goncharova had come under the
influence of Moscow's pro–Russian (or Slavophile) move-
ment, which opposed the pro–Western European stance
in St. Petersburg. She and her friends were convinced
that in order to participate in the international avant-
garde, they would, ironically, have to return to their own
roots. Reflecting these beliefs, the paintings she made
around 1905 are based on medieval Russian icons. The
works that she contributed to the first Golden Fleece
exhibition in 1908 created a sensation and launched the
Russian Neo-Primitive movement. Goncharova's *Haycut-
ting* (fig. 28-52) is typical of her Neo-Primitive paintings.

In it she expresses the Slavophile view that the simple
virtues of the provincial peasant represented the best of
Russia. Not an idealized depiction meant to delight city
people, it is, instead, a tribute to peasant strength in the
vein of Jean-François Millet (see fig. 27-19). The crude
style, meant to express the quality of peasant life, is
based on the cheap **woodblock** prints of religious and
political scenes (*lubok*) that decorated peasant homes.
Disregard for scale was characteristic of these prints.

Haycutting also seems to support a negative attitude
toward the industrialization of Russia. In the face of the
recent exodus of peasants to the burgeoning urban cen-
ters, this work appears to argue for a traditional way of
life. Three years later, however, Goncharova produced
Aeroplane over Train (fig. 28-53), which suggests a com-
pletely changed viewpoint, one now consistent with Fu-
turist values. The work combines two of the leading
symbols of technological progress in a style derived from
both early Analytic Cubism and Futurism. Blocky Cubist
shapes are closely packed in a dynamic Futurist rhythm
across a surface also marked by a series of sharp diago-
nals. Because knowledge of Analytic Cubism and Fu-
turism arrived in Moscow almost simultaneously and
because they were superficially similar, artists such as
Goncharova tended to link them. Thus, the style that
evolved from them in the period 1912–1914 is known as
Cubo-Futurism, even though it had less to do with Cubist
than with Futurist values.

The brief time between *Haycutting* and *Aeroplane
over Train* suggests the considerable confusion that many
Russians felt over the questions of rural versus urban,
agrarian versus industrial, and Russian versus French.
The one issue Goncharova and the Cubo-Futurists were
not in doubt about was artistic progress. They embraced
Cubism and Futurism out of a commitment to "advance"
art. And like Benois and Diaghilev, they were not satis-
fied simply with keeping up with the new advances; they
wanted to contribute to them.

The first Russian to go beyond Cubo-Futurism was
Kazimir Malevich (1878–1935). After Goncharova and
her husband, the artist Mikhail Larionov (1881–1964), left
for Paris in 1915 to work for Diaghilev's Ballets Russes,
Malevich emerged as the leading figure in the Moscow
avant-garde. By 1913 he was producing his own brand of
Cubo-Futurism and his first truly abstract work. Accord-
ing to his later reminiscences, "in the year 1913, in my
desperate attempt to free art from the burden of the
object, I took refuge in the square form and exhibited a
picture which consisted of nothing more than a black
square on a white field." Because he did not exhibit such
a work until 1915, there is some question about the exact
date of his first completely nonrepresentational work.
Whatever the case, Malevich exhibited thirty-nine works
in this radically new and highly controversial vein at the
"Zero Ten" exhibition in St. Petersburg in the winter of
1915–1916. One work, *Suprematist Painting (Eight Red
Rectangles)* (fig. 28-54), consists simply of eight red rec-
tangles arranged diagonally on a white painted ground.
Here is the move to total abstraction that Picasso and
Braque refused to make in 1912.

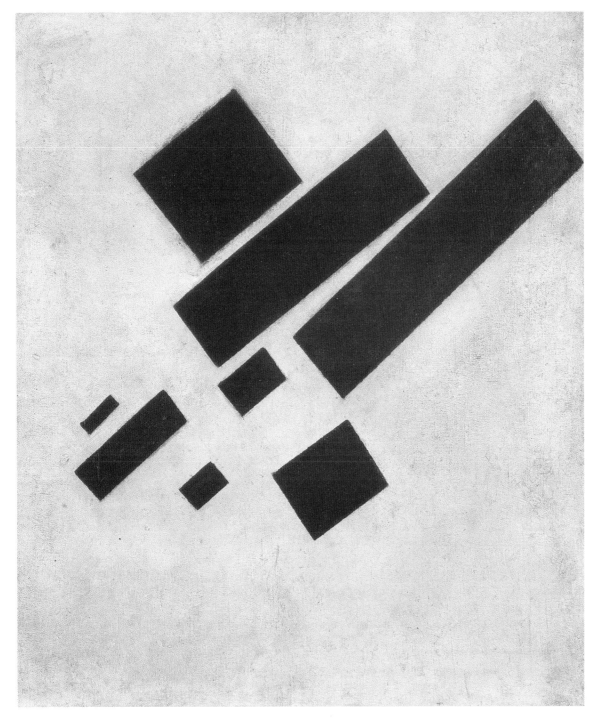

28-54. Kazimir Malevich. *Suprematist Painting (Eight Red Rectangles)*. 1915. Oil on canvas, 22 1/2 x 18 7/8" (57 x 48 cm). Stedelijk Museum, Amsterdam

Malevich's Suprematist works, like many abstract paintings, do not reproduce well—their aesthetically appealing subtleties of texture, line, and color are not readily apparent in photographs. Even more than other artworks, they need to be seen firsthand to be fully appreciated.

Malevich called this art Suprematism, short for "the supremacy of pure feeling in creative art." Although he sometimes spoke of this feeling in terms of technology ("the sensation of flight . . . of metallic sounds . . . of wireless telegraphy"), a later essay suggests that what motivated these works was "a pure feeling for plastic [that is, formal] values." By eliminating objects and focusing entirely on formal issues, Malevich thought that he was "liberating" the essential beauty of all great art.

While Malevich was launching an art that transcended the events and conditions of the present, his chief competitor for leadership of the Russian avant-garde, Vladimir Tatlin (1885–1953), was somewhat inadvertently opening a very different direction for Russian art, one inspired by Synthetic Cubism. In 1913 he went to Paris specifically to visit Picasso's studio. What impressed him most was the new Synthetic Cubist sculpture, such as *Mandolin and Clarinet* (see fig. 28-44).

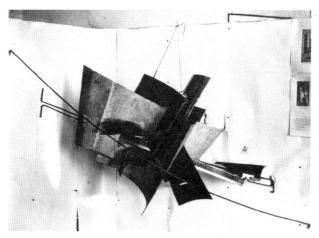

28-55. Vladimir Tatlin. *Corner Counter-Relief.* 1915.
Mixed mediums, 31 1/2 x 59 x 29 1/2" (80 x 150 x 75 cm).
Present whereabouts unknown

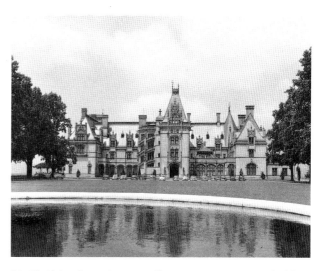

28-56. Richard Morris Hunt. Biltmore, George W. Vanderbilt
estate, Asheville, North Carolina. 1888–95

After returning to Moscow Tatlin produced an innovative series of entirely nonrepresentational relief sculpture constructed of various materials, including metal, glass, **stucco**, asphalt, wire, and wood. These Counter-Reliefs, as he called them, were based on the concept of *faktura*, the conviction that each material generates its own precise repertory of forms and colors. Partly because he wanted to place "real materials in real space," and because he thought the usual placement on the wall tended to flatten his reliefs, he began at the "Zero Ten" exhibition of 1915–1916 to suspend them across the upper corners of rooms (fig. 28-55). The upper corner of a room was also the traditional location for Russian icons. In effect, these Corner Counter-Reliefs were intended to replace the old symbol of Russian faith with one dedicated to the principle of respect for materials. But because his choice of materials increasingly favored the industrial over the natural, these modern icons should also be viewed as incipient expressions of the post–World War I shift away from aestheticism and toward utilitarianism in Russia, a topic to be explored more fully later in this chapter.

ARCHITECTURE BEFORE WORLD WAR I

The history of architecture between 1880 and World War I is a story of the impact of modern conditions and materials on the still-healthy Beaux-Arts **historicist** tradition, a tradition based on the emulation of historical models. Unlike painting and sculpture, where anti-academic forces dominated after 1880, in architecture the search for modern styles occurred somewhat later and met with considerably more resistance. While the artistic education offered at the École des Beaux-Arts in Paris was rapidly losing importance, its architecture department was becoming the central training ground for the profession in both Europe and the United States.

American Beaux-Arts Architecture

The dean of late-nineteenth-century American architects was Richard Morris Hunt (1827–1895). In 1846 Hunt became the first American to study architecture at the École des Beaux-Arts in Paris. In 1855, determined to raise the standards of American architecture, he opened an office in New York City. Extraordinarily skilled in Beaux-Arts eclecticism, he produced work in every accepted style, including Gothic, French Classicist, and Italian Renaissance. Hunt did much of his work after the American Civil War (1861–1865) for the growing class of wealthy Eastern industrialists and financiers. One of his most impressive works is Biltmore (fig. 28-56), constructed in Asheville, North Carolina, for George W. Vanderbilt, the youngest son of one of America's richest families.

Vanderbilt conceived the 125,000-acre estate he had assembled as a model farm and forest. With the assistance of Gifford Pinchot, who later established the national park system under President Theodore Roosevelt (in office 1901–1909), he introduced at Biltmore the concept of what he called "selective cutting [of trees] for sustained yield." Surrounding the house are a series of historic gardens designed by Frederick Law Olmsted (1822–1903), the United States' first landscape architect. These include an Italian water garden, a picturesque eighteenth-century English ramble, a walled medieval garden, and, fronting the mansion, a broad esplanade in the manner of those at Versailles (see fig. 19-23). The 225-room house itself is modeled on a French Renaissance **château**. Its aristocratic pretensions reflect the social ambitions not only of the young Vanderbilt but of his entire class, which wanted to establish in the United States a hereditary social hierarchy like that of Europe.

While Biltmore was under construction, Hunt participated in another large project with more democratic aims as head of the board of architects for the 1893 World's Columbian Exposition in Chicago. For the exposition, organized to commemorate the 400th anniversary

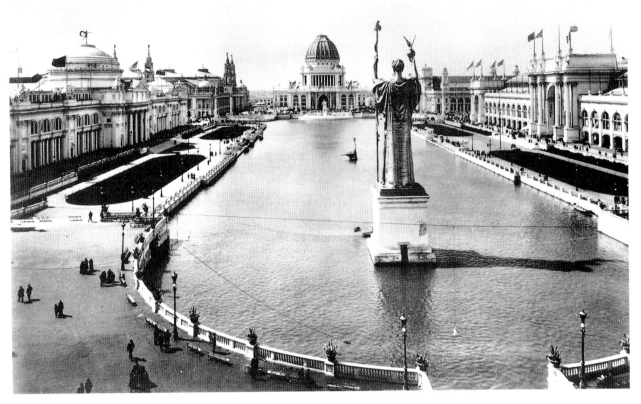

28-57. Richard Morris Hunt. Court of Honor, World's Columbian Exposition, Chicago. 1893

of Columbus's arrival in the Americas, the board abandoned the metal-and-glass architecture of earlier world's fairs in favor of the appearance of what it called "permanent buildings—a dream city." (The buildings were actually temporary ones composed of staff, a mixture of plaster and fibrous materials.) To create a sense of unity, they decided to use a single, classical, style for all the exposition's buildings. This style, with its associations both to the birth of democracy in ancient Greece and to the imperial power of ancient Rome, reflected United States pride in its democratic institutions and the country's incipient emergence as a world power. Hunt's design for the Administration Building at the end of the Court of Honor (fig. 28-57), like that for most of the buildings, was in the Renaissance classicist mode used by Jefferson and other early American architects for civic buildings (see fig. 26-58). This particular version of the classical was also meant to communicate that the United States was cultivating a new, more democratic renaissance after the Civil War.

The World's Columbian Exposition also provided a model for the new American dream city. The rapidly growing American urban centers of the late nineteenth century were, on the whole, ill-planned, sooty, and overcrowded. The exposition offered reassurance that the city of the future could be clean, timeless, carefully planned, and spacious. One of the most important features of what became known as the City Beautiful move-

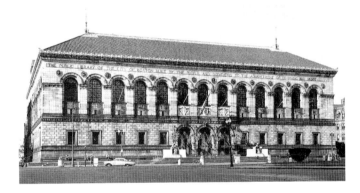

28-58. McKim, Mead, and White. Boston Public Library. 1887–92

ment signaled here was the concern for city parks. Frederick Law Olmsted, who designed the gardens at Biltmore, also contributed to the extensive landscape design of the World's Columbian Exposition. Olmsted spearheaded the city park movement in the United States and firmly believed that nature softened many of the harmful effects of modern city life. When he designed New York City's Central Park in 1858 he called it "the green lung of the city" (see fig. 26-61).

Many civic buildings of the late nineteenth century reflect a similar vision that informed the World's Columbian Exposition: that of the United States as a site of a democratic renaissance. One such building, the Boston Public Library (fig. 28-58), was designed by the New York

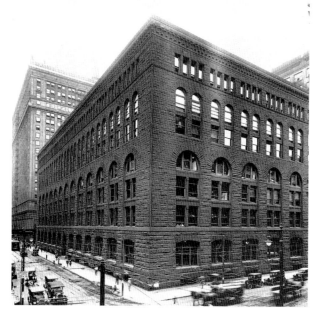

28-59. Henry Hobson Richardson. Marshall Field Warehouse,
Chicago. 1885–87. Demolished c. 1935

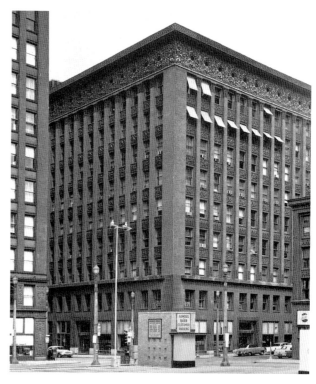

28-60. Louis Sullivan. Wainwright Building, St. Louis, Missouri.
1890–91

architectural firm of Charles Follen McKim (1847–1909), who had studied for three years at the École des Beaux-Arts, William Rutherford Mead (1846–1928), and Stanford White (1853–1906). During the 1890s McKim, Mead, and White was the largest architectural firm in the world. The Boston Public Library has a Renaissance palace-style design that reflects the trustees' request that it be a "palace of the people." The reading room inside is based on Florentine palace courtyards. On the exterior, **arcaded** windows (set in a row of connected arches) surmount smaller square windows on the street level. Although a group of wealthy families paid for the library, the inscription above the windows states that it was "built by the people and dedicated to the advancement of learning." The building housed the largest circulating library in the world and was intended as a testament to the power of learning. It is built of light pink granite and is raised above the ground on a platform base to suggest the uplifting effects of public education.

The second American architect to study at the École des Beaux-Arts was Henry Hobson Richardson (1838–1886). Born in Louisiana and schooled at Harvard, Richardson returned from Paris in 1865. Like Hunt, he worked in a variety of styles, but he became famous for a simplified Romanesque style known as Richardsonian Romanesque. His best-known building is probably the Marshall Field Warehouse in Chicago (fig. 28-59). Although it is reminiscent of Renaissance palaces in form and of Romanesque churches in its heavy stonework and arches, it has no precise historical antecedents. Instead, Richardson took a fresh approach to the design of the utilitarian building. Applied ornament is all but eliminated in favor of the intrinsic appeal of the rough stone and the subtle harmony between the red sandstone and the darker red granite of the base. The solid corner **piers**, the vertical structural supports, give way to the regular rhythm of the broad arches of the middle floors, which are doubled in the smaller arches above, then doubled again in the

square windows of the attic. The integrated mass of the whole is completed in the clean, crisp line of the simple cornice at the top.

Richardson's break with the historicist tradition may partly be explained in terms of a strong anti–East Coast establishment current among Chicago's business executives and architects. Whether or not Richardson meant to appeal to Chicago's businesslike self-image, he certainly did. The plain, sturdy building was a revelation to the young architects of Chicago then engaged in rebuilding the city after the disastrous fire of 1871, which had destroyed the entire downtown. Richardson's building helped them give shape to their emerging desire to develop a distinctly American architecture.

The American Skyscraper

From a technical standpoint, Richardson's Marshall Field Warehouse represents the end of a short-lived tradition of iron-framed buildings in the United States. Many of the first iron-framed buildings of the mid-nineteenth century also had cast-iron facade elements. These structures were soon found to have a fatal susceptibility to fire; exposed to intense heat, iron will warp, buckle, collapse, or melt altogether. The solution was to encase the internal iron supports in fireproof materials and return to masonry sheathing, which suited Richardson's taste.

The perfection at this time of a technique for making inexpensive steel (a more refined, stronger iron) introduced entirely new possibilities for architecture. Steel was first used for buildings in 1884 by the young architects soon to be grouped under the label of the Chicago School. These architects saw in the stronger, lighter material the answer to both their desire for an indepen-

ELEMENTS OF ARCHITECTURE
The Skyscraper

The evolution of the skyscraper depended on the development of these essentials: metal beams and girders for the structural-support skeleton; the separation of the building-support structure from the enclosing layer (the cladding); fireproofing materials and measures; elevators; and plumbing, central heating, artificial lighting, and ventilation systems. First-generation skyscrapers, built between about 1880 and 1900, were concentrated in the Midwest, especially Chicago (see figs. 28-59 and 28-60). Second-generation skyscrapers, with more than twenty stories, date from 1895. At first the tall buildings were freestanding towers, sometimes with a base, like the Woolworth Building of 1911-1913 (see fig. 28-61). New York City's Building Zone Resolution of 1916 introduced mandatory setbacks—recessions from the ground-level building line—to ensure light and ventilation of adjacent sites. Built in 1931, the 1,250-foot, setback-form Empire State Building is thoroughly modern in having a streamlined exterior—its cladding is in Art Deco style—that conceals the great complexity of the internal structure and mechanisms that make its height possible. The Empire State Building is still the third-tallest building in the world, after the Sears Tower in Chicago (1,454 feet) and the World Trade Center Towers in New York City (each 1,350 feet).

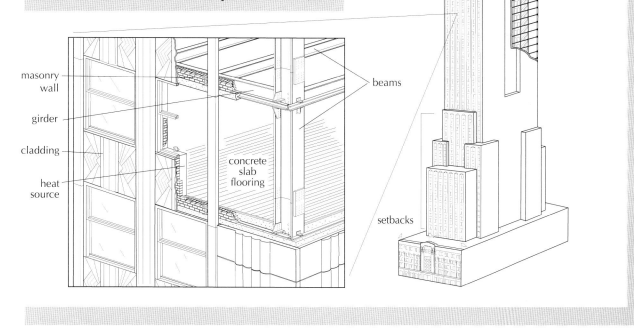

masonry wall

girder

cladding

heat source

beams

concrete slab flooring

elevator shafts (layer two)

stairwells (layer one)

setbacks

dent style and their clients' desire for taller buildings. Interest in tall buildings was essentially economic. By 1880 Chicago was the largest railroad juncture in the nation and the hub of the biggest system of inland waterways in the world. Between 1860 and 1880 its population had risen from about 100,000 to more than a million people. The rapidly rising cost of commercial property made its more efficient use a major consideration for businesspeople. Another technological development that made the tall office building feasible was the passenger elevator, the first of which was installed in 1857. The first electric elevator dates from 1889.

Equipped with steel and with the improved passenger elevators, driven by new economic considerations, and inspired by Richardson's radical departure from Beaux-Arts historicism, the Chicago School architects produced a new kind of building, the skyscraper, and a new style (see "Elements of Architecture," above). A fine early example of their work, and evidence of its rapid spread throughout the Midwest, is Louis Sullivan's Wainwright Building in St. Louis, Missouri (fig. 28-60). Sullivan (1856–1924), the creative leader of the firm of Adler and Sullivan, had studied for a year at the Massachusetts Institute of Technology (MIT), home of the United States' first architectural program, and equally briefly at the École des Beaux-Arts, where he seems to have developed his lifelong distaste for historicism. After apprenticeships in Philadelphia and in New York with Hunt, he moved to Chicago in 1875, partly because of the building boom there that followed the fire of 1871.

28-61. Cass Gilbert. Woolworth Building, New York. 1911–13

28-62. Frank Lloyd Wright. Larkin Building, Buffalo, New York. 1904. Demolished 1949

Wright later said about the Larkin Building: "Down all the avenues of time architecture was an enclosure . . . and the simplest form of enclosure was the box. . . . As a young architect, I began to feel annoyed, held back . . . by this sense of enclosure which you went into and there you were—boxed, crated. . . . I think I first *consciously* began to try to beat the box in the Larkin building. . . . I found a natural opening to the liberation I sought when (after a great struggle) I finally pushed the staircase towers out from the corners of the main building [and] made them into free-standing individual features... the first real expression of the idea that the space within the building is the reality of that building" (cited in Pfeiffer and Nordland, page 9).

Sullivan may have been against historicism, but he was no revolutionary, as the Wainwright Building attests. Like Richardson's Marshall Field Warehouse, Sullivan's ten-story office building adapts the formal vocabulary of the Beaux-Arts tradition. Its organization into three parts respects the basic compositional rule taught at the French Academy. Although Sullivan claimed to have renounced the classical column, with its base, shaft, and capital, the facade of the Wainwright Building nevertheless conforms to that time-honored model. The building's ornamentation also reflects ties to the historicist tradition. Giving expression to both his own taste and the growing desire to bring nature into the city, Sullivan invented the dense tendril motif on the terra-cotta tiles in the cornice and below the windows. What is entirely new is the building's vertical emphasis. Unlike Richardson's warehouse, this structure is taller than it is wide; whereas Richardson tried to make his building look shorter by organizing multiple floors into single arcades and by organizing his dominant rhythms horizontally, Sullivan used dominant verticals to emphasize height. The strong corner piers, borrowed from Richardson, rise in clean and uninterrupted lines to the cornice. The smaller piers between the windows, intended to suggest the steel framing beneath them, echo those dominant verticals and reinforce them.

In the period after 1900 New York City assumed leadership in the development of the skyscraper, although clients there rejected the innovative Chicago style for the historicist approach still in favor in the East. The Wool-

worth Building (fig. 28-61), designed by Cass Gilbert (1859–1934), is representative of this trend. Gilbert studied at MIT for a year before going to work for McKim, Mead, and White in 1880. Three years later, he opened his own office in St. Paul, Minnesota, where he had grown up. He won the prestigious commission to design the Woolworth Building, the headquarters of the giant department-store chain, in 1910. When completed at 792 feet and 55 floors, the gleaming white structure was the world's tallest office building. The Gothic style of the building, inspired by the great soaring towers of late medieval churches, resonated as well with the United States' increasing worship of business. Gilbert explained that he wished to make something "spiritual" of what others called his Cathedral of Commerce.

Frank Lloyd Wright

The most celebrated American architect of the Chicago School was Frank Lloyd Wright (1867–1959). His mother was so determined that he would be an architect that she hung engravings of cathedrals over his crib. Summers spent working on his uncle's farm in Wisconsin gave him a deep respect for nature, natural materials, and agrarian life. After studying engineering for two years at the University of Wisconsin, Wright apprenticed for a year with a Chicago architect, then spent the next five years with Adler and Sullivan, eventually becoming their chief drafter. Sullivan fired him in 1893 for moonlighting. Thus, in the

28-63. Frank Lloyd Wright. Taliesin, Spring Green, Wisconsin. Original built 1911, destroyed by fire 1914, rebuilt 1915–22, again destroyed by fire 1925, rebuilt 1927

year of the World's Columbian Exposition, Wright opened his own office, specializing in the domestic architecture he had been doing for Sullivan's firm. Seeking better ways to integrate house and site, he turned away from the traditional boxlike design and began by 1900 to create homes with a series of horizontal elements that echoed and opened into the surrounding landscape. These so-called **Prairie Style** houses also reflected the Japanese concept that the requirements of the interior spaces of a house should determine its shape.

One of the rare commercial buildings Wright produced in his early career was the Larkin Building in Buffalo, New York (fig. 28-62). The debt to Richardson's Marshall Field Warehouse (see fig. 28-59) is evident in the way Wright enclosed a series of windows between massive piers under a simple corniced roof. There the similarity ends, however, for Wright abandoned the historicist vocabulary for a completely modern one of simple geometric shapes. Only at the top of the window piers and above the entrance did he employ any decoration, and even then it was entirely of his own invention. The formal geometric vocabulary was apparently inspired by the large Froebel kindergarten blocks—named after the German educator and founder of the kindergarten system—that his mother had bought for him at the 1876 World's Fair. (Wright later mentioned the importance of these blocks to his education.) The outside piers, which echo the taller structural ones, contain stairways and the ductwork for an innovative ventilation system that alleviated the poor air quality of the building's polluted neighborhood. Partly because of its unsightly industrial surroundings, Wright turned the building in on itself. Where the Prairie house opened out onto the landscape, the Larkin Building looks inward, with every floor overlooking a central skylit atrium. By focusing the building onto a central space and using a warm-colored brick throughout, Wright also sought to foster a greater sense of community among the people working there.

In 1909 Wright experienced a personal crisis. Unhappy with his marriage and with his architecture, he abandoned (despite his oft-stated belief in the sanctity of the family) his wife, his six children, and his practice and

28-64. Frank Lloyd Wright. Living room, Taliesin

traveled to Europe with the wife of a neighbor. When he returned to the United States in 1911, he went back to Wisconsin, where his mother had bought him some property, a low hill on a small lake. There he built a home, Taliesin I (fig. 28-63), which he called "a natural house" and which finally fulfilled his stated desire for a completely "organic" and "American" architecture. Of his intentions for the dwelling, Wright wrote: "It was unthinkable to me, at least unbearable, that any house should be put *on* that beloved hill. . . . It should be *of* the hill. Belonging to it." Using the basic vocabulary developed in his early Prairie houses, Wright conceived Taliesin in terms of a series of horizontal elements irregularly assembled "low, wide and snug" to the hill, as if it had grown there naturally. The use of local stone and wood also wedded the building to its site. Instead of dominating the hill like certain ancient Greek temples, for example, Taliesin harmonizes with it, like earlier Cretan palaces. The building is not simply a testament to the ideal of living in harmony with nature but a declaration of warfare on the modern industrial city. When asked what could be done to improve a city, the architect responded bluntly: "Tear it down."

Wright also designed the furnishings at Taliesin himself (fig. 28-64). Unhappy that clients had violated the

28-65. Julia Morgan. *Drawing for the Oakland YWCA.* 1913.
Pen and ink and watercolor, 11³/₄ x 21" (30 x 53 cm).
Special Collections, California Polytechnic State
University, San Luis Obispo

28-66. Julia Morgan. Front entrance, Casa Grande, San
Simeon, California. 1922–26. Special Collections,
California Polytechnic State University, San Luis
Obispo

designs of his Prairie homes with eclectic furnishings of their own choosing, he had earlier embarked on a comprehensive program to design everything from lighting units to rugs and wall hangings. In 1897 he helped found the Chicago Arts and Crafts Society, an outgrowth of the movement begun in England by William Morris (Chapter 27). But whereas his English predecessors looked nostalgically back to the Middle Ages and rejected machine production, Wright did not. He detested standardization,

but he thought the machine could produce beautiful and affordable objects. Wright sought harmony among all the elements of a house, including its site, its exterior, its interior, and its furnishings. Thus, the stones and woods used on the exterior of Taliesin are repeated throughout the open, "organic" spaces of the interior.

Another architect who participated in the American Arts and Crafts movement was the Californian Julia Morgan (1872–1957). Morgan received her degree in engineering in 1894 from the University of California at Berkeley, where she was the only female student. Encouraged by a local architect, she decided to become one. Although the École des Beaux-Arts did not accept women, she moved to Paris anyway and in 1896 enrolled in a private architectural studio. Two years of persistence paid off when she was admitted to the École as its first female student. In 1904 she opened her own office in San Francisco and over the course of her career designed nearly 800 buildings. By 1927 she had a staff of fourteen architects, six of them women.

Morgan did much of her early work for friends and for women's organizations. At Mills College for women she designed several buildings in a revival of the Mission Style, first introduced by early Spanish settlers, that was then becoming popular. For the Oakland Young Women's Christian Association (YWCA), however, she used an Italian Renaissance style (fig. 28-65). The YWCA, founded in London in 1855, was one of the many women's organizations intended to address the social problems of the new industrial cities. The YWCA's particular mission was to provide temporary residences and recreational facilities for the young women flocking to cities to take low-paying factory and office jobs. Morgan almost never discussed her work, so it is difficult to know why she and her clients chose a Renaissance palace style to house poor working women. Certainly the perfect symmetry of her conception suggests that she wanted to provide the short-term residents with an image of stability.

The distinctive feature of Morgan's architecture was the quality and care of its detailing, or finishing elements. In the Oakland YWCA, for example, the terra-cotta decor used around the windows featured California fruits and flowers. The tiles were made in nearby Alameda from Morgan's own handsome designs. The same concern for careful craft is evident in the work she did for her major patron, William Randolph Hearst, shortly after World War I. In 1919 Hearst commissioned her to design a palatial estate on a hilltop in San Simeon, about 200 miles south of San Francisco. Although Hearst mentioned a "Jappo-Swisso bungalow" in his first meeting with her, he eventually decided on the popular Mission Style for his Casa Grande. The main building (fig. 28-66), of reinforced concrete (see "Space-Spanning Construction Devices," page 32), is a free interpretation of a Spanish Mission church. Above the single doorway and below the pair of wide, sturdy columns typical of such churches, Morgan added a house front to indicate the building's function. Since the Renaissance, the Greek temple had been adapted to domestic architecture, but similar domestic adaptation of the Christian church was rare.

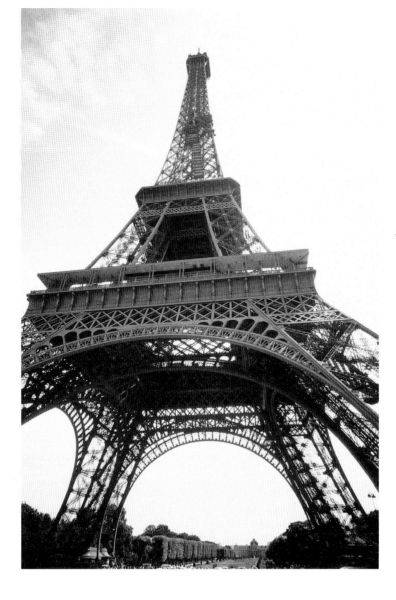

28-67. Gustave Eiffel.
Eiffel Tower,
Paris. 1887–89

The elaborate decoration on the facade of San Simeon reflects the detailing throughout. The decor and furnishings represent a final manifestation of the Arts and Crafts tradition. Morgan employed a host of stonecutters, experts in ornamental plasters, wood-carvers, iron casters, weavers, tapestry makers, and tile designers. All the craftwork was copied or improvised from historical models.

By the 1920s, most young designers, like their architect counterparts, had completely rejected historicism and handcrafts for a modern machine aesthetic. The story of that change begins in Europe in the late nineteenth century.

Art Nouveau

While the Chicago School was looking for an American alternative to the European Beaux-Arts tradition, its European counterparts had been calling for an end to historicism and the invention of an architectural and design style appropriate to the modern age. The search would lead eventually, in the early twentieth century, to the frank acceptance of new industrial materials and tech-

niques—like those that first appeared in buildings such as the Crystal Palace (see fig. 27-1)—as the basis of legitimate architecture. In the interim, the Art Nouveau ("New Art") phenomenon of the 1890s in Europe was a brief attempt at something less radical.

Art Nouveau was essentially a continental development with roots in the English Arts and Crafts Movement. Like that movement, it emerged initially in response to a world's fair, in this case the Paris Universal Exposition of 1889. The centerpiece of the fair was an enormous tower designed by civil engineer Gustave Eiffel (1832–1923), the winner of a competition for the design of a monument that would symbolize French industrial progress. The Eiffel Tower (fig. 28-67), composed of iron latticework, stands on four huge legs reinforced by trussed arches like those Eiffel used for his famous railway bridges. The passenger elevators, themselves an innovation, allowed fairgoers to ascend to the top of what was then, at 984 feet, the tallest structure in the world.

Although the French public loved the tower, most architects, artists, and writers found it completely lacking in beauty. Even before it was completed, several

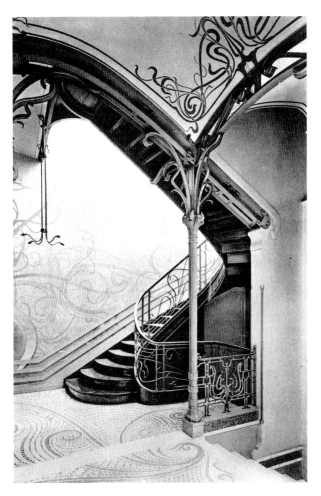

28-68. Victor Horta. Stairway, Tassel House, Brussels. 1892–93

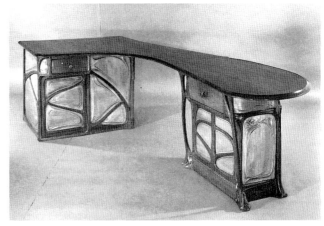

28-69. Hector Guimard. Desk. c. 1899 (remodeled after 1909). Olive wood with ash panels, 28³/₄ x 47³/₄" (73 x 121 cm). The Museum of Modern Art, New York

Gift of Madame Hector Guimard

dozen of them signed a petition protesting it to the government: "This tower dominating Paris, like a gigantic and black factory chimney, crushing with its barbarous mass Nôtre-Dame, the Sainte-Chapelle . . . all our monuments humiliated. . . . And in twenty years we shall see, stretching over the entire city . . . the odious shadow of the odious column built up of riveted iron plates" (cited in Holt, volume 1, page 70). The last part of their protest refers not to the literal shadow of the tower but to its metaphorical one, its anticipated influence on the future of architecture in Paris.

Art Nouveau, a style that attempted to be modern without the loss of a preindustrial sense of beauty, was one response to this concern, which extended beyond the French borders. Art Nouveau's commitment to the organically beautiful and its emphasis on traditional materials such as stone and wood were in many ways an attempt to forestall what might be called the industrialization of architecture and design. For the practitioners of Art Nouveau, a purely functional structure like the Crystal Palace or a railway bridge was just not beautiful. They appreciated the simplicity of such structures but found their naked engineering lacking in the linear grace long considered the very essence of beauty.

The man who launched the Art Nouveau style of the 1890s was a Belgian, Victor Horta (1861–1947). Horta trained as an architect at the Brussels Academy, then worked in the office of a Neoclassical architect. In 1892 he received his first independent commission, to design a private residence in Brussels for a Professor Tassel. The result, especially the house's entry hall and staircase (fig. 28-68), was strikingly original. The ironwork, wall decoration, and floor tile were all designed in terms of an intricate series of long, graceful curves. Although Horta's sources are still a matter of debate, he apparently was much impressed with the stylized linear graphics produced by artists of the English Arts and Crafts Movement of the late 1880s, such as the architect and designer Arthur Heygate Mackmurdo (1851–1942) and the painter and illustrator Walter Crane (1845–1915). Horta's concern for integrating the various arts into a more unified whole, like his reliance on a refined decorative line, also derived largely from English reformers.

The application of graceful linear arabesques to all aspects of design, evident in the entry hall of the Tassel House, began a vogue that lasted for more than a decade. During its lifetime the movement had a number of regional names. In Italy it was called *Stile floreale* ("Floral Style") and *Stile Liberty* (after the Liberty department store in London); in Germany, *Jugendstil* ("Youth Style"); in Spain, *Modernismo* (Modernism); in Vienna, *Secessionsstil*, after the secession from the Academy led by Klimt; in Belgium it was called *Paling Style* ("Eel Style"); and in France it had a number of names, including *moderne*. The name eventually accepted in most countries derives from a shop, La Maison de l'Art Nouveau ("The House of the New Art"), which opened in Paris in 1895.

In France it was also sometimes known as *Style Guimard* after its leading French practitioner, Hector Guimard (1867–1942). Like Horta, Guimard was more a designer than an architect in the strictest sense. His major production was in the area of interior design and furnishings. Typical of his work is the desk that he made for himself out of olive wood and ash wood (fig. 28-69). Instead of a static and stable object, Guimard has handcrafted an organic entity that seems to undulate and grow.

ered with cut stones hammered to give the surface a look of natural erosion, like beach cliffs. The organic effect is completed by the stylized ironwork, which seems to grow like foliage or seaweed on the balconies. Like Wright's organic architecture, this is a national alternative to both historicism and the threat of industrialism.

Despite the role the English Arts and Crafts Movement played in the formation of Art Nouveau, the English did not participate in the style. During the 1890s they remained faithful to the styles and principles associated with Morris. The British architect and designer whose work most closely approximates Art Nouveau was the Scot Charles Rennie Mackintosh (1868–1928). In 1891 he and a colleague at his firm, Herbert McNair, met and eventually married two students at the Glasgow School of Art, Margaret Macdonald (1865–1933) and Frances Macdonald (1874–1921), who shared their taste and ideas. The four soon began to collaborate in a variety of decorative projects, including posters, metalwork, glass, and fabrics. Their work, shown at La Maison de l'Art Nouveau in 1896, featured an elegant, elongated line reminiscent of Horta's and Guimard's but used more sparingly and in conjunction with large empty spaces.

The style developed by "The Four," or "Mac's Group," is evident in the Director's Room at the Glasgow School of Art (1897–1909), which was designed largely by Mackintosh but with considerable help from his wife, Margaret Macdonald (fig. 28-71). The Director's Room is the first of the Mackintoshes' innovative "white rooms." The wood paneling, instead of being left naturally dark, is painted white to match the walls. In sharp reaction to both the Victorian and the Arts and Crafts preference for filling the walls with decor, here they are refreshingly clean and spare. The focus is on the wooden furniture designed in

28-70. Antonio Gaudí. Casa Milá apartment building, Barcelona. 1905–7

Both the organic principle and the concern to unify all areas of life into a beautiful whole relate Art Nouveau to the nearly contemporary work of Frank Lloyd Wright. But whereas Wright wanted this integration to occur in a rural setting and to involve the way people actually lived, the Art Nouveau designers and architects were content to redecorate the modern city in a natural style. Guimard's desk, for example, is less a utilitarian object than it is an objet d'art.

The one major exception to this generalization is the Catalan architect Antonio Gaudí y Cornet (1852–1926). The son of an ironworker, Gaudí studied architecture in the 1870s at the Academy in Barcelona. Like Horta, he was familiar with the writings of Morris and the graphics of Crane, Mackmurdo, and other English Arts and Crafts practitioners. His work paralleled developments in the work of Horta and others but did not depend on them. Almost ten years before Horta's decorative ironwork at the Tassel House, Gaudí had produced similar work in Barcelona for his patron Count Güell.

Unlike his counterparts, Gaudí attempted to introduce the organic principle into the very structure of his buildings. In the Casa Milá apartment house in Barcelona (fig. 28-70), for example, the interior and exterior walls gently undulate like ocean waves. The work has no straight lines. Constructed around a steel frame, it is cov-

28-71. Charles Rennie Mackintosh. Director's Room, Glasgow School of Art. 1897–1909

28-72. Adolf Loos. Steiner House, Vienna. 1910

a simplified medieval style and produced by local crafts-people under Mackintosh's supervision. Some of the furniture, particularly the famous high-backed Mackintosh chair with the oval rail seen here, sacrifices utilitarian comfort to beauty. The linear designs used in the metalwork on the cabinet and in the frosted-glass lighting fix-

tures were inspired by the **interlaces** featured in Celtic manuscripts. The Mackintoshes, like Wright and Gaudí, were interested in developing not simply a modern style but one based on their own cultures.

Early Modernism

In 1900 the Mackintoshes were invited to design a room for an exhibition in Vienna. The restrained style of the result seems to have encouraged a number of young Viennese architects, already dissatisfied with Art Nouveau, to turn vehemently against it. The most radical of this group was Adolf Loos (1870–1933). Born in Austria-Hungary, Loos studied in Dresden, Germany. He spent three years in the United States and was impressed by the industrial buildings he saw there. In Vienna he began to make a name for himself not with his architecture, of which there is little, but with his writing. In his most famous essay, "Ornament and Crime" (1908), he insisted: "The evolution of culture is synonymous with the removal of ornament from utilitarian objects." For Loos, ornament was a sign of weakness.

Two years after that essay, Loos designed the Steiner House (fig. 28-72), a rather unimpressive building whose reputation depends largely on the fact that it illustrates

28-73. Walter Gropius and Adolph Meyer. Fagus Factory, Alfeld-an-der-Leine, Germany. 1911–16

28-74. Antonio Sant'Elia. Central Station project, Milan. 1914. After Banham

"We are no longer the men of the cathedrals, the palaces, the assembly halls," Sant'Elia wrote in the 1914 *Manifesto of Futurist Architecture,* "but of big hotels, railway stations, immense roads, colossal ports, covered markets . . . demolition and rebuilding schemes. We must invent and build the city of the future, dynamic in all its parts . . . and the house of the future must be like an enormous machine."

its architect's famous views. The simple stucco construction is devoid of embellishment. Windows are not arranged decoratively but simply where the needs of the interior call for them. For Loos, an exterior was not to delight the aesthetic sense but simply to provide protection from the elements. The curved roof allows rain and snow to run off but, unlike the traditional steeped roof, creates no wasted space.

The purely functional exteriors of Loos's buildings and his outspoken opposition to ornament would seem to qualify him as one of the founders of modernist architecture. Loos later objected to this attribution, however, because he found modernism too stark. Although his exteriors contributed to the emergence of modernism, his sumptuous interiors, which often featured colorful marble, reflect enduring ties to the nineteenth century.

A better candidate for founder of modernist architecture is Walter Gropius (1883–1969). After conventional architectural training in Munich and Berlin between 1903 and 1907, Gropius became the chief assistant to Peter Behrens, whose Berlin firm specialized in industrial architecture. In 1910 he opened his own office. His lectures on ways to increase workers' productivity by improving their workplace environment caught the attention of an industrialist, and in 1911 he was commissioned to design the facade for the Fagus Factory (fig. 28-73). This building represents the emergence of modernist architecture from the engineering advances of the

nineteenth century. Unlike the Crystal Palace or the Eiffel Tower, it was conceived not to demonstrate those advances or to solve a specific problem but as legitimate architecture. With it Gropius was the first to proclaim that modern architecture should make intelligent and sensitive use of what the engineer can provide.

Inspired partly by Wright, Gropius produced a purely functional building in the tradition of the Crystal Palace. Unlike the buildings of Wright and Behrens, however, the Fagus Factory facade has no elaboration beyond that dictated by its modern construction methods. The slender brick piers along the outer walls mark the building's steel frame, and the narrow bands of brickwork at the top and bottom, like the opaque panels between them, mark floors and ceilings. A **curtain wall**—an exterior wall that does not bear any weight but simply separates the inside from the outside—hangs over the frame. Large rectangular windows dominate the exterior. The corner piers standard in earlier buildings have been eliminated as unneeded gestures to tradition. The glass both reveals the building's structure and floods the workplace inside with light.

Just prior to World War I, a Futurist architect, Antonio Sant'Elia (1888–1916), conceived a more dynamic, less functional solution to the search for a modern style. Sant'Elia apparently joined the Futurists soon after taking his degree in 1912. Beginning that year, he produced a series of drawings of his vision of the city of the future (fig. 28-74), and in 1914, he published his *Manifesto of Futurist Architecture,* which explains those drawings. His conception of the new city is not based on new technology alone but on the way it can emphasize the energy of modern life. He wanted to use steel, glass, and reinforced concrete to create an architecture of dynamic appearance. The basic structure of the new city would be the skyscraper, serviced by dramatic exterior glass elevators and connected by open walkways. The stepped-back design of these high-rise buildings, like the soaring towers at their top, is not functional but expressive. The verticals, diagonals, and curves are meant to characterize the essential feature of the new city—rapid movement. Cutting through and beneath the city's architecture would be a network of roads and subways extending in places to seven levels below the ground. Nowhere is there a trace of nature.

Although Sant'Elia's visionary drawings had a profound effect on one strain of architecture after World War I, he did not live to see it. He was among the nearly 10 million young men who died in the war that broke out in 1914.

EUROPEAN ART AND ARCHITECTURE BETWEEN THE WARS

The Great War, as World War I was then known, had a profound effect on Europe's artists and architects. While many responded pessimistically, most sought in the war's ashes the basis for a new, more secure civilization. For many, that basis was to be found in the seemingly timeless culture of the classical tradition.

Postwar Classicism

Perhaps the most unexpected reaction to World War I was Picasso's. After Braque's departure for the front in 1914, Picasso stayed in Paris, where he faced a growing tide of nationalistic criticism against Cubism. Because many of the art dealers who sold Cubist works were German, their collections were confiscated, and Cubism itself was denounced as a manifestation of German "destructive" tendencies. That Spanish and French artists invented it was conveniently ignored in the heated rhetoric aimed at restoring the preeminence of what was considered a spiritually healthy French classicism.

Picasso responded to this climate by adopting a classical style. During the war and for several years after, the man who had earlier spurned a French style, then rejected conventional representation altogether, produced works like *Woman in White* (fig. 28-75). The large, calm, self-contained figure seems to derive directly from ancient Greek sculpture or from Puvis's murals. Even the chalky whites are reminiscent of classical marble and the muted tones Puvis preferred. The bohemian Picasso of the prewar years was giving way to the later Picasso who aspired to be counted among the wealthy. In 1918 he married Olga Koklova, a Russian dancer in Diaghilev's Ballets Russes.

The British sculptor Henry Moore (1898–1986) also adopted a form of classicism, but for less self-serving and

28-75. Pablo Picasso. *Woman in White (Madame Picasso).* 1923. Oil on canvas, 39 x 31 ½" (99 x 80 cm). The Metropolitan Museum of Art, New York
Rogers Fund

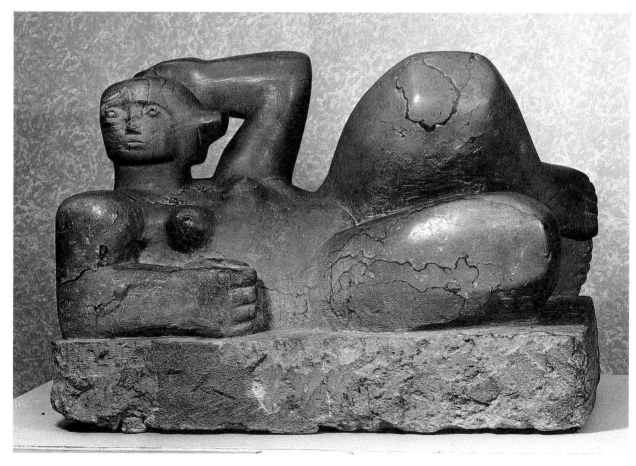

28-76. Henry Moore. *Reclining Figure.* 1929. Brown Hornton stone, 22 ½ x 33 x 15" (57 x 83.8 x 38 cm). Leeds City Art Gallery, England

personal reasons. In his early work from the late 1920s he attempted to reinvigorate the classical tradition with the strength and power of the "primitive" art very much in favor in Britain after the war. His *Reclining Figure* (fig. 28-76) combines the pose found in certain of the Elgin Marbles (sculpture from the Parthenon, housed in the British Museum) with the blocky formal language of pre-Columbian art. As with the women in Picasso's *Les Demoiselles d'Avignon* (see fig. 28-36), the erotic connotations of the figure's pose are subsumed by her psychological and physical strength. The erect head, based on that of Achilles from the Parthenon **frieze**, suggests intelligence. With its imposing monumentality, Moore's work, almost all of which was made for public display, comforts the modern viewer anxious about the human capacity to endure.

Russian Utilitarian Art Forms

In March 1917 growing Russian dissatisfaction with the war gave revolutionary elements the opportunity to overthrow the czarist monarchy. In October the government was seized by the Bolsheviks ("radical socialists") under Vladimir Lenin, who immediately took Russia out of the war.

Most members of the Russian avant-garde enthusiastically supported the Bolsheviks, who in turn supported them. Vladimir Tatlin's case is fairly typical. In 1919 he was appointed head of the Studio for Volumes, Materials, and Construction at the Petrograd State Free Art Studios (previously the St. Petersburg Academy). Partly as a result of his work on the committee in charge of implementing Lenin's Plan for Monumental Propaganda, Tatlin devised his own inspirational work, the Monument to the Third International (fig. 28-77). The monument he envisioned was intended to demonstrate that only a revolutionary formal language could properly commemorate the new revolutionary society. It also sought to show how the formal experiments of the prerevolutionary period could serve more utilitarian ends. In Tatlin's model for a 1,300-foot building to house the new Russian congress, the steel structural support, a spiraling diagonal, is on the outside rather than inside the building. Tatlin combined the Eiffel Tower with the formal vocabulary of the Cubo-Futurists to convey the dynamism of the new Soviet state. Inside the steel frame would be four separate spaces: a large cube to house legislative meetings, a smaller pyramid for executive committees, a cylinder for propaganda offices, and a hemisphere at the top, apparently meant for radio equipment. Each of these units would rotate at a different speed, from yearly at the bottom to hourly at the top.

Neither Tatlin nor anyone else had the slightest idea how such a visionary piece of architecture could actually be built. The monument is both an affirmation of faith in what Soviet science could achieve and an object meant to inspire the genius of the Russian people in that direction. The small model was shown in propaganda parades in 1920 and 1921, and a 130-foot model of iron and glass was later built in Petrograd.

28-77. Vladimir Tatlin. Model for the Monument to the Third International. 1919–29. Wood, iron, and glass. Destroyed

Karl Marx helped organize the International Working Men's Association, or First International, an uneasy alliance of British trade-union leaders and various continental Communist groups that lasted from 1864 to 1872. By 1889 Socialist parties had gained sufficient strength in enough European nations to form a loose international association, the Second (or Socialist) International, which came to an end at the onset of World War I, when most Socialist leaders abandoned internationalism for the nationalist interests of the war. The Third (or Communist) International was formed under Vladimir Lenin in March 1919 to promote the spread of communism through what he called "permanent revolution."

Tatlin's associates in the postrevolutionary period, known as the Constructivists, were committed to the notion that the artist must quit the studio and "go into the factory, where the real body of life is made." In place of those artists now considered "outlaws"—that is, those who were dedicated to pleasing themselves—they envisioned politically committed artists devoted to creating useful objects whose forms would be perfectly suited to their functions and to the mechanical processes necessary for their production. One of the founders of the movement, launched in 1921, was Aleksandr Rodchenko (1891–1956). His work in Moscow with Tatlin in about 1917–1919 gradually convinced him that painting and sculpture did not contribute enough to practical needs. In 1921, after exhibiting a triptych of red, yellow, and blue

28-78. Aleksandr Rodchenko. View of the Workers' Club, exhibited at the Exposition Internationale des Arts Décoratifs et Industriels Modernes, Paris. 1925. Rodchenko-Stepanova Archive, Moscow

canvases that he considered the end of painting, he gave up traditional "high art" mediums (painting and sculpture) to make photographs and to design posters, books, textiles, and theater sets, all of which were intended to promote the ends of the new Soviet society.

In 1925 Rodchenko also designed a model workers' club for the Russian pavilion at the Paris World's Fair (fig. 28-78). Although Rodchenko said such a club "must be built for amusement and relaxation," the space was essentially a reading room dedicated to the proper training of the Soviet mind. One corner of the room was devoted to materials on the life and ideas of Lenin, who had died the year before. Even the one recreational element, the chess table in the back beneath Lenin's photograph, sharpens the intellect. The furniture was designed for simplicity of use, standardization, and the necessity of being able to expand or contract the number of its parts. Thus many of the items were collapsible, so they could be stored when not in use. The furniture is wood because Russian industry was best equipped for mass production in that medium. The design of the chairs is not strictly util-

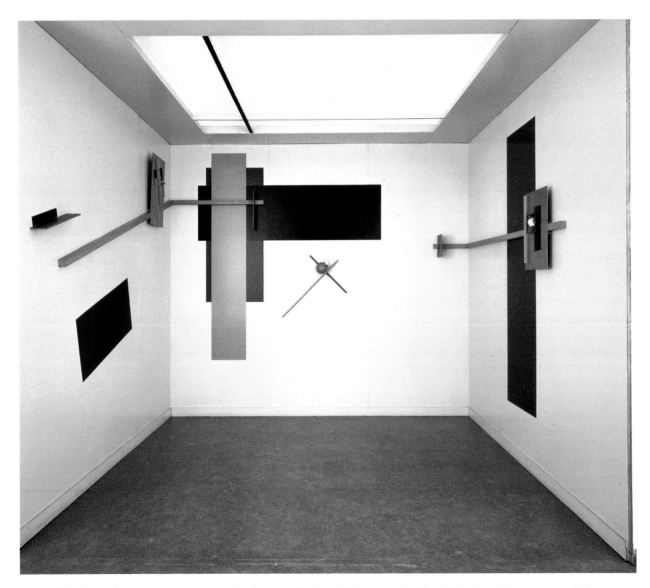

28-79. El Lissitzky. Proun space created for a Berlin art exhibition. 1923, reconstruction 1965. Van Abbemuseum, Eindhoven, the Netherlands

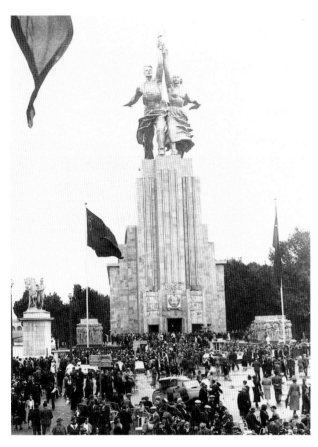

28-80. Vera Mukhina. *Worker and Collective Farm Worker,*
sculpture for the Soviet Pavilion, Paris Exposition. 1937

propaganda photographs and **photomontages**, the combination of several photographs into one work. During the 1930s he worked for *USSR in Construction*, a magazine meant to give its foreign readers a positive impression of Soviet society.

The move away from abstraction was led by a group of realists, deeply antagonistic to the avant-garde, who banded together in 1922 to form the Association of Artists of Revolutionary Russia (AKhRR) and promote a clear, representational approach to revolutionary art. The AKhRR looked back to artists such as Repin (see fig. 27-25) and dedicated itself to the depiction of workers, peasants, revolutionary activists, and, in particular, to the life and history of the Red Army. After Joseph Stalin succeeded Lenin in 1924, the artists of the AKhRR were more and more often called on to produce images for the state. Their tendency to create huge, overly dramatic canvases on heroic or inspirational themes established the basis for the Socialist Realism instituted by Stalin after he took control of the arts in 1932.

One of the sculptors who worked in this official style was Vera Mukhina (1889–1963), who had studied briefly in Paris before the war. Her most famous work is *Worker and Collective Farm Worker* (fig. 28-80), made for the Soviet Pavilion at the Paris Exposition of 1937. The powerfully built male factory worker and female farm laborer hold aloft their respective tools, a hammer and a sickle, to mimic their appearance on the Soviet flag. The two figures are shown as equal partners striding purposefully into the future. Their determined faces look forward and upward. The dramatic, windblown drapery and the forward propulsion of their diagonal poses, not unlike the forceful spiraling angles of Tatlin's Monument (see fig. 28-77), enhance the sense of vigorous idealism. The work was not meant for domestic inspiration but to convince an increasingly skeptical international audience of the continuing vitality of the Soviet system.

Dutch Rationalism

In the Netherlands the Dutch counterpart to the inspirational formalism of Lissitzky was the group de Stijl. The Dutch term *de Stijl* means "the Style." The movement's leading artist was Piet Mondrian (1872–1944), whose early naturalistic landscapes gave way during the first decade of the twentieth century to a more classically composed kind of Fauvism. The turning point in his life came in 1911 when he went to Paris and encountered Analytic Cubism. Beginning with works quite similar to Picasso's *Ma Jolie*, he gradually moved from radical abstractions of landscape and architecture to a simple, austere form of geometric art inspired by them, one whose basic schema of horizontals and verticals symbolized a whole range of opposites, including male versus female and material versus spiritual. In the Netherlands during World War I, he met Theo van Doesburg, another painter who shared his artistic views, and in 1917 the two started a magazine, *De Stijl*, which became the focal point of a Dutch movement of artists, architects, and designers that lasted until van Doesburg's death in 1931.

itarian, however. The high, straight backs were meant to promote a physical and moral posture of uprightness among the workers.

A less radical devotion to socialism and utilitarianism was practiced in the early 1920s by many artists, including El Lissitzky (1890–1941). After the 1917 Russian Revolution, Lissitzky, who had trained as an engineer in Germany, was invited to teach architecture and graphic arts at the Vitebsk School of Fine Arts. There he came under the influence of Malevich, who also taught at the school. By 1919 he was using Malevich's formal vocabulary for propaganda posters and for artworks he called Prouns, an acronym for "Project for the Affirmation of the New." Most are paintings, but a few, like that made for an exhibition in Germany (fig. 28-79), were Proun spaces. Lissitzky, who rejected conventional painting instruments as too personal and imprecise, produced his Prouns with the aid of mechanical instruments. Their engineered look is meant not merely to celebrate industrial technology but to encourage precise thinking among the public, to produce, as he suggested in one of his works, a "new man."

As was typical of the general trend in Russian art of the late 1920s, Lissitzky grew disillusioned with the power of formalist art to communicate broadly. By the end of the decade, he had turned to more utilitarian projects—architecture and typography, in particular—and had begun to produce, along with Rodchenko and others,

28-81. Piet Mondrian. *Composition with Red, Blue, and Yellow.* 1930. Oil on canvas, 20 x 20" (50.3 x 50.3 cm). Private collection

Mondrian so disliked the sight of nature, whose irregularities he held largely accountable for humanity's problems, that when seated at a restaurant table with a view of the outdoors, he would ask to be moved.

The de Stijl movement was grounded in the conviction that there are two kinds of beauty: a sensual or subjective one and a higher, rational or objective— "universal"—kind. In his mature works Mondrian sought the essence of the second kind, eliminating representational elements because of their subjective associations. In paintings such as *Composition with Red, Blue, and Yellow* (fig. 28-81) he "purified" his formal vocabulary, reducing it to basic elements—the horizontal and vertical, the three primary hues (red, yellow, and blue) and the two primary **values** (black and white)—in order to distill the essence of higher beauty. That essence, he believed, was to be found in what he called a dynamic equilibrium among basic elements, achieved in *Composition with Red, Blue, and Yellow* through the precise arrangement of color areas of different weight. The heavier weight of the red threatens to tip the painting to the right, but the placement of the tiny rectangle of yellow at the lower right prevents this by supporting its weight.

The tension between competing color areas in a Mondrian work is intended as a metaphor. For example, the relation between colors can symbolize the competi-

28-82. Gerrit Rietveld. Interior, Schröder House, Utrecht, the Netherlands. 1924

28-83. Le Corbusier. *Still Life.* 1922. Oil on canvas, 25 3/8 x 31 1/2" (64 x 80 cm). Musée National d'Art Moderne, Centre Georges Pompidou, Paris

tion between individuals in society, which the painting here harmonizes. More important, the ultimate purpose of such paintings is not to hang in the home of a wealthy collector but to demonstrate a universal style, based on ideas of balance, with applications beyond the realm of art. Like Art Nouveau, de Stijl wished to redecorate the world. But to Mondrian and his colleagues, nature's example only encourages what they felt were "primitive animal instincts," and they therefore rejected the organic style of Art Nouveau. If, instead of living in a state of nature, we lived in an environment designed according to the rules of "universal beauty," we too, like our art, would be balanced, our natural instincts "purified." For these reasons, Mondrian could hope to be the world's last artist. He felt that earlier art had provided humanity with something that was lacking in daily life. But if we did have beauty in every aspect of our lives, we would have no further need for art.

The major architect and designer of the de Stijl movement was Gerrit Rietveld (1888–1964), whose famous "red and blue" chair is shown here in the bedroom of his most important project, the Schröder House (fig. 28-82) in Utrecht. Inspired partly by both Wright and the Constructivists, Rietveld applied Mondrian's design principle of a dynamic symmetry of rectangular planes of color to the entire house and its built-in furnishings. Some of the compositional planes on the interior were sliding partitions designed to allow modifications in the spaces used for sleeping, working, and entertaining. These innovative wall partitions were actually the idea of the owner, Truus Schröder, who worked with Rietveld on the design of this and several later projects. A wealthy woman, Schröder wanted her austere home to suggest the rejection of luxury for simple necessities sensitively integrated into a beautiful whole.

French Rationalism

Among French artists, the dominant response to the Great War was similar to that of de Stijl. Many saw the war as the inevitable consequence of a culture in which the spirit of competition and individualism had run amok. For them the solution was what one conservative critic labeled "the return to order," the formation of a more disciplined society along lines suggested in visual terms by Seurat in *A Sunday Afternoon on the Island of La Grande Jatte* (see fig. 28-14). One expression of this widespread conviction was Purism, whose leading figure was the Swiss-born Charles-Édouard Jeanneret (1887–1965). A largely self-taught architect and designer, Jeanneret moved to Paris in 1917, where he met Amédée Ozenfant (1886–1966). In 1918 they published a book, *After Cubism*, and between 1920 and 1925 they edited a magazine, *L'Esprit nouveau (The New Spirit)*.

Like the Constructivists and the proponents of de Stijl, the Purists firmly believed in the power of art to change the world. In 1920 Jeanneret, partly to demonstrate his faith in the ability of individuals to remake themselves, renamed himself Le Corbusier, a play on the French word for raven. Le Corbusier and Ozenfant thought of themselves as producing a new and improved Cubism that would not only provide aesthetic pleasure but also, by placing viewers in an orderly frame of mind, promote social order in the world. These ideas led to a series of paintings like Le Corbusier's *Still Life* (fig. 28-83), in which the subdued harmony of colors supports the strict arrangement of elements along the horizontal and vertical axes. The Purists included musical instruments, especially guitars, to suggest the harmony they sought. And they featured simple containers, such as bottles, to emphasize what they considered the basic utilitarian purposes of their paintings.

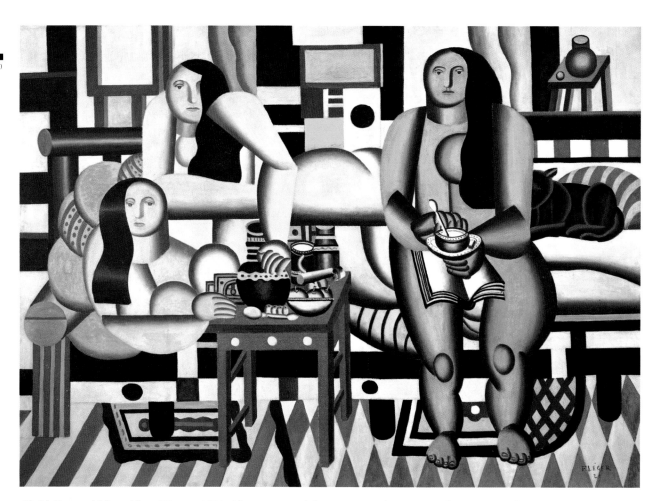

28-84. Fernand Léger. *Three Women*. 1921. Oil on canvas, 6' ¹/₂" x 8'3" (1.84 x 2.52 m). The Museum of Modern Art, New York Mrs. Simon Guggenheim Fund

28-85. Le Corbusier. Plan for a Contemporary City of Three Million Inhabitants. 1922

In 1925 Le Corbusier devised a similar plan for Paris, convinced that the center of the city needed to be torn down and rebuilt to accommodate automobile traffic. The Parisian street was a "Pack-Donkey's Way," he said: "Imagine all this junk . . . cleared off and carried away and replaced by immense clear crystals of glass, rising to a height of over six hundred feet!"

One of the artists strongly influenced by Purism was Fernand Léger (1881–1955). By 1910 he belonged to Picasso's circle and was producing a dynamic, personal brand of Analytic Cubism in which he attempted to reconcile traditional artistic subjects with his radical taste for industrial metal and machinery. In the early 1920s he briefly experimented with Purism in a series of still-life and figure paintings that included *Three Women* (fig. 28-84). His answer to the French odalisque tradition, the painting takes Delacroix's *Women of Algiers* (see fig. 26-47) and transforms it according to a Purist ideal of anonymity and order. The women, arranged within a geometric grid, stare out blankly at us. They have identical faces, and their bodies seem assembled from standardized, detachable metal parts. The bright, cheerful colors and patterns suggest a positive vision of an orderly industrial society.

Purism's most important contributions were not in painting or sculpture but in architecture. Although he never gave up painting, from 1922 until his death Le Corbusier concentrated on architecture and urban planning. One of his first mature projects was his conception for a Contemporary City of Three Million Inhabitants (fig. 28-85), a design he exhibited in Paris in 1922. Le Corbusier hated the crowded, noisy, chaotic, and polluted places that

cities had become in the late nineteenth century. What he envisioned for the future was a city of uniform style, laid out on a grid, and dominated, like Sant'Elia's (see fig. 28-74), by skyscrapers, with wide traffic arteries that often passed beneath ground level. Le Corbusier's city would be different from Sant'Elia's, however, in two fundamental respects. First, the buildings would be strictly functional, in the manner of Gropius's Fagus Factory (see fig. 28-73). And second, nature would not be neglected. Set between the widely spaced buildings would be large expanses of parkland. The result, Le Corbusier thought, would be a new, clean, and efficient city filled with light, air, and greenery. Le Corbusier's vision had a profound effect on later city planning, especially in the United States.

The Bauhaus

The German counterpart to the total and rational planning envisioned by de Stijl and Le Corbusier was conceived between 1919 and 1933 at the Bauhaus ("House of Building"), the brainchild of Walter Gropius. Gropius, who belonged to several utopian groups, including one in sympathy with the Russian Revolution, admired the spirit of the medieval building guilds—the *Bauhütten*—that had built the great German cathedrals. He sought to revive that spirit and commit it to the reconciliation of modern art and industry through what he called a cultural synthesis, which would emerge from the combined efforts of architects, artists, and designers. The Bauhaus was formed in 1919, when Gropius convinced the authorities of Weimar, Germany, to allow him to combine the city's schools of art and craft. The Bauhaus moved to Dessau and then to Berlin, where it remained until 1933, when Hitler, who detested the avant-garde, closed it (see "Suppression of the Avant-Garde in Germany," below). Gropius left the school in 1928.

There was no formal architectural curriculum at the Bauhaus. Gropius felt that workshop courses in construction, metalwork, carpentry, interior design (including painting), and furniture making—all of which emphasized the understanding of materials—had to be fully mastered before architecture. For teachers, Gropius hired ordinary craftspeople as well as famous artists, among them Kandinsky and Klee. The goal was the training of a generation of architects dedicated to "a clear, organic architecture, whose inner logic will be radiant

SUPPRESSION OF THE AVANT-GARDE IN GERMANY

During the 1930s in Germany there was strong political reaction to **avant-garde** art. One of the principal targets was the Bauhaus (see fig. 28-86), the art and design school founded in 1919 by Walter Gropius, where Paul Klee, Vasily Kandinsky, Josef Albers, Ludwig Mies van der Rohe, and other luminaries taught (see figs. 28-31, 28-33, 29-37). Through much of the 1920s the Bauhaus had been struggling against an increasingly hostile and reactionary political climate. As early as 1924, conservatives had accused the Bauhaus of being not only educationally unsound but also politically subversive. In order to avoid having the school shut down by this opposition, Gropius moved it to Dessau in 1926 at the invitation of the city's liberal mayor. Gropius left the Bauhaus not long after its relocation to Dessau. His successors faced increasing political pressure on the school because it was one of the prime centers of modernist practice, and they were again forced to move it in 1932, this time to Berlin.

After Adolf Hitler came to power in 1933, the Nazi party mounted an aggressive campaign against all modernist art. In his youth Hitler had been

a mediocre academic painter, and he had developed an intense hatred of the avant-garde. During the first year of his regime the Bauhaus was forced to close for good. A number of the artists, designers, and architects who had been on its faculty emigrated to the United States, including Albers, Gropius, and Mies van der Rohe.

The Nazis also launched attacks against the German Expressionists, whose often intense depictions of German soldiers defeated in World War I and of the economic depression following the war the Nazis considered unpatriotic. Most of all, the treatment of the human form in these works, such as the expressionistic exaggeration of facial features, was deemed offensive. The works of these and other artists were removed from museums, while the artists themselves were subjected to public ridicule and often forbidden to buy canvas and paint.

As a final move against the avant-garde, the Nazi leadership organized in 1937 a notorious exhibition of banned works. The "Degenerate Art" exhibition was intended to erase modernism once and for all from the artistic life of the nation. Seeking to brand as sick and "degenerate" all the experimental movements of art, it presented modern artworks as if they were

specimens of pathology. As part of the exhibition, the organizers printed derisive slogans and comments to that effect on the gallery walls. The 650 paintings, sculpture, prints, and books confiscated from German public museums were viewed by 2 million people in the four months the exhibition was on view in Munich and by another million during its subsequent three-year tour of German cities.

By the time World War II broke out, the authorities had confiscated countless works from all over the country. Most were burned, though the German government sold a number of the works at public auction in Switzerland to obtain foreign currency for its agenda.

Among the many artists crushed by the Nazi suppression was Ernst Ludwig Kirchner, whose *Street, Berlin* (see fig. 28-27) was included in "Degenerate Art." The state's open animosity was a factor in his suicide in 1938. Other artists, such as John Heartfield, left the country in order to continue their work and to voice their opposition to the Nazis. In his scathing caricatures of Hitler, such as *Have No Fear—He's a Vegetarian* (see fig. 28-91), Heartfield took some of the modernist artistic innovations that Hitler had condemned and used them to mock him.

28-86. Walter Gropius. Bauhaus Building, Dessau, Germany. 1925–26

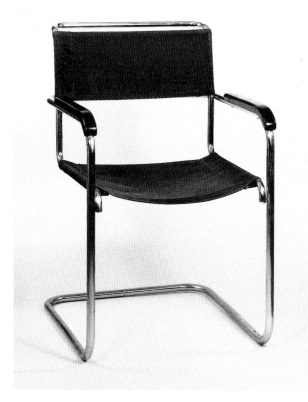

28-87. Marcel Breuer. Vasily chair. 1928. Chromium-plated tubular steel, painted wood, and canvas, 33¹/₂ x 21⁷/₈ x 24" (85.1 x 55.6 x 61 cm). Wadsworth Atheneum, Hartford, Connecticut

and naked, unencumbered by lying facades and trickeries; we want an architecture adapted to our world of machines, radios and fast motor cars, an architecture whose function is clearly recognizable in the relation of its forms" (cited in Bayer, Gropius, and Gropius, page 27).

What Gropius had in mind may be seen in his design for the new Dessau Bauhaus, built in 1925–1926 (fig. 28-86). The building frankly acknowledges the reinforced concrete, steel, and glass of which it is built; Gropius made no attempt to cover or decorate them. The building is not strictly utilitarian, however. The asymmetrical balancing of the large, cubical structural elements is meant to convey the dynamic quality of modern life. (If this design principle seems reminiscent of de Stijl, that is because van Doesburg worked briefly at the old Bauhaus in 1922 and influenced the development of Gropius's ideas.) The expressive glass-panel wall that wraps around two sides of the workshop wing of the building recalls the glass wall of the Fagus Factory (see fig. 28-73) and reflects the industrial activities of the workshop. The raised parapet below the workshop windows demonstrates the ability of modern engineering methods to create light, airy spaces unlike the heavy spaces of past styles.

The Vasily chair designed by Marcel Breuer (1902–1981), a Bauhaus instructor and former student, is characteristic of the kind of utilitarian objects Gropius hoped to see in this new architecture (fig. 28-87). Breuer, born in Hungary, was typical of the international student body attracted to the Bauhaus. From 1920 to 1924 he studied in the furniture design workshop. When the school moved to Dessau, he was promoted to "young master" in the same

studio. Shortly before he left to join an architect's firm in Berlin, he designed the Vasily chair, named in honor of one of his teachers, Vasily Kandinsky. The cantilevered frame, eliminating the need for back legs, is of chrome-plated steel tubing. The back and seat are of inexpensive canvas. Painted wood armrests complete the design. The simple utilitarian chair was intended to be cheaply mass-produced. Its elegant lines and industrial materials suggest what can be achieved through the marriage of modern industry and a trained artistic sensibility.

Dada

The emphasis on individuality and irrational instinct evident in the work of artists like Gauguin and many of the Expressionists did not die out entirely after World War I. It endured in the Dada movement, which began with the opening of the Cabaret Voltaire in Zürich on February 5, 1916. The cabaret's founders, German actor and artist Hugo Ball (1886–1927) and his companion, Emmy Hennings, a nightclub singer, had moved to neutral Switzerland when the war broke out. Their cabaret, in the neighborhood where Lenin then lived in exile, was inspired by the bohemian artists' cafés they had known in Berlin and Munich. The advertisement for the opening of the Cabaret Voltaire invited "young artists of Zürich, whatever their orientation . . . to come along with suggestions and contributions of all kinds." The cabaret immediately attracted a circle of avant-garde writers and artists of various nationalities who shared in Ball's and Hennings's disgust with bourgeois culture, which they blamed for the war. The way Ball performed one of his sound poems, "Karawane" (fig. 28-88), reflects the spirit of the place. His legs and body encased in blue cardboard tubes, his head surmounted by a white-and-blue "witchdoctor's hat," as he called it, and his shoulders covered with a huge cardboard collar that flapped when he moved his arms, he slowly and solemnly recited the poem, which consisted entirely of nonsense sounds. As was typical of Dada, this performance involved two separate and distinct aims, one critical and one playful. The first, as Ball said, was to renounce "the language devastated and made impossible by journalism." In other words, by retreating into precivilized sounds, he avoided language, which had been spoiled by the lies and excesses of journalism and advertising. The second aim was simply to amuse by reintroducing the healthy play of children back into what he considered overly restrained adult lives.

By the end of 1916 it was clear to Ball's circle that the group needed a name. *Dada* seems to have been chosen because of its flexibility. In German the term signifies baby talk; in French it means "hobbyhorse"; in Russian, "yes, yes"; and in Romanian, "no, no." The name and therefore the movement could be defined as the individual wished. Early in 1917 one of Ball's colleagues, Tristan Tzara (1896–1963), organized the Galerie Dada. Tzara also edited a magazine, *Dada*, which soon attracted the attention of like-minded men and women in various European capitals.

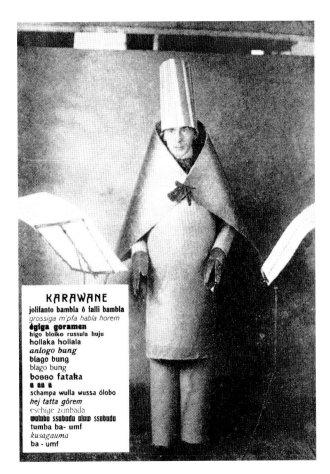

28-88. Hugo Ball reciting the sound poem "Karawane." Photographed at the Cabaret Voltaire, Zürich, 1916

The movement was spread farther when members of Ball's circle returned to their respective homelands. Even before the end of the war, writer Richard Huelsenbeck brought the Dada movement to Germany when he helped form the Berlin Dada Club. By early 1919 Huelsenbeck and his associates were organizing Dada evenings featuring nonsense poetry, poems read simultaneously by two or more poets, and other playful events, including a race between a typewriter and a sewing machine. Following the example of some of his Zürich predecessors, Johannes Baader took Dada out of the cabaret into the streets. His most famous "intervention" occurred during the 1919 inauguration of the president of the new German republic, when Baader scattered leaflets from a balcony proclaiming himself President of the World.

One of the distinctive features of Berlin Dada was its sympathies with the newly formed German Communist party. In 1919 Huelsenbeck and the Austrian painter and photographer Raoul Hausmann (1886–1971) formed a so-called Dadaist Revolutionary Central Council, which published a manifesto, "What Is Dadaism and What Does It Want in Germany?" One of their demands called for "the immediate expropriation of property (socialization) and the communal feeding of all." Such serious demands were undercut, however, by more playful requests.

The coauthor of this manifesto, Hausmann, worked in various mediums, including sculpture. *The Spirit of Our*

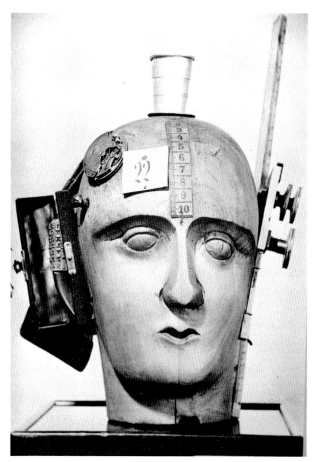

28-89. Raoul Hausmann. *The Spirit of Our Time.* 1921.
Assemblage, height 12³/₄" (32 cm). Musée National
d'Art Moderne, Centre Georges Pompidou, Paris

28-90. Hannah Höch. *Dada Dance.* 1922. Photomontage,
12⅝ x 9⅛" (32 x 23 cm). Collection Arturo Schwartz,
Milan

Time (fig. 28-89) is typical of the Dada artistic approach. The assemblage of various objects is not meant to be aesthetically appealing but to satirize contemporary folly. The instruments used for the ears, the clockworks attached to the head, and the measuring tape running down the forehead all refer to the growing popularity in Western Europe of the idea that humans should model themselves on the machine. The dummy's head reminds us that such a notion is dehumanizing.

Another distinctive feature of Berlin Dada was the amount of art it produced. Dada elsewhere tended to be more literary. Berlin Dada members especially favored the photomontage. One of the leading figures in this direction was Hannah Höch (1889–1978). At twenty-two she had come to Berlin to study applied arts and painting. From 1916 to 1926 she worked for Berlin's major newspaper in a department that produced brochures on knitting, crocheting, and embroidering. She became romantically involved with Hausmann in 1915 and seems to have been the source of many of his political commitments. Höch, the only woman associated with the Berlin Dada Club, remained a marginal member, apparently because she was a woman. She was admitted to the first Dada exhibition in Berlin in 1920 only because Hausmann threatened to withdraw his works if hers were refused.

Höch's photomontages focus on women's issues. In the aftermath of the war, the status of women improved in Germany when they received the vote and new job opportunities opened to them. The subject of the "new woman" was much discussed in the German news media, but Höch's contribution to this discussion was largely critical. In works such as *Dada Dance* (fig. 28-90), she seems to ridicule the way changing fashions establish standards of beauty that women, regardless of their natural appearance, must observe. On the right is an odd composite figure, wearing high-fashion shoes and dress, in a ridiculously elegant pose. The taller woman, with a small, black African head, looks down on her with a pained expression. For Höch, as for many in the modernist era, Africa represented what was natural, so Höch presumably meant to contrast natural elegance with its foolish, overly cultivated counterpart. The work's message is not immediately evident, however, nor is it spelled out clearly by the text, which reads: "The excesses of Hell fell into the cash box for innocent criminal catchers." Whether this statement is meant as an indictment of the fashion business or, in larger terms, of the hellish chaos of contemporary German life is uncertain.

Because the precise meaning of such works is extremely difficult to decipher, their power as social commentary is limited. One of the first to change his approach

arts. Heartfield literally jumped out his window to escape and moved to Prague, Czechoslovakia, then to England, where he produced his powerful anti-Hitler photomontages.

28-91. John Heartfield. *Have No Fear—He's a Vegetarian.* Photomontage in *Regards* no. 121 (153) (Paris), May 7, 1936. Stiftung Archiv der Akademie der Künste, Berlin

in recognition of this limitation was John Heartfield (1891–1968). Born Helmut Herzfeld near Berlin, he trained in a crafts school in Munich and subsequently worked as a commercial artist for a book publisher in Mannheim. He was drafted in 1914 but after a feigned nervous breakdown was released from the army to work as a letter carrier. He often dumped his mail deliveries in order to encourage dissatisfaction with the war. In protest against the nationalistic war slogan "May God Punish England," Herzfeld anglicized his name to John Heartfield. After the war he joined Berlin Dada but spent most of his time doing election posters and illustrations for Communist newspapers and magazines. Recognizing the primacy of the message, he evolved a clear and simple approach to photomontage that might be called post-Dada.

Typical of his mature work is *Have No Fear—He's a Vegetarian* (fig. 28-91), a version of which appeared in a French magazine in 1936. The work shows Hitler sharpening a knife behind a rooster, the symbol of France. The warning being communicated is ironic, given that the whispering man is Pierre Laval, then the pro-German premier of France. Hitler, then in the process of rising to power in Germany on a program of nationalism, militarism, and hatred for Jews, would soon pose a threat to France, as indeed he did. When the Nazis had gained control of Germany in 1933, Hitler ordered Heartfield's

Marcel Duchamp

A small group of French and American artists in New York, producing work similar to that of the European Dadaists, also adopted the Dada label. The leading figure in this group was the French artist Marcel Duchamp (1887–1968). In 1906 Duchamp had moved from Rouen to Paris, where he worked as a librarian and learned to paint essentially on his own. Through his two older brothers, both artists, he became a member of the avant-garde then assimilating Cubism. In this atmosphere his early Fauve-inspired landscapes gave way to a personal brand of Analytic Cubism. In 1915 he left Paris for New York, partly out of disgust with what he called the European "art factory."

Duchamp and his New York group maintained that art should appeal to the mind rather than the senses. A good example of this cerebral approach is Duchamp's *Fountain* (see fig. 28-1), with which this chapter began. *Fountain* is one of the first of Duchamp's **readymades**, ordinary objects transformed into artworks simply through the decision of the artist. The ideas expressed in Duchamp's art are complex and often cynical. Besides those ideas mentioned in the discussion of *Fountain* at the beginning of this chapter is a subtle reply to his modernist colleagues that art plays no important function in ordinary life. Here, as elsewhere in his art, a useful object is rendered useless by its transformation into art.

Duchamp's most intellectually challenging work is probably *The Bride Stripped Bare by Her Bachelors, Even* (fig. 28-92), usually called *The Large Glass.* He made his first sketches for the piece in 1913 but did not begin work on it until he arrived in New York. Notes he made while working on the piece confirm that it is enormously complex in conception and operates on several esoteric levels. At the most obvious level it is a pessimistic statement of insoluble frustrations of male-female relations. The tubular elements encased in glass at the top represent the bride. These release a large romantic sigh that is stimulating to the bachelors below, who are represented by nine different costumes attached to a waterwheel. The wheel resembles and is attached to a chocolate grinder, a reference to a French euphemism for masturbation. A bar separates the males from the female, preventing the fulfillment of their respective sexual desires. Male and female are not only separate but fundamentally different. The female is depicted as a gas—the three strips of gauze in her sigh punningly reveal this—while the males are represented as liquids. Duchamp not only contradicts the conventionally optimistic view of male-female relations found in much art, he also reverses the conventional power roles of men and women. Unlike what is implied in Kirchner's *Girl under a Japanese Umbrella* (see fig. 28-28), for example, Duchamp places the female in the superior position. The males merely react to her.

28-92. Marcel Duchamp. *Bride Stripped Bare by Her Bachelors, Even (The Large Glass)*. 1915–23. Oil and lead wire on glass, 9'1¹/₄" x 5'¹/₈" (2.77 x 1.76 m). Philadelphia Museum of Art

Bequest of Katherine S. Dreier

28-93. Salvador Dalí. *Accommodations of Desire.* 1929. Oil on panel, 8⅝ x 13¾" (21.9 x 34.9 cm). Private collection

While a student in 1922 at the Madrid Academy, Dalí became friends with the poet and dramatist Federico García Lorca (later killed by the Nationalists during the Spanish Civil War of 1936–39) and the film maker Luis Buñuel. He and Buñuel later collaborated on what is probably the most famous Surrealist film, *Un Chien Andalou* (*An Andalusian Dog*).

28-94. Joan Miró. *Painting.* 1933. Oil on canvas, 4'3¼" x 5'3½" (1.30 x 1.61 m). Wadsworth Atheneum, Hartford, Connecticut

The Ella Gallup Sumner and Mary Catlin Sumner Collection Fund

Surrealism

The second European movement that resisted the rationalist tide of postwar art and architecture, Surrealism, was the creation of a French writer, André Breton (1896–1966), one of the many writers involved in the Paris Dada movement after the war. Breton became dissatisfied with the playful nonsense activities of his colleagues and wished to turn Dada's implicit desire to free human behavior into something more programmatic. In 1924 he published his "Manifesto of Surrealism," outlining his own view of Freud's discovery that the human psyche is a battleground where the rational, civilized forces of the conscious mind struggle against the irrational, instinctual urges of the unconscious. The way to achieve happiness, Breton argued, does not lie in strengthening the repressive forces of reason, as the Purists insisted, but in freeing the individual to express personal desires, as Gauguin and Die Brücke had asserted. Breton and the group around him developed a number of techniques for liberating the individual unconscious, including dream analysis, free association, automatic writing, word games, and hypnotic trances. Their aim was to help people discover the larger reality, or "surreality," that lay beyond narrow rational notions of what was real.

Among the writers and artists around Breton was the Spanish painter and printmaker Salvador Dalí (1904–1989). In the early 1920s Dalí had trained at the Academy in Madrid, where he quickly mastered the traditional methods of representation. In 1928 he took a taxi from Spain to see Versailles and meet Picasso in Paris. While there, he also met the Surrealists and quickly converted to their cause. In 1929 he married Gala Éluard, the former wife of one of the Surrealist poets.

Dalí's desire for Éluard apparently triggered classically Freudian fears, which he recorded in works such as *Accommodations of Desire* (fig. 28-93). The combined figures of Éluard and Dalí's mother in the upper left—identified with a group of vases, a traditional symbol for the female as sexual "receptacle"—suggest that he associated his desire for Éluard with oedipal feelings toward his mother. The guilt and sorrow these feelings bring are reflected in the grieving figure just above center. The angry lion dominating the work represents Dalí's father, with whom he competes for the affection of his mother. Like the Prodigal Son of the Bible, son and father attempt reconciliation, in the scene at top center. The feeding ants at the lower right were one of Dalí's favorite devices for evoking anxiety and apprehension. Breton was so impressed with Dalí's ability to make Freudian concepts seem "real" that for several years he considered him the movement's official painter.

Another Spanish artist associated with the Surrealists was Joan Miró (1893–1983), who attempted in his early work to reconcile a diversity of French influences with his devotion to his native Catalan landscape. In 1922 he moved to Paris, where he began to produce a more fantastic brand of landscape painting, inspired, he later claimed, by the hallucinations brought on by hunger and produced by staring at the cracks in his ceiling. The Surrealist painter André Masson (1896–1987), who lived near Miró, brought his work to the attention of Breton, and he was asked to participate in the first Surrealist exhibition, in 1925, and in subsequent ones. Although Miró showed with the Surrealists, he never shared their theoretical interests.

Typical of his mature work is *Painting* (fig. 28-94), based partly on collages he made using illustrations of machine tools in catalogs. Miró developed these works by

28-95. Max Ernst. *The Joy of Life.* 1936. Oil on canvas, 28¾ x 36¼" (73 x 92 cm). Collection Sir Roland Penrose, London

28-96. René Magritte. *Time Transfixed.* 1939. Oil on canvas, 57½ x 38½" (146 x 97.8 cm). The Art Institute of Chicago
Winterbotham Collection

freely drawing a series of lines without considering what they might be or become, a technique called **automatism**, which he learned from Surrealists such as Masson. Next he consciously reworked the lines into the fantastic animal and vegetable forms that they suggested to his imagination. The result is a charming assortment of delicate flora and fauna that seems to float gracefully and effortlessly across a dry Catalan landscape.

As the work of Miró and Dalí suggests, the artists associated with Breton were generally more concerned with their own needs than with the liberation of others. This was particularly true of one of the most inventive artists in the group, the self-taught painter Max Ernst (1891–1976). Ernst was born near Cologne, Germany, in a family headed by a stern disciplinarian father. Horrified by World War I, Ernst helped organize a Dada movement in Cologne. In 1922 he moved to Paris and joined the Dada group there. When Paris Dada evolved into Surrealism, he participated in the search for new ways to free his imagination. One of the liberating techniques he developed was **frottage**, the rubbing of a pencil or crayon across a piece of paper placed on a textured surface. Ernst found that these imprints stimulated his imagination. He discovered in them a host of strange creatures and places. A good example of his frottage-inspired work is *The Joy of Life* (fig. 28-95), a dense jungle landscape populated by threatening creatures at first difficult to discern.

Breton's quest to free humanity from the tyranny of conscious, practical mental habits was also given a singular expression in the work of the Belgian painter René Magritte (1898–1967). Trained at the Brussels Academy in 1916–1917, he became a member of the city's vanguard literary circle, where the ideas of Dada and eventually Surrealism were discussed and applied. After the unsympathetic critical reception of his earliest Surrealist work, he moved in 1927 to Paris, where he played an active part in Breton's group of artists and writers. In 1930 he returned to Brussels, partly in order to free himself from Breton's emphasis on confessional content.

Magritte's work from before 1930 demonstrates two distinct tendencies, one toward the revelation of the psy-

che and the other toward surprising alterations of ordinary situations, often featuring unusual juxtapositions or changes in scale. It was in this latter mode that Magritte specialized after 1930, largely because he felt that it had a greater potential for public good. *Time Transfixed* (fig. 28-96), for example, features the startling appearance of a locomotive steaming out of an empty dining-room fireplace. Some of the work's effect depends on the fact that the two objects are such obvious male and female symbols. Magritte himself, however, insisted that his work not be approached in this way, in part because he did not wish to be psychoanalyzed via his art, but mostly because he thought that it led viewers away from his conscious intention. His purpose was to discredit ordinary reality and open to view what he called the world's mystery. Psychoanalysis is simply another way to explain things, whereas he, on the contrary, wished to demonstrate the "mystery *that has no meaning*." Therefore, instead of focusing on the allusive symbolism, Magritte would rather we simply enjoy the marvelous absurdity of the scene, wondering at the reduction of the locomotive or the enormous enlargement of the room. A determined enemy of the tired, colorless view of the ordinary, he meant to subvert it, to defamiliarize the ordinary for us, showing that we have the capacity to view the banal objects that populate our immediate existence in fresher, more interesting ways.

28-97. Leonora Carrington. *Self-Portrait.* 1937. Oil on canvas,
25 1/2 x 32" (64.7 x 81.2 cm). Private collection
Courtesy Pierre Matisse Foundation, New York

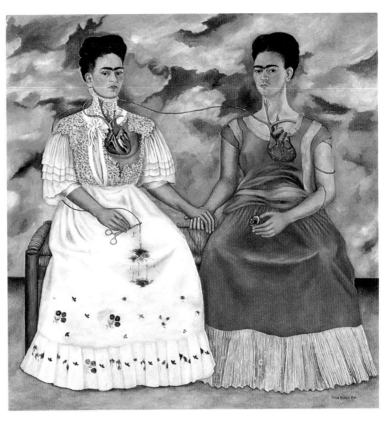

28-98. Frida Kahlo. *The Two Fridas.* 1939. Oil on canvas.
5'8 1/2" x 5'8 1/2" (1.74 x 1.74 m). Museo del Arte Moderno, Instituto National de Bellas Artes, Mexico City

However, Magritte rarely banished altogether the existential drabness he detested. The dining room in *Time Transfixed* is typically cold and barren, while the mirror suggests that the rest of the room is even emptier than the part we see. The prosaic handling of the paint itself contributes much to a residual sense of the everyday. Magritte was well aware of what he called "my defeatism." In 1943 he wrote: "I have few illusions; the cause is lost in advance. As for me, I do my part, which is to drag a fairly drab existence to its conclusion."

Surrealism, like most of the modernist movements, was essentially a male phenomenon, treating women for the most part merely as sexually desirable creatures who could liberate the male imagination. Beginning with the Surrealist exhibition of 1929, some women were allowed to participate in the movement at its margins. Most of those women who showed with the Surrealists were, like Leonora Carrington (b. 1917), also romantically involved with men in the group. As an adolescent Carrington had been outrageously rebellious. Against her wealthy parents' wishes she decided on a career in art and studied for a year in London with the Purist Amédée Ozenfant. The following year, 1937, she met the much older Ernst and went with him to Paris. There she wrote stories and made paintings loosely related to them. Her *Self-Portrait* (fig. 28-97), for example, includes the hyena from her short story "The Debutante." In the story the animal, masquerading as a debutante but emitting a foul odor, takes the place of a young woman who does not wish to attend the ball in her honor. The two horses featured in the painting reappear in a later play, *Penelope* (1946), in which the heroine falls in love with her rocking horse, Tartar (after Tartarus, the Greek underworld), and longs to escape from her authoritarian father and from men, who do not know magic and fear the night. She succeeds by becoming a white colt and flying into a world where imagination neutralizes the male enemies of magic. Beneath the rocking horse is the figure of Carrington herself, seated in a fussy Victorian chair but with her hair flying loose and wild, like her imagination.

The best known of the women artists associated with Surrealism is Frida Kahlo (1910–1954), born near Mexico City. Her father was a German photographer and her mother a Mexican. A nearly fatal trolley accident when she was fifteen left her crippled and in pain for the rest of her life. While convalescing from the accident, she taught herself to paint. Her work soon brought her into contact with Diego Rivera (see fig. 28-119), one of Mexico's leading artists, whom she later called her "second accident." In 1929, when she was eighteen, they married, but their relationship was always stormy. Although they later remarried, the two were divorced in 1939. While the divorce papers were being processed, she painted *The Two Fridas* (fig. 28-98), a large work intended for an international Surrealist exhibition in Mexico City in 1940, that deals with her personal pain. She once said of her paintings that they were "unimportant, with the same personal subjects that only appeal to myself and nobody else." Here she presents her two ethnic selves: the European one, in a Victorian dress, and the Mexican one, wearing a traditional Mexican peasant skirt and blouse. She told an art historian at the time that the European image was the Frida whom Diego loved and the Mexican one the Frida whom he did not. The two Fridas join hands, and they are intimately connected by the artery running between them. The artery begins at the miniature of Diego

28-99. Kenyon Cox. *The Arts*, mural in the Library of Congress, Washington, D.C. 1890

as a boy that the Mexican Frida holds, and it ends in the lap of the other Frida, who attempts without success to stem the flow of blood from it.

In 1939 Breton came to Mexico to meet Leon Trotsky, the exiled Russian revolutionary. Rivera arranged for Breton to meet Kahlo at that time, and he was so impressed with her that he wrote the introduction to the catalog of her New York exhibition in 1939 and the following year arranged for her to show in Paris. Although Breton claimed her as a natural Surrealist, she herself said she was not: "I never painted dreams. I painted my own reality." Whether she could have painted it in the imaginative ways that she did without the example of Surrealism is an open question.

AMERICAN ART

American painters and sculptors were slow to assimilate modernism. In fact, the radical changes being made by European artists during this period were almost entirely ignored by their American counterparts until after 1910. From a Western European vantage point, American art between 1880 and the outbreak of World War I was essentially provincial. Its artists continued either to develop realist traditions or to follow premodernist European examples.

European Influences

The European academic tradition continued to be a strong influence in the United States, partly because of the growing interest of American architects in the conservative training of the École des Beaux-Arts, discussed earlier. One of the most important advocates of academic art was the painter and critic Kenyon Cox (1856–1919). Cox studied first at the Art Academy in Cincinnati, then at the Pennsylvania Academy of the Fine Arts in Philadelphia, and finally, between 1877 and 1882, in the Paris studios of several leading academicians, including Alexandre Cabanel and Jean-Léon Gérôme (see fig. 27-8). After his return to the United States, he settled in New York City and specialized in images of classical nudes resting comfortably in idyllic landscapes.

His academic style brought him a number of mural commissions for the Beaux-Arts architecture then in vogue, including in 1890 the two **lunettes** in a long gallery at the new Library of Congress, constructed in a French classical style related to that of the Louvre (see fig. 19-21). The style of the two allegories Cox produced—one devoted to the sciences, the other to the arts (fig. 28-99)—was strongly influenced by Puvis de Chavannes, whom he considered the leading artist of the period. He thought, however, that the American public needed a more descriptive approach to the figure and a less subdued color scheme. And unlike the relaxed figures in Puvis's murals and in his own easel pictures, here the more monumental figures are symmetrically arranged, which Cox considered both more appropriate to public architecture and better suited to his conservative social message. He believed in a static society, one with as little change as possible. The female figures who personify the various art forms are generically classical and are statically posed and grouped to achieve a sense of timelessness.

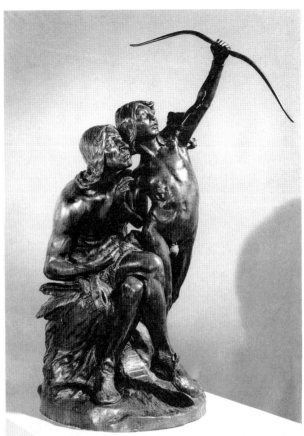

28-100. Herman Atkins MacNeil. *Sun Vow.* 1898. Bronze, height 6'1" (1.85 m). The Metropolitan Museum of Art, New York

The influence of French academicism can be seen also in the sculpture of Herman Atkins MacNeil (1866–1947). After briefly teaching sculpture at Cornell University he went to Paris in 1888 to study at the Academy. Soon after his return to the United States, he went to the World's Columbian Exposition, where he was particularly impressed with the finale of Buffalo Bill's Wild West Show, one of the fair's main attractions. The end of the show featured an attack on a wagon train by "Indians," even though by 1893 no such attack had occurred for almost twenty years. After seeing Buffalo Bill's show, MacNeil spent the next ten years studying the customs of the surviving Native American nations.

In works such as *Sun Vow* (fig. 28-100), the descriptive style, the slightly exaggerated poses and expressions, and the realistic details like the moccasins and hairstyles are derived from the French academic tradition. The particular theme and message, however, are American. An old man is instructing an adolescent in the ceremony of shooting an arrow toward the sun, a rite of passage accompanied by a vow of dedication. Such images of a communal life close to nature sustained by simple religious faith were, roughly speaking, the American counterpart to the European escapist ideals first evident in the Romantic period.

Another European style that American artists adopted after 1880 was Impressionism. During the 1880s, when French artists were reacting against Impressionism, a group of Americans were still in the process of absorbing it. One of these was Childe Hassam (1859–1935), who began his career producing naturalistic paintings of Boston city life. In 1886 he moved to Paris to study at one of the leading private academies. By the time he returned in 1889, he had become an Impressionist. He settled in New York City and specialized in painting pleasant views of the places he lived and visited. While many, like MacNeil and Cox, avoided the city, Hassam embraced it and presented it positively, as in *Union Square in Spring* (fig. 28-101), an image of a large, informal park in New York City, where dozens of people are enjoying the fine spring weather. The relaxed, informal brushstrokes add much to our sense of the activities of the place, as do the cheerful, high-keyed colors.

The African American painter Henry Ossawa Tanner (1859–1937) also learned from Impressionism. Raised in Philadelphia, Tanner studied under Thomas Eakins at the Pennsylvania Academy of the Fine Arts sporadically between 1879 and 1885. In search of further training and a more hospitable environment for his naturalistic landscape painting, he moved to Paris in 1891. There he assimilated something of the Impressionists' interest in light effects as well as their looser brushwork.

When he returned to Philadelphia in 1893, to recover from typhus, Tanner briefly turned these interests to the depiction of genre subjects featuring African Americans,

28-101. Childe Hassam. *Union Square in Spring.* 1896. Oil on canvas, 21½ x 21" (54.6 x 53.3 cm). Smith College Museum of Art, Northampton, Massachusetts

28-102. Henry Ossawa Tanner. *The Thankful Poor.* 1894. Oil on canvas, 35 x 44¼" (88.9 x 112.39 cm). Private collection

28-103. Albert Pinkham Ryder. *Jonah.* c. 1885. Oil on canvas, mounted on fiberboard, 27¼ x 34⅜" (69.2 x 87.3 cm). National Museum of American Art, Smithsonian Institution, Washington, D.C.
Gift of John Gellatly

such as *The Thankful Poor* (fig. 28-102). The light that streams across the wall and over the figures in this painting has less to do with Impressionist concerns than with spiritual connotations of light (seen earlier in fifteenth-century Netherlandish painting; see fig. 17-5, for example). Its soft glow, and the gentle brushwork that defines it, quietly envelops the old man and child shown offering thanks for their humble lot. The theme of the reverent poor, a popular one in European academic art of the period, was here put to a new use. As Tanner said in his writings at the time, he intended to counter the comic stereotype of African Americans then common in art and literature and to represent, instead, "the serious, and pathetic side of life among them." After his return to Paris in 1894, he gave up such subjects, partly because of a lack of European interest in them and partly as a result of his decision to pursue the goal his minister father imagined for him, to make his art serve religion.

One painter generally thought to have resisted Europe and to have evolved a purely personal style was Albert Pinkham Ryder (1847–1917). During the 1870s Ryder made several brief trips to Europe but never studied there. By the early 1880s he had evolved a distinctive approach to landscapes and seascapes, inspired in part by his love of opera, with its grand, generalized effects

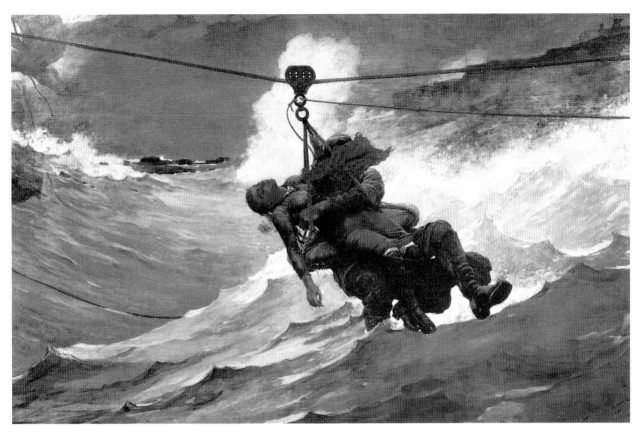

28-104. Winslow Homer. *The Life Line*. 1884. Oil on canvas, 28³/₄ x 44⁵/₈" (73 x 113.3 cm). Philadelphia Museum of Art
The George W. Elkins Collection

In the early sketches for this work, the man's face was visible. The decision to cover it focuses more attention not only on the victim but on the true hero of the scene, the breeches buoy.

and its reliance on classic themes. His interest in these features was also inspired by the European Romantic painting tradition, especially as represented by Delacroix and Turner.

A fine example of Ryder's mature work is the biblical *Jonah* (fig. 28-103). Jonah, fleeing from God's command to tell the people of Nineveh of their wickedness, took passage on a ship. When God sent a tempest that threatened to destroy the ship, Jonah's shipmates threw him overboard and he was swallowed by a great fish. But in the end he was forgiven and saved by the loving God, shown holding the orb, symbol of divine power, who appears in a blaze of redemptive light. Both the subject, being overwhelmed by hostile nature, and its intensified treatment through dynamic curves and sharp contrasts of light and dark are characteristically Romantic. The broad, generalized handling of the violent sea is particularly reminiscent of Turner, whose work Ryder had seen several times in the 1870s. The theme and its handling were unusual for the period.

Winslow Homer (1836–1910) also turned to dramatic images of the sea, following his return from a tiny English fishing village on the rugged North Sea coast, where he lived in 1881–1882. The strength of character of the people there so impressed him that he turned from the

pleasant subjects of his earlier work (see fig. 27-33) to serious themes involving confrontations with a dangerous nature.

During his stay in England he was particularly impressed with the breeches buoy, a device developed by the British to rescue those aboard foundering ships. This line-and-tackle device is featured in *The Life Line* (fig. 28-104). Homer spent part of the summer of 1883 in Atlantic City, New Jersey, apparently because the lifesaving crew there had imported one of the new breeches buoys. He had the crew demonstrate its use while he made sketches. On the basis of these, he painted *The Life Line* early the following year on the roof of his New York City tenement. The painting is not simply a testament to humanity's goodness and courage but to its ingenuity. Here someone is saved not through the grace of God but through human skill and bravery.

Realist Styles

By the early 1890s the American author Hamlin Garland was calling for an end to European domination of American art and for the development of a purely American style and subject matter. Perhaps the artist most committed to this cause was Robert Henri (1865–1929). Henri studied

28-105. Robert Henri. *Laughing Child.* 1907. Oil on canvas, 24 x 20" (61 x 50.8 cm). Whitney Museum of American Art, New York

Lawrence H. Bloedel Bequest

28-106. John Sloan. *Backyards, Greenwich Village.* 1914. Oil on canvas, 24 x 20" (61 x 50.8 cm). Whitney Museum of American Art, New York

Purchase

between 1886 and 1888 at the Pennsylvania Academy of the Fine Arts, where conventional academic training was tempered by the realist convictions of the director, Thomas Eakins. By 1892 Henri had become the leader of a group of young Philadelphia realists, four of whom were newspaper illustrators later prominent in the development of American realism: John Sloan (1871–1951), William J. Glackens (1870–1938), Everett Shinn (1876–1953), and George Luks (1867–1933). Henri spoke out against both the academic conventions and the Impressionist style then dominating American art. He advised his unofficial students: "Paint what you see. Paint what is real to you."

Henri nevertheless turned to Europe for models, living in Paris from 1895 to 1900 and studying the great European realists, especially Diego Velázquez, Frans Hals, and Édouard Manet. He particularly admired the rapid brushwork of these artists, which he felt conveyed their fresh and immediate response to their subjects. What mattered to him was not the European roots of this approach but its potential for American art. He felt, somewhat ironically, that by emulating it, American artists could free themselves from European conventions and express "themselves in their own time and in their own land."

Henri thought that only realism would appeal to the American public and contribute to "the progress of our existence." For him, America's reality was to be found in its children. After he settled in New York City in 1900, he specialized in paintings—like *Laughing Child* (fig. 28-105)—of happy, high-spirited, and wholesome youth who personified the nation and represented its essential goodness.

Henri's efforts to liberalize the teaching and exhibition standards at New York's National Academy of Design, which had been founded as an American counterpart to the French École des Beaux-Arts, put him at the center of a battle between progressives and conservatives there. When he was not reelected as a member of the Academy's exhibition jury in 1908, he responded by organizing an independent exhibition of eight artists. These artists were often thereafter referred to as The Eight, although they never all exhibited together again.

Five of The Eight were Henri and his earlier colleagues—Sloan, Glackens, Shinn, and Luks—who had moved to New York to be near him. The work of these five formed the core of what was known collectively as the Ashcan School, a name applied largely in response to the work of John Sloan. Sloan briefly attended the Pennsylvania Academy in 1892, then worked as an illustrator for the *Philadelphia Inquirer* newspaper. He moved to New York City in 1903, where he did illustrations for a number of national magazines. Beginning in 1907 he began to devote more time to painting.

Responding to Henri's advice to "paint what is real to you," Sloan painted scenes like *Backyards, Greenwich Village* (fig. 28-106), which depicts the backyard of an apartment in which he and his wife had once lived. Like the laundry in it, the work seems fresh and clean, an effect that depends on both the wet look of the paint and the refreshing blues that dominate it. Balancing those cool tonalities are the warm yellows of the building and fence,

which give the work its emotional temperature. Like much of Henri's work, this painting features children. Beneath the laundry, which suggests the presence of caring parents, two warmly dressed children are building a snowman, while an alley cat looks on. The most important figure is the little girl in the window, a stand-in for the artist, who looks out with joy on this ordinary backyard and its simple pleasures.

While Henri and his followers were developing a confident, American brand of realism in painting, a European immigrant, Jacob Riis (1849–1914), was initiating a new and harsher type of realistic documentary photography. The view of American life that emerged from his works was quite at odds with the celebratory view of Henri and Sloan. If Riis and the photographers he inspired were aware of these differences, they never addressed them. They did not think of themselves as artists. Their goal was to galvanize public concern for the unfortunate poor. For them photography was a means of bringing about social change, not an art form.

Riis was born in Denmark and learned journalism by helping his father, a schoolteacher, prepare a weekly paper. Riis emigrated to New York City in 1870. Three years later he was hired as a police reporter for the *New York Tribune*. He quickly established himself as a maverick among his colleagues by actually investigating slum life himself rather than merely rewriting police reports. His contact with the poor convinced him that crime, poverty, and ignorance were largely environmental problems that resulted from, rather than caused, harsh slum conditions.

Riis was convinced that if Americans knew the truth about slum life, they would support reforms to provide the poor with better sanitation, housing, education, and jobs. He later recalled: "It was upon my midnight trips with the . . . police [from the Health Department] that the wish kept cropping up in me . . . [for] some way of putting before the people what I saw there. . . . A drawing might have done it, but it would not have been evidence of the kind I wanted" (cited in Hales, page 169). In 1887 he decided to try the camera. His success was made possible by several technical advances in photography. In the 1870s manufacturers developed a dry-plate process that was much faster and far less clumsy than the wet-plate process still favored by professional photographers for its higher-quality results. Because photographs could now be taken at exposures of one-thirtieth of a second or less, manufacturers began producing cameras for amateurs that could be used either on or off a tripod. To permit interior and nighttime shots, they devised a flash powder that was shot from a pistol. At first Riis employed professional photographers to accompany him into the slums at night, but because they were so often reluctant to go, he soon began taking his own photographs.

His first works, such as *Tenement Interior in Poverty Gap: An English Coal-Heaver's Home* (fig. 28-107), were published in 1890 in his groundbreaking study, *How the Other Half Lives*. All the illustrations were accompanied by texts that described their circumstances in matter-of-fact terms. Riis said he found this family when he visited

28-107. Jacob Riis. *Tenement Interior in Poverty Gap: An English Coal-Heaver's Home.* c. 1889. Museum of the City of New York

The Jacob A. Riis Collection

During the late nineteenth and early twentieth centuries, American social and business life operated under the British sociologist Herbert Spencer's theory of Social Darwinism, which in essence held that only the fittest will survive. Riis saw this theory as merely an excuse for neglecting social problems.

a house where a woman had been killed by her drunken, abusive husband:

> The family in the picture lived above the rooms where the dead woman lay on a bed of straw, overrun by rats. . . . A patched and shaky stairway led up to their one bare and miserable room. . . . A heap of old rags, in which the baby slept serenely, served as the common sleeping-bunk of father, mother, and children—two bright and pretty girls, singularly out of keeping in their clean, if coarse, dresses, with their surroundings. . . . The mother, a pleasant-faced women, was cheerful, even light-hearted. Her smile seemed the most sadly hopeless of all in the utter wretchedness of the place.

What comes through clearly in the picture itself is the family's attempt to maintain a clean, orderly life despite the rats and the chaotic behavior of their neighbors. The broom behind the older girl suggests as much, as does the caring way the father holds his youngest daughter. These are decent people who deserve better.

In his successful campaign on behalf of social reform Riis delivered lectures illustrated with slides made from his photographs. Some of the scenes so shocked his audiences that some people are reported to have fainted, while others leapt yelling out of their chairs. In 1893 Riis delivered one of these lectures in Chicago in conjunction with the World's Columbian Exposition. Both he and the architects of the fair were concerned with the condition of the American city, he with its human inhabitants and they with the buildings in which they lived and worked.

Stieglitz and European Modernism

Shortly before Riis discovered the camera's documentary power, another American opponent of the Henri tradition, Alfred Stieglitz (1864–1946), was developing the camera's aesthetic potential. Stieglitz was born to a wealthy German immigrant family, who sent him to Berlin to study mechanical engineering. Through a course in photochemistry in 1883, he discovered photography and almost immediately, it seems, decided to try to make of it an art form: "I saw that what others were doing was to make hard cold copies of hard cold subjects in hard cold light. I did not see why a photograph should not be a work of art, and I studied to learn to make it one" (cited in Homer, page 13).

Typical of his early work, devoted to atmospheric studies of the city, is *Spring Showers* (fig. 28-108). The sanitation worker behind the tree is not the subject of the image; he is there only to balance the composition. The off-center placement of the tipping tree and the diagonal of the curb, inspired by the example of Japanese prints, would be aesthetically disturbing without the visual weight of his presence. The sanitation worker functions much as the yellow square does in Mondrian's *Composition with Red, Blue, and Yellow* (see fig. 28-81). The appeal of the work also depends on the contrast between the indefinite forms of the horse-drawn vehicles seen through the drizzle and the sharper forms of the tree and fence in the front. For Stieglitz the purpose of such a picture was purely aesthetic. He intended it not for public consumption but rather for the few with sufficient education and discernment to appreciate it.

Stieglitz's first vehicle for promoting his conception of photography was the Camera Club of New York. Between 1896 and 1902 he helped organize exhibitions of photographers he believed in, assembled loan shows to national and foreign institutions, and most important, edited and managed *Camera Notes*, the club's quarterly journal. A growing dissatisfaction with Stieglitz's extreme views among the club's conservative rank and file led him to organize the Photo-Secession group in 1902. The following year, he launched the magazine *Camera Works* and two years later opened the Little Galleries of the Photo-Secession on the top floor of 291 Fifth Avenue, which soon became known simply as 291.

Stieglitz's chief ally in these efforts was another American photographer, Edward Steichen (1879–1973), who then lived in Paris. They had decided from the first to exhibit modern art as well as photography at 291 in order to help break down what they considered the artificial barrier between the two. Through Steichen's contacts in Paris, the gallery arranged exhibitions unlike any seen before in the United States, including works by Matisse (1908 and 1911), Toulouse-Lautrec (1910), Rodin (1908 and 1910), Cézanne (1911), Picasso (1911), Brancusi (1914), and Braque (1915). Thus, in the years around 1910 Stieglitz's gallery became the American focal point not only for the advancement of photographic art but for the larger cause of European modernism.

The event that climaxed Stieglitz's pioneering efforts on behalf of European modernism was the International

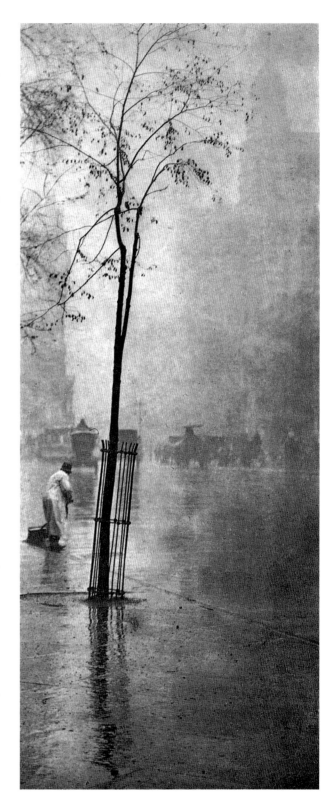

28-108. Alfred Stieglitz. *Spring Showers.* 1901. The Art Institute of Chicago

Exhibition of Modern Art, held in 1913 at the 69th Regiment Armory in Manhattan. It is one of the great ironies of American art that this exhibition, known as the Armory Show, was assembled not by Stieglitz or his colleagues but by one of The Eight, Arthur B. Davies, the only member of Henri's circle to attend events at the 291 gallery. The aim of the exhibition, quite simply, was to demonstrate how outmoded were the views of the

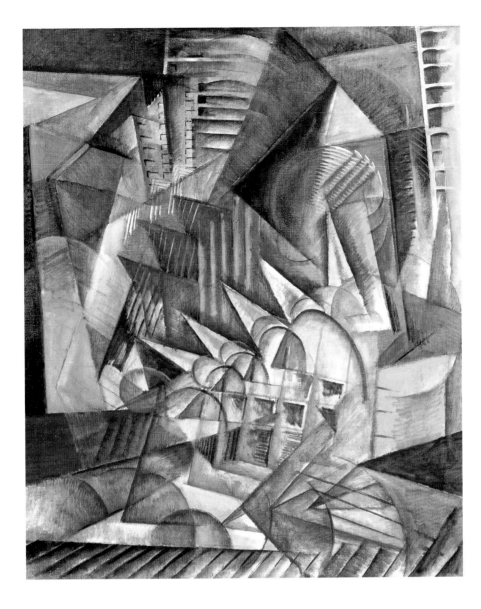

28-109. Max Weber. *Rush Hour, New York.* 1915. Oil on canvas, 36¼ x 30¼" (92 x 76.9 cm). National Gallery of Art, Washington, D.C. Gift of the Avalon Foundation

National Academy of Design. Unhappily for the Henri group, the Armory Show also demonstrated how old-fashioned their realistic approach was.

Of the more than 1,300 works in the show, only about a quarter were by Europeans, but it was to these works that all attention was drawn. Critics claimed that Matisse, Kandinsky, Braque, Duchamp, and Brancusi were the agents of "universal anarchy." Kenyon Cox called them mere "savages." When a selection of works continued on to Chicago, civic leaders there called for a morals commission to investigate the show. Faculty and students at the School of the Art Institute were so enraged they hanged Matisse in effigy.

A great many artists, however, responded positively. Although the impact of the Armory Show is sometimes exaggerated, it marks an important turning point. Between the 1913 exhibition and the early 1920s, American art was characterized by a new desire to assimilate the most recent developments from Europe. The issue of realism versus academicism, so critical before 1913, suddenly seemed inconsequential. For the first time in their history, American artists began fighting their provincial status.

Indicative of the work produced by Americans in the

aftermath of the Armory Show is that of Max Weber (1881–1961). Weber studied at the Pratt Institute in New York City in 1898–1900 and briefly with Matisse in Paris in 1907. During his stay in Paris in 1905–1908 he also became friendly with Picasso and Delaunay. Before the Armory Show he had worked in both the Fauvist and early Analytic Cubist styles. In the new climate established by the exhibition, however, he produced an American version of Cubo-Futurism, although no one called it that. *Rush Hour, New York* (fig. 28-109), for example, at first seems a fairly typical example of the Futurist embrace of city life. The tightly packed surface of angular and curvilinear elements suggests the noisy, crowded rush hour, but the harmony of soft grays, blues, browns, and greens undercuts that effect considerably and produces an aesthetically pleasing formal symphony as well.

Weber was one of the American artists whom Stieglitz showed at his 291 gallery. Another artist, who became a more intimate member of the gallery's circle after the Armory Show, was Georgia O'Keeffe (1887–1986). She studied at the Art Institute of Chicago in 1904–1905 and at the Art Students League in New York in 1907–1908.

28-110. Georgia O'Keeffe. *Drawing XIII.* 1915. Charcoal on paper, 29¹/₂ x 19" (62.2 x 48.4 cm). The Metropolitan Museum of Art, New York
Alfred Stieglitz Collection, 1949

28-111. Gaston Lachaise. *Standing Woman (Elevation).* 1912–27. Bronze, height 5'10" (1.79 m). Albright-Knox Art Gallery, Buffalo, New York

In 1914 or 1915 she read Kandinsky's *Concerning the Spiritual in Art*, which equated color and sound. Shortly afterward, she passed a college classroom where students were making rapid sketches to the music from a phonograph. Fascinated, she joined in. At first she resisted the implications of this experience, but encouraged by one of her teachers and emboldened by the budding feminist movement, she soon decided to follow her own artistic instincts. Convinced that color was a distraction, she decided to work only in charcoal until she had exhausted its possibilities. "It was like learning to walk," she said.

One of the works she produced at this time, *Drawing XIII* (fig. 28-110), features a series of budding organic shapes nestled against a fluid current of lines; both elements seem to rise gently against an angular geometric ground. The arrangement of shapes is less a formalist exercise than a self-expression. "Isn't it enough," she said at this point, "just to express yourself?" What she seemed to convey here was her profound feeling for nature. Her friends recall how she liked to rub a leaf between her fingers or, in a somewhat daring action for that era, thrust her bare feet into a stream to feel the cool water currents. Here the feeling for the basic forces of nature that would characterize all her mature art, whether done in New York or in her spiritual home, the Southwest, was first given shape.

In 1916 one of O'Keeffe's New York friends showed Stieglitz some of these drawings. The friend wrote O'Keeffe that Stieglitz had exclaimed: "At last, a woman on paper!"

when he finished looking at her work. Without consulting her, Stieglitz included the work in a small group show. The next year she had a one-person exhibition at 291. One critic said that O'Keeffe had "found expression in delicately veiled symbolism for 'what every woman knows,' but what women heretofore kept to themselves." This was the beginning of a long line of written criticism that focused on the artist's gender, to which O'Keeffe violently objected. She wanted to be considered an artist, not a woman artist.

American sculptors were slower to respond to contemporary developments in Europe than were painters, and none of them produced works in this period comparable to Weber's or O'Keeffe's. The most innovative sculptural work was produced by a Parisian who had moved to the United States, Gaston Lachaise (1882–1935). Lachaise entered the French Academy in 1898. Sometime between 1900 and 1902 he met Isabel Dutaud Nagle, an older married woman from Boston, who redirected the course of his life and his art. In 1906 he moved to Boston, and in 1912 to New York City to further his career. He dealt with the separation from Isabel by beginning the first of his monumental images of her, *Standing Woman (Elevation)* (fig. 28-111). The plaster model was shown in 1918, but Lachaise could not afford to cast it in

28-112. Charles Sheeler. *American Landscape.* 1930. Oil on canvas, 24 x 31" (61 x 78.7 cm). The Museum of Modern Art, New York
Gift of Abby Aldrich Rockefeller

bronze until 1927. The work is in the classical tradition of the strong female nude, and the simplified modeling of form is reminiscent of Maillol's classical nudes (see fig. 28-9). The work is not generic, however, but a specific tribute to Isabel. Nude photographs of her, now in the Lachaise Foundation, show the same arched back, slender calves and ankles, narrow waist, and proud bearing. What Lachaise exaggerated was her size, for Isabel was only about 5 feet 2 inches tall. The sculpture, 6 feet tall, makes her appear larger than life. But Lachaise also succeeded in making her seem quite light by raising her on her toes and by having her gracefully lift her arms. She closes her eyes, suggesting an inwardness that complements and intensifies our sense of her graceful elevation.

American Scene Painting and Photography

The entry of the United States into World War I in 1917 promised to further stimulate the new American fascination with contemporary European art. Instead, the country entered a period of isolationism that lasted from about 1920 to the bombing of Pearl Harbor in 1941 and had a powerful effect on its artists. A minority continued to look to Europe for direction, but the brief ascendancy of the Stieglitz viewpoint was followed by two decades when convictions more like Henri's prevailed. In the 1920s and 1930s American artists returned to realism, which they used to chronicle American life. The various tendencies of this broad movement in painting are grouped under the term *American Scene Painting.*

The shift back to realism is evident in the work of Charles Sheeler (1883–1965), who attended the Pennsylvania Academy in 1903 after studying for two years at the School of Industrial Art, also in Philadelphia. He apparently objected to the arts-and-crafts orientation but liked industrial design. From early Fauvist still lifes he moved to landscapes inspired by Cézanne and Analytic Cubism. By the early 1920s, however, he had shifted to a highly descriptive realism. This change was partly the result of his growing interest in photography. In 1912 he had opened a photographic business to support himself, and into the 1920s he continued to take commercial assignments, some of which he translated into paintings.

In 1927, for example, he was hired by an advertising firm to take photographs of the new Ford Motor Company plant outside Detroit. In 1930 he used one of these photographs to make *American Landscape* (fig. 28-112), a

28-113. John Steuart Curry. *Baptism in Kansas*. 1928. Oil on canvas, 40 x 50" (102.5 x 128 cm). Whitney Museum of American Art, New York

Gift of Gertrude Vanderbilt Whitney

Curry painted this work in his Greenwich, Connecticut, studio. He did not revisit the Midwest until the summer of the next year. Between that date and his appointment as artist-in-residence at the College of Agriculture at the University of Wisconsin, he made annual sketching trips to the Midwest for the paintings he produced in his Eastern studio during the winter.

28-114. Reginald Marsh. *Why Not Use the "L"?* 1930. Egg tempera on canvas, 36 x 48" (91.4 x 121 cm). Whitney Museum of American Art, New York

Purchase

remarkably faithful transcription of the photograph. Ford, determined to be independent of suppliers, made its own steel on the site, so the painting is, among other things, about the transformation of raw materials into industrial goods. The title suggests that Sheeler was responding to the enthusiastic discussion of modern industry that surrounded the opening of the plant. One journalist had commented that "Detroit . . . [should] be considered the mother-city of the new industrial America" (cited in Troyan and Hirschler, page 17). Another saw such factories as the new American churches, the sites of its new faith in

a better future. Sheeler's painting seems to celebrate this point of view. That he painted the work a year after the great stock-market crash of 1929, which began the Great Depression, suggests that the painting may well be a testament to his continuing faith in American industry and in its fundamental stability.

A small group of American painters that emerged about 1930, known collectively as the Regionalists, also responded to the crisis of the Great Depression but put their faith in agriculture. One of these was John Steuart Curry (1897–1946), born on a farm near Dunavant, Kansas. After ten years as a magazine illustrator he began to specialize in the late 1920s in paintings featuring Kansas farm life. The first and most famous of these is *Baptism in Kansas* (fig. 28-113). The painting, based on a real incident, focuses on a woman being baptized in a farm trough. Arranged in a circle around her is the church community. The solid basis of this larger group is the family, one of which is featured in the foreground. The automobile is here reduced to a peripheral place and role. The painting is characterized by a number of circles, a traditional symbol of unity. That the farm is a holy place is made clear by the churchlike arrangement of the barn and windmill, as well as the rays of sunshine and the birds, traditionally associated with the divine spirit. The painting thus honors the sanctity of the farm and its stable, conservative way of life.

The 1920 census had demonstrated that for the first time in history, more Americans were living in urban centers than in rural areas. The work of Curry and two other artists—Grant Wood (1891–1942) and Thomas Hart Benton (1889–1975)—represents one response to that change. These artists insisted that the real solution to the

28-115. Isabel Bishop. *Resting*. 1943. Oil on gesso panel, 16 x 17" (40.6 x 43.1 cm). Collection Dr. and Mrs. Howard C. Taylor, Jr., New York

many and growing problems of urban American life, made clear by the depression, was for the United States to return to its agrarian roots.

The Regionalists' argument received unintentional support from the so-called Urban Realists, who focused their attention on the city. One, Reginald Marsh (1898–1954), was born in Paris, the son of American artists then living there. After graduating from Yale in 1920, he moved to New York City, which he sketched for the cartoons he sold to various journals. When the *New Yorker* magazine was founded in 1925, he became one of its regular cartoonists. By the late 1920s, he was also producing paintings based on these studies from life.

One of his early paintings, *Why Not Use the "L"?* (fig. 28-114), is in the documentary tradition established by Toulouse-Lautrec. A record of the alienating effects of the city, it shows two women and a sleeping man on a subway car. The two women are alone and withdrawn. The woman on the left is tightly squeezed between the edge of the painting and the steel beam that separates her from the other two figures. The sign above the seated figures ironically tries to convince riders of the "comfort" of the open-air elevated ("L") trains that characterized much of New York's subway system, but the window is closed and barred. The sleeping man may be unemployed and homeless, as was a rapidly growing percentage of New York's work force then. Marsh, merely a fascinated observer, offers no solution to the problems documented here.

Another of the unaffiliated artists grouped under the label of the Urban Realists was Isabel Bishop (1902–1988). Her mother had worked to secure the vote for women in 1920 and had urged Bishop and her sisters toward the independence she had lost once she started her family. Bishop studied illustration at the School of Applied Design for Women in New York. Deciding on a career in painting, she then enrolled at the Art Students League, where she attended lectures by Henri and a course on Cubist painting taught by Weber. Her mentor at the school was another realist, Kenneth Miller, who

criticized Picasso and Matisse for celebrating their individual artistic personalities at the expense of commentary on contemporary life. The work of Bishop's new friend, Reginald Marsh, also reinforced in her the notion that art should address social, not individual, truths.

The social realities she focused on were those of women. Although women figure prominently in the work of both Miller and Marsh, Bishop's work is unique in its sensitivity to women's strength. In *Resting* (fig. 28-115), for example, she gently undercuts traditional stereotypes by showing a woman supporting a man. The woman's head forms the apex of a stable triangle established by the man's head and the arrangement of her right arm. Her relative strength is also evident in the darker, more sculptural forms used to depict her. His body, in contrast, appears vague and almost vaporous.

An artist not usually grouped with Marsh and Bishop but who perhaps should be is Jacob Lawrence (b. 1917). In 1930 Lawrence moved to Harlem, where he attended neighborhood art classes. Between 1932 and 1934 he studied at the Harlem Art Workshop. There he met Alain Locke, Langston Hughes, and other important thinkers and writers who had contributed to what was known as the Harlem Renaissance of the 1920s. During World War I thousands of African Americans left the rural South for jobs in Northern defense plants. The Great Migration, as it is known, created racial tensions over housing and employment that in turn fostered a concern for the rights of African Americans. It produced as well a growing concern among African American writers and artists with black experience and identity.

Alain Locke, educated at Harvard and Oxford and an influential voice in the Harlem Renaissance, encouraged younger black artists and writers to seek their contemporary cultural identity in their African and African American heritage. The influence of this advice can be seen in Lawrence's earliest depictions of Harlem, although the artist claimed that his intent was simply to "record my environment." The bright colors and flat

28-116. Jacob Lawrence. *Interior Scene.* 1937. Tempera on paper, 28½ x 33¾" (72.4 x 85.7 cm). Collection Philip J. and Suzanne Schiller

areas in *Interior Scene* (fig. 28-116) of 1937, for example, are borrowed from Southern folk art. The cheerful colors and lively patterning lend an almost playful air to what is otherwise a grim scene of a brothel infested with cockroaches and rats. Neighborhood children peek through the window at the women and their disheveled white patrons. Below a **tondo** of the Madonna and Child, a woman tucks her recently earned money into her stocking. The unstable composition and steep perspective suggest a world out of kilter. Lawrence's purposes here are unclear. Are we to be amused, appalled, or both?

In the final analysis Lawrence's work may occupy a position between the documentary concerns of the Urban Realists and the reformist aims of those artists who specifically used their art to criticize social injustices. Most of these artists, collectively known as the Social Realists, were affiliated with political organizations: with the various Communist groups that sprang up in the United States in the 1920s and 1930s, with labor organizations, and even with the U.S. government under President Franklin D. Roosevelt (in office 1933–1945).

One of the Social Realists associated with the Com-

munists was William Gropper (1897–1977), born to a poor working-class family in New York City. Gropper studied with Henri between 1912 and 1915, and he began working as a political cartoonist in 1919, when he was hired by the *New York Tribune*. During the 1920s he contributed biting political caricatures to a number of magazines, including *Vanity Fair* and *New Masses*, a Communist publication launched in 1926. By then he apparently was a convert to communism. In 1927 he visited the Soviet Union with the writers Theodore Dreiser and Sinclair Lewis, and while there he contributed work to the official Communist Party newspaper, *Pravda*. Although he also made paintings, he devoted most of his energy to his drawings and cartoons because they could reach a larger audience.

Sweatshop (fig. 28-117), of about 1938, is typical of the work he produced for the Communist press. Sweatshops—small businesses where people are employed at low wages, for long hours, and under harsh conditions—were common in American cities before the strict enforcement of labor, health, and safety laws and regulations. The destructive physical effect of such working conditions is

28-117. William Gropper. *Sweatshop*. c. 1938. Ink, 18 x 15¾"
(45.7 x 40 cm). Collection Eugene Gropper

Despite state laws enacted in the 1880s and 1890s,
called "anti-sweating" laws, it was not unusual for
people to work ten to twelve hours a day, seven
days a week in hot, crowded, and unsanitary work-
places. When Gropper made this drawing, effective
labor laws, including minimum-wage legislation,
were still years away.

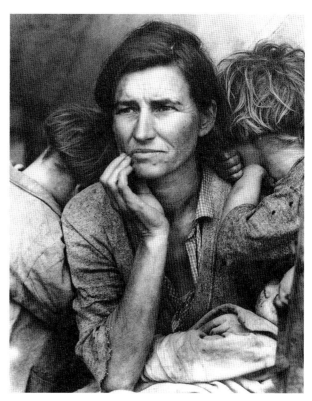

28-118. Dorothea Lange. *Migrant Mother, Nipomo, California*.
February 1936. Gelatin-silver print. Library of
Congress, Washington, D.C.

clearly evident in the tired and stooped bodies of the
workers shown here. The style is purely descriptive. "I
draw pictures of this world of ours," he said, "and they're
not all pretty." Like Riis, Gropper was trying simply to
enlist the viewer's sympathy, hoping to translate it into
political action.

The United States government also used art to sell its
political programs during the 1930s and 1940s. President
Roosevelt sought to use the power and resources of the
federal government to help those in need during the de-
pression. Drawing on the tradition inaugurated by Riis,
his newly established Farm Securities Administration
(FSA) began in 1935 to hire photographers to document
the problems of farmers. These photographs, with cap-
tions, were supplied free to newspapers and magazines.

Dorothea Lange (1895–1965) played a major role in
the formation of the FSA photography program. After
studying photography in 1917 at Columbia University in
New York City, she opened a studio in San Francisco
as a free-lance photographer and portraitist. Distressed
by the depression, she began photographing the city's
poor and unemployed. After seeing some of these pho-
tographs in 1934, Paul S. Taylor, an economics professor
at Berkeley, asked her to collaborate on a report on
migrant farm laborers in California. The report, which
helped convince state officials to build migrant labor
camps, was also influential in the federal government's
decision to include a photographic unit in the FSA. Lange
was hired as one of the first photographers in the unit in
1935.

Perhaps her most famous photograph is *Migrant
Mother, Nipomo, California* (fig. 28-118). The woman in
the picture is Florence Thompson, the thirty-two-year-
old mother of ten children. Two of her children are shown
leaning on her for support. She looks past the viewer
with a preoccupied, worried look. With her knit brow and
her hand on her mouth, she seems to capture the fears of
an entire population of disenfranchised people.

The Roosevelt administration's decision to enlist the
arts on behalf of its social programs had a precedent in
Mexico, where the revolutionary government that took
control in 1921 after a prolonged civil war employed
artists to help forge a national cultural identity. Diego
Rivera (1886–1957), one of the most prominent of these
artists, helped found the modern Mexican mural move-
ment. Rivera, who later married Frida Kahlo (see fig.
28-98), received his initial formal training at the Academy
in Mexico City around 1900. At the age of twenty-one he
won a scholarship to Europe, where he assimilated the
work of the modernists from Cézanne to Picasso and
became close friends with the latter. In 1920 he met David
Siqueiros (1896–1974), another future Mexican muralist,
with whom he began to discuss Mexico's need for a
national and revolutionary art. Rivera went to Italy to
study the great Renaissance frescoes and began studying
Mexico's pre-Columbian art. When he returned to Mexi-
co in 1921 he began a series of monumental murals, the
first of which were for Mexican government buildings.

Rivera's second commission was for the courtyard of
the Ministry of Education in Mexico City. Among the

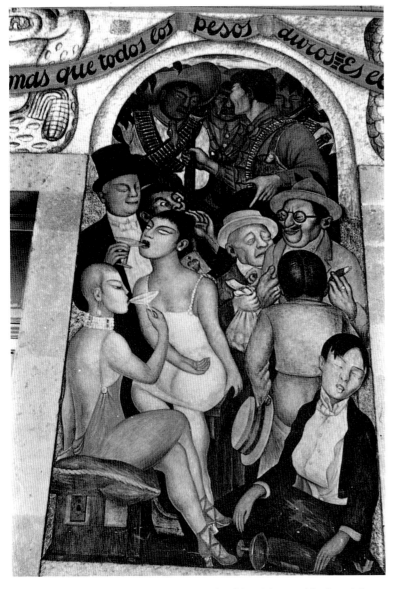

28-119. Diego Rivera. *Night of the Rich*, mural in the Ministry of Education, Mexico City. 1923–28

The Resurgence of Modernism in the 1930s

Although realism dominated American art in the period between the two world wars, some artists of that period showed a renewed interest in the nonrepresentational styles of European art. One of these was Theodore Roszak (1907–1981), whose family migrated to Chicago from Poland when he was two. On a trip to Europe in 1929 he was impressed with the Bauhaus industrial aesthetic, and after his return to New York City in 1931 he produced a series of constructions in modern industrial materials. An example is *Airport Structure* (fig. 28-120). Made of copper, aluminum, steel, and brass, the work resembles a scientific instrument. Roszak claimed that for him "the machine was a tool, not an ideological entity." What he seems to have meant was that although he resisted the Russian Constructivist notion that the person of the future would be more machinelike, he nevertheless felt that modern technology could contribute to human progress. His celebration of the beauty and utility of the machine is the nonrepresentational counterpart to Sheeler's homage to American industry in *American Landscape* (see fig. 28-112).

Roszak later joined the American Abstract Artists, a group that had banded together in 1937 to promote the abstract tradition of the European avant-garde. Another of the approximately forty artists in the group around 1940 was Lee Krasner (1908–1984). An exhibition of Matisse and Picasso at the Museum of Modern Art in 1929 (the year of its founding) so impressed her and some of her classmates at New York's conservative National Academy of Design that, as she put it, they "staged a revolution" there. When she painted a sketch in brilliant Fauve colors, her instructor told her to "go home and take a mental bath." After getting a teaching certificate, she stopped painting and supported herself as a waiter. She resumed her studies in 1937 under Hans Hofmann (1880–1966), a German teacher and painter who had studied in both Paris and Munich before World War I and was considered America's living link with the modernist tradition.

Unlike Hofmann, whose own work from the period was still tied to representation, Krasner was producing fully nonrepresentational works such as *Red, White, Blue, Yellow, Black* (fig. 28-121). This painting, a complicated arrangement of different shapes and colors, is based on the Analytic Cubism of Braque and Picasso (see figs. 28-40, 28-41, 28-42). It threatens to disintegrate into chaos but is held together by the balancing of colors and the even distribution of curvilinear and rectangular shapes across the surface.

The leading critic for the American Abstract Artists, George L. K. Morris, noted that works such as *Red, White, Blue, Yellow, Black* allowed one to escape from the problems of life into a world of order, a world where tensions are resolved. For those Americans tired of the Great Depression and worried by the growing signs of the coming war in Europe, the pleasures of what they called "pure" art seemed compelling.

scenes in this mural are the *Night of the Poor* and the *Night of the Rich*. The *Night of the Poor* shows some peasants sleeping peacefully while others study by lamplight to educate themselves. The *Night of the Rich* (fig. 28-119), in contrast, shows wealthy Mexicans and foreigners, the "debauchers," as Rivera called them, hoarding money and drinking champagne. One sly-looking man is plying a woman with the drink. Another man has passed out. Revolutionary soldiers in the background look on scornfully. The two scenes offer a clear and pointed contrast between the wholesomeness of the poor peasants—the descendants of Mexico's pre-Columbian civilizations—and the Europeanized decadence of the wealthy. The simple shapes and outlines, reminiscent of the art of ancient Maya, reinforce this message.

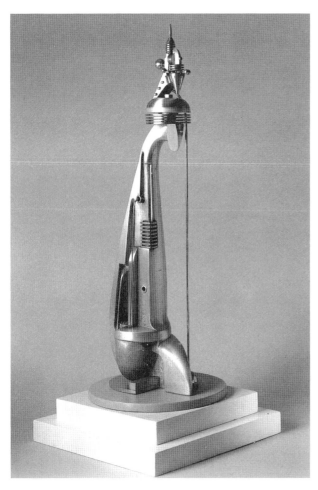

The American Abstract Artists provided an important training ground for some of the critics and artists, including Krasner, who put the United States in the forefront of modernism after World War II. Another important factor in this shift was Roosevelt's Works Progress Administration (WPA), formed in 1935 to help get Americans back to work. The most important work-relief agency of the depression era, the WPA, which remained in effect until 1943, employed more than 6 million workers by that date. Among its initiatives was a group of programs to support the arts, including the Federal Theater Project, the Federal Writers' Project, and the Federal Art Project. Although they involved only about 5 percent of WPA funds and employed only about 38,000 people, these programs had a profound impact on the arts community. The Federal Arts Program (FAP) paid the then-considerable salary of $26.86 a week (a salesclerk at Woolworth's earned only $10.80), allowing painters and sculptors to devote themselves full-time to art and to think of themselves as professionals in a way few had been able to do before 1935. New York City's painters, in particular, began to develop a group identity, largely because they now had time to meet and discuss art in the bars and coffeehouses of Greenwich Village, the city's answer to the cafés that played such an important role in the art life of Paris. Finally, the FAP gave New York's art community a sense that high culture was important in the United States. The FAP's monetary support and its professional consequences would prove crucial to the artists later known as the Abstract Expressionists, who would shortly transform New York City into the new art capital of the world.

28-120. Theodore Roszak. *Airport Structure.* 1932. Copper, aluminum, steel, and brass, height 19$\frac{1}{8}$" (48.6 cm). Newark Museum, New Jersey
Purchase 1977, The Members Fund

28-121. Lee Krasner. *Red, White, Blue, Yellow, Black.* 1939. Collage of oil on paper, 25 x 19" (63.5 x 48.5 cm). Thyssen-Bornemisza Collection, Lugano, Switzerland

1940 1950 1960 19

Giacometti
City Square
1948

de Kooning
Woman I
1950–52

Johns
Target with Four Faces
1955

Lichtenstein
*Oh, Jeff...I Love You,
Too...But*
1964

Smith
Cubii XIX
1964

Smithso
Spiral Je
1969–

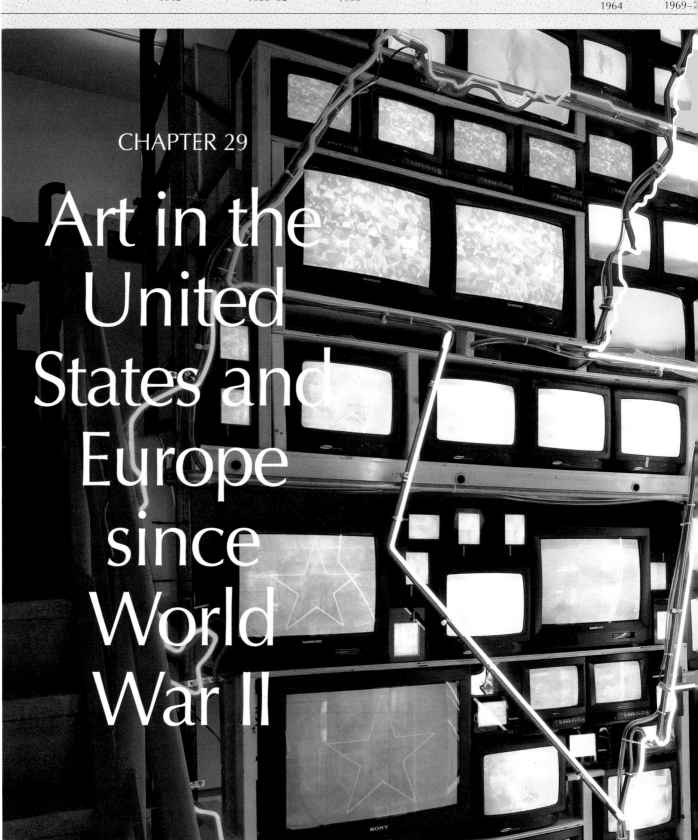

CHAPTER 29

Art in the United States and Europe since World War II

Chicago
The Dinner Party
1974–79

Rothenberg
Axes
1976

Serra
Tilted Arc
1981

Clemente
Untitled
1983

Rossi
Town Hall
1986–90

Horn
High Moon
1991

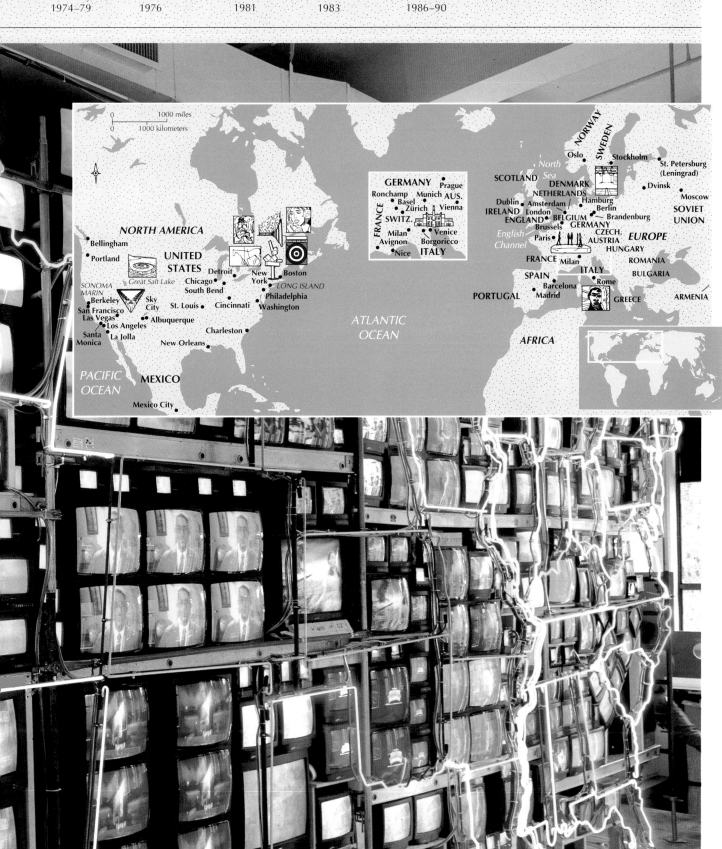

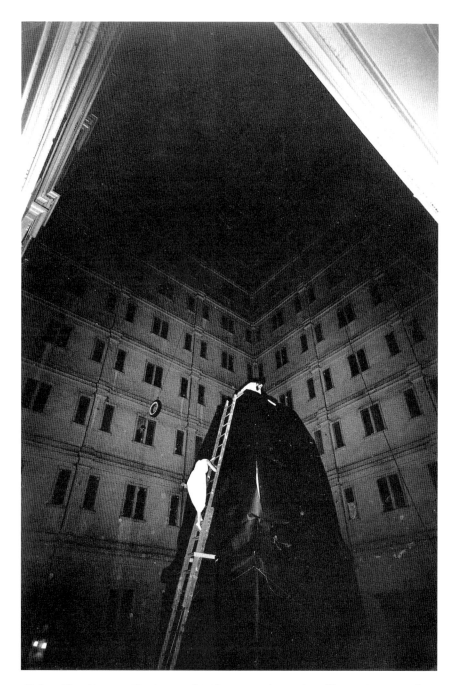

29-1. Allan Kaprow. *The Courtyard*. 1962. Happening at the Mills Hotel, New York

Consumers of culture in New York City have tended, over the years, to be quite blasé about innovations in artwork. There was a time in the early 1960s, however, when attendance at some rather unique art openings caused considerable excitement. At one such opening, of a 1962 work by Allan Kaprow called *The Courtyard* (fig. 29-1), the dominant feature of the work was the eruption of tar-paper balls from a volcanic mountain erected in a tenement courtyard. The viewers, who became participants after being given brooms, watched two men build an altar/bed of mattresses on top of the volcano. A young woman, wearing a nightgown and carrying a transistor radio, then climbed the mountain, where a kind of inverse mountain was lowered over her.

This new kind of art reflected a question and answer raised by musician and philosopher John Cage, who surveyed art and music in 1961 and

asked, "Where do we go from here?" His answer: "Towards theater." What emerged were happenings, theatrical events that were, in and of themselves, "objects" of art. Kaprow's works and those of his followers were badly received by the avant-garde New York art critics, because they were considered theater and because spectators enjoyed the happenings so much. One critic even asked the rhetorical question "Is artistic experience about being entertained?" Such questions about what art is and what role it plays in society have marked the richly innovative period following World War II.

THE "MAINSTREAM" CROSSES THE ATLANTIC

When the United States emerged from World War II as the most powerful nation in the world, its new stature was soon reflected in the arts. American artists and architects—especially those living in New York City—assumed a leadership in artistic innovation that by the late 1950s had been acknowledged across the Atlantic, even in Paris. Critics, curators, and art historians, trying to follow art's "mainstream," now focused on New York as the new center of modernism, viewing trends in Europe as secondary. This American dominance endured until around 1970, when the belief that there is such a thing as an identifiable mainstream, or single dominant line of artistic development, began to wane (see "The Idea of the Mainstream," page 1110).

POSTWAR EUROPEAN ART

Despite the shift of critical focus away from Europe, several European artists received worldwide attention following the war. One of these artists was the Dublin-born painter Francis Bacon (1909–1992). Trained as an interior decorator, Bacon taught himself to paint about 1930 but produced few pictures until the early 1940s, when the onset of World War II crystallized his harsh view of the world. His style draws on the **expressionist** works of Vincent van Gogh (see figs. 28-16, 28-17) and Edvard Munch (see fig. 28-19), as well as on Picasso's figure paintings. His subject matter comes from a wide variety of sources, including post-Renaissance Western art.

Head Surrounded by Sides of Beef (fig. 29-2), for example, is part of a famous series of paintings inspired by Diego Velázquez's *Pope Innocent X* (see "Artistic Allusions in Contemporary Art," page 1111). Bacon has transformed the solid and imperious pope of the original into an anguished and insubstantial figure howling in a black void. The feeling is reminiscent of Munch's *The Scream*, but unlike Munch's figure on the bridge, Bacon's pope is enclosed in a claustrophobic box that seems to contain his frightful cries. Bacon forces the viewer into that box to share his figure's terror, which the sides of beef behind him, copied from a Rembrandt painting, seem to magnify. Bacon said that for him, slaughterhouses and meat brought to mind the Crucifixion of Jesus. The figure is

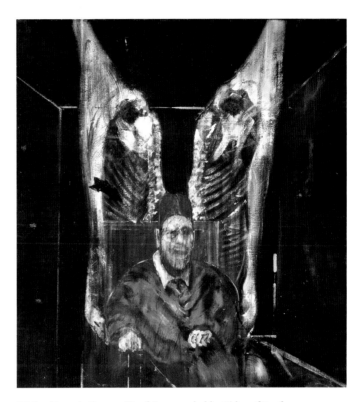

29-2. Francis Bacon. *Head Surrounded by Sides of Beef*. 1954. Oil on canvas, 50¾ x 48" (129 x 122 cm). The Art Institute of Chicago
Harriott A. Fox Fund

responding, then, to the realization that humanity is merely mortal flesh.

The French painter Jean Dubuffet (1901–1985) developed a very different but equally distinctive form of expressionism during the war. Dubuffet's paintings were inspired by what he called *art brut* ("raw art")—the work of children and the insane—which he considered "uncontaminated by culture." Like artists as diverse as Paul Gauguin, Maurice de Vlaminck, and the Surrealists, he thought that civilization corrupts innate human sensibilities. Working at times with paint mixed with tar, sand, and mud applied with his fingers and ordinary kitchen utensils, he developed a deliberately crude and spontaneous style in imitation of *art brut*. In the early 1950s he began to mix oil paint with new, fast-drying industrial enamels, laying them over a preliminary base of still-wet oils. The result was a texture of fissures and crackles that

THE IDEA OF THE MAINSTREAM

One of the central convictions cherished by modernist artists, critics, and historians was the existence of an artistic mainstream, the notion that some artworks are more important than others—not by virtue of their greater aesthetic quality but because they participate in the progressive unfolding of some larger historical purpose. According to this view, the overall evolutionary pattern was what conferred value, and any art that did not fit within it, regardless of how appealing, could be for the most part ignored.

Ultimately, such thinking depended on two long-standing Western ideas about historical change. The first was the ancient Greek belief that history records the steady advance, or progress, of human learning and accomplishment. The second was the Judeo-Christian faith that humanity is passing through successive stages that will inevitably bring it to a final state of perfection on earth, the restoration of Eden in the millennium. The specifically modern notion of the mainstream arose from the way the Enlightenment German philosopher Georg Wilhelm Friedrich Hegel (1770–1831) reformulated these old ideas about progress. In his "Lectures on the Philosophy of History" (first published in 1834, after his death), Hegel argued that history is the gradual manifestation of divinity over time. It is, in other words, the process by which the divine reveals itself to us. As one modern writer succinctly put it, history is thus "the autobiography of God." The important men and women who seem to shape events are actually the vehicles by which the divine "Spirit" unfolds itself.

Hegel's conception of history as the record of large, impersonal forces struggling toward some transcendent end had a profound effect on the following generations of Western European philosophers, historians, and social theorists. In France his ideas were assimilated and developed by the socialists responsible for the concept of the artistic **avant-garde**, a notion of artistic advance central to the rise of modernism.

In the period after World War II the critical discussion of what constituted the modernist mainstream, which had remained largely unstated earlier, was encouraged and shaped by the critical writings of Clement Greenberg (1909–1994), whose thinking was grounded in a Hegelian concept of the development of art since about 1860. In essence, Greenberg argued that modern art since Édouard Manet (Chapter 27) involved the progressive disappearance of both pictorial space and figuration because art itself—whatever the artists may have thought they were doing—was supposedly undergoing its own "process of self-purification" in reaction to a deteriorating civilization. Although Greenberg's conception of the mainstream was rejected by members of the art world during the Abstract Expressionist era, it was embraced by a powerful group of American critics and historians, the so-called Greenbergians, who began to express themselves around 1960.

In the ensuing decades, belief in the concept of the mainstream gradually eroded, partly because of the narrow way it had been conceived by Greenberg and his followers. Because it omitted so much of the history of recent art, observers quite simply began to question whether there had, in fact, ever been a single, dominant mainstream at all. The extraordinary proliferation of art styles and trends in the period after the 1960s greatly contributed to those doubts. Finally, and perhaps most important, these doubts were compounded by the general decline of faith in the very concept of historical progress. Few historians today would disagree with the assessment of the art critic Thomas McEvilley, "History no longer seems to have any shape, nor does it seem any longer to be going any place in particular." Thus, the concept of the mainstream has been relegated to the status of another of modernism's myths.

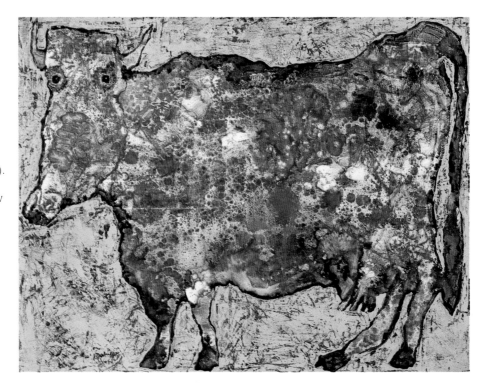

29-3. Jean Dubuffet. *Cow with the Subtile Nose.* 1954. Oil on enamel on canvas, 35 x 45³/₄" (89.7 x 117.3 cm). The Museum of Modern Art, New York

Benjamin Scharps and David Scharps Fund

ARTISTIC ALLUSIONS IN CONTEMPORARY ART

Contemporary artists, like their earlier counterparts (see "Artistic Allusions in Manet's Art," page 1007), have continued to find inspiration, both for subject matter and for formal elements, in the art of the past. Sometimes the borrowings are obvious, as in the case of Francis Bacon's *Head Surrounded by Sides of Beef* (see fig. 29-2), which refers to Rembrandt's *Butchered Ox* and Diego Velázquez's *Pope Innocent X*. Of his fascination with Velázquez's portrait, Bacon said: "It just haunts me, and it opens up all sorts of feelings . . . in me." The nature of those feelings is suggested by the fact that on his studio wall next to a reproduction of that painting were photographs of Nazi leaders and various newspaper images of death and disaster. This combination of real-life and high art imagery suggests that, as it was for earlier artists such as Manet, art is simply one of the sources used by contemporary artists to stimulate and promote the creative process.

Other connections with art of the past are subtly allusive and not apparent to the casual observer, as in the case of Mark Rothko's *Slow Swirl by the Edge of the Sea* (see fig. 29-7), which was inspired by Sandro Botticelli's Renaissance painting *The Birth of Venus*.

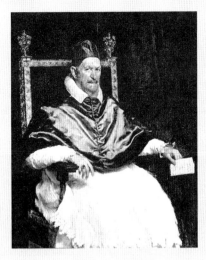

Diego Velázquez. *Pope Innocent X*. 1650. Oil on canvas, 55 x 45 1/4" (139.7 x 115 cm). Galleria Doria Pamphili, Rome

Rembrandt van Rijn. *Butchered Ox*. 1655. Oil on panel, 37 x 26 3/8" (94 x 67 cm). Musée du Louvre, Paris

Sandro Botticelli. *The Birth of Venus*. c. 1480. Tempera on canvas, 5'8 7/8" x 9'1 7/8" (1.8 x 2.8 m). Galleria degli Uffizi, Florence

1950
1940 2000

suggests organic surfaces, like those of *Cow with the Subtile Nose* (fig. 29-3). Dubuffet observed that "the sight of this animal gives me an inexhaustible sense of well-being because of the atmosphere of calm and serenity it seems to generate." What is particularly delightful about this cow is its dazed expression. The animal seems utterly content and unaware of its own gracelessness. Its entire being seems focused on its "subtile" nose, which appears to twitch just slightly, perhaps at the scent of some grassy morsel.

Another major French artist to emerge after the war was Swiss-born Alberto Giacometti (1901–1966). Between 1935 and 1945 Giacometti began modeling human figures in works that became, despite his conscious attempts to resist the tendency, progressively smaller. In the period immediately after World War II he sometimes organized these tiny figures into groups, as in *City Square* (fig. 29-4). The dominant feature of these lumpy, frail, and unbeautiful figures is their heavy feet. The very antithesis of the classical ideal, the figures are anonymous and alone in a desolate space. Their blank faces and mechanical body language suggest life without purpose.

The psychological isolation of Giacometti's figures reflects the influence of the existentialist philosophy of

29-4. Alberto Giacometti. *City Square*. 1948. Bronze, 8 1/2 x 25 3/8 x 17 1/4" (21.6 x 64.5 x 43.8 cm). The Museum of Modern Art, New York
Purchase

ART IN THE UNITED STATES AND EUROPE SINCE WORLD WAR II *1111*

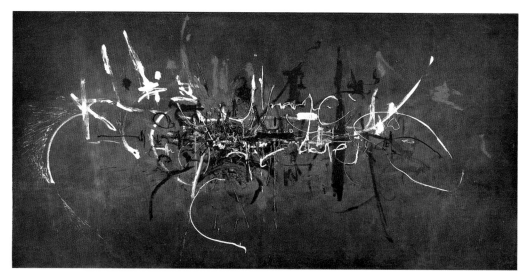

29-5. Georges Mathieu. *Capetians Everywhere*. 1954. Oil on canvas, 9'8¼" x 19'8¼" (2.95 x 6 m). Musée National d'Art Moderne, Centre Georges Pompidou, Paris

his friend Jean-Paul Sartre (1905–1980). According to existentialism, humans are alone in a universe without meaning. Sartre maintained that this condition leaves us absolutely free to choose how to live. Such themes pervaded European art and literature after the war. Many younger painters, seeking an appropriately **avant-garde** way to reveal states of inner being, adapted the Surrealist drawing technique of **automatism** to existential ends. The result was a gestural style—one in which the movement of the body is used to express an idea or a feeling—that swept Western Europe in the early 1950s, which some called *art informel* ("informal art") and others called *tachisme* (from the French for "patch").

One of the leading figures in this development was Georges Mathieu (b. 1921), who in 1944 began using an automatist technique to produce wholly spontaneous, nonrepresentational imagery. France was then under German control, which may explain Mathieu's attraction to such a completely "liberated" technique. More profoundly, he was convinced that only unmediated expressionism could capture the truth of existence. He first described the paintings that resulted with the term *psychic nonfiguration*, but by 1947 he was using the label *lyrical abstraction*. Many of these works, like *Capetians Everywhere* (fig. 29-5), are huge. Mathieu was descended from the Capetians—the kings who ruled France during much of the Middle Ages—so the work is about himself. As with all of his mature work, Mathieu painted *Capetians Everywhere* quickly—he called himself "the fastest painter in the world"—applying paint directly from the tube. Surrealists like Joan Miró (see fig. 28-94) had used automatism only as a first step, before consciously reworking the shapes and lines into a finished painting. By eliminating this more deliberate second step, Mathieu may have been trying to advance the Surrealist quest for total freedom.

As *art informel* was emerging, artists in the United States were also developing a form of expressionism that derived from Surrealism. The American version quickly overshadowed its European counterpart, partly because to many it appeared more profound.

ABSTRACT EXPRESSIONISM

The rise of fascism in Europe and the outbreak of World War II led a number of leading European artists and writers to move to the United States. By 1940, for example, André Breton, Salvador Dalí, Fernand Léger, Piet Mondrian, and Max Ernst were all living in New York. Although many of these émigrés kept to themselves, their very presence provoked fruitful discussions among American abstract artists, who were most deeply affected by the ideas of the Surrealists. The main result of this new American fascination with Surrealism was the emergence of Abstract Expressionism, a term that designates a wide variety of work—not all of it **abstract** or **expressionistic**—produced in New York between 1940 and roughly 1960. Abstract Expressionism is also known as the art of the New York School, a more neutral label many art historians prefer.

The Abstract Expressionists found inspiration in both Cubist formalism and Surrealist automatism, two very different strands of modernism. From the Cubists they learned certain pictorial devices and a standard of aesthetic quality. From the Surrealists they gained both a commitment to examining the unconscious and techniques for doing so. But whereas the European Surrealists had derived their notion of the unconscious from Sigmund Freud, many of the Americans subscribed to the thinking of Swiss psychoanalyst Carl Jung (1875–1961). His theory of the "collective unconscious" holds that beneath one's private memories is a storehouse of feelings and symbolic associations common to all humans. Dissatisfied with what they considered the provincialism of American art in the 1930s, Abstract Expressionists sought universal themes within themselves.

One of the first artists to bring these various influences together was Arshile Gorky (1904–1948). Gorky was born in Turkish Armenia. His mother died of starvation during Turkey's brutal repression and eviction of its Armenian population. He emigrated in 1920 and moved to New York in 1925. In the 1930s his work went through a succession of styles that followed the evolution of

PARALLELS

Years	Events
1940–1949	Modernist period in architecture emerges (United States); New York School arises (United States); Camus's novel *The Stranger* (France); Jews rise up against Nazis in Warsaw Ghetto (Poland); Pollock pioneers action painting (United States); United States drops first atomic bomb, on Hiroshima, Japan; World War II ends; first digital computer (United States); United Nations first meets; Orwell's novel *1984* (England); (Communist) People's Republic of China established
1950–1959	*Art informel* sweeps Western Europe; President Truman sends first U.S. military advisers to Vietnam; Rothko and Newman pioneer Color Field painting (United States); color television introduced in United States; Salinger's novel *The Catcher in the Rye* (United States); Frankenthaler's *Mountains and Sea* (United States); Independent Group produces British Pop art (England); de Kooning's *Woman I* (United States); Sartre's book *Being and Nothingness* (France); Gutai Bijutsu Kyokai formed by Jiro Yoshihara (Japan); Mies van der Rohe's Seagram Building designed (United States); U.S. Supreme Court bans racial segregation in public schools; Ray's film *Pather Panchali* (India); Martin Luther King, Jr., leads Montgomery, Ala., bus-desegregation strike, sparking civil rights movement in the United States; Bergman's film *The Seventh Seal* (Sweden); Elvis Presley's first recordings released (United States); first Earth-orbiting satellite (Soviet Union); Jewish Museum's "New York School: The Second Generation" exhibition (United States); Kerouac's novel *On the Road* (United States); Kaprow's first happening (United States); Minimalist art emerges (United States); Museum of Modern Art's "The New American Painting" exhibition (United States); the Beatles are formed (England); Museum of Modern Art's "New Images of Man" exhibition (United States); Resnais's film *Hiroshima, Mon Amour* (France); Wright's Guggenheim Museum opens (United States)
1960–1969	Berlin Wall built (Germany); Heinlein's novel *Stranger in a Strange Land* (United States); Cage's book *Silence* (United States); Lichtenstein's *Oh, Jeff . . .* (United States); Museum of Modern Art's "The Art of Assemblage" exhibition (United States); Peace Corps founded in United States; Carson's *Silent Spring* (United States); Maciunas launches the Fluxus movement (Germany); Solzhenitsyn's novel *One Day in the Life of Ivan Denisovich* (Soviet Union); Warhol's *Marilyn Diptych* (United States); assassination of President Kennedy (United States); escalation of Vietnam War; Civil Rights Act of 1964 (United States); Friedan's book *The Feminine Mystique* (United States); *Autobiography of Malcolm X* (United States); National Endowment for the Arts established (United States); Capote's "nonfiction novel" *In Cold Blood* (United States); Masters and Johnson's book *Human Sexual Response* (United States); National Organization for Women founded in the United States; assassination of Martin Luther King, Jr. (United States); student unrest in Europe and the United States; site-specific earthworks emerge (United States); Angelou's autobiographical novel *I Know Why the Caged Bird Sings* (United States); first astronauts on moon (United States); riot at Stonewall Inn in New York City begins gay liberation movement (United States); Woodstock popular music festival attended by 400,000 (United States)
1970–1979	Fiftieth anniversary of women's vote spurs feminist art movement (United States); postmodernist architecture and art arise (United States); Super Realism and Post-Conceptual art emerge (United States); Ginsberg's book *The Fall of America* (United States); last U.S. forces leave Vietnam; Watergate scandal forces President Nixon to resign (United States); Chicago's *The Dinner Party* (United States); first personal computer (United States); Haley's novel *Roots* (United States); New Museum's "Bad Painting" and Whitney Museum's "New Image Painting" exhibitions (United States); graffiti art movement launched by "Times Square Show" (United States)
1980–1989	Neo-Expressionism emerges in Europe and the United States; Neo-Conceptualism arises (United States); discovery of AIDS virus reported (France, United States); Morrison's novel *Beloved* (United States); Communist governments in Eastern Europe collapse; Berlin Wall dismantled (Germany)
1990–present	Unification of Germany; Cincinnati Contemporary Arts Center wins court case on Mapplethorpe exhibit (United States); breakup of Soviet Union; Persian Gulf War; apartheid in South Africa legally dismantled; war expands between Bosnians and Serbs in former Yugoslavia; civil wars continue in central Africa

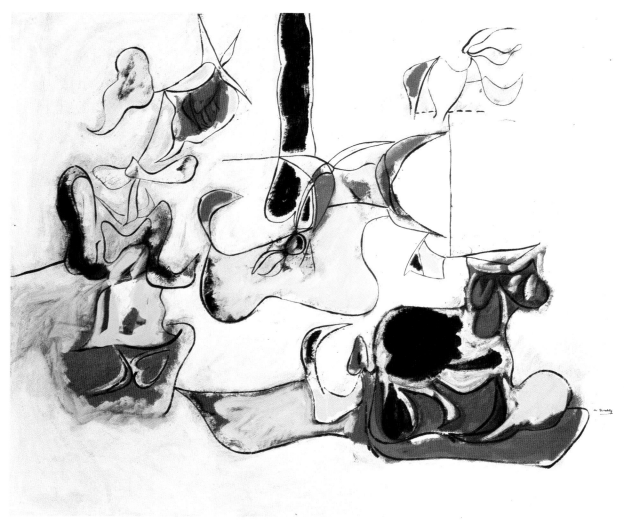

29-6. Arshile Gorky. *Garden in Sochi*. c. 1943. Oil on canvas, 31 x 39" (78.7 x 99.1 cm). The Museum of Modern Art, New York
Acquired through the Lillie P. Bliss Bequest

modernism from Cézanne to Picasso to Miró. Three factors converge in his mature work of the 1940s: his intense childhood memories of Armenia, which provided his primary subject matter; his growing interest in Surrealism, first sparked by a major exhibition, "Dada, Surrealism, Fantastic Art," presented in 1936 at the Museum of Modern Art in New York; and the many discussions of Jungian ideas he had with colleagues.

These factors began to come together in 1940 with Gorky's Garden in Sochi series (fig. 29-6). The title refers to his father's garden at his family's Armenian home, but the paintings, rather than illustrating the place, are meant to evoke its larger meaning. The fluid, organic shapes and sprouting forms—derived from Miró (see fig. 28-94)—suggest the vital forces of life itself. With these seemingly unpremeditated, automatist-generated forms and colors, Gorky meant to put himself and his viewers in touch not only with his own past but also with a universal, unconscious identification with the earth that dates to humanity's prehistoric, preanalytic past. Despite their improvisational appearance, Gorky's paintings were not completely spontaneous but were the result of a process that involved preparatory drawings. He wanted

the paintings to touch his viewers deeply, but he also wanted them to be formally beautiful.

In his paintings of the 1940s Mark Rothko (1903–1970) also sought to convey Jungian themes in works of high aesthetic quality. Born in the poor Jewish ghetto of Dvinsk in Russian-controlled Latvia, Rothko emigrated with his family to Portland, Oregon, when he was ten. His work of the 1930s included quiet street scenes in a somewhat decorative Urban Realist manner. About 1940 he and his friend the artist Adolph Gottlieb (1903–1974) became interested in Surrealism and in Jung and began to produce works based on mythic imagery culled from the subconscious. On a 1943 radio program explaining these works, they said: "If our titles recall the known myths of antiquity, we have used them again because they are eternal symbols. . . . They are the symbols of . . . primitive fears and motivations, no matter in which land, at what time, changing only in detail but never in substance." In a letter to the *New York Times* that same year, they also insisted that subject matter is crucial in art, "and only that subject matter is valid which is tragic and timeless" (cited in Ashton, pages 128–129).

This concern with "primitive fears" and the "tragic"

29-7. Mark Rothko. *Slow Swirl by the Edge of the Sea.* 1944. Oil on canvas, 6'3³/₈" x 7'³/₄" (1.91 x 2.15 m). The Museum of Modern Art, New York

Bequest of Mrs. Mark Rothko through the Mark Rothko Foundation, Inc.

quality of human experience partly reflects the widespread anxiety in the early years of World War II, but it also resonates with Rothko's character. Often depressed and deeply pessimistic, he enjoyed a rare period of optimism in 1944, when he met and fell in love with Mary Alice (Mell) Beistle, who became his second wife. During their courtship he painted *Slow Swirl by the Edge of the Sea* (fig. 29-7). This large canvas is the first in which he relied fully on the automatist technique and his first to depict a watery, primeval world where life is just beginning to develop. Rising from the sea floor amid a variety of indeterminate forms are two more-complicated organic shapes. Some critics have tried to identify these forms as male and female, but all that can be said of them is that they complement each other. The delicate beauty of their forms and colors seems far removed from the world of the tragic. This painting may be in part Rothko's response to a Renaissance painting by Sandro Botticelli, *The Birth of Venus* (see "Artistic Allusions in Contemporary Art," page 1111), which he saw in 1940 and found "the most marvelous thing" he had ever seen. This possibility is supported by the observation of a friend that "Mark thought Mell was his Venus." The painting takes the viewer back

to the very beginnings of life, while at the same time it records the beginning of Rothko's new life with Mell. Perhaps it is even a kind of Jungian wedding portrait—one intended to hold its own with the great art of Europe, modern and premodern. Although the artists of the emerging New York School were committed to innovation, most also saw themselves within the Western tradition of high art that reaches back to ancient Greece.

Jackson Pollock (1912–1956), however, the most famous of the Jung-influenced Abstract Expressionists, rejected much of the European tradition of aesthetic refinement for cruder, rougher formal values often identified with the American frontier. Pollock came to New York in the early 1930s and studied with the Regionalist painter Thomas Hart Benton (1889–1975). Pollock, self-destructive and alcoholic, was introduced to Jung's ideas in 1939, when his family sent him to a Jungian therapist. Pollock was reluctant to talk about his problems, so the therapist tried to engage him through his art, analyzing the drawings Pollock brought in each week in terms of Jungian symbolism.

Although the therapy had little apparent effect on Pollock's personal problems, it greatly affected his work, giving him a new vocabulary of signs and symbols and a

1940
■■■■■■■
1940 2000

29-8. Jackson Pollock. *Male and Female.* 1942. Oil on canvas, 6'1¼" x 4'1" (1.86 x 1.24 m). Philadelphia Museum of Art

Gift of Mr. and Mrs. Gates Lloyd

belief in the therapeutic role of the artist in society. Jung maintained that the artist whose images tapped into "primordial" human consciousness would have a positive psychological effect on viewers. In paintings such as *Male and Female* (fig. 29-8), which attempt to give new psychological and formal dimensions to a standard Picasso subject from the late 1920s and 1930s—two figures facing one another—Pollock apparently sought to put this belief into practice. The surface of the painting is covered with a variety of small signs and symbols Pollock ostensibly retrieved from his unconscious. Beneath this veneer is a firm compositional structure of strong vertical elements flanking a central rectangle. The more angular elements on the left, intended to represent the male principle, balance the more curvilinear ones on the right, intended to express the female principle. In the healthy adult psyche, as suggested here, they are balanced.

When he painted *Male and Female,* Pollock was beginning a relationship with the artist Lee Krasner (see fig. 28-121), and to some extent, like Rothko's *Slow Swirl by the Edge of the Sea,* Pollock's work is a kind of lovers' portrait. But Pollock's painting features a rougher paint surface than Rothko's, less-refined linear rhythms, and more-blatant color contrasts. Although these qualities were partly inspired by recent paintings of women by Picasso, whom Pollock and others of his generation revered as the greatest living artist, and were partly a

matter of innate inclination, they may reflect as well a conscious effort to introduce specifically American formal values. Many of the critics who reviewed Pollock's one-person exhibition in 1943, while less than enthusiastic about his work as a whole, noted approvingly that he had broken with French taste in favor of a "native sensibility." In the context of World War II, Pollock's rugged "Americanism" was much appreciated.

Action Painting

In the second phase of Abstract Expressionism, which dates from the late 1940s, two different approaches to expression emerged, one based on fields of color and the other on active paint handling. The second approach, known as action painting, or **gesturalism**, first inspired the label *Abstract Expressionism.* The term *action painting* was coined by art critic Harold Rosenberg (1906–1978) in his 1952 essay "The American Action Painters," in which he claimed: "At a certain moment the canvas began to appear to one American painter after another as an arena in which to act—rather than a space in which to reproduce, redesign, analyze, or 'express' an object, actual or imagined. What was to go on the canvas was not a picture but an event." Although he did not mention them by name, Rosenberg was referring primarily to Pollock and to Pollock's chief rival for leadership of the New York School, Willem de Kooning (b. 1904).

Pollock began to replace painted symbols with freely applied paint as the central element of his work during the mid-1940s. After moving in 1945 to Springs, a small, rural community on Long Island, New York, he created a number of rhythmic, dynamic paintings devoted to nature themes. The largest of these works were done on the floor of his upstairs studio because the room was too small to accommodate an easel.

Pollock found this working method congenial, and when he moved his studio into a renovated barn in the fall of 1946, he continued to place his canvases on the floor and to work on his knees over and around them. Sometime in the winter of 1946–1947, he also began to employ enamel house paints along with conventional oils, dripping them onto his canvases with sticks and brushes using a variety of fluid arm and wrist movements (fig. 29-9). As a student in 1936, he had experimented not only with this approach but also with industrial paints in the studio of the visiting Mexican muralist David Siqueiros. He had no doubt been reminded of those experiments by the 1946 exhibition of the small drip paintings of a self-taught painter, Janet Sobel (1894–1968), which he had seen in the company of his chief artistic adviser, the critic Clement Greenberg (1909–1994).

Greenberg's view that the mainstream of modern art (see "The Idea of the Mainstream," page 1110) was flowing away from representation and easel painting toward abstraction and large-scale murals may have influenced Pollock's formal evolution at this time, but his shift in working method was grounded in his own continuing interests in both automatism and nature. The result over the next four years was a series of graceful linear

abstractions such as *Autumn Rhythm (Number 30)* (fig. 29-10). As the titles of this and the other paintings in the series suggest, Pollock seems to have felt that in the free, unselfconscious act of painting he was giving vent to primal, natural forces.

Soon after he began the drip paintings Pollock wrote: "On the floor I am more at ease. . . . [T]his way I can . . . literally be *in* the painting. . . . When I am *in* the painting I am not aware of what I am doing. . . . [T]here is pure harmony" (cited in Chipp, page 546). His remarks suggest that one of the deepest pleasures of the new technique for Pollock was the sense it provided him of being fully absorbed in action, which eliminated the anxiety of self-consciousness—the existential sense of estrangement between oneself and the world. Even when the painting is shifted from the floor to the wall, the spectator can vicariously participate in this experience, without knowing about how Pollock painted, because of the mesmerizing way the delicate skeins of paint effortlessly loop over and under one another in a pattern without beginning or end.

In response to Pollock's claim that he found painting "pure harmony," Willem de Kooning insisted, "Art never seems to make me peaceful or pure." De Kooning emigrated to the United States from the Netherlands in 1926, and during the 1930s he shared a studio with his close friend Gorky. Although de Kooning adopted some of Gorky's formal language, he resisted the shift to Jungian Surrealism. For him it was more important to record accurately and honestly his sense of the world around him, which was never simple or certain. "I work out of doubt," he once remarked. During the course of the 1940s his nervous uncertainty was expressed in the agitated and sometimes frantic way he handled paint itself.

29-9. Hans Namuth. Photograph of Jackson Pollock painting, Springs, New York. 1950

In the summer and fall of 1950, Namuth made dozens of still photographs and one film of Pollock at work. Pollock apparently agreed to the sessions partly because he understood that they would help promote his growing fame.

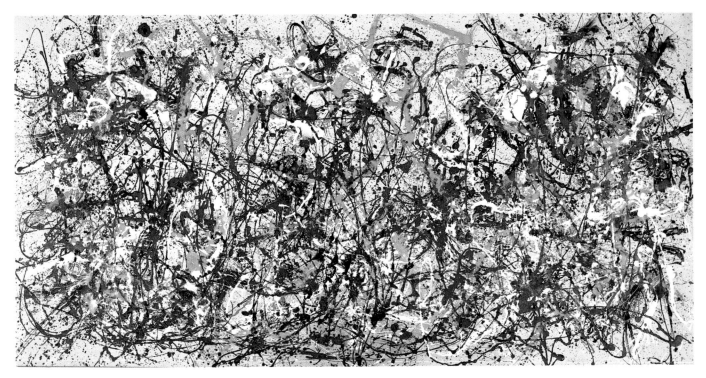

29-10. Jackson Pollock. *Autumn Rhythm (Number 30)*. 1950. Oil on canvas, 8'9" x 17'3" (2.66 x 5.25 m). The Metropolitan Museum of Art, New York

George A. Hearn Fund

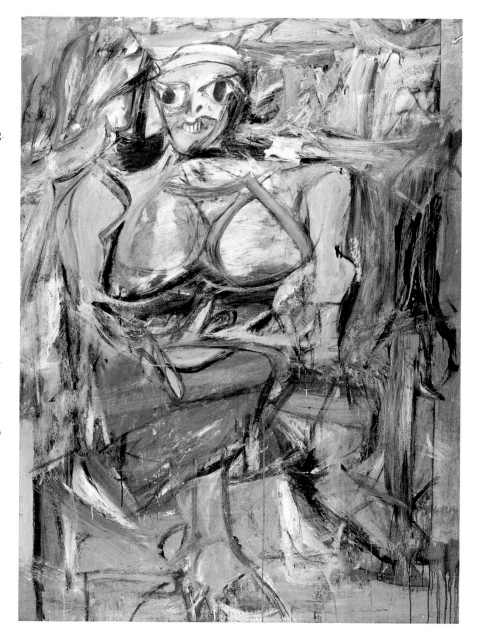

29-11. Willem de Kooning. *Woman I*. 1950–52. Oil on canvas, 6'3⁷⁄₈" x 4'10" (1.93 x 1.47 m). The Museum of Modern Art, New York

Purchase

Dissatisfied with the results of his extended work on this painting, de Kooning left it outside his studio, where Meyer Schapiro, a Columbia University art historian and supporter of the New York School, found it when he came to visit. He admired the work and convinced de Kooning that it was worth keeping and exhibiting.

De Kooning shocked the New York art world in the early 1950s by returning to the figure with a series of paintings of women. The paintings were also shocking because of the brutal way he depicted his subjects. The first of the series, *Woman I* (fig. 29-11), took him almost two years (1950–1952) to paint. His wife, the artist Elaine de Kooning (1918–1989), said that he painted it, scraped it, and repainted it several dozen times at least. Part of de Kooning's dissatisfaction stemmed from the way the images in this and the other paintings in the series kept veering away from the conventionally pretty women in American advertising that inspired them. What emerges in *Woman I* is not the elegant companion of Madison Avenue fantasy but a powerful adversary, more dangerous than alluring. Only the soft pastel colors and luscious paint surface give any hint of de Kooning's original sources, and these qualities are nearly lost in the furious slashing of the paint. Like *Les Demoiselles d'Avignon* did for Picasso (see fig. 28-36), the painting reflects de Kooning's feelings toward women. "Women irritate me sometimes," he said. "I painted that irritation in the Woman series."

De Kooning, like Gorky, was committed to the highest level of **aesthetic** achievement. As one of his friends claimed, for de Kooning being a painter "meant meeting full-force the professional standard set by the great Western painters old and new." Although paintings such as *Woman I* may appear blunt, they represent a carefully orchestrated buildup of interwoven strokes and planes of color based largely on the example of Analytic Cubism (see figs. 28-40, 28-41, 28-42). "Liquefied Cubism" is the way one art historian described them. The real roots of de Kooning's work, however, lie in the Venetian tradition of artists such as Titian (see figs. 18-28, 18-29), Rubens (see figs. 19-41, 19-42), and their heirs, who superbly transformed flesh into paint.

Color Field Painting

During the 1950s de Kooning dominated the avant-garde in New York. Among the handful of modernist painters who resisted his influence were Mark Rothko and Barnett Newman. By 1950 these two had evolved individual

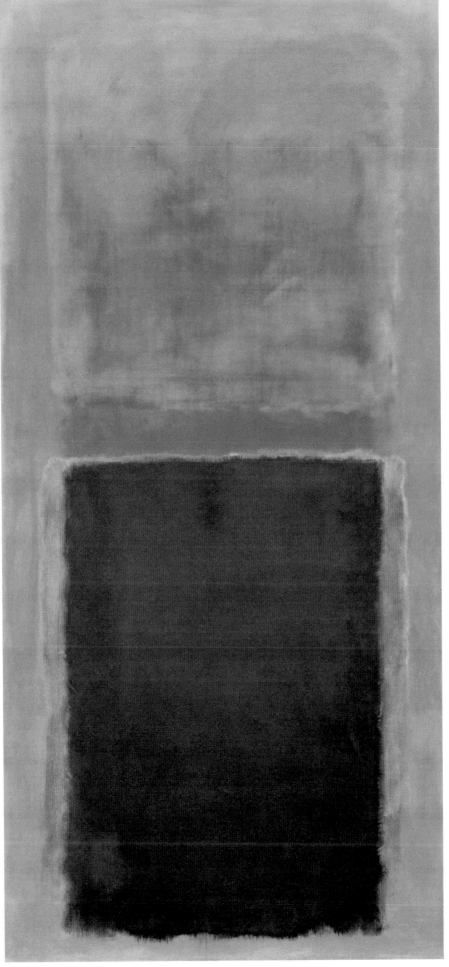

29-12. Mark Rothko. *Homage to Matisse*. 1953. Oil on canvas, 8'10" x 4'3" (2.69 x 1.3 m). Collection the Edward R. Broida Trust

styles that relied on large rectangles of color to evoke transcendent emotional states. Because of the formal and emotional similarities of their work, they were soon referred to collectively as Color Field painters.

In 1947 Rothko gave up his earlier pursuit of a "mythic" art for one inspired by the recent color abstractions of his painter friend Clyfford Still (1904–1980), which, he said, left him "breathless." In the summer of that year he taught with Still at the California School of Fine Arts in San Francisco. Rothko's first efforts in this new direction, freely painted and lacking any clear organizational structure, often looked like soft versions of Still's work. By 1948 he was beginning to organize his colors into rectangular units. By 1950 he had evolved his mature format, which typically involved two to four soft-edged rectangular blocks of color hovering one above another against a monochrome ground.

In works such as *Homage to Matisse* (fig. 29-12) Rothko consciously sought a profound harmony between the two divergent human tendencies that German philosopher Friedrich Nietzsche (1844–1900) called the Dionysian and the Apollonian. The rich color represents the emotional, instinctual, or Dionysian (after the Greek god of wine, the harvest, and inspiration) element, whereas the simple compositional structure is its rational, disciplined, or Apollonian (after the Greek god of light, music, and truth) counterpart. In his paintings Rothko sought to transform this fundamental human duality into a consonant and deeply satisfying unity. The title of *Homage to Matisse,* with its reference to the great colorist and creator of such harmonious works as *The Joy of Life* (see fig. 28-24), reflects this goal.

Unlike Matisse, however, Rothko could never fully surrender himself to the harmonic ideal. He was convinced of Nietzsche's contention, which he reread many times, that the modern individual was "tragically divided." Thus, the surfaces of Rothko's paintings are never completely unified but remain a collection of separate and distinct parts. What gives this fragmentation its particular force is that these elements offer an abstraction of the human form. In figure 29-12, as elsewhere, the three blocks approximate the human division of head, torso, and legs. The vertical paintings, usually somewhat larger than life, therefore present the viewer with a kind of mirror image of the divided self. Thus the dark tonalities that Rothko increasingly featured in his work emphasize the tragic implications of this division. The best of his mature paintings maintain a tension between the harmony they seem to seek and the fragmentation they regretfully acknowledge.

Rothko's colleague Barnett Newman (1905–1970) also devised a nonrepresentational art to address modern humanity's existential condition. Newman experimented with various styles until, on his forty-third birthday, he prepared a canvas with a single stripe running down the center of a darker monochrome field. Although he had intended to develop the work further, he found its simplicity surprisingly resonant. He looked at it for eight months before he decided that his quest for a style had ended. From this point on, Newman specialized

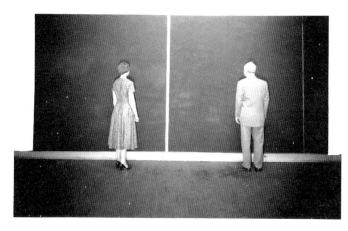

29-13. Barnett Newman. *Cathedra*. 1958. Installation. Photograph, National Museum of American Art, Smithsonian Institution, Washington, D.C.
Peter A. Juley and Son Collection

in monochrome canvases with one or more of these linear "zips," as he called them, dividing the surface, as in *Cathedra* (fig. 29-13). The zips, like Rothko's rectangles, are extreme abstractions of the single human figure and are meant to provide an element with which viewers can identify. Newman sought to contrast the small, finite vertical of the self with the infinite expanse of the universe, suggested in *Cathedra* and other works of its type by the monochromatic field that seems to extend beyond our vision. The word *cathedra* (Latin for "throne") refers here to the ecstatic vision of the prophet Isaiah (6:1): "I saw the Lord seated on a high and lofty throne, with the train of his garment filling the temple." Newman seems to have wanted the painting's viewer to feel what Isaiah must have felt: not the smallness of the self but the sublime fullness of the divine presence.

Sculpture

Although the New York School was made up almost exclusively of painters, a handful of sculptors also participated at its fringes. Many are just now emerging from undeserved relative obscurity. The one sculptor who rose to fame alongside his painter colleagues was David Smith (1906–1965). Born in Indiana, Smith learned metalworking when at nineteen he worked as a riveter in the Studebaker automobile plant in South Bend. Concentrating initially on painting, he turned to sculpture in 1933 after seeing a reproduction of a welded metal sculpture by Picasso and Julio González (1876–1942). Smith's early sculpture is diverse, ranging from social commentary to a three-dimensional version of automatist drawing.

During the 1950s he produced his Tank Totem series, a group of works that seems to look back to the sculpture of Picasso and González. The title of the series combines a reference to army tanks with the concept of a totem, an animal or plant that serves as an emblem for a clan. As a totem for himself, the tank may reflect Smith's belligerent streak as well as his experience as a welder helping to produce tanks during World War II. *Tank Totem III*

29-14. David Smith. *Tank Totem IV* (left). 1953. Steel, 7'8¹/2" x 3'7¹/2" x 2'5" (2.34 x 0.85 x 0.73 m). Albright-Knox Gallery, Buffalo, New York. *Tank Totem III* (right). 1953. Steel, 7'9" x 2'5" x 2'6¹/2" (2.36 x 0.73 x 0.77 m). Private collection

and *Tank Totem IV* (fig. 29-14), like others in the series, seem more amusing than dangerous, however. The warriors they portray, armed with shields and swords, seem to strut proudly across a landscape that they mean to conquer or defend, apparently unaware of how frail and foolish they appear.

The Second Generation of Abstract Expressionism

A second generation of Abstract Expressionists, most of whom took their lead from Pollock or de Kooning, emerged in the 1950s to produce the movement's last major phase. Among these artists were Joan Mitchell (1922–1992), Grace Hartigan (b. 1922), and Helen Frankenthaler (b. 1928). Frankenthaler, like Pollock, worked on the floor, drawn to what she described as Pollock's "dance-like use of arms and legs." She produced a huge canvas, *Mountains and Sea* (fig. 29-15), in this way, working from watercolor sketches she had made in Nova Scotia. Instead of using thick, full-bodied paint, as Pollock did, Frankenthaler thinned her oils and applied them in **washes** that soaked into the raw canvas, producing an effect that somewhat resembles watercolor. Clement Greenberg, who had introduced her to Pollock, saw in Frankenthaler's stylistic innovation a possible direction for avant-garde painting as a whole. That recognition played an important

29-15. Helen Frankenthaler. *Mountains and Sea*. 1952. Oil on canvas, 7'2³/4" x 9'8¹/4" (2.2 x 2.98 m). Collection of the artist on extended loan to the National Gallery of Art, Washington, D.C.

29-16. Richard
Diebenkorn.
*Girl on a
Terrace.* 1956.
Oil on canvas,
6'4" x 5'6"
(1.93 x 1.68 m).
Neuberger
Museum, State
University
of New York
at Purchase

Gift of Roy N.
Neuberger

part in what happened after the so-called crisis of Abstract Expressionism at the end of the 1950s.

ALTERNATIVE DEVELOPMENTS FOLLOWING ABSTRACT EXPRESSIONISM

In 1958–1959 the Museum of Modern Art organized an exhibition of first-generation Abstract Expressionist work, "The New American Painting," and circulated it to eight European capitals before its New York showing. But just at the moment when the Museum of Modern Art and many Europeans were finally acknowledging Abstract Expressionism as "the vanguard of the world," as one Spanish critic called it, there were growing suspicions in the New York art world about the group's right to such a title. The major cause of such doubt was the fact that Abstract Expressionism was no longer, in fact, new. Critic Harold Rosenberg, who disagreed with this emerging critical consensus, nevertheless summed it up succinctly in a published article: "Today it is felt that a new art mode is long overdue, if for no other reason than that the present avant-garde has been with us for fifteen years. . . . No innovating style can survive that long without losing its radical nerve and turning into an Academy." Thus by the end of the 1950s New York critics were dismissing second-generation Abstract Expressionists as "method actors" who faked genuine subjectivity and were accusing members of the first generation, such as de Kooning, of faltering. Amid the growing critical conviction that Abstract Expressionism had lost its innovative edge, attention turned to the question of what would succeed it as the next leading avant-garde development. A number of options quickly emerged.

Return to the Figure

The alternative with the least chance of success was figuration, because the history of modernist art was to a great extent the story of a turning away from representation and the human figure and moving toward increasing abstraction. Although many American artists in the 1940s and 1950s had continued to work in a representational mode, their reputations had suffered for it, which deterred others from following their path. The crisis of Abstract Expressionism now freed many of those artists to follow their long-frustrated inclination to paint the figure.

An artist who had returned to figural subjects even before the crisis of Abstract Expressionism, and not without consequences, was Richard Diebenkorn (1922–1993). After World War II he taught at the California School of Fine Arts, where he came under the influence of his colleagues Still and Rothko, although by 1950 his style was closer to the action painting of de Kooning. About 1954 he resumed working from the model and became a central figure among a group of figurative painters in the San Francisco area that included David Park (1911–1960) and Elmer Bischoff (1916–1991), who held that abstraction lacked sufficient contact with the real world. Many of Diebenkorn's former admirers saw his "defection" not as an act of courage but as a caving in to "provincial" West Coast taste.

Diebenkorn's figure paintings, such as *Girl on a Terrace* (fig. 29-16), reflect the influence of both action painting and Color Field painting. The loose, expressionistic handling of the paint comes from de Kooning, while the large blocks of color and the emphasis on a single figure derive from the work of Rothko. Diebenkorn, however, shared none of Rothko's existential concerns. The woman in the painting may be alone, but the details of her setting and the way she holds one arm behind the other suggest that she is quite happily so. The painting's compositional and coloristic harmony conveys a sense of what the subject is seeing and feeling and, like the paintings of Matisse, elevates her air of tranquillity to a higher, aesthetic plane.

One of the painters liberated by the "crisis" of Abstract Expressionism was Philip Pearlstein (b. 1924). The turning point in his career occurred in 1959 when he joined a drawing group organized by Mercedes Matter (b. 1913), a longtime member of the Abstract Expressionist circle and the founder of the New York Studio School who was then committed to reviving figure painting. Over the next few years Pearlstein's paintings became progressively more descriptive. Pearlstein was also influenced by Matter's approach, which was to pose two models together, emphasizing the formal rather than the narrative connections between them. In Pearlstein's *Two Models, One Seated* (fig. 29-17), for example, as in all of his mature work, there is no psychological connection between figures. To stress this detached, matter-of-fact approach, he often omits or hides his figures' heads. Instead of individuals involved in life's dramas, they are simply studio props arranged for purely aesthetic interest. The appeal of such work depends largely on their unusual compositional grouping.

Another artist who participated in the figural revival about 1960 was the sculptor George Segal (b. 1924). As a painter in the early and mid-1950s he was included among the second generation of Abstract Expressionists. By the late 1950s, however, he had grown tired of the modernist emphasis on flatness, which led him in 1958 to begin experimenting with sculpture. He constructed figures with supports of wood scraps and chicken wire, over which he modeled human forms in plaster. He was comfortable with these cheap materials, he said, because he had used them on a chicken farm he had owned since 1949. In 1961 he discovered that by making casts of live

29-17. Philip Pearlstein. *Two Models, One Seated.* 1966. Oil on canvas, 5'1/2" x 6'1/2" (1.54 x 1.84 m). The Frances Lehman Loeb Art Center, Vassar College, Poughkeepsie, New York

Purchase, the Betsy Mudge Wilson class of 1956, Memorial Fund 1968

29-18. George Segal. *Subway.* 1968. Construction with plastic, metal, glass, rattan, electrical parts, and light bulbs, 7'6" x 9'6½" x 4'5" (2.29 x 2.91 x 1.37 m). Collection Mrs. Robert B. Mayer, Chicago

models with plaster-soaked bandages he could get more satisfying results.

As in *Subway* (fig. 29-18), Segal liked to place his white, bandaged figures in realistic, three-dimensional settings. For this work he cut out a section of a discarded New York City subway car. The isolated figure, drained of color, appears ordinary, her lonely train ride a metaphor for the existential isolation of modern life.

29-19. Ben Vautier brushing his teeth after eating Flux Mystery Food at the "Fluxus Festival of Total Art and Comportment," Nice, France. July 1963

29-20. Shozo Shimamoto. *Hurling Colors*. 1956. Happening

Happenings

Segal's realistic environmental sculpture was largely inspired by the ideas of his friend Allan Kaprow (b. 1927), who, in turn, had been influenced by the ideas of the philosopher and musician John Cage (1912–1992). Cage later articulated in his 1961 book *Silence* the views he had promoted in the 1950s: that art and music should be "an affirmation of life—not an attempt to bring order out of chaos nor to suggest improvements in creation . . . a way of waking up to the very life we're living, which is so excellent once one gets one's mind and one's desires out of its way and lets it act of its own accord." Kaprow incorporated Cage's ideas, including the notion that art should move toward theater, into an influential essay he published in 1958, "The Legacy of Jackson Pollock," his response to the emerging crisis of Abstract Expressionism. In it he argued that Pollock left avant-garde artists with two options: to continue working in Pollock's style or to give up making paintings altogether and develop the ritualistic aspects of Pollock's act of painting. In a willful leap of logic he concluded that Pollock "left us at the point where we must become preoccupied with . . . the space and objects of our everyday life . . . chairs, food, electric and neon lights,

smoke, water, old socks, a dog, movies . . . or a billboard selling Draino [sic]." For modernists this was a shocking statement, for these were precisely the ordinary things they aspired to transcend.

Kaprow's **happenings**—the first of which was held on Segal's chicken farm in 1958—were not so much an embrace of the everyday as an attempt to reestablish meaningful communal rituals. His 1962 happening, *The Courtyard* (fig. 29-1), with which this chapter opened, was not an ordinary one but a revival of some sacrificial ritual. It was less a Cageian acceptance of ordinary life than a Gauguinesque expression of nostalgia for what modern urban dwellers have lost.

In 1960 one participant in the burgeoning happenings movement, George Maciunas (1931–1978), was led by his interest in avant-garde art and music, especially that of Cage, to open the AG Gallery, which specialized in happenings with a musical component. In 1962, temporarily living in what was then West Germany, Maciunas launched the Fluxus movement with a series of happenings, including *Après John Cage*, and the publication of an art magazine. The main thrust of the movement, he said, was to counter the traditional "separation of art and life," to "promote living art . . . to be grasped by all peoples, not only critics, dilettantes, and professionals."

Fluxus quickly attracted many young artists in Germany and France, among them Ben Vautier (b. 1935), a self-trained artist working in Nice, France. In 1963 he, Maciunas, and others organized the "Fluxus Festival of Total Art and Comportment" in Nice. One of Vautier's contributions to this festival was a work dedicated to the "de-elevation" of art. In it he ate what he called Flux Mystery Food—canned food from which the labels had been removed—and then brushed his teeth (fig. 29-19). By calling these objects and activities "art," he simultaneously raised the everyday to the level of art and lowered art to the status of an ordinary event, thereby eliminating the distinction between the two. The ultimate goal was less to criticize the transcendent purposes of modernist art than it was to enliven daily life and its stale routines. In this respect Fluxus represented a continuation of the playful side of the earlier Dada movement (Chapter 28). Maciunas, in fact, titled his inaugural lecture on Fluxus "Neo-Dada in the United States."

In the fall of 1963 Maciunas returned to New York, which became the new headquarters of his expanding Fluxus movement. Despite the lack of critical attention given Fluxus and the related happenings produced by members of Kaprow's circle, the artists themselves perceived their actions as part of a truly international movement that extended beyond the West. In 1959 Kaprow learned of a Japanese group—the Gutai Bijutsu Kyokai (Concrete Art Association)—that had been producing **performance art** similar to what he was advocating. Gutai had been formed in Osaka in 1954 by Jiro Yoshihara (1905–1972), a leading prewar Japanese abstractionist, in an effort to revitalize Japanese art. Inspired by the rich heritage of the Japanese Dada movement that had helped stimulate the arts in Japan following World War I and by European Dada, Gutai organized a series of outdoor

29-21. Yves Klein. *Anthropométries of the Blue Period*. 1960. Performance at the Galerie Internationale d'Art Contemporain, Paris

installations, theatrical events, and dramatic displays of art making. At the second Gutai Exhibition, in 1956, for example, Shozo Shimamoto (b. 1928), dressed in protective clothing and eyewear, produced *Hurling Colors* (fig. 29-20) by smashing bottles of paint on a canvas laid on the floor. The event was meant to be more exhilarating than violent. Thus Gutai was apparently pushing Pollock's drip technique (see fig. 29-10) into new and innovative territory some two years before Kaprow advocated doing so.

Assemblage

A third alternative development was **assemblage**. In 1961 the Museum of Modern Art organized "The Art of Assemblage," whose exhibition catalog argued that assemblage, the putting together of disparate elements to construct a work of art, "has indeed provided an effective outlet for artists of a generation weaned on abstract expressionism but unwilling to mannerize Pollock, de Kooning, or other masters who they admire." In other words, assemblage was the work of artists brought up on Abstract Expressionism who sought to move beyond its tired formulas into new and unexplored terrain. Avant-garde critics were not convinced, however, partly because so much of the work looked not like a new development but like a Dada revival; partly because it was mostly sculpture, at a time when painting took pride of place; and partly because almost none of it seemed to "transcend" the ordinary materials from which it was composed.

The European artists in the exhibition were all associated with the Paris-based movement called *nouveau réalisme* ("new realism"). The movement's leading figure, who, in fact, had not participated in the exhibition, was Yves Klein (1928–1962). In the mid-1950s he began making transcendent monochrome paintings of various hues, and in 1957 he turned to blue alone, which he considered the most spiritual color. The purpose of these blue paintings, he said, was to imbue the viewer with spirituality. Klein's desire to spiritualize humanity—to bring about what he called a "blue revolution"—was evident in his 1960 *Anthropométries of the Blue Period* (fig. 29-21). For this event Klein invited about a hundred members of the

29-22. Jean Tinguely. *Homage to New York*. 1960. Self-destroying sculpture in the garden of the Museum of Modern Art, New York

Paris art world to watch him direct nude female models covered in blue paint press themselves against large sheets of paper. This attempt to spiritualize flesh was accompanied by Klein's *Symphonie monoton*—twenty minutes of a slow progression of single notes followed by twenty minutes of silence—which he considered to be the aural equivalent of the color blue. *Anthropométries of the Blue Period* was Klein's only performance piece, although he had been moving toward that form in the late 1950s in the openings to some of his shows. At one of them, for example, he had served blue cocktails.

More representative of both *nouveau réalisme* and assemblage were the sculpture of the Swiss-born Jean Tinguely (1925–1991). After producing abstract paintings, constructions of various materials, and a few edible sculpture made of grass, Tinguely moved to Paris in 1951 and gave up painting for kinetic sculpture, or sculpture made of moving parts. He called his awkward and purposely unreliable motor-driven sculpture *métamécaniques* (meaning "beyond the machine," later shortened to *méta-matics*). They were the very antithesis of perfectly calibrated industrial machines. Tinguely, an anarchist, wanted to free the machine, to let it play. "Art hasn't been fun for a long time," he said. Not since Dada, he might have added. Like the creations of his Dada forebears, then, Tinguely's work was implicitly critical of an overly restrained and practical bourgeois mentality.

Tinguely's most famous work is probably *Homage to New York* (fig. 29-22), which he designed for a special

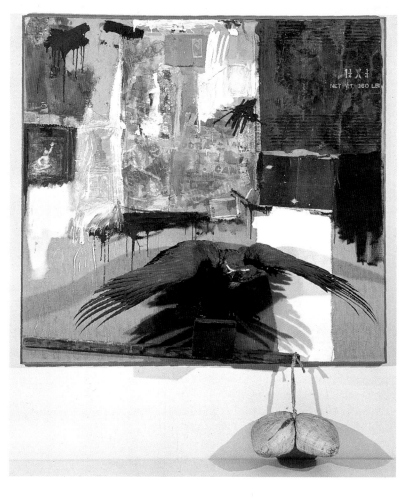

29-23. Robert Rauschenberg. *Canyon*. 1959. Combine painting: oil, pencil, paper, metal, photograph, fabric, wood on canvas, plus buttons, mirror, stuffed eagle, pillow tied with cord, and paint tube, 6'1" x 5'6" x 2'3/4" (1.85 x 1.68 x 0.63 m). Collection Mr. and Mrs. Michael Sonnabend, on infinite loan at the Baltimore Museum of Art

Avant-garde critics were not bothered by the fact that much of Rauschenberg's and the other assemblers' materials were drawn from popular culture. Many of the early-twentieth-century collagists, including Picasso and Braque, had worked with similar materials. However, critics such as Hilton Kramer (at the *New York Times*) and Thomas Hess (at *ArtNews*) pointed out that whereas earlier artists had aesthetically coordinated such elements, transforming the crude materials of life into the finer ones of art, Rauschenberg and his associates left them in their raw, "unpurified" condition. In this view, therefore, such work as this one was not art at all.

one-day exhibition in the sculpture garden of the Museum of Modern Art in New York City. The work was assembled from yards of metal tubing, several dozen bicycle and baby-carriage wheels, a washing-machine drum, an upright piano, a radio, several electric fans, a noisy old Addressograph machine, a bassinet, numerous small motors, two motor-driven devices that produced abstract paintings by the yard, several bottles of chemical stinks, and various noisemakers—all of which was painted white and topped by an inflated orange meteorological balloon. The machine was designed to destroy itself when activated. On the evening of March 17, 1960, before a distinguished group of guests, including Governor Nelson Rockefeller of New York, the work was plugged in. As smoke poured out of the machinery and covered the crowd, parts of the contraption broke free and scuttled off in various directions, sometimes threatening the onlookers. A device meant to douse the burning piano—which kept playing only three notes—failed to work, and fire fighters had to be called in. They extinguished the blaze and finished the work's destruction to boos from the crowd, which, except for the museum officials present, had been delighted by the spectacle.

Unlike his French colleagues, Robert Rauschenberg (b. 1925), one of two major American artists included in "The Art of Assemblage," rejected the antagonism to ordinary culture that had characterized the avant-garde. Rauschenberg went to Black Mountain College in North Carolina in 1948 to work with Joseph Albers (1888–1976),

a former Bauhaus instructor, but discovered there a more congenial mentor in John Cage. Under Cage's influence Rauschenberg evolved a distinctive style by chaotically mixing painted and found elements in assemblages he called combines. *Canyon* (fig. 29-23), for example, features an assortment of old family photographs (the boy with the upraised arm is Rauschenberg), public imagery (the Statue of Liberty, which echoes the boy's pose), fragments of political posters (in the middle), and various objects salvaged from trash (the flattened steel drum at upper right) or donated by friends (the stuffed eagle). The rich disorder challenges the viewer to make sense of it. In fact, Rauschenberg meant his work to be open to various readings, assembling material that each viewer might interpret differently. One could, for example, see the Statue of Liberty in *Canyon* as a symbolic invitation to interpret the work freely. Or perhaps, covered as it is with paint applied in the manner of action painting, it symbolizes that distinctively American style. Following Cage's ideas, Rauschenberg created a work of art that was to some extent beyond his control—a work of iconographic as well as formal disarray. Rauschenberg cheerfully accepted the chaos and unpredictability of modern urban experience and tried to find artistic metaphors for it. "I only consider myself successful," he said, "when I do something that resembles the lack of order I sense."

The other major American included in the assemblage exhibition was Rauschenberg's close friend Jasper Johns (b. 1930). In 1954, while working in a bookstore

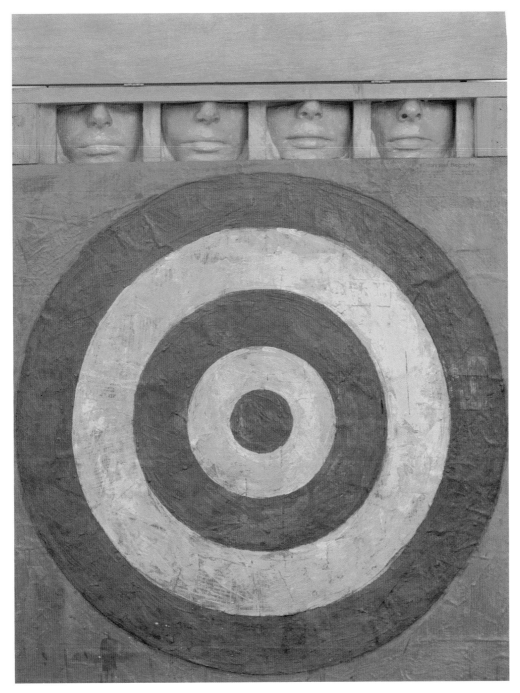

29-24. Jasper Johns. *Target with Four Faces*. 1955. Assemblage: encaustic on newspaper and cloth over canvas, surmounted by four tinted plaster faces in wood box with hinged front, overall, with box open, 33⁵/₈ x 26 x 3" (85.3 x 66 x 7.6 cm). The Museum of Modern Art, New York

Gift of Mr. and Mrs. Robert C. Scull

and producing art part time, Johns had met Rauschenberg, who encouraged him to pursue art more seriously. Unlike Rauschenberg's works, Johns's are controlled, emotionally cool, and highly cerebral. Inspired by the example of Marcel Duchamp (see figs. 28-1, 28-92), Johns produced conceptually puzzling works that seemed to bear on issues raised in contemporary art. Art critics and art historians, for example, had praised the evenly dispersed, "nonhierarchical" or "all-over" quality of so much Abstract Expressionist painting, particularly Pollock's (see fig. 29-10). The target in *Target with Four Faces* (fig. 29-24), an emphatically hierarchical, orga-

nized image, can be seen as a reference to this discourse. The image also raises thorny questions about the difference between representation and abstraction. The target, although arguably a representation, is flat, whereas representational art is usually identified with three-dimensional space. The target therefore occupies a troubling middle ground between the two kinds of painting then struggling for dominance in American art.

Johns's works are more than a simple reaction to the emotional and autobiographical dimensions of Abstract Expressionism. They also had a psychological dimension for Johns, providing him with a way to avoid certain

anxieties and fears, particularly concerning death. The sense of denial is particularly evident in the faces at the top of *Target with Four Faces*, which have been cut off below eye-level and thus depersonalized. The viewer can complete the process of depersonalization by closing the lid over the faces. The casts for the faces were made from the same model but at different times, so they are not identical, a feature that objectifies them further by inviting the viewer to compare them for formal differences. All four faces are as blank and neutral as the target below. In the final analysis, then, the intellectual issues do not disguise the more troubling concern with emptiness that pervades such a work.

The work of Johns had a powerful effect on the artists who matured around 1960. His interest in Duchamp, for example, helped elevate that artist to a place of importance previously occupied by Picasso. And Johns's conceptually intriguing use of subjects from ordinary life, a feature also evident in the work of Rauschenberg, helped open the way for the most controversial development to emerge after Abstract Expressionism, Pop art.

Pop Art

In 1961–1962 several exhibitions in New York City featured art that drew on **popular culture** for style and subject matter. Because of its popular sources (comic books, advertisements, movies, television), this emerging movement came to be called Pop art. Many critics were alarmed by the movement, uncertain whether Pop art was embracing or parodying popular culture and fearful that it threatened the survival of both modernist art and high culture—meaning a civilization's best, not its most representative, products.

Such fears were not entirely unfounded. Pop artists' open acknowledgment of the powerfully compelling realm of commercial culture contributed significantly to the eclipse, about 1970, of traditional modernism and thus, some argue, the very notion of "standards" that kept high culture safely insulated from low. This is not to say that all Pop artists embraced popular culture. Even the first post–World War II artists to turn to it for their inspiration, the British Pop group, reveal a somewhat ambivalent attitude toward their sources.

British Pop was the product of the Independent Group (IG), formed in 1952 by a few members of the Institute of Contemporary Art (ICA) in London who resisted the institute's commitment to modernist art, design, and architecture. The IG's most prominent figures were the artists Richard Hamilton (b. 1922) and Eduardo Paolozzi (b. 1924), the architecture critic Reyner Banham (1922–1988), the art critic Lawrence Alloway (1926–1990), and the writer John McHale. At their first meeting Paolozzi showed slides of American ads whose utopian vision of a future of contented people with ample leisure time to enjoy cheap and plentiful material goods was very appealing to those living under the austerity of postwar Britain. Members of the group were particularly intrigued by American automobile design, with its emphasis on "planned obsolescence," the intentional production of

29-25. Cover from the London *Sunday Times*, color section. 1955. Illustration from article "How American Are We?"

goods that would soon require replacement. In a 1955 article titled "Vehicles of Desire" Banham argued against the modernist search for "classic" and "timeless" styles in industrial design like that conducted by the Bauhaus artists (see fig. 28-87), advocating instead designs that met the need for "an expendable, replaceable vehicle of popular desires." His article included a reproduction of a recent London *Sunday Times* cover with a photograph of the tail fins of an American car against the backdrop of Big Ben that illustrated a feature article titled "How American Are We?" (fig. 29-25).

One of Banham's colleagues in the IG, the artist Richard Hamilton, was perhaps the first to create work based entirely on advertising sources. His *$he* (fig. 29-26), for example, includes a "cornucopia refrigerator" from an RCA Whirlpool ad, a pop-up toaster and a vacuum cleaner from General Electric appliance ads, and a stylized image of Vikky Dougan, a model who specialized in ads for backless dresses and bathing suits. Hamilton said he meant to counter the artistic image of women as timeless beings with the more down-to-earth picture of them presented in advertising. The evocative, somewhat mysterious result, however, seems closer to traditional art than it does to the clear, simple, and straightforward imagery of the advertisements on which it draws. In short, one of the primary imperatives of modern advertising—clarity of message—has here been sacrificed to those of avant-garde art: individuality and provocative invention.

American Pop artists, such as Roy Lichtenstein (b. 1923), were the first to accept the look as well as the

29-26. Richard Hamilton. *$he*. 1958–61. Oil, cellulose, collage on panel, 24 x 16" (61 x 40.6 cm). Tate Gallery, London

29-27. Roy Lichtenstein. *Oh, Jeff . . . I Love You, Too . . . But . . .* 1964. Oil on magna on canvas, 4 x 4' (1.22 x 1.22 m). Private collection

29-28. Claes Oldenburg in "The Store" exhibition, 107 East Second Street, New York. December 1961– January 1962

subjects of popular culture. Lichtenstein experimented with a number of approaches to popular imagery, even attempting, in the late 1950s, to apply a gestural style to cartoon characters, including Bugs Bunny. In 1960, however, he was producing simple stripe paintings using a stain technique inspired by the work of Helen Frankenthaler (see fig. 29-15). At Rutgers University in New Jersey, he became close friends with Kaprow, who was also teaching there.

Kaprow encouraged him to give up abstraction and return to comic-book imagery. In 1961 Lichtenstein began producing paintings whose style—featuring heavy outlines and the **Benday dots** used to add tone in printing—and imagery were drawn from cartoons and advertisements.

The most famous of these early works, such as *Oh, Jeff . . . I Love You, Too . . . But . . .* (fig. 29-27), were based on romance comics. When asked about his comic-book sources in 1963, Lichtenstein said that he turned to them for formal reasons. Although many assume that he merely copied from the comics, in fact he made numerous subtle yet important formal adjustments that tightened, clarified, and strengthened the final image. The cartoonist, he said, "intends to depict and I intend to unify." Nevertheless, the paintings retain a sense of the cartoon plots they draw on. *Oh, Jeff,* for example, compresses into a single frame the generic romance-comic story line, in which two people fall in love, face some sort of crisis, or "but," that temporarily threatens their relationship, and then live happily ever after. Lichtenstein reminds the grown-up viewer, however, that this plot is only an adolescent fiction; real-life relationships, as in the painting, often end with the "but."

Whereas Lichtenstein's impersonal style tends to subdue emotional content, the opposite is true of that of the Swedish-born Claes Oldenburg (b. 1929). In 1960 Oldenburg conducted a rigorous self-analysis to rid himself of a melancholic preoccupation with death. One of the first results of his new focus on the affirmation of life was "The Store," a collection of painted sculpture of ordinary things on sale—shoes, shirts, dresses, and food items—exhibited together in a New York shop front (fig. 29-28). The objects were not hung on the wall as art but were displayed in cases and on racks as the real objects would have been in an actual store. The implication seemed to be that art

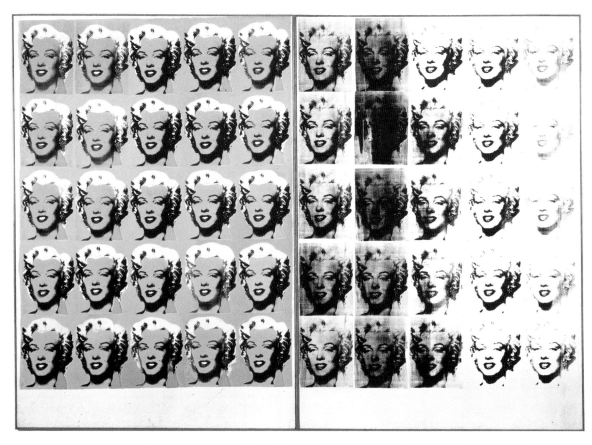

29-29. Andy Warhol. *Marilyn Diptych*. 1962. Oil, acrylic, and silk screen on enamel on canvas, 6'8⅞" x 4'9" (2.05 x 1.44 m). Tate Gallery, London

Warhol assumed that all the Pop artists shared his affirmative view of ordinary culture. In his account of the beginnings of the movement he wrote: "The Pop artists did images that anybody walking down Broadway could recognize in a split second—comics, picnic tables, men's trousers, celebrities, shower curtains, refrigerators, Coke bottles—all the great modern things that the Abstract Expressionists tried so hard not to notice at all."

was merely another commercial product. Oldenburg's intention, however, was the opposite: to render more "human" what he called the "hostile objects" of commerce. He meant to fight the clean, antiseptic dehumanization of the American marketplace with objects that seemed to fairly ooze with life's juices. In 1961 he wrote: "I am for an art that takes its lines from life itself, that twists and extends and accumulates and spits and drips, and is heavy and coarse and blunt and sweet and stupid as life itself." Like Gauguin, Kandinsky, Mondrian, and their heirs, Oldenburg was confident that, in the end, "the reality of art will replace reality."

The most famous Pop artist, Andy Warhol (1928?–1987), did not share Oldenburg's idealism. A successful commercial illustrator in New York City during the 1950s, Warhol grew envious of Rauschenberg's and Johns's emerging "star" status and decided in 1960 to pursue a career as an artist along the general lines suggested by their work. His decision to focus on popular culture was more than a careerist move, however; it also allowed him to celebrate the middle-class social and material values he had absorbed growing up amid the hardships of the Great Depression.

Warhol's lifelong interest in movie stars first surfaced in his art in 1962. Having decided to give up conventional painting for silk-screening photo-images on canvas be-

cause it was faster and thus more profitable, he had just begun working on portraits of male movie stars when Marilyn Monroe suddenly died. Thus, he said, "I got the idea to make screens of her beautiful face." One of the first of the series he did of her was the *Marilyn Diptych* (fig. 29-29). The strip of pictures in this work suggests the sequential images of film, the medium that made Monroe famous. The face Warhol portrays, taken from a publicity photograph, is not that of Monroe the person but of Monroe the star. Warhol was interested in her public mask, not in her personality or character. He borrowed the **diptych** format from the Byzantine **icons** of Christian saints he saw at the Greek Orthodox church services he attended every Sunday. By symbolically treating the famous actress as a saint, Warhol shed light on his own fascination with fame. Not only does fame bring wealth and transform the ordinary into the beautiful (Warhol was dissatisfied with his own looks), it also confers, like holiness for a saint, a kind of immortality.

Warhol attempted to keep his personal motives from showing through too clearly in his works, however, preferring to leave their meaning open to the interpretation of viewers. The success of the Marilyn series, in particular, has depended in great measure on viewers' ability to find in Warhol's images their own feelings and ideas about the tragedy of her life.

PATRONAGE AND COMMERCE

Art museums, both public and private, are relatively new, distinctly Western institutions. Museums evolved in the eighteenth century out of the tradition of private collecting. They continued to flourish under the lasting influence of the Enlightenment, which placed a high value on public education. In the twentieth century, museums emerged as major buyers of art and occasional patrons of living artists, sharing with private collectors the roles once played by religious institutions and aristocratic courts.

Major patrons must have money, and patterns of patronage shift according to where money is. For about a hundred years, from the mid-nineteenth to the mid-twentieth century, families of wealth, education, and social privilege were the primary supporters of the arts. Indeed, art patronage could secure or increase social standing. Such families gave heavily to establish and fund museums. Their generosity in loaning or giving works of art are often noted on museum labels and in captions for illustrations of works of art in books, including this one. Donor information is a major aspect of a work's **provenance** and for that reason alone merits such notice.

The late 1940s–1950s was a transition period for art buying in the United States. The New York School was the annointed avant-garde and was promoted by several critics whose opinions carried enormous weight with some museum curators and with adventuresome collectors, who were not paying high prices for the paintings and sculpture they added to their collections. It is often argued that such critics, notably Clement Greenberg and Harold Rosenberg, in fact had a profound influence on the work of New York School artists.

Sometime in the 1960s, as the United States consolidated its position as the wealthiest country in the world, patterns and intentions of art buying and art making began to change. Museums were built where none had been before, especially in the thriving Sun Belt of the United States. People with newly made fortunes, banks, and commercial corporations began to acquire art as investments. Prices rose. Critics began to accuse some contemporary artists of pandering to this new class of patrons.

By the 1980s the art market was booming. In the five years between 1982 and 1987, prices for major Impressionist paintings rose 400 percent. The art market went global, with Japanese and Latin American investors putting in some of the highest bids ever offered for "blue chip" Impressionist paintings. A painting by Jasper Johns, a living artist, that might have fetched a quarter of a million dollars in the early 1970s commanded $17 million in the late 1980s. Most museums just could not compete as buyers in this market. But they did benefit from loans and gifts from collectors who could reduce their taxes by such largesse. Ironically, artists now began to protest the commercialization of art.

With the advent of the sober 1990s the "commodification" of art suddenly cooled. Some works offered at auction failed to reach their minimum prices. Many corporations started divesting themselves of their art collections. The private collectors who sold their once overpriced artworks to raise cash rarely recovered what they had paid. Museums were again able to purchase works of art, at least modestly. The trend in the 1980s, then, proved to have been an exception for the art market. For those people who buy art because they love it, not because they plan to sell it for profit, that the inflated market was so short-lived was a relief.

Minimalism and Conceptualism

Three related styles that emerged in the wake of Abstract Expressionism—post-painterly abstraction, Hard Edge, or Minimalist, art, and Conceptualism—shared a commitment to reducing art to its essentials. Here we use the term *Minimalism* broadly to refer to the first two of these styles that developed in the period 1958–1970.

Most avant-garde critics, curators, and art historians, following the lead of Clement Greenberg, considered post-painterly abstraction to be the legitimate heir to Abstract Expressionism. Greenberg coined the term *post-painterly,* using it to describe the style that he believed had evolved naturally from the "painterly" or gestural abstraction of the New York School. He helped cultivate the style, promoting its practitioners and praising their efforts as the only "authentically new episode in the evolution of contemporary art."

In 1953 Greenberg introduced Morris Louis (1912–1962), a painter from Washington, D.C., then working in a late Cubist style, to the work of Helen Frankenthaler (see fig. 29-15). Impressed with Frankenthaler's stain technique and apparently convinced by Greenberg's ideas on the evolution of modernism and the historical inevitability of pure formalism (see "The Idea of the Mainstream," page 1110), Louis stepped "beyond" Abstract Expressionism by eliminating all extra-artistic meanings from his work. In

29-30. Morris Louis. *Saraband*. 1959. Acrylic resin on canvas, 8'5⅛" x 12'5" (2.57 x 3.78 m). Solomon R. Guggenheim Museum, New York

paintings such as *Saraband* (fig. 29-30) he purged not only the figural and thematic references found in the work of Frankenthaler but also the subjective, emotional connotations found in that of Pollock, de Kooning, Rothko, and Newman. Here, color does not represent emotion; it is simply color. Red is red, not passion. The painting is simply a painting, not a representation of something beyond art. The luscious rainbow of colors in *Saraband*—which he created by tipping the canvas to allow the thinned oils to

29-31. Frank Stella. *"Die Fahne Hoch."* 1959. Enamel on canvas, 12'1½" x 6'1" (3.67 x 1.85 m). Whitney Museum of American Art, New York

Gift of Mr. and Mrs. Eugene M. Schwarz and purchase with funds

While studying painting at Princeton University in the late 1950s, Stella and an undergraduate English major, Michael Fried, often went to New York City to hear Clement Greenberg lecture on the course of modern art. Fried went on to become the leading Greenbergian critic of the 1960s. He primarily wrote for *Artforum*, the most influential art journal of the period. *"Die Fahne Hoch"* is one of the names for the *Horst Wessel Lied*, a German folksong that was virtually an anthem for the German army in World War II. It translates "the banner raised aloft."

flow according to their inherent properties—offers pure delight to the senses.

Another artist motivated by Greenberg to purge art of its "inessentials" was Frank Stella (b. 1936). In his early Black series stripe paintings such as *"Die Fahne Hoch"* (fig. 29-31), inspired in part by a series of flag paintings by Johns, he eliminated the conventional notion of individual sensibility: he featured black, for example, not because it appealed to his taste or expressed his mood but because it signifies the absence of color, its denial. The rectangular design elements derive from the shape of the canvas itself. "Depicted shape," the artist claimed, was logically determined by the "literal shape" of the canvas support. Even the 3-inch widths of the stripes were determined by the physical object: the canvas stretchers are 3 inches deep. What Stella achieved was a group of artworks whose features refer not to the artist or the outside world but to other aspects of the art object itself. The individual paintings are therefore hermetically sealed from everything beyond their edges except other paintings of the series. In that sense they are "pure."

Greenberg's influence was also felt in sculpture, as reflected in his friend David Smith's decision around 1960 to turn from his earlier figural work (see fig. 29-14) and pursue a more formalist direction. This transition was also the result of a shift in materials; Smith had begun to build his figures from unpainted but burnished stainless steel and became increasingly preoccupied with that metal's formal qualities. The most famous of the resulting works are perhaps those of the Cubi series, monumental combinations of geometric forms inspired by and offering homage to Cubism, the painting style that helped give birth to formalism. Like the works of Picasso and Braque (see figs. 28-40, 28-41, 28-42), *Cubi XIX* (fig. 29-32) presents a tense, finely tuned balance of elements that threaten to collapse at the slightest provocation. The viewer's aesthetic pleasure depends as well on the way light, especially sunlight, catches and dynamically plays over the burnished surfaces.

One of the younger formalist sculptors to emerge at this time was Donald Judd (1928–1994). Judd's reductive sensibility had more in common with Stella's than with

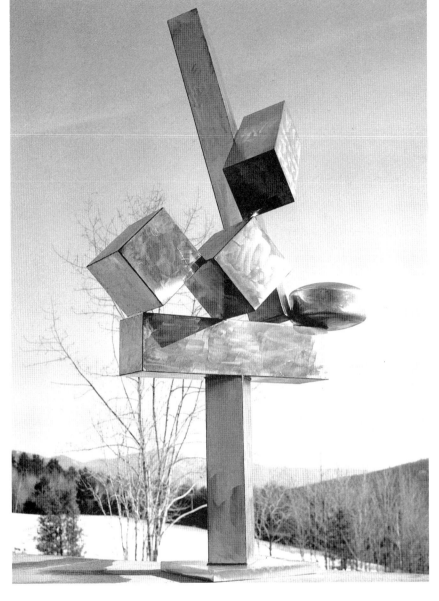

29-32. David Smith. *Cubi XIX*.
1964. Stainless steel,
9'5³⁄₈" x 1'9³⁄₄" x 1'8"
(2.88 x 0.55 x 0.51 m).
Tate Gallery, London

Smith's, however. Convinced along with Greenberg and others that Abstract Expressionism had deteriorated into a set of techniques for faking both the subjective and the transcendent, Judd began around 1960 to search for an art free of falsehood. By the early 1960s he had decided that sculpture offered a better medium than painting for creating literal, matter-of-fact art. Rather than *depicting* shapes, as Stella did—which Judd thought still smacked of illusionism and therefore fakery—he would create *actual* shapes. In search of a greater simplicity and clarity, he soon evolved a formal vocabulary featuring identical rectangular units arranged in rows and constructed of industrial materials, especially anodized aluminum and Plexiglas. Figure 29-33 is a typical example of his mature work.

Judd liked industrial materials because they had the crisp "certainty" he sought, were more impersonal than organic materials, and were imbued with their own color, thus minimizing his need to choose a color for them. His later boxes, like those in figure 29-33, are always open to avoid any uncertainty about what might be inside. He arranged them in rows—the simplest, most

29-33. Donald Judd. *Untitled*. 1969. Anodized aluminum and blue Plexiglas, each 3'11¹⁄₂" x 4'11⁷⁄₈" x 4'11⁷⁄₈" (1.2 x 1.5 x 1.5 m); overall 3'11¹⁄₂" x 4'11⁷⁄₈" x 23'8¹⁄₂" (1.2 x 1.5 x 7.2 m). The St. Louis Art Museum, St. Louis, Missouri
Purchase funds given by the Shoenberg Foundation, Inc.

29-34. James Turrell. *Rayzor*. Conceptualized 1968; constructed 1982. Fluorescent and outside light, 12' x 22'¹/₄" x 23'⁵/₈" (3.65 x 6.78 x 7.18 m)
Courtesy the artist

29-35. Eva Hesse. *Hang-Up*. 1965–66. Acrylic on cloth over wood and steel, 6' x 7' x 6'6" (1.8 x 2.1 x 2 m). The Art Institute of Chicago
Through prior gift of Arthur Keating and Mr. and Mrs. Edward Morris, 1988

impersonal way to integrate them—and avoided sets of two or three because of their potential to be read as representative of something other than a row of boxes. Judd provided the viewer with a set of clear, self-contained facts. The viewer's satisfaction derives from the contrast between the work's conceptual clarity and the messy complexity of the real world.

Greenberg's influence did not extend to all Minimalist art. California artist James Turrell (b. 1943), for example, produced a Minimalist art using light in empty rooms that reflects his fascination with the pure effects of illumination. Turrell was interested in the phenomenon of light itself, not in what it reveals or symbolically represents. Beginning with shaped slide projections on blank walls, he was, by the end of the 1960s, investigating the way light affects the perception of space. *Rayzor* (fig. 29-34), one of a group of works he called Shallow-Space Constructions, was conceived in 1968 but not realized until 1982. It consisted of powerful fluorescent lights hidden behind a partition at the end of a completely white room. The dazzling light emerging from a narrow slit all the way around the partition obscured the wall, floor, and ceiling joints. Without perspective cues, the chamber seemed to the viewer to fold into a shallow, ambiguous space. The partition wall, which appeared translucent, seemed to float at an uncertain distance. Such work not only provided viewers a serene perceptual experience but also raised interesting questions about the accuracy of ordinary vision.

Meanwhile, in New York City the sculptor Eva Hesse (1936–1970) was applying the formal vocabulary of Minimalism to self-expression. After graduating from Yale School of Art in 1959 she painted self-portraits, and in 1964 she began to produce abstract sculpture with a similar purpose. Her works, in effect, are Minimalist stand-ins for herself. *Hang-Up* (fig. 29-35), like much of her mature work, was meant to express the frailties of her body. The painted cloth wrapped over the wood frame and steel loop suggests flesh covering bone or bandages over damaged flesh. The steel loop that protrudes irrationally from the frame seems an unnatural growth. The empty frame, too, may have had a personal significance

for Hesse, who often lamented that she never had children. The absurdity of the empty frame and senseless cord are probably meant to echo Hesse's view of her life: "Art and life," she commented, "are very connected and my whole life has been absurd."

About this time a group of New York artists who came to be known as Conceptualists was pushing Minimalism to its logical extreme by eliminating the object itself. Although these artists always produced something physical, it was often no more than a set of directions or a documentary photograph. Part of this shift away from the aesthetic object toward the pure idea was inspired by the growing reputation of Marcel Duchamp within the Neo-Dada revivals of the early 1960s, and in particular by Duchamp's assertion that art should be a mental, not a physical, activity. Deemphasizing the art object also kept art from becoming simply another luxury product, a concern raised by the booming business for contemporary art that developed as a result of the rising prices of Abstract Expressionist works and the growing popularity of Pop art among collectors (see "Patronage and Commerce," page 1131). Without an object, there would be nothing to sell. Art would therefore remain safe from bourgeois materialism.

The Conceptual art of the 1960s, unlike the intellectually complex art of Duchamp, aimed for a simplicity and clarity similar to that found in the works of Stella and Judd. For example, Bruce Nauman's (b. 1941) *Bound to Fail* (fig. 29-36), a photograph of the artist tied with a rope, offers an obvious visual pun on the word *bound*.

29-36. Bruce Nauman. *Bound to Fail* from *Eleven Color Photographs*. 1966–67/70. One in a portfolio of eleven color photographs, published in an edition of eight by Leo Castelli Gallery, 1970, 19³/₄ x 23¹/₂" (50.2 x 59.7 cm). The Heithoff Family Collection

Although Conceptualist works usually provide little for the mind to ponder, on a second level the work suggests that given the overly ambitious social agenda of the modernist artist, he or she was bound to fail.

FROM MODERNISM TO POST-MODERNISM

Nauman's *Bound to Fail* and the loss of confidence in the transformative power of art it represents is symptomatic of a larger phenomenon affecting Western art and architecture in the 1960s and 1970s: the end of modernism. In retrospect, the Minimalist emphasis on reducing art to its essence should perhaps be seen as an admission of a diminished notion of its power. Minimalists continued to believe, however, that art represented a pure realm outside ordinary existence and that the history of art had a coherent, progressive shape. To most of the artists who followed them, by contrast, the concepts of artistic purity and the mainstream seemed naive. In fact, the entire generation that grew to maturity around 1970 shared little of the faith in either purity or progress that marked earlier generations. Precisely how and why this loss of faith happened are matters of debate, but among the contributing factors were a widespread sense of disillusionment that followed in the wake of the political protests and social reform movements of the 1960s and the growing awareness that the material improvements brought by industrial technology had a high environmental cost. In short, the utopian optimism that had characterized the beginning of the modernist era and had survived both world wars gave way to a growing uncertainty about the future and about art's power to influence it.

The decline of modernism in the various arts was neither uniform nor sudden. Its gradual erosion occurred over a long period and was the result of many individual transformations. The many approaches to art that have emerged from the ruins of modernism are designated by the catchall term *postmodernism*.

29-37. Ludwig Mies van der Rohe and Philip Johnson. Seagram Building, New York City. 1954–58

Architecture

As in painting and sculpture, modernism endured in architecture until about 1970. The stripped-down, rationalist style pioneered by Walter Gropius (see figs. 28-73, 28-86) and Le Corbusier (see fig. 28-85) dominated new urban construction in much of the world after World War II and came to be known as the International Style. Many of the most famous examples of International Style architecture were built in the United States by German architects associated with the Bauhaus, who during the Nazi era had been offered prestigious positions in American schools. Gropius, for example, was hired in 1937 by Harvard, where he eventually headed the architecture department. In the same year Ludwig Mies van der Rohe (1886–1969), who ran the Bauhaus from 1930 to its closing in 1933, was named director of the Armour Institute in Chicago, which later became the Illinois Institute of Technology. Even more than Gropius, Mies was committed to a radically simplified architecture of steel and glass.

Whether designing schools, apartments, or office buildings like the Seagram Building in New York City (fig. 29-37), Mies used the same simple, rectilinear industrial vocabulary. The differences among his buildings are to be found in their details. Because he had a large budget for the Seagram Building, for example, he used custom-made bronze (instead of standardized steel) beams on the exterior. Mies would have preferred to have visible steel supports for the structure, but building codes required him to encase them in concrete. The ornamental beams on the outside thus stand in for the functional beams inside, much as the shapes in a Stella painting refer to the structural frame that holds the canvas. The tall, narrow

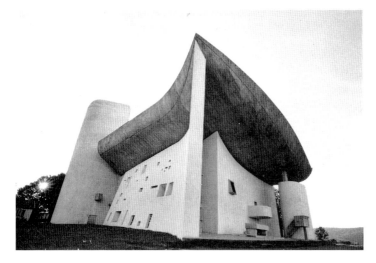

29-38. Le Corbusier. Nôtre-Dame-du-Haut, Ronchamp, France. 1950–55. View from the southwest

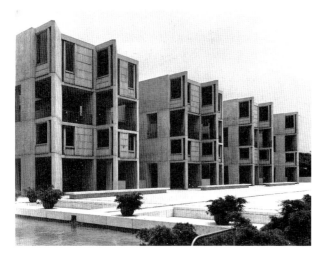

29-39. Louis Kahn. Salk Institute of Biological Studies, La Jolla, California. 1959–65

windows emphasize the verticality of the thirty-eight-story building, helping it compete for attention with surrounding skyscrapers. The building is set back from the street and rises quickly and impressively off pilotis (metal or concrete columns that raise a building above ground level) from a sunlit plaza with reflecting pools, fountains, and, originally, beech trees (the city air killed them).

The dark glass was meant to give the Seagram company a discreet and dignified image. The building's clean lines and crisp design seemed, in fact, to epitomize the efficiency, standardization, and impersonality that had become synonymous with the modern corporation itself—which, in part, is why this particular style dominated corporate architecture after World War II. Such buildings were also cheaper to build. For Mies, however, the goal was to find a suitable architectural style not only for American businesses but also for modern humanity. He believed that the industrial preoccupation with

streamlined efficiency was the dominant value of the entire age. As he intimated in his comment "Less is more," the only legitimate architecture was one that expressed this modern **zeitgeist** ("spirit of the age").

While business leaders, in particular, were embracing the International Style, a number of critics both inside and outside the architectural profession were growing increasingly hostile to it, not least because it had become so identified with the prevailing corporate zeitgeist. These critics called for an architecture that would provide the starved modern sensibility with the spiritual nourishment it so badly needed.

Among the first architects to offer a radical alternative to the International Style was one of its originators, Le Corbusier. Although he never entirely rejected his original vision of the rational, uniform city of the future (see fig. 28-85), he did come to recognize its deficiencies. In the early 1950s he shocked the architectural profession with his radically antimodernist design for Nôtre-Dame-du-Haut (fig. 29-38), a pilgrimage church on a hill above Ronchamp, France. Instead of a thin, industrial skin, the church has thick, rough, masonry walls faced with whitewashed Gunite (sprayed concrete). The darker concrete roof is finished in a contrasting striated pattern. The large overhang is partly functional, covering the entranceways and the exterior pulpit and altar used for outdoor services. More important, the upward lift of the roof recalls the spiritually symbolic vertical emphasis of conventional church architecture. It also appears to respond to the winds that sweep across the hill and the building. Finally, the shape of the roof was inspired, Le Corbusier said, by a crab shell. The building's organic, gently swelling curves are reminiscent of the work of Henry Moore (see fig. 28-76), but its identification of the natural with the spiritual harks back to the premodern ideas of the Romantics. Its dark, cavelike interior recalls the far earlier association of the natural with the divine that dates to humanity's prehistoric past.

Louis Kahn (1901–1974) developed a less radical antimodernist architecture. Trained in conventional Beaux Arts methods at the University of Pennsylvania in the early 1920s, he did not fully develop his own theories until he encountered the architecture of ancient Egypt, Greece, and Rome during a year spent at the American Academy of Rome in 1950–1951. What struck him about this architecture was the way it translated clearly conceived functions into boldly simple structures. He returned to the United States committed to finding a modern equivalent of those early Mediterranean styles. Rejecting the modernist preoccupation with a single, uniform style, he sought to tailor the form of each building to its intended use. He viewed a building as a living organism and maintained that like an organism, its form should efficiently integrate its functioning parts.

For the Salk Institute of Biological Studies on the shores of the Pacific Ocean in La Jolla, California, Kahn designed a large laboratory building and two rows of student and faculty housing on a severe courtyard open to the sea (fig. 29-39). The modular housing units, whose regularity is both punctuated and relieved by the abrupt

diagonal juts in the facades, are formed with concrete slabs, which he preferred to thinner industrial materials because of the way they more assertively defined space. The windows and balconies are simple geometric cuts in the walls. The harsh contrast of solid and void is somewhat softened by the wood around the facade openings. Kahn, who asked himself what institutional housing "wanted" to look like, seems to have decided that it wanted to look like it housed a community of equals. Although Kahn based his ideas on what he viewed as the simple functionalism of ancient architecture, his spare design for the Salk Institute's housing seems consistent with the Minimalism of contemporary painting and sculpture.

Postmodern Architecture. Although the historically informed antimodernism of Le Corbusier and Kahn contributed to the decline of modernism, it was the willingness of Robert Venturi (b. 1925) and his associates to turn to vernacular (meaning popular) sources that marks the emergence of postmodern architecture. Parodying Mies van der Rohe's famous aphorism "Less is more," Venturi claimed "Less is a bore" in his 1966 pioneering publication *Complexity and Contradiction in Architecture*. The problem with Mies and the other modernists, he argued, was their impractical unwillingness to accept the modern city for what it is: a complex, contradictory, and heterogeneous collection of "high" and "low" architectural forms. Taking these ideas further in 1972 in *Learning from Las Vegas*, he and his colleagues suggested that rather than turning their backs in disdain at ordinary commercial buildings, architects should get in "the habit of looking nonjudgmentally" at them. "Main Street is almost all right," they observed. Just as we "look backward at history and tradition to go forward; we can also look downward to go upward."

Venturi's first attempt to work within the vernacular tradition while improving it was the Guild House (fig. 29-40), a public-housing project with ninety-one apartments for seniors in a Philadelphia working-class neighborhood. Over the entrance is a large, billboard-inspired sign that proclaims the building's identity to passersby. The contrast between the pretentious name and the modest public housing it designates is the key to understanding the building's design. The sparse metal windows, although much larger than their ordinary mass-produced counterparts, and the inexpensive, dark brown brick recall earlier post–World War II urban-renewal projects. The building is designed to fit into its surroundings while subtly evoking features of the high architecture of the past. For example, the symmetrical massing of the wings around a central unit that projects out from them—a feature that helps make the arrangement of rooms more homelike and less institutional—was inspired by Baroque churches. Another historicist reference is the neo-**Palladian** window that fronts the common room above the entry. Above the common room is a fake TV antenna of gold anodized aluminum, which Venturi called "a symbol of the aged, who spend so much time looking at TV." Through such juxtapositions Venturi aims less to contrast the high art of the past with the inane distractions of pop-

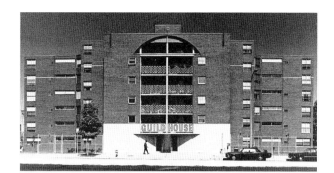

29-40. Robert Venturi and John Rauch. Guild House, Philadelphia. 1960–63

29-41. Philip Johnson and John Burgee. Pencil drawing made in 1977 for AT&T Headquarters, New York. 1978–83

After collaborating on the Seagram Building (see fig. 29-37) with Mies, who had long been his architectural idol, Johnson grew tired of the limited modernist vocabulary. During the 1960s he experimented with a number of alternatives, especially a weighty, monumental style that looked back to nineteenth-century Neoclassicism. At the end of the 1970s he became fascinated with the new possibilities opened by Venturi's postmodernism, which he found "absolutely delightful."

ular culture than to embrace the vernacular traditions of low culture and join them with high culture in an architecture of "complexity and contradiction."

Although both the accommodating message and the clever historicist references in the Guild House were lost on the general public, they provided many architects, including Philip Johnson (b. 1906), with a path out of modernism. Johnson's major contribution to postmodernism is the AT&T Headquarters in New York City (fig. 29-41), an

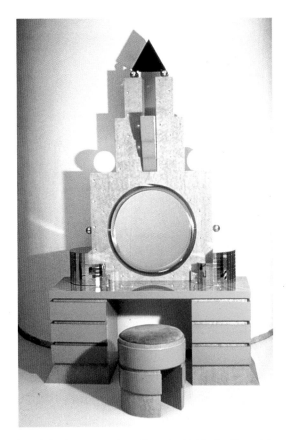

29-42. Michael Graves. Plaza Dressing Table for Memphis Furniture Company, Milan. 1981

Courtesy Michael Graves

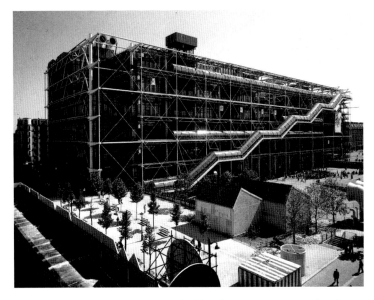

29-43. Renzo Piano and Richard Rogers. Centre National d'Art et de Culture Georges Pompidou, Paris. 1971–77

elegant, granite-clad building whose thirty-six oversized floors reach the height of an ordinary sixty-story building. Like Venturi's Guild House, the AT&T Headquarters makes gestures of accommodation to its surroundings. Its smooth, uncluttered surfaces match those of its International Style neighbors, while the classically symmetrical window groupings between vertical piers echo those in more conservative Manhattan skyscrapers of the early to middle 1900s. What critics focused on, however, was the

building's resemblance to a type of eighteenth-century furniture, the Chippendale highboy, a chest of drawers with a long-legged base. The piers at the base of the building resemble a giant highboy's spindly legs, the body of the building its cabinet drawers, and the top its scrolled "bonnet" ornament. Johnson seems to have intended a pun on the terms *highboy* and *high-rise.* In addition, the round notch at the top of the building and the arched entryway at the base recall the coin slot and coin return on old pay telephones. Many critics were not amused by Johnson's effort to add a touch of humor to high architecture. His purpose, however, was less to poke fun at his client or his profession than to create an architecture that would amuse the public and at the same time, like a fine piece of furniture, meet its deeper aesthetic needs with a formal, decorative elegance.

While Johnson and others were making architecture look like furniture, many postmodernist designers, such as the architect Michael Graves (b. 1934), were making furniture look more like architecture. In 1981 he designed the Plaza Dressing Table (fig. 29-42), whose name itself is architectural, meant to evoke the famous Plaza Hotel in New York. Like so much postmodernist architecture and design, this dressing table, inspired by an architectural mode popular in the 1920s known as Art Deco, recycles older styles into a new decorative ensemble. The blond maple-root wood, mirror-glass **tesserae**, globe lamps, geometrical drawers and stool, as well as the symmetrical massing of elements, all derive from Art Deco style.

One of the earliest manifestations of the decorative, playful use of historical forms that became identified with postmodern architecture was in the Centre National d'Art et de Culture Georges Pompidou (fig. 29-43) in Paris, designed by Renzo Piano (b. 1937) of Italy and Richard Rogers (b. 1933) of England. The building, which utilizes a modernist vocabulary, appears to have been whimsically turned inside out and then cheerfully painted. The coloring is not random, however. Red designates elevators, blue designates the air-conditioning ducts, green the water pipes, and yellow the electrical units. The external placement of these service structures increases the flexibility of the interior space. The arrangement also makes a historical reference to the origins of functional architecture in Paris, evoking both the glass-and-iron sheds that once stood in the historical market area adjacent to it and the most famous of the exposed-metal structures that gave birth to modernist architecture, the Eiffel Tower (see fig. 28-67).

Unlike Piano and Rogers, whose high-tech architecture lightheartedly revisits the technological basis of modernism, the Italian Aldo Rossi (b. 1931) has attempted to salvage modernism's rationalist and reductive tendencies. His approach to architecture, known as neorationalism, is based on a return to certain premodernist building archetypes (**typologies**)—such as the church, the house, and the factory—stripped of all elaboration and ornamentation and reduced to their geometric essentials, much as in the designs of Neoclassicists like Claude-Nicolas Ledoux and Étienne-Louis Boullée (see figs. 26-31, 26-32). His goal was to achieve both historical

continuity and universal timelessness. To enrich the emotional impact of these rationally conceived typologies, Rossi believed that architects should use them in mysterious and evocative ways.

The Town Hall Rossi built in Borgoricco, Italy (fig. 29-44), near Venice, illustrates these concepts. Because Borgoricco is in Italy's industrial belt, he based the central forms of the building on an industrial, rather than a civic, typology. The large windows, metal roof, and smokestack are based on nineteenth- and early-twentieth-century factory designs (see fig. 28-73), whereas the temple fronts on the flanking wings, which evoke the building's civic function, are done in a style typical of the housing in the surrounding countryside. The result is a provocative and unexpected marriage of local forms and other European architectural types. The blending succeeds because of the way Rossi plays the warm brick against the cool concrete in both the flanking and central elements and because of the way he has reduced the whole to strict geometric forms. This geometric reduction and the building's rigorous symmetry give it a stable, timeless air.

The early work of Frank Gehry (b. 1929), in contrast, took a radically destabilizing approach to postmodernist architecture. Consciously keeping his options open, Gehry avoided developing a comprehensive theory of architecture, seeking neither, like Rossi, to impose order on the environment nor, like Venturi, to join the vernacular to high culture. His approach was characterized, instead, by a willingness to accept the chaotic terms of urban life. His most famous early project is the renovation of his home in Santa Monica, California (fig. 29-45). The message he read in what he called the "body language of the neighbors' houses," with their chain-link fencing and concrete blocks, was "Stay out; leave me alone." Rather than resisting this message in his own house, he incorporated it. Several symbolic barriers separate him from his neighbors. A cinder-block wall encloses his front yard, an unlovely and unfriendly chain-link fence encloses his upstairs porch, and a corrugated-metal wall acts as part of the new facade below the porch. The unfinished look of the front door and steps creates the impression that the house, like many in the neighborhood, was being renovated by amateurs. Other similarly haphazard-looking effects were also carefully planned. One of the most peculiar of these effects resulted from Gehry's decision to make it appear that "a different mind had designed each window." Across the front are a wooden-framed window, in keeping with the original design of the house; a cheap, metal-framed picture window; and a customized, free-form opening of glass and timber. Though the chain-link fencing echoed his neighbors' desire for privacy, Gehry wanted this last window "to demonstrate to them that one could have windows that offer views into the private realm of the house without compromising the privacy of the house." Gehry's house, then, is a series of conflicting messages and materials, a hodgepodge of elements that not only accepts the architectural and social chaos of the modern city and its suburbs but revels in it.

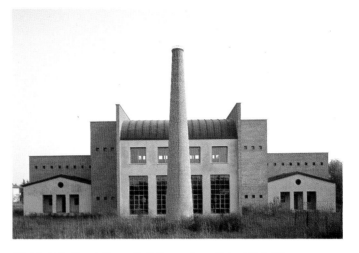

29-44. Aldo Rossi. Town Hall, Borgoricco, Italy. 1986–90
Courtesy Aldo Rossi

29-45. Frank O. Gehry. The architect's house, Santa Monica, California. 1978–79
Courtesy Frank O. Gehry and Associates, Inc.

Photography

Post–World War II photography before about 1970 can be divided into three categories: abstract, fantastic, and photojournalistic. All three shared both a belief in photography's access to a higher truth (whether aesthetic, personal, or social) and a commitment to a formally handsome finished product. By about 1970, however, a major change in photography, as great as that in architecture, became evident. This change was characterized by a shift—best seen in the work of photojournalists—from what might be called high art photography to deliberately bad or low art photography.

One of the leading photojournalists of the postwar period was Henri Cartier-Bresson (b. 1908) of France, who roamed the world as a free lance from the late 1940s to 1966, providing photographs for Western newspapers and magazines, including *Life.* Cartier-Bresson's goal

was to capture what he called "the decisive moment," one that revealed the essence of his subject in a formally coherent, rigorously organized image. He specialized in subjects of general human and historical interest, such as *The Berlin Wall* (fig. 29-46). The wall, a famous symbol of Communist oppression and the Cold War rivalry between the Soviet Union and the nations of the West, was built in 1961 by the Communist government of East Germany to prevent East Berliners from fleeing to the greater freedoms and economic opportunities of the West. Cartier-Bresson's photograph is both symbolically expressive and formally coherent. In it three men, well dressed and apparently prosperous, peer thoughtfully over the wall from the western side at the abandoned buildings on the eastern side. A gray sky lights this scene of hard, cold surfaces, evocative of the harsh political realities that created it. Two street signs on the far right, one of them marking a street interrupted by the wall, balance the figures on the left, closing the composition and directing the viewer's eye back along the row of houses.

The transition away from Cartier-Bresson's kind of aesthetic standards first appears in the work of the Swiss-born American photographer Robert Frank (b. 1924). Frustrated by the pressure and banality of the various news and fashion assignments on which he had been working, Frank packed his family into a used car in 1955 and undertook a yearlong photographic tour of the United States. From more than 28,000 images, he selected 83 for a book published first in France as *Les Américains* in 1958 and a year later in an English-language edition as *The Americans*, with an

29-46. Henri Cartier-Bresson. *The Berlin Wall*. 1963

> After World War II, Germany and its capital, Berlin, were each divided into separate zones controlled by the four wartime allies. Those parts of Germany controlled by Britain, France, and the United States became West Germany while those under Soviet control became the East German Communist state. Most of divided Berlin, though located in East Germany, became part of West Germany, a kind of remote outpost.

introduction by the beat writer Jack Kerouac (1922–1969).

The book was poorly received. The photographic community was disturbed by Frank's often haphazard style, by the way some elements were purposefully out of focus, sloppily cropped, and disorganized. Frank, however, was capable of producing classically balanced and

29-47. Robert Frank. *Trolley, New Orleans*. 1955–56. Gelatin-silver print, 9 x 13" (23 x 33 cm). The Art Institute of Chicago

29-48. Diane Arbus. *Child with Toy Hand Grenade, New York.* 1962. Gelatin-silver print, 7¼ x 8¼" (18 x 21 cm). The Museum of Modern Art, New York
Purchase

sharply focused images, but only when it suited his sense of the truth. The perfect symmetry of *Trolley, New Orleans* (fig. 29-47), for example, ironically underscores the racial prejudice of segregation that it documents. White passengers sit in the front of the trolley, African Americans in the back. At the same time, the rectangular frames of the trolley windows isolate the individuals looking through them, evoking a sense of urban alienation. Both children and adults stare at the viewer without warmth or recognition.

The harsh view of American life in works such as *Trolley, New Orleans* also upset many people outside the photography profession. What comes through in *The Americans* is a critical, disillusioned portrait of a culture with profound problems that contradicted the contented, self-satisfied view many in the United States had of their country in the 1950s. Frank's questioning perspective pales in comparison to the stark portrait of American people presented during the next decade by Diane Arbus (1923–1971). In her complete preoccupation with subject matter, Arbus, even more than Frank, rejected the concept of the elegant photograph, discarding the niceties of conventional art photography (fig. 29-48). She developed this approach partly in reaction to her experience as a fashion photographer during the 1950s, when she and her husband, Allan Arbus, had been *Seventeen* magazine's favorite cover photographers, but mostly because she did not want formal concerns to distract viewers from her compelling, often disturbing subjects.

Among the postmodernist heirs to the tradition of Frank and Arbus, perhaps the most radical was Duane Michals (b. 1932). An art director at *Dance Magazine* and

29-49. Duane Michals. *This Photograph Is My Proof.* Gelatin-silver print with text
Courtesy the artist

Time, Michals became increasingly dissatisfied with photography's inability to deal with the inner life. Inspired by the Surrealist paintings of René Magritte (see fig. 28-96), whom he came to know quite well, Michals began at the end of the 1960s to fabricate photographic sequences, often accompanied by written narratives. Although those series inspired by his Zen Buddhist convictions are optimistic, most treat themes of human limitation and disappointment. In some cases Michals tells the story in a single frame, as in *This Photograph Is My Proof* (fig. 29-49). Meant to resemble a snapshot in a personal photo album, the work purports to record a young man's attempt to cope with unrequited love. Convinced by the conventional notion that photographs do not lie, the man in the photo tries to persuade himself, and the viewer, that the woman hugging him once really did love him. This picture—a record of a single moment in a bleak little room—is his best and only proof. Michals's deliberate use of amateurish-looking photographs with scratchy writing on them underscores his banal stories and completes the shift from high art photography to the era of so-called bad photography.

"Bad Painting" and Super Realism

Michals's rough counterpart in painting was Philip Guston (1913–1980), who had intended to be a cartoonist. Guston's paintings and drawings of the 1930s focused on themes of social injustice, particularly those involving the Ku Klux Klan. After World War II he gave up the figure and evolved a refined, somewhat hesitant gestural style that earned him recognition as a leading member of the New York School. His increasing dissatisfaction with what he came to see as the narrow limitations of Abstract Expressionism, however, reached crisis proportions in the late 1960s, and he returned to figurative work. He later said, "I got sick and tired of all that purity. I wanted to tell stories." The stories he tells in his late paintings deal with his own shortcomings.

29-50. Philip Guston. *Ladder*. 1978. Oil on canvas, 5'10" x 9' (1.78 x 2.74 m). Collection the Edward R. Broida Trust

Often, as in *Ladder* (fig. 29-50), he represents himself simply by his large, clumsy feet. Here he attempts to climb a ladder to reach a goal on the horizon, a setting sun that is actually the forehead and hair of his wife, Musa. The contrast between her exalted status and his awkward attempt to reach her is more than a confession; it also seems to be a gentle exhortation to the viewer to strive for some higher goal, even if it is unattainable.

Guston's paint handling—"confessionally" crude, coarse, ungainly, and so unlike his elegantly executed work of the 1930s—had far-reaching influence. In 1978, works by artists who could be considered his heirs were shown in two New York exhibitions, "Bad Painting" at the New Museum and "New Image Painting" at the Whitney Museum of American Art. Susan Rothenberg (b. 1945), among those in the Whitney show, developed, like Guston, a self-referential imagery. One day in 1973, she doodled a horse's profile on a small piece of unstretched canvas and something clicked. The horse became her alter ego—a way, perhaps, of dealing with the self without actually painting it. This is suggested in some 1974 Polaroids she took of herself on all fours as studies for possible self-portraits.

Rothenberg's horses may at first seem somewhat ungainly. For example, because of its off-center placement in the picture frame, the horse in *Axes* (fig. 29-51) appears to be stumbling. The two straight lines, one dividing the picture frame and the other dividing the horse, are the axes of the painting's title. If these axes (and the parts of the horse they align) were reoriented to be parallel on the vertical axis, the animal would be upright, in midstride. The painting's "awkward" aspects are countered by the rich, appealing buildup of painting strokes and the low-keyed harmony of its creams and blacks—derived, like its simple forms, from the Minimalist aesthetic of the 1960s.

Another, very different kind of painting, which also had ties to Minimalism, developed around 1970 and came to public attention in 1972 in an exhibition called "Sharp Focus Realism" at the Sidney Janis Gallery in New York City. Instead of being personal, deliberately rough, and painterly, works of this kind, known by the label *Super Realist*, are impersonal, technically impressive, and

so carefully descriptive that they are often mistaken for color photographs.

One of the leading figures in the Super Realist movement was American painter Richard Estes (b. 1936). Inspired by the urban photographs of Eugène Atget and the paintings of Philip Pearlstein (see fig. 29-17), Estes had developed his mature style by the late 1960s. He was particularly intrigued by Atget's images of reflections in shop windows, like *Magasin, Avenue des Gobelins* (see fig. 28-5). During the 1970s and early 1980s he produced a series of paintings on the theme, including *Prescriptions Filled (Municipal Building)* (fig. 29-52). Seeking to objectify his scenes, Estes always eliminated people when he transcribed his source photographs to canvas. Like Pearlstein, Estes was interested in the aesthetic pleasures of refined compositional arrangements. The window reflection in *Prescriptions Filled,* for example, allows Estes to create a nearly perfect symmetry. The picture's formal tension comes from the subtle differences between the two halves, especially at the very center of the painting, the point between the lamppost and the edge of the glass window.

Estes, like Monet, was also drawn to reflections because they are in some ways visually more stimulating than the solid reality they mirror. The reflection in *Prescriptions Filled* is more engaging than the scene reflected, just as the painting as a whole is more rewarding to look at than the original live scene would have been. Estes thus used the language of realism against realism. He was not interested in celebrating or condemning something in the world. Instead, his cool, static, and closed paintings are the representational counterpart to Minimalism.

Much less typical of Super Realist painting in the 1970s is the work of Audrey Flack (b. 1931). In the late 1960s Flack projected a slide image directly onto a canvas in order to copy it and became fascinated with the brilliant colors she observed. Using an airbrush (a mechanical device often used in photo retouching that produces a fine spray of paint), she began to create paintings with colors of an even greater lushness that appealed to her for their emotional effect. During the 1970s she employed these methods to create a series of still lifes inspired by seventeenth-century **vanitas** paintings, a genre dominated by symbols of the transitory nature of life and its pleasures (Chapter 19). Many of these paintings, including *Marilyn (Vanitas)* (fig. 29-53), feature imagery that relates specifically to women. The many *vanitas* reminders of time—watch, calendar, hourglass, and candle—are contrasted with conventional and popular objects of another kind of "vanity"—mirror, jewelry, cosmetics—in what can be seen as a powerful comment on the human quest for love and beauty. The text in the book at the back of the painting, decorated by a traditional symbol of love, the rose, poignantly recounts how being made up and told she was pretty brought Marilyn Monroe her first compliments and sense of being loved. Her lips rouged, Marilyn's face beams triumphantly from the book. Among the beautiful fruits with which Marilyn is identified is an opened peach, a traditional

29-51. Susan Rothen-
berg. *Axes*. 1976.
Synthetic polymer
paint and gesso
on canvas, 5'4⁵/₈"
x 8'8⁷/₈"
(1.64 x 2.66 m).
The Museum
of Modern Art,
New York

Purchased with the
aid of funds from the
National Endowment
for the Arts

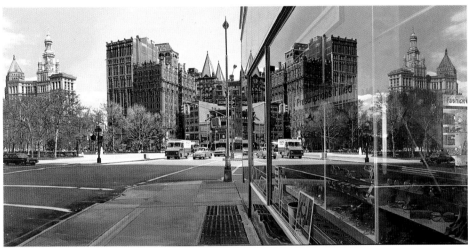

29-52. Richard Estes. *Prescriptions Filled (Municipal Building)*. 1983. Oil on canvas, 3 x 6' (0.91 x 1.83 m). Private collection

symbol of female sexuality. The peach pit, however, is a reminder that at her core was a hard, tough center.

Near the middle of the painting is an old photograph, probably of Flack and her brother as children. This detail is not simply another reminder of the passage of time but a signal of Flack's identification with the film star's struggle against it. The drop of bright red paint at the tip of the artists's paintbrush hovering magically above the open book is apparently meant to suggest that such paintings are invested with the artist's own life blood.

Another of the Super Realists who wished to communicate inspirational messages was the movement's major sculptor, Duane Hanson (b. 1925). His earliest works, which dealt with large social issues such as war, poverty, and racism, were highly dramatic, but about 1970 he turned to more mundane subjects. As he said of this change, "You can't always scream and holler, you have to once in a while whisper, and sometimes that whisper is more powerful than all the screaming and hollering." Since about 1970, Hanson has held an unflattering mirror up to American society, both its work and its leisure pursuits. One of his favorite themes is the American obsession with shopping. *The Shoppers*, for example

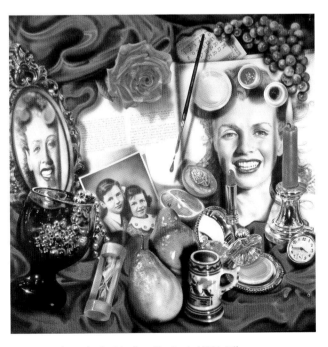

29-53. Audrey Flack. *Marilyn (Vanitas)*. 1977. Oil over acrylic on canvas, 8 x 8' (2.4 x 2.4 m). Collection of the University of Arizona Museum of Art, Tucson

Purchase Edward J. Gallagher, Jr., Memorial Fund

29-54. Duane Hanson. *The Shoppers*. 1976. Cast vinyl, poly-chromed in oil with accessories, lifesize. Collection the Nerman Family

29-55. Hans Haacke. *Shapolsky et al. Manhattan Real Estate Holdings, a Real-Time Social System, as of May 1, 1971.* Photograph by the artist

(fig. 29-54), shows two garishly dressed and overweight consumers carrying bags with their recent purchases. The material goods that are supposed to make them happy clearly do not. The communicative power of this work depends greatly on the fact that the figures are not only lifesize but lifelike. Every detail is convincing. For example, Hanson uses real hair and clothing (one arm is detachable to allow for the garments' removal and laundering). Gallerygoers often mistake them for real people, apologizing when they brush against them.

Post-Conceptual Art

Hanson's critique of American culture carried a strain of the modernist reform impulse into the postmodernist era. Most didactic art in the period after 1970 was less ambitious but more political. These qualities are evident in the work of German-born Hans Haacke (b. 1936), one of a number of artists working in the early 1970s who employed the Conceptual vocabulary of the preceding decade for decidedly anti-Minimalist purposes. Because their work otherwise shares little with the earlier Conceptualists, they are referred to as Post-Conceptualists.

Haacke came to the United States to teach in 1960. By the end of the decade he was producing a kind of Minimalist art that featured simple natural processes. In one piece, for example, he planted grass in a gallery. The turning point in his career came in 1968, after the assassination of Martin Luther King, Jr. "Nothing," he wrote in a letter, "but really absolutely nothing is changed by whatever type of painting or sculpture or happening you produce on the level where it counts, the political level"

(cited in Burnham, page 130). Despite these misgivings, by 1970 Haacke was making politically conscious art, although with modest aims and expectations. Rather than change the world, he hoped merely to educate a sizable number of people about specific wrongs, many of them involving the art world itself.

One of his first socially conscious pieces was *Shapolsky et al. Manhattan Real Estate Holdings, a Real-Time Social System, as of May 1, 1971* (fig. 29-55). The work documented the buildings, some of them slum apartments, owned by a trustee of the Guggenheim Museum, where an exhibition of Haacke's work was scheduled to open. When the museum's director learned of the nature of the work, he claimed that it wasn't art and canceled the exhibition.

Another Post-Conceptualist who came out of Minimalism, William Wegman (b. 1943), responded with unexpected humor to the disillusionment many felt with American culture. In 1972, about the time he began producing the photographs of his dog Man Ray that made him famous, he did a series of short videos satirizing commercial advertisements and mocking the pretensions and shortcomings of science, including the failure of the psychiatric profession to solve psychological problems. In *Rage and Depression* (fig. 29-56) Wegman assumed the role of a psychotic who relates the somewhat grotesque tale of how attempts to cure his anger through shock treatments only froze a permanent smile on his face. He remains depressed and dangerous, but everybody thinks he is happy. Like much of Wegman's work from this period and after, *Rage and Depression* suggests that laughter is the only sane response to incurable human ills.

Earthworks

As Post-Conceptualism was emerging, a number of sculptors, responding to the New York art scene in general and to the Minimalist retreat from the world in particular sought to take art back to nature and out of the marketplace. Because they often used raw materials

29-56. William Wegman. *Rage and Depression*.
1972–73. Video image
Courtesy the artist

29-57. Michael Heizer. *Double Negative*. 1969–70. 240,000-ton
displacement, 1,500 x 50 x 30' (457.2 x 15.2 x 9.1 m).
Museum of Contemporary Art, Los Angeles
Gift of Virginia Dwan. Photograph courtesy the artist

found at the location, their pieces are known as **earthworks**. They pioneered a new category of art making, called **site-specific sculpture**, works designed for a particular location, usually outdoors.

One of the leaders of the earthworks movement was Michael Heizer (b. 1944), the son of a specialist in Native American archeology. Disgusted by the growing emphasis on art as an investment, he spent the summer of 1968 in the Nevada desert, where, among other things, he dynamited huge boulders out of mountainsides and moved them to holes he had dug for them miles away. What Heizer liked about these works was that they could not easily be bought and sold, and they required a considerable commitment of time from viewers who wanted to see them. Recalling the ancient Native American art and architecture to which he had been exposed since childhood, they also seemed to him vaguely religious, suggesting mysterious rites and drawing attention to the sublime qualities of nature.

In 1969–1970 he returned to the Nevada desert and produced his most famous work, *Double Negative* (fig. 29-57). Using a simple Minimalist formal vocabulary, he made two gigantic cuts—the larger of which is longer than the Empire State Building is tall—in a canyon wall. To fully understand the work, the viewer needs to walk into the deep channels and experience their awe-inspiring scale. The work's title refers not only to the two cuts in the earth but also to the double zero on the roulette wheels of Las Vegas, 80 miles away. Heizer, who liked to gamble, meant to establish a sharp contrast between the raucous artificiality of Las Vegas and the unspoiled simplicity of nature. Heizer's implied criticism of the vulgarity of American culture and his search for a pure, transcendent artistic alternative, so reminiscent of Barnett Newman's work, are more modernist than postmodernist.

Another earthworks artist to carry similar modernist concerns into the postmodernist era is Nancy Holt (b. 1938). Since visiting the Nevada desert in 1968 with Heizer and her late husband, Robert Smithson (1938–1973), Holt has specialized in making intimate spaces for viewing the tranquil, sublime beauties of the natural world, especially the sky. In 1977–1978 she built *Stone*

29-58. Nancy Holt. *Stone Enclosure: Rock Rings*. 1977–78.
Brown Mountain stone, height 10' (3 m), outer ring diameter 40' (12.2 m), inner ring 20' (6.1 m). Western Washington University, Bellingham
Funding from the Virginia Wright Fund, the National Endowment for the Arts, Washington State Arts Commission, Western Washington University Art Fund, and the artist's contributions

Enclosure: Rock Rings (fig. 29-58) on the campus of Western Washington University, in Bellingham. The work consists of two concentric 10-foot-high stone rings, the outer one about 40 feet in diameter. Four aligned doorways suggestive of processional entryways give access to the interior of the rings. Strong, secure, and snug, the interior provides a number of impressive vistas—into the woods, across the campus, or into the heavens. On a clear night the contrast between the small, confined, earthbound space and the infinitely expanding sky is particularly stirring. Sublime, too, is the play between the present and the distant histories of early humans that the work evokes. *Stone Enclosure: Rock Rings* is meant to remind the viewer of a variety of prehistoric and historic forms, from the Neolithic Stonehenge to the Roman Colosseum. As Holt says, "I'm interested in conjuring up a sense of time that is longer than the built-in obsolescence we have all around us."

Holt's husband, Robert Smithson, also wanted to impress the spectator with the vastness of time, but his

29-59. Robert Smithson. *Spiral Jetty*. 1969–70. Black rock, salt crystal, and earth spiral, length 1,500' (457.2 m). Great Salt Lake, Utah

29-60. Christo and Jeanne-Claude. *Running Fence*. 1972–76. Nylon fence, height 18' (5.5 m), length 24 1/2 miles (40 km). Sonoma and Marin Counties in northern California

expression of it was less reassuring than Holt's and not at all modernist. In his mature work he sought to illustrate what he called the "ongoing dialectic" in nature between constructive forces—those that build and shape form—and destructive forces—those that destroy it. *Spiral Jetty* (fig. 29-59), a 1,500-foot spiraling stone and earth platform extending into the Great Salt Lake in Utah, reflects these ideas. Smithson chose the lake because it brought to mind both the origins of life in the salty waters of the primordial ocean and the end of life. One of the few organisms that lives in the otherwise dead lake is a bacterium that gives it a red tinge, vaguely suggestive of blood. Smithson also liked the way the abandoned oil rigs that dot the lake's shores suggested both prehistoric dinosaurs and some vanished civilization. He used the spiral because it is a fundamental shape that appears throughout the natural world, for example, in galaxies, seashells, and most important, salt crystals. Finally, Smithson chose the spiral because, unlike modernist squares, circles, and straight lines, it is a "dialectical" shape, one that opens and closes, curls and uncurls endlessly. More than any other shape, it suggested to him the perpetual "coming and going of things."

The work of Christo (b. 1935) and Jeanne-Claude (b. 1935), who think of themselves as environmental artists, reflects, in the view of many, a postmodern sense of social mission. Born and trained in Bulgaria, Christo Javacheff (who uses only his first name) emigrated to Paris in 1958, where he met Jeanne-Claude de Guillebon, the *nouveaux réalistes*, and some of the Fluxus artists. His interest in wrapping things, which apparently began as a form of social criticism, soon became an obsession. Even before the pair moved to New York City in 1964, Christo was packaging progressively larger items. In 1968 Christo and Jeanne-Claude wrapped the Kunsthalle in Bern and in 1969, 1 million square feet of the Australian coastline.

Their best-known work, *Running Fence* (fig. 29-60), consisted of a 24 1/2-mile-long, 18-foot-high nylon fence that crossed two counties in northern California and extended into the Pacific Ocean. Although ranchers in South Africa and Mexico had offered them land for *Running Fence*, the artists chose to locate it in Sonoma and Marin Counties because of the beautiful rolling hills there and because they wanted to immerse the work in the society and politics of late-twentieth-century United States. Before it could be created they spent forty-two months overcoming the resistance of landowners, county commissioners, and social and environmental organizations. The artists considered all these actions to be part of a work. Their purpose for *Running Fence* was not just to produce a work of art that would celebrate the beautiful contours of the land and, as they put it, "describe the wind." The Christos also wanted to open to greater scrutiny the workings of the political system. Most important, they wanted to bring people together in the making of the project, to forge a community drawn from groups as diverse as college students, ranchers, lawyers, and artists. They wanted their fence, unlike the Berlin Wall (which was about the same length and height), to break down barriers.

Feminist Art

An even more ambitious attempt to break down old barriers was initiated by feminist artists. During the 1970s, almost entirely as a result of the feminist movement, women finally began to achieve increased recognition in the American art world. The watershed event was the march in August 1970 commemorating the fiftieth anniversary of the Nineteenth Amendment to the Constitution, by which women gained the vote. The anniversary gave women an opportunity to assess their progress in various fields since 1920, and they were disappointed by what they found. A survey of women in art, for example, revealed that although they constituted half of the nation's practicing artists, only 18 percent of commercial New York galleries carried the work of any women at all. Of the 151 artists in the 1969 Whitney Annual, one of the country's most prominent exhibitions of the work of living artists, only 8 were women. The next year, the Ad Hoc Group, a number of women critics and artists disappointed by the lukewarm response of the Whitney's director to their concerns, organized a protest at the opening of the 1970 Annual. To focus more attention on women in the arts, feminist artists began organizing women's cooperative galleries. While feminist art historians wrote about women artists and the issues raised by their work in textbooks and journals, feminist curators and critics promot-

ed the work of both emerging women artists and long-neglected ones, like Alice Neel (1900–1984), who had her first major one-artist show at age seventy-four.

Neel received a solid academic training at the Philadelphia School of Design for Women in the 1920s. Reflecting a series of life crises, including the death in infancy of one of her children and the abduction of another by the child's father, Neel's early work featured distorted, expressionistic images of children. Her style softened after she moved to New York in 1932 and began to specialize in frank and revealing images of the people she knew. She became, as she said, "a collector of souls."

The revival of figurative art in the early 1960s first brought her to the attention of the New York art world, although her penetrating portraits were considered far too subjective for the prevailing aesthetic. Her subjects now included well-known critics, curators, and artists, such as Andy Warhol (fig. 29-61). The portrait of Warhol shows him unclothed from the waist up, revealing the scars from the 1968 attempt on his life. Exposed by Neel, he closes his eyes, as if denying his frail body, his pallid complexion, and his unbeautiful features. The indefinite handling of the upper body and the placement of the feet off the ground make the figure appear almost weightless. With his upturned head, Warhol seems to want to free himself of this body and rise above it. Neel has cut through Warhol's cool and distant public persona to reveal the fragile, wounded human being beneath it.

While events on the East Coast focused on gaining more attention for women artists, on the West Coast two feminist artists and teachers, Judy Chicago (b. 1939) and Miriam Schapiro (b. 1923), established in 1971 at the new California Institute of the Arts (CalArts) the Feminist Art Program, dedicated to training women artists.

Born Judy Cohen in the city whose name she took in 1970, Chicago was originally a Minimalist sculptor, but at

1970

1940 2000

29-61. Alice Neel. *Andy Warhol*. 1970. Oil on canvas, 5' x 3'4" (1.5 x 1 m). Whitney Museum of American Art, New York
Gift of Timothy Collins

the end of the 1960s she began to use female sexual imagery to expose the sexism of the male-dominated art world. Her most famous piece is *The Dinner Party* (fig. 29-62). The finished work, the combined labor of hundreds

29-62. Judy Chicago. *The Dinner Party*. 1974–79. White tile floor inscribed in gold with 999 women's names; triangular table with painted porcelain, sculpted porcelain plates, and needlework, each side 48' (14.6 m)
Courtesy the artist

29-63. Miriam Schapiro. *Heartfelt.* 1979. Acrylic and fabric on canvas, 5'10" x 3'4" (1.8 x 1 m). Collection the Norton Neuman Family
Courtesy Steinbaum-Krauss Gallery, New York

29-64. Ana Mendieta. Untitled work from the Tree of Life series. 1977. Color photograph, 20 x 13¼" (50.8 x 33.7 cm)
Courtesy Galerie Lelong, New York. © The Estate of Ana Mendieta

of women and several men, records the names of 999 notable women and pays special homage to 39 historic and legendary women—from Egyptian Queen Hatshepsut to Georgia O'Keeffe. Each side of the triangular table has thirteen settings, because thirteen is the number of witches in a coven and the number of men at the Last Supper. The triangular shape is a symbol for woman and during the French Revolution was an emblem of equality. Each individual place setting features a runner, designed in a style historically appropriate to the woman it represents, and a large ceramic plate. The stitchery, needlepoint, and china painting are all traditional women's art forms that Chicago wished to raise to the status granted to painting and sculpture. Most of the plates feature shapes based on female genitalia because, Chicago says, "that is all [the women at the table] had in common. . . . They were from different periods, classes, ethnicities, geographies, experiences, but what kept them within the same confined historical space" was the fact that they were women (cited in Broude and Garrard, page 71).

Of the various art movements of the 1970s, feminist art most displayed the old modernist optimism about art's capacity to contribute meaningfully to a better future. The function of Chicago's tribute to women and women's traditional art forms, for example, was not sim-

ply to improve women's place in history and their sense of themselves but, as she said, "to change the world."

Feminists were outspoken critics, however, of the increasingly restrictive modernist concept of mainstream art and its virtual exclusion of women (see "The Idea of the Mainstream," page 1110). The major champion of a specifically feminine aesthetic was Chicago's partner at CalArts, Miriam Schapiro. During the late 1950s and 1960s Schapiro had made explicitly female versions of the dominant modernist styles. At the end of the 1960s, for example, she was painting reductive, hard-edged abstractions of the female form: large **X** shapes with openings in their center.

Typical of Schapiro's mature work is *Heartfelt* (fig. 29-63), one of a type of construction she called femmage (from *female* and *collage*). Made with painted fabrics, these works celebrate traditional women's craftwork. *Heartfelt* is shaped like a house because that was where most women worked and because their domestic art forms were part of a larger concern with the care of others, which Schapiro associated with the idea of home. The patterns of *Heartfelt* suggest the curtains, shelf papers, wallpapers, quilts, rugs, and other decorative forms women make or use in their domestic spaces. The title evokes an essential feature, in Schapiro's and other

1970s feminists' view, of female sensibility. Both the formal and the emotional richness of *Heartfelt* were meant to counter the Minimalist aesthetic of the 1960s, which Schapiro and other feminists considered typically male.

Many feminists accepted and celebrated the notion that women have a deeper identification with nature than do men, a belief evident in a number of artworks from the 1970s, including those by Cuban-born Ana Mendieta (1948–1985). By 1972 Mendieta had rejected painting for performance and body art, which she documented through photography, film, and video. Inspired by the customs of Santería, an Afro-Caribbean religion emphasizing immersion in nature, she produced a series of ritualistic performances on film and about 200 earth and body works, called Silhouettes, which she recorded in color photographs. Some were done in Mexico, and others, like the Tree of Life series (fig. 29-64), were set in Iowa, where she had moved in 1961, after the Cuban Revolution. In Tree of Life Mendieta stands covered with mud, her arms upraised like a prehistoric goddess, appearing at one with nature, her "maternal source."

The feminist art movement of the 1970s was a widespread and multifaceted phenomenon fed by an assortment of common concerns with celebrating and improving the lives of women, especially artists. The category, like so many that historians employ to organize the diverse materials of history, is very flexible and at times simply a matter of emphasis. Audrey Flack, for example, belongs among the feminists if one focuses on the content of much of her work but with the Super Realists if one emphasizes her style.

POST-MODERNISM

Much of the art being made by the end of the 1970s was widely considered to be *postmodern.* Although there has been virtually no universal agreement on just what this term means, it involves rejection of the concept of the mainstream and a recognition of artistic **pluralism**, the acceptance of a variety of artistic intentions and styles. A number of critics have resisted using the label *postmodern,* insisting that pluralism applies to modernism as well and has been a characteristic of art since at least the Post-Impressionist era. Others, in response, argue that the art world's attitude toward pluralism has changed. Where critics and artists previously searched for what they considered a historically inevitable mainstream in the midst of pluralistic variety, many now accept pluralism for what it probably always was, a manifestation of our culturally heterogeneous age.

Those who resist the label *postmodern* also point to the continued use of the term *avant-garde* to describe the most recent developments in art. But whereas *avant-garde* formerly indicated a significant newness, it now lacks that connotation. Indeed, many recent avant-garde styles implicitly acknowledge the exhaustion of the old modernist faith in innovation—and in what it implied about the "progressive" course of history—by reviving older styles. For this reason, the names of a number of recent styles, in both art and architecture, begin with the prefix *neo,* denoting a new and different form of something that already exists.

29-65. David Salle. *What Is the Reason for Your Visit to Germany.* 1984. Oil, acrylic, and lead on wood and canvas, 8' x 15'11½" (2.44 x 4.86 m)
Courtesy Mary Boone Gallery, New York

Neo-Expressionism

A number of shows in leading New York art galleries in 1980 signaled the emergence of the first of the neos, Neo-Expressionism. The renewed interest in expressionism, long thought dead, was inspired partly by the emphasis on personal feeling in feminist art. Although six of the nineteen artists discussed in an early assessment of Neo-Expressionism in the magazine *Art in America* (December 1982–January 1983) were women, some of them, like Rothenberg, never fit comfortably under the label Neo-Expressionist. Other women were soon dropped from the category when critics decided, perhaps somewhat prematurely, that the style was a male phenomenon, reasserting masculine values and viewpoints.

David Salle (b. 1952) has been considered typical of Neo-Expressionism, even though only some aspects of his work are truly expressionistic. Salle studied at CalArts with the Conceptual photographer John Baldessari (b. 1931) and then worked at various jobs. Some of his images of women, including the bending figure in the left panel of *What Is the Reason for Your Visit to Germany* (fig. 29-65), derive from his experience doing layout for a pornographic magazine. Over each leg of this figure, Salle imposed a drawing of Lee Harvey Oswald (President Kennedy's presumed assassin) being shot. He splashed an acid green wash over one of these drawings and obscured the face of the other with an expressionistic **V** shape. The word *fromage* (French for "cheese"), lettered across the panel, may be a pun on Schapiro's term *femmage* and on *cheesecake,* a slang expression for erotic images of women. Inspired by Rauschenberg's example (see fig. 29-23), Salle presents a discontinuous world of coexistent fragments that defy synthesis. Some of his early advocates argued that Salle's chaotic paintings—badly drawn and painted in unpleasant, impure, dissonant colors—are meant to intensify, and therefore to indict, the empty anarchy of what art critic Robert Hughes calls the "image haze that envelops us," but most observers now seem to agree that Salle accepts and submits to it. According to one of his titles, what we see in his work is simply the unedited contents of "his brain" offered to us as art.

Salle's roommate at CalArts, Eric Fischl (b. 1948), evolved a more critical form of Neo-Expressionism in the

29-66. Eric Fischl. *A Visit To/A Visit From/The Island*. 1983. Oil on canvas, each panel 7 x 7' (2.13 x 2.13 m), overall 7' x 14' (2.13 x 4.26 m). Whitney Museum of American Art, New York

Purchased with funds from the Louis and Bessie Adler Foundation, Inc., Seymour M. Klein, President

29-67. Francesco Clemente. *Untitled*. 1983. Oil on canvas, 6'6" x 7'9" (1.98 x 2.36 m). Collection Thomas Ammann Fine Art, Zürich

late 1970s. Impressed by the emotional and personal content of recent feminist art, in 1976 he invented the Fishers, an archetypal Canadian seafaring family, around whom he built a body of related paintings. The Fishers were an apparent surrogate for the less idyllic Fischl family in which he had grown up in suburban Long Island, New York. Although many of his paintings about American suburban life had connections with his own, what Fischl set out to create about 1980 was a portrait of a class.

Many of his early paintings involve the middle-class pursuit of pleasure. Some, like *A Visit To/A Visit From/The Island* (fig. 29-66), feature an American family on vacation in the tropics. Signaling their desire to "return to nature" à la Gauguin, a mother and her children are naked on an island beach. Although the woman relaxes on a foam mattress, the scene is crowded, nervously painted, and, judging by the motorboat, noisy. The

daughter, who stands idly by, seems bored. The unsuccessful "escape" to the tropics is contrasted with the consequences of a more literal attempt at escape shown in the right panel. Here islanders on a stormy beach react to the sight of their dead comrades (one of whose legs seems almost to extend from the sunbathing woman in the left panel), apparently drowned in a desperate bid to flee the island. Exactly what is going on is uncertain, however. Fischl's intention is not to tell a story with a clear conclusion but to force viewers to confront for themselves his ambiguous and morally troubling images.

The Resurgence of European Art

In the early 1980s the work of a number of European artists, much of it stylistically consistent with the Neo-Expressionism then coming into vogue in the United States, gained widespread critical recognition. The Italian artist Francesco Clemente (b. 1952), for example, searching for an alternative to what he considered the overintellectualization of Italian art and criticism, developed a largely anti-intellectual and amoral form of Neo-Expressionism. Sensual experience and bodily functions became central elements of Clemente's art after he spent 1977 living in Madras, India. His basic premise is stated in an untitled painting (fig. 29-67) that is a kind of self-portrait. In each opening of the subject's head is another head, suggesting that we are what we see, hear, smell, and taste. The work is crudely painted, reflecting a deliberate lack of effort—particularly intellectual effort—and testifying to Clemente's pursuit of basic sensation. The problem with ordinary thought, Clemente felt, is that it takes us beyond direct experience to meaning. "Keep on the surface," he advises, "don't look for meaning." Thus, Clemente, like Salle, does not struggle to change, transcend, or even understand the world around him. He tries simply to experience and accept it.

American interest in contemporary European artists increased in 1981, when German art was shown in galleries all over New York City. One of the most fascinating of these German artists was Anselm Kiefer (b. 1945). Born in the final weeks of World War II—in what Germans who

29-68. Anselm Kiefer. *March Heath*. 1984. Oil, acrylic, and shellac on burlap, 3'10½" x 8'4" (1.18 x 2.54 m). Van Abbemuseum, Eindhoven, the Netherlands

wished to erase it from collective memory called Year Zero—Kiefer has long sought to confront his country's Nazi past. In 1969 he produced a book of photographs showing himself offering the Nazi salute in various European sites that had been occupied by Germans during the war. Interpreted by many as a right-wing celebration of Hitler's conquests, the book raised a storm of controversy.

In the early 1970s Kiefer turned to painting but continued his efforts to get other Germans to confront their country's troubled past, "in order," he said, "to understand the madness." The burned and barren landscape in *March Heath* (fig. 29-68) evokes the ravages of war that the Brandenburg area, near Berlin, has frequently experienced, most recently in World War II. The road that lures us into the landscape, a standard device in nineteenth-century landscape paintings, here invites us into the history of this region. Like those of his American counterpart Fischl, Kiefer's works compel viewers to come to grips with troubling historical and social realities.

Kiefer's unofficial mentor, Joseph Beuys (1921–1986), helped shape Kiefer's sense of art's social mission. Beuys was one of several older German artists whose reputations in the United States rose dramatically with the resurgent interest in European art. A fighter pilot during World War II, Beuys was shot down over the Soviet Union in 1943 and was saved by nomadic Tartars. Apparently in an effort to assuage the guilt and anxiety with which his war experiences left him, Beuys elaborated his rescue by the Tartars into a personal mythology of rebirth, which became central to his art. After joining Fluxus in 1962 he began producing performance art based on an exaggerated account of this experience in which he insisted not only that the Tartars had saved him—by wrapping him in fat and animal-hair felt—but that their leader had made him an honorary member of their community.

For his 1974 *Coyote: I Like America and America Likes Me* (fig. 29-69), Beuys landed in New York, was wrapped in felt, and was taken by ambulance to a Manhattan

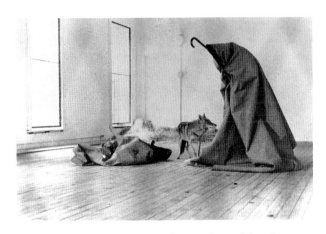

29-69. Joseph Beuys. *Coyote: I Like America and America Likes Me*. 1974. Weeklong action staged in the René Block Gallery, New York

Courtesy Ronald Feldman Fine Arts, New York

gallery, part of which was cordoned off with industrial chain-link fencing. Inside was a live coyote, a symbol of the American wilderness threatened with extinction by modern industrial society. For seven days Beuys and the coyote lived together. Beuys, wrapped in a felt tent from which a shepherd's crook protruded, silently followed the animal around, sometimes mimicking it. Beuys saw felt, in which the Tartars had supposedly wrapped him, as a regenerative natural material, one capable of healing the sick. The crook is the Tartar shaman's symbol. The artist was thus presenting himself as the shaman, come to help save the wildlife of the United States and in this way heal a sick nation. The artist's arrival in an ambulance suggested that he, too, was threatened and needed healing. In effect, the work showed two endangered species healing each other through their mutual communion. The work celebrates the power of empathy to save a world threatened, according to Beuys, by cutthroat economic and political competition.

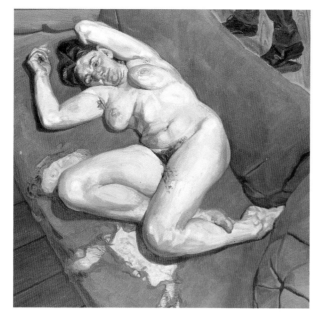

29-70. Lucian Freud. *Naked Portrait with Reflection*. 1980.
Oil on canvas, 35½ x 35½" (90.3 x 90.3 cm). Private
collection

Another long-neglected European whose reputation rose sharply in the 1980s was Lucian Freud (b. 1922). The grandson of Sigmund Freud, Lucian was born in Berlin and moved with his family to England in 1933. Inspired by the work of his friend Francis Bacon (see fig. 29-2), he gradually loosened his style, beginning around 1960. Although expressionistic elements appear in his late work, he remained a realist. Freud took his subjects from a group of acquaintances. In his later work he usually portrayed them nude, as in *Naked Portrait with Reflection* (fig. 29-70). Although the woman lies in a characteristically erotic pose, she seems more tired than relaxed and alluring, an impression reinforced by Freud's choice of colors. Her flesh is heavy and sad and echoes her weary expression. The painting conveys a sense of the irrevocable processes of age and the body's inevitable decay. Lushly painted, it seems to suggest from a distance that art can provide some consolation for the sadness of life. Up close, however, the coarsely caked paint on the woman's face is a frank reminder of human mortality.

Graffiti Art

Another formerly marginal arena that caught the attention of the New York art world about 1980 was street art, or **graffiti** art. The movement took shape following an exhibition called the "Times Square Show," held in an old massage parlor in 1980.

One of the artists to emerge from the "Times Square Show" was Keith Haring (1958–1990), who had been invited to participate on the basis of his graffiti-inspired paintings on black photographic backdrop paper. In 1981 Haring took his art into New York City subway stations. On the black panels used to block out obsolete advertising, he began to make cheerful chalk drawings, like *Art in Transit* (fig. 29-71), of a memorable cast of characters in a distinctive linear style. Haring said he was committed to an art "open to everybody" that would "break down this supposed

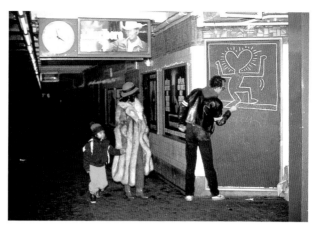

29-71. Keith Haring. *Art in Transit*. 1982
Courtesy Estate of Keith Haring

During the 1970s the East Village section of New York City was colonized by young artists and art students such as Haring, particularly those from the School of Visual Arts, in search of low-cost housing and gallery space. In addition to alternative galleries and performance-art spaces, a host of nightclubs catering to this clientele sprang up in the area. The art produced by these young artists, often inspired by street graffiti, was frequently used to decorate these nightclubs.

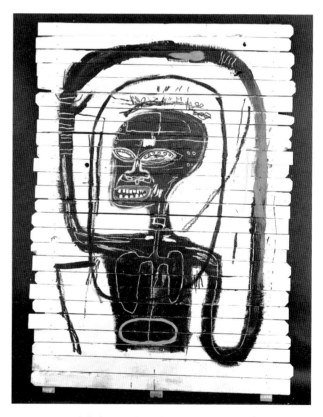

29-72. Jean-Michel Basquiat. *Flexible*. 1984. Acrylic
and oilstick on wood, 7'4" x 6'3" (2.59 x 1.9 m)
Courtesy Robert Miller Gallery, New York

barrier between low art and high art." His work features a personalized symbolism, however, which many found puzzling. When asked what a particular figure meant, he answered, "That's your part; I only do the drawings." The figure shown here is the harried commuter, whose head is sometimes a clock but in this example is a radiant heart, a sign of love and perhaps, as one critic observed, of "the uni-

29-73. Mark Tansey. *Triumph of the New York School*. 1984. Oil on canvas, 6'2" x 10' (1.88 x 3.05 m). Whitney Museum of American Art, New York

Promised gift of Robert M. Kaye

Tansey is the son of art historians. Inspired by the deconstructive critical method of Jacques Derrida, he set out around 1980, as he said, to "problematize and destabilize" some of the leading dogmas in the discourse of contemporary art. He made his monochromatic paintings resemble photographs because of that medium's reputation for unvarnished truthfulness.

fying force that courses through all beings and things."

Jean-Michel Basquiat (1960–1988) developed a less innocent brand of graffiti art. Basquiat, originally a street artist whose graffiti featured witty philosophical texts, was invited to paint a large wall for the "Times Square Show." His success encouraged him to begin painting professionally. Although he was untrained and wanted to make "paintings that look as if they were made by a child," he was a sophisticated artist. He carefully studied the Abstract Expressionists, Picasso's late paintings, and the works of Dubuffet (see fig. 29-3), among others. To give his work a less sophisticated look and to demonstrate his allegiance with naive artists of the Caribbean, he often painted on crudely constructed canvases and surfaces made from wooden slats, as in *Flexible* (fig. 29-72).

Like much of his work, *Flexible* features an African American male, perhaps the artist, with angry eyes and mouth. On his head he wears a combination crown and crown of thorns, a symbol Basquiat used to convey a sense of both superiority and suffering. The figure's flexible arms, which give the work its title, may suggest the social flexibility required of people, like the artist, who must live within both their own minority culture and the dominant culture of the larger society. As in paintings in the so-called **x-ray style** of the Australian Aborigines (see fig. 24-2), Basquiat shows the figure's internal organs, perhaps suggesting that beneath the skin we all share a common humanity.

Neo-Conceptualism

An analytic and often cynical style emerged in the mid-1980s that seemed to be a reaction both to the emotionalism of Neo-Expressionism and to the populism of graffiti art. Known as Neo-Conceptualism, it reflected the influence of the difficult and usually skeptical ideas on literature, philosophy, and society of a group of French intellectuals—among them Roland Barthes (1915–1980), Jacques Derrida (b. 1930), Jean Baudrillard (b. 1929), and Michel Foucault (1926–1984)—who had become popular among American intellectuals in the late 1970s.

One Neo-Conceptualist, the representational painter Mark Tansey (b. 1949), evolved a working technique by the mid-1980s that involved photocopying elements from his growing picture file and then collaging these pieces into various configurations that allowed him to explore a subject slowly and methodically. Characteristic of his work is *Triumph of the New York School* (fig. 29-73), a brownish monochrome painting that resembles the kind of photographic reproduction that used to appear in Sunday newspapers. The title refers to the received wisdom in art history that the New York School wrested control of art's mainstream from the Paris School after World War II. Tansey's painting, playing on the word *triumph*, depicts the event as a military victory formally recognized by the combatants on both sides—the French on the left in the uniforms of World War I, the Americans on the right

29-74. Louise Lawler. *Pollock and Tureen*. 1984. Cibachrome,
28 x 39" (71 x 99 cm)
Courtesy Metro Pictures, New York

29-75. Peter Halley. *Yellow Cell with Conduits*. 1985. Acrylic
and Day-Glo on canvas, 5'4" x 5'4" (1.63 x 1.63 m)
Courtesy the artist

in the uniforms of World War II—with the signing of a doc-
ument of surrender. All the soldiers are identifiable artists
and writers. Signing the surrender document for the
French, for example, is the Surrealist leader André Breton.
Behind him, dressed in fur, is Picasso. The American sol-
dier at the table is Clement Greenberg. Smoking a ciga-
rette behind him is Jackson Pollock. The work is rich with
ironies and subtle references. That Greenberg's "triumph"
should be recorded in a backward-looking illusionistic
style is but one. In addition to providing a series of tanta-
lizing intellectual treats for the sophisticated viewer, the
work's main purpose, following the ideas of the French
intellectuals, is to unsettle conventional notions about
history and truth. The juxtaposition of soldiers from World
War I surrendering to those from World War II is absurd,
as is the metaphorical comparison between art and war-
fare. And in another irony, the photography-like image of
an impossible event calls into question the documentary
reliability of that medium.

The work of Louise Lawler (b. 1947) also undertakes
a thought-provoking investigation into artistic issues.
About 1980 she began to document how specific presen-
tations of art objects—from public museums to private
homes to exhibition catalogs—reveal the way art is actu-
ally used and, thus, how it is conceived. Her photograph
Pollock and Tureen (fig. 29-74), for example, was taken in
a private home. It shows a detail of one of Pollock's drip
paintings hanging above a sideboard with an antique
soup tureen tastefully flanked by two vintage casserole
dishes. The classical format and the subtle harmonies
between the linear rhythms in the Pollock and those on
the tureen's surface and in its shape might suggest that
Lawler meant simply to make an aesthetically pleasing
photograph. Her interest, in fact, was to show how the
treatment of this famous painting as a decorative object
within a setting of other decorative objects alters the vital

meaning that it had for Pollock. The irony here, which
Lawler fully appreciates, is that her lovely photograph
contributes to this subversion of the painting's meaning.
Lawler does not mean to criticize the collectors so much
as simply to open to analysis—and its pleasure—the way
art objects take on meaning in context.

An equally nonjudgmental social commentary can
be found in the work of Peter Halley (b. 1953), which
reflects the influence of the French social critics Jean
Baudrillard and Michel Foucault. Baudrillard has argued
that movies, television, and advertising have made ours
the age of the "simulacrum," the substitution of images
that simulate reality for reality. These images, moreover,
often seem "hyperreal," or more real than the world they
purport to reflect. The television stereotype of the aver-
age American family, for example, has replaced the
social reality of family life, and advertising employs
supersaturated colors to make products seem hyperreal.

Halley realized that the fluorescent **Day-Glo** colors he
had been using in his work were themselves signs of this
new social phenomenon. Moreover, he also began to ques-
tion the Minimalist assertion that abstract forms are refer-
entially neutral, suggesting, for example, that the stripes in
a Stella painting from the mid-1960s could as easily be inter-
preted as a metaphor for the interstate highway system as
an exercise in pure form. By the beginning of the 1980s Hal-
ley was making abstract paintings with forms intended to
be read as meaningful signs of the contemporary cultural
phenomena described by Baudrillard and Foucault.

In *Yellow Cell with Conduits* (fig. 29-75), one of his so-
called Neo-Geo (or new geometry) paintings, he applied
hyperreal colors to the kind of simulated stucco used in
suburban housing. This false stucco surface is itself, there-
fore, a sign of the new domination of the simulacrum. The
large central square, or cell, represents both the home and
the brain (which is composed of cells). The rectangular

forms that connect with it thus refer on one level to plumbing and electrical circuitry, and on another to information reaching the brain. In this second sense the lower piping represents information reaching the brain from the subconscious and the upper piping represents information coming to it through conscious processes. Finally, the central cell has yet another meaning, that of jail, or imprisonment, a reference to Foucault's claim that modern bureaucratic political regimes imprison the individual. The central square has therefore three referents: home, brain cell, and prison cell. Halley's intent in works like *Yellow Cell with Conduits* is not to protest troubling social phenomena but to find an interesting way to illustrate them. The work of all the Neo-Conceptualists has been called "endgame" art, a reference to the moves in a chess game when loss is inevitable.

One of the most famous endgame moves was made by Sherrie Levine (b. 1947), who is known for work in which she "appropriates," or borrows, images from art history (see "Appropriation," below). In 1981 she began to attack the predominantly male Neo-Expressionist movement and its ideas about originality and individuality by making photographic copies of famous twentieth-century originals. As she explained, "I felt angry at being excluded. As a woman, I felt there was not room for me. The whole art system was geared to celebrating . . . male desire." Her endgame response was to copy only the work of male artists.

Untitled (After Aleksandr Rodchenko: 11) (fig. 29-76) is not an homage to the Russian Constructivist (see fig. 28-78)

29-76. Sherrie Levine. *Untitled (After Aleksandr Rodchenko: 11)*. 1987. Black-and-white photograph, 20 x 16" (50.8 x 40.6 cm)
Courtesy Marian Goodman Gallery, New York

APPROPRIATION During the late 1970s and 1980s, **appropriation**, or the representation of a preexisting image as one's own, became a popular technique among postmodernists in both the United States and Western Europe. The borrowing of figures or compositions has been an essential technique throughout the history of art, but the emphasis had always been on changing or personalizing the source. A copy or reproduction was not considered a legitimate work of art until Marcel Duchamp changed the rules with his **readymades** (Chapter 28). His insistence that the quality of an artwork depends not on formal invention but on the ideas that stand behind it established the theoretical basis for the recent popularity of the technique. Duchamp's own type of appropriations first inspired the Pop artists Andy Warhol and Roy Lichtenstein, whose reuse of imagery from popular culture, high art, ordinary commerce, and the tabloids, in turn, helped point the way for the artists of the 1970s and 1980s.

Unfortunately, perhaps, critics and historians now use the term *appropriation* to describe the activities of two distinct groups. To the first belong artists such as John Baldessari and his student David Salle (see fig. 29-65), who combine and shape their borrowings in personal ways. These, along with earlier artists such as Robert Rauschenberg (see fig. 29-23), might be called "collage appropriators." "Straight appropriators," on the other hand, include artists such as Sherrie Levine (see fig. 29-76), who simply repaint or rephotograph imagery from commerce or the history of art and present it as their own.

The work of the second group is grounded not only in the Duchampian tradition but in the recent ideas of the French literary and cultural critics known collectively as the Post-Structuralists. Of particular importance was their critique of certain basic and unexamined assumptions about art. In "Death of the Author" (1968), for example, Roland Barthes argued that the meaning of a work of art depends not on what the author meant (which Jacques Derrida and others argued was neither certain nor entirely recoverable) but on what the reader understands. Furthermore, Barthes questioned the modernist notion of originality, of the author as a creator of an entirely new meaning. The author, Barthes argued, merely recycles meanings from other sources. A text, he said "is a tissue of quotations drawn from the innumerable centers of culture" (cited in Fineberg, page 454). Levine's work seems almost to illustrate such ideas.

The straight appropriators soon ran into a legal problem. Levine's first high art reproductions were rephotographs of Edward Weston originals. When lawyers for the Weston estate threatened to sue her for infringement of copyright, she moved to the work Walker Evans produced during the 1930s for the Works Progress Administration, which has no copyright. Others faced with the possibility of legal action, especially from owners of commercial trademarks, have taken the same cautious route. What remains to be settled, then, is whether commercial copyright protections, when applied to art, constitute an infringement of freedom of speech.

but a critique of certain ideas associated with him and with modernism. Levine's work is inspired by the deconstructionism of Jacques Derrida, in which he unravels, or "deconstructs," prevailing cultural assumptions, or "myths," by revealing them to contain self-conflicting messages. By appropriating images of men associated with originality and innovation—the viewpoint of Rodchenko's photography, for example, was considered wholly innovative—Levine intended to deconstruct those concepts and suggest that all art and thought are derivative.

Later Feminism

Because of the feminist content of much of her work, Levine may also be grouped with a second generation of feminists. These artists, who emerged in the 1980s, tended to believe in the idea that differences between the sexes are not intrinsic but fabricated, or "socially constructed," primarily by media images and other cultural forces, to suit the needs of those in power. According to this view, young people, particularly women, learn how to behave from the role models they see heralded in magazines, movies, and other sources of cultural coercion. A major task of feminism and feminist art should, therefore, be to resist the power of these forces.

Barbara Kruger (b. 1945) is an important representative of this generation. Drawing on her experience as a designer and photo editor for women's magazines, by the end of the 1970s she began creating works that combined glossy high-contrast images, usually borrowed from advertisements, and bold, easily readable, catchy texts. The purpose of such work was to undermine the media with its own devices, "to break myths," as she put it, "not to create them."

Although she has said of her work that it can be effective in questioning sexual representations, it seems at times that she expresses a sense of futility as well. In *We Won't Play Nature to Your Culture* (fig. 29-77), for example, the text is strong and defiant. The female voice represented by the text asserts that women will no longer accept the dichotomy—forced on them by men—between men as producers of culture and women as products of nature. In the image, however, the woman is symbolically blinded by the leaves over her eyes.

One of the most prominent of the later feminists, Cindy Sherman (b. 1954), is known for challenging and provocative photographs of herself in various assumed roles. In 1977 she began work on a series of black-and-white photographs that simulate stills from B-grade movies of the 1940s and 1950s. Each photograph from

VIDEO ART Among the many new mediums of art making created by the technology revolution in the late twentieth century, the video monitor is one of the most provocative. The video form, like film, uses a variety of approaches and styles, from raw documentary material to scripted theatrical performance, from animation to pure abstraction. As in film, time is an element of the medium, and video art may consist of images only seconds long or be a full-length feature. A key difference is that for the video artist the monitor is itself a visible part of the artwork.

Video art may use sophisticated computer programs or a simple handheld video camera. It may include only still images or a running narrative. Originally an inexpensive alternative to film, video has its own distinctive visual qualities, often including washed-out or intense color; unlikely juxtapositions of images and scenes; jerky, staccato camera motions; rough cutting; and a sense of spontaneity and immediacy, as in home movies. The essential technical distinction between video and film is that video is based on an electronic transmission of images, while film is a sequence of translucent images, using projected light and motion.

Because video has developed in a period in which many artists are self-consciously avant-garde, video artists pay particular attention to the relationship between the imagery of popular culture (commercial television, newscasts, advertising) and the traditional arts of painting and sculpture. Video art may be distinguished from other kinds of video (a television show, for example) by its special concern with the visual values of the screen images and its critical, often ironic view of the mass-media television culture to which it refers. Video art is often political in content, and like some experimental dance and theater, it links the performing arts with the visual arts.

Video art sometimes uses monitors inserted as elements within larger sculpture or structures, such as Nam June Paik's (b. 1932) 1995 *Electronic Superhighway*. It may be austere and minimal, like Bruce Nauman's ethereal self-portraits, or quite ornate, as in Paik's colorful, rapidly flickering multiple patterns, which are often computer generated or manipulated. Installations may be accompanied by sound, music, or a voice-over, and some are interactive, including cameras that permit the viewer to enter the artwork by appearing on screen. Feminist artist Adrian Piper makes harsh, raw, talking heads. Some video art shows the stylized theatricality of performance art, as in the work of Matthew Barney. Alan Rath's richly humorous composite creatures have eyes and noses made from tiny, odd-shaped video screens.

Nam June Paik. *Electronic Superhighway*. 1995. Installation: multiple television monitors, laser disk images, and neon, 15 x 32' (4.57 x 9.95 m). Holly Solomon Gallery, New York
Courtesy Holly Solomon Gallery, New York

29-77. Barbara Kruger. *We Won't Play Nature to Your Culture.* 1983. Photostat, red painted frame, 6'1" x 4'1" (1.85 x 1.24 m)

Courtesy Mary Boone Gallery, New York

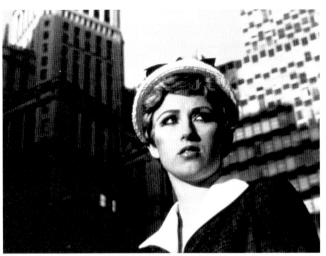

29-78. Cindy Sherman. *Untitled Film Still.* 1978. Black-and-white photograph, 8 x 10" (20.3 x 25.4 cm)

Courtesy Metro Pictures, New York

In the context of feminist film criticism's emphasis on the negative impact of movie "representations," it appeared that Sherman intended to re-create such roles as part of a critical, deconstructive agenda. Sherman suggested as much when she said: "And there's always me making fun—making fun of these role models of women from my childhood. And part of it maybe is to show that . . . these actresses know what they're doing, know they are playing stereotypes—but what can they do?" (cited in Marks, page 359).

the series, which numbered about seventy-five, shows a single female figure, always Sherman in some guise. In *Untitled Film Still* (fig. 29-78) she is dressed as a perplexed young innocent apparently recently arrived in a big city, its buildings looming threateningly behind her. The image suggests a host of films in which some such character is overwhelmed by dangerous forces, perhaps to be destroyed, or perhaps to be rescued by some hero. While Sherman's motives are complex, many observers have suggested that in these works she indicts Hollywood's stereotypical images of women and femininity by showing how one can "invent" oneself in a variety of roles.

Art and the Public

The issue of the relationship between art and the community at large, long a central concern of the modern period, took on a new prominence in the 1990s and seems destined to shape emerging styles and trends. As artists take advantage of such new mediums as video (see "Video Art," opposite), they nevertheless continue their search for a set of artistic principles to replace the old modernist ones. At the same time, their search—and their community's response to it—is resulting in many sensational controversies involving public funding, censorship, and individual rights.

One of the least controversial public artists is Jenny Holzer (b. 1950), whose work is often grouped with that of the later feminists. In the mid-1970s Holzer took a course in the history of contemporary art at the Whitney Museum of American Art in New York City. The reading, much of it by postmodern intellectuals like those who influenced the Neo-Conceptualists, seemed to her "important and profound." She then set out to try "to translate these things into a language that was accessible. The result was the *Truisms*." For two years, 1977 and 1978, she rephrased the ideas from her reading as one-liners suited to the reading habits of Americans raised on advertising messages. She compiled these statements in alphabetical lists, had them printed, and plastered them all over her neighborhood. With an accumulation of remarks reflecting a variety of viewpoints and voices, such as "Any Surplus Is Immoral" and "Morality Is for Little People," she hoped to "instill some sense of tolerance in the onlookers or the reader."

Since her first posters, Holzer has moved progressively into mediums that would allow her to address an even wider audience. She turned to some of advertising's more technical tools, including electronic signage, to reach more than the proportionally small number of people who go to galleries and museums. Moreover, she preferred to use popular media devices already in place. In her

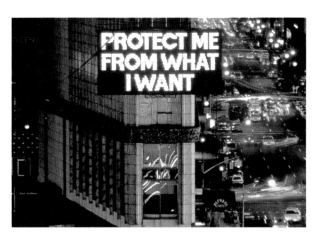

29-79. Jenny Holzer. *Protect Me from What I Want*, excerpt
from Survival series. 1985–86. Spectacolor board,
Times Square, New York

Courtesy Barbara Gladstone Gallery, New York

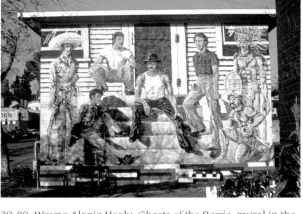

29-80. Wayne Alaniz Healy. *Ghosts of the Barrio*, mural in the
Ramona Gardens Housing Project, Los Angeles. 1974.

Courtesy the artist

Survival series (fig. 29-79), for example, she used the Spectacolor board in New York City's Times Square to flash a series of short, provocative messages, now in her own voice. The one illustrated here, *Protect Me from What I Want*, is a reference to the way advertising generates a desire in people for products and services they may not need.

Another, very different concept of public art emerged in the late 1980s, partly as a result of growing interest in Hispanic art, itself a response to the growing influence of **multiculturalism**—the recognition that American culture is a heterogeneous mix of ethnic, racial, sexual, and socioeconomic subcultures. Beginning in the 1970s, reviving a tradition started by Diego Rivera (see fig. 28-119) and other Mexican artists following the Mexican revolution in the early twentieth century, Mexican American artists, particularly in the Chicano community in East Los Angeles, began painting murals. Until the 1990s these murals were considered by art professionals a sociological, not an artistic, phenomenon.

Typical of the Chicano muralists is Wayne Alaniz Healy (b. 1949). A social activist from East Los Angeles, Healy joined Mechicano, a nonprofit art center specializing in graphics, in 1972. He had no professional training in art but had been interested in it since childhood. When members of Mechicano decided quite spontaneously to do a mural at a grocery store, Healy says he was "terminally bitten by the mural bug."

A good example of Healy's work is *Ghosts of the Barrio* (fig. 29-80), done on a housing project wall. The mural shows four *vatos locos* ("street dudes") with three ancestors: an Aztec, a Spanish conquistador, and a revolutionary soldier. According to Healy, the mural addresses the question Where do we go from here? The figures look outward for advice, thus including the viewer in the group. Healy's audience, however, is not the public at large but the local Chicano population. The work speaks to that population in its own visual language, drawn from Mexican culture. Healy is concerned not with artistic innovation but with social effectiveness.

The strategy of reaching a particular public with its own signs and symbols has also been employed by cer-

tain African American artists who, like the Chicano muralists, were until the 1980s working well outside the acknowledged art world. One African American artist, David Hammons (b. 1943), has been an outspoken critic of that art world despite its interest in him, viewing it as a system that encourages and rewards work that is "so watered down that the bourgeoisie can consume it." Art today is "like Novocain. It used to wake you up but now it puts you to sleep." Only street art, uncontaminated by commerce, he maintains, can still serve the old function.

Although Hammons sometimes addresses a broader audience, for the most part his work has been aimed at specific segments of the African American community. His best-known work is probably *Higher Goals* (fig. 29-81), several versions of which were made between 1982 and 1986. The one shown here, temporarily set up in a Brooklyn park, has backboards and baskets set on telephone poles—a reference to communication—that rise 40 feet into the air. The poles are decorated with bottle caps, a substitute for the cowerie shells used not only in African design but in some African cultures as money. Although the series may appear to honor the game, Hammons said it is "antibasketball sculpture." "Basketball has become a problem in the black community because kids aren't getting an education. . . . It means you should have higher goals in life than basketball."

As a result of these and many other similar examples, some of them from Europe, the international art world in the 1980s witnessed a growing commitment to the notion that art is most effective as a social tool when it avoids an institutional setting, moves to a specific community, and addresses locally important issues in straightforward language. In other words, like environmental earthworks, socially conscious art seems to function best when it is site-specific.

Following this principle, a European television company collaborated with a regional arts association to commission a series of works for economically and politically troubled places. One of Britain's leading young sculptors, Antony Gormley (b. 1950), was assigned to make a piece for a site overlooking the religiously divided

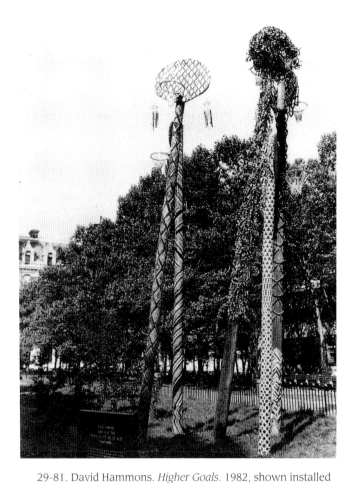

29-81. David Hammons. *Higher Goals*. 1982, shown installed in Brooklyn, New York, 1986. Poles, basketball hoops, and bottle caps, height 40' (12.19m)

Hammons likes to allow local conditions and issues to dictate the subjects and to some degree the appearance of his public sculpture. In preparation for a given piece, he goes out onto the streets to discover the local concerns. He admits that in order "to let the community speak, I have to give up my ego."

city of Derry in Northern Ireland, a region torn by civil warfare in which Protestants generally support continued union with the United Kingdom and Catholics generally oppose it. From a cast of his own body Gormley made a double image in iron of two figures with arms outstretched, facing away from each other but joined back to back (fig. 29-82). With its obvious reference to Jesus on the Cross, the work is a pointed reminder of the countless casualties on both sides—Catholic and Protestant, Irish and British—and a plea to find in shared grief a basis for reconciliation and unity. Within days the piece was vandalized with political graffiti and a burned tire was hung around its neck, a demonstration that the work had at least been understood and taken seriously.

In the late 1980s Europeans also pioneered a new kind of site-specific art exhibition, temporary pieces by several artists set up throughout a particular community, all dealing with a single relevant political or historical issue. In 1991 the directors of the Spoleto Festival U.S.A., in Charleston, South Carolina, decided to emulate this European precedent with an event called "Places with a Past." The event's curator invited eighteen artists, including Gormley and Hammons, to find sites in the city for temporary works that would provide an "intimate and meaningful exchange" with the citizens of Charleston on issues from its history.

Because Charleston had been a center for the slave trade in the South and was the place where the Civil War began, Ann Hamilton (b. 1956) originally planned to deal with the issue of slavery in her work for "Places with a Past." When she found an abandoned automobile repair shop on Pinkney Street, however, she decided to treat an aspect of American life ordinarily overlooked by most historians. The street was named for Eliza Lucas Pinkney, who in 1744 introduced the cultivation of indigo to the American colonies. Indigo produces a blue dye used for, among other things, blue-collar work clothes. Hamilton thus decided to use the garage—a blue-collar

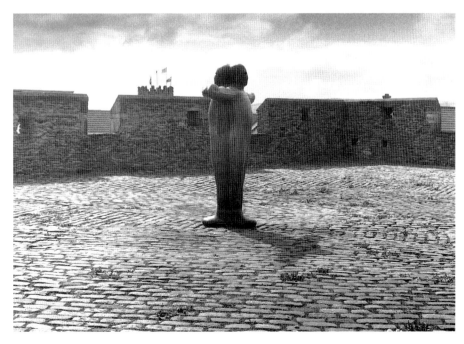

29-82. Antony Gormley. *Derry Sculpture*. 1987. Cast iron, 6'5⅛" x 6'4" x 1'9¼" (1.96 x 1.93 x 0.54 m) Courtesy the artist

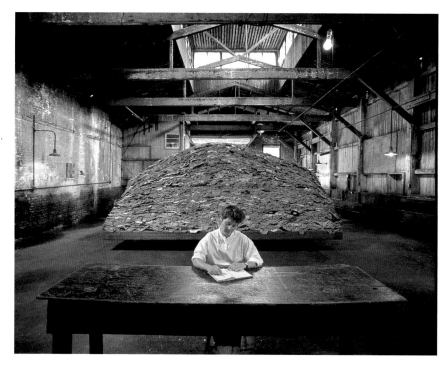

29-83. Ann Hamilton. *Indigo Blue*. 1991. Installation for "Places with a Past," Spoleto Festival U.S.A., Charleston, South Carolina

workplace—for a piece she called *Indigo Blue* (fig. 29-83). The focal point of the piece was a pile of about 48,000 neatly folded work pants and shirts. *Indigo Blue* is more a tribute to the women who washed, ironed, and folded such clothes than to the men who worked in them. The piece is meant to show respect for the labor involved in laundry. Hamilton and a few women helpers, including her mother, did all the folding and piling. In front of the great mound of shirts and pants sat a woman erasing the contents of old history books—creating page space, Hamilton claimed, for the ordinary, working-class people usually omitted from conventional histories.

The many references and meanings in Hamilton's work perhaps escaped most viewers, though its impressive visual force and moral integrity may have affected many at some level. This piece illustrates a central problem faced by artists trying to communicate to a large public: To what extent should the artist be willing to compromise artistic vision for clear communication?

"Places with a Past" was funded partly through a $200,000 grant from the National Endowment for the Arts (NEA), an agency of the federal government established in 1965 to help support writers, dancers, artists, and the organizations that make their work available to the American public, as well as to fund community art education programs. In the spring of 1989 the NEA came under fire from members of Congress who threatened to curtail or eliminate the agency's funding because they were offended by the art of a few artists who had received direct or indirect funds from the NEA. Since then, the threat to the NEA and other arts agencies has grown, amplified by those who believe the government has no business spending tax dollars on the arts.

One of the principals who figured in this controversy was Karen Finley (b. 1956), a performance artist. Her work is raw, uninhibited, and, while it often conveys a powerful message, certainly not suited to everyone's taste. In *We Keep Our Victims Ready* (fig. 29-84), she denounces the

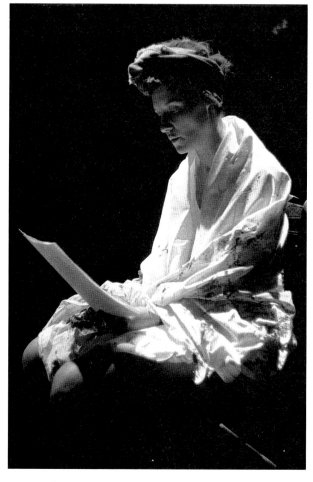

29-84. Karen Finley. *We Keep Our Victims Ready*. Performance at The Kitchen, New York, 1990

In an interview published in 1991 Finley said: "I was really upset when the NEA tried to censure my work as 'obscene,' because I think my work is extremely moral. I'm trying to speak out about sexual violence and how hateful that is, and make it *understandable*. Yet many times I'm just viewed as 'hysterical'—as a sexual deviant who's 'out of her mind.'"

29-85. Robert Mapplethorpe. *Ajitto (Back)*. 1981. Gelatin-silver print, 16 x 20" (40.6 x 50.8 cm). The Robert Mapplethorpe Foundation, New York

29-86. Richard Serra. *Tilted Arc*. 1981. Hot-rolled steel, length 120' (36.58 m). Formerly, Federal Plaza, Foley Square, New York; removed in 1989

In his 1989 article on the destruction of the work, Serra pointed out that during a three-day hearing in 1985, some 122 people spoke in favor of retaining the sculpture and only 58 spoke for removal. Moreover, the new petition for removal presented at the hearing had 3,791 signatures, which represented fewer than a quarter of the approximately 12,000 employees in the federal buildings at the site. Also, a petition with 3,763 signatures was presented against removal. He argued that the general perception that the majority of the public wanted its removal was simply untrue, a useful exaggeration for those who simply did not like the work.

mistreatment of women, the homeless, and people with AIDS, alternately howling, moaning, chanting, crying, and screaming. In another performance that has particularly incensed opponents of NEA and public funding of the arts, she covers her body with chocolate syrup to make a point about the way society perceives women.

An artist whose work was at the core of the controversy over public funding was photographer Robert Mapplethorpe (1946–1989), who was openly gay. Most of the 150 photographs in his 1989–1990 touring retrospective exhibition (funded in part by an NEA grant to the show's organizing institution) consisted of classic studies of nudes and flowers. *Ajitto (Back)* (fig. 29-85), for example, is a fairly conventional investigation of the subtle formal nuances of the human body. Some of the photographs, however, showed homoerotic subjects and explicit sex acts. Fears of protests by some members of Congress caused the Corcoran Gallery in Washington, D.C., to cancel its plans to mount the show in 1989. The Cincinnati Contemporary Arts Center, however, presented it in 1990, putting the controversial works in their own room with a clear printed advisement. Cincinnati officials nevertheless charged the museum and its director with obscenity and put them on trial. The jury was not convinced that the photographs "lack[ed] serious literary, artistic, political, or scientific value"—one of the criteria for obscenity set by the Supreme Court in a 1973 decision—and acquitted the museum and its director. The jury had decided, as one juror commented, "we may not have liked the pictures" but they were art. "We learned," he added, "that art doesn't have to be pretty."

Richard Serra's (b. 1939) Minimalist sculpture *Tilted Arc* (fig. 29-86) figured in a different controversy involving art and the public. In this case the issue was the artist's right to control what happens to a work commissioned or purchased for that public. *Tilted Arc*, a steel wall 12 feet high and 120 feet long that tilts 1 foot off its vertical axis, was commissioned for the plaza of a government building complex in New York City on the recommendation of an artists' panel appointed by the NEA. Typical of Serra's work, it was strong, simple, tough, and given its tilt, quite threatening. Some employees in the building found the work objectionable. Calling it an "ugly rusted steel wall" that "rendered useless" their "once beautiful plaza," they petitioned to have it removed. The government agreed to do so, but Serra went to court to preserve his work. He eventually lost his case, and the sculpture was removed in 1989.

29-87. Maya Ying Lin. *Vietnam Veterans Memorial*. 1982. Black granite, length 500' (152 m). The Mall, Washington, D.C.

The *Vietnam Veterans Memorial* (fig. 29-87), now widely admired as a fitting and moving testament to the Americans who died in that conflict, was also a subject of public controversy when it was first proposed. In its request for proposals for the design of the monument, the Vietnam Veterans Memorial Fund—composed primarily of veterans themselves—stipulated that the memorial be without political or military content, that it be reflective in character, that it harmonize with its surroundings, and that it include the names of the more than 58,000 dead and missing. In 1981 they awarded the commission to Maya Ying Lin (b. 1960), then an undergraduate in the architecture department at Yale University. Her Minimalist-inspired design called for two 200-foot-long walls (later expanded to almost 250 feet) of polished black granite, to be set into a gradual rise in Constitution Gardens on the Mall in Washington, D.C., meeting at a 136-degree angle at the point where the walls and slope would be at their full 10-foot height. The names of the dead, arranged chronologically in the order in which they died, were to be incised in the stone, with only the dates of the first and last deaths, 1959 and 1975, to be recorded.

While construction was under way, several veterans groups—who had provided much of the approximately $8 million for the project and who originally had supported the Lin proposal—asked that a realistic 8-foot sculpture of three soldiers on patrol be added toward the **apex** of the memorial and that a 50-foot flagpole be raised some dis-

tance behind. The veterans felt that in this way the survivors, too, would be honored at the site. After much negotiation between the concerned parties, a compromise was worked out whereby the additions would be made farther from the Lin design, at one entrance to the memorial grounds.

The additions as originally proposed would have fatally compromised the simple power of Lin's design. To visitors, the memorial has turned out to be one of the most compelling monuments in the United States, largely because it creates an understated encounter between the living, reflected in the mirrorlike polished granite, and the dead, whose names are etched in its black, inorganic permanence. Quiet and solemn, the work allows visitors the opportunity for individual contemplation. Adding significantly to the memorial's intrinsic power are the many individual mementos, from flowers to items of personal clothing, that have been left below the names of loved ones by friends and relatives.

Art and Craft

Since the Renaissance, Western artists, critics, and art historians have generally maintained a distinction between the so-called high or fine arts—painting, sculpture, and architecture—and the so-called minor arts— such as printmaking, the decorative arts, pottery, and folk art. (A further distinction, although rarely stated, has been

29-88. Peter Voulkos. *29, Sculpture, 5000 Feet*. 1958. Fired clay, including base 45½ x 21¹³/₁₆" (115.57 x 55.62 cm). Los Angeles County Museum of Art

Purchase award, 1958 (Annual Exhibition of Artists of Los Angeles and Vicinity)

29-89. Robert Arneson. *Portrait of George*. 1981. Glazed ceramic, height 8' (2.44 m). Collection Foster Gold-strom

Courtesy Estate of Robert Arneson

observed during the modern period between certain kinds of painting, sculpture, and architecture considered to be the mainstream and others outside it and therefore of less significance.) In recent years, however, the notion that one medium is intrinsically superior to another, like the idea of the mainstream, has come under scrutiny.

Peter Voulkos (b. 1924) is one of many artists who have helped overcome long-standing hierarchical distinctions between art and craft. (Another is glass artist Dale Chihuly; see fig. 13, page 22.) Voulkos was trained as a potter at the California College of Arts and Crafts. His career changed direction when he came under the influence of the gestural painters he met on a visit to New York City in 1953. Inspired by their example, as well as by Picasso's ceramic works, he advocated to his students at the Otis Art Institute in Los Angeles that they freely adapt long-established ceramic traditions to self-expressive ends. By the late 1950s he had moved away from the pot form entirely and was making large sculptural works.

One such piece, *29, Sculpture, 5000 Feet* (fig. 29-88), was assembled from fired-clay pieces, covered with black iron **slip** wash, and then **glazed**. Inspired by Cubist sculpture and painting (see fig. 28-42), as well as by the improvisational jazz he loved to listen to, play, and compose, Voulkos combined the formal elements of the sculpture in a "musical" arrangement of free-form shapes.

In 1959 Voulkos left Otis to teach at the University of California at Berkeley, where Robert Arneson (1930–

1992), then a conventional potter, became his unofficial student. Under Voulkos's influence Arneson also began experimenting with a more innovative approach to his medium. In 1961, while demonstrating pottery techniques at the California State Fair, he made a sturdy bottle of about quart size, carefully sealed it with a clay bottle cap, and stamped it "No Return." This piece, which provoked the irritation of local critics, was simply the beginning of a series of increasingly uninhibited works that included his John series of toilets—reminiscent of Marcel Duchamp's *Fountain* (see fig. 28-1)—impertinent remakes of famous paintings, and portraits of political figures.

Portrait of George (fig. 29-89) depicts the former San Francisco mayor George Moscone, who with the first openly gay city supervisor, Harvey Milk, was assassinated in 1978 by Dan White, a former city supervisor. Commissioned for San Francisco's new Moscone Center, Arneson's work was considered too irreverent for public display, placed in storage, and later sold to a private collector. The column that supports Moscone's smiling face is adorned with graffiti-like writing that gives details of his education and career and the facts surrounding his assassination. The Hostess Twinkies wrapper near the

29-90. Viola Frey. *Woman in Blue and Yellow II*. 1983.
Ceramic, 8'8" x 2'2¹/₂" x 1'5" (2.64 x 0.67 x 0.43 m)
Courtesy Rena Bransten Gallery, San Francisco

large-scale works based on the cheap ceramic figurines found in variety stores and flea markets, which reminded her of her childhood. "I decided," she said, "to make them big—take them out of the crib and off the coffee tables, make them myths of childhood." The culmination of this process was the series of 7- to 10-foot figures of women and men that she produced in the late 1970s and 1980s.

The men in this series often appear angry and disapproving, the women either reassuring or fearful. The startled woman in *Woman in Blue and Yellow II* (fig. 29-90), for example, raises her hands protectively. The scale—which makes adults, including the artist, feel like children—and the 1940s-style clothing suggest that the artist has represented figures and events from her own childhood. By presenting these generalized but often dark events in the beguiling guise of figurines, Frey demonstrates what she sees as the function of figurines: "to make acceptable those things [we find] unacceptable."

The sculptural works of Voulkos, Arneson, and Frey helped ceramics gain acceptance as a high art medium, but they left intact the distinction between sculpture as art and pottery as craft. The hierarchy of materials had been challenged, but the hierarchy of the arts was still secure. During the 1970s and 1980s, however, a number of critics began to ask why a ceramic pot should not be considered as valuable as a ceramic sculpture. Many of these critics, such as John Perreault, came to question the dogmas of their art historical training as a result of their experience with the new importance given certain craft forms by 1970s feminists (see figs. 29-62, 29-63).

Although critics and historians such as Perreault are still in the minority, they seem to be getting a hearing, partly because of the high quality of the artwork they have attempted to bring to public notice. One of the craft artists who received considerable attention in the 1990s is Pueblo potter Lucy M. Lewis (c. 1900–1992). A member of the Acoma Pueblo people, Lewis grew up near Albuquerque, New Mexico, and learned to make pottery in the traditional manner from her great-aunt. Acoma pottery is based on that of the Anasazi people (Chapter 23), believed to be their ancestors. The Anasazi explored with great ingenuity and finesse a basic format of black paint on a white ground. The early potters who inherited this tradition quickly transformed it into a less austere and more polychromatic one, adding a greater repertoire of figures to the largely geometric patterns of the Anasazi. Although much of Lewis's work, especially when she was young, was in the traditional orange, brown, and black bird-and-flower patterns, she also revived the austere geometric style of her earlier ancestors, as in *Black on White Jar with Lightning Pattern* (fig. 29-91). The "fine-line decoration" here is Lewis's own invention, inspired by ancient shards but not a copy of them. Like other Native American artists, Pueblo potters such as Lewis seek personal solutions within the confines of tradition.

base refers to what has come to be known as the Twinkies defense, the claim that White killed Moscone and Milk while temporarily insane from eating too much junk food. The defense was successful enough that the jury sentenced White to only eight years in prison.

While the controversy over his portrait of Moscone was raging in San Francisco, another involving Arneson was brewing in New York City as a result of an innovative event at the Whitney Museum: an exhibit of six West Coast ceramicists, including Voulkos and Arneson. The first exhibition of its kind in a major New York museum, it appeared to signal the art world's acceptance of ceramics as a legitimate medium for high art.

The show was criticized, however, because it included no women. In response the Whitney organized an exhibition of the work of Viola Frey (b. 1933), another San Francisco Bay Area ceramicist. Inspired by Pop art and Arneson's iconoclasm, in the 1960s Frey began to make

Continuity versus Change

The growing interest in works by artists such as Lewis has been fed by a number of extra-aesthetic factors: the

29-91. Lucy M. Lewis. *Black on White Jar with Lightning Pattern*. c. 1970–80. Earthenware, height 5" (12.7 cm), diameter 4" (10.1 cm)

Courtesy Adobe Gallery, Albuquerque, New Mexico

The Lewis heritage is being maintained, in particular, in the work of two of her sons, Ivan and Andrew, and three of her daughters, Emma, Dolores, and Belle.

29-92. Martin Puryear. *Empire's Lurch*. 1987. Painted ponderosa pine, 6'3" x 4' x 2'1½" (1.91 x 1.22 x 0.65 m). Private collection, New York

Courtesy McKee Gallery, New York

In the same year that he made this work, Puryear said: "I think all my work has an element of escape. . . . The materials tend to be natural; I don't have a lot of feeling for materials that are highly processed and industrialized. But I am a city person, and perhaps because I am, an urge for the country comes out."

fear that traditional methods are fast disappearing; the conviction that art should be an affordable part of daily life, not a luxury item set apart in a gallery or museum; and, not least of all, the psychological appeal that traditional art forms have in an era of rapid, uncertain change. Lewis's pottery, for example, presents a reassuring image of uninterrupted continuity.

A concern for continuity can also be seen in the 1980s work of a number of painters and sculptors, among them the African American sculptor Martin Puryear (b. 1941). While in the Peace Corps in Sierra Leone on the west coast of Africa, Puryear studied the traditional, preindustrial woodworking methods of local carpenters and artisans. In 1966 he moved to Stockholm, Sweden, to learn the techniques of Scandinavian cabinetmakers. Two years later he began graduate studies in sculpture at Yale, where he encountered the work of a number of visiting Minimalist sculptors, including Serra (see fig. 29-86). By the middle of the 1970s he had combined these formative influences into a distinctive personal style reminiscent, in its organic simplicity, of Constantin Brancusi (see fig. 28-10).

Typical of Puryear's mature work is *Empire's Lurch* (fig. 29-92). This simple, dark green form of carefully fit-

ted pieces of ponderosa pine conveys a sense of continuity with both the natural world and the art of the past. Its indefinite organic shape suggests both the body and neck of an animal and a plant bursting through the soil. Although it reflects Brancusi's influence in its organic simplicity and soothing textures and contours, unlike his work it has no clear referent. Brancusi always began with a clear theme, but Puryear discovers his final product in the process of making it. Sounding like an early-twentieth-century modernist, Puryear has said, "The task of any artist is to discover his own individuality at its deepest."

Another contemporary artist who would rather work

29-93. Brice Marden. *Cold Mountain 3*. 1988–91. Oil on linen, 9 x 12' (2.74 x 3.66 m). Collection John and Frances Bowes, San Francisco
Courtesy Mary Boone Gallery, New York

within and deepen the artistic traditions of the past than break with them is the painter Brice Marden (b. 1938). A 1963 graduate of the Yale School of Art, he became an important Minimalist, specializing in one-color paintings, usually gray. From these monochromes he moved on in the 1970s to paintings that featured a subtle dialogue between blocks of subdued color. Increasingly interested in Asian art and philosophy, in the mid-1980s Marden started making calligraphic drawings using twigs of ailanthus wood, known to the Chinese as the tree of heaven. From these drawings came a series of large paintings (fig. 29-93) dedicated to Cold Mountain, an eighth-century Chinese poet who quit the imperial court, retired to a mountain community of Buddhist monks, and wrote short, simple, and beautifully penned verses declaring his independence from the material "world of dust." Marden's allegiance to that philosophical stance is embodied by his painting style, which combines the delicate nuances and slower rhythms of classic Chinese **calligraphy** with the monumental scale and looser tracery of Pollock. Marden thus aligns himself with the modernist view of art as a transcendent and spiritually nourishing form of expression. Like Puryear's and Lewis's, his work suggests that innovation need not come at the cost of either disruption or interruption.

The continuing vitality of the contrary view—that avant-garde art should be shockingly new and different—can be seen in the work of the itinerant German artist Rebecca Horn (b. 1944). Raised in post–World War II Berlin, Horn now divides her time between Hamburg and New York City. In 1968, after a near-fatal asphyxiation from polyester resin fumes, she turned from conventional sculpture to mysterious and ritualistic performances focused on the human body. These works gave way in the late 1970s to a dual focus on fictional films and kinetic installations such as *High Moon* (fig. 29-94), which apparently refers to the concluding shootout in the classic Western film *High Noon*. The machines in these installations are human substitutes, or "Melancholic actors," as Horn called them in an interview. Of *High Moon*, Horn said: "In it, two Winchester rifles hanging at about the height of a person's heart move in the gallery space. First, they focus on the people coming into the gallery. Then, they move until they face each other. Finally, they shoot red liquid [fed by tubes from two glass funnels]. I've always wanted to make two rival guns shoot each other with bullets that melt, like a kiss of death." The result is a bloody-looking pool that spills out onto the gallery floor, making it look like a crime scene. Even Horn isn't sure what the work means. "There is never a story per se," she admits. "I sim-

29-94. Rebecca Horn. *High Moon*. 1991. Installation: two Winchester rifles, two glass funnels, motor, metal, water, and dye, dimensions variable

Courtesy Marian Goodman Gallery, New York

ply allow the consequences of whatever the machine is doing to meet with the particular reality or mood each person brings to it." Whatever interpretation one chooses, *High Moon*'s subtle interweaving of contrasting elements—male and female, human and machine, danger and pleasure, life and death—is unsettling.

The contrast between the soothing art of Puryear and Marden and the challenging art of Horn is hardly new. Since the Renaissance, at least, the history of art has involved just this debate over the function of art. Some artists have sought to comfort us, others to unsettle us. Both of these positions demonstrate the continuing relevance of art to our lives. The case for art and the artist

was eloquently made at a congressional subcommittee hearing by Robert Motherwell (1915–1991), a major New York School painter:

Most people ignorantly suppose that artists are the decorators of our human existence, the esthetes to whom the cultivated may turn when the real business of the day is done. But actually what an artist is, is a person skilled in expressing human feeling. . . . Far from being merely decorative, the artist's awareness . . . is one . . . of the few guardians of the inherent sanity and equilibrium of the human spirit that we have.

Glossary

abacus The flat, usually square slab placed on top of a **capital**, directly underneath the **entablature**.

absolute dating A method of assigning a precise historical date to ancient periods and objects previously dated only by **relative dating**. Based on known and recorded events in the region as well as technically extracted physical evidence (such as carbon-14 disintegration). *See also* **radiometric dating**.

abstract, abstraction Any art that does not represent observable aspects of nature or transforms visible forms into a pattern resembling something other than the original model. Also: the formal qualities of this process.

academy, academician An academy is an institutional group established for the training of artists. Most academies date from the Renaissance and after, and they were particularly powerful state-run institutions in the seventeenth and eighteenth centuries. In general, academies replaced the **guilds** as the venue where students learned the craft of art and were also provided with a complete education, including art theory and artistic rules. The academies helped artists be seen as trained specialists, rather than craftspeople, and promoted the change in the social status of the artist. An academician is an official academy-trained artist, whose work conforms to the accepted style of the day.

acanthus A leaflike architectural ornamentation used in the **Corinthian** and **Composite orders**, based on the forms of a Mediterranean plant.

acropolis In general, the **citadel** of an ancient Greek city, located at its highest point and consisting of grouped temples, a **treasury**, and sometimes a royal palace. Specifically, the Acropolis refers to this structure as it is found in Athens, where the ruins of the Parthenon and other famous temples can be found.

acrylic A synthetic paint popular since the 1950s, which has a very fast drying time.

adobe Sun-baked building material made of clay mixed with straw. Also: the buildings made with this material.

adyton The innermost **sanctuary** of a Greek temple. If a temple with an **oracle**, the place where the oracles were delivered. More generally, a very private space or room.

aedicula (aediculae) A type of decorative architectural frame, usually found around a **niche**, door, or window. An aedicula is made up of a **pediment** and **entablature** supported by **columns**, **pilasters**, or **piers**.

aesthetics The philosophical theories relating to the concept of beauty in art and, by extension, to the history of art appreciation and taste.

agora An open space in a Greek town used as a central gathering place or market. In Roman times, called a **forum**.

album A book consisting of blank pages (leaves) on which typically an artist may sketch, draw, or paint.

album leaves *See* **album**.

alignment In prehistoric architecture, an arrangement of **menhirs** in straight rows.

allegory The representation in a work of art of an abstract concept or idea using specific objects or human figures.

altar A place, invariably raised, where religious rites are performed. In Christian churches, the altar is the site of the rite of the **Eucharist**.

altarpiece A painted or carved **panel** or winged structure placed at the back of or behind an **altar**. Contains religious imagery, often specific to the place of worship for which it was made.

amalaka In Hindu architecture, the circular or square-shaped element on top of a **shikhara**, often crowned with a **finial**, symbolizing the cosmos.

ambulatory The passage or aisle that leads around the **apse** of a Christian church. Developed for use in pilgrimage churches, an ambulatory usually allows general passage from the **nave** around the east end of a church without giving access to the restricted areas of the **choir** and **altar**.

amphiprostyle Term describing a building, usually a temple, with **porticoes** at each end but without **columns** along the other two sides.

amphora An ancient Greek jar for storing oil or wine, with an egg-shaped body and two curved handles.

Andachtsbild (Andachtsbilder) Literally "devotional image," a painting or sculpture that **expressionistically** depicts themes of Christian grief and suffering, such as the **pietà**. Popular in German-speaking areas beginning in the late thirteenth century.

aniconic A term describing a representation without images of human figures, often found in Islamic cultures.

animal interlace Decoration made up of interwoven animal-like forms, often found in Celtic and northern European art of the medieval period.

animal style A type of artistic design popular in Europe and western Asia during the ancient and medieval periods, characterized by **linear**, animal-like forms arranged in intricate patterns. The style is often used on metalwork or other precious materials.

ankh A **hieroglyph** signifying life, used by ancient Egyptians.

anta (antae) A rectangular **pier** or **pilaster** found at the ends of the framing walls of a recessed **portico**.

antependium (antependia) The front panel of a **mensa**.

anticlassical A term designating any image, idea, or **style** that opposes the **classical** norm propounded by classicism.

apex A peak or top point.

apotheosis Religious glorification or deification of an individual. In painting, often shown as an ascent to Heaven, borne by angels or **putti**.

appliqué A piece of any material applied as a decorative **motif** onto another.

apprentice A student of art or artist in training. In a system of artistic training established under the **guilds** and still in use today, master artists took on an apprentice (who usually lived with the master's family) for several years. The apprentice was taught every aspect of the artist's craft, and he or she participated in the workings of the master's workshop or **atelier**.

appropriation Term used to describe an artist's practice of borrowing from an external source for a new work of art. While in previous centuries artists often copied one another's figures, **motifs**, or **compositions**, in modern times the sources for appropriation extend from material culture to wholesale lifting of others' works of art.

apse, apsidal A large semicircular or polygonal (and usually **vaulted**) **niche** protruding from the end wall of an **axial** building. Also: the eastern end of a Christian church, containing the **altar**. Apsidal is an adjective describing the condition of having a semicircular or polygonal space within a building.

aquamanile A vessel used for washing hands, whether during the celebration of the Catholic Mass or before eating at a secular table. An aquamanile is often formed in the shape of a human figure or a grotesque animal.

aquatint A type of **intaglio** printmaking developed in the eighteenth century that produces an area of even **tone** without laborious **cross-hatching**. Basically similar in technique to an **etching**, the aquatint is made through use of a porous resin coating of a metal plate, which when immersed in acid allows an even, all-over biting of the plate. When printed, the end result has a granular, textural effect.

aqueduct A trough to carry flowing water. Under the Romans, built over long distances at a gradually decreasing incline.

arabesque A type of **linear** surface decoration based on organic forms, usually characterized by flowing lines and swirling shapes.

arcade A series of **arches**, carried by **columns** or **piers** and supporting a common wall. In a blind arcade, the arches and supports are engaged (attached to the background wall) and have a decorative function.

arch In architecture, a curved structural element that spans an open space. Built from wedge-shaped stone blocks called **voussoirs**, which, when placed together and held at the top by an oblong **keystone**, form an effective weight-bearing unit. Requires support at either side to contain outward thrust of structure. Found in a variety of shapes and sizes, depending upon style of period. **Corbel arch**: an arch over an open space created by the layering of **corbels** and finished with a **capstone**. **Horseshoe arch**: an arch with a rounded horseshoe shape; the standard arch form in western Islamic architecture. **Ogival arch**: a pointed arch created by **S** curves; a popular arch form in Islamic architecture. **Relieving arch**: an arch built into a heavy wall just above a **post-and-lintel** structure (such as a gate, door, or window) to help support the wall above. Relieves some of the weight on the lintel by transferring the load to the side walls.

Archaic smile The fixed expression of an ancient Greek statue, usually interpreted as a half smile.

architectonic Resembling or relating to the spatial or structural aspects of architecture.

architectural interior A subject in **genre painting** particularly popular in Holland in the seventeenth century, depicting the interiors of churches and other important civic buildings, usually with small figures going about ordinary activities.

architrave The bottom layer of an **entablature**, beneath the **frieze** and the **cornice**. More generally, the frame surrounding a door or window.

archivolt One of several continuous decorative bands or **moldings** on the face of an **arch**, across the **voussoirs**.

ashlar *See* **dressed stone**.

assemblage An artwork created by gathering together and manipulating found objects and other three-dimensional items. The technique of assemblage was especially popular in the first half of the twentieth century.

astragal A thin convex decorative **molding**, often found on **Classical entablatures**, and usually decorated with a continuous row of beadlike circles.

atelier The studio or workshop of a master artist or craftsperson, usually consisting of junior associates and **apprentices**.

atmospheric perspective *See* **perspective**.

atrial cross The cross placed in the **atrium** of a church. In Colonial America, used as a marker of a gathering and teaching place. Atrial crosses were often carved by native sculptors in local styles.

atrium An interior courtyard or room built with an opening in the roof, usually over a pool or garden. Most often found in Roman domestic buildings. Also: the vestibule of an Early Christian **basilica-plan** church, usually roofed.

attached column *See* **column**.

attic The portion of a **Classical** temple or **facade** above the **entablature** and below the crowning element (such as a roof or **pediment**).

attic story The top level or division of a building. In Greek architecture, the (often highly decorated) level found above the **entablature**.

attribute The symbolic object or objects that identify a particular deity or saint in art.

automatism A technique whereby the usual intellectual control of the artist over his or her brush or pencil is foregone. The artist's aim is to allow the subconscious to create the artwork without rational interference. Also called automatic writing, automatism was developed by the Surrealists in the 1910s, and it was influential for later movements such as Abstract Expressionism.

avant-garde A term derived from the French word meaning "before the group" or "vanguard." Avant-garde denotes those artists or concepts of a strikingly new, experimental, or radical nature for the time.

axial Term used to describe a **plan** or design that is based on a symmetrical, **linear** arrangement of elements.

axis mundi A Buddhist concept of an axis of the world, which denotes important sacred sites and provides a link between the human and celestial realms. In Buddhist art, the *axis mundi* can be marked by **monumental** freestanding decorated **pillars**.

axonometric projection A type of building diagram that represents graphically all the parts of a building. Axonometric projections use an established vertical axis, from which the vertical lines are drawn, while the horizontal lines are drawn at unequal angles to the base horizontal axis.

background Within the depicted space of an artwork, the area of the image at the greatest distance from the **picture plane**.

backstrap loom A type of loom common among the indigenous peoples of Asia and the Americas in which the **warp** threads are wound between two bars, one attached to an object such as a pole or tree and the other to the weaver's waist. Also called a body-tensioned loom.

bailey The outermost walled courtyard of castle fortifications. Usually the first line of defense, the bailey was bounded on the outer side by a defensive wall such as a palisade.

baldachin A canopy (whether suspended from the ceiling, projecting from a wall, or supported by **columns**) placed over an honorific or sacred space such as a throne or church **altar**.

balustrade A series of short circular posts (called balusters), with a rail on top. Sometimes balusters are replaced by decorated panels or ironwork under the rail.

baptismal font A large open vessel, usually made of stone, containing water for the Christian ritual of baptism.

baptistry A building used for the Christian ritual of baptism. It is usually separate from the main church and often octagonal or circular in shape.

barbican A defensive structure located at the gate to a city or castle. Found close to (or sometimes attached to) the exterior wall, a barbican is usually heavily fortified for the use of guards.

bargeboard A wooden board, often carved in a decorative manner, affixed to the apex of a roof **gable** to conceal or protect the end of a roof timber.

barrel vault *See* **vault**.

bar tracery *See* **tracery**.

base A slab of masonry supporting a statue or the **shaft** of a **column** (also called a **plinth**).

basilica A large rectangular building with an open interior space. Often built with a **clerestory** and side aisles separated from the center space by **colonnades**. Used in Roman times as centers for administration or justice and later adapted to the Christian church. A **basilica-plan** structure incorporates the essential elements of this plan.

basilica plan *See* **basilica**.

bas-relief *See* **relief sculpture**.

battered A building technique used in the construction of stone walls without mortar. For stability, a battered wall is built with a distinct inward slope at the top.

battlement The uppermost, fortified sections of a building or **parapet**, used for military purposes, usually including **crenellated** walls and other defensive structures.

bay One segment of a decorative system of a building. The bays divide the space of a building into regular spatial units and are usually marked by elements such as **columns**, **piers**, **buttresses**, windows, or **vaults**.

beadwork Any decorative elements created with beads. Also: a type of **molding** made from convex circles, often found on furniture.

beehive tomb A type of aboveground burial place

marked by an earthen mound with a rounded, conical shape like a beehive.

Benday dots In modern printing and typesetting, the individual dots which, together with many others, make up lettering and images. Often machine- or computer-generated, the dots are very small and closely spaced to give the effect of density and richness of **tone**.

bevel, beveling A cut made at any angle except a right angle. Also: the technique of cutting at a slant, which creates shadows. Used in architecture, carpentry, printmaking, metalwork, and sculpture.

bi A jade disk with a hole in the center used in China for the ritual worship of the sky. Also: a badge indicating noble rank.

black-figure A decorative style of ancient Greek pottery in which black figures are painted on a red clay background.

blackware An ancient ceramic technique that produced pottery with a primarily black surface. As rediscovered and adapted by Maria Montoya Martinez, a Native American potter in the United States, blackware exhibits alternating **matte** and glossy patterns on the black surfaces of the objects.

blind arcade *See* **arcade**.

blind window The outlining elements of a window applied to a solid wall, often to help create symmetry on a **facade**, but without the actual window opening.

block book A book printed from carved blocks. Common in medieval times, block books were superseded by the invention, about 1450, of printing from movable type. *See also* **movable-type printing**, **woodblock print**.

block printing A printed image, such as a **woodcut** or wood **engraving**, made from a carved wooden block.

bobbin A cylindrical reel around which a material such as yarn or thread is wound when spinning, sewing, or weaving.

bodhisattva A deity that is far advanced in the long process of transforming itself into a buddha. While seeking enlightenment or emancipation from this world (nirvana), bodhisattvas help others attain salvation.

boiserie Wood paneling or wainscoting, usually applied to seventeenth- and eighteenth-century French interiors, where it was often decorated with painting and **relief carving**.

boss A decorative knoblike element. Bosses can be found many places, such as at the intersection of Gothic ceiling or **vault** ribs (and, similarly, at the end of a **molding**) and as buttonlike projections in medieval decorations and metalwork. Also: the projecting ornamental element at the top of a **Corinthian capital**, placed directly underneath the **entablature**.

bracket, bracketing An architectural element that projects from a wall, and that often helps support a horizontal part of a building, such as beams or the eaves of a roof.

breakfast piece A painting depicting a **still life** of plates and food, usually shown in a post-eating disarray. The breakfast piece was popular in Dutch seventeenth-century painting and may have had a *vanitas* significance.

broken pediment *See* **pediment**.

bronze A metal made from copper alloy, usually

mixed with tin. Also: any sculpture or object made from this substance.

bulwark A raised promontory built for the purposes of defense.

buon fresco See **fresco.**

burin A metal instrument used in the making of **engravings** to cut lines into the metal plate. The sharp end of the burin is trimmed to give a diamond-shaped cutting point, while the other end is finished with a wooden handle that fits into the engraver's palm.

bust A portrait sculpture depicting only the head and shoulders of the subject.

buttress, buttressing A type of architectural support. Usually consists of a masonry **pillar** with a wide base built against an exterior wall to brace the wall and strengthen **vaults.** Acts by transferring the weight of the building from a higher point to the ground. Flying buttress: An **arch** built on the exterior of a building that transfers the thrust of the roof vaults at important stress points through the wall to a detached **buttress pier.**

cabinet piece A term often applied to seventeenth-century Dutch art, meaning a small-scale painting executed with a luscious surface and finest detail. The cabinet piece carries the associations of a precious object meant for close scrutiny and leisured appreciation.

caduceus In Classical mythology, the staff carried by the god Hermes. It possessed various powers, including the guarantee of safe passage by any messenger. The caduceus is shaped like a wand with two wings at the top and snakes intertwined around the shaft.

cairn A pile of stones or earth and stones that served both as a prehistoric burial site and as a marker of underground tombs.

calligraph A form of writing with pictures, as in the Chinese language.

calligraphy The art of highly ornamental handwriting.

calotype The first photographic process utilizing negatives and paper positives. It was invented by William Henry Fox Talbot in the late 1830s.

calyx krater *See* **krater.**

came (cames) A lead strip used in the making of leaded or **stained-glass** windows. Cames have an indented vertical groove on the sides into which the separate pieces of glass are fitted to hold the design together.

cameo A gemstone (or, alternatively, a **medium** such as clay, glass, or a shell) carved in low **relief.**

camera obscura An early cameralike device used in the Renaissance and later for capturing images of nature. Made from a dark box (or room) with a hole in one side (sometimes fitted with a lens), the camera obscura operates when bright light shines through the hole, casting an image of an object outside onto the inside wall of the box. This image then can be traced.

campanile The campanile, from the Italian word meaning "bell tower," is usually a freestanding structure found near a church entrance.

canon of proportions A set of ideal mathematical ratios in art, especially sculpture, originally applied by the Egyptians and later the ancient Greeks to measure the various parts of the human body in relation to each other.

capital The sculpted block which tops a **classical column.** According to the conventions of the **orders,** capitals include different decorative elements. For example, a **Composite** capital is one in which the elements from **Ionic** and **Corinthian** orders are mixed.

capriccio A painting or print of a fantastic, imaginary landscape, usually with architecture.

capstone The final, topmost stone in a **corbel arch** or **vault,** which joins the sides and completes the structure.

Caravaggism A style of painting based on the example of the Italian seventeenth-century painter Michelangelo da Caravaggio and popular throughout Europe around 1600–1620. Caravaggist painters are marked by, among other elements, the use of half-length figures, strong **chiaroscuro,** and lower-class types for subjects.

caricature An artwork that exaggerates a person's features or individual peculiarities, usually with humorous or satirical intent.

Caroline minuscule The clear and legible script developed in Carolingian times, using spaces between words and large initials at the beginning of sections of text.

cartoon A full-scale drawing used to transfer the outline of a design onto a surface to be painted (such as a wall, canvas, or **panel).**

cartouche A frame for a **hieroglyphic** inscription formed by a rope design surrounding an oval space. Used to signify a sacred or honored name. Also: in architecture, a decorative device or plaque, usually with plain center and rolled or sculpted edges, used for inscriptions or epitaphs.

caryatid A **column** that supports an **entablature** and that is carved into a sculpture of a draped female figure.

catacomb An underground system of tunnels used by the Romans for burial; also called a **hypogeum.** Urns and busts of the dead were placed in **niches** along the tunnels, which crisscrossed the area under an existing cemetery and often incorporated rooms (**cubiculae**) and several different levels.

cella The principal interior structure at the center of a Greek or Roman temple within which the cult statue was usually housed. Also called the **naos.**

cenotaph A funerary monument commemorating an individual or group buried elsewhere.

centaur In Greek mythology, a creature with the head, arms, and torso of a man and the legs and lower body of a horse.

centering The wooden scaffolding and supports erected in the construction of **vaults, arches,** or **domes.** The centering is a temporary structure, which supports the vault or arch until the mortar is fully dried and the arch is self-sustaining.

central-plan building Any structure designed with a primary central space surrounded by symmetrical areas on each side. Also called a **Greek-cross plan.**

Chacmool In Mayan sculpture, a half-reclining figure, often on a **monumental** scale and carved in a block style. Probably representing fallen warriors, or used for particular religious rites, such Chacmools can be found at Chichen Itza.

chaitya A type of Buddhist temple found in India.

Built in the form of a hall or **basilica,** a chaitya hall is highly decorated with sculpture, and usually carved from a cave or natural rock location. It houses the sacred shrine or **stupa** for worship.

chamfer The slanted surface produced when an angle is trimmed or **beveled,** common in building and metalwork.

château (châteaux) The country house or castle of a French aristocrat. Usually built on a grand scale, châteaux are luxurious homes intended for an elegant lifestyle (although many do incorporate defensive fortifications such as **moats** and towers).

chattri (chattra) A decorative pavilion with an umbrella-shaped **dome** common in Indian architecture.

cherub (cherubim) In painting, the head of an angelic child with wings. Also: in general, any angelic small child, usually depicted naked and with wings.

chevet The easternmost end of a church, including all sections east of the **crossing** (such as the **apse, ambulatory,** and any radiating apsidal chapels).

chevron A decorative **motif** made up of repeated inverted **Vs.**

chiaroscuro An Italian word designating the relative contrast of dark and light in a painting, drawing, or print. Artists use **chiaroscuro** to create spatial depth and volumetric forms through slight gradations in the intensity of light and shadow.

chinoiserie The imitation of Chinese art and style common in the eighteenth century, and related to the lighthearted art of the Rococo period.

chip carving A type of decorative incision, usually made with a knife or chisel, characterized by small geometric patterns and often found on furniture.

chiton A thin sleeveless garment, held in place at waist and shoulders, worn as a gown by men and women in ancient Greece.

choir The section of a church, usually between the **crossing** and the **apse,** where the clergy presides and singers perform.

chromolithography A type of **lithographic** process utilizing color. A new stone is made for each color, and all are printed onto the same piece of paper to create a single, colorful lithographic image.

chronophotography In the mid-nineteenth century, the development of the camera to the point where quick shutter speeds allowed the freezing of motion enabled photographers to use multiple-exposure photographs to analyze movement. Chronophotographs, such as those by Eadward Muybridge, showed the subject against a black background performing a particular action, each frame depicting a different moment in the movement.

Churrigueresque A showy, **painterly** style of Baroque architecture and ornament seen in Spain, Portugal, and Central America, named after the Spanish architect José Benito de Churriguera (1665–1725).

ciborium An honorific pavilion erected in Christian churches to mark places of particularly sacred significance, such as an **altar.** The ciborium usually consists of a domed roof supported by **columns,** all highly decorated. Also: the

receptacle for the **Eucharist** in the Catholic Mass.

circus An oval arena built around a racetrack by ancient Romans and usually enclosed by an extensive **stadium** with raised seats for spectators.

citadel An area of a fortress or defended city placed in a high, commanding spot.

clapboard Horizontal planks used as protective siding for buildings, particularly houses in North America.

Classical A term referring to the art and architecture of the ancient Greeks and Romans.

classical, classicism Any aspect of later art or architecture reminiscent of the rules, canons, and examples of the art of ancient Greece and Rome. Also: in general, any art aspiring to the qualities of restraint, balance, and rational order exemplified by the ancients.

Classical orders *See* **order**.

clerestory The topmost zone of a wall with windows (especially of a church or temple), when it extends above any abutting aisles or secondary roofs. Provides direct light into the central interior space.

cloison *See* **cloisonné**.

cloisonné A technique in **enameled** decoration of metal involving metal wire (**filigree**) that is affixed to the surface in a design. The resulting areas (cloisons) are filled with decorative enamel.

cloister A square or rectangular courtyard, sometime with gardens, surrounded on all sides by a **vaulted arcade**. Typically devoted to spiritual contemplation or scholarly reflection, a cloister is usually part of a monastery, a church, or occasionally, a university.

cloth of honor A piece of fabric, usually rich and highly decorated, hung behind a person of great rank on ceremonial occasions. Signifying the exalted status of the space before it, cloths of honor can be found behind thrones as well as **altars**, or behind representations of holy figures.

codex (codices) A group of **manuscript** pages held together by stitching or other binding on one side.

codex style A style of vase painting derived from the fluid and elegant script of **manuscripts**.

coffer A recessed decorative panel that, with many other similar ones, is used to decorate ceilings or **vaults**. The use of coffers is called coffering.

coiling A technique in basketry. Coiled baskets are made from a spiraling structure of wood to which another material is sewn.

collage A technique in which cutout paper forms (often painted or printed) are pasted onto another surface in a composition. Also: an image created using this technique.

colonnade A sequence or row of **columns**, supporting a straight **lintel** (as in a **porch** or **portico**) or a series of **arches** (an arcade).

colonnette A small columnlike vertical element, usually found attached to a **pier** (with several others) in a Gothic church. Colonnettes are decorative features, and they can reach into the **vaulted** sections of the building, contributing to the vertical effect of a Gothic cathedral.

colophon The data placed at the end of a book, especially a late medieval **manuscript**, listing the

book's author, publisher, **illuminator**, and other information related to its production; sometimes called the imprint.

colossal order *See* **order**.

column An architectural element used for support and/or decoration. Consists of a rounded vertical **pillar** (**shaft**) placed on a raised block (**base**) topped by a larger, usually decorative block (**capital**). Usually built in accordance with the rules of one of the architectural **orders**. Although often **freestanding**, columns can be attached to a background wall, when they are called **engaged**.

column statue A carved image, usually of a religious person but also of **allegorical** or mythological themes, that is attached to a **column** or carved from it.

complementary color A term used to describe an optical phenomenon in color theory. In the color circle, when a **primary color** is juxtaposed with a secondary color (created from a mix of the two other primary colors), the secondary color appears brighter. In this case, the primary color is called the complementary color because it strengthens the secondary color.

Composite order *See* **order**.

composition The arrangement of elements in an artwork.

compound pier Typically found in a Romanesque or Gothic church, a compound pier is a **pier** or large **column** with multiple **shafts**, **pilasters**, or **colonnettes** attached to it on one or all sides.

conch A semicircular recess, such as an **apse** or **niche**, with a half-dome **vault**.

concrete A building material invented by the Romans, which was easily poured or molded when wet, and hardened into a particularly strong and durable stonelike substance. Made primarily from lime, sand, cement, and rubble mixed with water.

cone mosaic A type of decoration of planar surfaces created by pressing colored bits of baked clay or stones into prepared wet plaster.

cong A square or octagonal tube made of jade with a cylindrical hole in the center. A symbol of the earth, it was used for ritual worship and astronomical observations in ancient China.

connoisseurship A term derived from the French word *connaisseur*, meaning "an expert," and signifying the practice of art history based primarily on formal visual and stylistic analysis. A connoisseur studies the **style** and technique of an object with an eye to deducing its relative quality and possible maker. This is done through visual association with other, similar objects and styles the connoisseur has seen in his or her study. *See also* **contextualism**, **formalism**.

content When discussing a work of art, the term can include all of the following: its subject matter; the ideas contained in the work; the artist's intention; and even its meaning for the beholder.

contextualism A methodological approach in art history of recent origin, which focuses on the cultural background of an art object. Unlike connoisseurship, contextualism utilizes the literature, history, economics, and social developments (among others) of a period, as well as the object itself, to inform the meaning of an artwork. *See also* **connoisseurship**.

contrapposto A way of representing the human

body so that its weight appears to be resting on one leg. These observations were translated into sculpture during the ancient Greek age, when sculptors adopted a great degree of **naturalism** in their works.

corbel, corbeling Early roofing technique in which each **course** of stone projects inward slightly over the previous layer (a corbel) until all sides meet. Results in a high, narrowly pointed **arch** or **vault**. A corbel table is a table supported underneath by corbels.

corbel arch *See* **arch**.

corbel vault *See* **vault**.

Corinthian order *See* **order**.

cornice The uppermost section of a **Classical entablature**. More generally, any horizontally projecting element of a building, usually found at the top of a wall or a **pedestal**. A raking cornice is formed by the junction of two slanted cornices, most often found in **pediments**.

course A horizontal layer of stone used in building.

cove A concave **molding** or area of ceiling where a wall and ceiling converge. A cove ceiling incorporates such moldings on all sides.

cove ceiling *See* **cove**.

crenellation A pattern of open notches built into the top **parapets** and **battlements** of many fortified buildings for the purposes of defense.

crocket A leaflike decorative element found in Gothic architecture, often on **pinnacles**, **gables**, and the open surfaces of roofs. A crocket is shaped like an open leaf which gently curves outward, its edges curling up.

cromlech In prehistoric architecture, a circular arrangement of **menhirs**.

cross vault *See* **vault**.

cross-hatching A technique primarily used in printmaking and drawing, in which a set of parallel lines (hatching) is drawn across a previous set, but from a differing (usually right) angle. Cross-hatching gives a great density of **tone**, and allows the artist to create the illusion of shadows efficiently.

crossing The part of a cross-shaped church where the **nave** and the **transept** meet, often marked on the exterior by a tower or **dome**.

cruciform A term describing anything that is cross-shaped, as in the cruciform **plan** of a church.

crypt The **vaulted** underground space beneath the floor of a church, usually at the east end, which contains tombs and relics.

cubiculum (cubicula) A private chamber for burial in the **catacombs**. The **sarcophagi** of the affluent were housed there in arched wall **niches**.

cuneiform writing An early form of writing with wedge-shaped marks, impressed into wet clay with a **stylus**, primarily by ancient Mesopotamians.

curtain wall A wall in a building that does not support any of the weight of the structure. Also: the freestanding outer wall of a castle, usually encircling the inner **bailey** and **keep**.

cycle A series of paintings, **frescoes**, or **tapestries** depicting a single story or theme and

intended to be displayed together.

cyclopean construction Any large-scale, **monumental** building project that impresses by sheer size. Based on Greek myth of giants of legendary strength. Also: a prehistoric method of building, utilizing megalithic blocks of rough-hewn stone.

cylinder seal A small cylindrical stone decorated with **incised** patterns. When rolled across soft clay or wax, a raised pattern or design (**relief**) is left, which served in Mesopotamian times as an identifying signature.

dado (dadoes) The lower part of a wall, differentiated in some way (by a **molding** or different color) from the upper section. Also: the part of a **pedestal** between the **base** and the **cornice**, usually constructed of plain stone without decoration.

daguerrotype An early photographic process invented and marketed in 1839 by Louis-Jacques Mondé Daguerre. The first practically possible photographic system, a daguerrotype was a positive print made onto a light-sensitized copperplate.

Day-Glo A trademark name for fluorescent materials.

Deesis In Byzantine art, the representation of Christ (usually enthroned or in a **hieratic** pose) flanked by the Virgin Mary and Saint John the Baptist.

demotic writing An informal script developed under the ancient Greeks in about the eighth century BCE, and used exclusively for nonsacred texts.

dentil Small, toothlike blocks arranged in a continuous band to decorate a **Classical entablature**.

diorama A large painting made to create an environment giving the viewer the impression of being at the site depicted. Usually hung on several walls of a room and specially lit, the diorama was a popular attraction in the nineteenth century, and could be exhibited with sculpted figures.

dipteral A term that describes a building with a double **peristyle**, that is, surrounded by two rows of **columns**.

diptych A form created when two images (usually paintings on **panel** or **reliefs**) are hinged together.

dogu Small human figurines made in Japan during the Jomon period. Shaped from clay with exaggerated expressions and in contorted poses, *dogu* were probably used in religious rituals.

dolmen A prehistoric structure made up of two or more large (often upright) stones supporting a large, flat, horizontal slab or slabs (called **capstones**).

dome A round **vault**, usually over a circular space. Consists of the supporting vertical wall (**drum**), from which the vault springs, and a curved masonry vault of shapes and cross sections that can vary from hemispherical to bulbous to **ovoidal**. Usually crowned by an open space (**oculus**) and/or an exterior **lantern**. When a dome is built over a square space, an intermediate element is required to make the transition to a circular drum. There are two types: A dome on **pendentives** incorporates sloping intermediate sections of wall at the upper corners of the space (called pendentives) to spread the weight of the dome evenly. A dome on

squinches uses an **arch** built into the wall (squinch) in the upper corners of the space to carry the weight of the dome across the corners of the square space below.

donjon *See* **keep**.

Doric order *See* **order**.

dormer A vertical window built into a sloping roof. A dormer window has its own roof and side panels that adjoin the body of the roof proper.

dressed stone A highly finished, precisely cut block of stone. When laid with others in even **courses**, dressed stone creates a uniform face with fine joints. Most often used as a facing on the visible exterior of a building, especially as a **veneer** for the **facade**. Also called **ashlar**.

drillwork In sculpture, the decorative effect created by the use of the drill. Also: the technique of using a drill for the creation of certain effects in sculpture.

drum The wall that supports a **dome**. Also: a segment of the circular **shaft** of a **column**.

drypoint An **intaglio** printmaking process by which a metal (usually copper) plate is directly inscribed by means of a pointed instrument (**stylus**). The resulting design of scratched lines is inked, wiped, and printed. Also: the print made by this process.

earthworks Artwork and/or sculpture, usually on a large scale, created by manipulating the natural environment.

easel painting Any painting of small to intermediate size that can be executed on an artist's easel.

echinus A cushionlike circular slab found below the **abacus** of a Doric capital. Also: a similarly shaped **molding** (usually with **egg-and-dart motifs**) underneath the **volutes** of an **Ionic capital**.

edition A single printing of a book (or print). An edition can be of differing numbers but includes only the objects printed at a particular moment (and usually pulled from the same press by the same publisher).

egg-and-dart A decorative **molding** made up of an alternating pattern of round (egg) and downward-pointing tapered (dart) elements.

elevation The arrangement, proportions, and details of any vertical side or face of a building. Also: an architectural drawing showing an exterior or interior wall of a building. A building's main elevation is usually its **facade**.

emblema (emblemata) In a **mosaic**, the elaborate central **motif** in a floor, usually a self-contained unit done in a more refined manner, with smaller **tesserae** of both marble and semi-precious stones. Also: an object or action represented in painting, prints, and drawings as a symbol for an idea, action, or other subject (as in an **allegory**). Emblemata are commonly associated with seventeenth-century Dutch art.

emblem book A collection of individual symbolic images, often concerning a single theme, and published with texts or verse. These books were sometimes used by artists as a source of inspiration. They were especially popular as literature in the Netherlands and England during the sixteenth and seventeenth centuries.

embossing *See* **repoussé**.

embroidery The technique in needlework of decorating fabric by stitching designs and figures of colored threads of fine material (such as silk) into another material (such as cotton, wool, leather, or paper). Also: the material produced by this technique.

emotionalism Any aspect of art that appeals overtly to sentimentality, melodrama, excitement, or other strong emotion.

enamel A technique in which powdered glass is applied to a metal surface in a decorative design. After firing, the glass forms an opaque or transparent substance that is fused with the metal background. Also: an object created with enamel technique.

encaustic A type of painting technique utilizing pigments mixed with a **medium** of hot wax. Encaustic paintings were typically made in ancient times, particularly in Egypt.

engaged column *See* **column**.

engraving The process of inscribing an image, design, or letters onto a metal or wood surface from which a print is made. An engraving is usually drawn with a sharp implement (**burin**) directly onto the surface of the plate. Also: the print made from this process.

entablature In the **Classical orders**, the horizontal elements above the **columns** and **capitals**. The entablature consists of, from top to bottom, a **cornice**, **frieze**, and **architrave**.

entasis A slight bulge built into the **shaft** of a Greek **column**. The optical illusion of entasis makes the column appear from afar to be consistent and straight from end to end.

etching An **intaglio** printmaking process, in which a metal plate is coated with acid-resistant resin and inscribed with a **stylus** in a design, revealing the plate below. The plate is then immersed in acid, and the design of exposed metal is eaten away by the acid. The resin is removed, leaving the design etched permanently into the metal and the plate ready to be inked, wiped, and printed.

Eucharist The Christian ritual marking the Last Supper of Jesus. It is celebrated as a Mass, also known as Holy Communion, in which bread, symbolizing the body of Jesus, and wine, symbolizing his blood, are consumed.

exedra (exedrae) In architecture, a semicircular **niche**. On a small scale, often used as decoration, whereas larger exedrae can form interior spaces (such as an **apse**).

expressionism, expressionistic Terms describing a work of art in which forms are created primarily to evoke subjective emotions rather than to portray objective reality.

extrados The uppermost, curving surface of a **vault** or **arch**.

facade The face or front wall of a building, usually including the main **elevation**.

faience A **glazing** technique for ceramic vessels, utilizing a glass paste that, upon firing, acquires a lustrous shine and smooth texture.

faktura An idea current among Russian Constructivist artists and other Russian artists of the early twentieth century that referred to the inherent forms and colors suitable to different materials. Used primarily in their mixed-medium constructions of a **nonrepresentational** type,

faktura focused the artists' attention on the manner in which different materials create a variety of effects.

fang ding A square or rectangular bronze vessel with four legs. The *fang ding* was used for ritual offerings in ancient China during the Shang dynasty.

fête galante A subject in painting depicting well-dressed people at leisure in a park or country setting. It is most often associated with eighteenth-century French Rococo painting and the work of Antoine Watteau.

filigree Thin strips of metal used in **cloisonné enamel** and **openwork** decoration.

finial A knoblike architectural decoration usually found at the top points of a spire, **pinnacle**, canopy, or **gable**. Also found on furniture.

flower piece Any painting with flowers as the primary subject. **Still lifes** of flowers became particularly popular in the seventeenth century in the Netherlands and Flanders.

fluting In architecture, a decorative pattern of evenly spaced parallel vertical grooves incised on **shafts** of **columns** or columnar elements (such as **pilasters**).

flying buttress *See* **buttress**.

folio In technical bookmaking terms, a large sheet of paper, which, when folded and cut, becomes four separate pages in a book. Also: a page or leaf in a large-scale **manuscript** or book; more generally, any large book.

foreground Within the depicted space of an artwork, the area that is closest to the **picture plane**.

foreshortening The illusion created on a flat painted or drawn surface in which figures and objects appear to recede or project sharply into space. Often accomplished according to the rules of **perspective**.

form In speaking of a work of art or architecture, the term refers to purely visual components: line, color, shape, texture, mass, spatial qualities, and **composition**—all of which are called formal elements.

formal elements *See* **form**.

formalism, formalist An approach to the understanding, appreciation, and valuation of art based almost solely on considerations of **form**. This approach tends to regard an artwork as independent of its time and place of making.

formline In Native American works of art, a line that defines a space.

forum The central square of a Roman town, often used as a market or gathering area for the citizens. Site of most community temples and administrative buildings.

freestanding column *See* **column**.

fresco A painting technique in which pigments are applied to a surface of wet plaster (called *buon fresco*). *Fresco secco* is created by painting on dried plaster. Wall murals made by both these techniques are called frescoes.

fresco secco *See* **fresco**.

frieze The flat middle layer of an **entablature**, between the **architrave** and the **cornice**. Usually decorated with sculpture, painting, or **moldings**. Also: any continuous flat band with **relief sculpture** or painted decorations.

fritware A type of pottery made from a mix of white clay, quartz, and other chemicals that, when fired, produces a very brittle substance.

frontispiece An illustration opposite or preceding the title page of a book. Also: the primary **facade** or main entrance **bay** of a building.

frottage A design produced by laying a piece of paper over a **relief** or **incised** pattern and rubbing with charcoal or other soft **medium**.

fusuma Sliding doors covered with paper, used in an East Asian house. Fusuma are often highly decorated with paintings and colored backgrounds.

gable The triangular wall space found on the end wall of a building between the two sides of a pitched roof. Also: a triangular decorative panel that has a gablelike shape.

gadrooning A form of decoration most frequently found on architecture and in metalwork, characterized by sequential convex **moldings** that curve around a circular surface.

galleria A long room, usually above the ground floor in a large residence, used for entertainment and sometimes to display paintings. In English, gallery.

gallery In church architecture, the story found above the side aisles of a church, usually open to and overlooking the **nave**. In a large church, such as a cathedral, the gallery may also be used as a corridor. Also: in secular architecture, a long room in a private house or a public building for exhibiting pictures or promenading.

garbhagriha From the Sanskrit word meaning "womb chamber," a small room or shrine in a Hindu temple containing a holy image.

genre A type or category of artistic form, subject, technique, **style**, or **medium**. Also: a subject in art representing scenes of daily life. *See also* **genre painting**.

genre painting A term used to loosely categorize paintings depicting scenes of everyday life, including (among others) domestic interiors, merry companies, inn scenes, and street scenes.

geoglyphs Earthen designs on a colossal scale, often created in a landscape as if to be seen from an aerial viewpoint.

geometric A term describing Greek art, especially pottery, from about 1100 to 600 BCE and characterized by patterns of rectangles, squares, and other **abstract** shapes. Also: any **style** or art using primarily these shapes.

gesso A thick **medium** usually made from glue, gypsum, and/or chalk and often forming the ground, or priming layer, of a canvas. A gesso ground gives a smooth surface for painting and seals the absorbency of the canvas.

gesturalism The motivation behind painting and drawing in which the brushwork or line visibly records the artist's physical gesture at the moment the paint was applied or the lines laid down. Associated especially with **expressive styles**, such as European Baroque, Zen painting, and Abstract Expressionism.

gilding The application of paper-thin **gold leaf** to an object made from another **medium** (for example, a sculpture or painting). Usually used as a decorative finishing detail.

giornata Adopted from the Italian term meaning "a day's work," a *giornata* is the section of a **fresco** plastered and painted in a single day.

glaze *See* **glazing**.

glazing In ceramics, a method of treating earthenwares with an outermost layer of vitreous liquid (glaze) that, upon firing, renders waterproof and decorative surface. In painting, a technique particularly used with oil **mediums** in which a transparent layer of paint (glaze) is laid over another, usually lighter, painted or glazed area.

gloss A type of clay **slip** used in ceramics by ancient Greeks and Romans that, when fired, imparts a colorful sheen to the surface.

golden section A linear measurement said to be of ideal proportions, supposedly discovered by the ancient Greeks. When the measurement is divided into two, the smaller part is the same proportion to the larger as the larger is to the whole.

gold leaf The paper-thin sheets of hammered gold that are used in **gilding**. In some cases (such as Byzantine **icons**), also used as a ground for paintings.

Good Shepherd The representation in art of Jesus with a sheep around his shoulders or at his side, based on the biblical parable of the Good Shepherd.

gopura The towering gateway to an Indian Hindu **temple complex**. A temple complex can have several different *gopuras*.

gouache A type of opaque **watercolor** that has a distinct, chalky effect.

graffiti Imposed on public structures by anonymous persons, graffiti usually consists of drawings and/or text of an obscene, political, or violent nature, and can be found in all periods and all **mediums**.

Grand Manner A grand and elevated style of painting popular in the Neoclassical period of the eighteenth century. An artist working in the Grand Manner looked to the ancients and to the Renaissance for inspiration; for portraits as well as **history painting**, the artist would adopt the poses, **compositions**, and attitudes of Renaissance and antique models.

granulation A technique for decorating gold in which tiny balls of the precious metal are fused to the main surface in a pattern.

graphic arts A term referring to those branches of the arts that utilize paper as primary support. The graphic arts, whether drawn, typeset, or printed, often have a heavy emphasis on **linear** means of expression.

graphic design A concern in the visual arts for geometric shape, line, and two-dimensional patterning, often especially apparent in works including typography and lettering.

Greek-cross plan *See* **central plan**.

Greek-key pattern *See* **meander**.

grid A system of regularly spaced horizontally and vertically crossed lines that gives regularity to an architectural **plan**. Also: in painting, use of a grid enables designs to be enlarged or transferred easily. *See also* **cartoon**.

griffin A creature with the head, wings, and claws of an eagle and the body and hind legs of a lion.

grisaille A painting executed primarily in various tones of gray.

groin vault *See* **vault**.

groundline The solid baseline that indicates the ground plane of an image, on which the figures stand. In ancient representations, such as those of the Egyptians, the figures and objects are placed on the groundline without reference to their actual spatial relationships.

grout A soft cement placed between the **tesserae** of a **mosaic** to hold the design together. Also used in tiling.

guild The association of craftspeople in a particular town, established during medieval times. The guild had great political power, as it controlled the selling and marketing of its members' products, and it provided economic protection, political solidarity, and training in the craft to its members. The artists' guild was usually dedicated to Saint Luke, the patron saint of artists.

half-barrel vault *See* **quadrant vault**.

half-timber construction A method of building utilized in the sixteenth and seventeenth centuries, particularly in northern European areas, for vernacular structures. Beginning with a timber framework built in the **post-and-lintel** manner, the builder constructed walls between the timbers with bricks, mud, or **wattle**. The exterior could then be faced with plaster or other material.

hall church A church (typified by those in the Gothic style in Germany), with a **nave** and aisles that are all the same height, giving the impression of a large, open hall.

halos An outdoor pavement used by ancient Greeks for ceremonial dancing.

handscroll A long, narrow, horizontal painting or text (or combination thereof) common in Chinese and Japanese art, and of a size intended for individual use. A handscroll is stored wrapped tightly around a wooden pin and is unrolled for viewing or reading.

hanging scroll In Chinese and Japanese art, a vertically oriented painting or text mounted within sections of silk. At the top is a semicircular rod; at the bottom is a round dowel. Hanging scrolls are kept rolled and tied except for special occasions, when they are hung for display, contemplation, or commemoration.

haniwa Pottery figures that were placed on top of Japanese tombs or burial mounds.

happening A type of art form incorporating performance, theater, and visual images, developed in the 1960s. A happening was organized without a specific narrative or intent; with audience participation, the event proceeded according to chance and individual improvisation.

header In building, a brick laid so that the end, rather than the side, forms the face of the wall.

heliograph A type of early photograph created by the exposure to sunlight of a plate coated with light-sensitive asphalt.

hemicycle A semicircular interior space or structure.

henge A circular area enclosed by stones or wood posts set up by Neolithic peoples. It is usually bounded by a ditch and raised embankment.

herm A statue that has the head and torso of a human, but the lower part of which is a plain, tapering **pillar** of rectangular shape. Used primarily for architectural decoration.

hieratic In painting and sculpture, when the concern for spiritual over material values results in a **formalized**, grand style for representing sacred or priestly figures. Can also be seen in the use of different scales for holy figures and those of the everyday world.

hieroglyphic An alphabet of phonetic signs rendered in the form of pictorial symbols, utilized primarily for sacred names and ceremonial inscriptions (**cartouches**) by the ancient Egyptians.

high relief *See* **relief sculpture**.

himation In ancient Greece, a garment wrapped around the body, with a rectangular piece of cloth thrown over the shoulder. Worn by both men and women.

historicism A nineteenth-century consciousness of and attention to the newly available and accurate knowledge of the past, made accessible by historical research, textual study, and archeology.

history painting The term used to denote those paintings that include figures in any kind of historical, mythological, or biblical narrative. Considered since the Renaissance (until the twentieth century) as the noblest form of art, history paintings generally convey a high moral or intellectual idea, and often adopted a grand pictorial style.

hollow-casting *See* **lost-wax casting**.

horizon line A horizontal "line" formed by the actual or implied meeting point of earth and sky. In scientific **perspective**, the **vanishing point** or points are located on this line.

horseshoe arch *See* **arch**.

house-church In early Christian times, any small and relatively secret church, usually located in a private home.

house-synagogue A Jewish place of worship located in a private home.

hue The shade of a color, as opposed to its brightness or saturation.

hydria A large ancient Greek and Roman jar with three handles (horizontal ones at both sides and one vertical at the back), used for storing water.

hypogeum (hypogea) *See* **catacomb**.

hypostyle hall In ancient Egyptian architecture, a large interior gathering room of a **temple complex** that precedes the **sanctuary.** Marked by numerous rows of tall, closely spaced **columns**.

icon A **panel painting** representing a sacred figure of the Eastern Orthodox Church according to ancient established pictorial conventions.

iconoclasm Any movement that prescribes the banning or destruction of images. Historically iconoclasm has occurred primarily as a result of different opinions about the function and purpose of imagery in religion.

iconography In the visual arts, the study of the subject matter of a representation and its meaning.

iconology The study of the significance and interpretation of the subject matter of art. Iconology often incorporates contextual evidence regarding traditions of representation of specific subjects to aid in understanding.

iconostasis The wall or screen in an Early Christian or Greek Orthodox church between the **sanctuary** (where the Mass was performed) and the body of the church (where the congregation assembled). The iconostasis was usually hung with **icons**.

idealization A process in art through which artists strive to make their forms and figures attain perfection, based on pervading cultural values or their own mental image of what the ideal is.

ideograph A **motif** or written character that expresses an idea or symbolizes an action in the world. It is distinct from a **pictograph**, which symbolizes or represents an actual object, person, or thing. Egyptian **hieroglyphs** and Chinese **calligraphs** are examples of writing which consist of both ideographs and pictographs.

ignudi A nude male figure, particularly those found on Michelangelo's Sistine Ceiling.

illumination A painting on paper or **parchment** used as illustration and/or decoration for **manuscripts** or **albums**. Usually done in rich colors, often supplemented by gold and other precious materials. The illustrators are referred to as illuminators. Also: the technique of decorating manuscripts with such paintings.

illusionism, illusionistic An appearance of reality in art created by the use of certain pictorial means, such as **perspective** and **foreshortening**. Also: the quality of having this type of appearance.

impost, impost block A decorative block imposed between the **capital** of a **column** and the springing of an **arch** above.

impression Any single printing of an **intaglio** print (**engraving** or **etching**). Each and every impression of a print is by nature different, given the possibilities for variation inherent in the printing process, which requires the plate to be inked and wiped between every impression.

in antis Term used to describe the position of **columns** set between two walls, as in a **portico** or a **cella**.

incising A technique in which a design or inscription is cut into a hard surface with a sharp instrument.

ink painting A style of painting developed in China using only monochrome colors, usually black ink with gray **washes**. Ink painting was often used by artists in the **literati painting** style and is connected with Zen Buddhism.

inlay A decorative process in which pieces of one material are set into the surface of an object fashioned from a different material.

intaglio Term used for a technique in which the design is carved out of the surface of an object, such an engraved seal stone. In the graphic arts, intaglio includes **engraving**, **etching**, and **drypoint**, all processes in which ink transfers to paper from incised, ink-filled lines cut into a metal plate.

intarsia The decoration of wood surfaces with **inlaid** designs created of contrasting materials, such as metal, shell, and ivory.

interlace A type of **linear** decoration particularly popular in Celtic art, in which ribbonlike bands are **illusionistically** depicted as if woven under and over one another.

intrados The curving inside surface of an **arch** or **vault**.

intuitive perspective *See* **perspective**.

Ionic order *See* **order**.

isometric projection A building diagram that represents graphically the parts of a building. Isometric projections have all planes of the building parallel to two established vertical and horizontal axes. The vertical axis is true, while the horizontal is drawn at an angle to show the effect of recession. All dimensions in an isometric drawing are proportionally correct. *See also* **plan**, **section**.

iwan A large, **vaulted** chamber in a **mosque** with a **monumental arched** opening on one side.

jamb In architecture, the vertical element found in pairs on both sides of an opening in a wall, such as a door or window.

japonisme A style in American nineteenth-century art that was highly influenced by Japanese art, especially prints.

joined-wood sculpture A method of constructing large-scale wooden sculpture developed by Japanese craftspeople. The entire work is constructed from smaller hollow blocks, each individually carved, and assembled when complete. The joined-wood technique allowed the production of larger sculpture, as the multiple joints alleviate the problems of drying and cracking found with sculpture carved from a single block.

ka The name given by ancient Egyptians to the human life force, or spirit.

kantharos A type of Greek vase or goblet with two large handles and a wide mouth.

keep The most heavily fortified defensive structure in a castle, usually built in the form of a tower and located at the heart of the castle complex.

kente A woven cloth made by the Ashanti peoples of Africa. *Kente* cloth is woven in long, narrow pieces with a complex and colorful pattern, which are then sewn together.

key block A key block is the master block in the production of a colored **woodcut**, which requires different blocks for each color. The key block is a flat piece of wood with the entire design carved or drawn on its surface. From this, other blocks with partial drawings are made for printing the areas of different colors.

keystone The topmost **voussoir** at the center of an **arch**, usually last to be placed. The pressure of this block holds the arch together. Often of a larger size and/or highly decorated.

kiln An oven designed to produce enough heat for the baking, or firing, of clay.

kiva The room in a Native American pueblo used for community gatherings and rituals.

kondo The main hall inside a Japanese Buddhist temple where the images of Buddha are housed.

kore An archaic Greek statue of a young woman.

kouros An archaic Greek statue of a young man or boy.

krater An ancient Greek vessel for mixing wine and water, with many subtypes that each have a distinctive shape. **Calyx krater**: a bell-shaped vessel with handles near the base that resemble a flower calyx. **Volute krater**: a type of krater with handles shaped like scrolls.

kylix A shallow Greek vessel or cup, used for drinking, with a wide mouth and small handles near the rim.

lacquer A type of hard, glossy surface varnish used on objects in East Asian cultures. Lacquer can be layered and manipulated or combined with pigments and other materials for various decorative effects.

lakshana Term used to designate the thirty-two marks of the Buddha. These characteristics of the historical Buddha have come to be part of the **iconography** of the Buddha in general. The *lakshana* includes, among others, the Buddha's golden body, his long arms, the wheel impressed on his palms and the soles of his feet, and his elongated earlobes.

lancet A tall narrow window crowned by a sharply pointed **arch**, typically found in Gothic architecture.

landscape architecture Any design for an outdoor space.

landscape painting A painting in which a natural outdoor scene or vista is the primary subject.

lantern A cylindrical turretlike structure situated on top of a **dome**, with windows that allow light into the space below.

Latin-cross plan A cross-shaped building **plan**, incorporating one longer stem (**nave**) and three arms of equal length. The common form for a Christian church, popular both for practical liturgical reasons and for the symbolic resemblance of the plan to the shape of the cross on which Christ was crucified.

lectionary An ecclesiastical book. A lectionary is part of the fittings of a church and contains readings from Christian Scripture. It is the book from which the officiant reads to the congregation during holy services.

lekythos A slim Greek oil vase with one handle and a narrow mouth.

limner The name used to denote an artist, particularly a portrait painter, in England during the sixteenth and seventeenth centuries and in New England during the eighteenth and nineteenth centuries.

linear, linearity A descriptive term indicating an emphasis on line, as opposed to mass or color, in art.

linear perspective *See* **perspective**.

lingam shrine A place of worship centered on an object or representation in the form of a phallus (the lingam), which symbolizes the power of the Hindu god Shiva.

lintel A horizontal element of any material carried by two or more vertical supports to form an opening.

list An open section of the grounds of a fortified building or castle, usually in the **bailey**, that was set aside for knightly combat.

literary illustration An image or artwork with a subject or content drawn from a literary source.

literati *See* **literati painting**.

literati painting A style of painting that reflects the taste of the educated class of East Asian intellectuals and scholars. Aspects include an appreciation for the antique, smaller scale, and an intimate connection between maker and audience.

lithograph A print made from a design drawn on a flat stone block with greasy crayon. Ink is applied to the stone, and when printed, adheres only to the open areas of the design. *See also* **chromolithography**.

loculus (loculi) A **niche** in a tomb or **catacomb** in which a **sarcophagus** was placed.

loggia Italian term for a covered open-air **gallery**. Often used as a corridor between buildings or around a courtyard, loggia usually have **arcades** or **colonnades** on the exterior side.

lost-wax casting A method of casting metal, such as **bronze**, by a process in which a wax mold is covered with clay and plaster, then fired, melting the wax and leaving a hollow form. Molten metal is then poured into the hollow space and slowly cooled. When the hardened clay and plaster exterior shell is removed, a solid metal form remains to be smoothed and polished.

low relief *See* **relief sculpture**.

lozenge A decorative **motif** in the shape of a diamond.

lunette A semicircular wall area, framed by an **arch** over a door or window. Can be either plain or decorated with **reliefs**.

lusterware A type of ceramic pottery decorated with colorful metallic **glazes**.

madrasa An Islamic institution of higher learning, where teaching is focused on theology, law, and the sciences.

maenad In ancient Greece, a female devotee of the wine god Dionysos who participated in orgiastic rituals. She is often depicted with swirling drapery and a tambourine. More generally, a mad or frenzied woman. (Also called a Bacchante, after Bacchus, the Roman name of Dionysos.)

majolica Pottery painted with a tin **glaze** that, when fired, gives a lustrous and colorful surface.

maki-e In Japanese art, the effect achieved by sprinkling gold or silver powder on successive layers of **lacquer** before each layer dries.

mandala An image of the cosmos represented by an arrangement of circular or concentric geometric shapes containing diagrams or images. Used for meditation and contemplation, mandalas are most often found in Buddhist temples.

mandapa In a Hindu temple, an open hall dedicated to ritual worship.

mandorla An almond- or womb-shaped area in which a sacred figure, such as Christ in Heaven, is represented.

manifesto A written declaration of an individual or group's ideas, purposes, and intentions.

manuscript A handwritten book or collection of handwritten documents.

maqsura A separate enclosure in a Muslim **mosque** near the **mihrab**, designated for dignitaries.

martyrium (martyria) A sacred place in Catholic churches where the relics of martyrs are buried, often marked by shrines for worship.

mastaba A flat-topped, one-story building with

slanted walls. Invented by the ancient Egyptians to mark underground tombs.

mathematical perspective *See* **perspective**.

matte A surface that is smooth but without shine or luster.

mausoleum A **monumental** building used as a tomb. Named after the tomb of Mausolos erected at Halikarnassos around 350 BCE.

meander A type of two-dimensional ornament made up of intertwined **geometric motifs** and often used as a decorative border. Also called **Greek-key pattern**.

medallion In architecture, any round ornament or decoration. Also: a large medal.

medium (mediums) In general, the material from which any given object is made. In painting, the liquid substance in which pigments are suspended to create paint.

megaron The main hall of a Mycenaean palace or grand house. Usually of a rectangular shape, and sometimes subdivided into two unequal spaces by **columns**.

memento mori From Latin terms meaning "reminder of death." An object, such as a skull or extinguished candle, typically found in a *vanitas* image, symbolizing the transience of life.

menhir A megalithic stone block, placed by prehistoric peoples in an upright position.

menorah A Jewish lamp, usually in the form of a candelabrum, divided into seven or nine branches; the nine-branched menorah is used during the celebration of Hanukkah. Representations of the seven-branched menorah, once used in the Temple of Jerusalem, became in general a symbol of Judaism.

mensa The blocklike table serving as the **altar** in a Christian church.

metope The rectangular spaces, sometimes decorated but often plain, between the **triglyphs** of a Doric frieze.

mezzanine Any intermediate story of a building, inserted between two stories of regular size.

middle ground Within the depicted space of an artwork, the area that takes up the middle distance of the image. *See also* **foreground**, **background**.

mihrab A recess or **niche** that distinguishes the wall oriented toward Mecca (**qibla**) in a **mosque**.

minaret A tall slender tower on the exterior of a **mosque** from which believers are called to prayer.

minbar A high platform or pulpit in an Islamic mosque.

miniature A small-scale painting. Miniatures have a variety of uses, from illustrations within **albums** or **manuscripts** to intimate portraits.

mirador A three-sided balcony common in Spanish and Islamic palace architecture. The mirador usually has windows on the three sides, and is found overlooking gardens or courtyards.

mithuna The amorous male and female couples in Buddhist sculpture, usually found in the entrance to a sacred building. The *mithuna* symbolize the harmony and fertility of life.

moat A large ditch or canal dug around a castle or fortress for military defense. When filled with water, the moat protects the walls of the building from direct attack.

modeling In painting, the process of creating the illusion of three-dimensionality on a two-dimensional surface by use of light and shade. In sculpture, the process of molding a three-dimensional form out of a malleable substance.

module A segment or portion of a repeated design.

molding A shaped or sculpted strip with varying contours and patterns. Used as decoration on architecture, furniture, frames, and other objects.

monolith Tall **monumental** wall-like **pillars** used for commemoration and sacred ritual. Monoliths are often capped with sculpture and decorated on the sides.

Monophysitism The Christian doctrine stating that Jesus Christ has only one nature, and that it is partly divine and partly human.

monoprint A single print pulled from a hard surface (such as a blank plate or stone) that has been prepared with a painted design. Each print is an individual artwork, as the original design is a transient one, lost in the printing process.

monumental A term used to designate a project or object that, whatever its physical size, gives an impression of grandeur, excellence, and simplicity.

mortise-and-tenon joint A method of joining two elements. A projecting pin (tenon) on one element fits snugly into a hole designed for it (mortise) on the other. Such joints are very strong and flexible.

mosaic A method of creating designs with small colored stone or glass pieces (**tesserae**), which are affixed to a cement surface.

mosque An edifice dedicated to communal Muslim worship.

motif Any discrete element of a design or **composition**, often referring to those that can be easily separated from the whole for the purposes of copying or study.

movable-type printing A method of printing text in which the individual letters, cast on small pieces of metal (die), are assembled into words on a mechanical press. When each edition was complete, the type could be reused for the next project. Movable-type printing, invented around 1450, revolutionized the printing industry in Europe and allowed the large-scale dissemination of affordable books.

mudra A symbolic hand gesture in Indian art. The many different mudras each denote certain behaviors, actions, or feelings.

mullion A slender vertical element or **colonnette** that divides a window into subsidiary sections.

multiculturalism A policy of inclusion of all cultures and ethnicities in a society or civilization.

multiple-point perspective *See* **perspective**.

muqarna The geometric patterning used in Islamic architecture to smooth the transition between decorative flat and rounded surfaces; usually found on the **vault** of a **dome**.

mural Any painting done directly on a wall.

naos *See* **cella**.

narthex The rectangular vestibule at the main (usually western) entrance of a church. In Early Christian architecture, it can also be an entrance **porch** with **columns** on the outside of a church.

naturalism, naturalistic A style of depiction in which the physical appearance of the rendered image in nature is the primary inspiration. A naturalistic work appears to resemble visible nature.

nave The long central space of a Christian church, usually rectangular in shape and often separated from the side aisles by **colonnades**.

necking On a **column**, the **molding** or cluster of moldings between the column **shaft** and the **capital**.

necropolis A large cemetery or burial area.

negative space Empty or open space within or bounding a painting, sculpture, or architectural design. Negative space emphasizes the overall form of the work.

niche A hollow or recess in a wall or other solid architectural element. Niches can be of varying size and shape, and may be intended for many different uses, from display of objects to housing of a tomb.

niello An **inlay** technique in which a black sulphur alloy is rubbed into fine lines **engraved** into a metal (usually gold or silver). The alloy becomes fused with the surrounded metal when heated, and provides contrasting detail.

nishiki-e A multicolored and ornate Japanese print.

nocturne A night scene in painting, usually lit by artifical illumination.

nonfinito An Italian term designating the unfinished effect used by Michelangelo in his sculpture to enliven and give texture to marble surfaces.

nonrepresentational A term describing any artwork of an **abstract** nature. Nonrepresentational art does not attempt to reproduce the appearance of the natural world.

obelisk A tall stone **shaft** of four-sided rectangular shape, hewn from a single block, that tapers at the top and is completed by a **pyramidion**. Erected by the ancient Egyptians in ceremonial spaces (such as entrances to **temple complexes**) as commemorative monuments.

oblique perspective *See* **perspective**.

oculus (oculi) In architecture, a circular opening. Oculi are usually found either as windows or at the **apex** of a **dome**. When at the top of a dome, it is either open to the sky or covered by a decorative exterior **lantern**.

odalisque A subject in painting of a reclining female nude, usually shown with the accoutrements of an exotic, haremlike environment.

ogival arch *See* **arch**.

oil painting Any painting executed with the pigments floating in a **medium** of oil. Oil paint has particular properties that allow for greater ease of working (among others, a slow drying time, which allows for corrections, and a great range of relative opaqueness of paint layers, which permits a high degree of detail and luminescence). It

was adopted on a wide scale in Europe after about 1450.

oil sketch An oil painting, usually on a small scale, intended as a preliminary stage for the production of a larger work. Oil sketches are often very **painterly** in technique.

oinoche A Greek wine jug with a round mouth and a curved handle.

olpe Any Greek vase or jug without a spout.

one-point perspective *See* **perspective**.

openwork Decoration, such as **tracery**, with open spaces incorporated into the pattern. Also: a needlework technique in which some of the fabric support is left visible within the design.

oracle A person, usually a priest or priestess, who acts as a conduit for divine information. Also: the information itself or the place at which this information is communicated.

orant The representation, usually in ancient or Early Christian art, of a standing figure praying with outstretched arms.

order A system categorizing **Classical** architecture into five standardized types. **Doric**: the **column shaft** of the Doric order can be **fluted** or smooth-surfaced and has no **base**. The Doric **capital** consists of an undecorated **echinus** and **abacus**. The Doric **entablature** has a plain **architrave**, a **frieze** with **metopes** and **triglyphs**, and a simple **cornice**. **Tuscan**: a variation of Doric characterized by a smooth-surfaced column shaft with a base, a plain architrave, and an undecorated frieze. **Ionic**: the column of the Ionic order has a fluted shaft and a capital on top decorated with **volutes**. The Ionic entablature consists of an architrave decorated with **moldings**, a frieze usually containing sculpted **relief** ornament, and a cornice with **dentils**. **Corinthian**: the most ornate of the orders, the Corinthian includes a fluted column shaft with a capital elaborately decorated with **acanthus** leaf carvings. Its entablature consists of an architrave decorated with moldings, a frieze often containing sculpted relief ornament, and a cornice with dentils. **Composite**: a combination of the Ionic and the Corinthian in one. Composite columns are slender, and the capital combines acanthus leaves with spiralling volutelike scrolls at the top. A **colossal** order is any of the above types built on a large scale, stretching over several stories in height and often raised from the ground by a **pedestal**.

orthogonal Any line running back into the represented space of a picture perpendicular to the imagined **picture plane**. In linear **perspective**, all orthogonals converge at a single **vanishing point** in the picture and are the basis for a **grid** that maps out the internal space of the image. An orthogonal **plan** is any plan for a building or city that is based exclusively on right angles, such as the grid plan of many modern cities.

orthogonal plan *See* **orthogonal**.

ovoid An adjective describing a rounded oval object or shape. Also: a characteristic form in Native American art, consisting of a rectangle with bent sides and rounded corners.

pagoda A heavily decorated Buddhist temple in the form of a tower built with successively smaller, repeated stories. Each story is usually marked by an elaborate projecting roof.

painterly A painting, or **style** of painting, that emphasizes the techniques and surface effects of brushwork.

palace complex A group of buildings used for living and governing by a particular ruler, usually located in a fortress or **citadel**.

palette An oval or otherwise rounded handheld support used by artists for the storage and mixing of paint during the process of painting. Also: the choice of a range of colors made by an artist in a particular work, or typical of his or her **style**.

Palladian An adjective describing a style of architecture, or an architectural detail, reminiscent of the **classicizing** work of the sixteenth-century Italian architect Andrea Palladio.

palmette A fan-shaped ornament with radiating leaves.

panel painting Any painting executed on a wood support. The wood is usually planed down to a board to provide a smooth surface and easy transportation. A panel can consist of several boards joined together.

papyrus A native Egyptian plant from the stems of which ancient Egyptians produced an early form of paper. Also: a decorative form adapted from this plant used in Egyptian architecture.

parapet A low wall at the edge of a balcony, bridge, roof, or other place from which there is a steep drop, built for the safety of onlookers. A parapet walk is the passageway, usually open, immediately behind the uppermost exterior wall or **battlement** of a fortified building.

parapet walk *See* **parapet**.

parchment A writing surface made from treated skins of animals and used during antiquity and the Middle Ages.

Paris Salon The annual display of art by French artists in Paris during the eighteenth and nineteenth centuries. Originally established in the seventeenth century as a venue to show the work of members of the French **Academy**, the Salon and its judges favored primarily academic art of the accepted official style at the time.

parterre An ornamental, highly regimented flower bed. Parterre became a crucial element of the ornate gardens of seventeenth-century palaces and **châteaux**.

passage In painting, passage refers to any particular area within a work, often those where **painterly** brushwork or color changes exist. Also: a term used to describe the style of Paul Cézanne and his technique of blending shapes open on one side with adjacent ones.

passage grave A prehistoric tomb under a **cairn**, reached by a long, narrow, slab-lined access passageway or passageways.

pastel A drawing material in stick or crayon form. Composed of dry pigment, chalk, and gum, pastel imparts soft color **tones** to drawings.

pedestal A platform or base supporting a sculpture or other monument. Also: the block found below the **base** of a **Classical** column (or **colonnade**), serving to raise the entire structure off the ground.

pediment A triangular **gable** found over major architectural elements such as **Classical** Greek **porticoes**, windows, or doors. Formed by an **entablature** and the ends of a sloping roof or a **raking cornice**. A similar architectural element is often used decoratively above a door or window, sometimes with a curved upper **molding**. A bro-

ken pediment is a variation on the traditional pediment, with an open space at the center of the topmost angle and/or the horizontal cornice. Often filled with a decorative element, such as a **cartouche**.

pendentive The concave triangular section of a wall that forms the transition between a square or polygonal space and the circular base of a **dome**.

pendentive dome *See* **dome**.

peplos A loose outer garment worn by women of ancient Greece. Belted below the bust or at the hips, it was worn in billowing folds.

performance art An artwork based on a live, theatrical performance by the artist.

peripteral A term used to describe any building (or room) that is surrounded by a single row of **columns**. When such columns are engaged instead of freestanding, called **pseudo-peripteral**.

peristyle A surrounding **colonnade** in Greek architecture. A peristyle building is surrounded on the exterior by a colonnade. Also: a peristyle court is an open courtyard with the same colonnade form found on all sides.

perspective A system for reproducing three-dimensional space on a flat surface. There are several different techniques. **Atmospheric perspective**: A method of rendering the effect of spatial distance on a two-dimensional plane by subtle variations in color and clarity of representation. **One-point** and **multiple-point perspective** (also called **linear**, **scientific**, or **mathematical perspective**): A method of creating the illusion of three-dimensional space on a two-dimensional surface by delineating a **horizon line** and multiple **orthogonal** lines. These recede to meet at one or more points on the horizon (called **vanishing points**), giving the appearance of spatial depth. Called scientific or mathematical because its use requires some knowledge of geometry and mathematics, as well as optics. **Intuitive perspective**: A method of representing three-dimensional space on a two-dimensional surface by the use of **formal elements** that act to give the impression of recession. This impression, however, is achieved by visual instinct, not by the use of an overall system or program (usually involving scientific principles or mathematics) for depicting the appearance of spatial depth. **Oblique perspective**: An intuitive spatial system used in painting, in which a building or room is placed with one corner in the **picture plane**, and the other parts of the structure all recede to an imaginary vanishing point on its other side. Oblique perspective is not a comprehensive, mathematical system. **Reverse perspective**: A Byzantine perspective theory in which the orthogonals or rays of sight do not converge on a vanishing point in the picture, but are thought to originate in the viewer's eye in front of the picture. Thus, in reverse perspective the image is constructed with orthogonals that diverge, giving a slightly tipped aspect to objects.

photomontage A photographic work created from many smaller photographs arranged (and often overlapping) in a **composition**.

piazza The Italian word for an open city square.

pictograph A highly **stylized** depiction serving as a symbol for a person or object. Also: a type of writing utilizing such symbols.

pictured stone A stone used in medieval northern Europe as a commemorative monument, which is carved or inscribed with representations of human figures or other natural forms.

picture plane The theoretical spatial plane corresponding with the actual surface of a painting (usually vertical).

picturesque A term describing the taste for the familiar, pleasant, and pretty, popular in the eighteenth and nineteenth centuries in Europe. When contrasted with the **sublime**, the picturesque stood for all that was ordinary but pleasant.

piece-mold casting A casting technique in which the mold consists of several sections that are connected together during the pouring of molten metal, usually **bronze**. After the cast form has hardened, the pieces of the mold are then disassembled, leaving the completed object. Because it is made in pieces, the mold can be used again.

pier A large columnar support, often square or rectangular in plan, used to carry the heaviest architectural loads. Also: the masonry structure found between paired openings such as windows, doors, and **arches**.

pietà A devotional subject in religious painting from the life of Jesus, which occurs after the Crucifixion, when the body of the dead Jesus is laid across the lap of his grieving mother, Mary.

pietra dura (pietre dure) A type of **mosaic** made in **relief** from semiprecious stones. Popular among the Florentine nobility of the seventeenth century, *pietre dure* often depicted ornamental designs such as flowers or fruit. In singular, *pietra dura* indicates a mosaic made entirely from the same type of stones; in plural, the mosaic includes a mix of stones.

pilaster An engaged columnar element that is rectangular in format and used for decoration in architecture.

pillar In architecture, any large, freestanding vertical element. Usually functions as an important weight-bearing unit in buildings.

pinnacle In Gothic architecture (especially cathedrals), the small vertical elements placed on spires, **buttresses**, and **facades** for decoration. Often capped with a **finial**, pinnacles can be constructed in a variety of shapes and sizes.

plaiting In basketry, the technique of weaving strips of fabric or other flexible substances under and over each other.

plan A graphic convention for representing the arrangement of the parts of a building.

plasticity The three-dimensional quality of an object, or the degree to which any object can be **modeled**, shaped, or altered.

plinth The slablike **base** or **pedestal** of a **column**, statue, wall, building, or piece of furniture.

pluralism A social structure or goal that allows members of diverse ethnic, racial, or other groups to exist within the society while continuing to practice the customs of their own divergent cultures. Also: an adjective describing the state of having many valid contemporary styles available at the same time to artists.

podium A raised platform that acts as the foundation for a building. Most often used for Etruscan, Greek, and Roman temples.

polychromy The multicolored painted decoration applied to any part of a building, sculpture, or piece of furniture.

polyptych An altarpiece constructed from multiple panels, sometimes with hinges to allow for movable **wings**.

popular culture The accoutrements of society that are shared by the general public. Popular culture has the associations of something cheap, fleeting, and accessible to all.

porcelain A type of extremely hard and fine pottery made from a mixture of kaolin and other minerals. Porcelain is fired at a very high heat, and the final product has a translucent surface.

porch The covered entrance on the exterior of a building. With a row of **columns** or **colonnade**, also called a **portico**.

portal A grand entrance, door, or gate, usually to an important public building, and often decorated with elaborate sculpture.

portcullis A fortified gate, often made of metal bars, used for the defense of a city or castle. When lowered, the portcullis prevents access to the main doors and thus entry into the defended area.

portico In architecture, a projecting roof or **porch** supported by **columns**, often marking an entrance.

post-and-lintel construction An architectural system of construction with two or more vertical elements (posts) supporting a horizontal element (**lintel**).

postern A side entrance into a fortified city or castle, usually on a much smaller scale than the main gates.

potsherd A broken piece of ancient ceramic **ware**, most often found in archeological sites.

Prairie Style A style of architecture originally describing the work of Frank Lloyd Wright done during the first decade of the twentieth century. Characterized by large flat roofs with broad overhanging eaves and open-planned spatial arrangements, the style is epitomized by the houses of Wright in Illinois and Wisconsin and was popularized generally in the following decades by the houses of his followers, such as Walter Burley Griffin and the firm of Purcell & Elmslie.

predella The lower zone, or base, of an **altarpiece**, decorated with painting or sculpture related to the main **iconographic** theme of the altarpiece.

primary colors Blue, red, and yellow, the three colors from which all others are derived.

Prix de Rome A prestigious scholarship offered by the French **Academy** at the time of the establishment of its Roman branch in 1666. The scholarship allowed the winner of the prize to study in Rome for four years at the expense of the state. Originally intended only for painters, the prize was later expanded to include printmakers, architects, and musicians.

pronaos The enclosed vestibule of a Greek or Roman temple, found in front of the **cella** and marked by a row of **columns** at the entrance.

propylon (propylaia) A large, often elaborate gateway to a temple or other important building.

proscenium The stage of an ancient Greek or Roman theater. In modern theater, the area of the stage in front of the curtain. Also: the framing **arch** which separates a stage from the audience.

prostyle A term used to describe a **Classical** temple with a **colonnade** placed across the entrance.

provenance The history of ownership of a work of art from the time of its creation to the present.

pseudo-kufic Designs intended to resemble the script of the Arabic language.

pseudo-peripteral *See* **peripteral**.

punchwork Decorative designs that are stamped onto a surface, such as metal or leather, using a punch (a handheld metal implement).

putto (putti) A divine figure in the form of a plump, naked little boy, often with wings. Also called a cupid or **cherub**.

pylon A massive gateway formed by a pair of tapering walls of oblong shape. Erected by ancient Egyptians to mark the entrance to a **temple complex**.

pyramidion A pyramid-shaped block set as the finishing element atop an **obelisk**.

qibla The **mosque** wall oriented toward Mecca that includes the **mihrab**.

quadrant vault *See* **vault**.

quatrefoil A four-lobed decorative pattern common in Gothic art and architecture.

quillwork A Native American decorative craft technique. The quills of porcupines and bird feathers are dyed, woven together in patterns, and attached to fabric, birch bark, or other material.

quincunx The name for a square building **plan** that incorporates a central hall and similar units extending from each side.

quoin A stone, often decorated for emphasis, forming the corner of two walls.

radiometric dating A method of dating prehistoric works of art made from organic materials, based on the rate of degeneration of radiocarbons in these materials. *See also* **relative dating**, **absolute dating**.

raigo A painted image that depicts the Buddha Amida and other Buddhist deities guiding the soul of a dying worshiper to paradise.

raking cornice *See* **cornice**.

raku A type of ceramic pottery made by hand, coated with a thick dark **glaze**, and fired at a low heat. The resulting vessels are irregularly shaped and glazed, and are highly prized. Raku **ware** is the pottery used in the Japanese tea ceremony.

rampart The raised walls or **embankments** used as primary protection in the fortification of a city or castle. Ramparts may be of different heights or thicknesses, and are usually surmounted by a **parapet**.

readymade An object from popular or material culture presented as an artwork by the artist without further manipulation.

realism The representation in art of things and experiences as they appear to be in actual, visible reality.

recto The right-hand page in a book or **manuscript**. Also: the principal or front side of a leaf of paper, as in the case of a drawing.

red-figure A style of ancient Greek vase painting made in the sixth and fifth century BCE. Characterized by red clay-colored figures on a black background.

refectory The dining hall for monks or nuns in a monastery or convent.

register A device used in systems of spatial definition. In painting, a register indicates the use of differing **groundlines** to differentiate layers of space within an image. In sculpture, the placement of self-contained bands of **reliefs** in a vertical arrangement. In printmaking, the marks at the edges used to align the print correctly on the page, especially in multiple-block color printing.

reintegration The process of adaptation and transformation of European craft techniques and stylistic models by artists in colonial areas.

relative dating A method of dating ancient artifacts by their relation to other objects, not to a historical moment. *See* also **radiometric dating**, **absolute dating**.

relief sculpture A sculpted image or design whose flat background surface is carved away to a certain depth, setting off the figure. Called **high** or **low** (**bas**) depending upon the extent of projection of the image from the background. Called **sunken** relief when the image is modeled below the original surface of the background, which is not cut away.

relieving arch *See* **arch**.

reliquary A container, often made of precious materials, used as a repository for sacred relics.

replica A very close copy of a painting or sculpture, sometimes done by the same artist who created the original.

repoussé A technique by which metal **reliefs** are created. Thin sheets of metal are gently hammered from the back to create a protruding image. More elaborate reliefs are created with wooden forms against which the metal sheets are pressed.

representational Any art that attempts to depict an aspect of the external, natural world in a visually understandable way.

reredos A decorated wall behind the **altar** of a church.

retablo The screen placed behind an altar. Often built on a large scale, with multiple painted **panels** and successive stories, a retablo can substitute for an **altarpiece**. Retablos are most commonly found in Spain or in Spanish-influenced areas such as Latin America.

reverse perspective *See* **perspective**.

revetment A covering of cut stone, fine brick, or other solid facing material over a wall built of coarser materials. Also: surface covering used to reinforce a retaining wall, such as an embankment.

revivalism The practice of using older styles and modes of expression in a conscious manner. Revivalism does not usually entail the same academic and historical interest of **historicism**.

rhyton A vessel in the shape of a figure or an animal, used for drinking or pouring liquids on special occasions.

ribbon interlace A **linear** decoration made up of interwoven bands, often found in Celtic and northern European art of the medieval period.

rib vault *See* **vault**.

ridge rib *See* **tierceron**.

ring wall Any wall surrounding a building, town, or fortification, intended to separate and protect the enclosed area.

rock-cut tomb Ancient Egyptian multichambered burial site, hewn from solid rock and often thoroughly hidden. Most often found in remote cliffs and valleys of southern Egypt.

rood screen In a church, a screen that separates the public **nave** from the private and sacred area of the **choir**. The screen is usually topped by a rood (sculpted crucifix).

roof comb In a Mayan building, a masonry wall along the **apex** of a roof that is built above the level of the roof proper. Roof combs support the highly decorated false **facades** that rise above the height of the building at the front.

rosette A round or oval ornament resembling a rose.

rose window A round window, often made of **stained glass**, with **tracery** patterns in the form of wheel spokes. Large, elaborate, and finely crafted, rose windows are usually a central element of the **facade** of Gothic cathedrals.

rotulus (rotuli) A term usually applied to medieval **manuscripts** that are rolled or in a tubular form.

rotunda Any building (or part thereof) constructed in a circular (or sometimes polygonal) shape, usually producing a large open space crowned by a **dome**.

round arch *See* **arch**.

roundel Any element with a circular format, often placed as a decoration on the exterior of architecture.

round vault *See* **vault**.

rune stone A stone used in medieval northern Europe as a commemorative monument, which is carved or inscribed with ancient German or Scandinavian writing.

running spirals A decorative **motif** based on the shape formed by a line making a continuous spiral.

rustication In building, the rough, irregular, and unfinished effect deliberately given to the exterior facing of a stone edifice. Rusticated stones are often large and used for decorative emphasis around doors or windows, or across the entire lower floors of a building, probably deriving from fortifications.

sacristy In a Christian church, the room in which the priest's robes and the sacred vessels are housed. Sacristies are usually located close to the **sanctuary** and often have a place for ritual washing as well as a private door to the exterior.

sahn The central courtyard of a Muslim **mosque**.

sanctuary In Greek architecture, a sacred or holy enclosure used for worship consisting of one or more temples and an **altar**. Also: the space around the altar in a church, usually at the east end (also called the chancel or presbytery).

sand painting Ephemeral designs created with different colored sands by Native Americans of North America, Australian Aborigines, and other peoples in Japan and Tibet.

sanghati The robe worn by a Buddhist monk. Draped over the left shoulder, the robe is made from a single piece of cloth wrapped around the body.

sarcophagus (sarcophagi) A rectangular stone coffin, used by ancient Egyptians, Greeks, and Romans, and others. Often decorated with **relief sculpture** in side panels.

scarification Ornamental marks, scars, or scratches made on the human body.

school of artists An art historical term describing a group of artists, usually working around the same time and sharing similar styles, influences, and ideals. The artists in a particular school may not necessarily be directly associated with one another, unlike in a workshop or **atelier**.

scientific perspective *See* **perspective**.

scriptorium (scriptoria) A room in a monastery for writing or copying **manuscripts**.

scroll painting A painting executed on a rolled paper support. Usually found with rigid bars at either end, scroll paintings can be stored rolled or hung as decoration.

sculpture in the round Three-dimensional sculpture that is carved free of any attaching background or block.

section A method of representing the three-dimensional arrangement of a building in a graphic manner. A section is produced when an imaginary vertical plane intersects with a building, laying bare all the elements that make up the structure at that point.

segmental pediment A **pediment** formed when the upper cornice is a shallow arc.

sepia An ink **medium** often used in drawing that has an extremely rich, dark **tone** of brownish color.

seraph (seraphim) An angel of high rank in the Christian hierarchy.

serdab In Egyptian tombs, the small room in which the **ka** statue was placed.

sesto The curve of an **arch**.

sfumato In painting, the effect of haze in an image. Resembling the color of the atmosphere at dusk, sfumato gives a very **naturalistic**, smoky effect and was perfected by Leonardo da Vinci.

shade Any area of an artwork that is shown through various technical means to be in shadow. Also: the technique of making such an effect.

shaft The main vertical section of a **column** between the **capital** and the **base**, usually circular in cross section.

shater A type of roof or **dome** used in Russia and the Near East with a steep pitch and tentlike shape.

shikhara In the architecture of northern India, a conical (or pyramidal) spire found atop a Hindu temple and often crowned with an **amalaka**.

shoin The architecture of the aristocracy and upper classes in Japan, built in traditional asymmetrical fashion and incorporating the traditional elements of residences, such as the *tokonoma* and **shoji** screens.

shoji A standing Japanese screen covered in translucent rice paper and used in interiors.

sinopia The preparatory design or underdrawing of a **fresco**. Also: a reddish chalklike earth pigment.

site-specific sculpture A sculpture commissioned and designed for a particular spot. Most site-specific sculpture requires the location for which it was designed in order to be complete.

slip A mixture of clay and water applied to a ceramic object as a final decorative coat. Also: a solution that binds different parts of a vessel together, such as the handle and the main body.

spandrel The area of wall adjoining the exterior curve of an **arch** between its springing and the **keystone**, or the same between two arches, as in an **arcade**.

speech scroll A scroll painted with words indicating the speech or song of a depicted figure.

squinch A small **arch** built over the upper corners of a square space, allowing a circular or polygonal **dome** to be more securely set above the walls.

stadium In ancient Greece, a usually oval building or outdoor arena for sports, with tiers of seats for spectators.

stained glass A decorative process in glassmaking by which glass is given a color (whether intrinsic in the material or painted onto the surface). Stained glass is most often used in windows, for which small pieces of differently colored glass are precisely cut and assembled into a design, held together by **cames**.

stela (stelae) A stone slab placed vertically and decorated with inscriptions or **reliefs**. Used as a grave marker or memorial.

still life A type of painting that has as its subject inanimate objects (such as food, dishes, fruit, or flowers).

stoa In Greek architecture, a **portico** or promenade with long rows of **columns** attached to a building or meeting place.

stockade A defensive fencelike wood fortification built around a village, house, or other enclosed area.

stretcher The wooden framework on which an artist's canvas is attached, usually with tacks, nails, or staples. Also: a reinforcing horizontal brace between the legs of a piece of furniture, such as a chair. Also: in building, a brick laid so that the side, rather than the end, faces the wall.

stringcourse A continuous horizontal band, such as a **molding**, decorating the face of a wall.

stucco A mixture of lime, sand, and other ingredients into a material that can be easily molded or **modeled**. When dry, produces a very durable surface used for covering walls or for architectural sculpture and decoration.

stupa In Buddhist architecture, a bell-shaped or pyramidal religious monument, made of piled earth or stone, and containing sacred relics.

style A particular manner, form, or character of representation, construction, or expression typical of an individual artist or of a certain school or period.

stylization A manner of representation that conforms to an intellectual or artistic idea rather than to **naturalistic** appearances.

stylobate In **Classical** architecture, the stone foundation on which a temple **colonnade** stands.

stylus An instrument with a pointed end (used for writing and printmaking), which makes a delicate line or scratch. Also: a special writing tool for **cuneiform** writing with one pointed end and one triangular, wedge end.

subject matter *See* **content**.

sublime A concept, thing, or state of exceptional and awe-inspiring beauty and moral or intellectual expression. The sublime was a goal to which many nineteenth-century artists aspired in their artworks.

sunken relief *See* **relief sculpture**.

swag A decorative device in architecture or interior ornament (and in paintings), in which a loosely hanging garland is made to look as if constructed of flowers or gathered cloth.

syncretism In religion or philosophy, the union of different ideas or principles.

talud-tablero A design characteristic of Mayan architecture at Teotihuacan in which a sloping *talud* at the base of a building supports a wall-like *tablero*, where ornamental painting and sculpture are usually placed.

taotie A mask with a dragon or animal-like face common as a decorative **motif** in Chinese art.

tapa A cloth made in Polynesia by pounding the bark of a tree, such as the paper mulberry. It is also known as bark cloth.

tapestry A highly decorated piece of woven fabric meant to be hung from a wall or placed on a piece of furniture.

tatami Mats of woven straw used in Japanese houses as a floor covering.

temenos A group of buildings, including a temple as well as residences and recreational buildings, used for ritual worship.

tempera A painting **medium** made by blending egg yolks with water, pigments, and occasionally other materials, such as glue. The technique was often used during the fourteenth and fifteenth centuries to paint **frescoes** and **panel paintings**.

temple complex A group of buildings dedicated to a religious purpose, usually located close to one another in a **sanctuary**.

tenebrism A term signifying the prevalent use of dark areas in a painting. A tenebrist style, such as **Caravaggism**, uses strong **chiaroscuro** and artificially illuminated areas to create a dramatic contrast of light and dark.

tepee A dwelling constructed from stretched hides on a structure of poles set at the base in a circle and leaning against one another at the top. Tepees were typically found among the nomadic Native Americans of the North American plains.

terminal Any element of sculpture or architecture that functions as decorative closure. Terminals are usually placed in pairs at either end of an object (such as furniture) or **facade** (as on a building) to help frame the **composition**.

terra-cotta A **medium** made from clay fired over a low heat and usually left un**glazed**. Also: the orange-brown color typical of this medium.

tessera (tesserae) The small piece of stone, glass, or other object that is pieced together with many others to create a **mosaic**.

tholos A small, round, **domed** building. Sometimes built underground, as in a Mycenaean tomb.

tierceron In **vault** construction, a secondary rib that arcs from a springing point to the rib that runs lengthwise through the vault, called the ridge rib.

tint The dominant color in an object, image, or pigment.

tokonoma A **niche** for the display of an art object (such as a scroll or flower arrangement) in a Japanese tearoom.

tomb effigy A sculpted image on a tomb or **sarcophagus** that commemorates a deceased individual or group of individuals.

tondo A painting or **relief** of circular shape.

tone The overall degree of brightness or darkness in an artwork, often combined with a particular **hue**.

torana In Indian architecture, an ornamented gateway arch in a temple, usually leading to the **stupa**.

torii The ceremonial entrance gate to a Shinto temple.

toron In West African **mosque** architecture, the wooden beams that project from the walls. *Torons* are used as support for the scaffolding erected annually for the replastering of the building.

torque A type of neckpiece. Worn as jewelry in ancient times, the torque could be fashioned as a metal chain or rigid collar.

tracery The thin stone or wooden bars in a Gothic window, screen, or panel, which create an elaborate decorative matrix or pattern.

transept The entire arm of a **cruciform** church, perpendicular to the **nave**. The transept includes the **crossing** and often marks the beginning of the **apse**.

travertine A mineral building material similar to limestone, typically found in central Italy.

treasury A building, room, or box for keeping holy (and often highly valuable) offerings.

trefoil An ornamental design made up of three rounded lobes placed adjacent to one another.

triforium An **arcaded** element of the interior **elevation** of a Gothic church, usually found directly below the **clerestory** and consisting of a series of **arched** openings. The triforium can be made up of openings from a passageway or **gallery**, or can be a purely decorative device built into the wall.

triglyph Rectangular blocks between the **metopes** of a **Doric frieze**. Identified by the three carved vertical grooves, which approximate the appearance of the ends of wooden beams.

triptych A painting, usually an **altarpiece**, made up of three **panels**. The panels are often hinged together so the side segments (**wings**) fold over the central area.

triumph In Roman times, a celebration of a particular military victory, usually granted to the commanding general upon his return to Rome. Also: in later times, any depiction of a victory.

triumphal arch A freestanding, massive stone gateway with a large central **arch**, built as urban ornament and/or to celebrate military victories (as by the Romans).

trompe l'oeil A manner of representation in which the appearance of natural space and objects is re-created with the express intention of fooling the eye of the viewer, who may be convinced that the subject actually exists as three-dimensional reality.

trophy A grouping of captured military objects such as armor and weapons that Romans displayed in an upheld pole or tree to celebrate victory. Also: a similar grouping that recalls the Roman custom of displaying the looted armor of a defeated opponent.

trumeau A **column**, **pier**, or post found at the center of a large **portal** or doorway, supporting the **lintel**.

tugra The **calligraphic** imperial monograms used in Ottoman courts.

tunnel vault *See* **barrel vault**.

turret A tall and slender tower.

Tuscan order *See* **order**.

twining A basketry technique in which short rods are sewn together vertically. The panels are then joined together to form a vessel.

tympanum The roughly semicircular area of stone or other material enclosed by an **arch** that springs from a **lintel**. Usually found in medieval architecture above a doorway or **portal**, and often highly decorated. Also: in **Classical** architecture, the area enclosed by a **pediment**.

typology The study of symbolic types of representation in art history, especially of Old Testament events of the Bible as they prefigure those of the New Testament.

ukiyo-e A Japanese term for a type of popular art that was favored from the sixteenth century, particularly in the form of color **woodblock prints**. Ukiyo-e prints often depicted the world of the common people in Japan, such as courtesans and actors, as well as landscapes and myths.

undercutting A technique in sculpture by which a form is carved to project outward, then under. Undercutting gives a highly three-dimensional effect with deep shadows behind the forms.

underglaze *See* **glazing**.

urna In Buddhist art, the curl of hair on the forehead that is a characteristic mark of a Buddha. The *urna* is a symbol of divine wisdom.

ushnisha In Eastern art, a round turban or tiara symbolizing royalty and, when worn by a Buddha, enlightenment.

value The relative relationships in a painting between darks and lights, as well as differing **hues**.

vanishing point In a **perspective** system, the point on the **horizon line** at which **orthogonals** meet. A complex system can have multiple vanishing points.

vanitas An image, especially popular in Europe during the seventeenth century, in which all the objects symbolize the transience of life. *Vanitas* paintings are usually of **still lifes** or **genre** subjects.

vault An **arched** masonry structure or roof that spans an interior space. In different shapes, called by different names. **Barrel vault**: a continuous semicircular vault. **Corbel vault**: a vault made by the technique of **corbeling**. **Groin vault** or **cross vault**: a vault created by the intersection of two barrel vaults of equal size. **Rib vault**: a rib vault is found when the joining of curved sides of a groin vault is demarcated by a raised rib. **Quadrant vault**: a vault with two diagonally crossed ribs, which creates four side compartments of equal size and shape.

veduta (vedute) A term derived from the Italian word for a vista, or view. *Veduta* paintings are often of expansive city scenes or of harbors.

vellum A type of paper made from animal skins. Vellum is a thick, expensive support.

veneer In architecture, the exterior facing of a building, often in decorative patterns of fine stone or brick. In decorative arts, a thin exterior layer for decoration laid over wooden objects or furniture. Made of fine materials such as rare wood, ivory, metal, and semiprecious stones.

verism A style in which artists concern themselves with capturing the exterior likeness of an object or person, usually by rendering its visible details in a finely executed, meticulous manner.

verso The left-hand page of a book or **manuscript**. Also: the subordinate or back side of a leaf of paper, as in the case of drawings.

vignette A small **motif** or scene that has no established border and that fades on the edges into the background. Also: the foliated decoration around a capital letter in an **illuminated manuscript**.

vihara From the Sanskrit term meaning "for wanderers." A vihara is, in general, a Buddhist monastery in India. It also signifies the monks' cells and gathering places in such a monastery.

vimana The main element of a Southern Indian Hindu temple, usually in the shape of a pyramidal or tapering tower raised on a **plinth**.

volumetric A term indicating the concern for rendering the impression of three-dimensional volumes in painting, usually achieved through **modeling** and the manipulation of light and shadow (**chiaroscuro**).

volute A spiral scroll, most often decoration on an **Ionic capital**.

volute krater *See* **krater**.

votive figure An image created as a devotional offering to a god or other deity.

voussoirs The oblong, wedge-shaped stone blocks used to build an **arch**. The topmost voussoir is called a **keystone**.

wall painting A large-scale painting intended for a particular interior space, usually as part of a scheme for interior decoration.

ware A general term designating the different techniques by which pottery is produced and decorated. Different wares utilize different procedures to achieve different decorative results. *See also* **black-figure**, **red-figure**, and **white-ground**.

warp The vertical threads in a weaver's loom. Warp threads make up a fixed framework that provides the structure for the entire piece of cloth, and are thus often thicker than **weft** threads.

wash A diluted **watercolor**. Often washes are applied to drawings or prints to add **tone** or touches of color.

watercolor A type of painting using water-soluble pigments that are floated in a water **medium** to make a transparent paint. The technique of watercolor is most suited to a paper support.

wattle and daub A wall construction method combining upright branches (wattles) plastered with clay or mud (daub).

weft The horizontal threads in a woven piece of cloth. Weft threads are woven at right angles to and through the **warp** threads to make up the bulk of the decorative pattern. In carpets, the weft is often completely covered by the rows of trimmed knots that form the carpet's soft surface.

westwork The **monumental** west-facing entrance section of a Carolingian, Ottonian, or Romanesque church. The exterior consists of multiple stories between two towers; the interior includes an entrance vestibule, a chapel, and a series of **galleries** overlooking the **nave**.

white-ground A type of ancient Greek pottery ware in which the background color of the object is painted with a type of **slip** that turns white in the firing process. Figures and details were added by painting on or **incising** into this slip. White-ground wares were popular in the High Classical period as funerary objects.

wing The side panel of a **triptych** (usually found in pairs), which was hinged to fold over the central panel. Wings often held the depiction of the donors or of subsidiary scenes relating to the central image.

woodblock print A print made from a block of wood that is carved in **relief** or **incised**.

woodcut A type of print made by carving a design into a wooden block. The ink is applied to the plate with a roller. As the ink remains only on the raised areas between the carved-away lines, these carved-away areas and lines provide the white areas of the print. Also: the process by which the woodcut is made.

x-ray style In aboriginal art, a manner of representation in which the artist depicts a figure or animal by illustrating its outline as well as essential internal organs and bones.

yaksha, yakshi The male (yaksha) and female (yakshi) nature spirits that act as agents of the Hindu gods. Their sculpted images are often found on Hindu temples and other sacred places, particularly at the entrances.

zeitgeist From the German word for "spirit of the time," the term means cultural and intellectual aspects of a time period that pervade human experience and are expressed in all creative and social endeavors.

ziggurat A tall, stepped tower of earthen materials, often housing a temple or shrine. Built by ancient Near Eastern cultures.

Bibliography

Susan Craig

This bibliography is composed of books in English that are appropriate "further reading" titles. Most items on this list are available in good libraries, whether college, university, or public institutions. There are three classifications of listings: general surveys and art history reference tools, including journals; surveys of large periods (ancient art in the Western tradition, European medieval art, European Renaissance through eighteenth-century art, modern art in the West, Asian art, and African and Oceanic art and art of the Americas); and books for individual Chapters 1 through 29. Sources of quotations cited in short form in the text will also be found in this bibliography.

General Art History Surveys and Reference Tools

Adams, Laurie. *A History of Western Art*. Madison: Brown and Benchmark, 1994.

Bazin, Germain. *A Concise History of World Sculpture*. London: David & Charles, 1981.

Brownston, David M., and Ilene Franck. *Timelines of the Arts and Literature*. New York: HarperCollins, 1994.

Bull, Stephen. *An Historical Guide to Arms and Armor*. Ed. Tony North. New York: Facts on File, 1991.

Chadwick, Whitney. *Women, Art, and Society*. New York: Thames and Hudson, 1990.

Cole, Bruce, and Adelheid Gealt. *Art of the Western World: From Ancient Greece to Post-Modernism*. New York: Summit, 1989.

Crofton, Ian, comp. *A Dictionary of Art Quotations*. New York: Schirmer, 1989.

Crouch, Dora P. *A History of Architecture: Stonehenge to Sky-scrapers*. New York: McGraw-Hill, 1985.

Encyclopedia of World Art. 16 vols. New York: McGraw-Hill, 1972–83.

Fleming, John, Hugh Honour, and Nikolaus Pevsner. *The Penguin Dictionary of Architecture*. 4th ed. New York: Penguin, 1991.

Fletcher, Banister. *Sir Banister Fletcher's A History of Architecture*. 19th ed. Ed. John Musgrove. London: Butterworths, 1987.

Gardner, Helen. *Gardner's Art through the Ages*. 9th ed. Ed. Horst de la Croix, Richard G. Tansey, and Diana Kirkpatrick. San Diego: Harcourt Brace College, 1991.

Hall, James. *Dictionary of Subjects and Symbols in Art*. Rev. ed. New York: Harper & Row, 1979.

Hartt, Frederick. *Art: A History of Painting, Sculpture, Architecture*. 4th ed. New York: Abrams, 1993.

Heller, Nancy G. *Women Artists: An Illustrated History*. New York: Abbeville, 1987.

Holt, Elizabeth Gilmore, ed. *A Documentary History of Art*. 3 vols. New Haven: Yale Univ. Press, 1986.

Honour, Hugh. *The Visual Arts: A History*. 3rd ed. New York: Abrams, 1991.

Janson, H. W. *History of Art*. 5th ed. Rev. and exp. Anthony F. Janson. New York: Abrams, 1995.

Jervis, Simon. *The Penguin Dictionary of Design and Designers*. London: Lane, 1984.

Jones, Lois Swan. *Art Information: Research Methods and Resources*. 3rd ed. Dubuque: Kendall/Hunt, 1990.

Kostof, Spiro. *A History of Architecture: Settings and Rituals*. New York: Oxford Univ. Press, 1985.

Kurtz, Bruce D. *Visual Imagination: An Introduction to Art*. Englewood Cliffs, N.J.: Prentice-Hall, 1987.

Lindemann, Gottfried. *Prints and Drawings: A Pictorial History*. Trans. Gerald Onn. Oxford: Phaidon, 1976.

Mair, Roslin. *Key Dates in Art History: From 600 BC to the Present*. Oxford: Phaidon, 1979.

Mayor, A. Hyatt. *Prints and People: A Social History of Printed Pictures*. New York: Metropolitan Museum of Art, 1971.

McConkey, Wilfred J. *Klee as in Clay: A Pronunciation Guide*. Lantham, Md.: Univ. Press of America, 1985.

Myers, Bernard, ed. *McGraw-Hill Dictionary of Art*. 5 vols. New York: McGraw-Hill, 1969.

Rothberg, Robert I., and Theodore K. Rabb, eds. *Art and History: Images and Their Meaning*. Cambridge: Cambridge Univ. Press, 1988.

Stangos, Nikos. *The Thames and Hudson Dictionary of Art and Artists*. Rev ed. World of Art. New York: Thames and Hudson, 1994.

Steer, John, and Antony White. *Atlas of Western Art History: Artists, Sites and Movements from Ancient Greece to the Modern Age*. New York: Facts on File, 1994.

Thacker, Christopher. *The History of Gardens*. Berkeley: Univ. of California Press, 1979.

Trachtenberg, Marvin, and Isabelle Hyman. *Architecture, from Prehistory to Post-Modernism: The Western Tradition*. New York: Abrams, 1986.

Tufts, Eleanor. *Our Hidden Heritage: Five Centuries of Women Artists*. New York: Paddington, 1974.

Wilkins, David G., Bernard Schultz, and Katheryn M. Linduff. *Art Past/Art Present*. 2nd ed. New York: Abrams, 1994.

The World Atlas of Architecture. Boston: Hall, 1984.

Art History Journals: A Selected List

African Arts. Quarterly. Los Angeles, Calif.

American Art. Quarterly. Washington, D.C.

American Journal of Archaeology. Quarterly. Boston, Mass.

Antiquity. Quarterly. Oxford

Apollo. Monthly. London

Architectural History. Annually. London

Archives of American Art Journal. Quarterly. Washington, D.C.

Archives of Asian Art. Annually. New York

Ars Orientalis. Ann Arbor, Mich.

Art Bulletin. Quarterly. New York

Artforum. Monthly. New York

Art History. Quarterly. Oxford

Art in America. Monthly. New York

Art Journal. Quarterly. New York

Art News. Monthly. New York

Arts and the Islamic World. Annually. London

Asian Art and Culture. Triannually. New York

Burlington Magazine. Monthly. London

Flash Art. Bimonthly. New York

Gesta. Semiannually. New York

History of Photography. Quarterly. London

Journal of Egyptian Archaeology. Quarterly. London

Journal of Hellenic Studies. Annually. London

Journal of Roman Archaeology. Annually. Ann Arbor, Mich.

Journal of the Society of Architectural Historians. Quarterly. Philadelphia

Journal of the Warburg and Courtauld Institutes. Annually. London

Marg. Quarterly. Bombay, India

Oriental Art. Quarterly. Richmond, Surrey, England

Oxford Art Journal. Semiannually. Oxford

Simiolus. Quarterly. Apeldoorn, Netherlands

Textile History. Semiannually, London

Woman's Art Journal. Semiannually, Laverock, Penn.

Ancient Art in the Western Tradition, General

Adam, Robert. *Classical Architecture: A Comprehensive Handbook to the Tradition of Classical Style*. New York: Abrams, 1991.

Amiet, Pierre. *Art in the Ancient World: A Handbook of Styles and Forms*. New York: Rizzoli, 1981.

Becatti, Giovanni. *The Art of Ancient Greece and Rome, from the Rise of Greece to the Fall of Rome*. New York: Abrams, 1967.

Ehrich, Robert W., ed. *Chronologies in Old World Archaeology*. 3rd ed. Chicago: Univ. of Chicago Press, 1992.

Groenewegen-Frankfort, H. A., and Bernard Ashmole. *Art of the Ancient World: Painting, Pottery, Sculpture, Architecture from Egypt, Mesopotamia, Crete, Greece, and Rome*. Library of Art History. Englewood Cliffs, N.J.: Prentice-Hall, 1972.

Huyghe, René. *Larousse Encyclopedia of Prehistoric and Ancient Art*. Art and Mankind. New York: Prometheus, 1966.

Laing, Lloyd Robert, and Jennifer Laing. *Ancient Art: The Challenge to Modern Thought*. Dublin: Irish Academic, 1993.

Lloyd, Seton, and Hans Wolfgang Muller. *Ancient Architecture*. New York: Rizzoli, 1986.

Oliphant, Margaret. *The Atlas of the Ancient World: Charting the Great Civilizations of the Past*. New York: Simon & Schuster, 1992.

Powell, Ann. *Origins of Western Art*. London: Thames and Hudson, 1973.

Saggs, H. W. F. *Civilization before Greece and Rome*. New Haven: Yale Univ. Press, 1989.

Scranton, Robert L. *Aesthetic Aspects of Ancient Art*. Chicago: Univ. of Chicago Press, 1964.

Smith, William Stevenson. *Interconnections in the Ancient Near East: A Study of the Relationships between the Arts of Egypt, the Aegean, and Western Asia*. New Haven: Yale Univ. Press, 1965.

Stillwell, Richard, ed. *Princeton Encyclopedia of Classsical Sites*. Princeton: Princeton Univ. Press, 1976.

European Medieval Art, General

Calkins, Robert C. *Monuments of Medieval Art*. New York: Dutton, 1979.

Duby, Georges. *Sculpture: The Great Art of the Middle Ages from the Fifth to the Fifteenth Century*. New York: Skira/Rizzoli, 1990.

Hurlimann, Martin, and Jean Bony. *French Cathedrals*. Boston: Houghton Mifflin, 1951.

Kenyon, John. *Medieval Fortifications*. Leicester: Leicester Univ. Press, 1990.

Labarge, Margaret Wade. *A Small Sound of the Trumpet: Women in Medieval Life*. London: Hamilton, 1990.

Larousse Encyclopedia of Byzantine and Medieval Art. London: Hamlyn, 1963.

Mâle, Emile. *Religious Art in France: The Late Middle Ages: A Study of Medieval Iconography and Its Sources*. Princeton: Princeton Univ. Press, 1986.

Murphey, Cecil B., comp. *Dictionary of Biblical Literacy*. Nashville: Oliver-Nelson, 1989.

Snyder, James. *Medieval Art: Painting-Sculpture-Architecture, 4th–14th Century*. New York: Abrams, 1989.

Stoddard, Whitney. *Art and Architecture in Medieval France: Medieval Architecture, Sculpture, Stained Glass, Manuscripts. The Art of the Church Treasuries*. New York: Harper & Row, 1972.

Stokstad, Marilyn. *Medieval Art*. New York: Harper & Row, 1986.

Zarnecki, George. *The Art of the Medieval World: Architecture, Sculpture, Painting, the Sacred Arts*. New York: Abrams, 1975.

European Renaissance through Eighteenth-Century Art, General

Art and Politics in Late Medieval and Early Renaissance Italy, 1250–1500. South Bend, Ind.: Univ. of Notre Dame Press, 1990.

Black, C. F., et al. *Cultural Atlas of the Renaissance*. New York: Prentice Hall, 1993.

Blunt, Anthony. *Art and Architecture in France, 1500 to 1700*. Pelican History of Art. Harmondsworth, Eng.: Penguin, 1957.

Circa 1492: Art in the Age of Exploration. Washington, D.C.: National Gallery of Art, 1991.

Cole, Bruce. *Italian Art, 1250–1550: The Relation of Renaissance Art to Life and Society*. New York: Harper & Row, 1987.

Cuttler, Charles D. *Northern Painting from Pucelle to Bruegel: Fourteenth, Fifteenth and Sixteenth Centuries*. New York: Holt, Rinehart and Winston, 1973.

Evers, Hans Gerhard. *The Modern Age: Historicism and Functionalism*. Art of the World. London: Methuen, 1970.

Hartt, Frederick. *History of Italian Renaissance Art: Painting, Sculpture, Architecture*. 3rd ed. New York: Abrams, 1987.

Heydenreich, Ludwig Heinrich. *Architecture in Italy, 1400 to 1600*. Pelican History of Art. Harmondsworth, Eng.: Penguin, 1966.

Huizinga, Johan. *Waning of the Middle Ages: A Study of the Forms of Life, Thought, and Art in France and the Netherlands in the XIVth and XVth Centuries*. Garden City, N.Y.: Doubleday, 1954.

Husband, Timothy. *Wild Man: Medieval Myth and Symbolism*. New York: Metropolitan Museum of Art, 1980.

Huyghe, René. *Larousse Encyclopedia of Renaissance and Baroque Art*. Art and Mankind. New York: Prometheus, 1964.

Kubler, George, and Martin Soria. *Art and Architecture in Spain and Portugal and Their American Dominions, 1500–1800*. Pelican History of Art. Harmondsworth, Eng.: Penguin, 1959.

Levey, Michael. *Early Renaissance*. Harmondsworth, Eng.: Penguin, 1967.

Murray, Peter. *Renaissance Architecture*. History of World Architecture. Milan: Electa, 1985.

———, and Linda Murray. *The Art of the Renaissance*. World of Art. London: Thames and Hudson, 1963.

Stechow, Wolfgang. *Northern Renaissance, 1400–1600: Sources and Documents*. Englewood Cliffs, N.J.: Prentice-Hall, 1966.

Waterhouse, Ellis K. *Painting in Britain: 1530 to 1790*. 4th ed. Pelican History of Art. Harmondsworth, Eng.: Penguin, 1978.

Whinney, Margaret Dickens. *Sculpture in Britain: 1530–1830*. 2nd ed. Rev. by John Physick. Pelican History of Art. London: Penguin, 1988.

Modern Art in the West, General

Arnason, H. H. *History of Modern Art: Painting, Sculpture, Architecture, Photography*. 3rd ed. rev. New York: Abrams, 1986.

Bearden, Romare. *A History of African American Artists: From 1792 to the Present*. New York: Pantheon, 1993.

Brown, Milton W. *American Art: Painting, Sculpture, Architecture, Decorative Arts, Photography*. New York: Abrams, 1979.

Canaday, John. *Mainstreams of Modern Art*. 2nd ed. New York: Holt, Rinehart and Winston, 1981.

Chipp, Herschel Browning. *Theories of Modern Art: A Source Book by Artists and Critics*. California Studies in the History of Art. Berkeley: Univ. of California Press, 1984.

Craven, Wayne. *American Art: History and Culture*. New York: Abrams, 1994.

Eitner, Lorenz. *An Outline of Nineteenth Century European Painting: From David to Cezanne*. 2 vols. New York: Harper & Row, 1987.

Ferebee, Ann. *A History of Design from the Victorian Era to the Present*. New York: Van Nostrand Reinhold, 1980.

Ferrier, Jean Louis, ed. *Art of Our Century: The Chronicle of Western Art, 1900 to the Present*. New York: Prentice Hall, 1989.

Frampton, Kenneth. *Modern Architecture: A Critical History*. World of Art. New York: Oxford Univ. Press, 1980.

Hamilton, George Heard. *19th and 20th Century Art: Painting, Sculpture and Architecture*. Library of Art History. New York: Abrams, 1972.

Hammacher, A. M. *Modern Sculpture: Tradition and Innovation*. Enlg. ed. New York: Abrams, 1988.

Handlin, David P. *American Architecture*. World of Art. London: Thames and Hudson, 1985.

Harris, Ann Sutherland, and Linda Nochlin. *Women Artists: 1550–1950*. Los Angeles: Los Angeles County Museum of Art, 1976.

Harrison, Charles, and Paul Wood, eds. *Art in Theory, 1900–1990: An Anthology of Changing Ideas*. Cambridge: Blackwell, 1992.

Hitchcock, Henry Russell. *Architecture: Nineteenth and Twentieth Centuries*. 4th ed. Pelican History of Art. Harmondsworth, Eng.: Penguin, 1977.

Hunter, Sam, and John Jacobus. *American Art of the 20th Century: Painting, Sculpture, Architecture*. New York: Abrams, 1973.

———. *Modern Art: Painting, Sculpture, Architecture*. 3rd ed. New York: Abrams, 1992.

Jeffrey, Ian. *Photography: A Concise History*. London: Thames and Hudson, 1981.

Lynton, Norbert. *The Story of Modern Art*. 2nd ed. Oxford: Phaidon, 1989.

McCoubrey, John W. *American Art, 1700–1960: Sources and Documents*. Englewood Cliffs, N.J.: Prentice-Hall, 1965.

Newhall, Beaumont. *The History of Photography: From 1839 to the Present*. Rev. ed. New York: Museum of Modern Art, 1982.

Pevsner, Nikolaus, Sir. *The Sources of Modern Architecture and Design*. World of Art. New York: Oxford Univ. Press, 1968.

Read, Herbert. *A Concise History of Modern Painting*. London: Thames and Hudson, 1974.

———. *A Concise History of Modern Sculpture*. World of Art. New York: Praeger, 1964.

Rosenblum, Naomi. *A World History of Photography*. Rev. ed. New York: Abbeville, 1989.

Rosenblum, Robert. *19th Century Art*. New York: Abrams, 1984.

Schapiro, Meyer. *Modern Art: 19th and 20th Century Art*. New York: Braziller, 1978.

Selz, Peter. *Art in Our Times: A Pictorial History 1890–1980*. New York: Abrams, 1981.

Sparke, Penny. *Introduction of Design and Culture in the Twentieth Century*. New York: Harper & Row, 1986.

Stangos, Nikos, ed. *Concepts of Modern Art*. 3rd ed. World of Art. New York: Thames and Hudson, 1994.

Tafuri, Manfredo. *Modern Architecture*. 2 vols. History of World Architecture. New York: Electa/Rizzoli, 1986.

Tuchman, Maurice. *The Spiritual in Art: Abstract Painting 1890–1985*. Los Angeles: Los Angeles County Museum of Art, 1986.

Weaver, Mike, ed. *The Art of Photography, 1939–1989*. London: Royal Academy of Arts, 1989.

Wilmerding, John. *American Art*. Pelican History of Art. Harmondsworth, Eng.: Penguin, 1976.

Asian Art, General

Akiyama, Terukazu. *Japanese Painting*. Treasures of Asia. Geneva: Skira, 1961.

Arts of China. 3 vols. Tokyo: Kodansha International, 1968–70.

Blunden, Caroline, and Mark Elvin. *Cultural Atlas of China*. New York: Facts on File, 1983.

Bussagli, Mario. *Oriental Architecture*. 2 vols. History of World Architecture. New York: Electa/Rizzoli, 1989.

Chang, Leon Long-Yien, and Peter Miller. *Four Thousand Years of Chinese Calligraphy*. Chicago: Univ. of Chicago Press, 1990.

Collcutt, Martin, Marius Jansen, and Isao Kumakura. *Cultural Atlas of Japan*. New York: Facts on File, 1988.

Craven, Roy C. *Indian Art: A Concise History*. World of Art. New York: Thames and Hudson, 1985.

Fisher, Robert E. *Buddhist Art and Architecture*. World of Art. New York: Thames and Hudson, 1993.

Frankfort, Henri. *Art and Architecture of the Ancient Orient*. 4th ed. Pelican History of Art. Harmondsworth, Eng.: Penguin, 1970.

Goetz, Hermann. *The Art of India: Five Thousand Years of Indian Art*. 2nd ed. Art of the World. New York: Crown, 1964.

Harle, James C. *Art and Architecture of the Indian Subcontinent*. Pelican History of Art. Harmondsworth, Eng.: Penguin, 1987.

Lee, Sherman E. *A History of Far Eastern Art*. 4th ed. New York: Abrams, 1982.

Loehr, Max. *The Great Painters of China*. New York: Harper & Row, 1980.

Martynov, Anatolii Ivanovich. *Ancient Art of Northern Asia*. Urbana: Univ. of Illinois Press, 1991.

Mason, Penelope. *History of Japanese Art*. New York: Abrams, 1993.

Medley, Margaret. *Chinese Potter: A Practical History of Chinese Ceramics*. 3rd ed. Oxford: Phaidon, 1989.

Michell, George. *The Penguin Guide to the Monuments of India*. 2 vols. New York: Viking, 1989.

Mikami, Tsugio. *Art of Japanese Ceramics*. Trans. Ann Herring. Heibonsha Survey of Japanese Art, vol. 29. New York: Weatherhill, 1972.

Nakata, Yujiro. *Art of Japanese Calligraphy*. Trans. Alan Woodhull. Heibonsha Survey of Japanese Art, vol. 27. New York: Weatherhill, 1973.

Paine, Robert Treat, and Alexander Soper. *Art and Architecture of Japan*. 3rd ed. Pelican History of Art. Harmondsworth, Eng.: Penguin, 1981.

Rowland, Benjamin. *Art and Architecture of India: Buddhist, Hindu, Jain*. Pelican History of Art. Harmondsworth, Eng.: Penguin, 1977.

Seckel, Dietrich. *Art of Buddhism*. Art of the World. New York: Crown, 1964.

Sickman, Lawrence, and Alexander Soper. *Art and Architecture of China*. Pelican History of Art. Harmondsworth, Eng.: Penguin, 1971.

Speiser, Werner. *The Art of China: Spirit and Society*. Art of the World. New York: Crown, 1961.

Stanley-Baker, Joan. *Japanese Art*. World of Art. New York: Thames and Hudson, 1984.

Stutley, Margaret. *Harper's Dictionary of Hinduism: Its Mythology, Folklore, Philosophy, Literature and History*. New York: Harper & Row, 1977.

Tregear, Mary. *Chinese Art*. World of Art. New York: Oxford Univ. Press, 1980.

Vainker, S. J. *Chinese Pottery and Porcelain: From Prehistory to the Present*. London: British Museum, 1991.

Varley, H. Paul. *Japanese Culture*. 3rd ed. Honolulu: Univ. of Hawaii Press, 1984.

Yoshikawa, Itsuji. *Major Themes in Japanese Art*. Trans. Armins Nikovskis. Heibonsha Survey of Japanese Art, vol. 1. New York: Weatherhill, 1976.

African and Oceanic Art and Art of the Americas, General

Anderson, Richard L. *Art in Small-Scale Societies*. 2nd ed. Englewood Cliffs, N.J.: Prentice Hall, 1989.

Berlo, Janet Catherine, and Lee Ann Wilson. *Arts of Africa, Oceania, and the Americas: Selected Readings*. Englewood Cliffs, N.J.: Prentice Hall, 1993.

Blocker, H. Gene. *The Aesthetics of Primitive Art*. Lantham, Md.: Univ. Press of America, 1994.

Coote, Jeremy, and Anthony Shelton, eds. *Anthropology, Art, and Aesthetics*. New York: Oxford Univ. Press, 1992.

D'Azevedao, Warren L. *The Traditional Artist in African Societies*. Bloomington: Indiana Univ. Press, 1989.

Drewal, Henry, and John Pemberton III. *Yoruba: Nine Centuries of African Art and Thought*. New York: Center for African Art, 1989.

Guidoni, Enrico. *Primitive Architecture*. Trans. Robert Eric Wolf. History of World Architecture. New York: Rizzoli, 1987.

Leiris, Michel, and Jacqueline Delange. *African Art*. Arts of Mankind. London: Thames and Hudson, 1968.

Leuzinger, Elsy. *Africa: The Art of the Negro Peoples*. 2nd ed. Art of the World. New York: Crown, 1967.

Mbiti, John S. *African Religions and Philosophy*. 2nd ed. Oxford: Heinemann, 1990.

Mexico: Splendors of Thirty Centuries. New York: Metropolitan Museum of Art, 1990.

Murray, Jocelyn, ed. *Cultural Atlas of Africa*. New York: Facts on File, 1981.

Price, Sally. *Primitive Art in Civilized Places*. Chicago: Univ. of Chicago Press, 1989.

Willett, Frank. *African Art: An Introduction*. Rev ed. World of Art. New York: Thames and Hudson, 1993.

Chapter 1 Prehistory and Prehistoric Art in Europe

Anati, Emmanuel. *Camonica Valley: A Depiction of Village Life in the Alps from Neolithic Times to the Birth of Christ, as Revealed by Thousands of Newly Found Rock Carvings*. Trans. Linda Asher. New York: Knopf, 1961.

Bandi, Hans-Georg, et al. *Art of the Stone Age: Forty Thousand Years of Rock Art*. 2nd ed. Trans. Ann E. Keep. Art of the World. London: Methuen, 1970.

Beltrán Martínez, Antonio. *Rock Art of the Spanish Levant*. Trans. Margaret Brown. Cambridge: Cambridge Univ. Press, 1982.

Castleden, Rodney. *The Making of Stonehenge*. London: Routledge, 1993.

Chippindale, Christopher. *Stonehenge Complete*. New York: Thames and Hudson, 1994.

Freeman, Leslie G. *Altamira Revisited and Other Essays on Early Art*. Chicago: Institute for Prehistoric Investigation, 1987.

Gowlett, John A. J. *Ascent to Civilization: The Archaeology of Early Humans*. 2nd ed. New York: McGraw-Hill, 1993.

Graziosi, Paolo. *Paleolithic Art*. New York: McGraw-Hill, 1960.

Leroi-Gourhan, André. *The Dawn of European Art: An Introduction to Paleolithic Cave Painting*. Trans. Sara Champion. Cambridge: Cambridge Univ. Press, 1982.

———. *Treasures of Prehistoric Art*. New York: Abrams, 1967.

Lewin, Roger. *The Origins of Modern Humans*. New York: Scientific American Library, 1993.

Lhote, Henri. *The Search for the Tassili Frescoes: The Story of the Prehistoric Rock-Paintings of the Sahara*. 2nd ed. Trans. Alan Houghton Brodrick. London: Hutchinson, 1973.

Marshack, Alexander. *The Roots of Civilization: The Cognitive Beginnings of Man's First Art, Symbol, and Notation*. New York: McGraw-Hill, 1971.

Moscati, Sabatino, ed. *The Phoenicians*. New York: Abbeville, 1988.

O'Kelly, Michael J. *Newgrange: Archaeology, Art, and Legend*. New Aspects of Antiquity. London: Thames and Hudson, 1982.

Powell, T. G. E. *Prehistoric Art*. World of Art. New York: Oxford Univ. Press, 1966.

Price, T. Douglas, and Gray M. Feinman. *Images of the Past*. Mountain View, Calif.: Mayfield, 1993.

Renfrew, Colin, ed. *The Megalithic Monuments of Western Europe*. London: Thames and Hudson, 1983.

Ruspoli, Mario. *The Cave of Lascaux: The Final Photographs*. New York: Abrams, 1987.

Sandars, N. K. *Prehistoric Art in Europe*. 2nd ed. Pelican History of Art. Harmondsworth, Eng.: Penguin, 1985.

Sieveking, Ann. *The Cave Artists*. Ancient People and Places, vol. 93. London: Thames and Hudson, 1979.

Soffer, Olga. *The Upper Paleolithic of the Central Russian Plain*. Studies in Archaeology. Orlando, Fla.: Academic, 1985.

Torbrugge, Walter. *Prehistoric European Art*. Trans. Norbert Guterman. Panorama of World Art. New York: Abrams, 1968.

Ucko, Peter J., and Andree Rosenfeld. *Paleolithic Cave Art*. New York: McGraw-Hill, 1967.

Chapter 2 Art of the Ancient Near East

Akurgal, Ekrem. *The Art of the Hittites*. Trans. Constance McNab. New York: Abrams, 1962.

Amiet, Pierre. *Art of the Ancient Near East*. Trans. John Shepley and Claude Choquet. New York: Abrams, 1980.

Baring, Anne, and Jules Cashford. *The Myth of the Goddess: Evolution of an Image*. London: Viking Arkana, 1991.

Bottero, Jean. *Mesopotamia: Writing, Reasoning, and the Gods*. Trans. Zainab Bahrani and Marc Van De Mieroop. Chicago: Univ. of Chicago Press, 1992.

Collon, Dominque. *First Impressions: Cylinder Seals in the Ancient Near East*. Chicago: Univ. of Chicago Press, 1987.

Ferrier, R. W., ed. *Arts of Persia*. New Haven: Yale Univ. Press, 1989.

Ghirshman, Roman. *The Arts of Ancient Iran from Its Origins to the Time of Alexander the Great*. Trans. Stuart Gilbert and James Emmons. Arts of Mankind. New York: Golden, 1964.

Giedion, Sigfried. *The Eternal Present: A Contribution on Constancy and Change*. 2 vols. New York: Pantheon, 1962–64.

Harper, Prudence, Joan Arz, and Françoise Tallon, eds. *The Royal City of Susa: Ancient Near Eastern Treasures in the Louvre*. New York: Metropolitan Museum of Art, 1992.

Kramer, Samual Noah. *History Begins at Sumer: Thirty-Nine Firsts in Man's Recorded History*. 3rd rev. ed. Philadelphia: Univ. of Pennsylvania Press, 1981.

———. *The Sumerians, Their History, Culture, and Character*. Chicago: Univ. of Chicago Press, 1963.

Lloyd, Seton. *Ancient Turkey: A Traveller's History of Anatolia*. Berkeley: Univ. of California Press, 1989.

Mellaart, James. *The Earliest Civilization of the Near East*. London: Thames and Hudson, 1965.

Oppenheim, A. Leo. *Ancient Mesopotamia: Portrait of a Dead Civilization*. Rev. ed. completed by Erica Reiner. Chicago: Univ. of Chicago Press, 1977.

Parrot, André. *The Arts of Assyria*. Trans. Stuart Gilbert and James Emmons. Arts of Mankind. New York: Golden, 1961.

———. *Sumer: The Dawn of Art*. Trans. Stuart Gilbert and James Emmons. Arts of Mankind. New York: Golden, 1961.

Porada, Edith. *The Art of Ancient Iran: Pre-Islamic Cultures*. Art of the World. New York: Crown, 1965.

Roaf, Michael. *Cultural Atlas of Mesopotamia and the Ancient Near East*. New York: Facts on File, 1990.

Roux, Georges. *Ancient Iraq*. 3rd ed. London: Penguin, 1992.

Russell, John Malcolm. *Sennacherib's Palace without Rival at Nineveh*. Chicago: Univ. of Chicago Press, 1991.

Saggs, H. W. F. *Everyday Life in Babylonia and Assyria*. New York: Dorset, 1987.

———. *Civilization before Greece and Rome*. New Haven: Yale Univ. Press, 1989.

Wolkstein, Dianne, and Samuel Noah Kramer. *Inanna: Queen of Heaven and Earth*. New York: Harper & Row, 1983.

Woolley, Leonard. *The Art of the Middle East including Persia, Mesopotamia and Palestine*. Trans. Ann E. Keep. Art of the World. New York: Crown, 1961.

Chapter 3 Art of Ancient Egypt

Aldred, Cyril. *Akenaten and Nefertiti*. New York: Brooklyn Museum, 1973.

———. *Egyptian Art in the Days of the Pharaohs, 3100–320 B.C.* World of Art. London: Thames and Hudson, 1980.

Andrews, Carol. *Ancient Egyptian Jewelry*. New York: Abrams, 1991.

Baines, John, and Jaromir Málek. *Atlas of Ancient Egypt*. New York: Facts on File, 1980.

Bierbrier, Morris. *Tomb-Builders of the Pharaohs*. London: British Museum, 1982.

Breasted, James Henry. *A History of Egypt from the Earliest Times to the Persian Conquest*. New York: Scribner's, 1909.

Brier, Bob. *Egyptian Mummies*. New York: Morrow, 1994.

David, A. Rosalie. *The Pyramid Builders of Ancient Egypt: A Modern Investigation of Pharaoh's Workforce*. London: Routledge, 1986.

Edwards, I. E. S. *The Pyramids of Egypt*. Rev. ed. Harmondsworth, Eng.: Penguin, 1985.

The Egyptian Book of the Dead: The Book of Going Forth by Day: Being the Papyrus of Ani (Royal Scribe of the Divine Offerings). Trans. Raymond O. Faulkner. San Francisco: Chronicle, 1994.

Grimal, Nicolas. *A History of Ancient Egypt*. Trans. Ian Hall. Oxford: Blackwell, 1992.

James, T. G. H. *Egyptian Painting*. London: British Museum, 1985.

———, and W. V. Davies. *Egyptian Sculpture*. Cambridge: Harvard Univ. Press, 1983.

Kozloff, Arielle P., and Betsy M. Bryan. *Egypt's Dazzling Sun: Amenhotep III and His World*. Cleveland: Cleveland Museum of Art, 1992.

Manniche, Lise. *City of the Dead: Thebes in Egypt*. Chicago: Univ. of Chicago Press, 1987.

Martin, Geoffrey Thorndike. *The Hidden Tombs of Memphis: New Discoveries from the Time of Tutankhamun and Ramesses the Great*. London: Thames and Hudson, 1991.

Montet, Pierre. *Everyday Life in Egypt in the Days of Ramesses the Great*. Trans. A. R. Maxwell-Hysop and Margaret S. Drower. Philadelphia: Univ. of Pennsylvania Press, 1981.

Pemberton, Delia. *Ancient Egypt*. Architectural Guides for Travelers. San Francisco: Chronicle, 1992.

Reeves, C. N. *The Complete Tutankhamun: The King, the Tomb, the Royal Treasure*. London: Thames and Hudson, 1990.

Russmann, Edna R. *Egyptian Sculpture: Cairo and Luxor*. Austin: Univ. of Texas Press, 1989.

Smith, W. Stevenson. *The Art and Architecture of Ancient Egypt*. Rev. ed. Pelican History of Art. Harmondsworth, Eng.: Penguin, 1981.

Strouhal, Eugen. *Life of the Ancient Egyptians*. Norman: Univ. of Oklahoma Press, 1992.

Treasures of Tutankhamun. New York: Ballantine, 1976.

Wilkinson, Charles K. *Egyptian Wall Paintings: The Metropolitan Museum of Art's Collection of Facsimiles*. New York: Metropolitan Museum of Art, 1983.

Winstone, H. V. F. *Howard Carter and the Discovery of the Tomb of Tutankhamun*. London: Constable, 1991.

Woldering, Irmgard. *The Art of Egypt: The Time of the Pharaohs*. Trans. Ann E. Keep. Art of the World. New York: Crown, 1963.

Chapter 4 Aegean Art

Barber, R. L. N. *The Cyclades in the Bronze Age*. Iowa City: Univ. of Iowa Press, 1987.

Castleden, Rodney. *The Knossos Labyrinth: A New View of the "Palace of Minos" at Knossos*. London: Routledge, 1990.

Demargne, Pierre. *The Birth of Greek Art*. Trans. Stuart Gilbert and James Emmons. Arts of Mankind. New York: Golden, 1964.

Doumas, Christos. *The Wall-Paintings of Thera*. Trans. Alex Doumas. Athens: Thera Foundation, 1992.

Fitton, J. Lesley. *Cycladic Art*. Cambridge: Harvard Univ. Press, 1990.

Higgins, Reynold. *Minoan and Mycenean Art*. Rev. ed. World of Art. New York: Oxford Univ. Press, 1981.

Immerwahr, Sara Anderson. *Aegean Painting in the Bronze Age*. University Park: Pennsylvania State Univ. Press, 1990.

Marinatos, Nanno. *Art and Religion in Thera: Reconstructing a Bronze Age Society*. Athens: Mathioulakis, 1984.

Marinatos, Spyridon, and Max Hirmer. *Crete and Mycenae*. New York: Abrams, 1960.

Matz, Friedrich. *The Art of Crete and Early Greece: Prelude to Greek Art*. Trans. Ann E. Keep. Art of the World. New York: Crown, 1962.

Morgan, Lyvia. *The Miniature Wall Paintings of Thera: A Study in Aegean Culture and Iconography*. Cambridge: Cambridge Univ. Press, 1988.

Pellegrino, Charles R. *Unearthing Atlantis: An Archaeological Survey*. New York: Random House, 1991.

Chapter 5 Art of Ancient Greece

Akurgal, Ekrem. *The Art of Greece: Its Origins in the Mediterranean and Near East*. Trans. Wayne Dynes. Art of the World. New York: Crown, 1968.

Andrewes, Antony. *The Greeks: History of Human Society*. New York: Knopf, 1967.

Arafat, K. W. *Classical Zeus: A Study in Art and Literature*. Oxford: Clarendon, 1990.

Arias, Paolo. *A History of 1000 Years of Greek Vase Painting*. New York: Abrams, 1962.

Ashmole, Bernard. *Architect and Sculptor in Classical Greece*. Wrightsman Lectures. New York: New York Univ. Press, 1972.

Avery, Catherine, ed. *The New Century Handbook of Greek Mythology and Legend*. New York: Appleton-Century Crofts, 1972.

Berve, Helmut, and Gottfried Gruben. *Greek Temples, Theatres, and Shrines*. New York: Abrams, 1963.

Biers, William. *The Archaeology of Greece: An Introduction*. Rev. ed. Ithaca: Cornell Univ. Press, 1987.

Blumel, Carl. *Greek Sculptors at Work*. 2nd ed. Trans. Lydia Holland. London: Phaidon, 1969.

Boardman, John. *Greek Art*. Rev. ed. World of Art. New York: Oxford Univ. Press, 1973.

———. *Greek Sculpture: The Archaic Period: A Handbook*. World of Art. New York: Oxford Univ. Press, 1978.

———. *Greek Sculpture: The Classical Period: A Handbook*. London: Thames and Hudson, 1985.

———. *Oxford History of the Classical World*. Oxford: Oxford Univ. Press, 1986.

———. *The Parthenon and Its Sculptures*. Austin: Univ. of Texas Press, 1985.

Branigan, Keith, and Michael Vickers. *Hellas: The Civilizations of Ancient Greece*. New York: McGraw-Hill, 1980.

Camp, John M. *The Athenian Agora: Excavations in the Heart of Classical Athens*. New York: Thames and Hudson, 1986.

Carpenter, Thomas H. *Art and Myth in Ancient Greece: A Handbook*. World of Art. London: Thames and Hudson, 1991.

Charbonneaux, Jean, Robert Martin, and François Villard. *Archaic Greek Art (620–480 B.C.)*. Trans. James Emmons and Robert Allen. Arts of Mankind. New York: Braziller, 1971.

———. *Classical Greek Art (480–330 B.C.)*. Trans. James Emmons. Arts of Mankind. New York: Braziller, 1972.

———. *Hellenistic Art (330–50 B.C.)*. Trans. Peter Green. Arts of Mankind. New York: Braziller, 1973.

Chitham, Robert. *The Classical Orders of Architecture*. New York: Rizzoli, 1985.

Finley, Moses. *The Ancient Greeks: An Introduction to Their Life and Thought*. New York: Viking, 1963.

Francis, E. D. *Image and Idea in Fifth-Century Greece: Art and Literature after the Persian Wars*. London: Routledge, 1990.

Havelock, Christine Mitchell. *Hellenistic Art: The Art of the Classical World from the Death of Alexander the Great to the Battle of Actium*. 2nd ed. New York: Norton, 1981.

Homann-Wedeking, Ernst. *The Art of Archaic Greece*. Trans. J. R. Foster. Art of the World. New York: Crown, 1968.

Hood, Sinclair. *Arts in Prehistoric Greece*. Pelican History of Art. Harmondsworth, Eng.: Penguin, 1978.

Hopper, Robert John. *The Acropolis*. London: Weidenfeld and Nicolson, 1971.

Hurwit, Jeffrey M. *The Art and Culture of Early Greece 1100–480 B.C.* Ithaca: Cornell Univ. Press, 1985.

Jenkins, Ian. *The Parthenon Frieze*. Austin: Univ. of Texas Press, 1994.

Kagan, Donald. *The Outbreak of the Peloponnesian War*. Ithaca: Cornell Univ. Press, 1969.

Lawrence, A. W. *Greek Architecture*. 4th ed. Pelican History of Art. Harmondsworth, Eng.: Penguin, 1983.

Lullies, Reinhart, and Max Hirmer. *Greek Sculpture*. Rev. ed. Trans. Michael Bullock. New York: Abrams, 1957.

Martin, Roland. *Greek Architecture: Architecture of Crete, Greece, and the Greek World*. History of World Architecture. New York: Electa/Rizzoli, 1988.

Morg, Catherine. *Athletes and Oracles: The Transformation of Olympia and Delphi in the Eighth Century B.C.* Cambridge: Cambridge Univ. Press, 1990.

Onians, John. *Art and Thought in the Hellenistic Age: The Greek World View 350–50 B.C.* London: Thames and Hudson, 1979.

Papaioannou, Kostas. *The Art of Greece*. Trans. I. Mark Paris. New York: Abrams, 1989.

Pedley, John Griffiths. *Greek Art and Archaeology*. New York: Abrams, 1993.

Pollitt, J. J. *Art in the Hellenistic Age*. Cambridge: Cambridge Univ. Press, 1986.

———. *The Art of Ancient Greece: Sources and Documents*. Cambridge: Cambridge Univ. Press, 1990.

Ridgway, Brunilde Sismondo. *Fifth Century Styles in Greek Sculpture*. Princeton: Princeton Univ. Press, 1981.

———. *Hellenistic Sculpture I: The Styles of ca. 331–200 B.C.* Wisconsin Studies in Classics. Madison: Univ. of Wisconsin Press, 1990.

Robertson, Martin. *Greek Painting: The Great Centuries of Painting*. Geneva: Skira, 1959.

Roes, Anna. *Greek Geometric Art: Its Symbolism and Its Origin*. London: Oxford Univ. Press, 1933.

Schefold, Karl. *Classical Greece*. Trans. J. R. Foster. Art of the World. London: Methuen, 1967.

Schmidt, Evamaria. *The Great Altar of Pergamon*. Trans. Lena Jack. Leipzig: VEB Edition Leipzig, 1962.

Scully, Vincent. *The Earth, the Temple, and the Gods: Greek Sacred Architecture*. Rev. ed. New Haven: Yale Univ. Press, 1979.

Smith, R. R. R. *Hellenistic Sculpture: A Handbook*. World of Art. New York: Thames and Hudson, 1991.

Stewart, Andrew F. *Greek Sculpture: An Exploration*. 2 vols. New Haven: Yale Univ. Press, 1990.

———. *Skopas of Paros*. Park Ridge: Noyes, 1977.

Webster, T. B. L. *The Art of Greece: The Age of Hellenism*. Art of the World. New York: Crown, 1966.

Whitley, A. James M. *Style and Society in Dark Age Greece: The Changing Face of a Pre-literate Society, 1100–700 B.C.* New Studies in Archaeology. Cambridge: Cambridge Univ. Press, 1991.

Chapter 6 Etruscan Art and Roman Art

Andreae, Bernard. *The Art of Rome*. Trans. Robert Erich Wolf. New York: Abrams, 1977.

Aries, Philippe, and Georges Duby, eds. *A History of Private Life*. Vol. 1: *From Pagan Rome to Byzantium*. Trans. Arthur Goldhammer. Cambridge, Mass.: Belknap, 1987.

Balsdon, J. P. V. D. *Roman Women: Their History and Habits*. London: Bodley Head, 1962.

Bianchi Bandinelli, Ranuccio. *Rome: The Centre of Power: Roman Art to A.D. 200*. Trans. Peter Green. Arts of Mankind. London: Thames and Hudson, 1970.

———. *Rome: The Late Empire: Roman Art A.D. 200–400*. Trans. Peter Green. Arts of Mankind. New York: Braziller, 1971.

Bloch, Raymond. *Etruscan Art*. Greenwich, Conn.: New York Graphic Society, 1965.

Boardman, John. *Oxford History of the Classical World*. Oxford: Oxford Univ. Press, 1986.

Boethius, Axel, and J. B. Ward-Perkins. *Etruscan and Early Roman Architecture*. 2nd ed. Pelican History of Art. Harmondsworth, Eng.: Penguin, 1978.

Breeze, David John. *Hadrian's Wall*. London: Allen Lane, 1976.

Brendel, Otto J. *Etruscan Art*. Pelican History of Art. Harmondsworth, Eng.: Penguin, 1978.

Brilliant, Richard. *Roman Art from the Republic to Constantine*. London: Phaidon, 1974.

Brown, Peter. *The World of Late Antiquity: A.D. 150–750*. New York: Norton, 1989.

Buranelli, Francesco. *The Etruscans: Legacy of a Lost Civilization from the Vatican Museums*. Memphis: Lithograph, 1992.

Christ, Karl. *The Romans: An Introduction to Their History and Civilisation*. Berkeley: Univ. of California Press, 1984.

Cornell, Tim, and John Matthews. *Atlas of the Roman World*. New York: Facts on File, 1982.

Guilland, Jacqueline, and Maurice Guilland. *Frescoes in the Time of Pompeii*. New York: Potter, 1990.

Heintze, Helga von. *Roman Art*. New York: Universe, 1990.

Henig, Martin, ed. *A Handbook of Roman Art: A Comprehensive Survey of All the Arts of the Roman World*. Ithaca: Cornell Univ. Press, 1983.

Kahler, Heinz. *The Art of Rome and Her Empire*. Trans. J. R. Foster. Art of the World. New York: Crown, 1963.

Ling, Roger. *Roman Painting*. Cambridge: Cambridge Univ. Press, 1991.

L'Orange, Hans Peter. *The Roman Empire: Art Forms and Civic Life*. New York: Rizzoli, 1985.

MacDonald, William L. *The Architecture of the Roman Empire: An Introductory Study*. Rev. ed. 2 vols. Yale Publications in the History of Art. New Haven: Yale Univ. Press, 1982.

———. *The Pantheon: Design, Meaning, and Progeny*. Cambridge: Harvard Univ. Press, 1976.

Maiuri, Amedeo. *Roman Painting: The Great Centuries of Painting*. Trans. Stuart Gilbert. Geneva: Skira, 1953.

Mansuelli, G. A. *The Art of Etruria and Early Rome*. Art of the World. New York: Crown, 1965.

Pollitt, J. J. *The Art of Rome, c. 753 B.C.–337 A.D.: Sources and Documents*. Englewood Cliffs, N.J.: Prentice-Hall, 1966.

Quennell, Peter. *The Colosseum*. New York: Newsweek, 1971.

Ramage, Nancy H., and Andrew Ramage. *Roman Art: Romulus to Constantine*. New York: Abrams, 1991.

Rediscovering Pompeii. Rome: L'Erma di Bretschneider, 1990.

Sprenger, Maja, and Bartolini, Gilda. *The Etruscans: Their History, Art, and Architecture*. New York: Abrams, 1983.

Strong, Donald. *Roman Art*. 2nd ed. Pelican History of Art. Harmondsworth, Eng.: Penguin, 1980.

Ward-Perkins, J. B. *Roman Architecture*. History of World Architecture. New York: Electa/Rizzoli, 1988.

Wheeler, Robert Eric Mortimer, Sir. *Roman Art and Architecture*. World of Art. New York: Oxford Univ. Press, 1964.

Wilkinson, L. P. *The Roman Experience*. New York: Knopf, 1974.

Chapter 7 Early Christian, Jewish, and Byzantine Art

Age of Spirituality: Late Antique and Early Christian Art, Third to Seventh Century. New York: Metropolitan Museum of Art, 1979.

Beckwith, John. *The Art of Constantinople: An Introduction to Byzantine Art 330–1453*. 2nd ed. London: Phaidon, 1968.

———. *Early Christian and Byzantine Art*. 2nd ed. Pelican History of Art. Harmondsworth, Eng.: Penguin, 1979.

Boyd, Susan A. *Byzantine Art*. Chicago: Univ. of Chicago Press, 1979.

Buckton, David, ed. *The Treasury of San Marco, Venice*. Milan: Olivetti, 1985.

Carr, Annemarie Weyl. *Byzantine Illumination, 1150–1250: The Study of a Provincial Tradition*. Chicago: Univ. of Chicago Press, 1987.

Christe, Yves. *Art of the Christian World, A.D. 200–1500: A Handbook of Styles and Forms*. New York: Rizzoli, 1982.

Cutler, Anthony. *The Hand of the Master: Craftsmanship, Ivory, and Society in Byzantium (9th–11th Centuries)*. Princeton: Princeton Univ. Press, 1994.

Demus, Otto. *Byzantine Art and the West*. Wrightsman Lectures. New York: New York Univ. Press, 1970.

———. *Byzantine Mosaic Decoration: Aspects of Monumental Art in Byzantium*. New Rochelle: Caratzas, 1976.

———. *The Church of San Marco in Venice: History, Architecture, Sculpture*. Washington, D.C.: Dumbarton Oaks, 1960.

Ferguson, George Wells. *Signs and Symbols in Christian Art*. New York: Oxford Univ. Press, 1967.

Gough, Michael. *Origins of Christian Art*. World of Art. London: Thames and Hudson, 1973.

Grabar, André. *The Art of the Byzantine Empire: Byzantine Art in the Middle Ages*. Trans. Betty Forster. Art of the World. New York: Crown, 1966.

———. *Early Christian Art: From the Rise of Christianity to the Death of Theodosius*. Trans. Stuart Gilbert and James Emmons. Arts of Mankind. New York: Odyssey, 1969.

———. *The Golden Age of Justinian from the Death of Theodosius to the Rise of Islam*. Trans. Stuart Gilbert and James Emmons. Arts of Mankind. New York: Odyssey, 1967.

Hubert, Jean, Jean Porcher, and W. F. Volbach. *Europe of the Invasions*. Trans. Stuart Gilbert and James Emmons. Arts of Mankind. New York: Braziller, 1969.

Kitzinger, Ernst. *Byzantine Art in the Making: Main Lines of Stylistic Development in Mediterranean Art, 3rd–7th Century*. Cambridge: Harvard Univ. Press, 1977.

Krautheimer, Richard. *Early Christian and Byzantine Architecture*. 4th ed. Pelican History of Art. Harmondsworth, Eng: Penguin, 1986.

Lane Fox, Robin. *Pagans and Christians*. Harmondsworth, Eng.: Viking, 1986.

Mainstone, R. J. *Hagia Sophia: Architecture, Structure and*

Liturgy of Justinian's Great Church. London: Thames and Hudson, 1988.

Mango, Cyril. *Art of the Byzantine Empire, 312–1453: Sources and Documents.* Englewood Cliffs, N.J.: Prentice-Hall, 1972.

———. *Byzantine Architecture.* History of World Architecture. New York: Rizzoli, 1985.

Manicelli, Fabrizio. *Catacombs and Basilicas: The Early Christians in Rome.* Florence: Scala, 1981.

Mathew, Gervase. *Byzantine Aesthetics.* London: J. Murray, 1963.

Milburn, R. L. P. *Early Christian Art and Architecture.* Berkeley: Univ. of California Press, 1988.

Oakshott, Walter Fraser. *The Mosaics of Rome: From the Third to the Fourteenth Centuries.* London: Thames and Hudson, 1967.

Rice, David Talbot. *Art of the Byzantine Era.* New York: Praeger, 1963.

———. *Byzantine Art.* Harmondsworth, Eng.: Penguin, 1968.

Schapiro, Meyer. *Late Antique, Early Christian, and Mediaeval Art.* New York: Braziller, 1979.

Simson, Otto Georg von. *Sacred Fortress: Byzantine Art and State-craft in Ravenna.* Chicago: Univ. of Chicago Press, 1948.

Snyder, James. *Medieval Art: Painting, Sculpture, Architecture, 4th–14th Century.* Englewood Cliffs, N.J.: Prentice-Hall, 1989.

Stevenson, James. *The Catacombs: Rediscovered Monuments of Early Christianity.* Ancient Peoples and Places. London: Thames and Hudson, 1978.

Weitzmann, Kurt. *Late Antique and Early Christian Book Illumination.* New York: Braziller, 1977.

———. *Place of Book Illumination in Byzantine Art.* Princeton: Art Museum, Princeton Univ., 1975.

Wharton, Annabel Jane. *Art of Empire: Painting and Architecture of the Byzantine Periphery: A Comparative Study of Four Provinces.* University Park: Pennsylvania State Univ. Press, 1988.

Chapter 8 Islamic Art

Akurgal, Ekrem, ed. *The Art and Architecture of Turkey.* New York: Rizzoli, 1980.

Al-Faruqi, Ismail R, and Lois Lamya'al Faruqi. *Cultural Atlas of Islam.* New York: Macmillan, 1986.

Aslanapa, Oktay. *Turkish Art and Architecture.* London: Faber, 1971.

Atasoy, Nurhan. *Splendors of the Ottoman Sultans.* Ed. and Trans. Tulay Artan. Memphis, Tenn.: Lithograph, 1992.

Atil, Esin. *The Age of Sultan Suleyman the Magnificent.* Washington, D.C.: National Gallery of Art, 1987.

———. *Art of the Arab World.* Washington, D.C.: Smithsonian Institution, 1975.

———. *Islamic Art and Patronage: Treasures from Kuwait.* New York: Rizzoli, 1990.

———. *Renaissance of Islam: Art of the Mamluks.* Washington, D.C.: Smithsonian Institution, 1981.

Blair, Sheila S., and Jonathan M. Brown. *The Art and Architecture of Islam 1250–1800.* New Haven: Yale Univ. Press, 1994.

Brend, Barbara. *Islamic Art.* Cambridge: Harvard Univ. Press, 1991.

Dodds, Jerrilynn D., ed. *Al-Andalus: The Art of Islamic Spain.* New York: Metropolitan Museum of Art, 1992.

Ettinghausen, Richard, and Oleg Grabar. *The Art and Architecture of Islam: 650–1250.* Pelican History of Art. Harmondsworth, Eng.: Penguin, 1987.

Falk, Toby, ed. *Treasures of Islam.* London: Sotheby's, 1985.

Ferrier, R. W., ed. *Arts of Persia.* New Haven: Yale Univ. Press, 1989.

Frishman, Martin, and Hasan-Uddin Khan. *The Mosque: History, Architectural Development and Regional Diversity.* London: Thames and Hudson, 1994.

Glasse, Cyril. *The Concise Encyclopedia of Islam.* San Francisco: Harper & Row, 1989.

Grabar, Oleg. *The Alhambra.* Cambridge: Harvard Univ. Press, 1978.

———. *The Formation of Islamic Art.* Rev. ed. New Haven: Yale Univ. Press, 1987.

———. *The Great Mosque of Isfahan.* New York: New York Univ. Press, 1990.

———. *The Mediation of Ornament.* A. W. Mellon Lectures in the Fine Arts. Princeton: Princeton Univ. Press, 1992.

Grube, Ernest J. *Architecture of the Islamic World: Its History and Social Meaning.* Ed. George Mitchell. New York: Morrow, 1978.

Hoag, John D. *Islamic Architecture.* History of World Architecture. New York: Abrams, 1977.

Jones, Dalu, and George Mitchell, eds. *The Arts of Islam.* London: Arts Council of Great Britain, 1976.

Khatibi, Abdelkebir, and Mohammed Sijelmassi. *The Splendour of Islamic Calligraphy.* New York: Rizzoli, 1977.

The Koran. Rev. ed. Trans. N. J. Dawood. London: Penguin, 1993.

Lentz, Thomas W., and Glenn D. Lowry. *Timur and the Princely Vision: Persian Art and Culture in the Fifteenth Century.* Los Angeles: Los Angeles County Museum of Art, 1989.

Papadopoulo, Alexandre. *Islam and Muslim Art.* Trans. Robert Erich Wolf. New York: Abrams, 1979.

Petsopoulos, Yanni, ed. *Tulips, Arabesques and Turbans: Decorative Arts from the Ottoman Empire.* New York: Abbeville, 1982.

Raby, Julian, ed. *The Art of Syria and the Jazira, 1100–1250.* Oxford Studies in Islamic Art. Oxford: Oxford Univ. Press, 1985.

Rice, David Talbot. *Islamic Art.* World of Art. New York: Thames and Hudson, 1965.

Schimmel, Annemarie. *Calligraphy and Islamic Culture.* New York: New York Univ. Press, 1983.

Sharma, Arvind, ed. *Our Religions.* San Francisco: HarperSanFrancisco, 1993.

Ward, R. M. *Islamic Metalwork.* New York: Thames and Hudson, 1993.

Welch, Anthony. *Calligraphy in the Arts of the Muslim World.* Austin: Univ. of Texas Press, 1979.

Chapter 9 Art of India before 1100

Berkson, Carmel. *Elephanta: The Cave of Shiva.* Princeton: Princeton Univ. Press, 1983.

Chandra, Pramod. *The Sculpture of India, 3000 B.C.–1300 A.D.* Washington, D.C.: National Gallery of Art, 1985.

Coomaraswamy, Ananda K. *Yaksas: Essays in the Water Cosmology.* Rev. ed. Ed. Paul Schroeder. New York: Oxford Univ. Press, 1993.

Czuma, Stanisław J. *Kushan Sculpture: Images from Early India.* Cleveland: Cleveland Museum of Art, 1985.

De Bary, William, ed. *Sources of Indian Tradition.* New York: Columbia Univ. Press, 1958.

Dehejia, Vidya. *Art of the Imperial Cholas.* New York: Columbia Univ. Press, 1990.

———. *Early Buddhist Rock Temples.* Ithaca: Cornell Univ. Press, 1972.

Dessai, Vishakha N., and Darielle Mason. *Gods, Guardians, and Lovers: Temple Sculptures from North India, A.D. 700–1200.* New York: Asia Society Galleries, 1993.

Dimmitt, Cornelia. *Classical Hindu Mythology.* Philadelphia: Temple Univ. Press, 1978.

Eck, Diana L. *Darsan: Seeing the Divine Image in India.* 2nd rev. ed. Chambersburg, Penn.: Anima, 1985.

Errington, Elizabeth, and Joe Cribb, eds. *The Crossroads of Asia: Transformation in Image and Symbol in the Art of Ancient Afghanistan and Pakistan.* Cambridge, Eng.: Ancient India and Iran Trust, 1992.

Goswamy, B. N. *An Early Document of Indian Art: The Citralak·sa·na of Nagnajit.* New Delhi: Manohar Book Service, 1976.

Harle, James C. *Art and Architecture of the Indian Subcontinent.* Pelican History of Art. Harmondsworth, Eng.: Penguin, 1987.

———. *Gupta Sculpture.* Oxford: Clarendon, 1974.

Huntington, Susan L. *Art of Ancient India.* New York: Weatherhill, 1985.

———. *Leaves from the Bodhi Tree: The Art of Pala India (8th–12th Centuries) and Its International Legacy.* Dayton: Dayton Art Institute, 1990.

Hutt, Michael. *Nepal: A Guide to the Art and Architecture of the Kathmandu Valley.* Boston: Shambala, 1995.

Johnston, E. H. *Buddhacharita, or Acts of the Buddha.* 2nd ed. New Delhi: Oriental Books Reprint, 1972.

Knox, Robert. *Amaravati: Buddhist Sculpture from the Great Stupa.* London: British Museum, 1992.

Kramrisch, Stella. *The Art of Nepal.* New York: Abrams, 1964.

———. *The Hindu Temple.* 2 vols. Calcutta: Univ. of Calcutta, 1946.

———. *Presence of Siva.* Princeton: Princeton Univ. Press, 1981.

———. *Vichnudharmottara, Part III: A Treatise on Indian Painting and Image-Making.* 2nd rev. ed. Calcutta: Calcutta Univ. Press, 1928.

Meister, Michael, ed. *Discourses on Siva: On the Nature of Religious Imagery.* Philadelphia: Univ. of Pennsylvania Press, 1984.

O'Flaherty, Wendy. *Hindu Myths.* Harmondsworth, Eng.: Penguin, 1975.

Pal, Pratapaditya, ed. *Aspects of Indian Art.* Leiden: Brill, 1972.

———. *The Ideal Image: The Gupta Sculptural Tradition and Its Influence.* New York: Asia Society, 1978.

Peterson, Indira Vishnvanathan. *Poems to Shiva: The Hymns of the Tamil Saints.* Princeton: Princeton Univ. Press, 1989.

Possehl, Gregory, ed. *Ancient Cities of the Indus.* Durham: Carolina Academic, 1979.

———. *Harappan Civilization: A Recent Perspective.* 2nd ed. New Delhi: American Institute of Indian Studies, 1993.

Poster, Amy G. *From Indian Earth: 4,000 Years of Terracotta Art.* Brooklyn: Brooklyn Museum, 1986.

Rosenfeld, John M. *The Dynastic Arts of the Kushans.* California Studies in the History of Art. Berkeley: Univ. of California Press, 1967.

Shearer, Alistair. *Upanishads.* New York: Harper & Row, 1978.

Singh, Madanjeet. *The Cave Paintings of Ajanta.* London: Thames and Hudson, 1965.

Skelton, Robert, and Mark Francis. *Arts of Bengal: The Heritage of Bangladesh and Eastern India.* London: Whitechapel Gallery, 1979.

Smith, Bardwell L., ed. *Essays in Gupta Culture.* Delhi: Motilal Banarsidass, 1983.

Thapar, Romila. *Asoka and the Decline of the Mauryas.* 2nd ed. Delhi: Oxford, 1973.

———. *History of India.* Harmondsworth, Eng.: Penguin, 1972.

Weiner, Sheila L. *Ajanta: Its Place in Buddhist Art.* Berkeley: Univ. of California Press, 1977.

Williams, Joanna G. *Art of Gupta India, Empire and Province.* Princeton: Princeton Univ. Press, 1982.

Zimmer, Heinrich Robert. *Myths and Symbols in Indian Art and Civilization.* ed. Joseph Campbell. Bollingen Series. New York: Pantheon, 1946.

Chapter 10 Chinese Art before 1280

Ackerman, Phyllis. *Ritual Bronzes of Ancient China.* New York: Dryden, 1945.

The Art Treasures of Dunhuang. Hong Kong: Joint, 1981.

Arts of China. 3 vols. Tokyo: Kodansha International, 1968–70.

Barnhart, Richard. *Along the Border of Heaven: Sung and Yuan Painting from the C. C. Wang Family Collection.* New York: Metropolitan Museum of Art, 1983.

Billeter, Jean François. *The Chinese Art of Writing.* New York: Skira/Rizzoli, 1990.

Blunden, Caroline, and Mark Elvin. *Cultural Atlas of China.* New York: Facts on File, 1983.

Cahill, James. *Art of Southern Sung China.* New York: Asia Society, 1962.

———. *Chinese Painting.* Treasures of Asia. Geneva: Skira, 1960.

———. *Index of Early Chinese Painters and Paintings: T'ang, Sung, and Yuan.* Berkeley: Univ. of California Press, 1980.

Cleary, Thomas, trans. *The Essential Tao: An Initiation into the Heart of Taoism through the Authentic Tao Te Ching and the Inner Teachings of Chuang Tzu.* San Francisco: HarperSanFrancisco, 1991.

De Silva, Anil. *The Art of Chinese Landscape Painting: In the Caves of Tun-huang.* Art of the World. New York: Crown, 1967.

Fong, Wen, ed. *Beyond Representation: Chinese Painting and Calligraphy, 8th–14th Century.* Princeton Monographs in Art and Archaeology. New York: Metropolitan Museum of Art, 1992.

———. *The Great Bronze Age of China: An Exhibition from the People's Republic of China.* New York: Metropolitan Museum of Art, 1980.

Fong, Wen, and Marilyn Fu. *Sung and Yuan Paintings.* New York: New York Graphic Society, 1973.

Gridley, Marilyn Leidig. *Chinese Buddhist Sculpture under the Liao: Free Standing Works in Situ and Selected Examples from Public Collections.* New Delhi: International Academy of Indian Culture, 1993.

Ho, Wai-kam, et al. *Eight Dynasties of Chinese Painting: The Collections of the Nelson Gallery-Atkins Museum, Kansas City, and the Cleveland Museum of Art.* Cleveland: Cleveland Museum of Art, 1980.

Juliano, Annette L. *Art of the Six Dynasties: Centuries of Change and Innovation.* New York: China House Gallery, 1975.

Lawton, Thomas. *Chinese Art of the Warring States Period: Change and Continuity, 480–222 B.C.* Washington, D.C.: Freer Gallery of Art, Smithsonian Institution, 1982.

———. *Chinese Figure Painting.* Washington, D.C.: Smithsonian Institution, 1973.

Lim, Lucy. *Stories from China's Past: Han Dynasty Pictorial Tomb Reliefs and Archaeological Objects from Sichuan Province, People's Republic of China.* San Francisco: Chinese Culture Foundation, 1987.

Medley, Margaret. *Chinese Potter: A Practical History of Chinese Ceramics.* 3rd ed. Oxford: Phaidon, 1989.

Munakata, Kiyohiko. *Sacred Mountains in Chinese Art.* Champaign: Krannert Art Museum, Univ. of Illinois, 1991.

Paludan, Ann. *Chinese Spirit Road: The Classical Tradition of Stone Tomb Sculpture.* New Haven: Yale Univ. Press, 1991.

———. *Chinese Tomb Figurines.* Hong Kong: Oxford Univ. Press, 1994.

Powers, Martin J. *Art and Political Expression in Early China.* New Haven: Yale Univ. Press, 1991.

Rawson, Jessica. *Ancient China: Art and Archaeology.* London: British Museum, 1980.

Sickman, Lawrence, and Alexander Soper. *Art and Architecture of China.* Pelican History of Art. Harmondsworth, Eng.: Penguin, 1971.

Speiser, Werner. *The Art of China: Spirit and Society.* Art of the World. New York: Crown, 1961.

Tregear, Mary. *Chinese Art.* World of Art. New York: Oxford Univ. Press, 1980.

Vainker, S. J. *Chinese Pottery and Porcelain: From Prehistory to the Present.* London: British Museum, 1991.

Watson, William. *Art of Dynastic China.* New York: Abrams, 1981.

Weidner, Marsha, ed. *Latter Days of the Law: Images of Chinese Buddhism, 850–1850.* Lawrence: Spencer Museum of Art, Univ. of Kansas, 1994.

Whitfield, Roderick, and Anne Farrer. *Caves of the Thousand Buddhas: Chinese Art from the Silk Route.* London: British Museum, 1990.

Chapter 11 Japanese Art before 1392

Bethe, Monica. *Bugaku Masks.* Japanese Arts Library, vol. 5. New York: Kodansha International, 1978.

Egami, Namio. *The Beginnings of Japanese Art.* Trans. John Bester. Heibonsha Survey of Japanese Art, vol. 2. New York: Weatherhill, 1973.

Elisseeff, Danielle, and Vadime Elisseeff. *Art of Japan.* Trans.

I. Mark Paris. New York: Abrams, 1985.

Fujioka, Ryoichi. *Shino and Oribe Ceramics.* Trans. Samuel Crowell Morse. Japanese Arts Library, vol. 1. New York: Kodansha International, 1977.

Fukuyama, Toshio. *Heian Temples: Byudo-in and Chuson-ji.* Trans. Ronald K. Jones. Heibonsha Survey of Japanese Art, vol. 9. New York: Weatherhill, 1976.

Hashimoto, Fumio, ed. *Architecture in the Shoin Style: Japanese Feudal Residences.* Trans. and adapted by H. Mack Horton. Japanese Arts Library, vol. 10. New York: Kodansha International, 1981.

Hayashi, Ryoichi. *Silk Road and the Shoso-in.* Trans. Robert Ricketts. Heibonsha Survey of Japanese Art, vol. 6. New York: Weatherhill, 1975.

Ienaga, Saburo. *Japanese Art: A Cultural Appreciation.* Trans. Richard L. Gage. Heibonsha Survey of Japanese Art, vol. 30. New York: Weatherhill, 1979.

———. *Painting in the Yamato Style.* Trans. John M. Shields. Heibonsha Survey of Japanese Art, vol. 10. New York: Weatherhill, 1973.

Ishida, Hisatoyo. *Esoteric Buddhist Painting.* Trans. and adapted by E. Dale Saunders. Japanese Arts Library, vol. 15. New York: Kodansha International, 1987.

Itoh, Teiji. *Traditional Domestic Architecture of Japan.* Trans. Richard L. Gage. Heibonsha Survey of Japanese Art, vol. 21. New York: Weatherhill, 1972.

Kidder, J. Edward. *Early Buddhist Japan.* Ancient People and Places. New York: Praeger, 1972.

———. *Early Japanese Art: The Great Tombs and Treasures.* Princeton: Van Nostrand, 1964.

———. *Japanese Temples: Sculpture, Paintings, Gardens, and Architecture.* London: Thames and Hudson, 1964.

———. *Prehistoric Japanese Arts: Jomon Pottery.* Tokyo: Kodansha International, 1968.

Kobayashi, Takeshi. *Nara Buddhist Art: Todai-ji.* Trans. and adapted by Richard L. Gage. Heibonsha Survey of Japanese Art, vol. 5. New York: Weatherhill, 1975.

Kurata, Bunsaku. *Horyu-ji, Temple of the Exalted Law: Early Buddhist Art from Japan.* New York: Japan Society, 1981.

Miki, Fumio. *Haniwa.* Trans. and adapted by Gino Lee Barnes. Arts of Japan, 8. New York: Weatherhill, 1974.

Miner, Earl, Hiroko Odagiri, and Robert E. Morrell. *The Princeton Companion to Classical Japanese Literature.* Princeton: Princeton Univ. Press, 1985.

Mino, Yutaka. *The Great Eastern Temple: Treasures of Japanese Buddhist Art from Todai-ji.* Chicago: Art Institute of Chicago, 1986.

Mizuno, Seiichi. *Asuka Buddhist Art: Horyuji.* Trans. Richard L. Gage. Heibonsha Survey of Japanese Art, vol. 4. New York: Weatherhill, 1974.

Mori, Hisashi. *Japanese Portrait Sculpture.* Trans. Widayati Roesijadi. Japanese Arts Library, vol. 2. New York: Kodansha International, 1977.

———. *Sculpture of the Kamakura Period.* Trans. Katherine Eickman. Heibonsha Survey of Japanese Art, vol. 11. New York: Weatherhill, 1974.

Murase, Miyeko. *Iconography of the Tale of Genji: Genji Monogatari Ekotobá.* New York: Weatherhill, 1983.

Nakagawa, Sensaku. *Kutani Ware.* Trans. and adapted by John Bester. Japanese Arts Library, vol. 7. New York: Kodansha International, 1979.

Nishiwara, Kyotaro, and Emily J. Sano. *The Great Age of Japanese Buddhist Sculpture, A.D. 60–1300.* Fort Worth, Tex.: Kimbell Art Museum, 1982.

Okazaki, Joji. *Pure Land Buddhist Painting.* Trans. Elizabeth ten Grutenhuis. Japanese Arts Library, vol. 4. New York: Kodansha International, 1977.

Okudaira, Hideo. *Narrative Picture Scrolls.* Trans. Elizabeth ten Grutenhuis. Arts of Japan, 5. New York: Weatherhill, 1973.

Ooka, Minoru. *Temples of Nara and Their Art.* Trans. Dennis Lishka. Heibonsha Survey of Japanese Art, vol. 7. New York: Weatherhill, 1973.

Pearson, Richard J. *Ancient Japan.* Washington, D.C.: Sackler Gallery, 1992.

Rosenfield, John M., Fumiko E. Cranston, and Edwin A. Cranston. *The Courtly Tradition in Japanese Art and Literature: Selections from the Hofer and Hyde Collections.* Cambridge: Fogg Art Museum, Harvard Univ., 1973.

———. *Japanese Arts of the Heian Period: 794–1185.* New York: Asia Society, 1967.

Sato, Kanzan. *Japanese Sword.* Trans. and adapted by Joe Earle. Japanese Arts Library, vol. 12. New York: Kodansha International, 1983.

Sawa, Takaaki. *Art in Japanese Esoteric Buddhism.* Trans. Richard L. Gage. Heibonsha Survey of Japanese Art, vol. 8. New York: Weatherhill, 1972.

Soper, Alexander Coburn. *Evolution of Buddhist Architecture in Japan.* Princeton Monographs in Art and Archaeology, no. 22. New York: Hacker Art, 1978.

Sugiyama, Jiro. *Classic Buddhist Sculpture: The Tempyo Period.* Trans. and adapted by Samuel Crowell Morse. Japanese Arts Library, vol. 11. New York: Kodansha International, 1982.

Suzuki, Kakichi. *Early Buddhist Architecture in Japan.* Trans. and adapted by Mary Neighbor Parent and Nancy Shatzman Steinhardt. Japanese Arts Library, vol. 9. New York: Kodansha International, 1980.

Swann, Peter. *The Art of Japan: From the Jomon to the Tokugawa Period.* Art of the World. New York: Crown, 1966.

Tanaka, Ichimatsu. *Japanese Ink Painting: Shubun to Sesshu.* Trans. Bruce Darling. Heibonsha Survey of Japanese Art, vol. 12. New York: Weatherhill, 1972.

Varley, H. Paul. *Japanese Culture.* 3rd ed. Honolulu: Univ. of Hawaii Press, 1984.

Watanabe, Yasutada. *Shinto Art: Ise and Izumo Shrines.* Trans. Robert Ricketts. Heibonsha Survey of Japanese Art, vol. 3. New York: Weatherhill, 1974.

Yamane, Yuzo. *Momoyama Genre Painting.* Trans. John M. Shields. Heibonsha Survey of Japanese Art, vol. 17. New York: Weatherhill, 1973.

Yonezawa, Yoshiho, and Chu Yoshizawa. *Japanese Painting in the Literati Style.* Trans. and adapted by Betty Iverson Monroe. Heibonsha Survey of Japanese Art, vol. 23. New York: Weatherhill, 1974.

Chapter 12 Art of the Americas before 1300

Abel-Vidor, Suzanne. *Between Continents/Between Seas: Precolumbian Art of Costa Rica.* New York: Abrams, 1981.

Abrams, Elliot Marc. *How the Maya Built Their World: Energetics and Ancient Architecture.* Austin: Univ. of Texas Press, 1994.

Alcina Franch, José. *Pre-Columbian Art.* Trans. I. Mark Paris. New York: Abrams, 1983.

Anton, Ferdinand. *Art of the Maya.* Trans. Mary Whitall. London: Thames and Hudson, 1970.

Berlo, Janet Catherine, ed. *Art, Ideology, and the City of Teotihuacan: A Symposium at Dumbarton Oaks.* Washington, D.C.: Dumbarton Oaks, 1992.

Berrin, Kathleen, ed. *Feathered Serpents and Flowering Trees: Reconstructing the Murals of Teotihuacan.* San Francisco: Fine Arts Museums of San Francisco, 1988.

———, and Esther Pasztory. *Teotihuacan: Art from the City of the Gods.* New York: Thames and Hudson, 1993.

Brody, J. J. *The Anasazi: Ancient Indian People of the American Southwest.* New York: Rizzoli, 1990.

———. *Anasazi and Pueblo Painting.* Albuquerque: Univ. of New Mexico Press, 1991.

Clewlow, C. William. *Colossal Heads of the Olmec Culture.* Contributions of the Univ. of California Archaeological Research Facility. Berkeley: Archaeological Research Facility, Univ. of California, 1967.

Coe, Michael D. *The Jacuar's Children: Pre-Classical Central Mexico.* New York: Museum of Primitive Art, 1965.

Coe, Ralph T. *Sacred Circles: Two Thousand Years of North American Indian Art.* London: Arts Council of Great Britain, 1976.

Donnan, Christopher B. *Ceramics of Ancient Peru.* Los Angeles: Fowler Museum of Cultural History, Univ. of California, 1992.

———. *Moche Art of Peru: Pre-Columbian Symbolic Communication.* Rev. ed. Los Angeles: Museum of Cultural History, Univ. of California, 1978.

Fash, William Leonard. *Scribes, Warriors, and Kings: The City of Copan and the Ancient Maya.* London: Thames and Hudson, 1991.

Fewkes, Jesse Walter. *The Mimbres: Art and Archaeology.* Albuquerque: Avanyu, 1989.

Fitzhugh, William, and Aron Crowell, eds. *Crossroads of Continents: Cultures of Siberia and Alaska.* Washington, D.C.: Smithsonian Institution, 1988.

Frazier, Kendrick. *People of Chaco: A Canyon and Its Culture.* New York: Norton, 1986.

Herreman, Frank. *Power of the Sun: The Gold of Colombia.* Antwerp: City of Antwerp, 1993.

Heyden, Doris, and Paul Gendrop. *Pre-Columbian Architecture of Mesoamerica.* Trans. Judith Stanton. History of World Architecture. New York: Electa/Rizzoli, 1988.

Korp, Maureen. *The Sacred Geography of the American Mound Builders.* Native American Studies. Lewiston, N.Y.: Mellen, 1990.

Kubler, George. *The Art and Architecture of Ancient America: The Mexican, Maya, and Andean Peoples.* 2nd ed. Pelican History of Art. Harmondsworth, Eng.: Penguin, 1975.

———. *Esthetic Recognition of Ancient Amerindian Art.* Yale Publications in the History of Art. New Haven: Yale Univ. Press, 1991.

Miller, Arthur G. *The Mural Painting of Teotihuacan.* Washington, D.C.: Dumbarton Oaks, 1973.

Miller, Mary Ellen. *The Art of Mesoamerica: From Olmec to Aztec.* World of Art. New York: Thames and Hudson, 1986.

———, and Karl Taube. *The Gods and Symbols of Ancient Mexico and the Maya: An Illustrated Dictionary of Mesoamerican Religion.* New York: Thames and Hudson, 1993.

Moseley, Michael. *The Incas and Their Ancestors: The Archaeology of Peru.* London: Thames and Hudson, 1992.

Pang, Hildegard Delgado. *Pre-Columbian Art: Investigations and Insights.* Norman: Univ. of Oklahoma Press, 1992.

Paul, Anne. *Paracas Art and Architecture: Object and Context in South Coastal Peru.* Iowa City: Univ. of Iowa Press, 1991.

Schele, Linda, and David Freidel. *A Forest of Kings: The Untold Story of the Ancient Maya.* New York: Morrow, 1990.

Schele, Linda, and Mary Ellen Miller. *The Blood of Kings: Dynasty and Ritual in Maya Art.* New York: Braziller, 1986.

Stone-Miller, Rebecca. *To Weave for the Sun: Andean Textiles in the Museum of Fine Arts, Boston.* Boston: Museum of Fine Arts, 1992.

Townsend, Richard, ed. *The Ancient Americas: Art from Sacred Landscapes.* Chicago: Art Institute of Chicago, 1992.

———. *The Aztecs.* Ancient Peoples and Places. London: Thames and Hudson, 1992.

Wuthenau, Alexander von. *The Art of Terracotta Pottery in Pre-Columbian Central and South America.* Art of the World. New York: Crown, 1970.

Chapter 13 Art of Ancient Africa

Bassani, Ezio, and William Fagg. *Africa and the Renaissance: Art in Ivory.* New York: Center for African Art, 1988.

Ben-Amos, Paula. *The Art of Benin.* London: Thames and Hudson, 1980.

———, and Arnold Rubin. *The Art of Power, the Power of Art: Studies in Benin Iconography.* Monograph Series, no. 19. Los Angeles: Museum of Cultural History, Univ. of California, 1983.

Cole, Herbert M. *Igbo Arts: Community and Cosmos.* Los Angeles: Museum of Cultural History, Univ. of California, 1984.

Connah, Graham. *African Civilizations: Precolonial Cities and States in Africa: An Archaeological Perspective.* Cambridge: Cambridge Univ. Press, 1987.

Eyo, Ekpo, and Frank Willett. *Treasures of Ancient Nigeria.* Ed. Rollyn O. Kirchbaum. New York: Knopf, 1980.

Ezra, Kate. *Royal Art of Benin: The Perls Collection in the Metropolitan Museum of Art.* New York: Metropolitan Museum of Art, 1992.

Fagg, Bernard. *Nok Terracottas.* Lagos: Ethnographica, 1977.

Garlake, Peter S. *Great Zimbabwe.* London: Thames and Hudson, 1973.

———. *The Painted Caves: An Introduction to the Prehistoric Art of Zimbabwe.* Harare: Modus, 1987.

Huffman, Thomas N. *Symbols in Stone: Unravelling the Mystery of Great Zimbabwe.* Johannesburg: Witwatersrand Univ. Press, 1987.

Lhote, Henri. *The Search for the Tassili Frescoes: The Story of the Prehistoric Rock-Paintings of the Sahara.* 2nd ed. Trans. Alan Houghton Brodrick. London: Hutchinson, 1973.

Shaw, Thurstan. *Unearthing Igbo-Ukwu: Archaeological Discoveries in Eastern Nigeria.* New York: Oxford Univ. Press, 1977.

Willcox, A. R. *The Rock Art of Africa.* London: Croon Helm, 1984.

Willett, Frank. *Ife in the History of West African Sculpture.* New York: McGraw-Hill, 1967.

Chapter 14 Early Medieval Art in Europe

Alexander, J. J. G. *Medieval Illuminators and Their Methods of Work.* New Haven: Yale Univ. Press, 1992.

Backes, Magnus, and Regine Dolling. *Art of the Dark Ages.* Trans. Francisca Garvie. Panorama of World Art. New York: Abrams, 1971.

Backhouse, Janet, D. H. Turner, and Leslie Webster. *The Golden Age of Anglo-Saxon Art, 966–1066.* Bloomington: Indiana Univ. Press, 1984.

Beckwith, John. *Early Medieval Art: Carolingian, Ottonian, Romanesque.* World of Art. New York: Oxford Univ. Press, 1974.

Calkins, Robert G. *Illuminated Books of the Medieval Ages.* Ithaca: Cornell Univ. Press, 1983.

Cirrker, Blanche, ed. *The Book of Kells: Selected Plates in Full Color.* New York: Dover, 1982.

Conant, Kenneth John. *Carolingian and Romanesque Architecture, 800–1200.* 3rd ed. Pelican History of Art. Harmondsworth, Eng.: Penguin, 1973.

Davis-Weyer, Caecilia. *Early Medieval Art, 300–1150: Sources and Documents.* Englewood Cliffs, N.J.: Prentice-Hall, 1971.

Dodds, Jerrilynn D. *Architecture and Ideology in Early Medieval Spain.* University Park: Pennsylvania State Univ. Press, 1990.

Dodwell, C. R. *The Pictorial Arts of the West, 800–1200.* Pelican History of Art. New Haven: Yale Univ. Press, 1993.

Evans, Angela Care. *The Sutton Hoo Ship Burial.* London: British Museum, 1986.

Fernie, E. C. *The Architecture of the Anglo-Saxons.* London: Batsford, 1983.

Henderson, George. *Early Medieval.* Style and Civilization. Harmondsworth, Eng.: Penguin, 1972.

———. *From Durrow to Kells: The Insular Gospel-Books, 650–800.* London: Thames and Hudson, 1987.

Horn, Walter W., and Ernest Born. *Plan of Saint Gall: A Study of the Architecture and Economy of and Life in a Paradigmatic Carolingian Monastery.* 3 vols. California Studies in the History of Art. Berkeley: Univ. of California Press, 1979.

Hubert, Jean, Jean Porcher, and W. F. Volbach. *Carolingian Renaissance.* Arts of Mankind. New York: Braziller, 1970.

Laing, Lloyd. *Art of the Celts.* World of Art. New York: Thames and Hudson, 1992.

Lasko, Peter. *Ars Sacra, 800–1200.* Pelican History of Art. Harmondsworth, Eng.: Penguin, 1972.

Mayr-Harting, Henry. *Ottonian Book Illumination: An Historical Study.* 2 vols. New York: Oxford Univ. Press, 1991.

Megaw, Ruth, and Vincent Megaw. *Celtic Art: From Its Beginnings to the Book of Kells.* New York: Thames and Hudson, 1989.

New American Bible. New York: Catholic, 1992.

Nordenfalk, Carl Adam Johan. *Early Medieval Book Illumination.* New York: Rizzoli, 1988.

Palol, Pedro de, and Max Hirmer. *Early Medieval Art in Spain.* Trans. Alisa Jaffa. London: Thames and Hudson, 1967.

Richardson, Hilary, and John Scarry. *An Introduction to Irish High Crosses.* Dublin: Mercier, 1990.

Treasures of Irish Art, 1500 B.C. to 1500 A.D.: From the Collections of the National Museum of Ireland, Royal Irish Academy, Trinity College, Dublin. New York: Metropolitan Museum of Art, 1977.

Verzone, Paola. *The Art of Europe: The Dark Ages from Theodoric to Charlemagne.* Art of the World. New York: Crown, 1968.

Williams, John. *Early Spanish Manuscript Illumination.* New York: Braziller, 1977.

Wilson, David M. *Anglo-Saxon Art: From the Seventh Century to the Norman Conquest.* London: Thames and Hudson, 1984.

———, and Ole Klindt-Jensen. *Viking Art.* 2nd ed. Minneapolis: Univ. of Minnesota Press, 1980.

Chapter 15 Romanesque Art

Armi, C. Edson. *Masons and Sculptors in Romanesque Burgundy: The New Aesthetics of Cluny III.* 2 vols. University Park: Pennsylvania State Univ. Press, 1983.

Busch, Harald, and Bernd Lohse. *Romanesque Sculpture.* London: Batsford, 1962.

Cahn, Walter. *Romanesque Bible Illumination.* Ithaca: Cornell Univ. Press, 1982.

Evans, Joan. *Cluniac Art of the Romanesque Period.* Cambridge: Cambridge Univ. Press, 1950.

Focillon, Henri. *The Art of the West in the Middle Ages.* 2 vols. Ed. Jean Bony. Trans. Donald King. London: Phaidon, 1963.

Forsyth, Ilene H. *The Throne of Wisdom: Wood Sculptures of the Madonna in Romanesque France.* Princeton: Princeton Univ. Press, 1972.

Gantner, Joseph, and Marvel Pobe. *Romanesque Art in France.* London: Thames and Hudson, 1956.

Grape, Wolfgang. *The Bayeux Tapestry: Monument to a Norman Triumph.* New York: Prestel, 1994.

Hearn, M. F. *Romanesque Sculpture: The Revival of Monumental Stone Sculptures in the Eleventh and Twelfth Centuries.* Ithaca: Cornell Univ. Press, 1981.

Holt, Elizabeth Gilmore. *A Documentary History of Art.* 3 vols. Princeton: Princeton Univ. Press, 1982.

Jacobs, Michael. *Northern Spain: The Road to Santiago de Compostela.* Architectural Guides for Travelers. San Francisco: Chronicle, 1991.

Kennedy, Hugh. *Crusader Castles.* Cambridge: Cambridge Univ. Press, 1994.

Kubach, Hans Erich. *Romanesque Architecture.* History of World Architecture. New York: Electa/Rizzoli, 1988.

Kuhnel, Biana. *Crusader Art of the Twelfth Century: A Geographical, and Historical, or an Art Historical Notion?* Berlin: Gebr. Mann, 1994.

Kunstler, Gustav. *Romanesque Art in Europe.* Greenwich, Conn.: New York Graphic Society, 1969.

Little, Bryan D. G. *Architecture in Norman Britain.* London: Batsford, 1985.

Mâle, Emile. *Religious Art in France, the Twelfth Century: A Study of the Origins of Medieval Iconography.* Bollingen Series. Princeton: Princeton Univ. Press, 1978.

Nebosine, George A. *Journey into Romanesque: A Traveller's Guide to Romanesque Monuments in Europe.* Ed. Robyn Cooper. London: Weidenfeld and Nicolson, 1969.

Norton, Christopher, and David Park. *Cistercian Art and Architecture in the British Isles.* Cambridge: Cambridge Univ. Press, 1986.

Radding, Charles M., and William W. Clark. *Medieval Architecture, Medieval Learning: Builders and Masters in the Age of Romanesque and Gothic.* New Haven: Yale Univ. Press, 1992.

Rollason, David, Margaret Harvey, and Michael Prestwich, eds. *Anglo-Norman Durham: 1093–1193.* Rochester, N.Y.: Boydell, 1994.

Schapiro, Meyer. *Romanesque Art.* New York: Braziller, 1977.

———. *The Romanesque Sculpture of Moissac.* New York: Braziller, 1985.

Swarzenski, Hanns. *Monuments of Romanesque Art: The Art of Church Treasures of North-Western Europe.* 2nd ed. Chicago: Univ. of Chicago Press, 1967.

Tate, Robert Brian, and Marcus Tate. *The Pilgrim Route to Santiago.* Oxford: Phaidon, 1987.

Theophilus. *On Divers Arts: The Treatise of Theophilus.* Trans. John G. Hawthorne and Cyril Stanley Smith. Chicago: Univ. of Chicago Press, 1963.

Wilson, David M. *The Bayeux Tapestry: The Complete Tapestry in Color.* New York: Random House, 1985.

The Year 1200. 2 vols. New York: Metropolitan Museum of Art, 1970.

Zarnecki, George. *Romanesque Art.* New York: Universe, 1971.

———, Janet Holt, and Tristam Holland. *English Romanesque Art, 1066–1200.* London: Weidenfeld and Nicolson, 1984.

Chapter 16 Gothic Art

Alexander, Jonathan, and Paul Binski, eds. *Age of Chivalry: Art in Plantagenet England, 1200–1400.* London: Royal Academy of Arts, 1987.

Andrews, Francis B. *The Mediaeval Builder and His Methods.* New York: Barnes & Noble, 1993.

Armi, C. Edson. *The "Headmaster" of Chartres and the Origins of "Gothic" Sculpture.* University Park: Pennsylvania State Univ. Press, 1994.

Aubert, Marcel. *The Art of the High Gothic Era.* Rev. ed. Art of the World. New York: Greystone, 1966.

Binski, Paul. *Medieval Craftsmen: Painters.* London: British Museum, 1991.

Bogin, Magda. *Gothic Cathedrals of France and Their Treasures.* London: Kaye, 1959.

———. *The Women Troubadours.* New York: Norton, 1980.

Bony, Jean. *French Gothic Architecture of the 12th and 13th Centuries.* California Studies in the History of Art. Berkeley: Univ. of California Press, 1983.

Borsook, Eve, and Fiorella Superbi Gioffredi. *Italian Altarpieces, 1250–1550: Function and Design.* Oxford: Clarendon, 1994.

Bottineau, Yves. *Notre-Dame de Paris and the Sainte Chapelle.* Trans. Lovett F. Edwards. London: Allen, 1967.

Branner, Robert. *Manuscript Painting in Paris during the Reign of Saint Louis: A Study of Styles.* California Studies in the History of Art. Berkeley: Univ. of California Press, 1977.

Chiellini, Monica. *Cimabue.* Trans. Lisa Pelletti. Florence: Scala, 1988.

Coe, Brian. *Stained Glass in England, 1150–1550.* London: Allen, 1981.

Cole, Bruce. *Giotto and Florentine Painting, 1280–1375.* New York: Harper & Row, 1975.

Crosby, Sumner McKnight. *The Royal Abbey of Saint-Denis from Its Beginnings to the Death of Suger, 475–1151.* Yale Publications in the History of Art. New Haven: Yale Univ. Press, 1987.

Erlande-Brandenburg, Alain. *Gothic Art.* Trans. I. Mark Paris. New York: Abrams, 1989.

Favier, Jean. *The World of Chartres.* Trans. Francisca Garvie. New York: Abrams, 1990.

Franklin, J. W. *Cathedrals of Italy.* London: Batsford, 1958.

Frisch, Teresa G. *Gothic Art, 1140–c. 1450: Sources and Documents.* Englewood Cliffs, N.J.: Prentice-Hall, 1971.

Grodecki, Louis. *Gothic Architecture.* Trans. I. Mark Paris. History of World Architecture. New York: Electa/Rizzoli, 1985.

———, and Catherine Brisac. *Gothic Stained Glass, 1200–1300.* Ithaca: Cornell Univ. Press, 1985.

Herlihy, David. *Medieval Households.* Cambridge: Harvard Univ. Press, 1985.

Jantzen, Hans. *High Gothic: The Classic Cathedrals of Chartres, Reims, Amiens.* Trans. James Palmes. New York: Pantheon, 1962.

Katzenellenbogen, Adolf. *The Sculptural Programs of Chartres Cathedral: Christ, Mary, Ecclesia.* New York: Norton, 1964.

Mâle, Emile. *Chartres.* Trans. Sarah Wilson. New York: Harper & Row, 1983.

———. *Religious Art in France, the Thirteenth Century: A Study of Medieval Iconography and Its Sources.* Princeton: Princeton Univ. Press, 1984.

Martindale, Andrew. *Gothic Art.* World of Art. London: Thames and Hudson, 1967.

McIntyre, Anthony. *Medieval Tuscany and Umbria. Architectural Guides for Travellers.* San Francisco: Chronicle, 1992.

Moskowitz, Anita Fiderer. *The Sculpture of Andrea and Nino Pisano.* Cambridge: Cambridge Univ. Press, 1986.

Panofsky, Erwin. *Abbot Suger on the Abbey Church of St. Denis and Its Art Treasures.* 2nd ed. Ed. Gerda Panofsky-Soergel. Princeton: Princeton Univ. Press, 1979.

———. *Gothic Architecture and Scholasticism.* Latrobe, Penn.: Archabbey, 1951.

Pevsner, Nikolas, and Priscilla Metcalf. *The Cathedrals of England.* 2 vols. Harmondsworth, Eng.: Viking, 1985.

Pope-Hennessy, John. *Italian Gothic Sculpture.* 3rd ed. Oxford: Phaidon, 1986.

Sauerlander, Willibald. *Gothic Sculpture in France, 1140–1270.* Trans. Janet Sandheimer. London: Thames and Hudson, 1972.

Simson, Otto Georg von. *The Gothic Cathedral: Origins of Gothic Architecture and the Medieval Concept of Order.* 3rd ed. Bollingen Series. Princeton: Princeton Univ. Press, 1988.

Smart, Alastair. *The Dawn of Italian Painting, 1250–1400.* Ithaca: Cornell Univ. Press, 1978.

White, John. *Art and Architecture in Italy, 1250 to 1400.* 3rd ed. Pelican History of Art. Harmondsworth, Eng.: Penguin, 1993.

———. *Duccio: Tuscan Art and the Medieval Workshop.* New York: Thames and Hudson, 1979.

Wieck, Roger S. *Time Sanctified: The Book of Hours in Medieval Art and Life.* New York: Braziller, 1988.

Wilson, Christopher. *The Gothic Cathedral: The Architecture of the Great Church, 1130–1530.* New York: Thames and Hudson, 1990.

Chapter 17 Early Renaissance Art in Europe

Ainsworth, Maryan Wynn. *Petrus Christus: Renaissance Master of Bruges.* New York: Metropolitan Museum of Art, 1994.

Baxandall, Michael. *Painting and Experience in Fifteenth-Century Italy: A Primer in the Social History of Pictorial Style.* Oxford: Clarendon, 1972.

Blum, Shirley. *Early Netherlandish Triptychs: A Study in Patronage.* California Studies in the History of Art. Berkeley: Univ. of California Press, 1969.

Borsi, Franco. *Leon Battista Alberti: The Complete Works.* New York: Electa/Rizzoli, 1989.

———, and Stefano Borsi. *Paolo Uccello.* Trans. Elfreda Powell. New York: Abrams, 1994.

Campbell, Lorne. *Renaissance Portraits: European Portrait-Painting in the 14th, 15th, and 16th Centuries.* New Haven: Yale Univ. Press, 1990.

Chastel, André. *The Flowering of the Italian Renaissance.* Trans. Jonathan Griffin. Arts of Mankind. New York: Odyssey, 1965.

———. *Studios and Styles of the Italian Renaissance.* Trans. Jonathan Griffin. Arts of Mankind. New York: Odyssey, 1966.

Christianity and the Renaissance: Image and Religious Imagination in the Quattrocento. Syracuse. N.Y.: Syracuse Univ. Press, 1990.

Christiansen, Keith. *Andrea Mantegna: Padua and Mantua.* New York: Braziller, 1994.

———, Laurence B. Kanter, and Carl Brandon Strehlke. *Painting in Renaissance Siena, 1420–1500.* New York: Metropolitan Museum of Art, 1988.

Cole, Bruce. *Masaccio and the Art of Early Renaissance Florence.* Bloomington: Indiana Univ. Press, 1980.

Davies, Martin. *Rogier van der Weyden: An Essay, with a Critical Catalogue of Paintings Assigned to Him and to Robert Campin.* London: Phaidon, 1972.

de Pisan, Christine. *Le Livre de la Cité des Dames (The Book of the City of Ladies).* Trans. Earl J. Richards. New York: Persea, 1982.

Dhanens, Elisabeth. *Van Eyck: The Ghent Altarpiece.* New York: Viking, 1973.

Flanders in the Fifteenth Century: Art and Civilization. Detroit: Detroit Institute of Arts, 1960.

Freeman, Margaret B. *The Unicorn Tapestries.* New York: Metropolitan Museum of Art, 1976.

Gilbert, Creighton, ed. *Italian Art, 1400–1500: Sources and Documents.* Evanston: Northwestern Univ. Press, 1992.

Goffen, Rona. *Giovanni Bellini.* New Haven: Yale Univ. Press, 1989.

Goldwater, Robert, and Marco Treves. *Artists on Art: From the XIV to the XX Century.* New York: Random House, 1945.

Hind, Arthur M. *An Introduction to a History of Woodcut.* New York: Dover, 1963.

Joannides, Paul. *Masaccio and Masolino: A Complete Catalogue.* London: Phaidon, 1993.

Krautheimer, Richard. *Ghiberti's Bronze Doors.* Princeton: Princeton Univ. Press, 1971.

Lane, Barbara G. *The Altar and the Altarpiece: Sacramental Themes in Early Netherlandish Painting.* New York: Harper & Row, 1984.

Lightbown, Ronald. *Piero della Francesca.* New York: Abbeville, 1992.

———. *Sandro Botticelli: Life and Work.* New ed. New York: Abbeville, 1989.

Lloyd, Christopher. *Fra Angelico.* Rev. ed. London: Phaidon, 1992.

Meiss, Millard. *French Painting in the Time of Jean de Berry: The Limbourgs and Their Contemporaries.* New York: Braziller, 1974.

Muller, Theodor. *Sculpture in the Netherlands, Germany, France, and Spain: 1400–1500.* Trans. Elaine and William Robson Scott. Pelican History of Art. Harmondsworth, Eng.: Penguin, 1966.

Pacht, Otto. *Van Eyck and the Founders of Early Netherlandish Painting.* Ed. Maria Schmidt-Dengler. Trans. David Britt. London: Miller, 1994.

Panofsky, Erwin. *Early Netherlandish Painting: Its Origins and Character.* 2 vols. Cambridge: Harvard Univ. Press, 1966.

Plummer, John. *The Last Flowering: French Painting in Manuscripts, 1420–1530, from American Collections.* New York: Pierpont Morgan Library, 1982.

Pope-Hennessy, Sir John. *Donatello: Sculptor.* New York: Abbeville, 1993.

Saalman, Howard. *Filippo Brunelleschi: The Buildings.* University Park: Pennsylvania State Univ. Press, 1993.

Seymour, Charles. *Sculpture in Italy, 1400–1500.* Pelican History of Art. Harmondsworth, Eng.: Penguin, 1966.

Snyder, James. *Northern Renaissance Art: Painting, Sculpture, the Graphic Arts from 1350 to 1575.* New York: Abrams, 1985.

Vos, Dirk de. *Hans Memling: The Complete Works.* Ghent: Ludion, 1994.

Chapter 18 Renaissance Art in Sixteenth-Century Europe

Ackerman, James S. *The Architecture of Michelangelo.* Rev ed. Studies in Architecture. London: Zwemmer, 1966.

Baldini, Umberto. *The Sculpture of Michelangelo.* Trans. Clare Coope. New York: Rizzoli, 1982.

Baxandall, Michael. *The Limewood Sculptors of Renaissance Germany.* New Haven: Yale Univ. Press, 1980.

Beck, James H. *Raphael.* New York: Abrams, 1994.

Bier, Justus. *Tilman Riemenschneider, His Life and Work.* Lexington: Univ. of Kentucky Press, 1982.

Blankert, A. *Vermeer of Delft.* Oxford: Phaidon, 1978.

Blunt, Anthony. *Art and Architecture in France: 1500–1700.* 4th ed. Pelican History of Art. Harmondsworth, Eng.: Penguin, 1981.

Bosquet, Jacques. *Mannerism: The Painting and Style of the Late Renaissance.* Trans. Simon Watson Taylor. New York: Braziller, 1964.

Boucher, Brude. *Andrea Palladio: The Architect in His Time*. New York: Abbeville, 1994.

Bronstein, Leo. *El Greco (Domenicos Theotocopoulos)*. New York: Abrams, 1990.

Brown, Jonathan. *The Golden Age of Painting in Spain*. New Haven: Yale Univ. Press, 1991.

Bruschi, Arnaldo. *Bramante*. London: Thames and Hudson, 1977.

Chastel, André. *The Age of Humanism: Europe, 1480–1530*. Trans. Katherine M. Delavenay and E. M. Gwyer. London: Thames and Hudson, 1963.

Ettlinger, Leopold D., and Helen S. Ettlinger. *Raphael*. Oxford: Phaidon, 1987.

Farmer, John David. *The Virtuoso Craftsman: Northern European Design in the Sixteenth Century*. Worcester, Mass.: Worcester Art Museum, 1969.

Foote, Timothy. *The World of Bruegel, c. 1525–1569*. New York: Time-Life, 1968.

Freedberg, S. J. *Painting in Italy, 1500 to 1600*. 3rd ed. Pelican History of Art. New Haven: Yale Univ. Press, 1993.

Gibson, Walter. *Hieronymus Bosch*. World of Art. New York: Oxford Univ. Press, 1973.

Goldschneider, Ludwig. *Leonardo da Vinci: Life and Work, Paintings and Drawings*. 7th ed. London: Phaidon, 1964.

Hartt, Frederick. *Michelangelo*. New York: Abrams, 1984.

Hayum, André. *The Isenheim Altarpiece: God's Medicine and the Painter's Vision*. Princeton Essays on the Arts. Princeton: Princeton Univ. Press, 1989.

Heydenreich, Ludwig H. *Leonardo—"The Last Supper."* Art in Context. London: Allen Lane, 1974.

Hollingsworth, Mary. *Patronage in Renaissance Italy: From 1400 to the Early Sixteenth Century*. London: Murray, 1994.

Howard, Deborah. *Jacopo Sansovino: Architecture and Patronage in Renaissance Venice*. New Haven: Yale Univ. Press, 1975.

Huse, Norbert, and Wolfgang Wolters. *Art of Renaissance Venice: Architecture, Sculpture and Painting, 1460–1590*. Trans. Edmund Jephcott. Chicago: Univ. of Chicago Press, 1990.

Jones, Roger, and Nicholas Penny. *Raphael*. New Haven: Yale Univ. Press, 1983.

Klein, Robert, and Henri Zerner. *Italian Art, 1500–1600: Sources and Documents*. Englewood Cliffs, N.J.: Prentice-Hall, 1966.

Kubler, George. *Building the Escorial*. Princeton: Princeton Univ. Press, 1982.

Landau, David, and Peter Parshall. *The Renaissance Print: 1470–1550*. New Haven: Yale Univ. Press, 1994.

Langdon, Helen. *Holbein*. 2nd ed. London: Phaidon, 1993.

Lazzaro, Claudia. *The Italian Renaissance Garden: From the Conventions of Planting, Design, and Ornament to the Grand Gardens of Sixteenth-Century Central Italy*. New Haven: Yale Univ. Press, 1990.

Lieberman, Ralph. *Renaissance Architecture in Venice, 1450–1540*. New York: Abbeville, 1982.

Linfert, Carl. *Hieronymus Bosch*. Masters of Art. New York: Abrams, 1989.

Martineau, Jane, and Charles Hope. *The Genius of Venice, 1500–1600*. New York: Abrams, 1984.

McCorquodale, Charles. *Bronzino*. New York: Harper & Row, 1981.

McMullen, Roy. *Mona Lisa: The Picture and the Myth*. Boston: Houghton Mifflin, 1975.

Murray, Linda. *The High Renaissance*. World of Art. New York: Praeger, 1967.

———. *Late Renaissance and Mannerism*. World of Art. London: Thames and Hudson, 1967.

———. *Michelangelo*. World of Art. New York: Oxford Univ. Press, 1980.

Olson, Roberta J. M. *Italian Renaissance Sculpture*. World of Art. New York: Thames and Hudson, 1992.

Osten, Gert von der, and Horst Vey. *Painting and Sculpture in Germany and the Netherlands, 1500–1600*. Pelican History of Art. Harmondsworth, Eng.: Penguin, 1969.

Perlingieri, Ilya Sandra. *Sofonisba Anguissola: The First Great Woman Artist of the Renaissance*. New York: Rizzoli, 1992.

Pietrangeli, Carlo, et al. *The Sistine Chapel: The Art, the History, and the Restoration*. New York: Harmony, 1986.

Pignatti, Terisio. *Giorgione*. New York: Phaidon, 1971.

Pope-Hennessy, Sir John. *Cellini*. New York: Abbeville, 1985.

———. *Italian High Renaissance and Baroque Sculpture*. 3rd ed. Oxford: Phaidon, 1986.

———. *Italian Renaissance Sculpture*. 3rd ed. Oxford: Phaidon, 1986.

Rearick, William R. *The Art of Paolo Veronese, 1528–1588*. Washington, D.C.: National Gallery of Art, 1988.

Rosand, David. *Painting in Cinquecento Venice: Titian, Veronese, Tintoretto*. New Haven: Yale Univ. Press, 1982.

Russell, Francis. *The World of Dürer, 1471–1528*. New York: Time-Life, 1967.

Settis, Salvatore. *Giorgione's Tempest: Interpreting the Hidden Subject*. Trans. Ellen Bianchini. Chicago: Univ. of Chicago Press, 1990.

Shearman, John. *Mannerism*. Harmondsworth, Eng.: Penguin, 1967.

Smith, Jeffrey Chipps. *Nuremberg, a Renaissance City, 1500–1618*. Austin: Huntington Art Gallery, Univ. of Texas, 1983.

Stechow, Wolfgang. *Pieter Bruegel the Elder*. Masters of Art. New York: Abrams, 1990.

Strong, Roy C. *Artists of the Tudor Court: The Portrait Miniature Rediscovered, 1520–1620*. London: Victoria and Albert Museum, 1983.

Summerson, John. *Architecture in Britain: 1530 to 1830*. 7th ed. Pelican History of Art. Harmondsworth, Eng.: Penguin, 1983.

Tavernor, Robert. *Palladio and Palladianism*. World of Art. New York: Thames and Hudson, 1991.

Valcanover, Francesco. *Tintoretto*. Trans. Robert Erich Wolf. Library of Great Painters. New York: Abrams, 1985.

Vasari, Giorgio. *The Lives of the Artists*. Trans. Julia Conaway Bondanella and Peter Bondanella. New York: Oxford Univ. Press, 1991.

Verheyen, Egon. *The Paintings in the Studiolo of Isabella d'Este at Mantua*. Monographs on Archaeology and Fine Arts. New York: New York Univ. Press, 1971.

Vitruvius Pollio. *Vitruvius: The Ten Books on Architecture*. Trans. Morris Hicky Morgan. New York: Dover, 1960.

Whiting, Roger. *Leonardo: A Portrait of the Renaissance Man*. London: Barrie and Jenkins, 1992.

Chapter 19 Baroque, Rococo, and Early American Art

Ackley, Clifford S. *Printmaking in the Age of Rembrandt*. Boston: Museum of Fine Arts, 1981.

The Age of Caravaggio. New York: Metropolitan Museum of Art, 1985.

Bazin, Germain. *Baroque and Rococo*. Trans. Jonathan Griffin. World of Art. New York: Praeger, 1964.

Berger, Robert W. *The Palace of the Sun: The Louvre of Louis XIV*. University Park: Pennsylvania State Univ. Press, 1993.

———. *Versailles: The Chateau of Louis XIV*. Monographs on the Fine Arts. University Park: Pennsylvania State Univ. Press, 1985.

Blunt, Anthony, et al. *Baroque and Rococo Architecture and Decoration*. New York: Harper & Row, 1982.

Boucher, François. *François Boucher, 1703–1770*. New York: Metropolitan Museum of Art, 1986.

Brown, Christopher. *Scenes of Everyday Life: Dutch Genre Painting of the Seventeenth Century*. London: Faber & Faber, 1984.

Brown, Dale. *The World of Velázquez, 1599–1660*. New York: Time-Life, 1969.

Brown, Jonathan. *The Golden Age of Painting in Spain*. New Haven: Yale Univ. Press, 1991.

———. *Velázquez, Painter and Courtier*. New Haven: Yale Univ. Press, 1986.

Dominguez Ortiz, Antonio, Alfonso E. Perez Sanchez, and Julian Gallego. *Velázquez*. New York: Metropolitan Museum of Art, 1989.

Enggass, Robert, and Jonathan Brown. *Italy and Spain 1600–1750: Sources and Documents*. Englewood Cliffs, N.J.: Prentice-Hall, 1970.

Frankenstein, Alfred Victor. *The World of Copley, 1738–1815*. New York: Time-Life, 1970.

Fuchs, R. H. *Dutch Painting*. World of Art. New York: Oxford Univ. Press, 1978.

Gerson, Horst, and E. H. ter Kuile. *Art and Architecture in Belgium, 1600–1800*. Pelican History of Art. Baltimore: Penguin, 1960.

———. *Rembrandt Paintings*. Trans. Heinz Norden. Ed. Gary Schwartz. New York: Reynal, 1968.

Grasselli, Margaret Morgan, and Pierre Rosenberg. *Watteau, 1684–1721*. Washington, D.C.: National Gallery of Art, 1984.

Grimm, Claus. *Frans Hals—The Complete Work*. Trans. Jurgen Riehle. New York: Abrams, 1990.

Haak, Bob. *The Golden Age: Dutch Painters of the Seventeenth Century*. Trans. and ed. Elizabeth Willems-Treeman. New York: Abrams, 1984.

Held, Julius Samuel, and Donald Posner. *17th and 18th Century Art: Baroque Painting, Sculpture, Architecture*. Library of Art History. New York: Abrams, 1971.

Hempel, Eberhard. *Baroque Art and Architecture in Central Europe: Germany, Austria, Switzerland, Hungary, Czechoslovakia, Poland. Painting and Sculpture: 17th and 18th Centuries. Architecture: 16th to 18th Centuries*. Trans. Elisabeth Hempel and Marguerite Kay. Pelican History of Art. Harmondsworth, Eng.: Penguin, 1965.

Jacobson, Dawn. *Chinoiserie*. London: Phaidon, 1993.

Kalnein, Wend, and Michael Levey. *Art and Architecture of the Eighteenth Century in France*. Pelican History of Art. Harmondsworth, Eng.: Penguin, 1972.

Köning, Hans. *The World of Vermeer, 1632–1675*. New York: Time-Life, 1967.

Lagerlof, Margaretha Rossholm. *Ideal Landscape: Annibale Caracci, Nicolas Poussin, and Claude Lorrain*. New Haven: Yale Univ. Press, 1990.

Martin, John Rupert. "The Baroque from the Viewpoint of the Art Historian." *Journal of Aesthetics and Art Criticism* 15(2): 164–70.

Moir, Alfred. *Anthony Van Dyck*. New York: Abrams, 1994.

———. *Caravaggio*. Library of Great Painters. New York: Abrams, 1982.

Montagu, Jennifer. *Roman Baroque Sculpture: The Industry of Art*. New Haven: Yale Univ. Press, 1989.

Norberg-Schulz, Christian. *Baroque Architecture*. New York: Rizzoli, 1986.

———. *Late Baroque and Rococo Architecture*. History of World Architecture. New York: Rizzoli, 1985.

Rosenberg, Jakob, Seymour Slive, and E. H. ter Kuile. *Dutch Art and Architecture, 1600 to 1800*. 3rd ed. Pelican History of Art. Harmondsworth, Eng.: Penguin, 1977.

Rosenberg, Pierre. *Chardin, 1699–1779*. Trans. Emilie P. Kadish and Ursula Korneitchouk. Ed. Sally W. Goodfellow. Cleveland: Cleveland Museum of Art, 1979.

———. *Fragonard*. New York: Metropolitan Museum of Art, 1988.

Russell, H. Diane. *Claude Lorrain, 1600–1682*. Washington, D.C.: National Gallery of Art, 1982.

Schwartz, Gary. *Rembrandt, His Life, His Paintings*. New York: Penguin, 1991.

Scribner, Charles, III. *Gianlorenzo Bernini*. Masters of Art. New York: Abrams, 1991.

———. *Peter Paul Rubens*. Masters of Art. New York: Abrams, 1989.

Slive, Seymour, et al. *Frans Hals*. London: Royal Academy of Arts, 1989.

Stechow, Wolfgang. *Dutch Landscape Painting of the Seventeenth Century*. 3rd ed. Oxford: Phaidon, 1981.

Summerson, John. *Architecture of the Eighteenth Century*. World of Art. New York: Thames and Hudson, 1986.

———. *Inigo Jones*. Harmondsworth, Eng.: Penguin, 1966.

Sutton, Peter. *The Age of Rubens*. Boston: Museum of Fine Arts, 1993.

Wallace, Robert. *The World of Bernini, 1598–1680*. New York: Time-Life, 1970.

Temple, R. C., ed. *The Travels of Peter Mundy in Europe and Asia, 1608–1667*. London: n.p., 1925.

Wedgwood, C. V. *The World of Rubens, 1577–1640*. New York: Time-Life, 1967.

Welu, James A., and Pieter Biesboer, eds. *Judith Leyster: A Dutch Master and Her World*. New York: Yale Univ. Press, 1993.

Wheelock, Arthur K., Jr. *Jan Vermeer*. New York: Abrams, 1988.

———, Susan J. Barnes, and Julius S. Held. *Anthony Van Dyck*. Washington, D.C.: National Gallery of Art, 1990.

White, Christopher. *Peter Paul Rubens: Man & Artist*. New Haven: Yale Univ. Press, 1987.

———. *Rembrandt*. World of Art. London: Thames and Hudson, 1984.

Wittkower, Rudolf. *Art and Architecture in Italy, 1600 to 1750*. 3rd ed. Pelican History of Art. Harmondsworth, Eng.: Penguin, 1982.

Chapter 20 Art of India after 1100

Asher, Catherine B. *Architecture of Mughal India*. New York: Cambridge Univ. Press, 1992.

Beach, Milo Cleveland. *Grand Mogul: Imperial Painting in India, 1600–1660*. Williamstown: Sterling and Francine Clark Art Institute, 1978.

———. *Imperial Image, Paintings for the Mughal Court*. Washington, D.C.: Freer Gallery of Art, Smithsonian Institution, 1981.

———. *Mughal and Rajput Painting*. New York: Cambridge Univ. Press, 1992.

Blurton, T. Richard. *Hindu Art*. Cambridge: Harvard Univ. Press, 1993.

Davies, Philip. *Splendours of the Raj: British Architecture in India, 1660 to 1947*. London: Murray, 1985.

Desai, Vishakha N. *Life at Court: Art for India's Rulers, 16th–19th Centuries*. Boston: Museum of Fine Arts, 1985.

Losty, Jeremiah P. *The Art of the Book in India*. London: British Library, 1982.

Miller, Barbara Stoller. *Love Song of the Dark Lord: Jayadeva's Gitagovinda*. New York: Columbia Univ. Press, 1977.

Mitchell, George. *The Royal Palaces of India*. London: Thames and Hudson, 1994.

Nou, Jean-Louis. *Taj Mahal*. Text by Amina Okada and M. C. Joshi. New York: Abbeville, 1993.

Pal, Pratapaditya. *Court Paintings of India, 16th–19th Centuries*. New York: Navin Kumar, 1983.

———, et al. *Romance of the Taj Mahal*. Los Angeles: Los Angeles County Museum of Art, 1989.

Tillotson, G. H. R. *Mughal India*. Architectural Guides for Travelers. San Francisco: Chronicle, 1990.

———. *The Tradition of Indian Architecture: Continuity, Controversy and Change since 1850*. New Haven: Yale Univ. Press, 1989.

Welch, Stuart Cary. *The Emperors' Album: Images of Mughal India*. New York: Metropolitan Museum of Art, 1987.

———. *India: Art and Culture 1300–1900*. New York: Metropolitan Museum of Art, 1985.

Chapter 21 Chinese Art after 1280

Andrews, Julia Frances. *Painters and Politics in the People's Republic of China, 1949–1979*. Berkeley: Univ. of California Press, 1994.

Barnhart, Richard M. *Painters of the Great Ming: The Imperial Court and the Zhe School*. Dallas: Dallas Museum of Art, 1993.

———. *Peach Blossom Spring: Gardens and Flowers in Chinese Painting*. New York: Metropolitan Museum of Art, 1983.

———, et al. *The Jade Studio: Masterpieces of Ming and Qing Painting and Calligraphy from the Wong Nan-p'ing Collection*. New Haven: Yale Univ. Art Gallery, 1994.

Beurdeley, Michael. *Chinese Furniture*. Trans. Katherine Watson. Tokyo: Kodansha International, 1979.

Billeter, Jean François. *The Chinese Art of Writing*. New York: Skira/Rizzoli, 1990.

Bush, Susan, and Hsui-yen Shih, eds. *Early Chinese Texts on Painting*. Cambridge: Harvard Univ. Press, 1985.

Cahill, James. *The Compelling Image: Nature and Style in Seventeenth-Century Chinese Painting*. Charles Norton Lectures 1978–79. Cambridge: Harvard Univ. Press, 1982.

———. *The Distant Mountains: Chinese Painting in the Late Ming Dynasty, 1580–1644*. New York: Weatherhill, 1982.

———. *Hills beyond a River: Chinese Painting of the Y'uan Dynasty, 1279–1368*. New York: Weatherhill, 1976.

———. *Parting at the Shore: Chinese Painting of the Early and Middle Ming Dynasty, 1368–1580*. New York: Weatherhill, 1978.

Chan, Charis. *Imperial China*. Architectural Guides for Travelers. San Francisco: Chronicle, 1992.

Fontein, Jan, and Money Hickman. *Zen Painting and Calligraphy: An Exhibition of Works of Art Lent by Temples, Private Collectors, and Public and Private Museums in Japan*. Boston: Museum of Fine Arts, 1971.

Ho, Wai-Kam, ed. *The Century of Tung Ch'i-Chiang*. 2 vols. Kansas City: Nelson-Atkins Museum of Art, 1992.

In Pursuit of the Dragon: Traditions and Transitions in Ming Ceramics: An Exhibition from the Idemitsu Museum of Arts. Seattle: Seattle Art Museum, 1988.

Jenyns, Soame. *Later Chinese Porcelain: The Ch'ing Dynasty, 1644–1912*. 4th ed. London: Faber & Faber, 1971.

Keswick, Maggie. *The Chinese Garden: History, Art and Architecture*. New York: Rizzoli, 1978.

Knapp, Ronald G. *China's Vernacular Architecture: House Form and Culture*. Honolulu: Univ. of Hawaii Press, 1989.

Lee, Sherman, and Wai-Kam Ho. *Chinese Art under the Mongols: The Y'uan Dynasty, 1279–1368*. Cleveland: Cleveland Museum of Art, 1968.

Li, Chu-tsing. *The Autumn Colors on the Ch'iao and Hua Mountains: A Landscape by Chao Meng-fu*. Artibus Asiae, supplementum 21. Ascona: Artibus Asiae, 1965.

Lim, Lucy. *Contemporary Chinese Painting: An Exhibition from the People's Republic of China*. San Francisco: Chinese Culture Foundation of San Francisco, 1983.

———, ed. *Wu Guanzhong: A Contemporary Chinese Artist*. San Francisco: Chinese Culture Foundation, 1989.

Liu, Laurence G. *Chinese Architecture*. New York: Rizzoli, 1989.

Ng, So Kam. *Brushstrokes: Styles and Techniques of Chinese Painting*. San Francisco: Asian Art Museum of San Francisco, 1993.

Polo, Marco. *The Travels of Marco Polo*. Trans. Teresa Waugh and Maria Bellonci. New York: Facts on File, 1984.

Shih-t'ao. *Returning Home: Tao-chi's Album of Landscapes and Flowers*. Commentary by Wen Fong. New York: Braziller, 1976.

Sullivan, Michael. *Symbols of Eternity: The Art of Landscape Painting in China*. Stanford: Stanford Univ. Press, 1979.

Tregear, Mary. *Chinese Art*. World of Art. New York: Oxford Univ. Press, 1980.

Tsu, Frances Ya-sing. *Landscape Design in Chinese Gardens*. New York: McGraw-Hill, 1988.

Vainker, S. J. *Chinese Pottery and Porcelain: From Prehistory to the Present*. London: British Museum, 1991.

Walters, Derek. *Feng Shui: The Chinese Art of Designing a Harmonious Environment*. New York: Simon & Schuster, 1988.

Yu Zhuoyun, comp. *Palaces of the Forbidden City*. Trans. Ng Mau-Sang, Chan Sinwai, and Puwen Lee. New York: Viking, 1984.

Chapter 22 Japanese Art after 1392

Addiss, Stephen. *The Art of Zen: Painting and Calligraphy by Japanese Monks, 1600–1925*. New York: Abrams, 1989.

———. *Zenga and Nanga: Paintings by Japanese Monks and Scholars, Selections from the Kurt and Millie Gitter Collection*. New Orleans: New Orleans Museum of Art, 1976.

Baekeland, Frederick, and Robert Moes. *Modern Japanese Ceramics in American Collections*. New York: Japan Society, 1993.

Doi, Tsugiyoshi. *Momoyama Decorative Painting*. Trans. Edna B. Crawford. Heibonsha Survey of Japanese Art, vol. 14. New York: Weatherhill, 1977.

Forrer, Matthi. *Hokusai*. New York: Rizzoli, 1988.

Hayakawa, Masao. *The Garden Art of Japan*. Trans. Richard L. Gage. Heibonsha Survey of Japanese Art, vol. 28. New York: Weatherhill, 1973.

Hayashiya, Tatsusaburo, Masao Nakamura, and Seizo Hayashiya. *Japanese Arts and the Tea Ceremony*. Trans. and adapted by Joseph P. Macadam. Heibonsha Survey of Japanese Art, vol. 15. New York: Weatherhill, 1974.

Hinago, Motoo. *Japanese Castles*. Trans. and adapted by William H. Coaldrake. Japanese Arts Library, vol. 14. New York: Kodansha International, 1986.

Hirai, Kiyoshi. *Feudal Architecture of Japan*. Trans. Hiroaki Sato and Jeannine Ciliotta. Heibonsha Survey of Japanese Art, vol. 13. New York: Weatherhill, 1973.

Hosono, Masanobu. *Nagasaki Prints and Early Copperplates*. Trans. and adapted by Lloyd R. Craighill. Japanese Arts Library, vol. 6. New York: Kodansha International, 1978.

Leach, Bernard. *Kenzan and His Tradition: The Lives and Times of Koetsu, Sotatsu, Korin and Kenzan*. London: Faber, 1966.

Kanazawa, Hiroshi. *Japanese Ink Painting: Early Zen Masterpieces*. Trans. and adapted by Barbara Ford. Japanese Arts Library, vol. 8. New York: Kodansha International, 1979.

Kawahara, Masahiko. *The Ceramic Art of Ogata Kenzan*. Trans. and adapted by Richard L. Wilson. Japanese Arts Library, vol. 13. New York: Kodansha International, 1985.

Kawakita, Michiaki. *Modern Currents in Japanese Art*. Trans. and adapted by Charles S. Terry. Heibonsha Survey of Japanese Art, vol. 24. New York: Weatherhill, 1974.

Meech-Pekarik, Julia. *The World of the Meiji Print: Impressions of a New Civilization*. New York: Weatherhill, 1986.

Merritt, Helen. *Modern Japanese Woodblock Prints: The Early Years*. Honolulu: Univ. of Hawaii Press, 1990.

Michener, James A. *The Floating World*. New York: Random House, 1954.

Mizuo, Hiroshi. *Edo Painting: Sotatsu and Korin*. Trans. John M. Shields. Heibonsha Survey of Japanese Art, vol. 18. New York: Weatherhill, 1972.

Muraoka, Kageo, and Kichiemon Okamura. *Folk Arts and Crafts of Japan*. Trans. Daphne D. Stegmaier. Heibonsha Survey of Japanese Art, vol. 26. New York: Weatherhill, 1973.

Murase, Miyeko. *Emaki, Narrative Scrolls from Japan*. New York: Asia Society, 1983.

———. *Masterpieces of Japanese Screen Painting: The American Collections*. New York: Braziller, 1990.

———. *Tales of Japan: Scrolls and Prints from the New York Public Library*. Oxford: Oxford Univ. Press, 1986.

Noma, Seiroku. *Japanese Costume and Textiles Arts*. Trans. Armins Nikoskis. Heibonsha Survey of Japanese Art, vol. 16. New York: Weatherhill, 1974.

Oka, Isaburo. *Hiroshige: Japan's Great Landscape Artist*. Trans. Stanleigh H. Jones. Tokyo: Kodansha International, 1992.

Okakura, Kakuzo. *The Book of Tea*. Ed. Everett F. Bleiler. New York: Dover, 1964.

Okamoto, Yoshitomo. *The Namban Art of Japan*. Trans. Ronald K. Jones. Heibonsha Survey of Japanese Art, vol. 19. New York: Weatherhill/Heibonsha, 1972.

Okawa, Naomi. *Edo Architecture: Katsura and Nikko*. Trans. Alan Woodhull and Akito Miyamoto. Heibonsha Survey of Japanese Art, vol. 20. New York: Weatherhill, 1975.

Okyo and the Maruyama-Shijo School of Japanese Painting. Trans. Miyeko Murase and Sarah Thompson. St. Louis: St. Louis Art Museum, 1980.

Takahashi, Seiichiro. *Traditional Woodblock Prints of Japan*. Trans. Richard Stanley-Baker. Heibonsha Survey of Japanese Art, vol. 22. New York: Weatherhill, 1972.

Takeda, Tsuneo. *Kano Eitoku*. Trans. Catherine Kaputa. Japanese Arts Library, vol. 3. New York: Kodansha International, 1977.

Takeuchi, Melinda. *Taiga's True Views: The Language of Landscape Painting in Eighteenth-Century Japan*. Stanford: Stanford Univ. Press, 1992.

Terada, Toru. *Japanese Art in World Perspective*. Trans. Thomas Guerin. Heibonsha Survey of Japanese Art, vol. 25. New York: Weatherhill, 1976.

Thompson, Sarah E., and H. D. Harpptunian. *Undercurrents in the Floating World: Censorship and Japanese Prints*. New York: Asia Society Gallery, 1992.

Wilson, Richard L. *The Art of Ogata Kenzan: Persona and Production in Japanese Ceramics*. New York: Weatherhill, 1991.

Yamane, Yuzo. *Momoyama Genre Painting*. Trans. John M. Shields. Heibonsha Survey of Japanese Art, vol. 17. New York: Heibonsha, 1973.

Chapter 23 Art of the Americas after 1300

Archuleta, Margaret, and Rennard Strickland. *Shared Visions: Native American Painters and Sculptors in the Twentieth Century*. Phoenix: Heard Museum, 1991.

Baquedano, Elizabeth. *Aztec Sculpture*. London: British Museum, 1984.

Berdan, Frances F. *The Aztecs of Central Mexico: An Imperial Society*. New York: Holt, 1982.

Bringhurst, Robert. *The Black Canoe: Bill Reid and the Spirit of Haida Gwaii*. Seattle: Univ. of Washington Press, 1991.

Broder, Patricia Janis. *American Indian Painting and Sculpture*. New York: Abbeville, 1981.

Coe, Ralph. *Lost and Found Traditions: Native American Art 1965–1985*. Ed. Irene Gordon. Seattle: Univ. of Washington Press, 1986.

Conn, Richard. *Circles of the World: Traditional Art of the Plains Indians*. Denver: Denver Art Museum, 1982.

Dockstader, Frederick J. *The Way of the Loom: New Traditions in Navajo Weaving*. New York: Hudson Hills, 1987.

Feest, Christian F. *Native Arts of North America*. Updated ed. World of Art. New York: Thames and Hudson, 1992.

Haberland, Wolfgang. *Art of North America*. Rev. ed. Art of the World. New York: Greystone, 1968.

Hawthorn, Audrey. *Art of the Kwakiutl Indians and Other Northwest Coast Tribes*. Vancouver: Univ. of British Columbia Press, 1967.

Hemming, John. *Monuments of the Incas*. Boston: Little, Brown, 1982.

Highwater, Jamake. *The Sweet Grass Lives On: Fifty Contemporary North American Indian Artists*. New York: Lippincott and Crowell, 1980.

Jonaitis, Aldona. *Art of the Northern Tlingit*. Seattle: Univ. of Washington Press, 1986.

———, ed. *Chiefly Feasts: The Enduring Kwakiutl Potlatch*. Seattle: Univ. of Washington Press, 1991.

Kahlenberg, Mary Hunt, and Anthony Berlant. *The Navajo Blanket*. New York: Praeger, 1972.

Levi-Strauss, Claude. *Way of the Masks*. Trans. Sylvia Modelski. Seattle: Univ. of Washington Press, 1982.

MacDonald, George F. *Haida Monumental Art: Villages of the Queen Charlotte Islands*. Vancouver: Univ. of British Columbia Press, 1983.

Maurer, Evan M. *Visions of the People: A Pictorial History of Plains Indian Life*. Minneapolis: Minneapolis Institute of Arts, 1992.

McNair, Peter L., Alan L. Hoover, and Kevin Neary. *Legacy: Tradition and Innovation in Northwest Coast Indian Art*. Vancouver: Douglas and McIntyre, 1984.

Nicholson, H. B., and Eloise Quinones Keber. *Art of Aztec Mexico: Treasures of Tenochtitlan*. Washington, D.C.: National Gallery of Art, 1983.

Parezo, Nancy J. *Navajo Sandpainting: From Religious Act to Commercial Art*. Tucson: Univ. of Arizona Press, 1983.

Pasztory, Esther. *Aztec Art*. New York: Abrams, 1983.

Penney, David. *Art of the American Indian Frontier: The Chandler-Pohrt Collection*. Detroit: Detroit Institute of Arts, 1992.

Peterson, Susan. *The Living Tradition of Maria Martinez*. Tokyo: Kodansha International, 1977.

Smith, Jaune Quick-to-See, and Harmony Hammond. *Women of Sweetgrass: Cedar and Sage*. New York: American Indian Center, 1984.

Stewart, Hilary. *Totem Poles*. Seattle: Univ. of Washington Press, 1990.

Stierlin, Henri. *Art of the Aztecs and Its Origins*. New York: Rizzoli, 1982.

———. *Art of the Incas and Its Origins*. New York: Rizzoli, 1984.

Trimble, Stephen. *Talking with the Clay: The Art of Pueblo Pottery*. Santa Fe: School of American Research Press, 1987.

Wade, Edwin, and Carol Haralson, eds. *The Arts of the North American Indian: Native Traditions in Evolution*. New York: Hudson Hills, 1986.

Walters, Anna Lee. *Spirit of Native America: Beauty and Mysticism in American Indian Art*. San Francisco: Chronicle, 1989.

Wood, Nancy C. *Taos Pueblo*. New York: Knopf, 1989.

Chapter 24 Art of Pacific Cultures

Allen, Louis A. *Time before Morning: Art and Myth of the Australian Aborigines*. New York: Crowell, 1975.

Barrow, Terrence. *The Art of Tahiti and the Neighbouring Society, Austral and Cook Islands*. New York: Thames and Hudson, 1979.

———. *An Illustrated Guide to Maori Art*. Honolulu: Univ. of Hawaii Press, 1984.

Buhler, Alfred, Terry Barrow, and Charles P. Montford, *The Art of the South Sea Islands, including Australia and New Zealand*. Art of the World. New York: Crown, 1962.

Caruana, Wally. *Aboriginal Art*. World of Art. New York: Thames and Hudson, 1993.

Craig, Robert D. *Dictionary of Polynesian Mythology*. New York: Greenwood, 1989.

Gauguin, Paul. *Intimate Journals*. Trans. Van Wyck Brooks. Bloomington: Indiana Univ. Press, 1958.

Gell, Alfred. *Wrapping in Images: Tattooing in Polynesia*. Oxford Studies in Social and Cultural Anthropology. New York: Oxford Univ. Press, 1993.

Greub, Suzanne, ed. *Art of Northwest New Guinea: From Geelvink Bay, Humboldt Bay, and Lake Sentani*. New York: Rizzoli, 1992.

Guiart, Jean. *The Arts of the South Pacific*. Trans. Anthony Christie. Arts of Mankind. New York: Golden, 1963.

Hammond, Joyce D. *Tifaifai and Quilts of Polynesia*. Honolulu: Univ. of Hawaii Press, 1986.

Hanson, Allan, and Louise Hanson. *Art and Identity in Oceania*. Honolulu: Univ. of Hawaii Press, 1990.

Heyerdahl, Thor. *The Art of Easter Island*. Garden City, N.Y.: Doubleday, 1975.

Jone, Stella M. *Hawaiian Quilts*. Rev. 2nd ed. Honolulu: Daughters of Hawaii, 1973.

Layton, Robert. *Australian Rock Art: A New Synthesis*. New York: Cambridge Univ. Press, 1992.

Leonard, Anne, and John Terrell. *Patterns of Paradise: The Style and Significance of Bark Cloth around the World*. Chicago: Field Museum of Natural History, 1980.

Mead, Sydney Moko, ed. *Te Maori: Maori Art from New Zealand Collections*. New York: Abrams, 1984.

Morphy, Howard. *Ancestral Connections: Art and an Aboriginal System of Knowledge*. Chicago: Univ. of Chicago Press, 1991.

People of the River, People of the Trees: Change and Continuity in Sepik and Asmat Art. St. Paul: Minnesota Museum of Art, 1989.

Rabineau, Phyllis. *Feather Arts: Beauty, Wealth, and Spirit from Five Continents*. Chicago: Field Museum of Natural History, 1979.

Scutt, R. W. B., and Christopher Gotch. *Art, Sex, and Symbol: The Mystery of Tattooing*. 2nd ed. New York: Cornell Univ. Press, 1986.

Serra, Eudaldo, and Alberto Folch. *The Art of Papua and New Guinea*. New York: Rizzoli, 1977.

Sutton, Peter, ed. *Dreamings, the Art of Aboriginal Australia*. New York: Braziller, 1988.

Wardwell, Allen. *Island Ancestors: Oceania Art from the Masco Collection*. Seattle: Univ. of Washington Press, 1994.

Chapter 25 Art of Africa in the Modern Era

Abiodun, Rowland, Henry J. Drewal, and John Pemberton III, eds. *The Yoruba Artist: New Theoretical Perspectives on African Arts.* Washington, D.C.: Smithsonian Institution, 1994.

Adler, Peter, and Nicholas Barnard. *African Majesty: The Textile Art of the Ashanti and Ewe.* New York: Thames and Hudson, 1992.

Astonishment and Power. Washington, D.C.: National Museum of African Art, Smithsonian Institution, 1993.

Barley, Nigel. *Foreheads of the Dead: An Anthropological View of Kalabari Ancestral Screens.* Washington, D.C.: National Museum of African Art, Smithsonian Institution, 1988.

———. *Smashing Pots: Feats of Clay from Africa.* London: British Museum, 1994.

Biebuyck, Daniel P. *Lega Culture: Art, Initiation, and Moral Philosophy among a Central African People.* Berkeley: Univ. of California Press, 1973.

Brincard, Marie-Therese, ed. *The Art of Metal in Africa.* Trans. Evelyn Fischel. New York: African-American Institute, 1984.

Cole, Herbert M., ed. *I Am Not Myself: The Art of African Masquerade.* Los Angeles: Museum of Cultural History, Univ. of California, 1985.

———. *Icons: Ideals and Power in the Art of Africa.* Washington, D.C.: National Museum of African Art, Smithsonian Institution, 1989.

———. *Mbari, Art and Life among the Owerri Igbo.* Bloomington: Indiana Univ. Press, 1982.

Drewal, Henry John. *African Artistry: Technique and Aesthetics in Yoruba Sculpture.* Atlanta: High Museum of Art, 1980.

———, and Margaret Thompson Drewal. *Gelede: Art and Female Power among the Yoruba.* Bloomington: Indiana Univ. Press, 1983.

Fagg, William Buller, and John Pemberton III. *Yoruba Sculpture of West Africa.* Ed. Bryce Holcombe. New York: Knopf, 1982.

Gilfoy, Peggy S. *Patterns of Life: West African Strip-Weaving Traditions.* Washington, D.C.: National Museum of African Art, Smithsonian Institution, 1987.

Glaze, Anita. *Art and Death in a Senufo Village.* Bloomington: Indiana Univ. Press, 1981.

Heathcote, David. *The Arts of the Hausa.* Chicago: Univ. of Chicago Press, 1976.

Kennedy, Jean. *New Currents, Ancient Rivers: Contemporary Artists in a Generation of Change.* Washington, D.C.: Smithsonian Institution, 1992.

Laude, Jean. *African Art of the Dogon: The Myths of the Cliff Dwellers.* Trans. Joachim Neugroschell. New York: Brooklyn Museum, 1973.

Martin, Phyllis, and Patrick O'Meara, eds. *Africa.* 2nd ed. Bloomington: Indiana Univ. Press, 1986.

McEvilley, Thomas. *Fusion: West African Artists at the Venice Biennale.* New York: Museum for African Art, 1993.

McNaughton, Patrick R. *The Mande Blacksmiths: Knowledge, Power and Art in West Africa.* Bloomington: Indiana Univ. Press, 1988.

Neyt, François. *Luba: To the Sources of the Zaire.* Trans. Murray Wyllie. Paris: Editions Dapper, 1994.

Perrois, Louis, and Marta Sierra Delage. *The Art of Equatorial Guinea: The Fang Tribes.* New York: Rizzoli, 1990.

Picon, John, and John Mack. *African Textiles.* New York: Harper & Row, 1989.

Roy, Christopher D. *Art of the Upper Volta Rivers.* Meudon, France: Chaffin, 1987.

Schildkrout, Enid, and Curtis A. Keim. *African Reflections: Art from Northeastern Zaire.* Seattle: Univ. of Washington Press, 1990.

Sieber, Roy. *African Furniture and Household Objects.* Bloomington: Indiana Univ. Press, 1980.

———. *African Textiles and Decorative Arts.* New York: Museum of Modern Art, 1972.

———, and Roslyn Adele Walker. *African Art in the Cycle of Life.* Washington, D.C.: National Museum of African Art, Smithsonian Institution, 1987.

Thompson, Robert Farris, and Joseph Cornet. *The Four Moments of the Sun: Kongo Art in Two Worlds.* Washington, D.C.: National Gallery of Art, 1981.

Vogel, Susan. *Africa Explores: 20th Century African Art.* New York: Center for African Art, 1991.

Chapter 26 Neoclassicism and Romanticism in Europe and the United States

Abrams, Ann Uhry. *The Valiant Hero: Benjamin West and Grand-Style History Painting.* Washington, D.C.: Smithsonian Institution, 1985.

Age of Neoclassicism. London: Arts Council of Great Britain, 1972.

Bindman, David. *William Blake: His Art and Time.* New Haven: Yale Center for British Art, 1982.

Boime, Albert. *Art in an Age of Bonapartism, 1800–1815.* Chicago: Univ. of Chicago Press, 1990.

———. *Art in an Age of Revolution, 1750–1800.* Chicago: Univ. of Chicago Press, 1987.

Braham, Allan. *The Architecture of the French Enlightenment.* Berkeley: Univ. of California Press, 1980.

Brion, Marcel. *Art of the Romantic Era: Romanticism, Classicism, Realism.* World of Art. New York: Praeger, 1966.

Byson, Norman. *Tradition and Desire: From David to Delacroix.* New York: Cambridge Univ. Press, 1984.

Clark, Kenneth. *The Romantic Rebellion: Romantic versus Classic Art.* New York: Harper & Row, 1973.

Cooper, Wendy A. *Classical Taste in America 1800–1840.* Baltimore: Baltimore Museum of Art, 1993.

Eitner, Lorenz. *Neoclassicism and Romanticism, 1750–1850: An Anthology of Sources and Documents.* New York: Harper & Row, 1989.

French Painting 1774–1830: The Age of Revolution. Detroit: Wayne State Univ. Press, 1975.

Harris, Enriqueta. *Goya.* Rev. ed. London: Phaidon, 1994.

Honour, Hugh. *Neo-Classicism.* Harmondsworth, Eng.: Penguin, 1968.

———. *Romanticism.* London: Allen Lane, 1979.

Kroeber, Karl. *British Romantic Art.* Berkeley: Univ. of California Press, 1986.

Lindsay, Jack. *Death of the Hero: French Painting from David to Delacroix.* London: Studio, 1960.

Manners and Morals: Hogarth and British Painting 1700–1760. London: Tate Gallery, 1987.

Mayoux, Jean-Jacques. *English Painting.* Trans. James Emmons. New York: Grove, 1975.

Middleton, Robin, and David Watkin. *Neoclassical and 19th Century Architecture.* 2 vols. History of World Architecture. New York: Electa/Rizzoli, 1987.

Novotny, Fritz. *Painting and Sculpture in Europe, 1780–1880.* Pelican History of Art. Harmondsworth, Eng.: Penguin, 1980.

Paulson, Ronald. *The Art of Hogarth.* London: Phaidon, 1975.

Perez Sanchez, Alfonso E., and Eleanor A. Sayre. *Goya and the Spirit of Enlightenment.* Boston: Museum of Fine Arts, 1989.

Powell, Earl A. *Thomas Cole.* New York: Abrams, 1990.

Prideaux, Tom. *World of Delacroix, 1798–1863.* New York: Time-Life, 1966.

Roberts, Warren E. *Jacques-Louis David, Revolutionary Artist: Art, Politics, and the French Revolution.* Chapel Hill: Univ. of North Carolina Press, 1989.

Rosenblum, Robert. *Jean-Auguste-Dominique Ingres.* Masters of Art. New York: Abrams, 1990.

Rousseau, Jean-Jacques. *Emile.* Ed. F. and P. Richard. New York: French & European, 1962.

Roworth, Wendy Wassyng. *Angelica Kauffman: A Continental Artist in Georgian England.* London: Reaktion, 1992.

Rykwert, Joseph, and Anne Rykwert. *Robert and James Adam: The Men and the Style.* New York: Rizzoli, 1985.

Shapiro, Michael Edward. *George Caleb Bingham.* New York: Abrams, 1993.

Turner, Roger. *Capability Brown and the Eighteenth Century English Landscape.* London: Weidenfeld and Nicolson, 1985.

Vaughan, William. *German Romantic Painting.* New Haven: Yale Univ. Press, 1980.

———. *Romanticism and Art.* World of Art. New York: Thames and Hudson, 1994.

Walker, John. *John Constable.* New York: Abrams, 1991.

Wilton, Andrew. *Turner in His Time.* New York: Abrams, 1987.

Wolf, Bryan Jay. *Romantic Revision: Culture and Consciousness in Nineteenth-Century American Painting and Literature.* Chicago: Univ. of Chicago Press, 1986.

Chapter 27 Realism to Impressionism in Europe and the United States

Adams, Steven. *The Barbizon School and the Origins of Impressionism.* London: Phaidon, 1994.

Art of the July Monarchy: France, 1830 to 1848. Columbia: Univ. of Missouri Press, 1989.

Ashton, Dore. *Rosa Bonheur: A Life and a Legend.* New York: Viking, 1981.

Barger, M. Susan, and William B. White. *The Daguerreotype: Nineteenth-Century Technology and Modern Science.* Washington, D.C.: Smithsonian Institution, 1991.

Baudelaire, Charles. *The Painter of Modern Life, and Other Essays.* Trans. and ed. Jonathan Mayne. London: Phaidon, 1964.

Boime, Albert. *The Academy and French Painting in the Nineteenth Century.* London: Phaidon, 1971.

Cachin, Françoise, Charles S. Moffett, and Michel Melot, eds. *Manet, 1832–1883.* New York: Metropolitan Museum of Art, 1983.

Clark, T. J. *The Absolute Bourgeois: Artists and Politics in France, 1848–1851.* London: Thames and Hudson, 1973.

———. *Image of the People: Gustave Courbet and the 1848 Revolution.* London: Thames and Hudson, 1973.

Clarke, Michael. *Corot and the Art of Landscape.* London: British Museum, 1991.

Cumming, Elizabeth, and Wendy Caplan. *Arts and Crafts Movement.* World of Art. New York: Thames and Hudson, 1991.

Denvir, Bernard. *The Thames and Hudson Encyclopedia of Impressionism.* World of Art. New York: Thames and Hudson, 1990.

Faxon, Alicia Craig. *Dante Gabriel Rossetti.* Oxford: Phaidon, 1989.

Fried, Michael. *Courbet's Realism.* Chicago: Univ. of Chicago Press, 1982.

Gordon, Robert, and Andrew Forge. *Degas.* Trans. Richard Howard. New York: Abrams, 1988.

Hanson, Lawrence. *Renoir: The Man, the Painter, and His World.* London: Thames and Hundson, 1972.

Harding, James. *Artistes Pompiers: French Academic Art in the 19th Century.* New York: Rizzoli, 1979.

Hargrove, June, ed. *The French Academy: Classicism and Its Antagonists.* Newark: Univ. of Delaware Press, 1990.

Hendricks, Gordon. *Albert Bierstadt: Painter of the American West.* New York: Abrams, 1974.

Higonnet, Anne. *Berthe Morisot's Images of Women.* Cambridge: Harvard Univ. Press, 1992.

Hilton, Timothy. *Pre-Raphaelites.* World of Art. London: Thames and Hudson, 1970.

Homer, William Innes. *Thomas Eakins: His Life and Art.* New York: Abbeville, 1992.

Lindsay, Jack. *Gustave Courbet: His Life and Art.* New York: State Mutual Reprints, 1981.

Mathews, Nancy Mowll. *Mary Cassatt.* Library of American Art. New York: Abrams, 1987.

McKean, John. *Crystal Palace: Joseph Paxton and Charles Fox.* Architecture in Detail. London: Phaidon, 1994.

Mead, Christopher Curtis. *Charles Garnier's Paris Opera: Architectural Empathy and the Renaissance of French Classicism.* Cambridge: MIT Press, 1991.

Murphy, Alexandra R. *Jean-François Millet.* Boston: Museum of Fine Arts, 1984.

Needham, Gerald. *19th-Century Realist Art.* New York: Harper & Row, 1988.

Nochlin, Linda. *Impressionism and Post-Impressionism, 1874–1904: Sources and Documents.* Englewood Cliffs, N.J.: Prentice-Hall, 1966.

———. *Realism and Tradition in Art, 1848–1900: Sources and Documents.* Englewood Cliffs, N.J.: Prentice-Hall, 1966.

Pissarro, Joachim. *Camille Pissarro.* New York: Abrams, 1993.

Pool, Phoebe. *Impressionism.* World of Art. New York: Praeger, 1967.

The Pre-Raphaelites. London: Tate Gallery, 1984.

Prideaux, Tom. *The World of Whistler, 1834–1903.* New York: Time-Life, 1970.

Rewald, John. *The History of Impressionism.* 4th rev. ed. New York: Museum of Modern Art, 1973.

Rouart, Denis. *Renoir.* New York: Skira/Rizzoli, 1985.

Schaaf, Larry J. *Out of the Shadows: Herschel, Talbot and the Invention of Photography.* New Haven: Yale Univ. Press, 1992.

Schneider, Pierre. *The World of Manet, 1832–1883.* New York: Time-Life, 1968.

Spate, Virginia. *Claude Monet: Life and Work.* New York: Rizzoli, 1992.

Stansky, Peter. *Redesigning the World: William Morris, the 1880s, and the Arts and Crafts.* Princeton: Princeton Univ. Press, 1985.

Touissaint, Hélène. *Gustave Courbet, 1819–1877.* London: Arts Council of Great Britain, 1978.

Triumph of Realism. Brooklyn: Brooklyn Museum, 1967.

Valkenier, Elizabeth Kridl. *Ilya Repin and the World of Russian Art.* New York: Columbia Univ. Press, 1990.

Wagner, Anne Middleton. *Jean-Baptiste Carpeaux: Sculptor of the Second Empire.* New Haven: Yale Univ. Press, 1986.

Walker, John. *James McNeill Whistler.* Library of American Art. New York: Abrams, 1987.

Weisberg, Gabriel P. *The European Realist Tradition.* Bloomington: Indiana Univ. Press, 1982.

Wilmerding, John, et al. *American Light: The Luminist Movement, 1850–1875: Paintings, Drawings, Photographs.* Washington, D.C.: National Gallery of Art, 1980.

Zafran, Eric M. *French Salon Paintings from Southern Collections.* Atlanta: High Museum of Art, 1983.

Chapter 28 The Rise of Modernism in Europe and America

Ades, Dawn. *Photomontage.* Rev ed. World of Art. New York: Thames and Hudson, 1986.

Alexandrian, Sarane. *Surrealist Art.* World of Art. London: Thames and Hudson, 1970.

Art into Life: Russian Constructivism, 1914–32. New York: Rizzoli, 1990.

Baigell, Matthew. *The American Scene: American Painting of the 1930's.* New York: Praeger, 1974.

Banham, Reyner. *Theory and Design in the First Machine Age.* 2nd ed. Cambridge: MIT Press, 1980.

Barr, Alfred H., Jr. *Cubism and Abstract Art: Painting, Sculpture, Constructions, Photography, Architecture, Industrial Arts, Theatre, Films, Posters, Typography.* Cambridge, Mass.: Belknap, 1986.

Barron, Stephanie, ed. *Degenerate Art: The Fate of the Avant-Garde in Nazi Germany.* Los Angeles: Los Angeles County Museum of Art, 1991.

Bayer, Herbert, Walter Gropius, and Ise Gropius. *Bauhaus, 1919–1928.* New York: Museum of Modern Art, 1975.

Brown, Milton. *Story of the Armory Show: The 1913 Exhibition That Changed American Art.* 2nd ed. New York: Abbeville, 1988.

Cate, Phillip Dennis, and Sinclair Hamilton Hitchings. *The Color Revolution: Color Lithography in France, 1890–1900.* Santa Barbara: Smith, 1978.

Champigneulle, Bernard. *Rodin.* World of Art. New York: Oxford Univ. Press, 1994.

Chipp, Herschel B., ed. *Theories of Modern Art.* Berkeley: Univ. of California Press, 1969.

Cowling, Elizabeth. *Picasso: Sculptor/Painter.* London: Tate Gallery, 1994.

Curtis, James. *Mind's Eye, Mind's Truth: FSA Photography Reconsidered*. Philadelphia: Temple Univ. Press, 1989.

Curtis, William J. R. *Le Corbusier: Idea and Forms*. New York: Rizzoli, 1986.

Dachy, Marc. *The Dada Movement, 1915–1923*. New York: Skira/Rizzoli, 1990.

Davidson, Abraham A. *Early American Modernist Painting, 1910–1935*. New York: Harper & Row, 1981.

Denvir, Bernard. *Post-Impressionism*. World of Art. New York: Thames and Hudson, 1992.

———. *Toulouse-Lautrec*. World of Art. New York: Thames and Hudson, 1991.

Doherty, Robert J., ed. *The Complete Photographic Work of Jacob A. Riis*. New York: Macmillan, 1981.

Dube, Wolf-Dieter. *Expressionism*. Trans. Mary Whittall. World of Art. New York: Praeger, 1973.

Duncan, Alastair. *Art Nouveau*. World of Art. New York: Thames and Hudson, 1994.

Eldredge, Charles C. *Georgia O'Keeffe*. Library of American Art. New York: Abrams, 1991.

Freeman, Judi. *The Fauve Landscape*. Los Angeles: Los Angeles County Museum of Art, 1990.

Fry, Edward. *Cubism*. New York: McGraw-Hill, 1966.

Gay, Peter. *Art and Act: On Causes in History—Manet, Gropius, Mondrian*. New York: Harper & Row, 1976.

Gerdts, William H. *American Impressionism*. New York: Abbeville, 1984.

Gilot, Françoise, and Carlton Lake. *Life with Picasso*. New York: McGraw-Hill, 1964.

Glackens, Ira. *William Glackens and the Ashcan Group: The Emergence of Realism in American Art*. New York: Crown, 1957.

Golding, John. *Cubism: A History and an Analysis, 1907–1914*. Cambridge, Mass.: Belknap, 1988.

Gordon, Donald E. *Expressionism: Art and Idea*. New Haven: Yale Univ. Press, 1987.

Gowing, Lawrence. *Matisse*. World of Art. New York: Oxford Univ. Press, 1979.

Gray, Camilla. *Russian Experiment in Art, 1863–1922*. New York: Abrams, 1970.

Hahl-Koch, Jelena. *Kandinsky*. New York: Rizzoli, 1993.

Haiko, Peter, ed. *Architecture of the Early XX Century*. Trans. Gordon Clough. New York: Rizzoli, 1989.

Hales, Peter B. *Silver Cities: The Photography of American Urbanization, 1839–1950*. Philadelphia: Temple Univ. Press, 1984.

Hamilton, George Heard. *Painting and Sculpture in Europe, 1880–1940*. 2nd ed. Pelican History of Art. Harmondsworth, Eng.: Penguin, 1981.

Harrison, Charles, Francis Frascina, and Gill Perry. *Primitivism, Cubism, Abstraction: The Early Twentieth Century*. New Haven: Yale Univ. Press, 1993.

Harrison, Charles, and Paul Wood, eds. *Art in Theory, 1900 to 1990*. Cambridge, Mass.: Blackwell, 1993.

Herbert, James D. *Fauve Painting: The Making of Cultural Politics*. New Haven: Yale Univ. Press, 1992.

Herrera, Hayden. *Frida Kahlo: The Paintings*. New York: HarperCollins, 1991.

Hilton, Timothy. *Picasso*. World of Art. New York: Praeger, 1975.

Holt, Elizabeth Gilmore, ed. *The Expanding World of Art, 1874–1902*. New Haven: Yale Univ. Press, 1988.

Homer, William Innes. *Alfred Stieglitz and the American Avant-Garde*. Boston: New York Graphics Society, 1977.

Hulsker, Jan. *The Complete Van Gogh: Paintings, Drawings, Sketches*. New York: Abrams, 1980.

Hulten, Pontus. *Futurism and Futurisms*. New York: Abbeville, 1986.

Jaffe, Hans L. C. *De Stijl, 1917–1931: The Dutch Contribution to Modern Art*. Cambridge, Mass.: Belknap, 1986.

Kuenzli, Rudolf, and Francis M. Naumann. *Marcel Duchamp: Artist of the Century*. Cambridge: MIT Press, 1989.

Lane, John R., and Susan C. Larsen. *Abstract Painting and Sculpture in America 1927–1944*. Pittsburgh: Museum of Art, Carnegie Institute, 1984.

Larkin, David, and Bruce Brooks Pfeiffer. *Frank Lloyd Wright: The Masterworks*. New York: Rizzoli, 1993.

Lloyd, Jill. *German Expressionism: Primitivism and Modernity*. New Haven: Yale Univ. Press, 1991.

McQuillan, Melissa. *Van Gogh*. World of Art. New York: Thames and Hudson, 1989.

Milner, John. *Vladimir Tatlin and the Russian Avant-Garde*. New Haven: Yale Univ. Press, 1983.

Norman, Dorothy. *Alfred Stieglitz, an American Seer*. New York: Aperture, 1990.

O'Gorman, James F. *Three American Architects: Richardson, Sullivan, and Wright, 1865–1915*. Chicago: Univ. of Chicago Press, 1991.

Overy, Paul. *De Stijl*. World of Art. New York: Thames and Hudson, 1991.

Pfeiffer, Bruce Brooks, and Gerald Nordland, eds. *Frank Lloyd Wright in the Realm of Ideas*. Carbondale, Ill.: Southern Illinois Univ. Press, 1988.

Picon, Gaetan. *Surrealists and Surrealism, 1919–1939*. Trans. James Emmons. New York: Rizzoli, 1977.

Post-Impressionism: Cross-Currents in European and American Painting, 1880–1906. Washington, D.C.: National Gallery of Art, 1980.

Rewald, John. *Post-Impressionism: From Van Gogh to Gauguin*. 3rd ed. New York: Museum of Modern Art, 1978.

Rosenblum, Robert. *Cubism and Twentieth-Century Art*. Rev. ed. New York: Abrams, 1984.

Rubin, William, ed. *Pablo Picasso, a Retrospective*. New York: Museum of Modern Art, 1980.

———, comp. *Picasso and Braque: Pioneering Cubism*. New York: Museum of Modern Art, 1989.

Russell, John. *Seurat*. World of Art. London: Thames and Hudson, 1965.

———. *The World of Matisse, 1869–1954*. New York: Time-Life, 1969.

Spate, Virginia. *Orphism: The Evolution of Non-Figurative Painting in Paris, 1910–1914*. Oxford Studies in the History of Art and Architecture. Oxford: Clarendon, 1979.

Stich, Sidra. *Anxious Visions: Surrealist Art*. New York: Abbeville, 1990.

Sutter, Jean, ed. *The Neo-Impressionists*. Greenwich, Conn.: New York Graphic Society, 1970.

Thomson, Belinda. *Gauguin*. World of Art. New York: Thames and Hudson, 1987.

Tisdall, Caroline, and Angelo Bozzolla. *Futurism*. World of Art. New York: Oxford Univ. Press, 1978.

Troyan, Carol, and Erica E. Hirschler. *Charles Sheeler: Paintings and Drawings*. Boston: New York Graphic Society, 1987.

Verdi, Richard. *Cezanne*. World of Art. New York: Thames and Hudson, 1992.

Weiss, Jeffrey S. *The Popular Culture of Modern Art: Picasso, Duchamp, and Avant-Gardism*. New Haven: Yale Univ. Press, 1994.

Whitford, Frank. *Bauhaus*. World of Art. London: Thames and Hudson, 1984.

Wilkin, Karen. *Georges Braque*. New York: Abbeville, 1991.

Zhadova, Larissa A. *Malevich: Suprematism and Revolution in Russian Art*. Trans. Alexander Lieven. London: Thames and Hudson, 1982.

Chapter 29 Art in the United States and Europe since World War II

Alloway, Lawrence. *Roy Lichtenstein*. New York: Abbeville, 1983.

Andersen, Wayne. *American Sculpture in Process, 1930–1970*. Boston: New York Graphic Society, 1975.

Anfam, David. *Abstract Expressionism*. World of Art. New York: Thames and Hudson, 1990.

Ashton, Dore. *American Art since 1945*. New York: Oxford Univ. Press, 1982.

———. *The New York School: A Cultural Reckoning*. Harmondsworth, Eng.: Penguin, 1979.

Atkins, Robert. *Artspeak: A Guide to Contemporary Ideas, Movements, and Buzzwords*. New York: Abbeville, 1990.

Baker, Kenneth. *Minimalism: Art of Circumstance*. New York: Abbeville, 1988.

Battcock, Gregory. *Idea Art: A Critical Anthology*. New York: Dutton, 1973.

———. *Minimal Art: A Critical Anthology*. New York: Dutton, 1968.

———, and Robert Nickas. *The Art of Performance: A Critical Anthology*. New York: Dutton, 1984.

Beardsley, John. *Earthworks and Beyond: Contemporary Art in the Landscape*. New York: Abbeville, 1984.

Berger, Maurice. *Labyrinths: Robert Morris, Minimalism, and the 1960s*. New York: Harper & Row, 1989.

Blake, Peter. *No Place Like Utopia: Modern Architecture and the Company We Kept*. New York: Knopf, 1993.

Bolton, Richard, ed. *Culture Wars: Documents from the Recent Controversies in the Arts*. New York: New Press, 1992.

Bourdon, David. *Warhol*. New York: Abrams, 1989.

Broude, Norma, and Mary D. Garrard. *The Power of Feminist Art: The American Movement of the 1970s, History and Impact*. New York: Abrams, 1994.

Burnham, Jack. *Hans Haacke: Framing and Being Framed*. Halifax: Nova Scotia College of Art and Design, 1975.

Castleman, Riva, ed. *Art of the Forties*. New York: Museum of Modern Art, 1991.

Cernuschi, Claude. *Jackson Pollock: Meaning and Significance*. New York: Icon Editions, 1992.

Chase, Linda. *Hyperrealism*. New York: Rizzoli, 1975.

Collins, Michael, and Andreas Papadakis. *Post-Modern Design*. New York: Rizzoli, 1989.

Deutsche, Rosalyn, et al. *Hans Haacke, Unfinished Business*. Ed. Brian Wallis. Cambridge: MIT Press, 1986.

Dormer, Peter. *Design since 1945*. World of Art. New York: Thames and Hudson, 1993.

Endgame: Reference and Simulation in Recent Painting and Sculpture. Boston: Institute of Contemporary Art, 1986.

Ferguson, Russell, ed. *Discourses: Conversations in Postmodern Art and Culture*. Documentary Sources in Contemporary Art. Cambridge: MIT Press, 1990.

Fineberg, Jonathan. *Art since 1940: Strategies of Being*. New York: Abrams, 1994.

Goldberg, Rose Lee. *Performance Art: From Futurism to the Present*. Rev. ed. New York: Abrams, 1988.

Green, Jonathan. *American Photography: A Critical History since 1945 to the Present*. New York: Abrams, 1984.

Greenough, Sarah, and Philip Brookman. *Robert Frank*. Washington, D.C.: National Gallery of Art, 1994.

Grundberg, Andy. *Photography and Art: Interactions since 1945*. New York: Abbeville, 1987.

Hays, K. Michael, and Carol Burns, eds. *Thinking the Present: Recent American Architecture*. New York: Princeton Architectural, 1990.

Henri, Adrian. *Total Art: Environments, Happenings, and Performance*. World of Art. New York: Oxford Univ. Press, 1974.

Hertz, Richard. *Theories of Contemporary Art*. 2nd ed. Englewood Cliffs, N.J.: Prentice Hall, 1993.

Hobbs, Robert Carleton, and Gail Levin. *Abstract Expressionism: The Formative Years*. Ithaca: Cornell Univ. Press, 1981.

Hoffman, Katherine. *Explorations: The Visual Arts since 1945*. New York: HarperCollins, 1991.

Jencks, Charles. *Architecture Today*. 2nd ed. London: Academy, 1993.

———. *The New Moderns from Late to Neo-Modernism*. New York: Rizzoli, 1990.

———. *Post-Modernism: The New Classicism in Art and Architecture*. New York: Rizzoli, 1987.

———. *What Is Post-Modernism?* 3rd rev. ed. London: Academy Editions, 1989.

Joachimedes, Christos M., Norman Rosenthal, and Nicholas Serota, eds. *New Spirit in Painting*. London: Royal Academy of Arts, 1981.

Johnson, Ellen H., ed. *American Artists on Art from 1940 to 1980*. New York: Harper & Row, 1982.

Kaprow, Allan. *Assemblage, Environments & Happenings*. New York: Abrams, 1965.

Kingsley, April. *The Turning Point: The Abstract Expressionists and the Transformation of American Art*. New York: Simon & Schuster, 1992.

Kramer, Hilton. *The Age of the Avant-Garde: An Art Chronicle of 1956–1972*. New York: Farrar, Straus & Giroux, 1973.

Kuspit, Donald B. *Clement Greenberg, Art Critic*. Madison: Univ. of Wisconsin Press, 1979.

Levick, Melba. *The Big Picture: Murals of Los Angeles*. Boston: Little, Brown, 1988.

Lewis, Samella S. *African American Art and Artists*. Rev. ed. Berkeley: Univ. of California Press, 1994.

Lippard, Lucy. *Pop Art*. World of Art. New York: Praeger, 1966.

Livingstone, Marco. *Pop Art: A Continuing History*. New York: Abrams, 1990.

Lucie-Smith, Edward. *Art in the Eighties*. Oxford: Phaidon, 1990.

———. *Art in the Seventies*. Ithaca: Cornell Univ. Press, 1980.

———. *Art Today: From Abstract Expressionism to Superrealism*. 3rd ed. Oxford: Phaidon, 1989.

———. *Movements in Art since 1945*. Rev. ed. World of Art. London: Thames and Hudson, 1984.

———. *Super Realism*. Oxford: Phaidon, 1979.

Manhart, Marcia, and Tom Manhart, eds. *The Eloquent Object: The Evolution of American Art in Craft Media since 1945*. Tulsa: Philbrook Museum of Art, 1987.

Marks, Claude, ed. *World Artists: 1980–1990*. New York: Wilson, 1991.

Meisel, Louis K. *Photo-Realism*. New York: Abrams, 1989.

Morgan, Robert C. *Conceptual Art: An American Perspective*. Jefferson, N.C.: McFarland, 1994.

Nash, Steven A. *Arneson and Politics: A Commemorative Exhibition*. San Francisco: Fine Arts Museums of San Francisco, 1993.

Risatti, Howard, ed. *Postmodern Perspectives: Issues in Contemporary Art*. Englewood Cliffs, N.J.: Prentice Hall, 1990.

Rosen, Randy, and Catherine C. Brawer, comps. *Making Their Mark: Women Artists Move into the Mainstream, 1970–85*. New York: Abbeville, 1989.

Russell, John. *Pop Art Redefined*. New York: Praeger, 1969.

Sandler, Irving. *American Art of the 1960's*. New York: Harper & Row, 1988.

———. *The New York School: The Painters and Sculptors of the Fifties*. New York: Harper & Row, 1978.

———. *The Triumph of American Painting: A History of Abstract Expressionism*. New York: Harper & Row, 1976.

Sayre, Henry M. *The Object of Performance: The American Avant-Garde since 1970*. Chicago: Univ. of Chicago Press, 1989.

Shapiro, David, and Cecile Shapiro. *Abstract Expressionism: A Critical Record*. New York: Cambridge Univ. Press, 1990.

Slivka, Rose. *Peter Voulkos: A Dialogue with Clay*. Boston: New York Graphic Society, 1978.

Smith, Paul J., and Edward Lucie-Smith. *Craft Today: Poetry of the Physical*. New York: American Craft Museum, 1986.

Spaeth, David A. *Mies Van Der Rohe*. New York: Rizzoli, 1985.

Stich, Sidra. *Made in USA: An Americanization in Modern Art, the '50s & '60s*. Berkeley: Univ. of California Press, 1987.

Taylor, Paul, ed. *Post-Pop Art*. Cambridge: MIT Press, 1989.

Vaizey, Marina. *Christo*. New York: Rizzoli, 1990.

Waldman, Diane. *Collage, Assemblage, and the Found Object*. New York: Abrams, 1992.

———. *Jenny Holzer*. New York: Abrams, 1989.

———. *Transformations in Sculpture: Four Decades of American and European Art*. New York: Solomon R. Guggenheim Foundation, 1985.

——— *Willem de Kooning*. Library of American Art. New York: Abrams, 1988.

Wallis, Brian, ed. *Art after Modernism: Rethinking Representation*. Documentary Sources in Contemporary Art. New York: New Museum of Contemporary Art, 1984.

Wheeler, Daniel. *Art since Mid-Century: 1945 to the Present*. Englewood Cliffs, N.J.: Prentice Hall, 1991.

Word as Image: American Art, 1960–1990. Milwaukee: Milwaukee Art Museum, 1990.

Index

B

Nietzsche, Friedrich, 1039, 1041, 1120
Nightmare, The, John Henry Fuseli, 947, *947,* 975
Night of the Rich and the *Poor. See* Rivera, Diego, murals
nishiki-e, 868
Ni Zan, 840–41; *The Rongxi Studio* (hanging scroll),
 840–41, *841,* 846
nkisi (Kongo/Songye), 917–18
nkonde (Kongo/Songye), 917–18
nlo byeri (Fang), 922–23
Nobunaga, Oda, 859
nocturne, **775**
Nok culture (mixed media), Ouattara, 924–25, *924*
Nok culture (Nigeria), 911
Noli Me Tangere, Lavinia Fontana, *716,* 717
nonfinito, **690,** 699
nonrepresentational (nonobjective) style, **29,** **1023–24**
Nôtre-Dame-du-Haut, Le Corbusier, 1136, *1136*
nouveau réalisme, 1125, 1146
nsekh o byeri (Fang), 922
nudes: female, 641, 707; heroic, 650, 689; idealistic vs.
 realistic, 982; models, 1001; in religious art, 695–96;
 Renaissance, 641, 650, 664; as traditional subject,
 1016–17
Nuremberg, Germany, 733
Nymphenburg Park, Germany. *See* Amalienburg
Nymphs and a Satyr, Adolphe-William Bouguereau,
 982–83, *983,* 1017

O

Oakland YWCA, Oakland, California, Julia Morgan, 1068,
 1068
Oath of the Horatii, Jacques-Louis David, 956–57, *956,*
 961, 984
obelisk, 758
Oceanic art: iconography of, **898;** influence on
 modernism, 1042; recent, 905–7
oculus, **643,** **802**
odalisque, 959
Odundo, Magdalene, 925; *Asymmetrical Angled Piece,*
 925, *925*
Oedipus and the Sphinx, Gustave Moreau, *984,* 985
Officers of the Haarlem Militia Company of Saint Adrian,
 Frans Hals, 787–88, *787*
Oh, Jeff . . . I Love You, Too . . . But . . . , Roy Lichtenstein,
 1129, *1129*
oil painting, **619, 622,** 652, **704;** technique, 683
O'Keeffe, Georgia, 22, 1097–98; *Drawing XIII,* 1098, *1098;*
 Portrait of a Day, First Day, 22, *22*
Okyo, Maruyama, 867
Oldenburg, Claes, 1129–30; "The Store" exhibition,
 1129–30, *1129*
Old Saint Peter's, Rome, Italy, *701,* 757
Olmec culture, 875
Olmsted, Frederick Law, 970, 1062, 1063; Central Park
 (with Calvert Vaux), New York City, 970, *970,* 1063
Onjo-ji monastery, Shiga prefecture, Japan, Kojo-in,
 Guest Hall, 862, *862*
Open Door, The. See Talbot, William Henry Fox, *The
 Pencil of Nature* (book)
Opéra, Paris, France, 982, *982;* sculpture, Charles
 Garnier, 981–82, *981,* 1014
Orange, House of, 786
Order of the Golden Fleece, 635
Orléans, France, 615
Orme, Philbert de l, 722
Orphism, 1057
Orsanmichele, Church of, Florence, Italy, 651, *651;*
 sculpture for, 646–47
orthogonals, **30, 624,** 670
O'Sullivan, Timothy H., 999–1001; *Ancient Ruins in the
 Cañon de Chelley, Arizona,* 999–1001, *999*
Ottoman Turks, 609, 614
Ouattara, 924–25; *Nok culture,* 924–25, *924*
Outbreak, The, Käthe Schmidt Kollwitz, 1045, *1045*
overlapping, **30**
ovoid elements, **887**
Oxbow, The, Thomas Cole, 974–75, *974,* 996
Ozenfant, Amédée, 1079, 1089

P

Pacific peoples, 894–907; art of (*see* Oceanic art)
Padua, Italy, 660, 665
Paik, Nam June, *Electronic Superhighway,* 1156, *1156*
painterly style, **29, 1014**
painting, **30;** American, 973–75, 996–98; American
 Colonial, 817–19; Australian Aborigine, 895–97;
 Baroque, 773–76, 777–85, 786–800; on canvas, 704,
 765–69, 906; Chinese, 838–42, 846–51; Dutch,
 786–800; English, 941–50; finished vs. sketches, 1009;
 Flemish, 780–85; French, 617–18, 720–21, 773–76,
 809–12, 953–62; German, 729–39; Indian, 827–29,

831–32; Italian, 652–60, 665–72, 683–87, 691–97,
 704–9; Japanese, 860; Native American, 885;
 Neoclassical, 941–50, 953–60; Netherlandish, 724–28;
 oil, **619, 622,** 652, 683, **704;** panel, **613, 619,** 652; on
 paper, 827; Renaissance, 617–18, 665–72, 683–87,
 691–97, 704–9; Renaissance, early, 652–60; Rococo,
 809–12; Roman (ancient), 944; Romantic, 941–50,
 953, 958–62; Spanish, 746–47, 777–80
Painting, Joan Miró, 1087–88, *1087,* 1112, 1114
pakalala (Kongo), 918
palace architecture, 662, 770–73
Pala dynasty (India), 823, 824
palette (painter's choice of colors), 943
Paling Style, 1070
Palissy, Bernard, 723–24; Plate, "style rustique,"
 attributed to, 724, *724*
Palladian architecture, **935–36, 1137**
Palladio, Andrea, 707, 709–11, 746, 770, 935, 967;
 Church of San Giorgio Maggiore, Venice, Italy,
 710–11, *710,* 817; *Four Books of Architecture,* 711, 800,
 817; Villa Rotonda (Villa Capra), Vicenza, Venetia,
 Italy, 711, *711,* 770, 936, 967
Palmer, Erastus Dow, 996; *The White Captive,* 996, *997*
panel painting, **613, 619,** 652
Panini, Giovanni Paolo, 933; *View of the Piazza del
 Popolo, Rome,* 933, *933*
Pantheon, Rome, Italy, 711
Panthéon (Church of Sainte-Geneviève), Paris, France,
 Jacques-Germain Soufflot, 950–51, *950, 951*
Panthéon-Nadar (photograph series), 989
Paolozzi, Eduardo, 1128
paper, 674; painting on, 827
Papua New Guinea, 898–99
Paris, France, 953, 955, 981, 990, 1029, 1080–81, 1088;
 University of, 615; *see also* Arc de Triomphe;
 Carrousel Arch; Centre National d'Art et de Culture
 Georges Pompidou; Eiffel Tower; Louvre, Palais du;
 Opéra; Panthéon (Church of Sainte-Geneviève);
 Sainte-Geneviève, Bibliothèque; Soubise, Hôtel de;
 Vendôme Column
Paris Salon, **929,** 953, 984, 1008, 1013, 1014, **1029**
Paris Universal Exposition (1889), 1069
Park, David, 1123
Park, The, Stourhead, Wiltshire, England, Henry Flitcroft
 (with Henry Hoare), *938,* 939
Parkinson, Sydney, 903, 904; *Portrait of a Maori*
 (drawing), 902, 903, *904*
Parma, Italy, Cathedral, 686–87, *687*
Parmigianino (Francesco Mazzola), 712, 714, 723, 785;
 Madonna with the Long Neck, 714, *714,* 721
Parnassian poets, 1029
Parrish, Maxfield, 1028
Parson Capen House, Topsfield, Massachusetts, 816, *816*
parterre, 770
Patterson, James, Mount Vernon (with George
 Washington), Fairfax County, Virginia, 967, *967*
Paul III, Pope, 699
Paul V, Pope, 701, 756
Paxton, Joseph, 978, 980; Crystal Palace, London,
 England, 978, *978,* 980, 1069
Pearlstein, Philip, 1123, 1142; *Two Models, One Seated,*
 1123, *1123,* 1142, 1143
pedestal, **645,** *645,* **755**
pediment, **645,** *645,* **660, 754, 755,** *755,* **936**
Peeters, Clara, 785; *Still Life with Flowers, Goblet, Dried
 Fruit, and Pretzels,* *784,* 785
Pelham, Peter, 818
Pencil of Nature, The (book), Talbot, William Henry Fox,
 987; *The Open Door,* 986, 987
Pennsylvania Academy of the Fine Arts, 1001, 1094
Percy, Hugh, duke of Northumberland, 937
period, **29,** 31
peristyle, 699
Perrault, Charles, 785
Perrault, Claude, 770
Perreault, John, 1164
Persia (modern Iran), influence on Indian art, 827, 829
perspective: atmospheric (aerial), **30,** 623, 624, 655, 666,
 733; diagonal, **30;** divergent, **30;** intuitive, **30,** **624,**
 657; linear (scientific, mathematical, one-point), **30,**
 624, 638, 641, 646, 648, 653, 655, 657, 666, 667, 670,
 673, **684,** 729, 734, 785; two-point, *30;* vertical, **30**
Peru, 776, 882
Perugino (Pietro Vannucci), 669–70, 694; *Delivery of the*

Keys to Saint Peter (wall fresco), Rome, Italy, Vatican
 Palace, Sistine Chapel, 669–70, *669,* 686, 691
Philadelphia, Pennsylvania. *See* Guild House
Philip II, of Spain, 681, 691, 707, 728, 743, 745–46
Philip II and His Family, Pompeo Leoni, *746,* 761
Philip III, of Spain, 776
Philip IV, of Spain, 776, 778, 781
Philip the Bold of Burgundy, 615, 617
Philip the Good of Burgundy, 612, 621, 635
Philosopher Giving a Lecture on the Orrery, A, Joseph
 Wright, 943, *943*
Photodynamism, 1059
Photograph of Jackson Pollock painting, Hans Namuth,
 1116, *1117*
photography: American, 998–1002, 1103; as art, 988–89,
 1096; documentary, 1095, 1099, 1103; early, 985–89;
 effect on art, 982, 1028–29; portrait, 988–89; post–
 World War II, 1139–42; and realism, 16–18; rebellion
 against, 1005; scientific, 1002; technique, 18, 987
photojournalism, 1139–40
photomontage, **1077,** 1084
Photo-Secession group, 1096
Piano, Renzo, 1138; Centre National d'Art et de Culture
 Georges Pompidou (with Richard Rogers), Paris,
 France, 1138, *1138*
piano nobile, 645, *645*
piazza, **645, 709, 762**
Piazza del Campidoglio, Rome (print), Étienne Dupérac,
 699–700, *700*
Picasso, Pablo, 1052, 1053–55, 1126, 1154; Blue Period,
 1048; *Les Demoiselles d'Avignon,* 1049–51, *1050,* 1052,
 1075, 1118; *Les Demoiselles d'Avignon,* study for,
 1050–51, *1050;* early art, 1048–51; exhibitions, 1096,
 1097, 1104; *Glass and Bottle of Suze,* 1054, *1054;*
 Iberian Period, 1049–51; influence of, 1109, 1116, 1120,
 1128, 1153, 1163; *Ma Jolie,* 1053–54, *1053,* 1077, 1118,
 1132, 1163; *Mandolin and Clarinet,* 1054–55, *1055,*
 1061; reaction to World War I, 1074; Rose Period, 1048;
 Self-Portrait, 1048, *1048; Self-Portrait with Palette,* 1049,
 1049; Woman in White (Madame Picasso), 1074, *1074*
pictorial depth, **29**
pictorial space, **29**
picture plane, **29, 620, 624, 670, 684**
picturesque subject, **931, 935**
pier, **1064**
Piero della Francesca, 660, 665–67; *Battista Sforza* and
 Federico da Montefeltro (pendant portraits), 659, 666–
 67, *667; Discovery and Testing of the True Cross* (fresco),
 Arezzo, Italy, Church of San Francesco, 666, *666*
pietà (in Christian art), **688–89**
Pietà (Rondanini), Michelangelo, 688–89, *688,* 690,
 698–99, *698*
pietra dura, **831**
pietra serena, 643–44, 663
Pigalle, Jean-Baptiste, 951–52; *Monument to the Maréchal
 de Saxe,* 951–52, *952; Portrait of Diderot,* 952, *953*
pilaster, **638, 645, 755, 967**
Piles, Roger de, *The Principles of Painting,* 785
pilgrimage churches, 24
Pilgrimage to Cythera, The, Jean-Antoine Watteau, 809, *809*
Pinchot, Gifford, 1062
Pine Spirit, Wu Guanzhong, *850,* 851
Piper, Adrian, 1156
Piranesi, Giovanni Battista, 933–34; *Le Antichità Romane
 (Roman Antiquities),* 933–34; *The Arch of Drusus,* 933,
 933
Pissarro, Camille, 1010–11, 1023, 1028; *A Cowherd on
 the Route du Chou, Pontoise,* 1010, 1011
Pittura, La, Artemisia Gentileschi, 769, *769,* 1090
Pity, William Blake, 948, *948*
Pius VII, Pope, 768
Pizarro, Francisco, 882
"Places with a Past," Spoleto Festival U.S.A. (Charleston,
 South Carolina, 1991), 1159–60
plaiting (basketry), **888**
plan (architecture), **31**
Planche, Gustave, 994
Plan for a Contemporary City of Three Million
 Inhabitants, Le Corbusier, 1080–81, *1080,* 1135, 1136
Plate, "style rustique," Bernard Palissy, attributed to, 724,
 724
Plato, 641, 1031
Plaza Dressing Table, Michael Graves, 1138, *1138*
plein air painting, 1010
plinth, **717, 942**
Plowing in the Nivernais: The Dressing of the Vines, Rosa
 Bonheur, 990–92, *991*
pluralism, **1149**
Poet on a Mountain Top (handscroll), Shen Zhou, 846,
 846, 857
Pohnpei, Micronesia, 900

Sekisui, Ito, 870; Ceramic vessel, 870, *870*
Self-Portrait, Leonora Carrington, 1089, *1089*
Self-Portrait, Caterina van Hemessen, 728, *729*
Self-Portrait, Judith Leyster, 788, 789
Self-Portrait, Pablo Picasso, 1048, *1048*
Self-Portrait, Rembrandt van Rijn, 791, *792*
Self-Portrait Nude, Egon Schiele, 1039, *1039*
Self-Portrait with an Amber Necklace, Paula Modersohn-Becker, *1044*, 1045
Self-Portrait with a Sprig of Eryngium, Albrecht Dürer, *732*, 733
Self-Portrait with Palette, Pablo Picasso, 1049, *1049*
Self-Portrait with Two Pupils, Mademoiselle Marie Gabrielle Capet and Mademoiselle Carreux de Rosemond, Adélaïde Labille-Guiard, *954*, 955
Senefelder, Aloys, 985
Sen no Rikyu, 861; Myoki-an Temple, Tai-an tearoom, Kyoto, Japan, 861, *861*
sepia, **964**
Sepik River, Papua New Guinea. *See tamberan* house (Abelam culture)
Serlio, Sebastiano, 741, 745
Serra, Richard, 1161–62, 1165; *Tilted Arc*, 1161–62, *1161*, 1165
Sesshu, 857–58, 860; *Winter Landscape*, 857–58, *857*
setback, 1065
Seurat, Georges, 1026, 1033–34; *A Sunday Afternoon on the Island of La Grande Jatte*, 1033–34, *1034*, 1079
Severn River, bridge over, Coalbrookdale, England, Abraham Darby, III, *943*
Sévigné, Madame de, 805
Sèvres-Brimborion, View toward Paris, Jean-Baptiste-Camille Corot, 990, *991*, 1014
Sèvres Royal Porcelain Factory (France), 811; Potpourri jar, 814, *815*
Sforza, Battista, 666–67
Sforza, Lodovico, 684
Sforza family, 641, 699
sfumato, **686**
shaft, **645**, *645*
Shah Jahan, Indian ruler, 827, 830
Shakespeare, William, *Macbeth*, 800
Shakyamuni Buddha, 823
Shallow-Space Constructions, Turrell, James, 1134
shamanism, in Shang China, 837
Shang dynasty (China), 837
shape, **29**
Shapolsky et al. Manhattan Real Estate Holdings, a Real-Time Social System, as of May 1, 1971, Hans Haacke, 1144, *1144*
"Sharp Focus Realism" exhibition (New York, 1972), 1142
She, Richard Hamilton, 1128, *1129*
Sheeler, Charles, 1099–1100, 1104; *American Landscape*, 1099–1100, *1099*, 1104
Shen Zhou, 846; *Poet on a Mountain Top* (handscroll), 846, *846*, 857
Sherman, Cindy, 1156–57; *Untitled Film Still*, 1157, *1157*
Shimamoto, Shozo, 1125; *Hurling Colors* (happening), *1124*, 1125
Shimomura, Roger, *Diary*, 25, *25*
Shinn, Everett, 1094
Shinto, 855
Shiro, Tsujimura, 870; Ceramic vessel, 870, *870*
Shitao, 848–51; *Landscape* (album), *850*, 851
shoin architecture, **862**
shoji screens, **862**
Shona people (Great Zimbabwe), 911
Shoppers, The, Duane Hanson, 1143–44, *1144*
Shoulder bag (Native American, Delaware), 884, *884*
Shubun, 856
Shute, John, 741
Sidney Janis Gallery, "Sharp Focus Realism" exhibition (New York, 1972), 1142
Siena, Italy, Cathedral Baptistry, 649, *649*
Sight, detail. *See* Brueghel, Jan, Allegories of the Five Senses
Signboard of Gersaint, The, Jean-Antoine Watteau, 809–10, *810*
Silhouettes (performances), Mendieta, Ana, 1149
silver work, Inka, 880
Siqueiros, David, 1103, 1116
Sisters of the Artist and Their Governess, The, Sofonisba Anguissola, 716, *716*
Sistine Chapel. *See* Vatican Palace
Sistine tapestries, Raphael, 693–95, *693*
site-specific sculpture, **1145**
Sixtus IV, Pope, 669
Sixtus V, Pope, 753
sketch aesthetics, 1009
Skirt of Queen Kamamalu (Hawaiian), 902, *902*
skyscrapers, American, 1064–66

slavery, 928, 959
Slavophile movement, 1060
Sleep of Reason Produces Monsters. See Goya y Lucientes, Francisco, *Los Caprichos*
slip (pottery), **897**, **1163**
Sloan, John, 1028, 1094–95; *Backyards, Greenwich Village*, 1094–95, *1094*
Slow Swirl by the Edge of the Sea, Mark Rothko, 1111, 1115, *1115*, 1116
Sluter, Claus, 617–18, 620; Well of Moses, Dijon, France, Chartreuse de Champmol, 617–18, *617*
Small Cowper Madonna, The, Raphael, 686, *686*, 738
Smibert, John, 818; *Dean George Berkeley and His Family (The Bermuda Group)*, 818, *818*
Smith, David, 1120–21, 1132
 Cubi series, 1132; *Cubi XIX*, 1132, *1133*
 Tank Totem series, 1120–21; *Tank Totem III* and *IV*, 1120–21, *1121*, 1132
Smith, Jaune Quick-to-See, 891; *Trade (Gifts for Trading Land with White People)*, 891, *891*
Smithson, Robert, 1145–46; *Spiral Jetty*, 1146, *1146*
Smithsonian Institution, Washington, D.C., James Renwick, Jr., 969–70, *969*
Smythson, Robert, 745; Wollaton Hall, Nottinghamshire, England, 744, 745, *745*, 803
Snap the Whip, Winslow Homer, *1000*, 1001, 1093
Soap Bubbles, Jean-Siméon Chardin, 811, *812*
Sobel, Janet, 1116
Social Darwinism, 1095
Socialism, 1075
Socialist Realism (U.S.S.R.), 1077
Social Realists (American), 1102–3
Society of Etchers, 1005
Song dynasty (China), 836, 837, 838–39, 841–42, 843
Songhay, empire of, 911
Songye people (Zaire), 917–18
Sorel, Agnès, 638
Sotatsu, Tawaraya, 863; Matsushima screens, 863, *864–65*
Soubise, Hôtel de, Salon de la Princesse, Paris, France, Germain Boffrand, *804*, 805
Soufflot, Jacques-Germain, 950–51; Panthéon (Church of Sainte-Geneviève), Paris, France, 950–51, *950*
South America, indigenous peoples, 879–82
space, **29**
Spain, 681, 727, 745–47, 776, 965–66; American colonies, 776, 817; conquest of Americas, 882–83; Golden Age, 776
spandrel, **695**, **831**
Spanish Armada, 745
Spanish art: architecture, 745–46, 776–77; Baroque, 776–80; eighteenth-century, 964–66; Hispano-Flemish, 637–38; painting, 746–47, 777–80; sculpture, 746
spatial qualities, **29**
Spencer, Herbert, 1095
Spiral Jetty, Robert Smithson, 1146, *1146*
Spirit figure (*boteba*) (Lobi culture), Burkina Faso, 916, 917
Spirit mask (Guro culture), Côte d'Ivoire, 924, *924*
Spirit of Haida Gwaii, The, Bill Reid, 888, *888*
Spirit of Our Time, The, Raoul Hausmann, 1084, *1084*
Spirit spouse (*blolo bla*) (Baule culture), Côte d'Ivoire, 918, *918*
spirit world, in African art, 916–19
Spoleto Festival U.S.A. (Charleston, South Carolina, 1991), "Places with a Past," 1159–60
Spring Dawn in the Han Palace (handscroll), Qiu Ying, 842, *843*
Spring Showers, Alfred Stieglitz, 1096, *1096*
Staël, Madame de, 804–5
Staffelstein, Germany. *See* Vierzehnheiligen, Church of the
stage design, Baroque, 800
staircases, 722; monumental, 662
Stalin, Joseph, 1077
Standing Woman (Elevation), Gaston Lachaise, 1098–99, *1098*
Stanford, Leland, 1002
Stanza della Segnatura. *See* Vatican Palace
Starry Night, The, Vincent van Gogh, 1036–37, *1037*, 1109
States of Mind: The Farewells, Umberto Boccioni, 1058–59, *1058*
statues, 650, 688; freestanding, 650, 688
steel building construction, **32**, 980, 1064–65
Steen, Jan, 22–23, 795–97; *The Drawing Lesson*, 23, *23*; *The Feast of Saint Nicholas*, 795–97, *795*, 811
Steichen, Edward, 1096
Steiner House, Vienna, Austria, Adolf Loos, 1072–73, *1072*
Steinlen, Alexandre, 1028
Stella, Frank, 1132; *"Die Fahne Hoch,"* 1132, *1132*
Stieglitz, Alfred, 1096, 1097; *Spring Showers*, 1096, *1096*

Stijl, de, 1082
Stile floreale, 1070
Stile Liberty, 1070
Still, Clyfford, 1120, 1123
still life, **23**, **777**, 986–87; Dutch, 797–800
Still Life, Le Corbusier, 1079, *1079*
Still Life with Flowers, Goblet, Dried Fruit, and Pretzels, Clara Peeters, 784, 785
Still Life with Lemon Peel, Wilhelm Kalf, 798, *798*
Still Life with Quince, Cabbage, Melon, and Cucumber, Juan Sánchez Cotán, 777, *777*
still photography, **30**
Stone Breakers, The, Gustave Courbet, 992–93, *992*, 999, *999*, 1033
Stone Enclosure: Rock Rings, Nancy Holt, 1145, *1145*
Stonehenge, Salisbury Plain, England, 1145
"Store, The" exhibition, Claes Oldenburg, 1129–30, *1129*
Stoss, Veit, 740–41; *Saint Roche*, 728, 740–41, *740*
Stourhead, Wiltshire, England. *See* Park, The
Stravinsky, Igor, *The Firebird*, 1031
Strawberry Hill, Twickenham, England, Horace Walpole (and others), *938*, 939; Holbein Chamber, Richard Bentley, 939, *939*
Street, Berlin, Ernst Ludwig Kirchner, 1042, *1043*, 1081
stretcher course, **901**
stringcourse, **645**, *645*
Stubbs, George, 946–47; *Anatomy of a Horse* (book), 946; *Lion Attacking a Horse*, 946, 947
stucco, **757**, **967**, **1062**
Studiolo of Federico da Montefeltro. *See* Urbino, Italy
Stupefied Groom, Hans Baldung Grien, 736, *736*
style, **19**, **29**; meaning of term, 990
Style Guimard, 1070
subject matter of art, **29**; religious, 641, 683; secular, 641, 683, 724; traditional, 1016–17
sublime subject, **931**, **935**, 946–50
Subway, George Segal, 1123, *1123*
Suitor's Visit, The, Gerard Ter Borch, 795, *795*, 809
Sullivan, Louis, 1065–66; Wainwright Building, St. Louis, Missouri, *1064*, 1065
Summer (canvas mural), Pierre-Cécile Puvis de Chavannes, 1030, *1030*
Sumner, Charles, 970–71
sumptuary laws, 644
Sunday Afternoon on the Island of La Grande Jatte, A, Georges Seurat, 1033–34, *1034*, 1079
Sunflowers, Vincent van Gogh, 28, *28*
sunken relief, **31**
Sun Vow, Herman Atkins MacNeil, 1091, *1091*
Super Realism, 1142–44, 1149
Suprematism, 1061
Suprematist Painting (Eight Red Rectangles), Kazimir Malevich, 1060–61, *1061*
Surrealism, 1087–90, 1109, 1112, 1114, 1141
Survival series, excerpt *Protect Me from What I Want*, Jenny Holzer, 1158, *1158*
suspension, **32**
Suzhou, Jiangsu, China. *See* Garden of the Cessation of Official Life
swag, **755**, *755*
Swahili language, 911
Sweatshop, William Gropper, 1102–3, *1103*
symmetry, in African art, 922–23
Syon House, Middlesex, England, Robert Adam, 937, *937*, 967

T

tableaux vivants, 612–13
tachisme, 1112
Tai-an tearoom. *See* Myoki-an Temple
Taira clan (Japan), 855
Taj Mahal, Agra, India, 822, *822*, 829–31, *829*
Talbot, William Henry Fox, 987; *The Pencil of Nature* (book), *The Open Door*, 986, 987
Tale of Genji (Murasaki), 855
Tales of Ise, 864–66
Taliesin, Spring Green, Wisconsin, Frank Lloyd Wright, 1067–68, *1067*
tamberan house (Abelam culture), Sepik River, Papua New Guinea, 898–99, *898*
Tang dynasty (China), 836, 837, 839, 843, 845
Tank Totem series, *Tank Totem III* and *IV* from, David Smith, 1120–21, *1121*, 1132
Tanner, Henry Ossawa, 1091–92; *The Thankful Poor*, 1092, *1092*
Tansey, Mark, 1153–54; *Triumph of the New York School*, 1153–54, *1153*
tantric Buddhism, 823
Taos Pueblo (photograph), Laura Gilpin, 889, *889*

Credits